# Digital Course Materials

for

## *Art Matters*

### PAMELA GORDON

Carefully scratch off the silver coating (e.g., with a coin) to see your personal redemption code.

This code can be used only once and cannot be shared.

**Once the code has been revealed, this access card cannot be returned to the publisher. Access can also be purchased online during the registration process.**

The code on this card is valid for two years from the date of first purchase. Complete terms and conditions are available at **oup-arc.com**

Access Length: 6 months from redemption of the code.

**OXFORD**
UNIVERSITY PRESS

---

Directions for a
**Oxford University Press**

MW00789642

Your OUP digital course materials can be delivered several different ways, depending on how your instructor has elected to incorporate them into his or her course.

**BEFORE REGISTERING FOR ACCESS, be sure to check with your instructor to ensure that you register using the proper method.**

## VIA YOUR SCHOOL'S LEARNING MANAGEMENT SYSTEM

Use this method if your instructor has integrated these resources into your school's Learning Management System (LMS)—Blackboard, Canvas, Brightspace, Moodle, or other

> Log in to your instructor's course within your school's LMS.

> When you click a link to a resource that is access-protected, you will be prompted to register for access.

> Follow the on-screen instructions.

> Enter your personal redemption code (or purchase access) when prompted on the checkout screen.

## VIA THE OUP SITE

Use this method if your instructor has NOT integrated these resources into your school's LMS, and you are using the resources for self-study only. **NOTE:** *Scores for any quizzes you take on the OUP site will not report to your instructor's gradebook.*

> **Visit oup.com/he/gordon**

> Select the edition you are using, then select student resources for that edition.

> Click the link to upgrade your access to the student resources.

> Follow the on-screen instructions.

> Enter your personal redemption code (or purchase access) when prompted on the checkout screen.

## VIA OUP DASHBOARD

Use this method only if your instructor has specifically instructed you to enroll in a Dashboard course. **NOTE:** *If your instructor is using these resources within your school's LMS, use the Learning Management System instructions.*

> Visit **register.dashboard.oup.com** and select your textbook.

> Follow the on-screen instructions to identify your specific course section.

> Enter your personal redemption code (or purchase access) when prompted on the checkout screen.

> Once you complete your registration, you are automatically enrolled in your Dashboard course.

*For assistance with code redemption, Dashboard registration, or if you redeemed your code using the wrong method for your course, please contact our customer support team at **dashboard.support@oup.com** or 855-281-8749.*

Oxford University Press is a department of the University of Oxford.
It furthers the University's objective of excellence in research, scholarship,
and education by publishing worldwide. Oxford is a registered trade mark of
Oxford University Press in the UK and certain other countries.

Published in the United States of America by Oxford University Press
198 Madison Avenue, New York, NY 10016, United States of America.

© 2020 by Oxford University Press

For titles covered by Section 112 of the US Higher Education
Opportunity Act, please visit www.oup.com/us/he for the latest
information about pricing and alternate formats.

**Library of Congress Cataloging-in-Publication Data**

Names: Gordon, Pamela (Lecturer in art), author.
Title: Art matters : a contemporary approach to art appreciation / Pamela
  Gordon, Norwalk Community College.
Description: First edition. | New York : Oxford University Press, 2020. |
  Includes bibliographical references and index.
Identifiers: LCCN 2019038534 (print) | LCCN 2019038535 (ebook) | ISBN
  9780199946518 (paperback) | ISBN 9780199946556 (epub)
Subjects: LCSH: Art appreciation.
Classification: LCC N7477 .G67 2020  (print) | LCC N7477  (ebook) | DDC
  701/.18—dc23
LC record available at https://lccn.loc.gov/2019038534
LC ebook record available at https://lccn.loc.gov/2019038535

Printing number: 9  8  7  6  5  4  3  2  1
Printed by LSC Communications, Inc.
United States of America

# art
# MATTERS

**A Contemporary Approach to Art Appreciation**

## PAMELA GORDON

*Norwalk Community College*

New York      Oxford

OXFORD UNIVERSITY PRESS

*Art Matters* is dedicated to my husband, David.
Without his love, support, ideas, and inspiration, there would be no book.

# Brief Contents

Preface    xviii

**Part 1**    Introduction    1

  **1**    Art Matters    2

  **2**    What Is Art?    34

**Part 2**    The Language of Art    65

  **3**    The Visual Elements of Art    66

  **4**    The Principles of Design    102

**Part 3**    The Media    128

  **5**    Drawing    129

  **6**    Painting    151

  **7**    Printmaking    175

  **8**    Photography, Film, and Video    202

  **9**    Graphic Design    228

  **10**    Sculpture    248

  **11**    Traditional Craft Media    273

  **12**    Architecture    299

**Part 4**    The History of Art    329

  **13**    The Art of Prehistory and Ancient Civilizations in Europe and the Mediterranean    330

    Connections    Power, Servitude, and Ambition    364

  **14**    Early Jewish and Christian, Byzantine, and Medieval Art    366

    Connections    The Divine, Sacred Spaces, and Prayers    392

  **15**    Renaissance and Baroque Art    394

    Connections    War, Death, and Remembrance    426

  **16**    The Art of Africa and Islam    428

    Connections    Love, Birth, and Growing Up    451

  **17**    The Art of the Pacific and the Americas    453

    Connections    Wildlife, the Land, and the Environment    477

  **18**    The Art of Asia    479

    Connections    Work, Play, and Relaxation    510

  **19**    Eighteenth- and Nineteenth-Century Art in the West    512

    Connections    Art, the Artist, and the Inner Mind    541

  **20**    Modern Art in the Twentieth-Century Western World    543

    Connections    Suffering, Health, and Survival    575

  **21**    Art Since 1980    577

    Connections    Identity, Discrimination, and Social Ties    606

Glossary    G-1

Endnotes    E-1

Credits    C-1

Index    I-1

# Contents

Preface   xviii

**Part 1**   Introduction   1

**Chapter 1** Art Matters   2

   HOW ART MATTERS   Maya Lin's Vietnam Veterans Memorial   3

### The Importance of Art   6
   A Central Part of Our Lives   *7*
   A Strongly Supported Endeavor   *10*
      DELVE DEEPER   *Conserving Art*   14
   A Benefit to Society   *15*
   A Basis of Power   *16*
   *Practice* Art Matters **1.1**   Explore Whether Some Art Should Be Censored   19
   *Practice* Art Matters **1.2**   Explain Why a Memorial Shows How Art Matters   20

### The Purposes of Art   20
   Religion and Spirituality   *21*
   Politics and the Social Order   *22*
   *Practice* Art Matters **1.3**   Figure Out the Purpose of a Work of Art   24
   Recording and Communicating Information   *25*
   *Practice* Art Matters **1.4**   Judge Whether an Image Is Reliable   27
   Decoration   *28*
   Expression   *29*
   Social Action   *31*
   HOW ART MATTERS   A Look Back at the Vietnam Veterans Memorial   33

**Chapter 2** What Is Art?   34

   HOW ART MATTERS   Barnett Newman's *Voice of Fire*   35

### Defining Art   37
   Art as a Physical Object Made from Artistic Materials   *38*
   Art as an Aesthetic Experience   *39*
   Art as an Object of Value   *41*
   Art as Part of the Canon   *42*
   Art as a Work Crafted with Skill   *45*
   Art as a Work That Has Meaning   *47*
   *Practice* Art Matters **2.1**   Consider How Cultural Perception Impacts Views   50
   *Practice* Art Matters **2.2**   Explore How Physical Perception Changes Meaning   51
   Art as a Creative Work   *52*
   *Practice* Art Matters **2.3**   Discover How to Approach a Difficult Work of Art   55

**The Themes, Types, and Ingredients of Art   56**

Themes of Art   *56*

*Practice* Art Matters **2.4**   Judge What Theme a Work of Art Concerns   57

Types of Art   *58*

Ingredients of Art   *59*

**HOW ART MATTERS**   A Look Back at *Voice of Fire*   64

**Part 2**   The Language of Art   65

**Chapter 3**   The Visual Elements of Art   66

**HOW ART MATTERS**   Vincent van Gogh's Letters and Art   67

**Line   70**

The Character of Lines   *70*

The Direction of Lines   *70*

Actual and Implied Lines   *71*

The Different Uses of Lines   *71*

*Practice* Art Matters **3.1**   See How Lines Draw Attention   74

**Shape   74**

The Character and Direction of Shapes   *75*

Geometric and Organic Shapes   *75*

Positive and Negative Shapes   *75*

Overall Shapes   *77*

**Mass   77**

The Character and Direction of Masses   *77*

Geometric and Organic Masses   *78*

Mass and Negative Space   *78*

*Practice* Art Matters **3.2**   Explore the Masses of a Car   78

**Texture   78**

Actual and Simulated Texture in Two-Dimensional Works   *79*

Actual and Simulated Texture in Three-Dimensional Works   *79*

**Light and Value   80**

Light   *80*

Value   *80*

Light Hitting Three-Dimensional Opaque Objects   *81*

*Chiaroscuro*   *81*

Value to Heighten Expression   *81*

Light as a Material   *82*

**Color   82**

The Visible Spectrum   *83*

Why We See Color   *83*

The Subtractive and Additive Color Systems   *83*

DELVE DEEPER   *The Additive Color System*   84

The Color Wheel   *85*

The Properties of Color    *85*
Color Schemes    *86*

*Practice* Art Matters **3.3**    Discover How Scheme Impacts Content    90
The Characteristics of Color    *91*

**Space    92**
Three-Dimensional Space    *92*
Two-Dimensional Space    *93*

**Time    98**
HOW ART MATTERS    A Look Back at Vincent van Gogh's Letters and Art    100

**Chapter 4    The Principles of Design    102**
HOW ART MATTERS    The Taj Mahal    103

**Unity and Variety    107**
*Practice* Art Matters **4.1**    Identify How an Artist Created Variety and Unity    109

**Balance    109**
Symmetrical Balance    *111*
Asymmetrical Balance    *112*
Radial Balance    *113*

**Emphasis and Subordination    114**
*Practice* Art Matters **4.2**    Determine What Makes Something Visually Heavy    115

**Scale    118**

**Proportion    121**
*Practice* Art Matters **4.3**    Consider How Size Affects a Painting    122

**Rhythm    123**
DELVE DEEPER *The Golden Section*    124
HOW ART MATTERS    A Look Back at the Taj Mahal    126

**Part 3    The Media    128**

**Chapter 5    Drawing    129**
HOW ART MATTERS    Pablo Picasso's *Guernica* Drawings    130

**What Drawing Is    133**
An Intense Way to See    *134*
*Practice* Art Matters **5.1**    Observe a Piece of Fruit with Intensity    135
A Way to Understand the Creative Process    *135*
A Way to Take Notes    *136*
A Finished Work of Art    *137*

**Different Drawing Materials    138**
Drawing Surfaces and Tools    *138*

Dry Media   *139*

*Practice* Art Matters   **5.2**   Use Different Surfaces and Tools   139

Liquid Media   *145*

DELVE DEEPER   *Mixed Media*   148

Digital Drawing   *149*

HOW ART MATTERS   A Look Back at the *Guernica* Drawings   149

**Chapter 6**   Painting   151

HOW ART MATTERS   Judy Baca's *The Great Wall of Los Angeles*   152

**What Painting Is**   **155**

An Application of Paint   *155*

An Artform Created with Layers, Tools, and Techniques   *155*

A Message to Viewers   *158*

**Different Painting Media**   **159**

Encaustic   *159*

*Practice* Art Matters   **6.1**   Observe an Encaustic Painting Up Close   160

*Fresco*   *161*

*Practice* Art Matters   **6.2**   Consider the *Fresco* Painting of a Modern Artist   163

Tempera   *164*

Oil   *166*

Transparent Watercolor   *166*

*Practice* Art Matters   **6.3**   Compare Two Annunciations Created in Oil Paint   168

Gouache   *169*

Acrylics   *170*

Digital Painting   *172*

HOW ART MATTERS   A Look Back at *The Great Wall of Los Angeles*   174

**Chapter 7**   Printmaking   175

HOW ART MATTERS   The Prints of Honoré Daumier   176

**What Printmaking Is**   **179**

An Indirect, Two-Dimensional Art   *179*

A Collaborative Process   *179*

An Art of Multiple Originals   *180*

An Art Form   *182*

*Practice* Art Matters   **7.1**   Compare Two States   183

**Different Printmaking Techniques**   **184**

Relief   *184*

DELVE DEEPER   *Color Woodcut*   187

Intaglio   *190*

Planographic   *194*

*Practice* Art Matters   **7.2**   Compare an Aquatint and an Etching   195

Stencil   *197*

New Directions   *199*

HOW ART MATTERS   A Look Back at the Prints of Honoré Daumier   201

**Chapter 8**    Photography, Film, and Video    202

    HOW ART MATTERS    D. W. Griffith's Film *The Birth of a Nation*    203

    **Photography    205**

        What Photography Is    *205*

        *Practice* Art Matters    **8.1**    Contrast Two Photographers' Different Visions    209

        Different Types of Photographs    *212*

    **Film    214**

        What Film Is    *214*

        *Practice* Art Matters    **8.2**    See How a Film Helped Make a Difference    220

        Different Types of Films    *220*

    **Video    224**

        What Video Is    *224*

        Different Types of Videos    *225*

    HOW ART MATTERS    A Look Back at *The Birth of a Nation*    227

**Chapter 9**    Graphic Design    228

    HOW ART MATTERS    The Graphic Design for the Beijing Olympic Games    229

    **What Graphic Design Is    233**

        A Client's Message to a Specific Audience    *233*

        A Straightforward and Multiple Form of Communication    *234*

        DELVE DEEPER    *The Ancient Art of Graphic Design*    235

        An Art Form    *235*

    **Components of Graphic Design    236**

        Images    *237*

        Type    *239*

        Layout    *240*

        *Practice* Art Matters    **9.1**    Determine Why a Typeface Might Be Incompatible    241

    **Different Types of Graphic Design    242**

        Signs, Publications, and Packaging    *242*

        Corporate Identities    *243*

        *Practice* Art Matters    **9.2**    Compare an Updated Logo with the Original    244

        Motion Graphics and Interactive Digital Media    *245*

    HOW ART MATTERS    A Look Back at the Graphic Design for the Beijing
                         Olympic Games    246

**Chapter 10**    Sculpture    248

    HOW ART MATTERS    *Akua'mma* Sculptures    249

    **What Sculpture Is    251**

        A Three-Dimensional Work of Art    *251*

        An Art Form Created from Tangible Materials    *253*

        *Practice* Art Matters    **10.1**    Examine How Gold Affects a Sculpture    255

        A Meaningful Expression    *255*

**Different Types of Sculptures**  **255**
   Freestanding Sculptures  *256*
   Relief Sculptures  *257*
   Earthworks  *259*
   Installations  *260*
   *Practice* Art Matters  **10.2**  Consider the Changing Nature of Earthworks  260

**Different Sculpture Techniques**  **262**
   Carving  *262*
   Modeling  *265*
   Casting  *266*
   Constructing and Assembling  *268*
      DELVE DEEPER  *Casting Human Figures*  269
      *Practice* Art Matters  **10.3**  Evaluate Who Should Decide the Fate of Public Art  270
   Digital Sculpting  *270*
   HOW ART MATTERS  A Look Back at *Akua'mma* Sculptures  272

**Chapter 11**  Traditional Craft Media  **273**
   HOW ART MATTERS  The Pottery of Maria Martinez  274

**Conflicting Definitions of Craft**  **276**
   Skill versus Intellect  *276*
   Utility versus Appearance  *278*
   Individuality versus Mass Production  *279*
   *Practice* Art Matters  **11.1**  Consider Whether Mass-Produced Pots Are Art  280
   Handmade Feel versus Perfection  *280*
   Reflections of Societies versus Lone Visions  *280*
   *Practice* Art Matters  **11.2**  Explore How a Work Challenges Definitions of Craft  281

**Media Traditionally Associated with Craft**  **282**
   Clay  *282*
   Glass  *286*
   Metal  *289*
   Wood  *291*
   Fiber  *291*
      DELVE DEEPER  *Computer-Controlled Looms*  294
   HOW ART MATTERS  A Look Back at the Pottery of Maria Martinez  298

**Chapter 12**  Architecture  **299**
   HOW ART MATTERS  The Pantheon  300

**What Architecture Is**  **303**
   A Functional Place  *303*
   A Three-Dimensional Work  *304*
   A Work in an Environment  *305*
   A Collaborative and Individual Art Form  *307*
   An Art Form Structured to Withstand Forces  *309*

**Shell Construction Methods**   311

Load-Bearing and Corbel   *311*

Post-and-Lintel and Cantilever   *313*

  *Practice* Art Matters **12.1**   Explain Why a Paper Lintel Falls Down   314

  DELVE DEEPER  *The Three Orders*   316

Arch, Vault, and Dome   *317*

  *Practice* Art Matters **12.2**   Determine the Forces That Act on a Paper Arch   317

  *Practice* Art Matters **12.3**   Describe Why a Paper Pointed Arch Nearly Stands   319

  *Practice* Art Matters **12.4**   Explore the Effect of a Cup's Continuous Surface   321

Reinforced Concrete Construction   *322*

**Skeleton-and-Skin Construction Methods**   323

Frame Construction   *323*

Suspension   *325*

  *Practice* Art Matters **12.5**   Consider the Two Forces That Act on a Necklace   325

**Recent Innovations in Structures and Materials**   326

HOW ART MATTERS   A Look Back at the Pantheon   328

**Part 4**   The History of Art   329

**Chapter 13**   The Art of Prehistory and Ancient Civilizations in Europe and the Mediterranean   330

HOW ART MATTERS   The Parthenon Sculptures   331

**Prehistoric Cultures**   335

The Paleolithic Period   *335*

The Neolithic Period   *337*

**Early Civilizations**   338

Mesopotamia   *339*

Egypt   *343*

  *Practice* Art Matters **13.1**   Compare Sculptures of Elite and Non-Elite People   348

**The Greco-Roman World**   350

Greece   *350*

  *Practice* Art Matters **13.2**   Describe a Hellenistic Sculpture   356

Rome   *357*

HOW ART MATTERS   A Look Back at the Parthenon Sculptures   362

Connections   Power, Servitude, and Ambition   364

**Chapter 14**   Early Jewish and Christian, Byzantine, and Medieval Art   366

HOW ART MATTERS   The *Lindisfarne Gospels*   367

**The Late Roman Empire**   370

The Diverse Roman World   *370*

Christianity in the Period of Persecution   *372*

Christianity under Constantine   *373*

   *Practice* Art Matters   **14.1**   Label the Parts of Old St. Peter's   375

**The Byzantine Empire   376**

The Emperor Justinian and the Empress Theodora   *376*

Icons and Iconoclasm   *377*

   *Practice* Art Matters   **14.2**   Compare Images on a Chalice and an Icon   379

**The Middle Ages   379**

Early Medieval   *380*

Romanesque   *382*

   DELVE DEEPER   *Relics and Reliquaries*   384

Gothic   *385*

   *Practice* Art Matters   **14.3**   Contrast Romanesque and Gothic Churches   387

Toward the Renaissance   *388*

HOW ART MATTERS   A Look Back at the *Lindisfarne Gospels*   390

Connections   The Divine, Sacred Spaces, and Prayers   392

**Chapter 15**   Renaissance and Baroque Art   394

   HOW ART MATTERS   Michelangelo's Sistine Chapel Paintings   395

**The Renaissance   399**

The Early Renaissance in Italy   *400*

   *Practice* Art Matters   **15.1**   Identify Early Renaissance Ideals in a Work   403

The High Renaissance in Italy   *404*

The Renaissance in Venice and Mannerism   *407*

The Renaissance in Northern Europe   *407*

   DELVE DEEPER   *Mannerism*   408

The Reformation   *411*

   *Practice* Art Matters   **15.2**   Explore an Artist's Relationship with the Divine   412

**The Baroque   414**

The Baroque in Italy   *414*

   *Practice* Art Matters   **15.3**   Recognize Baroque Ideas in a Work   416

The Baroque in Spain and Flanders   *418*

The Baroque in France   *420*

The Baroque in the Dutch Republic   *421*

HOW ART MATTERS   A Look Back at the Sistine Chapel Paintings   424

Connections   War, Death, and Remembrance   426

**Chapter 16**   The Art of Africa and Islam   428

   HOW ART MATTERS   The Great Mosque in Djenné, Mali   429

**Africa   432**

Early Africa   *433*

Traditional Africa   *434*

   *Practice* Art Matters   **16.1**   Identify the Features of Traditional African Art in a Work   435

**Islam**   440
   Muhammad and Islam   *440*
   Early Islam   *442*
   Medieval Islam   *444*
   *Practice* Art Matters   **16.2**   Describe the Themes of Islamic Art in a Lamp   446
   Later Islam   *447*
HOW ART MATTERS   A Look Back at the Great Mosque In Djenné, Mali   449
Connections   Love, Birth, and Growing Up   451

**Chapter 17**   The Art of the Pacific and the Americas   453
   HOW ART MATTERS   Hawaiian Featherwork   454

**The Pacific**   456
   Australia   *456*
   Melanesia   *458*
   Polynesia   *459*
   *Practice* Art Matters   **17.1**   Compare Two Polynesian Sculptures   462

**The Americas**   462
   Mesoamerica   *462*
   *Practice* Art Matters   **17.2**   Determine the Features of Aztec Society in a Work   467
   South America   *468*
   *Practice* Art Matters   **17.3**   Identify South American Themes of Art in a Tunic   471
   North America   *471*
HOW ART MATTERS   A Look Back at Hawaiian Featherwork   476
Connections   Wildlife, the Land, and the Environment   477

**Chapter 18**   The Art of Asia   479
   HOW ART MATTERS   The Japanese Tea Ceremony   480

**The Indian Subcontinent and Southeast Asia**   483
   The Early Indian Subcontinent   *484*
   Buddhism on the Indian Subcontinent and in Southeast Asia   *485*
   Hinduism in India   *489*
   *Practice* Art Matters   **18.1**   Identify the Aspects of Indian Art in a Work   490
   Islam in India   *491*

**China and Korea**   492
   Early China and Korea   *492*
   Confucianism, Daoism, Buddhism, and Their Offshoots in China   *495*
   *Practice* Art Matters   **18.2**   Recognize the Buddha's Attributes   498
   Later China   *500*

**Japan**   503
   Classical Japan   *503*
   Medieval Japan   *505*
   *Practice* Art Matters   **18.3**   Contrast Heian Period and Northern Song Dynasty Paintings   506
   Early Modern Japan   *507*

HOW ART MATTERS    A Look Back at the Japanese Tea Ceremony    509

Connections    Work, Play, and Relaxation    510

**Chapter 19    Eighteenth- and Nineteenth-Century Art in the West    512**

HOW ART MATTERS    Edouard Manet's *The Luncheon on the Grass*    513

**The Eighteenth Century    516**

The Rococo    *516*

Neoclassicism    *518*

*Practice* Art Matters    **19.1**    Identify the Neoclassical Features in a Work    520

**The Nineteenth Century    522**

Romanticism    *524*

*Practice* Art Matters    **19.2**    Contrast Neoclassical and Romantic Images    525

Realism    *527*

Impressionism    *530*

*Practice* Art Matters    **19.3**    Identify Japanese Influence in a Work    533

Post-Impressionism    *533*

Art Nouveau    *539*

HOW ART MATTERS    A Look Back at *The Luncheon on the Grass*    540

Connections    Art, the Artist, and the Inner Mind    541

**Chapter 20    Modern Art in the Twentieth-Century Western World    543**

HOW ART MATTERS    The Earth-Body Works of Ana Mendieta    544

**The Early Twentieth Century through World War II    547**

Expressionist Movements    *547*

*Practice* Art Matters    **20.1**    Identify the Features of Fauve Art    549

Cubism    *552*

DELVE DEEPER    *Responses to Analytic Cubism*    555

The Art of the Irrational    *556*

*Practice* Art Matters    **20.2**    Explain Why a Work Is Classified as Dada    558

Art for a Better World    *558*

Art in the United States    *561*

**Post–World War II through 1980    562**

The New York School    *563*

Art and Reality    *565*

Minimalism    *568*

The Art of Ideas    *569*

*Practice* Art Matters    **20.3**    Contrast the Goals of Minimalism and Conceptual Art    570

Earthworks    *571*

Combatting Prejudice    *571*

HOW ART MATTERS    A Look Back at the Earth-Body Works of Ana Mendieta    574

Connections    Suffering, Health, and Survival    575

**Chapter 21** Art Since 1980   577

   HOW ART MATTERS   The Art of Yinka Shonibare MBE   578

   **The Postmodern Period   581**

   Postmodern Ideas   *582*
   Architecture   *583*
   Painting   *585*
   Diverse Media   *586*
   *Practice* Art Matters **21.1**   Explain Why an Installation Is Postmodern   588
   Protest Art   *591*
   *Practice* Art Matters **21.2**   Consider Whether a Work Is Protest Art   593
   *Practice* Art Matters **21.3**   Explore How Museums Influence Our Views   594
   Art That Draws on Prior Work   *595*

   **The Contemporary Global World   597**

   Globalization and Art   *597*
   Art of Diverse People   *597*
   *Practice* Art Matters **21.4**   Describe How a Work References Identity   599
   Art of a Global World   *602*
   HOW ART MATTERS   A Look Back at the Art of Yinka Shonibare MBE   605
   Connections   Identity, Discrimination, and Social Ties   606

Glossary   G-1
Endnotes   E-1
Credits   C-1
Index   I-1

# Preface

## Art Matters

Have you ever been confused by a text or IM? For example, if your friend texts: "Just ate & now need ER!" Is she joking around or is something really wrong? How would you know?

When people speak to us in person, we understand what they mean because of how their gestures, facial expressions, and voices change. Without those hints, words are vague. So, how do most people replace the emotional cues that are missing from textual communication? They use emojis. Consider these two different emojis:

"Just ate & now need ER!" 😂

"Just ate & now need ER!" 😦

Invented in Japan in 1999 by Shigetaka Kurita, emojis were originally intended for use on pagers. Kurita considered emoticons, the then-popular faces created from keyboard characters, such as this one (-___-). At the time, emoticons were used to clarify text messages, just as we use emojis today. Kurita realized that emoticons had become time consuming for users to type. He decided he would create simple images that people could send using one character.

Today, emojis are a global phenomenon. More than 90 percent of people who use digital technology incorporate emojis in communications, and more than six billion are sent daily.[1] Emojis are used not only in text messages and on social networking sites, but are also found on pillows and keychains, on customer satisfaction surveys and hospital pain charts, and in books. In 2015, Oxford dictionaries named the emoji called "the face with tears of joy" 😂 its "word" of the year. While the face may not be a traditional "word," just think of how much essential language it conveys.

Chances are good that you use emojis, and they may even play an important role in your world. But have you ever considered that emojis are a type of art? In 2016, the Museum of Modern Art in New York added Kurita's original group of 176 emojis to its collection. In fact, every time you send an emoji, you are using the power of art.

What else that you use or encounter daily is considered art? How does art fit into your world? *Art Matters* will help you learn about the different *matters* pertaining to *art*, but it will also show you how *art matters* in your life. Art is accessible to anyone, and *Art Matters* will demonstrate how important, valued, and influential art can be and, also, why you should put in the effort to study and understand it.

## A Contemporary Approach

*Art Matters* offers you the ability to explore art in depth, to think about what you see, and to be drawn into **a compelling narrative and interesting stories**, like the story about the

emojis. Through *Art Matters*, you will find that art is a vibrant subject, that art has significance, and that art is worth discovering.

*Art Matters* also introduces you to the **wide range of art that is around you**. It includes an enormous assortment of types of art that numerous diverse artists have created for different people around the world. This tremendous variety will enable you to see how pervasive and critical art is in your life and how many objects that you see, and even use, on a day-to-day basis are art—from the emojis you text, to the furniture you sit on, to the building you live in, to the photographs you see. Throughout this text, you will also be exposed to numerous contemporary works to help you navigate today's art world.

*Art Matters*, furthermore, allows you to experience the **dynamic topic of art**. In your course, you may be asked to speak, write, think critically, and form conclusions about what you *see*; you may have to formulate your own opinions about previously unseen works and apply your knowledge to previously unasked questions; and you may need to speak up for what you believe in and support your point of view, all while collaborating with classmates who may have similar or opposing beliefs. *Art Matters* will guide you with these processes. By asking questions and exposing you to different viewpoints and ideas, you will learn how to experience art actively and meaningfully.

# A Structured Organization

*Art Matters* is divided into four basic parts:

- **Part 1 introduces you to the subject of art** through a discussion of traditional and contemporary topics. These topics range from the purposes, themes, types, styles, physical appearances, and symbols of art to discussions of how you can approach art that you may not like, how you can figure out the meaning of different works, why being an active viewer is so important, and why art matters. Part 1 enables you to see not only the traditional material that has always been covered in art classes, but also the new ways that people are thinking about art and how you can begin to approach art yourself.
- **Part 2 introduces you to the visual elements of art and the principles of design**—essential topics such as color, shape, proportion, and emphasis that you need to explore art. Part 2 addresses not only the physical appearance of art, but also how the way something looks affects its meaning.
- **Part 3 addresses the many types of two- and three-dimensional media**, showing you the broad number of materials and techniques that art encompasses and how much these various media are a part of the different aspects of your life.
- The final part of *Art Matters*, **Part 4, offers you a brief, contextual history of art**, delving into the main themes of different cultures and using the works of art as examples. This contextual approach helps you to understand the different cultures and introduces you to the universality of art. **Also in Part 4, special Connections sections, located after each chapter, allow you to explore universal themes in art that connect us all**. These sections show you how people from widely different backgrounds, places, genders, and time periods have much in common.

# Pedagogy to Facilitate Learning

*Art Matters* offers an array of features that allow you to explore art in depth, think critically about and apply what you are learning, retain and understand concepts, and assess your understanding:

- **"How Art Matters" stories** introduce you to art in every chapter. These in-depth narratives, like the story of the controversial print and digital materials of the Beijing Olympics in Chapter 9, are presented at the beginning of chapters, referenced at points throughout the chapter, and returned to at chapter ends. The stories allow you to slow down, discover, and reflect about art, as you progress through the chapter. They also bring art to life; show how art mattered to different people in different times and in different ways; and serve as a window into broader themes about art, society, and life.

- So that you know how to pronounce difficult terms or artists' names and see definitions of key words, **pronunciation guides** and a **marginal glossary** are placed right on the page you are reading. Additionally, to help you recognize important information that you need to know, **italics** are used throughout the text to emphasize key points.

- **Learning Objectives** included on the first page of each chapter identify the content you should master by the time you have completed the chapter.

- **"Quick Review" questions** throughout each chapter relate to chapter learning objectives and cover key points from the reading, ensuring that you understand the material before moving on to a new section.

- **"Critical Thinking" questions** at the end of each chapter ask you to analyze and synthesize what you have learned.

- **"Practice Art Matters" activities** appear several times in each chapter and are quick applications. Like the activity in Chapter 20 in which you confirm that you can identify the features of a certain style in a particular image, they make sure you can use the content you have just read.

- **"Delve Deeper" boxes** appear in certain chapters to give you the opportunity to explore topics in greater depth. These features, like the one in Chapter 3 on additive color systems used by lighting designers in theatres, enable you to see the expansive nature of the subject of art and how much more you can explore after you finish the course.

# An Instructive Art Program

The illustrations in *Art Matters* are designed not only to expose you to numerous high-quality images, but also to help you learn how to look:

- **Image Walkthroughs** "walk" you though a number of images in each chapter, pointing out important parts of artworks with arrows and descriptive labels and encouraging you to break down the different components of a work of art and understand how to look at an image.

- Numerous, author-developed **drawings, maps, timelines, diagrams, and charts** help you better grasp complex concepts.

- **Superb, color-accurate reproductions** appear throughout the text, so that your experience of seeing art in the printed book or eBook will be as close as possible to engaging with real art.

- **"Artists Matter" photos** in the margins of each chapter allow you to see what some of the artists discussed in the chapter look like, so you can relate to the creators as people.
- **Extended captions** provide you with important facts about the works of art and suggest main ideas that you can consider as you look at the illustrations.

# Digital Learning Tools

All new print and electronic versions of *Art Matters* come with access to a full suite of engaging digital learning tools that work with the text to bring content to life, reinforce key concepts, and allow you to experience art actively. Marginal callouts direct you to many of these tools.

**Digital access to *Art Matters* includes the following resources:**

- **An enhanced eBook** integrates the text's engaging narrative with a rich assortment of audio and video resources.
- **Compelling videos,** including **demonstrations of art techniques** by contemporary artists and **"How Art Matters" mini-documentaries** tied to each chapter opening, provide you with an inside look into the creation of art, further emphasize why art matters, and allow you to engage with and answer questions about multimedia content.
- **"Explore Art Matters" activities** at the end of each chapter enable you to get involved with art in a multi-part project, so that you can broadly analyze and apply what you have learned in the text. They also help you develop key competencies that you will need in life such as the ability to communicate successfully, think critically, collaborate as an effective team member, understand social and ethical responsibilities, and be aware of global and cultural issues.
- **Interactive Image Walkthroughs** guide you through two annotated artworks from each chapter, zooming in to show details. Brief multiple-choice assessments follow each interactive walkthrough.
- **Interactive timelines** for select chapters in Part IV allow you to explore the chapter's artwork outside of the textual narrative. From the timeline, jump right into the rich content of the text that interests you.
- **Quizzes, assessments, and flashcards** test your comprehension of key ideas and concepts, allow you to quiz yourself on terms and artworks, and supply immediate feedback on your understanding and knowledge. Flashcards offer recorded pronunciations of difficult-to-pronounce terms.
- **Interactive Quick Review questions** tied to each learning objective allow you to enter your own responses in the eBook and then see suggested answers.
- **An annotated bibliography** guides you to key outside sources and provides brief descriptions of these resources, so you can begin research assignments with some basic information.
- **Audio pronunciations throughout the eBook and in a separate pronunciation guide** demonstrate how to pronounce difficult terms and artists' names.

# Flexible Delivery Options for Instructors

At Oxford University Press, we create high-quality, engaging, and affordable digital material in a variety of formats, and deliver it to you in the way that best suits the needs of you, your students, and your institution. You can choose to have your students access *Art Matters* as a printed text or in one of the following ways:

- **In your local learning management system with Oxford's interoperable course cartridge**
  With an interoperable course cartridge from Oxford University Press, there is no need for you and your students to learn a separate publisher-provided courseware platform in order to access quality digital learning tools within your Learning Management System. Instructors and their LMS administrators simply download Oxford's interoperable cartridge and, with the turn of a digital key, incorporate engaging content into their LMS for assigning and grading. Download the interoperable cartridge from Oxford's online Ancillary Resource Center (ARC). See the Additional Instructor Resources section of this preface for more information on the ARC.

- **In Oxford's cloud-based Dashboard**
  Ideal for instructors who do not use a LMS or prefer an easy-to-use alternative to their school's designated LMS, Dashboard delivers engaging learning tools within an easy-to-use cloud-based courseware platform. Pre-built courses in Dashboard provide a learning experience that instructors can use off the shelf or customize to fit their course. A built-in gradebook allows instructors to quickly and easily identify trends in the course as a whole and the way individual students are performing. Visit **www.oup.com/dashboard** or contact your Oxford University Press representative to learn more.

- **In a stand-alone enhanced eBook**
  Ideal for self-study, the *Art Matters* enhanced eBook delivers the full suite of digital resources in a format that is independent from any courseware or learning management system platform. The enhanced eBook is available through leading higher education eBook vendors.

# Additional Instructor Resources

Save time in course and lecture planning with these valuable tools, most of which are available for download on Oxford's online Ancillary Resource Center (ARC):

- **High-resolution images** of all illustrations from the book for use in lectures
- **PowerPoint lecture outlines** with all of the images incorporated for each chapter
- **An instructor's manual** with detailed chapter outlines, answers to questions that appear in the text, suggested discussion topics, activities, and links to related websites
- **A computerized test bank** for building exams
- **Interoperable course cartridge** for integrating the full suite of *Art Matters* digital resources into your course

Visit www.oup.com/he/gordon or contact your Oxford University Press representative to request access.

# Reviewers, Advisors, Focus Group Participants, and Class Testers

Countless reviewers, advisors, focus group participants, and class testers (instructors *and* students) have shared their thoughts, offered advice, and provided expertise. Oxford and I are indebted to them for their feedback. We continue to seek input from instructors and students around the country on various aspects of the *Art Matters* program. To the six anonymous reviewers and hundreds of anonymous students, to all those whose thoughtful comments arrived after this preface went to press, and to everyone in the list that follows, we extend our sincere thanks.

**ALABAMA**
*Naomi Slipp (Auburn University at Montgomery)
Robin Snyder (Samford University)

**ALASKA**
*Charles E. Licka (University of Alaska–Anchorage)

**ARIZONA**
Helaine M. McLain (Northern Arizona University)
*Susan Ramos (Central Arizona College)

**ARKANSAS**
Laura Amrhein (University of Arkansas, Little Rock)

**CALIFORNIA**
Victoria Bryan (California State University, Long Beach)
Cheyanne Cortez (Foothill College)
*Patricia Drew (Irvine Valley College)
Thomas Folland (Irvine Valley College)
Guy Glassford (Golden West College)
Deborah Gustlin (Gavilan College)
Rainer Mack (Oxnard College)
Margaret Nowling (California State University, Bakersfield)
Susan Patt (La Sierra University)
Simon Pennington (Foothill College)
Michael Redfield (Saddleback College)
Craig Smith (American River College)
Masami Toku (California State University, Chico)

**CONNECTICUT**
Jim Bergesen (Norwalk Community College)
Michael Demers (Asnuntuck Community College)
Steven DiGiovanni (Norwalk Community College)
Renae Edge (Norwalk Community College)
Joan Fitzsimmons (Norwalk Community College)
Melissa Slattery (Norwalk Community College)

**DISTRICT OF COLUMBIA**
*Melanee Harvey (Howard University)

**FLORIDA**
Melissa Arrant (Chipola College)
Kristal Boyers (Palm Beach State College)
*Dorotha Lemeh (Florida Atlantic University, Jupiter)
*Kristen (KC) Williams (Northwest Florida State College)

**GEORGIA**
Charlotte Lowry Collins (Kennesaw State University)
Angus Galloway (Perimeter College at Georgia State University)
Melissa Hebert-Johnson (Columbus State University)

**ILLINOIS**
*Don Bevirt (Southwestern Illinois College)
Randy Carlson (Bradley University)
*Ivy Cooper (Southern Illinois University–Edwardsville)

*Mark DeLancey (DePaul University)
Lina Grigorova (Wilbur Wright College)
Soo Y. Kang (Chicago State University)
Marybeth Koos (Elgin Community College)
Katrinka Lally (Daley College)
Karen Patterson (Harper College)
Betty Zacate (Joliet Junior College)

**INDIANA**
John David Arnold (Ivy Tech Community College of Indiana)
Scott Frankenberger (Purdue University)
Lanette Gonzalez (Ivy Tech Community College of Indiana)
George Kassal (Purdue University, North Central)
Josh Phillipe (Ivy Tech Community College of Indiana)
*Jean Robertson (Indiana University–Purdue University Indianapolis)
Sue Uhlig (Purdue University)

**KANSAS**
*Kelly Watt (Washburn University)

**KENTUCKY**
Ingrid Cartwright (Western Kentucky University)
Adrienne DeAngelis (Morehead State University)
Laura Eklund (Madisonville Community College)
Paige Wideman (Northern Kentucky University)

* An asterisk denotes a Board of Advisors member.

LOUISIANA
Kelly McDade (Bossier Parish
Community College)
*John Wagoner (Bossier Parish
Community College)
Susan M. Zucker (Louisiana State
University)

MASSACHUSETTS
Ralph Caouette (Fitchburg
University)
Rita Moerschel (Curry College)
Julie Sawyer (University of
Massachusetts, Lowell)
*Sarahh Scher (Emerson
College)
*Gerry Ward (Museum of Fine
Arts, Boston)
Joanna Ziegler (College of the
Holy Cross)

MICHIGAN
Cat Crotchett (Western Michigan
University)
Stephanie Wooster (Grand Valley
State University)

MINNESOTA
David Hamlow (Minnesota State
University Mankato)
Lynn Metcalf (St. Cloud State
University)

MISSISSIPPI
Karlos Taylor (Jackson State
University and Belhaven
University)
Terrell Taylor (Meridian
Community College)

MISSOURI
V.A. Christensen (Missouri
Southern State University)
Kathleen Desmond (University of
Central Missouri)

NEVADA
Sharon Tetly (Western Nevada
College)

NEW JERSEY
Kay Klotzbach (Camden County
College)
Cheryl Knowles-Harrigan
(Atlantic Cape Community
College–Mays Landing)
Jennifer Noonan (Caldwell
University)

NEW MEXICO
*Susan Braun (Central New
Mexico Community College)
Todd Christensen (New Mexico
Highlands University)
Diane Reid (Central New Mexico
Community College)

NEW YORK
*Amy Gansell (St. John's
University–Queens)
Stephen Lamia (Dowling College)

NORTH CAROLINA
Laura Ginn Bailey (Alamance
Community College)
Shawnya Harris (Elizabeth City
State University)
Ann Marie Kennedy (Wake
Technical Community College)
Melissa Lovingood (High Point
University)
Sondra Martin (Fayetteville State
University)
Leo Morrissey (Winston-Salem
State University)
Jennifer Reich (University of
North Carolina, Greensboro)

OHIO
Rosemarie Basile (Ohio University)
Sherry Howard (Northwest State
Community College)
Kelly Joslin (Sinclair Community
College)
Paul Miklowski (Cuyahoga
Community College,
Metropolitan Campus)
Lisa Morrisette (Wright State
University)
*Mysoon Rizk (University of
Toledo)
Renée Waite (Marietta College)

OKLAHOMA
Cecile Crabtree (Cameron
University)
Kathleen Rivers (Eastern Central
University)

PENNSYLVANIA
Andree Flageolle (Pittsburg State
University)
Max Blobner (Community College
of Allegheny County)
Deborah Burrows (DeSales
University)
Pamela Hemzik (York College of
Pennsylvania)
*Larry Silver (University of
Pennsylvania)
Karen Stabley (York College of
Pennsylvania)
Li-Ling Tseng (Pittsburg State
University)

SOUTH CAROLINA
Karen Stock (Winthrop
University)

SOUTH DAKOTA
Carol Geu (University of South
Dakota)

TENNESSEE
Mariana Aguirre (Middle
Tennessee State University)
James Jackson (University of
Memphis)
*Tamara Smithers (Austin Peay
State University)
Jennifer Snyder (Austin Peay State
University)

TEXAS
*Rachael Bower (Northwest Vista
College)
*Kent Boyer (El Centro College)
Kurt Dyrhaug (Lamar University)
Katie Edwards (Baylor University)
Jill Foltz (Collin College)
Richard Gachot (Lamar
University)
Michelle Kaiserlian (Austin
Community College)
Ruth Keitz (University of Texas,
Brownsville)
Dottie Love (Hill College)
*Jacqueline Mitchell (El Paso
Community College)
*Chelsey Moore (Austin
Community College)
Kate Peaslee (Texas Tech
University)
Kurt Rahmlow (University of
North Texas)
Jennifer Yucus (Midwestern State
University)

VIRGINIA
Andrew Arbury (Radford
University)
Richard Bay (Radford University)
Vittorio Colaizzi (Old Dominion
University)
Michelle Delano (Richard Bland
College)
Thomas Larose (Virginia State
University)
William Ratcliffe (Radford
University)
*Mary Shira (James Madison
University)

WASHINGTON
Pamela Lee (Washington State
University)
*Hallie Meredith (Washington
State University–Pullman)
Alma Rocha (Washington State
University–Pullman)

WEST VIRGINIA
Bradford Hamann, Shepherd
University

# Acknowledgments

All books take many people to produce, but an art book is a massive project and this book was truly a group effort. My publisher, Oxford University Press, has been a devoted partner. My development editor Lisa Sussman and former editor Richard Carlin worked tirelessly with me throughout this process. I hardly know how to thank Lisa for her extraordinary devotion to this project—many nights until the wee hours of the morning—and invaluable suggestions that can be found on every page of this text, and Richard's vision and hard work led to countless ideas throughout the chapters. Jaime Burns effectively implemented remarkable digital resources. Grace Li, Katherine Moretti, and Olivia Clark were instrumental in securing reviews and working on numerous details. Marianne Paul expertly shepherded the book through production, Michele Laseau created a beautiful design, and Sean Dugdale and Sean Hynd worked tirelessly to track down hundreds of permissions for the art. James M. Fraleigh skillfully ensured my sentences were correct, Dragonfly Media Group drew the striking illustrations, and Colleen Dunham put together the terrific index. Clare Castro spearheaded an innovative marketing campaign, and Mary Hess arranged all of the class tests. Finally, a dedicated group of individuals, directed by Lisa, Jaime, and Olivia, took on the elaborate supplements package. Hallie Meredith from Washington State University produced the invaluable PowerPoint slides, test bank, and quizzes. Sarahh Scher from Emerson College created the superb instructor's manual and contributed to the test bank and quizzes. Mike Stipe from 36 North produced all of the compelling videos. A number of contemporary artists presented in the excellent technique videos: Kathryn Cellerini Moore; Joe Rozewski; Kim Fink from the University of North Dakota; Jodie Garrison from Western Oregon University; and Kay Bunnenberg-Boehmer, Martin Giovannini, Hector Hernandez, Burkhardt Kleiber, and Jane Lieber Mays from Chemeketa Community College.

My colleagues at Norwalk Community College have been a true source of support. Joe Fucigna gave me new ideas every time I walked into his office, and John Alvord provided much encouragement. Jim Bergesen, Steven DiGiovanni, Renae Edge, Joan Fitzsimmons, Susan Hardesty, Lori Lohstoeter, Valerie Sioufas-Lalli, and Natalie Westbrook offered recommendations for my course and the text. Most importantly, my students have played a central role in teaching me what works best for them.

A number of colleagues, friends, and family members have offered information, guidance, and notes on chapters. I need to thank Wendy Albert, Gail Berritt, Ginny Blanford, Josh Cohen, Nancy Cohen, Alice Davenport, Garet Gordon, Sanford Gordon, Akira Goto, Lynn Hudock, Laura LaMorte, Susan Madeo, Holly MacCammon, Hillary Prim, Jon Stevens, Meri Stevens, and Roth Wilkofsky. My husband, David, and my children, Josh and Rebecca, have lived this book with me every day. There is no way I can thank them enough for their support and the time they have given me to work on this project. Finally, I want to recognize my late mother, Barbara Diesenhof Gordon, an artist and art teacher, who first showed me how much art matters.

Pamela Gordon

# Introduction 1

The detail of a uniform left at the foot of
Maya Lin's Vietnam Veterans Memorial
(shown on the opening page of Chapter 1,
pg. 2) illustrates how visitors leave me-
mentos at this work of art. Millions of
people are drawn to the memorial every
year, and over the years hundreds of
thousands have left such offerings. The
memorial has an emotional significance
for many visitors, and it also serves to
record the names of those who died. Like
other memorials, the Vietnam Veterans
Memorial is an example of how people
throughout the world and across time
have responded to tragedy through art.
The memorial's physical appearance—its
two reflective, black walls dug into the
earth with almost fifty-eight thousand
names carved into its surface—may
help us understand the enormity of loss.
All of these factors—the importance
of the work; purpose of the memorial;
classification of the work as art; and
theme, appearance, and meaning of the
memorial—add to our understanding
of Lin's work. Part 1 of this text looks at
these topics in introducing you to art and
explores why art matters.

**CHAPTER 1**
Art Matters

**CHAPTER 2**
What Is Art?

# 1

# Art Matters

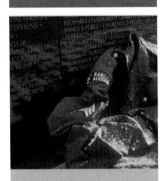

**DETAIL OF FIGURE 1.5.**
One of the reasons that
art matters is because of
its power to heal. Here,
as part of that process,
a visitor to the Vietnam
Veterans Memorial has
left a uniform of a lost
loved one at the foot of
the work of art.

## LEARNING OBJECTIVES

**1.1** Describe four ways in which art can be considered a central part of our lives.

**1.2** List three entities that support art.

**1.3** Explain the ways in which art is a benefit to society.

**1.4** Describe how art is used as a basis of power.

**1.5** Summarize three religious and spiritual functions of art.

**1.6** Contrast two types of political art.

**1.7** Determine why it is important to question what you see.

**1.8** Distinguish between two types of decorative art.

**1.9** Explain how art has been used for expression.

**1.10** Summarize the three ways that art has been employed for social action.

## MAYA LIN'S VIETNAM VETERANS MEMORIAL

In 1961, when the U.S. military expanded its presence in Vietnam to contain the spread of communism, most Americans didn't notice. But by 1966, over half a million U.S. soldiers were operating in the area. Back in the United States, disturbing pictures began appearing on televisions and more and more body bags arrived home. Many people began to protest, splitting the country into pro- and antiwar factions. When it was over, more than 2.5 million veterans returned home to a country that wanted to forget the war, and the families of the nearly 58,000 who had died or remained missing lived with the pain of their loss in silence.

How Art Matters

### A Tribute to Those Lost

Veteran Jan C. Scruggs had experienced horrors in Vietnam that he would never forget. He wanted to build a tribute to those who had given their lives and *elevate those lost to their rightful, honored place*. In 1979, he and a few supporters organized the Vietnam Veterans Memorial Fund and made bold plans for a memorial on the Washington Mall. The veterans secured *government approval* for land near the Lincoln Memorial and began to raise the needed private funds from *individuals* (over $8 million).

### The Competition for the Design

In 1980, the Fund announced a competition to design the memorial. The Fund received *more than fourteen hundred entries*—so many that if hung side by side they would have stretched 1.3 miles. When the jury of world-renowned artists unveiled the winner in 1981, the choice was unexpected and not universally praised. Rather than selecting the work of a recognized artist, the jury chose the design of Maya Ying Lin (MY-uh ying LIN), a twenty-one-year-old Yale University student and the Ohio-born daughter of Chinese immigrants.

### Lin's Design

Lin had created her design for a college course, which had explored how best to memorialize the dead. Her haunting design imagined two reflective black granite walls that were set into the earth and that met in the middle at an angle (figure 1.1). The names of the thousands of dead and missing were listed on the walls and arranged chronologically by date of death, so that those who had fallen together would forever be linked. At each end of the design, the walls began at ground level, but grew progressively in height to reach ten feet at the middle. However, because the walls were dug lower and lower into the earth, the tops of the walls remained at ground level throughout. The two ends of the memorial pointed toward the Lincoln Memorial and Washington Monument, placing the names solidly in the nation's history.

Lin's design created *a dignified space for quiet reflection and healing*, honoring the lost without glorifying or critiquing the war. Because the design did not depict anything specific from the real world, each visitor could bring with him or her *personal recollections and emotions*. Most of all, the design focused on the names—*documenting the deaths of the people who were lost*. If you have ever visited a grave, you may have experienced the power of a carved name. Seeing and running your fingers across the name can make the death seem more concrete.

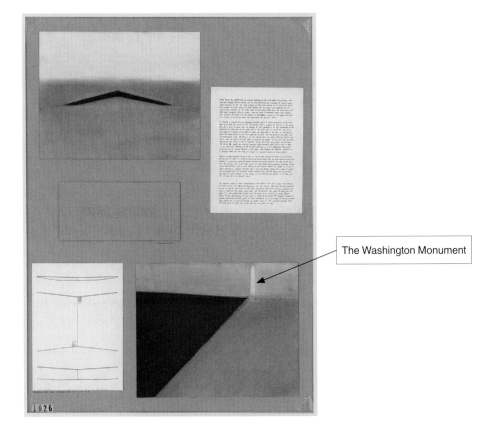

FIGURE 1.1. Maya Ying Lin. *Vietnam Veterans Memorial Competition Drawing.* *1980 or 1981. Mixed media on paper on board, 3' 4 ⅛" × 2' 6 ⅛". The Library of Congress, Washington, DC.* Lin's submission included several views of the memorial—aerial (top), the two walls meeting (bottom left), and the right wall pointing toward the Washington Monument (bottom right).

The Washington Monument

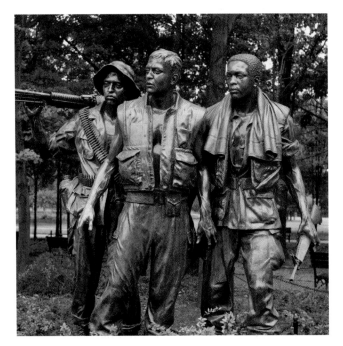

FIGURE 1.2. Frederick Hart. *Three Servicemen,* Vietnam Veterans Memorial. *1984. Bronze, just larger than life size. The Mall, Washington, DC.* Hart's sculpture is shown here as it was eventually installed.

## Criticisms of the Design, and Compromise

While the jury's decision had been unanimous and a number of people were happy with the choice, others were not. A group of veterans *attacked the design* and even Maya Lin herself (she was young, Asian American, and wore her hair long like a hippie—a member of the counterculture movement). Some of their critiques about the design included that it

» was black and below ground,
» did not celebrate the cause for which the war had been fought,
» was not patriotic or heroic,
» contained no flag or anything from the real world, and
» had not been selected by veterans

To address these concerns, the veterans from the Fund agreed to add near Lin's memorial a flag and a sculpture of three servicemen (figure 1.2) by Frederick Hart, who had placed third in the contest. The realistic sculpture was *more in line with how these critics felt a memorial should look.*

## Building and Dedicating the Memorial

Production on the memorial, known simply as "The Wall," began in January 1982. In October, workmen put the last panel

in place. Meanwhile, organizations, veterans' groups, and over 650,000 individuals contributed money to ensure that the monument could be built.

The dedication in November commenced with a five-day salute to the veterans. Over 250 volunteers read all 57,939 names aloud in a fifty-hour vigil in Washington National Cathedral. There were workshops, religious services, and parades. Washington, DC was flooded with thousands of veterans and their families and friends. Since the dedication, much has happened to the memorial (see table 1.1).

| TABLE 1.1: | Changes to the Memorial since the Dedication. |
|---|---|
| **Year** | **Change** |
| 1984 | Hart's sculpture and the flag were put in place. |
| 1993 | A Women's Memorial was added to honor the ten thousand women who served. |
| 1996 | A half-size replica of The Wall, known as "The Moving Wall," was built and has since traveled to more than six hundred communities across the United States. |
| 2000 | A plaque was placed to honor postwar casualties. |
| 2009 | A virtual Wall of Faces was initiated on the Fund's website, linking photographs with the names. |

## The Nation's Experience with the Memorial

The Wall has become *the most visited monument in Washington*, seen by an average of thirteen thousand people a day (figure 1.3). *It is a place of quiet reflection, mourning, and healing.* Visitors descend a gentle path, and The Wall expands slowly, as did the war. They walk 246 feet (approximately the length of a football field) to the center, where The Wall reaches up above them. Yet, each name is only half an inch high. The enormity of loss is staggering. As visitors walk the distance of the other side, The Wall fades, following the course of the war.

The Wall is reflective. In it, the living, the surrounding landscape, and the other national monuments are seen as a backdrop to the names (figure 1.4). A shift in the hour or weather offers a new experience, as The Wall changes based on what it reflects.

To find a name, a visitor must consult a directory. Finding a name becomes a journey, in which the visitor must participate in the work, read other names, and become aware of others who died. Many visitors touch the names, the tactile experience making the person's involvement with The Wall more direct. People can also create tracings of the letters to bring home.

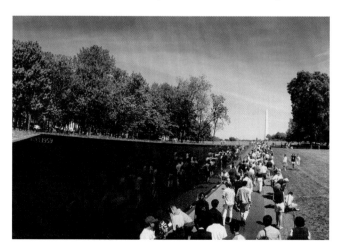

FIGURE 1.3. **Maya Ying Lin. Vietnam Veterans Memorial.** *1982. Polished black granite, 492'. The Mall, Washington, DC.* The Wall has been described as the most meaningful memorial ever built.

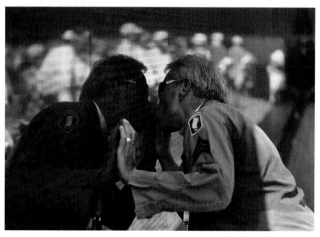

FIGURE 1.4. **A man kisses a name on the memorial.** As people interact with The Wall, their image is reflected among the names.

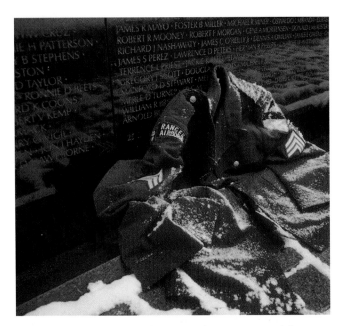

**FIGURE 1.5.  An offering at the memorial.**  Here, someone left a uniform at The Wall.

Many visitors find the experience absorbing, and many are *overcome with emotion*. Yet, the memorial also allows visitors to appreciate what is around them, as The Wall works harmoniously with the surrounding landscape. Even though visitors descend into the earth, they remain in the world of the living.

As part of *the healing process*, many people leave offerings at The Wall, such as stuffed animals, photographs, letters, medals, and uniforms (figure 1.5). Over four hundred thousand offerings have been left, and since 1984, the National Parks Service has stored these objects.

Many of these offerings are moving tributes. One letter from a mother to her dead son reads:

Dear Bill . . . I see your name on a black wall. A name I gave you as I held you so close after you were born, never dreaming of the too few years I was to have you . . . And as I look around at the thousands of other names, I remember that each name here represents, on the average, twenty years that each boy was some Momma's little boy, as you were mine. I miss you so.[1]

The Vietnam Veterans Memorial is a physical representation of *how art can make a difference in the world—how art can matter*. Art mattered to Scruggs and the veterans at the Fund who wanted a design that would honor those who gave their lives; it mattered to Lin and the design contest entrants who used their creativity to ensure those who had died would not be forgotten; it mattered to the critics of the original design who wanted to ensure that the memorial reflected their vision of the war; it also mattered to the over 650,000 contributors and the millions of people who have visited the monument since its dedication.

You might ask why. Why did Scruggs and his supporters feel that through art they could most honor Vietnam veterans? Why were 1,421 people compelled to create designs? Why was the way the design looked so vital to the different sides? Why did so many individuals send money? Why have so many people visited The Wall? Why has the National Parks Service preserved all the offerings? This chapter starts our exploration into the answers to these questions and others, as we delve into all the ways that art matters and is used in our world. Before moving forward, based on reading this story, consider: How does art matter in your life? How do you interact with and use art?

# 1 The Importance of Art

What draws more than 4.7 million people a year to visit the Vietnam Veterans Memorial?[2] The war has been over for more than forty years, yet still people come. Across the world, in different moments, we see the significance of art:

- In 1989, Chinese students used art to symbolize their dream for freedom and call for democracy in their homeland. The *Goddess of Democracy* (figure 1.6) stood for five days before being crushed by a tank, as the army silenced protestors.

- In 2005, a Danish newspaper created a firestorm because of art when it printed cartoons of the Prophet Muhammad that offended many Muslims. After several papers republished the cartoons, violent protests erupted. European embassies were firebombed, people were killed, Western businesses were destroyed, and the cartoonists went into hiding.
- In 2014, when the City of Detroit faced bankruptcy, the Detroit Institute of Arts was under pressure to sell off much of its collection to help the city pay creditors. However, recognizing the value of this collection to the city and its people, the state of Michigan, the Institute itself, private donors, and nine different charitable foundations committed over $800 million to ensure that no artworks would need to be sold.

Art has the power to represent ideals, heal pain, and fulfill lives. Art can also influence, provoke powerful responses, and heighten emotions. This section explores the importance of art as *a central part of our lives, a strongly supported endeavor, a benefit to society,* and *a basis of power.*

## A Central Part of Our Lives

If you consider yourself a casual observer of art, you may not realize *the central role art plays in your life.* Art is an impulse that humans seem unable to live without. This tendency has been seen across the globe and throughout history. *Art is everywhere,* and it is *a characteristically human endeavor, an inner calling,* and *a sensation to which we are drawn.*

### Art Is Everywhere

*Art is everywhere* in our lives and includes obvious objects like sculptures at colleges and paintings in museums. But, art also consists of the jewelry that we wear, the video games that we play, and even the icons of apps that are on our mobile devices. Figure 1.7 depicts icons for social media apps such as Facebook, Instagram, and Twitter. These simple images, each designed by artists, are used to visually identify and give a sense of the personality or function of the social media sites.

However, art isn't just all around us. Across the globe, *millions of people are involved in art every day.* Some people who produce art include:

- *Artists,* like Maya Lin, who create works using many different techniques, such as painting, printmaking, and building furniture
- *Architects and designers,* who conceptualize buildings and spaces

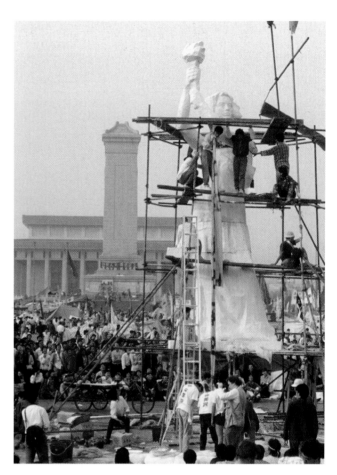

**FIGURE 1.6.** Chinese students building the *Goddess of Democracy* in Tiananmen Square, Beijing, China, 1989. Students modeled the *Goddess of Democracy* after the *Statue of Liberty.*

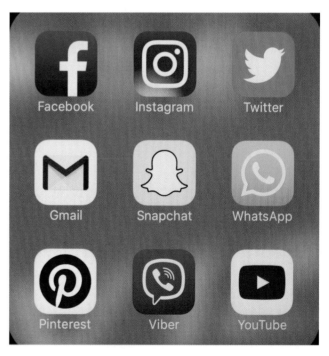

**FIGURE 1.7.** An Apple iPhone shows icons of social media applications on a screen. Each app has a unique design that puts forth a distinct look that users can recognize.

- *Graphic designers,* who produce everything from book designs to corporate logos, websites, and video games
- *Film and video producers,* who create movies
- *Fashion and jewelry designers,* who conceive of items for us to wear

Other people employed in the art industry include:

- *Museum and gallery* staff
- *Auctioneers and appraisers,* who help sell art at auction houses
- *Conservators,* who protect, repair, and clean art
- *Art consultants,* who buy art for corporations
- *Critics and authors,* who write about art
- *Teachers,* who instruct students about art
- *Art therapists,* who help people heal using art

Still more people *visit museums and galleries* to enjoy art. For example, the Metropolitan Museum of Art in New York attracts 7.4 million visitors a year, while the museum's website annually receives 30.4 million visits.[3] Across the world, people take the time to visit 55,000 different museums.[4] This count doesn't include galleries that allow for a multitude of other art viewing opportunities. Just in the city of Chicago, for example, people can see art at over 130 different galleries.[5]

However, even if you are not involved with art as an artist, someone who works in art, or a visitor to museums, *you still confront art every day.* When you go to the movies, recognize your favorite spaghetti sauce by the label on the jar, sit in a chair, or use any textbook, even one for criminal justice, engineering, or accounting—all of which have their pages arranged by a designer—you are involved with art. We are all consumers of art. Just think about the ways in which you might run into art in your own major or career.

## Art Is a Characteristically Human Endeavor

Art is *characteristically human,* arising independently in all cultures, without outside influence. Across time, in every society throughout the globe, no matter the challenges, people have felt compelled to form and keep art.

Stonehenge is a testament to prehistoric people's drive to have art in their lives. Built in England in four phases from 2900 to 1500 BCE, the massive stone structure is one of thousands of such sites across Western Europe. The site today features missing and fallen stones. However, archaeologists have determined how its builders arranged it in a circular form using a construction method, discussed in Chapter 12, in which two vertical posts support a horizontal beam (figure 1.8).

The stones are massive. One post made from sandstone is twenty-five feet high and weighs fifty tons. It supports a sixteen-foot beam. This rock came from twenty-three miles away. Bluestones at the site weigh up to forty tons each and came from 150 miles away.

How could people with no wheeled carts or machines have moved the stones such great distances or lifted the beams to be placed on the posts? Clearly, the effort involved hundreds if not thousands of people working together, expending great physical effort toward what could only have been an extremely important goal.

Scholars are not certain why Stonehenge was created. Explanations include that it was a site of sacred rituals or a solar calendar. The cycle of the seasons would have been important to these early farmers. Thousands of years ago, if a person stood at the center of Stonehenge on the summer solstice, the sun would have risen directly over the heel stone (a sandstone located outside the circle), indicating that the days would be growing shorter and the growing season would in time be over.

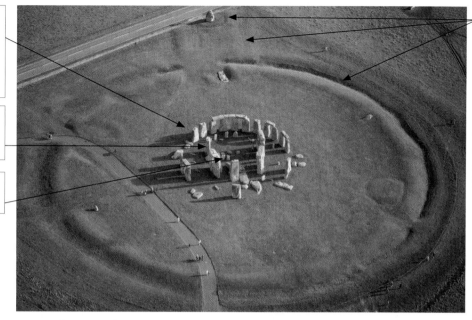

A series of sandstones formed an outer circle almost one hundred feet in diameter.

In the middle was a horse-shoe form of sandstones.

In the very center were bluestones.

The site was surrounded by a ditch, through which ran an avenue. Within the avenue, and outside the ditch, was a huge, vertical sandstone, known as the heel stone.

**FIGURE 1.8.** **Stonehenge.** *c. 2900–1500 BCE, Salisbury Plain, Wiltshire, England.*

## Art Is an Inner Calling

Many people believe that artists feel *a strong inner calling* to create art. Consider how many entries the Vietnam Veterans Fund received. Throughout history, artists have created even when faced with physical disabilities, pain, and financial ruin.

However, *even ordinary people feel a compulsion to make art.* In 2013 on World Peace Day, British artists Jamie Wardley and Andy Moss organized the creation of nine thousand silhouettes of bodies (figure 1.9) on the Normandy beaches in France. (During World War II, when the Nazis occupied Europe, these beaches were the site of an invasion by British, American, and Canadian forces.) The tribute remembered those lost in the initial battle and visually illustrated the colossal waste of war. Five hundred ordinary people—including locals who happened to walk by and people who came from all over the world after hearing about the project—felt compelled to help, even though the work was erased by the tide just hours after it was completed.

## Art Is a Sensation to Which We Are Drawn

Most of us are *drawn to art,* even if we are not its creators. The sensation stems from the value humans find in art. Art can:

- Bring *joy*
- Stimulate us *intellectually*

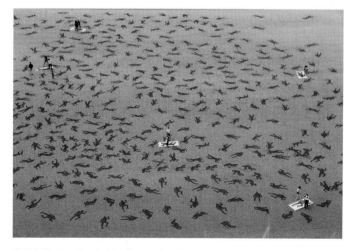

**FIGURE 1.9.** **Jamie Wardley and Andy Moss.** *The Fallen.* 2013. *Nine thousand silhouettes in sand. Arromanches Beach, Normandy, France.* Volunteers raked the sand inside templates (the white rectangular shapes seen in the photo) to form the silhouettes.

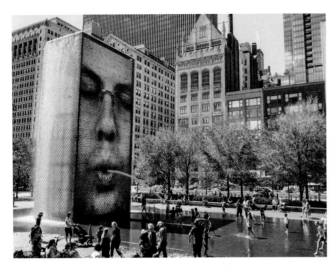

- Move us *emotionally*
- Appeal to us *visually*
- Allow us to *understand* another people, time, and place
- Help us with *important functions*

Consider the appeal of *The Crown Fountain* (figure 1.10), designed by contemporary Spanish artist Jaume Plensa (JHOW-mah plen-SAH) for Chicago's Millennium Park. Two facing towers pull people in with a display of the faces of one thousand different Chicagoans. Water tumbles over the towers and spurts out of the faces' mouths, attracting visitors, who frolic in the water or watch from the sides.

Each person may have a different reason for being attracted to the fountain. Some may find joy in the cool water. Others might wonder about the technology that displays the changing images. Still others might be drawn to the faces that record specific people.

**FIGURE 1.10.** Jaume Plensa. *The Crown Fountain.* 2004. *Glass, stainless steel, LED screens, light, wood, black granite, and water, two towers, each 52' 6" high upon a water pool 229' 7" × 45' 11". Millennium Park, Chicago.* This image shows one of the fountain's towers splashing water onto people.

*Quick Review 1.1*: In what four ways can art be considered a central part of our lives?

## A Strongly Supported Endeavor

Another way to gauge the importance of art is in considering the *broad support it receives across the globe*. Belief in sustaining the arts is strong *from governments*, *the international community*, and *individuals*.

### Government Support

*Governments lend support to the arts.* Even though budgets are often stretched, societies understand the value in helping to make art a part of people's lives. Governments can:

- *Supply public land where art can be located.* For example, the U.S. government provided the site for the Vietnam Veterans Memorial.
- *Allocate part of their budgets to support museums, arts agencies and organizations, art education, and artists.* For example, the U.S. government subsidizes the Smithsonian, the world's largest museum complex, which in 2019 received over $1 billion.[6]
- *Hire artists.* For example, during the Great Depression, the U.S. government's Works Progress Administration employed out-of-work artists to paint murals in public buildings.
- *Reserve a percentage of the construction costs for public art when erecting community or civic buildings or spaces.* For example, since 1975, the state of Oregon has set aside no less than 1 percent of construction funds of state buildings with budgets greater than $100,000 for art.

While many governments back the arts, not everyone within the governments or in the public necessarily agrees on which art should be supported. Just in these disagreements, we can see the power of art. Two examples illustrate *controversies that have surrounded government support for the arts*.

## A Controversy Surrounding a Government Arts Agency

From 1988 through 1990, the National Endowment for the Arts (NEA), a U.S. federal agency that backs arts organizations, artists, and art education, funded an exhibition of American Robert Mapplethorpe (MAY-p'l-thorp), whose photographs included flowers, portraits, and figures (figure 1.11) as well as sadomasochistic, homoerotic images. When the exhibition traveled to the Contemporary Art Center in Cincinnati, the director and the museum were indicted on charges of obscenity for including the erotic photographs.

Even though the director and museum were eventually acquitted, the controversy sparked a backlash. Members of the U.S. Congress, in an attempt to silence controversial artists, drastically reduced the NEA budget, prohibited the NEA from offering grants to individual visual artists, and required the NEA to consider standards of decency when awarding grants. The requirements against individual grants and for standards of decency remain in place today. Recently, the NEA has come under new attack by some politicians. For example, President Donald Trump's 2019 budget proposed the complete elimination of the agency. However, the U.S. Congress rejected the plan.

## A Controversy Surrounding Public Art

In 1981, the U.S. government installed a sculpture by Richard Serra in front of a federal building in New York. Serra, an American sculptor, conceived *Tilted Arc* to be **site specific**: it was meant for this location. Everything about the site, from the box-shaped buildings to the rectangular windows, was uniform. Into this regularity, Serra placed *Tilted Arc* across the plaza (figure 1.12). Independent and daring, *Tilted Arc* made people walk a different path, perhaps asking them to be individuals and not go with the flow. The sculpture's expression depended on experiencing it within this site.

**artists**
MATTER

Robert
Mapplethorpe

**site specific** A sculpture that is designed for a particular location

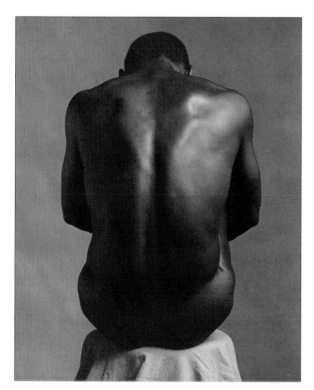

**FIGURE 1.11.** **Robert Mapplethorpe.** *Ajitto (Back).* *1981. Gelatin silver print, 17 ¹¹⁄₁₆″ × 13 ¹⁵⁄₁₆″. The J. Paul Getty Museum, Los Angeles.* Mapplethorpe's photographs of figures emphasize the beauty of the human form placed in stark settings.

Tilted Arc

**FIGURE 1.12.** **Richard Serra.** *Tilted Arc.* *Installed 1981 in Federal Plaza, New York. Steel, 12′ × 120′.* This image shows *Tilted Arc* in place, before it was removed in 1989.

Once installed, the work generated anger among some of the public who felt the sculpture inhibited pedestrian travel and attracted graffiti. When the government decided to remove the sculpture, Serra sued, but lost. This example raises many questions about public art:

- *Who should control public spaces?* The court decided that, in this case, because the government owned the work, the government could make decisions about its placement. Yet, should Serra have had some control over his work? How much of a say should the public, some of whom liked the sculpture, have had?
- *Should public art promote the values of society?* If so, which values?
- *Should public art be pleasing?* Can it be pleasing to all viewers?
- *Must public art be noncontroversial?*
- *What limitations on public art are reasonable?*

## International Support

*The international community, too, supports art,* in particular by combatting the destruction of art brought on by pollution, construction, nature, tourism, vandalism, and wars. The United Nations Educational, Scientific, and Cultural Organization (UNESCO) has spearheaded the preservation of the world's art. The 193 states that have ratified UNESCO's 1972 convention can include sites within their borders on the World Heritage List (which lists 845 endangered cultural sites).[7] These states also have access to monetary assistance through the World Heritage Fund.

Probably UNESCO's best-known effort occurred in the 1960s. The governments of Egypt and Sudan planned to build a dam, but the project was going to flood a valley containing two Egyptian temples from over three thousand years ago. UNESCO led the international campaign to secure $80 million to move and save the temples. As they had been carved into a cliff rather than having been constructed of bricks, the temples could not be disassembled and rebuilt. In the end, after considering hundreds of plans, the temples were cut into huge blocks and relocated to higher ground (figure 1.13).

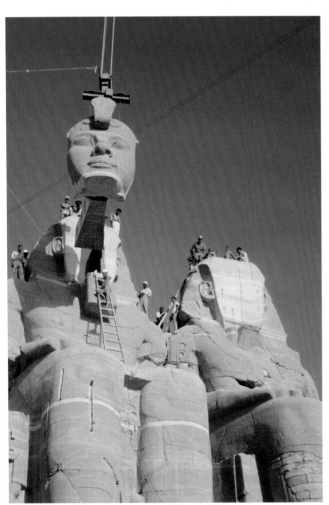

**FIGURE 1.13.** **Ramses II's temple at Abu Simbel being reconstructed in 1967.** Workers put in place a piece of one of the five-story-high statues of Ramses II from the temple's façade.

## Individual Support

*Individuals can also support the arts.* Just as 650,000 people helped fund the Vietnam Veterans Memorial, so, too, can individuals show the importance of art through *monetary donations*, *patronage* (commissioning works of art), and *actions*.

### Monetary Support

Individuals have supported art through *donations*. For example, people from across the globe contribute to World Monuments Fund (WMF), a nonprofit organization involved with heritage preservation. Since its founding in 1966, WMF has helped conserve more than 600 sites around the world and provided advocacy for more than 800 treasured places.[8]

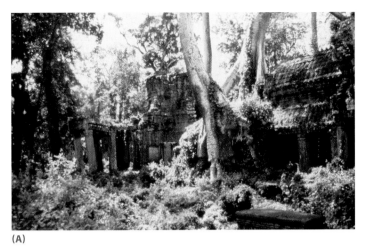

(A)

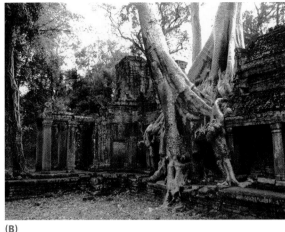

(B)

**FIGURE 1.14A (PRE-RESTORATION) AND B (POST-RESTORATION).** **The entrance to the site of Preah Khan.** *Twelfth century, Angkor, Cambodia.* The photos of before (1.14A) and after (1.14B) restoration show the changes WMF has brought to Preah Khan.

WMF has helped to save Angkor, a two-hundred-square-mile site of historic Hindu and Buddhist temples in Cambodia. The complex had been neglected for twenty years because of war and isolation, during which time the jungle had encroached on the temples. Since 1990, WMF has restored several areas of Angkor such as Preah Khan (figure 1.14A and B).

Conservation is a time-consuming and expensive process. Yet, many organizations and individuals feel it is the community's responsibility to *protect and save art*. To learn more about conservation, see *Delve Deeper: Conserving Art*.

### Patronage

Another way that individuals have championed art is through *patronage*. For centuries, **patrons** from religious institutions or powerful families or groups have supported artists by commissioning art. While the rationale behind patronage was often to increase the patron's prestige, this support nonetheless enabled artists to produce art.

**patron** A person who supports an artist by commissioning works of art

### Actions

Some individuals are so passionate about art that they *take actions to support, protect, and save it* during times of peace and stability or natural disasters and wars. One extreme case involved Khaled al-Asa'ad, who was the lead archaeologist in Palmyra, Syria, a UNESCO site known for ancient ruins. After war broke out in 2011, the eighty-two-year-old Asa'ad was determined to protect the art.

Archaeologists hid a number of works that could easily be moved, because ISIS fighters had been stealing and selling antiquities to fund their activities and destroying art they found offensive. When ISIS invaded Palmyra in 2015, the fighters demanded Asa'ad reveal the location of the hidden works. He refused, so they beheaded him in the public square; afterward, the fighters dynamited several ruins (figure 1.16A and B).

*Quick Review 1.2*: What are three entities that support the arts?

# DELVE DEEPER

## Conserving Art

Efforts to conserve art are going strong across the world. Conservation is an overarching name for preventative work, analysis, and restoration.

*Preventative work* involves minimizing potential damage to art. For example, works on paper are vulnerable to exposure to humidity and light. Accordingly, conservators limit the length of time works are exhibited.

*Analysis* includes evaluating a work's condition (figure 1.15). With a painting, conservators might employ ultraviolet light to examine the surface for damage, use X-rays to explore lower paint layers, or take tiny samples from edges to analyze.

Finally, *restoration* involves cleaning and repairing works. All art is vulnerable to damage. For example, art made from wood can warp, crack, and be susceptible to insects. Even past restorations might have been harmful. Conservators use a host of methods such as removing dirt with solvents or adhering flaking paint with adhesives.

**FIGURE 1.15.** Jan Vermeer's *Girl with a Pearl Earring* being examined with an X-ray fluorescence (XRF) spectrometer at the Mauritshuis Museum, The Hague, The Netherlands. XRF allows conservators to identify the chemical elements in works to figure out what may be causing deterioration.

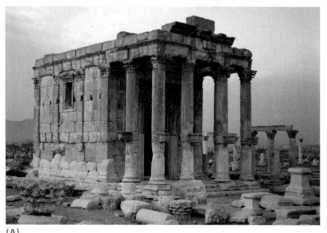

(A)

(B)

**FIGURE 1.16A (PRE-DESTRUCTION) AND B (POST-DESTRUCTION).** The Temple of Baal-Shamin. *130 CE, Palmyra, Syria.* ISIS fighters dynamited this ancient Roman temple in Syria, shown before (1.16A) and after (1.16B) its destruction.

## A Benefit to Society

_Art aids our world._ Many people benefit directly from art. Specifically, _art education_ can help children develop into well-rounded adults, _art therapy_ can help people heal, and art can offer people _general support._

### Art Education

Art is an important part of _educating children_ and is taught in schools across the world. In the United States, over 80 percent of public elementary schools designate a time for visual arts instruction separate from art that is included as part of other subjects.[9] Art is prioritized in schools for many reasons:

- _Art can help children develop intelligence._ Art education develops brain capabilities in nonsequential and visual intelligence.
- _Art can help children become informed citizens._ Learning about different disciplines enables students to understand the world around them. By studying art, children can become well-rounded members of society.
- _Art can help children acquire life skills._ Art fosters creativity, flexibility, and confidence. It teaches communication skills, problem solving, and critical thinking. It allows for multiple right answers and teaches the value of effort.
- _Art can help children recognize the power of images._ We live in a world filled with images that attempt to inform, persuade, and provoke. By working with art, children can learn to interpret images and appreciate their power to influence our opinions.
- _Art can promote acceptance of other cultures._ Art crosses boundaries. By studying art, children often learn about other cultures. They can understand that art is a common human experience and draw parallels with people who are not like them. They can learn respect and acceptance.
- _Art enables all children to participate._ Art can be a particularly effective subject for children with special needs because it allows children to express themselves in new ways, using whatever mechanisms they may have available (figure 1.17).

Because art teaches so much, schools have recognized that art is not just for those with a special talent, but for every student. Art can help all children succeed in life.

### Art Therapy

Another way in which art can benefit our world is through its _power to heal._ Art therapists can help individuals suffering from disabilities, medical conditions, and tragedies. Art therapy has been used in:

- _Diagnosis._ People who have suffered an illness or traumatic event are sometimes unable or unwilling to talk about what happened. Art making can offer a different way to communicate. Furthermore, sometimes a patient may have suppressed the problem, and art creation can offer hints into what is wrong.
- _Treatment._ Art may allow patients to gain a sense of reality as they can see their personal challenges in their art and work to overcome them.

**FIGURE 1.17.** An art teacher guides visually impaired students in coloring lizards formed from raised outlines that the students can feel with their fingers. All children can benefit from art education, even the visually impaired.

**FIGURE 1.18.** **A child who witnessed a Boko Haram attack in Nigeria, Africa, draws a therapeutic picture.** In this image of a child's recollection, men arrive on a truck at a village and shoot people.

**FIGURE 1.19.** **Tulane University's URBANbuild. Build 12.** *2017, New Orleans.* Tulane University built this home in 2017, as part of a program to support low-income residents of New Orleans.

**FIGURE 1.20.** **Steven Spielberg.** *Jaws. 1975. Film still of Chrissie being attacked by the shark.* In this scene, the shark attacks its first victim.

- *Assessment.* Therapists can see how patients are progressing as they create art later in treatment.

Art therapy has been particularly useful with children, who often have difficulty voicing feelings after an ordeal. Creating art enables them to express themselves visually and then describe what they have created, so they can potentially come to terms with what happened, regain some control, and start to move on with their lives.

In 2015, art therapy helped treat traumatized Nigerian children. After Boko Haram fighters attacked their villages, killing people and burning homes, art was used to help the surviving children begin to heal (figure 1.18).

### General Support

Art can also generally help people who are *underprivileged or down on their luck.* For example, in the years since Hurricane Katrina in 2005, Tulane University's School of Architecture has aided low-income residents of New Orleans.

Students have designed and built affordable houses for disadvantaged families (figure 1.19). The program gives students real-world experience while helping those in need.

*Quick Review 1.3*: In what ways is art a benefit to society?

### A Basis of Power

Art is a *basis of power.* Throughout the centuries, governments and individuals have been able to wield control by using art to *influence* opinions, deceive people through *propaganda*, curtail ideas through *censorship*, eliminate beliefs through the *destruction of art*, and devastate the cultural heritage of countries through *illegal trafficking of art.*

### Influence

Because it is visual, art can *powerfully influence how people think and behave.* For example, while it has been over forty years since *Jaws* opened, the film's impact has been striking. In the movie, a killer shark stalks the waters off a beach community (figure 1.20). Still today, many who saw the movie are afraid of sharks, even though the chances of being killed by a shark are infinitesimally small—only one in 3.7 million.[10]

Numerous factors have led to the long-standing paranoia. The film was released in the summer, so many people saw the film as they were enjoying beach vacations. American director Steven Spielberg showed the (mechanical) shark for only four minutes during the film, which gave audiences time to conjure a beast more terrifying than the real thing. Finally, composer John Williams added chilling music that played

when the shark was about to appear, so audiences knew that something bad was going to happen.

## Propaganda

*Propaganda manipulates people in a biased and deceptive way* to sway their opinions toward a group, person, cause, or way of thinking. Art has been instrumental in much of the propaganda created over the years.

German filmmaker Leni Riefenstahl (LEN-ee REEF-en-shtal) crafted *Triumph of the Will* as propaganda to mislead the masses. Working for the Nazis, she intended to create the appearance of the overwhelming dominance and military might of their regime. In the film, Adolf Hitler is shown as a savior, commanding thousands of loyal followers (figure 1.21). Images of strict organization and unified forces were produced to inspire people and silence nonconformists.

## Censorship

Because art can be so influential, people, organizations, and regimes sometimes try to stop art from reaching its intended audience. *With censorship, art is removed from view.* Art has been censored throughout history, often by repressive governments that limit free speech. However, censorship can also occur in Western democracies.

Facebook, for example, has rules against nudity on its website to protect users from obscene images. However, sometimes images that most people would consider great art are censored. In 2015, Facebook did not allow the publisher of a respected book, *After Abel and Other Stories*, to purchase an advertisement on its site. The author Michal Lemberger had designed the promotion, superimposing quotes praising the book on top of depictions of biblical women from famous art history works (figure 1.22).

## Destruction of Art

Sometimes art's influence is perceived to be so great that *governments or others seek to destroy art*, so that its powerful message cannot ever be seen. Throughout history, across the globe, art has been destroyed for numerous reasons—from political to religious to social. The destruction of art can be orchestrated from above by governments or religious institutions or from below by individuals or groups.

*Governments can destroy artworks,* such as in 2001, when the Taliban regime ordered the destruction of all statues in Afghanistan. Claiming the works were idols, the Taliban dynamited the world's two largest standing statues of the Buddha (the founder of the Buddhist religion) (figure 1.23A and B). The 121- and 180-foot sculptures had been carved into a cliff during the sixth century.

*Individuals may also destroy works of art.* In 1914, Mary Richardson slashed *The Rokeby Venus* (figure 1.24) by Diego

**FIGURE 1.21.** Leni Riefenstahl. *Triumph of the Will. 1935. Film still.* To produce the sought-after message, the government gave Riefenstahl full support. Well over one hundred people worked on her crew, and she had access to an airplane for aerial shots, such as this one.

**FIGURE 1.22.** Michal Lemberger. Trailer for *After Abel and Other Stories. Published by Prospect Park Books. 2015. Film still.* A quote praising Lemberger's book is superimposed over *Susanna and the Elders,* painted by Artemisia Gentileschi in 1610.

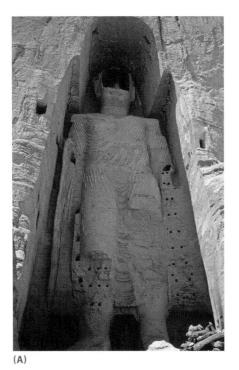 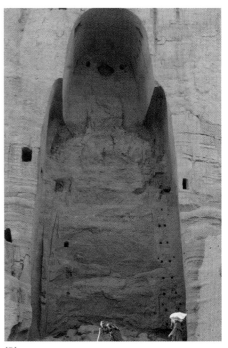

(A)                                                         (B)

**FIGURE 1.23A (PRE-DESTRUCTION) AND B (POST-DESTRUCTION).** One of the monumental standing Buddhas destroyed by the Taliban in Bamiyan Valley, Afghanistan, in 2001. *554. Rock covered in mud plaster mixed with straw and horsehair originally painted red, 180'.* Because the Budhhas had been carved into rock (1.23A), it took a month of dynamiting to bring the statues down (1.23B).

Velázquez (dee-AY-goh veh-LAS-kes) in the National Gallery of London. She hoped to draw attention to the plight of Emmeline Pankhurst, a leader in the fight for women's right to vote, who was on a hunger strike in prison. The painting by the seventeenth-century Spanish artist bothered Richardson because she felt that men stared at Venus's nude body.

While most people would be horrified by Richardson's conduct, even if they agreed with her concerns, her act begs the question: Is it ever OK to censor or destroy art? Often our opinion depends on our perspective (see *Practice Art Matters 1.1: Explore Whether Some Art Should Be Censored*).

## Illegal Trafficking of Art

Another place we see the power of art is through *art stolen from different countries*. Known as illegal trafficking, such destruction of a nation's cultural heritage has spurred international efforts to stop the process and prompted museums to return objects to their countries of origin.

Illegal trafficking is of concern because art helps define a country's culture and identity. Artifacts created by people's ancestors are a source of pride for these individuals. When these objects are stolen, the crime goes beyond the loss of their monetary value.

Illegal trafficking is a rampant problem involving diggers, thieves, dealers, auction houses, and collectors. Art objects that are in war zones are particularly at risk. Traffickers have both illegally dug up antique objects from archaeological sites and stolen objects from vulnerable museums.

Iraq has been hit badly by trafficking. During the second Iraq War, begun in 2003, looters carried off numerous art

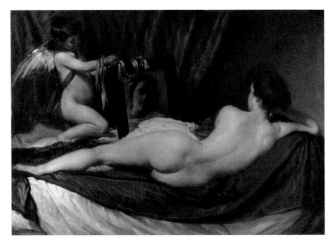

**FIGURE 1.24.** Diego Velázquez. *The Rokeby Venus.* *1647–51. Oil on canvas, 4' ¼" × 5' 9 ¾". The National Gallery, London.* Richardson slashed this painting of the Roman goddess of love gazing at her nude body in front of a mirror. The painting has since been restored.

## 1.1 Explore Whether Some Art Should Be Censored

When communism fell, statues of Eastern European leaders were brought down in support of democracy movements, and people in the West cheered. However, when the Vichy government in France during the Nazi occupation melted down statues to reuse the metal for industrial purposes, people were appalled. Today, the call to bring down monuments to Confederate soldiers and politicians has further added to the debate.

Consider these questions:

- Should artists' free speech rights to produce all art (no matter what it depicts or means) be defended at all costs? Why or why not?

- Should all art be valued, tolerated, and protected, even if some of it is hateful, offensive, or sways people to act in unlawful or unwanted ways? Why or why not?

- Is it OK to censor or destroy some art? Why or why not?

---

objects from sites (figure 1.25). Thieves also stole fifteen thousand works from the National Museum in Baghdad. The museum did not reopen to the public until 2015, with only one-third of the stolen items having been recovered.[11]

Both the international community and individual countries have worked to stop illegal trafficking. A UNESCO convention, ratified by 139 countries, prohibits the transfer of stolen art objects between countries.[12] Moreover, almost all countries have laws protecting their art, establishing the states as the owners of objects found within their borders.

Countries have begun to make a case to have illegally trafficked objects returned. This topic has become important to museums, many of which possess objects with questionable histories of ownership. Some have begun to return objects. In 2015, the Honolulu Museum of Art agreed to hand over seven artifacts (figure 1.26). The artifacts, stolen from sacred sites in India, were evidence in the case against an art dealer linked to looting thousands of objects and eventually will be returned to India. The museum had acquired the objects innocently after being given falsified records of the objects' histories of ownership.

This chapter has considered a number of ways in which art matters. To try applying these points, see *Practice Art Matters 1.2: Explain Why a Memorial Shows How Art Matters.*

*Quick Review 1.4*: In what ways is art used as a basis of power?

**FIGURE 1.25. Evidence of looting appears at the Al-Aqiser archaeological site in Iraq.** The holes seen in the ground are from looters, who, during the second Iraq War, dug up thousands of artifacts from ancient sites such as this one and sold the items on the black market.

**FIGURE 1.26. One of the seven artifacts recovered from the Honolulu Museum of Art looted from India.** Shown here is one of the artifacts that was identified as evidence against an art dealer accused of illegal trafficking.

## 1.2 Explain Why a Memorial Shows How Art Matters

In 1996, British artist Rachel Whiteread (white-REED) won the commission to create a Holocaust Monument in Vienna to commemorate the seventy-seven thousand Austrian Jews killed during World War II. The memorial, originally proposed by an individual, was to be paid for by the city.

Whiteread's design, called the Nameless Library, foresaw a large, concrete, tomb-like block placed in a historic square (figure 1.27A). The structure represented the empty space inside a library—the void where we normally have nothing but air.

Around the edges of the block ran inverted books (figure 1.27B); their spines faced inward, with only the edges of their closed pages visible. The monument also had closed doors with no doorknobs. Both the knowledge and space appear lost forever.

Whiteread's memorial immediately ran into problems. Some locals sought to stop construction. They felt the memorial did not fit into the quaint square. Also, upon excavating the site, workers discovered the remains of a fifteenth-century synagogue, destroyed during a wave of Jewish persecution. A number of Vienna's Jews objected to the memorial being placed over a site they believed to be holy.

After much debate, a compromise allowed the memorial to be constructed. The city shifted the memorial (so it was still in the square, but not directly above the synagogue's pulpit) and funded a museum that allowed access to the synagogue ruins.

Consider that art is a central part of our lives, a strongly supported endeavor, a benefit to society, and a basis of power. Which of these ways do you think applies to Whiteread's memorial? Why?

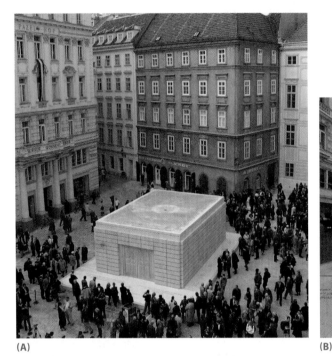

(A)

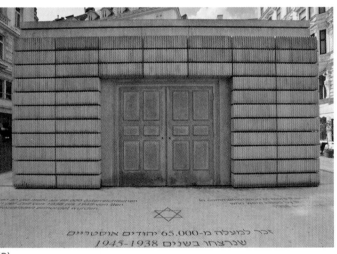

(B)

**FIGURE 1.27A AND B (DETAIL).** Rachel Whiteread. *Nameless Library Holocaust Monument. 1995/2000. Concrete, 12' × 33' × 24'. Judenplatz Square, Vienna, Austria.*

# The Purposes of Art

Different works of art have specific purposes, and some might have more than one. By considering these functions, we gain an understanding of how art matters to people in the ways it is used for:

- *Religion and spirituality*
- *Politics and the social order*
- *Recording and communicating information*
- *Decoration*
- *Expression*
- *Social action*

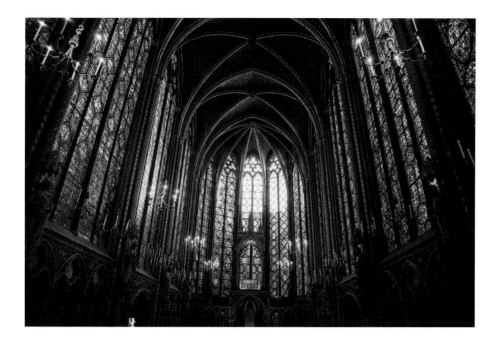

## Religion and Spirituality

Throughout time, art has *helped people in their relationship with the divine* and in reaching out to the unknown. Religious art can provide *a wondrous space* in which we feel a spiritual presence. It can serve as *an intermediary*, allowing people to appeal directly to a deity. Finally, it can form a concrete visual *representation of the divine*.

### A Wondrous Space

Some buildings feel unlike others. *Their spaces are designed to make people feel closer to God.* Sainte-Chapelle (sant shah-PELL) evokes an otherworldly experience (figure 1.28). King Louis IX of France had the chapel built in the thirteenth century to house relics (sacred remains and objects). Walls containing stained glass soar to the heavens. The cut colored pieces of glass, held together with lead strips, change the light, so inside the chapel the light shimmers mystically, allowing visitors to enter a spiritual world that is distinct from the everyday.

### An Intermediary

Sometimes, *people seek the help of a deity* through art. One late-nineteenth-century example is a *nkisi n'kondi* (en-KEE-see en-KOHN-dee) nail figure (figure 1.29) from the Democratic Republic of the Congo. Figures like this one enabled Kongo people to call upon the spiritual world for support. A priest placed a mixture of materials (human hair, nail clippings, etc.) in the cowrie shell that protrudes from the figure's belly. It was believed these materials inspired the sculpture to fight for the petitioner's request. Appeals were made for healing, helping with livelihoods, or harming enemies. The petitioner then drove a nail into the figure to provoke it to action.

### A Representation of the Divine

Art has also been crafted to *transform abstract concepts of gods into concrete images.* In Hinduism, depictions of deities aid believers in finding salvation through devotion to multiple gods. One supreme deity is *Shiva*, who is known as both a destroyer and creator. In figure 1.30, an Indian sculpture of the god from the twelfth century performs a cosmic dance of death and rebirth surrounded by a circle of flames. With his foot, he stomps on a figure that represents ignorance, while his multiple hands are held in different positions that each have specific meanings.

One interpretation of the work suggests that we should not be led astray by ignorance. Instead, we should come forward without fear and find salvation through devotion.

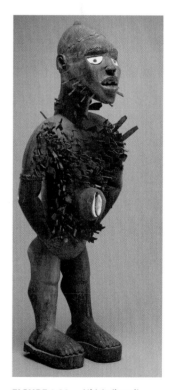

This hand holds a drum that beats out the rhythm of the cycle of the universe.

This hand holds a flame representing destruction.

This hand forms a symbol that means have no fear.

This hand points to his foot, suggesting the faithful can find refuge there.

**FIGURE 1.30.** *Shiva, Lord of the Dance.* From Tamil Nadu Province, India. Chola Dynasty, 1100s. Bronze, 3′ ⅞″ high. Denver Art Museum, Colorado.

*Quick Review 1.5*: What are three religious and spiritual functions of art?

## Politics and the Social Order

Another important purpose of art is *political.* There are two types: art used by governments and rulers to *promote the social order* and art employed by individuals to *protest the social order.*

### Promoting the Social Order

Art can *promote the social order* by *identifying leaders, endorsing power,* and *establishing a method for how society should be organized.* Among the Kuba in Africa, hierarchical attire denotes status. Title holders wear emblems, displaying their role in society. The higher the rank of the person, the more elaborate the attire.

The most adorned is the king. His state dress weighs almost two hundred pounds. This dress expands his size so that he is physically larger than others, making him appear fierce and intimidating. Others must help him dress and move, which further denotes his superiority. Every aspect of his attire can be interpreted as denoting his esteemed position (figure 1.31).

### Protesting the Social Order

Conversely, art has also been used to *protest the social order.* Art can *criticize governments, point out social injustice,* or *object to the status quo.*

**artists**
MATTER

Emily
Jacir

Emily Jacir (jah-SEER), a Palestinian-American artist, has criticized Israel's government. Unlike most other Palestinians, Jacir can travel freely in Israel, Gaza, and the West Bank, because she has an American passport. Conversely, Israel has limited the movement of other Palestinians because of security concerns from the threat of terrorism. Jacir both disapproves of the policy and has tried to draw attention to the hardships it has created for Palestinians.

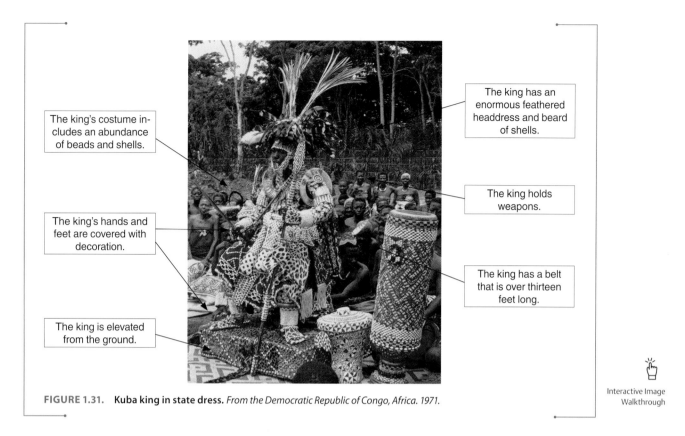

The king's costume includes an abundance of beads and shells.

The king has an enormous feathered headdress and beard of shells.

The king holds weapons.

The king's hands and feet are covered with decoration.

The king has a belt that is over thirteen feet long.

The king is elevated from the ground.

FIGURE 1.31. **Kuba king in state dress.** *From the Democratic Republic of Congo, Africa. 1971.*

Interactive Image Walkthrough

In her series "Where We Come From," Jacir asked thirty Palestinians what she could do for them in Israel. Then, she traveled to these locations and performed the requests, documenting her visits in photographs and writing (figure 1.32).

Contemporary artist Emma Sulkowicz used Performance art (see Chapter 20)—a theatrically based type of art—to object to the status quo in *Mattress Performance (Carry That Weight)* (figure 1.33). Sulkowicz protested against the disturbing frequency of sexual

FIGURE 1.32. **Emily Jacir.** *Munir. From the series "Where We Come From." 2001–03. Chromogenic print and framed text, 2′ 11 ¾″ × 3′ 2 ¾″ × 1 ¼″. Whitney Museum of American Art, New York.* Jacir documented a man named Munir's request to visit the grave of his mother.

FIGURE 1.33. **Emma Sulkowicz.** *Mattress Performance (Carry That Weight). 2014–15. Performance at Columbia University, New York.* Sulkowicz carried the same mattress type as the one used when she said she was raped.

assault on college campuses and limited support for victims. While a sophomore at Columbia University in New York, Sulkowicz alleges she was raped. In her senior year, she carried a mattress to draw attention to the widespread troubling issue. The enormous, awkward load she hauled was a physical weight that may have represented the mental one victims carry.

Sometimes, it is not so easy to determine the purpose of a work. For example, some people might find parallels between Sulkowicz's carrying the mattress and the image of Jesus carrying his cross before he was crucified. Does this fact make Sulkowicz's work religious? To discover one technique you may use to decipher a work's function, see *Practice Art Matters 1.3: Figure Out the Purpose of a Work of Art.*

---

*Practice* **art**MATTERS

## 1.3 Figure Out the Purpose of a Work of Art

One method to decipher the purpose of a work is to:

- *Describe* the figures, objects, shapes, and areas in the image.
- *Analyze* the items you described by explaining their appearance, relationships with one another, activities, and locations.
- *Obtain* more information about the image, such as the work's title, artist, time period, location, size, reason for being made, and place originally intended to be seen.
- *Interpret* what you think the image means based on what you have described, analyzed, and obtained.
- *Judge* what you think the purpose of the work is.

Figure 1.34 depicts a painting of Emperor Napoleon by nineteenth-century French painter Jean-Auguste-Dominique Ingres (jawn oh-GOOST dohm-een-EEK AN-gr'). Figure out whether the purpose of this work is religious or political. To do so, consider the image and answer these questions:

*Describe* the image:

- Who is depicted?
- What does he wear on his hands, feet, head, and neck?
- What does he hold in his hands?
- What is on the floor in front of him?

*Analyze* the image:

- What colors is he dressed in?
- What materials were used to make his clothing?
- What is the texture of his clothing?
- How much of the painting does he take up?
- Is he located in the center or on the side of the image?
- Is he on flat or elevated ground?

*Obtain* information about the image from the caption.

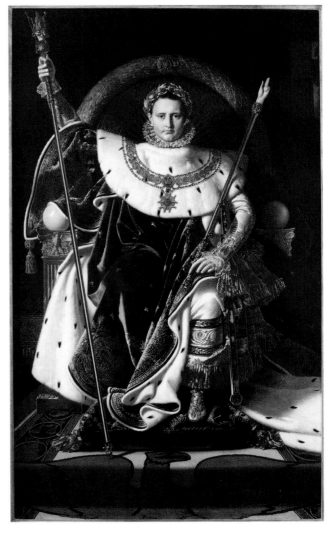

**FIGURE 1.34.** **Jean-Auguste-Dominique Ingres.** *Napoleon Enthroned.* *1806. Oil on canvas, 8′ 8″ × 5′ 5 ¼″. Musée de l'Armée, Paris.*

*Interpret* what you think the image means by asking yourself questions about why what you *described, analyzed,* and *obtained* might be the way it is and coming up with possible answers. For example:

- Why might Napoleon be wearing what he is? One interpretation may be that it is because he is of a high rank.
- Why might Napoleon be holding what he has in his hands? Maybe, it could be suggested, because they are symbols of the ruler.

- Why might Napoleon's clothes have those textures? Maybe to show his wealth.
- Why might the painting be over eight feet tall? Possibly to aggrandize him.

*Judge* what you think the purpose of the work was, considering the three types of religious art and the two types of political art. Why do you think the work had this purpose?

*Quick Review 1.6*: How do two types of political art differ?

## Recording and Communicating Information

Another way in which art has been used is to *record and communicate information.* Because art is visual, art that informs is often more easily understood, memorable, and powerful than verbal description. Artists have recorded and communicated information by *documenting life* in previous time periods and places, *reflecting the world* around us, *relaying messages, recounting past events,* and *manipulating depictions* to convey false information.

### Documenting Life

Art has helped *capture different time periods.* From art, we can see how people lived. For example, *Flood Victims, Louisville, Kentucky* by American Margaret Bourke-White shows African Americans standing in a relief line under a billboard of smiling white faces after a disastrous flood during the Great Depression (figure 1.35). The stark contrast between the supposed American dream and the reality of suffering captured the people's lives during this period in a way words likely could not have.

**artists**
MATTER

Margaret
Bourke-White

### Reflecting the World

Through art, people can also *learn about places* they have never been. Frederic Edwin Church's *Niagara* shows a realistic depiction of rushing water over the great falls (figure 1.36). Even if someone had never seen the falls, the grand size of the work and the energy of the water would illustrate the awesome power of the place.

### Relaying Messages

Art has also been instrumental in *communicating messages.* While sometimes this undertaking is deceptive, as with *Triumph of the Will* (figure 1.21), even an artist of a painting such as *Niagara* (figure 1.36) usually wishes to convey an idea. Active in mid-nineteenth-century America, Church believed that the land was the nation's God-given destiny. His inclusion of a rainbow in the painting probably symbolizes a divine presence. One hundred thousand people saw the painting in the first two weeks when it was exhibited (and even more subsequently); this widespread message helped to establish a mood of optimism and pride in the country.

**FIGURE 1.35.  Margaret Bourke-White.** *Flood Victims, Louisville, Kentucky. From* Life Magazine. *1937. Gelatin silver print, 10″ × 13 ⅓″. George Eastman House, Rochester, New York.*  Bourke-White's image not only documented the specific distress brought on by the devastating natural disaster of the flooding of the Ohio River, but also illustrated the larger misery of the period.

FIGURE 1.36. Frederic Edwin Church. *Niagara.* 1857. *Oil on canvas, 3′ 6 ½″ × 7′ 6 ½″. The National Gallery of Art, Washington, DC.* Church's painting reflected the falls so exactly that nineteenth-century viewers brought binoculars when it was exhibited to be able to see the painting's realistic details.

## Recounting Past Events

Furthermore, art has been used to *recount events* by providing information about history and the people who lived that history, just as the Vietnam Veterans Memorial, by listing the names, documents the human toll of war. A handscroll from thirteenth-century Japan recounts an attack on Sanjo Palace. In the detail in figure 1.37, archers on horseback slaughter defenders, and fire sweeps through the palace. The brutal specifics record the event for posterity.

## Manipulating Depictions

Because of the power of images, *art that records is highly believable*. But, just because an artist appears to reflect the truth, doesn't necessarily mean that we should trust a depiction. *Night Attack on Sanjo Palace* (figure 1.37) was actually created about a hundred years after the event occurred. The scroll reflects what the artist imagined happened and wanted to communicate to viewers.

Even with photography or film (see Chapter 8), artists decide how and what we will see. Canadian Jeff Wall digitally manipulates photographs, so that what at first appears spontaneous, on second look proves impossible. In figure 1.38, a grave is filled with water. However, a closer inspection reveals the grave is occupied by starfish and sea anemones. Wall created the fantastic image by combining different pieces of digital photographs.

While it is easy to recognize that Wall manipulated this image, sometimes determining reliability is not so straightforward and *it is important to question what we see.* To discover one method of analyzing images for authenticity, see *Practice Art Matters 1.4: Judge Whether an Image Is Reliable.*

FIGURE 1.37. *Night Attack on Sanjo Palace,* detail. *From Japan. Kamakura period, late thirteenth century. Handscroll, ink and colors on paper, 1′ 4 ¼″ × 22′ 11 ½″. Museum of Fine Arts, Boston.* While this image shows a detail, the complete handscroll is almost twenty-three feet long so it can tell the different events of the story.

*Practice* **art**MATTERS

## 1.4 Judge Whether an Image Is Reliable

One method to decide whether an image is believable is to follow the process used to figure out the purpose of a work (see *Practice Art Matters 1.3: Figure Out the Purpose of a Work of Art*), but modify the judging step:

- *Describe* what you see.
- *Analyze* what you described.
- *Obtain* more information.
- *Interpret* what the image means.
- *Judge* whether the image is reliable: is it really documenting the truth or was it manipulated?

Carrie Mae Weems used black-and-white, historical photographs of African American slaves that appeared to have been documenting the truth. She rephotographed the images, and then tinted, framed, and covered the new photos in glass, inscribing words on the glass. Figure 1.39 shows one of her new images.

Figure out whether the original photo documented the truth or was manipulated.

*Describe* the image:

- Who is depicted?
- What parts of the person's body are shown?

*Analyze* the image:

- Is the person nude or dressed?
- From which view is the person depicted?
- What color did Weems tint the original black-and-white photograph?

FIGURE 1.39. **Carrie Mae Weems.** *You Became a Scientific Profile.* *From the series "From Here I Saw What Happened and I Cried." 1995–96. Monochrome c-print with sandblasted text on glass, framed 2′ 2 ¾″ × 1′ 10 ¾″ × 1″. Harvard Art Museums, Cambridge, Massachusetts.*

- What shape is Weems's frame?
- What words did Weems write on the glass?

Some information you should *obtain*:

- The original photo is from 1850. The American Civil War had not yet occurred, and African Americans were still unjustly enslaved.
- A white scientist who was attempting to prove his false, highly disturbing theory that black people belonged to a different species than white people took the photo.
- Weems is a contemporary African American artist. The title of Weems's series is "From Here I Saw What Happened and I Cried."

Using what you described, analyzed, and obtained, *interpret* what the original image means:

- Why do you think the scientist posed the woman as she was?

- Why might Weems have chosen the color she did to tint the image?
- Why do you think Weems framed the image and put it behind glass?
- Why did Weems title the series as she did?

*Judge* whether the original image is reliable:

- Do you think Weems believed the original photo was racist? Do *you* think it was racist?
- Do you think the original scientist thought the original photo was racist? Do you think the original creator of a work is the ultimate authority on the meaning of a work? Or, do the viewers' opinions also help create meaning?
- Was the original photo documenting the truth or was it manipulated?

---

*Quick Review 1.7*: Why do you need to question what you see?

## Decoration

Another use for art has been for *decoration*. Art has transformed *spaces and common objects* into the extraordinary *through embellishment*, and it has informed our identities by *adorning people*.

### Embellishing Spaces and Objects

To make our lives more uplifting, artists have *adorned spaces and objects to make them more lavish or more understated*. Nicolas Pineau's Varengeville Room, designed for a noble's eighteenth-century townhouse in Paris, is an elaborate, decorated space (figure 1.40). By

Ornate gold molding displays swirls and floral designs.

Large mirrors reflect the space, increasing the overall ornamental effect.

Furniture is carved and gilded.

**FIGURE 1.40.** **Nicolas Pineau. Varengeville Room in the Hôtel de Varengeville.** *From the Hôtel de Varengeville, Paris. c. 1735. The Metropolitan Museum of Art, New York.*

transforming a common room into a sumptuous space, Pineau attempted to provide an enriching environment.

An opposite approach can be seen in a bottle produced during the twelfth or thirteenth century in China (figure 1.41). The bottle was created for the imperial court, and was purposely crafted to be understated, in line with Southern Song dynasty tastes. The symmetrical structure, rounded bottom, long neck, and subdued color contribute to a meditative impression.

### Adorning People

*Individuals can also adorn themselves in ways that form statements about their identities.* Native Americans have created bandolier bags as decorative objects to be worn. Figure 1.42 shows an example from the early 1900s. The bags have been used for display or to identify different group members at intertribal events. However, they have not been used for transporting goods—some are even too small to hold anything or contain no pocket at all.

*Quick Review 1.8*: What are two types of decorative art?

## Expression

Another purpose of art is as a *form of expression*. Art gives artists and viewers a chance to think, feel, and dream. Art can *capture an emotion* or experience, allow people to *look inward*, or enable an artist to *imagine another world*.

### Capturing an Emotion

Art can *pull together viewers' or artists' feelings and thoughts*. The Vietnam Veterans Memorial has served as a poignant form of expression, allowing visitors to experience sadness.

Similarly, Robert Motherwell, in *Elegy to the Spanish Republic No. 34*, sought to express grief for a country and way of life (figure 1.43). The title refers to the Spanish

**FIGURE 1.41.** **Bottle.** *From Hangzhou, China. Southern Song dynasty, 1127–1279. Guan stoneware with celadon glaze with crackle, height 6 ⅝".* The British Museum, London. To further highlight the bottle's humble appearance, what appear to be cracks (that were intentionally formed) cover its surface.

**FIGURE 1.42.** **Bandolier bag.** *Early 1900s. Beaded cotton and velvet, tube beads, and cotton braiding, 3′ 4″ × 1′ 1″. South Dakota Art Museum, Brookings.* Women have typically created these decorative bags, while men have carried them across their shoulders. Glass beads stitched into elaborate arrangements form different designs, giving each bag a distinctive appearance.

**FIGURE 1.43.** **Robert Motherwell.** *Elegy to the Spanish Republic No. 34.* *1953–54. Oil on canvas, 6′ 8″ × 8′ 4″. Albright-Knox Art Gallery, Buffalo, New York.* Powerful black verticals and ovals alternate across the canvas, wiping out a background of red and yellow, the colors of the Spanish flag.

Kahlo's two sides are set in a barren landscape against a threatening sky.

An artery of blood connects to both sides through their hearts.

Kahlo's European self tries to stem the flow of blood with forceps.

Kahlo's Mexican self holds a tiny portrait of her husband as a child.

**FIGURE 1.44.** **Frida Kahlo.** *The Two Fridas.* *1939. Oil on canvas, 5′ 8 ½″ × 5′ 8 ½″. Museo de Arte Moderno, Instituto Nacional de Bellas Artes, Mexico City.*

Republic, which was overtaken by a dictator in 1939 after a civil war. Motherwell came of age in the United States in the 1930s, and the Spanish Civil War had a profound effect on him.

Motherwell believed in expressing emotion in a work through shapes and colors that did not depict the real world. The painting is one of over one hundred "elegies" (poems for the dead) in which Motherwell bared his soul about the Spanish Republic through similar imagery.

### Looking Inward

Art also *allows viewers or artists to look inward to explore themselves.* In particular, self-portraits have enabled artists to delve into their psyches and reveal their personal experiences.

Frida Kahlo's *The Two Fridas* explores the two sides of this twentieth-century artist's life. Born to a European father and Mexican mother, she appears in European dress at left and Mexican at right. The two Fridas hold hands linking them as one (figure 1.44).

The painting appears as a graphic expression of the trauma of Kahlo's existence. She suffered from the physical pain of an almost deadly bus accident and psychological pain from a stormy marriage to Mexican artist Diego Rivera (dee-AY-goh ree-VER-uh). In the painting, Kahlo seems to explore the depth of her anguish.

**artists**
MATTER

Hieronymus Bosch

### Imagining Another World

Artists have also employed art to *express their imaginations.* They have supplied a look into their ideas for wild new worlds. Dutch artist Hieronymus Bosch (heer-AHN-ih-mus BOSH) painted a fantastic vision in *The Garden of Earthly Delights* in 1505. The painting unfolds in three parts (figure 1.45).

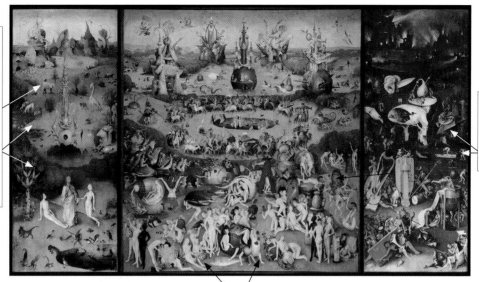

In part 1, exotic animals, including a giraffe and elephant, are seen in the distance, an odd pink fountain sits in a pond, and God presents Eve to Adam in the Garden of Eden.

In part 3, damned souls are tortured in a terrifying hell.

In part 2, countless humans frolic among fantastic, imaginary animals, huge birds, and gigantic pieces of fruit, which may symbolize sex and fertility.

**FIGURE 1.45.** **Hieronymus Bosch.** *The Garden of Earthly Delights.* c. 1505–15. Oil on wood, central panel 7' 2 ⅝" × 6' 4 ¾", each wing 7' 2 ⅝" × 3' 2 ¼". Prado Museum, Madrid.

The bizarre scene's meaning is hotly debated. One interpretation suggests the painting may be a commentary on sins of the flesh leading to the Final Judgment, when Christians believe Christ will judge all souls. Another reading suggests the painting symbolizes the medieval science of alchemy—the attempt to turn base metals into gold. Fountains and glass globes, seen throughout, would then represent the alchemist's tools and vessels.

Interactive Image
Walkthrough

*Quick Review 1.9*: How has art been used for expression?

## Social Action

Finally, art has been used for *social action*. Art has helped *raise awareness for unsung causes, champion different issues,* and *solve problems.*

### Raising Awareness of Unsung Causes

Art *reminds people of causes that need attention.* For example, the *AIDS Memorial Quilt* (figure 1.46) has raised awareness of the impact of the AIDS virus. The virus first appeared among gay men and intravenous drug users, prompting many narrow-minded people to blame the victims for their own deaths, rather than see the virus as a health crisis.

Begun in 1987, and today over 1.3 million square feet, the quilt is the largest ongoing community art project in history, with new panels added weekly. Too large to be displayed at once, the quilt is shown in sections.

The quilt is composed of more than 49,000 three-by-six-foot panels—sized intentionally to mimic the size of graves.

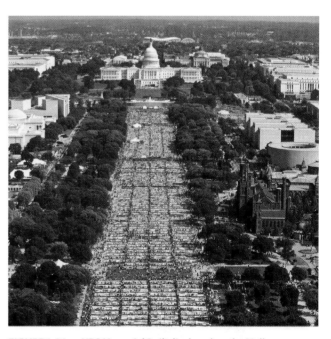

**FIGURE 1.46.** *AIDS Memorial Quilt* **displayed on the Mall, Washington, DC, in 1996.** This was the last time and place where the entire quilt was shown together.

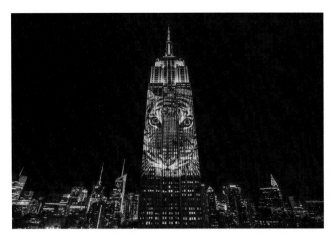

**FIGURE 1.47.** Louie Psihoyos and Travis Threlkel. *Projecting Change: Empire State Building.* *2015. Projection, 375' × 186'. Realized in New York.* Images of different endangered animals moved across the Empire State Building over three hours.

When the quilt is laid out on the ground for display, it represents a seemingly endless cemetery. Each panel is handmade and donated by the friends or family of someone who died of AIDS and is a tribute to that person's life. The panels have been painted, sewn, stenciled, and glued and contain numerous personal mementos.

The quilt has put a human face on the disease and brought attention to the enormity of the epidemic, the importance of preventative education, and the necessity of funds. Since its creation, the quilt has raised over $5 million for AIDS organizations, been nominated for the Nobel Peace Prize, and been seen by over 25 million people.[13]

## Championing Different Issues

Art has also *brought further awareness to issues* that are already in the spotlight. Colorado-based Louie Psihoyos (sih-HOY-os) and California-based Travis Threlkel highlighted the plight of endangered species through *Projecting Change: Empire State Building.* In 2015, they projected numerous animals at risk for extinction onto the Empire State Building in New York, creating a thirty-three-story-high light display (figure 1.47).

Some artists champion issues on a smaller scale. Andy Goldsworthy works with natural materials to highlight our fragile relationship with the environment. One of the contemporary British artist's projects focused on the elm tree—many of which have been lost to disease. In figure 1.48, the artist used vibrant leaves from a living tree and stuck them to the limb of a dead tree, using only stream water for glue. He then tore a line down the center. The temporary nature of the work suggests the vulnerability of the natural world.

## Solving Problems

Finally, art has been used to *help solve the world's problems.* Similar to how the Vietnam Veterans Memorial has helped people heal, other works of art have come to the aid of those in need.

Los Angeles–based artist Mary Beth Heffernan used art to solve a problem during the 2015 Ebola crisis in West Africa (figure 1.49). The deadly disease was sickening numerous people, and healthcare workers were wearing protective suits that left patients feeling they were being cared for by robots. With no access to family or friends because of fears of contamination, patients had no sense of human contact to comfort them.

**FIGURE 1.48.** Andy Goldsworthy. *Torn Leaf Line Held to Fallen Elm with Water, November 15, 2002.* *Cibachrome print on paper, 1' 8" × 4' 11 ½". Ulrich Museum of Art at Wichita State University, Kansas.* Because he uses items such as twigs, leaves, snow, and ice, Goldsworthy's works often are destroyed by gusts of winds or changing tides and are recorded only in photographs, like here.

**FIGURE 1.49.** Mary Beth Heffernan pastes a photo of a nurse on the front of her protective suit in Liberia, Africa. Heffernan's solution helped not only patients, but also medical workers, because having the ability to see the faces of coworkers improved morale for all.

Heffernan took photos of healthcare workers' smiling faces and printed them on stickers. Every time workers suited up, they stuck the photos on their gear, so patients could appreciate the humans inside.

*Quick Review 1.10*: In what three ways has art been employed for social action?

## A Look Back at the Vietnam Veterans Memorial

Studying the Vietnam Veterans Memorial allows us to consider a powerful work of art. However, it also gives us an understanding of *how much art matters* in our world and the *purposes that art serves*.

Lin's work is a *central part* of numerous people's lives. Since 1984, over 123 million individuals have visited the memorial.[14] Some go to find a name, but others happen upon The Wall accidentally. Art is *all around us* whether we seek it out or not. Artists, too, can be found in all cultures throughout the world. Their creation is *characteristically human* and their *inner calling to create is powerful*.

Moreover, society recognizes the importance of art. Lin's work was *strongly supported*. The memorial received federal and individual backing. The U.S. *government* approved it, while *individuals* put up money. As a work of *public art*, not surprisingly, the memorial was controversial. Even though Lin's design fit harmoniously into the space, many wanted to control what it would look like.

The memorial has *benefited society*. Lin designed the memorial as part of a class, reminding us of the importance of *art education*. Furthermore, since its dedication, the memorial has served as a *place of healing* for veterans, families, and friends.

From the memorial, we also see the *power of art*. The Vietnam veterans at the Fund understood how art could *change*

*public opinion and elevate the status of veterans*. They knew that art becomes an enduring part of a national heritage—something that is revered—so through art they could best honor those who served.

Furthermore, The Wall has several *purposes*. Even though Lin designed the memorial to make no political statement, the memorial is still a *political form of art* in that it both elevated the status of the veterans and challenged the status quo. The memorial is also a form of *record*. Because of the memorial, the names of those who died will not be forgotten. Finally, the memorial is a form of *expression*. Not only does it represent Lin's vision, but it has permitted countless visitors to find an outlet to express grief. The memorial poignantly reminds us of what we have lost.

As you move forward from this chapter, consider how Lin's memorial has made a difference in so many lives by helping to heal the nation. Both pro- and antiwar visitors have been able to join as one to remember. Art has the power to make us more human, build connections, and promote common values. Just as ordinary people—strangers—were drawn together to form silhouettes on a Normandy beach (figure 1.9), all of us have the chance to be touched by art and discover how art makes life more worth living.

Flashcards

## CRITICAL THINKING QUESTIONS

1. What art did you experience during your day yesterday?
2. Should the government have been allowed to take down Richard Serra's *Tilted Arc* (figure 1.12)? Why or why not?
3. Given how images that record can be manipulated, why is art education important?
4. Imagine the town where you live has decided to cut the art program at the school that your child with special needs attends. Why might the cuts specifically harm your child?
5. If someone has gone camping her whole life, goes to the movies, and is then suddenly nervous to camp, what is one reason involving art that might have caused her fear? Why would it have occurred?
6. Pick a work of art from your life that shows one of the ways discussed in the chapter that art matters. What is your work of art? Why does it represent this way and matter to you?
7. Some religious groups hold ceremonies at Stonehenge (figure 1.8). Why might they choose this location?
8. When Chinese students built the *Goddess of Democracy* (figure 1.6), what kind of political art was it? How do you know?
9. Why do historians depend on art?
10. Must all finely decorated objects be extravagantly embellished? Why or why not?
11. This chapter describes Emma Sulkowicz's work (figure 1.33) as political. Could you make the case that it also functions as a form of expression? How?
12. Do you think Andy Goldsworthy's work (figure 1.48) can really be considered social action if it is so small? Why or why not?

Comprehension Quiz          Application Quiz

# CHAPTER

# 2

# What Is Art?

## LEARNING OBJECTIVES

**2.1** Explain why not all art can be classified as physical objects made from artistic materials.

**2.2** Characterize how the study of art is identified with beauty.

**2.3** Summarize three ways in which art can have value.

**2.4** Identify the problems with the canon.

**2.5** Distinguish between the types of expertise associated with artistic skill.

**2.6** Explain why a viewer plays an essential role in the artistic process.

**2.7** Summarize the ways in which a viewer can approach difficult art.

**2.8** Explain how one work of art can be associated with more than one theme.

**2.9** Differentiate among representational, nonobjective, and abstract art.

**2.10** Explain how subject matter and form are related to content.

## BARNETT NEWMAN'S *VOICE OF FIRE*

▷

How Art
Matters

In 1990, the National Gallery of Canada announced the purchase of *Voice of Fire*, a huge painting by American Barnett Newman, for $1.76 million Canadian ($1.5 million U.S.). The gallery directors were enthusiastic about acquiring a work from a *renowned artist* that they thought would have an *uplifting impact on viewers* because of its height and colors (figure 2.1).

However, the purchase sparked an uproar. Many Canadians did not think the work qualified as art. They believed the work took no *skill to produce*, was not *creative*, and had no *financial value*. So, is *Voice of Fire* art?

To answer this question, we need to understand *what was going on during the period* when Newman began forming these types of works. In the late 1940s, many artists were wondering what direction art should take. These artists had survived the Great Depression and two world wars. Given the harsh reality the world had lived through, many artists wondered:

» What the point was of painting *beautiful pictures*
» How artists could express their feelings, if they were stuck recording meaningless *recognizable objects from the real world*
» Why artists should even bother recording reality when photographers could *serve the purpose* of documenting the world more easily

This was Barnett Newman's world when he and others *struggled to create a new, original art* that mattered. He did so using only colors, shapes, and lines to represent the human condition.

**FIGURE 2.1.** **Barnett Newman.** *Voice of Fire* **in the National Gallery of Canada, Ottawa, Ontario.** *1967. Acrylic on canvas, 17′ 10″ × 8′.* When purchased, this painting had already been hanging in the gallery (on loan), so public outrage surprised directors.

### Be 1

If we look at *Be 1* (figure 2.2) from this period, we can begin to understand the *meaning of Newman's art*. At over seven feet tall, the painting is larger than life. The red is deep, intense, and made up of layers of different reds. At the center is a single thin white line, which Newman called a zip, splitting the canvas like a beam of light.

What does "Be" mean? Perhaps "Be" is a direction to us or Newman's direction to himself. Be who you are. Be true to yourself. Be all that you can. These ideas would likely have been meaningful to Newman, who was inventing a new type of art.

Now, imagine Newman trying to create art that *did not depict anything from the real world*, but that *expressed an idea* by manipulating just color, shape, and line, and consider *Be 1*. Does Newman's single thin line in the sea of red convey the idea of being? What if the line were thicker, there were two lines, or the red were green? Would a message about individuality and courage still be there? While the painting seems so simple, a slight difference would change the entire effect.

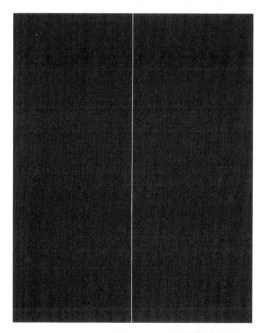

**FIGURE 2.2.** **Barnett Newman.** *Be 1. 1949. Oil on canvas, 7′ 6″ × 4′ 6″. The Menil Collection, Houston.* In discussing the meaning of this painting, we can ignore the "1." It means only that there is another painting, *Be 2.*

### First Station

In the years before he painted *Voice of Fire*, Newman painted a series of paintings that represented the moment when Christians believe that Jesus, nailed to the cross, cried out to God, "Why hast thou forsaken me?"[1] Newman completed the paintings after he had suffered a heart attack and contemplated giving up art because of widespread rejection of his work.

One interpretation of the series suggests that Newman was expressing *the idea* of Jesus's intense despair at possibly having been forgotten by God. Newman may have sympathized given his own situation.

Figure 2.3 shows one of the paintings, *First Station*. While we can *identify the work as Newman's in its characteristic zips*, it is a complete change from the all-encompassing red of *Be 1*. Here, the work is limited to blacks, whites, and grays. Even though Newman only moved around lines and changed colors, the impact seems different.

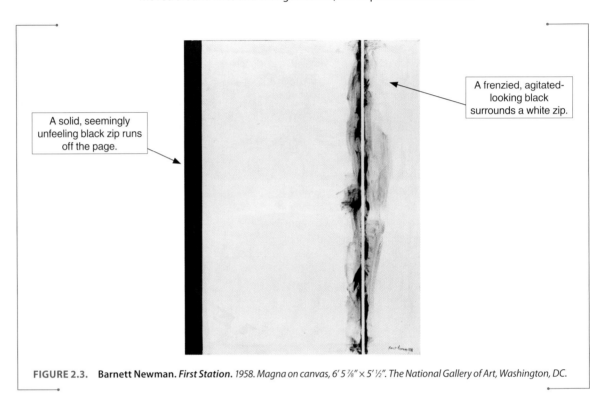

A solid, seemingly unfeeling black zip runs off the page.

A frenzied, agitated-looking black surrounds a white zip.

**FIGURE 2.3.** **Barnett Newman.** *First Station.* *1958. Magna on canvas, 6′ 5 ⅞″ × 5′ ½″. The National Gallery of Art, Washington, DC.*

### Voice of Fire

In reconsidering *Voice of Fire*, note that the title comes from the Bible. When God gave the people of Israel the Ten Commandments at Mount Sinai, Moses reminded them, "The Lord spoke to you out of the midst of the fire; you heard the sound of words, but saw no form—there was only a voice."[2] This passage may have been meaningful to Newman, who created paintings to have a voice or *meaning*, yet *no form* or recognizable appearance. Knowing this information, reexamine *Voice of Fire* to see how Newman *conveyed meaning* through three simple stripes *presented in a particular way* (figure 2.4).

*Voice of Fire* serves as a model for how we might approach art that is *new* and possibly *difficult*. The painting also asks us to consider what art is. While you might now see the meaning, does that make the work art? Should art have to be crafted with skill or be pleasing? What if art makes people angry? Who should decide what qualifies as art? This chapter explores these questions and looks at the themes, types, and ingredients of art. Before moving forward, based on reading this story, what do you think art is? Write down your answer so that you can reevaluate your opinion after you have completed the chapter.

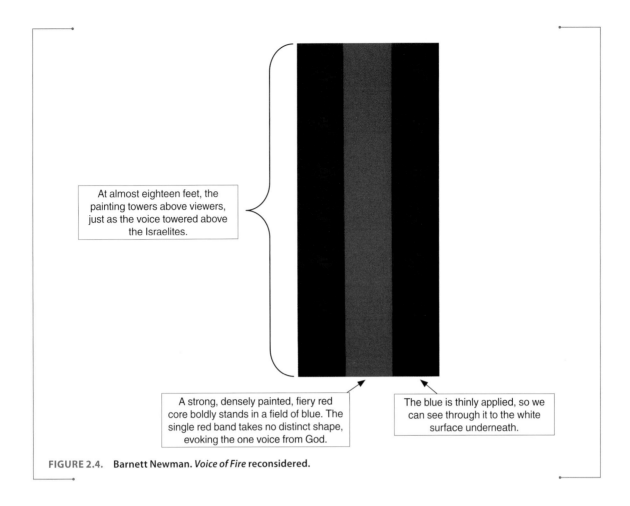

At almost eighteen feet, the painting towers above viewers, just as the voice towered above the Israelites.

A strong, densely painted, fiery red core boldly stands in a field of blue. The single red band takes no distinct shape, evoking the one voice from God.

The blue is thinly applied, so we can see through it to the white surface underneath.

**FIGURE 2.4.** Barnett Newman. *Voice of Fire* reconsidered.

# Defining Art

Defining art is challenging because art encompasses so much. Art includes works:

- From *all time periods* and *around the world*
- That *deal with different topics* and are used *in different ways*
- That are made in different **media**: materials such as paint, bronze, or fabric; and types of art such as paintings, sculptures, and quilts
- That are **two-dimensional**: flat works having height and width, such as drawings and paintings; and **three-dimensional**: solid works with bulk having height, width, and depth, such as buildings and clay pots

In addition, art is hard to define because ideas about art change and people disagree. As with *Voice of Fire*, the Gallery staff and public disagreed. We each experience art on our own terms.

This chapter offers a number of ways to define art—as *a physical object made from artistic materials*, as *an aesthetic experience*, as *an object of value*, as *part of the canon*, as *a*

**medium** (singular)/**media** (plural)  The material used by an artist to create a work of art; an art form or type of art that uses a particular material

**two-dimensional**  Having height and width, but not depth

**three-dimensional**  Having height, width, and depth

*work crafted with skill*, as *a work that has meaning*, and as *a creative work*. No definition explains all of art, and no definition is problem free. To appreciate what art is, we must consider multiple views.

## Art as a Physical Object Made from Artistic Materials

Probably the easiest way to define art is as a *work made from artistic materials* such as paint, clay, or ink that are *tangible so that we can display the work in a museum or other area*. Twentieth-century American artist Alice Neel used the artistic material of paint to create *Gerard Malanga*. The work is a physical object that could exist in a museum or gallery. Neel loosely applied paint to capture the poet/photographer (figure 2.5).

However, this definition does not work for all art as *not all art is made from artistic materials or can be displayed in a museum*. British artist Chris Drury used beetle-eaten trees to make a forty-six-foot whirlpool-like form in a Montana park (figure 2.6). Beetles have attacked whole forests in recent years. By placing dead trees in a configuration in which they appear to be pulled into the earth, Drury was likely commenting on this devastation.

In addition, defining art by artistic materials also doesn't work for all art as *some materials are short lived*. Cai Guo-Qiang (tsye gwoh-CHEE-ANG) uses explosives to create his artistic events. After, no physical object is left; instead, the memory of the experience allows the work to live on. Figure 2.7 depicts *Sky Ladder*, which Cai created in his hometown in China in 2015, using fireworks to form a ladder of light in the sky.

**artists**
MATTER
Cai Guo-Qiang

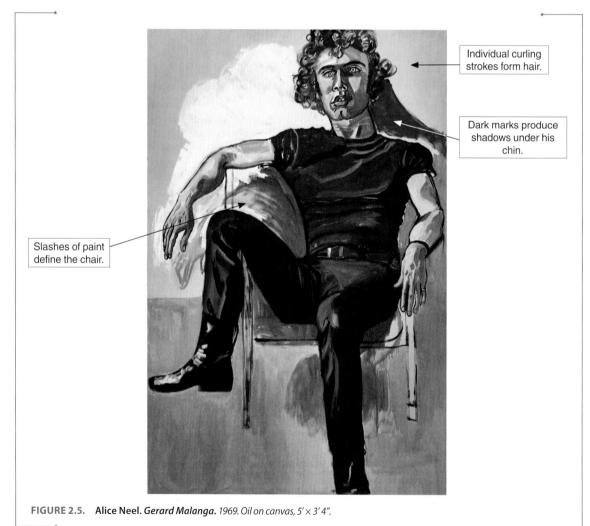

Individual curling strokes form hair.

Dark marks produce shadows under his chin.

Slashes of paint define the chair.

**FIGURE 2.5.** **Alice Neel.** *Gerard Malanga. 1969. Oil on canvas, 5′ × 3′ 4″.*

The display reflects a story Cai heard while visiting Jerusalem, Israel. Legend has it that good souls buried in the city's valley will be the first to ascend to heaven before the apocalypse. Here, a ladder of golden light leads the way.

*Quick Review 2.1*: Why can't all art be defined as a physical object made from artistic materials?

## Art as an Aesthetic Experience

Another way that art has been defined is as *being beautiful, extraordinary, and uplifting*. The formal branch of philosophy dedicated to the study of art and the nature of beauty is called **aesthetics**. When we define art aesthetically, we focus on what we see—the colors, shapes, figures, and the like—and how those items make us feel differently from how we do ordinarily. Art that gives viewers an aesthetic appreciation provides a *multisensory experience* and displays an *idealized beauty*.

### A Multisensory Appreciation

In responding to something aesthetically, *we experience it with all our senses*. For example, if you were to witness the sun setting on a beach, you would smell the ocean, hear the waves, touch the sand, and taste the salt, in addition to seeing the sun. The combination of your senses would give you an aesthetic appreciation of the beauty of the scene.

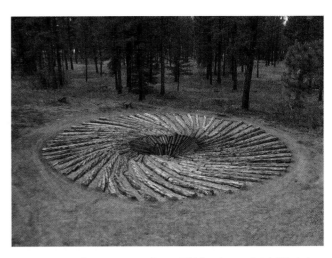

**FIGURE 2.6.** **Chris Drury.** *Ponderosa Whirlpool.* *2016. Beetle-killed pine and fir trees and stone, 46' in diameter. Blackfoot Pathways Sculpture in the Wild International Sculpture Park, Lincoln, Montana.* Among other factors, milder winters have allowed the beetle population to explode, so Drury's work can also be interpreted as a protest against global warming.

**aesthetics** The philosophy or study of the arts, the nature of beauty, and the multisensory reaction we have to phenomena that make us feel differently than we do ordinarily

Cai released a helium-filled balloon into the sky.

The balloon was attached to a ladder, so it pulled the ladder (which was covered in gold-colored fireworks) up.

Once the ladder stretched the length of five and a half football fields into the sky, Cai lit it from the ground, so that the exploding fireworks sped upward into the heavens before disappearing.

**FIGURE 2.7.** **Cai Guo-Qiang.** *Sky Ladder.* *June 15, 2015. 2 minutes, 30 second explosion event. Realized on Huiyu Island, Quanzhou, China.*

The same is true in responding to art aesthetically. Consider *Jupiter and Europa* (figure 2.8) by Italian seventeenth-century painter Guido Reni (GWEE-doh REH-nee). The ancient Roman god Jupiter, disguised as a flower-decorated bull, has carried Europa to the sea. The painting does not just delight the eyes with radiant colors. We can also almost feel the bull's soft fur, hear the frothy water, and smell the breeze that blows Europa's robes.

## An Idealized Beauty

The concept of aesthetics in art also involves the idea of *idealized beauty that goes beyond what we see in everyday life*. The ancient Greeks, who crafted this idea, believed that beauty could be found in perfect figures with flawless proportions and forms.

One of the most renowned beautiful Greek sculptures was of the Goddess Aphrodite (ah-froh-DYE-tee) (figure 2.9). The artist Praxiteles (prak-SIT-eh-leez) portrayed Aphrodite's body in a way that many thought to be flawless. Writers of the time spoke of the soft appearance of Aphrodite's skin and the beauty of her gaze.

With this sculpture, Praxiteles equated the notion of ideal beauty with the female nude—a concept that has lasted for thousands of years and led to many images of undraped women in Western art. Praxiteles depicted the goddess preparing for a bath, dropping her robe on a water jug and modestly, yet erotically, covering herself with her hand. Praxiteles combined the idealization of Aphrodite's figure with the commonness of her action to create an image that was simultaneously beautiful and familiar.

## The Problem with a Set Notion of Beauty

Aesthetics, though, is not a great way to define art because *people often disagree on standards for what is ideal*. Such differences become even more obvious when contrasting art

FIGURE 2.8. **Guido Reni.** *Jupiter and Europa.* *c. 1636. Oil on canvas, 5′ 2″ × 3′ 9″. National Gallery of Canada, Ottawa, Ontario.* The year after it purchased *Voice of Fire*, the National Gallery purchased this painting for almost twice as much money. No one said a word. Perhaps one reason was that Reni's work could be defined as a beautiful painting.

FIGURE 2.9. **Praxiteles.** ***Aphrodite of Knidos.*** *Composite of two Roman copies after the lost original from the ancient Greek city of Knidos in what is today Turkey. c. 350 BCE. Marble, height 6′ 8 ¾″. Vatican Museums, Rome.* The ancient Greeks so loved the statue of Aphrodite that they came from all over Greece to see it.

(A)                              (B)

**FIGURE 2.10A AND B.** **(A) Scarification patterns on the face of a Suri woman.** *From Omo Valley, Ethiopia, Africa. 2018;* **(B) Henna painting on the hands of a bride.** *From India. 2001.* Even though scarification (2.10A) and henna (2.10B) both decorate the skin, scarification patterns are permanent, while henna designs will typically last only several weeks.

from different periods or cultures. For example, the Suri people of Ethiopia in Africa practice the body art of scarification (figure 2.10A). Girls have their skin carved with tiny cuts, which when healed scar into a raised, even **pattern** of repetitive, similar marks. The designs are a sign of beauty, and Suri girls elect to go through the process voluntarily to make themselves more attractive to traditional Suri men. By contrast, in India, many brides have henna (a paste made from dried henna leaves that dyes the skin) applied to their hands and feet (figure 2.10B). The patterns usually consist of curving lines, flowers, or other objects. While both scarification and henna are forms of body art, they conform to *different cultural notions of beauty.*

**pattern** A repetitive design of exact or similar forms, figures, elements, or motifs in either regular or irregular intervals

### The Problem with a Focus on Appearance

Aesthetics as a definition for art is also problematic because it *focuses solely on a work's appearance, while ignoring the work's meaning.* Russian-born contemporary artists Vitaly Komar and Alexander Melamid surveyed people from different countries to find out what people wanted to see in paintings and used the answers to paint a country's "most wanted" image. In the United States, 44 percent of respondents said their favorite color was blue, 88 percent wanted an outdoor scene, 51 percent preferred an image with wild animals, and 50 percent said it makes no difference whether there are famous or ordinary people in the image. The results of the survey appear in *United States: Most Wanted Painting*, in which the artists made choices to appeal to the average American's aesthetic sensibilities. However, the random combination of figures, objects, and scenery makes no sense at all (figure 2.11).

*Quick Review 2.2*: How is the study of art identified with beauty?

## Art as an Object of Value

Art can also be defined as *something that has value.* In particular, art can have *financial, functional,* or *emotional* significance.

The scene is outside, and there is lots of blue.

Wild deer wade in the water.

Several ordinary people walk by.

George Washington stands in full uniform.

**FIGURE 2.11.** Vitaly Komar and Alexander Melamid. *United States: Most Wanted Painting.* 1994. Oil and acrylic on canvas, 2′ × 2′ 8″.

When art has *financial worth* it is valued for money. *Voice of Fire* had financial worth, which was tied to authenticity. Newman's work was worth $1.5 million, but if someone painted a copy, it would not be worth anything close to that amount. Works can also be valued highly because of factors such as scarcity, uniqueness, hype, or innovation.

Additionally, as described in Chapter 1, art can be valuable because it is used for a *certain purpose*. *Projecting Change: The Empire State Building* (figure 1.47) brought awareness to the plight of endangered species. The work's functional use gives it value.

**artists**
MATTER

Nancy
Spero

Art also has value when it is of *emotional significance* to people. In *Maypole-War* (figure 2.12), a work from 2009, American Nancy Spero changed the traditional association of a maypole from festivals that celebrate the arrival of spring to the brutality of war. Severed heads hang from ribbons usually intertwined by dancers. Even though the image may be horrifying, we can gain value from the profound experience of seeing it.

A problem, though, with defining art according to value is that *not all people agree that every work is worthy*. Many Canadians did not see value in *Voice of Fire*. They did not feel that it was worth the money, served any function, or moved them emotionally.

*Quick Review 2.3*: What are three ways in which art can have value?

## Art as Part of the Canon

**canon** The established body of work accepted by the art world as part of the story of art

Another way to define art is by what is included in the **canon**—the established body of work that the art world considers art. For example, when the National Gallery purchased *Voice of Fire*, it was included in the canon and, therefore, classified as art. The canon is helpful in defining art because it focuses on works that *the art world views as important*. You wouldn't, for example, want to take an art course and never discuss the *Mona Lisa*. The canon also *tells a story of art*, showing a progression of how one type of art led to another.



Art historians established what was in the canon in the nineteenth and first half of the twentieth centuries, drawing on roots from the sixteenth century. However, many of these scholars' decisions do not make sense to us today. The art historians:

- *Celebrated established artists*, whom they considered geniuses, but ignored those outside the art world;
- *Included male, white, Western artists*, but excluded women, people of color, and non-Western people; and
- *Focused on fine art* (painting, sculpture, and architecture) *that they said was just for art's sake* rather than utilitarian functions, but left out practical arts, such as traditional crafts, including objects like clay bowls and wooden furniture; and commercial arts, such as films and advertisements.

For example, *Three Standing Figures* (figure 2.13A) by twentieth-century British artist Henry Moore was part of the canon, while the warrior columns (figure 2.13B), by unknown artists in the tenth century (from what is today Mexico), were not.

Today, museums, galleries, art historians, and critics play a role in moving works into the canon over time. Rather than a formal ceremony, works enter the canon as they are exhibited in galleries and museums and covered in books and articles. Furthermore, today many people in the art world are working to make the canon more inclusive. However, because the canon's long-standing biases still affect who is omitted, the canon retains problems as a definition of art.

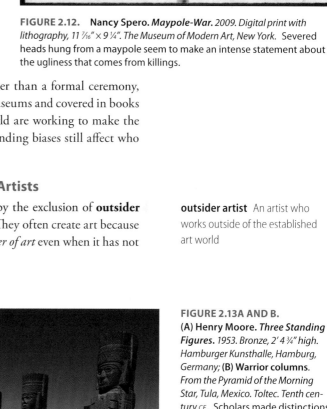

FIGURE 2.12.    Nancy Spero. *Maypole-War. 2009. Digital print with lithography, 11 ⁷⁄₁₆″ × 9 ¼″. The Museum of Modern Art, New York.* Severed heads hung from a maypole seem to make an intense statement about the ugliness that comes from killings.

## The Problem with Focusing on Only Established Artists

Establishing the canon as a definition of art is complicated by the exclusion of **outsider artists** who may be untrained or work outside the art world. They often create art because of a calling, spiritual or otherwise. They remind us of the *power of art* even when it has not been promoted by societal forces.

**outsider artist**  An artist who works outside of the established art world

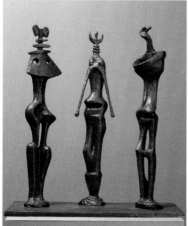

(A)

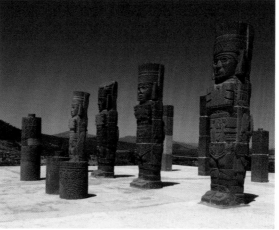

(B)

FIGURE 2.13A AND B.
**(A) Henry Moore. *Three Standing Figures.* 1953. Bronze, 2′ 4 ¾″ high. Hamburger Kunsthalle, Hamburg, Germany; (B) Warrior columns.** *From the Pyramid of the Morning Star, Tula, Mexico. Toltec. Tenth century CE.* Scholars made distinctions between *Three Standing Figures* (2.13A) and the warrior columns (2.13B) even though both works represented simplified figures and were formed with artistic materials through artistic acts.

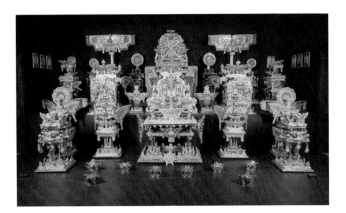

**FIGURE 2.14.** James Hampton. *The Throne of the Third Heaven of the Nations' Millennium General Assembly.* c. 1950–64. 180 pieces, gold and silver aluminum foil, kraft paper, and plastic over wood furniture, paperboard, and glass, dimensions variable. Smithsonian American Art Museum, Washington, DC. Hampton built this work from 180 pieces of discarded furniture, cardboard, glass, and light bulbs, which he covered with foil.

Outsider artist James Hampton grew up in a community of African American sharecroppers in South Carolina and became a janitor. He crafted *The Throne of the Third Heaven of the Nation's Millennium General Assembly* (figure 2.14) in a garage in the 1950s and '60s. The work includes thrones and altars in preparation for Christ's second coming. Today, the work resides in the Smithsonian Institution; however, such an artist previously would not have been included as part of the canon.

## The Problem with Focusing on Only Male, White, Western Artists

Still more problems surface with the canon when considering *women, artists of color, and non-Western artists missing from it*. For example, during the fifteenth and sixteenth centuries, women were expected to become wives and mothers, so few women could become artists. Women who wanted to become artists faced numerous restrictions. Women were:

- *Barred from apprenticeships in artists' workshops*, the traditional route of becoming trained artists; and membership in guilds, associations of craftsmen;
- *Almost always prohibited from working with nude models* (even female nudes!) and forced to study anatomy from animals such as cows; and
- *Expected to work in mostly anonymous craft media*, such as needlework, considered appropriate to their sex.

However, even women who succeeded in becoming highly regarded in their time were not included in the canon or had their work credited to male or unknown artists. For example, Judith Leyster (YOO-dit LYE-stur) was elected by 1633 to the Haarlem painter's guild in the Netherlands, but nevertheless was ignored by art historians. In her self-portrait in figure 2.15, Leyster proclaims her position as an artist.

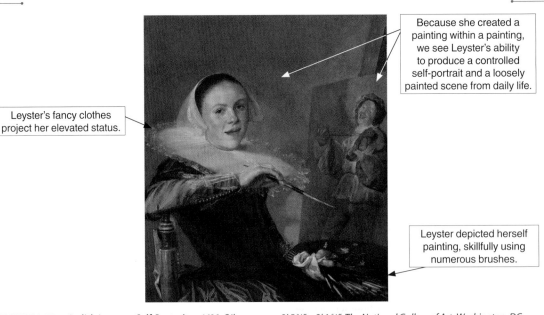

Because she created a painting within a painting, we see Leyster's ability to produce a controlled self-portrait and a loosely painted scene from daily life.

Leyster's fancy clothes project her elevated status.

Leyster depicted herself painting, skillfully using numerous brushes.

Interactive Image Walkthrough

**FIGURE 2.15.** Judith Leyster. *Self-Portrait.* c. 1630. Oil on canvas, 2' 5 ⅜" × 2' 1 ⅝". The National Gallery of Art, Washington, DC.

Still today, contemporary women are also disturbingly missing from the canon because of discrimination. In 1985, a group of women artists founded the "Guerrilla Girls," appearing in gorilla masks to hide their identities, to protest and distribute posters. A 1989 poster (figure 2.16) shows how women are still seen as objects to view rather than artists who create. The poster informs that, "Less than 5% of the artists in the [Metropolitan Museum's] Modern Art sections are women." When the *Guerrilla Girls* counted again in 2012, the numbers were worse! Only 4 percent of the artists were women.[3]

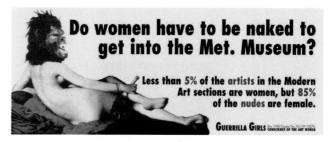

**FIGURE 2.16.** **Guerrilla Girls. Poster.** *1989.* The Guerrilla Girls have used posters to raise awareness about bias in the art world.

## The Problem with Focusing Only on Fine Art That Is Just for Art's Sake

We run into another problem when we think that art should be created for art's sake—for aesthetic pleasure—and no other reason. Such distinctions make little sense as *many works of fine art also served a purpose,* such as Sainte-Chapelle (see figure 1.28), created for religious reasons. Also, limiting the canon to fine arts cuts out other media that may be aesthetically pleasing. For example, contemporary American artist Liza Lou (LOO) created *Color Field* (figure 2.17) from a craft material, glass. Consisting of over seven million glass beads threaded on vertically placed wires, the work, which has no utilitarian function, creates a field of vivid color patches across the floor.

*Quick Review 2.4*: What are the problems with the canon?

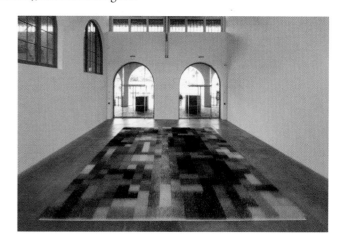

**FIGURE 2.17.** **Liza Lou.** *Color Field. From the installation at the Museum of Contemporary Art San Diego, California. 2013. Glass beads, stainless steel, Perspex, 20' × 26'.* Lou rebuts another idea of the canon—that of a lone, established artist. For *Color Field*, thirty African women, whom Lou employed, strung beads on wires, and groups of volunteers set up the project on the floor of the museum.

## Art as a Work Crafted with Skill

Art can also be defined as *a work crafted with skill.* One complaint about *Voice of Fire* was that a child could have produced the painting. Many people believe that art should be created with two types of technical prowess, specifically in *manipulating materials and techniques* and *depicting the natural world.*

### Manipulating Materials and Techniques

The *mihrab* (MEE-rahb) in figure 2.18A shows the importance of *manipulating materials and techniques* in creating many works. (A *mihrab* is a niche in a mosque wall that indicates for worshippers the direction of the holy city Mecca.) This *mihrab* was created in Iran in the fourteenth century. Using the intricate technique of mosaic, the artist formed the surface from tiny colored tiles. Each was expertly cut and laid in plaster to create flowers and words formed with fine handwriting called calligraphy (figure 2.18B).

### Depicting the Natural World

Often skill in art is also associated with an artist's *ability to represent the natural world* convincingly. The *Mona Lisa* (figure 2.19), painted by Italian Leonardo da Vinci (lay-oh-NAHR-doh dah VEEN-chee) in the early 1500s, creates the illusion of a three-dimensional figure in a believable space on a flat surface. Leonardo skillfully built up the figure using lights and shadows and created a haze that deepens as the space appears to recede. Both techniques align with how we see, because our eyes distinguish objects because of changes in light and see distant items as less focused.

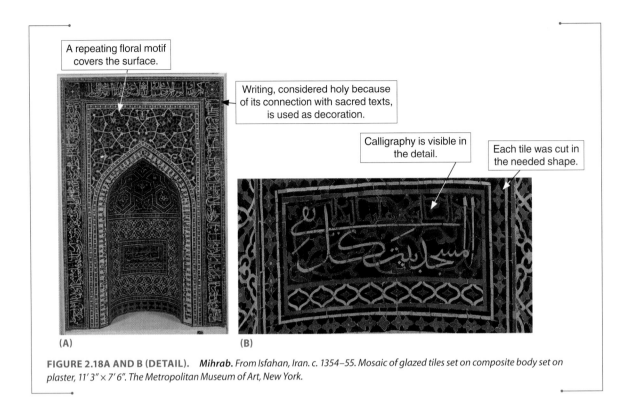

A repeating floral motif covers the surface.

Writing, considered holy because of its connection with sacred texts, is used as decoration.

Calligraphy is visible in the detail.

Each tile was cut in the needed shape.

(A)                    (B)

**FIGURE 2.18A AND B (DETAIL).** *Mihrab. From Isfahan, Iran. c. 1354–55. Mosaic of glazed tiles set on composite body set on plaster, 11′ 3″ × 7′ 6″. The Metropolitan Museum of Art, New York.*

## The Problem with Requiring Artistic Skill

While craftsmanship is often desired, *not all art is created with skill*. Cuban-born American artist Felix Gonzalez-Torres (gawn-ZAH-lais TOH-rais) had formal training, but he did not need technical expertise to create *"Untitled" (Death by Gun)* (figure 2.20). He took

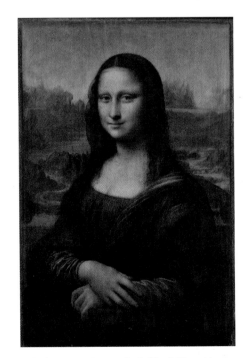

**FIGURE 2.19.** Leonardo da Vinci. *Mona Lisa.* c. 1503–19. Oil on wood, 2′ 6 ¼″ × 1′ 9″. Louvre Museum, Paris. A shadow under the *Mona Lisa's* chin helps create the illusion that she is three dimensional.

**FIGURE 2.20.** Felix Gonzalez-Torres. *"Untitled" (Death by Gun). 1990. Print on paper, endless copies, stack at ideal height 9″ × 3′ 8 ¹⁵⁄₁₆″ × 2′ 8 ¹⁵⁄₁₆″. The Museum of Modern Art, New York.* Because visitors can take sheets throughout the day, the pile continuously diminishes.

facts from *Time* magazine about 464 people who had died of gunshots during one week in 1989 in the United States and printed the information, using a commercial process, in black ink on white sheets. Then, he placed the papers, which viewers are allowed to take, on the floor in a squared-off pile. The work requires so little expertise that, when displayed, the museum staff can reprint the sheets and replenish the pile every night.

*Quick Review 2.5*: What are the types of expertise associated with artistic skill?

## Art as a Work That Has Meaning

Another way to define art is as a *work that has meaning*. In *Voice of Fire*, meaning based on a passage in the Bible was what made Newman's work more than just stripes.

But how do we generally go about discovering meaning? One way is to use the categories discussed in Chapter 1. Reconsider *"Untitled" (Death by Gun)* (figure 2.20):

- We can *describe* the image: A stack of paper sits on the ground.
- We can *analyze* what we see: The sheets are printed in black and white in an organized grid of photos and words. The papers are large and placed on the floor in a neat, rectangular, nine-inch-high stack that gets smaller throughout the day.
- We can *obtain* information about the work: We know the sheets portray people who died from gunshots during one week in the United States in 1989 and that the museum replenishes the pile every night.
- We can *interpret* what the work says by questioning what we described, analyzed, and obtained. Why do the sheets and stack look like they do? Why are they on the floor? Why are people allowed to take sheets and why are they replaced? There are multiple answers to these and other potential questions. Some might see the sheets as newspapers, possibly meaning that every week new deaths are reported in a never-ending cycle. Others might consider that the papers are on the floor, maybe commenting on how little attention society pays to gun deaths. Still others might note that these people have been memorialized, potentially establishing a tribute to those who died.
- Finally, we can *judge* what we think the art means. What does it say about guns, gun deaths, and society? Is the work pro- or antigun? Might the work have meant something different when and where it was created? Does the work still resonate today?

When asked to judge the meaning of a work, we need to consider what we can see, obtain, and think. Meaning in art is tied to the *ideas* a work represents based on how it looks, the *context* or association a work has with the world around it, and our own *personal experience*.

### Ideas

Art has meaning because *the way it looks makes us think about different concepts and concerns*. For example, in 1917, the Society of Independent Artists announced an exhibition in which all works would be accepted. Among the objects received was a urinal turned on its side and titled *Fountain* (figure 2.21). French artist Marcel Duchamp (mahr-SELL doo-SHAHM), who was part of a movement that rejected traditional values, had submitted the work because it had a certain appearance that he thought represented a meaningful idea.

To understand Duchamp's position, we need to consider the longstanding associations of urinating boys with European fountains, such as *Manneken Pis* (figure 2.22), a seventeenth-century fountain in Brussels, Belgium, by Jerôme Duquesnoy (doo-ken-wah). By calling a urinal *Fountain*, Duchamp expected viewers to get this joke that depended on an idea.

FIGURE 2.21. **Marcel Duchamp.** *Fountain.* *1964 copy after the original from 1917. Painted and glazed ceramic, black oil paint, 1′ 2″ × 1′ 7 5/16″ × 2′ 5/8″. Eskenazi Museum of Art, Indiana University, Bloomington.* Because Duchamp believed art was in the meaning, the original *Fountain* was not more authentic than copies, so Duchamp created replicas, like this one, that are now in museums around the world.

FIGURE 2.22. **Jerôme Duquesnoy.** *Manneken Pis. 1619. Bronze, height 24″. Brussels, Belgium.* This fountain commemorates the legend of a two-year-old lord whose troops were fighting a battle. Looking for inspiration, they placed the lord in a basket in a tree. From his perch, the child urinated on the enemy troops, who eventually lost the battle.

## Context

**context** The cultural, historical, social, economic, political, religious, and personal factors around a work of art that affect its meaning

Art also has meaning based on **context**, the association that a work has with the world around it. Contextual information includes factors such as:

- *What was going on* culturally, historically, socially, economically, politically, and religiously during a period
- *What we know about the artist*
- *Why and for whom a work was made*
- *Where and how a work was displayed* or used

If we know the context of the work being created in figure 2.23, we can better understand the meaning. The image is of a sand painting being formed by a Navajo medicine man. Traditionally, sand paintings have been created as part of a sacred ritual to contact the spiritual world to heal the sick. A medicine man sprinkles colored sand, flowers, and pollen over the ground in the shapes of gods or heroes, and the painting is destroyed after the ceremony.

## Personal Experience

Our individual backgrounds further help establish the meaning we find in a work. Because we each have different experiences, *no work says the same thing to everyone and works can have multiple meanings.*

American Cindy Sherman explored how viewers create personal meanings in her series *Untitled Film Stills*. In each work, the contemporary artist photographed herself in a different location, clothes, and wig. The images look like old movie stills, but none represents a real film. In *#65* (figure 2.24), we could each find a different story about what might be going on based on the visual evidence. One person might think the woman is waiting and another that she is being followed.

Because viewers can find different meanings in a work, we each play a role in the artistic process. For art to be effective, *both the artist and viewer need to communicate.* Reacting to art is the viewer's job. However, while each work has multiple meanings, this does not mean that any interpretation is valid. *Opinions must be supported with facts* based on a sound analysis of the object and its context.

The reason people find different meanings in a work is because of *perception*. Perception is how we become aware of and understand the world. We perceive both *culturally and physically*.

## Perceiving Culturally

We perceive things in our own way because of who we are. In the United States, extending an index finger is interpreted as pointing, but in Central Africa, the same gesture is vulgar. We learn to understand things based on our *culture, community, religion, upbringing, parents, and schooling.*

This individuality holds true for how we perceive art. Figures 2.25A and B show how people from diverse cultures perceived the same body art differently. Both images depict the tattoos of Te Pehi Kupe (ti PEH-hee KOO-pay), a Maori chief from New Zealand in the nineteenth century. John Sylvester, an Englishman, created figure 2.25A and the chief himself formed figure 2.25B. Each man represented the chief's tattoos differently based on *cultural perception*. To see how cultural perception affects how you see the world differently from others, see *Practice Art Matters 2.1: Consider How Cultural Perception Impacts Views*.

**FIGURE 2.24.** **Cindy Sherman.** *Untitled Film Still #65.* *1980. Gelatin silver print, 3′ 4″ × 2′ 6″. Modern Art Museum of Fort Worth, Texas.* Sherman showed a stereotypical view of a woman to which any number of meanings can be ascribed. One person might think this woman is in a museum and another, in a college building.

(A)

(B)

**FIGURE 2.25A AND B.** **(A) John Sylvester.** *Portrait of Maori Chief Te Pehi Kupe Wearing European Clothes.* *1826. Watercolor on paper, 8 ⅓" × 6 ¼". National Library of Australia, Canberra;* **(B) Te Pehi Kupe. Self-portrait.** *1826. Ink on paper, 3" × 2 ½".* Sylvester's portrait (2.25A) shows the tattoos as one of a number of the chief's physical characteristics, while the chief's portrait (2.25B) shows his tattoos as the sole representation of his identity.

*Practice* **art**MATTERS

## 2.1 Consider How Cultural Perception Impacts Views

Consider New Jersey native Willie Cole's *Stowage* (figure 2.26). To create this work, Cole cut holes in a piece of plywood, inserted different irons into the holes around the edges, and placed an ironing board into the hole in the center. He then applied black ink to the surface and pressed a sheet of paper to it. Figure 2.26 shows the final work on the paper. Black ink coats the over eight-foot-wide sheet, while the shapes from the ironing board and iron bottoms are visible in white.

Some context:

- Cole's great-grandmother, grandmother, and mother were domestic workers, required to work long hours ironing.
- The work is called *Stowage*, which is the same name as the area on ships where African American slaves were held. Figure 2.27 shows the horrific conditions in stowage in which Cole's ancestors were packed for transport to the United States from Africa.

**FIGURE 2.26.** **Willie Cole.** *Stowage. 1997. Relief print on paper, 4' 8" × 8' 8". Walker Art Center, Minneapolis.*

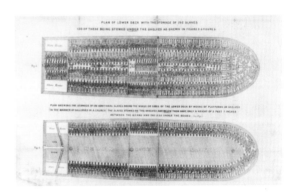

**FIGURE 2.27.** Detail of a diagram showing how slaves were packed into stowage on the British slave ship *Brookes* for transport from Africa to the United States. *c. 1788. Etching, Overall image 18 ¾" × 15 ⅞". Library of Congress, Washington, DC.*

Consider how you perceive culturally as you interpret and judge the image:

- How did your ancestors come to the country where you live?
- Did they or you ever have to work at an undesirable job?
- Do you or anyone you know have a brand, tattoo, or skin carving? What do you think of it?
- Have you or your family ever employed a domestic worker?

- What similarities do you see between Cole's ironing board and the ship? What might this mean?
- What similarities do you see between the scarification patterns (figure 2.10A) and the irons? What might that mean?
- What does Cole's work mean to you in terms of race, discrimination, employment practices, and pride in heritage?
- Why might others find different meaning in the work? What does this have to do with cultural perception?

### Perceiving Physically

Each of us also perceives differently because of *how our eyes and brains function physically*. When we see, information (in the form of light) hits our eyes and is converted to electrical impulses that are transmitted to our brains. However, our eyes limit what these impulses transmit, and we see only what our brains think is important. We perceive an incomplete picture, and each person's vision is slightly different. To discover how physical perception affects how you see the world differently from others, see *Practice Art Matters 2.2: Explore How Physical Perception Changes Meaning*.

---

*Practice* **art**MATTERS

## 2.2 Explore How Physical Perception Changes Meaning

Spend ten seconds looking at contemporary American artist Audrey Flack's *Bounty* (figure 2.28). Now, without looking at the painting, list everything you saw in the image, including colors and locations of objects. When you are done, look again at the image and answer these questions:

- What did you accurately record?
- What did you get wrong?
- Why, if someone else looked at the image, would he or she have gotten different things right and wrong?
- Why does this activity explain why we each find different meanings in different works?

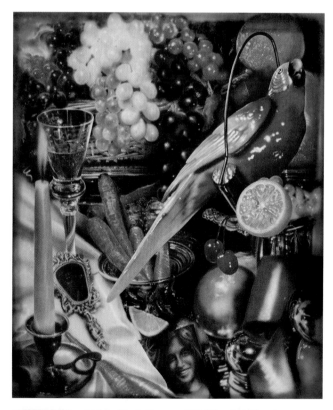

**FIGURE 2.28.** **Audrey Flack.** *Bounty.* *1978. Oil and acrylic paint on canvas, 6′ 8 ¼″ × 5′ 7 ¼″. Reynolda House Museum of American Art at Wake Forest University, Winston-Salem, North Carolina.*

FIGURE 2.29. Donald Judd. *Untitled.* 1980. Steel, aluminum, and perspex, overall 15' 10 ⅛" × 3' 4" × 2' 7". Tate Gallery, London. Judd stripped his art of references, so viewers could have a complete art experience with no distractions.

## The Problem with Meaning as a Definition

Defining art as a work that has meaning also has problems because some artists have created works that *have no meanings, functions,* or *illusions.* Figure 2.29 consists of manufactured boxes that are methodically mounted on a wall. Twentieth-century American artist Donald Judd hoped viewers would come to this work to clear their minds and be able to experience nothing but the visual art itself.

*Quick Review 2.6*: Why does a viewer play an essential role in the artistic process?

## Art as a Creative Work

Another way to define art is as a *creative work.* Twentieth-century Spanish artist Pablo Picasso (pab-loh pee-CAH-soh) innovatively fashioned *Bull's Head* (figure 2.30). He placed a bicycle seat and handlebars in a new relationship. He had the creativity to see that if he joined the parts in this unique way he could make a convincing illusion of a bull's head.

All of us have experienced a creative moment. Maybe you came up with an idea when writing a paper or solved a problem at work. Often, the creative moment comes after struggling with a complex problem. Creativity allows you to *see things in an original way,* but the innovative solution may be *upsetting to the status quo.*

### Seeing Things in an Original Way

One of the key components of creativity is *originality.* Creative people try new things and take chances. Often, they must go against established practices to invent new things or make us think of things in an original way.

In 1907, Frenchman Henri Matisse (ahn-REE ma-TEES) went against the norm when he created works such as *Blue Nude* (figure 2.31). To form art in which the expression went beyond what had been conveyed previously in works by other artists, Matisse broke with established artistic principles. He:

- *Placed unnatural, garish* colors in random combinations
- *Distorted* and *flattened the figure,* placing her in an unbelievable space
- *Used crude brushstrokes.*

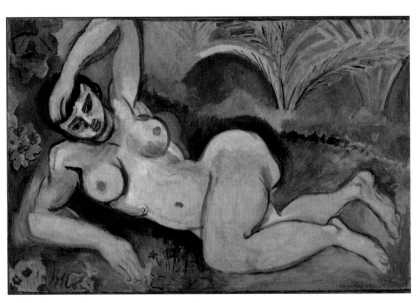

FIGURE 2.30. Pablo Picasso, *Bull's Head.* 1943. Assemblage of bicycle seat and handlebars, 13 ¼" × 17 ⅛" × 7 ½". Picasso Museum, Paris. It took Picasso's vision and wit to recognize that the re-arranged items would become a bull.

FIGURE 2.31. Henri Matisse. *Blue Nude.* 1907. Oil on canvas, 3' ¼" × 4' 7 ¼". Baltimore Museum of Art, Maryland. Matisse's unnatural colors can be seen in the blue cast to the woman's skin.

## Upsetting the Status Quo

Often, because creative art rejects societal norms, it *upsets the status quo*. When *Blue Nude* was displayed at the 1913 Armory Show in New York, the public found the painting offensive. Most viewers had never seen such an aggressively distorted work, and Matisse had portrayed the female nude, which, as we know from *Aphrodite* (figure 2.9), was thought to be the essence of beauty itself. As a result, his painting was seen as an attack on aesthetics and the very foundation of art. When the Armory show moved to Chicago, art students burned a replica of the painting in anger.

Throughout this book, you may encounter art that you find challenging. The art might be like nothing you have experienced, like *Blue Nude* was for people in 1913. The work could be from a different culture or period. You might not think the work qualifies as art. You might not understand the art, or it might make you uncomfortable or angry. Here are some *strategies for approaching this difficult art*:

- *Accept that you are not going to love every work and that is OK:* Actually, it is expected. You might even feel better knowing that if you think a work is difficult, people around you probably do, too.
- *Understand that difficulty is just a component of the relationship between the artwork and the viewer:* While we may find art made outside our culture (like skin carving) difficult, people within the culture do not. The artwork itself is not difficult, just our perception of it. When we try to *understand the differences between us and the artist*, the art may become more accessible.
- *Know that information allows you to appreciate art more fully:* With knowledge, things get easier.

Exploring *The Holy Virgin Mary* by Chris Ofili (oh-FEE-lee) shows how we can use these strategies to approach difficult art. The painting depicts a black Virgin Mary with African features and what many consider offensive additions (figure 2.32).

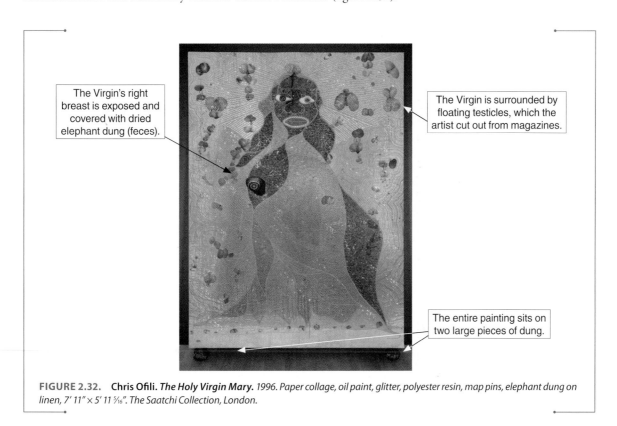

The Virgin's right breast is exposed and covered with dried elephant dung (feces).

The Virgin is surrounded by floating testicles, which the artist cut out from magazines.

The entire painting sits on two large pieces of dung.

**FIGURE 2.32.** **Chris Ofili. *The Holy Virgin Mary.*** *1996. Paper collage, oil paint, glitter, polyester resin, map pins, elephant dung on linen, 7' 11" × 5' 11 5/16". The Saatchi Collection, London.*

*Acceptance:* It is OK not to like this work. Many people have found it difficult and offensive. In 1999, the Brooklyn Museum of Art exhibited the work, and the mayor of New York City was so offended that he tried to rescind the museum's funding. Remember, if you are upset, others probably are as well.

*Understanding:* There are differences in cultural perception. Ofili is of African descent. In Africa, elephant dung fertilizes soil for crops. Dung nurtures the people and symbolizes fertility. Similarly, many traditional works contain exaggerated sexual parts as symbols of abundance (as in figure 2.33, where the nursing mother's breasts are exaggerated).

*Knowledge:* Information allows us to make sense of the painting. A comparison of *The Holy Virgin Mary* and a twelfth-century icon (figure 2.34), a sacred image revered by the faithful, shows similarities. Both images display gold backgrounds and Mary dressed in a blue robe. In fact, other icons have depicted Mary with her breast exposed, nursing the infant Jesus. These depictions, known as the "Virgin of Humility," represent Mary as the mother of all humanity, nurturing the faithful. Similarly, countless depictions of Mary have been surrounded by floating, naked cherubs, with their genitals exposed.

If you are also given the information that Ofili is a devout Catholic, you can see what the painting might mean. Maybe Ofili created a contemporary icon, combining his African and Catholic backgrounds. While the artist certainly meant to provoke, the provocation could symbolize the difficulty of cultures coming together.

Now that we have considered *The Holy Virgin Mary*, you still might not like it, and that is OK. *You don't have to like art to appreciate it.* Many people think because images are all around them that art should be immediately understandable, but art requires consideration.

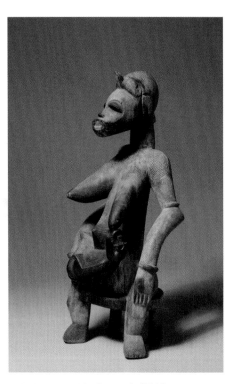

**FIGURE 2.33.** **Mother-and-child figure.** *From the Guinea Coast, Africa. Senufo. 1800s–1900s. Wood, height 2′ 1″. The Cleveland Museum of Art, Ohio.* The floating genitals in *The Holy Virgin Mary* are reminiscent of enlarged sexual parts in African works like this one.

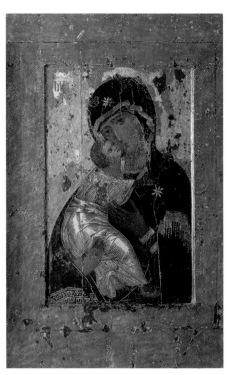

**FIGURE 2.34.** *Virgin of Vladimir. Probably from Constantinople. Twelfth century. Tempera on panel, height 2′ 7″. Tretyakov Gallery, Moscow.* Mary's knowing, sorrowful look in this icon and in *The Holy Virgin Mary* indicate she likely knows Jesus's future, tragic fate.

In fact, if you think of difficult art as a mystery to decipher rather than a threat, then you likely will be able to get past anger and move to understanding. You might even find that difficult art does what art is supposed to. If we understand art to be a *communication between an artist and viewer*, then difficult art—which makes us feel differently than we do ordinarily and requires us to strive actively to understand it—may be the most exciting kind of art. To try out strategies for approaching difficult art, see *Practice Art Matters 2.3: Discover How to Approach a Difficult Work of Art.*

### The Problem with Defining Art Creatively

Like other ways of defining art, creativity has problems as a definition. Our different backgrounds and perceptions of works make us *see some art as creative and others not*. As we saw, many Canadians did not see *Voice of Fire* as creative, while the National Gallery staff did. In addition, not every work is seen by all viewers as original.

*Quick Review 2.7*: What are the ways in which a viewer can approach difficult art?

---

*Practice* **art**MATTERS

## 2.3 Discover How to Approach a Difficult Work of Art

Consider German-born Meret Oppenheim's *Object (The Luncheon in Fur)* (figure 2.35), which most people find difficult. The work consists of a teacup, saucer, and spoon covered in gazelle fur.

*Acceptance:*

- If you do not like this work, is that OK?
- Are you repulsed by the idea of getting fur in your mouth?
- Do you think anyone else might be too?

*Understanding:*

- This work was created by a woman in 1936. What was it like to be a female artist in the past?

*Knowledge:*

- Oppenheim was part of a group of twentieth-century Western artists who showed the irrational in art through dream images. Can you imagine this cup being in a nightmare?
- Tea has been associated with polite society. Do you think Oppenheim approved of or was challenging this society?

**FIGURE 2.35.** **Meret Oppenheim.** *Object (The Luncheon in Fur). 1936. Fur-covered cup, saucer, and spoon, cup diameter 4⅜", saucer diameter 9⅜", spoon length 8". The Museum of Modern Art, New York.*

- A gazelle is a small antelope known for its graceful and dainty movements. Why might Oppenheim have chosen fur from a gazelle rather than another animal?
- What does the juxtaposition of the fur and the cup mean to you?
- If you found this work difficult at first, does it seem less difficult now?

# The Themes, Types, and Ingredients of Art

**FIGURE 2.36.** **Barbara Kruger.** *Untitled (Your gaze hits the side of my face).* *1981. Photograph, red painted frame, 4′ 7″ × 3′ 5″.* The sculpture in Kruger's image looks like an ancient Greek work of art, linking the woman to notions of idealized female beauty.

To gain a full understanding of art, we must look beyond definitions to art's properties. We can look at the *themes of art*, *types of art*, and *ingredients of art*.

## Themes of Art

Throughout time and across the world, *common concerns* have appeared in art. These ideas allow us to see connections among people from different times and places. We can organize these commonalities into themes:

- Power, servitude, and ambition
- The divine, sacred spaces, and prayers
- War, death, and remembrance
- Love, birth, and growing up
- Wildlife, the land, and the environment
- Work, play, and relaxation
- Art, the artist, and the inner mind
- Suffering, health, and survival
- Identity, discrimination, and social ties

All nine of these themes are explored in depth in *Connections* sections, located after each chapter in Part 4 of this text. Here we discuss how you can *align a work of art with a theme* and how each theme includes *a broad array of art*.

### Aligning Art with Themes

When aligning a work with a theme, we look at the work's *main concern* and decide into which theme that idea fits best. For example, in figure 2.36, contemporary American artist Barbara Kruger (KROO-ger) positioned the words, "Your gaze hits the side of my face" over a picture of a sculpture that is reminiscent of *Aphrodite* (figure 2.9). It is as if the sculpture is talking to viewers and equating our gazes to a physical assault. As Kruger seems to protest objectifying women rather than valuing them for their intellect, many people would say the work should be categorized according to the theme of identity, discrimination, and social ties.

However, many works can be *categorized under more than one theme*. For example, Kruger placed text on a photograph of a sculpture that she found, so that the work almost looks like an advertisement in a magazine. She did not form the actual sculpture that we see in the image. In her method of creation, she seems to indicate that art does not need to be the fine art of the canon, but should be expanded to include art that is not so traditional. Since her work questions the nature of art, her work could also be considered under the theme of art, the artist, and the inner mind.

### The Broadness of Themes

Each of the nine themes includes *a broad variety of works*. Some works within each theme address *similar concerns*. For example, Canadian-born American Miriam Schapiro crafted *Barcelona Fan* (figure 2.37) in 1979 from pieces of fabric. Traditionally, fans have been used by women, and the creation of works in fabric was relegated to women. As we have seen, such media were left out of the canon. However, Schapiro made this fan twelve feet wide, a size

FIGURE 2.37.   Miriam Schapiro. *Barcelona Fan*. *1979. Fabric and acrylic on canvas, 6′ × 12′. The Metropolitan Museum of Art, New York.* As functional objects, fans would not have been placed into the canon in the past.

FIGURE 2.38.   Kerry James Marshall. *Many Mansions*. *1994. Acrylic on paper mounted on canvas, 9′ 6″ × 11′ 3″. Art Institute of Chicago, Illinois.* The anonymous buildings of the project loom up behind the men, where the official identification name of the project, IL 2-22, is painted in large letters.

typical for fine art. The fan's enormous dimensions appear to demand that women's work receive the same canonical recognition as artwork typically produced by men. In the work's focus on the discriminatory treatment of women (here, as artists), it is similar to Kruger's work and can be categorized under the theme of identity, discrimination, and social ties.

Other works within a theme may address *different concerns*. For example, American Kerry James Marshall's *Many Mansions* (figure 2.38) from 1994 depicts a Chicago city housing project where despite crime and gang violence, men in their Sunday best tend to a garden, proudly working together to bring forth flowers from the ground. Marshall's work could also fit within the theme of identity, discrimination, and social ties, but many people believe his work concerns shared identities, community, and social ties.

You, too, can place different works into one or more of the different broad themes. To try this out, see *Practice Art Matters 2.4: Judge What Theme a Work of Art Concerns*.

*Practice* **art**MATTERS

## 2.4  Judge What Theme a Work of Art Concerns

Six months after the September 11, 2001, terrorist attacks, the Municipal Art Society of New York presented *Tribute in Light* (figure 2.39). The work has been displayed every year since, on the anniversary of the attacks. Two square-shaped beams of light shine four miles up into the sky, representing the World Trade Center towers destroyed in the attack.

- What theme do you think *Tribute in Light* concerns? Why?
- Could the work be placed into any other themes? Why or why not?
- Would you place *Sky Ladder* (figure 2.7) into the same theme? Why or why not?

FIGURE 2.39.   John Bennett, Gustavo Bonevardi, Richard Nash Gould, Julian Laverdiere, Paul Myoda, and Paul Marantz. *Tribute in Light*. *2002–ongoing. Eighty-eight 7,000-watt xenon light bulbs positioned into two 48-foot squares, height 4 miles. Realized in New York.*

## Types of Art

There are three categories by which many artworks can be classified: *representational*, *nonobjective*, and *abstract*. Three works by twentieth-century Dutch artist Piet Mondrian (PEET MOHN-dree-ahn) show the differences among the types.

### Representational

**representational art** Art in which recognizable objects and figures from the real world are depicted

Figure 2.40 depicts a representational Mondrian drawing of a tree. **Representational art** depicts recognizable objects and figures from the real world. Mondrian tried to recreate the natural world and capture a close likeness of what we see.

Some representational works are more realistic than others. The objects depicted in *Bounty* (figure 2.28), for example, seem as though they are right in front of us. We call such works, which try to fool us into thinking they are real, ***trompe l'oeil*** (trump-LOY).

**trompe l'oeil** French for "deceives the eye"; a painting that tries to fool us into thinking it is real rather than a painted surface

*Aphrodite* (figure 2.9) is also representational, even though idealized, since Praxiteles captured the qualities of a person. Furthermore, the work is representational even though it depicts a goddess. In representational works, *what is portrayed does not have to exist in real life*. Depictions of angels, deities, and ghosts can all be representational, if they are portrayed to look like recognizable figures.

### Nonobjective

**nonobjective art/ nonrepresentational art** Art that does not depict anything representational from the real world

Figure 2.41 shows a Mondrian nonobjective work with a grid of rectangles and lines. **Nonobjective** (or **nonrepresentational**) **art** does not depict anything we recognize from the real world. While nonobjective art might convey an idea or an emotion, as in a Newman painting, it does not portray anything we normally see.

**FIGURE 2.40.** **Piet Mondrian.** *Tree* **(Study for** *The Gray Tree***).** *1911. Black crayon on paper, 1' 11" × 2' 10⅛". Haags Gemeentemuseum, The Hague, The Netherlands.* Mondrian created a representational work by drawing every branch of the tree's thicker and thinner limbs.

**FIGURE 2.41.** **Piet Mondrian.** *Composition with Red, Blue, Yellow, Black, and Gray. 1922. Oil on canvas, 16½" × 19⅛". Toledo Museum of Art, Ohio.* In this nonobjective work, nothing that we see is linked to the natural world.

## Abstract

A final Mondrian work (figure 2.42) is abstract. With **abstract art**, the artist purposely distorts or changes objects from the real world, so that they verge on being unfamiliar. However, there are links to reality. Figure 2.42 might look nonobjective because of the grid of lines. However, the title *Apple Tree* allows us to see familiar items from the real world. The centralized trunk that appeared in figure 2.40 is also in figure 2.42. While the lines of the branches are no longer as evident, we still see their basic shape.

Abstraction is *a broad category*. Artists can abstract their work a little, so it is closer to representational work, or a lot, so it is closer to nonobjective work. The *Virgin of Vladimir* (figure 2.34) seems representational, but folds on Jesus's garments are a pattern of lines rather than soft pleats. On the other extreme, the figure in the sand painting (figure 2.23) is more abstract, as it is formed completely of shapes. However, we can still make out a figure.

Artists abstract art in four ways, by:

- *Simplifying a work to its most important idea,* as Picasso did in *Bull's Head* (figure 2.30); even though there are only two features, there is enough to recognize the bull
- *Stylizing a work* as in the *mihrab* (figure 2.18A), where the flowers conform to the overall design rather than imitate reality
- *Distorting or altering certain components*, so that the image appears unrealistic; Matisse did this by using unnatural colors in *Blue Nude* (figure 2.31)
- *Exaggerating or emphasizing what they feel is important* at the expense of other items, as Te Pehi Kupe did in his self-portrait (figure 2.25B)

*Quick Review 2.9*: How do representational, nonobjective, and abstract art differ?

**FIGURE 2.42.** **Piet Mondrian.** *Apple Tree.* c. 1912. Charcoal on paper, 18 5/16" × 24 3/16". Museum of Fine Arts, Boston. *Apple Tree* is abstract because Mondrian distorted shapes that are linked to reality.

**abstract art** Art in which objects from the real world are purposely distorted or changed

**stylizing** A way of representing objects from the natural world so that they conform to the overall design of a work of art rather than imitate reality

## Ingredients of Art

As we look to understand art, we can also consider the properties that make up different works. These ingredients include *subject matter, form, and content*, as well as *iconography* and *style*.

### Subject Matter, Form, and Content

Three ingredients of art—subject matter, form, and content—are closely linked. The **subject matter** of a work is the person(s), object(s), and/or event(s) that are portrayed. The **form** is the physical appearance of a work including its materials and how those materials are organized, presented, and manipulated. The **content** is the meaning, message, mood, or feeling conveyed in a work.

Every decision an artist makes, including what to depict (the subject matter) and how to depict it (the form), along with the context and the viewer's experiences, helps inform the viewer's understanding of a work's meaning (the content). *The Boating Party* by American Mary Cassatt and *Boating* by German Gabriele Münter (gab-REE-eh-lah MUEN-ter) show how this concept works. Both paintings depict the same *subject matter*: upper-middle-class folk out for a boat ride. However, the forms in the two works differ leading to distinct contents.

**subject matter** The person(s), object(s), or event(s) that a work of art portrays

**form** The physical appearance of a work of art including its materials and how those materials are organized, presented, and manipulated

**content** The meaning, message, mood, or idea conveyed in a work of art

**artists**
MATTER

Gabriele
Münter

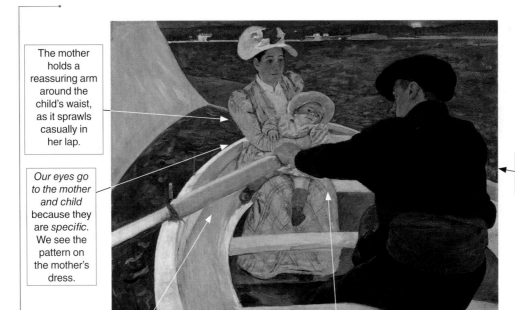

The mother holds a reassuring arm around the child's waist, as it sprawls casually in her lap.

*Our eyes go to the mother and child* because they are *specific*. We see the pattern on the mother's dress.

The *rower* is *anonymous* in silhouette.

We further look to the pair because the oar and rower's arm *point to the two*, highlighting their significance.

**FIGURE 2.43.** **Mary Cassatt.** ***The Boating Party.*** *1893–94. Oil on canvas, 2′ 11 ⁷⁄₁₆″ × 3′ 10 ⅛″. The National Gallery of Art, Washington, DC.*

The *form* in Cassatt's painting (figure 2.43) is filled with peaceful colors and bright light. All figures are large and fill the space. The view is from up close and above, and we focus on the mother and child.

Conversely, Münter's painting (figure 2.44) has a *form* in which the colors are bold and conflicting. The figures seem layered on top of one another into too small a space. In addition, the view is straight on as if we are sitting directly behind the rower, and we see the scene from her perspective, yet we seem to focus on different points in the painting.

To most people, the forms of the two paintings suggest different *contents*. Cassatt seems to offer a tender depiction of mother and child. The child's pose and the mother's embrace show a comfortable, everyday moment. The tranquil colors and shimmering light add to the warm feeling. One interpretation, supported by context, is that of a nurturing, maternal relationship. Cassatt's depiction is consistent with Western societal views in the nineteenth century that the most essential task of women was to nurture their children.

The forms in Münter's painting seem to speak of a different world. Even though the figures share a tight space, no one interacts. The harsh colors further isolate the figures. While the man appears to dominate, it is the woman rower who controls the passengers' fate, as the storm approaches. One interpretation of Münter's form suggests a content in which relationships are combative and individuals strive on their own in a menacing world. Again, our interpretation is supported by context, as Münter captured a real excursion from 1910 in which the boaters each had awkward romantic and familial relationships with one another.

*Nonobjective works may seem complex* when discussing subject matter, form, and content, but become easier to understand if *we consider the definitions of these terms*. To figure out *subject matter* in nonobjective works, focus on what is depicted. In *Voice of Fire*, a non-representational work, the subject matter is the stripes. When deciphering *form*, consider how materials are used to portray the subject matter. In *Voice of Fire*, the form is how the

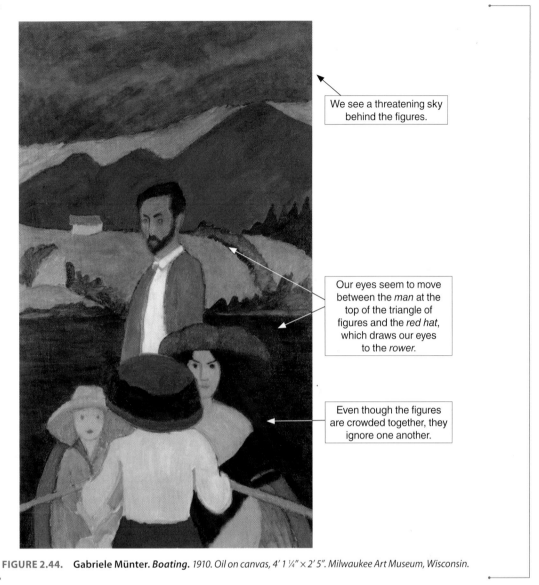

We see a threatening sky behind the figures.

Our eyes seem to move between the *man* at the top of the triangle of figures and the *red hat*, which draws our eyes to the *rower*.

Even though the figures are crowded together, they ignore one another.

**FIGURE 2.44.** **Gabriele Münter.** *Boating.* *1910. Oil on canvas, 4' 1 ¼" × 2' 5". Milwaukee Art Museum, Wisconsin.*

Interactive Image
Walkthrough

stripes are presented: their size, color, density, and so forth. Finally, to figure out *content*, look for meaning, based on what you see, know, and think.

## Iconography

**Iconography** is symbols or images in a work that have been invested with additional meaning that are specific to a culture and time. If a work includes iconography, *we must understand the symbols to interpret the content.* While we usually understand the symbols used in our own society, it is often difficult for outsiders to interpret these same symbols.

The importance of understanding symbols can be seen in interpreting a painting from 1434 by Jan van Eyck (yahn van IKE), a northern European artist. This painting has so many realistic-looking objects in it that represent higher meaning that no one today is sure what the puzzling iconography means.

The painting depicts a couple in a bedroom. For years, the work was thought to record the marriage between Giovanni Arnolfini and Giovanna Cenami; however, scholarship has discovered their marriage occurred after the painting was created. Accordingly,

**iconography** Symbols or images in a work of art that have been invested with additional meaning and that are specific to a particular culture and time period

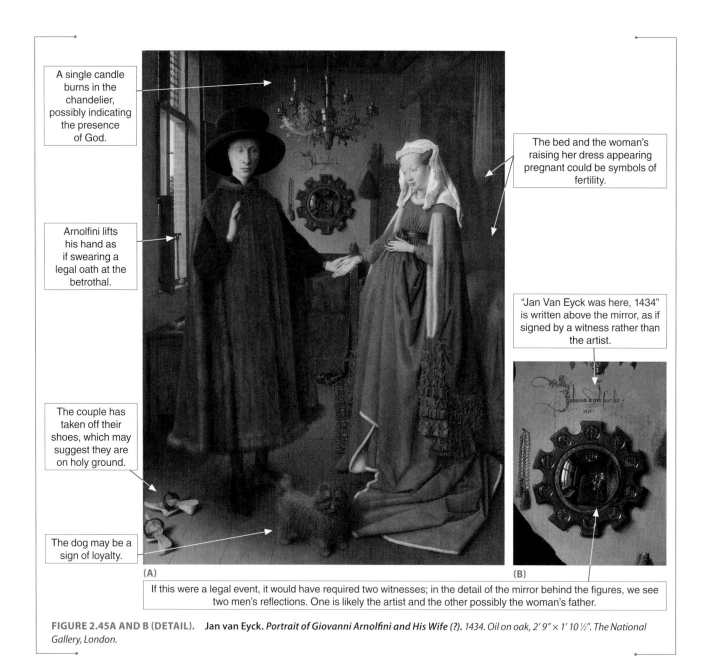

A single candle burns in the chandelier, possibly indicating the presence of God.

Arnolfini lifts his hand as if swearing a legal oath at the betrothal.

The couple has taken off their shoes, which may suggest they are on holy ground.

The dog may be a sign of loyalty.

The bed and the woman's raising her dress appearing pregnant could be symbols of fertility.

"Jan Van Eyck was here, 1434" is written above the mirror, as if signed by a witness rather than the artist.

(A)

(B)

If this were a legal event, it would have required two witnesses; in the detail of the mirror behind the figures, we see two men's reflections. One is likely the artist and the other possibly the woman's father.

**FIGURE 2.45A AND B (DETAIL).** **Jan van Eyck.** *Portrait of Giovanni Arnolfini and His Wife (?)*. 1434. Oil on oak, 2' 9" × 1' 10 ½". *The National Gallery, London.*

another interpretation suggests the painting records their engagement, which would have been a legally contracted event. The iconography in the painting may support this conclusion (figure 2.45A and B).

According to a more recent interpretation, however, the picture was a memorial portrait, depicting a different Giovanni Arnolfini and his wife, who had died in childbirth. This interpretation explains why the woman has generalized features, while Arnolfini's are specific. It also clarifies why the woman looks pregnant, as well as the presence of the dog, which was commonly associated with death.

## Style

**style** The way in which a work of art is characteristically expressed that allows us to identify and categorize a work of art as part of an individual's, group's, or culture's common work

**Style** is the characteristic way a work is expressed, based on how the artist manipulates its form, that allows us to categorize a work with others. When a work has a certain style, it has a quality that can be seen in additional pieces.

Style is not unique to art. Two professors might have clothing with different styles. One might wear jeans; the other, a suit. However, if a third professor also wears jeans,

that professor would have the same style as the first, even if the jeans were not identical. Similarly, in art, works that share a style need to be *similar in approach or have common aspects*, but they do not need to match exactly.

*Red Blue Chair* (figure 2.46A) by twentieth-century Dutch architect Gerrit Rietveld (GAY-rit REET-velt) and Mondrian's nonobjective painting (figure 2.46B) have the same style. Both Rietveld and Mondrian used similar forms, even while working in different media.

We speak of three levels of style:

- *Individual artists have styles*, as Newman's paintings have a characteristic striped style.
- *Groups of artists sometimes work in the same style*, as Rietveld and Mondrian both did with *De Stijl* (de STY-al), an art movement following World War I in the Netherlands that they believed would lead to a better world (see Chapter 20).
- *Time periods and regions have styles*, because often works from the same place and time have similar characteristics, even if the artists were not sharing ideas. Both Leonardo (figure 2.19) and van Eyck (figure 2.45A) lived in Europe in the fifteenth and sixteenth centuries, and their works are part of the Renaissance style that is associated with a revival of Classical ideas and naturalism (see Chapter 15).

While style helps us group artists and works, it also creates a *story of art*. As many styles in art were based on, reactions to, or rebellions against a preceding style, we can understand the progression of changes in form through time.

*Quick Review 2.10*: How are subject matter and form related to content?

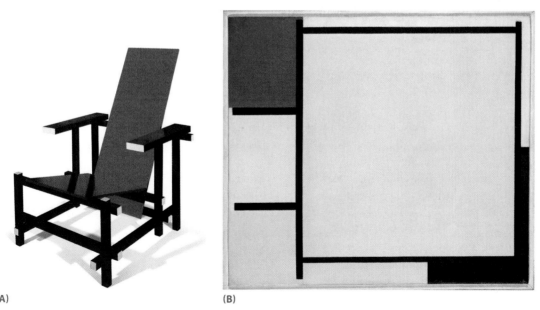

(A)    (B)

**FIGURE 2.46A AND B.** **(A) Gerrit Rietveld.** *Red Blue Chair. Designed 1917–18, manufactured 1950–59. Beechwood, oil paint, and metal, 2' 10" × 2' 7 ¾" × 2' 2". David Owsley Museum of Art at Ball State University, Muncie, Indiana;* **(B) Piet Mondrian.** *Composition with Red, Blue, Yellow, Black, and Gray* **reconsidered.** Rietveld's (2.46A) and Mondrian's (2.46B) works share the same style because they both have rectangular forms and straight lines in primary colors and black.

## A Look Back at *Voice of Fire*

Considering *Voice of Fire* allows us to study a provocative painting. However, it also gives us insight into different *definitions of art* and the *themes*, *types*, and *ingredients* of art.

Many Canadians did not see Newman's striped work as art. However, there are many ways in which we can define the work as art. The painting is made from *artistic materials* and is part of the **canon**. It has value in its *price tag* and *emotional significance*. However, most people classify the work as art by its *meaning* in that Newman conveyed an idea. The stripes convey the notion not only of the voice of God, but also of Newman's own struggles in life. We, as viewers, bring further meaning to the work because of our backgrounds. Maybe some of us have even faced challenges, like Newman, in fighting the status quo. In this respect, the painting can also be seen as *creative*. While the painting is *difficult*, we know we can get past it by working to understand the art.

*Voice of Fire* also introduces us to the themes and types of art. The work can be categorized under the theme of *the divine, sacred spaces, and prayers*, given its title, and *art, the artist, and the inner mind*, because we can imagine Newman equating himself with the work, along with his creativity, expression, and emotional state. In terms of type, the work is **nonobjective** because what is depicts is not from the natural world.

Finally, the work has a **subject matter, form, content, and style**. The *subject matter* is the three vertical stripes. The *form* stems from the equal-sized, strong red and translucent blue stripes that tower above viewers at a height of over seventeen feet. The *content* relates to the voice of God, but could also refer to Newman himself or other interpretations, as we each bring our own understanding to the work based on analysis and context. The *style* can be interpreted on three levels. It is Newman's *individual style*, which we see in his characteristic zips; the *group style* of Color Field painting, a post–World War II movement, and the *style of a time and region*—the major movement of the twentieth century in the West, Modern art.

As you move forward from this chapter, consider how, because original art confronts the status quo, it can upset people. Newman's provocative painting caused an uproar in Canada. Similarly, *Blue Nude* (figure 2.31) was so distressing to people in 1913 that visitors to the Armory named the room where it and other new European works were displayed, the "Chamber of Horrors." While as a society we seek creative ideas, they are sometimes hard at first to accept. However, when art works the way that it is supposed to, it involves a *dialogue*, an *exchange of ideas*, and an *openness* to unfamiliar things.

Flashcards

## CRITICAL THINKING QUESTIONS

1. If you were having an aesthetic reaction to Flack's *Bounty* (figure 2.28), how would you describe the painting?
2. Does Gonzalez-Torres's *"Untitled" (Death by Gun)* (figure 2.20) have value? Why or why not?
3. Other than the fact that he was not an established artist, what other reasons precluded Hampton (figure 2.14) from being included in the canon?
4. How do you know that Leonardo (figure 2.19) had expertise with manipulating artistic materials and techniques in addition to depicting the natural world?
5. All people are creative. How can you defend this statement?
6. At the beginning of the chapter you considered what art is. How did you define art originally? How have your opinions changed? What limited understanding did you have about the definitions of art previously?
7. Look back at Chapter 1. How are the purposes of art similar to the themes of art?
8. Is the mother-and-child figure (figure 2.33) representational, abstract, or nonobjective? Why?
9. What is the subject matter, form, and content of *Tribute in Light* (figure 2.39)?
10. In what ways are Drury's work (figure 2.6) and Goldsworthy's work (see figure 1.48) similar? Consider purpose, theme, subject matter, form, and content.

Comprehension Quiz     Application Quiz

# The Language of Art

The detail of Vincent van Gogh's *Self-Portrait* (shown on the opening page of Chapter 3, pg. 66) illustrates the artist (van Gogh) looking out at the viewer. Fluid, blue lines dance around van Gogh, repeating in a regular rhythm. These lines contrast with van Gogh's scratchy, orange beard, creating a sense of variety and disjointedness. Further, that beard, with its fiery color, attracts our attention, so that our eyes stay focused on van Gogh's face. The entire effect seems to make van Gogh look intense. These factors regarding the form—specifically, the visual elements of art (such as lines, colors, and textures) and the principles of design (such as rhythm, variety, and emphasis)—communicate meaning to us and help us decipher van Gogh's image. Part 2 of this text explores these aspects of art in looking at the language of art.

**CHAPTER 3**
The Visual Elements of Art

**CHAPTER 4**
The Principles of Design

# 3

# The Visual Elements of Art

**DETAIL OF FIGURE 3.4.**
Lines express emotions. Here, in a detail of a self-portrait by Vincent van Gogh, the swirling, animated marks may give a hint of the artist's psyche.

## LEARNING OBJECTIVES

**3.1** Contrast actual and implied lines.

**3.2** Describe the different appearances of geometric and organic shapes.

**3.3** Explain why negative space is important in considering mass.

**3.4** Distinguish between actual and simulated texture.

**3.5** Explain how *chiaroscuro* mimics the effects of light.

**3.6** Describe the different properties of color.

**3.7** Summarize the different methods for depicting the illusion of three-dimensional space on a two-dimensional surface.

**3.8** Explain how repetition shows time in art.

## VINCENT VAN GOGH'S LETTERS AND ART

In 1891, Johanna van Gogh returned to her Paris apartment following her husband's funeral. In her sorrow, she turned to stacks of letters from her husband's brother, Vincent van Gogh (VIN-sent van-GOH)—a relatively unknown Dutch artist who had taken his own life. The two brothers had corresponded for years. Surrounded by walls covered with van Gogh's paintings, Jo began to appreciate the brother-in-law she had barely known.

Many of these letters detailed van Gogh's daily thinking about his art and today contribute to our understanding of the content of van Gogh's works. However, to decipher meaning, we also must analyze the *visual elements of art* (items such as lines and shapes) in the works themselves (table 3.1).

How Art Matters

| TABLE 3.1: | The Visual Elements of Art in van Gogh's Paintings. |
| --- | --- |
| **Element** | **Description** |
| Line | A mark that has a greater length than width |
| Shape | A flat area |
| Texture | The surface characteristic of a work that relates to touch |
| Light | A kind of energy that absorbs into or reflects off of different opaque objects, making them look lighter or darker |
| Color | What we see when light reflects off of different objects |
| Space | The flat area of a picture or the illusion of depth in a picture |
| Time | A period of a certain duration |

Artists use visual elements of art as *tools for communication*. Just as you employ tools to communicate when you speak—you use words combined in sentences and pause to group words logically—artists need tools to create a work's *form*. Considering the visual elements of art in van Gogh's paintings allows us to see how form works with the context of the letters to convey meaning.

### The Potato Eaters

In 1885, van Gogh attempted his first large-scale painting, *The Potato Eaters* (figure 3.1). After visiting a peasant family one evening, he depicted the scene. Five large figures sit eating a meal of potatoes in a small *space* that doesn't seem quite right. A single lamp and a light that seems to shine up from the potatoes *highlight the figures,* while the rest of the room *remains in shadow*. The illusion of *coarsely textured clothing* speaks of harsh lives. *Paint has been laid on thickly*, and dark marks *outline* the figures. The painting also includes distortions. We might imagine it a clumsy, beginner's attempt. Yet, somehow, the painting feels true to life, like we have walked in on the humble scene.

One of van Gogh's letters documents how he purposely employed distortion to portray reality (figure 3.2). If van Gogh had created perfectly proportioned people in a realistic-looking space with true light, the scene might have appeared like one posed in a studio, rather than one captured *mid-movement over time*. As van Gogh explained:

> . . . *I should be desperate if my figures were correct* . . . real artists . . . do not paint things as they are . . . but as *they* . . . feel them . . . My great longing is to learn to make those

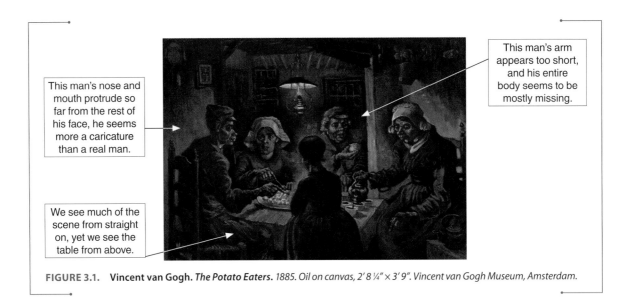

This man's nose and mouth protrude so far from the rest of his face, he seems more a caricature than a real man.

This man's arm appears too short, and his entire body seems to be mostly missing.

We see much of the scene from straight on, yet we see the table from above.

**FIGURE 3.1.** Vincent van Gogh. *The Potato Eaters.* 1885. Oil on canvas, 2′ 8 ¼″ × 3′ 9″. Vincent van Gogh Museum, Amsterdam.

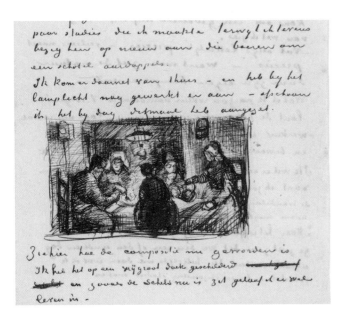

**FIGURE 3.2.** Vincent van Gogh. *Five Persons at a Meal.* 1885. Sketch in letter 399, 8 ⅛″ × 10 ⅖″. Vincent van Gogh Museum, Amsterdam. Van Gogh included a sketch of *The Potato Eaters* in his letter, so he could illustrate his efforts.

very incorrectnesses, those deviations, remodelings, changes in reality, so that they may become, yes, lies if you like—but truer than the literal truth.[1]

### The Night Café

In 1888, van Gogh worked on *The Night Café* (figure 3.3), also based on a real place. At this establishment, the down-on-their-luck could spend the night drinking. In van Gogh's painting, the *space again doesn't seem right,* with the pool table looking like it could slide into our laps, and the *colors seem impossibly unrealistic.* However, other than the distortions, *The Potato Eaters* (figure 3.1) and *The Night Café* have little in common. Could the same artist have painted both scenes?

A letter explains how when van Gogh devised the painting, he had recently returned from southern France where he had been overwhelmed by the depth of color. In this painting, the violently colored café looms around the spent customers. Rather than use colors from real life, van Gogh changed the colors, using their *emotional powers* to depict the feeling in the café. While the technique was different in *The Potato Eaters,* van Gogh's efforts to distort reality to describe the truth were the same. As he wrote:

> I have tried to express the terrible passions of humanity by means of red and green . . . Everywhere there is a clash and contrast of the most disparate reds and greens in the figures of the little sleeping hooligans, in the empty, dreary room . . . [the] color is not locally true from the point of view of a delusive realist, but color suggesting some emotion of an ardent temperament.[2]

### Self-Portrait

In 1889, van Gogh painted a *Self-Portrait.* Again, the contrast with prior works is extreme. The entire painting is made up of *dynamic lines of color* (figure 3.4). Van Gogh seemed to be combining past styles.

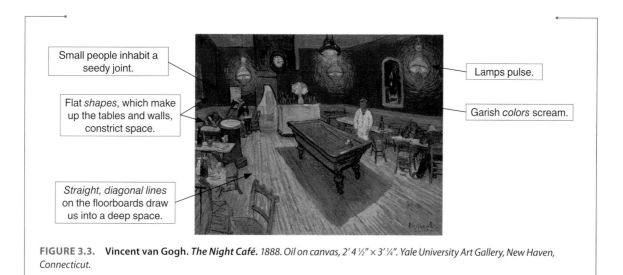

Small people inhabit a seedy joint.

Lamps pulse.

Flat *shapes*, which make up the tables and walls, constrict space.

Garish *colors* scream.

*Straight, diagonal lines* on the floorboards draw us into a deep space.

**FIGURE 3.3.** **Vincent van Gogh.** *The Night Café.* *1888. Oil on canvas, 2′ 4 ½″ × 3′ ¼″. Yale University Art Gallery, New Haven, Connecticut.*

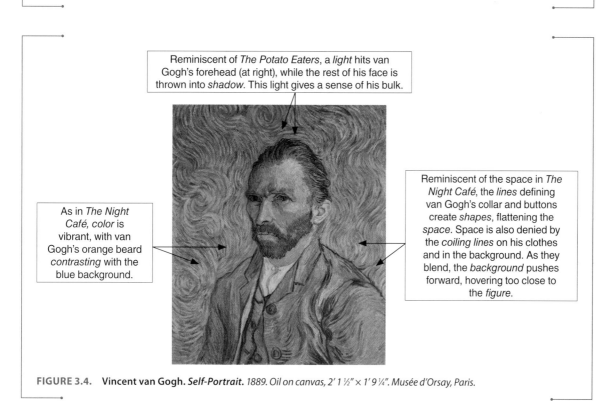

Reminiscent of *The Potato Eaters*, a *light* hits van Gogh's forehead (at right), while the rest of his face is thrown into *shadow*. This light gives a sense of his bulk.

As in *The Night Café, color* is vibrant, with van Gogh's orange beard *contrasting* with the blue background.

Reminiscent of the space in *The Night Café*, the *lines* defining van Gogh's collar and buttons create *shapes*, flattening the *space*. Space is also denied by the *coiling lines* on his clothes and in the background. As they blend, the *background* pushes forward, hovering too close to the *figure*.

**FIGURE 3.4.** **Vincent van Gogh.** *Self-Portrait.* *1889. Oil on canvas, 2′ 1 ½″ × 1′ 9 ¼″. Musée d'Orsay, Paris.*

The letters offer insight into this final period in van Gogh's life. He painted this portrait while living in an asylum, committing himself after cutting off his own ear. In this portrait, van Gogh tried to make himself appear healthy enough to leave the asylum: his hair is combed, he wears a jacket, and he looks directly at us. Despite this show of stability, however, many people have seen the frenzied, colored brushstrokes as symbols of van Gogh's tormented mind.

## The Efforts of Jo van Gogh

In 1891, when Jo sat in her apartment, van Gogh had sold just one painting. Jo was moved by his letters and works, though, so she began to champion his art. As van Gogh's reputation grew, Jo tracked down works that van Gogh had left all over France and the Netherlands.

One painting had been used to cover a hole in a chicken coop. Today, it hangs in the Pushkin Museum in Moscow.

After keeping the letters private for years, Jo finally published them in 1914. Arguably, there is no other source that so documents the life and thoughts of any other artist in history. The letters have helped make van Gogh one of the most beloved artists of all time. In 1990, one of his paintings sold for a record $82.5 million.

We can learn a lot about van Gogh's art from his letters, but they take us only so far. We also need to gain understanding from an analysis of the visual elements of art in the works themselves. This chapter considers the visual elements of art, including *line, shape, mass, texture, light/value, color, space,* and *time* and how those elements communicate content. While artists use the elements together in works, this chapter breaks them apart to appreciate the characteristics of each. Before moving forward, based on this story, how would you describe the shapes and colors in van Gogh's paintings, and what effect do these elements have on you?

## 3

# Line

Each of us is familiar with lines. We have stood on lines, written on lined paper, and stepped over lines on pavement. In art, a **line** is any actual or perceived mark or area that has a notably greater length than width. Lines can be found in two- and three-dimensional works.

**line** Any actual or perceived mark or area that has a notably greater length than width

## The Character of Lines

As in life, lines in art vary in *character*. They can be thick or thin; bold or delicate; long or short; smooth or jagged; straight or bent; light or dark; or change midstream from one character to another. Depending on their appearance, lines suggest emotions, moods, and attitudes:

- *Scratchy lines* might look *prickly*.
- *Fluid lines* might appear *stable*.
- *Bold lines* might feel *dynamic*.
- *Faint lines* might seem *shy*.

The twisting lines in contemporary American artist Tim Hawkinson's *Lophophore* (figure 3.5) seem to feel creepy and animated. Lophophores are tentacles that bring food to the mouths of some aquatic animals. Here, the slinking lines bulge from thin to thick and are reminiscent of snakes slithering up a hole.

## The Direction of Lines

Lines also have *direction*. Their course often suggests an attitude:

- *Horizontal lines*, like someone resting, often appear *peaceful, subdued,* and *stable*.
- *Vertical lines*, like someone standing, usually feel *alert, assertive,* and *bold*.
- *Diagonal lines*, like someone moving, often seem *dynamic, exciting,* and *energetic*.

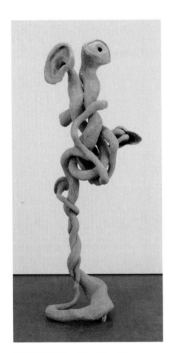

**FIGURE 3.5. Tim Hawkinson.** *Lophophore. 2006–07. Bondo, 7′ 4″ × 1′ 11″ × 2′. Pace Gallery, New York.* At the top of the seven-foot height, the lines open mouth-like structures that appear to await their prey.

In figure 3.6, Jacob Lawrence, a twentieth-century American painter, suggested lively movement in his frolicking children, whose outstretched limbs are diagonal lines. Lawrence depicted abolitionist Harriet Tubman as a slave child, as yet unaware of her miserable circumstance. Lawrence's uncluttered landscape emphasizes the diagonals of the figures—the direction of the lines propelling the children's energy.

## Actual and Implied Lines

In art, there are two types of lines: *actual* and *implied*. **Actual lines** are lines we can see, like Lawrence's (figure 3.6). **Implied lines** are lines we can't see, but feel are there. Implied lines include two types: lines suggested by *someone pointing, gesturing, moving,* or *looking* in a certain direction and lines that are *broken, dotted,* or *created out of pieces* of lines.

French eighteenth-century painter Jean-Honoré Fragonard (jawn oh-noh-RAY frah-goh-NAHR) created actual and implied lines in *The Swing.* A chaperone in the bottom right corner pushes a young woman on a swing, while her lover looks on. He hides in the bushes at lower left. Both actual and implied lines suggest the couple's relationship (figure 3.7).

## The Different Uses of Lines

Artists employ lines to achieve a number of purposes. These uses include as *contour lines, gesture lines, hatched or cross-hatched lines, lines that create expression,* and *lines that guide our eyes* (table 3.2).

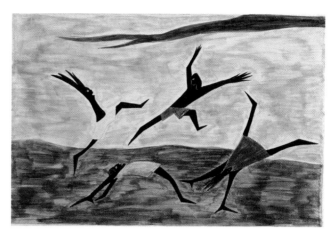

**FIGURE 3.6.** **Jacob Lawrence.** *Panel #4.* From the series "Harriet Tubman." 1939–40. Tempera on board, 12" × 17 ⅞". Hampton University Museum, Hampton, Virginia. Lawrence's lines show how we see any linear objects, like children's limbs, as lines.

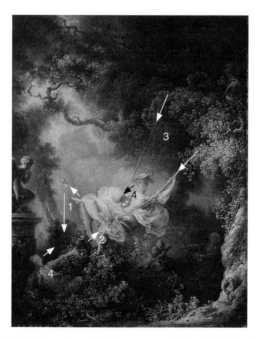

1. She kicks off a shoe, which flies in an *implied line* at a sculpture of Cupid, ancient Roman god of love. The shoe will eventually fall on the lover in an *implied line.*

2. He reaches out his hat to her starting an *implied line.*

3. *Actual lines* from the ropes point down from the woman to the man.

4. The two gaze at each other, creating *implied lines.*

**FIGURE 3.7.** **Jean-Honoré Fragonard.** *The Swing.* 1766. Oil on canvas, 2' 11" × 2' 8". Wallace Collection, London.

**TABLE 3.2:** Uses of Lines.

| Line Uses | Description |
| --- | --- |
| Contour lines | Lines create the edges of forms. |
| Gesture lines | Quickly drawn lines capture the posture or movement of an entire figure. |
| Hatched or cross-hatched lines | Parallel or intersecting lines darken areas. |
| Lines that create expression | Lines express attitude or emotion. |
| Lines that guide our eyes | Lines point to important areas in a work. |

**actual line** A line that exists in reality that we can see and that is continuous

**implied line** A line that we visually complete that does not actually exist, but that we feel is present because it is suggested by the artist by way of segments, a glance, or a motion

**contour line** A type of actual or implied line that creates an edge or border of a form or figure

**gesture** A form of expression that emphasizes or sums up the overall impulse and expressive and physical qualities of its subject matter

**hatching** A technique in which parallel lines are closely spaced to darken an area to suggest shading

**cross-hatching** A technique in which intersecting sets of lines are closely spaced to darken an area to suggest shading

**shading** A technique in two-dimensional art in which an artist darkens an area

**FIGURE 3.8.    Benny Andrews.** *Chalking Up.* 1989. Pen and ink on paper, 19 ½″ × 13 ¾″. Museum of Contemporary Art of Georgia, Atlanta.  The player who chalks his cue stares down his opponent, the contour lines emphasizing his head, hands, and stick. His opponent jabs his hands in his pockets and appears to lower his head for the fight.

## Contour Lines

Anyone who has opened a coloring book knows what a contour line is. **Contour lines** create the edges of shapes. They exist where one area borders another and are used to *describe objects* and *focus our attention* on defined parts. Contour lines can be actual or implied.

Georgia-born twentieth-century artist Benny Andrews used contour lines in *Chalking Up* (figure 3.8). The contour lines include *both the external outlines* of the players' bodies and *the internal lines* such as on the left-hand player's belt. The clean, intense lines support the subject matter.

## Gesture Lines

Artists use **gesture** lines to give a spontaneous overall sense of form, direction, and impulse. They can *capture the posture or movement of an entire figure*—its action, expression, and energy—using quick, fluid, and loose lines.

Eugène Delacroix (you-JEHN duh-lah-KRWAH), a nineteenth-century French artist, used gesture lines in *Studies of Lions* (figure 3.9). Rather than carefully rendering the manes, ears, and legs, Delacroix formed lines to show the essential, expressive qualities and attitudes of the lions.

## Hatched and Cross-Hatched Lines

In two-dimensional art, artists can use **hatching** (figure 3.10A), by placing parallel lines close together, and **cross-hatching** (figure 3.10B), by placing intersecting lines close together, to darken areas by **shading**. The closer and more numerous the lines, the darker the area will be. Using these techniques, artists can create an *infinite number of grays*.

An illustration from 1865 by Englishman John Tenniel (TEH-neel) for *Alice's Adventures in Wonderland* (figure 3.11) shows the shaded effect of hatched and cross-hatched lines. Alice stands in the right foreground, a duchess holds a baby at center, and a cook stirs a cauldron of soup in the back left. Hatching and cross-hatching define the space and figures' bulk and location.

**FIGURE 3.9.    Eugène Delacroix.** *Studies of Lions.* c. 1829. Graphite on cream laid paper, 9″ × 13 ⅜″. Art Institute of Chicago, Illinois.  Gesture lines capture the lions' character and power.

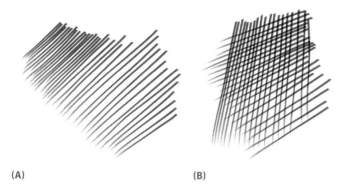

FIGURE 3.10A AND B.  Hatched (3.10A) and cross-hatched (3.10B) lines.

(A)    (B)

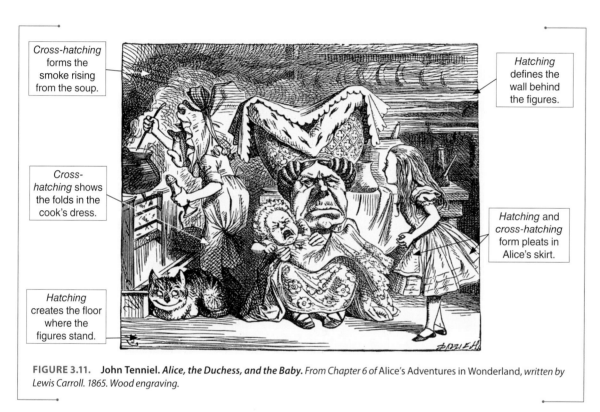

Cross-hatching forms the smoke rising from the soup.

Cross-hatching shows the folds in the cook's dress.

Hatching creates the floor where the figures stand.

Hatching defines the wall behind the figures.

Hatching and cross-hatching form pleats in Alice's skirt.

**FIGURE 3.11.**   John Tenniel. *Alice, the Duchess, and the Baby.* *From Chapter 6 of* Alice's Adventures in Wonderland, *written by Lewis Carroll. 1865. Wood engraving.*

## Lines That Create Expression

Because we relate to lines and sense their *attitude and emotion,* artists also use lines for *expression.* Italian Marcello Gandini (mahr-CHEH-loh gan-DEE-nee) planned his Stratos HF Zero car (figure 3.12) with thoughts of the future and space travel. One compelling feature is the line that races along the top edge of the car from the front (at right) diagonally up to the roof and back down again toward the rear (at left). On the car's side are also long, sleek diagonals, which add to the impression of the car's speed.

## Lines That Guide Our Eyes

Gandini's car also shows how lines help *guide our eyes where they are supposed to go.* For example, intersecting lines can draw our attention to what is important. In the car, the lines come together at the front, as if they form an arrowhead, pointing in the direction in which the car will go.

**FIGURE 3.12.**   **Marcello Gandini (designer) and Gruppo Bertone (fabricator). Lancia (Bertone) Stratos HF Zero.** *1970. 2' 9" high. XJ Wang Collection, New York.*  Angled lines make the car appear to shoot by, even though it is standing still.

## 3.1 See How Lines Draw Attention

In *Raft of the "Medusa"* (figure 3.13), French artist Théodore Géricault (tay-oh-DOHR jeh-ree-KOH) recorded the story of the "Medusa." The ship had gone aground off the coast of Africa in 1816, and 150 passengers had pieced together a raft. After drifting for two weeks with no food or water, only fifteen passengers survived. Géricault depicted the moment when the survivors first saw a rescue boat. Yet, in Géricault's vision, a large wave simultaneously threatens the passengers. Consider how Géricault arranged the lines to point and draw our attention in opposite directions toward the rescue boat and wave.

- What creates the lines that point to the ship? What direction are these lines? Are these actual, implied, or both?
- What creates the lines that point to the wave? What direction are these lines? Are these actual, implied, or both?

The wave is advancing on the raft.

The rescue ship is a distant spot that is barely visible.

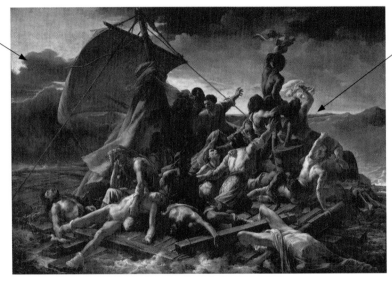

FIGURE 3.13.  Théodore Géricault. *Raft of the "Medusa."* 1819. Oil on canvas, 16′ × 23′ 6″. Louvre Museum, Paris.

Both actual and implied lines can guide our eyes. To get a sense of how this works, see *Practice Art Matters 3.1: See How Lines Draw Attention.*

*Quick Review 3.1*: What is the difference between actual and implied lines?

# Shape

A shape is a familiar concept to us. However, in art, we refer to shapes only when discussing *two-dimensional works*. A **shape** is a distinct, flat area with dimensions of height and width that is separated from the surrounding area by a distinguishable boundary. That boundary can be created by a line or by changes in texture, light, or color. In van Gogh's *Self-Portrait* (figure 3.4), lines distinguish the shapes of his buttons, while the shape of his beard is distinct because of the difference in color and texture.

**shape** A two-dimensional area that we perceive as distinct and that is separated from the surrounding area by a distinguishable boundary

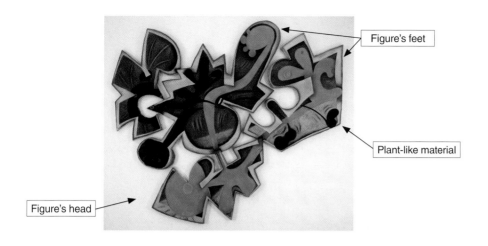

**FIGURE 3.14.** **Elizabeth Murray.** *Landing.* 1999. Oil on canvas, 9' 7" × 11' 6". Nerman Museum of Contemporary Art, Johnson County Community College, Overland Park, Kansas. A shape of a bright, blue figure with head down and feet in the air appears to be surrounded by shapes of plant-like material.

Figure's feet

Plant-like material

Figure's head

## The Character and Direction of Shapes

Shapes vary in terms of *character* and *direction*. They can be large or small; bold or delicate; clearly defined or unstructured; filled in or hollow; or horizontal, vertical, or diagonal. A shape's appearance and direction *suggest different attitudes*. A pointy, straight, diagonal shape might appear abrupt, while a long, curving, horizontal shape could appear lazy.

Twentieth-century American artist Elizabeth Murray's paintings, created from cutout shapes, show this expressive effect. In *Landing* (figure 3.14), bold, diagonal, nonrepresentational shapes make up the overall work, looking like unmatched puzzle pieces. Painted across the interior, less clearly defined diagonal shapes hint at recognizable objects. The mix of bulbous and pointy cartoon-like shapes and the angled direction help to convey a youthful and fun impression of activity.

## Geometric and Organic Shapes

There are two different types of shapes. **Geometric shapes**:

- *Can be identified*, like circles, squares, and triangles
- *Are precise*, mathematical, and regular
- *Tend to be more formal*

By contrast, **organic shapes**:

- *Relate to shapes often found in nature*
- *Are undefined* and irregular
- *Tend to be more relaxed*

Geometric and organic shapes lead to *different expressions*. Two paintings show the effect. Twentieth-century French painter Fernand Léger (fair-NAHN lay-JHAY) used geometric shapes in *Three Women* (figure 3.15). Three monumental nudes stare out from an ordered scene of geometric shapes.

Conversely, twentieth-century Swedish painter Hilma af Klint used organic shapes in *The Ten Biggest, No. 7, Adulthood* (figure 3.16). Bulging, nonrepresentational shapes float on a murky background.

## Positive and Negative Shapes

When artists create two-dimensional works, they also consider positive and negative shapes. The **positive shape** is the shape—called a figure—that we perceive as dominant and significant. The **negative shape** is the surrounding area—called a ground—that is

**geometric shape** A type of shape that is mathematical and regular such as a circle, square, or rectangle

**organic shape** A type of shape that is irregular that resembles those found in nature

**positive shape** In two-dimensional art, a shape that we perceive as dominant, significant, and in the foreground

**negative shape** In two-dimensional art, a shape that we perceive as being in the background

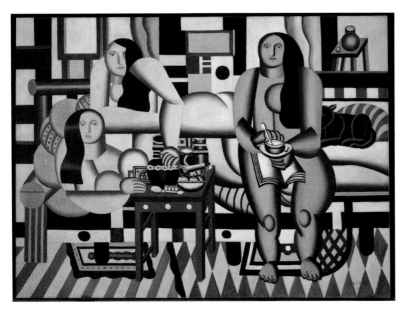

FIGURE 3.15.  Fernand Léger. *Three Women.* 1921–22. Oil on canvas, 6′ ¼″ × 8′ 3″. *The Museum of Modern Art, New York.*  Léger's hard-edged shapes present a world that seems machine-like and efficient.

When a positive shape (in this instance the black shape) is placed on a background (in this instance a white background), the positive shape creates a negative shape around it.

FIGURE 3.17.  A positive and a negative shape.

FIGURE 3.16.  Hilma af Klint. *The Ten Biggest, No. 7, Adulthood.* 1907. Oil and tempera on paper, 10′ 9 ⅛″ × 7′ 11″. Af Klint's organic shapes seem carefree and mysterious, as if out of a vision.

background or empty. When an artist creates a shape on a surface, it sets up a relationship between that shape and the surrounding background (figure 3.17).

In most two-dimensional art, the **figure–ground relationship**—the connection between the positive and negative shapes—is straightforward. However, sometimes, as in twentieth-century Dutch artist M. C. Escher's *Sky and Water I* (figure 3.18A), the figure–ground relationship is confusing. At top, birds (the figures) fly on a white ground. At bottom, fish (now the figures) swim on a black ground. In the center, the figure and ground become ambiguous. **Figure–ground reversal** occurs when the negative and positive shapes continually flip.

**figure–ground relationship**  In two-dimensional art, the connection between the dominant shape that the artist depicts and the background area

**figure–ground reversal**  In two-dimensional art, ambiguity between the figure (the dominant shape that the artist is depicting) and the ground (the background area), so that at different moments what we perceive as the figure becomes the ground and what we perceive as the ground becomes the figure

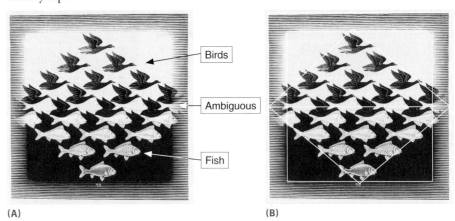

(A)                                    (B)

FIGURE 3.18A AND B (with overall shapes indicated).  M. C. Escher. *Sky and Water I.* 1938. Woodcut on laid Japan paper, 17 ¼″ × 17 ¼″. National Gallery of Canada, Ottawa, Ontario.  There is figure–ground reversal in the ambiguous space in the middle (3.18A). Escher created overall shapes of a diamond, two rectangles, and a square (3.18B).

## Overall Shapes

*Overall shapes* often bring *organization* and *harmony* to a work, even if they may not be as noticeable. To see overall shapes, we need to *group together different figures and areas.*

In Escher's work, if you hold the work at a distance or squint, you notice that the birds and fish—taken together as an entire shape—create a diamond within a square (figure 3.18B). You can also see two equal-sized rectangles, one white on top and the other black on bottom, on which the birds and fish sit. While Escher used individual organic shapes to show seemingly impossible transitions, he used overall geometric shapes to *hold the work together* and *promote stability.*

*Quick Review 3.2*: How do geometric and organic shapes differ in appearance?

# Mass

While two-dimensional works have shapes, *three-dimensional works have mass.* A **mass** is a form with dimensions of height, width, and depth that takes up volume in space.

**mass** A solid form that has bulk that occupies volume in space

## The Character and Direction of Masses

Masses *vary in appearance*, which may affect a work's personality. Masses may be large or small; unified or in pieces; simple or detailed; or vertically, horizontally, or diagonally positioned. The masses in *Eyes* (figure 3.19) by Louise Bourgeois (boor-JWAH), a contemporary French American artist, and *Reclining Figure* (figure 3.20) by Henry Moore, a twentieth-century English artist, look dissimilar, so they communicate different moods. *Eyes* is bulky, compact, and made from several bold, upright forms. *Reclining Figure* stretches horizontally in one long piece with twisting, less-structured components. Many people would say that *Eyes* feels alert, while *Reclining Figure* seems relaxed.

**FIGURE 3.19.  Louise Bourgeois. *Eyes.** 1982. Marble, 6′ 2 ¾″ × 4′ 6″ × 3′ 9 ¾″. The Metropolitan Museum of Art, New York.*  The exact masses of this sculpture seem perky.

**FIGURE 3.20.  Henry Moore. *Reclining Figure.** 1939. Elmwood, 3′ 1″ × 6′ 7″ × 2′ 6″. Detroit Institute of Arts, Michigan.*  The spread-out, horizontal mass seems calm.

## 3.2 Explore the Masses of a Car

**FIGURE 3.21.** Marcello Gandini (designer) and Gruppo Bertone (fabricator). Lancia (Bertone) Stratos HF Zero reconsidered.

Reconsider Gandini's car (figure 3.21).

- Are the masses geometric or organic?
- How do you know?
- What does this type of mass communicate to the viewer about the type of car it is?

### Geometric and Organic Masses

Mass can be both *geometric* and *organic*. These terms mean the same things for mass as they did for shape. In Bourgeois's work (figure 3.19), geometric eyes stare out from what seems like an imposing, house-like, cubic structure. Conversely, the organic mass of Moore's sculpture (figure 3.20) may add to the feeling of irregularity. To see how mass affects the expression in a car, see *Practice Art Matters 3.2: Explore the Masses of a Car.*

### Mass and Negative Space

**negative space** The empty, unfilled area around and within a mass

Often **negative space**, or the surrounding, empty void, is as meaningful in a work as the positive mass of material. In Moore's figure (figure 3.20), the mass and negative spaces interchange to assume different forms, such as the holes under the shoulders, which could be breasts or spaces between the arms and waist. The open cavities also let us see through the sculpture, emphasizing the sculpture's depth.

*Quick Review 3.3*: Why is negative space important in considering mass?

# Texture

Have you ever touched a kitten? If so, you probably remember the feeling. Our tactile memories stay with us. Everything that we touch has a surface characteristic, but even if we don't touch an object, because of our past experiences, we sense what it would feel like if we did.

**texture** The surface characteristic of a work that relates to our experience of touch

   **Texture** is the surface characteristic of a work that relates to our experience of touch. Because we can't touch most art, *we see texture with our eyes and understand it in our minds*.
   Just as in life, there are a *multitude of textures with different characters* in art. Textures can be furry, soft, prickly, rough, stiff, slick, or scratchy; squishy or hard; shiny or matte; or inviting or unpleasant.

## Actual and Simulated Texture in Two-Dimensional Works

In *two-dimensional works*, we have two types of texture: actual and simulated. **Actual texture** is the real texture we can feel physically with our fingers. If we were to touch *The Night Café* (figure 3.3), the surface would feel rough. Van Gogh, using a thick **impasto**, built up globs of paint that stand away from the surface. Because we could *feel the actual material*, the painting has actual texture.

A two-dimensional work can also have the illusion of texture, known as **simulated texture**. In *The Night Café*, van Gogh imitated textures: the worn floor looks different from the hard tabletops. Because van Gogh *implied the feel* of objects, the painting has simulated texture.

Contemporary Nigerian artist Jimoh Buraimoh created actual texture in *Birds* (figure 3.22). Buraimoh adhered beads to the surface of his two-dimensional work. Because we would be able to feel the real bumpy beads—the physical material—the piece has *actual texture*.

*Self-Portrait with Two Pupils* (figure 3.23) by eighteenth-century French painter Adélaïde Labille-Guiard (ah-deh-LAID lah-BEE GWEE-ahr) displays textures of satins, feathers, and lace. However, because they are an illusion, these textures are *simulated*.

## Actual and Simulated Texture in Three-Dimensional Works

*Three-dimensional works* also have *actual and simulated texture*. Actual texture has to do with the *real texture of the material* in use. Bourgeois carved *Eyes* (figure 3.19) from marble. In the two crescent-shaped marks on the sculpture's base, Bourgeois left the stone rough,

**actual texture** Texture that is real that we could feel physically with our fingers

**impasto** A style of painting in which thick, built-up, opaque paint stands away from the surface in textured brushstrokes; the paint applied to a surface using this technique

**simulated texture** Texture suggested by an artist through illusion

**FIGURE 3.22.** **Jimoh Buraimoh.** *Birds.* 1970. *Plywood, glass beads, oil paint, and string, 4' 8 ½" × 2' 1 ½". Yale University Art Gallery, New Haven, Connecticut.* The actual texture of the beads makes a different impression from flat paint.

**FIGURE 3.23.** **Adélaïde Labille-Guiard.** *Self-Portrait with Two Pupils.* 1785. Oil on canvas, 6' 11" × 4' 11 ½". The Metropolitan Museum of Art, New York.* When Labille-Guiard painted this work, the French art establishment allowed only four women to be included in its ranks, Labille-Guiard among them. This work was likely meant as a challenge to authorities: It seemed to ask why more women were not included.

**FIGURE 3.24.** Marilyn Levine. *Spot's Suitcase.* 1981. Ceramic, 8 ½" × 2' 5" × 1' 6". *Philbrook Museum of Art, Tulsa, Oklahoma.* Levine tried to fool us into believing her work is made from something it is not by simulating texture.

while on the eye-like spheres above the base, she polished the stone to a smooth finish. Both are the actual textures of the stone.

Simulated texture in three-dimensional works *imitates the look of another material.* Twentieth-century Canadian artist Marilyn Levine used clay to form the look of old, worn leather in *Spot's Suitcase* (figure 3.24). The simulated texture emphasizes every scratch and bulge.

*Quick Review 3.4*: What is the difference between actual and simulated texture?

# Light and Value

**light** A form of electromagnetic energy that can be seen by human eyes

**value** The degree of lightness or darkness of a tone or color

We need light to see. We see because our eyes receive light and transmit impulses representing that light to our brains. The impulses carry information about our world, and our brains interpret that information.

## Light

**Light** is a kind of energy that travels in *waves.* One way to understand a light wave is to think about a wave in water. When a boat crosses a body of water, it creates waves made up of energy. Light waves are also made up of energy that comes from a source like the sun. Light waves travel through transparent objects, like air, plastic, water, and glass. However, they do not travel through opaque objects, like furniture.

Light waves travel in straight lines. They change direction only when they run into *transparent material and are refracted* (bent) or into something *opaque and are absorbed or reflected* (bounced) in another direction. If you have ever held a mirror in a stream of light, you might have seen light bounce off the mirror and appear on an opposite wall.

## Value

**Value** is how light or dark something is based on how much light that object reflects. The more light that is reflected, the lighter the value.

Value includes an *infinite number of tones* with subtle differences. Figure 3.25 shows a ten-step value scale that moves from white to black tones, gradually and consistently darkening in each step. While there are ten steps, we could add more with additional intermediary grays. Artists can use these numerous tones throughout their works, just as van Gogh did in *The Potato Eaters* (figure 3.1).

Value is also *relative.* A tone of the same value (like the circle in figure 3.26) shown on lighter or darker backgrounds appears to have a different value. The circle looks darker on lighter backgrounds and lighter on darker backgrounds, even though the value of the circle hasn't changed. We recognize an object as light or dark when we *compare* it with other lighter or darker values. Artists can make tones appear to have different values based on their placement.

**FIGURE 3.25.** A ten-step value scale.

**FIGURE 3.26.** A circle of the same value on backgrounds of different values.

## Light Hitting Three-Dimensional Opaque Objects

Because light travels only in straight lines, when it hits a three-dimensional, opaque object, the result is four different value areas (figure 3.27):

- *Highlight*: This is the lightest-valued spot on the object that is most intensely hit by the light and that reflects the most light.
- *Darker-valued area on the object:* This area reflects less light because it receives less light.
- *Completely dark-valued area on the object:* This area is not hit by the light and reflects no light.
- *Shadow:* This is the completely dark-valued area on the surface behind the object; the object blocks the light from this surface, so no light is reflected.

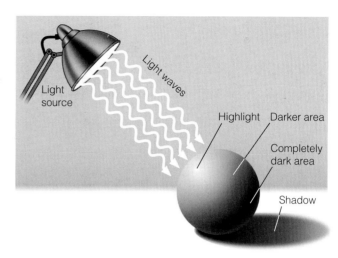

**FIGURE 3.27.  Light hitting a three-dimensional object.**

### Chiaroscuro

During the Renaissance in Italy, the period during the fifteenth and sixteenth centuries, artists invented *chiaroscuro* (kee-AH-roh-SKOOR-oh). This technique uses contrasts in light and dark values to **model** the illusion of three-dimensional forms on a flat surface, thus creating the impression that objects are real. Knowing that when light hits an opaque, solid object, the results are a highlight, darker area, completely dark area, and shadow, artists have *copied this phenomenon by using tones of different values* in their works.

Italian Renaissance artist Annibale Carracci (ahn-NEE-bah-leh kah-RAH-chee) used *chiaroscuro* in his *Head of a Woman Looking to Upper Left*. The effect makes the head look spherical and real. An apparent light source outside and to the left of the drawing appears to cause different tones to fall across the woman's head (figure 3.28).

### Value to Heighten Expression

Value can also be used to affect a work's expression. Different value relationships influence the emotion conveyed. *Highly contrasting values feel dramatic, exciting, and conflicting,* while *soft value contrasts feel stable, calm, and harmonious.*

**highlight**  The lightest, most intensely lit area on an object or in a work

**shadow**  The dark area behind an object that is being blocked from the light

**chiaroscuro**  Italian for "light-dark"; a technique in two-dimensional art in which the artist uses contrasting light and dark tones, mimicking how light plays across solid objects in the real world, to render the illusion of three-dimensional forms on a flat surface

**modeling**  In two-dimensional art, the depiction of the illusion of a three-dimensional form on a flat surface

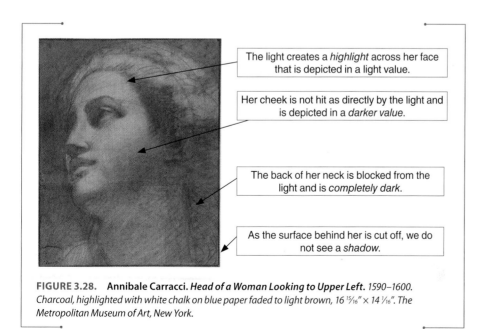

The light creates a *highlight* across her face that is depicted in a light value.

Her cheek is not hit as directly by the light and is depicted in a *darker value*.

The back of her neck is blocked from the light and is *completely dark*.

As the surface behind her is cut off, we do not see a *shadow*.

**FIGURE 3.28.  Annibale Carracci. *Head of a Woman Looking to Upper Left*. 1590–1600.** *Charcoal, highlighted with white chalk on blue paper faded to light brown, 16 ¹⁵⁄₁₆″ × 14 ¹⁄₁₆″. The Metropolitan Museum of Art, New York.*

Both women are caught in *light-valued*, dynamic diagonals that echo down Judith's face, the curve of her arm, the bend of her knee, and the servant's face.

The contrast of the light with these *dark values* in the rest of the room seems to give the painting a strong, chilling effect.

Judith holds the bloody sword.

Judith's servant pushes Holofernes's head into a sack.

**FIGURE 3.29.** **Artemisia Gentileschi.** *Judith and Her Maidservant with the Head of Holofernes.* c. 1623–25. Oil on canvas, 6′ 7⁄16″ × 4′ 7 ¾″. *Detroit Institute of Arts, Michigan.*

## artists
### MATTER

Artemisia Gentileschi

Artemisia Gentileschi (ahr-tuh-MEE-zhyuh jen-till-ESS-kee), a seventeenth-century Italian painter, used value relationships to intensify the emotional impact of *Judith and Her Maidservant with the Head of Holofernes.* The painting depicts the Israelite heroine Judith (who, after plying the enemy general Holofernes with liquor, cut off his head) and her servant. Gentileschi showed the moment after the killing, as the two women glance in implied lines to the left of the painting as if they hear someone coming. The violent value contrasts created by the candlelight appear to heighten the dramatic scene (figure 3.29).

### Light as a Material

In some three-dimensional works, light is just as important a material as the components the artist forms from tangible objects. Contemporary American artist Alyson Shotz's *Geometry of Light* (figure 3.30) takes advantage of *light as a material*. Her work consists of plastic lenses, which magnify and focus the light, and glass beads, which reflect the light, all strung on wire. For this installation at the Indianapolis Museum of Art, Shotz placed the work in the glass-surrounded entrance. As the weather and time of day changed, the piece captured the natural light, acquiring highlights that shimmered. However, the piece also changed the space around it with soft beams, reflections, and shadows.

***Quick Review 3.5***: How does *chiaroscuro* mimic the effects of light?

**FIGURE 3.30.** **Alyson Shotz.** *Geometry of Light. From the installation at the Indianapolis Museum of Art, Indiana. 2012–13. Cut plastic Fresnel lens sheets, silvered glass beads, stainless-steel wire, 50′ × 29′ 11″ × 13′ 1″.* Shadows caused by Shotz's work are evident on the floor.

# Color

Have you ever tried to pick out clothes at night without turning on the lights? With limited light, you might be able to find

a shirt and pants, but you wouldn't be able to see whether they matched. *We need light to see color.* **Color** is a function of how our *eyes and brains perceive light.*

## The Visible Spectrum

In 1666, Isaac Newton discovered the relationship between color and light. He placed a triangular piece of glass, called a prism, in a stream of sunlight (figure 3.31). While colorless sunlight called *white light entered the prism*, a stream of light that had *the same colors and order as a rainbow exited the other side.* Newton called this band of colors the **visible spectrum**.

Newton discovered that *white light is a mixture of all of the colors in the rainbow.* When light travels, it does so in waves, and when it enters a transparent material like glass, it bends. In the prism, when the light waves bent, they *separated into individual waves that Newton saw as different colors.* Similarly, a rainbow is created when sunlight is bent and split up as it travels through transparent water drops in the atmosphere.

## Why We See Color

Light waves themselves do not contain colors. We see colors because of *the way our eyes and brains perceive light waves that have different wavelengths* (the distance from the peak of one wave to the peak of the next). We see red as opposed to violet because the wavelength that we see as red is about twice the size of the wavelength that we see as violet.

Every tangible object in our world contains **pigments**, substances that allow us to see color. Natural objects have natural pigments, such as chlorophyll in grass and melanin in skin. Human-made objects have artificial pigments, such as paints and dyes. Different pigments, because of their physical structures, *vary in their capacities to reflect and absorb wavelengths of light.* For example, when white light hits an object that we see as green, the pigments in that object *reflect* the green wavelengths and *absorb* the wavelengths for all the other colors.

## The Subtractive and Additive Color Systems

Artists can work with either *pigments* or *lights*, but these materials function *in opposite ways.* When artists who work with pigments mix them all together, they appear black. (In practice, they look dark gray because of imperfections in the pigments.) This phenomenon occurs because each pigment absorbs light waves of different lengths, so there is nothing left to reflect back. Because artists *subtract reflected light* when they mix pigments, we call their system the **subtractive color system**.

We identify certain colors as primary and secondary (figure 3.32). **Primary colors** are those that theoretically cannot be made by mixing other colors and that can be used to make all of the other colors. The primary colors in the subtractive color system are red, yellow, and blue. **Secondary colors** result from mixing two primary colors. The secondary

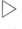

Color

**color** The sensation we perceive upon seeing different wavelengths of light because of how our eyes and brains interpret the wavelengths

**visible spectrum** The band of colors that we can see when white light is refracted

**pigments** Substances that absorb and reflect different wavelengths of light that allow us to see color

**subtractive color system** The method by which pigments are mixed by subtracting different reflected waves of light

**primary colors** Colors that theoretically cannot be made by mixing other colors and that can be used to make all of the other colors

**secondary colors** Colors resulting from the mixing of two primary colors

**FIGURE 3.31. White light entering a prism, refracting inside, and exiting as a band of colors.**

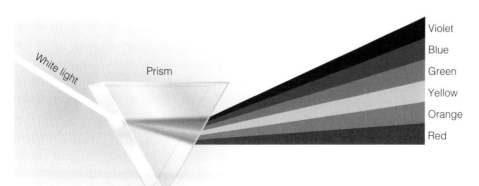

White light    Prism

Violet
Blue
Green
Yellow
Orange
Red

FIGURE 3.32.  Mixing pigments
in the subtractive color system.

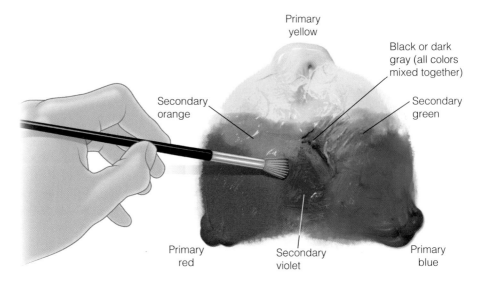

Primary
yellow

Black or dark
gray (all colors
mixed together)

Secondary
orange

Secondary
green

Primary
red

Secondary
violet

Primary
blue

**additive color system**  The
method by which light is mixed by
adding different refracted waves
of light

colors are orange (a mix of red and yellow), green (a mix of yellow and blue), and violet (a mix of blue and red).

Although most artists work with pigments, some work with light. For information about the **additive color system** in which artists mix light by *adding different refracted waves of light*, see *Delve Deeper: The Additive Color System.*

# DELVE DEEPER

## The Additive Color System

When artists work with light (like theatrical lighting designers), they mix all light waves together to get white. Because these artists add refracted light when they mix colors, we call their system an additive color system.

As with the subtractive system, we identify certain colors as primary and others as secondary. In the additive system, the primary colors are red, green, and blue, and the secondary colors are yellow (a mix of red and green), cyan (a greenish blue, a mix of green and blue) and magenta (a purplish pink, a mix of blue and red) (figure 3.33).

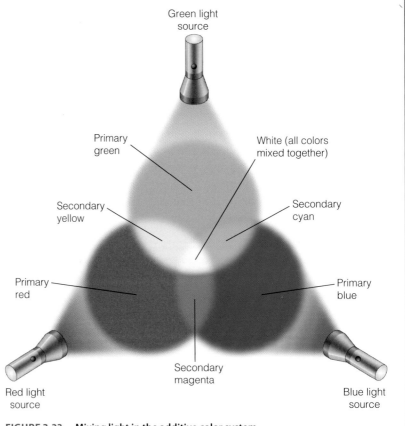

Green light
source

Primary
green

White (all colors
mixed together)

Secondary
yellow

Secondary
cyan

Primary
red

Primary
blue

Red light
source

Secondary
magenta

Blue light
source

FIGURE 3.33.  Mixing light in the additive color system.

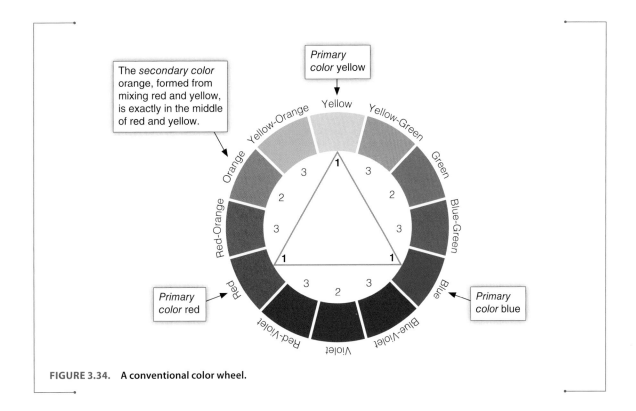

The *secondary color* orange, formed from mixing red and yellow, is exactly in the middle of red and yellow.

*Primary color* yellow

*Primary color* red

*Primary color* blue

**FIGURE 3.34.** **A conventional color wheel.**

## The Color Wheel

Color theorists have arranged the visible spectrum in a circle, called a **color wheel**, which helps us see color relationships. Figure 3.34 shows a conventional color wheel. Each primary color from the *subtractive color system* (which the rest of this chapter will highlight because most artists work with pigments) is shown with a number 1 next to it, each secondary color with a number 2, and each tertiary color with a 3. **Tertiary colors** result from mixing the neighboring primary and secondary colors. The tertiary color yellow-orange, for example, is formed by mixing yellow and orange and lies between yellow and orange on the color wheel. The triangle in the center of the wheel (with the points on the primary colors) shows how the primary colors are equidistant from one another. The triangle also shows that each secondary color (formed from mixing the two closest primaries) is equidistant between the primaries.

**color wheel** A way to organize the visible spectrum in a circle that helps illustrate color relationships

**tertiary colors** Colors resulting from the mixing of a primary and neighboring secondary color

## The Properties of Color

Colors have three properties. These properties—hue, value, and intensity—describe the differences in colors.

**Hue** refers to the standard characteristics of colors that allow us to group them in families such as green, red, or blue. For example, the colors emerald, olive, and forest all have attributes that make them seem related (figure 3.35). They all "feel" like green to us. We therefore classify all three of these colors as having a green hue and not some other hue, like red or blue. The words *color* and *hue* do not mean the same thing. There are a multitude of colors, but just twelve hues: those that are in their *purest states on the color wheel*.

*Value* is how light or dark something is. Just as different tones of gray are lighter or darker, *different hues can*

**hue** The standard characteristics of colors that allow us to group them in families such as red, green, or blue

Emerald green     Olive green     Forest green

**FIGURE 3.35.** **Three different colors that all have the hue of green.**

*be lighter or darker* too. The easiest way to make a hue lighter or darker is to add white or black:

**tint** A light color formed from mixing a hue with white

**shade** A dark color formed from mixing a hue with black

**intensity/saturation** The degree of pureness or brightness of a color

- *Adding white to a hue* creates a lighter color called a **tint.**
- *Adding black to a hue* creates a darker color called a **shade**.

In figure 3.36, red changes as we add white to make pink (a tint of red) or black to make maroon (a shade of red).

While every hue can be made lighter or darker, each also has a *normal value*, the value we expect a hue to have. The hues on the color wheel are at their normal values.

**Intensity** or **saturation** is how bright or dull a color is. When colors are at their most intense and are fully saturated, they are at their purest. Colors that have a *high intensity look energetic, sparkly, and brilliant*. Colors that have a *low intensity look drab, soft, and subdued*. Hues on the color wheel are at full intensity. There are two ways to *lower intensity*: by *mixing a color with its complement* (the color that sits directly opposite on the color wheel) or *mixing a color with gray* (figure 3.37A and B).

*Value and intensity are different properties* of a color. Just because we lower intensity, doesn't mean the value changes. Just because a color is light doesn't mean it is bright, and just because a color is dark doesn't mean it is dull.

## Color Schemes

When artists work with color, they consider color relationships, expressive impacts, and cultural associations. When artists create representational and abstract art, they also consider whether to use **local colors**—the colors we expect objects to be as they are in regular daylight—or colors that are *expressive* (and, thereby, distorted) as van Gogh used in *The Night Café* (figure 3.3). In choosing colors, artists can create different groupings or *color schemes*, including *monochromatic, complementary, analogous, triadic, warm,* and *cool* (figure 3.38).

**local color** The actual color we expect an object to be because we see the object in that color during regular daylight

**FIGURE 3.36. Red lightened with white and darkened with black.**

Add black for shades | Red | Add white for tints

Maroon ← ——————— Red ——————— → Pink

**FIGURE 3.37A AND B. Two methods to lower the intensity of colors.**

(A)

Mixing yellow with violet *lowers the brightness* of the yellow.

Mixing violet with yellow *tones down* the violet.

Yellow ——————→ Neutrals ←—————— Violet

In the middle, the mixed colors look like a murky, brownish, neutral gray.

(B)

Mixing yellow with gray *lowers the intensity*.

Yellow ——————→ Gray

| Color scheme | Description | Example of a work of art with this scheme |
|---|---|---|
| Monochromatic | One hue has different values. | |
| Complementary | Hues are opposite each other on the color wheel. | |
| Analogous | Hues are adjacent to one another on the color wheel. | |
| Triadic | Three hues are equidistant from one another on the color wheel. | |
| Warm | Hues are on the yellow, orange, and red side of the color wheel. | |
| Cool | Hues are on the green, blue, and violet side of the color wheel. | |

**FIGURE 3.38.** Examples of works of art using different color schemes.

(A)

(B)

**FIGURE 3.39A AND B.** **(A) Color wheel showing a monochromatic scheme; (B) Berni Searle.** *On Either Side.* *From the series "About to Forget." 2005. Pigmented inkjet print, 3' 3 ¼" × 6' 6 ¼". The Museum of Modern Art, New York.* In Searle's image, people fade away, possibly reflecting how our ties to one another can be lost. The single hue of red-orange (3.39A), which spans from deepest darks on the left to hazy lights on the right, appears to merge the figures together, giving them a consistent look (3.39B).

**artists**
MATTER

Berni Searle

**monochromatic color scheme** A color scheme that uses only one hue in different values

**complementary color scheme** A color scheme that uses hues that are opposite each other on the color wheel and that feel contrasting

**simultaneous contrast** The effect created when two complementary colors are placed together, making each appear more intense

**analogous color scheme** A color scheme that uses hues that are close to one another on the color wheel and that feel related

**triadic color scheme** A color scheme that uses three hues that are equidistant on the color wheel

**Monochromatic color schemes** use one hue of different values (such as different values of green). These schemes can create a *unified look* as in *On Either Side* by contemporary South African artist Berni Searle (BUR-nee SURL) (figure 3.39A and B).

**Complementary color schemes** use hues that are opposite on the color wheel (such as red and green). When placed next to each other, complementary colors have an effect, called **simultaneous contrast**, in which each looks more brilliant. Complementary color schemes can seem *intense*, like in the early-twentieth-century dragonfly lamp (figure 3.40A and B), or *contrasting*, as van Gogh explained in his letter about *The Night Café* (figure 3.3).

**Analogous color schemes** use hues that are adjacent on the color wheel (such as yellow, yellow-green, and green). Analogous color schemes can feel *harmonious* such as in twentieth-century American painter Lee Krasner's *Free Space* (figure 3.41A and B).

**Triadic color schemes** use three hues that are equidistant from one another on the color wheel (such as red, yellow, and blue). Because the hues come from different parts of the color wheel, yet balance out, triadic schemes can give a work an *even power and strength* (figure 3.42A and B) as in *La Belle Jardinière,* produced in the early sixteenth century by Italian painter Raphael (RAF-fye-ell).

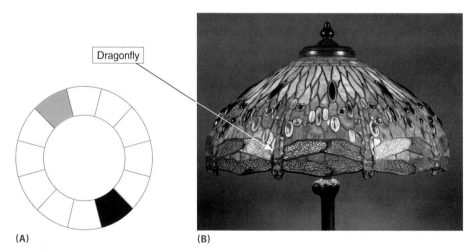

(A)

(B)

**FIGURE 3.40A AND B.** **(A) Color wheel showing a complementary scheme; (B) Tiffany Studios. Dragonfly lamp.** *1899–1920. Leaded glass and bronze, 2' 4" × 1' 10". New York Historical Society.* Downward-facing, yellow-orange dragonflies form the base of a glass lamp shade contrasting with a blue-violet sky. The intense complements (3.40A) form an energy that seems to make the dragonflies glow (3.40B).

FIGURE 3.41A AND B. **(A) Color wheel showing an analogous scheme; (B) Lee Krasner.** *Free Space.* *1976. Screenprint, 1′ 7 ½″ × 2′ 2″. Whitney Museum of American Art, New York.* Crisp, bright green shapes swirl amidst imprecise yellow areas and dark-green, messy strokes. The analogous scheme (3.41A) appears to add to the overall uninhibited feeling (3.41B).

FIGURE 3.42A AND B. **(A) Color wheel showing a triadic scheme; (B) Raphael.** *La Belle Jardinière (The Beautiful Plant Box).* *1507. Oil on panel, 4′ × 2′ 7 ½″. Louvre Museum, Paris.* The Virgin Mary and babies Jesus and John appear in a pastoral landscape. The triadic scheme (3.42A) gives the figures a seemingly noble and heroic quality (3.42B).

**Warm color schemes** use hues on the warm (yellow, orange, and red) side of the color wheel. As warm colors remind us of fire and the sun, these schemes, like the one in *Stump in Red Hills* (figure 3.43A and B) by twentieth-century American artist Georgia O'Keeffe, often feel *alive, energetic, and enriching.*

**Cool color schemes** use hues on the cool (green, blue, and violet) side of the color wheel. As cool colors remind us of the sky and water, these schemes often feel *calm, sad, and peaceful* such as in the painting *Rainy Day* (figure 3.44A and B) by twentieth-century Swiss artist Paul Klee. To see how different groupings of hues affect the feeling in another work, see *Practice Art Matters 3.3: Discover How Scheme Impacts Content.*

**warm color scheme** A color scheme that uses hues on the yellow, orange, and red side of the color wheel that remind us of fire and the sun

**cool color scheme** A color scheme that uses hues on the green, blue, and violet side of the color wheel that remind us of the sky and water

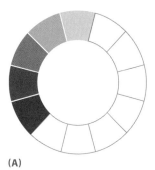

**FIGURE 3.43A AND B.** **(A) Color wheel showing a warm scheme; (B) Georgia O'Keeffe.** *Stump in Red Hills.* *1940. Oil on canvas, 2′6″ × 2′. Georgia O'Keeffe Museum, Santa Fe, New Mexico.* The remains of a dead tree curve up in front of a desert landscape. The warm scheme (3.43A) appears to relate the object to a vibrant, dancing flame (3.43B).

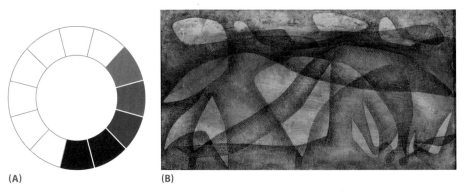

**FIGURE 3.44A AND B.** **(A) Color wheel showing a cool scheme; (B) Paul Klee.** *Rainy Day.* *1931. Oil, crayon, and ink on paper, 7¾″ × 15″. Private Collection.* Nonrepresentational violet, blue, and green shapes and a multitude of hatch marks give the impression of a rainstorm. The cool color scheme (3.44A) makes it seem like a soothing, refreshing shower (3.44B).

---

*Practice* **art**MATTERS

### 3.3 Discover How Scheme Impacts Content

Reconsider a color wheel (figure 3.45A) and Fragonard's *The Swing* (figure 3.45B):

• What are the two predominant hues used in the painting?

• What is the scheme?

• Knowing the context (see figure 3.7), what do you think this scheme communicates to the viewer about the content of the painting?

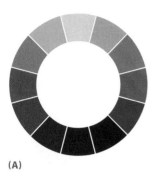
(A)

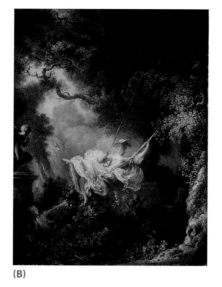
(B)

FIGURE 3.45A AND B.  (A) Color wheel; (B) Jean-Honoré Fragonard. *The Swing* reconsidered.

## The Characteristics of Color

Colors have several characteristics. These include *emotional and cultural effects*, the *illusion of three-dimensional space*, and the *tendency to blend at a distance*.

### Emotional and Cultural Effects

*Color affects us emotionally.* Studies have shown that certain colors (pinks and blues) relax us, while others (reds and oranges) make us anxious. Additionally, our cultural backgrounds have taught us to *associate certain colors with specific experiences and feelings.* For example, in Western cultures, white is symbolic of marriage, but in some Asian cultures, white is used in funerals.

### Illusion of Three-Dimensional Space

Colors offer artists working in two dimensions a way of creating the *illusion of three-dimensional space*. Warm and highly saturated colors grab our attention and appear to come forward, while cool and duller colors tend to be less noticeable and appear to recede. This spatial effect makes the nonobjective image in figure 3.46 into something that we

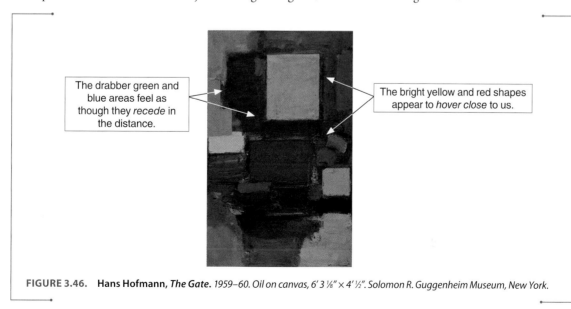

The drabber green and blue areas feel as though they *recede* in the distance.

The bright yellow and red shapes appear to *hover close* to us.

FIGURE 3.46.  **Hans Hofmann, *The Gate.*** *1959–60. Oil on canvas, 6′ 3 ⅛″ × 4′ ½″. Solomon R. Guggenheim Museum, New York.*

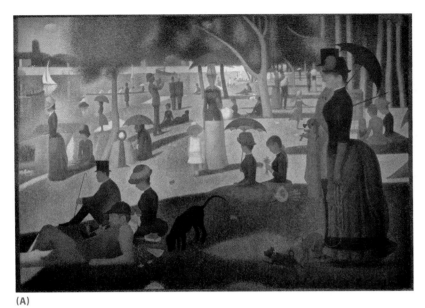
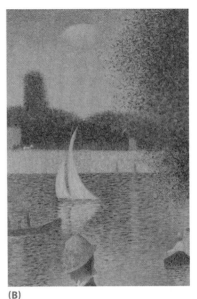

(A)                                                                                                                                              (B)

**FIGURE 3.47A AND B (DETAIL).** Georges Seurat. *A Sunday on La Grande Jatte.* *1884–86. Oil on canvas, 6′ 9 ¾″ × 10′ 1 ¼″. Art Institute of Chicago, Illinois.* Seurat used adjacent strokes of colors to create optical mixtures that shimmer on his canvas (3.47A). The numerous individual marks can be seen in the detail (3.47B).

may think we should be able to recognize, especially because the German-born twentieth-century artist Hans Hofmann titled the painting *The Gate*.

### Tendency to Blend at a Distance

Our eyes *blend small areas of adjacent colors seen at a distance*. Rather than being mixed ahead by the artist, the colors are blended in our minds. This effect can be seen in *A Sunday on La Grande Jatte* (figure 3.47A) by nineteenth-century French artist Georges Seurat (jorjh suh-RAH). Seurat applied thousands of small strokes of almost pure color to his canvas (figure 3.47B). His painstaking approach required that he systematically calculate how much of each color to employ to achieve a new blended color that would be seen from a distance.

*Quick Review 3.6*: What are the different properties of color and how do they describe the differences in colors?

# Space

**Space** is the area in which forms exist. Space can be both around and within masses and shapes. We exist within three-dimensional space, and art objects do too, but we cannot physically enter into two-dimensional space.

### Three-Dimensional Space

Three-dimensional art occupies and encloses *three-dimensional space*. We can think of three-dimensional space as *the area where the air is within and around masses*. Even though we cannot see space, it is an important part of three-dimensional art.

The exterior of the extension to the Denver Art Museum (figure 3.48A) by Polish American contemporary architect Daniel Libeskind (LEE-beh-skin) juts into three-dimensional space and creates a dynamic area around its slanting walls. Designed to mimic the Rocky Mountains, the masses interact with the open space. In the museum

**space** In three-dimensional art, the actual area in which forms exist; in two-dimensional art, the area of the flat surface and the illusion on the flat surface of an actual, three-dimensional area in which forms exist

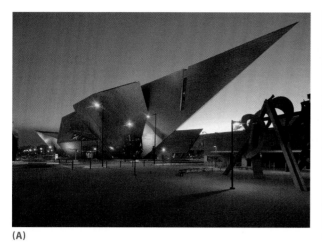

(A)

(B)

FIGURE 3.48A (EXTERIOR) AND B (INTERIOR). Daniel Libeskind. Extension to the Denver Art Museum, Frederic C. Hamilton Building. *2006, Denver.* The space around (3.48A) and within (3.48B) the extension to the Denver Art Museum appears dynamic.

interior, three-dimensional space is enclosed. The angled masses and diverse spaces appear here, too, in an enormous atrium (figure 3.48B) and in galleries.

## Two-Dimensional Space

The actual space of *two-dimensional art* is *flat*. This flat surface is called the **picture plane**. Some artists *emphasize this surface* through, for example, using flat planes of color without modeling. However, other artists *create the appearance of three dimensions on the flat surface,* employing methods we have considered (such as using the spatial effects of colors' intensities) or through *conceptual representations*; *atmospheric perspective*; *overlapping, vertical positioning, and diminishing size*; and *linear perspective* (table 3.3).

**picture plane** The flat surface of a two-dimensional work of art

**TABLE 3.3:** Methods for Representing Three Dimensions on a Flat Surface.

| Method | Explanation |
|---|---|
| Conceptual representations | Objects are depicted so that they hint at three-dimensional reality rather than being shown the way we see them in real life. |
| Atmospheric perspective | Objects are depicted to show the effect of the atmosphere so that objects that are blurrier, lighter, and duller are understood to be farthest in the distance. |
| Overlapping | Objects are positioned one in front of another so that objects that are blocked are understood to be farthest in the distance. |
| Vertical positioning | Objects are placed at different heights so that objects at the top are understood to be farthest in the distance. |
| Diminishing size | Objects are depicted in different sizes so that objects that are smallest are understood to be farthest in the distance. |
| Linear perspective | Objects are depicted so that parallel lines that recede in the distance appear to converge on one or more points. |

**atmospheric perspective** The technique of illustrating distant, three-dimensional space on a two-dimensional surface in which the artist imitates the atmosphere's effects on light, so that objects that are farther in the distance appear blurrier, lighter, and duller

**overlapping** The technique of illustrating three-dimensional space on a two-dimensional surface in which objects are positioned one in front of another, with objects that are blocked being understood as farthest in the distance

**vertical positioning** The technique of illustrating three-dimensional space on a two-dimensional surface in which objects are placed at different heights, with objects at the top being understood as farthest in the distance

**diminishing size** The technique of illustrating three-dimensional space on a two-dimensional surface in which objects are depicted in different sizes, with objects that are the smallest being understood as the farthest in the distance

**linear perspective** The mathematical technique of creating the illusion of three-dimensional space on a two-dimensional surface in which parallel lines, which recede in the distance, converge at one or more vanishing points

## Conceptual Representations

Conceptual representations hint at three-dimensional reality, but *do not depict the world the way we see it in real life*. Nakht's *Book of the Dead* shows a conceptual view of space. In ancient Egypt, people believed the dead were put through trials to judge their fitness for an afterlife. The wealthy were buried with spell books, like the one in figure 3.49, to ensure they would pass the tests. Here, figures and objects are shown from multiple viewpoints, so each part is seen from a position that is easiest to understand. Gods decide Nakht's fate (at left) and Nakht and his wife worship the gods (at right) in a *combined view* in which we see the figures' chests from the front, but their feet from the side. We also look down on a pool, likely symbolic of rebirth, from an *overhead view*.

## Atmospheric Perspective

Dust and moisture in the atmosphere interfere with the light that exists between us and objects, *making distant objects appear blurrier, lighter, and duller than they would be if close by*. When artists copy this effect on flat surfaces, the technique is called **atmospheric perspective**. A thirteenth-century Chinese artist employed atmospheric perspective to help create the illusion of three-dimensional space in *Temple among Snowy Hills*. Mountains appear to recede behind vegetation and calm waters (figure 3.50).

## Overlapping, Vertical Positioning, and Diminishing Size

Three other methods of depicting the illusion of three dimensions include overlapping, vertical positioning, and diminishing size. In **overlapping**, objects are positioned so that one is in front of another and we recognize that a blocked object is farthest away. In **vertical positioning**, objects are positioned at different heights and we see the highest as farthest away. In **diminishing size**, objects are portrayed in different sizes and we know the smallest is farthest away. In *The Harvesters* (figure 3.51), sixteenth-century Dutch painter Pieter Bruegel (PEE-tur BROY-guhl) portrayed peasants during a harvest on a summer day. He combined all three methods to show the appearance of a vast, receding three-dimensional space on a flat surface.

## Linear Perspective

Artists working during the Renaissance saw the picture plane as a window through which they could look into a three-dimensional space. Using **linear perspective**, they copied what happens when parallel lines that are perpendicular to the picture plane recede in the distance and appear to converge. To understand the effect, consider figure 3.52A and B.

**FIGURE 3.50.** *Temple among Snowy Hills. From China. Southern Song dynasty, early thirteenth century. Ink and color on silk, 9¾" × 10 1⁄16". Museum of Fine Arts, Boston.* In the background, snow-capped hills are fuzzy, light, and soft. In the foreground, textures are distinct, values are dark, and contrasts are great.

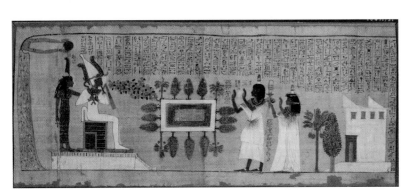

**FIGURE 3.49.** *Book of the Dead of Nakht. From Thebes, Egypt. Late eighteenth dynasty, 1350–1300 BCE. Papyrus, 1' 3½" × 3' ¾". The British Museum, London.* We see the trees from a frontal view, some growing upside down around the edge of the pool.

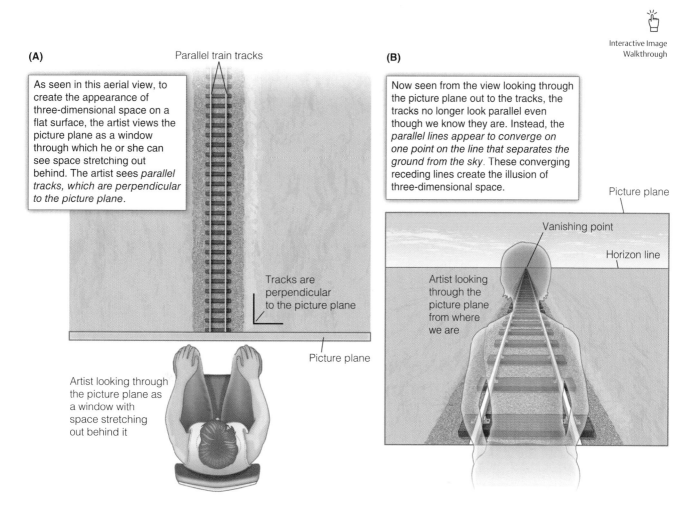

The foreground tree is so big, it doesn't even fit in the painting, while, in the distance, the trees, houses, and boats *diminish in size*.

In the foreground, the people *overlap* the landscape that is behind them in the background.

The foreground figures are *vertically positioned* lower down on the picture plane than the fields that are higher up and farther away.

**FIGURE 3.51.** **Pieter Bruegel the Elder.** *The Harvesters.* *1565. Oil on wood, 3′ 9 ⅞″ × 5′ 2 ⅞″. The Metropolitan Museum of Art, New York.*

Interactive Image
Walkthrough

**(A)**

Parallel train tracks

As seen in this aerial view, to create the appearance of three-dimensional space on a flat surface, the artist views the picture plane as a window through which he or she can see space stretching out behind. The artist sees *parallel tracks, which are perpendicular to the picture plane.*

Tracks are perpendicular to the picture plane

Picture plane

Artist looking through the picture plane as a window with space stretching out behind it

**(B)**

Now seen from the view looking through the picture plane out to the tracks, the tracks no longer look parallel even though we know they are. Instead, the *parallel lines appear to converge on one point on the line that separates the ground from the sky.* These converging receding lines create the illusion of three-dimensional space.

Picture plane

Vanishing point

Horizon line

Artist looking through the picture plane from where we are

**FIGURE 3.52A AND B.** **Linear perspective.**

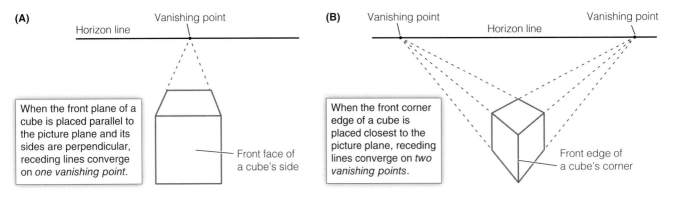

**(A)** Horizon line    Vanishing point

When the front plane of a cube is placed parallel to the picture plane and its sides are perpendicular, receding lines converge on *one vanishing point*.

Front face of a cube's side

**(B)** Vanishing point    Horizon line    Vanishing point

When the front corner edge of a cube is placed closest to the picture plane, receding lines converge on *two vanishing points*.

Front edge of a cube's corner

**FIGURE 3.53A AND B.** One- and two-point perspective.

**vantage point** In linear perspective, the artist's viewing location

**one-point perspective** The mathematical technique of illustrating three-dimensional space on a two-dimensional surface in which parallel lines, which recede in the distance, converge on one vanishing point

**vanishing point** In linear perspective, the point toward which parallel lines converge

**horizon line** In linear perspective, the line that the artist creates that distinguishes between the earth and sky

**two-point perspective** The mathematical technique of illustrating three-dimensional space on a two-dimensional surface in which parallel lines, which recede in the distance, converge on two vanishing points

Linear perspective assumes that the artist has chosen a single, fixed viewing location, or **vantage point**, from which to create the work. The artist then depicts everything in front of him or her as receding in an organized way from this position:

- In **one-point perspective**, like in the train track example, receding lines converge on *one* **vanishing point** on the **horizon line**, the line that separates the ground from the sky (figure 3.53A).
- In **two-point perspective**, receding lines converge on *two* vanishing points on the horizon line (figure 3.53B).

*One-point perspective* often feels *rational and balanced*, while *two-point perspective* can look *dynamic*. *The Last Supper* (figure 3.54A), painted at the end of the fifteenth century by Italian Leonardo da Vinci (lay-oh-NAHR-doh dah VEEN-chee), shows a logically organized space created with one-point perspective. If we extend each of the receding lines, they converge on one point (figure 3.54B).

Leonardo depicted the moment when Jesus had just proclaimed that one of his disciples would betray him. He sits at peace, while the emotion of the moment ripples down the table. Leonardo, though, countered the excitement with the one-point system. Jesus is the dignified center of the painting—the meeting point of the three-dimensional illusion of converging lines and the center of the flat, two-dimensional picture plane.

*Standard Station* (figure 3.55A) by twentieth-century American artist Edward Ruscha (roo-SHAY), contrastingly, shows a vibrant space where the corner edge of a gas station is closest to the picture plane, so receding lines converge on two points (figure 3.55B). Ruscha added to the effect as the right receding lines extend toward the painting's edge. Moreover, the structure has no shading, emphasizing solid gray and white areas. One interpretation would say that the two-point perspective, extended shape, and flat planes give the station a dramatic, slick look as if it is worthy of celebration. The two-colored background, in which a fiery orange surrounds the station, completes the transformation of an ordinary place into one of iconic status.

Despite its utility, linear perspective assumes that the artist *sees a scene from one fixed point*. In reality, though, we rarely stand still. Van Gogh tried to adapt his paintings, so that they did not feel so contrived. If we were to draw receding lines on *The Potato Eaters* (figure 3.1), they would not converge on vanishing points. Instead, it is as if our vantage point keeps changing (like we are moving) as lines recede to different locations, allowing us to see what van Gogh described in his letter as a "truer" view of the space.

**(A)**

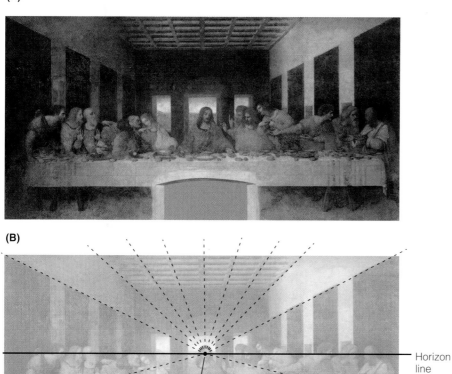

**(B)**

Horizon
line

Vanishing point

**FIGURE 3.54A AND B (with receding lines showing one-point perspective).** **Leonardo da Vinci.** *The Last Supper.* From the Refectory, Monastery of Santa Maria delle Grazie, Milan, Italy. 1495–98. Oil and tempera on plaster, 15′ 1 ⅛″ × 28′ 10 ½″.  Leonardo used one-point perspective in *The Last Supper* (3.54A), so that receding lines converge on one vanishing point (3.54B).

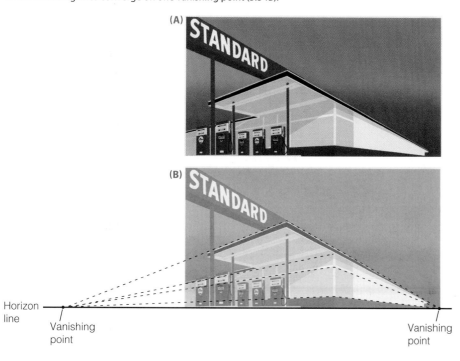

**(A)**

**(B)**

Horizon
line

Vanishing
point

Vanishing
point

**FIGURE 3.55A AND B (WITH RECEDING LINES SHOWING TWO-POINT PERSPECTIVE).** **Edward Ruscha.** *Standard Station.* 1966. Color screenprint on ivory wove paper, 1′ 7 ½″ × 3′ ¾″. Art Institute of Chicago, Illinois.  Ruscha used two-point perspective in *Standard Station* (3.55A), so that receding lines converge on two vanishing points (3.55B).

# Time

**time** An interval of a certain duration

**Time** is a period of a certain duration that allows us to understand how events or acts occur in succession. There are several characteristic ways in which time appears in art:

- A period can *be represented in the subject matter.*
- A work itself can *unfold in a sequence.*
- Forms can *repeat* in a work.
- A work itself or forms in it can *move*, *appear to move*, or show the *potential for movement.*

One way to recognize time in a work is when it is *part of the subject matter.* For example, in *The Harvesters* (figure 3.51), we are made aware of the time of year (because it is the late summer when the crops were brought in) and the time of day (because some of the peasants have stopped working to picnic, likely for lunch).

We also see time in work because some art forms *occur over time and unfold in a sequence.* Often, films and performance works tell stories or present ideas in succession. If we see only one moment from a film or performance, we do not see the entire art form.

Art also appears to occur over time when artists *repeat figures and objects that are in a continuous narrative.* The repetitions signal that episodes occur in a progression. In *The Tribute Money*, fifteenth-century Italian painter Masaccio (ma-ZAH-choh) repeated figures (including St. Peter and a tax collector) in three separate scenes (figure 3.56).

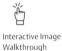

Interactive Image Walkthrough

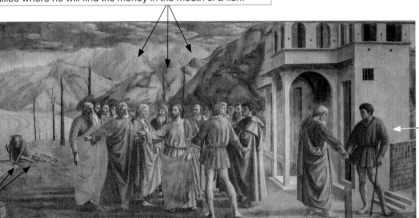

*In scene one*, a Roman tax collector, in the short tunic, asks Jesus, in the blue cloak, for a tax. Jesus directs Peter, in the orange cloak, to go to the Sea of Galilee where he will find the money in the mouth of a fish.

*In scene two*, Peter retrieves coins from the fish's mouth. We know it is Peter because he has left his orange garment next to him. His *repetition* shows this moment is a different point in the story.

*In scene three*, Peter pays the tax collector. Both men are *repeated*, showing a third moment in time.

**FIGURE 3.56.** **Masaccio.** ***The Tribute Money.*** *From the Brancacci Chapel, Santa Maria del Carmine, Florence, Italy. c. 1425. Fresco, 8′ 1″ × 19′ 7″.*

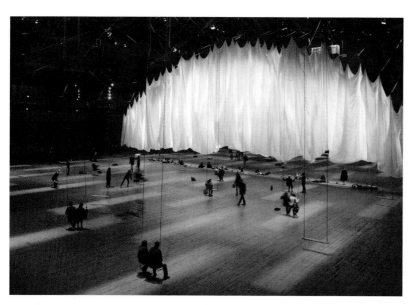

FIGURE 3.57. **Ann Hamilton.** *The Event of a Thread.* *From the installation and perfor-mance at the Park Avenue Armory, New York. 2012–13.* Hamilton imagined each motion as a crossing, as if visitors were interlacing threads to form the enormous piece of fabric.

FIGURE 3.58. **"Germantown Eyedazzler" blanket.** *Navajo. 1895–99. Wool tapestry weave, 4′ 5 ½″ × 3′ 3 ⅜″. Museum of Fine Arts, Boston.* Each Navajo blan-ket is an original design, yet follows certain motifs.

We understand the change in time through repetition, even though there are changes in Peter and the tax collector over the three scenes. Artists can change numerous aspects of figures, animals, or objects, and yet we can still see through repetition that there is a change in time. In *The Night Café* (figure 3.3), van Gogh depicted three seemingly differ-ent patrons slumped over tables. While each is placed in various positions and attires, the three could represent one man, who moved to different locations throughout the night.

We also appreciate time in some artworks because of *movement*, which can only be experi-enced over time. Contemporary American artist Ann Hamilton created a piece called *The Event of a Thread* (figure 3.57) that moved. The work was made of an enormous white silk curtain suspended across the Park Avenue Armory in New York and forty-two swings at-tached to the curtain with chains. Visitors swayed on the swings, their movement setting the curtain aflutter as they pulled it over time.

**artists**
MATTER

Ann
Hamilton

Some works give the *illusion that they move over time*, even though they really do not. Figure 3.58 shows a Navajo blanket from the late 1800s. Women have woven these blan-kets as a sacred form of expression, following the ritual of a mythic ancestor whom the Navajo believe wove the universe together. In this example, serrated diamonds and lines repeat in close succession. As the shapes vibrate, the work becomes dynamic, and we are aware of the quick passage of time.

Finally, some works show the *potential for movement*. For example, in Fragonard's *The Swing* (figure 3.7), we know that in an instant the woman will swing back toward the chaperone. This prospect, even though she is not moving and does not even appear to move, gives us a sense of time.

*Quick Review 3.8*: How does repetition show time in art?

## A Look Back at Vincent van Gogh's Letters and Art

Van Gogh's letters describe the stylistic changes he made in his work over his short life. However, as we have seen in this chapter, we must also look to the *visual elements of art* in the paintings themselves to gain complete insight into meaning.

Van Gogh used **lines** to express different ideas. In *The Potato Eaters* (figure 3.1), he employed **contour lines** to focus attention on purposely distorted figures. In *The Night Café* (figure 3.3), he used *diagonal lines* that help convey the dynamism of the café. In his *Self-Portrait* (figure 3.4), van Gogh tried to convince others of his sanity. He employed **actual lines** that curve as **gesture**, giving an overall sense of the jacket that he hoped to wear home. Van Gogh also stares out at us from his *Self-Portrait* in an **implied line**, seemingly pleading his case.

Van Gogh additionally *communicated meaning* through **shapes**. In van Gogh's *Self-Portrait*, his face and body are composed from **organic shapes**. But, van Gogh's *overall shape* is a triangle, a **geometric shape**, possibly showing stability and that he was ready to leave the asylum. The overall shape also produces a figure against a ground. Yet, the **figure–ground relationship** is confused because the ground appears to come forward in space, which perhaps throws into question his stability.

The *Self-Portrait* similarly shows van Gogh's use of **texture**. Van Gogh differentiated his jacket from his scruffy beard from his slicked back hair. These **simulated textures** describe his features. However, van Gogh also built up **actual texture** in the thick **impasto** on the painting's surface.

*The Potato Eaters* illustrates van Gogh's use of **light** and **value**. Van Gogh used *chiaroscuro* to create the appearance of believable forms in a three-dimensional space. Light, though, functions unnaturally as it shines up from the potatoes. Van Gogh additionally used light to make the work more *expressive*. *Value relationships* in the painting increase the drama because the light potatoes contrast with the dark room.

*The Night Café* displays van Gogh's strong use of **color**. Van Gogh used fully saturated *complements* to convey the passions of the café. **Simultaneous contrast** makes the colors even more intense because they clash. Van Gogh used the *emotional power of color*, painting the walls an anxiety-provoking red. By painting the rear door a bright, warm yellow, van Gogh also brought the door that is farthest away radically forward in space. This decision emphasizes the *flatness* of the **picture plane**, making the illusion of the three-dimensional space confusing.

*The Potato Eaters* allows us to consider van Gogh's use of **space**. Figures in the foreground **overlap** those behind and are **vertically positioned** lower on the picture plane, creating a believable three-dimensional illusion. However, we have an unrealistic, *conceptual* depiction of space, because we look down on the table, but straight out at the figures. Van Gogh similarly broke with the principles of **linear perspective**. The table sits with an edge toward the picture plane, so should be depicted using **two-point perspective**. Yet, because van Gogh wanted to portray the people as he entered the room, he did not establish a set **vantage point** and receding lines do not converge on two **vanishing points**.

Finally, we can appreciate **time** in the works, through *movement*. Van Gogh's changing vantage point in *The Potato Eaters* gives the impression that the scene is being viewed during different moments over time. We are also aware of the *potential movement* of each figure. The man in the back holds a cup that he is about to lift to his lips, while the woman on the right is pouring. We know in a moment their positions will shift as they continue their meal.

As you move forward from this chapter, consider how the letters support and enhance what we see in van Gogh's paintings. We, as viewers, construct meaning from context (such as from letters), but also from the visual elements of art. We must consider a variety of sources and complete a thorough analysis in order to decipher art for ourselves.

Flashcards

## CRITICAL THINKING QUESTIONS

1. Considering Tenniel's *Alice, the Duchess, and the Baby* (figure 3.11), how could you make the case that line has an additional use beyond those described in this chapter—to create texture? Is this texture in figure 3.11 actual or simulated?
2. Look back at the three figures of the chaperone, woman, and lover in Fragonard's *The Swing* (figure 3.7). What overall shape do the figures create? (Hint: Think of the woman's hat as the top point of the shape.) Is the shape geometric or organic?
3. Are there geometric or organic shapes in Ruscha's *Standard Station* (figure 3.55A)? How does this type of shape add to the expression?
4. Why is it important to see a work of art that has mass in person?

5. Several museums have recently created exhibitions for blind visitors in which they reproduce copies of paintings with enhanced painterly texture and allow visitors to touch the artwork. Which kind of texture are the blind visitors enjoying?

6. In *Judith and Her Maidservant with the Head of Holofernes* (figure 3.29), Gentileschi used *chiaroscuro*. What does this statement mean and what is the effect of the *chiaroscuro*?

7. Reconsider Labille-Guiard, *Self-Portrait with Two Pupils* (figure 3.23). Where is the light source coming from that hits the three women? What happens to the other side of the figures? Why?

8. We know that if we add violet to yellow, we lower the intensity of yellow as the hues are complements. However, we also know that every hue on the color wheel has a normal value. Could we also alter the value of yellow if we mix the two hues at their normal values? Why or why not?

9. Which works of art in this chapter, other than *Temple among Snowy Hills* (figure 3.50), use atmospheric perspective? How do you know?

10. What techniques other than atmospheric perspective do you see in *Temple among Snowy Hills* (figure 3.50) that help give the impression of a deep space? Where do you see them?

11. Chapter 2 discusses the work of Cindy Sherman (figure 2.24) in which she appears in different clothes and wigs in different images. Why is time an important element in her series? Hint: Consider the different characteristic ways that time can appear in art and which she is using.

Comprehension Quiz    Application Quiz

# 4

# The Principles of Design

### LEARNING OBJECTIVES

**4.1**  Distinguish between the ways that artists can achieve unity and variety in a work.

**4.2**  Compare and contrast symmetrical and asymmetrical balance.

**4.3**  Describe how areas of emphasis and subordination can be created in a work.

**4.4**  List some reasons that artists distort scale.

**4.5**  Explain the difference between a change in scale and a change in proportion.

**4.6**  Identify what elements can be repeated in a work to create rhythm.

# THE TAJ MAHAL

How Art Matters

In June of 1631, Mumtaz Mahal, Queen of Hindustan (present-day India), accompanied her husband, Emperor Shah Jahan, to a distant city to suppress a rebellion. Having met nearly twenty-five years before when they were both teenagers (and he only a prince), the two were inseparable. The queen accompanied the emperor wherever he went. However, this time, Mumtaz Mahal was nine months pregnant.

On the eve of June 16, Mumtaz Mahal gave birth to a healthy baby, but the queen did not fare well herself. She died the next morning in her husband's arms. Shah Jahan was inconsolable, secluding himself for a week and refusing all food. Court documents recorded that when he emerged, his black beard had turned gray. According to the requirements of Islam (the religion followed by Muslims), the queen was buried immediately. However, when Shah Jahan finished his military campaign, he brought her remains to the city of Agra where they had first met. He had her buried on the banks of the Yamuna River where he planned to build her a tomb of incomparable magnificence—the Taj Mahal.

Shah Jahan probably hoped the Taj Mahal would be a place of pilgrimage, but also reflect the greatness of his Mughal (MOO-gahl) Empire. He likely worked with a team of architects to create the complex of buildings and gardens. Precious materials were shipped from all over Asia, and twenty thousand workers toiled on the project for twelve years.

To produce the complex, the architects incorporated *the principles of design*. These principles include *unity and variety*; *balance*; *emphasis and subordination*; *scale*; *proportion*; and *rhythm* (table 4.1). The principles of design helped the architects:

» *Select, arrange, and organize the visual elements of art* (including line, shape, mass, texture, light and value, color, space, and time) into a *design*
» *Lend structure to the work* and help make it look and feel right
» *Create meaning* in the work

| TABLE 4.1: The Principles of Design in the Taj Mahal. | |
|---|---|
| **Principle** | **What the Principle Suggests a Design Should Have** |
| Unity and variety | Unity: Quality of "oneness" or wholeness<br>Variety: Quality of contrast or difference |
| Balance | Even distribution of weight |
| Emphasis and subordination | Emphasis: Areas that are visually more prominent to attract a viewer's attention<br>Subordination: Areas that are deemphasized, so they do not attract attention |
| Scale | Objects that are sized relative to what is normal |
| Proportion | Parts of objects that are sized relative to the whole object |
| Rhythm | Repetition of visual elements of art |

Just as writers usually follow guidelines when they compose essays—they establish theses and write introductory and concluding paragraphs—artists typically follow principles of design when creating art. Considering the Taj Mahal, which still stands today almost four hundred years after it was built, allows us to see how the architects used the principles of design to structure the complex and convey meaning.

## The Gate

Visitors approach the complex through a massive, nearly hundred-foot-tall gate that prepares them for the transition from the bustle of the everyday world to the peacefulness of the tomb. The gate is constructed of red sandstone and white marble, and its surface is inlaid with floral patterns and Arabic calligraphy from the Koran (the book Muslims believe is sacred). The gate is *symmetrical*—the right side mirrors the left. *Repetition* of architectural features throughout seems to make the gate feel *consistent* and causes *our eyes to move across the structure* from one similar element to the next (figure 4.1).

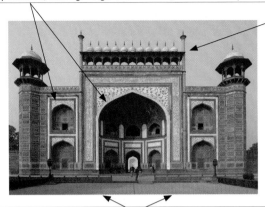

An enormous, open, recessed area topped with a half dome welcomes visitors through a pointed arch. Other arches, which are *scaled* relatively smaller, mimic the central arch in appearance, making the gate feel *unified*, as if all of the pieces go together.

Small, domed, open pavilions *repeat* across the top, their *common forms* making our eyes seem to jump from one to the next in a steady *rhythm*.

Architectural features on both sides of the gate *have similar placements, sizes, and colors* and *are made from the same materials*, so that everything on the right seems to *balance* with everything on the left.

**FIGURE 4.1.** **Main gate of the Taj Mahal.** *Mughal period, 1632–48, Agra, India.*

## The Tomb Complex

When visitors pass through the gate, they encounter the serenity, grace, and grandeur of the complex (figure 4.2), which adheres to the *principles of design*. The tomb of Mumtaz Mahal sits over nine hundred feet away, *emphasized* on a high platform. To either side, the building is flanked by a mosque and guest house. Behind the tomb lies the Yamuna River. Stretching

The tomb building is *emphasized*. It is *centrally located* and *scaled larger* than the other buildings. The *matching* mosque and guest house appear at right and left in exactly *comparable positions*, as if the two *balance* each other.

Stemming from this central point are four *similar* water channels, creating an ordered division of the garden.

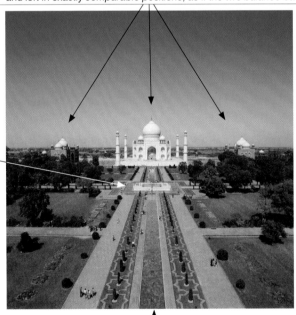

This line, which is composed of two water channels (running end to end), helps *draw our eyes* toward the tomb, like an arrow.

**FIGURE 4.2.** **The Taj Mahal complex.** *Mughal period, 1632–48, Agra, India.*

in front of the tomb is a geometrically divided garden. The garden was a typical feature of Mughal tombs meant to symbolize heaven, described by the Koran as a garden of paradise with four rivers. To recreate the garden of paradise, builders formed four straight channels of water that radiated from a central point to divide the garden into four equal parts. All of the components of the complex—the three buildings and garden—were meant to be *coherent* and *symmetrical*. They were also intended to *emphasize* the tomb building.

In the 1990s, scholars discovered a second garden across the Yamuna River from the tomb. As can be seen in the view from above (figure 4.3), the garden is a *mirror image* on the opposite bank. This moonlight garden, with night-flowering plants, was meant to be enjoyed in the evening. When Shah Jahan visited this garden, the Taj Mahal would have been reflected in the Yamuna River. The Taj Mahal, then, actually has two gardens of paradise: the first spreads out in front of the tomb as seen in figure 4.2, and the second incorporates the Yamuna River and the *matching* gardens on both river banks. Within this overall, *unified* garden of paradise, the reflection of the tomb falls at the central point.

## The Tomb Building

The tomb building itself also shows how the architects followed the *principles of design*. As it is the most ornate structure in the complex, the tomb is *emphasized*. Built in an octagonal form, it looks identical from the north, south, east, or west. Each face contains the same large- and smaller-sized alcoves in the same *symmetrical* positions, similar to the recessed areas on the gate (figure 4.4).

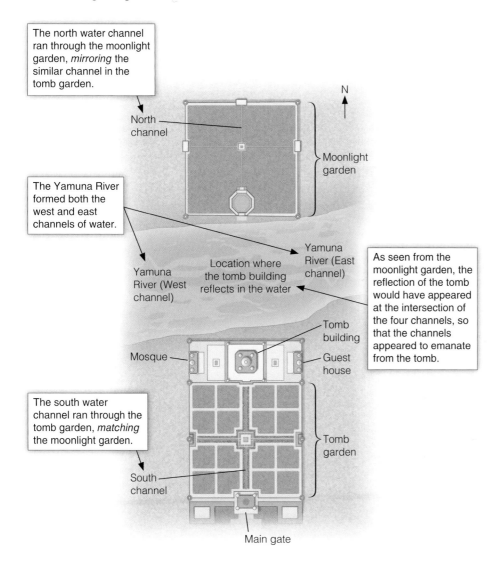

The north water channel ran through the moonlight garden, *mirroring* the similar channel in the tomb garden.

North channel

N

Moonlight garden

The Yamuna River formed both the west and east channels of water.

Yamuna River (East channel)

Yamuna River (West channel)

Location where the tomb building reflects in the water

As seen from the moonlight garden, the reflection of the tomb would have appeared at the intersection of the four channels, so that the channels appeared to emanate from the tomb.

Mosque

Tomb building

Guest house

The south water channel ran through the tomb garden, *matching* the moonlight garden.

Tomb garden

South channel

Main gate

FIGURE 4.3. Site plan of the Taj Mahal complex including the Yamuna River and moonlight garden.

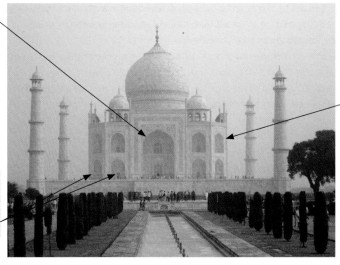

The large alcove *draws attention* and is *emphasized* because of its central position and great size.

The alcoves add *interest and variety* because of the way light hits the building, placing the alcoves in shadow, so that value changes across the façade.

Numerous, repeating alcoves seem to make our eyes move across the surface in a calm, even *rhythm*.

**FIGURE 4.4.** **The Taj Mahal tomb building.** *Mughal period, 1632–48, Agra, India.*

A large, onion-shaped dome sits atop the tomb, and it is mimicked in smaller-scaled surrounding domes, *unifying* the building and making the parts feel consistent. In addition, tall, slim minarets (designed for a Muslim crier to call people to prayer) stand at the corners of the platform. While functionally only one minaret was needed, the two on one side and the two on the other seem to *balance* each other.

The tomb is covered in white marble. While the surface looks *uniform* from afar, it is adorned with intricate inlaid stones that form flowers and Arabic calligraphy. These echo patterns on the main gate and create a *variety* of shapes across the surface. The letters positioned higher up on the tomb are larger than those below, making all the calligraphy appear from the ground to be written at the same size.

Inside the tomb (figure 4.5), exactly in the center of the room, sits the queen's false grave (her remains are believed to be buried in the crypt below). Directly to the west is a second false grave, belonging to Shah Jahan. He lived the last years of his life imprisoned, the victim of a coup d'état by his son. When Shah Jahan died, he was buried at the Taj Mahal. His false grave is larger than the queen's and feels squeezed in on the side and off *balance*. It is the only item in the complex that breaks the *symmetry* of the tomb.

## An Immense Undertaking

The Taj Mahal is a testament to how far people will go to support, create, and perfect art. The cost, time, and labor required to build the Taj Mahal were monumental. Similarly, the

**FIGURE 4.5.** **The Taj Mahal, interior of the tomb building showing the false graves of Mumtaz Mahal and Shah Jahan.** *Mughal period, 1632–48, Agra, India.* A carved marble screen surrounds the two false graves. The queen's false grave is in the center of the tomb, positioned in front of the screen's opening. Shah Jahan's is crowded in on the side.

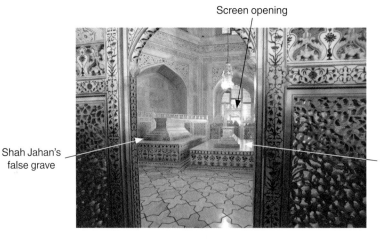

Screen opening

Shah Jahan's false grave

Mumtaz Mahal's false grave

architects took great care to *arrange* every aspect of the complex to work within the entire plan. They followed the principles of design to *organize the visual elements*, creating a particular complex, which conveyed a message relating to the greatness of Shah Jahan and the elegance, dignity, and order of the tomb of his queen.

This chapter considers the principles of design. While artists use the principles of design together in works, this chapter breaks them apart to appreciate the characteristics of each. Before moving forward, based on this story, why do you think artists organize their works? Do you believe that every work should be as organized as the Taj Mahal?

# Unity and Variety

Think about your bedroom. Chances are that you have selected, arranged, and organized your furniture, bedding, and decorations in a way that feels right to you. Like you, artists go through a similar process when creating works of art. They select, arrange, and organize the visual elements of art into **designs** or **compositions** (two-dimensional designs).

Now, think about the walls in your bedroom. Are they all the same color? If so, the room probably feels coherent to you. If, instead, each wall is a different color, even if you like all the colors, perhaps your room feels disconnected. Now, consider your walls in relation to the rest of the room. Chances are your walls are not the same color as your furniture, bedding, and decorations. If they were, your room might feel dull. Most people like to have some diversity in a room, just not too much.

The same is true in art—in general, when artists put together designs, they use visual elements of art that seem to belong together. When a design has this oneness, coherence, or wholeness, it has **unity**. But, too much unity would be boring. Therefore, artists also strive to make their designs interesting and lively. This quality of contrast, difference, and diversity is called **variety**. However, if a work has too much diversity, it feels disjointed. All works need both unity and variety.

Unity in art can be created in many ways. Artists can use:

- *Common and repeated lines, shapes, masses, textures, values, or colors*
- *Space or time in a consistent manner*
- *A similar material or technique*

In the Taj Mahal, unity is created, in the repetition of the masses and open spaces formed by alcoves, domes, and arches and in the consistent technique of inlaid marble.

Variety can similarly be created in different ways. Artists can include:

- *Different and unique lines, shapes, masses, textures, values, or colors*
- *Space or time in an inconsistent manner*
- *Dissimilar materials or techniques*

In the Taj Mahal, variety is created through different-sized alcoves, domes, and arches and in the change in value (see Chapter 3) across the façade.

In the late nineteenth century, French artist Auguste Rodin (oh-GOOST roh-DAN) created unity and variety in *The Burghers of Calais* (figure 4.6) using these techniques. The sculpture commemorates a dramatic moment from Calais's history. In 1347, the English offered to spare the French town from a devastating siege, if six leading citizens

**design** The selection, arrangement, and organization of the visual elements in a work of art; the process of organizing the elements in a work of art

**composition** The selection, arrangement, and organization of the visual elements specifically in a two-dimensional work of art

**unity** The quality of oneness, coherence, or wholeness among the visual elements of a work of art

**variety** The quality of contrast, difference, or diversity among the visual elements in a work of art

FIGURE 4.6. Auguste Rodin. *The Burghers of Calais*. *1884–89, cast 1953–59. Bronze, 6′ 7 ⅜″ × 6′ 8 ⅞″ × 6′ 5 ⅛″. Hirshhorn Museum and Sculpture Garden, Smithsonian Institution, Washington, DC.* This cast, which is on a low base as Rodin intended, shows unity in the bronze color and variety in the men walking in multiple directions.

(burghers) offered themselves to be killed. Rodin depicted the burghers, dressed in burlap sacks, walking to what they thought was their demise (they were eventually spared).

Rodin unified the design, commemorating the group sacrifice, in the similar draped masses of the men's attire and the common color and texture of the bronze. However, Rodin used variety to convey the drama of the situation. Each man faces his fate showing a different response, from resignation to fear to acceptance to sadness. Their various emotions seem to be broadcast in the different gestures and forms of their distorted hands and in how each man moves toward a different direction in space. Rodin wanted the sculpture installed on a low base, so the citizens would be able to relate to each individual. However, Rodin's manipulation of the form to convey the variety of emotions so disturbed the town's commissioners—who expected a monument that displayed unified heroism—that they placed the sculpture on a high pedestal in a remote location.

When an artist like Rodin achieves the right relationship between unity and variety, it can lead to an effective design. However, that doesn't mean that unity and variety must always be equal. *Some successful designs have more unity, while others have more variety.*

In *Metas 1* (figure 4.7A), El Anatsui (ell ah-NAH-tsoo-ee), a contemporary Nigerian artist, created tremendous unity in the consistent pale surface, neutral color, and what seems to be soft texture. Each of these elements likely contributes to the overall quiet and simple appearance. But, the work also has diversity when viewed more closely (figure 4.7B). Anatsui stitched together different newspaper printing plates. He bent the plates, creating various masses, and left the printing ink on some of them, showing different colors. The work could be seen as having an environmental message: by creatively repurposing different recycled pieces, Anatsui created a new, unified work.

Unlike *Metas 1*, some works show a lot of variety. To consider an example, see *Practice Art Matters 4.1: Identify How an Artist Created Variety and Unity.*

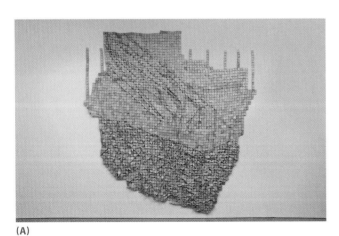

(A)

(B)

FIGURE 4.7A AND B (DETAIL). El Anatsui. *Metas 1*. *2014. Aluminum and copper wire, 10′ 1 ½″ × 9′ 11 ½″.* Even though Anatsui used tremendous unity in the color and value across his design (4.7A), he included variety in how he manipulated each plate (4.7B).

## 4.1 Identify How an Artist Created Variety and Unity

*Swing Landscape* (figure 4.8) by twentieth-century American artist Stuart Davis incorporates diverse visual elements that can give the feeling of an exciting dance. The painting represents Davis's impression of the Gloucester, Massachusetts, waterfront, and its variety helps to convey the feelings of the energy of a New England port. Davis also included typical sites of a seaside town, including a house, ladder, and ship's mast.

Consider how Davis created variety:

- What are the characters and directions of Davis's lines?
- What kind of shapes did Davis use—organic, geometric, or both?

- How many hues did Davis use? What parts of the color wheel do the hues come from?

Even with the intense variety, there is still unity. Consider how Davis created unity:

- Is the texture all smooth or is some rough?
- Are most of the colors intense or dull?
- Did Davis create the illusion of three dimensions using one method or many?

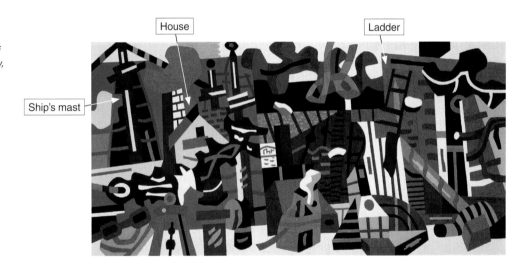

**FIGURE 4.8. Stuart Davis.** *Swing Landscape. 1938. Oil on canvas, 7' 2 ¾" × 14' 5 ⅛". Eskenazi Museum of Art, Indiana University, Bloomington.*

Conceptual unity, or common ideas and content across a work, can also play an important role in creating harmony in a piece. For example, in *Wigs* (figure 4.9), contemporary artist Lorna Simpson protested the prejudice inherent in how African American women are viewed based on how they style their hair. Simpson, an African American woman herself, took hair and turned it into disembodied wigs. The wigs become dehumanized objects displayed and categorized as if for scientific study. Rather than allowing women to be understood based on personalities and intellect, in Simpson's display, women appear to be measured only on appearance.

**artists** MATTER

Lorna Simpson

*Quick Review 4.1*: In what ways can artists achieve unity and variety in a work?

# Balance

When gymnasts perform on four-inch-wide balance beams, they stay centered. If they lean too far to one side, they must counterbalance their weight, using their other leg and arm, or they will fall off.

FIGURE 4.9.  **Lorna Simpson.** *Wigs (Portfolio).* *1994. Waterless litho-graph on felt, 38 total elements (21 panels and 17 text panels), 6′ × 13′ 6″. Walker Art Center, Minneapolis.*  Because of the single focus on how African American women are viewed, this work has conceptual unity.

FIGURE 4.10.  **Xu Zhen.** *In Just a Blink of an Eye. From the performance at the James Cohan Gallery, New York. 2007.*  In this performance, Chinese immigrants seemed to defy principles of actual weight, their physical heaviness supported by armatures beneath their clothes.

**balance**  An even distribution of weight throughout a design

**actual weight**  The physical heaviness of an object

**visual weight**  The apparent heaviness of an object based on the amount of attention it attracts

Just like a gymnast, in art, we crave **balance** or an even distribution of weight through-out a design. When something is off balance, it feels uncomfortable. When ensuring a work is balanced, though, artists consider two types of weight, *actual weight* and *visual weight*.

**Actual weight** is the physical heaviness of an object that we could measure on a scale. *Only three-dimensional art has actual weight.* An artist balances a work's actual weight so that the work doesn't fall over. In the performance piece *In Just a Blink of an Eye*, Xu Zhen (shoo jen), a contemporary Chinese artist, posed immigrants from Chinatown, New York, in frozen falling poses (figure 4.10). Metal armatures (rigid skeletal structures) hidden under the performers' clothing supported their actual weight. The disconcerting positions perhaps mirrored the immigrants' unresolved legal status in real life.

Artists also consider visual weight when designing works. **Visual weight** refers to the apparent heaviness of an object based on the amount of attention it attracts. When our eyes are *drawn to look at part of a work, it is visually heavy*; when they are not, that area is visually light. *Both three- and two-dimensional works have visual weight.*

To understand visual weight, consider three pictures of a brick and feather split by an imaginary line down the center (figure 4.11A, B, and C). No matter how large the feather, a brick has more *actual weight*. However, the same is not true with *visual weight*. We can make one or the other object visually heavier by making it attract our attention more. For example, one way to make an object attract attention is to make it big. When the brick and feather are equally sized, they have roughly the same visual weight; however, when one is enlarged or reduced in size, our eyes are drawn toward the bigger object.

**artists**
MATTER

Gian Lorenzo
Bernini

Gian Lorenzo Bernini (jawn loh-REN-zoh bayr-NEE-nee), a seventeenth-century Italian artist, balanced the visual weight in *David* (figure 4.12), so that we are drawn to look at both sides of the sculpture. As the biblical hero readies a stone in his slingshot, he twists his body to one side. To form this pose, Bernini placed David's interesting face and more of his body, which takes up more space, on the left side of the sculpture. Our eyes seem to be pulled to that visual weight. So that our eyes don't get stuck looking there, Bernini formed a fierce look in David's eyes that sets up an implied line to the right. Our eyes feel compelled to follow that line, where we envision the giant Goliath would be looming. This look toward the imagined adversary evens out the visual weight. Our eyes can move back and forth between David and the perceived giant.

We will discuss three ways that artists can balance visual weight in works of art. Artists use *symmetrical*, *asymmetrical*, and *radial balance*.

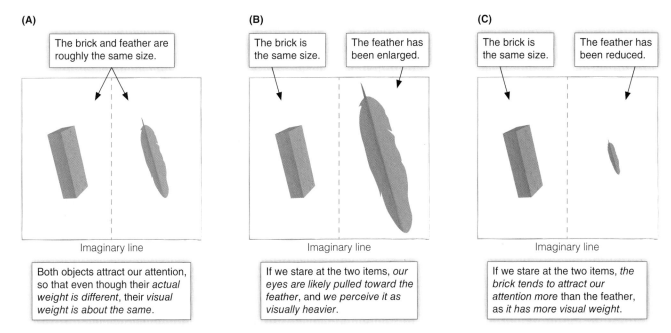

**(A)**

The brick and feather are roughly the same size.

Imaginary line

Both objects attract our attention, so that even though their *actual weight is different*, their *visual weight is about the same.*

**(B)**

The brick is the same size.

The feather has been enlarged.

Imaginary line

If we stare at the two items, *our eyes are likely pulled toward the feather*, and *we perceive it as visually heavier.*

**(C)**

The brick is the same size.

The feather has been reduced.

Imaginary line

If we stare at the two items, *the brick tends to attract our attention more* than the feather, as *it has more visual weight.*

**FIGURE 4.11A, B, AND C.** The visual weight of a brick and a feather.

## Symmetrical Balance

The easiest way to balance a work is with **symmetrical balance**. When a work is symmetrically balanced:

- Both sides of an imaginary vertical, central dividing line *have an even distribution of visual weight*
- The left and right sides *have a similarity of form*; items and figures are similar in shape, mass, placement, size, texture, value, and/or color
- The work usually *feels stable, formal, and grand*

Some symmetrically balanced works have **absolute** or **pure symmetry**, where everything on the right side is an exact mirror image of everything on the left. The Taj Mahal complex has absolute symmetry. If we were to draw an imaginary vertical, central axis through the main gate, garden, tomb, and moonlight garden, the two sides would match perfectly.

A robe made by the Tlingit people of Alaska in approximately 1900 contains absolute symmetry (figure 4.13). Designed by men and woven by women, each robe has different symbolic motifs. While many eyes and faces peek out from the flat, geometric shapes, the main form is an abstracted, centrally located diving whale whose eyes are at the bottom, flippers in the middle, and tail at the top. The robe was worn over the shoulders during ceremonies, and the faces moved as the owner danced. Every shape and color on one side of the robe is a mirror image of the other; this absolute symmetry helps give the work a strong appearance.

*Not all works that are symmetrically balanced have absolute symmetry.* If a work has some variations, but feels similar on each side because of common elements (such as shapes or colors), it is still symmetrically balanced. Variations add interest, but they also require the artist to work harder to ensure balance.

The exterior of the *Isenheim Altarpiece*, painted by German artist Matthias Grünewald (mah-TEE-ess GROON-eh-vahlt) in 1515, is symmetrically balanced, even though the sides are not precise reflections of each other. Many different figures, who do not match exactly, populate the scene (figure 4.14).

**FIGURE 4.12.** **Gian Lorenzo Bernini.** *David. 1623. Marble, 5′ 7″ high. Borghese Gallery, Rome.* Imagine a central vertical line. Visual weight is mostly at left.

**symmetrical balance** An even distribution of visual weight in a design achieved because of the similarity of form on both sides of an imaginary central dividing line

**absolute/pure symmetry** A design in which one side is an exact mirror image of the other

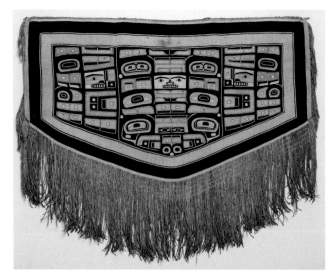

**FIGURE 4.13.** **Ceremonial robe.** *From Chilkat, Alaska. Tlingit. c. 1900. Wool and cedar bark, 4′ 7″ × 7′. University of Kentucky Art Museum, Lexington.* The shapes on the right side of this robe are replicated exactly on the left, meaning the robe has absolute symmetry.

Grünewald also positioned Christ off center. Grünewald likely made this modification because he designed the altar for a hospital chapel that specialized in treating St. Anthony's fire, a disease that often led to limb amputations. When the altarpiece was opened (at the point where the slit runs down the altar at the midpoint), this slight variation in the symmetrically balanced composition led to Christ's right arm being separated from his body. Therefore, patients with amputations could presumably relate their misery to Christ's suffering.

The work, however, is still symmetrically balanced because of a number of similar elements on each side:

- The altar has four panels
- Christ's arms reach out on both sides of the cross
- Two saints, each in red robes, flank the outside of the altar

Symmetrical balance is common in religious works as it *lends visual weight to what is in the middle* of the design. Here, Christ takes center stage, assuming the position of importance. The symmetry also seems to lend the painting dignity.

## Asymmetrical Balance

**asymmetrical balance** An even distribution of visual weight in a design achieved even though the different sides of a work of art do not match

A more difficult way to balance a work is with **asymmetrical balance**. When a work is asymmetrically balanced:

- Both sides of an imaginary vertical, central dividing line *have an even distribution of visual weight*
- The two sides of a work *do not match in form at all*; items and figures differ in shape, mass, placement, size, texture, value, and/or color
- The work often *feels dynamic, casual, and exciting*

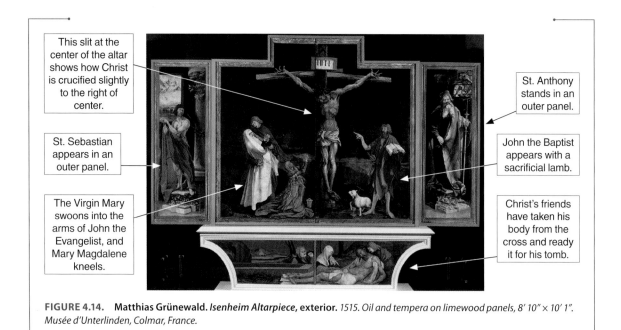

This slit at the center of the altar shows how Christ is crucified slightly to the right of center.

St. Sebastian appears in an outer panel.

The Virgin Mary swoons into the arms of John the Evangelist, and Mary Magdalene kneels.

St. Anthony stands in an outer panel.

John the Baptist appears with a sacrificial lamb.

Christ's friends have taken his body from the cross and ready it for his tomb.

**FIGURE 4.14.** **Matthias Grünewald.** *Isenheim Altarpiece*, **exterior.** *1515. Oil and tempera on limewood panels, 8′ 10″ × 10′ 1″. Musée d'Unterlinden, Colmar, France.*

The key to understanding how an artist balances asymmetrical works is to remember that *visual weight corresponds with what attracts attention*. As in the example of the brick and feather (figure 4.11), larger objects are visually heavier. However, objects can appear heavier for reasons other than *size*, such as their *color, value, texture, configuration*, and *placement*. For example, a shape painted an intense fire-engine red placed on one side of a painting would attract our attention more than a similar shape painted a dull gray on the other side, because the red shape is visually heavier. To balance this red shape, we would need to add weight to the gray shape: we could make the gray shape larger or give it an intricate texture. When artists balance asymmetrical designs, they do so understanding what is visually heavy (figure 4.15).

Vassily Kandinsky (vah-SEE-lee kan-DIN-skee), a Russian-born artist, employed asymmetrical balance in *Composition 8*. In the early twentieth century, Kandinsky sought to capture spirituality and express feelings in his paintings, even in non-objective works. He could achieve this goal by asymmetrically balancing a variety of shapes and colors in different positions. In figure 4.16, the right side is filled with many shapes and lines that seem to draw our eyes to the right, while the left side contains relatively few forms. However, if we draw an imaginary vertical line down the center, we can see that Kandinsky still balanced the painting because of the individual visually heavy items that tend to draw our eyes to the left.

Contemporary American artist Beverly Pepper's *Excalibur* (figure 4.17) illustrates how asymmetrical balance can be employed in three-dimensional works. *Excalibur* is the name of a mythic sword that was stuck in a stone that only the true king of England, Arthur, could remove. The large, triangular form at left emerges from the ground. Its slick, pointed mass perhaps recalls the sharp edges of a sword, and the dramatic diagonal may suggest movement. If Pepper had left the sculpture as a single, large mass, though, it might have looked like it was going to topple. With its line soaring left, the sculpture would have been visually too heavy on that side. To direct our eyes right, Pepper included the small, triangular mass.

Artists also use asymmetrical balance in everyday objects. To see how asymmetrical balance works with this art, see *Practice Art Matters 4.2: Determine What Makes Something Visually Heavy*.

## Radial Balance

A third way to balance works is through **radial balance**. With radial balance:

- All areas around a central point *have an even distribution of visual weight*
- Forms *are positioned and balanced in a circle*
- The central point *is a place of importance that draws attention*

| Category | What is visually heavy | Some ways to achieve asymmetrical balance |
|---|---|---|
| Size | A large shape | Balance a large shape with two small shapes. |
| Color | A warm color | Balance a small warm shape with a large cool shape. |
| | An intense color | Balance a small, intensely colored shape with a large, dull-colored shape. |
| Value | A dark value | Balance a small dark-valued shape with a large, light-valued shape. |
| Texture | A rough texture | Balance a small rough shape with a large smooth shape. |
| Configuration | A complex shape | Balance a small complex shape with a large simple shape. |
| Placement | A shape that is close to an edge (as if it has moved to the edge in an implied line) | Balance a small shape placed close to the edge with a large shape placed away from the edge. |

**FIGURE 4.15.** Some ways to achieve asymmetrical balance.

artists
MATTER

Vassily Kandinsky

**radial balance** An even distribution of visual weight in a design achieved because the forms are positioned around a central point

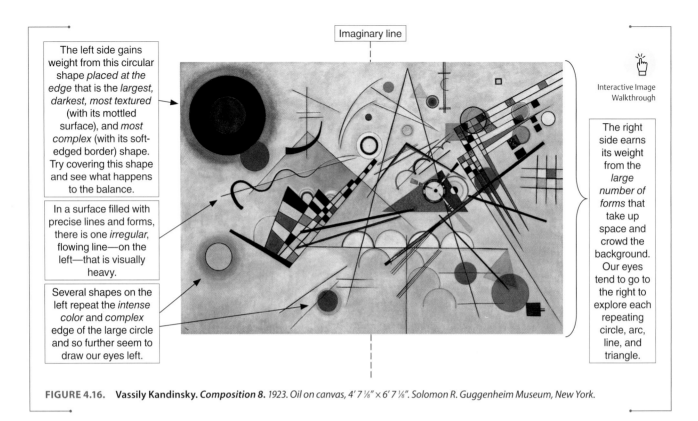

Imaginary line

The left side gains weight from this circular shape *placed at the edge* that is the *largest, darkest, most textured* (with its mottled surface), and *most complex* (with its soft-edged border) shape. Try covering this shape and see what happens to the balance.

In a surface filled with precise lines and forms, there is one *irregular, flowing line*—on the left—that is visually heavy.

Several shapes on the left repeat the *intense color* and *complex* edge of the large circle and so further seem to draw our eyes left.

Interactive Image Walkthrough

The right side earns its weight from the *large number of forms* that take up space and crowd the background. Our eyes tend to go to the right to explore each repeating circle, arc, line, and triangle.

**FIGURE 4.16.** **Vassily Kandinsky. *Composition 8.*** *1923. Oil on canvas, 4′ 7 ⅛″ × 6′ 7 ⅛″. Solomon R. Guggenheim Museum, New York.*

**FIGURE 4.17.** **Beverly Pepper. *Excalibur.*** *1975–76. Painted black steel, 35′ × 45′ × 45′. San Diego Federal Court House, California.* Try covering up the small mass on the right and see what happens. Only by including that small mass did Pepper balance the work, so the main triangle became dynamic rather than lopsided.

**patron**  A person who supports an artist by commissioning works of art

**emphasis**  The visual dominance of an area in a design that attracts the viewer's attention

Radial balance is common in round objects meant for everyday use. The canteen in figure 4.19 was made in the thirteenth century by a Syrian artist for a Christian **patron** (a person who supports an artist by commissioning art). It reflects a mix of Middle Eastern and Western motifs. Running around the edge is Arabic calligraphy, wishing the patron good fortune, while inside this circle, three scenes from the life of Jesus are uniformly positioned so they are radially balanced around a central image. The consistent use of color, value, and texture in the scenes further assures an even distribution of weight.

*Quick Review 4.2*: How are symmetrical and asymmetrical balance similar and different?

# Emphasis and Subordination

When visitors enter the Taj Mahal complex (figure 4.2), they see the garden, water channels, mosque, guesthouse, and minarets, but the majestic, central tomb building commands their attention. The tomb is the largest and most complicated form, and the south water channel points toward it. The site's architects clearly meant to emphasize this building.

A part of a work is defined as an area of **emphasis**, when it:

- Dominates because it *carries the most visual weight*
- *Attracts viewers' attention* to what is most important
- *Ensures that viewers' eyes focus* there

## 4.2 Determine What Makes Something Visually Heavy

The poster for the 2018 superhero movie *Black Panther* (figure 4.18) is balanced. The film tells the story of T'Challa, who becomes king of Wakanda. Known to the world as a poor African nation, Wakanda is hiding its futuristic, technological advances. T'Challa assumes the role of Black Panther to protect Wakanda and the world from a powerful enemy. The film's content can be understood from the image of Wakanda, seen at left with different spaceships flying above, and T'Challa, seen at right as Black Panther, standing atop an enormous sculpture of the panther goddess. The two look left, forming implied lines toward Wakanda, as if they watch over the country. Filled with such different images, the two sides of the work do not match. Yet, since the work has asymmetrical balance, both sides have equal visual weight.

Consider what makes something visually heavy (including size, color, value, texture, configuration, and placement) and answer these questions:

- What gives the right side visual weight?
- What gives the left side visual weight?

**FIGURE 4.18.** **Marvel Studios.** *Black Panther. 2018. Poster for the film, 1′ 8 ½″ × 1′ 1 ¾″.*

In the central place of importance, the Virgin Mary and Jesus sit enthroned.

The Virgin Mary presents Jesus in the temple.

The nativity (birth of Jesus) unfolds.

Jesus rides a donkey into Jerusalem.

**FIGURE 4.19.** **Canteen.** *From Syria. Mid-thirteenth century. Brass with silver inlays, 17 ⅝″ × 14 ⅜″. Freer Gallery of Art, Washington, DC.*

| Category | Some ways to achieve emphasis | |
|---|---|---|
| Size | Make a shape the largest. | |
| Color | Give a shape color. | |
| Value | Give a shape the darkest value. | |
| Configuration | Make a shape complex. | |
| | Make a shape have a different appearance. | |
| Placement | Place a shape in a central location. | |
| | Place a shape in a different position. | |
| | Place a shape at the center of lines. | |
| | Place a shape in a frame. | |
| Recurrence | Repeat a shape. | |
| Focus | Depict a shape in a sharp focus. | |

**FIGURE 4.20.** **Some ways to achieve emphasis.**

**FIGURE 4.21.** **Henri Cartier-Bresson.** *Valencia. 1933. Gelatin silver print, 7 ¹¹⁄₁₆″ × 11 ½″. The Metropolitan Museum of Art, New York.* When he took this photo in 1933, Cartier-Bresson amazingly stood inside the bullfighting ring, a feat made possible with a then-new handheld camera. Previously, only larger, less portable cameras had been available.

In the Taj Mahal, even more than the entire tomb building, the dramatic dome seems to draw our eyes to it. When a particular spot in a design attracts attention, it is called a **focal point**.

Emphasis can be achieved in a design in many ways. Artists can modify a form's *size, color, value, configuration, placement, recurrence, or focus* (figure 4.20). When artists emphasize a form, they do so knowing where our eyes will go when we look at a work.

French photographer Henri Cartier-Bresson (ahn-ree KAR-tee-ay bress-OHN) considered what to emphasize when he photographed *Valencia* (figure 4.21). Two attendants at a bullfighting arena stand near an open gate. One man (at right) watches the action, while the other looks away. At the moment that everything combined to emphasize the right-hand attendant—when his head was framed in the opening, he had the darkest values, and the sun reflected off of one of his eyeglass lenses, so the round form repeated the shape painted on the door—Cartier-Bresson took the photograph. He also focused sharply on this attendant, whereas much of the rest of the image is slightly blurred.

However, if every area of a design received equal emphasis, our eyes could not focus. Accordingly, artists also create areas of **subordination**. A part of a work is defined as an area of subordination, when it:

- *Is deemphasized* because it carries less visual weight
- *Does not distract* because it is less important
- *Ensures that viewers' eyes can move to areas of emphasis*

In the Taj Mahal, the areas around the tomb building (the garden, mosque, etc.) are areas of subordination.

Artists play down areas of subordination by giving them less visual weight. For example, artists can make subordinated areas:

- *Smaller*
- *Duller in color*
- *Lighter valued*
- *Less complex*
- *Less distinct*

A comparison of *The Last Supper* by Leonardo da Vinci (lay-oh-NAHR-doh dah VEEN-chee) and a painting of the same scene by Tintoretto (teen-toh-REH-toh) shows how artists use emphasis and subordination in different designs. Both artists worked in Italy and pictured Jesus and his disciples at a table. Leonardo's depiction from the fifteenth century seems peaceful and ordered, and the table sits horizontally, parallel to the picture plane. Tintoretto's scene from the sixteenth century has clutter and chaos with servers readying a meal, angels swooping, and a table set on

a diagonal. While the designs are dramatically different, both artists emphasized Jesus and subordinated other figures, using the same techniques of framing, placement, and pointing, allowing our eyes to find Jesus (figures 4.22 and 4.23).

Sometimes, artists create afocal works. In **afocal** works:

- There *is no focal point or area of emphasis*
- Visual weight *is evenly distributed* across the work
- Our eyes travel around and never focus on any area of emphasis, since no one form *is more important or emphasized than any other*

**focal point** A particular spot in a design that attracts attention

**subordination** The deemphasis of certain areas in a design so that they do not attract attention

**afocal** A type of work that has no focal point or area of emphasis

The window *frames* Jesus's head.

Jesus is *placed* at the painting's center.

Receding perspective lines *point* to Jesus's head, making it the vanishing point.

Other figures are not framed, are not central, and have no lines pointing to them, and are thus subordinated.

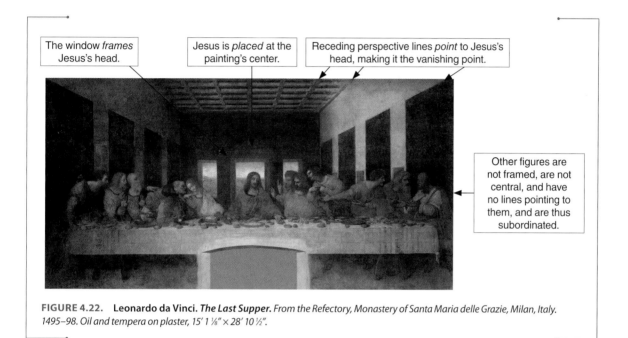

FIGURE 4.22. Leonardo da Vinci. *The Last Supper.* From the Refectory, Monastery of Santa Maria delle Grazie, Milan, Italy. 1495–98. Oil and tempera on plaster, 15′ 1 ⅛″ × 28′ 10 ½″.

A halo *frames* Jesus's head.

Jesus is *placed* at the painting's center.

The many lines that radiate from Jesus's halo also *point* back to him.

Other figures are not framed, are not central, and have no lines pointing to them, and are thus subordinated.

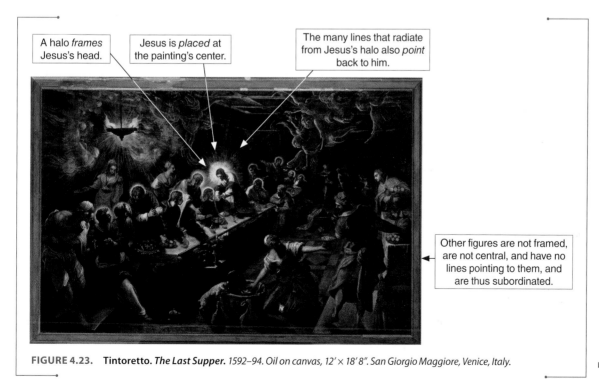

FIGURE 4.23. Tintoretto. *The Last Supper.* 1592–94. Oil on canvas, 12′ × 18′ 8″. San Giorgio Maggiore, Venice, Italy.

Interactive Image Walkthrough

(A)

(B)

**FIGURE 4.24A AND B (DETAIL).** **Jane Hammond.** *Fallen.* 2004–12. *Recto and verso color inkjet prints from digital files, matte medium, jade glue, sumi ink, acrylic paint, gouache, fiberglass strand, and handmade cotton rag paper, 1′ 3″ × 23′ 10″ × 7′ 6″. Whitney Museum of American Art, New York.* Hammond's installation has no area of emphasis (4.24A), forcing our eyes to move around the work and be continually confronted with new names of soldiers who were lost (4.24B).

American Jane Hammond's installation *Fallen* (figure 4.24A) is afocal. Commemorating U.S. soldiers killed in the Iraq War, the work contains a low platform covered in fabricated leaves, each marked with the name of one of the fallen (figure 4.24B). As every death was a tragedy, the afocal design helps give meaning to the enormity of loss, rather than emphasizing any particular soldier. Hammond began the project in 2004 and worked on it until 2012. By 2012, there were 4,487 leaves. Each leaf is based on a real leaf that Hammond gathered. Hammond scanned the front and back of each real leaf. Then, she printed and cut out the scan (including any holes); creased the leaf, so it took on the three-dimensional qualities of the original; and wrote a name on the leaf. Each leaf is distinct, as in real life each soldier was an individual.

**scale** The size of an object relative to what is normal

*Quick Review 4.3*: How can areas of emphasis and subordination be created in a work?

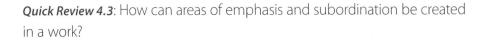

# Scale

An average car is about fifteen feet long. However, a child's model car is only about ten inches long. Comparing real and model cars is a good way to think about **scale**, which refers to the size of an object relative to what is normal. With scale, we consider an *object's size in relationship to what would occur in real life*. When a form is:

- Smaller than we expect or what is standard in real life, it is *small scale*
- Normal, it is *normal scale*
- Larger, it is *large scale*

In this example, the regular car would be considered normal scale, and the model car, small scale.

Scale can have a large impact on a viewer. Consider the scale of *Woman from Willendorf* (figure 4.25), found by archaeologists in Willendorf, Austria. Prehistoric people carved the sculpture over twenty-five thousand years ago, before the existence of written records that could help us decipher its meaning. One interpretation suggests that the sculpture may have been used as a charm to promote fertility. It is only when we consider the sculpture's

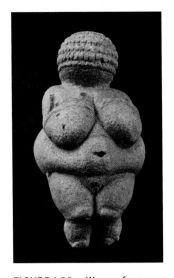

**FIGURE 4.25.** *Woman from Willendorf. From Austria. c. 24,000 BCE. Limestone, 4 ⅜″ high. Naturhistorisches Museum, Vienna, Austria.* The small scale of this work, which would have fit in a woman's hand, allows us to understand one interpretation for how the sculpture might have been used.

small scale in relation to an average-sized woman, though, that we likely can understand this explanation. The sculpture stands only about four inches high and would have fit in the palm of a woman longing for a successful pregnancy. While the sculpture is faceless, we can tell from the position of the stylized hair that she peers down at her large belly. She rests her arms on her breasts, just as pregnant women are apt to place their hands on their stomachs.

Similarly, *Black Venus* (figure 4.26) by twentieth-century French-American artist Niki de Saint-Phalle (NEE-kee duh san-FAHL) may take on new meaning when we learn its scale in relation to our own. As we see the sculpture reproduced here, it might feel fun. However, when we learn it is over nine feet tall, our reaction might change. The woman in the sculpture towers over people and looks poised to hurl a ball at the viewer. She seems powerful and in charge of her actions. Her large scale compared to our own throws traditional stereotypes of women's passivity aside.

Scale is one design principle that can be totally lost when objects are reproduced in books. While it is a convenient way to study art, a reproduction can be deceiving because forms may appear to be larger or smaller than they really are. We understand how scale can be misconstrued when we view figure 4.27, which shows what *Woman from Willendorf* and *Black Venus* would look like if placed next to an average-sized woman.

Artists manipulate scale in art for a *specific purpose*. A small scale can make a work seem intimate and bring the viewer in for a closer look. Conversely, a large scale can

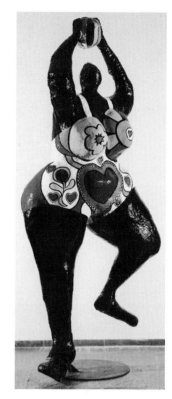

**FIGURE 4.26.** Niki de Saint-Phalle. *Black Venus. 1965–67. Painted polyester, 9′ 2″ × 2′ 11″ × 2′. Whitney Museum of American Art, New York.* The large scale of this sculpture—she is over nine feet tall—likely impacts how the viewer interprets the work.

**artists**
MATTER

Niki de Saint-Phalle

**FIGURE 4.27.** *Black Venus* and *Woman from Willendorf* shown to scale with an average-sized woman. It is easier to appreciate scale in a text when art is sized relative to other works, as it is here.

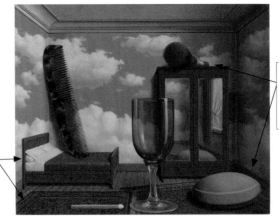

Objects such as the bed and rugs appear *normal scale* in relationship to the floor and ceiling of the room.

Objects such as the shaving brush and soap appear *large scale* in relationship to the floor and ceiling of the room.

**FIGURE 4.28.** **René Magritte.** *Les Valeurs Personnelles (Personal Values).* 1952. Oil on canvas, 2′ 7 ½″ × 3′ 3 ⅜″. San Francisco Museum of Modern Art, California.

create a sense of the colossal and cause a viewer to step back. Artists also distort scale for other reasons.

René Magritte (reh-NAY ma-GREET), a Belgian artist, manipulated scale in *Les Valeurs Personnelles* (*Personal Values*) to create a fantasy world. Each object in the image is faithfully reproduced as it would appear in the real world. However, Magritte composed the objects in different scales. The juxtaposition of large and normal scale renders the scene implausible (figure 4.28).

Magritte furthered the confusion by depicting the walls in the indoor space as sky, so that the room appears to float above the ground. The objects in the room inconceivably cast shadows onto what appears to be open space.

By distorting the scale of accurately depicted objects and putting them in a confusing space, Magritte created a world that appears as if from a disturbing dream. He was one of a number of twentieth-century artists who wished to explore the unconscious mind in his art.

A screen (figure 4.29), carved in Nigeria in the late nineteenth century, distorts scale for a different reason: to convey the high status of an important individual. Created by Kalabari Ijaw men, who organize themselves into economic associations to facilitate trade, the screens honor a leader who has died and create a home for his spirit. The leader is shown, at center, flanked by two smaller-scale assistants. Even though all figures are adults, the artist depicted the leader in a larger scale to convey his higher ranking symbolically. This technique of depicting figures using different scales so that an important person is larger is called **hierarchical scaling**. Of course, enlarging a figure lends it visual weight. The larger-scaled, centrally located leader in this symmetrically balanced design aptly commands attention, while the smaller-scaled assistants are deemphasized.

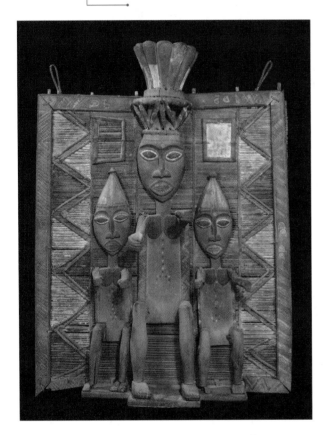

**FIGURE 4.29.** **Memorial screen.** *From Abonnema Village, Nigeria. Kalabari Ijaw. Late nineteenth century. Wood, raffia, and pigment, 3′ 1 ½″ × 2′ 4″ × 9 ¾″. Minneapolis Institute of Art, Minnesota.* The leader is scaled larger than his assistants to illustrate his importance, not because he was physically larger in life than the other men.

**hierarchical scaling** The technique of depicting different figures or objects using different scales so that people or objects of greater importance are depicted larger

*Quick Review 4.4*: What are some reasons that artists distort scale?

# Proportion

A regular pickup truck is sized so that the truck's cab and cargo bed fit nicely on top of the wheels. However, a monster truck has a normal-sized truck body sitting on top of enormous wheels. Regular trucks and monster trucks help explain **proportion**—the relationship between the size of a part of an object to the size of the whole object. When an artist changes the proportions of an object, the artist *changes the size of one or more of the parts of the object*, while *leaving the rest of the object in its original size.*

If you were to break your hand, in all likelihood, only your hand would swell, not the rest of your body. The ratio of the part (your larger hand) to the whole (your regular-sized body) would change, so the proportion would change (figure 4.30A). This is different from scale in which the size of an entire object or person changes (figure 4.30B).

As with scale, changes in proportion can also be *manipulated for artistic expression.* Figure 4.31 shows a staff created in Southern Africa in the early twentieth century. High-ranking members of society have traditionally carried these staffs or walking sticks. A leader of the Northern Sotho people owned this staff, which is topped with a representation of the leader himself. Carved so his form mimics the appearance of the length of the staff, the figure's torso and neck are elongated compared to his body as a whole. The artist's bold changes to the proportions seem to relate the leader to this symbol of status.

The two examples from Africa in figures 4.29 and 4.31 show changes in scale or proportion in sculptures. But artists of two-dimensional images can also manipulate size for effect (see *Practice Art Matters 4.3: Consider How Size Affects a Painting*).

Some artists create artworks illustrating figures with what they believe are *ideal human proportions.* Leonardo (the same artist whose work was in figure 4.22) formed his idea of a perfectly proportioned man in figure 4.33. He based this drawing on the ideas of Vitruvius, a Roman architect from the first century BCE. Leonardo lived in the 1400s during the Renaissance, when many artists revived ancient ideas in their work (see Chapter 15). Vitruvius had written that if an artist proportioned a figure well, so that all its parts were the perfect size, then the figure would fit within a circle and square. Because the

**proportion** The mathematical relationship between the size of a part of an object and the size of the whole

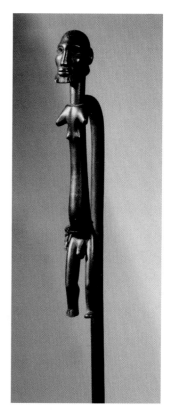

**FIGURE 4.31. Staff, top.** *From Southern Africa. Sotho. Early twentieth century. Wood, 3' 9" high. The British Museum, London.* Other items beyond proportion also highlight the similarity between the depiction of the leader and the staff. The artist stunted the arms, so they don't distract from the line of the body; balanced the figure symmetrically, emphasizing the central, vertical axis; and polished the figure, mimicking the smooth surface of the staff.

**(A) A change in proportion**

**(B) A change in scale**

**FIGURE 4.30A AND B. The difference between a change in proportion and a change in scale.** With a change in proportion, only a part of the body, here the hand, gets larger (4.30A). With a change in scale, the entire body gets larger (4.30B).

## 4.3 Consider How Size Affects a Painting

In *The Drawing Class*, by contemporary American artist Nicole Eisenman (EYE-zen-min), aspiring artists sketch a model (figure 4.32). The students are an unsettling crew, from the bohemian with clawed fingers on the right to the man with the green complexion in the distant center. Eisenman also included a pair of hands holding a sketch book and pencil in the extreme foreground as if either she or we are taking part in the class.

The painting stands nearly five-and-a-half-feet tall, so that the part of the thumb on the lower left is over a foot long—Eisenman or the sketching viewer must be a giant. Meanwhile, the people at the back of the room are barely two-and-a-half-feet tall.

Consider these questions:

- Did Eisenman manipulate scale or proportion? How do you know?

- Consider other principles of design such as unity, variety, balance, emphasis, or subordination. Which other principles did Eisenman follow when she manipulated size? How do you know?

- Why do you think Eisenman played with size? What might Eisenman have been trying to communicate?

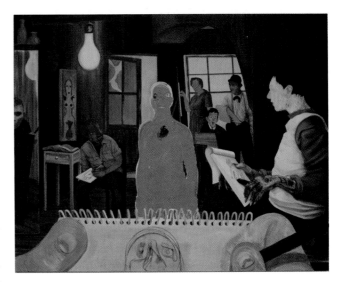

**FIGURE 4.32.** Nicole Eisenman. *The Drawing Class.* 2011. Oil and charcoal on canvas, 5' 5" × 6' 10". Art Institute of Chicago, Illinois.

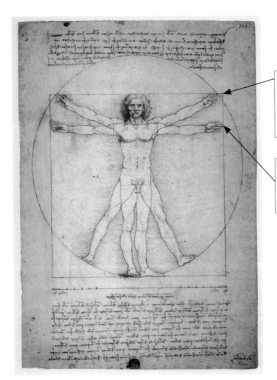

When the artist extended the figure's arms and legs, a *circle* could be drawn around the figure with the navel falling at the center.

When the artist extended the figure's arms to the sides, a *square* could be created.

**FIGURE 4.33.** Leonardo da Vinci. *Proportion of the Human Figure,* after Vitruvius. *c. 1485–90. Pen and ink, 13 ½" × 9 ¾". Academia, Venice, Italy.*

ancients saw the circle and square as perfect shapes, a figure that fit within them followed the ideal proportions of the universe.

Architects have also formed what they consider perfect proportions in buildings. The ancient Greeks used a mathematical ratio called the **golden section**, and a shape based on this standard called the **golden rectangle**, to proportion buildings ideally. The golden section is a ratio thought to have inherent beauty (see *Delve Deeper: The Golden Section*).

*Quick Review 4.5*: What is the difference between a change in scale and a change in proportion?

**golden section** A type of proportion in a work of art thought to have inherent beauty whereby a whole is cut into two unequal parts and the smaller section is in the same ratio to the larger section as the larger section is to the whole

**golden rectangle** A rectangle that has the ideal proportions of the golden section in which the longer side divided by the shorter side equals 1.618

# Rhythm

We usually think of rhythm in music, poetry, or dance. In these art forms, rhythm is associated with the regular repetition of a sound or step. Rhythm creates a sense of movement, speed, and the passage of time (just as our eyes would follow a dancer across a stage as she moves in time to the beat) and a mood (just as we might happily tap a foot to a cheerful tune).

**Rhythm** in the visual arts features similar qualities. In the visual arts, rhythm:

**rhythm** The repetition of a particular visual element or similar visual elements in a work of art

- *Is associated with repetition*, and the repeated visual elements could be the same or similar lines, shapes, masses, textures, values, or colors
- *Creates a sense of movement and speed in a work*, as our eyes follow and land on repeating elements, because our brains look for similarities in form at set intervals over time
- *Establishes a mood and feeling*, because the repeating elements may be in different positions, be repeated a few or a number of times, and have different forms, textures, values, or colors

Rhythm can affect how a viewer perceives a work. Because our eyes move around a work at different rates, we *perceive different speeds*. A work may seem fast and jerky or slow and smooth. Similarly, because of changes in the elements, we may *sense different feelings*, such as happiness, sadness, anger, or relaxation. For example, the repeating arches on the façade of the Taj Mahal are positioned equidistant from one another, in graceful peaks of the same form, value, and color. Only the size of the central arch differs from the others. In the coherent, grand complex, the rhythm could be described as having a slow and peaceful speed and a stately and somber feeling.

*Accelerator* by Nigerian-born, U.S.-based Odili Donald Odita (oh-DEE-lee DAH-nohld oh-DEE-tah) alternatively appears to have a pulsing and chaotic speed that may feel jarring and intense (figure 4.37). Odita's works frequently refer to our contemporary lives, and this work may suggest the fast pace and complicated character of our world. Slick, angular shapes appear like diagonal facets across the surface, our eyes tending to follow their clipped, spikey progression as they join in repeating points. The many shapes also create numerous changing patterns. We continually see new forms, just as we do when we race through life.

A very different rhythm is found in American Wes Wilson's poster for a concert at San Francisco's Fillmore Auditorium that featured Otis Rush, the Grateful Dead, and Canned Heat. San Francisco was at the heart of the counterculture scene in the late sixties, when psychedelic music tried to imitate the hypnotic and hallucinatory experience of being on drugs. The poster visually captures the repetitive, melodic patterns found in the music.

# DELVE DEEPER

## The Golden Section

In a golden section, a whole line is cut into two unequal parts. The larger section of the line is in the same ratio to the smaller section of the line as the whole line is to the larger section (figure 4.34).

In a golden section, the ratio on either side of the equation is always 1.618 to 1. In other words, if we divide the measurement of the larger section by the smaller or the measurement of the whole line by the larger section, we get 1.618.

Similarly, this ideal mathematical ratio can be employed in a golden rectangle. Here, the rectangle has two sides of different precise lengths that have the same ratio as the golden section (figure 4.35).

The ancient Greeks believed that the golden section and rectangle were the essence of perfect beauty. Ancient Greek architects Iktinos (ick-TEE-nus) and Kallikrates (kah-LIK-rah-teez) designed the Parthenon (figure 4.36A), a temple dedicated to the Greek goddess Athena, according to these mathematically devised ratios. While they built the entire building with ideal proportions, it is easiest to see how they proportioned the façade to fit into a golden rectangle (figure 4.36B). The many harmonious proportions throughout the temple help give it a feeling of order, stability, and perfection.

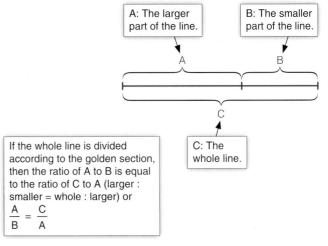

A: The larger part of the line.

B: The smaller part of the line.

If the whole line is divided according to the golden section, then the ratio of A to B is equal to the ratio of C to A (larger : smaller = whole : larger) or

$$\frac{A}{B} = \frac{C}{A}$$

C: The whole line.

**FIGURE 4.34.** The golden section.

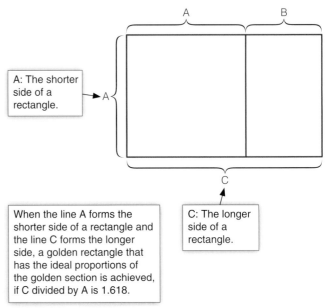

A: The shorter side of a rectangle.

When the line A forms the shorter side of a rectangle and the line C forms the longer side, a golden rectangle that has the ideal proportions of the golden section is achieved, if C divided by A is 1.618.

C: The longer side of a rectangle.

**FIGURE 4.35.** The golden rectangle.

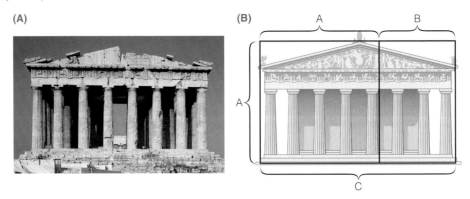

**FIGURE 4.36A (CURRENT PHOTOGRAPH) AND B (RECONSTRUCTION DRAWING OF THE FAÇADE SHOWING A GOLDEN RECTANGLE).** Iktinos and Kallikrates. The Parthenon. *447–432 BCE, Athens, Greece.* Figure 4.36A shows the Parthenon façade as it looks today, and figure 4.36B shows what it would look like if restored. The golden rectangle fits perfectly over the façade with the width of the building (C) divided by the height of the building (A) equaling 1.618.

The speed seems slow and smooth and the mood, laid back. We see this rhythm in how Wilson arranged and formed the recurring elements (figure 4.38).

We also find rhythm in three-dimensional works such as the Pont du Gard (figure 4.39). The bridge was part of an aqueduct built by the ancient Romans to carry water to Nîmes, France, from a spring thirty miles away. Water flowed through the aqueduct using gravity with the conduit running downhill throughout its distance. While much of the channel is underground, when it reached the Gardon River, the Romans raised the channel above the valley by building a three-level bridge. The Romans constructed repeating arches to support the bridge, but their different sizes are for visual effect and they move our eyes rhythmically across the valley at different rates. The smaller-scaled arches, which are closer together, make the rhythm of the top level, where the water flowed, seem faster.

*Quick Review 4.6*: What elements can be repeated in a work to create rhythm?

**FIGURE 4.37.** **Odili Donald Odita.** *Accelerator.* *2014. Acrylic on canvas, 4′ 2″ × 5′.* The hard-edged lines and sharp angles in Odita's work seem to create a staccato rhythm.

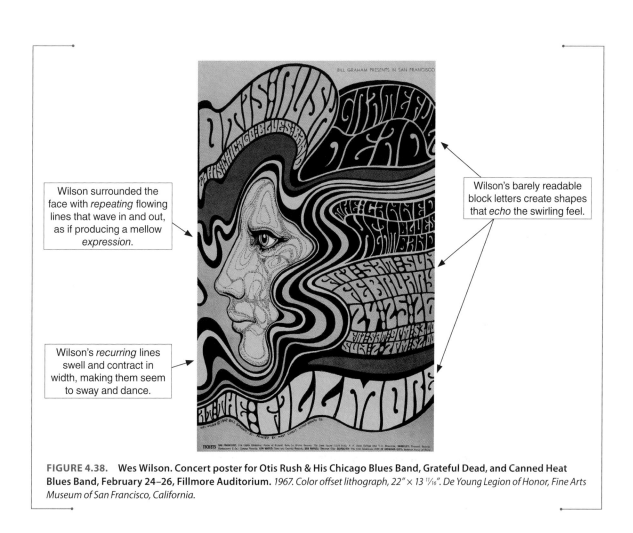

Wilson surrounded the face with *repeating* flowing lines that wave in and out, as if producing a mellow *expression*.

Wilson's barely readable block letters create shapes that *echo* the swirling feel.

Wilson's *recurring* lines swell and contract in width, making them seem to sway and dance.

**FIGURE 4.38.** **Wes Wilson. Concert poster for Otis Rush & His Chicago Blues Band, Grateful Dead, and Canned Heat Blues Band, February 24–26, Fillmore Auditorium.** *1967. Color offset lithograph, 22″ × 13 ¹¹⁄₁₆″. De Young Legion of Honor, Fine Arts Museum of San Francisco, California.*

**FIGURE 4.39.  Pont du Gard.**
*Late first century* BCE, *Nîmes, France.* In the first two levels, the arches are the same size, yet in the third level, the arches are one-fourth the size.

# HOW **art** MATTERS

## A Look Back at the Taj Mahal

The principles of design are closely interrelated. While it is easier to split design principles apart to study them, artists work with the principles together. When artists **balance** a work, they consider **visual weight**. But, visual weight also creates **emphasis**. One way to create **emphasis** is through repeating forms, but repeating forms also create **rhythm**. In the Taj Mahal, we can see how the principles unite in one design.

The entire complex is devoted to **unity**. There is *repetition* throughout in *similar* architectural features like recessed areas and domes. *Common* materials like white marble and red sandstone and *consistent* techniques like inlaid flowers and calligraphy also make the complex feel coherent. Yet, there is **variety** as well. Only the tomb building is completely covered in white marble, while the other buildings and gate *contrastingly* are mostly sandstone. The tomb building is also *different* in that it is larger and more complicated than the other buildings. On the tomb, the recessed areas bring **variety** to the exterior. In addition, the intricate patterns in the inlaid designs enliven the surface and create *interest*.

The tomb complex is a model of **symmetrical balance**. **Absolute symmetry** is everywhere except in the false grave of Shah Jahan, which was added later. Not only does the tomb building have *similarity of form on both sides*, but so do the main gate, two buildings that flank the tomb, minarets, tomb garden, and moonlight garden. The symmetry does not end there. As the aerial view of the octagonal tomb building illustrates (figure 4.3), it also has **radial balance**. The symmetry helps give the entire complex a formal, ordered, and peaceful feeling.

The tomb building is **emphasized** in numerous ways. It is the *largest* and most *intricate* building in the complex and is *centrally located*. The large dome creates a **focal point** that seems to draw us in. Other parts of the complex function as areas of **subordination** and help draw our eyes to the area of **emphasis**. The south water channel *leads* to the tomb, the platform *elevates* it, the minarets *frame* it, and the main gate begins the **rhythm** of the domes and recessed areas that are on the tomb.

The tomb complex is of enormous **scale** in relationship to the size of each visitor. The main gate stands almost one hundred feet high. The tomb garden is over three football fields

long. The platform on which the tomb sits is eighteen feet high, and the central dome rises two hundred feet. The **scale** of the complex is huge.

The builders **proportioned** every *part* of the tomb to work with the *whole*. For example, the artist who formed the calligraphy harmonized it with the entire complex. He enlarged the letters positioned higher up on the tomb, so all calligraphy seen from the ground appears to be the same size.

The many *repeating elements* in the tomb create a **rhythm** that seems peaceful. Masses and spaces created by domes and alcoves on the main gate continue inside the complex and *repeat* on the tomb. The *recurring* forms in the garden, the lines of the four matching minarets, and the masses of the mosque and matching guest house help set a calm speed and quiet mood.

Shah Jahan imagined the Taj Mahal to be both a *peaceful resting spot* for his queen and a *destination of great pilgrimage* for visitors—two seemingly contradictory goals. The complex arguably fulfills its first purpose, maintaining the serenity and majesty befitting the tomb of a queen. It does so in large part because of the architects' adherence to the *principles of design*. However, the complex also achieves Shah Jahan's second goal. Today, the complex receives an average of twenty-two thousand visitors every day.[1]

As you move forward from this chapter, consider the lengths people will go to *create, maintain,* and *experience* art. Shah Jahan had twenty thousand workers toil for twelve years to create the Taj Mahal. Today, the worldwide community and Indian government are working to ensure that the Taj Mahal exists for future generations. At risk from adverse climate conditions, local pollution, acid rain, and even tourists, the site has been on the UNESCO World Heritage List since 1983. Today, the complex can be accessed only by foot, bicycle, or electric-powered vehicles, and the government has worked to close local industries with harmful emissions. We saw another enormous effort for art in Jane Hammond's *Fallen* (figure 4.24A). Hammond spent eight years creating nearly forty-five hundred distinct leaves to honor those who had died in Iraq. In fact, many artworks require years to complete, and many individuals spend their lives investing energy in conserving art.

Flashcards

## CRITICAL THINKING QUESTIONS

1. The text makes the case that Simpson's work (figure 4.9) shows conceptual unity. However, the work also shows unity and variety in its appearance. Where do you see unity and variety? Hint: Consider line, shape, texture, value, material, and technique.

2. Imagine you are going to an amusement park with your two-year-old niece. When her parents drop her off, she is dressed in a bright red shirt. "I put her in this shirt," her mother says to you, "so that if she gets away from you, you will be able to see her." Is the mother's safety trick using actual weight or visual weight? How do you know? Why will this trick work?

3. Why is a work that has absolute symmetry always balanced?

4. How did Wilson balance his concert poster (figure 4.38)? Hint: Describe how he organized the visual weight to balance.

5. Is Odita's nonrepresentational work (figure 4.37) afocal? Why or why not? Do you think afocal works are more likely to be nonrepresentational, representational, or abstract? Why?

6. In Grünewald's *Isenheim Altarpiece* (figure 4.14), Christ's body is larger than that of any other figure. Why? What is this technique called?

7. The text describes how *Woman from Willendorf* (figure 4.25) has undergone a change in overall size to make the woman small scale. Could you also describe that this sculpture has undergone a change in proportion? How?

8. What creates the rhythm in the ceremonial robe from Chilkat, Alaska (figure 4.13)?

Comprehension Quiz    Application Quiz

# 3 The Media

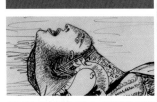

CHAPTER 5
Drawing

CHAPTER 6
Painting

CHAPTER 7
Printmaking

CHAPTER 8
Photography, Film, and Video

CHAPTER 9
Graphic Design

CHAPTER 10
Sculpture

CHAPTER 11
Traditional Craft Media

CHAPTER 12
Architecture

The detail of Pablo Picasso's *Mother with Dead Child* (shown on the opening page of Chapter 5, pg. 129) shows a mother screaming in grief to the heavens as she holds her dead child. To create this two-dimensional drawing, Picasso used pen and ink. In some places Picasso scratched the pen against the paper, while in others he let the ink seep into the page. The easy-to-use drawing medium also allowed Picasso to sketch spontaneously. Finally, pen and ink gave Picasso the ability to create a stark look of black lines against the white page. All of these factors—the type of work, process through which Picasso made it, characteristics of drawing media, and specific material he used—add to the expression and message of Picasso's image. Part 3 of this text explores these aspects of art in looking at the media.

# Drawing

## LEARNING OBJECTIVES

**5.1** Discuss how artists see differently when they draw.

**5.2** Explain how drawings can be used to understand an artist's creative process or way of thinking.

**5.3** Characterize three ways that artists use the drawing medium to take notes.

**5.4** Describe how drawing changed over the last few centuries to become a recognized art form.

**5.5** Summarize features of different drawing surfaces and tools.

**5.6** Distinguish among the characteristics of five different dry media including graphite, charcoal, chalk, crayon, and conté crayon.

**5.7** Compare and contrast the features of four different liquid media including pen and ink, pen and wash, brush and ink, and brush and wash.

**5.8** Evaluate whether digital drawings should be considered drawings.

## PABLO PICASSO'S *GUERNICA* DRAWINGS

April 26, 1937, was a beautiful day in Guernica, a quiet village in northern Spain. While Spain was in the midst of a civil war, Guernica posed no threat and offered no strategic military advantage. At 4:30 on that fateful afternoon, however, during the busiest hours of market day, the sky suddenly filled with German planes. Spanish General Francisco Franco had made a pact with the Germans. In exchange for helping Franco fight against the legitimately elected democratic government, the Germans were given the opportunity to test a new tactic: bombing the civilian population to break the enemy's spirit.

How Art Matters

### The Destruction of Guernica

Fifty bombers descended upon the defenseless town, dropping thousands of pounds of high explosives. After reducing virtually every building in the core of the town to rubble, the pilots turned on fleeing civilians with machine guns. Planes then dropped incendiary bombs, igniting fires that burned for three days. In the devastating aftermath of this assault—which terrorized the population but left a nearby munitions factory and bridge untouched—more than 70 percent of the town lay in ruins, more than sixteen hundred civilians had been slaughtered, and almost nine hundred lay wounded.

Such a swift, calculated massacre of civilians shocked the world. With heart-wrenching eyewitness accounts filling newspapers, more than a million Parisians marched in protest on May 1. Appalled by the massacre, Pablo Picasso (pab-loh pee-CAH-soh), a Spaniard living in Paris, saw an opportunity to protest the atrocity and depict the horror of the attack through art. Four months earlier, the Spanish democratic government had asked Picasso to create a painting for the 1937 World's Fair, which would feature exhibitions from countries around the world. The horrific events at Guernica led Picasso to depict the scene that is in this painting. To help create the finished work, which he would call *Guernica* (GARE-nee-kah), Picasso made a series of sixty-one preliminary drawings.

Picasso's drawings are significant for several reasons. First, they allowed him to *take notes and plan out* his finished work, experimenting with different ideas for individual forms and the overall composition of the final painting. Second, Picasso's drawings *open a door to his artistic process*, enabling us to *see his initial ideas and the path he took to arrive at the final painting*. Finally, the drawings show how Picasso, through the act of drawing, *saw things that the rest of us might not necessarily have noticed*.

### Two Early Pencil Sketches

For his first sketch—drawn with large, quick movements in only a minute or two—Picasso worked in pencil on a small, square piece of blue paper (figure 5.1). Several forms take the shapes of what might be animals and perhaps a building. *This first drawing is an example of an artist "taking notes."* Like a writer jotting thoughts in a journal for a story in progress, he used this drawing as shorthand to record some initial ideas.

In another sketch, dated a week later, Picasso again worked in pencil, but this time on white paper (figure 5.2). Comparing the two drawings, we can see how Picasso *experimented and developed his ideas*. We begin to understand his creative thought process. Here, Picasso used an elongated, rectangular page (the shape of the final painting), probably to experiment with the composition. He also used his pencil differently, showing *the versatility of the medium*. Now, with the pencil, he was able to depict exact features of the figures as well as tonal qualities of light and dark. As a result, we can make out clearly the animals—a bull and horse—hinted at in the first drawing.

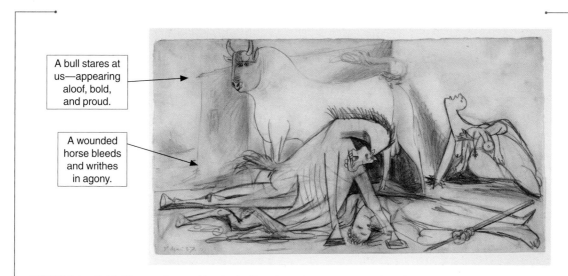

This shape looks like an animal.

This shape looks like an animal.

This rectangular shape resembles a building, at the top of which may be a figure, with an outstretched arm, who leans out what appears to be a window.

**FIGURE 5.1.** **Pablo Picasso.** *First Composition Study for Guernica.* (Drawing #1) May 1, 1937. Pencil on blue paper, 8 ¼" × 10 ⅝". *Museo Nacional Centro de Arte Reina Sofía, Madrid.*

A bull stares at us—appearing aloof, bold, and proud.

A wounded horse bleeds and writhes in agony.

**FIGURE 5.2.** **Pablo Picasso.** *Composition Study.* (Drawing #12) May 8, 1937. Pencil on white paper, 9 ½" × 17 ⅞". *Museo Nacional Centro de Arte Reina Sofía, Madrid.*

But why did Picasso use these animals in a drawing about the atrocity at Guernica rather than the airplanes, bombs, and machine guns from that day? Perhaps one explanation relates to the fact that Picasso grew up in Spain and had become fascinated with the violence and tragedy of the bullfight, involving a battle to the death between bull and horse. It seems likely that Picasso used the animals and Spanish imagery as a symbolic protest against the evils and suffering of war.

Figure 5.2 also includes two figures that appear in the final painting, although they are altered in both form and location. The first is a dead soldier who lies beneath the horse with his sword in hand. The second, on the right, is a mother, crawling on her knees, crying to the heavens in anguish as she holds her dead child's limp body in her arms.

## Two Drawings of the Mother and Dead Child

In another drawing, dated May 9 (figure 5.3), Picasso used the medium of pen and ink, which allows for only *clear, black marks* against *white paper*, to *focus intensively* on the mother and

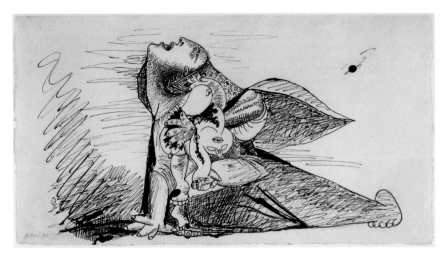

**FIGURE 5.3.** Pablo Picasso. *Mother with Dead Child.* *(Drawing #14) May 9, 1937. Pen and ink on white paper, 9 ½″ × 17 ⅞″. Museo Nacional Centro de Arte Reina Sofía, Madrid.* While there are changes between the mother on the right side of figure 5.2 and here, there are also similarities. Both mothers' bodies create triangular forms that point up to the heavens.

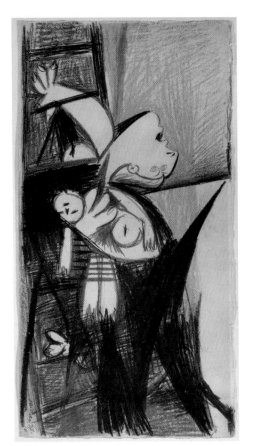

**FIGURE 5.4.** Pablo Picasso. *Mother with Dead Child on Ladder.* *(Drawing #21) May 10, 1937. Pencil and colored crayon on white paper, 17 ⅞″ × 9 ½″. Museo Nacional Centro de Arte Reina Sofía, Madrid.* In this drawing, Picasso experimented with color, but he ultimately rejected color for the final work. Perhaps he sought to evoke the newspaper photographs that documented the atrocity.

child. Through his study of this tortured individual, Picasso offered an intimate sense of horror at the death of a child, in a sense *capturing the essence of a person in grief.* Picasso shows us the mother's face, down to the teeth in her wailing mouth, indicating how her cry must have sounded. We see the flowing black blood drenching the infant and can imagine how the mother's knees must have felt scraping on the ground. This drawing also lets us *experience Picasso's artistic journey* as he responded to news of the tragic events at Guernica; we are able to see *the change in the mother* from the right side of figure 5.2 (an earlier drawing) to here.

By contrast, in yet another sketch of the mother with the dead child (figure 5.4), created a day after figure 5.3, we see a *different moment in Picasso's artistic journey.* Here, Picasso explored the figures with pencil and colored crayon. The mother stands on a ladder, with only her hands, head, child, and foot visible in the shapes surrounding her. She and the child appear starkly white against the different *colored, layered marks* of the crayons.

## The Painting

In considering the painting, we can understand why Picasso formed drawings before moving to the final work. The painting itself is so large that Picasso had to stand on a ladder and paint with brushes strapped to sticks, so working with smaller drawings allowed Picasso to *"take notes" and plan easily.* Second, Picasso used the preliminary drawings to *try out different ideas,* many of which became complex figures populating the final work. The drawings show Picasso's path to the painting and so the *process of his art.* Third, Picasso's drawings allowed him to *see the individual figures in a more intense way,* so he could capture them more fully. In Picasso's final painting, done only in blacks, grays, and whites, we can see how the earlier drawings of people and animals have been transformed and how other forms, which Picasso explored in additional drawings, have been included (figure 5.5).

## The Legacy

As planned, *Guernica* was exhibited at the 1937 World's Fair. After, with Franco's forces overrunning Spain, Picasso declared that the painting and drawings could not go home until Spain was free. Throughout its years of exile, *Guernica* was seen by millions of people, both in its home at the Museum of Modern Art in New York

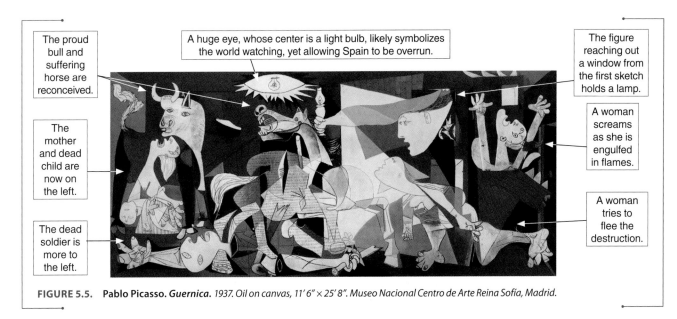

The proud bull and suffering horse are reconceived.

A huge eye, whose center is a light bulb, likely symbolizes the world watching, yet allowing Spain to be overrun.

The figure reaching out a window from the first sketch holds a lamp.

The mother and dead child are now on the left.

A woman screams as she is engulfed in flames.

The dead soldier is more to the left.

A woman tries to flee the destruction.

**FIGURE 5.5.** **Pablo Picasso.** *Guernica.* *1937. Oil on canvas, 11′ 6″ × 25′ 8″. Museo Nacional Centro de Arte Reina Sofía, Madrid.*

and on tours to other cities. The painting came to represent a cry for peace and the evils of war. In Spain, the work was so meaningful that countless Spaniards hung reproductions on their walls in an act of defiance against Franco's brutal dictatorship and as a symbol of hope for a better future. Not until 1981, following Franco's death, were the painting and drawings finally brought to Spain and made available to the people who had suffered and endured. Crowds lined up for blocks to see them.

Picasso's *Guernica* drawings offer a compelling example of *the importance of preparation, exploration, compromise, and hard work.* With careful study and problem solving, Picasso created what many consider one of the masterpieces of twentieth-century art. The story of *Guernica* also illustrates much about drawing. This chapter will look more closely at many of these issues, considering the nature of drawing and different drawing materials. Before moving forward, based on this story, how would you define drawing? What would you say the key differences are in the drawing media that Picasso used?

# What Drawing Is

Drawings are everywhere. They can be found in every culture in the world throughout history. The act of drawing is an essential part of most people's everyday lives. Children draw before they write and, if given a crayon, are apt to draw on any available surface—even on walls. How many times have you doodled in class? How many times have you tried to explain something and said, "Let me draw you a picture"? Drawing is the fastest and most direct way to communicate information visually.

**Drawings** have two common characteristics:

1. *An artist runs a tool*—such as a pencil or pen—*over a surface to make descriptive marks.*
2. *The surface is flat* (even if it has a bumpy texture, such as a rock).

Many professionals, such as illustrators, film animators, graphic designers, decorators, engineers, scientists, and artists, draw every day. Keith Haring did. He drew with white

**drawing** The technique of running a tool over a two-dimensional surface and leaving descriptive marks; a work of art created by this technique

**FIGURE 5.6.** **Keith Haring drawing in the New York City subway, 1983.** Between 1980 and 1984, Keith Haring drew every day, creating countless cartoon-like images.

chalk on unused black panels meant to hold advertisements in the New York City subway system (figure 5.6). Some days he drew forty different works in various locations.

While drawing is a familiar activity, used in everything from forming shapes in geometry class to giving directions, here we will consider drawing as an art medium. We will look at drawing as *an intense way to see, a way to understand the creative process, a way to take notes,* and *a finished work of art.*

## An Intense Way to See

Drawing is about seeing. When artists draw what they observe, it is as if they *experience what they are drawing through all their senses*—not just sight, but other senses, too, such as touch or hearing. When drawing, artists *investigate, record, and notice things that the rest of us might not see in a quick look,* so they can portray an entity (a person or object) in its entirety.

Elizabeth Peyton, a contemporary American artist, captured the essence of the man in figure 5.7 as she drew him. Peyton saw this man so intensely and captured him so completely that it is almost as though we can hear his voice as he sits in conversation with us. She explored the intricacies of his intense eyes and chiseled nose, emphasizing those important parts of his makeup.

By drawing this man, Peyton saw and understood his features more than most of us would in a casual glance. To get a sense of what it is like to explore a subject more closely, see *Practice Art Matters 5.1: Observe a Piece of Fruit with Intensity.*

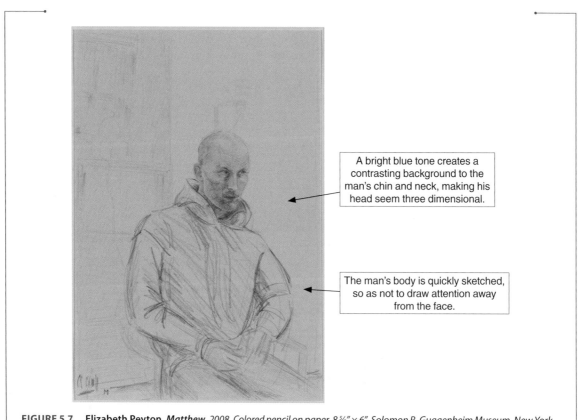

A bright blue tone creates a contrasting background to the man's chin and neck, making his head seem three dimensional.

The man's body is quickly sketched, so as not to draw attention away from the face.

**FIGURE 5.7.** **Elizabeth Peyton.** *Matthew.* 2008. Colored pencil on paper, 8 ⅜″ × 6″. Solomon R. Guggenheim Museum, New York.

## 5.1  Observe a Piece of Fruit with Intensity

Get a piece of fruit and put it aside where you can't see it. Describe the fruit and write down your description.

Now, place the fruit in front of you, but not close enough to touch or smell it, and spend five minutes studying your fruit. Consider *exactly* what you are seeing and write down what you notice:

- What colors do you actually see on your fruit?
- What is the exact form?
- Are there any bruises?
- Even though you can't touch the piece of fruit, what is the texture like?

- Even though you can't smell the fruit, how would you describe the scent?

Consider your two descriptions:

- What things did you fail to notice until you looked carefully at your fruit?
- Why do you think that artists who draw what they observe experience what they are drawing through all of their senses?
- Why do you think artists who draw what they observe see and understand more intensely?

*Quick Review 5.1*: How do artists see differently when they draw?

## A Way to Understand the Creative Process

Imagine how you would have reacted to *Guernica* (figure 5.5) if you had not seen the preliminary drawings. Could you have fully appreciated Picasso's ideas? With drawing, we can *see the artist's creative journey*—the trial and error, direction, and initial visual responses to an idea. In his drawings, Picasso could spontaneously put down on paper what was in his mind. His materials were easy to use and did not require extensive preparation, so he could immediately brainstorm ideas. In a drawing, we often have the *closest view of the thoughts of the artist.*

Käthe Kollwitz (KAY-tuh KOHL-vitz) illustrated the link between the artist's mind and hand in her *Self-Portrait, Drawing.* In figure 5.8, Kollwitz, a twentieth-century German artist, depicted herself drawing. A bold, zigzag line moves from her head to her hand, visually connecting the energy that flows from one to the other. Moreover, Kollwitz used detailed lines for her head and hand, emphasizing the parts of her body involved in the creative process. In addition, the piece of charcoal Kollwitz holds in her hand is the same size as the width of her zigzag line. It is as if she had just laid that very piece of charcoal sideways to form the line itself, allowing us to share in her moment of inspiration. Kollwitz makes us aware of the physical action needed to form the line and the intellectual connection between mind and hand.

Because drawing is so closely linked to what is in the artist's mind, many artists use drawing to express feelings. Dan Perjovschi (DON pur-JOV-skee) drew images on the wall of the atrium of the Museum of Modern Art (figure 5.9A) to share his views on current events (figure 5.9B). Perjovschi grew up in communist Romania and understood firsthand what it was like to live in a repressive regime that limited freedom of expression. By drawing on a white wall with a black, permanent marker, Perjovschi broke conventional "rules"—making his expression seemingly more poignant.

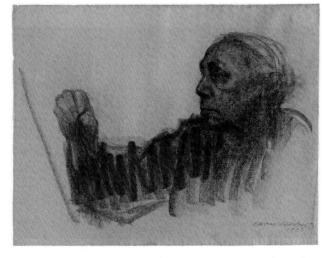

**FIGURE 5.8.**  **Käthe Kollwitz. *Self-Portrait, Drawing.*** *1933. Charcoal on brown laid Ingres paper, 18 ¾" × 25". The National Gallery of Art, Washington, DC.*  The connection between the artist's vision and the physical act of drawing is evident in Kollwitz's self-portrait; the zigzag line connects her head to her hand.

FIGURE 5.9A AND B
(DETAIL). Dan Perjovschi.
**WHAT HAPPENED TO US?** *From
the installation at the Museum of
Modern Art. 2007. Permanent marker
on wall, 110' high. The Museum
of Modern Art, New York.* On the
monumental wall in the atrium of
the Museum of Modern Art (5.9A),
Perjovschi expressed his views
about the world (5.9B).

(A)

(B)

During creation, Perjovschi's work took on a performance quality, as he developed the drawing for two weeks during museum hours, breaking the "rules" in front of hundreds of people. Visitors watched the process of creation as Perjovschi stood on a machine that lifted him far above their heads. He called the installation *WHAT HAPPENED TO US?* The title plays with the letters "US," which could stand for the word "us" or the abbreviation "U.S." (United States). Images took on topics such as the Iraq War and globalization. Through the drawings, Perjovschi could freely express his views on these topics.

*Quick Review 5.2*: In what ways can drawings be used to understand an artist's creative process or way of thinking?

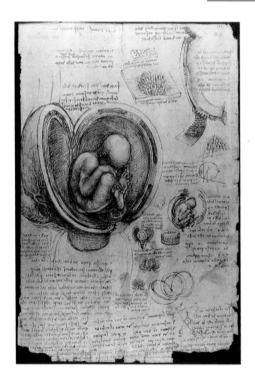

FIGURE 5.10. Leonardo da Vinci. *The Fetus in the Womb. c. 1510. Pen and ink over red chalk, 12" × 8⅔". Royal Collection, Windsor Castle, Royal Library, London.* This drawing, showing a uterus and fetus, helped Leonardo better understand how complex natural mechanisms and phenomena were structured and worked.

## A Way to Take Notes

Artists use drawing in the same intimate way that other people write in journals. Most artists keep private sketchbooks that contain preliminary and often small-scale sketches. These notes can include:

* *Ideas they want to put down* or save for later
* Studies they use to *gain understanding about a subject matter*
* *Preparations* they do *for work completed in another medium*

Picasso used his first *Guernica* drawing (figure 5.1) to *jot down his thoughts.* The sketch was a way to record his ideas that he would flesh out subsequently.

Conversely, Leonardo da Vinci (lay-oh-NAHR-doh dah VEEN-chee), an Italian artist, drew to *help gain understanding.* He compiled volumes of drawings on anatomy, botany, and mechanics to help him investigate these topics. Leonardo based *The Fetus in the Womb* (figure 5.10) from 1510 on one of more than thirty human dissections he completed. He used the drawing as notes for himself regarding how the human body works. Leonardo's drawings were revolutionary; he was one of the earliest artists to record the natural world with such precision.

Finally, Christo (KREE-stoh) and Jeanne-Claude, like Picasso, have used drawings (created by Christo) as *preparation to plan their art completed in other media.* The artists have temporarily modified rural and urban settings with large-scale works. While the French-born American Jeanne-Claude died in 2009, the Bulgarian-born American Christo has continued their projects in works such as *The Floating Piers* (figure 5.11A and B). Here, Christo floated almost

(A)

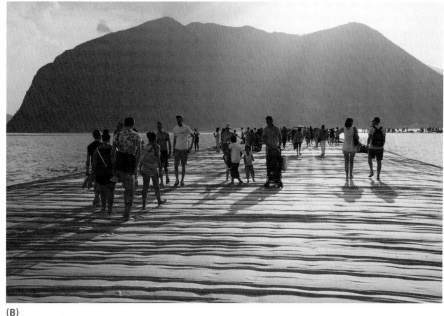

(B)

**FIGURE 5.11A AND B.** **(A) Christo.** *Floating Piers Drawing. 2014. Pencil, charcoal, and pastel, 13 ⅞″ × 8 ¾″;* **(B) Christo and Jeanne-Claude. The** *Floating Piers, Lake Iseo, Italy, 2014–16. On view June 18–July 3, 2016. 100,000 square meters of yellow fabric carried by a modular dock system of 220,000 high-density polyethylene cubes, walkway 1 ⅘ miles long × 52′ 6″ wide × 13 ¾″ high (at center, as sides drop down to the water).* Christo's drawing (5.11A) shows Christo and Jeanne-Claude's concept for the project in which fabric-covered walkways run between different islands, so that the art works with the nature around it. When realized (5.11B), people could walk on the piers across the water between the islands.

two miles of yellow, fabric-covered walkways on a lake in Italy for sixteen days. Christo and Jeanne-Claude's projects blend art and environment to enhance the viewer's appreciation of the art and space.

*The Floating Piers* was in the planning stages since 1970, when the artists began the process of searching for a possible site. All of Christo and Jeanne-Claude's projects have required years of technical, logistical, and visual planning, which the artists considered part of their works. Drawings have been essential to the process, enabling the artists to explore ideas and work out difficulties in a less expensive and less time-consuming manner than the actual projects. Moreover, the drawings have helped authorities, environmental groups, and citizens envision and understand the merits of the works and alleviate concerns about their effects. Christo has also sold the drawings to finance the costly projects. Unwilling to accept government or commercial sponsorship—so as to maintain artistic control—he has used drawings as a major source of funding.

*Quick Review 5.3*: What are three ways that artists use the drawing medium to take notes?

## A Finished Work of Art

For many years, artists used drawings to take notes, and students used drawings to copy works of their masters and learn about technique. In the eighteenth century, though, *people came to appreciate drawings as legitimate works of art* and framed and hung them on walls. Since that time, artists have created many drawings as *end products*; today, the medium is well recognized as *its own art form*.

*Louis XV as a Young Man* (figure 5.12) by Rosalba Carriera (roh-SAL-bah car-YAIR-ah) is an example of a drawing that is a finished work. The Italian artist

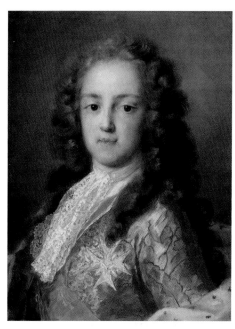

**FIGURE 5.12.** **Rosalba Carriera.** *Louis XV as a Young Man. 1721. Pastel on paper, 18″ × 14″. Museum of Fine Arts, Boston.* Carriera's sensitive depiction shows a precisely finished face and more sketchily drawn clothes and hair.

FIGURE 5.13. Georges Seurat. *At the Café Concert*. c. 1887–88. Conté crayon with white heightening on laid paper, 12″ × 9⁵⁄₁₆″. Museum of Art, Rhode Island School of Design, Providence. Seurat worked his tool into the texture of his surface, leaving small, discrete particles that combine to form the image.

**artists**
MATTER

Georges
Seurat

**support** The surface on which an artist creates a two-dimensional work

**grain/tooth** The roughness of a surface, which creates a texture in a work

**binder** The adhesive substance in a medium that holds the particles of pigment together and to the support

**dry media** Drawing materials that scratch the surface and are abrasive

**liquid media/fluid media** Drawing materials that are wet and flow onto a surface

drew this portrait of the ten-year-old king on a trip to Paris in 1721. Created as an end in itself, the drawing seems to capture the spirit of the young king and the richness of his finery from his lace tie to his soft curls.

*Quick Review 5.4*: How did drawing change over the last few centuries to become a recognized art form?

# Different Drawing Materials

To create a drawing, an artist runs a tool across a two-dimensional surface, leaving a descriptive mark. The artist manipulates *the surface* and *the tool* to obtain a desired effect. Both the surface and the tool affect the final look of the work.

## Drawing Surfaces and Tools

A drawing's surface, also called its **support,** can be made from different materials including a variety of types of paper, cloth, wood, clay, metal, and wall. A surface can greatly affect a drawing's appearance because of its *different characteristics* such as *color, texture, and absorbency*. Artists choose surfaces based on the desired effect.

The surface of *At the Café Concert* by Georges Seurat (jorjh suh-RAH) (figure 5.13), for example, has a rough texture, also called **grain** or **tooth**. The support's tooth is as important to the final appearance of the drawing as the drawing tool, because Seurat's marks settled into the paper's depressions rather than on the raised portions. The paper's texture breaks up Seurat's tones into small dots characteristic of the haze in a smoky café, where concerts were popular during the late nineteenth century in Paris. (These dots are similar to the small specks of color in Seurat's painting in Chapter 3.)

Artists also have a variety of tools, or drawing media, available to them, each with different characteristics:

- Some are *precise*, while others are *sketchier*
- Some are *erasable*, while others are *permanent*
- Some come in *multiple colors*, while others are available only in *black or gray*

All drawing materials contain a substance that leaves *a mark of pigment particles*. Sometimes the pigment particles hold together naturally, as in a piece of charcoal. Other times, the pigment particles are mixed with a **binder**, an adhesive substance that holds them together and to the support, as in a child's crayons.

Artists divide drawing materials into two types: *dry* and *liquid*. The **dry media** are abrasive, scratch, and create friction when dragged across a surface, as with a pencil. The **liquid media** (also called **fluid media**) are wet, flow onto a surface, and are absorbed by it, as with a pen. Each medium has a distinct appearance, certain benefits, and other limitations. Artists can manipulate each medium to produce a variety of visual effects.

Korean-born Yooah Park used the unique qualities of a liquid medium to form *Movement II* (figure 5.14). Park drew a series of abstract figures, who twist across the page,

FIGURE 5.14. **Yooah Park.** *Movement II.* *1993. Meok Oriental ink on paper, 1' 1" × 4' 7". Walker Art Center, Minneapolis.* Park used graceful, fluid lines of ink to create the look of movement in the figure.

mirroring the path of a real dancer who performed live in Park's studio. Park captured the dancer's dynamic gestures with a brush and ink, gliding across her surface.

If Park had drawn this figure using a scratchy, dry chalk, the drawing's character would be quite different. The fluidity of the brush and ink helped Park establish a feeling of freedom and energy that defines the work. To get a sense for yourself of how much surfaces and tools affect a drawing, see *Practice Art Matters 5.2: Use Different Surfaces and Tools.*

*Quick Review 5.5*: What are the features of different drawing surfaces and tools?

## Dry Media

All dry tools *scratch the drawing surface.* There are a number of dry media including *graphite, charcoal, chalk, crayon,* and *conté crayon* (table 5.1).

**TABLE 5.1: Dry Media.**

| Dry Medium | Description and Use |
|---|---|
| Graphite | The material in a pencil is used to create a sharp, gray line or gradations of tone. |
| Charcoal | A piece of pure, black carbon is sharpened to create fine lines or worked on its side to render tonal gradations or bold strokes. |
| Chalk | An earth-colored piece of chalk or a brilliantly colored pastel is used to produce precise lines or sketchy strokes. |
| Crayon | A wax- or oil-based crayon or colored pencil is employed to create a permanent line. |
| Conté crayon | A tool that mixes qualities of both chalk and crayon is used to form strokes and tones. |

*Practice* **art**MATTERS

### 5.2 Use Different Surfaces and Tools

Take a magic marker or felt-tip pen and draw a line on a piece of multipurpose paper. Then, take the same pen and draw a line on a paper towel. Compare the lines:

- Did they stay on the surface or sink in and bleed?
- How did the absorbency and texture of the surfaces make the lines look different?
- If you were an artist, why might you choose either surface?

Now take a ballpoint pen and draw another line on both surfaces. Compare the new lines to the old ones:

- How do the lines compare in appearance?
- Are the marks of some tools more affected in how they look by the surface than others?
- If you were an artist, why might you choose either marking instrument?

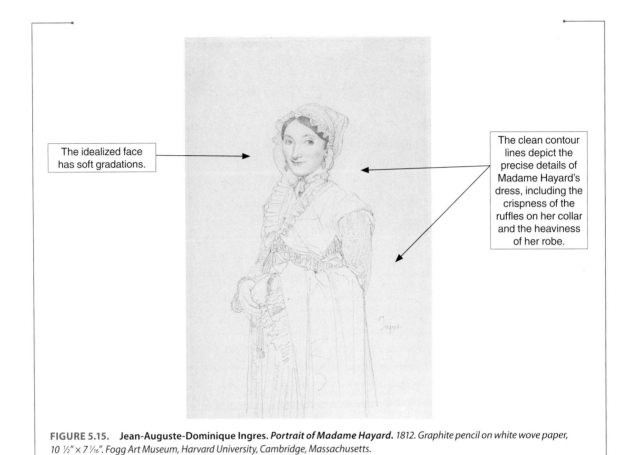

The idealized face has soft gradations.

The clean contour lines depict the precise details of Madame Hayard's dress, including the crispness of the ruffles on her collar and the heaviness of her robe.

**FIGURE 5.15.** Jean-Auguste-Dominique Ingres. *Portrait of Madame Hayard.* 1812. *Graphite pencil on white wove paper, 10 ½" × 7 ⅟₁₆". Fogg Art Museum, Harvard University, Cambridge, Massachusetts.*

**graphite** A drawing material made of a form of carbon

**linear** A style of a work of art characterized by the dominance of line

## Graphite

**Graphite** (a form of carbon similar to coal) is a popular drawing medium with artists. To make a drawing tool, it is most commonly encased in pencils. Pencils are mass-produced, inexpensive, and easy to use. They are versatile and can create a wide range of effects, as was the case in the *Guernica* drawings (figures 5.1 and 5.2). Artists can use pencils to:

- *Create thin, exact, pale, silver-gray lines* (if the pencils are hard) or *thick, sketchy, darker gray and black lines* (if the pencils are soft)
- *Smudge, blend, or erase* lines
- *Make precise lines* (with the sharpened tip) or *build up gradations of tone* (with the side of the point)
- *Make lines darker or lighter*, depending on the amount of pressure exerted on the point

Nineteenth-century French artist Jean-Auguste-Dominique Ingres (jawn oh-GOOST dohm-een-EEK AN-gr') used a pencil to create his *Portrait of Madame Hayard.* Graphite's flexibility made it possible for Ingres to create a tonal quality to the face and a **linear** quality, a style emphasizing the dominance of line, to the garment (figure 5.15).

Latvian American artist Vija Celmins (VEE-ya SELL-muns), in her *Untitled (Ocean)*, offers additional insight into the expressive qualities of pencil. If you didn't know figure 5.16

**FIGURE 5.16.** Vija Celmins. *Untitled (Ocean).* 1968. *Graphite on paper, 12 ⅗" × 17 ½". Art Institute of Chicago, Illinois.* In this drawing, Celmins used graphite for precision.

was created with graphite, you might have thought it was a black and white photograph. The drawing is a startling recreation of waves in the ocean. Celmins meticulously depicted the natural space. She used the pencil's flexibility to form both the crisp light peaks of the waves and the silvery darker tones of the water.

## Charcoal

To form **charcoal**, hard wood is baked until only pure carbon is left. The best-quality charcoal has no binder. This quality makes charcoal a delicate medium, requiring a grainy surface and the application of a **fixative** spray (used to prevent the pigments from rubbing off). Charcoal is one of the most versatile of the dry media. Artists can use charcoal to:

- *Produce different grades of black* (the softer the charcoal is, the darker the tones it can produce)
- *Smudge, blur, or mostly erase* markings
- *Draw fine, meticulous lines* (by sharpening the charcoal) or *subtle, tonal gradations* (by working the charcoal on its side)
- *Vary the darkness of a tone* by exerting pressure on the tool (forming broad, powerful strokes or soft, smoky shadows)

In *The Shell* (figure 5.17), with its precise lines, velvety strokes, and full range of values, twentieth-century artist Georgia O'Keeffe used the sensuous qualities of charcoal to portray a modeled form. Although the Wisconsin-born artist rendered the shell realistically, the extreme close-up view divorces the shell from its maritime subject matter and forces us to consider its design. O'Keeffe used the subtle characteristics of charcoal to form the shell's concentric curves, circular rhythms, and creamy texture.

William Kentridge's drawing in figure 5.18 shows the bold, sketchy, and expressive qualities of charcoal and how it can be used for innovative effect. This image is from a sequence from Kentridge's film *Other Faces*. The film depicts two people—a black man and a white man—who get into a car accident in Johannesburg, South Africa (Kentridge's birthplace). The accident takes place during the years following the repeal of apartheid (the policy of racial discrimination by the country's white minority against the country's black majority). The two men scream at each other, and bystanders even join in the heated

**charcoal** A drawing material made from baked hard wood

**fixative** An adhesive liquid usually sprayed on charcoal, chalk, or pastel drawings to prevent the pigments from rubbing off

**artists**
MATTER

Georgia
O'Keeffe

**FIGURE 5.17.** **Georgia O'Keeffe.** *The Shell.* *1934. Charcoal on laid paper, 18⅜" × 24½". The National Gallery of Art, Washington, DC.* O'Keeffe's drawing illustrates how artists can use charcoal to create line and tone. Note the exact strokes and range in values, from full deep blacks to shadowy grays.

**FIGURE 5.18.** **William Kentridge. Drawing for** *Other Faces.* *2011. Charcoal and colored pencil on paper, 1' 5⅜" × 1' 5¼". The Broad, Los Angeles.* Kentridge used charcoal so he could rework this drawing easily. A ghosted figure that Kentridge erased appears behind the man.

exchange. The scene may indicate that perhaps lasting racial tensions in the country are more deeply rooted than the matter at hand.

The image also shows the effects of Kentridge's artistic process in which he continually erases and redraws on the same sheet of paper. Kentridge used a stop-action film camera to record each new iteration of the drawing. When the series of static images that Kentridge has caught on film is played back rapidly, the sequence creates the illusion of movement in the film. In figure 5.18, a faint figure betrays that, in an earlier version, the screaming man originally had his head farther back and that Kentridge reworked him to shift his head forward in the later version that we see. With charcoal, Kentridge could erase and redraw the man easily.

## Chalk

**chalk** A drawing material made from pigment and a nonfat binder

**Chalks** are drawing materials made from pigment and a nonfat binder. They are available in a range of earth colors. Unlike charcoal, artists cannot easily erase chalk lines because of the binder. However, like charcoal, artists can:

- *Create various tones* by using chalks of different grades of hardness
- *Smudge chalks* for effect, because they are fragile
- *Produce precise lines* with the tip or *gradations* and *sketchier, bolder strokes* with the side

**pastel** A high-quality, finely textured chalk; a drawing made from this material

**FIGURE 5.19.** Michelangelo Buonarroti. *Studies for the Libyan Sibyl.* *For the Sistine Chapel ceiling. c. 1510–11. Red chalk on paper, 11 ⅜″ × 8 ⁷⁄₁₆″. The Metropolitan Museum of Art, New York.* The Sibyl's powerful muscles in her back are precisely modeled with hatching, forming the illusion of the mass of a sculpted, three-dimensional figure. The face, hand, and foot on the bottom of the page were more quickly drawn.

Michelangelo Buonarroti (mee-kel-AN-jel-oh bwoh-nah-ROE-tee) used chalk in his *Studies for the Libyan Sibyl* (figure 5.19), drawn in preparation for his early-sixteenth-century mural on the ceiling of the Sistine Chapel in Rome (see Chapter 15). The Libyan Sibyl—a figure from ancient legend who was believed to have foretold the coming of Christ—was one of more than three hundred figures that Michelangelo incorporated into the finished work. Michelangelo used the qualities of chalk in the study both for careful modeling, giving us a keen sense of anatomical detail and the illusion of the play of light across the sibyl's form, and rough sketching in the other drawings on the page.

**Pastels** are high-quality, finely textured chalks that come in a full range of colors. Pastels allow artists to *combine the spontaneity of drawing with the colors of painting.* They also give artists the flexibility to draw both precise and sketchy lines, characteristics similar to other chalks.

Edgar Degas (ed-GAHR deh-GAH) used pastels to produce *Entrance of the Masked Dancers*. The qualities of the medium enabled Degas to create what seems to be a candid glimpse of the figures during a moment in time, which would have changed a second later in real life (figure 5.20).

Degas's technique further helped him generate the spontaneous effect. He built up one layer of colorful pastels on top of another, separating each layer with a coating of fixative. The blurry quality he achieved enabled Degas to capture a sense of the energy and movement of urban, modern life in late nineteenth-century Paris.

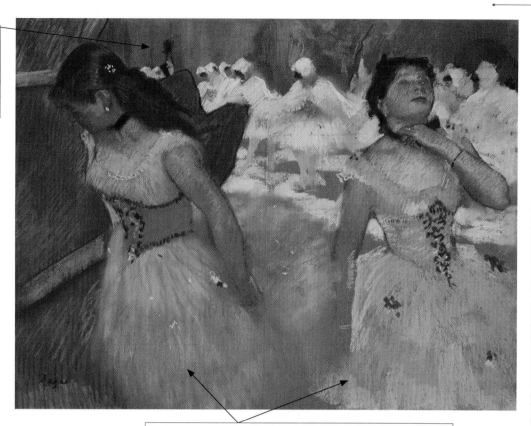

A man wearing a formal black overcoat and hat peaks out from the wings. He is *precisely rendered* in *dark tones.*

Dancers are in the midst of moving, as one turns to make her entrance onto the stage and the other raises her hand to her collar. They are drawn in a *loose, sketchy manner* using *vibrant colors.*

**FIGURE 5.20.** Edgar Degas. *Entrance of the Masked Dancers.* c. 1879. Pastel on gray wove paper, 19 ⁵⁄₁₆″ × 25 ½″. The Clark Art Institute, Williamstown, Massachusetts.

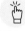

Interactive Image Walkthrough

## Crayon

The difference between the drawing materials of chalks and **crayons** is in the binder; crayons have a *fatty binder.* This fatty binder can be either wax or oil based. As with blackboard chalk and children's crayons, chalks are dry, and crayons are *greasy.* Artists *cannot smudge, erase, or create modeled effects* with crayons. However, crayons come in a variety of colors, and artists can use crayons to produce distinct, clear marks that flow across the surface.

Colored pencils are wax-based crayons. Although they share a name, colored pencils have little else in common with graphite pencils. We can see colored pencils' wax-based qualities in *The Battle of Little Big Horn* (figure 5.21), a drawing by the artist Yellow Nose. In the famous nineteenth-century battle, the Sioux and Cheyenne defeated the attacking U.S. army troops of General George Custer, killing all of them. The battle so enraged white Americans that the U.S. government forcibly moved Yellow Nose and his people to the Cheyenne Reservation in present-day Oklahoma. The colored pencils gave Yellow Nose precise, tight control, as well as the ability to make translucent marks and use a variety of colors.

Beverly Buchanan, an American artist, used a type of oil-based crayons (pastels combined with oil) in *Five Shacks.* Located throughout Georgia where Buchanan lived, shacks

**crayon** A drawing material made from pigment and either a waxy or oily binder

*Different colors*, such as the red and blue on the flags and the yellow on the horse, help to convey the story.

*Clear, individual lines* form the soldiers' guns.

The *translucent* red allows us to see the soldiers beneath the depiction of their blood.

**FIGURE 5.21.** Yellow Nose. *The Battle of Little Big Horn,* **detail.** *c. 1885. Lined paper and colored pencil, 7 ½" × 12 ¼". National Museum of Natural History, Washington, DC.*

**FIGURE 5.22.** Beverly Buchanan. *Five Shacks.* 2004. Oil pastel on paper, 1' 10" × 2' 6". Mead Art Museum, Amherst College, Massachusetts. Buchanan used oil-based pastels to create the vibrant, colorful strokes that seem to take on the handmade quality of the homes themselves.

**conté crayon** A drawing material with a crumbly texture and slightly waxy binder that combines features of both chalk and crayon

are cared for by their owners and are often pieced together from found materials. One of a series of works in which Buchanan paid tribute to the pride and resiliency of owners of shacks, figure 5.22 depicts five of these structures. *Oil pastels merge pastels' brilliant colors with the flowing and adhering qualities of crayons.* Each bold, bright stroke in the drawing, made possible by the greasy, colorful oil pastels, appears like the individual owners' efforts. Yet, in depicting these ramshackle homes, Buchanan also may have been raising questions about inequality.

### Conté Crayon

**Conté crayons** (kahn-tay kray-on) share qualities of chalks and crayons. They feel and look like dry, crumbly chalks, but they have a slightly waxy binder. They come in a variety of colors, like crayons (although traditionally they were limited to earth tones). Artists can use conté crayons to:

- *Draw thin or thick strokes* with a somewhat crayon-like, greasy flow
- *Produce tones,* similar to chalks
- *Erase slightly and smudge,* like chalks

**artists**
MATTER

Whitfield Lovell

Contemporary artist Whitfield Lovell formed thin lines and built up tone with conté crayon in his *Kin XXXII (Run Like the Wind)* (figure 5.23). The image is one of a number of works that pair drawings of African Americans with real, found objects. In this work, a somber woman stares at the viewer, while a real, three-dimensional piece of barbed wire is gathered in a circle below. Lovell used conté crayon to draw the thin lines of her hair and the soft tones on her cheeks. He likewise used the medium to form shining blacks, rich middle tones, and pale lights. The effect forms the convincing illusion of a black and white photograph of a face. (In fact, Lovell, who is African American himself, often uses historical photographs of African Americans as inspiration for his work.) The stark realism

of the drawing combined with the actual barbed wire may recall images of African American slaves held against their will.

*Quick Review 5.6*: What are the characteristics of graphite, charcoal, chalk, crayon, and conté crayon?

## Liquid Media

Unlike dry media, liquid media are *wet and flow onto the page.* This fluidity lends itself to fast and spontaneous application. *All liquid media use ink.* Today, ink is available in many colors. Where the liquid media differ is in the tool that is used to apply the ink and whether water is added to the ink.

Surface plays an important role in liquid media drawings. *The absorbency of the support affects the quality of an ink line.* Wet ink seeps into the fibers of absorbent surfaces, which results in a velvety line, while it lies on top of less absorbent surfaces, creating a crisp line. The liquid media include *pen and ink, pen and wash, brush and ink,* and *brush and wash* (table 5.2).

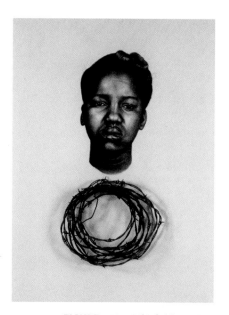

FIGURE 5.23. **Whitfield Lovell.** *Kin XXXII (Run Like the Wind).* 2008. *Conté crayon on paper with barbed wire, 2' 6" × 1' 10 ½" × 3 ¾". Smith College Museum of Art, Northampton, Massachusetts.* Lovell used conté crayon to form the lines of the woman's eyes and tones of her face.

| **TABLE 5.2:** | **Liquid Media.** |
|---|---|
| **Liquid Medium** | **Description and Use** |
| Pen and ink | A pen is used to make clear, precise, permanent lines. |
| Pen and wash | A pen is employed with full-strength ink to form lines, and a brush is used with diluted ink to form tones. |
| Brush and ink | A brush is manipulated to apply undiluted ink lines. |
| Brush and wash | A brush with full-strength ink is used to create lines, and a brush with diluted ink is employed to create tones. |

## Pen and Ink

Although pens have been around for over two thousand years, they have undergone technical changes over time. Ancient people crafted the first pens from hollow reeds. In the Middle Ages, people made pens from **quills**, feathers plucked from live birds. In the nineteenth century, pens were mass-produced with a sharp, metal tip called a **nib** mounted on a small pointed instrument called a **stylus**. This type of pen remains popular with artists today. All such pens hold only a small amount of ink and must be dipped repeatedly in an ink jar as they run dry. The length of each line depends upon the amount of ink the pen holds. Today, many types of pens—for example, ballpoint and felt-tip pens—incorporate places to hold ink into their design so they do not need to be dipped. These pens allow artists to form uninterrupted, flowing lines. Artists use pens to:

- *Create clear, precise, permanent lines* (just as Picasso did in figure 5.3)
- *Form a variety of types of lines,* including scratchy, smooth, broad, delicate, elegant, or heavy ones
- *Generate linear effects*; to model forms, artists must use hatching (see Chapter 3)
- *Produce different effects,* by changing the type of pen or ink, the size of the point, the amount of ink, and the amount of pressure on the pen

Jean Dubuffet (jawn doo-boo-FAY) used the linear quality of pen and ink in his chaotic drawing, *Tumultuous Landscape* (figure 5.24). While the twentieth-century French artist's disorderly scribble may suggest the random cracks and coarse textures of the land,

**quill**  A pen made from a bird's feather

**nib**  The sharp point or tip of a pen

**stylus**  A small pointed implement

**FIGURE 5.24.** Jean Dubuffet. *Tumultuous Landscape.* 1952. *Pen and ink on paper, 18¾″ × 23⅞″. The Museum of Modern Art, New York.* Dubuffet's lines vary from bold, thick, and powerful to scratchy, thin, and fading.

**FIGURE 5.25.** Isabel Bishop. *Waiting.* 1935. *Pen and wash on paper, 7⅛″ × 6″. Whitney Museum of American Art, New York.* In that Bishop redrew the child's legs several times with the exact lines of the pen, the effect is one of a fidgeting child, while the smooth densities of the wash (the varying tones in the figures and background) offer a sense of the place where the two sit.

**artists**
MATTER

Katsushika
Hokusai

it also may recall the instability of a mind that has lost control. In his work, Dubuffet tried to recreate the art of the mentally disturbed, whose art he found genuine and uninhibited. The bold ink lines that Dubuffet scrawled across the page, until at times his pen ran dry, appear to communicate raw emotion and expression.

### Pen and Wash

Artists who use pen and **wash** (a thin transparent layer of ink diluted with water) use two tools: *a pen with ink to form lines* and *a brush with wash to develop tones*. This medium offers much flexibility, as artists can attain the linear, exact effect of the pen and can use wash to create shadows, modeled forms, and a greater sense of depth. Artists can vary the density of the wash by altering how much water they add to the ink: the more water, the more transparent the wash.

*Waiting* (figure 5.25) by Isabel Bishop shows the variety possible with pen and wash. Bishop used line to form features and outlines and different densities of wash to produce tonal contrasts that give an illusion of three-dimensional figures in space. Taking advantage of this linear and tonal flexibility, Bishop could capture the people she saw on the streets of twentieth-century New York, including the working poor and homeless.

### Brush and Ink

In brush and ink drawings, artists apply *undiluted ink to a surface with a brush*. Depending on the type of brush and how it is used, artists can form lines that are flowing, stiff, thin, delicate, bold, strong, continuous, or interrupted. Artists use brush and ink to:

- Produce *a linear effect* due to the single, dark tone of the ink
- *Change the character of a single line* along the course of its path by exerting pressure on the brush
- Form a *broken, strained stroke* (by dragging a brush squeezed of much of its ink across a surface) or a *sweeping, spontaneous line* (by using a brush fully loaded with ink)

Brush and ink has long been used in Asia. *A Maid Preparing to Dust* from the early nineteenth century by Japanese artist Katsushika Hokusai (kat-s'-SHEE-kah HOH-k'-sye) is representative of the tradition and demonstrates the expressive, linear qualities of the medium. Hokusai used different strokes in the depiction, providing detail with each line (figure 5.26).

Hokusai presented an everyday woman in an unguarded moment. Yet, the sweep of her robes, the rhythm of the lines, and the curvature of her pose appear anything but ordinary.

### Brush and Wash

With brush and wash, artists use *a brush with full-strength ink to create lines* and *a brush with diluted ink washes for tones*. Artists can manipulate the brush in any of the ways described in the brush and ink drawings—creating linear, dark lines. They can also

employ washes as they would in a pen and wash drawing—forming tones of different translucencies. In addition, they can produce a broad range of effects using the combined approaches.

In *A Young Woman Sleeping*, seventeenth-century Dutch artist Rembrandt van Rijn (rem-BRANT van RYN) made an intimate brush and wash portrait of his common-law wife (figure 5.27). Rembrandt's lines of varying thickness, tones of changing translucencies,

**wash** A thin transparent layer of diluted ink spread on an area of a surface with a brush

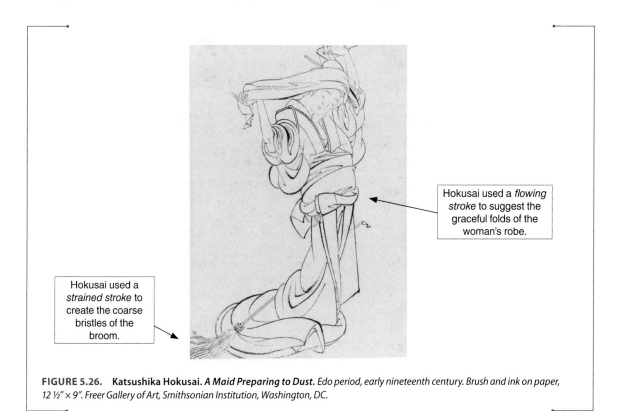

Hokusai used a *flowing stroke* to suggest the graceful folds of the woman's robe.

Hokusai used a *strained stroke* to create the coarse bristles of the broom.

**FIGURE 5.26.** **Katsushika Hokusai. *A Maid Preparing to Dust.*** *Edo period, early nineteenth century. Brush and ink on paper, 12 ½″ × 9″. Freer Gallery of Art, Smithsonian Institution, Washington, DC.*

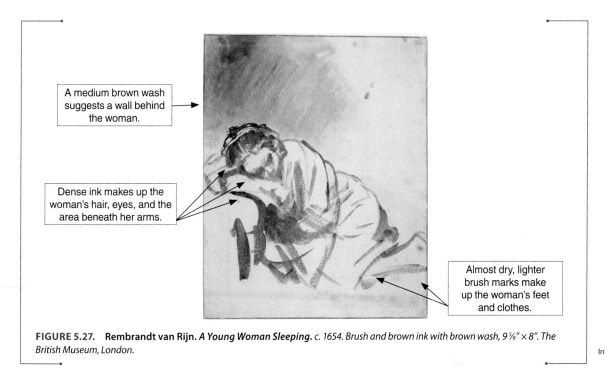

A medium brown wash suggests a wall behind the woman.

Dense ink makes up the woman's hair, eyes, and the area beneath her arms.

Almost dry, lighter brush marks make up the woman's feet and clothes.

**FIGURE 5.27.** **Rembrandt van Rijn. *A Young Woman Sleeping.*** *c. 1654. Brush and brown ink with brown wash, 9 ⅜″ × 8″. The British Museum, London.*

Interactive Image Walkthrough

and brushstrokes of different ink densities convey an illusion of the woman's features, her bulk, and the space where she sleeps.

Rembrandt conveyed meaning using just a few subtle and bold lines and tones. The untouched portions of the paper, the contrasting strengths of ink, and the background wash serve to create the illusion of a soft light landing on the woman's back, shoulders, and feet, as if Rembrandt gave tenderness and warmth to her slumber.

Brush and wash works give artists the flexibility to form both lines and tones; however, some artists don't want to choose between media. These artists combine two or more media to create these and other effects in one work. This combination work, which can employ drawing or other media, is called **mixed media** (see *Delve Deeper: Mixed Media*).

**mixed media** The combination of two or more media in a single work of art

*Quick Review 5.7*: How are the features of pen and ink, pen and wash, brush and ink, and brush and wash similar and different?

# DELVE DEEPER

## Mixed Media

One popular mixed-media combination is a dry drawing medium with an ink wash. This mixture offers the exactness of the dry medium with the gradations of wash. In figure 5.28, Eva Hesse (AY-vuh HESS-uh) used pencil to produce the contours of the perfect circles and wash to create the tones. The drawing may seem stable and rote. Yet, the longer we look, the more the circles might begin to vibrate across the page, making her drawing seem unpredictable. The diverse media of the dry graphite and liquid wash add to the effect.

Hesse had a difficult life, escaping the Holocaust in Europe and living through her parents' divorce and mother's suicide. One interpretation suggests that the conflicting characteristics of the precise pencil and translucent washes enabled Hesse to convey life's instability in her work.

Hesse formed the thin, precise lines with graphite.

Hesse changed the density of the wash, enabling her to produce the variety of subtle tones.

**FIGURE 5.28. Eva Hesse.** *Untitled.* *1966. Gray wash and graphite on cream wove paper, 13 ¾″ × 10 ¹³⁄₁₆″. Harvard Art Museums, Cambridge, Massachusetts.*

## Digital Drawing

Some artists *draw on computers, tablets, and smartphones* by moving a tool, such as a stylus (a digital pen), mouse, or their fingers across the surface of the screen. Artists use digital drawing technology to:

- *Select the look of the line*, choosing from a myriad of options that can resemble different media (such as traditional pens, pencils, and brushes), line weights, and colors
- *Erase a mark* or *modify its direction, color, boldness, or character*
- *Add special effects* (such as inserting shadows or filling in shapes with color)
- *Record the sequence of creation*, so that it can be played back to see the steps of the creative process

In figure 5.29, David Hockney employed these effects to draw a country road in northern England. Numerous lines, dappled values, and broad areas of consistent color populate the image, showing the range of the medium. Even with an array of textures and linear qualities, however, the work is cohesive, documenting the arrival of spring.

Digital art *challenges our ideas of the nature of drawing*. For the image in figure 5.29, Hockney printed the work on paper, leading to questions of where this type of work exists: on the screen, on a printout, or on both? Moreover, if an artist saves earlier versions of a drawing, how should those versions be classified? Are they also separate works? We know that many drawings, like Picasso's for *Guernica*, give us insight into the artist's creative thoughts. Drawing programs permit artists to save earlier versions and record their creative processes. So, perhaps, digital drawing is just another traditional drawing form after all.

**FIGURE 5.29.** David Hockney. *The Arrival of Spring in Woldgate, East Yorkshire in 2011—11 May. iPad drawing printed on paper, 4' 7" × 3' 5 ½".* Hockney used an iPad to create a number of textures, colors, and lines. The sky appears a consistent, light blue, the leaves are tiny specks of different tints and shades, and the road is streaked with chalk-like marks of many colors.

*Quick Review 5.8*: Should digital drawing be considered drawing? Why or why not?

# HOW art MATTERS

## A Look Back at the *Guernica* Drawings

From the outset, people have understood the importance of *Guernica* (figure 5.5) and have seen it as a memorial to the dead, a renunciation of acts of horror, and a call for peace. Through the drawings, we can trace Picasso's preparation before he moved on to the complex work. The drawings also illustrate much about the medium of drawing.

Picasso's art *exemplifies the different definitions of drawing*. Picasso used *all of his senses to see* people. In the drawing of the *Mother with Dead Child* (figure 5.3), it is as if we can hear the woman's screams. Moreover, Picasso likely recognized that

viewers could *gain insight into his creative process* through his drawings. He numbered each, knowing that the order of the development of his vision could be reconstructed. Additionally, Picasso used his drawings as *notes to record and try out his ideas*. He experimented with the overall composition and the form of the tortured individuals to prepare for the larger work.

Picasso used *a variety of surfaces* in his drawings—different-colored **supports** (such as blue or white) in different sizes and shapes (such as small and square or larger and elongated)—which resulted in *varied effects*. Picasso also used a *variety of*

*tools* that, because of the distinct qualities of the media, enabled him to explore different ideas. While we will never know exactly what was in Picasso's head, we can see connections. In *Composition Study* (figure 5.2), Picasso experimented with the pale, silvery tones and dark blacks possible with **graphite**. These same tones make up the final painting. In *Mother with Dead Child* (figure 5.3), Picasso used the *thin, black lines of a pen* to outline the mother's and child's forms. Throughout the final painting, contour lines surround the figures. In *Mother with Dead Child on a Ladder* (figure 5.4), Picasso used **crayons** to *break up the figures and background into distinct shapes*. Such flat forms likewise make up the figures and background in the final painting. While the different surfaces and media give each drawing a distinct look, it was the way Picasso manipulated these materials that allowed him to create his timeless message.

As you move forward from this chapter, consider *how drawings can be both finished works* and *preparations for other final pieces of art*. Similarly, in life, sometimes initial ideas are worthy of final presentation, while other times they need multiple trials to perfect. Picasso took many small steps before he attempted the larger and more complex painting. He took the time to observe individuals closely, so he could truly capture their emotions, just as Peyton captured the essence of the man in *Matthew* (figure 5.7). In that the *Guernica* drawings display the value in intense exploration, Picasso's art is an important model for the hard work of life.

Today, a tapestry version of *Guernica* hangs outside of the United Nations Security Council. Because the Council is tasked with maintaining world peace, the tapestry serves to remind the members to recall the past, work hard to consider all options before moving forward, and be mindful of the power of their actions once they have made decisions.

Flashcards

## CRITICAL THINKING QUESTIONS

1. Some of the earliest art ever made includes markings made on walls of caves. If drawings need to be two dimensional, are these works drawings? Why or why not?
2. How could you make the case that Georgia O'Keeffe saw intently when drawing *The Shell* (figure 5.17)?
3. How can you understand Maya Lin's creative process by considering the *Vietnam Memorial Competition Drawing* illustrated in Chapter 1 (figure 1.1)?
4. Imagine you have just moved into a new room. You are trying to figure out the best way to organize furniture. You have decided a good way to experiment with ideas is to draw out different floor plans without having to keep moving the furniture. Why would all three ways that drawings can be used as notes suggest that this idea would be a good plan?
5. What drawings in this chapter, aside from Rosalba Carriera's *Louis XV as a Young Man* (figure 5.12), do you think are finished works? Based on this assessment, do you agree that the drawing medium is well recognized as an art form rather than as a tool just used for studies and education?
6. What characteristics do you see in Käthe Kollwitz's *Self-Portrait, Drawing* (figure 5.8) that indicate that it was made with charcoal?
7. In what way are crayons like pen and ink?
8. Why can artists create so many effects with pen and wash?

Comprehension Quiz       Application Quiz

# 6

# Painting

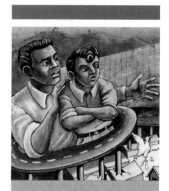

**DETAIL OF FIGURE 6.4.**
Artists typically try to communicate a message, feeling, or idea in a painting. Here, in a detail of *The Great Wall of Los Angeles*, Judy Baca and the painters who worked with her attempted to convey how Mexican Americans were adversely affected when newly built highways divided their neighborhood.

## LEARNING OBJECTIVES

**6.1** Identify and explain the role of the two components of paint.

**6.2** Describe the layers, tools, and techniques that artists can use when they paint.

**6.3** Discuss how artists convey a particular message with paint.

**6.4** List the qualities of encaustic paintings.

**6.5** Contrast the *fresco secco* and *buon fresco* techniques.

**6.6** Discuss the qualities of tempera paint.

**6.7** Summarize the different features of oil paint.

**6.8** Describe the characteristics of transparent watercolor paints.

**6.9** Compare and contrast gouache with transparent watercolor.

**6.10** Evaluate the ways that acrylic paints mimic the effects of other paints.

**6.11** Assess whether digital painting should be considered a type of painting.

## JUDY BACA'S *THE GREAT WALL OF LOS ANGELES*

In 1969, Judy Baca, a young American of Mexican descent, graduated from Cal State Northridge with an art degree, becoming the first woman in her family to graduate from college. Upon looking at some of her drawings, Baca's grandmother asked her what they were for. The question made Baca stop to think: What was the purpose of her art? From that moment on, Baca decided to use her art to express ethnic pride rather than for personal financial gain. Her decision followed the goals of the Chicano Movement, an effort by Mexican Americans to gain civil rights and uphold the value in being different.

How Art Matters

Baca began working for the city of Los Angeles, where she brought together members of rival street gangs to create *murals*. Over ten years, diverse youths painted over 250 of these murals all over Los Angeles under her direction. The murals celebrated ethnicity, promoted cross-cultural connections, and fostered pride in the painters and in the community. The murals brought art to the people and made it possible for the people to express themselves through art.

### An Opportunity to Create *The Great Wall*

In 1974, the Army Corps of Engineers approached Baca for help with a beautification project planned for the Tujunga Wash Drainage Canal. The flood channel was a massive, concrete eyesore. Although she didn't know it then, Baca was to create the longest mural in the world: *The Great Wall of Los Angeles.*

*A number of people working together*, including artists, historians, community members, and over four hundred inner-city youths (many of whom were referred by the juvenile justice system and who had no previous artistic experience), painted the mural over five summers. The teens were paid, offered social services, given art and history lessons, and participated in team-building exercises. For many of the young people, working on the mural offered them the chance to improve their creativity, flexibility, and problem solving—all crucial life skills.

### An Elaborate Process

The planning process for the mural was complex and challenging. Before the painting could begin, Baca and the muralists had to consider how visitors would experience the mural; the painting would not be viewed entirely at once and would be *seen from multiple vantage points*. In addition, the changing light during different times of day and different seasons would *change the appearance of the mural*. Baca and the muralists also had to research and plan each section of the painting to tell an accurate story and *convey a compelling message* before making designs and turning them into blueprints. Further, the muralists needed to divide each blueprint into a grid of uniform squares, so the drawings could be enlarged and transferred to the wall.

There also was the challenge of preparing the surface of the wall. Prior to painting, the muralists had to blast the wall with sand and water to clean it; coat the wall to ensure a sealed surface; and put chalk lines on the wall to create a grid, so blueprints could be copied one square at a time onto the surface (figure 6.1).

Only once this preparation was complete could the muralists begin *applying the paint in layers*. The muralists first laid down an even paint coat to ensure later colors would be unified, then applied paint in flat, broad-base colors (figure 6.2). Darker and lighter values of each color were then layered on top to depict shadows and highlights. Finally, the muralists added a clear sealer to protect the finished work.

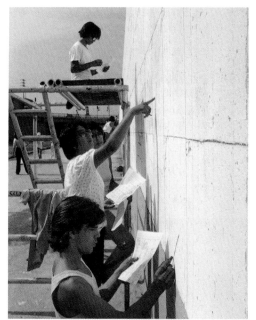

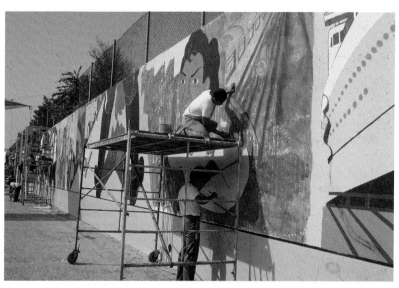

**FIGURE 6.2.** **Painting *The Great Wall*.** Here, in the summer of 1982, teens paint the segment of the wall with Luisa Moreno, who fought for workers' rights.

**FIGURE 6.1.** **Transferring the drawings to *The Great Wall*.** This picture shows teens transferring the drawings to the wall, the wall's smooth white surface, and the lines on it from the grid system.

## An Inclusive History

Today, the mural stretches some 2,754 feet and depicts an inclusive history of California not found in traditional textbooks. Documenting the many tragic and triumphant stories of ethnic peoples, minorities, and women, the mural moves through the past, covering events from prehistoric times to the 1950s.

Figure 6.3 shows the section of the mural that tells the story of Japanese Americans from the 1940s. While nearly twenty thousand Japanese Americans risked their lives fighting in

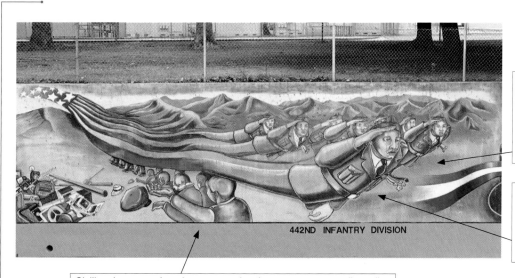

The Japanese American 442nd Infantry Regimental Combat Team dynamically rushes forth from the American flag.

Note the cream-colored highlight and deep brown shadow applied over the medium brown of this soldier's uniform.

442ND INFANTRY DIVISION

Civilian Japanese Americans retreat into internment camps, discarding belongings that they were prohibited from bringing with them.

**FIGURE 6.3.** **Judith F. Baca. *The Great Wall of Los Angeles,* detail of *World War II*.** *1976–continuing. Photo taken May 2019. Acrylic on wall, 13′ × 2,754′. Tujunga Wash Flood Control Channel, Los Angeles.*

World War II, over one hundred thousand in the United States were incarcerated. The muralists' technique of painting *a flat, base color and two tones layered above* can be seen in the depiction of the soldiers. While their uniforms are middle-toned, there are light highlights on top of their bodies and dark shadows below.

Figure 6.4 shows the story of Mexican Americans. In the 1950s, new highways divided their community, and one of their neighborhoods was bulldozed to make way for Dodger Stadium. Again, the muralists' overlapping technique to create *highlights* and *shadows* is here; the muralists also introduced a different layering method of *placing a translucent film of paint over an opaque one*.

Dodger Stadium floats in from above, while a thin veil of light beams from the UFO-like arena. Through this *translucent film of paint*, the *opaque mountains are visible beyond*.

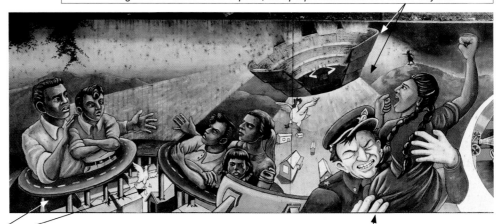

Two encircling freeways hold neighbors apart, as the pillars of the highway crash through homes below.

A police officer forcibly evicts a resident, who screams in protest. His hands pull at her red dress. Her resistance is underscored by the maroon lines that fall into *shadow* on her dress, while her face is lit by a *highlight*.

**FIGURE 6.4.** Judith F. Baca. *The Great Wall of Los Angeles*, detail of the *Division of the Barrios and Chavez Ravine*. *1976–continuing. Photo taken May 2019. Acrylic on wall, 13′ × 2,754′. Tujunga Wash Flood Control Channel, Los Angeles.*

Amazingly, even at a half mile in length, the mural remains a work in progress. Baca plans to create sections to cover the remaining decades of the century, extending the mural's length to a mile. Figure 6.5 shows a sketch of a proposed section for the 1960s.

## The Impact

Since its creation, the mural has gained international fame and enabled thousands of people to understand and identify with a more inclusive history of California that was not previously available. In this respect, *The Great Wall* illustrates the immense *power of art to teach* by offering new insights about the past. However, *The Great Wall's* impact goes beyond its message to the story of its creation. By participating in the painting process, hundreds of teens *became more informed about their history, acquired essential life skills* such as how to work in teams and the importance of a good work ethic, and *learned to understand other cultures.*

At its most basic, the mural also teaches a great deal about painting. This chapter will consider many of the issues touched on in the story of *The Great Wall*. Before moving forward, based on this story, how would you define painting? What characteristics of the paint used by the muralists might have resulted in the specific appearance of *The Great Wall*?

**FIGURE 6.5.** Judith F. Baca. *The Great Wall of Los Angeles,* **detail of a proposed design for the 1960s.** *1976–continuing.* In this proposed design, African Americans are refused service at a "whites only" lunch counter at left, while they are sprayed with high-powered hoses at right.

# What Painting Is

Think of a work of art. Did you think of a painting? Lots of people do. This is because in many parts of the globe, painting has been considered the most important art form. While artists have painted on a number of surfaces (today, even on tablets), there are two basic, traditional types of paintings: murals and easel paintings.

A **mural** (like *The Great Wall*) is a large painting that is painted on a wall or ceiling. Murals:

- Must *fit with their surroundings*
- Are intended to be *viewed from different angles* and, if located outdoors, must *withstand various weather conditions*
- Are frequently *created by artists working together*

Other paintings are called **easel paintings**, whether they are made on easels or not. Easel paintings:

- *Are self-contained, portable works* of art
- Are expected to be *displayed straight on* in front of the viewer
- Tend to be *created by solitary artists*

Whether murals or easel paintings, however, all paintings require *an application of paint* and are *created with different layers, tools, and techniques*. The artist's ultimate purpose is to convey a *message to viewers*.

## An Application of Paint

**Painting** is the technique of applying fluid color (or paint) to a two-dimensional surface. Paint is made from two ingredients—tiny particles of pigment and a liquid called a vehicle.

**Pigments** are fine, dry powders that absorb and reflect different wavelengths of light that allow us to see color. All paints use the same pigments with few exceptions. Because pigments don't dissolve, they are suspended in vehicles.

**Vehicles** (or **mediums**) have two main ingredients: thinners and binders. **Thinners** (or **solvents**) are rapidly evaporating materials that dilute the paint. Water and turpentine are two common types of thinners. They give the pigment a fluid consistency, so it can be spread easily. **Binders**, like egg or oil, are adhesive substances that ensure the pigment particles hold together and adhere to the surface, so the dried paint doesn't rub off. *Binders create the paint's unique characteristics*. Some binders dry quickly; others, slowly. Some change chemically as they dry and cannot be changed back into their original form, while others can be redissolved and reworked. Binders also give the paint a characteristic look (its relative intensity, value, glossiness, opacity, etc.). The same pigments look dissimilar in different binders because as light passes through various binders, it refracts differently.

*Quick Review 6.1*: What role does each of the two components in paint play?

## An Artform Created with Layers, Tools, and Techniques

Painting is a technical process that requires certain skills. In the past, many painters started as apprentices and learned from established masters. Artists must understand the *layers, tools,* and *techniques* to be able to paint to their creative potential.

**mural** A large painting that is painted on a wall or ceiling

Mural Painting

**easel painting** A painting that is a self-contained, portable work of art

**painting** The application of fluid color to a two-dimensional surface; a work of art created by this technique

**pigments** Substances that absorb and reflect different wavelengths of light that allow us to see color

**vehicle/medium** The material that together with pigment forms paint

**thinner/solvent** A rapidly evaporating material that dilutes paint

**binder** The adhesive substance in a medium that holds the particles of pigment together and to the ground

**FIGURE 6.6. An exploded view of the layers of a painting.** Even though paintings are two-dimensional works of art, they are composed of a series of layers superimposed one on top of another.

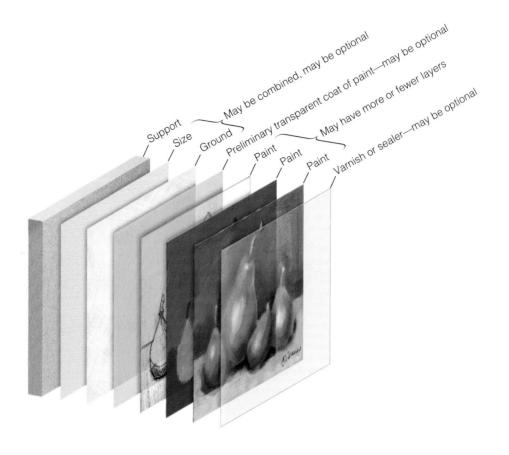

Support / Size / Ground / Preliminary transparent coat of paint—may be optional / May be combined, may be optional / Paint / Paint / Paint / May have more or fewer layers / Varnish or sealer—may be optional

**priming** Applying a preparatory coating to a surface as a base

**size** A preliminary coating of diluted glue applied to a surface to seal it, reduce its absorbency and porosity, and separate it from the paint

**ground** A preparatory coating applied to a two-dimensional surface as a base for a painting

**palette** The colors used in a work of art or the colors available for use; a surface used to hold and mix an artist's paints

**artists**
MATTER

Lady
Pink

## Layers

Paintings are made in *multiple layers*. The number of layers can vary. *The Great Wall* had six layers. Not all paintings have this many layers, and some have more (figure 6.6).

All paintings have a *support* (see Chapter 5), typically a flat surface such as a wall, ceiling, wood panel, canvas stretched on a frame, or paper. Artists often prepare the support, using a technique called **priming**, in which they apply a coating of a **size** to seal the surface and a **ground** to ensure the surface is uniform. Grounds create optical effects as well. A white, smooth ground increases the brightness of the final painting, while a dark, rough ground leads to a lusterless look. After priming, some artists put on a *translucent layer of paint* to unify the color **palette**. When artists finally paint the image, they often *layer the paint*, as the muralists did in *The Great Wall*. Last, to ensure that the paint is protected, many artists finish with a coating of protective *varnish* or *sealer*.

## Tools

Artists paint with *different tools to yield different effects*. Paint can be applied with a variety of implements, such as a sponge, or poured right out of a container. By far, the most common tool is a brush. Brushes are made from different materials, come in different sizes and forms, and can be used with varying amounts of pressure on the surface.

The work of graffiti artist Sandra Fabara, known as Lady Pink, shows just how unique the appearance of the paint can be, based on the tool used to apply it. Born in Ecuador, Pink was raised in New York City. She illegally used spray paint (paint sprayed from a pressurized, aerosol can) to cover subway cars as a teenager. Today, she maintains her original tool, but works only lawfully.

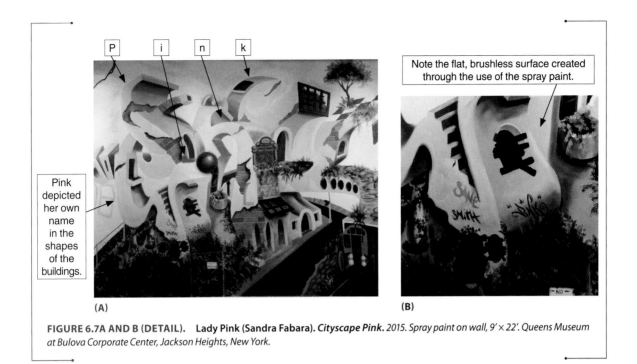

P i n k

Pink depicted her own name in the shapes of the buildings.

Note the flat, brushless surface created through the use of the spray paint.

(A)                                                        (B)

**FIGURE 6.7A AND B (DETAIL).** Lady Pink (Sandra Fabara). *Cityscape Pink.* 2015. *Spray paint on wall, 9' × 22'. Queens Museum at Bulova Corporate Center, Jackson Heights, New York.*

Figure 6.7A shows a mural she created for the Queens Museum in New York. In the image, the artist fashioned letters of her own name "Pink" to produce a brightly colored, fantastic city. Using spray paint, Pink laid a fine mist over the wall and formed even coats, clean edges, and dripless surfaces (figure 6.7B). However, her tool also produced thousands of fine dots, giving the final product a shimmering appearance. The gaudy colors of the spray paint along with the slick appearance create a commercial feel.

### Techniques

Artists can use different methods to paint. While they can *apply paint flatly* after blending it on a palette, two other common techniques include *applying glazes* and *building up impastos.*

With a **glaze**, an artist applies a thin, transparent layer of paint mixed with extra vehicle over a previously painted coating of another color. Glazes make the lower layers richer and more luminous; light can pass through transparent glazes, bounce off an opaque undercoat, and reflect back to the viewer. In *Still Life with Flowers* (figure 6.8), the Dutch painter Rachel Ruysch (ROYSH) gradually built up multiple layers of thin glazes to depict a floral bouquet in which the flowers are shown at the peak of life right before they begin to fade. Some even bend down having already begun to wilt. With the smooth, transparent paint films, Ruysch captured the deep color of the flowers. When she painted this piece in the early eighteenth century, such works were meant to comment on how good looks are fleeting; the beauty of the painting—*enhanced by the glazes*—seems to help drive home the message.

Conversely, with an **impasto**, an artist builds up thick, opaque paint that stands away from the surface in textured brushstrokes. Figure 6.9A shows one of twentieth-century American artist Joan Mitchell's nonobjective, emotionally charged paintings in which pronounced impastos, visible in figure 6.9B, are smeared across the surface. Mitchell's intense brushstrokes highlight her physical process of application. A whirling quantity of blue is scrawled across the bottom and top left, while vivid, orange strokes dance on the top right of the work.

**glaze** In painting, a technique in which a thin, transparent color is applied over a previously painted coating of another color to modify the color and appearance of the lower layer; the transparent layer of paint created using this technique

**FIGURE 6.8.** Rachel Ruysch. *Still Life with Flowers.* c. 1704–11. Oil on canvas, 3' 1 ½" × 2' 7 ½". Private collection. The multiple layers of glazes can be most clearly seen in the rich color of the flowers, which radiate a warm glow.

FIGURE 6.9A AND B
(DETAIL). Joan Mitchell.
**Wood, Wind, No Tuba.** *1980. Oil
on canvas, two panels, 9' 2 ¼" × 13'
1 ⅛". The Museum of Modern Art,
New York.* Mitchell's use of paint
is spontaneous and bold (6.9A).
The detail shows how she formed
impastos (6.9B).

(A)                                             (B)

**impasto** A style of painting in which
thick, built-up, opaque paint stands
away from the surface in textured
brushstrokes; the paint applied to a
surface using this technique

*Quick Review 6.2*: What layers, tools, and techniques can artists use when
they paint?

## A Message to Viewers

So far, we have discussed the technical side of painting, but we also need to consider a
painting's meaning. All of an artist's decisions regarding materials, tools, and techniques
help form the content in a work. An artist uses these technical attributes to *communicate a
message, an illusion, an expression, or an idea.*

During the early twentieth century, Tom Thomson frequently depicted the Canadian
wilderness as a symbol of national pride. In figure 6.10, a pine tree is silhouetted in front
of a lake and mountain. While the evergreen's branches are laden with needles and cones,
it stands determinedly. To form this image, Thomson specifically used oil paint to create
impastos and a vast array of colors that *helped convey the message* of his nation's strength
and beauty.

*Quick Review 6.3*: How do artists convey a particular message with paint?

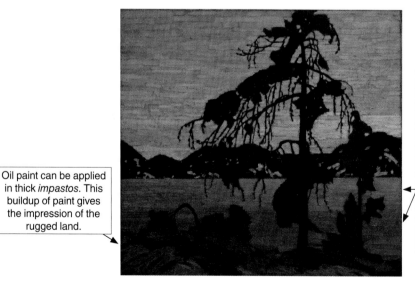

Oil paint can be applied
in thick *impastos*. This
buildup of paint gives
the impression of the
rugged land.

Oil paint can be easily
blended into numerous
subtly different colors.
This blending of paint
allowed Thomson to create
the countless variations
of colored brushstrokes
visible in the lake, includ-
ing ones representing the
shimmering water that is
hit by light toward the back
and the shadowy water
that is falling into shade at
the front.

FIGURE 6.10.   Tom Thomson. *The Jack Pine. 1916–17. Oil on canvas, 4' 2 ⅜" × 4' 7". National Gallery of Canada, Ottawa, Ontario.*

# Different Painting Media

Various painting media have been popular in different historical periods and cultures and been attractive to artists because of individual tastes and artistic goals. Each medium offers visual opportunities but also comes with technical limitations. Here, we explore *encaustic, fresco, tempera, oil, transparent watercolor, gouache,* and *acrylic* (table 6.1). We will then look at *digital painting.*

| TABLE 6.1: Painting Media. | |
|---|---|
| **Painting Medium** | **Description and Use** |
| Encaustic | Pigments suspended in wax are used to create rich-colored works. |
| *Fresco* | Two techniques are used to form murals: pigments suspended in a binder are painted on a dry wall, or pigments mixed only with water are painted on a fresh, wet plaster wall. |
| Tempera | Pigments combined with an emulsion are applied with a hatching technique to form linear, delicate works. |
| Oil | Pigments mixed with linseed oil are used to form works with numerous possible colors. |
| Transparent watercolor | Pigments suspended in gum arabic sink into white paper, creating a light-filled look to transparent colors. |
| Gouache | Transparent watercolor mixed with extra binder and chalk forms an opaque, dense paint coat. |
| Acrylic | Pigments suspended in a synthetic resin create an easy-to-use paint that mimics the qualities of other painting media. |

## Encaustic

With **encaustic**, pigments are suspended in wax. When the wax is heated to a liquid state, the paint can be spread. Once cooled and hardened, the wax acts as a binder. To understand encaustic, imagine brushing candle drippings onto a surface. Artists use a heated palette to warm the wax and work quickly, so the paint doesn't harden on the brush. The wax gives encaustic paintings a distinctive look.

**encaustic** From the Greek *enkaustikos*, meaning "to burn in"; a type of paint made with pigments suspended in a hot wax binder; a method of painting using this paint

Encaustic paintings:

- *Possess a fresh and direct appearance* because of the speed of application
- *Vary in expression* because the binder allows for robust, opaque, textured impastos or thin, transparent, smooth glazes
- *Project vibrant and luminous colors* because the binder brings out the rich brilliance of the pigments

Figure 6.11 shows the unique look of encaustic. In the second century, Egyptians mummified and buried their dead with encaustic portraits. These paintings were lifelike and inserted over the faces of the deceased (possibly so the dead could be recognized in the afterlife). The colors, over eighteen hundred years old, retain their freshness and brilliance owing to the durability of the binder and Egypt's dry climate. In the portrait here, the artist created a boy's distinct features using *encaustic's versatility.*

Seeing encaustic paintings in a detail gives a real sense of the distinctive look the wax binder enables. To get a better sense of the surface of an encaustic painting see *Practice Art Matters 6.1: Observe an Encaustic Painting Up Close.*

*Quick Review 6.4*: What are the qualities of encaustic paintings?

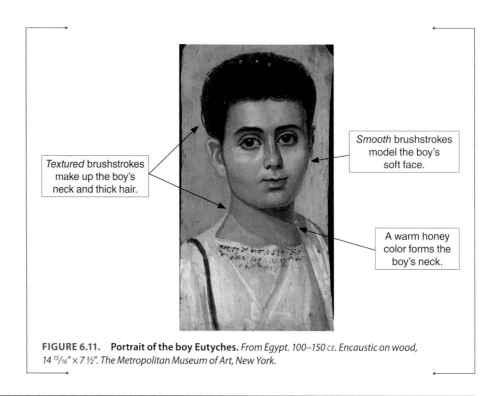

Textured brushstrokes make up the boy's neck and thick hair.

Smooth brushstrokes model the boy's soft face.

A warm honey color forms the boy's neck.

FIGURE 6.11. **Portrait of the boy Eutyches.** *From Egypt. 100–150* CE. *Encaustic on wood, 14* 15/16" × 7 1/2". *The Metropolitan Museum of Art, New York.*

---

*Practice* art MATTERS

## 6.1 Observe an Encaustic Painting Up Close

Several twentieth-century painters have been drawn to the expressive medium of encaustic, including American Jasper Johns. *Numbers in Color* (figure 6.12A) is one of a series of paintings in which Johns used ordinary objects, such as numbers, letters, and flags, to explore the boundary between art and the everyday world. Johns stenciled numbers onto his surface and painted them with encaustic. While the impersonal numbers repeat endlessly, row after row, they also look like shapes, leaving the viewer to wonder when numbers are real and when they are nonobjective forms.

The detail of the painting (figure 6.12B) gives a sense of the effect encaustic paint had on the surface. Consider the surface and answer these questions:

- What technique did Johns use: impastos, glazes, or both? How do you know?

- What do the colors look like?

- Given the description of Johns's work, why do you think he might have chosen to use encaustic?

FIGURE 6.12A AND B (DETAIL). **Jasper Johns.** *Numbers in Color.* *1958–59. Encaustic and newspaper on canvas, 5' 6 1/2" × 4' 1 1/2". Albright-Knox Art Gallery, Buffalo, New York.*

(A)

(B)

## Fresco

*Fresco* (meaning "fresh") was devised for painting murals. There are two types: *fresco secco* and *buon fresco*. **Fresco secco** (FRES-coh SE-koh), or "dry *fresco*," involves painting on a dry lime plaster wall. However, it is not a preferred technique because moisture can creep behind the paint and lead to peeling.

**Buon fresco** (BWOHN FRES-coh)—meaning "good or true *fresco*"—involves painting pigments suspended in water on "fresh" (thus the name), wet, lime plaster walls. As the plaster dries, the pigment sinks in and becomes an integral part of the wall, so there is no problem with peeling. After the wall dries, it gradually reacts further with the atmosphere, chemically changing into a durable surface. The lime plaster thus serves as both the support and the binder.

*Buon fresco*, usually called just *fresco*, is a complex, many-stepped process, often completed by an artist with assistants. To prepare, the artist typically begins with a small-scale drawing, and then assistants enlarge it to the exact size of the mural, creating a **cartoon**: a drawing intended to be transferred to the painting. Artists almost always start with drawings because the only way to make corrections to a *fresco* is to chisel away dry plaster and start again. The complicated process then continues with work directly on the wall (figure 6.13).

**fresco secco**  Italian for "dry *fresco*"; a technique of mural painting in which pigments suspended in a binder are applied to a dry lime plaster wall

**buon fresco**  Italian for "good" or "true *fresco*"; a technique of mural painting in which pigments suspended in water are applied to a fresh, wet lime plaster wall

**cartoon**  A full-size preparatory drawing intended for transfer to a painting, tapestry, or other work of art

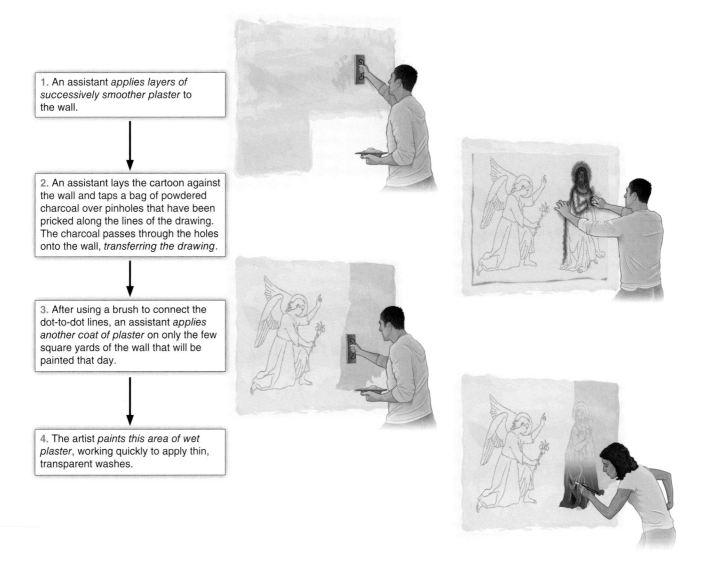

1. An assistant *applies layers of successively smoother plaster* to the wall.

2. An assistant lays the cartoon against the wall and taps a bag of powdered charcoal over pinholes that have been pricked along the lines of the drawing. The charcoal passes through the holes onto the wall, *transferring the drawing*.

3. After using a brush to connect the dot-to-dot lines, an assistant *applies another coat of plaster* on only the few square yards of the wall that will be painted that day.

4. The artist *paints this area of wet plaster*, working quickly to apply thin, transparent washes.

**FIGURE 6.13.  The *fresco* process.**

The *fresco* technique has both limitations and advantages. *Fresco*:

- *Features a limited color palette*, because not all pigments are resistant to the alkaline lime surface
- *Makes it difficult to manipulate tones*, because artists must work quickly
- *Lends itself to broad areas of color*, but not thick impastos, due to the thin wash technique
- *Is ideal for murals* because the paint is lusterless and there is no glare

The *fresco* technique has been used for centuries, and multiple civilizations developed the technique independently. In Teotihuacán (tay-OH-tee-hwah-CAHN)—the first large city-state in the Americas located in present-day Mexico—the temples and houses of the elite were decorated with *frescos*. (These types of murals inspired *The Great Wall* painters.)

Figure 6.14 shows one of these early *frescos* from the sixth century. A priest is dressed in an elaborate costume and feathered headdress. He uses the spiky leaves of the maguey plant to draw his own blood and sprinkle it on the ground as a ritualistic gift to the earth goddess in a ceremony likely intended to guarantee a good crop. Out of his mouth flows a visual representation of the words of the ritual. The subtle palette in the work, which is typical of *fresco*, is mostly limited to various shades and tints of red. The monochromatic scheme (see Chapter 3) helps unify the composition.

*Fresco* was a popular technique in fourteenth-century Italy. Giotto di Bondone (JAH-toe dee bone-DOH-nay) used the method to depict the lives of Jesus and Mary in a series of thirty-eight paintings on the walls of a simple family chapel.

In the scene in figure 6.15, angels and Christ's followers lament his death. Giotto's use of the *fresco* medium helps draw us into the suffering. The simple, broad areas of color result in a stark scene. In addition, by layering washes, Giotto was able to create the illusion of *convincing highlights and shadows*. This effect encourages the viewer to sympathize with the grief of the mourners by making the figures appear realistic with robes that hang

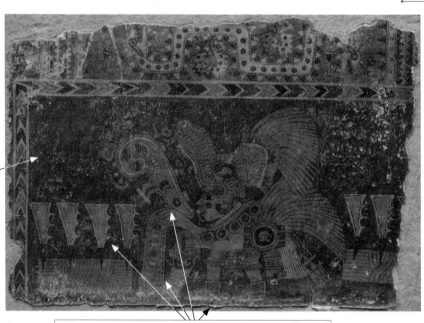

A dark, flat red area is evident in the background.

A lighter-valued red is noticeable in the maguey plants, the sprinkle of blood, the priest's words, and the priest himself.

**FIGURE 6.14.** **Elite male and maguey cactus leaves.** *From Teotihuacán, Mexico. c. 500–550 CE. Fragment of a fresco, 2' 8 ¾" × 3' 9 ¹¹⁄₁₆". The Cleveland Museum of Art, Ohio.*

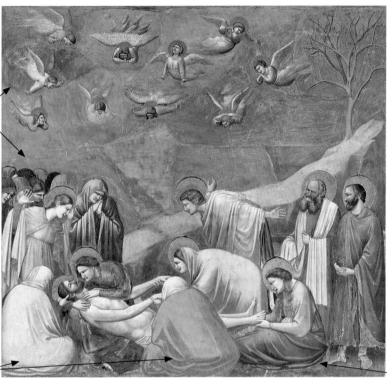

The sky is a flat, lusterless area of color. The faint lines in the sky show where sections from different days of painting meet up.

These figures' backs press up to the front of the painting, making it seem as though we stand right behind them.

Layered washes on Mary Magdalene's robe create the illusion of convincing folds, as if a real light were hitting a three-dimensional object, producing *highlights and shadows*.

**FIGURE 6.15.** **Giotto di Bondone.** *The Lamentation.* *From the Arena (Scrovegni) Chapel, Padua, Italy. c. 1305. Fresco, 6′ 6 ¾″ × 6′ ¾″.*

Interactive Image Walkthrough

in believable patterns around solid-looking bodies. The mourners also appear to exist in the shallow foreground of the picture—right near us in space. It is as if we, too, become additional mourners at the scene, as Christ is held by his mother, Mary, and she stares into his face.

Fresco is a labor-intensive and expensive process, so it hasn't often been used in more recent times. To learn about the work of one twentieth-century artist who used the technique, see *Practice Art Matters 6.2: Consider the Fresco Painting of a Modern Artist.*

*Quick Review 6.5*: What are the differences between the *fresco secco* and *buon fresco* techniques?

*Practice* **art**MATTERS

### 6.2 Consider the *Fresco* Painting of a Modern Artist

In 1932 and 1933, Diego Rivera (dee-AY-goh ree-VER-uh), working with a number of assistants, painted a series of *frescos* for the Detroit Institute of Arts. (Rivera was an activist muralist from Mexico whose works Judy Baca studied.) The United States was in the midst of the Great Depression, with people out of work and starving, and Rivera believed technology could free people from the crisis. Figure 6.16A shows many men working together in a smoothly running automobile plant. The painting seems to be a celebration of the machine: one mammoth machine, at

right, rises above the people, almost like a god. Rivera created what appears to be a harmonious, efficient world of steel and working men.

Consider these questions:

- What are the steps that Rivera and his assistants would have taken to create the mural?

- Looking at the detail in figure 6.16B, what four distinctive characteristics of *fresco* are evident in the work?

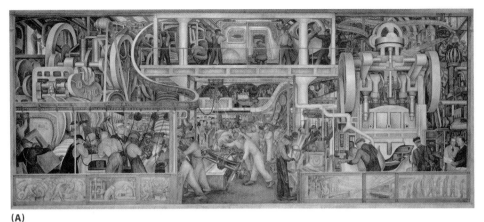

(A)                                                                                           (B)

**FIGURE 6.16A AND B (DETAIL).** Diego Rivera. *Detroit Industry,* view of the south wall, *Production of Automobile Exterior and Final Assembly.* 1932–33. Fresco, 17' 8 ½" × 45'. Detroit Institute of Arts, Michigan.

## Tempera

If you have ever made oil and vinegar salad dressing, you know that, even if you shake the bottle, after a while the oil floats to the top. This separation happens because oily and watery liquids resist each other—that is, unless you have an *emulsifier*. An emulsifier helps a watery liquid and an oily, fatty, or resinous liquid hold together by dispersing tiny droplets of one uniformly throughout the other. Milk contains an emulsifier; the butterfat doesn't separate from the watery part of the milk. Milk is a good way to understand **tempera**, a type of paint made with pigments suspended in an emulsion.

There are several kinds of tempera paints, but all include a vehicle that is an *emulsion.* The most common is made with egg yolks. Egg yolk is also a remarkably strong binder. If you have ever scrambled eggs and left the bowl to clean for later, you know that it is much more difficult to clean after it dries. Eggs can be diluted with water when wet, but once an egg dries, it becomes insoluble. For the tempera artist, this means that lower layers of paint, once dry, become a resistant film and won't dissolve or mix with other colors painted over them.

Tempera has specific characteristics that have required artists to develop certain strategies. Tempera:

- *Dries incredibly quickly,* which does not allow for blending. Artists typically apply paint in a labor-intensive technique, using short, parallel, closely lying strokes. This method gives the illusion of blending tones together, but make the paintings appear *linear, precise, and delicate.*
- *Is brittle and susceptible to cracking* when dry. Artists traditionally paint thin layers on primed, wooden boards, which yield a satin-like luminosity, making paint colors appear pale, pure, and brilliant.
- *Is translucent* and hard to cover if there are errors. Artists almost always prepare detailed drawings prior to the start of painting.

In figure 6.17A, Simone Martini (see-MOH-nay mar-TEE-nee), a fourteenth-century Italian painter, depicted in tempera the *Annunciation,* the moment when Christians believe the Angel Gabriel announced to the Virgin Mary that she was pregnant with the son of God. Gabriel's words, which are raised above the surface of the painting, stream from

**tempera** A type of paint made with pigments suspended in an emulsion; a method of painting using this paint

his mouth to Mary's ear. Silhouetted against a gleaming gold, the figures seem courtly, graceful, and weightless. Martini used tempera's *linear and translucent qualities* in his depiction, noticeable in both the painting and the detail of Gabriel (figure 6.17B).

*Quick Review 6.6*: What are the qualities of tempera paint?

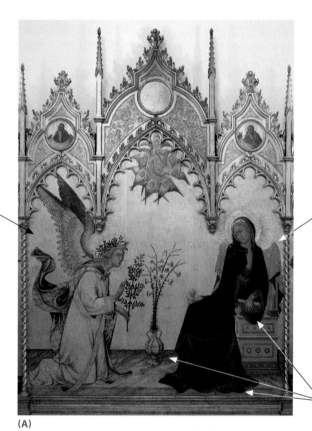

The winged Gabriel has just landed, cape aflutter. Martini's *delicate and linear* style is particularly visible in the detail of the angel.

The *delicate* Mary shrinks from the heavenly figure, her body curved with concern. She sits on a throne-like chair (an allusion to her coming role as queen of heaven), which is more ornamental than solid.

The *linear quality* is evident in the figures' long, thin hands, the ornamental intricacies such as the lilies (which symbolize Mary's purity), and the meandering edge of Mary's robe.

(A)

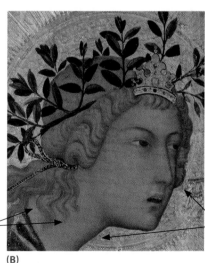

*Exact* brushstrokes form Gabriel's individual strands of hair, and a series of fine marks, *meticulously applied in rows*, form Gabriel's pale face and neck.

*Translucent*, thinly applied layers of paint form the varying tones in Gabriel's face (the pink cheeks) and neck (the green cast of the shadow).

(B)

**FIGURE 6.17A AND B (DETAIL OF GABRIEL).** **Simone Martini. *Annunciation*, central panel of the altarpiece.** *From Sienna Cathedral, Italy. 1333. Tempera and gold on wood panel, 10′ × 8′ 9″. Uffizi Gallery, Florence, Italy.*

## Oil

**oil paint** A type of paint made with pigments suspended most commonly in linseed oil; a method of painting using this paint

Oil Painting

Since its invention in the fifteenth century, oil paint has been a favorite medium of artists who create easel paintings. With **oil paint**, pigments are combined most often with linseed oil and thinned with turpentine.

One of the biggest differences between tempera and oil paints is the drying time. Linseed oil is a vegetable oil, just like cooking oils. If you have ever tried to clean a pan after frying something, you know if you don't do it well that even weeks later the pan can retain a greasy film. Oil paints also dry gradually and, as they do, they undergo a chemical transformation into a tough, durable, adherent film, which is resistant to solvents. The paint can be applied to a variety of surfaces, from wood panels to stretched canvases.

Oil paint is a fluid and flexible medium that can be:

- *Applied over long periods of time,* which allows artists to *rework areas and blend colors* that have been applied days apart into an infinitely broad range of colors
- *Applied in thin, transparent glazes* of luminous colors on white grounds, so the light can pass though the glazes and reflect back to the viewer, creating a *tonal depth, richness, and internal glow* not possible in other media
- *Built up into tactile, opaque impastos* with bold, textured brushstrokes
- *Manipulated to produce a wide range of complex effects* from broad swaths of color to intricate details

Jan van Eyck (yahn van IKE), a fifteenth-century northern European artist, used oils to create *The Annunciation* (figure 6.18A), in which—as in Martini's painting (figure 6.17A)—Gabriel appears to Mary, words streaming from his lips. However, van Eyck's figures are in a church, and he *used the qualities of oil paint to fill his painting with symbolism.*

The detail of Gabriel (figure 6.18B) allows us to contrast the qualities of oil used here with those of tempera in Martini's depiction of Gabriel (figure 6.17B). While Martini created pure, sparkling colors, he could not produce with tempera the deep luminosity that van Eyck could achieve with oil. Additionally, Martini could not blend his colors, which helps make his Gabriel appear more abstract and less realistic than van Eyck's.

Martini painted his *Annunciation* using tempera and van Eyck used oils; however, we can also compare van Eyck's painting with another in the same oil medium. To see how artists can use the characteristics of oils to create different appearances, see *Practice Art Matters 6.3: Compare Two Annunciations Created in Oil Paint.*

*Quick Review 6.7*: What are the different features of oil paint?

## Transparent Watercolor

**transparent watercolor/ aquarelle** *Aquarelle* is French for "transparent watercolor"; a type of transparent paint made with pigments suspended in gum arabic; a method of painting using this paint; a work of art produced using this method

**gum arabic** A sticky substance used in art materials, which comes from the acacia tree

With **transparent watercolor**, also called *aquarelle* (AK-wah-rell), pigments are suspended in gum arabic and thinned with water. **Gum arabic** is a sticky substance that comes from the acacia tree and is a powerful yet brittle binder. Transparent watercolor is a favorite painting medium of amateurs, children, and artists who wish to sketch quickly, because of its ease of use. However, this medium also has been used to create many final, fully developed works. Technically, the medium is easily applied directly to dampened paper, but artistically it is *one of the most complex media because it is impossible to hide mistakes.* In addition, there is no white paint, so artists must be sure not to paint those areas of the paper that they want to remain white in the final work.

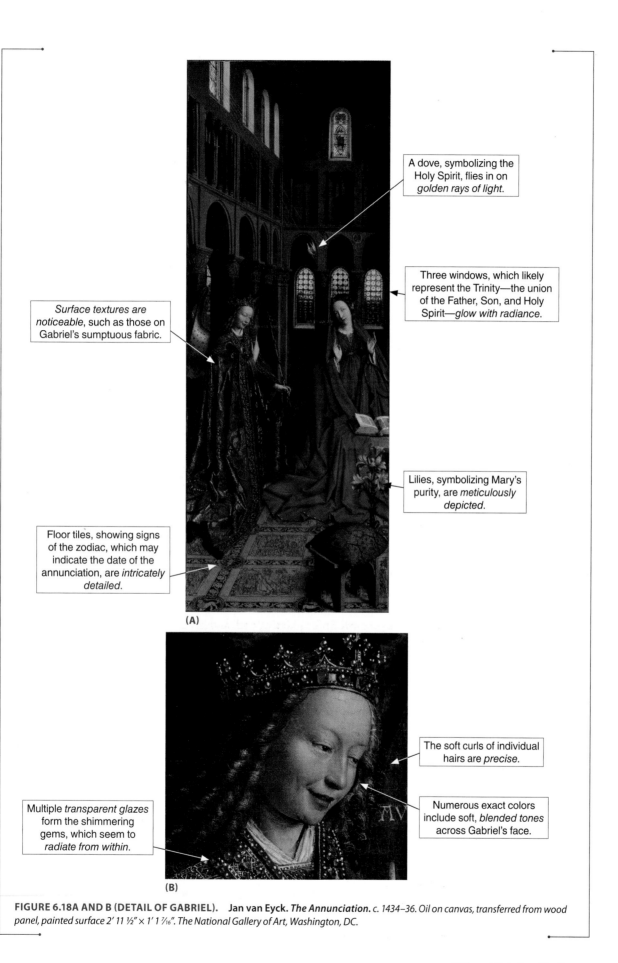

A dove, symbolizing the Holy Spirit, flies in on *golden rays of light*.

Three windows, which likely represent the Trinity—the union of the Father, Son, and Holy Spirit—*glow with radiance*.

Surface textures are *noticeable*, such as those on Gabriel's sumptuous fabric.

Lilies, symbolizing Mary's purity, are *meticulously depicted*.

Floor tiles, showing signs of the zodiac, which may indicate the date of the annunciation, are *intricately detailed*.

**(A)**

The soft curls of individual hairs are *precise*.

Multiple *transparent glazes* form the shimmering gems, which seem to *radiate from within*.

Numerous exact colors include soft, *blended tones* across Gabriel's face.

**(B)**

**FIGURE 6.18A AND B (DETAIL OF GABRIEL).** **Jan van Eyck.** *The Annunciation. c. 1434–36. Oil on canvas, transferred from wood panel, painted surface 2′ 11 ½″ × 1′ 1 ⁷⁄₁₆″. The National Gallery of Art, Washington, DC.*

## 6.3 Compare Two Annunciations Created in Oil Paint

In contrast to van Eyck's sumptuous portrayal, Henry Ossawa Tanner's *Annunciation* (figure 6.19A and B) shows an ordinary and humble Mary. Tanner, an American artist who worked in France in the late nineteenth and early twentieth centuries, placed Mary in a plain robe sitting in an unassuming room. She is visited by a mysterious sacred force that appears only as a luminous form.

Compare van Eyck's painting to Tanner's:

- How do the artists' brushstrokes differ?
- What is the difference in the level of detail in the paintings?
- What are the different hues, values, and intensities of the colors (see Chapter 3) that the artists used?

**FIGURE 6.19A AND B (DETAIL OF MARY).** **Henry Ossawa Tanner,** *Annunciation.* 1898. *Oil on canvas, 4' 9" × 5' 11 ¼". Philadelphia Museum of Art, Pennsylvania.*

(A)
(B)

Watercolor has a number of characteristics. The paints:

- *Look matte with a bright, clear, and light-filled color*, because they are made with not much binder and are usually painted on white paper, which allows light to reflect back from the surface
- *Are often spread in lean, broad washes* that may be brushed on loosely or built up in layers to create depth
- *Can be applied in controlled, precise marks*
- *Cannot be blended easily*, because they dry quickly; however, overcoats may pick up pigment from lower layers, because the paint is resoluble

American artist Winslow Homer made use of the fluid and expressive qualities of watercolor in a fresh, spontaneous, and grand image (figure 6.20) from 1900. Homer's soft-edged washes are diffuse. The transparent paint is well suited to impressions of the vivid, brilliant blue water, the smoky light in the gray sky, and the shadows of the dark foreground. Homer laid on soft washes of darker colors and pale tints with confident, broad strokes of his brush. Even the dense application of dark colors is not quite opaque.

By contrast, figure 6.21 illustrates a watercolor painting of another American artist, Ralph Goings. His works rival those of a photograph in their realism. Goings shows the intricate detail possible with watercolors in his view of an ordinary diner. Goings's careful, disciplined approach distinguishes the distinct texture of plates, clothing, and stools. The

FIGURE 6.20. **Winslow Homer.** *Bermuda.* *1900. Watercolor on paper, 13 ½″ × 20 ½″. Philadelphia Museum of Art, Pennsylvania.* Homer's work shows the transparent, sweeping washes and brilliant, clear color of watercolor.

FIGURE 6.21. **Ralph Goings.** *Diner 10 A.M.* *1986. Watercolor on white wove paper, 12 ⅞″ × 19 ⅛″. Mary and Leigh Block Museum of Art, Northwestern University, Evanston, Illinois.* Goings shows how watercolor can be used to represent a scene with multiple objects in incredibly detailed and precise terms.

bright characteristics of the watercolors also enhance his depiction of light reflecting off the many shiny surfaces, showing how he can find beauty and interest in an everyday scene.

*Quick Review 6.8*: What are the characteristics of transparent watercolor paints?

## Gouache

**Gouache** (gwahsh) is created by adding chalk and additional binder (traditionally gum arabic) to watercolor paints. Watercolor and gouache share many characteristics; however, the handling and effects of the media are quite different. Like watercolor, gouache:

- *Is painted on a paper support*
- *Dries quickly*
- *Can be painted precisely*
- *Can be thinned* to create semitranslucent areas

Unlike watercolor, gouache:

- *Is opaque, robust, and dense*, so artists can paint over items they want to change or apply broad, flat, saturated areas
- *Is blended by hatching*
- *Offers a white paint*

Jacob Lawrence, a twentieth-century American artist, used gouache in both broad, opaque shapes and thinned, mottled areas (figure 6.22). Lawrence often painted African American experiences, and this work is from a series about life in Harlem. Lawrence gave each painting a narrative title. In *You Can Buy Bootleg Whiskey for Twenty-Five Cents a Quart*, the table, which angles precariously toward us, indicates a three-dimensional space. However, the figures are flattened by the dense paint, which leads to a shifting instability that seems to mirror the subject matter.

**gouache** Opaque watercolor; a method of painting using this paint

**artists**
MATTER

Jacob Lawrence

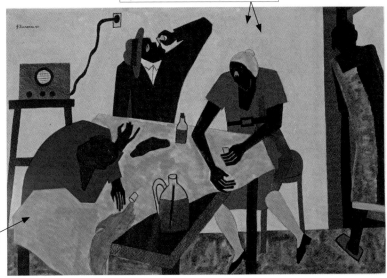

Flat, bold shapes of color make up the wall and this figure's dress.

Mottled areas are evident in the tablecloth.

**FIGURE 6.22.** **Jacob Lawrence.** *You Can Buy Bootleg Whiskey for Twenty-Five Cents a Quart.* *From the series "Harlem." 1943. Gouache on paper, 15 ⁷⁄₁₆" × 22 ½". Portland Art Museum, Oregon.*

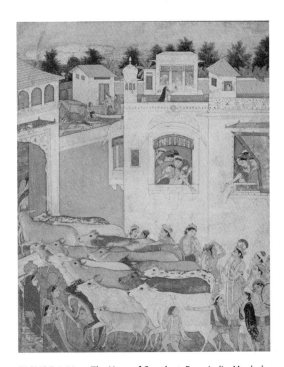

**FIGURE 6.23.** *The Hour of Cowdust. From India. Mughal period, c. 1810–15. Gouache and gold on paper, 14 ¹⁵⁄₁₆" × 12 ⁹⁄₁₆". Museum of Fine Arts, Boston.* This village scene illustrates the fine lines possible with gouache, in which the artist has portrayed precise details down to the individual beads around Krishna's neck.

**miniature** A small, independent painting

A nineteenth-century Indian **miniature** (figure 6.23), a small, independent painting, illustrates gouache's capacity for fine lines and specifics. In the Hindu religion, the faithful believe that gods can assume many forms and coexist with everyday people. Here, the cow herdsman Krishna, the human incarnation of the god Vishnu, walks through a village, playing a flute. The fine details on his peacock crown and yellow robe are captured with the gouache medium. Krishna enchants women, who gaze at him from under their water jugs and reach out to him from windows. While the painting creates a sense of space, the gouache paint also contributes to the flat, stylized approach.

*Quick Review 6.9*: How is gouache similar to and different from transparent watercolor?

## Acrylics

**Acrylics** are made with pigments suspended in an emulsion of synthetic resins (a liquid form of plastic) dispersed in water. They are *easy to use* because they are thinned with water and *can be applied directly to supports*. When the paint dries, acrylics undergo a chemical reaction and become an insoluble, continuous film. Baca used acrylic paints on *The Great Wall.*

Acrylics are durable and versatile. Acrylics:

- *Can be manipulated to function like other paints*, so they may be applied with rugged brush strokes like encaustic, in thin washes like watercolors, in opaque fields like gouache, or in transparent glazes like oils
- *Are quick drying*, so can be layered like tempera

- *Cannot be blended* as oils due to the quick drying time
- *Permit hard-edged lines*

**acrylic** A type of paint made with pigments suspended in a synthetic emulsion binder; a method of painting using this paint

While acrylics have few limitations and can impersonate the effects of other paints, they are not exact replicas of the appearance and characteristics of other painting media. In addition, painters have developed techniques to exploit the qualities of other media. Because of acrylics' versatility, some people feel that the medium lacks a strong personality of its own.

Nonetheless, many painters have used acrylics in a variety of effective ways. Twentieth-century American artist Helen Frankenthaler poured diluted acrylic onto unprimed canvases placed on the floor. The lean color soaked into the raw fabric creating a stained, flat effect that mirrored the characteristics of watercolor. The paintings seem to feel accidental and take organic forms. In figure 6.24, the clear, rich color and decorative shapes draw our attention. It is only when we consider the title *The Bay* that we learn the work is based on an aerial view of water.

Other artists have used acrylics' broad areas of color and crisp edges. Roger Shimomura employed this slick look to depict the outrageous violation of civil rights that occurred when Japanese Americans were incarcerated during World War II (the same period portrayed in *The Great Wall* in figure 6.3). Figure 6.25 shows a four-panel painting of the Minidoka Internment Camp, where Shimomura and his family were held.

The opaque acrylic blocks out everything behind it. This effect is particularly apparent in the black, menacing storm clouds that hang low and intermingle with the camp buildings. These flat and unvarying clouds with exactly formed edges appear like black holes that have been torn from the image, just as those interned had their own lives torn apart.

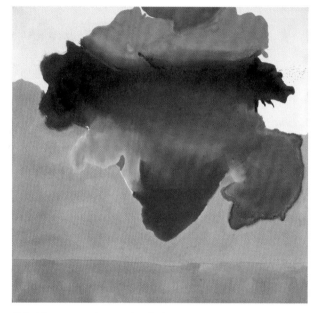

**FIGURE 6.24.** Helen Frankenthaler. *The Bay.* 1963. Acrylic on canvas, 6′ 8 ¾″ × 6′ 9 ¾″. Detroit Institute of Arts, Michigan. To create the fluid effect in the painting, Frankenthaler poured acrylic onto raw canvas.

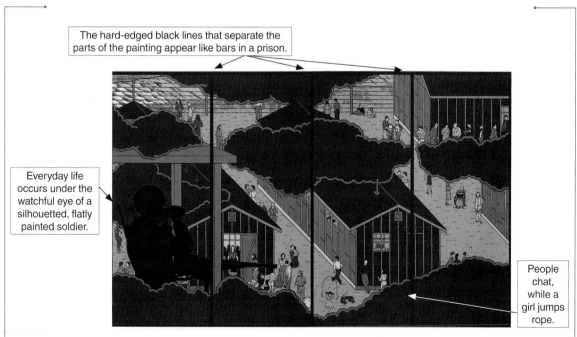

The hard-edged black lines that separate the parts of the painting appear like bars in a prison.

Everyday life occurs under the watchful eye of a silhouetted, flatly painted soldier.

People chat, while a girl jumps rope.

**FIGURE 6.25.** **Roger Shimomura.** *American Infamy.* 2006. Acrylic on canvas, 5′ × 8′. Nerman Museum of Contemporary Art at Johnson County Community College, Overland Park, Kansas.

Interactive Image Walkthrough

Finally, some artists have been attracted to acrylics because they can mimic the effects of other media. In the 1970s, American Susan Rothenberg, who had been an oil painter, switched to acrylics when she had a child because it was easier to clean up. During this period, Rothenberg painted a series of images of horses; figure 6.26 depicts a huge one of these paintings called *Red Banner*. Rothenberg's brushwork is reminiscent of oils, giving the painting a thick texture and bold color scheme. These features, along with the horse's undefined position in space next to the nonrepresentational forms, seem to make the horse appear as one more shape on the surface.

*Quick Review 6.10*: In what ways do acrylic paints mimic the effects of other paints?

## Digital Painting

Technology enables artists to produce a variety of painterly effects. Computers and apps can be used *for designing and printing what appear to be traditional paintings* and *for creating codes that form paint-like digital works*.

The American artist Wade Guyton formed what looks like a large, geometric painting in figure 6.27. He used type on his computer to create a pattern of *X*'s, then printed the image onto linen that he ran through an inkjet printer. In order to produce an image that was wider than the printer, Guyton folded the linen and ran it through the printer twice, so it would print on both halves of the fabric.

While we may think that machine-made images are more "perfect" than those made by hand, Guyton's digitally derived paintings have "flaws." Because the two sides of the fabric were printed separately, the *X*'s do not line up. Similarly, smears caused by the

**FIGURE 6.26.   Susan Rothenberg. *Red Banner.*** *1979. Acrylic on canvas, 7′ 6″ × 10′ 3 ⅞″. The Museum of Fine Arts, Houston.* Rothenberg's horse, depicted with heavy, textured brushstrokes, shows how acrylic can mimic the characteristics of oil paint.

fabric's being caught in the printer are also evident. These imperfections seemingly bring Guyton's work more in line with traditional painting where we are used to seeing the hand of the artist.

California-based Camille Utterback also uses the computer, but to create digital, painting-like images. Utterback's works use computer code to translate the movements of viewers into patterns of colors that are projected onto surfaces. In *Entangled*, she hung a set of back-to-back scrims (fabrics) across a room. Viewers were encouraged to stand on either side of them; as the viewers moved, their gestures (figure 6.28A) were translated into moving colors, lines, and shapes that were projected onto the scrims (figure 6.28B). Because the scrims were translucent, participants could see not only their own movements, but also those of other participants on the other side. The juxtaposition kept the human touch present alongside the technology.

Guyton and Utterback's works *challenge a traditional understanding of painting* in which we expect an artist to apply fluid color to a two-dimensional surface directly. While Guyton applies color to a surface, the effect that feels handmade is actually created by a machine. In Utterback's work, much of the imagery is made by people other than the artist. Yet, both artists' works can feel like they belong in the painting medium because of the final appearances of the images, the sense of the human touch, and the messages they express.

**FIGURE 6.27.** **Wade Guyton.** *Untitled*. *2010. Epson UltraChrome inkjet on linen, 7′ × 5′9″.* Imperfections in Guyton's work are particularly noticeable in the blue X that has smears of ink rising from its form.

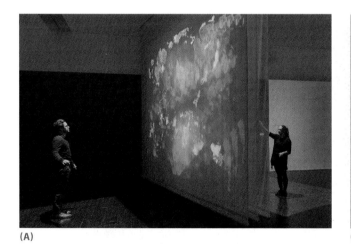

(A)

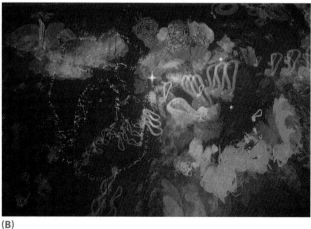

(B)

**FIGURE 6.28A AND B (DETAIL OF SCRIM).** **Camille Utterback.** *Entangled. From the installation "New Experiments in Art and Technology" at the Contemporary Jewish Museum, San Francisco. 2015. Custom software, computer video cameras, projectors, scrims, lighting, two 6′ 9″ × 12′ projections.* Utterback's works involve viewers' movements in the process of creation (6.28A). Her images appear like paintings even though she uses no paint (6.28B).

*Quick Review 6.11*: Do you think digital painting should be considered a type of painting?

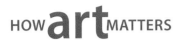

## A Look Back at *The Great Wall of Los Angeles*

*The Great Wall of Los Angeles* stands as a testament to the advantages of *numerous people working together on a common goal* and the *power of painting to tell stories*. The mural also offers examples of the characteristics, techniques, and styles of the medium of **painting**.

In creating her work, Baca understood the specific requirements of an unmovable **mural** that would not be seen from straight on and that had to contend with flood waters and weather. She was knowledgeable about how the paint was formed from **pigment** and a **vehicle** of synthetic resin and water. She also made decisions regarding the number of layers of the painting. In *The Great Wall*, the muralists started with the wall support, **primed** the wall, transferred the drawing to the wall, added a layer of paint to unify the color palette, applied a base coat of color and darker and lighter colors on top, and finished with a sealer. Baca further chose to use *brushes as tools*, knowing the effect they would have on the surface, and she directed the muralists to *apply the paint in layers*, so they could *create highlights and shadows* and form the illusion of three-dimensional forms. Finally, she *communicated a message*. As a Mexican American, Baca understood the tradition of Mexican mural painting and the power that murals have for expression.

Baca also *chose her medium to address the goals of the project*. **Acrylic** was an ideal medium for the inexperienced muralists. It is *simple to clean up*, because it is thinned with water. It can be *applied opaquely*, which meant mistakes could be painted over. It *dries quickly*, so work could proceed rapidly. Acrylic *met the artistic needs of the project*, because it could be layered and allowed for hard-edged lines to distinguish forms and figures. Last, acrylic *satisfied the requirements of the outdoor location* because the paints were *relatively durable* and could be *laid on thinly* (so the mural could be seen from different locations).

Painting gave Baca's young muralists the ability to beautify their city, display their cultural heritage, and communicate the unheard stories of the past. The painting also fostered change by having rival gang members cooperate, and it encouraged community pride. The young muralists had a major impact on the painting, but equally important is the impact that the mural has had on them and those who have had a chance to experience it.

As you move forward from this chapter, consider *the role that art plays in educating people*. The young muralists helped create a mural that enabled them to teach others about the past, all while learning about their own history and themselves. In the process, the muralists *acquired life skills* related to creativity, work ethic, collaboration, and problem solving. As is the case in many art classes, the art-making experience was also *inclusive*—with painters from different backgrounds and abilities participating and learning side by side. We also saw this communal effort in *Detroit Industry* (figure 6.16A), where Diego Rivera collaborated with a number of assistants to create a **fresco**. In fact, *many art forms*, such as film, sculpture, and architecture, *can require collaboration, foster teamwork, build acceptance*, and *provide a learning environment*, whereby people who are skilled impart instruction to those with less experience about art and life.

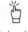

Flashcards

## CRITICAL THINKING QUESTIONS

1. Is Joan Mitchell's work (figure 6.9A) a mural or an easel painting? How do you know?
2. What are the two ingredients in the vehicle of watercolor and what does each ingredient do?
3. Why don't artists who create murals in *buon fresco* use a size?
4. Did Susan Rothenberg (figure 6.26) use impasto in her work? How do you know? Is impasto considered actual or simulated texture (see Chapter 3)?
5. In what ways are the characteristics of encaustic similar and different from oil paint?
6. The *Great Wall* painters applied paint on top of the wall, rather than in a *buon fresco* technique. What kind of concerns might this mural have faced in the years after it was produced?
7. In what way is tempera similar to a drawing technique like pen and ink (see Chapter 5)?
8. How is Homer's *Bermuda* (figure 6.20) similar to Frankenthaler's *The Bay* (figure 6.24) with regard to media, subject matter, and form?
9. If you had to do a painting project for a class, which painting medium would you choose to use? Why?

Comprehension Quiz

Application Quiz

# Printmaking

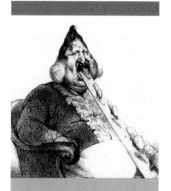

DETAIL OF FIGURE 7.2.
The art of printmaking produces multiple originals and is, therefore, ideal for spreading ideas. Here, Honoré Daumier used printmaking to persuade people that the king of France was unfairly taking money from the poor—Daumier formed the king literally eating sacks of coins.

## LEARNING OBJECTIVES

**7.1** Identify the factors that make printmaking an indirect, two-dimensional art.

**7.2** Explain why printmaking is so often a collaborative process.

**7.3** Discuss why printmaking is ideal for sharing images and ideas with large masses of people.

**7.4** Detail some of the reasons artists might choose to create prints over other art forms.

**7.5** Compare and contrast three relief printmaking methods.

**7.6** Distinguish between intaglio methods that use a cutting tool to create matrices and those that use acid.

**7.7** List the range of effects possible with lithography.

**7.8** Discuss how screenprinting improved upon traditional stencil methods.

**7.9** Summarize some new directions in printmaking.

# THE PRINTS OF HONORÉ DAUMIER

It was July 27, 1830, and Paris was in an uproar. King Charles X had dissolved the legislature, censored the press, and reduced the number of eligible voters to twenty-five thousand men. The lower and middle classes revolted, and after three days of fighting, with seven hundred dead, Charles fled the country. Within a week, middle-class politicians declared a new king, Louis-Philippe. The king moved quickly to champion the middle class who supported him, but he effectively shut out the lower class. Twenty-eight million people could not vote, and conditions for the poor were abysmal.

How Art Matters

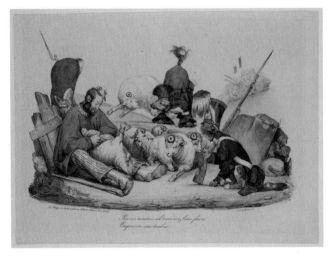

**FIGURE 7.1.** Honoré Daumier. *Poor sheep oh! You struggle in vain. You will always be fleeced. 1830. Lithograph, 10 ⅛" × 13 ⅞". Detroit Institute of Arts, Michigan.* In Daumier's first attack on the king, Louis-Philippe is a shepherd shearing the citizen sheep, as a loyal soldier dog stands by. After being printed, this image was hand-painted to add color.

## *La Caricature* and the First Attack on the King

Although there were still censors, Louis-Philippe had passed new laws that guaranteed the freedom of the press. Critics of the king took advantage of this new freedom, establishing important new newspapers reflecting the popular sentiment of the working class. One such newspaper was *La Caricature*, which was founded in November 1830 and included articles and political cartoons. Every week, the printer posted a copy of the paper in the print shop's window, *so it was accessible* to those who could not afford to purchase the paper. Many of the poor were illiterate, and so it was the cartoons that *communicated ideas to the masses.*

One of the artists who created cartoons was Honoré Daumier (ohn-ohr-AY dohm-mee-YAY). In December of 1830, Daumier produced his first attack on King Louis-Philippe (figure 7.1). It shows Louis-Philippe, as a shepherd, shearing the lower-class citizens of France, represented as sheep. The king says, "Poor sheep oh! You struggle in vain. You will always be fleeced." The message was obvious: the poor would never enjoy the same power as the upper class.

### The Printmaking Process

Daumier *worked collaboratively* with a printer to reproduce his artwork through a printmaking technique called *lithography*. Using an oily crayon, Daumier drew on a *flat*, smooth stone. A printer then prepared the stone and washed it with water; Daumier's greasy crayon marks repelled the water, while the background of the drawing was dampened. When the printer applied ink, it conversely adhered to the crayon marks, but was repelled by the water-soaked background, because water and oil don't mix. The printer then pressed a paper to the stone, printing the drawing and, thereby, *transferring the design to a paper* in reverse. If approved by the artist and a government censor, the image could easily and inexpensively be *reproduced in multiple copies* by reinking and pressing additional papers to the stone. While Daumier worked on the stone, we consider the *actual artworks to be the multiple printed papers.*

### More Attacks on the King

Louis-Philippe originally found the cartoons amusing, but throughout 1831, the situation deteriorated. While the working poor lived in squalor earning roughly 750 francs a year,

the king's salary was eighteen million francs. Newspapers mounted continued attacks, and Louis-Philippe soured on what were now full-fledged assaults.

The police began daily raids of *La Caricature's* print shop and the government levied steep fines. However, Daumier was not intimidated. He continued to produce attacks on the king, including the one in figure 7.2, created in December 1831. Here, Louis-Philippe is portrayed as Gargantua, a giant character from a novel. The enormous king dwarfs the tiny people, who suffer or profit around him. The lithographic crayon allowed Daumier to form *detailed lines* and *gradations of tones* to describe the scene.

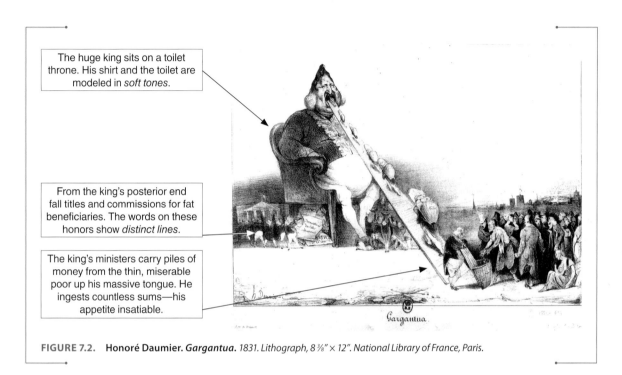

The huge king sits on a toilet throne. His shirt and the toilet are modeled in *soft tones*.

From the king's posterior end fall titles and commissions for fat beneficiaries. The words on these honors show *distinct lines*.

The king's ministers carry piles of money from the thin, miserable poor up his massive tongue. He ingests countless sums—his appetite insatiable.

**FIGURE 7.2.** **Honoré Daumier.** *Gargantua. 1831. Lithograph, 8 ⅜" × 12". National Library of France, Paris.*

The print caused a sensation! The police raided the print shop, seized all copies, and destroyed the printing stone. Eventually, after still more cartoons, Daumier was imprisoned. Yet, when he left prison in 1833, he was eager to carry out more attacks.

In the highly charged environment, the government pressed on, enacting other restrictions, and the people rioted, setting up barricades. Then, on April 14, 1834, someone fired shots at troops dismantling a barricade on Transnonain Street. Furious, the soldiers stormed into a tenement house and massacred nineteen civilians including children.

At the young age of twenty-six, Daumier responded in what many consider to be one of the greatest prints of all time (figure 7.3). There is no caricature here. Using the *unique qualities of lithography*, Daumier formed a starkly realistic scene. The troops have gone. There is only the morning after. A dead working-class man, in his nightshirt, has fallen on his dead child. Pools of black blood surround them. An elderly man lies dead to the right, and a woman in the back shadows at left. Light streams into the hauntingly silent room, causing intense highlights and shadows. Strong compositional lines point to the worker, the eternal

**FIGURE 7.3.** **Honoré Daumier.** *Rue Transnonain (Transnonain Street), 15 April 1834. 1834. Lithograph, 13 ½" × 20 ¼". The Los Angeles County Museum of Art, California.* It is amazing to see the progression of Daumier's prints over the short period from 1830 to 1834. The subtlety of this print, in which Daumier appears to attack no one, since those responsible are absent, arguably makes a more powerful statement than those of the earlier caricatures.

victim of government aggression. When the printer displayed the image in the window, throngs of angry citizens lined up to see it. The government immediately ordered all prints confiscated and the stone destroyed.

## Silencing the Press

In July of 1835, an attempt was made to assassinate Louis-Philippe. While the king escaped unharmed, he now had the excuse he needed to silence the press. In August, Daumier drew a touching cartoon for *La Caricature*, in which he lamented what had gone wrong in the five short years since July 1830 (figure 7.4).

Three shocked and disheartened martyrs from the fighting of 1830 emerge from their grave to view the world of 1835. Behind them is a column with the words "Morts pour la Liberté" (Death for Liberty).

The church does nothing as the government moves against the people.

The military chases the lower class.

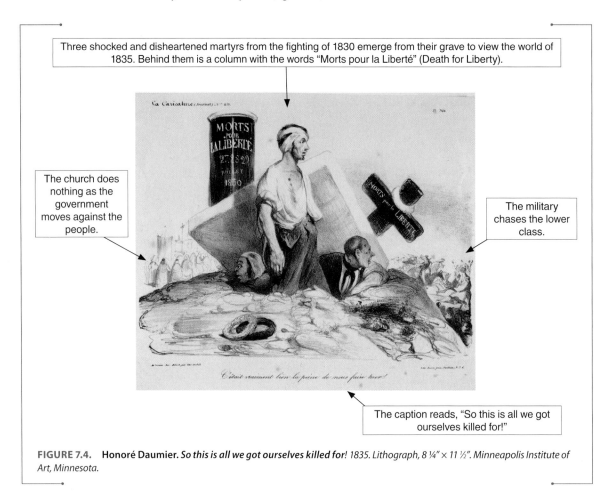

The caption reads, "So this is all we got ourselves killed for!"

**FIGURE 7.4.** **Honoré Daumier.** *So this is all we got ourselves killed for!* 1835. Lithograph, 8 ¼″ × 11 ½″. *Minneapolis Institute of Art, Minnesota.*

When new press laws passed in September, *La Caricature* was forced to fold. Louis-Philippe ruled for thirteen more years until the Revolution of 1848 finally toppled him.

## The Power of the Print

In reflecting on this story, consider that Daumier, a lower-class artist, challenged a king. The government was so afraid of Daumier's visual message that it shut him down completely. Remarkably, the captions on the lithographs were never really necessary, because the *images themselves powerfully conveyed their message*. In a world filled with illiterate masses, Daumier's prints drove the passions of the people. In this respect, Daumier's art illustrates the power of prints and of all art forms that can, by their nature, be *produced in multiples* and *distributed to and seen by many*. This chapter will explore many of the printmaking issues raised in the story of Daumier's lithographs. Before moving forward, based on this story, how would you describe the art of printmaking? Why is lithography such a practical method for creating prints?

# What Printmaking Is

Have you ever tracked mud on a floor when wearing sneakers? Ever had a package stamped "First Class"? Ever used stencils to create letters on a report? Ever heard of an arrestee being fingerprinted? Each of these actions is a form of making prints. Artists have also used printmaking to create art for centuries.

## An Indirect, Two-Dimensional Art

**Printmaking** is the technique of creating a design on a **matrix** or **plate** and transferring that design to a surface. The image made through this process is called a **print**. The art of printmaking is *indirect*: the artist works on the matrix that will create the work of art rather than on the work itself. The matrix can be made out of a variety of materials such as stone (as with Daumier's lithographs), wood, metal, linoleum, glass, or another material. The artist uses tools specific to the process—Daumier used a lithographic crayon—to create the design. Once the matrix is complete, the artist or a printer applies fluid pigment to the matrix and presses it onto a surface, creating an **impression**, which is one print out of the total number that will be pulled.

Prints are *two dimensional*. While many matrices are three-dimensional, the prints that they create are flat. Consider your sneakers. If you turned them over, you would notice that there are grooves that give them depth. However, if you were to walk through mud and then on a floor, the prints you would create would be two-dimensional. The same is true for art prints.

Artists can use different fluid pigments (such as paints) to transfer a design, but they most often use ink. While colored inks can be used with any of the different printmaking techniques, like with drawing, printmaking is an art form that often lends itself to smaller works created in black and white. In addition, many prints have a linear quality where tones are created with hatching, crosshatching, and **stippling** (a technique in which tiny dots are closely spaced to darken an area to suggest tones).

Also similar to drawing, while artists can make prints on different surfaces, they most often make prints on paper. Different papers with different absorbencies, weights, and textures affect the final look of the print (see Chapter 5).

**printmaking** The technique of creating a design on a matrix and transferring that design to a surface

**matrix/plate** In printmaking, the surface that the artist manipulates that will create the print

**print** An image made by an artist's creating a design on one surface and transferring that design to another surface

**impression** A single print out of the total number of prints pulled from a printmaking matrix

**stippling** A technique in which tiny dots are closely spaced to darken an area to suggest tones

*Quick Review 7.1*: What are the factors that make printmaking an indirect, two-dimensional art?

## A Collaborative Process

Daumier did not work alone. His publisher often contributed ideas, and the printer prepared and printed the stones. Printmaking is frequently, but not always, *a collaborative process*. A number of techniques require complex mixtures of chemicals and large, expensive presses. Often artists work with skilled printers to create a work of art. In addition, it is often more efficient to produce prints with multiple people taking on different roles.

Nowhere was this collaborative atmosphere more systematic than in the early modern period in Japan. Prints were in high demand, and so a system was devised to mass-produce them:

- A *publisher* came up with an idea.
- An *artist* created a brush and ink design to be copied that included color suggestions.

**FIGURE 7.8.** **José Guadalupe Posada.** *A Jig beyond the Grave.* *After 1888. Relief engraving, 4 15/16″ × 8 5/16″. The Museum of Modern Art, New York.* This print of *calaveras* or skeletons illustrates the folk courtship dance better known as the Mexican Hat Dance.

satirical songs and stories. The sheets were sold at markets and fairs for a few pennies each, allowing people from all classes to own original prints. *A Jig beyond the Grave* (figure 7.8) shows a favorite Posada theme of *calaveras*, or skeletons, which were associated with the Day of the Dead. During this festive holiday, which occurs around Halloween, Mexicans remember the souls of the dead with macabre symbols.

*Quick Review 7.3*: Why is printmaking ideal for sharing images and ideas with large masses of people?

**FIGURE 7.9.** **Francisco Goya.** *The Sleep of Reason Produces Monsters.* *Number 43 from the series "Los Caprichos." 1799. Etching and aquatint, 10 ¾″ × 7 11/16″. Ackland Art Museum, University of North Carolina, Chapel Hill.* Goya used printmaking techniques to create effects that seem creepy and nightmarish.

## An Art Form

Artists often choose to create prints because of *printmaking's unique qualities.* The matrices, tools, and pressure of a press create unique effects often not possible with painting or drawing. Moreover, many artists are also attracted to the *uncertainty of creating a print.* The indirect process means that the artist doesn't know what the print will really look like until it is pulled.

*The Sleep of Reason Produces Monsters* (figure 7.9) is one of eighty prints from a series called "Los Caprichos" ("The Caprices") produced in the late eighteenth century. In the images, Francisco Goya (frahn-SISS-koh GOY-ah) satirically criticized the corruption of the Spanish government and church. Here, while reason, personified as a man (likely the artist), sleeps, terrifying monsters and disturbing animals lurk and fly free. The particular grainy effect of the gray, foreboding sky, the stark contrasts of dark and light, the absence of any gradations of tone, and the vigorous lines are all characteristic of the printmaking techniques Goya employed.

In addition to exploring the appearance of prints, another way to explore the creative and artistic processes of prints is to consider **states**. Unlike final prints, pulled after a matrix is complete for a numbered edition, states are progressive **proofs**, trial prints, pulled in the midst of creating a matrix to see how a print is shaping up. *States allow for a unique look at the artist's method* and the *intermediary stages of printmaking* to see how a matrix changed and developed as the artist worked (see *Practice Art Matters 7.1: Compare Two States*).

**state** A proof stage of a print pulled while the plate is being developed to see how the plate is shaping up

**proof** A trial print made before the regular edition is pulled

*Quick Review 7.4*: What are some reasons that artists might choose to create prints over other art forms?

## 7.1 Compare Two States

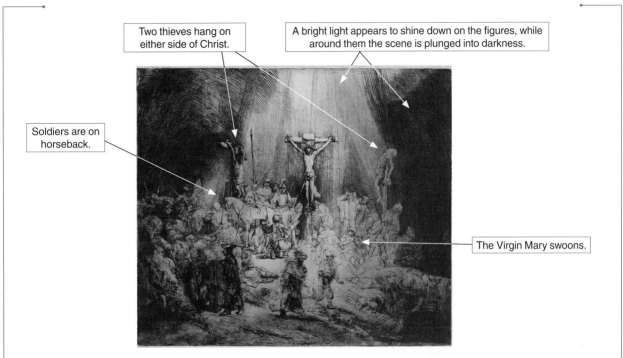

Two thieves hang on either side of Christ.

A bright light appears to shine down on the figures, while around them the scene is plunged into darkness.

Soldiers are on horseback.

The Virgin Mary swoons.

**FIGURE 7.10.** **Rembrandt van Rijn.** *Christ Crucified between the Two Thieves (The Three Crosses),* **second state.** *1653. Drypoint and engraving, 15 ⅛″ × 17 ¹¹⁄₁₆″. Museum of Fine Arts, Boston.*

We can see Rembrandt's creative process in two states of *The Three Crosses*. The images depict the moment when Jesus, crucified between two thieves, calls out to the Lord. In both states, heavenly light streams from above.

Consider Rembrandt's artistic journey. The second state shows a stark contrast between light and dark areas and a straight, realistic depiction with many distinguishable people crowding the scene (figure 7.10).

The fourth state, by contrast, seems to show a more intense spiritual and emotional moment (figure 7.11). The inner luminosity of the print appears to add to the holiness and mystery. Consider how Rembrandt changed the matrix for the fourth state to create this effect by answering these questions:

- What did Rembrandt do to the values shown throughout the image?

- What did Rembrandt do to the original detail?

- What did Rembrandt add to the surface of the matrix to change the value and detail? (Hint: There are tons of these across the surface.)

- How has the emphasis changed in the image, given the modifications that Rembrandt made from the second state to the fourth?

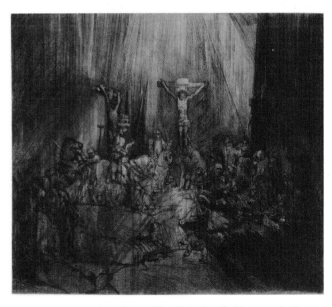

**FIGURE 7.11.** **Rembrandt van Rijn.** *Christ Crucified between the Two Thieves (The Three Crosses),* **fourth state.** *1653–55. Drypoint and engraving, 15 ¹⁄₁₆″ × 17 ¾″. Philadelphia Museum of Art, Pennsylvania.*

# Different Printmaking Techniques

There are four different printmaking techniques. Daumier drew on stone, yet Utamaro's matrix was carved on wood (figure 7.5). Printmaking methods are classified by the characteristics of their matrices:

- In *relief*, prints are made by printing from a *raised surface*.
- In *intaglio* (in-TAHL-yoh), prints are formed by printing from an *incised surface*.
- In *planographic*, prints are produced by printing from a *flat surface*.
- In *stencil*, prints are made by printing *through a surface*.

These matrices correspond to the four printmaking methods (figure 7.12). Artists have also explored new directions in printmaking in recent years.

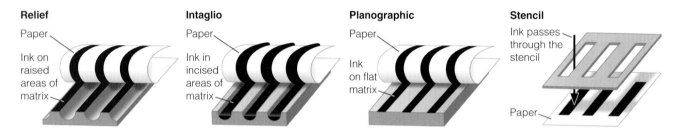

**FIGURE 7.12.** **The four printmaking methods.**

## Relief

<div style="float:left; width:30%;">

**relief** A matrix in which the raised areas on the surface hold the ink and print and the areas that are carved away do not print; a printmaking technique using this matrix

</div>

With **relief** printing, the raised areas on the surface hold the ink and print, and the areas that are carved away do not print. Relief matrices can be made from a number of materials such as wood, metal, linoleum, and stone. Schoolchildren sometimes carve matrices made from raw potatoes. Your sneakers are good examples of relief matrices. The part of the sneaker that creates the print is raised above the grooves that do not print.

To create a relief print, an artist:

1. *Carves away anything on the matrix that s/he doesn't want to print*, leaving the areas on the matrix that are to be printed as untouched original surface
2. *Rolls the completed matrix with a thick, sticky ink* that won't spread into the carved-out areas
3. *Presses a paper to the matrix*, so that when the paper is lifted, the design is printed on the paper in reverse

We will discuss three relief printmaking methods. These include *woodcut*, *wood engraving*, and *linocut* (table 7.1).

| TABLE 7.1: | Relief Methods. |
|---|---|
| **Relief Method** | **Description** |
| Woodcut | The background of a design is cut away on a wood-block plank, so that the lines of the image remain raised and will print. |
| Wood engraving | The lines of a design are cut away on an end-grain wood block, so that the background of an image remains raised and will print. |
| Linocut | The background and/or lines of a design are cut away on a piece of linoleum, so that any areas of an image that remain raised will print. |

## Woodcut

Woodcut is the oldest form of printmaking. The *Diamond Sutra* (figure 7.7) is the oldest known print on paper and was created with woodcut in the ninth century, but Middle Eastern fabrics printed from wood are known from as early as the fifth century. With **woodcut**, the artist cuts away areas around the lines of a design on a wood-block plank. Because the background is cut away, the design is left in relief (figure 7.13).

Woodcuts have a distinct look. The prints:

- *Feature only dark lines and white backgrounds* because there is no in-between with woodcut (what is raised gets printed and what is below does not)
- *Include lines of varying thickness* because the artist cuts the area around the lines
- *Contain hatch marks* when there is modeled form because the artist cannot create tones with the technique

The *type of wood* an artist uses also affects the appearance. Woodcuts can have sharp lines, tightly controlled detail, and flat areas of ink (if they are printed from a close-grained, hard wood) or carved wide cuts and the texture of the wood grain (if they are printed from a broad-grained, soft wood).

Woodcut flourished in the fifteenth century in Europe. *The Four Horsemen* is one of fifteen illustrations from this period that Albrecht Dürer (AHL-brehkt DUR-uhr), a German artist, created for the last book of the New Testament, the Apocalypse of St. John. Dürer depicted the day at the end of time. The print, which

**woodcut** A relief printmaking technique carved on a wood-block plank, in which the areas around the lines of a design are cut away, leaving the lines to hold the ink and print; a print created using this technique

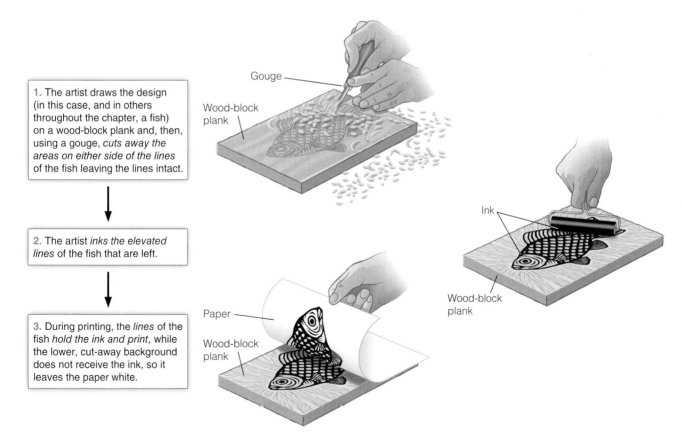

1. The artist draws the design (in this case, and in others throughout the chapter, a fish) on a wood-block plank and, then, using a gouge, *cuts away the areas on either side of the lines* of the fish leaving the lines intact.

2. The artist *inks the elevated lines* of the fish that are left.

3. During printing, the *lines* of the fish *hold the ink and print*, while the lower, cut-away background does not receive the ink, so it leaves the paper white.

Gouge

Wood-block plank

Ink

Wood-block plank

Paper

Wood-block plank

**FIGURE 7.13.** **Woodcut.**

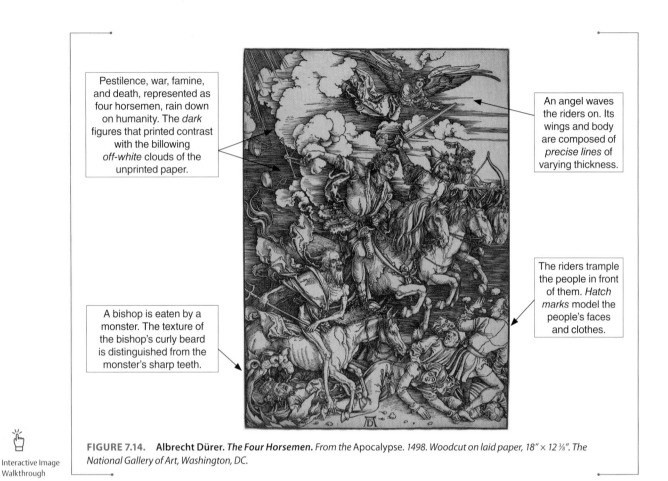

Pestilence, war, famine, and death, represented as four horsemen, rain down on humanity. The *dark* figures that printed contrast with the billowing *off-white* clouds of the unprinted paper.

An angel waves the riders on. Its wings and body are composed of *precise lines* of varying thickness.

A bishop is eaten by a monster. The texture of the bishop's curly beard is distinguished from the monster's sharp teeth.

The riders trample the people in front of them. *Hatch marks* model the people's faces and clothes.

Interactive Image Walkthrough

**FIGURE 7.14.** **Albrecht Dürer.** *The Four Horsemen. From the* Apocalypse. *1498. Woodcut on laid paper, 18" × 12⅜". The National Gallery of Art, Washington, DC.*

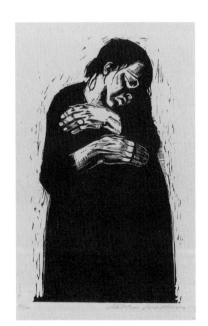

**FIGURE 7.15.** **Käthe Kollwitz.** *Die Witwe I (The Widow I). 1921–22. Woodcut, 14⅝" × 9 5/16". The Museum of Modern Art, New York.* The impression made from Kollwitz's thick cuts shows the bold expression possible with woodcut.

Dürer created with a close-grained hardwood, shows bold contrasts of light and dark; sharply defined lines that create harsh, realistic textures; and aggressive, diagonal shapes that seem to contribute to the energy, chaos, and violence of the image (figure 7.14).

Contrastingly, *Die Witwe I (The Widow I)* by Käthe Kollwitz (KAY-tuh KOHL-vitz)—an artist who also worked in Germany, but four hundred years later—shows the starkly different effects and expressions possible with woodcut (figure 7.15). Kollwitz used a soft wood that shows the grain. Unlike Dürer, Kollwitz gouged bold, wide, crude cuts into a textured surface. The distraught woman hangs her head almost as if its weight is too much to carry and clutches at herself with oversized hands. Kollwitz's design, with its primitive forms, made from gashes and a rough surface, helps lend a disturbing and emotionally intense feeling to the print.

Woodcuts can also offer diverse effects because of the possibility of printing multiple colors. To create a color woodcut, a number of matrices are used (see *Delve Deeper: Color Woodcut*).

## Wood Engraving

Commercial publishing houses invented wood engraving in the nineteenth century. Woodcuts had often been used to illustrate books because the matrix could be cut to the same thickness as letters on a press. The illustrations and type thus could be printed simultaneously, saving time and money. However, woodcut was labor

# DELVE DEEPER

## Color Woodcut

With color woodcut, an artist carves multiple wood-block planks—one for each color—leaving in relief the part of the design that is to print in that color. Each matrix is aligned (to ensure that the design on each matrix prints in the right place on the paper), inked, and printed in succession. While figure 7.16 shows two colors, the printmaker could continue to add more colors by using other matrices.

As we saw with Utamaro (figure 7.5), color woodcut was popular in early modern Japan. *The Great Wave* by Katsushika Hokusai (kat-s'-SHEE-kah HOH-k'-sye) shows another Japanese color woodcut from this period (figure 7.17) printed with multiple matrices.

Hokusai's design, with its defined edges, slick presentation, and broad areas of color, is characteristic of color woodcut. The precise, elegant detail was carved on a close-grained, hardwood matrix. The graphic, decorative qualities stem from the multiple-matrix printing method, which lays on separate, flat colors in step-by-step succession.

1. After cutting away everything but the part of the design that is to print in the first color (the lines of the fish), the artist inks and prints the first matrix on a sheet of paper.

2. After cutting away everything but the part of the design that is to print in the second color (the eye of the fish), the artist inks and prints the second matrix on the same sheet of paper.

Paper

First wood-block plank

Paper

Second wood-block plank

**FIGURE 7.16.   Color woodcut.**

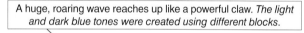

A huge, roaring wave reaches up like a powerful claw. *The light and dark blue tones were created using different blocks.*

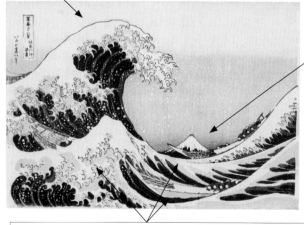

In the distance, Mount Fuji, an active volcano, sits ominously quiet. Its base is formed in dark blue. *The gray haze around it had to be separately printed.*

The wave tosses three tiny boats in its fury, but the men in the boats seem peaceful and respectful of the power of the natural world. *The white of the wave is the unprinted paper.*

**FIGURE 7.17.   Katsushika Hokusai. *The Great Wave.** From the series "Thirty-Six Views of Mount Fuji." Edo period, c. 1831. Color woodcut, 10 3/16" × 15 3/16". Honolulu Museum of Art, Hawaii.*

FIGURE 7.18. Wood engraving.

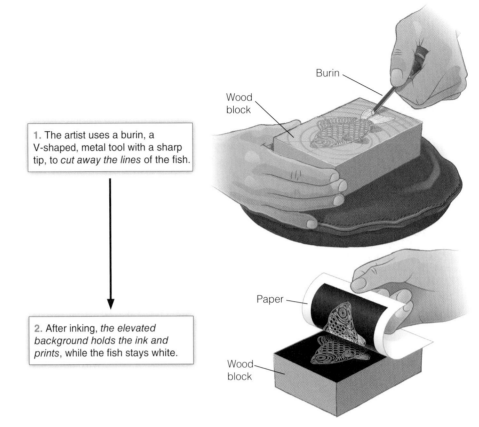

1. The artist uses a burin, a V-shaped, metal tool with a sharp tip, to *cut away the lines* of the fish.

2. After inking, *the elevated background holds the ink and prints*, while the fish stays white.

**wood engraving** A relief printmaking technique carved on an end grain wood block, in which the lines of the design are cut away, leaving the background areas to hold the ink and print

**linocut** A relief printmaking technique in which a piece of linoleum is carved to create a matrix

**FIGURE 7.19.** **Fritz Eichenberg.** *The Follies of Old Age. From* In Praise of Folly *written by Erasmus. 1972. Wood engraving, 18" × 12". Smithsonian American Art Museum, Washington, DC.* It is evident that Eichenberg used wood engraving to create this satirical print because of the fine, white lines.

intensive. **Wood engraving** enabled artists to cut away the lines of a design on an end-grain wood block (leaving the background in relief), an easier technique.

The technique of wood engravings (figure 7.18) leads to a specific appearance. Prints:

- *Feature white lines against a dark background*, like white pen drawings on dark paper
- *Show only white and dark*, as there is no in-between
- *Have fine and thin lines* because of the sharp tip of the burin tool that is used

German-born printmaker Fritz Eichenberg illustrated *In Praise of Folly*—the satirical novel by Erasmus—with wood engraving. In *The Follies of Old Age* (figure 7.19) from 1972, he used the thin, white marks to create textures as diverse as coarse pig bristle, sagging skin, and fur trim—all with the precise lines formed with the burin. The contrast of white against black, the stacked composition, and the silhouette effect of the characters, all arguably add to the humor of the work.

## Linocut

**Linocut** is a relief printmaking technique in which linoleum is carved to create a matrix. As with other relief methods, the raised areas on the surface hold the ink and print, while cut-away areas do not print. Linoleum has been used in schools to teach students relief printmaking because it is soft and easy to cut, can be cut with

FIGURE 7.20. Linocut.

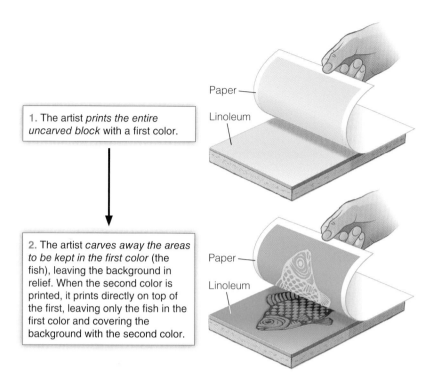

1. The artist *prints the entire uncarved block* with a first color.

2. The artist *carves away the areas to be kept in the first color* (the fish), leaving the background in relief. When the second color is printed, it prints directly on top of the first, leaving only the fish in the first color and covering the background with the second color.

a variety of tools, and has no grain so can be cut in any direction. For this reason, many artists had shied away from what they perceived was an "amateurish" material.

In the 1950s, though, Pablo Picasso revolutionized linocut by developing a new color relief printmaking method. Artists had previously printed in color with multiple linoleum matrices (like artists print color woodcuts; see figure 7.16). However, Picasso printed in color using only one matrix, continually reducing the same linoleum block. In each stage of printing, Picasso cut out the matrix areas that he did not want to print and then inked and printed a new color. In figure 7.20, there are only two colors. However, the artist could have added more colors by continuing to carve away parts of the same matrix.

Linocuts have a characteristic look. Prints:

- *Feature lines that run in any direction*
- *Have flat areas of ink with no grain*
- *Lend themselves to fluid, free-flowing lines*

Elizabeth Catlett used the soft, yielding linocut to form a multitude of lines in *Sharecropper* (figure 7.21). Many former African American slaves became sharecroppers at the end of the Civil War. They farmed land they had worked as slaves and were forced to share profits with wealthy landlords. Catlett, though, the granddaughter of former slaves herself, gave her sharecropper a sense of dignity. We look up at the towering, female figure. The easy-to-cut linoleum allowed Catlett to create ordered patterns and simulated textures.

*Quick Review 7.5*: How are woodcut, wood engraving, and linocut relief methods similar and different?

FIGURE 7.21. **Elizabeth Catlett.** *Sharecropper.* *1970. Color linocut, 15 ⅓" × 10 ⅛". Art Institute of Chicago, Illinois.* Catlett formed the sharecropper's chiseled-looking face with color and hatch marks, giving this woman what seems like a determined and bold look.

## Intaglio

**intaglio** Italian for "cut into"; a matrix in which the carved-out areas below the surface hold the ink and print and the areas on the surface of the plate do not print; a printmaking technique using this matrix

**Intaglio** is the opposite of relief printing: the recessed, carved-out parts below the surface hold the ink and print, and the areas on the surface of the plate do not print. To create an intaglio print, an artist (and for certain tasks, sometimes, a printer):

1. *Creates sunken lines in a metal plate* either by cutting into the plate with a tool or by using acid to eat away at the plate through a chemical reaction
2. *Forces ink into the depressions* and carefully wipes the plate, so that the elevated surface is clean and the ink remains only in the sunken areas
3. *Uses a strong press to force a dampened sheet of paper into the recessed grooves* of the plate, printing a mirror image of the original matrix and creating a slight ridge in the paper where it has been inked

We will discuss four types of intaglio printmaking: *engraving*, *drypoint*, *etching*, and *aquatint* (table 7.2).

| **TABLE 7.2:** | **Intaglio Methods.** |
|---|---|
| **Intaglio Method** | **Description** |
| Engraving | Lines are cut into a metal plate. |
| Drypoint | Lines are scratched into a metal plate, raising a metal ridge. |
| Etching | Lines are drawn on a metal plate that is covered with an acid-resistant ground. The plate is then soaked in an acid bath, where the acid bites into exposed lines. |
| Aquatint | A powdery, acid-resistant ground is applied to a metal plate. Areas that are not supposed to be bitten are covered with varnish. The plate is soaked in an acid bath, and the acid bites into the areas around each ground particle. |

### Engraving

Developed in the fifteenth century, engraving is the oldest intaglio technique. Since ancient times, goldsmiths had been cutting designs into metal goblets, plates, and mirrors and rubbing pigment into the impressions to make them stand out. Printing from these cut designs was probably invented so that artisans could keep a record of their designs. Engraving was a popular method of reproducing great works of art, as was the case in Raimondi's print (figure 7.6). Today, we use engraving to print paper money.

**engraving** An intaglio printmaking technique in which the artist carves the lines of the design into a metal plate using a burin

With **engraving**, the artist cuts lines into a metal plate using a burin. The tool is the same one employed in wood engraving, but engraving is an intaglio method of printing, so offers an opposite look: the engraved lines print dark and the background remains white (figure 7.22).

With engraving, the artist painstakingly manipulates the burin with varying amounts of force, creating deep gouges or shallow indentations. This technique creates a specific effect. Engravings:

- *Are made solely of lines*: dark, heavy, severe, thick strokes; fine, light, thin, delicate scratches; or marks that widen or taper, changing as they move
- *Tend to look precise and controlled* due to the nature of the medium
- *Can have tones or texture*, even though this is a linear technique, as they are formed from hatched lines or stippling

FIGURE 7.22.   Engraving.

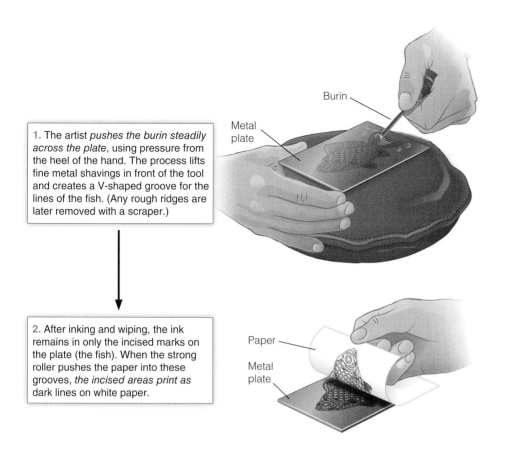

**1.** The artist *pushes the burin steadily across the plate*, using pressure from the heel of the hand. The process lifts fine metal shavings in front of the tool and creates a V-shaped groove for the lines of the fish. (Any rough ridges are later removed with a scraper.)

Burin

Metal plate

**2.** After inking and wiping, the ink remains in only the incised marks on the plate (the fish). When the strong roller pushes the paper into these grooves, *the incised areas print as* dark lines on white paper.

Paper

Metal plate

When Antonio Pollaiuolo (ahn-TOH-nyoh poh-lay-WOH-loh) engraved *Battle of the Nudes* (figure 7.23) in the late fifteenth century in Italy, artists were trying to perfect how to depict the human body. Pollaiuolo showed off his technical mastery, illustrating men

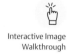

Interactive Image Walkthrough

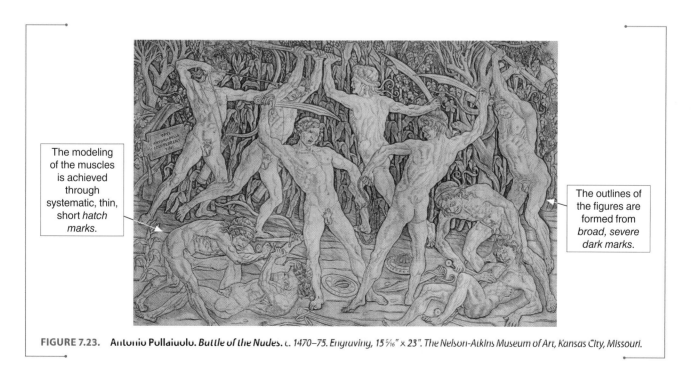

The modeling of the muscles is achieved through systematic, thin, short *hatch marks*.

The outlines of the figures are formed from *broad, severe dark marks*.

**FIGURE 7.23.**   Antonio Pollaiuolo. *Battle of the Nudes.* c. 1470–75. Engraving, 15 ⁵⁄₁₆" × 23". The Nelson-Atkins Museum of Art, Kansas City, Missouri.

The artist *pulls the needle* in the outline of the fish, creating both the groove and the elevated burr.

Drypoint needle

Metal plate

Burr

Incised line

Side view

**FIGURE 7.24. Creating a drypoint plate.**

**drypoint** An intaglio printmaking technique in which the artist scratches the lines of the design into a metal plate using a drypoint needle, which pushes up a burr that will print with a velvety effect

**burr** The rough ridge pushed up on an intaglio plate, which holds the ink and creates a velvety line

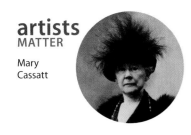

artists
MATTER

Mary Cassatt

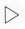

Etching

**etching** An intaglio printmaking technique in which the artist lays an acid-resistant ground on a metal plate, draws on the plate with a needle exposing the plate below, and immerses the plate into an acid bath, allowing the acid to eat away at the exposed areas of the plate

**ground** A preparatory acid-resistant coating applied to a metal plate in etching and aquatint used to protect the covered areas of the plate from acid

in different poses. However, the figures look a bit stiff because Pollaiuolo did not realize that all muscles need not contract for the body to move in a certain way. Pollaiuolo used engraving's deliberate and labored technique to form each of the muscular figures. The diversity of the engraved, sharply defined lines mimics a pen and ink drawing.

## Drypoint

A method similar to engraving that uses a different tool to carve lines in a metal plate is **drypoint**. With drypoint, the artist uses a needle, instead of a burin. As the needle scratches the plate, it pushes up a metal ridge called a **burr**, leaving extra metal on the edges of the lines (figure 7.24).

When a drypoint plate is inked, the ink not only sinks into the groove, but also gets caught and clings to the rough, irregular burr. The burr is higher than the surface of the plate, so it wears off during printing. As a result, the first prints tend to be the best, and the number of impressions is limited to about twenty-five.

Drypoint prints take on certain qualities. The prints:

- *Have lines that are fuzzy and blurred* because of the burr that holds the ink
- *Look spontaneous* because it is relatively easy to pull a needle across a plate
- *Resemble a pencil drawing* because of the soft appearance

Mary Cassatt, an American-born artist who lived much of her life in France in the late nineteenth and early twentieth centuries, used the velvety line characteristic of drypoint to catch a mother and child in a private moment of tender caress (figure 7.25). The delicate line and lack of sharp detail seems to enhance the richness, sensitivity, and intimacy of the print.

## Etching

The intaglio printmaking technique of etching was first used to create incised decorations on weapons. The first prints on paper were created in the sixteenth century.

In an **etching**, the artist covers a metal plate with an acid-resistant coating called a **ground** and draws on that ground with a needle, which exposes the plate underneath. The artist then submerges the plate into an acid bath. The acid bites or corrodes the exposed metal, but leaves the areas covered by the ground intact (figure 7.26).

We can compare engraving and etching to understand the two more clearly. With engraving, it is the force of the artist's tool that creates the width of the printed lines. With etching, the acid predominantly affects the thickness of lines. The longer the artist leaves the plate in the bath, the deeper and wider the grooves on the exposed areas of the plate will become, the more ink they will hold, and the darker they will print.

To create a variety of lines, the artist can soak the plate in phases. After soaking the entire plate with the image scratched into the ground, the artist can cover the lines that he or she wants to print the faintest with varnish and re-submerge the plate in the acid. The varnish stops the acid from eating away the covered areas, while the remaining surface continues to be bitten, making deeper grooves that hold more ink.

While both etching and engraving are linear techniques, etching creates different types of lines than engraving. Etched lines:

- *Tend to be more spontaneous, relaxed, and fluid*, because it is easier to scratch an etched ground than push a burin across a plate
- *Are not as crisp and sharply defined*, because the acid creates the grooves rather than a tool
- *Have a uniform thickness* throughout the length of a bitten area, because acid eats into lines consistently

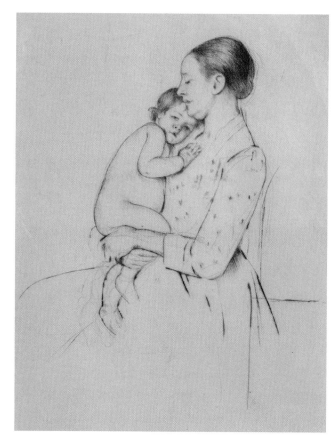

**FIGURE 7.25.** **Mary Cassatt.** *Quietude.* c. 1891. Drypoint, 10 5/16" × 7 1/16". *University of Kentucky Art Museum, Lexington.* Cassatt used the irregular burr in drypoint to create the soft lines in this print.

**1.** The artist *prepares the acid-resistant ground*.

↓

**2.** The needle *scratches through the ground* where the artist draws the outline of the fish.

↓

**3.** The acid *bites into the exposed areas*, incising the fish design on the metal plate. When the plate is removed from the acid and the ground taken off, those *incised lines hold the ink and print*.

Ground

Etching needle

Acid bath

**FIGURE 7.26.** **Creating an etched plate.**

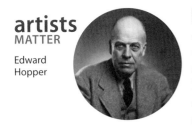

**artists**
MATTER

Edward
Hopper

Edward Hopper, a twentieth-century artist, showed the effects of etching in *Night Shadows* (figure 7.27). There is a stark contrast between the light highlights and deep, dark shadows that seem to give a haunting sense of isolation to this image. The highlights appear where the ground stopped the acid from biting the plate. The shadows exist where Hopper had scratched away the ground and the acid could eat away the plate for a lengthy time. The value contrasts created by the successive stopping out and acid baths are also noticeable in the lines on the sidewalk that stretch from the right and point out toward the lone, anonymous walker. Lines that were drawn identically on the ground move from dark, bold strokes at the right and grow fainter until they disappear in the middle of the print. If the print had been pulled in a first state after the first acid bath, these lines would have appeared very light throughout their entire length.

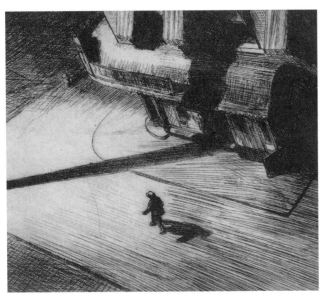

**FIGURE 7.27.** **Edward Hopper.** *Night Shadows.* 1921. Etching, 13 ³⁄₁₆″ × 14 ⁷⁄₁₆″. *The Metropolitan Museum of Art, New York.* In the relaxed lines that stretch toward the sole pedestrian, Hopper's print illustrates the ease of manipulating the etching needle across the plate.

### Aquatint

The intaglio printmaking method of **aquatint** was invented in the eighteenth century to create tones. The artist applies a porous, acid-resistant ground to a metal plate, and the acid bites around each particle. Because the ground is composed of individual particles rather than a continuous film, the acid eats into the plate, creating a sandpaper-like texture (figure 7.28).

Aquatint prints have a specific appearance. The prints:

- *Have a grainy look*, because the acid has bitten the surface of the plate around each ground particle
- *Have flat and even areas of different values and no tonal gradations*, because the acid bites evenly into exposed areas of the plate
- *Lack lines*, as aquatint is a method of creating tones

If artists want to create both lines and tones, they can combine different techniques. For example, Goya used aquatint and etching to create tones and lines in *The Sleep of Reason Produces Monsters* (figure 7.9). He created the stippled background with aquatint and the lines of the monsters' disturbing features with etching. To see the different effects of these two methods on separate prints, see *Practice Art Matters 7.2: Compare an Aquatint and an Etching.*

*Quick Review 7.6*: What is the difference between intaglio methods that use a cutting tool to create matrices and those that use acid?

**aquatint** An intaglio printmaking technique that creates tones by the artist applying a porous, acid-resistant ground to a metal plate and allowing acid to bite around each particle

**planographic** A matrix in which the flat surface prints; a printmaking technique using this matrix

**lithography** Greek for "stone drawing"; a printmaking technique in which the matrix is made from a stone and printing and nonprinting areas are separated chemically, since grease and water don't mix

## Planographic

A **planographic** printing technique uses a flat matrix to print. Alois Senefelder discovered the planographic method of lithography in Germany at the end of the eighteenth century, and the process spread quickly because of its practicality, immediacy, and ease of use. Daumier was making lithographs just several decades later.

**Lithography** is based on the principle that watery and oily materials don't mix. While with the relief and intaglio processes, there is a physical separation between areas that are

FIGURE 7.28. **Creating an aquatint plate.**

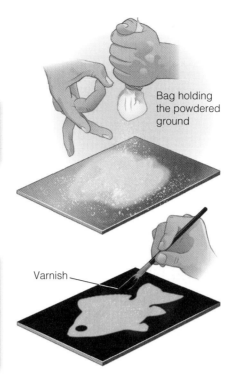

Bag holding the powdered ground

1. The artist *shakes acid-resistant, powdered resin particles* onto a plate and applies heat, so the particles cling to the metal plate.

2. The artist *stops out areas that are not supposed to be bitten* (the background) with varnish, then *immerses the plate in an acid bath*. When the plate is removed from the acid and the ground and varnish taken off, only the fish will be incised, hold the ink, and print.

Varnish

*Practice* art MATTERS

## 7.2 Compare an Aquatint and an Etching

Jane Leone Dickson used aquatint to create *White-Haired Girl* (figure 7.29). The print is both similar to and different from the etching by Hopper called *Night Shadows* (figure 7.27). Compare and contrast the prints by the two American artists. Consider these questions:

- What are the subject matters?
- What are the characteristics of the printmaking techniques used?
- How do the characteristics of the printmaking techniques used affect the appearance of the prints?
- What do you think are the meanings of the prints?

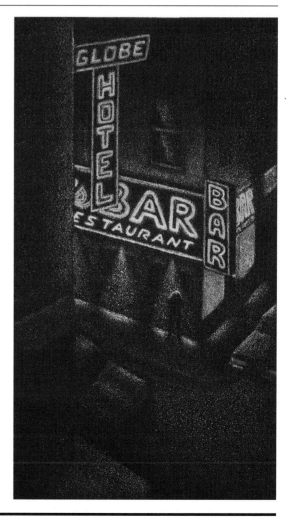

FIGURE 7.29. **Jane Leone Dickson.** *White-Haired Girl.* *1984. Color aquatint, 3′ × 1′ 11 ¾″. Whitney Museum of American Art, New York.*

inked and not, with lithography the separation is chemical. In lithography, an artist (and for certain tasks, sometimes, a printer):

1. *Uses a greasy material* to draw or paint on a *flat, limestone slab*
2. *Prepares the stone and wets it with water*, which, repelled by the oil of the drawing, absorbs only into the nonimage areas
3. *Rolls the surface with greasy ink*, which clings to the drawing and is repelled by the watery background, so that when printed on a press, the image is transferred to the paper in reverse (figure 7.30).

Of all the printmaking techniques, lithography allows for the most freedom and range. Lithographic crayons or paint brushes slide over the smooth surface, eliminating the need to carve a matrix. Artists can use crayons as they would a dry drawing medium:

- *Sharpening them* to a point to create lines
- *Using them on their sides* to cover broader areas or create soft gradations of tones
- *Varying the amount of pressure* to change the intensity of effects

Similarly, artists can use paint as they would a liquid drawing medium:

- *Painting with full-strength, rich, dark ink or diluted washes*
- *Spraying, spattering, or stippling ink*
- *Dragging a mostly dry brush across* the surface

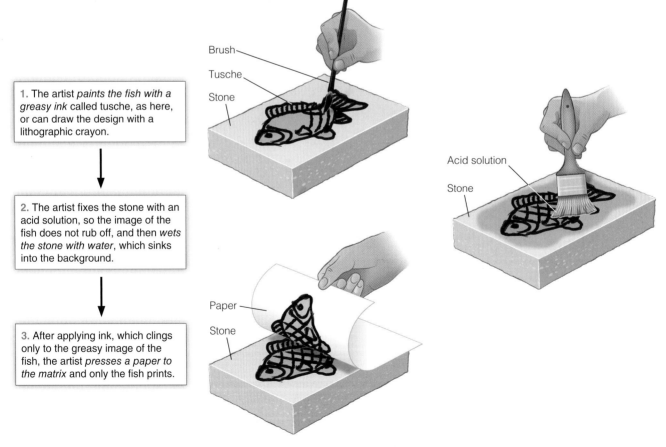

1. The artist *paints the fish with a greasy ink* called tusche, as here, or can draw the design with a lithographic crayon.

2. The artist fixes the stone with an acid solution, so the image of the fish does not rub off, and then *wets the stone with water*, which sinks into the background.

3. After applying ink, which clings only to the greasy image of the fish, the artist *presses a paper to the matrix* and only the fish prints.

Brush
Tusche
Stone

Acid solution
Stone

Paper
Stone

**FIGURE 7.30. Lithography.**

Twentieth-century American artist Elaine de Kooning painted on a lithographic stone to form a series of prints created after she visited the cave paintings of Lascaux, France. Prehistoric people depicted numerous animals in the caves, placing animals strategically and using the edges of the rock to enhance their depictions. While at first glance the de Kooning print might appear as a jumble of expressively painted ink, upon closer examination the shape of a bull can be found in the midst of the swirling brushwork (figure 7.31). De Kooning was able to capture the spirit of the caves in a modern medium.

*Quick Review 7.7*: What is the range of effects possible with lithography?

**FIGURE 7.31.** **Elaine de Kooning.** *Lascaux #4.* *1984. Lithograph, 16 1/16" × 20 3/8". Mount Holyoke College Art Museum, South Hadley, Massachusetts.* Lithography allowed de Kooning to create a print that looks like a brush and wash drawing.

## Stencil

Stencil is the oldest method of duplicating an image. Used by prehistoric people to create handprints on cave walls, stenciling was later used to decorate textiles, walls, and furniture. Stenciling was first used on paper in the fifteenth century.

To **stencil**, an artist cuts a design into a flat masking material, places it on top of a surface, and applies ink or paint *through the cut-out spaces*. When the stencil is lifted, any areas that were cut out will print, while those areas that were blocked by the stencil will not. Unlike every other printing technique, stenciled works do *not* appear as mirror images.

As anyone who has worked with stenciled letters knows, stencils lead to a problem with freestanding pieces. Think of the letter O. If you were to cut an O in a stencil, when you lifted the stencil, the inside circle would fall out. Instead of printing an O, you'd print a filled-in circle. Accordingly, stencil makers create ties to hold freestanding pieces in a design.

This problem with freestanding pieces was solved more effectively in the twentieth century with the invention of the stencil printmaking method of **screenprinting**. The technique, also called **silkscreen** and **serigraphy**, enables an artist to produce a limitless range of designs. The artist:

1. *Creates a stencil*
2. *Attaches the stencil to a mesh material* stretched on a frame (because the stencil is attached to the screen, all of it stays in place)
3. *Forces ink through the porous fabric in the open areas*, printing on the surface below
4. *Uses additional screens to print multiple colors*, lining up the stencils through **registering,** a technique of alignment used with color printmaking to ensure that successive matrices print their respective colors in the right place on the paper (figure 7.32).

Screenprinting can produce a variety of effects. Prints:

- *Often contain broad, bold, flat areas of color*, because each screen produces set forms
- *Can have mixed colors*, even though there is no direct blending, by printing small dots of different colors that mix optically from a distance, layering inks, and pulling multiple colors across a screen at once
- *May have various effects* from hard-edged areas to painterly forms

**stencil** A flat masking material in which a design has been cut to allow ink or paint to pass through the open areas onto a surface below; a printmaking technique using this cut-out material

**screenprinting/silkscreen/ serigraphy** *Seri* is Latin for "silk" and *graphos* is Greek for "to write"; a stencil printmaking method in which a stencil is attached to a mesh material stretched on a frame and printed with ink or paint being forced through the openings; serigraphy was the particular name given to the fine arts technique of screenprinting to distinguish it from the commercial use of the process

**register** A technique of alignment used with color printmaking to ensure that successive matrices print their respective colors in the right place on the paper

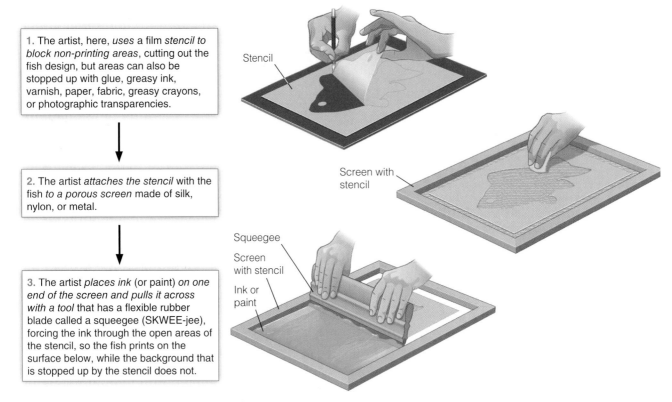

1. The artist, here, *uses* a film *stencil to block non-printing areas*, cutting out the fish design, but areas can also be stopped up with glue, greasy ink, varnish, paper, fabric, greasy crayons, or photographic transparencies.

2. The artist *attaches the stencil* with the fish *to a porous screen* made of silk, nylon, or metal.

3. The artist *places ink* (or paint) *on one end of the screen and pulls it across with a tool* that has a flexible rubber blade called a squeegee (SKWEE-jee), forcing the ink through the open areas of the stencil, so the fish prints on the surface below, while the background that is stopped up by the stencil does not.

Stencil

Screen with stencil

Squeegee

Screen with stencil

Ink or paint

FIGURE 7.32. **Screenprinting.**

Contemporary American artist Ester Hernandez used the hard edges and smooth, broad planes of color typical of screenprinting to create *Sun Mad* (figure 7.33). Hernandez, who had worked as a farmhand earlier in her life, was enraged over the exposure of grape pickers to pesticides and the contamination of the water in her hometown. She borrowed the appearance of the familiar and brightly colored Sun-Maid raisins box to express her discontent. In her print, the wholesome woman pictured on the box has been transformed into a skeleton, reminiscent of the *calaveras* found in Posada's prints (figure 7.8). As many of the farm workers were Mexican American, Hernandez was able to draw on their past to make a biting statement about the present. Because screenprinting has also often been used for commercial labels, her medium fits her message.

Contemporary American artist Chuck Close created his huge *Self-Portrait* (figure 7.34) using 246 different colors—each printed from a different screen! Close worked from an enlarged photograph that he systematically divided into squares, which he then transferred to stencils. The painstaking technique created hundreds of tiny circles and ovals of flat color, which combine visually to form tonal gradations when seen from afar or a pattern of nonobjective shapes when viewed up close. The tiny spots could even seem like pixels in a computerized image.

*Quick Review 7.8*: How did screenprinting improve upon traditional stencil methods?

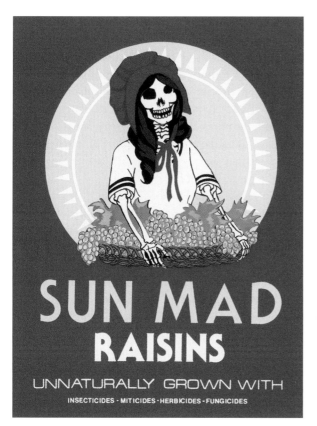

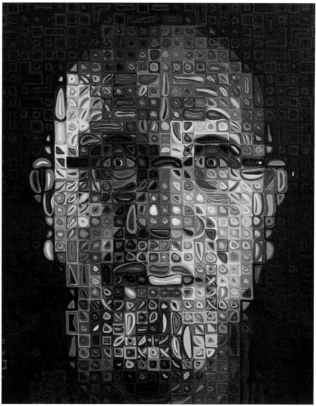

**FIGURE 7.33.** Ester Hernandez. *Sun Mad.* 1982. *Color screenprint, 22" × 17". Smithsonian American Art Museum, Washington, DC.* To voice her protest, Hernandez used the flat colored areas of screen-printing to simulate the mass-produced Sun-Maid raisin box.

**FIGURE 7.34.** Chuck Close. *Self-Portrait.* 2012. *Silkscreen in 246 colors on wove paper, 5' 6 ½" × 4' 7". Hood Museum of Art, Hanover, New Hampshire.* Even though he used so many colors, Close could still create a silkscreen by using multiple screens.

## New Directions

A number of printmakers have experimented with new methods and ideas. While artists have created works from a mixture of techniques, tried new surfaces, worked with new water-based inks, and employed sophisticated printers to create prints, here we will look at *nontraditional matrices* and *digital printmaking*.

## Nontraditional Matrices

Tara Donovan, a contemporary American artist, has explored working with nontraditional matrices. To create the image in figure 7.35, she used Slinky toys, inking and printing them. Through her arrangement, the impression of the common toys is transformed into what appears to be playful, swarming snakes. While the toys may be familiar to us, their arrangement and their curling, coiling, organic shapes in the print link them to the natural world.

**artists**
MATTER

Tara
Donovan

## Digital Printmaking

Newer printmaking techniques often are based on using digital technologies. Some artists *use computers to form designs*, which they print with traditional techniques, while others *use computer-controlled machines to create matrices*. Two Texas-based artists illustrate these different approaches.

**FIGURE 7.35.** **Tara Donovan.** *Untitled.* *2015. Print from Slinky matrix, 4' 9" × 8' 1". Pace Gallery, Menlo Park, California.* Donovan used everyday objects, Slinkys, rather than a traditional matrix to create her print.

Randy Bolton uses digital technology to create images that he prints with conventional methods. After taking a photo of objects with his phone, Bolton manipulates the photo digitally, forming a stylized, brightly colored image. He then converts the image into four color separations (cyan, magenta, yellow, and black) that he makes into stencils. Finally, he prints each stencil, layering one color on top of the next, using the traditional method of screenprinting. When these four stencils are registered, so that they match up on the paper, the four colors combine to recreate all of the colors in the original image.

In figure 7.36, Bolton used this method to form two faces from fruit. While the images might appear light-hearted because of the style, reminiscent of a children's book, the two-image sequence and frowning face could suggest a more serious topic. While a child might see the fruit as solely a delicious snack, an adult might focus on the price stickers and high cost of healthy food that is out of reach for many. Even with the digital component, screenprinting's bold colors are evident, adding to the irony of the possible message.

By contrast, Lari Gibbons uses a computer-controlled router to form relief matrices. For *Paths II* (figure 7.37), she used the machine to create a woodcut matrix with precise and flawless lines that are smooth, even, and the same thickness. While the computer-controlled machine formed her matrix, Gibbons still pulled the image by hand, rolling ink on the four carved matrices and pressing four sheets of paper to them. The perfect lines, which mechanically flow around the image, and the enormous tangled maze, which seems to grow organically out of the base of the paper, are an apt analogy for the dual machine and handmade components of the image.

*Quick Review 7.9*: What are some new directions in printmaking?

**FIGURE 7.36.** **Randy Bolton.** *Happy + Sad.* *2016. Two-panel screenprint on Yupo paper, each panel 2' 5 ¼" × 1' 10 ½".* Bolton created his design digitally before printing a traditional screenprint.

**FIGURE 7.37.** **Lari Gibbons.** *Paths II.* *2012. Woodcut print, 7' 2" × 12' 3". Juanita Harvey Art Gallery, Midwestern State University, Wichita Falls, Texas.* To create the intricate pattern, Gibbons used a computer-controlled router to form her matrix.

## A Look Back at the Prints of Honoré Daumier

Honoré Daumier's prints show *art's power to reach the masses* and change opinions. They also coincide with many of the topics covered in this chapter.

Daumier worked *indirectly*, designing on a stone slab rather than on the artworks themselves. Like many prints, these works were the product of *collaboration* between the artist, publisher, and printer.

Daumier believed in distributing his images by producing *multiple originals*. By making his work more *accessible to all*, his intention was to influence public opinion. There is no question that his work challenged the government and changed the minds of the people. He even supported the *democratic spirit of the medium*, as his prints were hung in the printer's window, so that all who could not afford to buy them could still see them.

Daumier and his contemporaries saw his newspaper prints as political commentary. They likely did not often consider the artistic qualities of caricatures. Today, we see the prints as art, yet Daumier's talents were so great that even his contemporaries realized his work's *artistic merits*. As *La Caricature*'s publisher said about *Rue Transnonain* (figure 7.3):

This indeed is not a caricature, it is not an exaggeration, it is a page of our modern history bespattered with blood, a page drawn with a powerful hand and dictated by noble anger. In creating this drawing, Daumier has raised himself to his full stature.[1]

There is no question that **lithography**, invented just over thirty years before, was key to Daumier's success. The **printmaking** technique was easy to use and enabled Daumier to create a wide range of effects including precise details, bold lines, intense darks, and creamy lights. Lithography gave Daumier the flexibility, speed, and range he needed to challenge a king.

As you move forward from this chapter, consider the *power and significance* of printmaking and other techniques that allow art to be *produced in multiples*. Multiples can be used not just to challenge a political regime—as Daumier did—but also for other significant purposes, such as attempts to spread religions, as was done with the *Diamond Sutra* (figure 7.7), or efforts to protest environmental and health concerns, as Hernandez did in *Sun Mad* (figure 7.33).

Flashcards

## CRITICAL THINKING QUESTIONS

1. This chapter makes the case that prints are similar to drawings. How are prints different from drawings?
2. Prints were often used in the past to distribute images and ideas. What would you use today for the same purpose? How is this form of expression similar to prints?
3. Do you think states are original prints? Why or why not?
4. Why might you describe wood engraving as the opposite of woodcut?
5. *Woman at the Height of Her Beauty* (figure 7.5) was created with woodcut. Did the carver use a close-grained hardwood or a broad-grained soft wood? How do you know?
6. Several artists in the chapter came from similar countries. Both Utamaro (figure 7.5) and Hokusai (figure 7.17) hailed from Japan, while Dürer (figure 7.14), Kollwitz (figure 7.15), and Eichenberg (figure 7.19) came from Germany. Given that the author chose representative works from multiple artists from similar locations, what do you think it says about these locations with regard to printmaking? Knowing what you do about printmaking processes, why might multiple renowned artists have hailed from certain areas and not others?
7. In what way are drypoint lines similar to etched lines?
8. If you want a print to have gradations of tone, which printmaking technique would you use?
9. Silkscreened prints do not appear as mirror images of their matrices. Why?
10. Even though Donovan (figure 7.35) used Slinkys to create her print, there are still traditional components to her matrix and print. Is her matrix relief, intaglio, planographic, or stencil? Why? Considering your answer to the previous question and how prints created with this method traditionally look, in what ways does her nontraditional print look like a traditional one?

Comprehension Quiz

Application Quiz

# 8

# Photography, Film, and Video

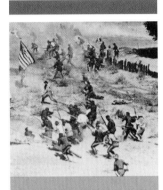

## LEARNING OBJECTIVES

**8.1** Explain why photography is both a technical process and an art form.

**8.2** Differentiate among the types of photographs.

**8.3** Describe the four artistic decisions that filmmakers make.

**8.4** Distinguish between narrative and other types of films.

**8.5** Explain the artistic and technical differences between video and film.

**8.6** Illustrate how video artists have developed different methods of presentation for their works.

# D. W. GRIFFITH'S FILM *THE BIRTH OF A NATION*

In 1915, the unprecedented film *The Birth of a Nation* opened. The story of a Northern and Southern family caught in the American Civil War and its aftermath is arguably the most creative, yet troubling, film ever produced.

American director D. W. Griffith used every known innovative technique, many of which had never been seen by audiences, let alone combined in one film. The *reach of the film* was huge. Thirty million people flocked to theaters, and for fifty years *Birth* remained the most widely seen film.

However, the film, based on the racist novel *The Clansman*, outrageously and inaccurately credited the Ku Klux Klan (a violent white-supremacy group) with saving the South after the war. Griffith's offensive depiction of African Americans arguably reinforced racist beliefs in an entire generation.

How Art Matters

## Griffith's Innovations in *Birth*

Today, it is hard to imagine just how innovative *Birth* was. When it premiered in 1915, most films ran fifteen minutes; *Birth* ran three hours. In addition, most movies had budgets of less than five hundred dollars and were filmed in one day. *Birth* cost $100,000 and took six months to make.

To create this extravagant production, Griffith controlled a series of *artistic decisions*, including:

» *What was filmed*
» *How the camera was used*
» *How shots* (segments of film) *were put together*
» *What sounds were used*

First, Griffith manipulated *what was filmed* by placing realistic, grand scenes in front of his camera. For example, to create a never-before-imagined battle scene, Griffith spread armies of men costumed in authentic-looking Civil War uniforms over several miles (Figure 8.1).

Second, Griffith controlled *how the camera was used*. To show the grand scale of the war, for instance, he shot expanses from *great distances*. However, he also *brought the camera near his stars*, so the audience could identify with their emotions. Figure 8.2 illustrates another innovative technique: to focus our attention on an important character, he framed the shot with a black circle, masking out the rest of the scene.

Third, Griffith controlled *how shots were put together*. At the end of the film, to heighten excitement, he *alternated between scenes that took place at the same time*: the heroine attacked by a villain (figure 8.3), the Southern family besieged in a cabin, and Klansmen racing to rescue both. As the heroine's and the family's situations became more desperate, Griffith sped up the cuts, making for shorter back-and-forth shots, heightening the rhythm to a frenzied pace.

Finally, Griffith controlled *the sounds that were used*, ensuring that *the music was appropriate*. Previously, as a film

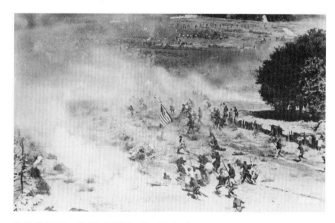

**FIGURE 8.1.** D. W. Griffith. *The Birth of a Nation*. *1915. Film still of a battle scene.* Griffith dropped real grenades on the troops to generate authentic explosions.

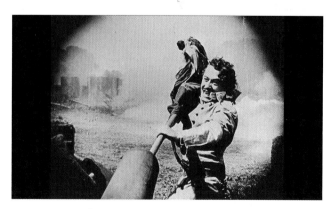

**FIGURE 8.2.** D. W. Griffith. *The Birth of a Nation*. *1915. Film still of Ben Cameron stuffing a flag in a cannon.* Ben Cameron (played by Henry B. Walthall) shoves a flag into a Union cannon, while a black circle surrounds him emphasizing his action.

**FIGURE 8.3.** **D. W. Griffith.** *The Birth of a Nation.* *1915. Film still of Elsie Stoneman being attacked.* Silas Lynch (played by George Siegmann) attacks the heroine, Elsie Stoneman (played by Lillian Gish).

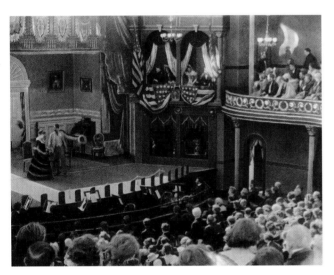

**FIGURE 8.4.** **D. W. Griffith.** *The Birth of a Nation.* *1915. Film still of Ford's Theatre just before the assassination of President Lincoln.* In a realistic recreation of Ford's Theatre, the play commences just before John Wilkes Booth (played by Raoul Walsh) will jump onto the stage after assassinating President Lincoln (played by Joseph Henabery).

was shown, live musicians improvised an accompaniment (synchronized sound had not yet been invented), making the experience different in every theater. *Birth* had its own unique score that complemented the scenes and increased the emotional intensity of the film. Three months in the making, the score was created for a forty-piece orchestra.

## Griffith's Distorted Version of History

The incredible technical innovations and the accurate portrayal of *certain* historical events led many viewers to believe that everything they saw in the film was true. Griffith used the power of film to *manipulate the truth.* He intermingled accurate depictions of real events with a distorted view of history, leaving audiences unable to distinguish fact from fiction.

Many scenes were based on real events, which Griffith recreated by using historical writings, photographs, or paintings. Figure 8.4 shows a still of a realistic recreation of Ford's Theatre, on April 14, 1865, when John Wilkes Booth assassinated President Abraham Lincoln.

However, interspersed with these more realistic depictions were demeaning views of African Americans and inaccurate and preposterous scenes. In one racist scene, an African American man chases the youngest daughter from the Southern family. Griffith showed the man foaming at the mouth (a shocking effect Griffith created with hydrogen peroxide) as if he were a rabid animal.

Worked into a frenzy by the power of the film, audiences believed Griffith's deformed version of the truth and cheered as the Klan rescued "helpless" Southern whites. Many people acted on their newfound prejudiced beliefs. While the original Klan had disbanded in 1869, a new, reinvigorated Klan, inspired by *Birth,* resurfaced in 1915 and used the film to gather recruits in the 1920s.

## Mixed Responses to *Birth*

In retelling the story of the Civil War, Griffith had picked an emotionally charged subject matter. Many Americans had fathers who had fought in the war, and Griffith went to extraordinary lengths to enable audiences to relive difficult moments that had happened just fifty years before.

Not everyone was swept away with Griffith's extravaganza, however. A number of newspaper columnists shared their disdain for the film's techniques and portrayal of African Americans. Jane Addams wrote in *The New York Evening Post*, "You can use history to demonstrate anything when you take certain facts and emphasize them to the exclusion of others."[1]

The film also inspired protest from the National Association for the Advancement of Colored People (NAACP), which had been formed in 1909 to fight for the rights of African Americans. In every city where the NAACP had an office, it protested *Birth*, but Griffith had free speech on his side.

Undoubtedly, one of the more positive consequences of *Birth* was that it encouraged African American cinema. While African Americans had been making films since 1912, after *Birth*, the community committed to a response and made over one hundred films from

1915 until the early 1920s. These films contradicted the stereotypes in *Birth* and portrayed African Americans as educated, resourceful, and multidimensional adults.

*Within Our Gates* by Oscar Micheaux (mee-SHOW) countered *Birth's* historical distortions and Griffith's racism by depicting the infinitely more common white injustice and violence against blacks. Using Griffith's own methods, Micheaux, during the film's climax, cross-cut between scenes of a white man assailing the black heroine (figure 8.5) and her family's being lynched.

Even today, *Birth* provokes responses. In 2016, a new film entitled *The Birth of a Nation* opened, which chronicles the story of Nat Turner, a slave who led an uprising in 1831. The new *Birth* asks audiences to evaluate an alternate beginning to the American nation than that proposed in the 1915 film— one in which intelligent and brave blacks suffered at the hands of whites.

### Evaluating *Birth*

Discussing Griffith's *Birth* leads to complicated questions:

» Should we consider works that are technically superior art even if we find their message repugnant?
» Should controversial works be included in the canon?
» Considering many people worked on the film, should we hold Griffith responsible?
» What should Griffith's legacy be?

Finally, *Birth* asks us to consider the camera arts—media that by their very nature often *lead us to question what is fact. Birth* shows the power of these media to influence us as individuals and reminds us to be wary of this impact on our beliefs and actions. This chapter considers many of the issues touched on with *Birth*. Before moving forward, based on this story, what types of artistic decisions do you think are the most important for filmmakers to make?

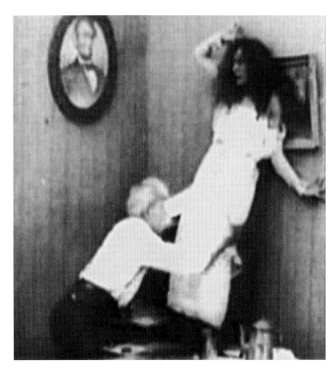

**FIGURE 8.5.** **Oscar Micheaux.** ***Within Our Gates.*** *1920. Film still of the attempted rape of Sylvia Landry.* Armand Gridlestone (played by Grant Gorman) attacks the heroine, Sylvia Landry (played by Evelyn Preer).

8

# Photography

All of us have appeared in photographs. In fact, billions of photographs are taken every year. Despite its popularity, photography is a relatively young art. The first photograph was taken less than two hundred years ago.

## What Photography Is

**Photography** is a technical process of recording images on a photosensitive surface with light. With a photograph, the light itself creates an image on a treated surface. Even though photography has a technical component, it is the artist's control of this technology that makes photography an art.

**photography** Greek for "writing with light"; the process of recording images on a photosensitive surface with light

### The Image-Making Properties of Light

During the fifth century BCE, Chinese philosopher Mo Ti was the first person to observe that light created an image when it entered a darkened area through a small hole. As discussed in Chapter 3, light rays reflect off an object. This reflected light can travel through a hole into a darkened area and appear on a surface opposite the hole. For example, if you think of a room, the light would appear on the wall opposite to the hole. However, this reflected light does not have uniform intensity: because the intensity of the light on the wall corresponds to the light and dark areas reflecting off of the object, a matching image appears on the wall.

However, this reflected image appears *upside down*. This phenomenon occurs because light rays travel in a straight line. Think of aiming a flashlight through the small hole: if you direct the beam from a lower position, it will appear higher up on the opposite wall and vice versa (figure 8.6). Likewise, the image appears inverted because the light waves reflecting from the top or bottom of an object shine into an opposing position.

It was not until the Renaissance, the period in Western history during the fifteenth and sixteenth centuries, that people first used the image-making power of light as a tool to record the three-dimensional world on a two-dimensional surface. Renaissance artists placed a **camera obscura** (KAM-er-uh ob-SKOOR-uh), a dark box with a pinhole, in front of a brightly lit scene that they wanted to draw. The pinhole allowed light reflecting off the scene to shine through and create a blurry, upside-down image on the opposite, inside wall of the box. The artist stood inside the box and traced the outline of the reflected image on paper attached to the opposite wall (figure 8.7).

Eventually, smaller *camera obscuras* were made featuring angled mirrors that reflected the inverse image out of the box and onto a drawing surface. *Camera obscuras* were further improved with the inclusion of a lens made out of curved glass that allowed the user to focus the light for a sharper image.

### The First Photographs

Today, two men are credited with having made the first photographs in 1839 in which the light itself created the image: Louis-Jacques-Mandé Daguerre (loo-EE JAHK mahn-DAY dah-GAYR), working in France, perfected a technique called the **daguerreotype**, while William Henry Fox Talbot, an Englishman, announced a process called **photogenic drawing.**

---

*camera obscura* Italian for "dark chamber"; a dark box with a pinhole through which reflected light shines and creates an upside-down image on the opposite wall

*daguerreotype* A type of photograph, invented by Louis-Jacques-Mandé Daguerre, which used treated metal plates to capture a brightly lit scene, creating a detailed, unique positive image

*photogenic drawing* A type of photographic process, invented by William Henry Fox Talbot, which used treated paper to capture a negative image of an object; a work created using this process

---

**artists**
MATTER

Louis-Jacques-Mandé Daguerre

**FIGURE 8.6. Light waves and inverted positioning.**

When shining a flashlight from a lower position through the pinhole, the circle of light on the opposite wall appears higher up.

Flashlight pointing up from a low position

When shining a flashlight from a higher position through the pinhole, the circle of light on the opposite wall appears lower down.

Flashlight pointing down from a high position

FIGURE 8.7. An early *camera obscura.*

Light-tight box (except for light coming in from pinhole)

*Light waves reflecting off the tree*

Pinhole

Artist

Paper

The artist traces the upside-down image of the tree that comes into the box through the pinhole.

Using copper plates covered in light-sensitive silver iodide, Daguerre captured brightly lit scenes. He placed a treated plate in a *camera obscura*, exposed the plate to the scene through a lens, chemically developed the plate to bring out the image, and fixed it so that it remained permanent. Daguerreotypes:

- *Captured amazing detail* that looked exactly like the scene in front of the camera
- *Had a lengthy exposure time* of four to five minutes and did not capture any moving figures
- *Resulted in only single images* that could not be replicated

The street in figure 8.8 appears to be deserted, but Daguerre took this photograph at the height of day when many people were bustling down the boulevard. Because of the lengthy exposure time, just one man, who stood still, registered on the plate.

During the same period, William Henry Fox Talbot, an Englishman, developed an alternate way to capture an image. Talbot placed an object on top of light-sensitive, silver-chloride-soaked paper, exposed the paper to light, and fixed the image. Since the light turned the paper dark and areas where the object blocked the light from hitting the paper remained light, he was left with a **negative** image, or one in which the dark and light areas are reversed from how they appeared in real life (figure 8.9).

Talbot eventually realized that by shining a light through the negative and exposing a second sheet of light-sensitive

**negative** In photography, the exposed image in which the values (lights and darks) are reversed from the way they are in real life

Man getting his shoes shined.

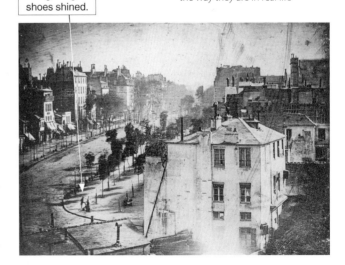

FIGURE 8.8. **Louis-Jacques-Mandé Daguerre.** *Le Boulevard du Temple. 1839. Daguerreotype, 6 ½″ × 8 ½″. Bayerisches Nationalmuseum, Munich.* Because of the length of the exposure time, Daguerre captured only one man who lingered to get his shoes shined, even though the street was actually very busy.

**FIGURE 8.9.** William Henry Fox Talbot. *Leaves of Orchidea. 1839. Photogenic drawing, 6 ¾″ × 8 ³/₁₆″. The J. Paul Getty Museum, Los Angeles.* While leaves in real life would be dark and paper light, Talbot's negative process reversed the values.

▷

How a Camera Works

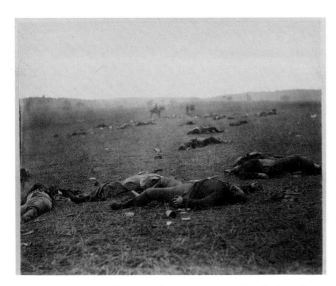

**FIGURE 8.10.** Timothy H. O'Sullivan. *A Harvest of Death, Gettysburg, Pennsylvania. From Alexander Gardner's* Photographic Sketchbook of the War. *1863. Albumen silver print, 7″ × 8 ¹¹/₁₆″. The J. Paul Getty Museum, Los Angeles.* Multiple copies of O'Sullivan's images brought home to the public the horror of the war.

paper, he could produce a positive image, where the values matched the original object. While Talbot's images were not as sharp as Daguerre's, they:

- *Could be placed in books*, because they were on paper
- *Allowed for a more creative process*, because further changes could be made to the final image upon the second exposure
- *Could be reproduced multiple times*, because they were made from negatives

## Still Cameras

Just like Daguerre's camera, all modern still cameras have:

- A *light-tight box* (that keeps light out)
- A *lens* for focusing the light that is reflecting off of objects
- A *light-sensitive material* that records the image

Modern cameras also have two features that control how much light enters the light-tight box: an aperture expands or contracts to different sizes, and a shutter snaps open and closed at different speeds.

Today, digital cameras, particularly ones found on smartphones or tablets, are considerably more popular than those using film. Traditional and digital cameras differ in how they record images and in the photographs they produce:

- In a *still film camera*, the inverted image is recorded *on film as a negative* that can be developed and printed into a final image. These photographs have continuous colors or tones that blend.
- In a *digital camera*, light sensors record the image *on a memory card in a digital format*. This image can be viewed on the camera's screen, uploaded, downloaded, sent, or printed. These photographs are composed of a grid of microscopic squares called pixels that each contain a different, uniform color and tone and that combine visually to create the image.

## An Art of Multiples

Because of the nature of the film and digital camera processes, *many photographic prints can be created from a single image*. Producing multiple copies means that photographs can be widely seen.

During the American Civil War, Scottish-born American photographer Alexander Gardner was inspired to publish a collection of photographs recording the conflict. One of the hundred photographs included was American Timothy O'Sullivan's *A Harvest of Death* (figure 8.10), taken after the Battle of Gettysburg. Even during this period, when the effort and cost to put together such a complicated project were monumental, Gardner produced approximately two hundred copies of the book.

## A Record or a Manipulation of the Truth

Since the early years of photography, people have been impressed with the camera's ability to *record the world accurately*. O'Sullivan's photograph (figure 8.10) allowed those on the home front to witness the aftermath of the battle as if they had been there in person. Corpses are strewn about, their pockets turned inside out and their boots missing—the living having robbed the victims of their valuables. O'Sullivan cropped some of the bodies at the edges of his frame as if to indicate that the scene was just a fragment of a larger tragedy. However, even during the Civil War, photographers sometimes *manipulated what was in front of their cameras*, by moving corpses and adding props such as rifles, to give people a "truer" account of what a battleground was like than they felt the real scene provided.

When we look at a photograph, we must *question what we see*. To interpret the visual information, we must judge whether a photo is realistic or manipulated. While determining whether a photo represents reality has become even more difficult because of how easy it is to manipulate digital images, here are four things you can do:

- *Be skeptical* and question whether an image makes sense
- *Check for inaccuracies in the image* such as shadows that are missing or textures that don't align
- *Consider the photographer's agenda* and whether he or she has anything to gain from changing the image
- *Evaluate the reliability of the organization or person* who distributed or published the image

However, it is not just a matter of knowing when photos are altered or purposely manipulated. We must also be aware that all photos are a reflection of photographers' cultural biases and personal preferences (see *Practice Art Matters 8.1: Contrast Two Photographers' Different Visions*).

---

*Practice* **art** MATTERS

## 8.1 Contrast Two Photographers' Different Visions

Photographers can shoot the same subject matter differently based on their interests and backgrounds. For example, American Alfred Stieglitz (STEEG-litz) in *The Steerage* (figure 8.11) and American Dorothea Lange (dore-THEE-ah lang) in *Migrant Mother* (figure 8.12), both took oppressed peoples as their subject matters; however, the two images could not be more different in their visions.

Stieglitz's photograph from 1907 shows immigrants who had been refused entry to the United States and were being sent back to Europe in steerage. Lange's shows a mother with a baby at her breast and two children standing at her sides—the family was starving because the pea crop they had come to pick in California in 1936 had frozen. However, one of the photographers was interested in form and the arrangement of lines and shapes, while the other was captivated by the plight of the people and passion of the moment. Both photographers manipulated their images to reflect a "truth" that mattered to them.

Consider these questions:

- Which photographer was concerned with form? How do you know? Where do you see repeating lines and shapes?

- Which photographer was concerned with the plight of people? How do you know?

- Do either of the images remind you of any typical depictions of Christian figures that you have seen before? If so, which figures and how would this help the artist reflect the reality he or she wanted to create?

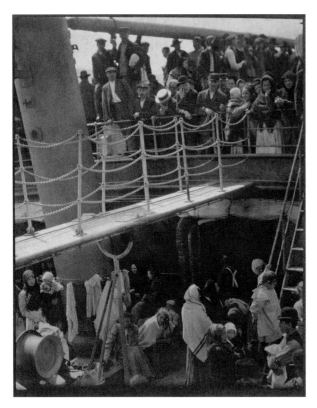

FIGURE 8.11.  Alfred Stieglitz. *The Steerage.* 1907. Photogravure, 13 ⅛" × 10 ⅜". *The J. Paul Getty Museum, Los Angeles.*

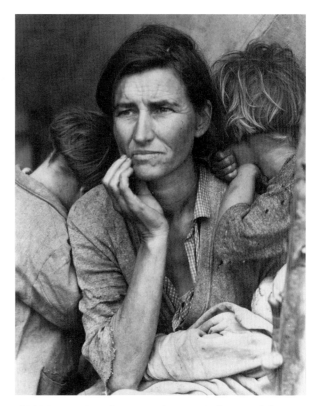

FIGURE 8.12.  Dorothea Lange. *Migrant Mother.* 1936. Gelatin silver print, 9" × 7". *The Library of Congress, Washington, DC.*

### A Series of Artistic Decisions

Photographs are not products of a copying device. Rather, photographers use the camera as a tool and make choices to express their messages, just as Griffith made with his film. Photographers *control a series of artistic decisions*:

- What *is in front of their cameras*
- How their *cameras work*
- How *photographs are manipulated* after they have been shot

Every time photographers take photos, they consider *what is in front of their cameras* and whether it should be changed. Photographers can:

- *Alter the lighting*
- *Move, add, or take away objects or figures*
- *Change objects or figure*s physically, such as their color or texture
- *Decide when* to shoot

Sandy Skoglund, a contemporary American artist, manipulated what was in front of her camera prior to taking her photo. She created the three-dimensional, room-sized installation (figure 8.13), by placing painted plaster cats—which she had individually formed—into a room with live actors and furniture. The green cats appear

radioactive and have overtaken a dismal, gray world. Unlike cuddly real cats, the cats in Skoglund's photo seem menacing.

Photographers also must consider *how their cameras work.* Photographers decide on technical factors, including:

- What to *keep or exclude* from the frame
- Whether the *camera should be close, far away,* or *at a particular angle* from the item being photographed
- What kind of *light-sensitive material* and *focus to use*
- How *much light to let in* the camera

Twentieth-century Japanese photographer Masahisa Fukase manipulated how his camera worked to fashion what seems like an eerie image—ravens that might appear in a horror film (figure 8.14). Fukase made technical decisions to achieve the sinister effect.

Finally, photographers determine *how to manipulate a photo after it has been shot.* For photos taken with film, the photographer can control how the film is developed, deciding on darkness and contrast. For digital images, the photographer can:

- *Merge* or *layer multiple images* into one
- *Change colors* and *values* of parts of an image
- *Rotate, resize,* and *remove sections* of photographs
- *Blur* or *sharpen* how *objects* appear

For all photos, photographers can then decide how to print, size, and crop an image.

In the digital photograph *Guimarães 003* (figure 8.15), Filip Dujardin, a contemporary Belgian photographer, combined real photographs to create the illusion of a nonsensical castle. (Guimarães was the original capital of Portugal, known for its medieval buildings.) Divided into walls that appear one after the next, the irrational structure appears to defy gravity as each wall stands with seemingly no support. Yet, the textures and shadows are true to life. In his work, Dujardin often combines up to 150 different

**FIGURE 8.13.** **Sandy Skoglund.** *Radioactive Cats.* *1980. Color photograph, 2' 1 ½" × 2' 9".* To create her photograph, Skoglund first formed a strange scene that appears as an eerie fantasy.

Developing Film and Printing Photographs

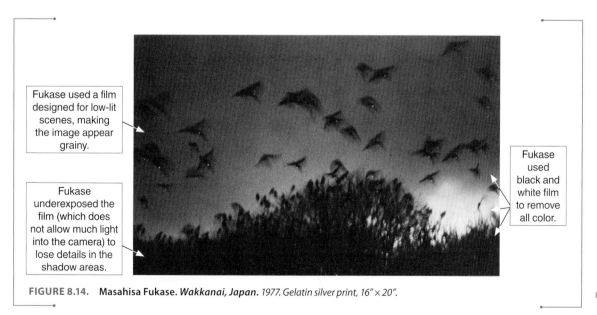

Fukase used a film designed for low-lit scenes, making the image appear grainy.

Fukase underexposed the film (which does not allow much light into the camera) to lose details in the shadow areas.

Fukase used black and white film to remove all color.

**FIGURE 8.14.** **Masahisa Fukase.** *Wakkanai, Japan.* *1977. Gelatin silver print, 16" × 20".*

Interactive Image Walkthrough

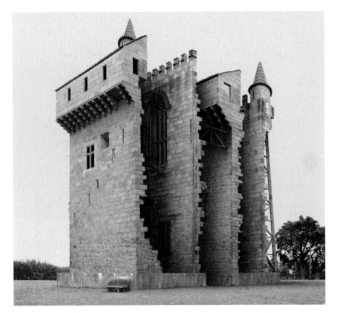

**FIGURE 8.15.** Filip Dujardin. *Guimarães 003*. *2012. Digitally combined photographs, 3′8″ × 3′8″.* This photograph seems so realistic, in part, because Dujardin made each wall appear to throw a shadow on the next even though the walls could not possibly be standing as they are.

**FIGURE 8.16.** Ansel Adams. *The Tetons and the Snake River, Grand Teton National Park, Wyoming*. *1942. Gelatin silver print, 10 ½″ × 13 ⅜″. Center for Creative Photography, University of Arizona, Tucson.* To capture this inspirational scene, Adams waited for just the right moment, when the light and weather combined into the most dramatic image.

components to create a believable image—a testament to why we need to be skeptical when looking at images.

*Quick Review 8.1*: Why is photography both a technical process and an art form?

## Different Types of Photographs

A photograph's type is distinguished by its subject matter and purpose. While it isn't possible to describe every type, a photograph can generally be characterized as *landscape, portrait, photojournalism, documentary,* or *artistic expression* (table 8.1).

| TABLE 8.1: | Types of Photographs. |
|---|---|
| **Type** | **Description** |
| Landscape | Images portray the physical features of the earth. |
| Portrait | Images depict people. |
| Photojournalism | Images illustrate current events. |
| Documentary | Images provide a factual record. |
| Artistic expression | Images capture an inner feeling or prompt reflection. |

### Landscape

Landscapes take as their subject matter the physical features of the earth. The subject matter of twentieth-century American photographer Ansel Adams's *The Tetons and the Snake River* (figure 8.16) is the majestic land of the American West. His goal was to create a landscape of grandeur and beauty that reminded Americans of what they were fighting for during World War II.

### Portrait

Portrait photographers take as their subject matter different people. Nineteenth-century British photographer Julia Margaret Cameron's subject matters were the famous and not-so-famous individuals she persuaded to sit for her. Cameron sought to record her sitters' outward appearances and capture their characters. Figure 8.17 shows Sir John Herschel, an early experimenter with photography. To illustrate Herschel's creative spirit, Cameron had him stare intently at the camera, lit him starkly, blurred the focus, and kept his hair uncombed, so it looked energetic.

### Photojournalism

Photojournalists take images to illustrate different news stories. The photograph by American Lynsey Addario in figure 8.18 illustrated an article about the plight of a family of Syrian refugees. This family was stuck in a camp in Greece for months in 2017 and then

**FIGURE 8.17.** Julia Margaret Cameron. *Sir John Frederick William Herschel.* 1867. Albumen print, 14 ¾″ × 11 ¼″. Cameron made a number of artistic decisions to capture Herschel's inner spirit in her photograph.

**FIGURE 8.18.** Lynsey Addario. *Syrian Refugees Riding a Bus.* 2017. 18 ½″ × 12 ⅔″. Addario captured Taimaa Abazli, her baby, and three-year-old son, as they rode a bus to Athens to attend an asylum meeting about resettling in a new country.

was relocated to Estonia—a country they had never heard of. The subject matter, though, is the worried mother and her two children on a bus.

## Documentary

Documentary photographs provide a factual record. Cuban-born contemporary artist Maria Magdalena Campos-Pons's installation *The Seven Powers* (figure 8.19) used multiple photographs to document the difficult history of her people. (Campos-Pons's African ancestors were brought to Cuba as slaves to work on sugar plantations.) Amid these photographs (not visible in figure 8.19) are letters spelling out, "Let us never forget." The installation projects a sense of the importance of identity and difficulty of loss.

Interactive Image
Walkthrough

Seven large, color photographs on panels represent renowned African Cuban deities.

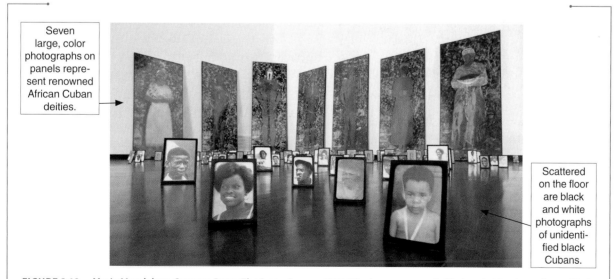

Scattered on the floor are black and white photographs of unidentified black Cubans.

**FIGURE 8.19.** Maria Magdalena Campos-Pons. *The Seven Powers.* 1994. *Cibachromes on panels, black and white photos, letters, black frames. North Dakota Museum of Art, Grand Forks.*

FIGURE 8.20. Alison Rossiter. *Kilbourn Acme Kruxo, exact expiration date unknown, c. 1940s. Processed in 2013. Gelatin silver print, 5″ × 7″. The J. Paul Getty Museum, Los Angeles.* This image could be said to resemble two bleak mountains in front of a white winter sky.

## Artistic Expression

Photographs that are artistically expressive attempt to capture an inner feeling or prompt reflection. Contemporary American artist Alison Rossiter's images can be described as artistically expressive. She does not take any actual photos with a camera. Instead, she develops and fixes old, expired sheets of black-and-white photo paper, never knowing exactly how the images will turn out. Over the years, the papers have been exposed to light, humidity, or mold, which appear as murky shapes and ambiguous effects. The images can take on qualities of abstract landscapes such as in figure 8.20. Rossiter's images counter the traditional role of the photograph, invented to capture the real world, and defy the current trend toward digital photography in their hand-processed technique.

*Quick Review 8.2*: What are the differences among the various types of photographs?

# Film

Film is an art form with which most people likely are familiar. Today, we can see films not only in theaters, like Griffith's audiences, but also on televisions, computers, and handheld devices.

## What Film Is

**film** The process of recording moving images on a photosensitive surface with light

**Film** is the process of recording moving images on a photosensitive surface with light. Film relies on the principles of photography and an optical illusion: while we think we see moving pictures, we really see a series of rapidly shown static images.

## The Roots of Film

Film finds its roots in a bet that racehorse owner and former California governor Leland Stanford made about whether all four of a galloping horse's legs leave the ground simultaneously. Because a horse's legs move too quickly for the human eye to see, no one knew whether a horse became airborne for an instant as it ran. Stanford thought the horse did, and he hired British photographer Eadweard Muybridge (ED-werd MY-bridj) to settle the bet. In 1878, Muybridge did so by stretching twelve wires perpendicularly across a track. He attached each wire to the shutter of a different still camera that he set up in a row alongside the track. When the horse ran by, it tripped each wire, snapping each shutter open and closed and creating an exposure in each camera. The resulting images (figure 8.21), each capturing a slightly different position of the horse, enabled people to see stop-action photos that they had never seen before. The photos also proved Stanford was right.

While stop-action photos give a sense of motion, to create the illusion of movement seen in a film, stop-action

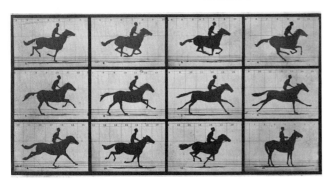

FIGURE 8.21. **Eadweard Muybridge.** *Motion Study. June 19, 1878. Collotype, 5 ¼″ × 8 ½″. The Library of Congress, Washington, DC.* These photos allowed Governor Stanford to win a $25,000 bet.

images have to be shown in rapid succession. Just like the photographs of Muybridge's horse, the static images must have only minimal differences. If you have ever hit the pause button while watching a film, you have seen one of these still, stop-action images. It is only when you hit play, and the static images are shown rapidly one after the next, that the characters and objects in the images appear to move. *Our brains see slightly altered static images shown in quick succession as movement.*

A number of inventions made during the nineteenth century led to the first film:

- A *single camera* that could make successive rapid exposures
- *Film* that could capture multiple frames of static images on a single strip
- A *projector* that could pull the series of frames in front of a light and project them onto a screen

In 1895, Auguste (oh-GOOST) and Louis Lumière (lwee LOO-me-air) projected the first films in France.

## Movie Cameras

A movie camera works similarly to a still camera with a light-tight box that records upside-down, negative images on film. However, a movie camera pulls the film from one reel to another. As each frame moves in front of the aperture, the film pauses as a rotating shutter exposes the film and moves when the shutter blocks the film. Movie cameras today also record sound.

As with photography, digital technology has altered film. Filmmakers can:

- *Capture images electronically* or *create images digitally*, so the footage can be played back instantaneously
- *Modify films* by changing their color and lighting
- *Add to what is in a* **shot**—a segment of the film in which the camera runs continuously—by incorporating extra actors, complex costumes and makeup, and intricate sets that are all created digitally
- *Combine different shots* that originally were taken at different times and in different locations, making objects and/or actors appear side by side

**shot**  A segment of film in which the camera runs continuously

## A Series of Artistic Decisions

Of the art media, film is one of the most difficult for people to think of as art because it can be so commercial. However, just as Griffith did in 1915, filmmakers today can manipulate four factors to express themselves artistically and create effects: *mise en scène* (meez-ahn-sen), *cinematography*, *editing*, and *sound*.

### Mise en scène

Filmmakers control the ***mise en scène***, or everything that is filmed, specifically the:

- *Setting*, *props*, and *lighting*
- *Costumes* and *makeup*
- *Movement* and *behavior* of the actors

***mise en scène***  French for "put in the scene"; everything that is filmed by a movie camera

When considering *mise en scène*, we treat a film like other artworks and look for how the filmmaker has worked with the visual elements of art and principles of design.

Twentieth-century American filmmaker Victor Fleming manipulated *mise en scène* in *Gone with the Wind*. Like *Birth*, *Gone with the Wind* was set during the American Civil War. Fleming created incredible settings, from the prosperous plantations of the South to the

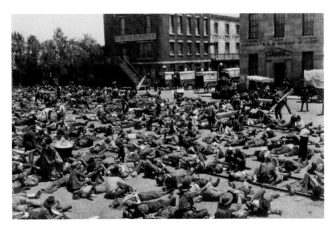

**FIGURE 8.22.** Victor Fleming. *Gone with the Wind*. *1939. Film still of Scarlett O'Hara with the wounded.* Scarlett (played by Vivien Leigh) is a single, living beacon of vibrant, shiny red in a mass of dying, dull, gray soldiers.

**cinematography** The artistic way in which a movie camera is used to film a scene

**zoom** A film technique, achieved during a single shot with a special lens, in which the camera appears to move closer or farther away from the scene when in actuality it remains still

**pan** The technique in film in which, during a single shot, the camera moves from side to side, achieved by swiveling the camera on a stationary axis

**artists**
MATTER

Orson
Welles

**tilt** The technique in film in which during a single shot the camera moves up or down, achieved by swiveling the camera on a stationary axis

**close-up** A shot in which the camera is focused very close to the actors or objects in a scene; a close-up shot of a person shows only his or her face

burning of Atlanta. Costumes and lighting change from the elaborate attires and brightly lit scenes before the war to dirty, battered clothing and candle-lit darkness during the war. Interesting, contradictory characters help move the plot along.

Figure 8.22 shows a dramatic scene and illustrates the *mise en scène*. Scarlett, one of the characters, winds her way through a sea of wounded Confederate soldiers as she races to find a doctor at a makeshift hospital. The stark difference in color and texture between Scarlett and the soldiers helps create variety and emphasizes the sense of the overwhelming waste of war.

### Cinematography

Filmmakers also control **cinematography**—how the camera is used. Like still photographers, filmmakers can change:

- What is *kept in the frame*
- Shot *closeness* and *angle*
- *Film* and *focus*
- *Amount of light* let into the camera
- How the film is *developed*

However, because it is film, they can also change whether the camera:

- *Runs in regular time* or at *a different rate* (e.g., slow motion)
- **Zooms** closer or farther away, **pans** left or right, or **tilts** up or down
- Focuses near to the scene in a **close-up** or far away in a **long shot**
- **Tracks** by moving with the actors
- Takes *shorter* or *longer shots*

Orson Welles (OHR-son WELS), a twentieth-century American filmmaker, used innovative cinematography in *Citizen Kane*. The movie tells the story of a reporter named Thompson, who tries to solve the mystery of newspaper tycoon Charles Foster Kane's strange dying word, "Rosebud," by interviewing people from Kane's past. These people tell Thompson what they know about Kane by way of **flashbacks**, scenes that show events that happened in a previous time period. Welles used the camera almost as if it were a character in the drama itself. The camera seems to investigate Kane's life by moving forward in space, as if delving into Kane's character.

Thompson never does find out the meaning of "Rosebud," but we do. The camera tells us. After Thompson comes back to Kane's mansion, we see Kane's many possessions. Then, the camera moves in to reveal the meaning of "Rosebud." Figure 8.23A, B, and C illustrates how this works.

### Editing

After a film is shot, the filmmaker controls the **editing**, deciding which shots to use and how to order them. Shots can be put together:

- *Spatially, to link places*: for example, one shot shows people walking inside a building and the next shows the same people in a room, so it seems the room is inside the building

1. The camera focuses far away in a long shot, showing Kane's possessions stacked in piles.

2. The camera shows a closer shot in which a man lifts Kane's childhood sled.

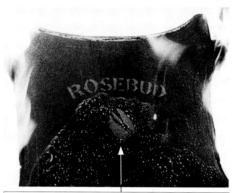

3. The camera focuses very closely on the sled, which the man has thrown into a furnace, where we see the word "Rosebud."

**FIGURE 8.23A, B, AND C.** Orson Welles. *Citizen Kane.* 1941. *Film stills of Charles Foster Kane's possessions.*

- *Temporally, to relate the time period*: for example, alternating shots, like in the last scene of *Birth*, make it seem as though events are happening concurrently
- *Graphically, to compare compositions*: for example, one shot can end on a circular shape and another begin on a different circular shape, creating related forms
- *Rhythmically, to establish tempos*: for example, quicker shots, as in the last scene of *Birth*, make a scene feel more exciting, while longer-lasting shots make a scene feel calmer

Filmmakers also decide how to join shots, and different joining techniques create various effects. Filmmakers can use:

- A **cut**—one shot follows directly after another
- A **fade**—one shot changes to black and then changes back into a different shot
- A **dissolve**—the end of one scene is superimposed onto the beginning of the next

Typically, filmmakers edit shots so that transitions are smooth and continuous. In *Battleship Potemkin*, though, twentieth-century Russian director Sergei Eisenstein (sair-gay EYE-zen-schtine) created a ***montage*** (mon-TAHJ), a series of shots that have graphic and/or rhythmic edits, so that juxtapositions are purposely jarring. Eisenstein's edits ask the audience to consider why shots have been put together. In one sequence, shots placed together in quick succession show czarist troops murdering Odessa's citizens on the city's steps, the montage heightening the effect of the disturbing scene (figure 8.24A, B, and C).

**long shot** A shot in which the camera is focused very far away from the actors or objects in a scene, giving an overall view

**tracking** A type of shot in which the film camera moves along with the actors or objects in a scene

**flashback** A nonlinear film technique in which a film is interrupted with a scene that shows events that happened in a prior time period

**editing** The process of organizing a film by putting shots together

**cut** In film, a way to combine two shots so that when the sequence is shown, one shot instantaneously ends and the next shot instantaneously begins

**fade** A technique in film of transitioning two shots in which the final image in a shot slowly changes to darkness and the darkness slowly changes back into the first image in another shot

**dissolve** A technique in film of transitioning two shots in which the end of the first shot is superimposed on the beginning of the next shot, so that the first shot blends into the next

***montage*** In film, a group of shots that have been organized specifically to highlight graphic and rhythmic relationships between shots rather than spatial and temporal ones

1. A mother has just been killed and has fallen on a baby carriage. The carriage speeds uncontrollably down the steps, moving from left to right.

2. The next shot shows a man screaming. It seems he screams because he's worried the baby will be harmed.

3. The next shot shows the carriage moving from right to left (the opposite of how it moved previously). The change seems confusing and startling.

The screaming man's round glasses and the round wheels of the carriage relate these two shots graphically.

**FIGURE 8.24A, B, AND C.** Sergei Eisenstein. *Battleship Potemkin. 1925. Film stills of the Odessa steps scene.*

## Sound

Even though film is a visual art, a filmmaker also controls sound, specifically speech, music, and noise. The filmmaker manipulates the type of sound, its quality, and its loudness. Sounds can:

- *Work with mise en scène, cinematography,* and *editing,* supporting the action and rhythm, or *oppose them,* creating a jolting experience
- *Give hints* of visual action that is to come
- *Play with our emotions*

Sound is an important factor in American filmmaker Steven Spielberg's 2015 film *Bridge of Spies.* The story is based on real events that occurred at the height of the Cold War. At the outset of the film, U.S. agents arrest Soviet spy Rudolph Abel in New York and the Soviets shoot down an American spy pilot over the Soviet Union.

During the first nine minutes of the film, there are only a couple of terse words of dialogue and no music. The audience is left to determine the story, location, and time period from the images and noises in the film, such as that of a '57 Chevy that drives by. In addition, when Abel sits in his room (figure 8.25), we are meant to understand from the sounds that he is in a New York apartment where the walls are paper thin. We hear a couple in another apartment arguing, the sound of feet shuffling in the apartment above, and someone practicing a violin elsewhere in the building.

## A Collaborative and an Individual Process

The making of any film involves numerous people. Back in 1915, five hundred people were cast in *Birth,* and that was just the actors! Today, in the United States alone, the

**FIGURE 8.25.** Steven Spielberg. *Bridge of Spies. 2015. Film still of Rudolf Abel in his apartment looking at treasonous material.* Rudolf Abel (played by Mark Rylance) commits treasonous acts as we hear the sounds of 1957 New York, such as the fan running behind him.

film industry employs hundreds of thousands of people in many jobs. Aside from actors, films can have directors, scriptwriters, costume designers, makeup artists, set designers, builders, painters, camera operators, composers, musicians, sound technicians, special effect supervisors, and editors. After production, other people distribute, market, and exhibit the film.

Despite all of the people involved, often one person leaves an indelible mark on a film. This person, usually the director, is like an author and is called an ***auteur*** (oh-TER). The film follows that person's style. Twentieth-century British-born filmmaker Alfred Hitchcock, for example, is well known for the style he used in his thrillers. He built suspense by giving the audience more information than the characters had and used frantic cuts that focus on details to frighten the audience.

In one of his most famous films, *Psycho*, a woman named Marion Crane steals money from her job and runs away. Stopping for the night at a motel run by a man named Norman Bates, who the audience sees spying on Marion through a peephole, she is murdered while taking a shower. Hitchcock's numerous cuts include shots looking up at the shower head, out through the shower curtain at the attacker, in at Marion's terrified face (figure 8.26), and down at Marion's blood running down the drain. The speed of the cuts, many camera angles, and sheer number of shots make the scene seem disorienting, violent, and terrifying even though we see almost no shots of the knife plunging into Marion.

**FIGURE 8.26.** **Alfred Hitchcock.** *Psycho. 1960. Film still of the shower scene.* In a quick shot, we see the terrified Marion Crane (played by Janet Leigh) and the shadow of her attacker.

***auteur*** French for "author"; the person who is the author of a film, whose artistic decisions leave a mark on the film

## A Mass Medium

In 1915, when *Birth* was released, approximately thirty million people saw the film. If we consider that there were only about one hundred million people in the United States at the time, we can begin to understand the power of film to communicate to the masses.

Today, films have a global reach. One of the most successful foreign films, *Slumdog Millionaire*, directed by British filmmaker Danny Boyle and Indian filmmaker Loveleen Tandan, sold more than $140 million in tickets in the United States alone.[2] The reach of the film was remarkable, especially given its Indian cast, the actors speaking the Hindi language in 15 percent of the film, and the film drawing on Indian culture. For example, in figure 8.27, a young boy named Jamal, in order to get the autograph of his favorite actor from Bollywood (the Hindi film industry), escapes from a locked outhouse by jumping into a pile of excrement.

Today, the reach of film is enormous. In 2018, $41.1 billion worth of movie tickets were sold worldwide. In the United States, more than twice as many movie tickets were sold than tickets to all theme parks and major professional sports leagues combined.[3] Such a far-reaching mass medium has the power to wield tremendous influence on people's actions and beliefs. To get a sense of the influence of one film, see *Practice Art Matters 8.2: See How a Film Helped Make a Difference.*

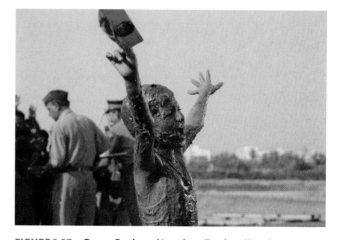

**FIGURE 8.27.** **Danny Boyle and Loveleen Tandan.** *Slumdog Millionaire. 2008. Film still of the young Jamal.* Jamal (played by Ayush Mahesh Khedekar), covered in chocolate and peanut butter (meant to resemble excrement), secures the autograph of his favorite Bollywood star.

## 8.2  See How a Film Helped Make a Difference

In February 2016, *A Girl in the River: The Price of Forgiveness* by Pakistani director Sharmeen Obaid-Chinoy won the Academy Award for Best Documentary (Short Subject). The film tells the story of Saba, an eighteen-year old woman who married against her uncle's wishes. She was shot in the face and hand and then thrown in a river to be left for dead by her father and uncle in an attempt at a so-called honor killing. Saba survived the attempt on her life because she tilted her head back at the exact right second, causing the bullet to miss her brain (figure 8.28).

In Pakistan alone, over one thousand daughters, sisters, and wives are murdered in these killings every year by close family members, who claim the women have dishonored the family. The killings not only often go unpunished, but also can bestow greater prestige on the murderers.

In October 2016, Pakistan passed a new law requiring prison sentences for the perpetrators of these crimes. Consider these questions:

- How do you think the film helped shine a light on the need for the new law?

- How likely do you think it is that the film directly changed lawmakers' positions or led to any sort of public outcry that swayed lawmakers?

- How does this story support the notion of the power of film as a mass medium?

**FIGURE 8.28.**  **Sharmeen Obaid-Chinoy. *A Girl in the River: The Price of Forgiveness*.** *2015. Film still of the injured Saba in the hospital.*

### A Record or a Manipulation of the Truth

Even though films are a technical process, because they reflect the style and biases of their makers, and because different artistic decisions lead to different meanings, we still must question what is real in films and what is not. We also must be aware of a filmmaker's efforts to manipulate information or press a point of view, whether intentionally or accidentally. As with *Birth*, simply because an event is recorded does not mean it is true.

*Quick Review 8.3*: What are the four artistic decisions that filmmakers make?

### Different Types of Films

The vast majority of films are *narratives* that tell scripted stories using live actors. However, there are other types of films, including *experimental* or *avant-garde* (ah-vahn GARD) *films*, *documentaries*, and *animated films*. Films are also distinguished by their *genre* or recognizable category of expression (table 8.2).

### Narrative versus Experimental Films

So far, every film that we have considered has been a **narrative**. Each has had a story that proceeds continuously, and each contains edits that make sense. Even nonlinear films such as *Citizen Kane* (figure 8.23), which includes flashbacks; *Birth*, which includes cross-cuts between concurrent scenes; and *Battleship Potemkin* (figure 8.24), which includes graphically related *montages*, still put shots together in a logical progression, so we can make sense of how the relationships fit together in time and space.

However, not all films are narratives. **Experimental** or ***avant-garde*** films purposely challenge expectations about what comes next to provoke certain ideas or feelings. By

**narrative film**  A film that tells a story or that follows a logical progression

**experimental/*avant-garde* film**  A film that purposely does not tell a story or follow a logical progression and that challenges ideas about what a film is

| TABLE 8.2: | Types of Films. |
| --- | --- |
| **Type** | **Description** |
| Narrative | Films tell a story, proceeding in a logical progression. |
| Experimental | Films purposely do not follow a logical progression. |
| Scripted | Films have actors who learn parts, rehearse roles, and are staged by directors. |
| Documentary | Films are presented to viewers as reliable depictions of real people, places, and events. |
| Live action | Films capture ongoing motion, with a rolling camera. |
| Animated | Films capture a series of slightly different static images, one frame at a time. |
| Different genre | Films have different types of content or styles. |

doing so, they upend typical forms of storytelling, which may lead to a confusing experience for audiences.

Spaniards Luis Buñuel (le-WEES boo-nyoo-EL) and Salvador Dalí (sal-vah-DOHR DAH-lee) made an experimental film with jarring edits and images, *Un Chien Andalou (An Andalusian Dog),* in 1928. Many of its sequences purposely do not make sense spatially or temporally and seem dreamlike. In one shot, narrative text announces that the next scene occurred sixteen years earlier, even though it shows a continuation of the same action that had been occurring before the inter-title. In another shot (figure 8.29), a man appears to slice a woman's eye with a razor. The simulation of this violent act appears to reinforce the interpretation that we should try to see in a different way than we do normally.

### Scripted versus Documentary Films

All of the films that we have considered so far have been scripted in that they have included actors who have learned parts, rehearsed roles, and been staged by directors. In **documentaries**, the filmmaker leaves much of the *mise en scène* to chance in order to capture real people, animals, and events. However, documentary filmmakers still control cinematography, editing, and sound.

Contemporary French filmmaker Luc Jacquet (luke jhah-KAY) braved the frigid weather of Antarctica to capture the lives of emperor penguins in *March of the Penguins* (figure 8.30). Over the year of filming, Jacquet had no control over the penguins' movements or the shifting weather. However, he could control how and when he filmed. Once filming was complete, Jacquet also controlled the editing and sound, adding music and an explanatory narrative voiceover.

There is a perception that documentaries show facts. However, while these films often present reliable portrayals of events, people, and places, the filmmaker can still manufacture what we see. In addition, like all people, each filmmaker has different biases. Given these realities, when we view a documentary, we should still question what is presented.

### Live-Action versus Animated Films

The films we have examined thus far have been live action: the camera captures ongoing movement by running continually. In **animated films**, by contrast, the camera captures a series of static images one frame at a time. After each successive image is filmed,

**FIGURE 8.29.** **Luis Buñuel and Salvador Dalí.** *Un Chien Andalou (An Andalusian Dog). 1928. Film still of the eye-slicing scene.* A man (played by Luis Buñuel) appears to cut the eye of a woman (played by Simone Mareuil); however, later the same woman appears unhurt.

**documentary film** A film that is not scripted, in which the filmmaker does not control the *mise en scène* and is therefore presented to viewers as a reliable depiction of events, people, places, and things

**animated film** A film in which the camera photographs a series of slightly different, static, traditional or computerized drawings or objects one frame at a time to create the illusion of movement

**FIGURE 8.30.** Luc Jacquet. *March of the Penguins.* *2005. Film still of two penguins interacting.* Films that capture animals in the wild, such as Jacquet's, fall into the category of documentaries.

**FIGURE 8.31.** Disney. *Fantasia.* *1940. Film still of "The Sorcerer's Apprentice."* Brooms, which have magically come to life and carry too many buckets of water, overcome Mickey Mouse, the sorcerer's apprentice.

the camera is stopped and another image is substituted in with slightly changed figures. When the sequence is projected back at twenty-four frames per second, the figures appear to move. Animated films can capture traditional (see figure 5.18) or digital drawings or three-dimensional objects such as clay figures or puppets. Animation may also be used in live-action films, particularly for special effects.

Making animated films is a time-consuming process; 172,800 drawings are needed for a two-hour film. Understandably, animated films usually involve the collaboration of numerous artists, but animators also use tricks to speed the process. When drawings are made by hand, nonmoving items are often drawn once on paper, while moving figures are drawn on multiple transparent plastic sheets called cels, which can be layered on top of the paper. Technology can also cut the workload, as artists may create, color, layer, repeat, and modify their art digitally.

Animated films can be experimental and/or narrative. Disney's *Fantasia* from 1940 has both experimental and narrative parts. Before the advent of synchronized sound, music was added to silent films, like *Birth*, after a film was complete. *Fantasia* used the opposite approach: artists were given music and asked to create drawings to accompany the sound. In the experimental parts, changing colors and shapes express the mood of the music. In the narrative parts, sequences tell stories, such as "The Sorcerer's Apprentice" (figure 8.31), in which Mickey Mouse as the apprentice uses magic to help him do his chores.

Today, digital technology helps artists produce a type of animation that looks like a cross between stylized drawings and real, three-dimensional objects. Using computers, the animators who made *Incredibles 2* created figures and objects that appear to have bulk, a multitude of textures, and a true tactile quality, such as the motorcycle in figure 8.32 for Elastigirl—a superhero who stretches into different forms. Computer animation allows for subtle movements that would have been extremely difficult by hand. When the characters move in the film, such as when Elastigirl rides her bike, not only does she change locations, but also her hair blows, the motorcycle exhaust billows behind her, and the tires depress differently as her weight shifts.

*Incredibles 2* is also an example of a film that was released in "3D," the name for a process that makes two-dimensional films appear to be three-dimensional. Using stereoscopic 3D technology, animators created the illusion of a believable space, in which characters seem to come out of the screen toward the audience and expansive landscapes appear to recede into vast distances.

Three-dimensional technology works on the same premise as how we see in real life. Because our eyes are approximately two inches apart, we always see two slightly different views that our brains fuse together. These two views create the illusion of depth. Similarly, when making a three-dimensional film, animators produce two different two-dimensional versions of every scene, each from a slightly different angle, and match them up in one film. When watching the film, audience members wear polarized glasses that allow each

eye to see only one version. The two versions combine in the viewer's brain and appear as depth.

## Films of Different Genres

Genre is the type of content a film contains or style it follows. There are many different genres, and we have already looked at films with a number of them. *Bridge of Spies* (figure 8.25) is a historical film that tries to capture a bygone era. *Psycho* (figure 8.26) is a thriller meant to keep viewers on the edge of their seats. *Incredibles 2* (figure 8.32) is a superhero film in which superhuman characters save the world.

**FIGURE 8.32.** **Brad Bird.** *Incredibles 2. 2018. Film still of Elastigirl, Mr. Incredible, and Jack-Jack.* Because of the use of computer animation, Elastigirl's bike looks as if it is a solid object with the real textures of rubber tires and a gleaming red body.

*La La Land* is a romance. In the 2016 film, Mia, an aspiring actress, and Sebastian, a struggling musician, fall in love. Contemporary American director Damien Chazelle made artistic decisions in the film to highlight how everything feels perfect when two people begin to fall in love. Consider the *mise en scène* in figure 8.33, in which everything looks right for a budding romance.

Sometimes films fall into more than one genre. *La La Land* is also a musical. Characters dance and sing throughout. Because in real life people do not often break into song whenever they want to express their feelings, musicals ask us to suspend reality. In *La La Land*, the music and dancing help make the action appear as if it is part of a dream, seeming to reinforce the aspirations that both Mia and Sebastian hold for their futures.

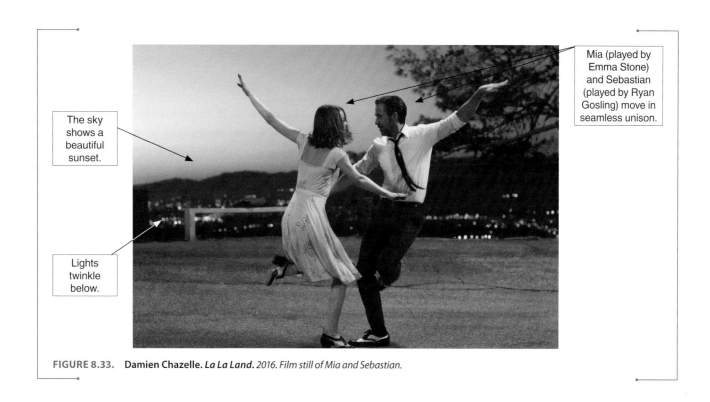

The sky shows a beautiful sunset.

Mia (played by Emma Stone) and Sebastian (played by Ryan Gosling) move in seamless unison.

Lights twinkle below.

**FIGURE 8.33.** **Damien Chazelle.** *La La Land. 2016. Film still of Mia and Sebastian.*

*Quick Review 8.4*: What are the differences among narrative and other types of films?

# Video

Anyone who has watched television has experience with video. Surveillance cameras used for security also use video, and artists have used video to create art.

## What Video Is

**Video** is the process of recording moving images electronically with light. The medium is portable, easy to use, and relatively inexpensive. In addition to being *a technical process*, video is also *an art form*, and video artists can use their medium to *manipulate the truth*.

### A Technical Process

Just like a film camera, a video camera *records multiple static moments of motion* by capturing reflected light that enters a camera through a lens and aperture. However, a traditional analog video camera transforms that light into electrical charges that can be recorded onto a tape as a magnetic pattern. In a modern digital video camera, the electrical charges are transformed into binary data to be recorded on a device.

Video is an *instantaneous medium*. Electronic signals can be immediately transformed back into pictures formed out of grids of pixels and be seen on a monitor, transmitted to a satellite, and broadcast in multiple different locations; or, if on digital video, streamed, downloaded to a device, or sent electronically. While film and video were originally distinguished because of their different physical materials, as filmmakers have moved to digital filmmaking, the line between the technical aspects of film and video has blurred.

**FIGURE 8.34.** **Gary Hill.** *Windows.* *1978. Color video.* By introducing extra electrical signals into his video of a window, Hill created a nonobjective image.

### An Art Form

Like filmmakers, video artists can make a number of artistic decisions; many have incorporated the elements that make video a unique medium into their art. American Gary Hill focused on the technology that analog video uses in *Windows* (figure 8.34). By feeding the video camera extra electronic signals, the image became distorted. Rather than a window, we see nonobjective shapes, colors, and the normally invisible pixel grid. By manipulating a window, Hill contrasted video with traditional art forms. As discussed in Chapter 3, artists since the Renaissance have thought of the picture plane as a window through which they could look into a believable space. Hill used the technical aspects of video to create flat forms.

### A Record or a Manipulation of the Truth

Video artists have also explored what is real and what is manipulated. Because video can be streamed live as it is recorded, it may seem impossible to manipulate. Even so, Peter Campus, an American video artist, asks us to consider whether video captures reality. In *Three Transitions,* Campus wipes off his face, leaving another view of his face underneath (figure 8.35). Throughout, both of his disappearing and appearing faces move, so that the image seems startling and invented.

**FIGURE 8.35.** **Peter Campus.** *Three Transitions.* *1973. Color video with sound.* We see two mouths and noses in this unbelievable image.

## Different Types of Videos

Videos can be distinguished by various factors, including how artists manipulate *mise en scène*, cinematography, editing, and sound, and how they present the video. For example, artists can create sequences using different concepts of space or time, or develop unique methods of displaying their works.

In *Mary*, American artist Bill Viola manipulated *mise en scène* and cinematography to form a work that distorts time. Viola shows a woman nursing a child set against a cityscape (figure 8.36). While her movements remain in regular time, the background is a *time-lapse video* that speeds through a day in minutes. Because the work is installed at St. Paul's Cathedral, we are likely to think of the nursing mother as the Virgin Mary. The work then shifts to show multiple, simultaneous, current clips that could reflect Mary's life. The video ends with a woman holding a dead man across her lap, undoubtedly a pietà (pee-ay-TAH; an image of Mary, holding and mourning her dead son). The image recalls other pietàs depicted throughout the history of art.

Viola technically manipulated time through cinematography, as he combined different video speeds. He also depicted the concept of time through *mise en scène*, because the baby ends up as an adult, and modern images reference biblical ones. These changes may lead us to consider how the ancient story of Mary and Jesus could still be relevant today.

A number of artists have explored how video is displayed. Nam June Paik, a South Korean–born American artist, showed video from multiple monitors. Paik set up a wall of eighty-four televisions in *Video Flag Z* (figure 8.37). The depth of the televisions gives the display the qualities of a three-dimensional work. Each monitor plays separate, extremely short clips of people, objects, and shapes, some shown for such a short moment that the viewer can barely register what they are. However, the videodiscs are synchronized to work together, so as they flicker from one shot to the next, they create different overall patterns reminiscent of an American flag. Monitors also work together in small groups, showing at times one image across several screens.

New York–based Tony Oursler includes videos of actors and moving objects in sculptures. The works exist in real space, appear to be alive, and make noise, like a theatrical presentation in front of an audience. In his exhibition at New York's Lehmann Maupin Gallery in 2015 (figure 8.38), Oursler inserted videos of real people's eyes and mouths into face-shaped sculptures. Each face also featured the markings of facial recognition software. Oursler's work may suggest that we are all trapped by the technology that is overtaking our world.

**FIGURE 8.36.** **Bill Viola.** *Mary.* 2016. Color high-definition video triptych on vertical plasma displays, 5' 1" × 7' 9" × 4". A nursing mother in regular time is shown against a cityscape that quickly changes from morning to night.

**artists**
MATTER

Nam
June Paik

**FIGURE 8.37.** **Nam June Paik.** *Video Flag Z.* 1986. Eighty-four television sets, videodiscs, videodisc players, and Plexiglas modular cabinet, overall 6' 3" × 11' 6 ½" × 1' 4". The Los Angeles County Museum of Art, California. Different pulsing images together form abstracted versions of an American flag.

FIGURE 8.38. Tony Oursler. View of the exhibition at the Lehmann Maupin Gallery in New York. *2015. Aluminum panel sculptures with video, dimensions variable.* During the exhibition, the embedded videos of eyes blinked and looked in different directions and the mouths murmured words.

In *Turbulent*, Shirin Neshat also focused on presentation by facing two screens opposite each other. Viewers must enter the space between the screens to experience the work. On one screen, a man confidently sings a traditional love song for an all-male audience (figure 8.39A). As he finishes, a woman, on the other screen, covered in a chador (a garment worn by some Islamic women), cries out to an empty room (figure 8.39B). In traditional Islamic cultures, women are not allowed to sing in public. By placing us between the screens, Neshat, an Iranian-born woman, introduces us to the complex issue of gender in the Islamic world.

*Quick Review 8.6*: In what ways have video artists developed different methods of presentation for their works?

(A)

(B)

FIGURE 8.39A AND B. Shirin Neshat. *Turbulent. 1998. Black and white video, each projected image a minimum of 13' wide.* Viewers of this work must continually pick which screen to watch—the one with the man singing (8.39A) or the woman crying out (8.39B).

## A Look Back at *The Birth of a Nation*

Griffith's *The Birth of a Nation* remains one of the most successful and controversial films of all time. The story of its creation and its audience's reaction reflect many of the issues that we have discussed in this chapter.

*Birth* was formed using the process of **film**, not **photography**, but there are connections. Like photography, the creation of *Birth* relied on the *image-making properties of light*. Moreover, *Birth* was made in *multiples*, which meant it could be experienced as *a mass medium* by an enormous audience in 1915—almost one-third of the country. It is this reach along with the questionable notion of the camera as *a displayer of truth* that makes this film so problematic.

The strongest connections can be seen with the topic of film. As in other films, Griffith manipulated the ***mise en scène***, creating grand sets and costumes and moving hundreds of people across vast expanses. His scenes looked factually accurate, but he intermingled these with disturbing racist scenes, misrepresenting the truth. Griffith also controlled the **cinematography**, using a number of techniques to tell his story. He manipulated his camera, using **long shots**, **close-ups**, **pans**, and **tracking** shots. In addition, he used **editing** to create different rhythms at various points in the film, playing on audience's emotions, and organizing the film temporally and spatially, cross-cutting between simultaneous scenes. Finally, Griffith's *sound* enhanced the effect of the film, as he gave

audiences a single auditory experience. While Griffith could use only music in his silent film, his score heightened the impact on the audience.

In terms of film *type*, *Birth* is a **narrative**, *scripted*, *live action* film. We could call its *genre* historical, but the categorization is troubling given Griffith's inaccurate portrayal of events.

*Birth* also shows a connection to video. Given the innovation and creativity involved in making *Birth*, Griffith changed the nature of the film medium. Like video artists, Griffith explored what makes film a unique medium.

As you move forward from this chapter, consider how we typically assume that photography, film, and video reflect reality, and how this notion *impacts what we believe and how we act*. When the camera arts deceive, the consequences for society and individuals can be devastating. Consider how *Birth* distorted facts and advanced stereotypes, leaving many in the audience with misconceptions about the Civil War era and prejudices against African Americans. However, when the camera arts reflect reality, individuals' lives—and society as a whole—can be changed for the better. When Obaid-Chinoy produced her film (figure 8.28; Practice Art Matters 8.2) showing the truth and devastating effects of honor killings, it brought attention to a serious issue and contributed to a change in the law. We depend on the camera arts to show us reality, but we must be skeptical of what we see.

Flashcards

## CRITICAL THINKING QUESTIONS

1. This chapter makes the case that it is the artist's control of technology that makes photography an art. Using a photograph from the chapter, can you defend this statement?
2. Whose photography method, Daguerre's (figure 8.8) or Talbot's (figure 8.9), do you think had a greater influence on photography? Why?
3. Locate a photograph on the internet that you believe has been digitally manipulated. How do you know it was distorted?
4. How did Campos-Pons use unity, variety, emphasis, subordination, scale, and rhythm in *The Seven Powers* (figure 8.19)?
5. Why are Muybridge's stop-action photographs (figure 8.21) important in understanding the process of film?
6. Documentaries present reliable portrayals of events, people, places, and things. Could anything be wrong with this statement? If so, what?
7. How can a film be classified as more than one genre? Use an example of a film you have seen in explaining your answer.
8. How are Buñuel and Dalí's *Un Chien Andalou* (figure 8.29) and Campus's *Three Transitions* (figure 8.35) similar and different in terms of the mediums, forms, and contents?

Comprehension Quiz          Application Quiz

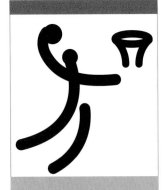

# Graphic Design

## LEARNING OBJECTIVES

**9.1** Summarize three decisions that a client makes before hiring a graphic designer.

**9.2** Explain why graphic designers must communicate clear messages.

**9.3** Describe several ways in which graphic design is similar to other art forms.

**9.4** Differentiate between pictographs and symbols.

**9.5** Identify three features that make letters appear different and evoke different feelings.

**9.6** Discuss how the layout of a design affects the overall presentation.

**9.7** Distinguish between signs, publications, and packaging.

**9.8** Define trademarks, and explain why corporations use them.

**9.9** Explain the challenges graphic designers face when producing motion graphics and interactive digital media.

# THE GRAPHIC DESIGN FOR THE BEIJING OLYMPIC GAMES

On July 14, 2001, the International Olympic Committee (IOC) awarded the honor of hosting the 2008 Olympic Games to Beijing, the capital city of China. Just eight years prior, China had lost a bid to host the 2000 games. It had been a long, emotional road to this moment, and people across Beijing celebrated.

$\triangleright$

How Art Matters

China began preparations for the games shortly after. The country had many daunting projects to complete, including building venues and an Olympic village to house the numerous athletes. However, behind these visible projects stood a monumental task about which most people were unaware: the creation of the *graphic design* of the Olympics, *the print and digital materials that carried the specific message that the organizers wanted to communicate* to the global audience about the look, feel, and spirit of the games. In this case, they hoped to convey that China was a welcoming, friendly, and modern country with a strong culture and long history, and that China deserved to be hosting the games. As with every modern Olympics, organizers designed a complete, interrelated design that was functional and informative.

## The Olympic Emblem

Officials announced one of the earliest examples of the design program, the Olympic emblem, in August 2003. Judges had chosen the design from among 1,985 entries submitted to an international design contest. The emblem was simple and direct. It was also *flexible enough to be used in a variety of sizes and formats*—enormous heights on billboards or small sizes on medals. It featured *images* of a figure dancing and the Olympic rings, and *type* showing the words "Beijing 2008," organized in a *layout*—a particular arrangement (figure 9.1A).

The emblem also had a symbolic meaning that helped present *the message the organizers wanted to convey.* The designer, Guo Chunning, based the image on the Chinese art of seals. Used in China for over 2,000 years, and thus showing China's long, proud history, seals are small, square-shaped prints that are stamped on important documents and artworks. Like all prints, seals are an indirect art form (see Chapter 7). To create a seal, an individual carves a design on a small stone, applies ink, and presses the stone to a paper, transferring the design. Seals in China have both an aesthetic value as prints and an official function as stamps (almost like signatures in the West). A seal contains Chinese calligraphic writing that often states the name of the creator or owner of the work.

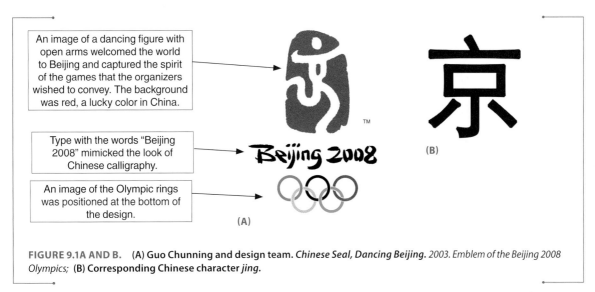

An image of a dancing figure with open arms welcomed the world to Beijing and captured the spirit of the games that the organizers wished to convey. The background was red, a lucky color in China.

Type with the words "Beijing 2008" mimicked the look of Chinese calligraphy.

An image of the Olympic rings was positioned at the bottom of the design.

**FIGURE 9.1A AND B.** **(A) Guo Chunning and design team.** *Chinese Seal, Dancing Beijing. 2003. Emblem of the Beijing 2008 Olympics;* **(B) Corresponding Chinese character** *jing.*

When we write words in English, we use letters to do so. For example, the word *ram* is spelled R-A-M. Each letter stands for a sound and has nothing to do with the animal. These letters in different orders also spell the words *arm* and *mar*. However, in China, people use pictures called characters. Each word is represented by a unique character. For example, the word for "capital city," *jing*, is written using the character shown in figure 9.1B.

If we compare the character for *jing* with the dancing-man emblem, the similarities are evident. The designers purposely and *creatively* used the character for *jing*, the short form of Bei*JING*, in making the emblem. With the emblem, they hoped to communicate (to those individuals who were familiar with the culture of seals and who would recognize the character) that the people of Beijing had given their "seal" with their name on it to the Olympics, indicating that they vouched for the games they were hosting for the world.

## The Pictographs

The emblem, though, was just the start of the design program. In March 2005, officials from the organizing committee solicited designs from forty different design teams for the creation of *pictographs*—images that represented each of the Olympic sports in an abstracted and simplified way (figure 9.2). As with the Olympic emblem, the pictographs were based on Chinese seal characters.

**FIGURE 9.2.** **Qian Zhe and design team.** *The Beauty of Seal Characters.* 2005. *Pictographs of the Beijing 2008 Olympics.* Pictographs for the Olympics immediately and clearly communicated the sport they represented for multilingual participants and spectators.

Created in a universal visual form rather than in a specific language, these pictographs *communicated ideas without words*. The pictographs enabled multilingual athletes and spectators to distinguish among the different sports and, when placed on signs, directed people to different events. Additionally, the pictographs identified and promoted individual sports.

Designers of the pictographs had to *work collaboratively with many groups who had specific ideas about what they wanted communicated*. The designers submitted individual pictographs to twenty-eight different international sports federations and the IOC for approval and had to *work under multiple parameters*. Each pictograph had to:

» Be based on an ancient seal character
» Be instantly recognizable, at any size, without any text, as the distinct sport
» Work as an individual design
» Meld with the other pictographs as an interrelated group and with the other aspects of the entire design program of the games

Just as designers were finalizing approvals on the Olympic pictographs, they began work on twenty other pictographs for the Paralympics (figure 9.3). Here, designers *worked collaboratively* with Paralympic athletes and specialists. Again, designers based the pictographs on characters from Chinese seals and had to ensure that pictographs were clear, flexible, powerful, and coherent. Again, approvals were needed, this time by the International Paralympic Committee and the individual sports federations. Wang Jie, a Beijing Olympics pictograph designer, described his experience creating the pictographs for the Paralympics: "I had known nothing about the Paralympics when I started. But as I got to know some disabled athletes and their stories, I was deeply moved, so I just tried to convey the dynamics of their body movements through the pictographs."[1]

**FIGURE 9.3.** Hang Hei and design team. *The Beauty of Seal Characters. 2006. Pictographs of the Beijing 2008 Paralympics.* Designers modeled the pictographs for the Paralympics after the design of the pictographs for the Olympics.

## The Mascots and Other Components of the Design

The organizing committee unveiled another aspect of the design program in November of 2005: five mascots (figure 9.4). Designed by Han Meilin, the *fuwa* or "friendlies"—with their five colors representing the Olympic rings, the Olympic emblem blazoned on their chests, and their cheerful expressions—offered a welcome to the world. The *fuwa* helped *express the message* that the organizers wanted to send out—that China was a friendly and hospitable country. Each *fuwa* had a name with a repeated syllable (Beibei, Jingjing, Huanhuan, Yingying, and Nini), an affectionate way of calling children in China. When strung together without the repeat, the names formed the sentence *"Beijing huan ying ni"* or "Beijing welcomes you."

The mascots appeared on numerous signs and in the form of life-size costumes, so people dressed as the mascots could appear at events. Designers made the mascots into dolls, and their images graced multiple, diverse objects, such as stamps, bags, and calendars, all for sale in Olympic stores. The inviting, brightly colored mascots *helped persuade consumers to buy these products*.

In keeping with the spirit of the emblem and pictographs, the *fuwa* had a symbolic meaning intended to *communicate the message* regarding China's strengths. Designers based the *fuwa*'s headdresses on Chinese traditional arts, culture, and the landscape. Nini's headdress resembled a Chinese kite, while Yingying's featured leaves from the lotus plant that grows in China. Additionally, each *fuwa* took a different form. The red *fuwa* (Huanhuan)

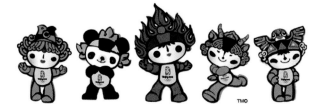

**FIGURE 9.4.** Han Meilin. *Fuwa (Friendlies). 2005. Five mascots of the Beijing 2008 Olympics.* Seen from left to right are Beibei, the fish; Jingjing, the panda; Huanhuan, the Olympic flame; Yingying, the Tibetan antelope; and Nini, the swallow.

represented the Olympic torch, while the others represented animals that lived in different parts of China: Beibei was a fish, Jingjing, a panda, Yingying, a Tibetan antelope, and Nini, a swallow. Han and his team had picked the final mascots from 662 different ideas submitted by people from different Chinese provinces. They hoped by picking five mascots rather than one that they could represent the multiple ethnic and regional groups in China. As Han said, "No single figure can embody China's profound and diversified culture."[2]

Designers created many other aspects of the comprehensive visual program beyond the emblem, pictographs, and *fuwa*. Each part of the design worked within an overall color scheme and style. Most importantly, whether the graphics were on a venue, a banner, or TV, they *conveyed the specific message that the organizers wished to communicate to the world*.

## Controversies Surrounding the Olympics and the Design

While the graphics might have been a success in conveying the spirit of the Olympics and the history of China, many saw both the visual program and the fact that China was picked to host the games in the first place as controversial. The IOC had awarded China the games in the hope that the coveted prize would help push China into becoming a more open society, one that respected freedom of speech and the press and that championed human rights.

Yet by 2008, China was still cracking down on, detaining, and torturing dissenters and activists, and many people saw the graphics program as just a part of the state's powerful propaganda machine. For example, they considered the inclusion of Yingying, the Tibetan antelope, as an affront because Tibet was a disputed land that they believed China had occupied illegally. Other people saw the overall Olympic emblem with its inclusive welcome as hypocritical. They felt the emblem presented a China that in reality did not exist.

In response, opposition groups had graphic designers create visuals to protest the Beijing games. Using *straightforward images and words* that represented their side of the issue, they produced many messages in a variety of formats including signs, T-shirts, and websites. For example, in one creative message (figure 9.5), the five Olympic rings were replaced by an *image* of handcuffs with the *words* "Beijing 2008" *arranged* underneath. Graphic design was essential in helping opposition groups *convey their messages to the world,* too.

## Considering Designs That Communicate Specific Messages

The graphic design of the Beijing Olympics tells much about messages that *inform*, *identify*, and *persuade*. Such messages can be found everywhere. Numerous graphic designs relate information, label entities and objects, and try to convince us to alter our thinking every day.

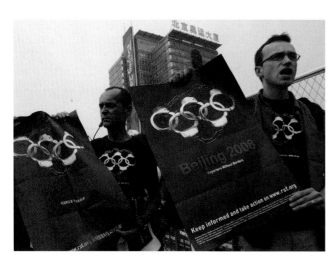

The story of the Beijing Olympics reminds us of the importance, usefulness, and influence of graphic design as an art form and as an essential part of our lives.

The Beijing Olympics visuals also lead to many questions about the art form itself:

» If the designers were communicating messages for others (the organizing committee and protestors), are they artists?
» If the designs were reproduced multiple times in many different sizes, on numerous types of gimmicky objects such as key chains and hats as well as on television and on websites, are they still art?
» Should the written words that made up parts of the messages be considered a part of the visual design?

This chapter will consider these issues and questions in the exploration of the art of graphic design. Before moving forward, based on this story, how do you think graphic design differs from other art forms you have studied? What different types of works do you think are considered graphic design?

**FIGURE 9.5.** **Protestors from Reporters Without Borders demonstrated against the Beijing Olympics on August 6, 2007, in Beijing.** The Olympic rings changed to handcuffs symbolized the imprisonment and torture of dissenters in China.

# What Graphic Design Is

Unlike some art that is found primarily in museums, **graphic design**—the print or digital material that communicates a specific message of a client to a targeted audience—is all around us and takes many forms. The billboards we pass on our way home, the greeting cards we get on our birthdays, the games we play on our smartphones, the websites we visit, and the books we read were all designed by graphic designers.

Graphic design has a different purpose than traditional art forms. While all artists try to communicate with viewers, graphic designers help *clients convey their particular messages to specifically chosen audiences*. To do so, graphic designers *communicate directly*, produce *multiple copies* of their messages, and create *works of art*.

**graphic design** Print or digital material that communicates a client's specific message to a targeted audience

## A Client's Message to a Specific Audience

Graphic design begins with a *client*, a person or group of people, *who wants to communicate with another group of people*. The client hires a graphic designer to help facilitate this communication. However, before a single design is made, the client first makes three decisions. The client decides:

1. *What message to communicate.* That message may persuade, identify, or inform. In contrast to other art forms in which artists try to convey their own messages, graphic designers convey a client's message.
2. *How to communicate.* The client establishes requirements within which the designer must work. These parameters may include the format, budget, images, text of the copy, size, shape, and schedule.
3. *Which audience to target.* Unlike traditional art, which is created for anyone who might see it, graphic design is placed and formatted to be seen by those people with whom the client wants to communicate.

Because a client dictates so much of the project, a graphic design is *a collaborative process*. When designers created the pictographs for the Beijing Olympics, the design needed to be approved by the client (the IOC) and many other individual sports federations. This collaborative aspect was not unusual. Most designers do not work alone.

While these parameters and the involvement of multiple people might feel restricting, graphic designers look at these boundaries as challenges. Graphic designers must be visual problem solvers. They must envision a design that *works within the established boundaries*, yet also functions aesthetically.

The tech company Apple had a number of requirements when creating a billboard in Union Square in San Francisco to advertise the Apple Watch. Designers had to communicate the purpose of the advertisement (that people should purchase the watches because they are stylish and functional), use a billboard (not a website ad, poster, etc.), and produce a design appropriate for Union Square (a public plaza with upscale shops, hotels, and restaurants that attracts tourists).

The design solution (figure 9.6) shows three Apple Watches each with a different display—a calendar entry, a standard watch face, and Apple Pay (an app that allows payment via the watch). The design met the client's requirements. It informs viewers that these sleek

**FIGURE 9.6.** **Apple Watch billboard.** *From Union Square, San Francisco. 2015.* The three watch faces tell a story that shows how a wearer might use the watch—the first reminds the wearer to "Buy flowers for mom," the second shows a flower, and the third displays an image of the purchase being made.

I SHOULD PROBABLY
GET A RIDE HOME.

NHTSA Ad

**FIGURE 9.7.** **The Ad Council.** *Buzzed Driving Is Drunk Driving. 2017. Out-of-home advertisement.* With the word "probably" crossed out by a red line, the sentence in this ad changes from "I should probably get a ride home" to "I should get a ride home." The graphic design stresses that if someone is questioning whether he or she should drive, then that thought should be a warning signal not to drive.

**FIGURE 9.8.** **Ronny Edry and Michal Tamir.** *Iranians, We Will Never Bomb Your Country, We ♥ You. From the Facebook page of Pushpin Mehina School. 2012.* In the poster, Edry's daughter holds an Israeli flag, indicating a peaceful message to Iranians.

watches with various colored bands are sophisticated and also practical—enabling watch owners to do multiple tasks without taking out their phones. The design was produced at an enormous size, set up in a rectangular format, and placed on top of a building. Finally, the design's location ensured that the right people—tourists who might be shopping for gifts—saw it.

*Quick Review 9.1*: What are three decisions that a client makes before hiring a graphic designer?

## A Straightforward and Multiple Form of Communication

When the Beijing Olympics designers created the pictographs, one major objective was to ensure that each would clearly communicate the sport it represented. Unlike traditional artists, whose work can be interpreted by different people in various ways, graphic designers *must convey a clear message* that is meant to be interpreted by everyone in the same way.

When designs communicate well, the results can be far reaching. This point is especially true when graphic designers take on a public service role to aid the common good. For example, the Ad Council has paired with the U.S. National Highway Traffic Safety Administration since 1983 to produce advertisements to prevent people from driving drunk. The campaign has focused on different objectives, such as encouraging people to intervene if someone is going to drive drunk ("Friends Don't Let Friends Drive Drunk") or making people aware that driving with a buzz is just as dangerous as driving drunk ("Buzzed Driving Is Drunk Driving"). The latest strategy, launched in 2017 ("Probably Okay Isn't Okay"), encourages people to recognize for themselves when they shouldn't drive (figure 9.7). While we will never know the full impact of the campaign, the effort has likely played an important role in preventing drunk driving. Since 1983, when the campaign started, almost 70 percent of Americans have attempted to stop someone from driving drunk.[3]

Graphic designers also try to communicate a straightforward message to as many potential interested people as possible. Accordingly, graphic designs, like prints, photographs, and films, are often *produced in multiples*. As with these other art forms, graphic designs are often available to a large audience, and social media has expanded that reach. Take Israeli couple Ronny Edry and Michal Tamir's 2012 message of love to the Iranian people. With tensions high between Israel and Iran, Edry posted an image with a plea for peace (figure 9.8) on social media. Within a few days, the poster went viral. Individuals from all over the world shared the image of Edry holding his five-year-old daughter and in response sent messages and created new versions of the poster that they then shared. Amazingly, even people within Iran, a highly controlled society, responded despite dangers of repercussions.

# DELVE DEEPER

## The Ancient Art of Graphic Design

In ancient Mesopotamia, one of the first civilizations, high officials used an early form of graphic design by creating marks from small cylinder-shaped objects called cylinder seals. The designs on the seals were unique to the owner, and they conveyed rank, proclaimed ownership, and authorized agreements. Because communicating identity was important in Mesopotamia, the seals had holes through them, so that officials could carry them on strings around their necks everywhere they went.

Similar to the seals used in ancient China on which the designers of the Beijing Olympics modeled their graphics, the seals in Mesopotamia were carved. However, the Mesopotamian seals were rolled on damp clay tablets instead of printed. The marks from the seal would transfer onto the tablet, leaving an impression that could easily be duplicated multiple times on other tablets by rolling the same seal, but that were nearly impossible to forge without the original. Using the seal in figure 9.9, a person could leave an indentation by rolling the cylinder or by impressing the base (both indentations are shown in figure 9.9 along with the seal itself). The rolled impression shows a scene with deities.

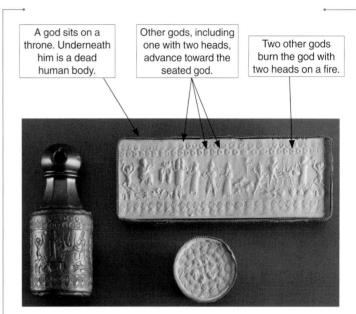

A god sits on a throne. Underneath him is a dead human body.

Other gods, including one with two heads, advance toward the seated god.

Two other gods burn the god with two heads on a fire.

**FIGURE 9.9.** **Stamp-cylinder seal.** *From Anatolia. Hittite. 1650–1200 BCE. Hematite handle on cylinder of intaglio gem, 2 5/16" × 7/8". Museum of Fine Arts, Boston.*

Today, graphic designs abound on social media, but people have actually been communicating straightforward messages in multiples for thousands of years. While graphic design may seem like a relatively young art form, it is not (see *Delve Deeper: The Ancient Art of Graphic Design*).

*Quick Review 9.2*: Why must graphic designers communicate clear messages?

## An Art Form

It might be hard to understand how graphic design can be considered an art form, because graphic designs are functional, commercial, and commissioned. However, graphic design has *many qualities similar to traditional art forms*. Graphic designers:

- *Use visual elements of art* and *principles of design* to form their works
- *Generate creative ideas* and *contents*
- *Employ art media*—including drawing, painting, printmaking, photography, collage, film, video, and digital imaging—or some combination of these media or even nontraditional media

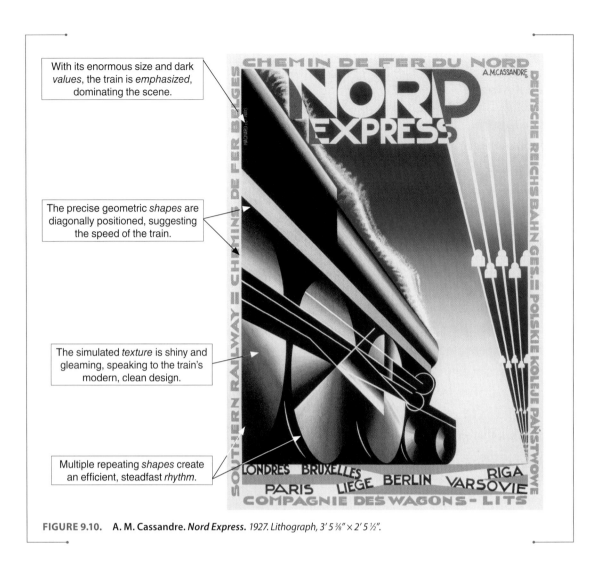

With its enormous size and dark *values*, the train is *emphasized*, dominating the scene.

The precise geometric *shapes* are diagonally positioned, suggesting the speed of the train.

The simulated *texture* is shiny and gleaming, speaking to the train's modern, clean design.

Multiple repeating *shapes* create an efficient, steadfast *rhythm*.

Interactive Image Walkthrough

**FIGURE 9.10.** **A. M. Cassandre.** *Nord Express.* *1927. Lithograph, 3′ 5 ⅜″ × 2′ 5 ½″.*

For example, even though twentieth-century French artist A. M. Cassandre created the poster *Nord Express* specifically to promote a railway company, he also made a work of art, manipulating form, content, and technique. First, he used the visual elements of art and principles of design (such as shape, texture, value, rhythm, emphasis, etc.) that other artists use (figure 9.10). Second, Cassandre devised an idea and meaning for the poster. While the client dictated that Cassandre advertise the train, Cassandre decided how to do so. In Cassandre's vision, the train appears as a slick, dominating, triangular form of monumental power—one that anyone would surely want to experience. Finally, Cassandre skillfully used the printmaking technique of lithography (see Chapter 7) to create his message.

*Quick Review 9.3*: How is graphic design similar to other art forms?

## Components of Graphic Design

When Guo Chunning and his team designed the Olympic emblem (figure 9.1A), they included the dancing-man seal, Olympic rings, and words "Beijing 2008." They organized these two images and group of letters in a layout with the seal on top, the letters

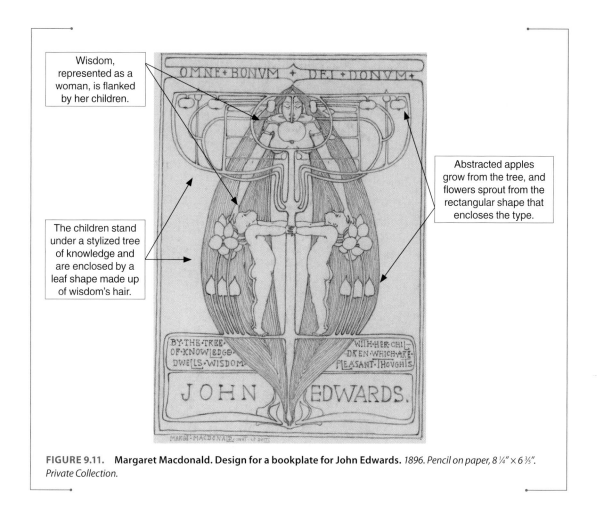

Wisdom, represented as a woman, is flanked by her children.

The children stand under a stylized tree of knowledge and are enclosed by a leaf shape made up of wisdom's hair.

Abstracted apples grow from the tree, and flowers sprout from the rectangular shape that encloses the type.

**FIGURE 9.11.** **Margaret Macdonald. Design for a bookplate for John Edwards.** *1896. Pencil on paper, 8 ¼″ × 6 ⅗″. Private Collection.*

in the middle, and the rings on the bottom. All designers can manipulate these three components—*images*, *type*, and *layout*—when they create a design.

## Images

Graphic designers often use images when producing a design. These *pictures or decorations* may already exist, or they can be created specifically for the design to evoke different moods and personalities.

In the late nineteenth century, British artist Margaret Macdonald created the image that is shown in figure 9.11 as a design for a bookplate—a decorative label that could be pasted into the front inside cover of a book to indicate ownership. While bookplates included the owner's name (as here, John Edwards) and often a family motto (here, "*Omne bonum dei donum*" or "Every good is the gift of God"), Macdonald took the occasion to include an illustration that supports the theme of books' leading to knowledge, as a stylized personification of wisdom is seen at center.

Graphic designers can use illustrations like Macdonald's in creating designs. However, they can also manipulate two different, specialized types of images called *pictographs* and *symbols*.

## Pictographs

**Pictographs** are simple images that communicate ideas and directions without words. They are understandable because they represent objects, places, or events in an abstract way. Pictographs are also meant to transcend culture; *no prior knowledge of a form is necessary to understand it.* Consider the pictographs created for the Beijing Olympics (figure 9.2). Even though they were designed in China by Chinese artists, they are understandable to people

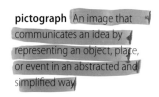

**pictograph** An image that communicates an idea by representing an object, place, or event in an abstracted and simplified way.

who have never seen them before. Take the pictograph for the basketball event, shown at the start of this chapter. Even if you had never seen this pictograph before or were unfamiliar with Chinese culture, you would likely still know that this image represented basketball because it is an unmistakable, simplified image of a basketball player dunking a ball in a hoop.

Xu Bing (shoo bing) is particularly interested in the power of pictographs to transcend culture. When the Chinese artist moved to the United States in 1989, he struggled with English. Noticing the pictographs in airports, Xu began researching and collecting pictographs that have been used in a variety of contexts from around the world and eventually organized them into a written language. As all the pictographs existed, Xu did not invent any of them. He formed the language in the same way as all language is formed—from actual usage.

In 2014, the MIT Press published a book Xu wrote in this language that in theory can be understood by anyone from anywhere, even by people who are illiterate. Throughout the book, Xu substituted words with pictographs. The book tells the story of a day in the life of Mr. Black, an office worker. Every chapter covers a different hour of a typical day. Figure 9.12 shows a page from Chapter 1.

### Symbols

**Symbols** are simple pictures that have meaning only because a culture has given them meaning. The Olympic graphics show how symbols differ from pictographs. In Chinese, the symbol for "capital city" is the character *jing* (figure 9.1B). When people who read Chinese see this symbol, they equate it with a capital city because they have seen it in their culture before. However, for someone who doesn't read Chinese, this symbol is meaningless. *Symbols rely on prior familiarity with form.*

**symbol** An image that communicates an idea that is understood because of prior familiarity with the form

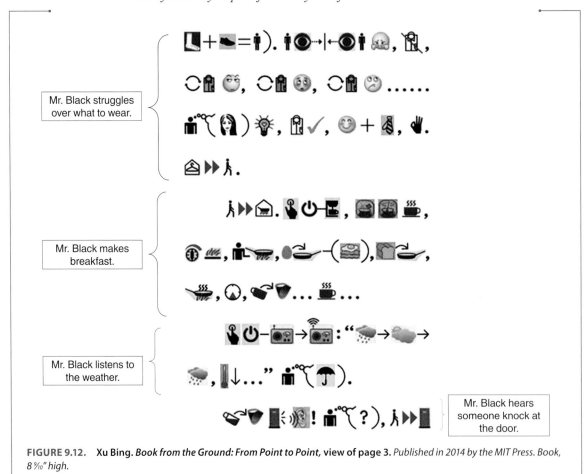

Mr. Black struggles over what to wear.

Mr. Black makes breakfast.

Mr. Black listens to the weather.

Mr. Black hears someone knock at the door.

**FIGURE 9.12.** Xu Bing. *Book from the Ground: From Point to Point,* **view of page 3.** *Published in 2014 by the MIT Press. Book, 8 ⁹⁄₁₀" high.*

In our culture, we know that an arrow (➜) means to go in a certain direction. We know this meaning, though, only because our culture has determined this meaning. We recognize an arrow's meaning because of prior exposure to other arrows.

*Quick Review 9.4*: What is the difference between pictographs and symbols?

## Type

As we read this page, we put the letters together to form words that have meaning to us. However, in addition to this verbal content, the letters also have a distinct look, shape, and size that *convey a visual message*. When graphic designers use letters, they are concerned with how the visual appearance of the type works with the verbal words to communicate a message and evoke different feelings.

Three features make a letter appear different and give it a unique personality:

1. *Main strokes*: Designers consider how thick or thin the weight (width) of the lines is, whether that thickness is even throughout the letter, and whether the strokes are curvy or straight.
2. **Serifs**: Designers consider whether the letter has serifs—small, decorative strokes that finish and come off of the end of the main strokes of a letter (if not, the letter is called **sans serif**)—and, if they do, what the serifs look like and how they are attached to the main strokes.
3. *Overall letterform*: Designers consider whether the letter is symmetrical, how tall and wide the letter is, where its individual pieces are placed (e.g., whether the cross stroke is lower or higher), whether the letter slants or is vertical, and how much white negative space is created inside and around the letter.

**serif** The small stroke that finishes and comes off of the end of the main stroke of a letter

**sans serif** Letters that do not have serifs (the small strokes that finish and come off the ends of the main strokes of letters)

The different capital "A" letters in figure 9.13A, B, C, and D illustrate how different letters appear. Variations in the main strokes, serifs, and overall letterforms give the letters their dissimilar appearance.

**(A)**

This "A" seems elegant and traditional.

The weight of the *main strokes* changes from being relatively thin on the left side of the letter and in the horizontal stroke to being thick on the right side.

*Serifs* gently curve off from the bottom of the main strokes, and they taper from thicker to thinner.

The *overall letter* is asymmetrical, as the left side does not match the right.

**(C)**

This "A" seems bold, heavy, and geometric, and it has a horizontal emphasis.

The thickness of all of the *main strokes* and the *serifs* is the same.

The *serifs* are enormous, like large slabs that sit at the top and bottom of the letter, and they come off the main strokes at a sharp angle.

The *overall letter* is symmetrical.

**(B)**

This "A" seems dramatic, light, and aloof, and it has a vertical emphasis.

The weights of the *main strokes* have a great contrast between the left and horizontal strokes and the right stroke.

The *serifs* are razor thin and come off the main stroke of the letter at a sharp angle rather than in a gentle curve.

The *overall letter* is asymmetrical.

**(D)**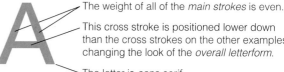

This "A" seems contemporary and unremarkable, as if lacking in style.

The weight of all of the *main strokes* is even.

This cross stroke is positioned lower down than the cross strokes on the other examples, changing the look of the *overall letterform*.

The letter is *sans serif*.

The *overall letter* is symmetrical.

**FIGURE 9.13A (SABON TYPEFACE), B (BAUER BODONI TYPEFACE), C (ROCKWELL TYPEFACE), AND D (UNIVERS TYPEFACE).** Capital "A" letters from four different typefaces.

ABCDEFGHIJKLM
NOPQRSTUVWXYZ
abcdefghijklmnopqrst
uvwxyz
&!?(),:;'

FIGURE 9.14. **The Sabon typeface.** In the consistent letters of the Sabon typeface, the stroke weight varies within each letter, but not drastically, and gently curving serifs come off the main strokes of the letters.

**typeface** A full set of letters and punctuation marks that have been designed to have a certain appearance and work together cohesively

**typography** The art of designing, sizing, and arranging the visual appearance of letterforms

**artists**
MATTER
Paula Scher

Each of the examples in figure 9.13 comes from a different existing **typeface** or full set of designed letters and punctuation marks. The "A" in figure 9.13A, for instance, comes from a typeface called Sabon. In addition to the "A," all the capital and small letters and punctuation marks that make up the Sabon typeface have a consistent feel, as can be seen in figure 9.14. The letters look like they belong together because they have been designed to function harmoniously. When graphic designers work with type in a design, they often choose an existing, previously designed typeface because the letters have this consistent look.

Alternatively, graphic designers sometimes create their own type to go with a design rather than using an existing one. The art of designing, sizing, and arranging the visual appearance of type is called **typography**. Creating a typeface is a daunting task, as a designer must consider not only how each letter appears, but also how each letter looks in tandem with others.

Designers *pick or design types that work with the message they are trying to send*. Because different types have unique looks and form different shapes on the page, they create individual moods. A designer producing a newspaper would likely use a very different typeface from one crafting a children's book. Type can look many ways, such as cold, proper, dignified, straightforward, precise, casual, lively, cozy, or wild.

Paula Scher, a contemporary American designer, used a uniformly weighted, sans serif, all-capital, wavy typeface in her design for the record album *Too Hot to Handle* (figure 9.15) for the group Heat Wave. The curving letters appear to have warped in the sun, adding to the effect of the melting album and hydrant. However, the repeating, rippling type also seems to pulse to a steady beat. The type could be characterized as playful, informal, and sizzling.

Not all types would have worked with Scher's album cover. To explore one type that likely would not fit as well, see *Practice Art Matters 9.1: Determine Why a Typeface Might Be Incompatible.*

FIGURE 9.15. **Paula Scher (designer) and Robert Grossman (illustrator).** *Too Hot to Handle.* 1977. Album cover for Heat Wave, 12 ⅜″ × 12 ⅜″. CBS Records. Scher's wavy type adds to the personality of the album cover.

*Quick Review 9.5*: What are three features that make letters appear different and evoke different feelings?

## Layout

When Paula Scher designed *Too Hot to Handle* (figure 9.15), she decided on the **layout** for the design, the arrangement of the image(s) and type. In particular, for this album she:

- *Organized type on an illustration* for a record cover that had a preset size
- *Placed the image in a frame*, with the words "Featuring 'Boogie Nights'" (the record's hit single) outside the frame in an oval outline
- *Positioned the group's and album's names above the melting record*, running "Heat Wave" diagonally and "Too Hot to Handle" more horizontally, but dipping

Just as different images and typefaces can communicate different personalities, so too can different layouts. The layout of the design *affects the overall presentation*. Most people would

## 9.1 Determine Why a Typeface Might Be Incompatible

Scher had a particular message in mind when she designed Heat Wave's *Too Hot to Handle* (figure 9.15). Imagine what would have happened to that message had she used the Sabon typeface instead. Consider the album as it stands and what it would look like if changed:

- What message do you think Scher was trying to communicate with the original image and type?
- Look back at the features of the Sabon typeface in figures 9.13A and 9.14 and consider main strokes, serifs, and overall letterforms. Why might the appearance of the Sabon typeface have felt mismatched with this message?

consider Scher's layout more carefree than the layout that Macdonald created for the bookplate design (figure 9.11), which they would see as more formal. Much of this formality stems from Macdonald's symmetrical, orderly, and unified design. Her type is centered and aligned so that it fits neatly in boxes. Scher's design, conversely, is asymmetrical and rhythmic. Scher's type is so large, the edges of her letters run beyond the box that frames the image. Both designers considered the individual elements that they were using as well as the overall effect that the elements would make when arranged together in a certain way.

Designers who produce books, magazines, newspapers, and websites face the special challenge of designing the layout for multiple pages. These designers can arrange the pages using a *grid* or *other layout*.

**layout** The organization of the images and type in a design

### Grids

Designers often use a **grid**, an underlying structure in a layout, so that different pages in a multipage text or site feel related. A grid is like a blueprint for a designer in arranging elements within set guidelines. It establishes certain parameters that are used across the design to create unity. However, each page uses different elements in different ways, which allows for variety.

The print book of *Art Matters* uses a grid. American Michele Laseau set up the grid for two eight-and-a-half-by-eleven-inch pages, each with a major (thicker) and minor (thinner) column (figure 9.16A). The grid determined the size of the margins, where to place the page numbers, and where the type and images could go. Figure 9.16B shows the layout of *Art Matters* for pages 240 and 241 of the print book. You can see how the images and type were placed within the grid on these pages. However, if you flip ahead or back in the print book, you'll see that every page of main text in *Art Matters* was set up to follow this grid. The grid gives the book an expected rhythm.

**grid** An underlying structure that establishes certain consistent parameters in a layout (e.g., number of columns, margin widths, page number location, etc.) that guide a designer in the placement and sizing of images and type so that a consistent look can be created across a multipage work

(A)

(B)

**FIGURE 9.16A (GRID) AND B (LAYOUT FOR PAGES 240 AND 241 OF PRINT BOOK).** **Michele Laseau.** *Art Matters,* **page design.** *2019. Trim size 8 ½″ × 11″. Art Matters* holds together as one text across multiple pages because of the use of a grid (9.16A) that guided the page designer in placing text and images (9.16B).

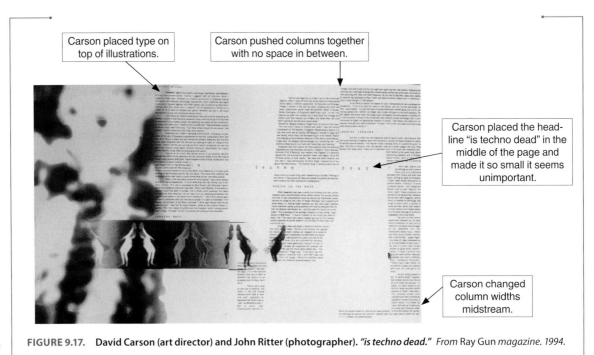

Carson placed type on top of illustrations.

Carson pushed columns together with no space in between.

Carson placed the headline "is techno dead" in the middle of the page and made it so small it seems unimportant.

Carson changed column widths midstream.

Interactive Image Walkthrough

**FIGURE 9.17.** David Carson (art director) and John Ritter (photographer). *"is techno dead."* From Ray Gun *magazine. 1994.*

### Other Layouts

Not all multipage works are set up in grids. Sometimes designers go against a grid to have a different effect. David Carson's layout for the text and images for the article "is techno dead" (figure 9.17) for the magazine *Ray Gun* follows no rules.

The contemporary Texas-born designer's arrangement features images and columns of type that appear to move in black, gray, and white forms across the page. The layout is more about creating interest than establishing a conventional, structured layout that a reader could easily follow. Carson's design worked with the content of *Ray Gun* magazine, which was devoted to alternative music.

*Quick Review 9.6*: How does the layout of a design affect the overall presentation?

# Different Types of Graphic Design

Graphic design is a broad field and falls into several different categories. Areas of graphic design include *signs, publications, and packaging*; *corporate identities*; and *motion graphics and interactive media*.

## Signs, Publications, and Packaging

Graphic designers create *signs and posters* for commercial, social, cultural, and political purposes. Henri de Toulouse-Lautrec (ahn-REE duh too-LOOZ loh-TREK) designed a poster (figure 9.18) in 1891 to advertise the Moulin Rouge, a nightclub in Paris. This image was hung all over the city. Through decorative silhouettes, flat color fields, and bold type, Toulouse-Lautrec presented a vision of lively fun with which he attempted to lure customers to the dance hall.

Graphic designers also create *publication designs.* These designers are responsible for the covers and interiors of all kinds of books from children's books, to textbooks, to novels.

**artists**
MATTER

Henri de Toulouse-Lautrec

**trademark** A simple image and/ or group of letters that spell out an organization's name in a particular type that visually identifies, distinguishes, and gives a sense of the personality of an organization

Designers also produce a variety of printed material including magazines, newspapers, reports, catalogs, advertisements, calendars, greeting cards, menus, and stamps. Georg Olden designed the stamp shown in figure 9.19 for the U.S. Postal service in 1963 to commemorate the hundred-year anniversary of the Emancipation Proclamation—the order issued during the American Civil War by President Abraham Lincoln that freed African American slaves in states that had seceded from the Union. Olden, the grandson of a slave, was the first African American to design a stamp in the United States. He created a simple, bold, universal image of a broken link of a chain—a metaphor for a release from bondage—which symbolizes the meaning of the great document.

Another area of graphic design is *package design*. Designers produce package labeling and point-of-purchase displays that encourage consumers to purchase products. When designing packaging, designers must consider what will convince a consumer to buy a product. Products must be attractive and informative, so consumers are drawn to the product and understand why they might want to buy it. In the Beijing Olympics, for example, the *fuwa* were used on different consumer products from T-shirts to coffee mugs.

*Quick Review 9.7*: What is the difference between signs, publications, and packaging?

## Corporate Identities

Designers are responsible for designing corporate identities. Designers help organizations put forward *a consistent, distinct, and recognizable look* that enables a company to advertise its products and services and relate them back to the company. One important aspect of that look is the company's **trademark**, which visually identifies an organization by a particular image and/or group of letters that spell out a company's name in a particular type. When only type is used, the trademark is called a **logo**.

The trademark established for the Beijing Olympics was an arrangement of two images (the dancing-man seal and the Olympic rings) along with type that spelled out "Beijing 2008." Once the trademark was established, Olympic organizers used it in a variety of different formats from signage, to T-shirts, to TV titles. Similarly, once a company creates a trademark, it will use the trademark on stationery, signage, product labels, delivery trucks, uniforms, annual reports, business cards, and websites—all in an effort to promote a cohesive message.

Because they are made from images and/or type, trademarks communicate different personalities that help corporations establish a face and public image. Consider two different logos. Figure 9.20 shows a proposed logo by twentieth-century American designer Herb Lubalin for a magazine that was never produced called *Mother & Child*. This logo appears soft and classic to many people, yet also bold and unshakable—the look of a magazine trying to appeal to mothers.

Conversely, figure 9.21 shows the IBM logo conceived by another twentieth-century American designer, Paul Rand. Many people find this logo modern, corporate, and authoritative—exactly the kind of image a company that produces computers for businesses would want to have. The logo gives off this feeling because the letters seem stable, geometric, and bold.

Sometimes companies decide they want to update their logos. Often, rather than starting from scratch, they revise the logo, basing it on the old version (see *Practice Art Matters 9.2: Compare an Updated Logo with the Original*).

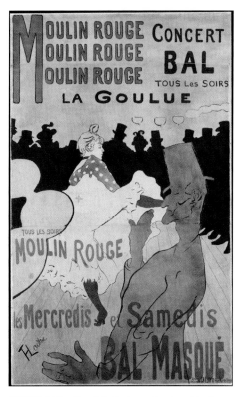

**FIGURE 9.18.** Henri de Toulouse-Lautrec. *Moulin Rouge: La Goulue.* 1891. Lithograph, 6′ 2 ¹³/₁₆″ × 3′ 9 ⅞″. *The Metropolitan Museum of Art, New York.* Toulouse-Lautrec's poster highlighted a cancan dancer and a contortionist.

**artists**
MATTER

Georg Olden

**FIGURE 9.19.** Georg Olden. **Stamp for the centenary of the Emancipation Proclamation.** *1963. The United States Postal Service.* To commemorate the emancipation of African American slaves, Olden designed an image of a broken chain.

**logo** Short for logotype; a type of trademark that uses only type and no images

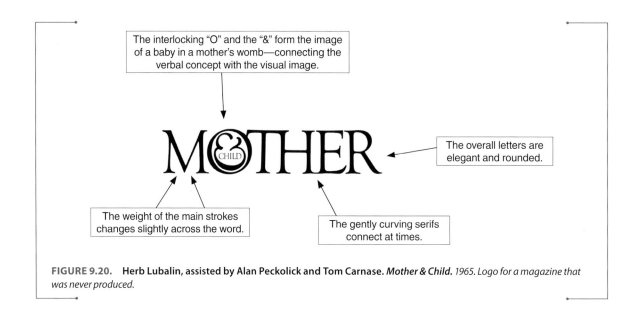

The interlocking "O" and the "&" form the image of a baby in a mother's womb—connecting the verbal concept with the visual image.

The overall letters are elegant and rounded.

The weight of the main strokes changes slightly across the word.

The gently curving serifs connect at times.

FIGURE 9.20. Herb Lubalin, assisted by Alan Peckolick and Tom Carnase. *Mother & Child*. 1965. *Logo for a magazine that was never produced.*

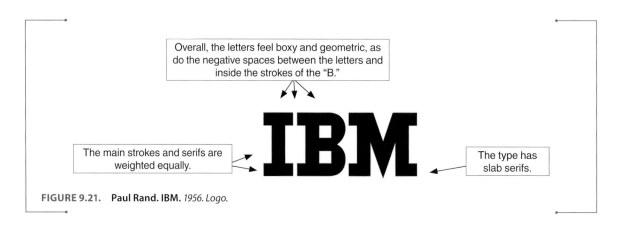

Overall, the letters feel boxy and geometric, as do the negative spaces between the letters and inside the strokes of the "B."

The main strokes and serifs are weighted equally.

The type has slab serifs.

FIGURE 9.21. Paul Rand. IBM. *1956. Logo.*

---

*Practice* art MATTERS

## 9.2 Compare an Updated Logo with the Original

In 1972, Paul Rand designed a revised version of the IBM logo (figure 9.22). The updated logo used his original logo (figure 9.21) as a starting point. Consider these questions:

- In what ways was the new logo the same as the old one?
- In what ways was it different?
- What message do you think Rand conveyed in the new logo?
- Why do you think a company might want to base a new logo on an old one?
- Why do you think a company might want to change its logo?

FIGURE 9.22. Paul Rand. IBM. *1972. Logo*

---

*Quick Review 9.8*: What are trademarks and why do corporations use them?

## Motion Graphics and Interactive Digital Media

Graphic designers also create motion graphics (images and type that move) and interactive digital media. Motion graphics and interactive media are used in films and videos and on computers, tablets, and smartphones. Designers of these media create the television and film titles that credit actors and production staff. They also design video games, websites, and advertisements.

These designers face several unique challenges, including:

- *Multiple formats*. For example, film title designers must be aware that movie watchers will see film titles on large movie house screens and smaller televisions and phones.
- *Navigation*. For example, website designers must create sites that are easy to use and consistent from one screen to the next and that allow each individual user to follow a different nonlinear path.
- *Interactivity*. For example, video game designers must balance memory constraints with realism to make the games authentic.
- *Constant updating*. For example, advertisers need to add, delete, or modify information continuously on a website to respond to new products or consumer interest.

An example of motion graphics and interactive digital media can be seen in *FIFA 17* (figure 9.23A and B), a video game in which players take part in a realistic soccer game. One aspect of the game called *The Journey* enables players to put themselves in the shoes of a player named Alex Hunter as he performs on and off the field. Because the game is so complex, the designers made different versions of it for different platforms. They also set it up so that users' decisions (such as what position to play) along with their successes and failures in playing (such as how many shots they make during practice) guide the narrative, leading to different outcomes. In addition, to create animated characters with authentic motion, the designers used real people to determine how figures in the game should move and react, attaching sensors to their bodies and cameras to their heads to track how different parts of a person's body react differently to each movement. However, the designers limited details and specific textures to those figures in the foreground, leaving objects in the background (such as crowds at soccer games) with less detail (to conserve memory). Finally, every year, designers come out with new versions of the game.

(A)

(B)

**FIGURE 9.23A (VIEW OF REAL ACTOR TOMIWA EDUN) AND B (VIEW OF DESIGNED ALEX HUNTER AND HIS TEAMMATES IN THE GAME).** *EA Sports. FIFA 17. 2016. Videogame for Xbox One, PlayStation 4, or PC.* Real actors wore head cameras and motion-capture suits with sensors (9.23A) to create authentic-looking animated people and movement in the video game (9.23B).

**FIGURE 9.24** **Six Flags, Samsung Gear VR, Oculus, and VR Coaster.** *The New Revolution Virtual Reality Coaster, view of virtual reality with inset of riders on the roller coaster. 2016. Gear VR, Six Flags Magic Mountain, Los Angeles.* Riders (shown in the inset) at Six Flags don headsets, so they can be immersed in a virtual reality story that coincides with the real twists and turns of the coaster.

One of the latest innovations in motion graphics and interactive media is the use of virtual reality. For example, at Six Flags Magic Mountain in Los Angeles the public can experience a virtual reality roller coaster (figure 9.24 inset). Riders board a real roller coaster and wear headsets through which they are put into a virtual alternate space created by designers. Participants no longer see the park, but rather have the impression that they are in an airplane cockpit, experiencing a takeoff, a fight with aliens, and a landing (figure 9.24), all calibrated to sync with the real movement on the coaster. Throughout, riders can see all around themselves in the virtual world, having the illusion of a three-dimensional immersive experience.

Even though the virtual reality roller coaster links graphic design to a new technology, it still fits with traditional definitions of graphic design. For example, the client, Six Flags, dictated everything to the designers at VR Coaster, even the storyline and how it exactly needed to calibrate with the ride. Moreover, the design reaches millions of people every year across different parks.

*Quick Review 9.9*: What challenges do graphic designers face when producing motion graphics and interactive digital media?

# HOW **art** MATTERS

## A Look Back at the Graphic Design for the Beijing Olympic Games

The **graphic design** of the Beijing Olympics featured officially sanctioned designs as well as protest designs. Designers who worked for both sides, though, still went through many of the same processes, used the same components, and created many of the types of designs discussed in this chapter.

These designers all understood the nature of design. They *collaborated with clients* and *targeted messages* toward *specific audiences*. The Olympics designers took direction from the Organizing Committee and individual sports federations. The protestors' designers worked for clients as diverse as Free Tibet to Amnesty International. Messages by both groups were targeted toward the international community that came to China and watched the games from home. Moreover, both sets of designers attempted to create *straightforward designs* and saw their work produced in *multiple copies*. It was essential that items such as **pictographs**, reproduced in numerous locations, help the multilingual

participants and spectators navigate around Beijing. On the other side, protest designers needed to be sure that the international community saw the significance of their messages. Both sets of designers also produced designs that were *art forms* in their use of the visual elements of art and principles of design, their creativity, and their employment of different media, such as using the character *jing* in the emblem or handcuffs to represent the Olympic rings.

Designers *manipulated images, type*, and **layout** throughout the designs. For the Olympic designs, the images included the dancing-man seal, the Olympic rings, the pictographs, and the mascots—all meant to reinforce the spirit of the games and highlight the culture of China. Furthermore, the Olympic design used both types of specialized images. **Pictographs** represented the different sports, and the Olympic emblem contained a **symbol** of the character *jing*. As for type, the emblem mimicked Chinese calligraphy, reinforcing the message, while

for the layout, the emblem combined different, related images from the history of China and the Olympic Games. Similarly, in the protest design in figure 9.5, the image of the handcuffs, the stark **sans serif** block type, and the simple layout of image and type on a black background reinforced the message the protestors wished to send.

During the Olympics, designers created *many types of designs* and introduced them to the public. Over three hundred saleable licensed products used the mascots alone. Designs appeared not only on items that were sold to the public, but also on signs, in television titles, on the website, and in the official magazine. Similarly, the graphic designs of the protestors appeared on different items from T-shirts to signs to videos.

As you move forward from this chapter, consider the essential role that graphic design plays in our lives. Graphic design changed how people experienced and viewed the Beijing Olympic Games. However, the graphic design of the Beijing Olympics is just one example of an art that *informs*, *identifies*, and *persuades*. Many additional essential elements of our world depend on straightforward graphic designs to communicate information. For example, public service announcements depend on clear graphic designs; recall the buzzed-driving campaign that has likely led to more people being responsible drivers and, thereby, safer roads and fewer drunk driving fatalities (figure 9.7). In addition, companies depend on good graphic designs to promote distinct and recognizable corporate identities, such as the IBM **logo** (figure 9.21).

Flashcards

## CRITICAL THINKING QUESTIONS

1. In what ways were the designers of *FIFA 17* (figure 9.23) visual problem solvers in meeting the three requirements that clients set as parameters?

2. Do you think Georg Olden's stamp (figure 9.19) communicates in a straightforward way? Why or why not?

3. Discuss the visual element of line in Cassandre's *Nord Express* poster (figure 9.10), considering character, direction, and actual/implied (see Chapter 3). How did Cassandre's decisions about line affect the message of the poster?

4. Is a check mark (√) a pictograph or a symbol? Why? How about an ampersand (&)? Why?

5. How would you describe the main strokes, serifs (or lack of serifs), and overall letterforms of the typeface used in the headings in *Art Matters*?

6. Why might a designer decide to use a symmetrical or asymmetrical layout in a design?

7. This chapter has considered a number of different posters (figures 9.5, 9.8, 9.10, and 9.18). How was each of the posters used? Why are posters an effective means of straightforward communication?

8. Pick a logo from a candy bar that you are familiar with. What personality does the logo evoke? Based on the form, including features of the type, the color used, and so on, why do you think the logo creates a positive response from consumers to the candy?

Comprehension Quiz      Application Quiz

# 10

# Sculpture

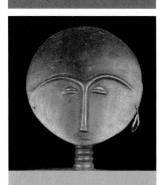

## LEARNING OBJECTIVES

**10.1** List three reasons why we need to experience the three-dimensional art of sculpture in person.

**10.2** Explain how the durability, value, and appearance of a material affect a sculpture.

**10.3** Describe how a sculpture can convey a message.

**10.4** Explain why a freestanding sculpture can only be fully understood from multiple views.

**10.5** Distinguish between low- and high-relief sculptures.

**10.6** List the different types of earthworks.

**10.7** Illustrate how the viewer is an active participant in an installation.

**10.8** Explain why carved sculptures have compact forms.

**10.9** Discuss the reason modeled sculptures are often built over armatures.

**10.10** Differentiate between solid and hollow casting methods.

**10.11** Compare and contrast constructing and assembling techniques.

**10.12** Identify two different digital sculptural techniques.

# *AKUA'MMA* SCULPTURES

There is an old legend that the Asante (Ah-SAN-tee) people of Ghana, Africa, tell of a woman named Akua who could not conceive a child. Desperate, Akua consulted a priest, who advised her to carry a sculpture of a child. The priest advised Akua to sing to the sculpture, give it trinkets and beads, and care for it like a real child. Akua did as she was told, but the village women teased her, calling the sculpture *akua'ba* (Akua's child; plural *akua'mma*). When Akua gave birth to a healthy girl, though, the women no longer laughed. (Among the Asante, family roots, descent, property, and political office are traced and inherited through the female line.) Instead, the women began the tradition that has been passed down among many Asante women eager to bear children ever since: that of carrying *akua'mma* on their backs (figure 10.1).

How Art Matters

## Objects Believed to Effect Change

Many traditional Africans believe that deities and spirits intervene in the world and that objects that the Western world would consider art help people commune with these forces to effect change. Asante women can use *akua'mma*, such as the one in figure 10.2, as a kind of petition to the spiritual world for help in solving problems.

Over the last several hundred years, tens of thousands of these "good-luck figures" have been carved, brought to shrines (sacred locations with altars, sculptures, and pottery, such as the one in figure 10.3), sanctified by priests, and carried by Asante women. Following a successful pregnancy, the women would return the *akua'mma* to a shrine as an offering of thanks to the deity.

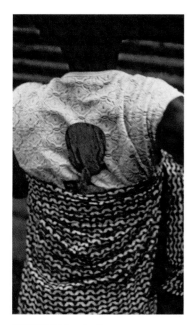

**FIGURE 10.1.   An Asante woman with an *akua'ba*.** *From Ghana. 1972.* Asante women can follow the Akua legend by carrying *akua'mma* in the backs of their wrapped garments (as real children are carried).

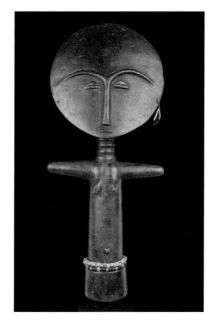

**FIGURE 10.2.   *Akua'ba* figure.** *From Ghana. Asante. Wood and pearl, 13" × 4¾" × 2⅛". Quai Branly Museum, Paris.* This figure is decorated with beads around the base, just as the legend instructed.

**FIGURE 10.3.   An Asante shrine.** *From Ghana. 1976.* A number of *akua'mma* are lined up on the bottom of this shrine.

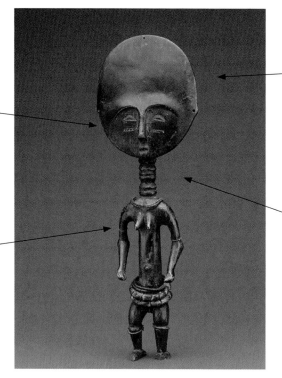

The face is placed low on the head, because the Asante believe that a long, flat forehead is a sign of beauty. Mothers stroke their real infants' heads to achieve this effect.

The smooth surfaces are painted black, portraying beautiful skin and, thereby, good health.

The rings of fat at the neck symbolize plenty and wellbeing.

The figure is a mature woman (with developed breasts) rather than a realistic baby.

**FIGURE 10.4.** *Akua'ba figure. From Ghana. Asante. Nineteenth to twentieth centuries. Wood, beads, and string, 10 ¹¹⁄₁₆" × 3 ¹³⁄₁₆" × 1 ⁹⁄₁₆". The Metropolitan Museum of Art, New York.*

**FIGURE 10.5.** *Akua'ba figure. From Ghana. Asante. Twentieth century. Wood, beads, and pigment, 16" × 6 ¹³⁄₁₆" × 2 ¼". The Fralin Museum of Art, University of Virginia, Charlottesville.* The only way to understand *akua'mma* figures is to see them from multiple views.

## The Characteristics of *Akua'mma*

Figures 10.2 and 10.4 show the characteristics typical among *akua'mma*. While they have a human female form, they are not naturalistic. The sculptors exaggerated idealized features and deemphasized incidental ones. Each sculpture embodies a stylized concept of a healthy and beautiful person.

Another similarity that the sculptures share is their *three-dimensional form*. While we can see the works from all angles and they exist in our space, they have a flattened appearance (figure 10.5). Considering that the figures are carried on women's backs, their overall form makes sense.

All three sculptures in figures 10.2, 10.4, and 10.5 are also made of the same *material*: wood. Wood is abundant in Ghana, but the sculptors chose wood for its sacred value, too. The Asante believe that spirits inhabit trees, and so wood is thought to be powerful before it is carved. By choosing wood, the sculptors hoped to transfer that power to the sculptures.

The sculptors also demonstrated respect for the wood by maintaining the columnar appearance of the tree in the deemphasized cylindrical bodies of the sculptures. While the forms of the *akua'mma* are angular, bold, and geometric, the wood gives the sculptures a tangible warmth and smooth, organic surface. Finally, the sculptors all used the same *technique of carving* to produce the works, using an ax to chip away unwanted areas of wood, cutting details with knives, and polishing the surface with leaves and an abrasive substance.

## Different Sculptures within the Accepted Motif

Each Asante sculptor serves a long apprenticeship with a master carver to learn not only carving techniques, but also the accepted traditional symbols of the community. Since the Asante had no written language until recently, recognizable symbols have been *meaningful expressions* and held power and importance in Asante society. The sculptors maintain the *akua'mma's* particular motif, so that the people can understand them.

While the sculptures share traits, each also embodies differences based on the region of origin and individual sculptor:

» Some have arms and/or legs, while others don't.
» Some arms are more naturalistic, while others look like cones and protrude at right angles from the bodies.
» Some faces are more abstract, while others are more realistic.

Each sculpture is a unique creative expression within the accepted tradition.

## Different Perceptions of Art and Life

The *akua'mma* are a good example of how much of what the Western world would consider art is *an integral part of daily life* for a number of people living in other regions and cultures. The ability to influence the future through art provides peace of mind to many in traditional African communities. However, a number of these *akua'mma* are now displayed in Western museums. While they can be appreciated aesthetically and conveniently, it is challenging to understand these sculptures fully because they have been removed from their culture and divorced from their contextual meaning. Unlike most Western art, in which artists seek to convey messages in their sculptures, many traditional African sculptures derive meaning from their use. When we view this type of African art in museums or photos, we need to *consider this context to understand the works*.

The story of the *akua'mma* also illustrates much about sculpture that will be covered in this chapter. Before moving forward, based on this story, do you think we should consider the environment around a sculpture when we study it? Can you think of some ways that an artist might create a sculpture, other than chipping away at wood as the Asante do?

# What Sculpture Is

A **sculpture** is a three-dimensional object made out of tangible materials. However, unlike many other three-dimensional art forms, sculpture is not functional. We can't live in a sculpture, like a building, or eat out of a sculpture, like a bowl. Although a sculpture might have a purpose, such as the *akua'mma* do, a sculpture is a *three-dimensional, tangible form of expression*.

**sculpture** A three-dimensional, tangible work of art that conveys meaning and may have a purpose, but is not functional

## A Three-Dimensional Work of Art

Imagine that you want to buy a car that you saw online. However, the person selling the car only posted one photo of the front. From this photo, there are many things you don't know:

• Whether the other sides are dented
• How big the trunk is
• Whether the car will be small enough to fit in the tiny space you have at work

From this one view, your understanding of the car is limited because you can see only part of the structure. You would only understand the car completely if you could circle its *three-dimensional form in place*.

As with the car, sculptures have depth and *exist in our space*. To appreciate them, we often need to consider different views because they frequently look different as we move around them. We also need to consider their *mass* and the *environment* in which they exist. While we benefit from experiencing all art in person, this is especially true with many sculptures.

### In Our Space

Because a *sculpture inhabits our world*, we interact with it differently than we do a two-dimensional work. We can walk around many sculptures and see them from different angles, which results in different effects, and we are also aware of their surface texture.

Magdalena Abakanowicz (mahg-dah-LAY-nah ah-bah-kah-NOH-vich) created changing effects from different angles in *Bronze Crowd*. From the front, the anonymous figures form overpowering, bulky masses (figure 10.6A). From the side, it's possible to contemplate only the figure at the end of a row. From the back, it becomes evident that the figures are hollowed out (figure 10.6B). When walking through the figures, one almost becomes part of the mass of human forms. While they appear uniform at first glance, when one scrutinizes the sculptures closely, it's clear the surface texture of each is unique.

Abakanowicz, who was Polish, experienced the cruelty of a nameless crowd blindly following Adolf Hitler—Germany's tyrannical leader during World War II. It is from different views of her sculpture that we can find a possible interpretation. From the front, her headless (and thus nonthinking) figures stand ready to march powerfully as one group. Yet, from the rear, the shells may indicate that the strength of the figures is an illusion. Up close, the different textures could signify that we are all unique individuals with the potential to disagree.

### A Work of Mass

It is difficult to understand sculpture as a three-dimensional art without considering *mass*. The weight, size, and solid form of a sculpture and how the *bulk takes up space* in our world influence the effect a sculpture has on a viewer.

Much of the power of *Bronze Crowd* stems from our relationship with the physical form of the figures. Each stands nearly six feet tall, meaning most of our heads would barely reach the top of the figures' shoulders. Their size bears down on us, making many people feel small and possibly inconsequential. Imagine if Abakanowicz had depicted the figures in a smaller size—about a foot tall. We would dominate the figures and perhaps sense how an individual can inflict his or her will on weak, similar souls.

It is not just the size of the mass that may affect us, but also the bulk. From the front, Abakanowicz's figures appear solid, rigid, and columnar. Placed one beside the next, they compress the negative (empty) space around them. This display of unyielding positive

(A)

(B)

**FIGURE 10.6A AND B (DETAIL FROM THE REAR).**   Magdalena Abakanowicz. *Bronze Crowd.* *1990–91. Bronze, each piece 5' 11 ⅛" × 1' 11" × 1' 3 ½".* *Nasher Sculpture Center, Dallas.* Thirty-six headless figures stand as if part of a military troop (10.6A), but the frontal view is deceptive, as the rear view reveals the sculptures are empty shells (10.6B).

A stooped older man

An alert young boy

(A)

(B)

**FIGURE 10.7A** (EXHIBITION AT THE BALTIC CENTRE FOR CONTEMPORARY ART, GATESHEAD, ENGLAND, 2003) AND B (EXHIBITION AT THE GREAT HALL, WINCHESTER, ENGLAND, 2004).   **Antony Gormley.** *Domain Field. 2003. Stainless steel bars, various sizes, derived from molds of inhabitants of Newcastle-Gateshead aged 2 to 84.* Each sculpture differs in form and size (10.7A). A new environment changes the overall effect of the sculptures (10.7B).

mass is quite different, though, from how the sculptures appear from the back, where the loss of mass makes them seem thin and weak.

Yet, both sides of Abakanowicz's sculptures also contrast with Antony Gormley's figures in *Domain Field*, shown in two different exhibition spaces in figure 10.7A and B. While also human figures, Gormley's skinless forms take up space without creating bulk. Gormley used negative space to create the illusion of mass and a tangible presence. Formed using the bodies of real people, so each is unique, Gormley's figures recreate the space in which real people existed, seeming to represent each person's energy or aura.

## A Work in an Environment

*Place is important in sculpture.* While many two-dimensional works can be seen anywhere, because sculptures exist in real space and are in three dimensions, sculptors often *design works for a particular site*. Consider the *akua'mma*, which lose their contextual meaning when divorced from their environment of being carried on a woman's back or placed at a shrine. Many sculptures have more significant meaning when seen in place.

The views of Gormley's sculptures in two different spaces allow for a comparison of how the same work changes based on the environment. In figure 10.7A, the British artist's figures were placed in the Baltic Centre, a contemporary art gallery housed in an old industrial building in England. In figure 10.7B, they were exhibited in the Great Hall of Winchester, a thirteenth-century British castle. At the Baltic, in the open, sparse space, the figures, with their shiny, stainless-steel bars, could seem futuristic, almost like alien creatures. However, in Winchester, the sculptures might appear medieval, their frames similar to skeletons or spirits of a world past.

*Quick Review 10.1*: What are three reasons that we need to experience the three-dimensional art of sculpture in person?

## An Art Form Created from Tangible Materials

Sculptures are formed from materials. The materials can be natural substances, such as stone, metal, wood, or clay; naturally derived substances, such as plaster of paris (the same

substance used to cast broken bones); or artificial substances, such as nylon or plastic. These various materials have different properties:

**patina** A brownish- or greenish-colored film that develops on the surface of bronze or copper, either through oxidation or from the introduction of a chemical treatment by an artist or foundry so that the corrosive reaction is immediate; the coloring gives the sculpture a distinct aesthetic quality

- *Durability.* Some materials, like stone, have great longevity; others, like wood, are susceptible to rot. Sometimes the permanence enhances the sculpture's message. For example, some cultures have created durable sculptures that express a leader's power.
- *Value.* Certain materials in and of themselves have significance, strengthening the message. While wood is sacred for the Asante, gold, silver, and jade are associated with importance elsewhere.
- *Appearance.* Materials have distinct looks, colors, and textures based on their nature, age, finish, and luminosity. For example, wood might show grain. An older bronze or copper sculpture can have a **patina**—a brownish- or greenish-colored film that develops on the surface (like the *Statue of Liberty*). Artists might have applied paints or chemicals or used tools to work a material. For example, a polished marble surface emits a glossy luster.

The sculptors of the next two figures used specific materials to give their sculptures a particular expression. Formed in durable baked clay, figure 10.8 depicts a *haniwa* figure from prehistoric Japan that is roughly fifteen hundred years old. These smooth, cylindrical sculptures were placed on mounds over tombs of the dead. The figures took many forms such as houses, people, and animals, and their bases were placed in the earth. The muddy, dull, and dried look of the clay seems to give the horse a simple and direct expression and links it to an earthy burial.

Figure 10.9 depicts another horse, contemporary sculptor Deborah Butterfield's *Rosey*, but it is made from previously used metal. The corroding metal seems to make the figure appear tattered. Even though it has no face and mane, the abstracted horse can be recognized in the rough surface and graceful curve of the horse's head, neck, and back.

In addition to clay and steel, other materials yield different qualities of durability, value, and appearance. To see how gold influences a work's message, see *Practice Art Matters 10.1: Examine How Gold Affects a Sculpture.*

**FIGURE 10.8.** Horse. *From Japan. Kofun period, fifth to sixth centuries* CE. *Earthenware (clay), 2′ 2″ × 2′ 4 ½″ × 9″. Art Institute of Chicago, Illinois.* While this figure is just over two feet tall, some *haniwa* sculptures range up to five feet.

**FIGURE 10.9.** Deborah Butterfield. *Rosey. 2016. Found steel, 3′ 3 ½″ × 4′ × 1′ 2″. Permission granted by Artists Rights Society.* Butterfield, who lives on a ranch in Montana, has crafted sculptures of horses for decades out of materials as diverse as the worn steel shown here, bronze, and mud with sticks.

## 10.1: Examine How Gold Affects a Sculpture

Figure 10.10 shows a llama, crafted in gold in South America about five hundred years ago. Unlike some other metals, gold does not rust, tarnish, or deteriorate.

The llama was formed by an artist from the Inca Empire, which in the year 1500 was the largest state in the world. Gold was a status symbol in the empire, worn only by people of high rank. The Inca celebrated llamas for their essential role in transportation (the Inca did not have wheels, so did not have carts) and as an important source of food and wool. Scholars believe gold llamas were used as offerings to gods. Consider these questions:

- What is the appearance of the gold?
- Why do you think the Incan artist chose gold for the material of this llama? Consider durability, value, and appearance.
- What message do you think the artist was trying to convey?

**FIGURE 10.10.** Miniature llama figurine. *From Peru. Inca. c. 1500. Gold, 2 ½" × ⅔". The British Museum, London.*

*Quick Review 10.2*: How does the durability, value, and appearance of a material affect a sculpture?

## A Meaningful Expression

A variety of factors affect the *meaning* that viewers take away from sculptures. We find meaning in the *akua'mma* sculptures because of their symbolism and *how they are used* in Asante society. In the West, a sculpture often expresses a meaningful message because of the artist's intent to *communicate an idea or feeling* and the viewer's perception of the work based on his or her background.

Constantin Brancusi (KAHN-stuhn-teen brahn-KOO-zee) believed in distilling objects down to their purest, simplest state. In his *Bird in Space* (figure 10.11), Brancusi tried to convey the essence of soaring movement and the freedom of flight through the smooth, shiny surface and curving, vertical form.

*Bird in Space* was at the center of a court case concerning this very notion of art being defined by its meaning. In 1926, the Romanian Brancusi sent the sculpture from France, where he worked, to New York for an exhibition. However, at entry, Customs officials declared the work a kitchen utensil. Such a classification required the payment of a steep import tax (artworks were exempt from the tax). Brancusi sued, and the court decided in his favor, broadening U.S. Customs's definition of sculpture to include nonobjective works that conveyed ideas.

*Quick Review 10.3*: How can a sculpture convey a message?

# Different Types of Sculptures

There are many different types of sculpture, including *freestanding, low and high relief, earthworks,* and *installations.* Each type offers a different form of expression.

**FIGURE 10.11.** Constantin Brancusi. *Bird in Space.* 1926. *Polished bronze, height including base 9' 7 ¼". Seattle Art Museum, Washington.* While there are no feathers, wings, or beak in Brancusi's sculpture, it still seems to communicate the idea of free flight.

## Freestanding Sculptures

Like an *akua'ba* sculpture, a **freestanding** or **in-the-round sculpture** is:

- Physically *set apart and unattached*
- Able to be circled and *seen from all vantage points*
- *Understood* fully from the *perspective of multiple views*

**artists**
MATTER

Gian Lorenzo
Bernini

Gian Lorenzo Bernini (jawn-loh-REN-zoh bayr-NEE-nee), a seventeenth-century Italian artist, told the myth of the sun god Apollo, who had fallen in love with the nymph Daphne, in the different views of his freestanding sculpture. As Apollo raced after Daphne, she called out for help to her father, a river god. To protect her from Apollo's advances, her father transformed her into a tree. Figure 10.12A, B, and C shows how Bernini used the viewer's motion around the freestanding sculpture to tell the story and move time forward. The myth unfolds in three different views.

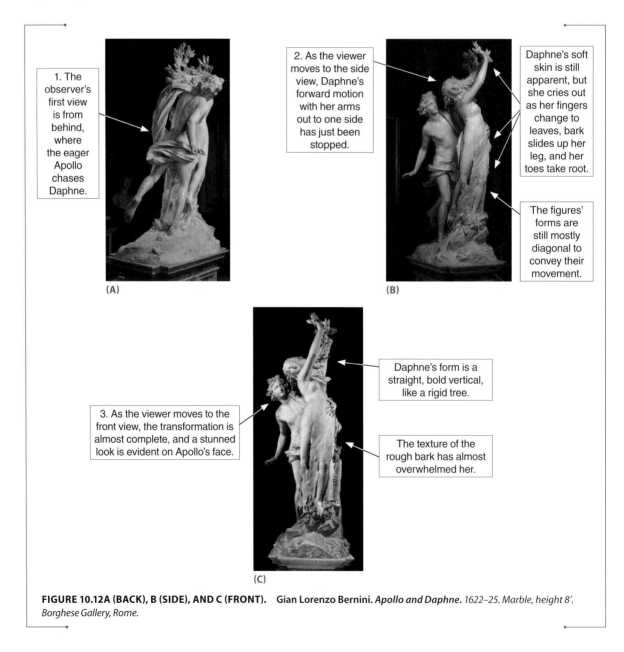

1. The observer's first view is from behind, where the eager Apollo chases Daphne.

(A)

2. As the viewer moves to the side view, Daphne's forward motion with her arms out to one side has just been stopped.

Daphne's soft skin is still apparent, but she cries out as her fingers change to leaves, bark slides up her leg, and her toes take root.

The figures' forms are still mostly diagonal to convey their movement.

(B)

3. As the viewer moves to the front view, the transformation is almost complete, and a stunned look is evident on Apollo's face.

Daphne's form is a straight, bold vertical, like a rigid tree.

The texture of the rough bark has almost overwhelmed her.

(C)

**FIGURE 10.12A (BACK), B (SIDE), AND C (FRONT).**   Gian Lorenzo Bernini. *Apollo and Daphne.* 1622–25. Marble, height 8'. *Borghese Gallery, Rome.*

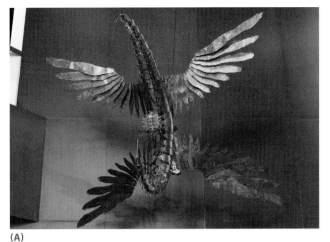

(A)

(B)

**FIGURE 10.13A AND B (DETAIL).** U-Ram Choe. *Imago.* 2014. Metallic material, machinery, resin, leather, electronic device (CPU board, motor, LED), 8′ 10 ¼″ × 9′ 5 ¾″ × 5′ 8 ⅖″. Leeum, Samsung Museum, Seoul, South Korea. In this work (10.13A), the combination of feathery-looking wings and metallic, mechanical parts (10.13B) contributes to an organic yet mechanical appearance.

Sometimes, artists do not rely solely on the viewer to move; they also set sculptures in motion. Sculptures that move, include elements that move, or appear to move are called **kinetic art**. Kinetic art can be propelled through a mechanical means, such as with a motor, magnet, or crank, or through natural phenomena, such as with wind. As when we move around a stationary sculpture, kinetic art allows us to appreciate time in sculpture because movement occurs over time. Movement also invests works with a sense of life, energy, and unpredictability.

South Korean artist U-Ram Choe (OO-ram choo-AY) creates kinetic sculptures. Computer programming and motors make his sculptures move. In *Imago* (figure 10.13A), he designed a dragon-like, mythical being. Over time, the creature's wings flap, while the body curls forward and back, as if the animal is alive and hovering in the air. The organism, which has one body, but two heads and sets of wings (one is upside down), plays out a tug of war, as the ends of the torso attempt to fly in opposite directions. The motion creates continuous variety across the work as does the eerie combination of life-like movement and electrical parts (figure 10.13B).

*Quick Review 10.4*: Why can a freestanding sculpture only be fully understood from multiple views?

## Relief Sculptures

**Relief sculpture** protrudes from a surface. Both the projecting design and background are integral parts of the work. In some ways, relief sculpture is similar to two-dimensional works in that we view them from the front. There are both *low-* and *high-relief sculptures*.

### Low Relief

In **low** or ***bas*** (BAH) **relief**, the raised, projecting design:

- *Protrudes slightly* from a background
- *Looks almost flat*, close to the appearance of a two-dimensional work, despite being three-dimensional
- *Differentiates the main figures and objects* in a scene

**kinetic art** A work of art that appears to move or has moving elements propelled either through a motor, magnet, crank, or natural phenomena

**relief sculpture** A sculpture that is made up of both a background and a projecting design

**low/*bas* relief** *Bas* is French for "low"; a relief sculpture in which the design protrudes from the background just a little

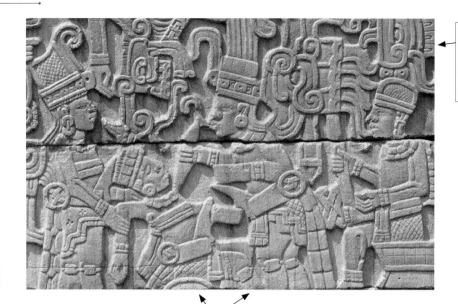

Numerous geometric forms create a stylized, rhythmic, pattern that is higher than the surface.

A priest stands over the unlucky victim, ready to plunge a knife into his chest, the figures projecting above the background.

**FIGURE 10.14.** **Relief panel depicting the sacrifice of a ball player.** *From the south ball court at El Tajín, Veracruz, Mexico. c. 500–900 CE. Flagstone, 5′ × 6′ 6″.*

Interactive Image
Walkthrough

Figure 10.14 portrays a low-relief sculpture from El Tajín, Mexico. Carved sometime between 500 and 900 CE, the relief appears on the wall of a court that was used for popular ball games. The raised design, which protrudes just a little, depicts the sacrificial killing of a losing ball player.

### High Relief

**high/*haut* relief** *Haut* is French for "high"; a relief sculpture in which some parts of the design protrude from the background by more than half their modeled form

In **high** or ***haut*** (OHT) **relief**, the raised design:

- *Protrudes from the background in some places by more than half the modeled form,* and at times projects entirely off of the surface
- *Forms a strong sense of space*
- *Creates contrast across a surface*—as light hits raised parts and shadows are cast on lower ones

Irish-born American artist Augustus Saint-Gaudens (aw-gus-tus saynt-GAW-dens) honored the brave commander and troops of the first African American regiment of the North in the American Civil War in a high-relief sculpture, *The Robert Gould Shaw Memorial*. Colonel Shaw, who was white, and many of his men were killed in an assault on Fort Wagner. Saint-Gaudens started the work just nineteen years after the war had ended, but he took thirteen years to perfect the project. The high relief allowed him to develop individual features on the rounded men's faces and a definite sense of space in which the regiment marches forward (figure 10.15).

*Quick Review 10.5*: What is the difference between low- and high-relief sculptures?

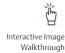
Interactive Image Walkthrough

Shaw, in the highest relief, projects from the background by more than half his modeled form and is even detached from the surface, placing him in the foreground.

The light hits Shaw's projecting horse, but behind the flat background falls in shadow.

These men protrude less than Shaw, placing them in the background. Many of their guns appear even more distant due to the low diagonal strips.

A difference in clarity in the levels of the relief emphasizes the space. The higher relief is sharper, while the lower looks fuzzier—the same way objects do in real life as they recede in the distance.

**FIGURE 10.15.** Augustus Saint-Gaudens. *The Robert Gould Shaw Memorial.* *1884–97. Bronze, 11' × 14'. Boston Common.*

## Earthworks

Works of art in which the artist places human-made forms in a natural environment, molds the earth, or uses nature to create the piece are known as **earthworks**. They frequently:

- Are **site specific**, meaning they are *designed for a particular location*
- *Can be entered*, so the viewer can walk into the artistic environment
- *Call attention to* our relationship with *the natural world*

American Nancy Holt arranged four concrete tunnels in the Utah desert in a site-specific earthwork of human-made forms placed in a natural landscape (figure 10.16). Patterns of holes on the tunnels, corresponding to constellations, allow the sun to shine through, producing shifting light patterns inside the tunnels throughout the day. To appreciate the tunnels completely, we need to view them at different times of the year, so

**earthwork** A work of art in which the artist places human-made forms in a natural environment, molds the earth, or uses nature to create the piece

**site specific** A sculpture that is designed for a particular location

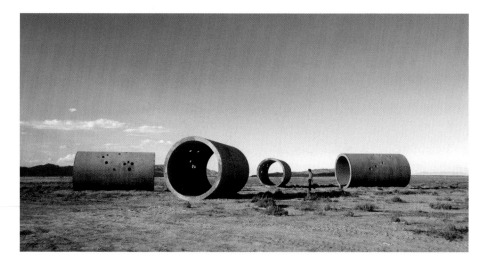

**FIGURE 10.16.** Nancy Holt. *Sun Tunnels. 1973–76. Concrete, steel, and earth, each tunnel 18' 1" × 9' 3" in diameter. Great Basin Desert, Utah.* Visitors to the *Sun Tunnels* are able to walk into and around them, seeing how the views of the surrounding landscape and the art change from different positions and over time.

we can see the effects of nature changing the work. Holt also aligned the tunnels to frame the rising and setting sun on the summer and winter solstices.

**artists**
MATTER

Robert
Smithson

Robert Smithson made another type of earthwork, *Spiral Jetty*, by sculpting earth and rock into a giant spiral that stretches fifteen hundred feet into Utah's Great Salt Lake (figure 10.17). Smithson pushed the earth into the form of sea shells and salt crystals that are found on rocks that ring the lake. Nature is changing Smithson's *Jetty*, so it looks different as time passes. Built in 1970 during a drought, the *Jetty* was submerged underwater for almost three decades when the waters rose after the drought ended. It reappeared in 1999, during a new drought. The *Jetty's* color has whitened as the rocks have been encrusted with salt and nature has eroded it. Someday the *Jetty* will disappear forever (see *Practice Art Matters 10.2: Consider the Changing Nature of Earthworks*).

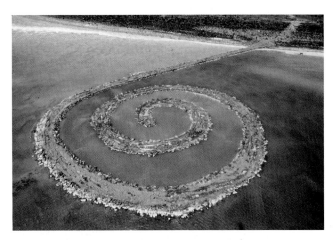

**FIGURE 10.17.** Robert Smithson. *Spiral Jetty.* 1970. *Mud, salt crystals, rocks, and water, 1,500' × 15'. Great Salt Lake, Utah.* Creating Smithson's design took more than six thousand tons of rocks and earth.

**installation** A three-dimensional work of art in which the artist uses an entire space or room to create the piece

*Quick Review 10.6*: What are the different types of earthworks?

## Installations

Indoor environments, referred to as **installations**, are three-dimensional works of art in which the artist uses an entire space to create the piece. They frequently:

- *Transform entire rooms* or spaces
- *Make the viewer an active participant* in the artistic process, because viewers enter these environments to experience the works
- *Are temporary*, leaving us with new ideas about the nature of the lifespan of a work; the only remaining aspect of the piece at the end of the exhibition is photographed, filmed, or written documentation

*Practice* **art**MATTERS

### 10.2: Consider the Changing Nature of Earthworks

As with *Spiral Jetty* (figure 10.17), time is an important element in many earthworks that change because of their environments. These changes raise issues regarding the nature of earthworks as art. Consider these questions:

- If a work changes over time, how does it exist?
- Are photos from the year *Spiral Jetty* was built a better representation of the work than the *Jetty* itself as it exists today? Why?

- Does art have to be static or can it have a life of its own? Why?
- Should works such as *Spiral Jetty* be preserved or should change over time be a part of the art? Why?

Smithson died in 1973 with his wishes regarding conservation of his work left as an open question.

In *Rainbow Assembly* (figure 10.18), Danish contemporary artist Olafur Eliasson (OLA-fur eh-LEE-ah-sun) transformed an exhibition space with his installation. Viewers entered a room in which a circle of mist fell from the ceiling. The room was dark save for spotlights aimed at the spray. The juxtaposition of water droplets and light created a ring of rainbows around the room. Even though Eliasson's materials—light and water—were minimal, when most people encountered the work, they were compelled to reach out their hands or walk through the drops. The installation brought a natural phenomenon indoors and seemed to make viewers more aware of their own presence within the space.

Adrian Piper's work compelled viewers to participate in her installation *Vote/Emote* (figure 10.19) in an even more far-reaching way. Piper, an American woman of multiracial ancestry, often uses her art to ask viewers to consider their own prejudices. In figure 10.19, Piper confronted viewers with four voting booths. In each, Piper placed a different photo of people of African descent behind windows, forming an illusion of people in real space.

Each booth contained a notebook for viewers to record their thoughts in response to a preprinted statement. In the first two booths, viewers were asked to react to prompts such as, "List your fears of what we might know about you" or "List your fears of what we might think of you." Viewers were placed in the position of considering how those looking at them might judge them based on nothing other than how they looked. Viewers' responses in a sense reversed stereotypical prejudice. However, the replies followed traditional forms of art in which a viewer evaluates the expression that an artist communicates through an object.

In the next two booths, the statements asked viewers to record their specific thoughts about people of African descent in the images based on nothing other than their appearance. Viewers' responses could have reflected racist opinions, but they were also untraditional artistic expression, in that Piper had viewers express their feelings back to the art object.

Through the installation, Piper asked viewers to confront their ideas about art and identity. The work also illustrates how meaning changes for every viewer, because these feelings varied as each person who entered the booths was of a different race and had different biases.

Sometimes artists transform specific sites with installations that are devised to work with and respond to a particular location. Doris Salcedo (sohl-SAY-doh), who is from Colombia, created *Shibboleth* especially for the five-story hall in London's Tate Modern Museum (figure 10.20). The work consisted of a crack in the floor that started out as a barely noticeable hairline and expanded to over a foot in width and six feet in depth along its over five-hundred-foot length.

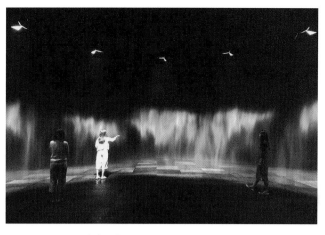

**FIGURE 10.18.** Olafur Eliasson. *Rainbow Assembly. From the installation at the Leeum, Samsung Museum. 2016. Spotlights, water, nozzles, wood, hose, and pump, dimensions variable.* Spectators could see the sprinkler heads and spotlights, so they could understand how Eliasson produced the effect of the rainbows indoors.

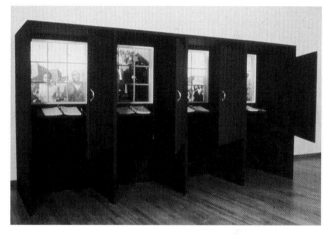

**FIGURE 10.19.** Adrian Piper. *Vote/Emote. 1990. Mixed media installation: four constructed booths with swinging doors, each containing a notebook with preprinted pages, pen, transparent photo print, light box, and framed window, 7' × 13' 8 ½" × 4' ¾". Collection of the Adrian Piper Research Archive Foundation Berlin. © APRA Foundation Berlin.* Piper's installation immersed viewers in her art by asking them to express their thoughts rather than just observe an artist's expression.

**artists**
MATTER

Doris
Salcedo

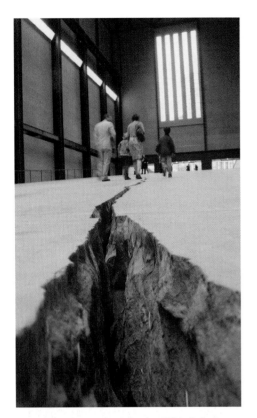

**FIGURE 10.20.** Doris Salcedo. *Shibboleth. From the installation at the Tate Modern, London. October 2007–April 2008.* After Salcedo's installation ended in 2008, the Tate Modern filled in the crack rather than removing it, meaning that the fissure still exists today, even though covered over—a further symbol worth considering.

Salcedo intended her work to be a comment on the ever-expanding political, economic, racial, and cultural gap between immigrants and Western residents. The word *shibboleth* comes from an Old Testament story in which one tribe used the word as a linguistic test to discover the identities of people from another tribe, whose population could not pronounce the sound "sh." Anyone who said the word incorrectly was recognized as an enemy and killed. Salcedo's line, similarly, helped symbolize the notion of exclusion. The gash appeared to crack the foundation of a recognized symbol of modern England. Salcedo perhaps was saying that hatred is a problem that starts out unnoticeable, but expands into a deep fault line—as if too much mistrust of others could bring down the building from an earthquake. Visitors stood on either side of the jagged gap, divided from one another both physically and metaphorically.

*Quick Review 10.7*: How is the viewer an active participant in an installation?

# Different Sculpture Techniques

Artists can use two processes in sculpture: a subtractive process or an additive one. In a **subtractive process**, artists start with a material and chip away at it, eliminating parts (as the Asante sculptors did). In an **additive process**, artists start with nothing and build up form. *Carving* is subtractive, and *modeling, casting, constructing,* and *assembling* are additive (table 10.1). More recently, artists have also used computers to create *digital sculptures*, using both subtractive and additive processes.

**subtractive process** A technique in sculpture in which the artist starts with a block of material and cuts away or subtracts unwanted material

**additive process** A technique in sculpture in which the artist starts with nothing and builds up and adds material to create a form

| TABLE 10.1 | Traditional Sculpture Techniques. | |
|---|---|---|
| **Type of Process** | **Technique** | **Description** |
| Subtractive | Carving | Unwanted areas of a block of hard material are cut away. |
| Additive | Modeling | Soft material is built up into a form. |
| | Casting | A mold is used to replicate a model made in a soft material with a permanent material. |
| | Constructing | Various created materials are joined. |
| | Assembling | Various found materials are joined. |

## Carving

**carving** A technique in sculpture in which an artist begins with a material such as wood, stone, or ivory and gouges and cuts away unwanted portions to create a form; a work of art produced using this method

With **carving**, an artist starts with a block of hard material that is bigger than the intended sculpture. Then, he or she gouges away unwanted portions to create a form (figure 10.21), just like the Asante sculptors chipped away at wood blocks to form *akua'mma.*

Carving requires physical labor and skill. Artists use their own strength to chip away at hard materials. They also must work around imperfections in the block that can cause cracks. Once a piece has accidentally fallen off or purposely has been cut off, artists cannot put it back.

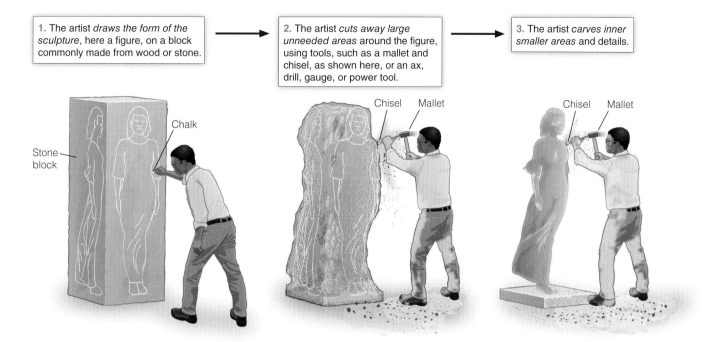

Stone block

Chalk

Chisel    Mallet

Chisel    Mallet

**FIGURE 10.21.** Carving.

Sixteenth-century Italian artist Michelangelo Buonarroti (mee-kel-AN-jel-oh bwoh-nah-ROE-tee) believed that every block contained a figure hiding within it that he could liberate by carving. The *Unfinished Slave* in figure 10.22 shows Michelangelo's process. It is almost as though the slave is struggling to free himself from the block that encases his head. To best understand Michelangelo's technique, imagine a figure lying underwater in a tub. If water drains, portions of the figure would emerge, until the entire figure was exposed. Such was the case with Michelangelo's technique: as he cut away unwanted areas, the figure slowly emerged until it was completely revealed.

Carved sculptures are usually *compact* and typically *do not have projections* that extend from the main form. There are several reasons for this characteristic. The sculptor must:

- *Fit the work* within the limits of a block
- *Cut away large amounts of material* under a projection, which is labor intensive
- *Limit outstretched extremities* as they often lead to structural problems; if the material does not have enough **tensile strength**, or the ability to support a projection, it may break

An ancient Egyptian sculpture shows the compact nature of carving. In figure 10.23, the solid figures of the Egyptian king, or pharaoh, and likely his queen are one with the dense, hard, stone block. There is no space between their arms and bodies as they face frontally in their formal, rigid pose.

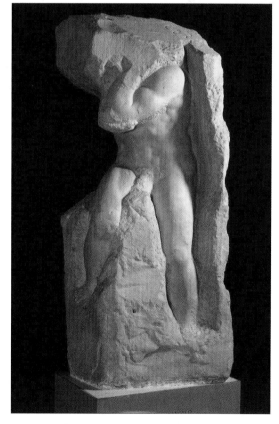

**FIGURE 10.22.** Michelangelo Buonarroti. *Unfinished Slave.* 1527–28. Marble, height 8′ 7 ½″. Accademia Gallery, Florence, Italy. This sculpture shows Michelangelo's method of liberating the figure from the block.

**tensile strength** The ability of a substance to support the tension of stretching or projecting out

Different Sculpture Techniques    **263**

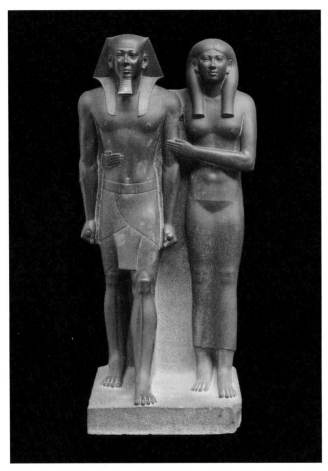

FIGURE 10.23. **Menkaure and a queen.** *From Giza, Egypt. Dynasty 4, c. 2490–2472 BCE. Greywacke, height 4' 8" × 1' 10 ½" × 1' 9 ¾". Museum of Fine Arts, Boston.* The compact nature of carving means the figures' arms remain close to their bodies rather than being extended out.

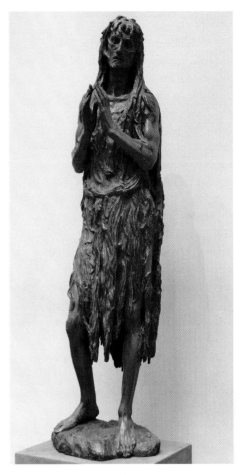

FIGURE 10.24. **Donatello.** *Mary Magdalene. 1453. Painted wood, height 6' 2". Museo dell'Opera del Duomo, Florence, Italy.* Carved wood helped Donatello portray a sympathetic view of Mary Magdalene.

In Egypt, it was believed that the dead pharaoh's *ka* or life spirit (similar to a soul) would intercede with the gods to protect Egypt forever. This sculpture was designed to be a resting place for the *ka* after death. Art played an important role in emphasizing this power through the carving technique: the compact form helped convey the permanent, solid, everlasting power of royalty.

Sculptures carved from *different materials create different expressions*. Figures 10.22 and 10.23 show the quality of different stones. Michelangelo's marble seems supple, forming the slave's soft, human-like skin, and perhaps linking us with the slave's plight. The hard stone from Egypt is dense, lending the sculpture an eternal feel, and serving to distance us from the powerful leaders. In figure 10.24, Donatello (dohn-ah-TELL-oh), a fifteenth-century Italian artist, depicted a devout Mary Magdalene in wood. Mary Magdalene, one of Jesus's followers, is clothed in her own hair, with sunken cheeks and an emaciated body. The warm, fibrous texture of the wood seems to add to Mary Magdalene's spirituality and despair and tangibly helps illustrate the ravages of a life of self-denial.

*Quick Review 10.8*: Why do carved sculptures have compact forms?

## Modeling

With **modeling**, an artist starts with nothing and builds up a soft, pliable material like clay or wax to create a three-dimensional form (figure 10.25). As artists work with their hands to shape the material, the technique is expressive and personal; often an artist's fingerprints are visible in the sculpture.

Clay does not have much tensile strength, so *projections and upright pieces sag if unsupported*. Therefore, sculptures with outstretched forms are often built over **armatures**, rigid skeletal structures usually made of wire. Think of a human body, which is made up of soft material such as skin and muscles, but also a hard skeleton that enables a person to stand. Upright clay similarly needs a support.

Clay is versatile. It is sticky and mud-like when wet, so is easily shaped. Because it is malleable, the artist can rework a piece until it is right. Once dry, clay can be baked in a **kiln**, an oven that reaches temperatures of 1,200 to 2,700 degrees Fahrenheit, so the clay becomes permanent. These **fired**, or baked, clay pieces are called **ceramics**.

Artists often use clay to create *preliminary small-scale models* of sculptures. An artist can move from idea to sculpture without a lot of labor, expensive materials, or complex techniques getting in the way. In this respect, clay is similar to drawing in that it allows the artist to consider several options and develop different views as he or she experiments before producing a final form.

When fired, clay can also be used for finished works. Because an armature cannot be fired, ceramics must be kept compact. If an artist wants to create complex forms, he or she models pieces of the sculpture separately and joins them after firing. Twentieth-century

**modeling** In sculpture, a technique in which an artist shapes a soft, pliable material such as clay or wax to create a three-dimensional form

**armature** A rigid skeletal structure made commonly of wire used in sculpture for support in the interior of soft materials such as clay

**kiln** An oven that reaches temperatures of 1,200 to 2,700 degrees Fahrenheit used for firing ceramics

**firing** The process of baking clay pieces in a kiln; through firing, clay pieces are changed physically and chemically so they are durable and hard

**ceramics** Clay pieces that have been fired in a kiln

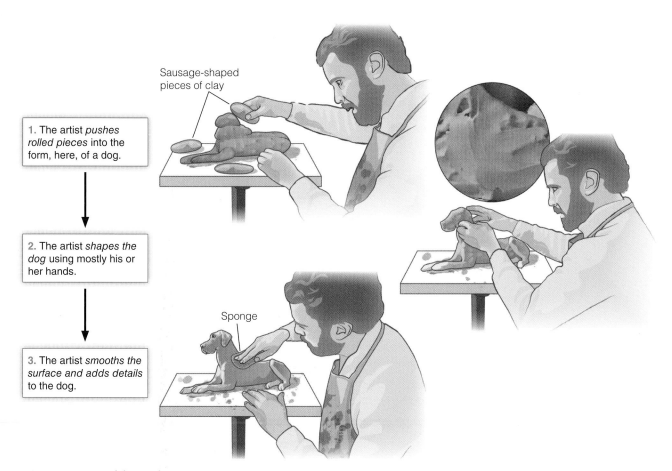

1. The artist *pushes rolled pieces* into the form, here, of a dog.

Sausage-shaped pieces of clay

2. The artist *shapes the dog* using mostly his or her hands.

3. The artist *smooths the surface and adds details* to the dog.

Sponge

**FIGURE 10.25.** Modeling in clay.

**FIGURE 10.26.** Helen Cordero. **Male storyteller figure.** *1965–67. Ceramic, 14 3/16″ × 5 7/8″ × 9 13/16″. Museum of International Folk Art, Santa Fe, New Mexico.* Cordero rolled the forms of the children in her hands.

**casting**  A technique in sculpture in which an artist creates a model in a soft material and uses a mold to replicate the model in a permanent material

**mold**  An exact negative impression of a model that forms a pattern for a replacement material in casting

**substitution/replacement technique**  A process in sculpture in which one material replaces another

**lost wax casting**  A hollow casting technique used to create a sculpture in which molten metal replaces wax; a wax replica is created from an artist's model, encased in a mold, and heated so that the wax drains away, then molten metal is poured into the cavity that the wax vacated

sculptor Helen Cordero formed figure 10.26 from separate pieces. Cordero modeled the sculpture after her grandfather, a Hopi Native American, who told stories to Cordero and his other grandchildren in Cochiti Pueblo in New Mexico. In the sculpture, swarms of children, which Cordero attached after firing, eagerly climb on him.

Modeled clay is also often used in the *first steps of casting*. While with firing, artists use clay as a final material, with casting artists use clay as a transitional step to another, more permanent material.

*Quick Review 10.9*: What is the reason modeled sculptures are often built over armatures?

## Casting

In **casting**, an artist creates a model for a sculpture out of a soft material, like clay, and uses a **mold**, an exact negative impression, to replicate the model precisely in a permanent material, like bronze. Casting works in much the same way as Jell-O. To make Jell-O, you mix gelatin and boiling water in a bowl and place it in the fridge. In a few hours, the Jell-O solidifies and conforms to the bowl, so that when you flip the bowl and plop the Jell-O out, it maintains the bowl form.

### Casting Materials and Molds

Like Jell-O, artists can use any casting material that changes from liquid to solid depending on environmental conditions. Many materials change to liquid when heated and become solid when cool. Others change to liquids as water is added and to solids when they set. While artists favor bronze, because of its durability and appearance, other materials can be used such as brass, aluminum, silver, plaster of paris, and plastic. Because the artist replaces a soft, easily worked, temporary material with a durable one, casting is known as a **substitution** (or **replacement**) **technique**. Cast materials have great tensile strength when hardened that allow for projections.

Also like Jell-O, casting a sculpture requires a mold (like the bowl). However, with sculpture, the mold first needs to be built around an exact, same-size model of the sculpture, like a glove goes around a hand. The artist does this by capturing in reverse the form and surface details of the model. Areas that jut out on the model are indented on the mold and vice versa.

### Different Casting Techniques

There are two types of traditional casting techniques: solid and hollow. In *solid casting*, the inside of the final sculpture is completely *filled in*, like the Jell-O. In *hollow casting*, the inside of the final sculpture has an *empty space*. A chocolate bunny is made with hollow casting—only a thin layer of chocolate surrounds air.

Solid casting is a much simpler process, but it is used only for smaller works. Artists form a mold around a clay model that they have sculpted; then, after removing the model, they pour liquid casting material into the mold in the hollow space where the clay model used to be.

Conversely, larger works are cast hollow, in a method known as **lost wax casting**, so that they are not as heavy and don't use as much material. Because hollow casting is a technical process, artists today almost always have their models cast at a foundry

that specializes in fine art casting. Foundry workers create a hollow wax replica of an artist's original clay model, fill and encase the replica with plaster, heat the wax so it drains away, and pour molten metal into the cavity that the wax vacated. The method is known as lost wax casting because the wax is melted out or "lost" during the process. The general steps of lost wax casting are shown in figure 10.27.

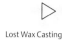

Lost Wax Casting

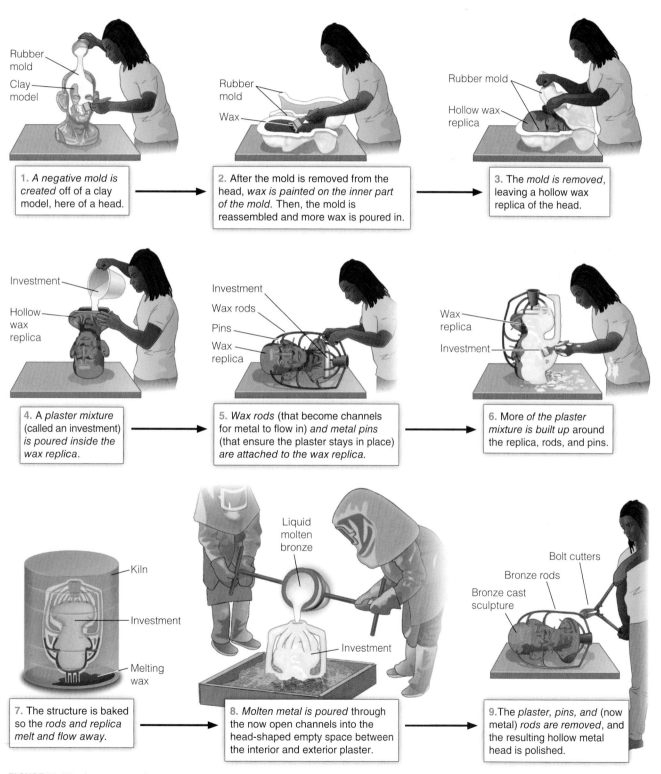

1. *A negative mold is created* off of a clay model, here of a head.

2. After the mold is removed from the head, *wax is painted on the inner part of the mold.* Then, the mold is reassembled and more wax is poured in.

3. The *mold is removed,* leaving a hollow wax replica of the head.

4. A *plaster mixture* (called an investment) *is poured inside the wax replica.*

5. *Wax rods* (that become channels for metal to flow in) *and metal pins* (that ensure the plaster stays in place) *are attached to the wax replica.*

6. More *of the plaster mixture is built up* around the replica, rods, and pins.

7. The structure is baked so the *rods and replica melt and flow away.*

8. *Molten metal is poured* through the now open channels into the head-shaped empty space between the interior and exterior plaster.

9. The *plaster, pins, and* (now metal) *rods are removed,* and the resulting hollow metal head is polished.

**FIGURE 10.27.** Lost wax casting.

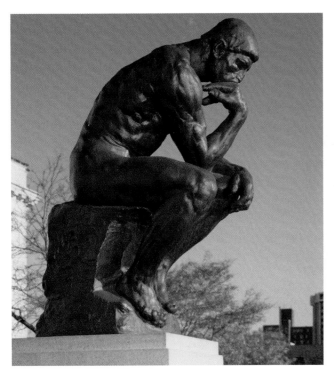

FIGURE 10.28. Auguste Rodin. *The Thinker*. 1904. *Bronze, height 6′ 6″. Detroit Institute of Arts, Michigan.* Even though this sculpture looks like it is dense, the hollow casting method created just a thin shell of bronze.

Because the foundry uses a rubber mold of the original modeled clay sculpture (figure 10.27, step 1), the mold is not destroyed in the process and can be reused to create multiple casts. Accordingly, as with prints, cast sculptures often have multiple originals.

*The Thinker* (figure 10.28), by French sculptor Auguste Rodin (oh-GOOST roh-DAN), who worked in the late nineteenth and early twentieth centuries, was cast in bronze. Because casting begins with a modeled form and replicates every detail, Rodin's vigorous shaping is evident. Rodin captured *The Thinker's* intensity in the details of every muscle, his introspective expression, and pose. Because Rodin's hands created the surface bulges and indentations, his personal touch comes through, even though the sculpture was cast in a hard material.

While artists have been casting models of sculptures for centuries, in modern times some artists have taken up an interesting twist on casting, by using humans as their models. To learn about the process, see *Delve Deeper: Casting Human Figures*.

***Quick Review 10.10***: What is the difference between solid and hollow casting methods?

Constructing: One Sculptor's Technique

## Constructing and Assembling

In both constructing and assembling, artists join items. The difference between the methods stems from *whether the artist crafts the materials that are joined or not.*

With **constructing**, artists:

- *Use various materials,* such as wood, metal, stone, or concrete
- *Carve, model, or cast the different materials,* being just as concerned with craftsmanship and surface finish as other sculptors
- *Join the parts,* using methods such as bolting, screwing, welding, gluing, or threading

Contemporary American artist Alice Aycock had her huge, outdoor *Passion/Passiflora Incarnation* (figure 10.31) constructed of aluminum, steel, and concrete. Following her design, artisans at a fabrication company joined multiple parts that they specifically crafted for this sculpture. The sculpture resembles two futuristic-looking flowers in a pond. As the city of Coral Gables was originally planned as a garden city, where buildings were arranged among green areas, some people see a close relationship between structure and site—others, however, do not (see *Practice Art Matters 10.3: Evaluate Who Should Decide the Fate of Public Art*).

With **assembling**, an artist:

- *Uses preexisting, everyday* **found objects**, which are items that an artist has obtained and does not alter
- *Combines the objects into a unified artwork,* called an **assemblage**, in which each of the objects has a different size, surface texture, and characteristics, making assembling a challenging art form
- *Transforms the original, recognizable components into a new design* with its own meaning, yet the design still reminds us of the old familiar objects

**constructing** A technique in sculpture in which an artist joins together different pieces that he or she has created

**assembling** A technique in sculpture in which an artist joins together different preexisting pieces that he or she has found

**found object** An item that an artist selects or finds that is incorporated into a sculpture without being altered; through juxtaposition with other objects or through placement, a found object will take on new or additional meaning

**assemblage** A work of art formed of joined, different, preexisting found objects

# DELVE DEEPER

## Casting Human Figures

(A)

(B)

**FIGURE 10.29A (APPLYING THE MOLD TO THE PERSON) AND B (IMPLANTING HAIR INTO THE SCULPTURE).** Duane Hanson creating *The Jogger* in 1983–84. In 10.29A, when applying the mold to the person's head, Hanson left the eyes and nostrils uncovered. In 10.29B, the head (which belongs to the sculpture, not the person) is incredibly realistic—note the ear, skin, and hair that Hanson implants (we see Hanson's hands holding the tool).

For his life-size, super-realist sculptures, twentieth-century American artist Duane Hanson cast people. Hanson created solid casts, but made several adjustments to the traditional method because he was working with human models:

- So that the molds could easily be removed, Hanson would have the person shave off body hair, apply Vaseline to the skin, and tape down hair on the head.

- Hanson worked in sections, casting only one part of the body, such as the head (figure 10.29A), at a time.

- To achieve the super-realist effect, Hanson worked with a casting material that when set was soft and somewhat translucent like skin. Then, he painted, dressed, accessorized, and stuck individual hairs into the sculptures (figure 10.29B).

The effect is truly authentic. The *Construction Worker* in figure 10.30 could easily be mistaken for a real person. To most of us, he would seem ordinary and familiar. Hanson tried to depict real people, often showing the emptiness in their lives.

**FIGURE 10.30.** Duane Hanson. *Untitled Sculpture (Construction Worker).* 1970. *Polyester resin and fiberglass, polychromed in oil.* To make this sculpture even more lifelike, Hanson placed it sitting on a bucket, rather than raised on a pedestal.

**FIGURE 10.31.** Alice Aycock. *Passion/Passiflora Incarnation*. 2016. Powder-coated aluminum, stainless steel, concrete pool with fountain plumbing, and LED lighting, sculpture 30' high × 30' diameter, pool 54' wide × 38' long × 16" deep. Roundabout at Segovia and Coral Way, Coral Gables, Florida.  As this outdoor sculpture is in Florida, it was built to withstand hurricane-force winds.

Melvin Edwards, a contemporary artist, formed the assembled sculpture in figure 10.32 called *Resolved*, which is from his "Lynch Fragments" series. Throughout the series, Edwards welded together different found objects including chains, railroad spikes, and hooks. By themselves, hooks, for example, do not connote violence. However, when combined with the other steel elements, the hooks can take on a menacing feel. Even though it is nonspecific, *Resolved* may recall brutal images of angry mobs lynching (killing violently) African Americans, because Edwards, who is African American himself, manipulated the pieces, joining familiar objects in a new way.

*Quick Review 10.11*: How are constructing and assembling techniques similar and different?

**artists**
MATTER

Melvin
Edwards

### Digital Sculpting

Some artists today are experimenting with innovative ways to create sculpture. These artists design sculptures digitally, producing virtual, three-dimensional forms. Then, they work with either a *computer-driven subtractive* or *additive technique* to create real three-dimensional sculptures. Digital sculpting allows an artist to generate multiple versions of a work.

British-born American artist Jon Isherwood used the computer to form the sculpture *French Mist* (figure 10.33). He first modeled the sculpture by hand in clay and scanned the work into a computer file, producing a digital, three-dimensional model. Then, he designed a digital, repeating texture, which he laid onto the surface of the digital model. When the design was finished, software directed a CNC (computer numerical control) milling machine in carving the sculpture in marble. The milling machine formed the organic, bulbous mass and the intricate surface texture that Isherwood planned digitally.

*Practice* art MATTERS

## 10.3  Evaluate Who Should Decide the Fate of Public Art

Aycock's sculpture (figure 10.31) is not only constructed, but also public art in that it was placed in a public space in Coral Gables. Some residents were unhappy with the sculpture and petitioned to have it removed, because they felt its form was ill-suited to the character of the city. These concerns arose despite the fact that before the sculpture was constructed, public meetings were conducted, a number of city boards approved the project, and the city received outside funding for some of the cost. Consider these questions:

- Who should decide whether the sculpture stays in place: the city, the artist, or the residents? Why?

- If you answered the residents, what about the fact that only some of the residents signed the petition to have it removed?

- Is the art site specific? Is that relevant in terms of whether the art can be removed? Why?

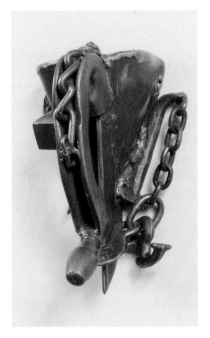

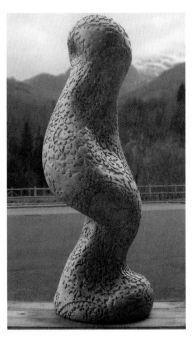

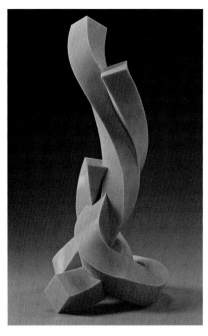

**FIGURE 10.32.** Melvin Edwards. *Resolved. From the series "Lynch Fragments." 1986. Welded steel, 12" × 8 ¼" × 7 ¾". Newark Museum, New Jersey.* The sculptures in the "Lynch Fragments" series are meant to be hung at eye level, perhaps suggesting they are abstracted faces seen in the act of being attacked.

**FIGURE 10.33.** Jon Isherwood. *French Mist. 2014. Novolato marble, 4' 3 ⅔" × 1' 10 ⅕" × 1' 5".* Unlike traditional carvers, who start with a hard material, Isherwood began his sculpture in clay.

**FIGURE 10.34.** Bruce Beasley. *Coriolis XXIII. 2013. Acrylonitrile butadiene styrene, 2' 7" × 1' 2" × 1' 1".* Digital sculpting enabled Beasley to create the complex configuration.

An alternative method of digital sculpting can be seen in the work of American Bruce Beasley. Beasley designed the sculpture in figure 10.34 on the computer. A 3D printer then reproduced pieces of the design by putting down one thin, horizontal layer of liquid plastic on top of the next until the sections were built up into three-dimensional forms. Beasley joined these pieces to produce the complete work. Called *Coriolis XXIII,* the sculpture is one in a series of works in which Beasley explored the idea of the Coriolis effect—the influence of the Earth's rotation on atmospheric winds. The spinning, upright form would have been much more difficult to produce using a traditional sculptural method.

An exciting aspect of digital sculpture is that objects can be created remotely. One or more artists can work on a project in different locations, finalizing the virtual design that can then be sent to still another location where it can be manufactured. This process allows for numerous possibilities. For example, digital sculpting can stimulate cross-cultural collaboration between artists from different backgrounds, make materials that are not available to an artist accessible, and promote a more democratic art that is readily available in numerous copies to individuals in different locations.

*Quick Review 10.12:* What are two different digital sculptural techniques?

HOW **art** MATTERS

## A Look Back at *Akua'mma* Sculptures

The story of the *akua'mma* illustrates how different people may use objects to petition the spiritual world. Many traditional Asante see objects—that people in the West would typically view as art—as powerful and important interventions in their lives. The story, though, also raises a number of issues that are important to a study of sculpture.

The *akua'mma* are **sculptures** by definition. They are *three-dimensional* and *exist in our world*, as the Asante women carry and interact with them. Moreover, they have a *mass* that is flat, columnar, and solid. This form enables the women to use them for their intended purpose. The form also plays a role in the meaning of the *akua'mma*. Each sculpture follows a cultural model, assuming an identifiable and symbolic form. The sculptures also change based on their *environment*. In daily life, they are items thought to help a woman become pregnant, while in a museum, they are objects of art.

These works also can be defined as sculpture through their *material* and *meaning*. The sculptures have a tactile, warm quality because the *material* from which they are made is wood. Given that trees are considered spiritual among the Asante, the wood is believed to impart extra power to the sculptures. The sculptures derive much of their *meaning* from their use and environment. Because of cultural context, each sculpted feature helps to convey the notion of an idealized person—from the sloping long forehead to the rings of fat at the neck.

The *akua'mma* are of a specific *sculptural type* and are crafted from a traditional *technique*. They are **freestanding** and physically set apart. We need to see them from *different views* to appreciate their three-dimensional form. Moreover, they are **carved**. Knowing the physical labor involved in *chipping and gouging away unwanted material*, we are aware of the process and exertion of the artists. Expending this effort further speaks to the importance of the *akua'mma* in the traditional Asante culture.

As you move forward from this chapter, consider how sculpture confronts us in our space. This interaction with works that exist in our environment sometimes makes them controversial, such as Aycock's *Passion/Passiflora Incarnation* (figure 10.31). Some people in Coral Gables did not believe it fit with the surroundings. Similarly, the *akua'mma*, at first and without context, may feel unfamiliar and be difficult to understand. While the *akua'mma* may not look like any sculptures we have ever seen, knowing *the context for which they are used*—to enhance a person's luck in becoming a mother—might make them more approachable. Do you know anyone who carries a rabbit's foot? Have you seen athletes who do not shave when they are on a winning streak? The *akua'mma* sculptures demonstrate the value in exploring context that can lead to understanding, appreciation, and connections.

Flashcards

## CRITICAL THINKING QUESTIONS

1. How would you describe the mass of the *haniwa* horse (figure 10.8) versus the mass of Butterfield's horse (figure 10.9)?
2. Figure 10.6A shows Magdalena Abakanowicz's sculptures at the Nasher Sculpture Center, lined up, outdoors. How would the effect change if the sculptures were placed randomly in the Great Hall at Winchester, where Antony Gormley's sculptures are shown in Figure 10.7B?
3. What are several reasons why Augustus Saint-Gaudens might have decided to use the material bronze in the sculpture in figure 10.15?
4. Is the sculpture of Menkaure and a queen (figure 10.23) freestanding, low-relief, or high-relief? Why?
5. Look through the images in the chapter. One subject matter dominates among the representational works and is seen across time and place. What subject matter is this? Why do you think this subject matter is so prevalent?
6. If you had seen Piper's work (figure 10.19), do you think you would have recorded your thoughts in the notebooks? Why or why not?
7. If you were going to create an assemblage that illustrated your life or interests, what type of objects would you include?
8. Even though they are produced with computers, digital sculptures can be additive or subtractive techniques. Is Isherwood's (figure 10.33) work additive, subtractive, or both? Why?

Comprehension Quiz    Application Quiz

# Traditional Craft Media

## LEARNING OBJECTIVES

**11.1** Relate how the distinction arose between crafts and the fine arts during the Renaissance.

**11.2** Describe why useful objects were labeled as craft in the past.

**11.3** Explain why people have traditionally thought of craft as being formed by a few individuals.

**11.4** Discuss how a handmade feel was used in the past to differentiate craft.

**11.5** Describe how craft works have reflected the cultures in which they were created.

**11.6** List the various techniques for forming and finishing clay works.

**11.7** Outline the steps in the technique of glassblowing.

**11.8** Compare and contrast cold-working and hot-working metal-shaping techniques.

**11.9** Explain why wood bending is a useful technique.

**11.10** Summarize how the technique of weaving is accomplished.

# THE POTTERY OF MARIA MARTINEZ

In 1908, Dr. Edgar Lee Hewett, director of the Museum of New Mexico, began excavations of prehistoric pueblos (Native American settlements) near Santa Fe. While digging, Dr. Hewett's team unexpectedly found pieces of a black, shiny pottery that was unlike other baked clay vessels typically found in the area. Intrigued, Dr. Hewett decided to see whether a local potter could recreate it.

How Art Matters

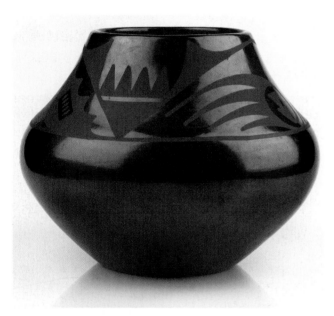

**FIGURE 11.1.** **Maria and Julian Martinez. Bowl.** *Early twentieth century. Blackware, height 6 ¾", diameter 9 ½". Smithsonian American Art Museum, Washington, DC.* The shiny base of this pot was similar to that of prehistoric pottery, but the matte design was new.

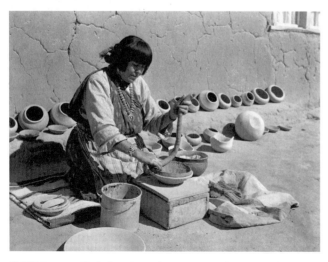

**FIGURE 11.2.** **Maria forming a clay pot.** Maria places a rolled piece of clay around a base that she had already pressed into a support.

## Maria and Julian Martinez's Discoveries

In San Ildefonso Pueblo, Dr. Hewett found Maria Martinez, who was known for her ability to form *perfect, symmetrical pots that did not look handmade*. These pots were formed from red clay and painted white, brown, and black. Hewett asked Maria (she was known by her first name, so we will continue that practice here) to try to recreate the all-black, shiny pottery. After working alongside her husband, Julian, for four years, they figured out the process. Then, in 1919, Maria and Julian invented a new type of pottery—black-on-black—that featured an intense and shiny black base with matte decoration (figure 11.1).

## Creating Black-on-Black Pottery

The creation of black-on-black pottery was an arduous process, involving *technical expertise* and a number of steps:

1. *Finding and mixing the clay*: Maria and Julian dug up two clays from separate deposits. Then, Maria combined the clays with water and ash. Only the correctly proportioned ingredients ensured the *clay mixture would have the strength and plasticity* (ability to be shaped) needed to form pots.
2. *Forming the pot*: To form the base of the pot, Maria rolled the *mud-like, malleable clay* into a ball and pressed it into a shallow, plate-shaped support. Using more clay, she rolled out *a rope-like coil of clay*, placing it on the rim of the base (figure 11.2). She then formed additional coils, placing them *one on top of another in spirals*, building up straight, steady walls and pinching the stacked coils together.
3. *Creating the final form*: Maria let *the clay dry and stiffen* and then pressed the sides of the pot in or out with her fingers (figure 11.3). Even though she created her pots by hand, they are proportioned, balanced, and symmetrical. Many are also large (some over one and a half feet high).
4. *Smoothing*: Maria allowed the pot to *dry until it was hard*. She then ran the edge of a metal lid from a jar over the walls many times, removing bumps. If not scraped perfectly, the pot could have been dented.

5. *Polishing to a high sheen*: Maria applied a *slip* (clay mixed with water) to the pot and rubbed the wet area with a smooth stone. The process, completed four to five times, was potentially destructive because, if the slip dried, the rubbing would scratch the pot.

6. *Decorating*: Julian painted the pot (figure 11.4) with a different *slip* that would appear matte when the pot was finished. He depicted objects (such as water serpents and mountains) or nonrepresentational designs.

7. *Firing*: Maria and Julian *baked the pot to ensure its permanence*. For efficiency, they fired numerous pots at once. After letting the fire burn for an hour, they smothered the mound with dried, powdered horse manure and then with ash. The smoke from the manure turned the red pots black, because the carbon was trapped in the clay surfaces. The ash sealed the mound, so no air could get in and ruin the uniform black surfaces. Because the pots changed as they lay buried in the mound, it was impossible to know what was happening to them until the firing was complete.

## Selling and Sharing Black-on-Black Pottery

Encouraged by the museum's staff, Maria and Julian perfected their craft and made more pots that the museum sold for them. These black-on-black pots were never meant to be used practically in cooking or ceremonies. Instead, the pots were conceived as *works to be displayed on the merits of their appearance, the skill needed to make them*, and the fact that they had been formed by Maria *individually*. Encouraged by the museum, Maria also signed her pots.

Seeing how popular the black-on-black pottery was, Maria and Julian shared their discovery with others in San Ildefonso, so they also could create black-on-black pots. By the mid-1920s, sales of pottery had increased the standard of living at the pueblo. In 1931, Maria began teaching classes at the Indian School in Santa Fe, *sharing her method with a wider community* of Native Americans.

Maria and Julian also taught pottery making to their family members, so, when Julian died in 1943, Maria could continue making pottery with her daughter-in-law and, then, with her son. Since her death in 1980, Maria's descendants have continued the pottery-making tradition. This custom of sharing knowledge with others in the community and future generations is part of many traditional Native Americans' way of life. Everything from pottery-making techniques to rituals, legends, and directions for making costumes is passed down in an oral tradition.

The story of Maria's pottery allows us to see how art is one important component of that valued way of life. As Maria said to her great-granddaughter when she asked Maria to make her a pot, "When I am gone, essentially other people have my pots. But to you I leave my greatest achievement, which is the ability to do it."[1]

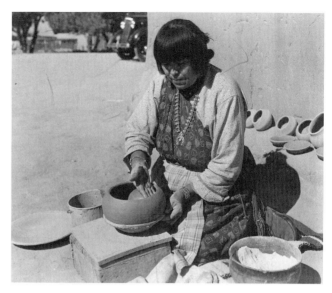

**FIGURE 11.3.** **Maria shaping a clay pot.** Maria presses the walls of the pot with her hands to shape the form.

**FIGURE 11.4.** **Julian painting a clay pot.** Julian always worked in freehand with no guiding marks, using a gritty slip and a brush made out of the leaves of a plant.

### The Complexity of Craft

In considering Maria's pottery, we can begin to appreciate the complexity of discussing craft and distinguishing it from other art forms:

» Do the media and techniques used to create an object define a work as craft?
» Does whether a work has a practical function establish it as craft?
» Do crafts need to look handmade or can they be perfectly formed?

This chapter considers these and other questions around the definition of craft. Before moving forward, based on this story, how would you distinguish craft from other art forms? Which media would you label as craft?

# 11 Conflicting Definitions of Craft

If you have ever been to a craft fair, you may think you have an idea of what crafts are. Numerous artisans display work, much of which is the result of hours of toil and expertise. Intricately shaped earrings may be displayed next to superbly produced rocking chairs. Some objects are items you could use in your home. Many look handmade. Why, then, the fuss about defining crafts and distinguishing them from the so-called fine arts of painting, sculpture, and architecture? The roots of this debate began centuries ago.

## Skill versus Intellect

Traditionally, one way that people defined craft was as work that required *skill*, while fine art was defined as work that required *intellect*. Think of walking around an art gallery where you might be likely to marvel at the meaning behind a painting rather than the technique used. This distinction between craft and fine art began during the Renaissance, a period in the fifteenth and sixteenth centuries in Europe.

### A Centuries-Old Distinction

Prior to the Renaissance, those who created paintings, sculptures, and architecture were typically grouped with those who worked with clay, glass, metal, wood, and fiber (thread-like strands). During the Renaissance, however, *painters, sculptors, and architects sought to elevate their status and began to draw distinctions* between the "fine art" they produced and the "crafts" formed by those who they claimed were "physical laborers." What made a great painting, sculpture, or building, they said, were the intellect and divine inspiration of a genius. Conversely, what made a great clay bowl, glass vase, suit of armor, wooden desk, or blanket were the technical expertise and manual dexterity of a tradesperson. Artists, they said, worked primarily with their minds, creating meaning, while craftspeople worked primarily with their hands, creating decorative objects.

This division between fine art and craft worked in the fine artists' favor as their status (versus that of craftspeople) rose. What had been only a theory during the Renaissance was, by the seventeenth century, the prevailing view in the West. Thereafter, based on these distinctions, *Westerners distinguished art from craft by material and technique*. For example, a painting, formed with the material of oil paint by the technique of glazes (see Chapter 6), was fine art, while a blanket, formed with the material of cotton by the technique of quilting, was craft.

## An Arbitrary Distinction

This distinction between fine art and craft, however, was arbitrary. Consider **stained glass** that, because it was made of cut pieces of glass, was labeled "craft." It is true that creating a stained-glass window was a technical feat. Skilled craftsmen:

1. *Cut large sheets of colored glass* into small, shaped pieces, arranging them on a template drawing of the design
2. *Painted details on the glass* with enamel and baked the glass to fuse the enamel to the glass
3. *Surrounded the cooled glass with lead strips* and framed it with iron

However, the detail of a stained-glass window from twelfth-century France in figure 11.5A still seems similar in many ways to fine art we have considered, like the altarpiece in Chapter 6 painted in tempera by fourteenth-century Italian painter Simone Martini (figure 11.5B). Such similarities lead to questions regarding distinctions. Both images show the Annunciation and were created for houses of worship, where their narratives educated and inspired worshipers. Even the forms of both are similar in how they show the Angel Gabriel appearing to Mary.

When we also recall the labor-intensive hatching technique the tempera medium requires (see Chapter 6), we realize that a similar level of skill was probably required to form both works. In addition, creating the window likely involved as much intellectual thought as the painting. Scholars believe that during the period when they were created, stained-glass windows, which filtered the natural light from outdoors (believed to be God's light), played a symbolic role in establishing a spiritual experience for worshippers.

## A Western and Discriminatory Distinction

These distinctions between craft and fine art also appear arbitrary because they originated in Europe and *have not necessarily been shared by people from other cultures.* For example,

**stained glass** A type of art form in which cut pieces of colored glass are held together with lead strips or in which glass is painted on with pigment

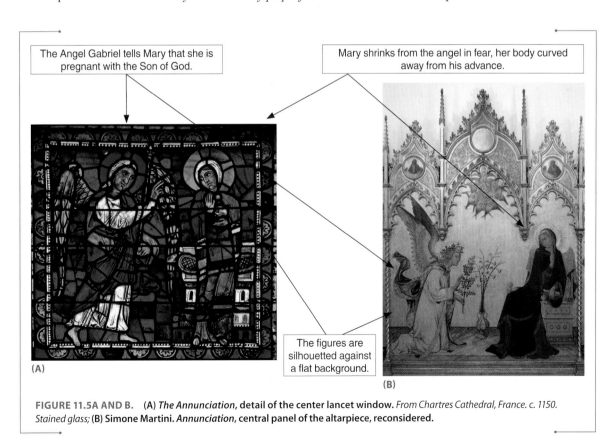

The Angel Gabriel tells Mary that she is pregnant with the Son of God.

Mary shrinks from the angel in fear, her body curved away from his advance.

The figures are silhouetted against a flat background.

(A)

(B)

**FIGURE 11.5A AND B.** **(A)** *The Annunciation,* **detail of the center lancet window.** *From Chartres Cathedral, France. c. 1150. Stained glass;* **(B) Simone Martini.** *Annunciation,* **central panel of the altarpiece, reconsidered.**

**FIGURE 11.6.** Devorah Sperber. *After the Mona Lisa 8.* 2010. 1,482 *large spools of thread, stainless-steel ball chain and hanging apparatus, clear acrylic sphere, metal stand, 5′ 8″ × 3′ 11″ (thread only) × 6′ (with viewing sphere).* While Sperber's works make use of the traditional craft material of thread, they also resemble the grid of uniformly colored squares called pixels that make up digital images.

among Chinese and Koreans, some of the highest forms of art have included materials that Westerners traditionally designated as second class, including metal, silk, and clay.

Another problem with this distinction is that it *helped reinforce the notion that women's work was inferior to men's.* During the Renaissance, most women were shut out of opportunities to create fine art (see Chapter 2). Craft techniques (such as needlework) were the primary artistic options available to many women. As society relegated works in craft to a second-class status, so too was the art of women. While some women, such as daughters of artists, were able to work around traditional gender roles, they were the exception.

Today, artists are challenging such traditional distinctions between craft and fine art. New York–based artist Devorah Sperber, for example, takes paintings considered great works from Western civilization and reproduces them upside down, using different colored spools of thread. Her work disputes the notion that a traditional craft material such as thread (typically used by women) cannot be used to produce superior works. Sperber places a plastic sphere in front of her arrangements to consolidate the spools into a more recognizable image and turn the image upright. In Figure 11.6, Sperber reproduced what many would consider the greatest painting in art, the *Mona Lisa.*

*Quick Review 11.1*: How did the distinction arise between crafts and the fine arts during the Renaissance?

## Utility versus Appearance

Traditionally, another way to distinguish craft from fine art was by *utility, since many crafts were used in everyday life.* For example, long before Maria made her first black-on-black pot, she fashioned vessels for cooking and cleaning. A number of objects labeled as "craft" were practical. Artisans did not sign these common, everyday works, and often, over time, people forgot the makers' names.

However, defining craft by utility is also problematic. For example, when Maria formed her black-on-black pots, she intended for them to be displayed based on their appearance rather than to be used. Also, like objects traditionally labeled "fine art," Maria signed her black-on-black pots. Should we then consider some of the pots that Maria fashioned craft and others fine art?

**artists**
MATTER

Peter
Voulkos

**Peter Voulkos,** a twentieth-century Montana-born ceramicist, also challenged the idea of defining craft by utility. Originally a painter, Voulkos believed that art was a means for expression. When he became a potter, he found easily shaped clay ideal for expressing emotions. Voulkos applied ideas from painting to clay. Rather than fashion a functional vessel, Voulkos purposely made clay pieces unusable by breaking their forms. Figure 11.7 shows a vessel designed for display rather than use. Voulkos's works, lying somewhere between sculptures and pots, defy classification.

*Quick Review 11.2*: Why were useful objects labeled as craft in the past?

## Individuality versus Mass Production

Often, craft objects are created by a *sole artisan* or a few people. Usually, *we don't think of craft as being mass produced in a factory* on an assembly line. For example, Maria built her pots, and Julian worked on finishing steps. Part of the pots' appeal comes from the fact that Maria built each one individually.

However, not all craft is formed solely by individuals. During the Qing Dynasty (which spanned from 1644 to 1912 in China), the demand for Chinese pottery was so great from Middle Eastern and South East Asian markets that potters set up factories to speed production. A single pot could be handled by up to seventy craftsmen, each focused on a sole, small, repetitive task, such as painting a single leaf, before handing the pot off to another artisan. Craftsmen in one of these workshops produced the vase with nine peaches (figure 11.8).

Pots like the one in figure 11.8 raise questions not only about definitions of craft, but also about how such pots fit into our concept of art. To examine why this is so, see *Practice Art Matters 11.1: Consider Whether Mass-Produced Pots Are Art.*

*Quick Review 11.3*: Why have people traditionally thought of craft as being formed by just a few individuals?

FIGURE 11.7. **Peter Voulkos. *Bucci.* 2000.** *Wood-fired stoneware, 3′ 4″ × 2′ 6 ½″ × 2′ 3″. Palm Springs Art Museum, California.* Voulkos slashed this clay vessel, so that it was no longer usable. However, he maintained the form of a traditional vase (see figure 11.8).

FIGURE 11.8. **Vase with nine peaches.** *From China. Qing Dynasty, 1736–95. Porcelain painted with colored enamels over transparent glaze, height 20″, diameter 16″. The Metropolitan Museum of Art, New York.* The process of mass production in China led to tremendous uniformity in pottery. This vase in the Metropolitan Museum of Art is just like others in the Asian Art Museum in San Francisco and the Indianapolis Museum of Art in Indiana.

## 11.1 Consider Whether Mass-Produced Pots Are Art

The way craftsmen produced the vase with nine peaches (figure 11.8) challenges what many of us think about the nature of artists and art. Consider these questions:

- If a person in a factory is responsible for painting a single leaf on a pot, is he or she an artist? Why or why not?

- If a work is mass-produced, is it art? Why or why not?
- How is the pot in figure 11.8 similar to other works formed in multiples, such as prints, photos, films, and cast sculptures?
- Does comparing this work to other works produced in multiples affect your answer regarding whether this work is art? Why or why not?

### Handmade Feel versus Perfection

When most people think of craft, they are reminded of objects that have a *handmade feel*. Another way in which craft has been distinguished from fine art is as works that look rustic. In many ways, we see a certain roughness as giving an object character.

**artists**
MATTER

Faith
Ringgold

Faith Ringgold, a contemporary American artist, used this association of craft and roughness in creating *Tar Beach* (figure 11.9). The handmade feel of the quilt—such as in the brightly colored and patterned fabrics pieced together—is reminiscent of bedcovers, fashioned by women in past centuries.

However, not all craft looks handmade. Maria's pots, for example, were perfectly proportioned and symmetrical. Additionally, some fine art looks handmade. In fact, we could classify Ringgold's work as fine art that just appears rustic. The work hangs on a wall (rather than being spread out on a bed) and depicts a narrative scene, similar to a representational painting.

*Quick Review 11.4*: How was a handmade feel used in the past to differentiate craft?

### Reflections of Societies versus Lone Visions

How much a work *reflects the culture in which it was created* is another way in which craft has been distinguished from fine art. Even though Maria and Julian figured out the technique of black-on-black pottery, they still drew on a shared pottery-making tradition that had been passed down to them.

Another example illustrates how the village of Hamburg in South Africa came together around a work, drawing on past traditions. Carol Hofmeyr and Noseti Makubalo planned the *Keiskamma* (KIES-kah-mah) *Altarpiece* (figure 11.10) in 2005 in reaction to the AIDS epidemic. At the time they started the work, the deadly disease had infected more than one-third of Hamburg's villagers. The work connected suffering people to those depicted on the altarpiece.

The altarpiece drew on the craft-making tradition in the community and furnished a sense of communal pride, a means of expression, and a source of employment. The project commissioned 120 village women to stitch and construct the altarpiece, which is made up of needlework, appliqué, beadwork, and photos.

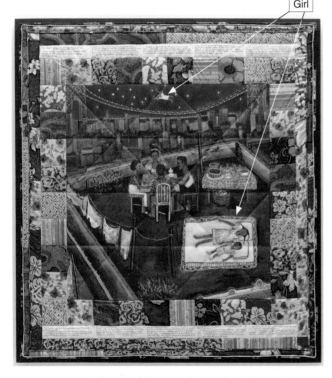

Girl

**FIGURE 11.9. Faith Ringgold.** *Tar Beach. Part I from the series "Woman on a Bridge." 1988. Acrylic on canvas, bordered with printed, painted, quilted, and pieced cloth. 6′ 2 ⅜″ × 5′ 8 ½″. Solomon R. Guggenheim Museum, New York.* The scene in this quilt seems like a painting. The work displays the story of a girl from Harlem, New York, in the 1930s. Her family spent summer evenings on the roof, where the girl would dream of flying and controlling her world, which in reality was marked by discrimination. We see the same girl lying on the blanket and flying in the sky.

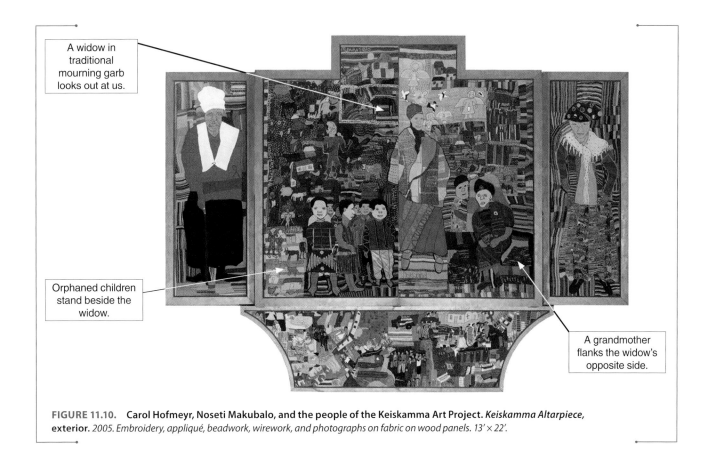

A widow in traditional mourning garb looks out at us.

Orphaned children stand beside the widow.

A grandmother flanks the widow's opposite side.

**FIGURE 11.10.** **Carol Hofmeyr, Noseti Makubalo, and the people of the Keiskamma Art Project.** *Keiskamma Altarpiece,* **exterior.** *2005. Embroidery, appliqué, beadwork, wirework, and photographs on fabric on wood panels. 13′ × 22′.*

However, not all works that have typically been labeled "craft" are reflective of the society in which they were made. When Peter Voulkos formed his slashed vessels (figure 11.7), he opposed traditions by working toward a new method of expression in clay and breaking with other artists' views on pottery's role in society.

As we have seen, craft is difficult to define, and each traditional definition has problems. For example, the *Keiskamma Altarpiece* fits the description of craft as a reflection of society, but it does not necessarily fit into other definitions (see *Practice Art Matters 11.2: Explore How a Work Challenges Definitions of Craft*).

Interactive Image
Walkthrough

*Quick Review 11.5*: How have craft works reflected the cultures in which they were created?

*Practice* **art**MATTERS

## 11.2  Explore How a Work Challenges Definitions of Craft

Reconsider the *Keiskamma Altarpiece* (figure 11.10). Even though it was made with traditional craft media and techniques and is reflective of the society in which it was created, the work also meets criteria of fine art. The altarpiece was modeled after the *Isenheim Altarpiece* (see figure 4.14) painted by Matthias Grünewald, a German artist, in 1515. Grünewald also designed the *Isenheim Altarpiece* as a response to a disease (St. Anthony's fire). Consider these questions about the *Keiskamma Altarpiece*:

- Does the *Keiskamma Altarpiece* look like a painting?
- Does it have a message?
- Is it designed for display or function?
- How many artisans worked on it?
- Why is it a good example of how a work can challenge the traditional definitions of craft?

# Media Traditionally Associated with Craft

The media that traditionally have been associated with craft include clay, glass, metal, wood, and fiber. Some of these media also traditionally have been used in fine art, which further complicates the definition of craft. For these media, we will consider only works that are utilitarian or those made with traditional craft techniques. Artists can use a number of methods to form works from *clay, glass, metal, wood,* and *fiber.*

## Clay

All fired clay pieces, called **ceramics**, are derived from *clay bodies*, which are combinations of various ingredients. Once these ingredients are mixed, potters *form, finish,* and *fire* their clay works.

### Clay Bodies

**Clay bodies** consist of clay and other ingredients added to improve the clay's plasticity and firing properties. When wet, all clay bodies are sticky, mud-like, and malleable. They become stiff when air dried, and hard and permanent when fired. However, different clay bodies have various characteristics, because the mixtures have different-sized particles, strengths, colors, and plasticities. The different properties also require different firing temperatures, anywhere from about 1,200 to 2,700 degrees Fahrenheit. These varying levels of heat lead to additional differences in the final ceramic **pottery**, the fired clay vessels.

There are three basic clay bodies:

- **Earthenware** is made from *common, coarse, reddish-brown clay* and is often used for flowerpots and bricks. Earthenware is fired at a relatively low temperature, so when the pottery emerges from the fire it is porous, not very hard, and easily chipped.
- **Stoneware** is made from a *brownish-gray clay* and is often used for dinner plates. It is fired at a high temperature, and the fired clay can hold liquid. Stoneware is hard and not easily broken.
- **Porcelain** is made from *rare, white clay*; it is highly prized, smooth, and used for fine dinnerware. It is fired at a high temperature and is nonporous. When it emerges from the fire, it has a translucent, glass-like, glossy appearance and is quite hard and strong. Because people from China discovered porcelain, we still call fine ceramics "china."

### Forming Clay Works

Once they have picked a clay body, potters can use different methods to form clay vessels. These include *coiling, pinching, slab building,* and *wheel throwing* (table 11.1).

| TABLE 11.1: | Methods for Forming Clay Works. |
|---|---|
| **Method** | **Description** |
| Coiling | Walls are built up with spiraling ropes of clay. |
| Pinching | Walls are pressed out from an impression in a ball of clay. |
| Slab building | Walls are created from rolled-out, flat sheets of clay. |
| Wheel throwing | Walls are raised by shaping clay on a revolving disk. |

**Coiling** is the method Maria used to create symmetrical pots. To form a vessel with coiling, the potter builds up walls by placing rope-like pieces of clay one on top of another in spirals around a hollow core (figure 11.11).

A second, simple yet expressive method that potters use to form vessels is **pinching**. With pinching, the potter pushes out walls from a hole in a ball of clay (figure 11.12).

---

**ceramics** Clay pieces that have been fired in a kiln

**clay body** A mixture that includes one or more types of clay along with other ingredients specifically formulated to improve the plasticity and firing properties of the clay

**pottery** Fired clay vessels

**earthenware** A type of clay body, made from a reddish-brown clay and fired at relatively low temperatures, that is porous and easily chipped after firing

**stoneware** A type of clay body, made from a brownish-gray clay and fired at relatively high temperatures, that is nonporous and hard after firing

**porcelain** A type of clay body, made from a white clay called kaolin and fired at relatively high temperatures, that is nonporous, hard, translucent, and glossy after firing

**coiling** A method of forming a clay pot in which the potter builds up walls by placing rope-like pieces of clay one on top of another in spirals around a hollow core

**pinching** A method of forming a clay pot in which the potter builds up walls by making an indentation in the center of a clay ball and then pressing and squeezing the clay up and outward

FIGURE 11.11.   Coiling a clay pot.

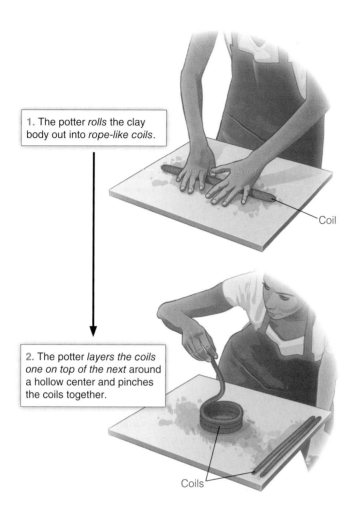

1. The potter *rolls* the clay body out into *rope-like coils*.

Coil

2. The potter *layers the coils one on top of the next* around a hollow center and pinches the coils together.

Coils

FIGURE 11.12.
Pinching a clay pot.

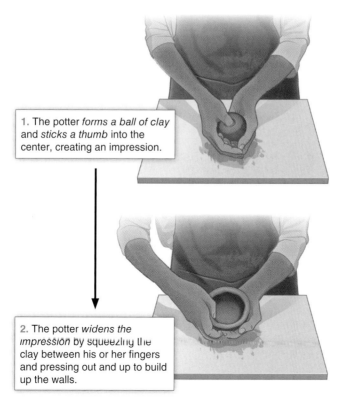

1. The potter *forms a ball of clay* and *sticks a thumb* into the center, creating an impression.

2. The potter *widens the impression* by squeezing the clay between his or her fingers and pressing out and up to build up the walls.

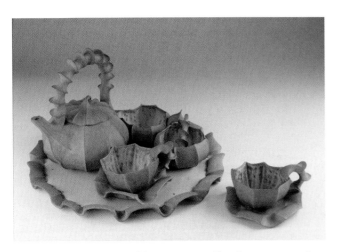

**FIGURE 11.13. Barbara Walch. Tea set.** *2001. Glazed stoneware, tray diameter 14 ½", teapot height 8", creamer diameter 4", sugar bowl diameter 4", cups each diameter 3 ½", saucers each diameter 5 ½", and sugar spoon length 4 ½". Smithsonian American Art Museum, Washington, DC.* The earthy color of the set and pumpkin form of the teapot seem to add to the autumn motif.

**slab building** A method of forming a clay object in which the artist builds a structure by creating flat sheets of clay and then assembling the sheets together

**wheel throwing** A method of forming a clay pot in which the potter raises walls by making an indentation in the center of a mound of clay placed on a revolving disk and then puts pressure on both the inside and outside of the pot simultaneously

▷

Slab Construction & Wheel Throwing

Contemporary Maine-based potter Barbara Walch used pinching to shape the tea set in figure 11.13. Squeezing the malleable clay between her fingers, she created dynamic, rippling forms, perhaps suggestive of leaves fluttering down from a tree on a fall day.

A third method of forming pottery is **slab building**, also called slab construction, which is useful when creating works that have straight sides or angles. With slab building, the artist builds a structure by forming flat sheets of clay and assembling them together (figure 11.14).

Lidya Buzio, a ceramicist born in Uruguay, made her vessels from slabs, such as one from 2012 (figure 11.15). She let the slabs dry partially and stiffen, so they had more strength, cut them into geometric shapes, and assembled them into vessels.

A fourth method that artists use to form a pot is **wheel throwing**. While people have been hand-forming pots for approximately thirty thousand years, they invented wheel

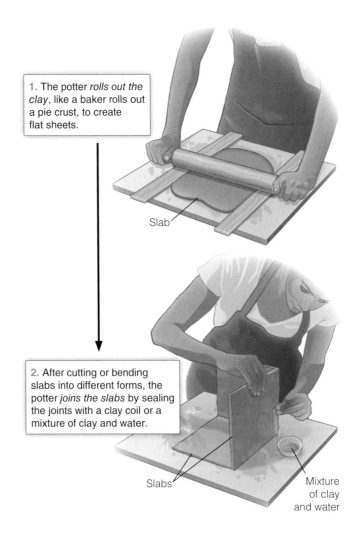

1. The potter *rolls out the clay*, like a baker rolls out a pie crust, to create flat sheets.

Slab

2. After cutting or bending slabs into different forms, the potter *joins the slabs* by sealing the joints with a clay coil or a mixture of clay and water.

Slabs

Mixture of clay and water

**FIGURE 11.14.
Slab building with clay.**

throwing only about six thousand years ago in the Middle East. With wheel throwing, the potter shapes clay on a flat revolving disk called a potter's wheel (figure 11.16). The wheel may be powered by a motor or turned by the potter through kicking a flywheel, which is attached to the disk by a shaft. Because the disk turns quickly, centrifugal force helps the potter rapidly shape round, uniform pots.

Hawaiian-born Toshiko Takaezu (toe-SHEE-koh tah-kah-YAY-zoo) threw her large-scale *Untitled Form* (figure 11.17) from 1993 on a wheel. The perfectly symmetrical work has round, repeating ridges around the base created by the artist's fingers as the work spun. However, even though this evidence of the wheel exists, the work is anything but uniform. Takaezu closed the top of the vessel, so it cannot be used. Like Voulkos's *Bucci* (figure 11.7), Takaezu's form is a work of expression rather than a utilitarian object.

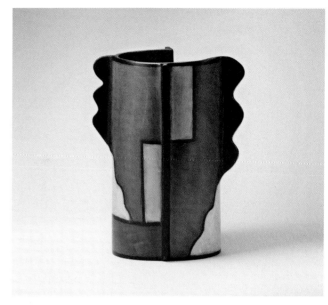

**FIGURE 11.15.** **Lidya Buzio.** *IX.* *2012. Earthenware, 9½" × 7½" × 6".* The slabs form the thin base for a pattern of colored forms and the black "wings" that jut straight out from the sides.

**FIGURE 11.16.** **Throwing a clay pot on a potter's wheel.**

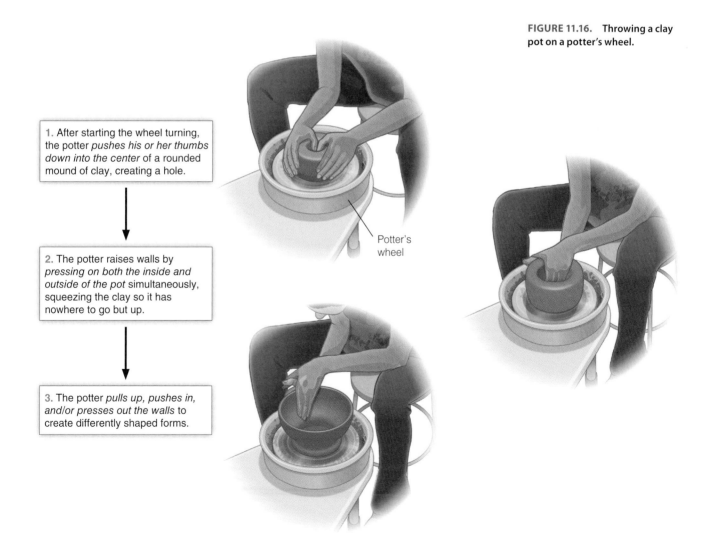

1. After starting the wheel turning, the potter *pushes his or her thumbs down into the center* of a rounded mound of clay, creating a hole.

2. The potter raises walls by *pressing on both the inside and outside of the pot* simultaneously, squeezing the clay so it has nowhere to go but up.

3. The potter *pulls up, pushes in, and/or presses out the walls* to create differently shaped forms.

Potter's wheel

## Finishing and Firing Clay Works

Once a work is formed, artists can finish surfaces of clay pieces to change or enhance the expression. The most common techniques include applying:

- A **glaze**, a mixture of finely ground minerals and water: When fired, glazes transform into glass-like surfaces that fuse to the clay and are nonporous. Glazes can also dramatically alter the surface appearance of a work. After firing, glazes can be translucent or opaque; shiny or dull; deeply colored or colorless; or rough or smooth. For example, Takaezu (figure 11.17) produced a misty, organic-looking design with glazes.
- A **slip**, a mixture of clay and water: Because different clays have different colors and properties, slips can change the appearance of a surface. For example, Julian finished Maria's pots with slip that had a matte finish, so it stood out from the shiny background.
- A *texture*: Textures can be added when the clay is soft (by pressing it with fingers or other objects) or after it has air-dried (by scratching or carving). For example, Takaezu formed ridges on her work as she threw her piece.

The final step in creating a ceramic piece is firing. Firing changes the clay chemically, so that the soft material becomes irreversibly hard and permanent. Potters can bake clay works in a fire, like Maria and Julian used, or in pits, caves, or high-temperature ovens called **kilns**. The amount of heat, the length of heating time, and whether a piece is smothered (as Maria and Julian did) can alter how the final work will look.

*Quick Review 11.6*: What are the different techniques for forming and finishing clay works?

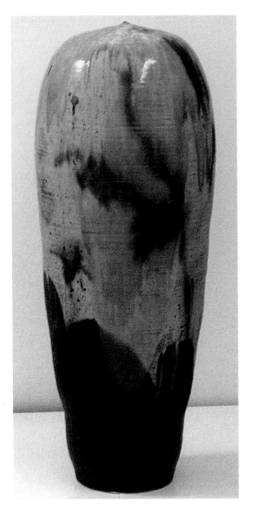

**FIGURE 11.17.** Toshiko Takaezu. *Untitled Form.* 1993. Stoneware, height 3' 5 ½", diameter 1' 4". Currier Museum of Art, Manchester, New Hampshire. The enormous size of this work, at almost three and a half feet tall, displays Takaezu's mastery of wheel throwing.

**glaze** In ceramics, a finely ground mixture of minerals and water that vitrifies into a glass-like surface when fired, used to decorate and seal a work in clay

**slip** A mixture of clay and water used to decorate, cast, or join pieces of clay

**kiln** An oven that reaches temperatures of 1,200 to 2,700 degrees Fahrenheit, used for firing ceramics

**glassblowing** The process of blowing air through a tube into molten glass to form glass objects

## Glass

People have been making glass for approximately five thousand years. Glass is made from a mixture of materials, the most important of which is silica, commonly found in sand. The other materials determine the color, translucency, strength, and melting point of the glass.

Glass is solid and fragile at room temperature, but when heated to a molten state can be poured, stretched, and shaped. Glass does not change chemically when heated, so it can continually be reheated after cooling to be shaped further. Glass can be formed into objects using either *hot* or *cold techniques*.

### Hot Glass Techniques

Hot glass can be shaped in numerous ways. It can be:

- *Cast* in a mold
- *Pulled into threads* and wrapped around wires or shaped cores to form beads or vessels
- *Bent, melted, or fused* to other pieces of glass
- *Blown* to create hollow forms

This last technique, known as glassblowing, was invented by the ancient Romans approximately two thousand years ago. With **glassblowing**, an artist blows air through a tube into molten glass to form glass objects (figure 11.18).

FIGURE 11.18.   Glassblowing.

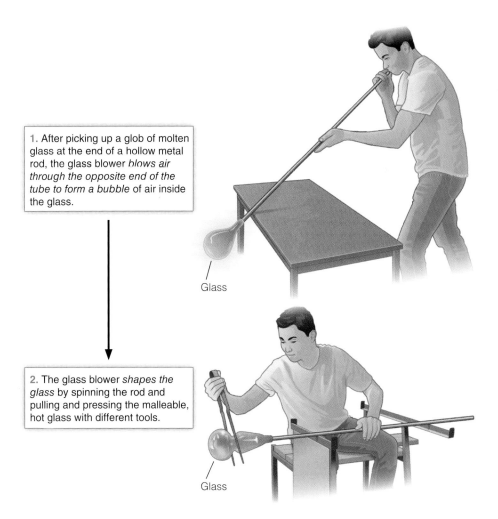

1. After picking up a glob of molten glass at the end of a hollow metal rod, the glass blower *blows air through the opposite end of the tube to form a bubble* of air inside the glass.

Glass

2. The glass blower *shapes the glass* by spinning the rod and pulling and pressing the malleable, hot glass with different tools.

Glass

Dale Chihuly, a multi-media artist known for his iconic glass sculptures, designed the *Three Graces Tower* (figure 11.19A) from blown glass. The *Tower* was one of twenty installations placed throughout the Atlanta Botanical Garden in 2016. All works contained multiple, organically shaped, colored glass forms, each individually blown. The detail of the *Tower* (figure 11.19B) gives an indication of the importance of light in glass and the brilliant, glowing nature of the medium.

**artists**
MATTER

Dale
Chihuly

## Cold Glass Techniques

Cold glass can also be worked in numerous ways. For example, it can be:

- *Cut* into smaller pieces with a diamond-tipped cutter or with a hot iron or steel cutter
- *Drilled* to form holes
- *Sandblasted* to form texture
- *Etched* with acid to frost
- *Engraved* to cut designs
- *Painted* to add decoration

Contemporary American artist Sidney Hutter formed the object in figure 11.20 from cold glass by scoring and using pressure to split apart a large piece of glass and then attaching the smaller pieces of glass together with adhesive. Assembling the layers to resemble

**FIGURE 11.19A AND B (DETAIL).**
**Dale Chihuly.** *Three Graces Tower.* *2016. 7' × 8' × 8'. Atlanta Botanical Garden, Georgia.* The tower of glass (11.19A) was installed above a fountain. The detail (11.19B) shows the variety of translucency, color, structure, and texture possible with glass.

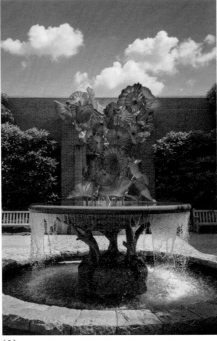

(A)

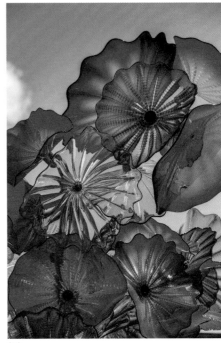

(B)

the form of a vase, Hutter created a nonfunctional work that counters traditional notions of craft as a utilitarian object.

Some artists have created glass designs digitally. When Gerhard Richter (GAIR-haht REEK-tah) planned the stained-glass window (figure 11.21) for the Cologne Cathedral, he used a computer to generate the arrangement of the 11,500 glass squares made from seventy-two different colors of cut, cold glass. Considering past associations of stained-glass windows as purveyors of a godly light into a holy space, perhaps the German artist hoped to symbolize the presence of a heavenly spirit even in our chaotic, seemingly unordered world.

**FIGURE 11.20. Sidney Hutter. Middy polished plate glass vase.** *2014. Polished and laminated glass, 12" × 6" × 6".* By adding dyes and pigments to his adhesive, Hutter introduces color into his works.

**FIGURE 11.21. Gerhard Richter. Window, detail.** *From the south transept of Cologne Cathedral, Germany. 2007. Stained glass, height 72'.* The detail in this image does not give a sense of the vast size of the entire window, which reaches to a height of seventy-two feet.

## Metal

Metal is a strong and durable material, although it is susceptible to rust. Artists may pick from different metals that vary in hardness, luster, and color. Metal can be *cast, worked cold,* and *worked hot.*

### Casting

Casting is one method of shaping metal. As described in Chapter 10, in casting, an artist *creates a model in a soft material and uses a mold to replicate the model exactly in a permanent material.* The two earrings from ancient Greece in figure 11.22 were cast in gold using the lost wax method (see figure 10.27). They were made this way to be hollow, undoubtedly, so that they would not be too heavy to wear. Both earrings repeat the same myth in which the god Zeus takes the form of an eagle.

If we didn't know the size of the earrings or their function, they could be mistaken for sculptures. However, the artist designed them as earrings, so that as their owner wore them, they would travel through space, reflecting the myth.

### Cold Working

Many metals are relatively malleable and soft enough to be shaped at room temperature. The metalsmith periodically heats and then submerges the metal in water to cool it, and, *with the temperature of the metal lowered, uses tools to bend the metal* into the desired form. This technique is known as cold working.

Silver can be worked cold. For example, silversmiths create the basic form of containers using raising and sinking. With **raising**, they hammer a silver sheet inward, bending it around a stake to raise walls. Then, with **sinking**, they work from the opposite side, hammering the metal outward against a piece of wood or a sandbag, stretching the silver

**raising** The process of hammering a metal sheet inward around a stake to form the walls of a vessel

**sinking** The process of hammering a metal sheet outward against a piece of wood or a sandbag to shape the form of a vessel

The god Zeus has assumed the form of an eagle. The cast metal captures the details of every feather on the wings that would have been intricately formed on the original model.

Zeus abducts the handsome mortal prince Ganymede to make him the cupbearer for the gods. The surface of Ganymede's body would have been smoothed on the original model.

**FIGURE 11.22.** *Ganymede Earrings. From Greece. c. 330–300 BCE. Hollow-cast gold, height 2⅜". The Metropolitan Museum of Art, New York.*

into a final form. Elizabeth Godfrey shaped the pair of George II tea caddies (figure 11.23) using raising and sinking.

Afterward, Godfrey decorated the caddies. She gently tapped a hammer on the inside to raise an ornate surface design of scrolls, leaves, and scenes of Chinese harvesters. Then, she refined details by incising, chiseling, and hammering on the exterior.

In England, in the eighteenth century, when Godfrey fashioned these pieces, tea was an expensive and exotic Chinese import brewed by the lady of the house. These caddies held the dried tea leaves, and women used them with other decorated items such as a creamer, sugar, and teapot.

## Hot Working

Iron and steel are such hard metals that to make complex or deeply indented forms or to shape thick pieces, the metals must be worked while hot and, thereby, softened. The black-smith *hammers the metal on a heavy iron block to shape a piece or draw out, bend, or twist it, heating the metal when necessary.* In the sixteenth century, Jacob Halder created the armor in figure 11.24, using the blacksmithing method. During this period, knights were fitted in iron or steel plates that covered their bodies from head to toe.

Halder also decorated the armor, producing a two-toned pattern. First, he heated the steel to such a high point that its color changed to blue. Then, he applied a heated mixture of gold and mercury to the steel, vaporizing the mercury and leaving the gold fused to the surface.

FIGURE 11.23.   **Elizabeth Godfrey. Pair of George II tea caddies.** *1755. Silver, 5 ¾″ × 4 ⅜″ × 3 ⅜″ and 5 ½″ × 4 ¼″ × 2 ⅞″. National Museum of Women in the Arts, Washington, DC.* The expensive and shimmering silver material reflects the esteemed position and luxurious nature of the tea service in eighteenth-century England.

FIGURE 11.24.   **Jacob Halder. Armor of George Clifford, Third Earl of Cumberland.** *c. 1586. Steel, gold, leather, and textile, height 5′ 9 ½″. The Metropolitan Museum of Art, New York.* Halder fashioned this armor to be worn in a tournament held in recognition of the anniversary of the coronation of Elizabeth I, queen of England.

*Quick Review 11.8*: What are the similarities and differences in cold-working and hot-working metal-shaping techniques?

## Wood

Wood differs from the other materials discussed so far in this chapter in that wood comes from trees that were once alive, which leads to several unique characteristics:

- *Limitations in sizes*, so works must be pieced together due to the dimensions of the original tree
- *Growth that is visible* in the wood's grain, rings, and knots
- A *warm, fibrous, and organic quality*

**FIGURE 11.25.** **Prow from a war canoe.** *From North Auckland, New Zealand. Maori. Eighteenth century. Wood, 3′ 8″ wide. The British Museum, London.* The intricately worked surface of the prow is carved on both sides and contains numerous piercings.

Wood is widely available and comes in many types. Different woods vary in color, value, hardness, density, and texture. While wood is sturdy, it is susceptible to rot, warping, cracking, and insect damage. Wood can be worked with *carving* or *bending*.

*Carving* is a popular method of working wood for craft. To carve an object, artists cut away unwanted areas with tools, such as chisels, gouges, axes, saws, or power tools, in the same way that sculptures are carved (see Chapter 10).

Figure 11.25 illustrates a wooden war canoe prow from the eighteenth century formed by a Maori carver. The Maori, indigenous people from New Zealand, tied prows to the front of canoes that could stretch as long as sixty feet and hold up to 140 warriors. The Maori viewed the prows as spiritual and sacred objects. The fact that they attached such respected, carved objects to their canoes indicates the importance that these boats held in Maori society.

Another method of working wood is **bending**, which has been used to form furniture. Up until the nineteenth century, craftsmen carved and joined parts of chairs, cabinets, and tables. However, in 1841, German-born Michael Thonet (TON-et) patented a new technique. By exposing wood to steam, so that it became pliable, he bent straight, solid rods into curved forms. *Bent wood is stronger than carved wood*, because the grain follows the curve, and is *cheaper and faster to produce*, because there is less wasted wood and a skilled carver is not required. While Thonet produced a variety of pieces, *Chair No. 14* (figure 11.26) was his most successful chair. By 1867, he had figured out how to create it from just six pieces of bent wood, ten screws, and a caned seat.

**bending** A method of forming wood furniture in which straight wooden rods are exposed to steam so that they become pliable and can be bent into curved forms

**FIGURE 11.26.** **Michael Thonet.** *Chair No. 14.* 1881. *Manufactured by Gebrüder Thonet. Beechwood and cane, 3′ ⅝″ × 1′ 4 ¹⁵⁄₁₆″ × 1′ 6 ¾″. The Museum of Modern Art, New York.* Workers at Thonet's production sites mass-produced these chairs, and by 1930 had created more than fifty million.

*Quick Review 11.9*: Why is wood bending a useful technique?

## Fiber

**Fibers** are threadlike strands. The strands may come from *vegetable, animal,* or *synthetic* sources. For example, linen threads come from flax plants, wool yarn comes from sheep, and nylon threads are human made. The source affects the appearance, texture, and flexibility of the strands. Strands may also be dyed to add color. People have been creating objects from fiber for over twenty-five thousand years. Fiber is widely available, yet not particularly durable.

**fiber** A threadlike strand made from natural or synthetic sources

There are many ways to create works in fiber. One way to distinguish works is whether the design is formed through the process of joining the strands—making the design an integral part of the work—or by using already constructed fabrics that are altered in some way or that have a design applied to them. Designs formed from *weaving, carpet making,* and *basket making* are made through *the process of joining strands,* and patterns produced from *quilting* and *creating surface designs* are made through *using already constructed fabrics* (table 11.2).

**weaving** A method of interlacing vertical and horizontal threads to form a fabric

**warp** In weaving and carpet making, the vertical, lengthwise threads that are held taut

**weft** In weaving and carpet making, the horizontal, widthwise threads that are interlaced

**loom** A structure used in weaving and carpet making that holds the warp threads taut and lifts or depresses select warp threads so that weft threads may be easily interlaced

**tapestry** A textile in which the material is woven on a loom using differently colored threads that create a design or image, making the image an integral part of the material; often hung on walls or used as upholstery

| TABLE 11.2: | Methods for Creating Designs in Fiber. | |
|---|---|---|
| **How Created** | **Method** | **Description** |
| Through joining strands | Weaving | Vertical and horizontal threads are interlaced. |
| | Carpet making | Short strands are tied in knots around vertical threads and locked in place with horizontal threads. |
| | Basket making | Reeds, roots, vines, or grasses are interlaced or coiled. |
| Through already-constructed fabric | Quilting | Previously constructed pieces of cloth are sewn together. |
| | Creating a surface design | Needlework or fluid media is used to alter the surface of a previously constructed piece of cloth. |

## Weaving

With **weaving**, a person constructs fabric using an interlacing pattern of vertical and horizontal threads (figure 11.27). The lengthwise, vertical threads are called the **warp** and the widthwise, horizontal threads are called the **weft**.

While weaving can be done by hand, it is simpler with a loom. A **loom** holds the warp threads taut on a frame. The loom is strung so that rods lift or depress select warp threads, so that the weft thread may be easily passed between the warp threads.

There are many complicated varieties of weaving patterns. One complex form is used to make tapestries. With **tapestries**, weavers use differently colored weft threads to form

**FIGURE 11.27.** Basic weaving.

The weaver *strings weft threads alternately over and under successive warp threads* across an entire row and, then, on the next row, interlaces the weft thread in the opposite direction, reversing the sequence.

Weft threads
Warp threads

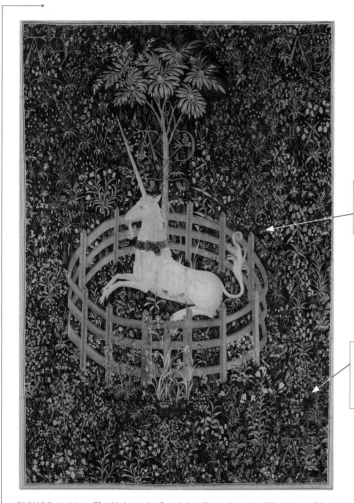

A mythical horse-like, one-horned creature is penned in a fence. The tapestry captures the intricate detail of the animal's collar and the individual curls of its tail.

Surrounding the unicorn are numerous detailed, authentic varieties of plants and flowers. Their many colors, different forms, and close proximity to one another are a testament to the complexity possible in tapestry.

**FIGURE 11.28.** *The Unicorn in Captivity.* From the series "The Hunt of the Unicorn." 1495–1505. Wool warp, wool, silk, silver, and gilt wefts, 12' 1" × 8' 3". The Cloisters Collection, The Metropolitan Museum of Art, New York.

Interactive Image Walkthrough

an intricate design. To begin, weavers place a template drawing or painting behind the warp threads as a guide. Then, they run each colored weft thread across only the portion of the loom where that color is supposed to appear in the final work. Some tapestries have patterns with as many as two thousand colors.

The tapestry in figure 11.28, *The Unicorn in Captivity*, illustrates the incredible richness of color, elaborateness in design, and fineness of thread possible in a tapestry. Little is known about the history of this tapestry, but today it is part of a group of seven tapestries called "The Hunt of the Unicorn." Some of the works were probably woven in honor of the marriage of Anne of Brittany to Louis XII of France in 1499. The unicorn was a popular image that symbolized romance, love, and marriage.

Today, artists can weave using computer-controlled looms, which allow for infinitely intricate patterns. To explore the work of a digital weaver, see *Delve Deeper: Computer-Controlled Looms*.

## Carpet Making

Carpet makers also use a loom to hold warp threads taut and a template to guide the design. However, to create a carpet, carpet makers must *tie a series of knots* out of short strands in addition to interlacing fibers (figure 11.30). The ends of the strands protrude from the base, giving the work depth and what is called a pile surface.

# DELVE DEEPER

## Computer-Controlled Looms

California-based Lia Cook's *Connect To Me* (figure 11.29) shows the complexity possible with a computer-controlled loom. The work is derived from a photograph of the artist, and the lines over the image are meant to represent scans of her brain. The artist is interested in understanding which part of her brain is active when she weaves. Illustrating both the image and lines may be an attempt to show a portrait of herself and her method.

Creating this complex design involved coordination with computer programs:

1. Cook scanned and manipulated a photograph on the computer, added the lines, and selected the weaves to be integrated into the work.

2. The computer program translated each pixel (see Chapter 8) into a single crossing of warp and weft.

3. Another computer program lifted and depressed the warp threads on a loom, following the designed sequence, so that Cook could weave the pattern into a cloth as each vertical thread was controlled independently.

**FIGURE 11.29.** **Lia Cook.** *Connect To Me.* *2016. Cotton and rayon, 6'3" × 4'3".* Cook reworked this image from an old photo of herself; she frequently manipulates family photos in her works, continually documenting parts of her life.

By using differently colored fine threads, carpet makers can create intricate designs. The finest carpets can have two thousand knots per square inch—a true indication of the laborious process required to craft such works.

The design of *The Ardabil Carpet* was made from twenty-five million knots. In the sixteenth century, an Iranian ruler commissioned this carpet as one of a pair. The two were placed in a funerary mosque located in Ardabil, Iran. The intricate design, made from just ten different colors, contains medallions and floral patterns

FIGURE 11.30. Carpet making.

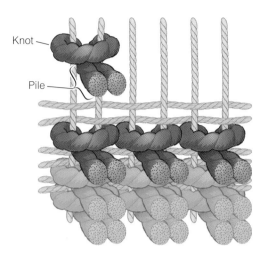

Knot

Pile

The carpet maker *ties knots around pairs of warp threads* across each row and weaves one or more weft threads through the warp to lock the knots in place.

Weft threads
Warp threads

(figure 11.31A). The clarity and intricacy of each element stems from the density of the pile. With so many knots of thread, each blossom could be clearly defined (figure 11.31B).

## Basket Making

Basket makers combine reeds, roots, vines, and/or grasses by hand (without a loom) to form containers. Basket makers can either *interlace warp and weft strands*, as is done with weaving, or *sew together coiled rows of ascending spiraling strands*, similar to the method that Maria used to coil pots. Intricate designs can be created through varying

**(A)**

**FIGURE 11.31A AND B (DETAIL).** *The Ardabil Carpet. From Iran. 1539–40. Wool pile on silk warp and weft, 34′ 5 ¾″ × 17′ 6″. Victoria and Albert Museum, London.* This carpet (11.31A) contains an intricately designed large medallion surrounded by sixteen smaller medallions. Numerous precisely formed flowers also wind through the surface, each created from multiple colors (11.31B).

**(B)**

weaving patterns, using differently colored strands, and adding decorative items such as beads.

The Pomo Native Americans of California formed intricate coiled baskets, some of which had as many as sixty stitches per inch. Basket makers used their baskets for their whole lives. When basket makers died, they were cremated with their baskets, showing their significance. Each design, such as the one in figure 11.32 from the late nineteenth century, was highly personal and held symbolic meaning.

### Quilting

Quilts are made by *sewing together previously constructed pieces of cloth*. Quilters cut out fabric in shapes and either piece them together or attach them to a backing. The shape, color, value, texture, size, and arrangement of the original pieces of cloth as well as the stitching form a new overall design.

The women of Gee's Bend, Alabama, have been creating quilts for generations—usually out of old, worn-out clothing and sheets. The women, mostly descendants of slaves, have fashioned the quilts to use as blankets.

**artists**
MATTER

Jessie
Pettway

A quilt from the 1950s (figure 11.33) by Jessie Pettway shows, however, the quilts also have an improvisational, vibrant design unlike traditional, ordered quilts that are commonly found in people's homes. Similarities to the quilts are more easily found in the works of Modern painters (such as Stuart Davis; see figure 4.8). Each quilter individually designs, cuts, and arranges her own pattern, creating a personally meaningful style.

Pettway's quilt was displayed between 2002 and 2006 as part of an exhibition organized by the Museum of Fine Arts, Houston, which traveled to other museums. The quilt

**FIGURE 11.32.** **Feathered basket.** *Pomo. c. 1877. Willow, bulrush, fern, feather, shells, and glass beads, height 5 ½", diameter 12". Philbrook Museum of Art, Tulsa, Oklahoma.* This basket contains not only differently colored coiled strands, but also feathers, shells, and beads.

**FIGURE 11.33.** **Jessie Pettway.** *Bars and String-Piece Columns. 1950s. Cotton, 7' 11" × 6' 4".* Pettway's quilt features bold geometric shapes, which rhythmically dance up and down in three wavy columns.

demonstrates how a utilitarian object made from the traditional craft medium of fiber can also be considered a work of art.

## Creating Works with a Surface Design

Once constructed, fabrics can also be designed in different ways by altering the surface. Artists can:

- *Use needlework to create a design on the surface* of a piece of fabric, employing the technique of **embroidery**, by stitching lines, outlining shapes, or blocking in entire areas by filling shapes with stitches
- *Alter the surface of a fabric with a fluid medium*, such as ink or dye, by printing it onto a fabric, applying it with a pen or brush, or placing it in a vat to be dipped and saturated with color

In *Pop-up* (figure 11.34), Nava Lubelski altered a piece of fabric with embroidery and ink. In a juxtaposition of destruction and repair, the contemporary American artist spilled ink on her canvas and cut holes in the surface, then stitched around the stains and over the holes. Like Pettway's quilt, Lubelski's work has more in common with a number of twentieth-century paintings such as those of Hilma af Klint (see figure 3.16) than with traditional needlework. However, while the image takes on the amorphous shapes of a twentieth-century painting, we are also aware of the meticulous, tiny stitches. These stitches form an actual texture on the surface, creating depth, which contrasts with the stains that soaked into the canvas. The holes additionally contribute a three-dimensional quality to the work, because we can see through them.

*Quick Review 11.10*: How is the technique of weaving accomplished?

**embroidery**  A method of creating a surface design on a piece of fabric using needlework; a work created using this technique

**FIGURE 11.34.**  **Nava Lubelski.** *Pop-up.* 2011. *Thread and fabric on stained canvas, 2′ × 2′ (double layer).*  A hole that allows us to see through the work appears directly to the right of the clustered yellow forms.

## A Look Back at the Pottery of Maria Martinez

The story of the pottery of Maria Martinez illustrates how she and Julian looked to ancient **pottery** to invent a new form—black-on-black pottery—that was highly prized by people outside of the pueblo. The story, though, also offers insights into traditional craft media.

Maria's pottery illustrates *how difficult it is to put craft into a neat category that is separate from fine art*. On the one hand, Maria's pottery has much in common with *fine art*. She intended for the black-on-black pottery to be *displayed* rather than used. She *signed* the pots, proclaiming herself as the artist. In addition, her pottery can be found today in numerous *museums* that display fine art.

On the other hand, Maria's pots fall into the category of *craft*. She used *clay*, one of the five materials traditionally associated with craft, and **coiling**, a technique that is firmly established as a craft method. She also needed *manual dexterity and technical expertise* to form such large, perfectly shaped pots. Further, Maria's pots were never formed in a factory; she *made them herself* with the help of her family. Finally, she *shared her art with her community*, so that eventually black-on-black pottery became associated with the pueblo.

As you move forward from this chapter, consider the role that craft plays in establishing culture. Maria learned pottery making from those in the pueblo who came before her. She shared her technique with her descendants and community. Pottery making was one of many important customs and values that helped define the people in the pueblo, essentially shaping them into who they were. Similarly, the women of Gee's Bend have been making quilts for generations (figure 11.33). Among these women, quilt making is a part of their heritage and traditions that have helped shape who they are. Art is universal. However, crafts also reflect the differences of the people who create them, serving both to *represent and help establish different cultures*.

Flashcards

## CRITICAL THINKING QUESTIONS

1. Why does the vase with nine peaches (figure 11.8) defy being classified as craft in terms of skill and a handmade feel?
2. Today, are there set distinctions as to whether a work of art is craft? Why or why not?
3. If you were trying to make a symmetrical clay pot and did not have access to a wheel, which hand-building technique would you choose and why?
4. If a computer designed the order of squares on the window in the south transept of Cologne Cathedral (figure 11.21), does this make Gerhard Richter any less of an artist than those who make design decisions themselves? Why or why not?
5. In what ways are the Godfrey tea caddies (figure 11.23) and the Walch tea set (figure 11.13) different? Consider how the diverse forms are reflected in the methods and materials used to craft the tea accoutrements.
6. Figure 11.24 shows armor that was worn in honor of the anniversary of the coronation of Elizabeth I, queen of England. Do you have any clothing that you wear that commemorates an event important to you? How do both the armor and your piece of clothing show the importance of art in people's lives?
7. What is the difference between wood carving and bending?
8. Often when Lia Cook's works (figure 11.29) are exhibited, they are hung in the center of the room from the ceiling, so that viewers can see both sides of the work. Why would this be an appropriate way to hang a woven work?
9. The chapter compares Jessie Pettway's *Bars and String-Piece Columns* (figure 11.33) to Stuart Davis's *Swing Landscape* (figure 4.8). How does Pettway's quilt similarly have a lot of variety, but still remain unified?

Comprehension Quiz      Application Quiz

# Architecture

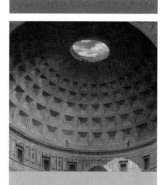

## LEARNING OBJECTIVES

**12.1** Explain why it is important for a building's form to fulfill its function.

**12.2** Summarize why mass and space are key to experiencing a structure.

**12.3** Explain two ways that architects can lessen the impact of a building on the environment.

**12.4** Describe how architecture can be both a collaborative and an individual art form.

**12.5** Distinguish among the various types of forces, materials, and structural systems and explain how they differ.

**12.6** Compare load-bearing and corbel construction methods.

**12.7** Contrast post-and-lintel and cantilever construction methods.

**12.8** Summarize the advantages that a pointed arch has over a round arch.

**12.9** Identify what makes reinforced concrete such a versatile material.

**12.10** Differentiate among types of frame construction.

**12.11** Explain why a bridge must be both suspended from upright supports and anchored on its sides.

**12.12** Describe how architects have created innovative structures and used new materials.

## THE PANTHEON

In the year 117 CE, Hadrian, a multitalented new emperor, rose to rule the Roman Empire. He began a number of building projects to proclaim the greatness of his reign. One of the most important of these structures was the Pantheon (figure 12.1). While the emperor was unlikely to have been the building's architect, he undoubtedly was involved in its design.

How Art Matters

### Entering the Pantheon

The exterior of the building has mostly remained as it was in the second century. However, in ancient times, the *setting* would have been more striking—Romans entered the building through a forecourt and steps led up to the massive porch that hid the rest of the building (figure 12.2). Today, forty-foot *columns* still form the porch, their tops decorated with stylized leaves. These *vertical posts* hold up an entablature, the *horizontal* part of the porch that supports the triangular-shaped pediment.

The columned porch is one that Roman citizens would have found familiar. However, upon entering through the porch, with its imposing *mass*, visitors passed through a rectangular block into one of the most unimaginable and impressive spaces ever conceived—*an expansive space with a round, domed roof* seeming to hover above.

There is no way to appreciate the size of the domed hall from photographs, although an eighteenth-century painting imparts a sense of the vastness (figure 12.3). The cylindrical wall has a 150-foot diameter, and the dome reaches up 150 feet to a circular opening at the top called an oculus—the only light source for the building. Sunken, square panels, called coffers, line the dome.

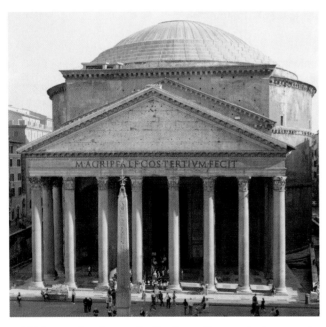

**FIGURE 12.1.** **Pantheon.** *118–125 CE, Rome.* Construction began on the Pantheon a year after Hadrian took power.

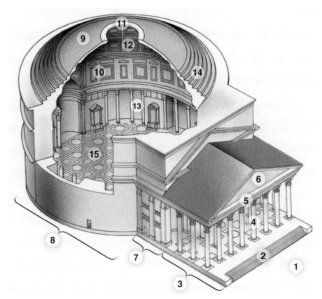

**FIGURE 12.2.** **Reconstruction drawing of the Pantheon with part of the domed hall cut away.** This restored view of the Pantheon shows (1) the forecourt, (2) steps, (3) porch, (4) columns, (5) entablature, (6) pediment, (7) rectangular block, (8) domed hall, (9) dome, (10) cylindrical wall, (11) oculus, (12) coffers, (13) interior niches, (14) stepped rings, and (15) floor.

## Why Doesn't the Dome Fall Down?

The triumph of the Pantheon is this magnificent open space, but how did the Roman builders create such a large space without any supports that would break it up? To stand, all buildings must overcome *forces*, the most basic of which is gravity. The dome weighs five thousand tons (the weight of about a thousand elephants) and spans half the length of a football field. However, *all of the dome's support comes from the circular wall around the edge*; there is no structure directly underneath.

One of the ways that the Romans achieved this gravity-defying feat was by developing *concrete construction*. Unlike wood and stone, which required craftsmen to carve, concrete did not require the same type of skill to lay. To meet structural demands, builders could mix in broken pieces of lighter or heavier rocks, changing the concrete mixture at every level of the building. In addition, concrete could be poured into a mold *to create any form*.

The Romans also made use of creative *structures* to support the dome. To lighten the weight of the wall, the Romans placed niches (open spaces) on its interior and exterior. These openings appear in two architectural drawings that show different views: from above in a plan (figure 12.4A) and from the side in a cross section (figure 12.4B).

Because the wall is not a solid cylinder, it acts like a series of piers on either side of each interior niche. To ensure that the weight from above the niches was transferred out onto the piers, the Romans built *curved structural elements* within the walls (figure 12.5). Some, called *arches*, were shallow in depth, while others were extended into curved ceilings called *vaults*.

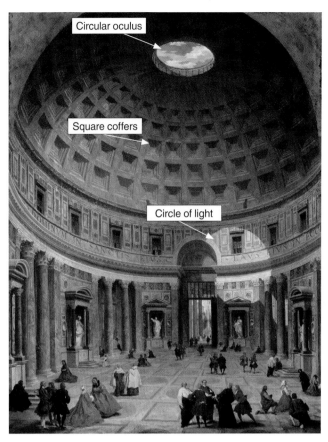

**FIGURE 12.3.** **Giovanni Paolo Panini.** *Interior of the Pantheon, Rome.* *c. 1734. Oil on canvas, 4' 8 ¾" × 3' 9". National Gallery of Art, Washington, DC.* The painting shows the circle of light that travels across the coffers, walls, and floor each day as light streams in from the oculus.

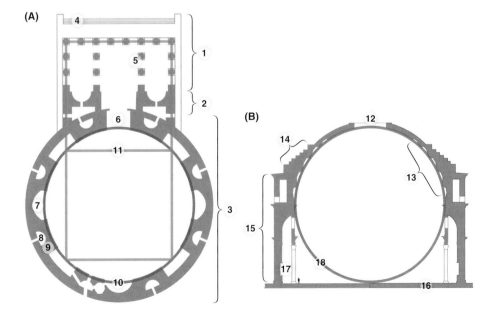

**FIGURE 12.4A (PLAN OF THE BUILDING) AND B (CROSS SECTION OF THE DOMED HALL).** **Architectural drawings of the Pantheon with ideal circles and squares overlaid.** The plan of the Pantheon (12.4A) shows (1) the porch, (2) rectangular block, (3) domed hall, (4) steps, (5) columns, (6) entrance to the domed hall, (7) interior and (8) exterior niches, (9) piers, (10) perfect circle formed by the cylinder, and (11) two perfect squares formed by the porch, rectangular block, and cylinder. The cross section of the domed hall (12.4B) shows (12) the oculus, (13) coffers, (14) stepped rings, (15) cylindrical wall, (16) floor, (17) interior niches, and (18) perfect circle formed by the domed hall.

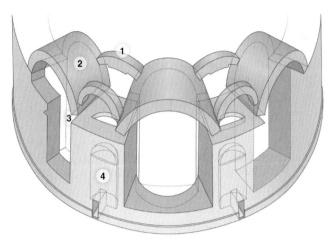

**FIGURE 12.5. Structural drawing showing arches and vaults in the wall of the Pantheon.** The structural drawing of the wall of the Pantheon shows the internal structure, including (1) an arch, (2) vault, (3) interior niche, and (4) exterior niche.

Much like the curved structures in the walls, the dome also acts like a series of arches circling a central axis. The curved form transfers the weight of the dome out to the cylinder.

Many vertical cracks (running from the oculus down to the wall) appear on the concrete dome. We know the cracks appeared shortly after the Pantheon was constructed. The Roman builders must have understood the *forces that would be acting on the dome*, because they added stepped rings (figure 12.4B) outside the dome to stabilize the cracked structure and keep the arched sections from thrusting outward.

## The Purpose and Meaning of the Building

When the builders completed the Pantheon, they dedicated the space to the gods (the word *Pantheon* means "all gods") and filled it with statues of divine figures. Art enabled the Romans to build a structure that had a *form* (or look) that was fittingly awe-inspiring for its *function* as a temple. In fact, the architectural elements likely conveyed a higher meaning:

» The *dome* probably represented the heavens, where the Roman gods resided.
» The *oculus* likely symbolized the sun. Like the real sun, it supplies the light in the building.
» A *circle of light* (visible in figure 12.3), created by the oculus, travels across the building as the position of the real sun changes. This movement probably represented how the real sun appears to forge a path across the sky.

The building was not built solely for religious purposes, however. Hadrian also used the building for a public function. He held court and conducted official business there. As such, the Pantheon's *appearance again fit its function* as the structure likely symbolized his ordered and ideal empire through perfect circles and squares (figure 12.4):

» A perfect circle fits inside the space because the diameter of the cylindrical wall equals the height of the dome
» A perfect circle is visible looking down on the plan
» Two perfect squares fit inside the cylinder and the block and porch

In addition, circles and squares decorate the floor, circular columns are footed by square bases on the porch, and square coffers rise to the circular oculus in the dome (figure 12.2).

Consider the effect the space would have had. Upon entering through the massive porch and block, a visitor would have likely been unprepared for the seemingly miraculous feat of engineering. The numerous statues of deities, the symbolic meaning of the architectural elements, and the ideal forms would have made it seem that Hadrian and his empire were backed by the gods. In this way, Hadrian used the *expressive possibilities of architecture to promote his power.*

## One of the Great Buildings

The Pantheon remains one of the great buildings of all time. Its innovative material, daring structure, and ideal proportions were remarkable engineering feats; a dome of this size was not built again until over twelve hundred years later. The Pantheon was dedicated as a Christian church in the seventh century and, thereby, preserved. It has come down to us from antiquity mostly intact, affording us a rare view of a complete Roman structure.

Studying the Pantheon introduces us to an extraordinary monument, but it also gives us insight into architecture, the art of structural design, and how architects use their designs to send *powerful messages that influence people.* Before moving forward, based on reading this story, how much consideration do you think architects give to a building's purpose before creating a design? How do the structures of buildings differ?

# What Architecture Is

**Architecture**, the art of structural design, affects so much of our lives that many of us may not think of it as an art form. However, architects design all the structures that we see, such as dormitories, football arenas, and churches. The demands placed on architecture are great. Buildings must meet *functional, three-dimensional, environmental, expressive,* and *structural* requirements.

**architecture** The art of structural design

## A Functional Place

All architecture performs some *societal purpose.* The Pantheon was both a temple and a place where Hadrian held court. Unlike other artists who may produce art just for the sake of creating, architects must remember the purpose of a structure.

### The Uses of Buildings

Architects design buildings for numerous uses. Structures can have:

- *Public* functions (such as train stations and government buildings)
- *Private* functions (such as homes and apartments)
- *Commercial* functions (such as stores, offices, and theaters)
- *Religious* functions (such as churches, synagogues, and mosques)

Architecture is also not limited to buildings. Aqueducts, bridges, and tombs are all structures with unique functions.

### Form Following Function

People often evaluate a building's success on how well its *form (how it looks) fulfills its function (how it is used).* It wouldn't be efficient to have a hospital that is made up of large, open spaces. People need privacy, so architects design separate rooms. Conversely, it wouldn't be useful to create an entertainment complex with small, enclosed spaces. Here, a large hall is needed, so many people can gather together.

Similarly, skyscrapers were first designed to maximize the amount of space a building provided for such uses as offices or apartments, while minimizing the land needed for the building's footprint. Skyscrapers' form fit their function in the increasingly crowded cities of the late 1800s, where land was at a premium.

Louis Sullivan's Wainwright Building, built in St. Louis at the end of the nineteenth century, was one of the first skyscrapers. The American architect took the form-following-function consideration even further as the building boasts three levels, each with a different look to address a different use (figure 12.6).

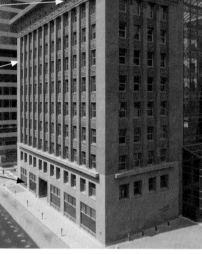

On the top floor, Sullivan hid the building's mechanical systems behind a decorative band.

In the middle, Sullivan stacked floors of offices in an orderly grid with small windows.

At the lowest level, Sullivan located shops behind large windows to show off merchandise.

**FIGURE 12.6.** Louis Sullivan and Dankmar Adler. Wainwright Building. *1890–91, St. Louis, Missouri.*

*Quick Review 12.1*: Why is it important for a building's form to fulfill its function?

## A Three-Dimensional Work

All structures are three-dimensional. A building—like all three-dimensional objects—exists in our world. On the exterior, we primarily consider *mass*. The building, though, also creates an area within its walls, so on the interior, we primarily consider the *negative space*, the empty area within. Today, architects design these masses and spaces using *digital technology*.

### Mass and Space

artists
MATTER

Frank
Gehry

We can walk around buildings, see them from different views, and enter them. Therefore, to appreciate structures fully, we must consider mass and space. The Guggenheim Museum (figure 12.7A) in Bilbao, Spain, designed by Canadian-born American architect Frank Gehry (GER-ree), is an example of an innovative structure that has numerous, fragmented masses. From the outside, various pieces—from sweeping arcs to angled towers to bulging forms—reach out and take up space in different ways. Gehry conceived the building to look like a blooming flower, the curved masses taking on the qualities of opening petals.

The building's interior space is also inventively designed. The museum's galleries include a 450-foot-long space that can accommodate large installations (figure 12.7B). The enormous length of this gallery is three times the diameter of the Pantheon.

### Designing Three-Dimensional Digital Models and Augmenting Reality

Because of the complications involved with constructing such irregular masses and spaces, Gehry scanned traditional architectural drawings into a computer program, which translated the designs into *virtual, three-dimensional, digital models*. Gehry then calculated exact specifications from the models and sent these to manufacturers, ensuring that all parts of the building would fit together when they arrived on site.

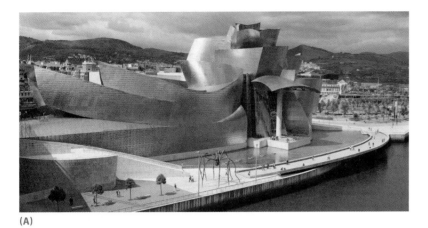

(A)

(B)

**FIGURE 12.7A (EXTERIOR) AND B (INTERIOR SHOWING THE "BOAT" GALLERY).** **Frank Gehry. Guggenheim Museum.** *1991–97, Bilbao, Spain.* On the exterior (12.7A) of the Guggenheim, the mass curves and twists, while on the interior (12.7B), the open space in the "Boat" Gallery is vast.

Today, architects can also use *augmented reality technology* to create holograms of their designs that appear as if they are in real space. The technology uses specialized computerized lenses worn over the eyes through which people see a blended view of the real world with the virtual design, offering a keen sense of what a designed building will look like before it has been constructed. Unlike a design on paper or a physical 3D scale model, the architect and client can:

- *Enter the design* to experience the space of interiors
- *Visualize the size, materials, and lighting of the designed building*
- *Change features of the designed building*, such as sizes of spaces, with a click of the finger

The Serpentine Pavilion, by Mexican Frida Escobedo, was modeled using augmented reality (figure 12.8). Every year, an architect designs the temporary structure, which holds cultural events. The technology allowed for a sense of the space during planning.

**FIGURE 12.8.** **Frida Escobedo. Virtual reality visualization of the Serpentine Pavilion.** *2018.* The virtual design shows the Mexican-inspired, perforated walls that let in light and breezes.

*Quick Review 12.2*: Why are mass and space key to experiencing a structure?

## A Work in an Environment

When designing, architects must consider a *building's setting*. Will the structure be in an urban or rural area near other buildings that have particular styles and sizes? What unique weather conditions might affect the building? Are there local or cultural traditions to be aware of? How will the building *impact the world around it*?

### Setting

Architects must be aware of the *setting* when designing a building. The Ancestral Puebloans, who built Cliff Palace in Mesa Verde (MAY-suh VAIR-day), Colorado, seven to nine hundred years ago, fit their architecture with the environment (figure 12.9). The area featured steep mountains with deep valleys. Building their homes in the valleys would have left the people exposed to bandits, the sun, and wind.

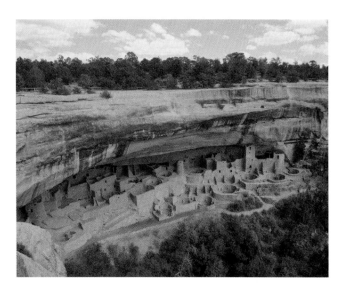

**FIGURE 12.9.** **Cliff Palace.** *Ancestral Puebloan. c. 1100–1300, Mesa Verde, Colorado.* Reaching these homes required the Ancestral Puebloans to build ladders and carve hand and footholds into the rock to make the climb easier.

Instead, the community created sheltered dwellings in a natural ledge of a high plateau. To maximize space on the ledge, they constructed residences with two houses often sharing one exterior wall. Second and third stories were also added, and sacred and communal areas were located underground below the dwellings.

## Sustainable Architecture

Today, some architects are concerned with more than how a building fits into an environment aesthetically and practically. They consider how a building *impacts the environment.* Buildings consume resources and pollute our planet. In the United States, buildings consume approximately 13 percent of the fresh water supply and 40 percent of the energy. In addition, buildings produce 40 percent of the carbon dioxide emissions and two-thirds of the nonindustrial solid waste.[1]

These statistics have led to an interest in creating sustainable structures, also called *green architecture*, that address the needs of people, while respecting the environment around them. Architects can build green structures by *recycling* old buildings and lessening the environmental impact during *new construction.*

### Recycling

One way to lessen the impact of architecture on the environment is to *recycle* old buildings. Italian Gae Aulenti (guy aw-LEN-tee) remodeled an old train station in Paris (figure 12.10A) to create a museum (figure 12.10B) in 1986. Her design retains the grand space of the former building, while adding two new smaller structures to display art. The new structures pick up the historic theme of the building in their resemblance to trains.

### New Construction

Architects can lessen the impact of *new buildings* on the environment, too, as the Pomona College Studio Art Hall (figure 12.11), designed by Thailand-born Kulapat Yantrasast (KOO-la-pot YON-tra-soss), shows. During construction, builders drew 20 percent of supplies from regional sources, shrinking the environmental impact of transporting materials. They used

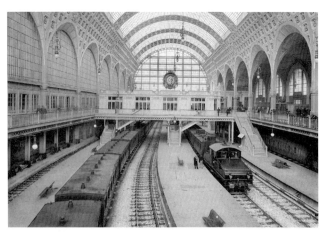

(A)

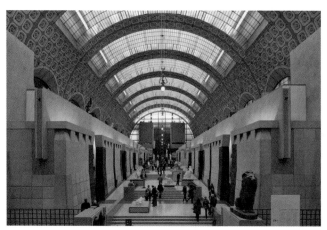

(B)

**FIGURE 12.10A (BEFORE RENOVATION) AND B (AFTER RENOVATION).** **Gae Aulenti. Musée d'Orsay.** *1986, Paris.* By using an old train station (12.10A) to house a museum (12.10B), Aulenti recycled resources.

recycled items for 20 percent of the building materials. The building also boasts rain-collecting basins and a drip-irrigation system that provide water for landscaping.[2]

While the building is a model of sustainable construction, Yantrasast also tried to ensure that it fit into the local environment. He mimicked the natural surroundings in the curving roof, which picks up the bowed form of local mountains.

*Quick Review 12.3*: What are two ways that architects can lessen the impact of a building on the environment?

**FIGURE 12.11.** **Kulapat Yantrasast. Pomona College Studio Art Hall.** *2014, Claremont, California.* Energy efficiencies of the building are visible in the shade-producing overhangs, which reduce the need for air conditioning, and glazed glass walls, which diminish the need for indoor lights.

## A Collaborative and Individual Art Form

Today, it takes *many people*—including engineers, inspectors, excavators, builders, roofers, painters, electricians, plumbers, and landscapers—to build a structure. Given the complex nature of buildings, often more people work on an architectural project than work collaboratively on other art forms. Before the advent of machines, the number of workers could be in the thousands.

However, even though many workers are involved in the process, *an individual architect* (or small group) conceives of the concept for a structure's overall design. This idea guides planning and construction and must be communicated to the people who draft the building's details, build the structure, and inhabit or visit the site. Many architects have a personal style that is reflected in the buildings they design.

### One Architect's Style

Maya Lin displayed her personal, minimal style in her interfaith chapel (figure 12.12A). The contemporary American architect designed the chapel for the grounds of a retreat owned by the Children's Defense Fund. The major structure is in the form of a gently curved boat, reflecting the Fund's motto, "Dear Lord be good to me. The sea is so wide and my boat is so small." Inside the chapel, she used an oculus to admit natural light (figure 12.12B), mimicking the Pantheon.

**artists**
MATTER

Maya Lin

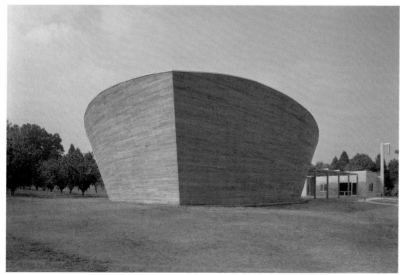

(A)

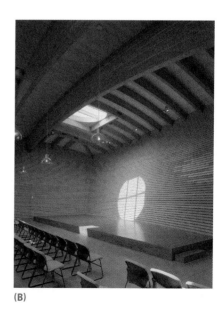

(B)

**FIGURE 12.12A (EXTERIOR) AND B (INTERIOR).** **Maya Lin. Riggio-Lynch Chapel.** *2004, Clinton, Tennessee.* The exterior of the chapel shows Lin's trademark minimal style (12.12A). The oculus brings a circle of moving light into the interior (12.12B).

## A Work of Art

Lin's vision reminds us that structures are *works of art*. Architects have unique goals for their designs. In the Pantheon, for example, the architect's motivation was likely to broadcast Hadrian's power. A building's *expressive statement*—the idea that the architect tries to communicate through the building's design—is driven by many factors, including:

- The building's *function*
- How well the building works with or against its *setting*
- The architect's *personal style*
- The *materials* and *structural systems* used to form the building
- The *visual elements of art* and *principles of design* incorporated in its makeup
- How we as viewers interpret the design

Even when architects seek to convey a similar message, their designs typically differ. Works by Iraqi-born British architect Zaha Hadid (ZAH-hah hah-DEED) and Finnish-born American architect Eero Saarinen (ee-ROH SAH-ree-nen) show their distinct expressions of the idea of flight.

Hadid's Bergisel Ski Jump (figure 12.13) design from 2002 is based on the concept of a coiled spring. The geometric form likely suggests an athlete's dynamic power.

On the other hand, Saarinen's Trans World Airline Terminal (figure 12.14) from 1962 seems to resemble the wings of a gigantic bird. Its sweeping slick curves and symmetrical organic form can make the building feel as if it could soar into the sky, just like the planes on the nearby runways.

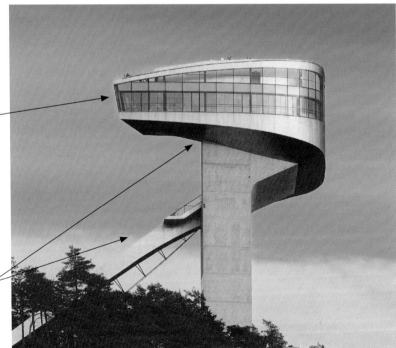

The jump features a café and waiting area for athletes that juts out from its supporting column.

The bold diagonal of the bottom of the café appears to uncoil from the strong diagonal of the opposing ski ramp.

**FIGURE 12.13.** **Zaha Hadid. Bergisel Ski Jump.** *2002, Innsbruck, Austria.*

**FIGURE 12.14.  Eero Saarinen. Trans World Airlines Terminal Building.** *1962, Kennedy Airport, Jamaica, New York.*  Saarinen's organic form is in stark contrast to Hadid's geometric ski jump.

*Quick Review 12.4*: How can architecture be both a collaborative and an individual art form?

## An Art Form Structured to Withstand Forces

Just as the ancient Romans had to keep the Pantheon's dome from falling down, all architects need to ensure that structures stay up under the loads that act upon them. To withstand these *forces*, all buildings use *materials* and *structural systems*.

### Forces

Buildings, bridges, and even ski jumps need to support their own weight and the weight of people and furniture within them. Structures must also withstand weather and earthquakes. These loads and stresses exert two types of forces on structures: *compression* and *tension*.

**Compression** is a squeezing force that pushes down on a structure. Imagine placing a heavy book on a sponge. The sponge would squish under the book's weight. The pushing force that squeezes the fibers of the sponge together is compression. In a building, a column is subject to the pressing force from the weight placed upon it.

**Tension** is a stretching force that pulls a structure apart. Imagine if you attached a set of keys to a rubber band. The rubber band would stretch from the weight. The pulling force that stretches the rubber band apart is tension. In a bridge, the cables are pulled by the weight that is put upon them.

**compression**  The squeezing force that pushes down on a structure

**tension**  The stretching force that pulls apart a structure

### Materials

Buildings can be made from numerous materials. The *strength of those materials is determined by how successfully they resist compressive and tensile forces.* For example:

- *Stone, brick, and concrete* resist compression effectively, but not tension
- *Canvas* resists tension effectively, but not compression
- *Steel, iron, wood, and **reinforced concrete**—*concrete that has been strengthened with embedded metal rods—resist both compression and tension effectively

Throughout history, builders have been limited by the strength of their materials. Over three thousand years ago in the Temple of Amun, Egyptian builders designed a

**reinforced concrete**  A building material composed of concrete that has been strengthened with embedded metal rods

The stone columns resist compression effectively, allowing them to be tall and support the heavy roof without collapsing under the weight.

The stone roof was not strong enough in resisting tension to stretch long horizontal distances without caving in, so columns were placed tightly together.

**FIGURE 12.15.** **Temple of Amun, hypostyle hall.** *Dynasty 19, c. 1295–1186 BCE, Karnak, Egypt.*

specific structure to accommodate the strengths and weaknesses of their material—stone (figure 12.15).

Only priests and royalty were allowed to pass through the towering, narrow spaces. The strength of the material served the temple's purpose of honoring the gods and likely communicated a message of strength, permanence, and mystery.

### Structural Systems

Beyond the materials they use to create a building, architects have developed different structural systems to fight the forces of compression and tension. While the structural elements of a building make it stay up, not all parts of a building are part of its structural system. In a tent, for example, the pole in the middle and the strings tied from the pole to the stakes keep the tent up. They are the structural system. However, the fabric stretched over this structural system provides only protection and seclusion. Structure and protection differentiate the structural systems in architecture: *shell* and *skeleton-and-skin*.

In **shell systems**, one material supports and encloses a building. Both the structural and protective elements of a building are the same. In a log cabin, for example, logs hold up the roof to provide the structural support and protect the inhabitants with covering.

**Skeleton-and-skin systems** have an interior structural frame and an exterior protective cover. In a tent, the skeleton is the pole, string, and stakes, and the skin is the fabric. Just as your body has a skeleton that keeps you upright and a skin to protect your organs, skeleton-and-skin buildings have skeletons (beams and columns) that provide structure and skins (walls and roofs) that provide covering and protection.

Over the centuries, builders have developed methods of construction based on these two structural systems (table 12.1). We will look at examples of each method.

**shell system** In architecture, a structural system in which one material both supports and sheathes a building

**skeleton-and-skin system** In architecture, a structural system that has a skeleton or frame made out of a strong material sheathed in a skin or covering made out of a more fragile material

**TABLE 12.1:** Methods of Construction.

| Structural System | Method of Construction | Description |
|---|---|---|
| Shell | Load-bearing | Stones or bricks are piled one on top of another. |
| | Corbel | Stones or bricks that extend slightly beyond the ones piled below are placed one on top of another. |
| | Post-and-lintel | Two vertical uprights support a horizontal beam. |
| | Cantilever | A beam that extends beyond a wall or column creates an overhang. |
| | Arch | A curved or pointed structure spans an open space. |
| | Vault | A curved or pointed structure that is extended in depth into a ceiling spans an open space. |
| | Dome | A hemispherically shaped roof spans an open space. |
| | Reinforced concrete | Concrete is strengthened with embedded metal rods. |
| Skeleton-and-skin | Frame | A skeleton is made out of a strong material and a skin is made out of a fragile material. |
| | Suspension | A roof or roadbed is hung on cables from columns or walls. |

*Quick Review 12.5*: What are the various types of forces, materials, and structural systems and how do they differ?

# Shell Construction Methods

There are a number of shell construction systems. These include *load-bearing, corbel, post-and-lintel, cantilever, arch, vault, dome,* and *reinforced concrete* construction methods.

## Load-Bearing and Corbel

Two methods of construction that involve stacking stones or bricks one on top of another are *load-bearing* and *corbel*. Both methods are shell systems of construction.

### Load-Bearing

One of the simplest methods of forming a building is **load-bearing** construction. With this method, builders:

- *Pile bricks, stones, or other materials one on top of another* until they reach the desired height
- *Form walls that support themselves* and a lightweight roof (such as one made of thatch)
- *Create walls that are often thicker* and, therefore, stronger at the base and thinner and lighter at the top
- *Ensure windows and doors are small*, if they appear at all, because it is difficult to support the weight above an open space

The Inca constructed the estate of Machu Picchu (MAH-choo PEEK-choo; figure 12.16A) using a load-bearing system in the fifteenth and sixteenth centuries. The site is located on a ridge, nine thousand feet above sea level, in Peru. Builders employed stone hammers to shape the granite stones, so they fit together like puzzle pieces (figure 12.16B). The stones fit so tightly that no mortar was required.

**load-bearing** In architecture, a method of construction in which rocks or bricks are piled one on top of another

(A)

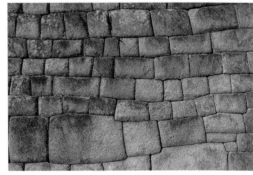

(B)

**FIGURE 12.16A AND B (DETAIL OF A WALL).** **Machu Picchu.** *Inca. 1450–1530, Peru.* The Inca built the royal retreat of Machu Picchu (12.16A) without the use of metal chisels to help shape the stones (12.16B).

## Corbel

**corbel** In architecture, a stone or brick that extends slightly beyond the one below it

A variation of the load-bearing design is **corbel** construction (figure 12.17). In this method, builders:

- *Stack two or more piles* of long, flat stones (or bricks) and *extend each stone*, called a corbel, slightly beyond the stone below it
- *Form piles* that meet at a midpoint to create an open space
- *Keep the structure from caving in* by having the weight of the stones above press down on the stones below

The Maya constructed the Palace of the Governor in Uxmal, Mexico, over a thousand years ago using corbels. The long, rectangular building has three parts that are connected by open interior spaces covered with corbels (figure 12.18).

*Quick Review 12.6*: How do load-bearing and corbel construction methods differ?

**FIGURE 12.17.** **A corbelled open space.**

Arrows show how the corbel both *pushes down on the stone below and pulls apart at the top* because of the unsupported weight near the opening.

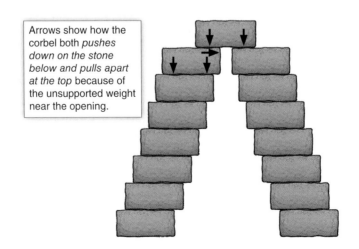

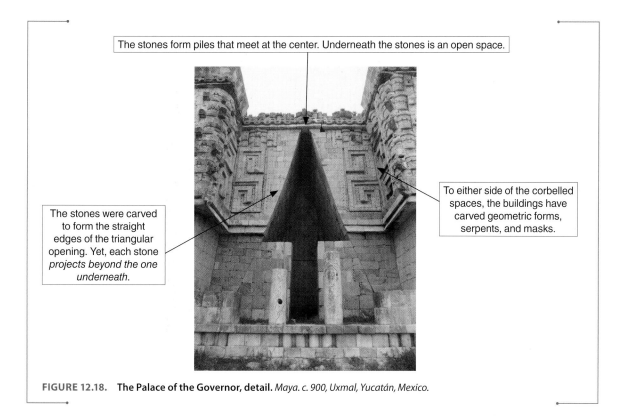

The stones form piles that meet at the center. Underneath the stones is an open space.

The stones were carved to form the straight edges of the triangular opening. Yet, each stone *projects beyond the one underneath*.

To either side of the corbelled spaces, the buildings have carved geometric forms, serpents, and masks.

**FIGURE 12.18.** **The Palace of the Governor, detail.** *Maya. c. 900, Uxmal, Yucatán, Mexico.*

## Post-and-Lintel and Cantilever

*Post-and-lintel* and *cantilever* are two different, but related, shell methods of construction. Both rely on horizontal beams being supported by vertical uprights.

### Post-and-Lintel

The shell method of construction called **post-and-lintel** is also known as column-and-beam (figure 12.19). In this method, builders:

- *Form two vertical posts* or walls that support a *horizontal beam* or lintel
- *Have posts hold the lintel up* and the *lintel press down on the posts*, ensuring that they do not fall over
- *May have one lintel* be supported by a row of *posts*

**post-and-lintel** A type of architectural structural system in which two vertical uprights or posts support a horizontal beam or lintel

**FIGURE 12.19.** **Post-and-lintel construction.**

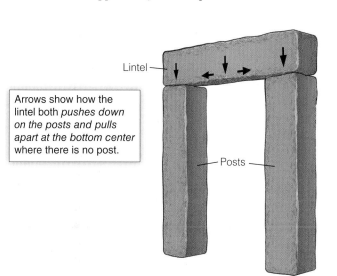

Lintel

Arrows show how the lintel both *pushes down on the posts and pulls apart at the bottom center* where there is no post.

Posts

## 12.1 Explain Why a Paper Lintel Falls Down

Take an 8½" × 11" piece of paper and cut it in half the long way, so that you end up with two long strips that are 4¼" × 11" each. Discard one of the strips. Use the other to complete this activity and others in this chapter.

Hold your hands straight up like columns and try to rest the edges of the strip of paper on top of your hands, so that the paper lies flat like a lintel (figure 12.20A). As you can see, you can't support the paper. It curves down in the middle and falls (figure 12.20B).

You have just tried to create a post-and-lintel system. Consider:

- Why does the paper fall—is the problem with the paper not resisting tensile forces or compressive forces?

- Consider what the Egyptians did in their post-and-lintel system in the Temple of Amun (figure 12.15). If you were to try again, how could you keep the paper in the air?

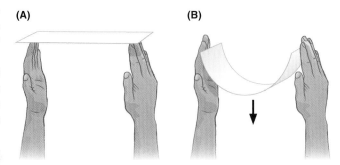

**(A)**          **(B)**

**FIGURE 12.20A AND B.**   Supporting a flat piece of paper.

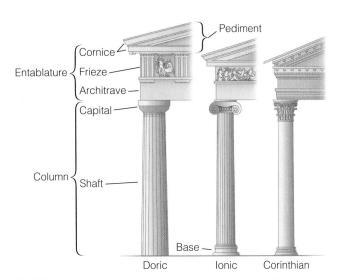

**FIGURE 12.21.**   **The ancient Greek and Roman post-and-lintel system.**   The image shows the parts of the column and entablature as well as the Doric, Ionic, and Corinthian orders.

**capital**  A decorative architectural element that crowns the top of a column

**entablature**  The horizontal part of a building that sits on top of a column that supports the pediment or roof

**architrave**  The horizontal architectural element that forms the lowest band of the entablature

Post-and-lintel construction is limited by the ability of the material of the lintel to resist tensile forces. This limitation often requires placing posts at small intervals, like in the Temple of Amun (figure 12.15). Post-and-lintel construction does not allow for wide open spaces. For a practical application of post-and-lintel construction, see *Practice Art Matters 12.1: Explain Why a Paper Lintel Falls Down.*

The ancient Greeks and Romans built with posts and lintels. However, they devised a structure for how the posts and lintels should look (figure 12.21). In the system, the upright post, called a *column*, can have three parts:

- A vertical *shaft*
- A decorative **capital** that crowns the top
- Often, a *base* that is found at the foot

The horizontal lintel, called an **entablature**, also has three sections:

- An **architrave** at the bottom
- A **frieze** (FREEZ)—a decorative band that often contains relief carvings—in the middle
- A **cornice**—a decorative architectural projection—at the top

Often the entablature, as in the Pantheon, is topped with a triangular **pediment**, around which the cornice continues.

Using these different parts, the Greeks and Romans developed three standardized architectural styles called **orders**: the bold **Doric**, the graceful **Ionic**, and the decorative **Corinthian**. To understand the differences among the styles, see *Delve Deeper: The Three Orders.*

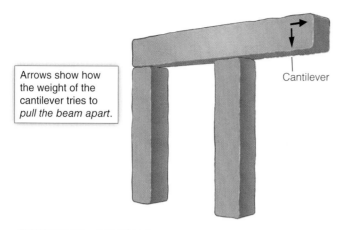

Arrows show how the weight of the cantilever tries to *pull the beam apart*.

Cantilever

**FIGURE 12.22.** **A cantilever.**

## Cantilever

Another shell method of construction that is similar to post-and-lintel is **cantilever**. With this method (figure 12.22), builders:

- *Place a post* toward the center of a lintel
- *Extend a projection*, called a cantilever, beyond the supporting post, creating an overhang
- *Form the cantilever out of a material with exceptional strength* in resisting tensile forces (such as steel or reinforced concrete)

Frank Lloyd Wright, an American, designed perhaps the most famous example from Modern architecture of a building featuring cantilevers. The house, called Fallingwater (figure 12.23), works with the natural landscape by including cantilevered terraces that jut out over a stream that flows through the Pennsylvania property. Wright also had stone quarried from the site for the columns and chimney, so they blend with the rock ledge on which the house rests. The house's glass walls further bring nature "inside" the structure, so that the residents could always be aware of their surroundings.

**frieze** The horizontal architectural element that forms the middle band of the entablature, often decorated with relief sculpture

**cornice** The architectural element that forms the top band of the entablature

**pediment** A triangular-shaped part of a building that sits on top of the entablature

**order** A standardized architectural style of columns and beams used by the ancient Greeks and Romans

**Doric** The plainest, boldest architectural order; contains a simple, rounded capital

**Ionic** The most delicate, graceful architectural order; contains a scrolled capital

**Corinthian** The most decorative architectural order; contains a capital of stylized leaves

**cantilever** In architecture, a beam that extends beyond a wall or column, creating an overhang

## artists
### MATTER

Frank Lloyd Wright

**FIGURE 12.23.** **Frank Lloyd Wright. Fallingwater (Edgar Kaufmann Residence).** *1937, Mill Run, Pennsylvania.* The cantilevers extend the rectangular forms of the terraces out to the natural surroundings.

Cantilevered terrace

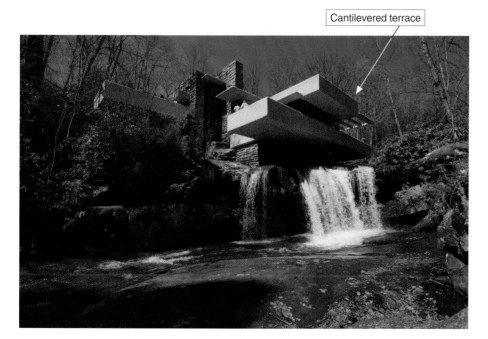

# DELVE DEEPER

## The Three Orders

The ancient Greeks and Romans used the different types of orders to create different appearances:

- *The Doric order is the heaviest and plainest* of the types, giving off what seems like a strong and stable look. The Parthenon, an ancient Greek temple dedicated to the goddess Athena, uses the Doric order around the exterior of the building (figure 12.24).

- *The Ionic order seems delicate and lighter.* Ionic columns are used on the Temple of Athena Nike, also dedicated to Athena, fitting the petite size of this ancient Greek temple (figure 12.25).

- *The Corinthian order is the most complex and detailed* of the orders. Corinthian columns can be seen on the porch of the Pantheon (figure 12.26).

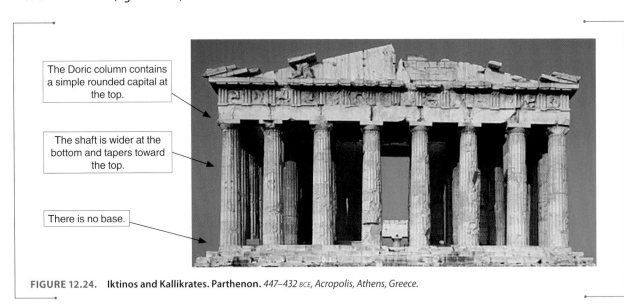

The Doric column contains a simple rounded capital at the top.

The shaft is wider at the bottom and tapers toward the top.

There is no base.

**FIGURE 12.24.** **Iktinos and Kallikrates. Parthenon.** *447–432 BCE, Acropolis, Athens, Greece.*

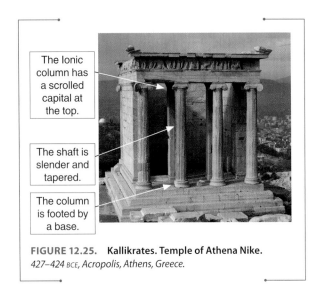

The Ionic column has a scrolled capital at the top.

The shaft is slender and tapered.

The column is footed by a base.

**FIGURE 12.25.** **Kallikrates. Temple of Athena Nike.** *427–424 BCE, Acropolis, Athens, Greece.*

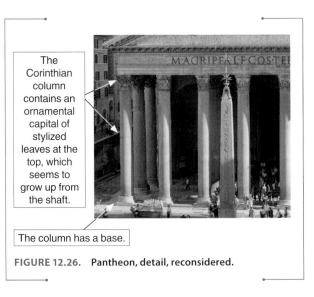

The Corinthian column contains an ornamental capital of stylized leaves at the top, which seems to grow up from the shaft.

The column has a base.

**FIGURE 12.26.** **Pantheon, detail, reconsidered.**

## Arch, Vault, and Dome

*Arches*, *vaults*, and *domes* are three shell systems that are related to one another. All rely on the structural benefits of curved forms.

### Arch

A key support element in architecture is the **arch**. An arch:

- *Is a curved or pointed structure* that is a strong structural support
- *Allows for large spans* and can create open spaces (as in the Pantheon)
- *Pushes down and out*, and both of these forces are *compressive*
- *Must be made from materials that are strong in resisting compression*, such as stone or brick

To see how an arch works, see *Practice Art Matters 12.2: Determine the Forces That Act on a Paper Arch*.

**arch** In architecture, a curved or pointed structure that spans an open space

---

*Practice* art MATTERS

### 12.2 Determine the Forces That Act on a Paper Arch

Take your 4¼" × 11" strip of paper and curve it up into a semi-circular form by resting the curved paper on your outstretched hands. You should be able to keep it from falling (figure 12.27A). The force that was weighing down the center of the paper (when you tried to make a post-and-lintel system before) has now been transferred to the edges and is "pushing down" on your supporting hands.

Now, put that same curved paper on a table. To keep the paper up in the curved form, you need to brace it from the sides, since you can see that the arch also "pushes out" (figure 12.27B).

Try attaching some paper clips to the top of your paper (figure 12.27C). With the post-and-lintel system, the paper could

not support even its own weight. Now, in this curved form, the same material can support other items.

You have just created an arch with the strip of paper. Consider:

- The paper no longer falls because the forces no longer all go straight down from the middle of the paper. In which directions are the forces going?
- Are the forces compressive or tensile?
- Given that you can now keep paper clips up (in addition to the paper) and you don't need any extra supports in the middle, why do you think the arch is such an incredible invention?

**(A)**                    **(B)**                                    **(C)**

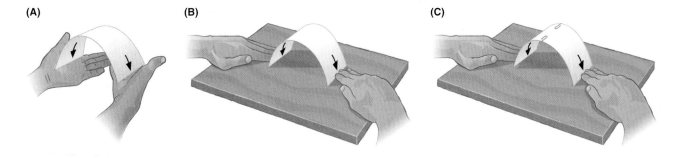

FIGURE 12.27A, B, AND C.    Supporting a curved piece of paper.

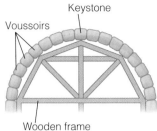

FIGURE 12.28. **A round arch on top of a wooden frame.**

## Round Arch

Round arches have curved, semicircular forms. To form a round arch, builders lay wedge-shaped stones called **voussoirs** (voo-SWAR) on top of a wooden frame (figure 12.28), working their way from the bottom of each end up. The arch is insecure until builders place the **keystone**—a stone at the highest, most central point in the arch—that locks the voussoirs into place. The weight of each stone pushes against the others and prevents movement. Once the keystone is in place, the builders can remove the frame.

The prayer hall of the Great Mosque in Córdoba, Spain, is supported by numerous arches (figure 12.29). The builders recycled the posts from older buildings. Given the limited height of the columns, the builders stacked two arches—a round one on top of a more horseshoe-shaped one—in long, double-tiered rows to extend the height of the hall and create the grand space. Enlarged over the eighth to the tenth centuries, the hall eventually grew to include 610 columns. The open space created by the arches appears to expand indefinitely.

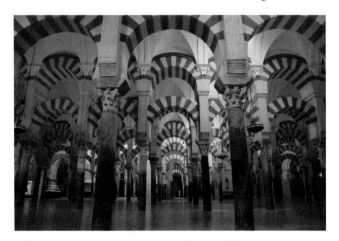

FIGURE 12.29. **Great Mosque, prayer hall.** *Eighth to tenth centuries, Córdoba, Spain.* The alternating, striped, red and white voussoirs reveal the structure of the arches and create a lively, rhythmic pattern throughout the hall.

## Barrel and Groin Vault

When an arch is made deeper to form a ceiling, it is called a **vault.** When a round arch is extended, the tunnel-like, curved structure is called a **barrel vault** (figure 12.30A). When two barrel vaults intersect at right angles, they form a **groin vault** (figure 12.30B).

While round arches and barrel vaults are good supports, they have their liabilities:

- *The width of the arch limits the height* (because there must be a perfect semicircle to be stable).
- *Supporting walls must be thick and heavy* (because arches and vaults thrust to the side).
- *Windows in supporting walls must be small*, if they exist at all, leaving interiors dim (because to brace arches effectively, walls cannot be weakened with large, open spaces).

One structure that uses a barrel vault to great advantage is the Arena Chapel (figure 12.31). The building features thick walls to brace the barrel vault and few windows.

**(A)**

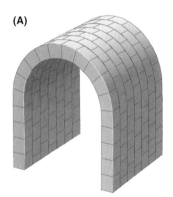

**(B)**

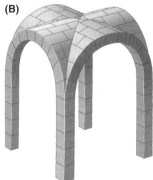

FIGURE 12.30A AND B. **A barrel (12.30A) and groin (12.30B) vault.**

FIGURE 12.31. **Arena (Scrovegni) Chapel, interior.** *c. 1305–06, Padua, Italy.* Giotto covered the flat surfaces of the walls with scenes depicting the lives of Mary and Jesus and the Last Judgment.

The structure created flat surfaces perfect for painting. On these walls, Italian painter Giotto di Bondone (JAH-toe dee bone-DOH-nay) devised a series of frescoes, one of which, *The Lamentation*, is pictured in Chapter 6 (figure 6.15). While we don't know who the architect of the chapel was, some scholars argue that it could only have been Giotto because the architectural elements of the chapel fit so perfectly with the painted design.

The chapel also shows the significance of art during the fourteenth century. A banker commissioned this chapel. Scholars suggest that the banker believed that this art would help him atone for the sin of moneylending, so he might be granted admission to heaven.

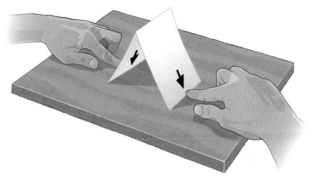

**FIGURE 12.32.** A pointed arch.

## Pointed Arch and Vault

A pointed arch (figure 12.32) solves the height limitations and thick-wall requirements needed by the round arch. A pointed arch:

- *Has a point at the top* and a steeper slope than a round arch
- *Creates downward and outward compressive forces* (like a round arch), but its steep slope makes it thrust outward much less than a round arch
- *Allows for taller structures* with thinner walls
- *Can be extended into a vault* (just like the round arch)

To consider the pointed arch more closely, see *Practice Art Matters 12.3: Describe Why a Paper Pointed Arch Nearly Stands*.

Pointed arches are evident in the **nave**, or central hall, of Chartres (SHAHR-truh) (figure 12.34A), a French cathedral from the thirteenth century. The cathedral replaced an earlier church that had burned almost to the ground. The predecessor housed a sacred relic of the Virgin Mary's, a tunic, which had survived the fire. Thinking the salvation miraculous, and believing it a sign from Mary, who desired a grander church to house her tunic, the people were inspired to build a church that would rise to great heights—made possible by the pointed arch and vault.

The builders transferred the downward weight from the pointed arches and vaults onto columns bundled into piers in the interior. The builders also placed supports on the exterior of the building to brace against the arches' and vaults' outward thrust (figure 12.34B and C). These structures, called **flying buttresses**, extend in arched bridges from the exterior nave wall (at the point where the outward thrust from the main interior vault is the greatest) down to solid, vertical supports.

**voussoir** A wedge-shaped stone used to create an arch

**keystone** The highest, centered voussoir in an arch that, when added, locks all of the voussoirs in place

**vault** In architecture, a roof or ceiling formed by extending an arch in depth

**barrel vault** A curved roof or ceiling built in the form of a tunnel

**groin vault** The structure created when two barrel vaults intersect at right angles to each other

**nave** The central hall in a church

**flying buttress** A structure that extends in an arched bridge from an exterior nave wall, at the point where the outward thrust from the main interior vault is the greatest, down to a solid, vertical support

---

*Practice* **art**MATTERS

## 12.3 Describe Why a Paper Pointed Arch Nearly Stands

Return to the paper strip and fold it in half, forming a sharp crease. Set the paper down on a table. The paper should stand up without much anchoring of the sides (figure 12.33).

You have just created a pointed arch with the strip of paper. Consider:

- In what directions are the forces going?
- Are the forces tensile or compressive?
- Your pointed arch no longer needs as much lateral support. Why?

**FIGURE 12.33.** Supporting a creased piece of paper.

**FIGURE 12.34A (INTERIOR), B (CROSS-SECTION DRAWING), AND C (EXTERIOR VIEW FROM THE SOUTH).** **Chartres Cathedral.** *1194–1260, Chartres, France.* Pointed arches and vaults allow for Chartres's great height (12.34A). The arrows on the section (12.34B) show how loads are carried to the ground. On the exterior, the lateral thrust is carried to the ground by flying buttresses (12.34C).

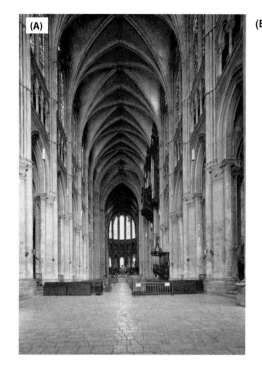

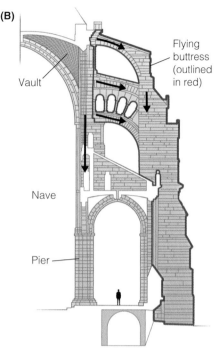

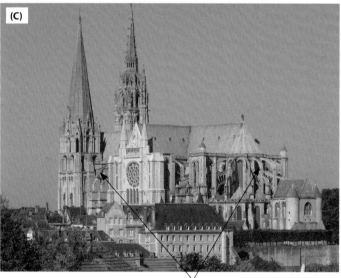

Flying buttresses

This structural system eliminated the need for thick, uninterrupted walls, allowing for nearly half of the wall surface to be filled with stained glass (see figure 11.5A). It also meant the builders could create the tremendous vertical height of the cathedral that soars 125 feet.

## Dome

A **dome** is closely related to an arch. A dome (figure 12.35):

- *Is a curved, hemispherically shaped roof* (as in the Pantheon)
- *Thrusts downward and outward* (like an arch), but a continuous surface means less outward thrust (than an arch)
- *Can usually be contained by a thick wall* (the Pantheon's cylindrical wall is twenty feet thick), so extra buttressing is not needed

**dome** In architecture, a hemispherically shaped roof

**FIGURE 12.35.** A round dome.

*Practice* art MATTERS

## 12.4 Explore the Effect of a Cup's Continuous Surface

Get two paper cups. Take one and cut vertical slits running from the rim to the base. Leave the other untouched. Flip both over, and lightly press down on them (figure 12.36). The cup with the slits collapses outward, while the other remains standing.

You have just created two domes. The cut one is like the Pantheon in which cracks formed in the dome, making it act like a series of arches. The other is a solid dome that has not cracked. Consider:

- Both cups still have outward thrust. Which cup has more?
- Why doesn't the uncut cup collapse?

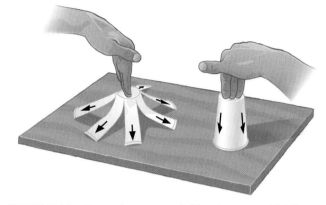

**FIGURE 12.36.** Comparing a cut cup (left) and uncut cup (right).

A dome has compressive forces pushing down and out. However, because a dome has a continuous surface, it also has tensile forces acting on it. These forces try to pull the continuous surface apart. When domes are built from materials strong only in resisting compression, like concrete, the tensile forces pull them apart. This creates vertical cracks, such as the ones seen on the Pantheon. To understand how the structure of a dome works, see *Practice Art Matters 12.4: Explore the Effect of a Cup's Continuous Surface.*

Domes can differ in two ways. First, they can have *different forms*; for example, they can be round, pointed, or onion shaped. Second, they can be used on *different types of buildings*. While the Pantheon dome tops a circular building, domes can top square structures as well (figure 12.37). Builders can use **pendentives**—curving, triangular, transitional structures—to bridge the gap between the round dome and square building.

Pendentives can be seen in the Hagia Sophia (HYE-uh soh-FEE-uh), built for the Emperor Justinian in the sixth century to serve as his private chapel and a cathedral for the city of Constantinople (present-day Istanbul, Turkey). Like Hadrian, Justinian used art to display his authority. The emperor was the only non-clergy member allowed in the central space under the main dome, while other laymen could enter only the sides.

Like the Pantheon, the Hagia Sophia is a massive, dome-topped space (figure 12.38A). The dome rises 180 feet above the ground and spans 107 feet. Most amazingly, the central dome is surrounded at its base by forty windows, a design that makes the dome appear to float above the building.

As with the Pantheon, the architects created a dome out of a series of arches, in this case that rise on either side of each window. The weight of the dome's arches is carried to the floor by pendentives, lower arches, and piers. Its lateral thrust is supported by half domes at the back and front (figure 12.38B).

However, the builders did not fully consider the lateral thrust from the arches that form the divided dome. The building was completed in 537, but the dome collapsed four times over the centuries, even though replacements were built with a steeper slope (to limit the lateral thrust) and additional buttressing. While the half domes had buttressed the main dome from the back and front, it was weak on the sides. When finally reconstructed correctly in 1847, the builders circled the dome's base with an iron chain to hold in the outward thrust (similar to the way the Romans buttressed the Pantheon's dome with stepped rings).

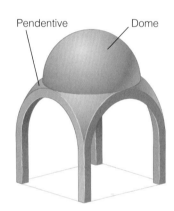

**FIGURE 12.37. A round dome covering a square building with pendentives bridging the gap.**

**pendentive** A curved, triangular structural element that bridges the gap between a round dome and a square building

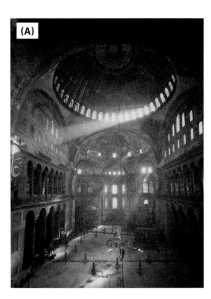

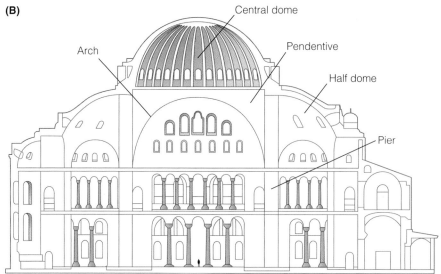

**FIGURE 12.38A (INTERIOR) AND B (CROSS-SECTION DRAWING).** Anthemius of Tralles and Isidorus of Miletus. Hagia Sophia. *532–537, Istanbul, Turkey.* The structures that support the dome (12.38A) are evident in the cross section of the building (12.38B).

*Quick Review 12.8*: What advantages does a pointed arch have over a round arch?

## Reinforced Concrete Construction

Reinforced concrete construction solves the weaknesses of concrete construction. In reinforced concrete construction, builders *embed metal rods into the concrete* before it hardens. As a result, the concrete resists tensile forces (in addition to compressive forces). This material can be used in different methods of construction such as the cantilever or in free forms not based on traditional building methods.

The Sydney Opera House in Australia, designed in 1956 by Danish architect Jørn Utzon (yern OOT-suhn), illustrates the dramatic, sculptural qualities possible when building with reinforced concrete (figure 12.39). The opera house is located on a platform that juts into the harbor, and its curved, white peaks appear to take on the quality of sails.

*Quick Review 12.9*: What makes reinforced concrete such a versatile material?

**frame construction** An architectural structural system that has a skeleton made out of a strong material such as iron, wood, or steel and a skin made out of a fragile material

**iron-frame construction** A frame architectural structural system in which iron is used as the skeleton

**FIGURE 12.39.** Jørn Utzon. **Sydney Opera House.** *1959–72, Australia.* No extra structure was used to support the reinforced concrete, even though the tallest peak soars to the daring height of two hundred feet.

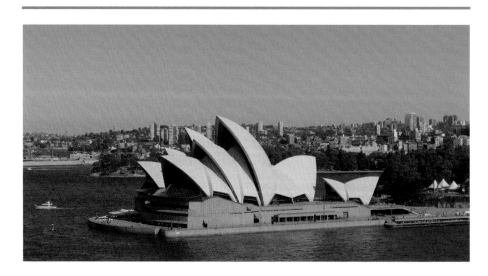

# Skeleton-and-Skin Construction Methods

Skeleton-and-skin systems were developed more recently than a number of the traditional shell methods. Skeleton-and-skin systems include *frame* and *suspension* construction methods.

## Frame Construction

**Frame construction** is a skeleton-and-skin system in which a strong frame provides structure and support, and a weaker outer surface provides covering. The frame is generally made of a strong material such as *iron*, *wood*, or *steel*.

### Iron

Iron had been used to make tools, but it was not considered for use in construction until the nineteenth century. Iron is a strong building material because it resists both compressive and tensile forces. In **iron-frame construction,** iron is used as the frame and a lighter material is used as the covering.

For the world's fair in London in 1851, Englishman Joseph Paxton used this new system for his exhibition space, the Crystal Palace (figure 12.40). Paxton built an enormous iron skeleton of slender columns, beams, arches, and vaults. They framed nine hundred thousand square feet of a glass, non–load-bearing skin, creating a light-filled space. In a bold move celebrating this new method of construction, the transparent glass exposed the building's iron skeleton. Covering almost one million square feet of space, the Crystal Palace wowed crowds and helped people to see architecture's possibilities for the future.

### Wood

Also introduced during the nineteenth century, **wood-frame construction** became possible thanks to the inexpensive mass production of nails. With wood-frame construction, builders nail together a wood skeleton, leaving spaces for windows and doors (figure 12.41). The non–load-bearing skin, then, can be made from materials such as glass, brick, stucco, or aluminum.

Often, roofs of wood-frame buildings contain **trusses**, stable triangular supports (figure 12.42). Like the pointed arch, the top two side legs of a truss thrust outward. A horizontal beam is placed across the bottom and attached to the two side pieces. This piece holds in the outward forces formed by the arch, so there is no need for external buttresses.

Wood-frame construction is a common building method for relatively small structures such as private homes. American Henry Hobson Richardson's Stoughton House (figure 12.43), constructed in the late 1800s in Cambridge, Massachusetts, is one of many examples. The simple, shingled, non–load-bearing skin helps highlight the geometric forms of the house. The shingles hide the wood frame completely.

### Steel

Steel is stronger than iron and wood, so it makes an ideal skeleton for large structures. Designed like a steel cage composed of floors and columns (figure 12.44), **steel-frame construction** can support a skyscraper. Builders can cover steel frames in different non-supporting materials. Interior walls, doors, windows, and stairs can be placed in any location within the structure, because they have no load-bearing role.

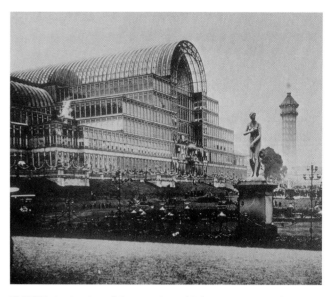

**FIGURE 12.40.** Joseph Paxton. Crystal Palace. *1850–51, London.* Paxton was a landscape architect, and his experience with greenhouses inspired his design.

**wood-frame construction** A frame architectural structural system in which wood boards are nailed together to create a skeleton

**truss** In architecture, a triangular supporting structure

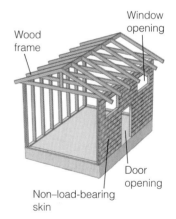

**FIGURE 12.41. Wood-frame construction.**

**FIGURE 12.42. A truss.**

**steel-frame construction** A frame architectural structural system in which steel is used as the skeleton

FIGURE 12.43. Henry Hobson Richardson. M. F. Stoughton House. *1882–83, Cambridge, Massachusetts.* Richardson carried the shingle skin around the entire house, even on the circular staircase.

FIGURE 12.44. Steel-frame construction.

**geodesic dome** An architectural structural system in which a dome is created out of a frame of triangular-shaped metal rods

FIGURE 12.46. A geodesic dome.

The thirty-eight-story Seagram Building (figure 12.45), constructed in New York City in the 1950s, shows the strength of a steel frame. Using steel, German-born American architect Ludwig Mies van der Rohe (LOOT-fik MEES vahn dair ROH-eh) was able to make a taller building that could offer more interior space on a smaller footprint. The building's sleek verticality is emphasized by decorative nonfunctioning bronze beams on the exterior of the glass-covered tower. These beams mimic the structural steel grid on the interior.

## Geodesic Dome

Another frame method of construction created from a skeleton of strong, metal rods is the **geodesic dome**. With this method, builders arrange the rods in three-dimensional triangles that fit together to form a three-quarter sphere (figure 12.46). Builders can cover this skeleton in any lightweight material.

FIGURE 12.45. Ludwig Mies van der Rohe and Philip Johnson. Seagram Building. *1956–58, New York.* Because the Seagram Building reached many stories into the sky, Mies could leave space for an open plaza in front of the building for pedestrians.

American R. Buckminster Fuller developed the geodesic dome, based on a structure found in nature. His geodesic dome designed for the U.S. Pavilion at the 1967 Montreal Expo in Canada enclosed an enormous open space: 250 feet in diameter by 206 feet in height (figure 12.47). The structure has subsequently proven advantageous in harsh climates, such as in the Arctic, where the sturdy configuration can withstand powerful winds and driving snow.

*Quick Review 12.10*: What are the differences among various types of frame construction?

## Suspension

When used for a building, a **suspension structure** is a skeleton-and-skin construction method. However, suspension can also be used for bridges. A suspension structure (figure 12.48):

- *Suspends a roadbed on a bridge or roof on a building from cables* that rest on columns that keep the structure from falling down
- *Anchors cables on both sides* to hold the columns and keep them from falling in
- *Compensates for the tensile forces* that pull both down and in

For a hands-on look at suspension, see *Practice Art Matters 12.5: Consider the Two Forces That Act on a Necklace.*

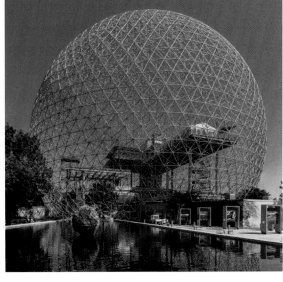

**FIGURE 12.47.** **R. Buckminster Fuller. U.S. Pavilion, 1967 Montreal Expo.** *Canada.* By placing triangular forms into a domed structure, Fuller created a wide-open space.

**suspension structure** An architectural structural system in which a roadbed or roof is hung on cables from columns or walls

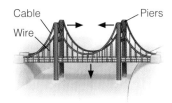

**FIGURE 12.48.** **A suspension structure.**

---

*Practice* **art**MATTERS

### 12.5 Consider the Two Forces That Act on a Necklace

Hold up a locket on a chain between your hands. Notice that the weight of the locket pulls down on the chain (figure 12.49A), making the chain droop, even though your hands are resisting those downward forces.

Now, pull out horizontally on both sides of the chain. The locket should rise to be level with your hands, even though you haven't pulled the chain up (figure 12.49B). Your pulling out counters inward forces and allows the locket to rise to the height of your hands.

You have just created a suspension structure with your locket and chain. The locket is like the roadbed or roof, and the chain is like the cables. Consider:

- What are the directions of the forces that are acting on your structure?
- Are these compressive or tensile forces?
- If you pull out, why can you make the locket rise?

**(A)**

**(B)**

**FIGURE 12.49A AND B.** Supporting a locket.

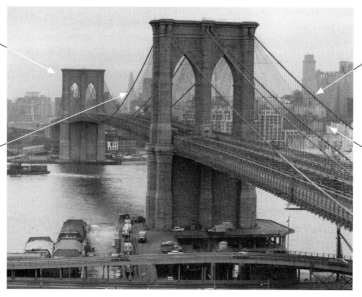

Two enormous granite towers have double arches.

Main cables extend toward either side and are anchored on each bank, so the towers do not fall in.

Four main steel cables hang from the towers.

Small steel cables run vertically, from the main cables down to the road-bed, suspending the roadbed. Additional cables extend from the top of the towers outward to the roadbed, forming multiple triangular trusses.

**FIGURE 12.50.** **John A. and Washington A. Roebling. Brooklyn Bridge.** *1869–83, New York.*

Interactive Image Walkthrough

The Brooklyn Bridge uses a suspension structure. During construction, the builders erected components that keep it from falling down and in (figure 12.50).

The Brooklyn Bridge uses a mix of construction methods. The bridge spans a long distance and is a suspension structure. However, its towers are pointed arches. Thicker buttressing can be seen in three heavy vertical lines on each tower. These support the lateral thrust of each arch.

Spanning the 1,600-foot distance between Brooklyn and Manhattan, New York, the bridge also stands as a testament to the importance of art. Before it was built in the late 1800s, people relied on ferries to cross the East River. These ferries were crowded, delayed, and, on days when the river froze or weather was bad, unreliable. The Brooklyn Bridge linked the two cities, opening up innumerable opportunities on both sides of the river.

*Quick Review 12.11*: Why does a bridge need to be both suspended from upright supports and anchored on its sides?

# Recent Innovations in Structures and Materials

Many buildings continue to be made using traditional methods of construction. However, some architects have been exploring new innovations to create radical *structures*, while others have been experimenting with novel *materials*.

The headquarters for China Central Television (CCT) in Beijing, for example, extended the cantilever to remarkable lengths, using modern structural enhancements. Designed by Dutch architect Rem Koolhaas and German architect Ole Scheeren, the CCT building comprises two slanted towers that meet both at the bottom and top in four oppositely projecting horizontals (figure 12.51). The top horizontals are the cantilevers.

The two cantilevers make this building unique. The angled overhang juts out 246 feet from one tower and 220 feet from the other.

Because one tower climbs to fifty-four floors and the other to forty-four, the cantilevers are angled along their roof lines.

The black, interlaced lines on the exterior are steel tubes that support the building. Where the forces are greatest and the building needs the most bracing, the lines merge together; where forces are less, the lines spread apart.

**FIGURE 12.51.** **Rem Koolhaas and Ole Scheeren. China Central Television Headquarters.** *2012, Beijing, China.*

Interactive Image Walkthrough

What makes this building even more astonishing is the fact that Beijing is prone to earthquakes. Structural engineers used a high-speed computational system, a three-story model, and a vibrating table, which simulates tremors, to study how forces would affect the building before they approved the design.

The building is also controversial because it is the home of China Central Television, the official broadcaster of the Communist Party. Some critics see the building as propaganda for a state that denies free speech to its citizens. Defenders, including the building's architects, say the building's form will force the organization to be more open. Top officials' offices in the overhang are intermingled with public spaces, bringing the executives into contact with the people whom they serve.

Architects have also experimented with incorporating novel materials into their buildings. Japanese architect Shigeru Ban (shee-GEH-roo BAHN) has provided vital disaster relief for numerous people throughout the world with basic, temporary structures. Building everything from churches to houses to schools, he has employed paper, which is inexpensive and easy to use, yet surprisingly strong.

In 2013, Ban used this innovative building material to help residents of Christchurch, New Zealand, after a devastating earthquake destroyed their cathedral. The replacement structure, known as the Cardboard Cathedral (figure 12.52), comprises paper tubes with wooden supports arranged in an immense peaked form. A translucent, waterproof roof allows sunlight to enter the church through spaces between the tubes, but not rain. At the entrance, multicolored triangular pieces of glass allow additional natural light to pass through and echo designs that had appeared on the old cathedral.

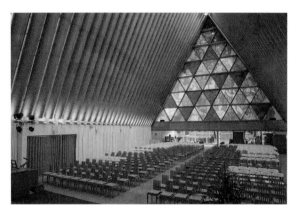

**FIGURE 12.52.** **Shigeru Ban. Cardboard Cathedral, interior.** *2013, Christchurch, New Zealand. Photo copyright Bridgit Anderson.* Ban's open, uplifting space can seat seven hundred people and has served as an inspiration to many in the devastated community of Christchurch.

**artists**
MATTER

Shigeru Ban

*Quick Review 12.12*: How have architects created innovative structures and used new materials?

## A Look Back at the Pantheon

The story of the Pantheon recounts how Roman builders created a remarkable building. But, the story represents more than just an individual structure built at a specific time. The Pantheon shows how **architecture** is a *work of art*. The story also illustrates many of the topics discussed in this chapter.

The Pantheon met *functional*, *three-dimensional*, *environmental*, and *expressive* requirements. The building had two *functions*: it served as a temple to the gods and a place where Hadrian held court. Its *form followed its function* in its impressive space supporting its religious and political uses. Furthermore, by focusing on *mass* in its porch, with its enormous, closely spaced columns, and *space* in its interior, with its expansive area, the Pantheon's architect emphasized the building's *three-dimensional* qualities. The architect, though, was also concerned with the building's *setting*. Visitors originally approached through a lower forecourt, so the porch hid the rest of the building. This setting would have made the inner space all the more thrilling. Moreover, the Pantheon's design worked with the *environment*. The oculus introduced daylight into the building and created a circle of light whose movement mimicked that of the sun. Finally, the design was meant to emphasize the expressive *message* that Hadrian's empire was ideal and powerful.

The Romans employed an *innovative building material* and several *structural systems* in the building. For the main material, they used concrete, which gave the Romans flexibility to create any form. However, because the concrete was not strong in resisting **tension**, it cracked in the dome. The building's structure includes a **post-and-lintel** system that holds up the porch; round **arches** and round **vaults** that allow for open niches; a **dome** that holds up the ceiling; and a thick, twenty-foot wall that combats the downward and outward forces from the dome. Stepped rings additionally hold in the outward thrust from the dome. These are similar to **flying buttresses** used to combat the outward thrust of arches.

As you move forward from this chapter, consider the power of architecture to *communicate messages*. The Pantheon's structure sought to communicate that Hadrian's government was strong. Similarly, the bold design of China Central Television (figure 12.51) seems to communicate that China's official broadcaster is forward-thinking. Yet, some people believe that the structure is just propaganda for a state that in reality censors its media. These examples remind us that we must be wary of taking what we see at face value. Corporations, governments, religions, hospitals, universities—any entities that build—put forward messages about themselves that they want the public to perceive.

Flashcards

## CRITICAL THINKING QUESTIONS

1. Knowing what you do about Cliff Palace (figure 12.9), why did its form fit the structure's function?
2. Find out whether your college has plans, is in the midst of, or has recently completed constructing or renovating a building. Were/are efforts being made to lessen the effect on the environment? How?
3. Compare Lin's personal style in the Riggio-Lynch Chapel (figure 12.12A) and the Vietnam Veterans Memorial (figure 1.3). In what ways are both structures similar in the approach to the designs?
4. What factors do you believe drove Frank Gehry's expressive statement when he created the Guggenheim Museum in Bilbao (figure 12.7A)?
5. If the Egyptians had been able to use canvas as a roof at the Temple of Amun (figure 12.15) instead of stone, how could this change have affected the placement of the pillars? Why?
6. How is a corbel similar to a cantilever?
7. How are the functions, spaces, expressive statements, and structures of the Arena Chapel (figure 12.31) and Chartres Cathedral (figure 12.34A) similar or different?
8. Why do you think that both Paxton in his Crystal Palace (figure 12.40) and Fuller in his U.S. Pavilion (figure 12.47) emphasized their frame construction methods, while Richardson in his Stoughton House (figure 12.43) hid his?
9. Why is reinforced concrete considered a shell system?
10. Ban's Cardboard Cathedral (figure 12.52) involved an architect solving a social problem. Why is architecture a particularly appropriate art form for helping communities in need?

Comprehension Quiz     Application Quiz

# The History of Art 4

The detail of a damaged ancient Greek sculpture (shown on the opening page of Chapter 13, pg. 330) depicts a priest. The priest's body looks naturalistic, youthful, and athletic. He shifts his weight, standing on one leg while relaxing the other. The sculpture was originally placed on a temple. This man stood with other men and women alongside gods, in a position of honor, serving to promote the supremacy of the people. Both of these factors—the style and context—add to our understanding of the work and how ancient Greeks used art. Part 4 looks at these factors as we explore the history of art. At the end of each chapter in this part, a *Connections* feature also focuses on exploring universal themes in art, showing the commonality among diverse people from different times and places.

CHAPTER 13
The Art of Prehistory and Ancient Civilizations in Europe and the Mediterranean

CHAPTER 14
Early Jewish and Christian, Byzantine, and Medieval Art

CHAPTER 15
Renaissance and Baroque Art

CHAPTER 16
The Art of Africa and Islam

CHAPTER 17
The Art of the Pacific and the Americas

CHAPTER 18
The Art of Asia

CHAPTER 19
Eighteenth- and Nineteenth-Century Art in the West

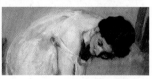

CHAPTER 20
Modern Art in the Twentieth-Century Western World

CHAPTER 21
Art Since 1980

# 13

# The Art of Prehistory and Ancient Civilizations in Europe and the Mediterranean

**DETAIL OF FIGURE 13.5.** Art in the ancient world was often a means to an end. Here, the placement of a sculpture of this ideal-looking Greek man along with other images of flawless everyday individuals on an ancient temple was meant to show the high status of the people.

## LEARNING OBJECTIVES

**13.1** Describe two types of art made by Paleolithic people.

**13.2** State the changes that came about because of the Neolithic revolution that affected art.

**13.3** Illustrate how different examples of Mesopotamian art show the same purpose of advancing the power of elites.

**13.4** Summarize the consistent conventions that were believed to promote order in Egypt.

**13.5** Explain how Greek art continued through four different periods to promote the status of individuals.

**13.6** Discuss how art in the Roman Empire was based on two historical precedents.

## THE PARTHENON SCULPTURES

In 480 BCE, an invading Persian army destroyed the Acropolis, *the spiritual center of the Greek city-state of Athens*. Three years later, Athens and other Greek city-states that shared the same culture, language, and gods joined together to form the Delian League to defeat the Persians. Ultimately, the League became a tool Athens used to establish an empire. With its superior military strength, Athens forced other city-states to pay money into the League to guarantee that Athens would protect them.

How Art Matters

### Rebuilding the Acropolis

In 449 BCE, the Athenians raided the League's defense fund to *restore the Acropolis* and *promote their prestige*. They hired Phidias to oversee the project. When completed, the rebuilt Acropolis (figure 13.1A and B) encompassed a grand entrance and a number of new temples. One of these new temples, called the *Parthenon*, was the crowning achievement.

### The Parthenon

The Parthenon occupied a prominent position in Athenian religious life. The Athenians dedicated the temple to Athens's patron goddess, Athena, and the temple became the destination of the annual procession of the Panathenaic festival. Held on Athena's birthday, the festival was a day when all Athenians would march to the Parthenon, and maidens would present a new robe they had woven to an ancient, wooden statue of Athena.

As discussed in Chapter 4, the Parthenon featured a *harmonious design*. Doric columns ran around the exterior; in the interior, two rectangular rooms, with entrances on opposing ends, were fronted by columned porches (figure 13.2A). The eastern room housed a

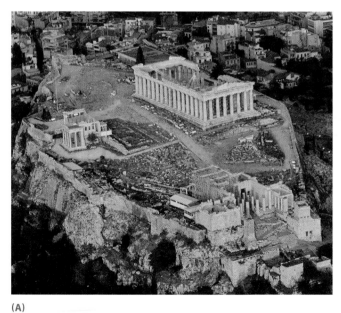

(A)

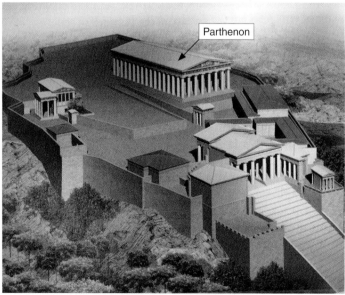

(B)

**FIGURE 13.1A (CURRENT AERIAL VIEW LOOKING SOUTHEAST) AND B (RECONSTRUCTION DRAWING).** **Acropolis.** *Fifth century BCE, Athens, Greece.* Even today (13.1A), the Parthenon impresses, sitting over the surrounding landscape from atop the Acropolis. When originally built (13.1B), the Acropolis must have made an even grander impact.

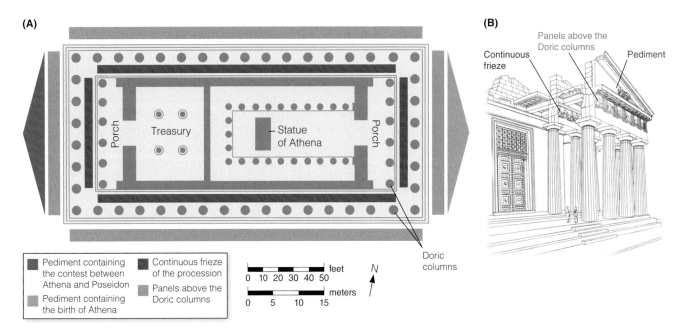

**(A)**

Porch

Treasury

○ ○
○ ○

Statue of Athena

Porch

**(B)**

Panels above the Doric columns

Continuous frieze

Pediment

Doric columns

■ Pediment containing the contest between Athena and Poseidon
■ Pediment containing the birth of Athena
■ Continuous frieze of the procession
■ Panels above the Doric columns

feet
0  10 20 30 40 50

meters
0   5   10   15

N

**FIGURE 13.2A (PLAN OF THE BUILDING) AND B (CUT-AWAY DRAWING OF THE EAST SIDE OF THE BUILDING).** Iktinos and Kallikrates. **Parthenon.** *447–432 BCE, Athens, Greece.* Phidias located sculpture in the pediments, panels above the Doric columns, and continuous frieze. All three locations can be seen on both the plan (13.2A) and cut-away drawing (13.2B).

forty-foot-tall, gold and ivory statue of Athena (now lost), crafted by Phidias, while the western room contained the goddess's treasure.

While the people could peer into the building to view the statue of Athena, they could not enter. Religious worship occurred outside, making the exterior the focus of the temple. To decorate the exterior, Phidias designed a sculpture program that promoted the supremacy of Athena, the Athenians, and the Greeks. He planned sculpture for *three locations* (figure 13.2B):

» In the two *pediments* under the slopes of the roof
» On each of the *panels* that ran *above* the exterior *Doric columns*
» In a *continuous frieze* that ran around the top of the interior rooms and porches

### The Pediment Sculpture

*Freestanding sculptures* in the pediments recounted two myths. The west end depicted the battle between Athena and another god, Poseidon, for the privilege of being named the patron deity of Athens. Already in this pediment, Phidias *was promoting the status of the Athenians*, as being worthy to judge the contest and also so important that gods competed for their favor.

The east pediment told the legend of the birth of Athena, who was believed to have miraculously sprung from her father Zeus's head fully grown. Figure 13.3 shows a mockup of what the surviving, damaged sculptures would have looked like, if placed in their original locations in the triangular pediment. Originally the sculptures were brightly painted. The sculptures of Athena and Zeus are now lost. The surviving statues depict other gods who witnessed the event. The figures are *anatomically correct*, yet they are also *generic and idealized*—more perfect than in real life.

### The Sculpture in the Panels above the Doric Columns

Above the Doric columns, the *high-relief sculptures* featured battles between mythic Greeks and non-Greek rivals, whom the Greeks considered barbarians (figure 13.4). Each panel

The nude, muscular male deity shows the *naturalistic* and *idealized* forms.

The now-lost sculptures of Athena and Zeus would have stood here.

**FIGURE 13.3.** **The existing sculptures from the east pediment of the Parthenon positioned as they would have appeared in place.** *From Athens, Greece. c. 438–432 BCE. Marble, 11' at central peak × 90' at base × 3'.*

*advanced the message of Greek supremacy.* The figures maintain the *naturalistic,* yet *idealized body types* of the pediment sculptures. Muscles strain and contort in the bodies, yet the heroic stances and blemish-free figures showcase their perfect form.

## The Continuous Frieze Sculpture

Finally, on the interior, *low-relief sculptures* occupied a 524-foot continuous frieze, depicting a public procession of men, women, and gods. Some scholars contend the frieze illustrated a contemporary Panathenaic procession, while others insist the frieze depicted the legendary, first Panathenaic festival. In either case, the frieze sculpture demonstrates *how highly the Athenians thought of themselves* that they would place themselves on temple sculpture when previously such a position had been reserved only for depictions of mythic heroes and gods.

In the surviving, damaged fragment in figure 13.5, the figures maintain the *naturalistic,* yet *idealized forms* from the pediments and panels. These flawless depictions of Athenians placed high on Athena's temple would have *promoted Athenians' prestige* to visitors from across the ancient world.

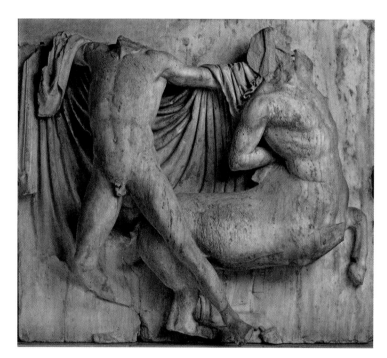

**FIGURE 13.4.** **An early Greek battling a centaur.** *From a Doric panel from the south side of the Parthenon, Athens, Greece. c. 447–438 BCE. Marble, 4' 5" × 4'. The British Museum, London.* This sculpture illustrates a legendary battle between a Greek and a centaur, a creature that was half horse and half human.

## The History of the Sculptures after Ancient Times

Today, many of the sculptures from Phidias's design have survived despite 2,500 years marked by conquest and war. *The sculptures that endure today have elicited controversy.* Between 1801 and 1803, when the Ottomans controlled Greece, a British ambassador to the Ottoman Empire claimed to be rescuing the sculptures when he removed many of them and sent them to England. The sculptures have remained on display in the British Museum ever since, protected from looters, accidents, and pollution. However, since the Greeks won independence from the Ottoman Empire in 1832, they have been trying

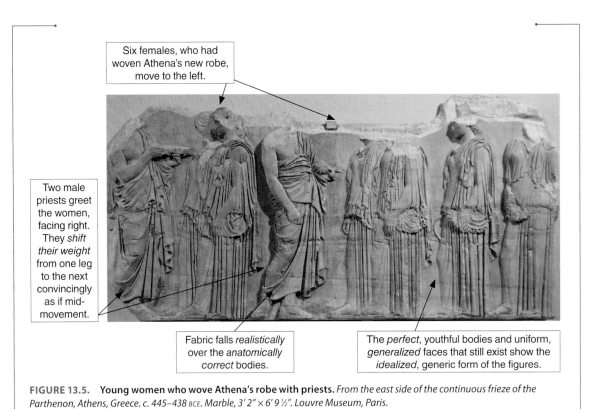

Six females, who had woven Athena's new robe, move to the left.

Two male priests greet the women, facing right. They *shift their weight* from one leg to the next convincingly as if mid-movement.

Fabric falls *realistically* over the *anatomically correct* bodies.

The *perfect*, youthful bodies and uniform, *generalized* faces that still exist show the *idealized*, generic form of the figures.

**FIGURE 13.5.** **Young women who wove Athena's robe with priests.** *From the east side of the continuous frieze of the Parthenon, Athens, Greece. c. 445–438 BCE. Marble, 3′ 2″ × 6′ 9 ½″. Louvre Museum, Paris.*

to recover the statues, maintaining that the Ottomans had no right to relinquish the sculptures in the first place. In addition, Greece opened the Acropolis Museum in 2007 and maintains it now has ample means to secure the sculptures' safety. Despite this, the sculptures remain in the British Museum with questions of ownership as yet unresolved. Ancient Greek motivations regarding *prestige* undoubtedly play a role in this controversy.

The Parthenon sculptures offer remarkable insight into the ancient Greek world. They illustrate not only *the style of Greek sculpture*, but also *how people who lived in Greece used art*. The sculptures chronicle the *values*, *beliefs*, and *motivations* of the people. The Athenians built the Parthenon and its sculptures as a religious temple for Athena, but also clearly as a political move to *promote and reinforce their status and identity*. This theme of using *art to advance a purpose* can be found throughout the ancient European and Mediterranean world, where art was a powerful means to a strategic end. This chapter will take a closer look at these periods and places. However, it is worth noting, as we start the historical part of this text, that scholars *continually question the understanding we have of ancient art (and, for that matter, all art from the past)*. As you proceed through this chapter, consider these points:

» *Not everything has survived from the past*, and some work that has been lost was likely even more important than the work that survives.
» Often the only *art that survives belonged to rulers or elites*, not ordinary people.
» Even with the art that has survived, *we base our explanations on interpretations*.
» Sometimes *artifacts don't fit neatly into the understanding scholars have of a period*, and so they may downplay the objects relative to pieces that do.

Before moving forward, based on this story and these ideas, why do you think art was so important to ancient people? What other purposes, beyond religious and political, might art have played in the ancient world?

# Prehistoric Cultures

The story of art begins tens of thousands of years before the Greeks. The earliest known art in Europe dates from prehistoric periods, before the invention of writing. While the lack of written records makes the art difficult to understand, that same absence makes art an indispensable tool in deciphering the lives of these early people.

## The Paleolithic Period

During the last ice age, in the Paleolithic period, people in Europe lived precariously as hunter-gatherers, residing in temporary shelters and entrances to caves. They followed the migrations of wild herds and the growth of seasonal wild plants that were their food sources. Despite being consumed with survival, people still made art including *paintings on the walls of caves* and small *portable sculptures*.

### Wall Paintings

Beginning about 32,000 BCE, and over thousands of years, people ventured into dark, maze-like passageways to draw, paint, and inscribe markings on the walls and ceilings deep within caves. About two hundred such prehistoric painted caves have been found in what is today France and Spain (see map in figure 13.6). The cave paintings:

- *Are in remote locations*, far from living quarters
- *Consist of depictions of animals, symbols, and handprints*
- *Display naturalistically rendered* animals

**FIGURE 13.6. Europe and the Mediterranean during Prehistoric Periods.** A number of prehistoric sites were located in Europe and in the lands surrounding the Mediterranean Sea.

Prehistoric Cultures     335

**FIGURE 13.7.** **Horses, rhinoceroses, and extinct oxen ancestors.** *From a wall in Chauvet Cave, Vallon-Pont d'Arc, Ardèche Gorge, France. c. 30,000–28,000 BCE. Paint on limestone.* Naturalistic images of animals from seventeen different species cover the walls of Chauvet Cave.

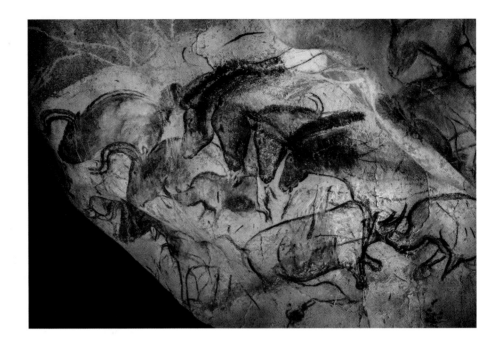

Some of the oldest known paintings are in Chauvet (show-VAY) Cave. Figure 13.7 shows a wall painting from Chauvet where about a dozen horses, rhinoceroses, and extinct oxen ancestors cover the wall. But, throughout the cave, depictions of hundreds of individual animals populate the surfaces. The images capture the graceful movements and spirit of real animals, even though they must have been drawn from memory.

The animals were depicted in a variety of ways. Sometimes, the artists stressed the animals' two-dimensional shapes either by not including ground lines or surrounding landscape or by fashioning animals from outlines. Other times, artists created the illusion of three-dimensional forms by adding modeling on animals. The artists also drew some animals over bulges in the walls, so that the wall creates a type of low relief, jutting in or out where appropriate on a particular animal.

From what the people left behind, scholars believe they have an understanding of how people made the images:

- Holes in the walls indicate the *use of scaffolding* made of tree limbs to work on out-of-reach surfaces.
- The discovery of what seem to be primitive stone lamps indicates *work was done by the light of burning fat.*
- Artists appear to have both *drawn using whole pieces of pigment* and *painted using fingers and twigs* to apply ground pigment that they had mixed with water on flat stone palettes.
- Artists likely *dissolved the ground pigment in their mouths and spit* or *used hollow reeds to spray pigment mixed with saliva* onto walls to create a speckled effect, or to create stencils (see Chapter 7) of human hands. The handprints reveal that men, women, and teenagers participated in the creative process.

Because no written records exist, understanding what the artists intended to convey is even more difficult, yet scholars have put forth interpretations. Some contend that the people drew the animals on the walls preceding hunts, so they could symbolically capture the animals before facing them in real life. However, early people did not

hunt many of the animals that appear on the walls, and so these theories have been criticized. Other interpretations stem from the paintings' remote locations. Found in dark, quiet, other-worldly spots, the paintings are far removed from the everyday world. Numerous footprints of different sizes indicate that men, women, and children visited the spaces, meaning that these locations may have been linked to early religious experiences that involved the entire community.

Whatever their true meaning, the paintings offer insight into early people's conception of art. Given its placement in such difficult-to-reach, remote locations, clearly the making and viewing of *art occupied a purposeful, essential role* in the lives of prehistoric peoples.

## Portable Sculptures

A second type of art created by these early people includes *small sculptures*. These sculptures:

- *Are hand-sized*—they would fit in the palm of your hand
- *Include* figures of mostly *women and animals*
- *Were easily portable* by people who were consistently on the move

Chapter 4 discussed the *Woman from Willendorf*, reproduced here again as figure 13.8. While this sculpture is from Willendorf (see map in figure 13.6), in what is today Austria, archaeologists have found approximately one hundred others of these sculptures throughout Europe.

Prehistoric people used a *variety of materials* for crafting portable art. This work is from stone, but bone, antler, ivory, and clay were also used. Even though many of these sculptures today appear the color of the sculpted material, they originally had added or painted color. The artist who formed the *Woman from Willendorf* originally painted her red.

Here again, no written records help to decipher the meaning of the sculptures. Chapter 4 discussed how Paleolithic people might have used works such as the *Woman from Willendorf* as a *fertility charm*. The sculpture would have fit into a woman's palm and, with its large breasts and belly, might have brought hope to a woman longing for a pregnancy. Yet, these same exaggerated body parts and small scale have prompted scholars to suggest that the sculptures might have been used as *symbols of shared values*. Opposing groups of hunter-gatherers, ever on the move, may have recognized one another as friendly if they shared the same sculptural type. In addition, larger, heavier sculptures would not have been practical for groups continuously moving from place to place.

**FIGURE 13.8.** *Woman from Willendorf* **reconsidered.** Nomadic Paleolithic people could carry this small sculpture with them when they moved from place to place.

*Quick Review 13.1*: What are two types of art made by Paleolithic people?

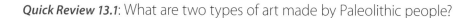

## The Neolithic Period

Around 9000 BCE in some areas, the invention of agriculture and the domestication of animals resulted in significant changes to the lands around the Mediterranean. During

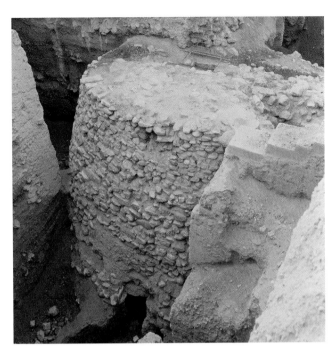

**FIGURE 13.9.** **Tower.** *c. 7500 BCE, Jericho, Israel.* To be able to build this round tower, Neolithic people must have worked together.

the same period, people began to settle down in small villages, and permanent architecture appeared, allowing people to shelter in a single place. Referred to as the Neolithic revolution by scholars, fundamental changes occurred slowly over several thousand years:

- *Food was readily available.* Agriculture and the domestication of animals made this possible.
- *Pottery became commonplace.* Fragile, heavy, and inefficient for nomadic people, pottery is invaluable to a food-producing community that needs waterproof containers to store seeds and grains.
- *Specialization of labor occurred.* Since not all community members were tasked with acquiring food, some people could fulfill different roles.
- *Large groups of people could be organized for important tasks.* Spurred on by experience with communal living and crop cultivation, hundreds of people worked together to construct large, permanent, stone monuments.

One example of large-scale organization comes from the Neolithic community of Jericho, located in present-day Israel (see map in figure 13.6). In 7500 BCE, the inhabitants constructed a wall. A full five feet thick and thirteen feet high, the wall gave the impression of standing even taller because it was circled by a six-foot-deep ditch. A round stone tower (figure 13.9), which stood twenty-eight-feet high and was thirty-three feet in diameter, contained a circular internal staircase that gave access to the ramparts.

While the biblical story of the battle of Jericho describes how the community's wall fell down, scholars are unsure whether the people built the wall to defend the village or even if the wall circled the entire community. Perhaps the wall served as protection against flash floods that would have brought damaging sands into the community. The tower also may have served a religious purpose. Regardless, the wall is an example of art that, like the Parthenon, *fulfilled an important purpose.*

*Quick Review 13.2*: What changes came about because of the Neolithic revolution that affected art?

# Early Civilizations

By approximately 3500 to 3000 BCE, agriculture had been perfected to such an efficient state that communities could support urban centers with upwards of forty thousand inhabitants. Food production was predictable, and this vital factor led to the emergence of early civilizations with fundamental differences from the Neolithic villages that preceded them. They had:

- *Cities* with large populations
- People divided into *separate social classes*

FIGURE 13.10. Ancient Mesopotamia and Egypt. Early civilizations arose around fertile rivers in Mesopotamia and Egypt.

- *Governments* that administered food production and distribution, defended the population, and resolved disputes
- Organized *religion*
- Large-scale *architecture*
- *Metal* production
- Sophisticated *irrigation* techniques
- *Written* language

The first civilizations around the Mediterranean emerged in *Mesopotamia* (in what is today Iraq) and *Egypt* (see map in figure 13.10). These early civilizations arose around rivers, which afforded water for drinking, irrigation, and travel. In Mesopotamia, two rivers, the Tigris and Euphrates, created an arc-shaped lush region appropriately called the Fertile Crescent. In Egypt, civilization arose around the Nile River, which flooded annually, creating a narrow fertile plain in a land otherwise surrounded mostly by deserts.

## Mesopotamia

For approximately three thousand years, different peoples, who hailed from different regions and spoke different languages, ruled Mesopotamia. With no natural defenses,

Mesopotamia was the target of frequent invasions. During this tumultuous period, the *various peoples formed art with different styles.* Nevertheless, the art across these distinct groups *featured the same purpose—advancing the power of the elite.* It was in Mesopotamia that the roots of the type of political and religious art that would appear later at the Parthenon began to emerge.

## Sumer

The Sumerians were the first recorded people to rule Mesopotamia, starting in about 3500 BCE, from a region known as Sumer (see map in figure 13.10). A remarkable people, the Sumerians invented the plow, the wheel, and a form of writing called **cuneiform**, made of wedge-shaped marks.

Like Greece, Sumer was divided into city-states, each with its own government and patron deity. To commune with these deities, the Sumerians built **ziggurats**, immense platforms, crowned with temples. The Sumerians believed that the ziggurat was a sacred mountain and that the patron god inhabited the top. Figure 13.11A and B shows a ziggurat dedicated to Nanna, the moon patron deity of the city-state of Ur.

*Ziggurats served essential religious, administrative, and political functions.* From the ziggurat, rulers communicated with the patron god to ensure the city-state's good fortune, and ran the city-state by supervising the distribution of seed to farmers, controlling irrigation, and collecting food for distribution.

However, the *ziggurats also served to promote the status of the ruling priestly class.* Every Sumerian city contained a ziggurat, which towered over the community and which the general population was not allowed to ascend. At Ur, every brick was stamped with the name of the ruler who had built the 190-foot-wide, fifty-foot-high ziggurat, just in case the people needed a reminder of who was in charge.

The graves of this ruling class show that these elites must have led a privileged life. In one tomb, undoubtedly belonging to a king, the Sumerians ritualistically laid out the bodies of seventy-four attendants, perhaps intentionally sacrificed, so that they could accompany the king to the afterlife. The Sumerians also filled elite tombs with elaborate grave goods such as jewelry, musical instruments, armor, and chariots.

One such grave good is called the *Standard of Ur* because its original excavator thought it had been a standard carried by troops; the object's function remains unknown. The *Standard* is in the form of a box, with panels on each side set up in **registers**, or horizontal strips. Figure 13.12 shows one panel. It reads from bottom to

**cuneiform** The writing developed in ancient Mesopotamia that consisted of wedge-shaped marks

**ziggurat** An enormous platform structure upon which a temple stood, from which Mesopotamian rulers communed with the gods and ran the city-state

**register** A horizontal strip in a work of art

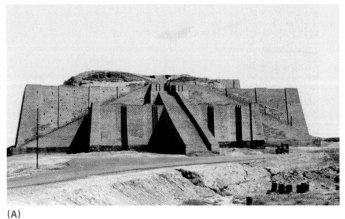
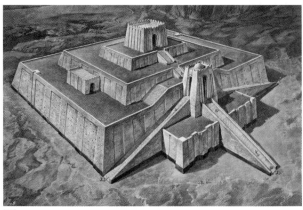

(A)  (B)

**FIGURE 13.11A AND B (RECONSTRUCTION DRAWING).** **Ziggurat, northeastern façade, with restored stairs.** *c. 2100 BCE, Ur (present-day Muqaiyir, Iraq).* The ziggurat formed the base for a temple, which does not survive today (13.11A), but is visible in the reconstruction drawing (13.11B).

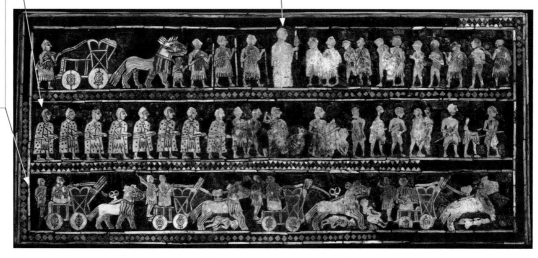

1. At the bottom, Sumerian chariots trample naked enemies (so shown to depict their lower, humiliated status).

2. In the middle, Sumerian soldiers lead captured, naked enemies.

3. At the top, soldiers present naked prisoners to a ruling figure, who is shown with such hierarchical scaling—*his large size denoting his importance*—that his head breaks through the line of the top register.

**FIGURE 13.12.** ***Standard of Ur,*** **war panel.** *From the Royal Cemetery, Ur (present-day Muqaiyir, Iraq). c. 2500 BCE. Wood inlaid with shell, lapis lazuli, red limestone, and bitumen, 8" × 1′ 7". The British Museum, London.*

top, from left to right, and is quite different from Paleolithic cave paintings in which the figures floated on the surfaces. Here, figures stand on the ground lines of the registers.

Like the Parthenon frieze created centuries later, the *Standard of Ur* panel portrays a procession. The panel likewise *communicates a message of power*—in this case, the supreme status of the ruler and his elite military men.

## Akkad

Yet another example of Mesopotamians *using art to promote their leaders* comes from the next people to control the Fertile Crescent. In 2334 BCE, an Akkadian king united the region into an empire, ruling from Akkad (see map in figure 13.10). The art that comes from this period promoted his and his successors' rule.

A hollow-cast, copper head of an Akkadian king who sports a formal, stylized beard shows a determined ruler (figure 13.13). The sculpture originally had eyes inset with precious stones and a complete body. It is probable that invading enemies decapitated the original sculpture as a deliberate attack on the king.

## Babylonia

In 1830 BCE, the Amorites took control of the Fertile Crescent, situating themselves in Babylonia (see map in figure 13.10). One ruler, Hammurabi, is famous for codifying a set of laws to ensure consistent consequences for misdeeds. Prior to Hammurabi, laws and punishments varied across the region. Hammurabi's laws were significantly more severe than many

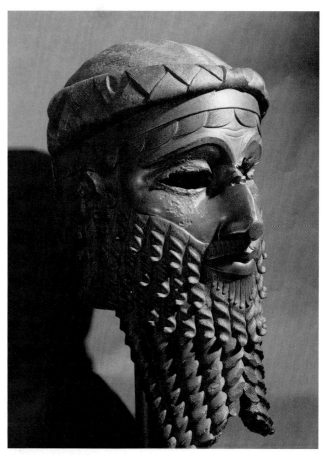

**FIGURE 13.13.** **Head of an Akkadian ruler.** *From an original full-body sculpture, from Nineveh (present-day Kuyunjik, Iraq). c. 2250–2200 BCE. Copper, original eyes from precious stones, 1′ 2 ⅜″ high. National Museum, Baghdad.* This head of a ruler features an idealized form.

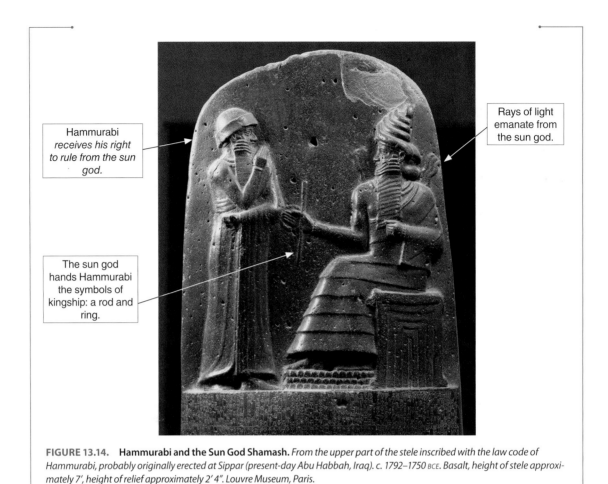

Hammurabi *receives his right to rule from the sun god.*

Rays of light emanate from the sun god.

The sun god hands Hammurabi the symbols of kingship: a rod and ring.

**FIGURE 13.14.** **Hammurabi and the Sun God Shamash.** *From the upper part of the stele inscribed with the law code of Hammurabi, probably originally erected at Sippar (present-day Abu Habbah, Iraq). c. 1792–1750 BCE. Basalt, height of stele approximately 7′, height of relief approximately 2′ 4″. Louvre Museum, Paris.*

**stele** A large upright stone slab upon which images and/or writing are often inscribed

laws today. For example, if a son hit his father, he would have his hand cut off, and if a thief stole an animal from the court, he would have to pay back thirty times the cost.

Hammurabi had his code inscribed on a vertical stone marker called a **stele** (STEE-lee). The top of the stele (figure 13.14) shows the continued Mesopotamian *promotion of the ruler's authority*, here linking Hammurabi with the divine.

### Assyria

Beginning in 1328 BCE, a new group took over Mesopotamia, ruling from Assyria (see map in figure 13.10). Again, the rulers *used art to promote their authority*. Ruling from monumental gated palaces raised on fifty-foot platforms with hundreds of rooms, the rulers were intent on impressing those around them.

A typical example of royal influence comes from the palace of King Assurnasirpal II, where the walls depicted stories of the king's heroics. In figure 13.15, the king follows the tradition of early Mesopotamian rulers by representing himself killing wild lions as a metaphor for protecting his people with his prowess. The king is at center, his bow outstretched, about to launch an arrow into a lion that appears to rear dangerously onto his chariot. What the low reliefs didn't mention was that by Assurnasirpal II's time, lion hunts occurred in the safe confines of the palace gardens. Yet, the *reliefs continued the Mesopotamian tradition of showcasing the king's power*, here, as propaganda, with stories orchestrated for effect.

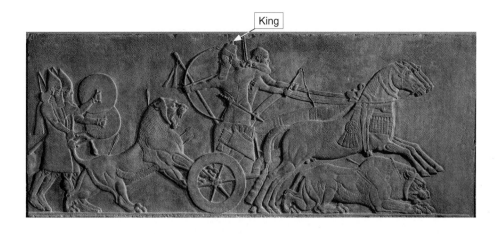

King

**FIGURE 13.15.** **King Assurnasirpal II hunting lions.** *From the palace complex of Assurnasirpal II, Kalhu (present-day Nimrud, Iraq). c. 883–859 BCE. Alabaster, 3′ 3″ × 8′ 4″. The British Museum, London.* Images showing Assurnasirpal II fighting off lions showcased the king's heroics to palace visitors even though the king was never in danger.

*Quick Review 13.3*: How do different examples of Mesopotamian art show the same purpose of advancing the power of elites?

## Egypt

Egyptian life followed the rhythm of the Nile. Every year, the river swelled from mountain rains. When it returned to its banks, the river left a layer of silt on the land that was ripe for cultivation. For Egyptians, the visible line between the dark, life-giving silt and the light-colored, unusable desert sand was symbolic of their *dual worldview*.

Egyptians believed that *order and chaos existed in the world in harmonious opposition* and that one could not exist without the other. Just as the fertile, ordered silt had its opposition in the chaotic desert sand, so too did other aspects of Egyptian life. For example, a duality existed between Egypt, which represented stability, and foreigners, who represented chaos.

The Egyptian king, known as *the pharaoh, was responsible for maintaining stability* in the land. The Egyptian people believed that the pharaohs were uniquely able to protect them because they alone had the ability to intercede with the gods.

The pharaoh's role in the Egyptian dual worldview can be seen in a necklace, which contains both figures and a **hieroglyph**—a character from the writing developed in ancient Egypt that consisted of pictorial representations and symbols of sounds and ideas. The necklace was given by the Pharaoh Senwosret III to the Princess Mereret. When Mereret wore the necklace, it represented *the pharaoh's ability to maintain stability* and *served as protection from the chaos of illness and bad luck*. The pharaoh's success was symbolized by the overall symmetry and order of the piece and specifically depicted figures (figure 13.16).

Unlike Mesopotamia, Egypt had a geography that allowed the pharaohs to maintain order relatively easily. The natural barriers of deserts and the Mediterranean Sea (see map in figure 13.10) protected the country from invasion, so Egypt enjoyed lengthy periods of continuous rule for thousands of years.

**hieroglyph** Writing developed in ancient Egypt that consisted of pictorial representations and symbols of sounds and ideas

### The Role of Art in Promoting the Rule of the Pharaoh

The Egyptian desire for *order over chaos* and the geopolitical stability in the country fostered a relatively *consistent style of art*. Artists worked within established parameters, conforming to certain visual conventions or norms that Egyptians expected. The *conventions promoted the strength, permanence, and rule of the pharaohs*.

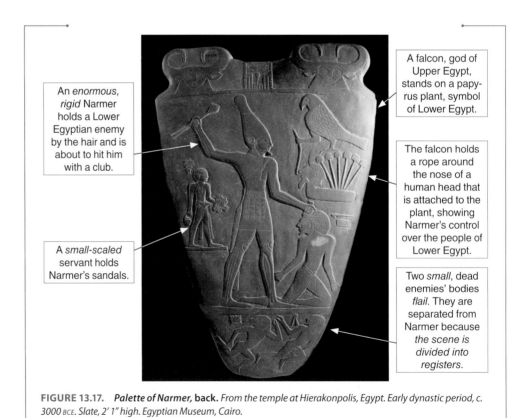

The pharaoh is represented by two bird-headed, feline creatures known as sphinxes.

A vulture deity spreads her wings over the *symmetrically balanced, structured* scene and stands on an oval shape in which Senwosret III's name is written.

The pharaoh physically *suppresses his enemies*: the sphinxes subdue two fallen enemies with their back legs and, with their front legs, they are about to crush two more foreigners who raise their hands for mercy.

**FIGURE 13.16.** **Necklace ornament of the Princess Mereret.** *From her burial in the pyramid complex of Senwosret III, from Dahshur, Egypt. Late twelfth dynasty, c. 1820 BCE. Gold, carnelian, lapis lazuli, and turquoise, 2 ⅜" × 3 ⅜". Egyptian Museum, Cairo.*

**palette** A flat stone with an indentation used for grinding eye makeup that the Egyptians used to ease sun glare and for decoration

We can see one of these rulers on the front of the *Palette of Narmer*. It is called a **palette** because the reverse side of the flat stone contained an indentation for grinding and mixing eye makeup. The scenes on the palette celebrated the unification of Lower and Upper Egypt under a single king, Narmer (figure 13.17).

An *enormous, rigid* Narmer holds a Lower Egyptian enemy by the hair and is about to hit him with a club.

A *small-scaled* servant holds Narmer's sandals.

A falcon, god of Upper Egypt, stands on a papyrus plant, symbol of Lower Egypt.

The falcon holds a rope around the nose of a human head that is attached to the plant, showing Narmer's control over the people of Lower Egypt.

Two *small*, dead enemies' bodies *flail*. They are separated from Narmer because *the scene is divided into registers*.

Interactive Image Walkthrough

**FIGURE 13.17.** ***Palette of Narmer,* back.** *From the temple at Hierakonpolis, Egypt. Early dynastic period, c. 3000 BCE. Slate, 2' 1" high. Egyptian Museum, Cairo.*

The palette shows some of the conventions that artists used in Egypt for centuries and how these conventions *depicted the ruler in a specific, standard, unrealistic way* to denote his high rank. Narmer is:

- *Hierarchically scaled.* He is larger than the enemies and his attendant, to denote his important rank.
- *Formal, vertical, and controlled, denoting order.* Conversely, the enemies' bodies flail in different directions, denoting chaos.
- *Depicted in a composite view, showing the most recognizable view of each part of his body.* The artist made no attempt to make him look three-dimensional; rather the artist combined two views. We see Narmer's face, feet, and hips from a profile view and his eye and chest from a frontal view.
- *Shaped so that the size and location of his body parts conformed to established norms rather than a likeness to his real physique.* Before depicting pharaohs and other elites, artists laid down grids on surfaces to ensure that they drew certain body parts in predetermined ways.

## Traditional Egyptian Art

For centuries, the Egyptians had no reason to change the consistent style of their art. This tradition can most easily be seen when considering tomb art. Certain religious practices developed around the belief that while every person had a human body that would eventually die, each also had a *ka* or life spirit (like a soul) that was divine and lived forever. As it was believed that pharaohs could intercede with the gods on the people's behalf both during life and after death, Egyptians particularly wanted to support the pharaoh's *ka* after the pharaoh had died to ensure that it could *intercede on the people's behalf for eternity*. The *ka*, therefore, needed a place to reside, and so art became indispensable, with Egyptians creating *tomb architecture* and *ka sculptures*.

### Tomb Architecture

Between 2551 and 2472 BCE, the Pharaohs Menkaure, Khafre, and Khufu had the most famous tombs, the Great Pyramids, built at Giza (figure 13.18A). The restored view in figure 13.18B shows that the pyramids were part of a funerary complex set up on an east–west axis. Scholars suggest that Egyptians believed that pharaohs were the descendants of the sun god, and they arranged the tomb complex to reinforce this link. Each day priests moved from east to west, just like the sun, moving from a valley temple, through a causeway, to a funerary temple (which abutted the pyramid). There, they performed rituals and brought food, drinks, and offerings for the dead pharaoh's *ka* to ensure its happiness, so it would continue to *promote stability* in Egypt.

Building the massive pyramidal structures was no easy task. The largest pyramid at Giza, belonging to Khufu, originally stood 479 feet high and was thirteen acres at its base. The builders used no mortar, so they had to cut the 2.3 million limestone blocks precisely; each block weighed two and a half tons.

The pyramids were solid stone except for the tomb chambers containing the dead pharaoh's remains and the passageways to access those chambers. Likely to ensure the *ka's* continued happiness in the afterlife, the Egyptians buried pharaohs with furniture, chariots, clothes, jewelry, wall paintings, and many other luxury and worldly possessions. The builders devised many methods to thwart grave robbers. In Khufu's pyramid, the builders constructed three false passageways and blocked the real passageway with a fifty-ton stone.

In addition to serving the dead pharaoh's *ka*, the pyramids *glorified the rule of the pharaohs*. Like the Parthenon centuries later, the pyramids were a monumental *sign of power*.

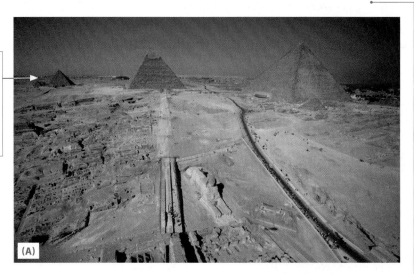

The Great Pyramids towered above the desert landscape, as we can still see today.

(A)

Originally, a valley temple stood at the edge of the cultivated flood plain.

Heading west into the desert ran a roofed causeway that connected the valley temple to a funerary temple.

The funerary temple abutted the sealed pyramid where the dead pharaoh's mummified remains resided.

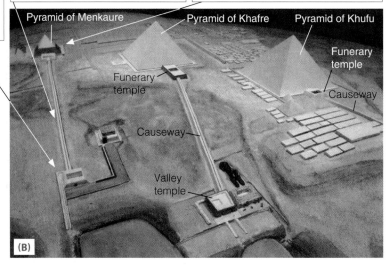

Pyramid of Menkaure    Pyramid of Khafre    Pyramid of Khufu

Funerary temple

Funerary temple

Causeway

Causeway

Valley temple

(B)

**FIGURE 13.18A (CURRENT VIEW) AND B (RECONSTRUCTION DRAWING).** **Great Pyramids, erected for Menkaure, Khafre, and Khufu.** *Fourth dynasty, c. 2551–2472 BCE, Giza, Egypt.*

Despite the precautions taken against grave robbery, many tombs were plundered, so later pharaohs had builders hide their tombs in the Valley of the Kings. Nevertheless, they continued to construct lavish funerary temples. Although the temples were no longer adjacent to the tombs, scholars believe priests still performed rituals in them for the pharaoh's *ka*.

One surviving funerary temple from this period belonged to Hatshepsut, one of the few female rulers of Egypt (figure 13.19). Hatshepsut was the daughter of one pharaoh and most important wife of another. However, after her husband died, leaving as his heir the son of a secondary wife, Hatshepsut declared herself pharaoh.

**artists**
MATTER

Senmut

Built by Senmut, Hatshepsut's chief administrator, Hatshepsut's temple was a tribute to her status as pharaoh and validation of her rule. Senmut's design reflected the pharaoh's role in *maintaining stability*. Horizontal terraces and vertical colonnades linked Hatshepsut to order versus the chaos of the surrounding landscape.

**FIGURE 13.19.** **Senmut. Funerary temple of Hatshepsut.** *Eighteenth dynasty, c. 1473–1458 BCE, Deir El-Bahri, Egypt.* Possibly to show Hatshepsut's power over chaos, Senmut had her temple cut directly into the cliffs.

### *Ka* Sculpture

*Ka* statues of the pharaoh played a major role in the temples. They served as another resting spot for the pharaoh's *ka*, allowing it to enjoy the rituals at the temples and intercede for the people for eternity. Similar to low-relief representations of the pharaoh, freestanding statues also followed certain conventions, as seen in figure 13.20. The Pharaoh Khafre is:

- *Rigid, immobile, and formal*, underscoring his divine authority.
- Shaped with *conventional proportions*.
- Shown *frontally*; many sculptures in the temples inhabited niches, so the frontal pose allowed the pharaoh's *ka* to look out from the niche from within the statue and be in the best position to appreciate the rituals performed by the living.
- Depicted in the *prime of life*, the idealized form used for elites.
- *One with the dense block*; no spaces separate his arms or legs from his body or the throne, showing his solid power.

While *ka* sculptures maintained convention, not all sculptures in Egypt had such appearances. For a different look, see *Practice Art Matters 13.1: Compare Sculptures of Elite and Non-Elite People.*

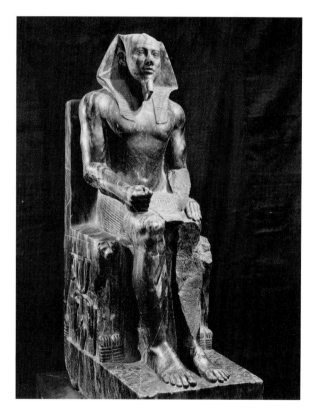

**FIGURE 13.20.** **The Pharaoh Khafre.** *From his valley temple, Giza, Egypt. Fourth dynasty, c. 2500 BCE. Diorite, height 5′6″. Egyptian National Museum, Cairo.* The compact form projects a permanence that would endure forever.

### Akhenaten's Revolution

In the history of Egypt, there was one pharaoh who deliberately changed Egyptian religion and artistic convention. Egyptians had traditionally worshipped multiple gods, but when Amenhotep IV came to the throne in 1353 BCE, he designated the sun god, Aten, as the sole god. Amenhotep changed his name to Akhenaten (meaning beneficial to the Aten)

## 13.1  Compare Sculptures of Elite and Non-Elite People

The conventions reserved for the pharaoh and other elite Egyptians are particularly evident when considering a sculpture of a person from a lower status. In Egypt, everyone had a place in an ordered hierarchy. The pharaoh was at the top, and the king's family and high-ranking officials were next. Common people were at the bottom. Artists depicted those of lower social status less formally and more realistically.

Figure 13.21 shows a freestanding sculpture from Egypt of a man who is brewing beer. Depicted without convention, he works to push the beer through a sieve.

How does the beer brewer's form differ from that of the Pharaoh Khafra's depicted in figure 13.20? To answer this question, consider all of the conventions mentioned about Khafra and how or if this man differs on each of those aspects.

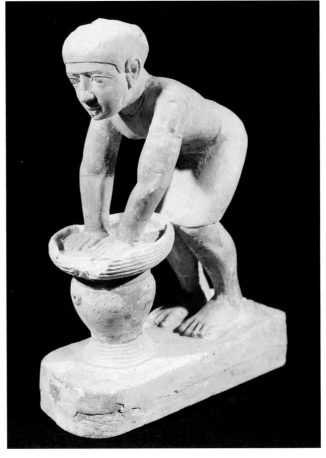

**FIGURE 13.21.**   **Model of a man making beer.** *From Saqqara, Egypt. Fifth dynasty, 2494–2345 BCE. Stone. Egyptian National Museum, Cairo.*

and moved his capital to Tell el-Amarna. Akhenaten dramatically *altered the established conventions* in order to *promote his vision and monotheistic religion.*

In a relief from Tell el-Amarna, Akhenaten appears less formally with his family in a tender, personal moment. The intimate portrait shows Akhenaten's *relaxed style* that defied traditional Egyptian conventions (figure 13.22).

Gone are the formal, timeless, idealized depictions of other rulers with the old system of proportion. Instead, the pharaoh's image shows seemingly *unflattering characteristics.* He has a long head, an extended neck, thin arms, an emaciated chest, a sagging belly, and large thighs. The pharaoh also appears elongated and curved.

While some scholars argue the new formula was a new convention, stylizing the pharaoh's body in an innovative way, others suggest it depicted the king's real physical deformities, maybe from a medical condition. If so, the change would have been even more revolutionary as it would have *shown the pharaoh in a naturalistic style, previously reserved for those of low status.*

Akhenaten's sun god, Aten, depicted as a disk, reaches out to the family with rays ending in human hands that hold the hieroglyphic symbol of everlasting life.

Akhenaten *affectionately brings his daughter to his face,* while his principal wife, Nefertiti, *holds the couple's two other daughters.*

**FIGURE 13.22.** **Akhenaten, Nefertiti, and their three daughters.** *From a shrine on an altar stele in a private home, from Tell el-Amarna, Egypt. Eighteenth dynasty, c. 1353–1336 BCE. Painted limestone sunken relief, 12 ¼" × 15 ¼". Agyptisches Museum, Berlin.*

**FIGURE 13.23.** **Innermost coffin of Tutankhamun.** *From his tomb, from Thebes, Egypt. Eighteenth dynasty, c. 1323 BCE. Gold with inlay of enamel and semiprecious stones, height 6' 11". Egyptian Museum, Cairo.* Tutankhamun's return to traditional Egyptian convention can be seen in the rigid position of his coffin.

## A Return to Tradition

After Akhenaten's death, life in Egypt abruptly returned to traditional ways. The next pharaoh changed his name from Tutankhaten to Tutankhamun to show he honored the old chief god, Amun, rather than Aten. Coming to power when he was only nine or ten, Tutankhamun was likely influenced by powerful priests and court officials eager to return to the status quo. He abandoned Tell el-Amarna, returned to the capital of Thebes, and reestablished the polytheistic religion. *Art returned to the formal proportions and conventional ways.*

Tutankhamun is well known today because in 1922 archaeologists discovered his tomb's inner chamber intact. The small tomb (likely due to the fact that Tutankhamun died suddenly at the age of eighteen) illustrates the remarkable grave goods buried with pharaohs. In Tutankhamun's tomb, there were five thousand objects, some related to daily life to enhance the happiness of the pharaoh's *ka* and others specific to funerary requirements.

Figure 13.23 shows a funerary item—the innermost of three nesting coffins that held Tutankhamun's remains. Made of 250 pounds of solid gold, it is impressive for both its value and symbolic *promotion of Tutankhamun's high status as a god.*

The coffin illustrates how previous artistic conventions had returned:

- The pharaoh holds a *stiff, formal pose.*
- He faces *frontally,* so that his *ka* could look out from his coffin.
- He has *idealized,* perfect features.
- *No negative space* intrudes into his closed form.

Even though Tutankhamun was Akhenaten's own son, he defied the earlier pharaoh's ideals. Akhenaten's revolution was short-lived in a country that had maintained convention for centuries.

# The Greco-Roman World

The next civilizations that dominated the lands around the Mediterranean hold a special place in the history of the Western world. It is upon the Greco-Roman world that many of the tenets of Western civilization today are based:

- From Greece come the concepts of *democracy*, the *potential of humanity*, and an interest in *understanding the natural world*.
- From Rome comes our understanding of the benefits of *multiculturalism, inclusion,* and *strategic infrastructure*.
- From both Rome and Greece come the basis of *modern politics, philosophy, science,* and *literature*.

## Greece

In approximately 900 BCE, the ancient Greeks began to form self-governing city-states. As in Athens, all Greeks envisioned themselves as members of their own sovereign communities. However, all Greeks also saw themselves as culturally different from non-Greeks: Greeks spoke the same language, worshipped the same gods, competed in the same Olympic Games, and held common values. They believed that *humanity was the most perfect creation, individuals were important,* and *people should strive to perfect their minds and bodies*. The attitude that these beliefs promoted helped foster the development of the first democracy, in 508 BCE in Athens, in which select males could participate in governing as citizens. The Greek world is shown in the map in figure 13.24.

**FIGURE 13.24.  The Ancient Greek World.**  Beginning in 900 BCE, the Greeks began to form city-states on mainland Greece, and eventually their influence extended to other outposts around the Mediterranean. In the Hellenistic period, beginning in 330 BCE, kingdoms to the north, south, and east of mainland Greece dominated the region.

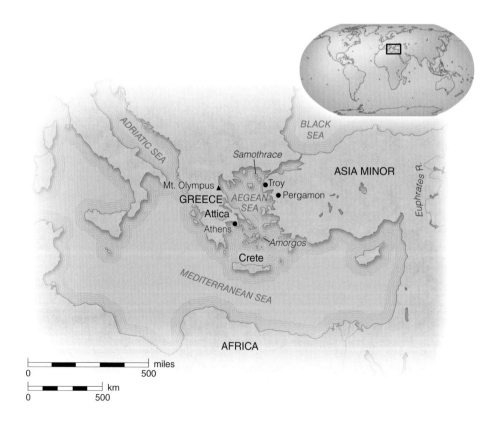

## The Greek Sense of Individual Identity and Status

Life in Greece had much to do with understanding who you were. Greeks were conscious of their position both as members of a city-state and the wider Greek world. However, they were also aware of their identities as part of a section of society within their city-states. *Different people had different standings*, and their *status determined their rights*.

For example, Greeks, citizens, and men had a high status, while non-Greeks, slaves, and women had a low status. The Greeks relegated women, for example, to the domestic sphere and banned them from participating in government or going to the theater. Women's ability to march in the Panathenaic festival in Athens (figure 13.5) was one of their only chances to leave their homes.

## The Role of Art in Promoting the Status of Different People

*The primary purpose of Greek art was to promote the status of certain people.* A vase painting depicting the legend of the Greek hero Achilles killing the Amazon Queen Penthesilea illustrates the role art played in reinforcing ideas about the status of different people (figure 13.25). As a woman warrior, Penthesilea had assumed a nontraditional, unnatural position.

To illustrate the story and reinforce traditional societal roles in which regular women's status was subordinate to men's, the artist Exekias depicted the fighters in different ways. The figures provided a *model for male and female social identity* in which men were dominant over women:

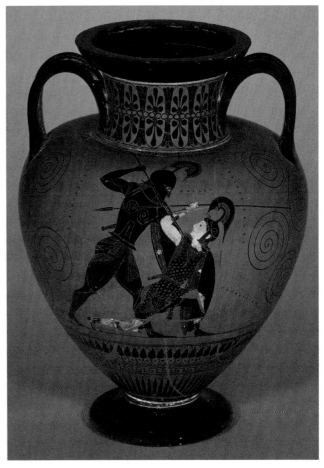

FIGURE 13.25.   Exekias. Amphora showing Achilles killing Penthesilea. *c. 530–525 BCE. Ceramic, height 16 ¼". The British Museum, London.* This image emphasized the superior role of men over women in Greek society.

- *Achilles is aggressive.* His body dominates Penthesilea's in a violent, diagonal line, with his arm raised menacingly over his head. She rhythmically mirrors his diagonal pose and raised arm, but falls backward, holding her arm in a defensive, weak position.
- *Achilles is mostly nude, a state associated with athleticism, heroism, and perfection.* (Men exercised and competed in the Olympic Games in the nude.) His body is muscular and idealized because the Greeks valued him for strength and character. Penthesilea, conversely, is dressed in a complex, patterned costume, with her body mostly hidden because the Greeks valued her only for fine clothing.
- *Achilles wears his helmet over his face.* He stares down at Penthesilea from inside a black mask of calm determination. Penthesilea's helmet is pushed back, exposing her vulnerable, fearful face.

This particular vase painting advanced the superior status of men. Unlike earlier civilizations that had promoted the status of rulers, in Greece, art *promoted the status of individuals*. While the style of Greek art changed quickly, this approach of *showing the position, success, and power of different regular people* was consistent in all the different chronological periods we will discuss next.

Deer

Funeral
scene

(A)

(B)

**FIGURE 13.26A AND B (DETAIL).** Dipylon Master. Geometric amphora. *From the Dipylon Cemetery, Athens, Greece. c. 750 BCE. Terra-cotta, height 5' 1". National Archaeological Museum, Athens, Greece.* Abstracted deer circle the top of this vase (13.26A), while a scene showing a funeral decorates a panel (13.26B).

## The Geometric Period

**Geometric period** The period of Greek art history from 900 to 600 BCE characterized by pots with geometric patterns

The earliest art to emerge in Greece beginning in 900 BCE is from the **Geometric period**. The art featured rows of zigzag patterns, lines, shapes, and sometimes simplified, geometric human and animal forms. Artists depicted designs on pottery that marked the graves of the dead.

Figure 13.26A shows a Geometric-period pot from the Dipylon Cemetery in Athens. Even in this early vase, the artist was already *promoting the status of an individual.* The size of the grave marker determined the prestige of the deceased and that individual's family. This enormous vessel, standing five feet and one inch tall, belonged to a member of an elite family. The size of the vase is particularly remarkable given that the Greeks threw pots on wheels spun not through the use of a flywheel (see Chapter 11), but by the hands of apprentices.

In addition, the artist promoted the status of the deceased in the funerary scene (figure 13.26B). During this period, to give the perception of prestige, wealthy families hired professional mourners to attend funerals to ensure a large turnout. Here, a number of mourners rip their hair in grief, showing how important the family of the deceased must have been.

## The Archaic Period

**Archaic period** The period of Greek art history from 600 to 480 BCE characterized by sculptures of large-scale, rigid, frontal figures

In approximately 600 BCE, a change overtook Greek art as artists began producing large, freestanding, stone sculptures. In the **Archaic period**, the *human figure took center stage.*

**kouros** A sculpture from the Archaic period of a standing, nude, male youth

**kore** A sculpture from the Archaic period of a standing, clothed, female youth

Figure 13.27 shows a typical freestanding sculpture from this period called a **kouros** (KOO-ros) or standing male youth. Artists made thousands of these statues at this time, some depicting young men and others, called **kore** (KO-rai), depicting standing young women. The sculptures were placed as grave markers and in sanctuaries. Since only the wealthy could afford to commission such expensive sculptures, they *promoted the individual and his or her family's status.*

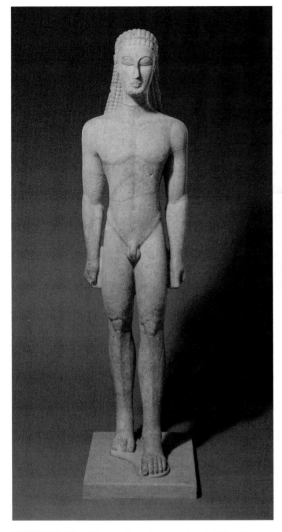

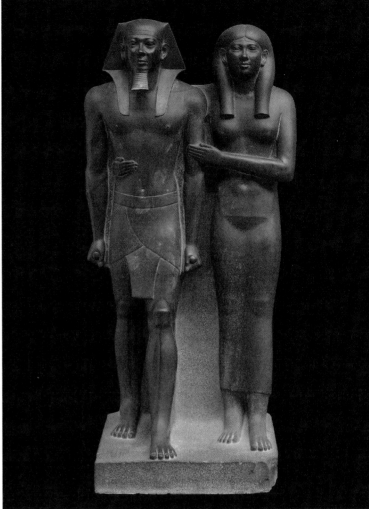

**FIGURE 13.27.** *Kouros. Found over a grave in Attica, Greece. c. 590–580 BCE. Marble, height 6' 1 ½". The Metropolitan Museum of Art, New York.* The *kouros's* pose is similar to that of an Egyptian Pharaoh.

**FIGURE 13.28.** **Menkaure and a queen reconsidered.** The frontal and rigid poses of Egyptian sculptures likely served as a model for Archaic *kouros*.

Egyptian style may have influenced the Archaic style. For a comparison, consider the Egyptian sculpture discussed in Chapter 10 of Menkaure and a queen reproduced here again as figure 13.28. Like Menkaure, the *kouros* is:

- *Unnaturally static and fixed,* even though he takes a step forward
- *Rigid, frontal,* and holds his hands stiffly at his sides
- *Idealized,* blemish-free, and muscular
- *Life sized*

However, there also are important differences between the *kouros* and the Egyptian sculpture:

- *The kouros depicts an individual, not a ruler.* Given the importance of the individual's status in Greek art, this very fact makes the *kouros* undeniably Greek.
- *The kouros is freed from the block, unlike the pharaoh and his queen.* Open space appears between his arms, body, and legs, making him less compact.

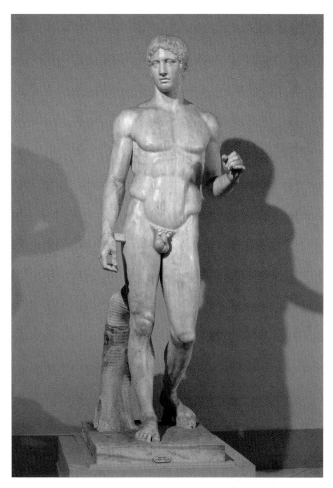

**FIGURE 13.29.** **_Spear Bearer._** *Roman marble copy (tree trunk and brace strut are Roman additions) after an original Greek bronze sculpture of c. 450–440 BCE by Polykleitos. Height 6′ 11″. National Archaeological Museum, Naples, Italy.* The original figure held a spear over his left shoulder, hence the title.

**Classical period** The period of Greek art history from 480 to 330 BCE characterized by sculptures of large-scale, idealized, weight-shifting figures

**contrapposto** A stance first used in Greek sculptures of standing figures during the Classical period to give the appearance of the potential for movement by having weight rest on one leg, while the other leg is relaxed and the rest of the body shifts

- *The kouros is nude.* Of course, the sculpture's nudity denotes this individual's status, making him even more idealized, akin to an athlete or hero. Not surprisingly, artists depicted similar statues of women with clothing.

### The Classical Period

In 480 BCE, a new **Classical period** style emerged in Greece. The Classical style fully encompassed Greek beliefs in the *importance of humanity and individuals* and the desire to *perfect body and mind*.

Polykleitos's *Spear Bearer* is an example of a Classical sculpture. The original bronze sculpture is lost, but we know of the sculpture from Roman marble copies such as the one in figure 13.29.

The sculpture embodied Classical ideals:

- *The Spear Bearer was a composite based on many men, not a specific individual.* Polykleitos measured numerous real men's bodies and then calculated exact ratios for how different body parts should ideally relate to one another (head to body, fingers to hand, etc.). Using these ideal proportions, he sculpted the *Spear Bearer* as an exemplary model of a harmoniously designed figure.
- *The Spear Bearer has an idealized, athletic, youthful body that is anatomically believable.* His skin is smooth and his muscles taut.
- *The Spear Bearer stands in a* **contrapposto** *(kohn-truh-POS-toh) pose, creating a sense of the possibility of movement.* He takes a step with one leg and transfers his weight from his back to his forward leg. Opposing forces balance each other diagonally across the body, so the tense, weight-bearing right leg is countered by a tense left arm, while a relaxed left leg is countered by a relaxed right arm. The entire body reacts convincingly to the shift in weight.
- *The Spear Bearer appears to have superior character and nobility.* The Greeks believed in harmony of the body leading to perfection of the spirit, so a sculpture with harmonious proportions, idealized features, and realistic anatomy exemplified these qualities. Polykleitos depicted these intangible features in the sculpture's calm, confident, and restrained expression.

Statues such as the *Spear Bearer* were also promoters of status. During this period, the Greeks often placed such statues in sanctuaries to celebrate the greatness of a champion athlete. Having a statue portrayed so perfectly and located in such a prominent place necessarily *advanced the status of the individual* being represented.

Of course, in no place were these tendencies of depicting perfection and promoting the people's status more evident than in the Classical sculptures of the Parthenon. Here, too, the figures were generic composites, idealized, and naturalistic. The Athenians planned the sculptures to *signal their greatness* and the *greatness of their goddess Athena* to the wider world.

## The Hellenistic Period

The **Hellenistic period**, beginning in 330 BCE, ushered in a new political period. Under the ruler Alexander the Great, the Greeks had conquered territory to the north, south, and east. However, when Alexander died, his generals fought for control, eventually splitting the territory into kingdoms. Gone were the city-states that had been the mainstay of Greece for centuries. Mainland Greece was no longer the center of the Greek world; rather, Greek culture, ideas, and customs spread to conquered non-Greek lands and flourished.

In this new environment, art changed in response to the cross-cultural contact and new sociopolitical climate. Created in a world of continuous warfare, the *art often commemorated victories.*

Figure 13.30 shows a Roman copy of an original bronze Hellenistic sculpture of this commemorative type. Created for the king of Pergamon, the sculpture celebrated the king and his people's victory over an invading Gallic army. The sculpture shows a Gallic chieftain killing himself after killing his wife, in order to avoid surrender and certain enslavement.

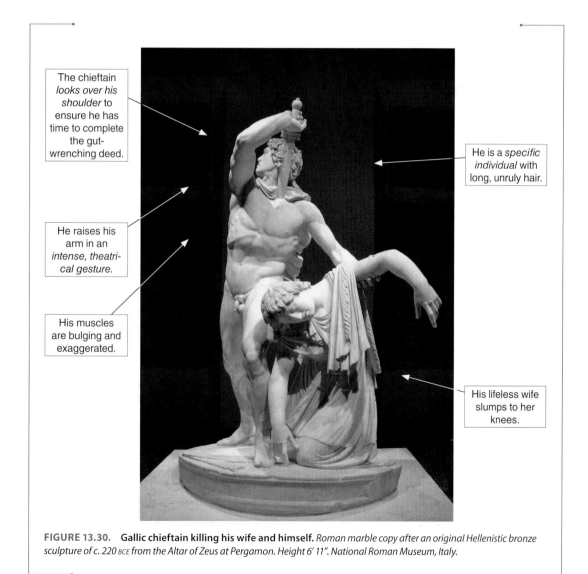

The chieftain *looks over his shoulder* to ensure he has time to complete the gut-wrenching deed.

He raises his arm in an *intense, theatrical gesture.*

His muscles are bulging and exaggerated.

He is a *specific individual* with long, unruly hair.

His lifeless wife slumps to her knees.

**FIGURE 13.30.** **Gallic chieftain killing his wife and himself.** *Roman marble copy after an original Hellenistic bronze sculpture of c. 220 BCE from the Altar of Zeus at Pergamon. Height 6′ 11″. National Roman Museum, Italy.*

Interactive Image Walkthrough

The sculpture reflects the new Hellenistic approach:

- *The pair is dramatic, violent, and emotional.* The chieftain's facial expression, posture, and gesture illustrate the anguish and heroism of his mental state.
- *The chieftain is a specific person.* He is in the midst of acting out his individual struggle, at a particular moment in time.
- *The sculpture takes full advantage of the idea of sculpture in the round.* The chieftain twists his posture, so he is in the midst of motion; we can barely see his face because of his action, and we would need to move around the sculpture to appreciate its entirety.

However, the sculpture is also quintessentially Greek. The two figures are *life-sized*, *naturalistic*, and *idealized*, and the sculptor understood principles of *weight* and *contrapposto*. The sculpture also *promotes the status of an individual*. Every decision the sculptor made to increase the worthiness of the chief—from presenting him well-muscled, heroic, and nude and his wife dressed—reflected back on the *superior status* of the people of Pergamon. While figure 13.30 offers one example of a Hellenistic sculpture, to explore how similar features can be seen in another work of art, see *Practice Art Matters 13.2: Describe a Hellenistic Sculpture.*

---

*Practice* art MATTERS

## 13.2 Describe a Hellenistic Sculpture

Figure 13.31 shows a sculpture of Nike, the Greek goddess of victory (her arms and head have been lost). The sculpture originally resided in a sanctuary atop a cliff overlooking the sea on the island of Samothrace. Positioned on a stone base meant to resemble the prow of a warship, the entire piece originally stood in the reflecting pool of a fountain, so that as the water flowed around the base, it appeared as if the ship was splashing through waves. Nike is shown, her wings still outstretched from her flight, alighting on the prow. The sculpture celebrated a victory at sea in 190 BCE during the Hellenistic period.

Consider these questions:

- What features make this piece stylistically Hellenistic?
- What features make this piece typically Greek?
- Why did the Hellenistic culture create sculptures that look like this one?

**FIGURE 13.31.** *Nike of Samothrace. From the Sanctuary of the Great Gods, Samothrace, Greece. c. 190 BCE. Marble, figure height 8′ 1″. Louvre Museum, Paris.*

## Rome

The history of Rome is divided into two main periods. In 509 BCE, the Romans established a republic in a small area of what is today central Italy. In the Republican period, most of the people were split into two classes based on wealth and lineage, and the two groups shared the power to rule. But, in 27 BCE, after a series of civil wars, Rome became an empire united under a single ruler, who controlled the government, military, and state religion.

Starting in the Republican period, the Romans began conquering territory. While Rome began as a small city-state, at its height, Rome controlled immense swaths of land around the Mediterranean. The map in figure 13.32 shows the Roman world in the second century CE, when its borders stretched west to Hispania (present-day Spain and Portugal), north to Britannia (present day England), east to Mesopotamia, and south to North Africa.

### Roman Inclusion and Multiculturalism

The secret to Rome's success was a practical decision to treat conquered peoples as new members of the Roman world rather than as outsiders. This approach was a completely new idea. The Romans offered conquered people the possibility of citizenship; an education in Roman literature, philosophy, and the Latin language; and the benefits of the Roman world, including new roads, aqueducts, police and fire protection, libraries, temples, and entertainment and recreational facilities. Roman excellence in civil engineering, including the use of the arch, vault, dome, and the material of concrete, as Chapter 12 discussed, contributed to the Roman ability to forge these changes in the provinces. *Art enabled Romans to spread Roman culture.*

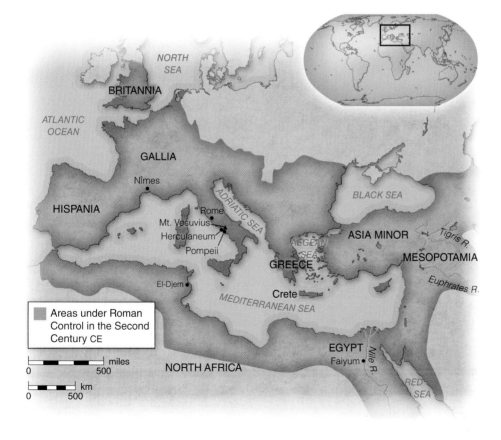

**FIGURE 13.32. The Roman Empire.** During its height in the second century CE, the Roman Empire was truly multicultural and enormous, extending west and north through Europe, south to North Africa, and east into Asia.

FIGURE 13.33. **Roman amphitheater.** *Third century* CE, *El-Djem, Tunisia.* In El-Djem, sixty thousand people sitting in rows of tiered bleachers could watch animal hunts in the morning, criminal killings at midday, and gladiator fights (man vs. man or man vs. animal) in the afternoon.

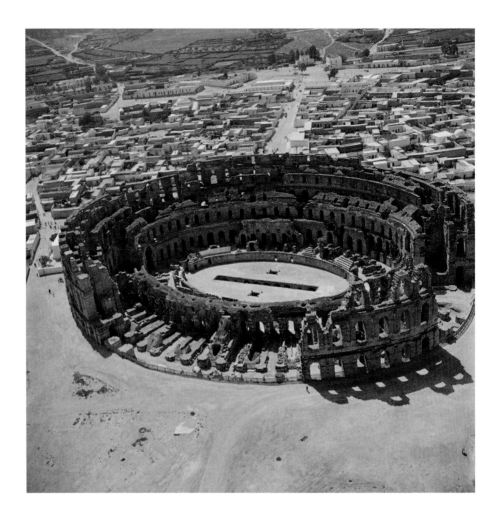

## The Role of Art in Creating an Inclusive Roman World

Roman art reflected the *inclusion, assimilation, and diffusion* that characterized Roman governance. Rome became a truly multicultural empire composed of people from different races, ethnicities, and regions. Many different people, not just Romans in Rome, created Roman art in a variety of locations.

Figure 13.33 shows an example of Roman art outside of Rome—an amphitheater from El-Djem, in what is today Tunisia in North Africa. Amphitheaters could be found all over the Roman world and catered to the people's fascination with spectacle and killing. Even though the amphitheater is in Tunisia, we cannot miss—having considered the Pantheon in Chapter 12—the concrete and the round arches and vaults that hold up the oval, three-leveled enclosure. Even with a multicultural factor, art still *contained features that were stylistically Roman.*

## Art in the Roman Republic

While during the Republican period, the wealthy and commoners officially divided power between them, in reality a small circle of men from prominent longstanding families dominated the government by the force of their prestige and wealth. Just as in other earlier civilizations, these men *used art to advance their position.*

Figure 13.34 shows a portrait of a man from the Republican period. Beginning in the fourth century BCE, important Roman statesmen and their families placed sculptures of themselves in prominent positions throughout the city to *increase their status.*

These sculptures show the distinct features of Roman Republican art. Scholars think that because the longest-serving men held the most important political positions, Romans associated

maturity and experience with wisdom, good judgment, and superior service. The sculptures therefore emphasized *age, unflattering features,* and *blemishes,* as these characteristics projected Republican values of patriotism and loyalty:

- The sculptures look *realistic, practical,* and *true-to-life.*
- The sculptures show *maturity.*
- The sculptures are *individualized.*

The individual in figure 13.34 is balding, with sunken cheeks, bags under his eyes, and lines across his forehead.

Moreover, these sculptures *promoted the status of individuals* by linking them with their prestigious ancestors. Scholars believe this type of realistic sculpture grew out of the tradition of creating wax death masks. Wealthy families created these masks, which were exact replicas of the faces of the dead, as a way of remembering a deceased individual and his achievements. The families displayed the masks at home and wore the masks at funerals of the newly deceased, allowing the family's ancestors to participate in the procession. Given that power rested in the hands of those with prestigious lineages, parading the faces of powerful ancestors also *promoted the family's status.*

**FIGURE 13.34.** **Head of a Roman.** *First century* CE. *Marble, height 14 ⅜".* *The Metropolitan Museum of Art, New York.* While we will never know what the man in this figure looked like in life, the sculpture may have been based on specific physical characteristics.

As the realistic style came to be associated with historic achievement, using the same style on sculptures of the living, in turn, helped give those depicted in the sculptures additional prestige.

## Art in the Roman Empire

During the Roman Empire, emperors ruled Rome with complete authority. These rulers needed to exert control over the immense, diverse territory of the empire and reinforce their supreme position. Throughout the rest of the empire, aside from slaves, people were still split into two classes: ordinary individuals, and those who were wealthy, socially privileged, and politically powerful. Both classes were concerned with their positions in society: the lower class sought to advance their position and the wealthy to reinforce theirs. For both the emperor and the rest of the people, *art was an important means to an end.*

### Imperial Art

In imperial Rome, emperors maintained authority by *promoting their status through images of themselves.* In an age before computers and televisions, an image of an emperor helped foster his popularity, promote his semi-divine status, and instill loyalty in the people. Numerous images of the emperor, all conforming to an approved official prototype, could be found all over the empire.

Emperors promoted their images by combining two different historical precedents. First, eager to continue the tradition of respected images from the republic, emperors *adopted the realistic style.* Second, trying to associate themselves with the glory of Greece, especially the Classical age of the Parthenon sculptures, emperors *idealized their images.*

One popular way that Roman emperors propagated their images was on coins, which circulated throughout the empire. Coins contained a low relief of the emperor's profile on one side and an imperial achievement on the other, thereby serving as a source of news about recent events and effective propaganda.

Figure 13.35 shows the front of a coin from the reign of Vespasian. The depiction of the emperor follows the combined *idealistic* and *realistic* style that the artist intended to

**FIGURE 13.35.** **Coin showing the head of Vespasian, obverse (front).** *From Antiocheia ad Orontem. 72–73* CE. *Gold, ¾".* *Ashmolean Museum, Oxford, England.* Emperors drew from two stylistic traditions to promote their rule.

*advance the emperor's status.* Vespasian wears a laurel wreath, like a Greek Olympian, and is idealized in his strong neck. Yet, Vespasian's large nose and chin appear to be individualized, realistic characteristics.

Emperors also promoted their achievements through monuments. The Emperor Augustus erected the Altar of Augustan Peace (figure 13.36A) to *promote his greatness* and celebrate his victory over Hispania and Gallia. The monument consists of an altar surrounded by a walled enclosure covered in relief sculptures. The detail of one such relief in figure 13.36B shows the imperial family as they appeared during a ceremony to consecrate the land for the monument. The combined style that *advanced the emperor's*

Reliefs can be seen on the monument's walls.

(B)     (A)

In the detail, Greek influence can be perceived in the *idealized* bodies. Figures are portrayed as *elegant, youthful, and godlike.* They also mostly face left, but a few face the opposite direction, as on the Parthenon frieze.

Republican influence is found in the *individualization.* The figures, based on *real people*, have distinct features and personalities. This child, likely one of Augustus's grandsons, tugs on his father's robe, like a real child might, while this man, a soldier in uniform, seems confident and strong.

**FIGURE 13.36A (WEST SIDE) AND B (DETAIL OF THE RELIEF OF THE IMPERIAL PROCESSION FROM THE SOUTH SIDE).** **Altar of Augustan Peace.** *13–9 BCE. Marble, outer wall 34′ 5″ × 38′ × 23′ and imperial relief height 5′ 3″. Rome.*

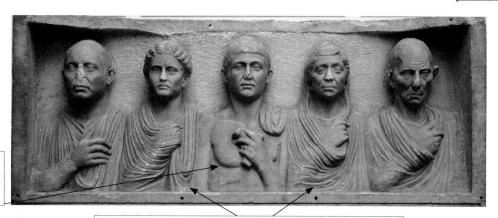

The deceased appears nude, connecting to Greek *idealized* images.

The freedman's siblings and parents take on the *realistic* qualities of respected Republican sculptures.

**FIGURE 13.37.** **Funerary relief of a freedman's family.** *From the façade of a tomb found near Porta Capena, Rome. Late first century* BCE. *Marble, 2′ 5 ¼″ × 6′ ¾″. Ny Carlsberg Glyptotek Museum, Copenhagen, Denmark.*

*status*, drawn from Republican realism and Greek idealism, is everywhere in the depiction of his family.

### The Art of the Lower Class

We can see how the style of imperial art trickled down to people in the lower class who were *looking to improve their status*. For example, freedmen were slaves who were freed upon their masters' deaths. Free Romans looked down on these freedmen.

In an attempt to improve their and their family's status, freedmen and their families often commissioned portraits for their tombs. Since they had been slaves, they owned no ancestor portraits. Placing portraits on their tombs was an attempt to *create a legitimacy that they lacked, illustrate their better status, and improve the reputation of their free-born children.*

Figure 13.37 shows a relief from the grave of a freedman. By using the idealized, realistic style of imperial art on this tomb, the freedman's family was attempting to *advance its position.*

### The Art of the Upper Class

We can get a sense of upper-class art by considering Pompeii, one of the towns buried by volcanic ash when Mount Vesuvius erupted in 79 CE. The ash preserved paintings in the homes of officials and important families, and the works are visible to us today.

The Roman upper and lower classes depended on each other. Through an institution known as *clientage*, an upper-class patron supported the legal rights of lower-class clients in return for political support. Patrons set up their homes as public spaces meant to welcome client visitors. The more dependents a patron had, the higher his prestige. Every morning, clients needing the patron's services gathered in his upper-class home in a large atrium that led directly into his *tablinum* (office). Murals covered the walls and gave the rooms a wealthier appearance.

Figure 13.38 shows a detail of a wall painting from the *tablinum* of a patron from Pompeii. While the space was decorated with what appear to be framed paintings and three-dimensional architectural features (including thin, spindle-like columns and elegant niches), in actuality, every item was painted flatly, directly on the wall, and nothing projects from the surface. Every painted object *symbolized a life of luxury.*

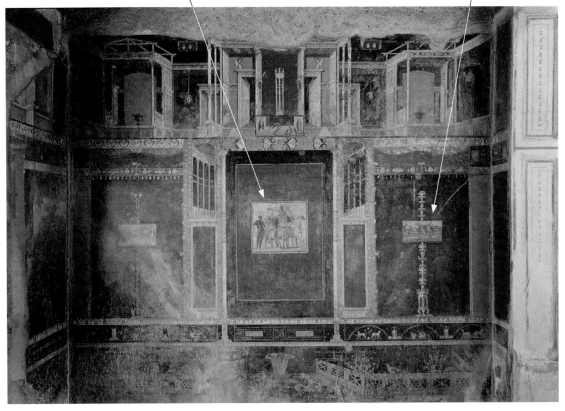

The framed painting shows Bacchus, the god of wine.

Images of beach homes are supported on what appear to be delicate, silver tripods.

FIGURE 13.38. **Wall painting from the tablinum.** *From the House of Marco Lucrezio Frontone, Pompeii, Italy. Mid-first century CE. Fresco.*

The mural added a sense of wealth to the room, even though none of the objects were real. This type of decoration would have helped the patron *reinforce his superior status*, a common goal that we have seen throughout the ancient Mediterranean world.

*Quick Review 13.6*: In what way was art in the Roman Empire based on two historical precedents?

# HOW art MATTERS

## A Look Back at the Parthenon Sculptures

The Parthenon sculptures helped the Athenians with many goals. The sculptures both *honored the goddess Athena* and *promoted the Athenians' status* in the wider Mediterranean world. The sculptures also *conveyed information about different people's roles* in Athenian society. However, the sculptures additionally serve as a model for understanding the prehistoric and ancient worlds in Europe and the Mediterranean. For, just like the Parthenon sculptures, the art in this period *was a means to an end*.

The sculptures have links to *prehistory*. Works of art were likely not solely decorative and may have *served some protective or religious role*.

With early civilizations of *Mesopotamia* and *Egypt*, the parallels with the Parthenon become more apparent. In these early civilizations, art probably served both *religious* and *political agendas* and *promoted the status of the people* depicted.

The *Greek* world, of course, holds the closest connection to the sculptures. The sculptures are the quintessential example of **Classical period** art. They are *naturalistic, yet idealized and generic*. They show that the artists of the Parthenon understood principles of shifting weight and **contrapposto**. The sculptures, moreover, embody the Greek goal of *advancing people's status*. They promoted the supremacy of Athenian and Greek identity. Yet, they also *illustrated the vastly unequal roles of different individuals in Greek society* in depictions such as the nude male god and clothed female gods in the pediment showing Athena's birth.

Finally, the Parthenon sculptures link to *Rome*: the Romans sought to copy what they considered the sophisticated Greek *idealized style*. Such interest in idealizing figures reached across class lines from the emperor to freedmen. Like the Parthenon

sculptures, Roman art *helped to advance the status and authority of different groups of people*. Even the family of a freedman in his funerary relief in figure 13.37 used the model of the Parthenon sculptures in showing that *art could be used as a means to advancing position*.

As you move forward from this chapter, though, also consider what we don't know about ancient art. Take, for example, the freedman and his family. What perishable items was he buried with that didn't last until today? What rituals might have been held when he died? How many interpretations might there be about this work of art? How many unknowns? Similarly, in life, sometimes we see clearly and other times, we don't. Sometimes evidence that seems solid actually prevents us from seeing another, better interpretation. Art historians spend lifetimes observing art and contemplating theories to try to come up with the story of art. In that this chapter is even able to tell a comprehensive story of such early art, the undertaking is an important model for the hard work of uncovering the truth.

Flashcards

## CRITICAL THINKING QUESTIONS

1. Why would the tower and wall in Jericho (figure 13.9) not have been built by people living during the Paleolithic period?
2. What technique did the artist of King Assurnasirpal II hunting lions (figure 13.15) use to depict the illusion of three-dimensional space other than the depth created from the low relief itself?
3. In Mesopotamian art, rulers attempted to promote their power through art, yet the form of Mesopotamian art changed from period to period. How could you make this case in comparing the purposes and contrasting the forms of the *Standard of Ur* (figure 13.12) and King Assurnasirpal II hunting lions (figure 13.15)?
4. Compare and contrast the forms and functions of the Mesopotamian ziggurat (figure 13.11) and the Egyptian pyramid (figure 13.18).
5. Can you think of objects today that people believe bring them luck? How are these objects similar to the necklace ornament of the Princess Mereret (figure 13.16)?
6. If both the Archaic *Kouros* (figure 13.27) and Classical *Spear Bearer* (figure 13.29) are freestanding, why does the chapter describe the Hellenistic Gallic chieftain killing his wife and

himself (figure 13.30) as contrastingly taking advantage of sculpture in the round? How do viewers appreciate Archaic and Classical sculptures differently from the Hellenistic work?
7. Nike is depicted in figure 13.31. Even though she is a goddess, what shows the fact that she does not have the same high status as male gods?
8. As the text explains, we will never know what the man in figure 13.34 looked like in life because Romans valued what we would consider unflattering features that denoted age as signs of wisdom. Accordingly, these features may have been exaggerated or not even accurate in the sculpture. Could we then say that even though Roman Republican sculptures look realistic, that the sculptures were in fact idealized? Why or why not?
9. Using examples from the chapter, how could you illustrate this statement: Much of the art during the periods covered in this chapter is concerned with the elevation of status.

Comprehension Quiz    Application Quiz

# Power, Servitude, and Ambition

The universal theme of power, servitude, and ambition is evident in artworks from this chapter and in art created by people from different backgrounds and periods from across this book. This theme concerns:

» *Power, authority, and supreme position*
» *Low stations and servitude*
» *Ambition and drives for equality*

## Power, Authority, and Supreme Position

In the Parthenon sculptures that we just studied, Greek artists conveyed the supreme position of Athenians. Figure 13.5 shows Athenians marching in the Panathenaic festival. The artists included this procession on a temple previously reserved for heroes and gods, connecting the Athenians to these superior figures. The idealized bodies of the figures may also have suggested the perfection of the Athenians themselves.

Art depicting the power of elites, states, or rulers can also be seen in later works such as *Triumph of the Will* (figure C13.1) by Leni Riefenstahl, from Chapter 1. Riefenstahl made the film in Germany in 1934 and 1935 as propaganda to display the power of the Nazis and Adolf Hitler and fabricate a myth about their seeming appeal. Shots like this one show great masses of people at a convention supporting the regime. In linking the participants to the divine (through the film's aerial views) and depicting a humanity that appears perfect (with the strict formation of the crowd), the similarities with the Parthenon sculptures are striking and concerning.

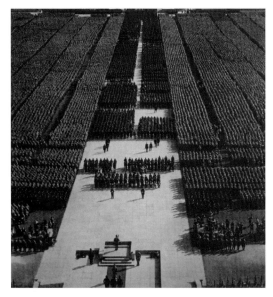

**FIGURE C13.1    Leni Riefenstahl,** *Triumph of the Will reconsidered.* This film helped cement the status of Hitler and the Nazis, but the prestige of others in authority has also been increased through impressive palaces, monuments, and attire.

## Low Stations and Servitude

The beer brewer depicted in figure 13.21 provides an example of a figure from a subordinate level of Egyptian society, who works for someone of a superior class. Unlike the sculpture of the pharaoh (figure 13.20), who is rigid, idealized, and part of the stone block, this working-class man bends naturally over his labor, looks like a regular guy, and has negative space around his limbs, which reinforces his low station.

Similarly, twentieth-century sculptor Duane Hanson, discussed in Chapter 10, also portrayed a working-class man in figure C13.2. Hanson cast an actual person for his sculpture. Like the Egyptian sculptor thousands of years earlier, Hanson knew how to make his worker look downtrodden and inconsequential to contemporary viewers. The man's low status comes through in his slumping half-hearted pose, dirty clothes, and ordinary accessories.

**FIGURE C13.2    Duane Hanson.** *Untitled (Construction Worker) reconsidered.* The *Construction Worker* appears pensive, perhaps considering his lot in life. Other artists have also taken up this idea of the seeming unfairness of life.

## Ambition and Drives for Equality

We've also studied a funerary relief that shows the ambition of the family members of a former Roman slave (figure 13.37). By placing their images on a tomb, they likely attempted to gain equal status and legitimacy for themselves. The combined realistic and idealized style that had trickled down to the lower class from the emperor may have suggested the family's equality with other free Romans.

In France in the 1700s, Adélaïde Labille-Guiard similarly used art to attempt to raise her status as a woman artist. At the time, the French Academy, the state-sanctioned art establishment, allowed a quota of only four women to be members, one of whom was Labille-Guiard. In *Self Portrait with Two Pupils* (figure C13.3), discussed in Chapter 3, Labille-Guiard portrayed herself and her two most talented students. As this painting was included in the 1785 official Academy exhibition, Labille-Guiard introduced these two women into the Academy in her own way. Additionally, by presenting the three realistically and ideally, with highly believable and elaborate attire, Labille-Guiard followed the same techniques as the ancient Roman artist of the tomb.

**FIGURE C13.3** Adélaïde Labille-Guiard. *Self-Portrait with Two Pupils* **reconsidered.** Labille-Guiard showed women artists in a realistic and ideal manner in a painting, but many media have effectively been used to protest the status quo.

## Make Connections

*Unfinished Slave* (C13.4), in Chapter 10, depicts a sixteenth-century sculpture that Michelangelo Buonarroti never completed. The sculpture was originally intended for the elaborate tomb of Pope Julius II, the leader of the Catholic Church. The slave appears as if trying to free himself from the unfinished block of stone. How might this sculpture relate to the theme of power, servitude, and ambition?

What other visual examples can you come up with from across the book and from today's world that reflect this theme? How are people's motivations across time and place similar and different?

**FIGURE C13.4** Michelangelo Buonarroti. *Unfinished Slave* reconsidered.

# 14

**DETAIL OF FIGURE 14.1.**
Religious subject matters and purposes were common in the art of the early Jewish and Christian, Byzantine, and medieval periods. Here, a holy man, likely Jesus, stares out to the faithful from a page in a sacred book.

# Early Jewish and Christian, Byzantine, and Medieval Art

## LEARNING OBJECTIVES

**14.1** Describe how late Roman Empire art included Roman ideas, specific religious traditions, and common motifs.

**14.2** Explain what the catacombs are and why they were important to early Christian art.

**14.3** Identify the architectural features of Old St. Peter's that became standard in church designs for centuries.

**14.4** Describe the subject matter, iconography, and style of the Justinian mosaic in San Vitale.

**14.5** Explain what icons are and why many people found them offensive during the iconoclast controversy.

**14.6** Summarize the characteristics of animal style.

**14.7** List the architectural features of a Romanesque church.

**14.8** Name the possible factors that influenced the establishment of the Gothic style.

**14.9** Contrast the ways in which Italian and northern artists in the fourteenth and early fifteenth centuries increased naturalism in their art.

In the year 635, a group of Christian monks traveled from Scotland to Lindisfarne Island, off the coast of England. They were charged with converting the English king's subjects to Christianity. On Lindisfarne, the monks established a monastery where they prayed, worked, and slept. On the mainland, they spread the teachings of Jesus—the first-century teacher and preacher, whom Christians believe is the savior (or Christ) and son of God.

How Art Matters

### Saint Cuthbert and the Gospels

The monastery's leader, Bishop Cuthbert, died in 687, and the monks placed his remains in a coffin beside the altar. These sacred remains, called *relics*, were thought to hold miraculous powers. Many pilgrims in search of healing and protection were drawn to the monastery in the years that followed, and in 698, the monks declared Bishop Cuthbert a saint. Over the next few decades, the monks assembled a shrine around him of sacred treasures.

One of the holy items was a book containing the *gospels*. These sacred texts tell the story of Jesus's life and teachings and were used to convert the people to Christianity. Written in the first century by the evangelists, Mark, Matthew, Luke, and John, the gospels had survived for centuries being hand-copied by scribes. The scribes sometimes included decorations to complement the words. Today, art historians call all such decorated, hand-made books that are painted with illustrations and decorations *illuminated manuscripts*.

### Creating the *Lindisfarne Gospels*

Making even one illuminated manuscript required years of dedication and illustrates just how important this form of art was to people during this period. The monks made pages from calfskins, and for the *Lindisfarne Gospels*, made for Saint Cuthbert's shrine, the monks had to slaughter several hundred animals. Each skin had to be soaked, stretched, scraped, and cut to ensure a consistent thickness and size.

Scholars believe that the Lindisfarne bishop at the time, Eadfrith, was, amazingly, the sole scribe and decorator of the Gospels. Eadfrith first copied the entire Latin text of the gospels onto the pages. He had to devise ahead how many words to fit on each page, as the folded pages would not have run in sequence. When he completed the text, Eadfrith added decorations. Using a compass and ruler, he worked out complex designs in reverse on the backs of pages. Colors had to be made by hand from local or imported sources—some from lands as far away as the Himalayas.

While Eadfrith added ornamental letters throughout to mark divisions in the text, he covered fifteen pages—most of which are found at the beginning of the Gospels—entirely with decoration. Each Gospel opens with an *evangelist portrait,* an *elaborate cross* (a symbol of Christianity), and *the initial words of the gospel.*

### Matthew's Portrait Page

On Matthew's portrait page, the evangelist writes his gospel in a book. He is surrounded by two figures (figure 14.1).

Even though Eadfrith angled the bench where Matthew sits to indicate that it is receding in space and shaded the curtain that is on the page, the overall effect is *flat color and lines.* Folds in Matthew's garment form linear patterns, his footrest floats in space, and his hair and features are stylized. Halos behind the figures' heads and circular designs on the bench create a rhythm across the page, *reinforcing the two-dimensional effect.*

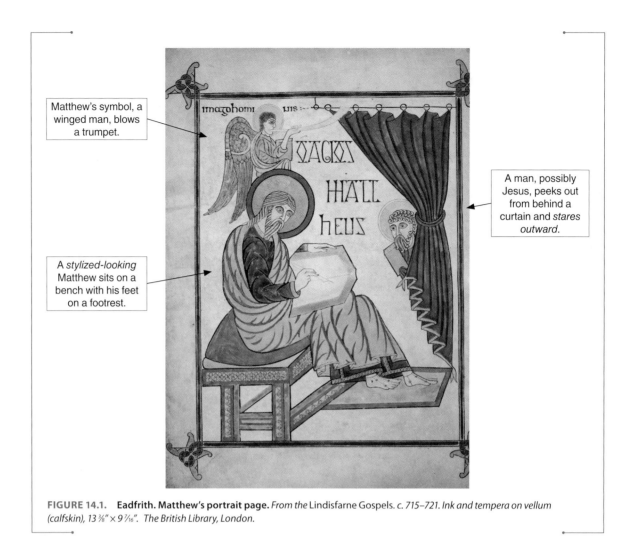

Matthew's symbol, a winged man, blows a trumpet.

A stylized-looking Matthew sits on a bench with his feet on a footrest.

A man, possibly Jesus, peeks out from behind a curtain and *stares outward*.

**FIGURE 14.1.** **Eadfrith. Matthew's portrait page.** *From the* Lindisfarne Gospels. *c. 715–721. Ink and tempera on vellum (calfskin), 13 ⅜″ × 9 ⁷⁄₁₆″. The British Library, London.*

## Matthew's Cross Page

Matthew's cross page (figure 14.2A) consists of an *interlacing pattern* of intricate shapes. The mazelike complexity seems nonrepresentational, until a closer observation (figure 14.2B) reveals that these looping lines are elongated, biting, snake-like creatures. While the design churns with energy, the dominating shape of the cross, with its *symmetrical, central position, stabilizes the page*. Crosses were believed to ward off evil and were carried in processions during services. Creating such a complex yet geometrically ordered design, in which every line could be traced to an animal's body, was a meditative exercise in which Eadfrith had to concentrate intensely on the spiritual in order to leave the everyday world behind.

## Matthew's Initial Page

Matthew's initial page opens in a rounded, ornate style of script, while other letters are more geometric. Interlaced animals form and fill many of the letters on the page (figure 14.3).

Two letters, the "e" and "r" on the first line, look incomplete, which suggests to some scholars that Eadfrith died before finishing the Gospels. The monks possibly left the letters unfinished as a tribute to him. The pages were sewn into a book, enclosed in a cover of precious gems and metals, and placed on Saint Cuthbert's shrine.

(A)

Eadfrith's "mistake"

(B)

**FIGURE 14.2A AND B (DETAIL OF THE LOWER RIGHT CORNER).** **Eadfrith. Matthew's cross page.** *From the* Lindisfarne Gospels. *c. 715–721. Ink and tempera on vellum, 13 ⅜″ × 9 ⁷⁄₁₆″. The British Library, London.* Within the image of the cross (14.2A), probably as a humble acknowledgment that he was not as perfect a creator as God, Eadfrith purposely introduced "mistakes" in the design (see the spiral in figure 14.2B).

The first three letters (which are an "L," "i," and "b") consist of *interlocking, elongated, abstracted creatures.*

The "b" takes the form of a snake. The top is the snake's head with two large, round eyes and flaring fangs.

The interiors of the letters teem with *writhing animals*, as here, where ducks' heads curl back on their own contorted bodies.

These letters are in a black, angular print.

Eadfrith may have stacked the letters in the fourth line to ensure that they fit on the page.

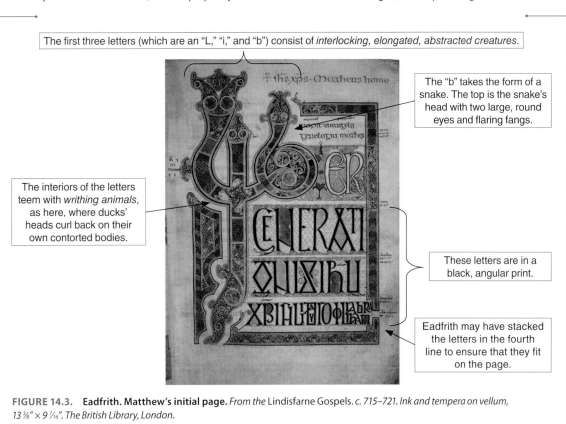

**FIGURE 14.3.** **Eadfrith. Matthew's initial page.** *From the* Lindisfarne Gospels. *c. 715–721. Ink and tempera on vellum, 13 ⅜″ × 9 ⁷⁄₁₆″. The British Library, London.*

### The History of the Gospels after They Were Completed

The Gospels remained in the monastery until the Vikings raided Lindisfarne in the late eighth century. By 875, the monks had packed up the relics and Gospels and sought refuge. En route, it is said that the Gospels were swept into the sea. According to legend, Saint Cuthbert appeared in a vision to a monk and told him to search for the Gospels in the quicksand of the island. The legend continues that the monk found the Gospels right where Saint Cuthbert had led him. While the Gospels today show no evidence of water staining, such a legend, in which the Gospels had survived a trial by water, further proved for the faithful *the miraculous powers of the sacred book*.

The story of the Gospels does not end with the legend. Around 960, a monk named Aldred, using red ink, translated the Gospels into old English in the margins (see right margin of figure 14.3) and between the lines of the Latin text. His work is remarkable for being the *oldest surviving translation of the Bible into English*. Aldred also added an endnote with information about the history of the manuscript's production. Because of his note, today we know Eadfrith's name as well as those of the men who created the binding and treasure cover. Historic and stylistic evidence supports Aldred's claims regarding the origin, even though he added this information over two hundred years later. The note offers art historians unique insight into an early eighth-century manuscript.

The *Lindisfarne Gospels* have held a prominent position since their creation. Today, they are kept in the British Library in London, where, as one of the rarest books in the world, they remain on permanent display.

The *Lindisfarne Gospels* provide information about the power of Christianity in the eighth century and the deep devotion of people of faith in *creating works of art to support their belief*. The gospels additionally show the extraordinary things someone can accomplish when he or she dedicates time every day toward a large, important goal. Through the Gospels, we can also begin to understand a culture that viewed *holy works of art as having miraculous powers* and as being all-important *conduits to God*. The Gospels also relate to art from the broader period, including Jewish and early Christian art from the late Roman Empire, art from the Byzantine Empire, and art from the Middle Ages. This chapter will take a closer look at art from these cultures. Before moving forward, based on this story, what are the ways that you would say that art changed from the ancient period covered in the last chapter, considering the purpose for the art as well as the objects being made?

CHAPTER

# 14

# The Late Roman Empire

Given that Chapter 13 focused on ancient people's belief in reason and human perfection in this world, it may be difficult to understand how this chapter could open with a discussion of a culture focused on faith and the chance for divine salvation in the next world. To begin to appreciate the change, we must go back to the earliest surviving art from the late Roman Empire, from the third and fourth centuries. During this period, the Roman world was filled with turmoil. Disputes over who was to rule threatened the empire, as did an influx of people from different lands and a decline in trade and agriculture. A number of religions competed for attention, as a variety of people rejected Roman gods.

## The Diverse Roman World

The Roman outpost of Dura-Europos, which was located in present-day Syria, gives a sense of *the diversity of beliefs* during this period. Archaeologists have unearthed houses of

worship from a number of different creeds there, including Roman, Greek, Jewish, and Christian, among others. The art follows certain tenets, even though people worshipped different faiths:

- A strong sense of *Roman style and ideas*
- Subject matters and purposes appropriate to the *individual groups*
- *Common motifs* borrowed by one group from another

Figure 14.4A shows an example from one of these groups, the Jews, a people who believe in one all-powerful God. The interior of the synagogue, a Jewish house of worship, shows murals, set up in registers, which recall the Roman practice of covering surfaces with horizontal scenes (see figure 13.36A). However, the subject matter depicts stories (figure 14.4B) from the Hebrew Bible—a sacred text that gives an account of early Jewish history and is a

Murals can be seen on the walls of the synagogue.

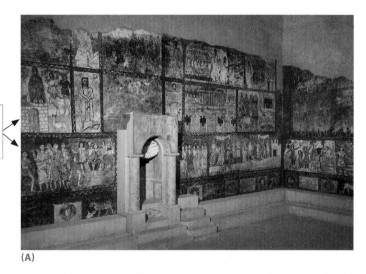

(A)

The mural is *Roman* in that Corinthian columns support a triangular pediment.

The mural is *Jewish* in that this story comes from the Hebrew Bible. Moses provides water that flows from a well to the tribes of Israel, represented as twelve men who stand in tents.

The mural is *Roman* in that Moses wears a toga and stands in a mild *contrapposto* pose, his right knee coming forward in a relaxed position.

The mural is *Jewish* in that a sacred candelabra dominates the scene.

The mural shows *common motifs* in that the men hold their hands in raised positions, a stance also used in the art of other faiths.

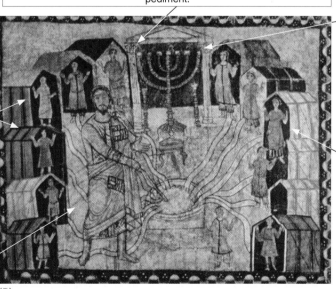

(B)

**FIGURE 14.4A (INTERIOR) AND B (DETAIL OF MOSES GIVING WATER TO THE TWELVE TRIBES OF ISRAEL). Synagogue, reconstruction.** *From Dura-Europos, Syria. c. 245. Tempera on plaster. National Museum of Damascus, Syria.*

basis of Jewish law. Also, appropriate to this individual group is the niche that held the Torah, a parchment scroll containing the first five books of the Hebrew Bible, which worshippers read aloud during prayer. The detail of Moses giving water to the twelve tribes of Israel similarly shows the *melded Jewish and Roman traditions* along with the *common motifs* shared with other religious groups. According to the Hebrew Bible, around the thirteenth century BCE, ancient Jewish ancestors, who were set up in tribes, were led by their leader Moses through the desert to the land of Canaan (present-day Israel), after being slaves in Egypt. Yet, this image of the biblical story is punctuated with Roman and shared ideas.

*Quick Review 14.1*: In what ways did late Roman Empire art include Roman ideas, specific religious traditions, and common motifs?

## Christianity in the Period of Persecution

While a number of religions existed in the troubling times of the late Roman Empire, the Christian message, offering hope for a better life in the next world, appealed to many. By the fourth century, Christianity was no longer a minority religion. Numerous followers taught how Jesus (believed by Christians to be the son of God and the Virgin Mary) had been killed on the cross and then resurrected before ascending to heaven. These missionaries told of the Second Coming, when Christ would return to earth to decide who would be saved and who would be damned for eternity. Essential to the spread of Christianity was the sense of belonging and security that came from the unified and organized Christian community, overseen by bishops and the supreme Christian authority in Rome—called the pope because he was believed to be the successor of Jesus's chosen leader for the church, Saint Peter.

The Roman citizens who believed in many gods, though, were suspicious of Christians who refused to worship Roman gods and who held religious services in private homes, performing unfamiliar rituals. At times, these Romans blamed Christians for the misfortunes of the empire and persecuted and killed them for their faith.

**catacomb** An underground complex of vaults and tunnels used as a burial place

Some of the earliest Christian art can be found in the **catacombs** of Rome, where Romans, including Christians, buried their dead. Catacombs were underground complexes of vaults and tunnels located outside the city. Associations of families dug underground rooms out of the bedrock with horizontal niches (somewhat like shelves), where they placed the dead. When rooms were full, they created passageways to new rooms, and when entire levels were filled, they tunneled lower. Some catacombs reached down five floors and connected to other sects' tunnels, spreading like a maze of ant colonies. It is estimated that the tunnels in Rome stretched for ninety miles.

*Artists decorated some catacomb rooms* (those belonging to the wealthy or important) *with paintings*. On the ceiling of one such room is a series of Christian images (figure 14.5). In a medallion at center, a shepherd carries a lamb and is surrounded by sheep. Around him, faithful Christians stand, their hands outstretched in a pose of prayer. In the semicircles between these worshippers is the story of Jonah from the Hebrew Bible, known as the Old Testament in the Christian Bible.

Like the synagogue paintings (figure 14.4A), *the images combine religious, Roman,* and *common motifs.* The *painting is religious* in that it takes the shape of a cross. To Christian faithful, the shepherd also represented Jesus, and the sheep, the faithful. A good shepherd sacrifices himself for his flock, just as Jesus had sacrificed himself for humanity. As Jesus carries one lamb, returning it to the flock, so the people trusted that Jesus would bring straying sinners back to the right path.

Christians also believed that the Jonah story foretold the Christian account of Jesus's death and resurrection. As Jonah stayed inside the sea monster for three days and escaped,

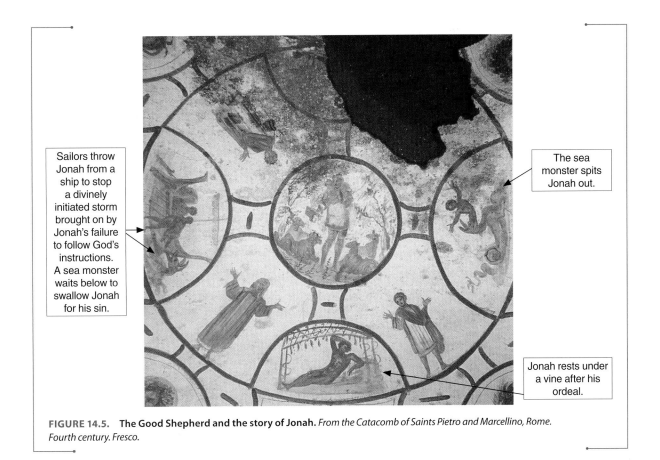

Sailors throw Jonah from a ship to stop a divinely initiated storm brought on by Jonah's failure to follow God's instructions. A sea monster waits below to swallow Jonah for his sin.

The sea monster spits Jonah out.

Jonah rests under a vine after his ordeal.

**FIGURE 14.5.** **The Good Shepherd and the story of Jonah.** *From the Catacomb of Saints Pietro and Marcellino, Rome. Fourth century. Fresco.*

so Jesus was entombed for three days and resurrected. The vine likely would have been seen as God's protection over the now faithful Jonah, who had prayed for salvation inside the sea monster. The water, in which Jonah found his faith, was symbolic of baptism, a rite in which Christians are submerged in water to be purified from sin and initiated into the faith. The entire cycle, then, scholars believe, *symbolized how the faithful would be rewarded with salvation in the world to come.*

Early Christians, though, also *adapted and reconceived Roman ideas and other common motifs* to depict Christian subject matters. The paintings, while loosely rendered, are **Classical** images, here meaning they recall images from the **Classical period** of ancient Greece and Rome (rather than the narrower definition from Chapter 13 referring to the period in Greek art history from 480 to 330 BCE). Jonah, resting under the vine, has a *naturalistic and idealized body*, and Jesus resembles depictions of Roman gods. In addition, the image of a man carrying a sheep had been a popular subject matter of Archaic Greek sculptures. Finally, just like the men representing the tribes in the synagogue (figure 14.4B), the faithful, here, in a *common motif*, raise their hands in the same position.

*Quick Review 14.2*: What are the catacombs and why were they important to early Christian art?

## Christianity under Constantine

In the early fourth century, two events altered Christians' lives and their art. First, an emperor named Constantine dreamed that Christ had asked him to *display his sign in battle.* As a result, Constantine placed the first two letters of Christ's name in Greek, chi and rho

**Classical** Art that recalls images from ancient Greece and ancient Rome characterized by idealized, proportioned, and harmonious forms

**Classical period** The period covering ancient Greek and ancient Roman art history

(XP), on his soldiers' shields and went on to win. Second, Constantine *granted religious freedom to all people, including Christians*, throughout the empire. However, in actuality, this may have been a ploy to support Christianity. Constantine favored Christianity, and he *began a building campaign to promote the religion*. He constructed numerous churches where the ever-growing Christian masses could gather and worship in the open, which had not previously been possible.

One of Constantine's churches, Old St. Peter's, appropriated a *Classical model*. Christian builders fashioned Old St. Peter's by adapting the layout of the Roman **basilica**, used by the empire as a secular, administrative building. Similar to basilicas, churches had to *hold numerous people, include a defined space* for important proceedings, and *enable light to enter* the building. Appropriating the Roman model also gave the church the legitimacy of the Roman Empire and recalled other early Christian art, like that found in the catacombs (figure 14.5), which had similarly used Roman motifs.

The model of St. Peter's (Figure 14.6A and B) was so successful that its architectural features became the *standard used in church designs for centuries*:

- People entered the church through an open courtyard called an **atrium** and a porch called a **narthex**.
- A **nave**—a central hall—which was more than three hundred feet long, provided an area for processions. Columns ran the length, creating a rhythm that marched down the nave and focused a visitor's attention toward the far end.
- At this far end stood the **apse**, a semicircular extended area of the church containing the altar, which marked the place where St. Peter was believed to have been buried.
- Running on either side of the nave were double side corridors, called **aisles**, with lower walls.
- **Clerestory** windows on the upper part of the nave walls lit the nave.
- A horizontal **transept** allowed a great number of people to get close to the altar. As the transept was placed perpendicular to the nave, the two areas also created the form of a cross.

Identifying the architectural features of a church is an essential component of being able to appreciate art in the late Roman period and beyond. To test your ability to remember the different components, see *Practice Art Matters 14.1: Label the Parts of Old St. Peter's*.

**basilica** A Roman secular administrative building whose form Christians appropriated for use in churches

**atrium** An open courtyard placed at the entrance to a church

**narthex** A porch placed at the entrance to a church

**nave** The central hall in a church

**apse** The semicircular extended area of a church where the altar is

**aisle** The corridors that run on either side of the nave

**clerestory** The area on the uppermost part of the nave walls that is set with windows that allow light to enter the nave

**transept** The arm of a cross-shaped church that is placed perpendicular to the nave

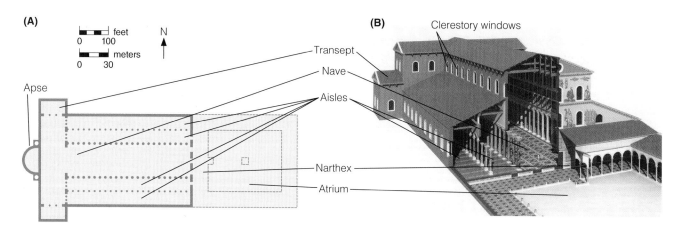

**FIGURE 14.6A (PLAN) AND B (RECONSTRUCTION DRAWING).** **Old St. Peter's.** *As it appeared c. 327, Rome.* The layout of Old St. Peter's includes an apse, transept, nave, aisles, narthex, atrium, and clerestory windows.

*Practice* art MATTERS

## 14.1  Label the Parts of Old St. Peter's

Without looking back at figure 14.6, label all of the different parts of Old St. Peter's including numbers 1 to 7 indicated in figure 14.7.

**FIGURE 14.7A (PLAN) AND B (RECONSTRUCTION DRAWING).**  Old St. Peter's reconsidered.

Old St. Peter's held 14,000 people, included lavish decorations, and showcased Christianity as the emperor's preferred religion. Yet, Constantine built the church on the outskirts of Rome with a plain exterior. Scholars believe that Constantine, ever shrewd, may have also been trying not to offend the numerous powerful Romans who believed in many gods.

While Constantine was the *promoter of the Christian faith*, he was also the *leader of the empire*. A colossal, thirty-foot-high statue *promoted this political role*. In the sculpture, Constantine originally sat on a throne, holding an orb (the symbol of world dominance). His head, chest, arms, and legs were white marble, and his clothing was bronze. Today, we appreciate the sculpture from a fragment of the head (figure 14.8), which alone towers to over eight feet. Given its monumental size and godlike appearance, as well as Constantine's formal demeanor, the sculpture was no doubt *meant to intimidate*. His strong chin, thin lips, and sculpted cheeks reinforce the *propaganda promoting the emperor's image*. Yet, the stylized hair, abstracted brows, and oversized eyes offer an otherworldly view of the emperor who seems to occupy a position capable of *spiritual transcendence*.

In the year 330, Constantine moved the capital of the empire from Rome east to a city he named Constantinople, which helped lead to the division of the empire into eastern and western entities. The divide was cemented in 395 when two emperors came to power. The periods of the art from the concurrent empires can be seen coexisting on the timeline in figure 14.9.

*Quick Review 14.3*: What are the architectural features of Old St. Peter's that became standard in church designs for centuries?

**FIGURE 14.8.   Portrait of Constantine.** *Fragment from the original, seated, full-body sculpture, from the Basilica Nova, Rome. c. 315–330. Marble, height of head 8′6″. Museo del Palazzo dei Conservatori, Rome.*  It is hard to imagine from a photo just how large the full-body, thirty-foot sculpture of Constantine rose—today, if you stood beside this remaining fragment of the head, the top of your head would likely reach up to its eyes.

The Late Roman Empire      375

**FIGURE 14.9.** **Timeline of Late Roman, Byzantine, and Medieval Art.** After the late Roman period, the empire split, leading to the Byzantine period in the East and the early medieval, Romanesque, and Gothic phases of the Middle Ages in the West.

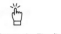

Interactive Timeline

# The Byzantine Empire

Today, the empire that flourished in the east is known as the Byzantine (BIH-zen-teen) Empire. Byzantine art diverged from that of its Classical heritage. *Byzantine artists were interested in representing the spiritual* rather than the importance of humanity and the here and now.

## The Emperor Justinian and the Empress Theodora

The Church of San Vitale (san vee-TAH-lay) (figure 14.10A and B), built during the reign of Emperor Justinian and Empress Theodora in the sixth century, illustrates this new *otherworldly approach*. The sacred, interior space would have contrasted sharply with the crowded secular realm outside it, in that the church had:

• *An unusual transition from the exterior world.* The entrance to the church is through a narthex, but this narthex is off axis on an angle. Someone entering from the narthex would have emerged into the church somewhat disoriented as *the apse is not directly across.* The entrance possibly suggested the *move from the material realm into the divine.*

• *A light, airy, and spacious interior.* San Vitale has a *centrally organized and domed form,* unlike churches modeled after the basilica. The church's structure consists

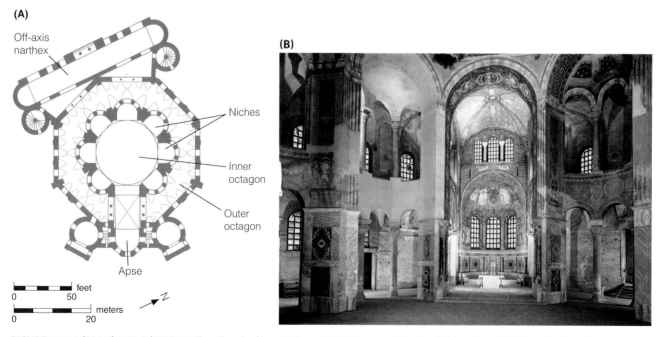

**(A)**

Off-axis narthex

Niches

Inner octagon

Outer octagon

Apse

feet
0    50

meters
0    20

**(B)**

**FIGURE 14.10A (PLAN) AND B (INTERIOR).** **Church of San Vitale.** *c. 526–547, Ravenna, Italy.* San Vitale's plan (14.10A) shows the off-axis narthex and centrally organized form. The interior view (14.10B) shows the effect of the airy, otherworldly space.

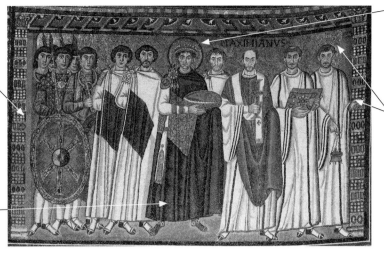

As *political leader*, Justinian's guard holds a shield with the XP (chi-rho) emblem of Christ, linking Justinian to Emperor Constantine.

As *political leader*, Justinian wears the purple color of a Roman emperor.

As *religious authority*, Justinian has a halo surrounding his head, indicating his holiness.

As *religious authority*, Justinian is placed against a gold, heavenly background and is accompanied by twelve men, equating him with Jesus, who similarly had twelve followers.

**FIGURE 14.11.** **Emperor Justinian and his attendants.** *From the Church of San Vitale, Ravenna, Italy. c. 547. Mosaic, 8′ 8″ × 12′.*

of two concentric octagons. Eight semicircular niches protrude from the inner octagon into the outer, expanding the space of the interior.

- *A glowing interior.* Glittering **mosaics**, works created using small, cut pieces of different materials (here, glass, stone, ceramics, and mother of pearl), are everywhere, *catching and reflecting the light* that streams in from the windows.

> **mosaic** A technique in which small, cut pieces of materials, such as glass or stone, are set in a cement or plaster foundation to create a picture or design; a work created using this technique

The *subject matter* and *iconography* in the mosaics also would have *added to the transformative experience*. For example, two mosaics show Justinian and Theodora taking part in religious processions, bringing offerings associated with the Eucharist (the central religious ceremony). In one, Justinian, standing in the center, carries a dish for the bread. Some iconography portrays Justinian, the political leader, as the *leader of the earthly realm*. However, other symbols in the image signal that he is a *divinely empowered authority of the sacred realm* (figure 14.11).

Similarly, the *style of the mosaics* was likely meant to *reinforce Justinian's divine authority* and to look as though he was *part of the sacred world*. He and his companions appear as *formal, unrealistic* figures:

- They are *frozen*, seeming to transcend time, like floating spirits.
- They appear *weightless* under their tubular garments, and their feet dangle and do not appear to support their forms.
- Their bodies are *elongated*.
- Their *eyes are wide* and staring.
- The *lines* meant to indicate folds in their clothing *are rhythmic, vertical stripes* (reminiscent of the patterning in Matthew's clothing in the *Lindisfarne Gospels*).

*Quick Review 14.4*: What is the subject matter, iconography, and style of the Justinian mosaic in San Vitale?

## Icons and Iconoclasm

Abstracted figures like those in the Justinian mosaic (figure 14.11) could also be found in **icons**—sacred images of saints or holy persons honored by the faithful and believed to have

> **icon** A religious or sacred image of a saint or other holy person venerated by the faithful and believed to have powers to convey messages to God

powers to convey messages to God. Found throughout the Byzantine Empire, icons were extremely important to people, attracted numerous devoted followers (just like Saint Cuthbert's relics), and served as intermediaries between a worshipper and the sacred. The figures were thought to take in prayers and transmit them to the holy people that they depicted, giving the faithful *direct access to the divine*. Like the San Vitale mosaics, icons were:

- Meant to be *timeless*, as if always awaiting the prayers of the faithful
- *Front facing and outward staring*, so that they could connect with viewers and receive their pleas
- *Abstracted and unrealistic*, thereby appearing otherworldly

The image of the Virgin and Child between Saints Theodore and George illustrates how the paintings were believed to *pass prayers through to God*, seen in the direction the figures are looking. The two saints in the image act as *conduits between the faithful and the holy figures* (figure 14.12).

A variety of features make the saintly interceders seem receptive to pleas and otherworldly. They are *symmetrical and frontal*. Their brocaded garments are panels of *flat patterns*. Their bodies are *thin and elongated*.

While other figures are more naturalistic, they also have *abstract qualities*. Mary sits on a throne that cannot possibly hold her girth, while Jesus takes the form of a small man, rather than that of a baby. These figures also retain the *symmetrical, formal position* of the saints.

Two saints *stare intensely out at the viewer*, as they accept the prayers of the viewer, inviting devotion.

Angels *look upward toward heaven*, where those who are faithful will be allowed to go, and *toward God*.

The saints *transmit the prayers to Mary*, mother of God, sitting enthroned, who, in turn, passes them to Jesus, on her lap. Both Mary and Jesus look into the distance, as they know the future.

FIGURE 14.12.   **Virgin and Child between Saints Theodore and George.** *Late sixth century. Encaustic on wood panel, 2′ 3″ × 1′ 7 ⅜″. Monastery of St. Catherine, Mount Sinai, Egypt.*

## Practice art MATTERS

### 14.2 Compare Images on a Chalice and an Icon

A chalice (figure 14.13), meant to hold wine during the Eucharist from the mid-tenth century, illustrates the triumph of icons after the iconoclast controversy had ended. The controversy seems forgotten as the chalice is ringed with fifteen different icons of Jesus, Mary, saints, bishops, and evangelists. How does the chalice support this position? To answer this question, explain how the images in the chalice are similar to those of the icon in figure 14.12.

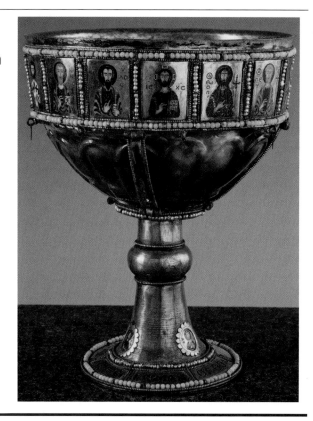

FIGURE 14.13. **Chalice of Emperor Romanos II.** *c. 960. Sardonyx, silver gilt, cloisonné, enamels, and pearl, height 8⅞", diameter 5½". San Marco Treasury, Venice, Italy.*

Some people were suspicious of icons. They thought that icons disregarded the biblical commandment against graven images and that the faithful engaged in idolatry by worshipping the icons rather than what they represented. These feelings came to a head in the eighth century during the iconoclast controversy. **Iconoclasm** is the destruction of icons or other religious images. Numerous misfortunes, including plagues and invasions, had befallen the empire, and many thought that God was punishing the empire over icons. New icons were banned and existing icons were destroyed, replaced by *symbolic, nonfigurative images* such as the cross. (The cross page in the *Lindisfarne Gospels* shows the influence of iconoclasm.) People devoted to icons were imprisoned and killed.

The controversy lingered until the mid-ninth century, when Empress Theodora, who supported icons, declared iconoclasm over. (This Theodora was a different woman than the Theodora depicted in San Vitale.) Byzantine art picked up where it had left off. *Artists returned to the tradition of otherworldly, abstract images* (see *Practice Art Matters 14.2: Compare Images on a Chalice and an Icon*).

**iconoclasm** The destruction of icons or other religious images

*Quick Review 14.5*: What are icons, and why, during the iconoclast controversy, did many people find them offensive?

# The Middle Ages

While the period that followed the late Roman Empire in the east is called Byzantine, in the west, the period is called the Middle Ages or the medieval period because it comes in between the Greek and Roman civilizations and the Renaissance. Art in the Middle Ages is usually categorized into three phases—*early medieval, Romanesque, and Gothic*—followed by a transitional period leading up to the Renaissance.

## Early Medieval

The movement of people plagued the west in the fourth and fifth centuries. Germanic people migrating from the east and north into Western Europe mixed with Romans and seized political control. Once part of the empire, though, many of these people continued to identify themselves ethnically with tribes that shared similar cultural roots, and they pledged themselves to local warlords. Cities, trade, and travel declined, and by the late fifth century, the Roman Empire had disintegrated. A series of small, independent kingdoms took its place. However, for a period in the eighth century, a leader named Charlemagne succeeded in unifying parts of Europe.

### The Art of Germanic People in Western Europe

Much of the art of the people who initially migrated to Western Europe has disappeared; however, some *items of personal adornment, weapons, and silverware* survive. These objects were:

- *Portable*
- Created using **animal style** with an *abstract, geometric design of interlocking creatures*
- Formed from *lively patterns* that were nonetheless *ordered and symmetrical*

A purse from the early seventh century is a good example of this early medieval art. The purse was buried with numerous other precious items in a ninety-foot-long ship at Sutton Hoo in England. Important people were buried in ships with luxurious possessions and necessities, perhaps because those who buried them believed that an afterlife involved a trip over water. Figure 14.14 shows the gold, precious stone, and enamel decorations and clasps from the cover of the purse, as the leather did not survive. The design is composed in the intricate patterns of *animal style*, yet remains *structured and symmetrically balanced*.

The interlocking yet controlled designs are reminiscent of the cross and initial pages of the *Lindisfarne Gospels*. The Lindisfarne monks had converted migratory, non-Christian people to Christianity, so Eadfrith would have been familiar with *animal style*. He might have even included the style, so that recently converted people would have felt an affinity toward the Gospels. In the small kingdoms that dotted the west, it is easy to see why the monks were likely successful in converting the masses. With decentralized government, the Church became a unifying element of society.

**animal style** The abstract, geometric style of interlocking creatures created by Germanic peoples in Western Europe during the ancient and early medieval periods

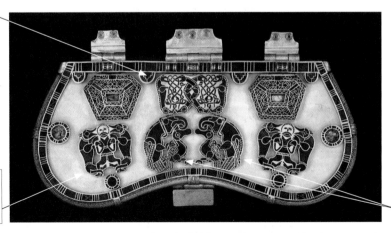

*Creatures* depicted in animal style do battle, their tails elongated and *intertwined*.

Figures are flanked by similarly formed, standing, bird-headed animals.

Pairs of eagles attacking ducks, which are mirror images of each other, display the *pure symmetry* in the work.

**FIGURE 14.14.** **Purse cover.** *From the Sutton Hoo Ship Burial. First half of the seventh century. Gold with garnets and enamels, length 8". The British Museum, London.*

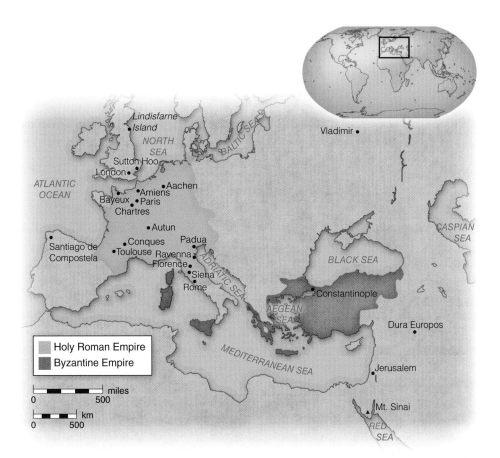

**FIGURE 14.15.** **The Holy Roman Empire and the Byzantine Empire in 814.** The eastern and western empires coexisted as different political and religious entities.

## Art in Charlemagne's Holy Roman Empire

In the second half of the eighth century, a new leader named Charlemagne reunified parts of Europe. Figure 14.15 shows Charlemagne's empire, known as the Holy (meaning Christian) Roman Empire. The map also shows the coexisting Byzantine Empire. Determined to cement his legitimacy, Charlemagne established a capital at Aachen (in present-day Germany) and began a *building program that showcased his supremacy.*

Charlemagne's palace chapel (figure 14.16) *emphasized the solidity, order, and power of his empire.* Recalling the glory of Rome, its rounded arches and massive piers support a dome. In its central plan and highly decorated walls, the chapel references the Church of San Vitale (figure 14.10B), likely because Charlemagne hoped to emulate the reign of the great Byzantine emperor, Justinian.

After Charlemagne's death, his grandsons split the empire into thirds, leaving it weak and vulnerable to raids. One of the groups that attacked was the Vikings—the same group that caused the monks to flee Lindisfarne. The empire disintegrated under the pressure, and the west returned to decentralized governments.

*Quick Review 14.6*: What are the characteristics of animal style?

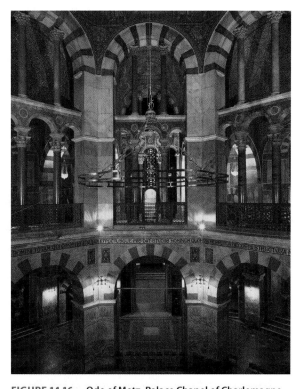

**FIGURE 14.16.** **Odo of Metz. Palace Chapel of Charlemagne, interior.** *792–805, Aachen, Germany.* Charlemagne housed his throne on the second floor of the church across from a second throne set up for Christ. The parallel positions symbolically put the emperor on equal footing with God.

## Romanesque

**Romanesque** The style of Western European art lasting from approximately 1000 to 1150 characterized in architecture by stone churches with round arches, heavy walls, and barrel vaults

By the beginning of the **Romanesque** period, around the year 1000, a socioeconomic structure called feudalism dominated Western Europe. Feudalism developed in response to the decentralization of power, the threat of invasion, and the need for local defense. With feudalism, lords offered land to vassals, who in turn pledged their loyalty and military service to the lords. Peasants worked the land and provided goods in return for protection. However, while the Romanesque period began with a variety of small political entities, by the middle of the twelfth century, larger states, controlled by kings, were taking shape.

### Art in Feudal Europe

The *Bayeux Tapestry*, a 226-foot-long strip of fabric, tells the story of William of Normandy's conquest of England and *illustrates the importance of the feudal oaths* made by vassals to their lords. The story begins with the king of England selecting William as his successor. Yet, when the king dies, William's vassal, Harold, takes the crown. William, seeking revenge, invades England, kills Harold in battle, and assumes the throne.

Even though called a tapestry, the work is actually an *embroidery*, a work created using needlework to form a surface design on fabric. English women likely created the elaborate stitching. The embroidery justifies William's actions and probably *served as a form of propaganda*. The section showing Harold's oath conspires to legitimize William's conquest of England (figure 14.17).

The figures are *linear and flat*, reminiscent of the Matthew figure in the *Lindisfarne Gospels*. The embroiderers used eight different colors of thread to create the figures, sewing outlines around each shape and then filling in the areas with colors. Even though the figures are abstracted, the *embroidery gives a strong sense of daily life* in feudal society.

### The Triumph of Christianity and the Romanesque Church

Numerous factors contributed to the strengthening of Western Europe toward the end of the Romanesque period. A population boom and increased agricultural production led to prosperity. As a result, trade and travel increased, which created markets and a stronger class of merchants. Towns developed around markets, and feudalism decreased.

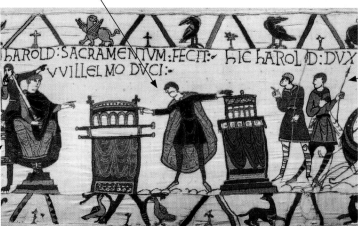

Harold commits himself to William in church by awkwardly reaching his hands out to touch two shrines. Because *the shrines hold relics*, like the shrine to Saint Cuthbert, Harold is shown making his oath to God.

William points, focusing attention on Harold through an *implied line*. In his exalted position on an elevated platform, William appears kingly. Even though seated, William is *hierarchically scaled* to be larger than Harold, *making William seem more important*.

A witness to the oath holds his hand to his heart.

**FIGURE 14.17.** **Harold swears a sacred oath to William.** *From the* Bayeux Tapestry. *c. 1070. Wool embroidery on linen, 20″ × 226′. Centre Guillaume le Conquérant, Bayeux, France.*

Interactive Image Walkthrough

Christianity was the main religion. The world had not come to an end in the year 1000 despite it having been prophesized, and so a new spiritualism sprung up. With this new religious mindset, people thought that they had to show that they had done good works in order to be worthy of salvation. Through faith and the church, people believed they could find shelter from the threat of damnation.

Increased prosperity and mobility allowed the faithful to *demonstrate their devotion materially*. Chief among the list of devotional activities was *visiting relics* at holy sites, in particular in Jerusalem, Rome, and Santiago de Compostela, Spain. Pilgrimage routes sprung up to reach the locations, along with a book of advice for travelers on making the difficult trips. The harder it was to reach a destination, the more pilgrims attempted to get there, as it was believed the undertaking had greater value in ensuring salvation. Dotted along the pilgrimage roads, *monasteries catered to and sheltered travelers*. Each monastery housed a church, where pilgrims could visit relics and pray en route to the main sites. Many monasteries *rebuilt their churches to attract even more pilgrims* and their donations.

These new Romanesque churches were specifically *designed to impress pilgrims* with the *strength and protective powers of the church*. The Church of Saint-Sernin (figure 14.18A) captures the fortress-like monumentality:

- *Bulky, massive piers* (the size of tree trunks) and *round, stable arches* hold up a barrel-vaulted ceiling of stone. Round arches and barrel vaults harkened back to Roman times, thus the labeling by later art historians of this period as Romanesque.
- *Round arches* stretch across the ceiling, methodically marching down the church horizontally toward the all-important apse containing the most holy relics.
- *Heavy, solid walls and no clerestory windows* left the church dimly lit and *feeling sober and mysterious.*

The plan (figure 14.18B) shows how Saint-Sernin *preserved traditional architectural features*, while also *catering to pilgrims' needs*. The church maintains the nave, side aisles,

(A)

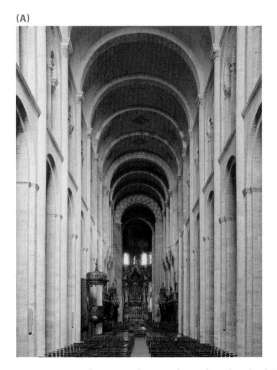

(B)

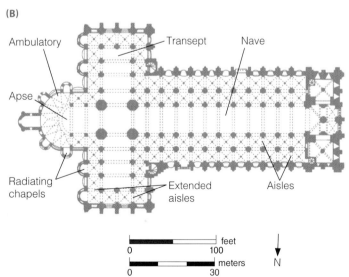

**FIGURE 14.18A (INTERIOR) AND B (PLAN).** **Church of Saint-Sernin.** *1070–1120, Toulouse, France.* The interior of Saint-Sernin (14.18A) illustrates the fortress-like space of a Romanesque church. The plan (14.18B) shows the new and traditional features of the church.

# DELVE DEEPER

## Relics and Reliquaries

Relics (just like those of Saint Cuthbert on Lindisfarne) were thought to hold miraculous powers and were believed to be a conduit to the holy person with whom they had originally been associated. They were so important to the wealth, reputation, and influence of a monastery that at times monks stole particularly desirable relics. Such was the case with the relic (her skull) of Sainte Foy (sant FWAH). The monks who did the pilfering claimed that Sainte Foy herself had told them she preferred to move to a new location.

Often, monks honored the holy person associated with a relic by placing the relic in a decorated container called a reliquary. Sainte Foy's relic was encased in a gilded reliquary made to resemble the figure of the saint (figure 14.19). While her reliquary rises just under three feet tall, her image is regal and confident. She is frontal, formal, and stiff and stares into our space, awaiting the prayers of the faithful, like an icon. The reliquary no doubt added to the worldview that the saint's relic could change a pilgrim's fate through the receipt of penance or a blessing.

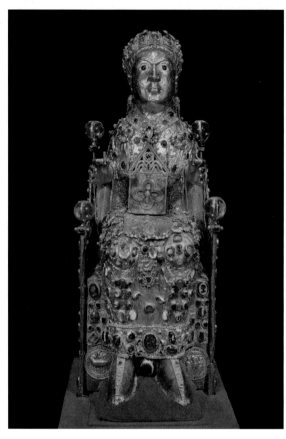

**FIGURE 14.19.** **Reliquary statue of Sainte Foy.** *Late ninth or tenth century. Silver gilt over the saint's skull and a wood core, with added gems and cameos, height 2′ 9″. Abbey Church of Conques, France.* Sainte Foy sits enthroned and crowned with precious stones, donated by pilgrims, decorating her robe.

---

**ambulatory** The semicircular walkway that surrounds the apse and allows visitors to walk to the chapels without disturbing the church service

**radiating chapel** A semicircular space in a church that protrudes from the ambulatory or transept and often contains altars holding relics

**reliquary** A container that holds the remains or objects associated with holy people

transept, and apse of Old St. Peter's (figure 14.6A). However, the side aisles that extend along the outside edge of the nave also continue around the edge of the walls of the transept and out into an **ambulatory**, a semicircular walkway that surrounds the apse. Extending the aisles created a *constant path around the church that pilgrims could travel* at any time without disturbing the liturgical service. Small, semicircular **radiating chapels** that protrude off the front end of the transept and from the ambulatory contained shrines with additional relics often placed in containers called **reliquaries** that pilgrims could visit to honor or repent for their sins (see *Delve Deeper: Relics and Reliquaries*).

### Romanesque Architectural Sculpture

While sturdy, protective spaces and decorative reliquaries reinforced the Christian message on the interior of the church, *complex sculptural programs promoted a faithful way of life on the exterior*. Arguably, in no place was the propaganda to avoid a life of sin more

A hierarchically scaled, enormous Christ *oversees the judgment of souls.*

An angel weighs a helpless soul on a scale that reveals which souls will be saved based on their faith in Christ. Monsters hang on one side, tipping the balance toward hell.

Across the bottom, souls emerge from their tombs. On the left are the saved. These two are pilgrims, carrying bags showing familiar souvenirs from visits to holy sites. The message would have been clear: those who complete pilgrimages will be among those who go to heaven.

The damned are tortured on the right. One is pulled from his grave by giant, claw-like fingers that close around his head.

**FIGURE 14.20. Gislebertus. Last Judgment.** *From the architectural sculpture above the west door of the Church of Saint-Lazare, Autun, France. c. 1120–1135. Marble, 21' wide at base.*

vivid. At the Church of Saint-Lazare, a sculpture placed above the entrance shows what likely would have seemed a terrifying vision of the Last Judgment and the fate that awaits sinners. Even the vast number of illiterate would have been able to understand the scene as they entered for worship (figure 14.20).

Everything about the sculpture served to influence—from its *enormous size* (twenty-one feet across at the base), to its *bright paint colors* (it was originally painted), to its *distorted and elongated demons and angels.* The everyday world and realistic depictions were thought to be unimportant. Christ stands peacefully in the center of the swirling action. *His formality and symmetry* would have reminded viewers that he would win out over chaos and evil.

*Quick Review 14.7*: What are the architectural features of a Romanesque church?

## Gothic

With the beginning of the **Gothic** period in the middle of the twelfth century, Western Europe built on the prosperity of the Romanesque. Cities grew and developed and with them cathedrals, the seats of bishops, increased in importance. New, grander structures were raised to *reflect the cathedrals' prominence.*

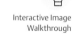

Interactive Image Walkthrough

**Gothic** The style of Western European art lasting from 1150 to 1400 characterized in architecture by towering churches with pointed arches, stained glass windows, and ribbed groined vaults

## The Gothic Cathedral

Scholars suggest a number of possible factors that came together in heralding a new style of cathedral architecture:

- *Technological innovation* allowed for new types of building structures.
- A desire to *reconcile reason and faith* led people to believe they had to carry on God's divine plan by employing newly understood, systematic concepts in *logical, orderly designs.*
- *Stained glass* was incorporated in building design to filter light through churches, *symbolizing the true light of God.*
- A new view of the holy figures emerged in which people focused on *Christ's and Mary's humanity, kindness, and divine love.*
- *Rivalries developed* among newly forming cities to build the most beautiful cathedrals.

While Gothic cathedrals maintained many of the aspects of Romanesque churches, they created a sharply contrasting space, as can be seen in the Gothic Amiens Cathedral (figure 14.21A, B, and C). *Romanesque features are evident in the plan*, including the nave, transept, aisles, apse, ambulatory, and radiating chapels. However, the Gothic builders also

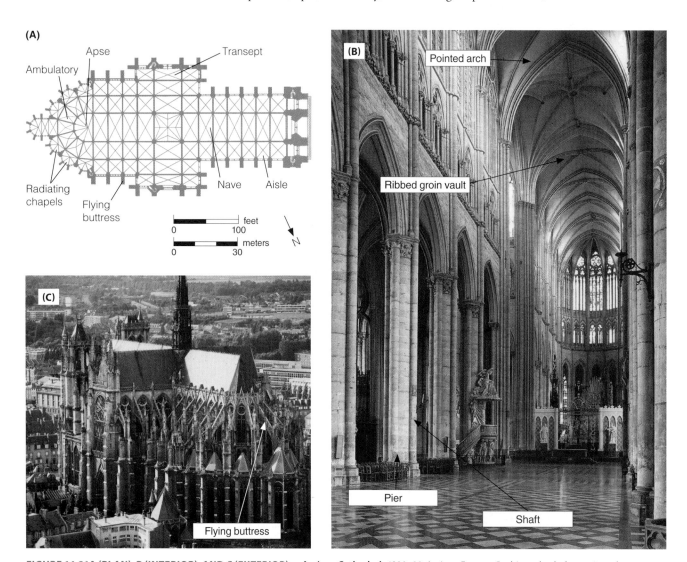

**FIGURE 14.21A (PLAN), B (INTERIOR), AND C (EXTERIOR).** **Amiens Cathedral.** *1220–88, Amiens, France.* Gothic cathedrals continued many Romanesque features as seen in the plan (14.21A). However, they differed in their lofty structures visible in the interior view (14.21B) and flying buttresses in the exterior view (14.21C).

designed a *towering, light-filled structure that soared upward toward the divine realm*. The immense verticality reaches to the height of 144 feet—about half the length of a football field.

A number of architectural innovations create this graceful, slender, and airy space:

- *Ribbed groined vaults*—with their skeletal arched system— crisscross the ceiling, channeling the forces to the corners and allowing for lighter material to be placed in the spaces in between.
- *Pointed arches and enormous piers* support the vaults, holding up the ceiling, but also adding to the appearance of verticality. The pointed arches reach high, and the shafts that run on the piers from floor to ceiling form lines that take our eyes skyward.
- Massive *stained-glass windows* overtake the surfaces, as the supports are more like skeletal systems than walls, filling the interior with beautiful, colored light (for an example of a stained-glass window in a Gothic cathedral see figure 11.5A).
- *Flying buttresses* on the exterior carry the forces to the ground (see Chapter 12).

This open, flowing space coincided remarkably with the Gothic period's outlook. The *overwhelming height* of the cathedrals depended on advancements in engineering based on an understanding of the divinely created, rational, natural world. The large *stained-glass windows* filtered the sun's rays, creating a mystical and divine light. *The verticality and luminosity* both formed a heavenly space where the faithful could experience being closer to a loving God and served the desire to compete for the grandest church. The overall effect and rationale were vastly different from the Romanesque (see *Practice Art Matters 14.3: Contrast Romanesque and Gothic Churches*).

---

*Practice* **art**MATTERS

## 14.3 Contrast Romanesque and Gothic Churches

A comparison of the Church of Saint-Sernin (figure 14.22A) and Amiens Cathedral (figure 14.22B) illustrates the vastly different sensibilities. Describe how the two differ in terms of:

- Architectural features
- Effect
- Reasons behind their appearances

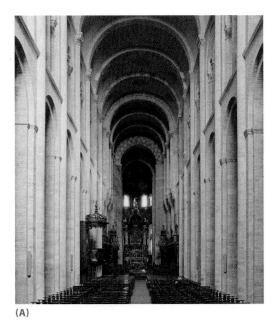
(A)

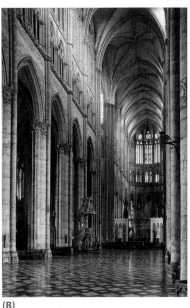
(B)

**FIGURE 14.22A AND B.** (A) Church of Saint-Sernin, interior, reconsidered; (B) Amiens Cathedral, interior, reconsidered.

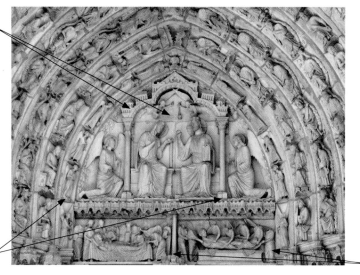

Christ crowns Mary to make her the queen of heaven. The two are naturalistic, calm, and composed.

Symmetrical angels flank Christ and Mary.

Scenes from the death of the Virgin and her assumption to heaven complete *the message of hope and salvation.*

**FIGURE 14.23.** **Coronation of the Virgin.** *From the architectural sculpture above the north door of Chartres Cathedral, France. c. 1210.*

## Gothic Architectural Sculpture

The exterior sculpture on Gothic cathedrals also took a different path from the Romanesque. Whereas Romanesque sculpture focuses on the fate of the damned, *Gothic sculpture emphasizes salvation.* In the Coronation of the Virgin from Chartres (SHAHR-truh) Cathedral, Mary takes a prominent role in the scene, as she was believed to be a divine intercessor for the faithful who would help them reach heaven (figure 14.23).

In figure 14.23, the Gothic sculpture:

- Captures the *positive attitude* of the period
- Is *ordered, symmetrical, and peaceful*
- Displays increased *naturalism* of the figures—for example, while still stylized, their clothing flows around their bodies believably rather than in linear patterns
- May have allowed visitors to Chartres to identify with *Jesus's and Mary's humanity,* as the holy figures *appear more like real people*

*Quick Review 14.8*: What were the possible factors that influenced the establishment of the Gothic style?

## Toward the Renaissance

In the fourteenth and early fifteenth centuries, new artistic innovations began to take root in Italy and northern Europe as *artists became even more interested in depicting the everyday world.* These changes would chart the way toward what we call the Renaissance, a period that Chapter 15 will explore.

### Changes in Italy

**artists**
MATTER

Giotto di
Bondone

In Italy, a groundbreaking painter named Giotto di Bondone (JAH-toe dee bone-DOH-nay) drove the transformation by introducing *naturalism in painting.* Giotto:

- Created the *illusion of solid figures*
- Formed a convincing *three-dimensional space*
- Depicted a distinct light source that produces *convincing highlights and shadows*

In his *Madonna Enthroned* (figure 14.24), an enormous, hierarchically scaled, bulky Mary sits with Jesus on her lap. Around Mary, angels stand in what looks like a receding space.

Giotto's approach to space and figures would have a monumental impact on those artists who came after him. The revolutionary approach is most noticeable in a comparison with the icon in figure 14.12. While the subject matters are similar, there is a world of difference in style. In the icon, Mary is timeless, awaiting the prayers of the faithful, and flat panels of fabric clothe impossibly slender saints. In Giotto's Mary, on the other hand, a group of angels appears to have just gathered around her. They move and turn their halos, blocking those behind them, who at any moment could be revealed by another movement. Here, simple tunics hang in soft folds over *realistically shaped, appropriately proportioned, weighty-looking* bodies. Natural-looking *highlights and shadows* help describe the figures' forms.

### Changes in the North

An interest in naturalism also materialized in the north in the lead-up to the Renaissance. However, in contrast to Italy, northern artists *prioritized the precise details of the secular, everyday world.*

In a prayer book that illustrates the months of the year, the Limbourg brothers depicted typical activities for October. The illustration gives an accurate understanding of the period's particular agricultural techniques and clothing (figure 14.25).

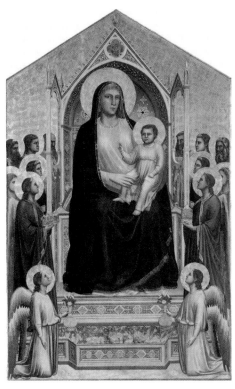

**FIGURE 14.24.** **Giotto di Bondone.** *Madonna Enthroned. From the Church of Ognissanti, Florence, Italy. c. 1310. Tempera on wood panel, 10′ 8″ × 6′ 8″. Uffizi Gallery, Florence, Italy.* Giotto transformed painting by creating the illusion of concrete figures existing in a believable space.

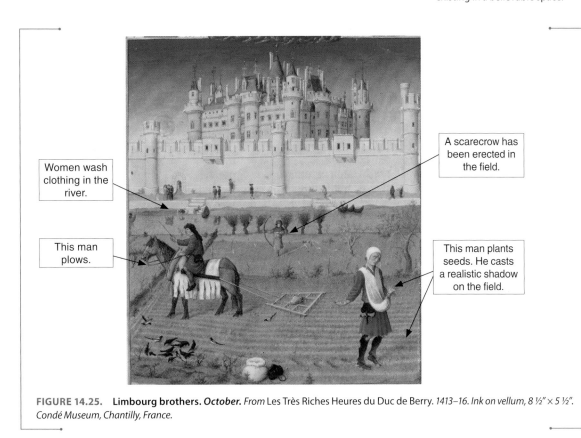

Women wash clothing in the river.

This man plows.

A scarecrow has been erected in the field.

This man plants seeds. He casts a realistic shadow on the field.

**FIGURE 14.25.** **Limbourg brothers.** *October. From* Les Très Riches Heures du Duc de Berry. *1413–16. Ink on vellum, 8 ½″ × 5 ½″. Condé Museum, Chantilly, France.*

The illustration also shows how *art and society were changing in the lead-up to the Renaissance*. Even though the depiction of October is from an **illuminated manuscript**, a handmade book with illustrations, the differences in it from the illuminated manuscript of the *Lindisfarne Gospels* are immense. While Eadfrith created the Gospels to honor a saint, the Limbourg brothers created this book for the pleasure of a wealthy duke. Most altered, though, is the style and subject matter. While the Gospels contain abstracted images that are mostly biblical, the depiction of October shows *naturalistic images of the everyday*. While artists created both religious and secular art in both periods, Western Europe was heading to a new age with new values and ideas.

*Quick Review 14.9*: In what two different ways did Italian and northern artists in the fourteenth and early fifteenth centuries increase naturalism in their art?

# HOW art MATTERS

## A Look Back at the *Lindisfarne Gospels*

The *Lindisfarne Gospels* were the religious calling of a monk who lived on a remote island in the early eighth century. Eadfrith created the Gospels to *show his devotion to God*. As such, the Gospels convey much about the religious zeal that characterizes this period. Yet, the Gospels also relate to late Roman Empire, Byzantine, and medieval art. For throughout these thousand years of history, *people saw art as a powerful link to God*.

The Gospels share similarities with art from the late Roman Empire in that as one of their tenets, *artists created symbolic content familiar to specific groups*. Eadfrith similarly used *iconography* that would have been familiar to the faithful. His image of Matthew (figure 14.1) shows Jesus behind a curtain. Christians likely would have understood that Christ could be found behind the words of the New Testament.

Even greater parallels can be seen with Byzantine art. The image of Jesus from the Matthew page is reminiscent of an **icon**. Jesus *stares into our space*, awaiting the prayers of the faithful. Matthew's cross page (figure 14.2A), furthermore, recalls **iconoclasm** in its *non-figural image*. To appreciate the cross page's mazelike form required intense study, which would enable a viewer to enter an altered spiritual state. As *Byzantine art showed viewers an otherworldly realm*, the cross page seems to ask viewers to suspend their place in the secular world and *enter a world closer to God*.

The easiest comparisons can be made with medieval art. As Eadfrith was familiar with **animal style** (figure 14.14),

his compositions were likely drawn from its feisty, yet ordered, example. Just as animal style decorated the prized possessions of the most important Germanic leaders, so its use in the Gospels probably would have indicated to recently converted people the *importance of the words of God*. However, the Gospels were not only valued. Like the relics encased in **reliquaries** (figure 14.19) on the altars of medieval churches, they were thought to be *miraculous objects*. As such, the faithful championed their power as *conduits to God*.

Eadfrith brought together a number of influences when creating the Gospels. The diversity parallels the objectives of the church. Interested in converting the masses, the church was open to various groups. By seemingly finding a place for multiple traditions within the design, Eadfrith masterfully gave the Gospels the most power of all.

As you move forward from this chapter, consider what Eadfrith was able to accomplish. Scholars believe that even though he was the bishop of Lindisfarne, with administrative and manual labor responsibilities and the necessity of attending eight religious services each day, he produced the Gospels himself. He did this working with a pen that had to be sharpened every few pages and dipped in ink every few lines. At night, he would have had to work by candlelight and in the winter with no heat. But, he set aside time, no matter the difficulties, to accomplish an aspiration he wanted to achieve.

Flashcards

## CRITICAL THINKING QUESTIONS

1. Figure 14.4A depicts the synagogue found in Dura-Europos. In the middle of the wall is a niche where the worshippers kept the Torah scroll. How does this niche support the idea that both Roman and religious motifs were used? Hint: For the Roman part of the answer, think back to the Pantheon discussed in Chapter 12.

2. Are the architectural features of St. Peter's (figure 14.6A), which can be seen in the plan, reflected in the house of worship that you frequent or in one that you have visited? If so, how? If not, is there another building represented in this chapter that is reflected in the architectural features, and in which way?

3. The *Virgin of Vladimir* (figure 2.34) depicted in Chapter 2 is an icon. What features of the work tell you this is the case?

4. Why do you think much of the art of the people who initially migrated to Western Europe disappeared?

5. The *Bayeux Tapestry* (figure 14.17) was likely commissioned by William's half-brother, Odo of Bayeux, who was a lord. It was probably made by peasant women. Works in fiber were seen as influential objects that glorified a lord, and Odo likely had the embroidery rolled, so it could travel with him to different castles and be rehung where he was residing. How did who owned and who made the *Bayeux Tapestry*, as well as how it was displayed, reinforce the feudal system?

6. Compare and contrast the Last Judgment (figure 14.20) and the Coronation of the Virgin (figure 14.23) in terms of their locations, subject matters, forms, and messages.

7. Giotto's *Madonna Enthroned* (figure 14.24) was created during the Gothic period. Knowing what you do about Gothic architecture, how might you know this fact other than by looking at the date when the painting was created?

8. A number of images in this chapter make use of hierarchical scale. Which ones? What does this technique tell us about the figures who are scaled large?

Comprehension Quiz

Application Quiz

# CONNECTIONS

## The Divine, Sacred Spaces, and Prayers

The universal theme of the divine, sacred spaces, and prayers is evident in artworks from this chapter and in art created by people from different backgrounds and periods from across this book. This theme concerns:

» *Deities, holy figures, and the divine*
» *Sacred spaces*
» *Prayers, rituals, and pilgrimages*

### Deities, Holy Figures, and the Divine

In figure 14.1, the eighth-century Scottish monk Eadfrith depicted Matthew, believed to be holy, and Jesus, believed to be divine. Iconography—such as Jesus hiding behind the curtain—likely symbolizes that Christ can be found behind the words of the New Testament. Moreover, Eadfrith illustrated the figures for the *Lindisfarne Gospels*, which told of Jesus's life and teachings and were used to convert people to Christianity. The gospels had survived for centuries by being passed down from one scribe to the next, and Eadfrith's work was believed to help him achieve salvation.

Artists have similarly depicted deities, holy figures, and the divine from other religions. The *Diamond Sutra* (figure C14.1), a ninth-century Chinese text from Chapter 7, contains the teachings of the Buddha, who lived 2,500 years ago in present-day India and Nepal. A comparison shows how people living worlds apart used similar techniques to accomplish religious goals. A follower of the faith created the *Diamond Sutra*, in a tradition carried down from one generation to the next, and people believed the work helped the creator achieve a better spiritual state after death. The scroll also contains an image of the Buddha, a figure believed to be sacred. The Buddha is displayed with iconography, and the scroll employs art and the written word to promote the Buddha's teachings.

FIGURE C14.1  *Diamond Sutra*, **detail, reconsidered.** In the *Diamond Sutra*, the Buddha is depicted with iconography (like a bump on his head that indicates wisdom). However, other images of deities from different religions are composed solely of symbols, because these religions forbid figurative representations of the divine.

### Sacred Spaces

We have also considered the sacred space of Saint-Sernin (figure 14.18A), a French, Romanesque church. There, builders constructed round arches to support the space. The church also catered to the needs of the faithful with its ambulatory and radiating chapels, creating a path to and space for shrines.

Another sacred structure formed with similar features and goals was the Islamic prayer hall of the Great Mosque in Córdoba, Spain (figure C14.2), discussed in Chapter 12. Like Saint-Sernin, the prayer hall used round arches. Moreover, the space was designed to accommodate followers. Regularly spaced columns created an area where the faithful could pray in long, orderly rows.

FIGURE C14.2.  **Great Mosque, prayer hall, reconsidered.** Since Muslims pray on the floor in long lines, the space is conducive to worship. Most architects of sacred buildings seek to create spaces that not only function well for the faithful, but also feel holy.

## Prayers, Rituals, and Pilgrimages

We've also discussed Romanesque pilgrimages to holy sites—thought to help the faithful achieve salvation. Visiting relics was an essential ritual. Monks honored Sainte Foy by placing her skull in a gilded reliquary (figure 14.19), which may have fostered the notion that the saint could help convey prayers to God.

Connections can be seen with a painting depicting an elite male and maguey cactus leaves (figure C14.3) from Teotihuacán, Mexico. Chapter 6 describes how a priest performed the bloodletting ceremony depicted in the image, using his own blood, probably to ensure a good crop. People likely thought that prayer and human body parts, or in this case fluids, could help them reach the divine.

FIGURE C14.3.   Elite male and maguey cactus leaves reconsidered. A priest scatters his own blood on the ground, likely in an offering to the earth goddess. In Teotihuacán, such ceremonies were not the only submissions to the divine; the people also performed human sacrifices.

## Make Connections

In ancient Egypt, individuals believed the dead had to undergo trials before reaching the afterlife. Books of spells, such as the *Book of the Dead* of Nakht (C14.4), described in Chapter 3, were put into tombs to instruct the dead in overcoming the tests. Nakht and his wife (at right) worship gods (at left), who decide their fate. Between them a pool likely symbolizes rebirth. At top are hieroglyphs. The god on the far left also holds the hieroglyph symbol for "life" in her hand. How might this book relate to the theme of the divine, sacred spaces, and prayer?

What other visual examples can you come up with from across the book and from today's world that reflect this theme? How are people's motivations across time and place similar and different?

FIGURE C14.4.   *Book of the Dead* of Nakht reconsidered.

# 15

# Renaissance and Baroque Art

**DETAIL OF FIGURE 15.2**
During the Renaissance, a new concept of God emerged. Here, in a detail of God from the Sistine Chapel in Rome, God looks like a man, with a determined look, flowing hair, and a wrinkled brow.

## LEARNING OBJECTIVES

**15.1** Name the characteristics of Early Renaissance art.

**15.2** Explain why Leonardo, Michelangelo, and Raphael are quintessential examples of the Renaissance spirit.

**15.3** List the two styles that appealed to wealthy patrons in Italy during the sixteenth century.

**15.4** Describe the methods Northern Renaissance artists used to portray their surroundings accurately.

**15.5** Summarize how art changed because of the Protestant Reformation.

**15.6** Identify the five characteristics of Baroque art that promoted the Counterreformation in Italy.

**15.7** Illustrate how Baroque art was used to glorify individuals in Spain and Flanders.

**15.8** Distinguish Baroque art in France from Baroque art in other countries.

**15.9** Explain why Baroque artists in the Dutch Republic created secular, everyday images.

## MICHELANGELO'S SISTINE CHAPEL PAINTINGS

In 1506, Pope Julius II decided that the Italian sculptor Michelangelo Buonarotti (mee-kel-AN-jel-oh bwoh-nah-ROE-tee) should paint the ceiling of the Sistine (sis-TEEN) Chapel, in Rome, where the pope celebrated mass daily. Michelangelo, who had almost no experience with the complex fresco painting method (see Chapter 6) that would be required, fled Rome. However, the determined pope persuaded Michelangelo to return.

How Art Matters

Michelangelo faced a daunting task. The twelve-thousand-square-foot ceiling is sixty-eight feet from the floor, and Michelangelo had to design scaffolding to reach the surface. He *painted the ceiling over a period of four years, standing on his scaffolding*—neck craned, head back, and arm up with paint dripping on his face.

### The Ceiling Organization

*Michelangelo's plan for the ceiling was bold.* He devised a complex scheme of over three hundred figures separated into scenes by a painted, faux, architectural structure (figure 15.1A and B). Running down the center of the ceiling and at the corners are scenes from the Old Testament. Around the central images are various Old Testament prophets and ancient sibyls, who foretold the coming of Christ. Above the windows, Michelangelo painted Christ's ancestors.

**(A)**

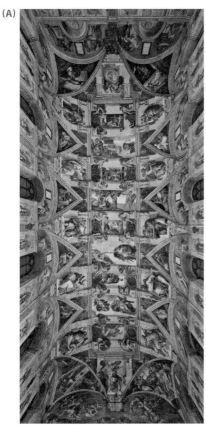

**FIGURE 15.1A (CEILING) AND B (DIAGRAM).**
**Michelangelo Buonarotti. Sistine Chapel ceiling.** *From the Vatican, Rome. 1508–12. Fresco, 45' × 128'.* Michelangelo's complicated plan for the ceiling is evident in the overall image (15.1A), but the diagram (15.1B) shows the organization.

**(B)**

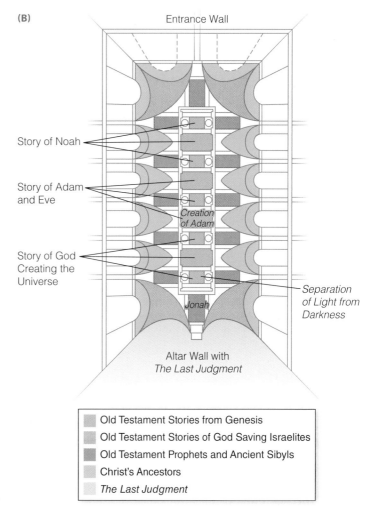

Entrance Wall

Story of Noah

Story of Adam and Eve

*Creation of Adam*

Story of God Creating the Universe

*Separation of Light from Darkness*

*Jonah*

Altar Wall with *The Last Judgment*

Old Testament Stories from Genesis
Old Testament Stories of God Saving Israelites
Old Testament Prophets and Ancient Sibyls
Christ's Ancestors
*The Last Judgment*

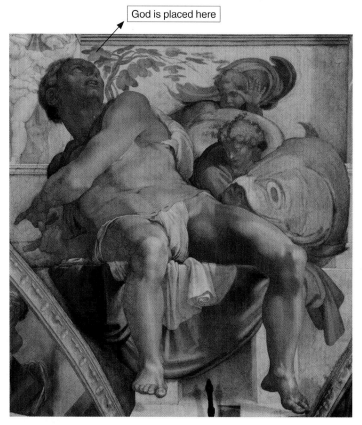

Probably Eve and Jesus

**FIGURE 15.2.** **Michelangelo Buonarotti.** *Creation of Adam. From the Sistine Chapel ceiling.* With God are other figures, including probably the yet-to-be-created Eve and the unborn Jesus.

God is placed here

**FIGURE 15.3.** **Michelangelo Buonarotti.** *The Prophet Jonah. From the Sistine Chapel ceiling.* As the Old Testament scene of God separating light from darkness is directly above the image of Jonah, Michelangelo connected Jonah with God by having Jonah gaze directly upward at God.

## The *Creation of Adam*

Michelangelo devised *revolutionary ways to depict the stories and personalities*. In the *ordered and balanced* Old Testament scene of the *Creation of Adam* (figure 15.2), an energized, outwardly curved God transmits life to a passive, inwardly rounded Adam through a mere touch of his finger. No longer the terrifying judge from the medieval period (see Chapter 14), *God is a rational, human-like father figure*. In addition, Adam has *naturalistic* sculpted muscles and *idealized* facial features and takes a graceful pose, unlike static, abstract medieval figures. He lies stretched out and lifeless on an imprecise piece of land. As each of the central Old Testament scenes foretells a story in the New Testament, Adam foreshadows the dead Christ. Contemporary viewers likely would have been reminded that Christ's sacrifice would redeem humanity for Adam's sin.

## Jonah

An example of one of the surrounding Old Testament prophets can be seen in *Jonah* (figure 15.3). Christians believe that Jonah's being trapped inside a whale for three days and then freed foretold Jesus's death and resurrection. Michelangelo *elevated the prophet* by painting him in the position closest to the altar wall and hierarchically larger than the other prophets. Jonah thus would have been the first prophet that the pope and other officials would have noticed upon entering the chapel. By placing Jonah closest to the altar, Michelangelo reminded viewers that through prayer, God would forgive humankind, as God ultimately forgave Jonah (see Chapter 14).

Scholars also believe that Michelangelo felt a connection to Jonah. In the image, Jonah looks up, just as Michelangelo looked skyward when painting. Michelangelo also initially ran from responsibility, like Jonah, and had to be brought back to God's work. By placing the prophet who was most similar to himself in *the position of prominence*, Michelangelo may have been suggesting a parallel that he, like a prophet, had *unique worth* in that he had been redeemed to serve as God's messenger, *spreading the divine message through art*.

## The Transformation in Michelangelo's Style

*During the four years that Michelangelo painted the ceiling, his technique and style changed.* The Old Testament scenes at the bottom of figure 15.1A that Michelangelo painted later are more confident, dynamic, and powerful than the ones at the top. *Michelangelo's method also changed*; for the first half, he worked from preconceived cartoons (see Chapter 6), but, for the second half, he scratched freehand drawings directly into the fresh plaster. In terms of style, in the *Creation of Adam*, painted earlier, Michelangelo looked back to *Classical models*

from ancient Greece and Rome, creating idealized, perfect forms. Yet, *Jonah*, painted later, *twists in a contorted, foreshortened position.*

## The Last Judgment

Michelangelo finished the ceiling in 1512, but it was not his last work in the chapel. Beginning in 1536, Michelangelo took on a project for Pope Paul III—a forty-eight-foot-high painting of *The Last Judgment* on the altar wall. Again, *Michelangelo rejected convention.* Rather than having the damned on the right and the saved on the left, Michelangelo's Second Coming unfolds in an oval that circles a large, hierarchically scaled Christ with souls rising on the left and the damned plunging toward hell on the right. The dramatic scene begins on the bottom left (figure 15.4A)

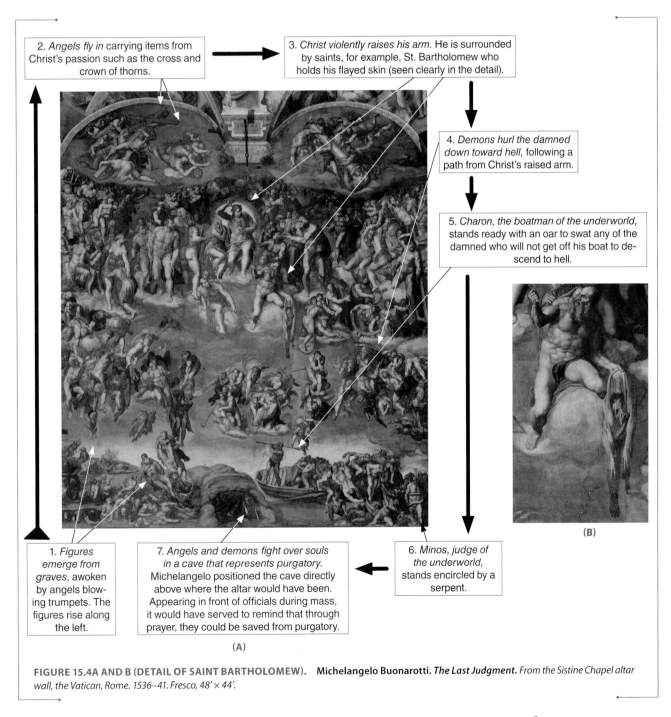

2. *Angels fly in* carrying items from Christ's passion such as the cross and crown of thorns.

3. *Christ violently raises his arm.* He is surrounded by saints, for example, St. Bartholomew who holds his flayed skin (seen clearly in the detail).

4. *Demons hurl the damned down toward hell,* following a path from Christ's raised arm.

5. *Charon, the boatman of the underworld,* stands ready with an oar to swat any of the damned who will not get off his boat to descend to hell.

6. *Minos, judge of the underworld,* stands encircled by a serpent.

7. Angels and demons *fight over souls* in a cave that represents purgatory. Michelangelo positioned the cave directly above where the altar would have been. Appearing in front of officials during mass, it would have served to remind that through prayer, they could be saved from purgatory.

1. *Figures emerge from graves,* awoken by angels blowing trumpets. The figures rise along the left.

(A)

(B)

**FIGURE 15.4A AND B (DETAIL OF SAINT BARTHOLOMEW).** Michelangelo Buonarotti. *The Last Judgment. From the Sistine Chapel altar wall, the Vatican, Rome. 1536–41. Fresco, 48′ × 44′.*

**FIGURE 15.5. Michelangelo Buonarotti's Sistine Chapel ceiling during the restoration.** The cleaned, bright colors of the restored paintings are in the lower half of the photograph, while the darker pre-restoration paintings are in the top half.

*The Last Judgment* plays out against a *radiant, ultramarine background* that is darker and more intense than the ceiling colors. Michelangelo created this color from lapis lazuli, a rare pigment acquired at enormous expense. The blue made *The Last Judgment* the focal point of the room given its *depth* and *saturation*.

*A new style pervades Michelangelo's The Last Judgment* that has its roots in the contorted pose of *Jonah*. On the altar wall, *distorted figures*, their heads too small for their massive bodies, writhe in violent positions. Gone is the peaceful harmony and controlled structure of the *Creation of Adam*, replaced by *anxious uncertainty and swirling motion*. The scene appears to *burst beyond its borders* as Michelangelo painted figures on the edges of the mural cut off as if it would expand infinitely.

When Michelangelo finished *The Last Judgment*, he was sixty-seven years old and no longer the spry, self-assured artist he had represented as Jonah on the ceiling. In *The Last Judgment*, Michelangelo placed his self-portrait on the old, flayed skin of the martyred Saint Bartholomew (figure 15.4B), which stressed his piety and impending fate.

## Controversies Surrounding the Murals

Today, Michelangelo's murals in the Sistine Chapel remain one of the great treasures of Western art; however, given their importance, they have *seen their share of controversy*. For example, even though the naked figures in *The Last Judgment* correspond with spiritual forms described in scripture, *some viewers have found the nudity offensive*. Michelangelo's first critic was a church official, who, while Michelangelo was still painting, claimed the figures were appropriate for the walls of a bathhouse. In response, Michelangelo painted the official's facial features on Minos in hell. The nudity controversy continued until 1565, when one of Michelangelo's students painted loincloths over the figures.

Another controversy arose when, between 1979 and 1999, the Vatican completed a restoration of the murals (figure 15.5). Over hundreds of years, the murals had been blackened by dust, past restoration efforts, and soot. When restorers unveiled the cleaned murals, many scholars found the bright colors startling. *They accused the restorers of having removed a final layer of paint applied by Michelangelo* after the murals had dried. Other scholars defended the restorations, arguing that viewers had just gotten used to the look of the dirty murals.

## A Quintessential Renaissance Work

Even with past controversies, Michelangelo's Sistine Chapel serves as a *quintessential work of Italian Renaissance art*. Completed over thirty-three years, the murals offer insight into two phases of the period. Through the changes in Michelangelo's approach to the murals, we can begin to see the *confidence of the people* at the beginning of the sixteenth century *as they looked back on their Classical heritage* and tried to revive its glory, and their *insecurity in the years following as the church came under attack*. We can also see the *value in considering the past and how it can lead to new innovations and ideas*. This chapter will consider work from the Renaissance, as well as the period that followed, called the Baroque. Before moving forward, based on this story, what do you think are some of the tenets of the Renaissance style?

# The Renaissance

The 1400s and 1500s in Europe cover a period known as the **Renaissance**. "Renaissance" means "rebirth," and the term aptly describes the *self-assured mentality of the age*. A number of new developments emerged:

- *A revival of ancient values:* People looked back on history and imagined themselves the rightful heirs of the ancient Greek and Roman past.
- *An interest in humanism:* A movement called humanism emerged that promoted the unique worth and potential of individuals and emphasized moral conduct, intellectualism, and rational thought. Toward this end, humanists focused on the study of humanities and classical texts, believing ancient knowledge served as a model for self-perfection.
- *A change in the view of God:* People no longer lived in fear of an all-powerful judge, as they had during the Middle Ages. Instead, Renaissance thinkers saw God in human terms and people in control of their potential. The rational, human-like God in Michelangelo's *Creation of Adam* (figure 15.2) reflects this new view.
- *A "rebirth" of Classical art:* The renewed fascination with antiquity led Renaissance artists to build on the harmonious designs and naturalism of the ancients by using logic, math, and science. They created more realistic images by developing linear and atmospheric perspective to form the illusion of three-dimensional space on a flat surface and *chiaroscuro* to create the appearance of rounded forms (see Chapter 3).
- *A renewed status of artists:* In forging ahead with a Classical model, artists reclaimed their status in society and strove to differentiate their work and describe its intellectual components.
- *An emergence of patrons:* Growth in a new class of patrons—those who supported artists by commissioning works of art—accompanied the emergence of artists. A rise of strong nations and city-states, population growth, and an increase in trade fostered strong rulers and wealthy merchants. These influential leaders were interested in art.

An ornate plate shows how many of these factors came together in Renaissance art. Nicola da Urbino (NEE-coh-la da oor-BEE-noh) created the plate as part of a set for the *renowned patron* Isabella d'Este (iz-ah-BELL-ah DEHS-tay), wife of the head of a powerful family in northern Italy. Each plate depicted a different *Classical myth*. The illustrated example shows Isabella's coat of arms, a symbol used to indicate ancestral descent, surrounded by the story of the musical contest between two ancient Greek gods, Pan and Apollo. A third god, Tmolus, was chosen to judge the musicians, and he pronounced Apollo the winner. However, King Midas, a mortal, overheard the playing and declared Pan the superior musician. Furious, Apollo changed Midas's ears into a mule's ears to match what Apollo believed was Midas's foolish hearing. In figure 15.6, the story appears on the plate.

The plate not only suggests the interest in the *Classical subject matter*, but also signals an appreciation for *depicting the natural world*. A defined light source hits each figure, creating the illusion of rounded, three-dimensional forms.

**Renaissance** The period in Western history during the fifteenth and sixteenth centuries, associated with an artistic and intellectual revival of values of the ancient Greek and Roman worlds

The *Classical legend* unfolds as Midas, depicted in his crown, listens to Apollo, while standing behind Tmolus.

Tmolus sits listening while Pan (represented with the hoofs and horns of a goat) lounges on the ground.

In a *repetition* of the figures, showing a new moment in time, Apollo watches from behind the tree as Midas listens to Pan and points his finger to indicate his selection.

**FIGURE 15.6.** **Nicola da Urbino.** *The Story of King Midas.* *Plate from the set of service created for Isabella d'Este. c. 1520–25. Tin-glazed earthenware, diameter 10 ¹³⁄₁₆″. The Metropolitan Museum of Art, New York.*

As can be seen in the timeline in figure 15.7, the Renaissance centered in two locations: Italy (which had several different phases including the Early Renaissance, the High Renaissance, and the Renaissance in Venice) and the North (which included both the Northern Renaissance and Reformation). The art made in the two locations overlaps in time. Mannerism, a reaction against the Renaissance, and the Baroque are also indicated on the timeline.

## The Early Renaissance in Italy

The Renaissance found its roots in Italy in the fifteenth century. Italian artists were spurred on by Giotto's naturalism (see figure 14.24), surrounded by ancient ruins, influenced by the papacy, and encouraged by wealthy, secular patrons. These artists:

- Depicted *Classical* architectural settings, motifs, and subject matters
- Championed *naturalism*
- Created *harmonious, ordered designs*

### Painting

One of the first artists to implement the Renaissance style in a painting was Masaccio (ma-ZAH-choh). His *Holy Trinity* (figure 15.8A) depicts the trinity—Christ, the dove of the Holy Spirit, and God the Father—flanked by the Virgin Mary and John the Evangelist.

The mural shows Masaccio's interest in *Classical ideals*. Even though this is a religious painting, Masaccio placed the figures in a barrel-vaulted chapel complete with Greek

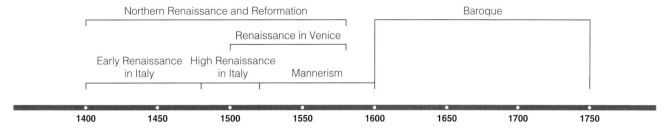

**FIGURE 15.7. Timeline of Renaissance and Baroque Art.** The Renaissance period in Italy overlapped with the Renaissance period in the north.

orders (see Chapter 12). He also mimicked the *harmony* used in the ancient world in his symmetrically balanced design.

A number of features also work to *persuade viewers that the image is real.* The figures appear to stand in a rational, three-dimensional space. Masaccio achieved this feat by being the *first artist to use one-point perspective* (see Chapter 3). Receding lines down the vault meet at a vanishing point below the cross (figure 15.8B). Masaccio also, like Michelangelo in the Sistine Chapel, gave his figures anatomically correct bodies and believable bulk, and used *chiaroscuro* (see Chapter 3) to form highlights and shadows across their bodies. Outside the chapel, appearing as if in the viewer's space, Masaccio painted the donors of the painting. By depicting the holy figures in the illusion of a recessed space and the donors in what appears to be the location outside of the chapel with us, it is as if *we along with the donors witness the miraculous vision together.*

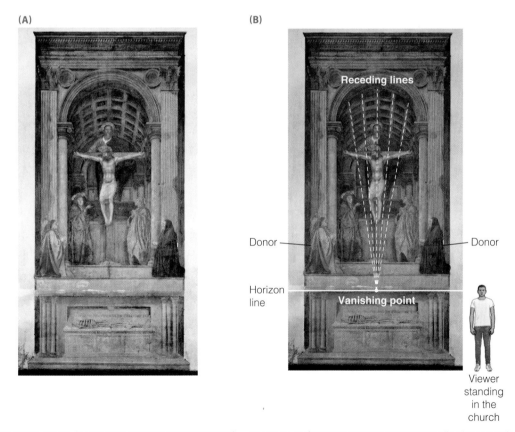

**FIGURE 15.8A AND B (SHOWING LINEAR PERSPECTIVE).** Masaccio. *Holy Trinity. From Santa Maria Novella, Florence, Italy. c. 1425. Fresco, 21′ 9″ × 9′ 4″.* Masaccio tried to form the illusion of a three-dimensional scene unfolding before us (15.8A). If we were standing in the church, with the one-point perspective system (15.8B) and the donors painted seemingly outside the chapel in our space, it makes it appear as though we look up into the niche that the holy figures occupy.

The Renaissance    **401**

*Birth of Venus* by Sandro Botticelli (SAHN-droh boh-ti-CHEL-lee) also shows the Early Renaissance approach. The image depicts the Roman goddess of love, after she has just been born fully grown as an adult (figure 15.9).

Botticelli incorporated a *Classical subject matter* and based Venus's pose on Praxiteles's ancient sculpture of *Aphrodite of Knidos* (see figure 2.9). Like Aphrodite, Venus modestly covers herself, yet erotically brings attention to the areas of her body that she attempts to hide.

Unlike Masaccio, Botticelli did not place his figures into an illusion of a three-dimensional space. Instead, an elongated Venus looks stuck onto a painted backdrop and an elegant outline curves around the figures. Botticelli, in a further attempt to mimic the Classical, may have based his work on ancient vase painting (see figure 13.25), which took a linear, flat approach.

Botticelli painted this work for the powerful Medici family, *patrons who promoted humanism* in Florence. The subject matter concerning the goddess of love indicates that the painting was probably created in honor of a Medici wedding. Venus likely represents the bride about to start her life as a wife and mother. As the Medici family was interested in reconciling Classical thinking with the Christian faith, Venus may also symbolize divine love and perhaps represent the Virgin Mary.

## Sculpture

Donatello formed another work commissioned by the Medici family, a sculpture of the biblical hero David (figure 15.10). The figure likely stood in the family courtyard in Florence where all could see it from the street. The Florentines considered David a symbol of the city, and the Medici may have seen the work as important in showing their support for Florence against its enemies.

Donatello's figure was the *first bronze, life-sized, freestanding nude that had been created since antiquity.* Unlike medieval sculpture, which had been attached to cathedral walls, David stands in a Classical

artists
MATTER
Donatello

FIGURE 15.10. **Donatello.** *David.* 1428–32. Bronze, height 5′ 2 ¼″. National Museum of Bargello, Florence, Italy. As David steps on Goliath's severed head with his foot and holds Goliath's enormous sword in one hand, David looks elegant and graceful. His appearance makes the miracle of his beating the unruly giant even more impressive.

The wind god and a mythological nymph gently blow Venus across the water.

The Classical goddess Venus floats gracefully to shore on a seashell.

The goddess of spring floats in to cover Venus with a flowered robe.

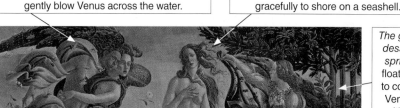

FIGURE 15.9. **Sandro Botticelli.** *Birth of Venus.* c. 1485. Tempera on canvas, 5′ 8 ⅞″ × 9′ 1 ⅞″. Uffizi Gallery, Florence, Italy.

*contrapposto* pose that was meant to be seen from all angles. Moreover, Donatello's sculpture depicts a nude, male body, returning to the heroic, *Classical ideal* (see Chapter 13). Finally, David seems *realistic*. He looks to be a teenager whose lanky body mimics that of an adolescent's.

Donatello's sculpture, though, also departs from ancient precedents and follows the tenets of *humanism*, showcasing the *importance of an individual*. David is a unique person, and we have a keen sense of his persona.

While Donatello produced a freestanding sculpture, other early Renaissance artists adopted the new approach in relief. To explore one of these early Renaissance sculptures, see *Practice Art Matters 15.1: Identify Early Renaissance Ideals in a Work*.

### Architecture

The work of Filippo Brunelleschi (fee-LEEP-poh broon-eh-LES-kee) shows how Renaissance concepts pervaded architecture. The silk manufacturer and goldsmith guild

---

*Practice* **art**MATTERS

## 15.1 Identify Early Renaissance Ideals in a Work

Lorenzo Ghiberti (loh-REN-tsoh gee-BER-tee) designed ten gilded relief panels for the doors of the Florence baptistery (where Christians were baptized) using early Renaissance ideals. The doors were called the *Gates of Paradise* because Michelangelo, it was said, thought Ghiberti's work so exceptional that the doors could have served as the doors to heaven. Each of the ten panels depicts a different Old Testament scene.

The *Jacob and Esau* panel tells the story of how Jacob managed to acquire the blessing of his father that rightfully belonged to his brother, Esau, the first-born son. Christians believe that the story foreshadows the fact that Christianity superseded Judaism.

Ghiberti told different parts of the story in different locations on the panel. As time progresses through the story, the figures move from the background into the foreground, so that the later, more dramatic events are closest to the viewer (figure 15.11).

Where do you see the following Early Renaissance ideas in the panel?

- Classical architectural settings, motifs, and/or subject matters
- Naturalism
- Harmonious, ordered designs

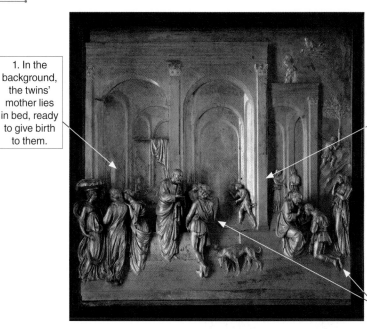

1. In the background, the twins' mother lies in bed, ready to give birth to them.

2. In the middle ground, Esau sells his future birthright blessing to Jacob.

3. In the foreground, the two most exciting parts of the story play out—Isaac gives the blessing to Jacob (right) and tells his mistake to Esau (left).

Interactive Image Walkthrough

**FIGURE 15.11.** **Lorenzo Ghiberti.** *Jacob and Esau. Panel from the* Gates of Paradise, *Baptistery of San Giovanni, Florence, Italy. c. 1435. Gilt bronze, 2' 7 ¼" × 2' 7 ¼".*

FIGURE 15.12. **Filippo Brunelleschi. Hospital of the Innocents.** *Begun 1421, Florence, Italy.* Brunelleschi's design included a covered porch, typical of charities wanting to project an image of offering shelter.

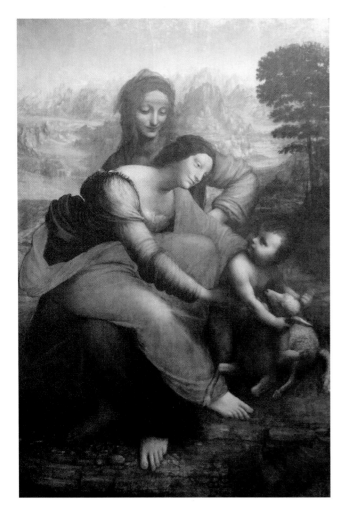

FIGURE 15.13. **Leonardo da Vinci. *The Virgin and Child with Saint Anne.*** *c. 1510. Oil on wood panel, 5′ 6 ⅛″ × 3′ 8″. Louvre Museum, Paris.* The overall hazy softness—from both the *sfumato* and atmospheric perspective—seems to give the painting a dreamlike quality appropriate for its symbolic premonition: the lamb (foreshadowing Jesus becoming a sacrificial lamb) and the tree (suggesting the true cross) point to Jesus's future fate.

financed Brunelleschi's design for the Hospital of the Innocents (figure 15.12), an orphanage for abandoned children in Florence, in line with the *new rise of patrons* interested in funding art. *Guilds were powerful associations of craftsmen* that established regulations and protected their members' interests. They served as benefactors of the arts because they felt a civic obligation to help beautify their cities and benefitted from the increase in prestige that came from their generosity.

*Classical architectural features are everywhere* in the building. Regularly recurring round arches, columns, and Corinthian orders grace the first floor, while second-floor windows are topped with triangular pediments. Brunelleschi also aligned the building with the new *interest in the individual.* He brought the size down to human scale and produced a horizontal emphasis by using a dominant, side-running molding. Finally, Brunelleschi repeated a standard unit of measurement throughout the building, creating a *rational and harmonious feel.* The contrasting white and gray stone shows off the order, elegance, and rhythm of the plan.

*Quick Review 15.1*: What are the characteristics of Early Renaissance art?

## The High Renaissance in Italy

As the Renaissance progressed, three artists—Leonardo da Vinci (lay-oh-NAHR-doh dah VEEN-chee), Michelangelo, and Raphael (RAF-fye-ell)—emerged as quintessential examples of the Renaissance spirit. Because of their prototypical achievements, this period from 1490 to 1520 is known as the High Renaissance. High Renaissance artists built on Early Renaissance achievements with works that were:

- Based on *Classical ideas*
- *Naturalistic*
- *Ordered* and *harmonious*

### Leonardo

Art historians believe Leonardo was exemplary of the High Renaissance ideals because of his *balanced designs* and intense interest in *copying the natural world.* In *The Virgin and Child with Saint Anne* (figure 15.13), the Virgin Mary, Jesus, Saint Anne (the Virgin's mother), and a lamb create a stable triangular composition. Moreover,

the figures sit in a believable, receding landscape. The painting is a testament to Leonardo's belief that to create realistic images, an artist had to *understand science and how we see the natural world* (see Chapter 5). Here, Leonardo used *chiaroscuro* to depict the soft light and dense shadows and **sfumato** (sfoo-MAH-toh) to blur transitions between colors and tones. He also employed atmospheric perspective to convey the recession into space.

The painting, though, also displays the difference between Early and High Renaissance art. While the Early Renaissance *Holy Trinity* (figure 15.8) painting has realistic figures with bulk, the figures here appear more believable. Swags of fabric fall over limbs seemingly made from real muscles, bones, and skin. *In the High Renaissance, the illusion of reality is greater.*

## Michelangelo

The introduction to the chapter described Michelangelo's High Renaissance paintings on the ceiling of the Sistine Chapel. Michelangelo, though, viewed himself primarily as a sculptor, and in this medium, he also held true to Renaissance ideals. Figure 15.14A shows Michelangelo's sculpture of David, which, like Donatello's, was carved for the city of Florence. Here, the biblical hero stands with a slingshot over his shoulder and a rock in his hand, contemplating Goliath, before the fight.

Michelangelo is characterized as a quintessential Renaissance artist because he *reinvented the Classical nude.* David is an *idealized*, large-scale figure in a *contrapposto* position. He is also a *specific individual* in a particular situation. While Donatello began the innovations in sculpture with his Early Renaissance work (figure 15.10), Michelangelo completed the transformation. First, David's athletic physique makes him appear godlike, capturing

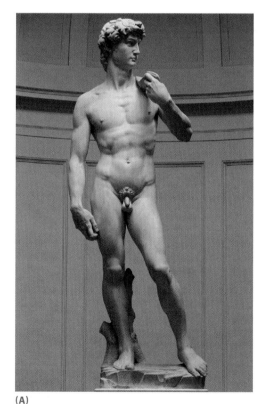
(A)

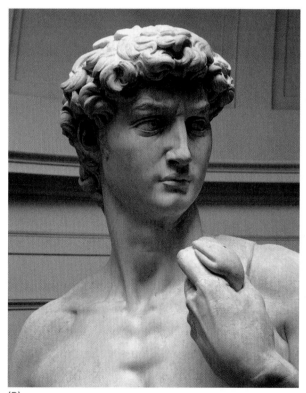
(B)

**FIGURE 15.14A AND B (DETAIL).**   **Michelangelo Buonarotti.** *David. 1501–4. Marble, height 17' ⅛". Accademia Gallery, Florence, Italy.* Every muscle is taut in David's naturalistic, yet idealized torso (15.14A), and we can all but feel the quickening of his pulse that would have run through the protruding veins in his hands as he stood poised to swing into action. He wrinkles his brow as he stares down his opponent (15.14B).

the *idealization of humanity* prevalent in ancient sculptures. Second, David's *individuality* and *potential* are shown in the expression on his face (figure 15.14B), which reflects an intensity unknown in Classical times and not found in Donatello's work.

### Raphael

Raphael completes the trio of High Renaissance artists with his *Classically inspired subject matters, harmonious compositions, and realistic depictions.* In the *School of Athens* (figure 15.15), Raphael organized a gathering of ancient philosophers and scientists, including Plato and Aristotle who walk nobly toward the viewer, in a barrel-vaulted, columned, Classical- and Renaissance-invented space. Receding lines converge at a single point between Plato and Aristotle, creating an *ordered and symmetrically balanced composition* derived from one-point perspective. In addition, all of the dignitaries have Renaissance-styled, *realistic bodies* that are lit by a light that gives the illusion of convincingly coming from the right, casting consistent shadows to the left of the figures.

Like Michelangelo, Raphael believed in *promoting the status of artists*, and we see that Renaissance characteristic here. Raphael included portraits of himself and other artists (including Leonardo and Michelangelo) at the elite gathering, signifying that the artists were intellectuals and not mere craftsmen.

The most quintessential Renaissance aspect of the work, though, may be its context. The painting is one of four that Pope Julius II had Raphael create for his private library. Each fresco depicts a different branch of Classical knowledge. *The School of Athens* portrays philosophy. Nothing could be more characteristic of the Renaissance than the fact that the leader of the church commissioned a secular work for his personal apartment. *The commission, in and of itself, shows the triumph of Classical ideals.*

*Quick Review 15.2*: Why are Leonardo, Michelangelo, and Raphael quintessential examples of the Renaissance spirit?

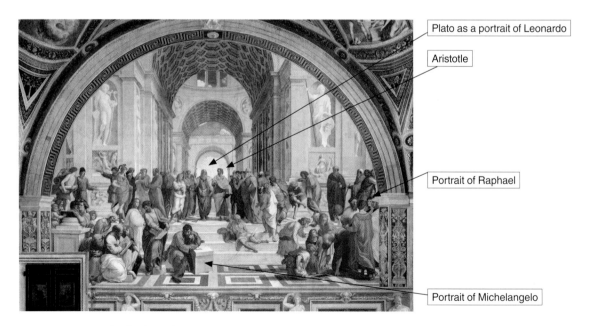

Plato as a portrait of Leonardo

Aristotle

Portrait of Raphael

Portrait of Michelangelo

**FIGURE 15.15.** **Raphael.** *School of Athens. From the Room of the Segnatura, the Vatican, Rome. 1510–11. Fresco, 26' × 18'.* In his depiction of Plato, Aristotle, and other intellectuals at a gathering, Raphael placed Leonardo's dignified features on Plato, Michelangelo's on the philosopher who sits gloomily in the foreground, and Raphael's own on the figure at far right.

## The Renaissance in Venice and Mannerism

Two different styles appeared in the sixteenth century in Italy that appealed to wealthy patrons. We call these approaches the *Renaissance in Venice* and *Mannerism.*

Venetian artists pursued some High Renaissance ideas, but they were also influenced by Byzantine art (see Chapter 14). In putting the styles together, artists created a unique look for wealthy patrons that included:

- *Classical subject matters*
- *Glowing, rich colors*
- *Shimmering surfaces*

*Venus of Urbino* (figure 15.16) by Titian (TISH-uhn) illustrates how the *Classical subject matter* of the Roman goddess of love was transformed by a Venetian painter. Venus lies on a bed, her soft, creamy skin highlighted against the silky, white bed sheet and plush, red pillows. Just like Botticelli's Venus (figure 15.9), she covers herself and the position of her hand makes the move seem erotic. There, though, the similarities to Botticelli's work end.

Titian was interested in *surface qualities*. Using oil paint, which he applied in numerous glazes (see Chapter 6), Titian portrayed *rich colors* (like the warm, red skirt of the woman in the background) and *lush textures* (like the sumptuous velvet that hangs behind Venus). He did not copy exact details, but used painterly brushstrokes to focus on what the eye perceives.

Rather than being an individual full of potential, Venus seems to exist for the sole purpose of being sensuous. Titian painted this picture for the Duke of Urbino, and the Classical subject matter may have just been a pretense, so that the duke could gaze upon a picture of what looks decidedly like a courtesan. Venus stares seductively out at the viewer, reinforcing this point of view.

However, new research suggests that the duke may have commissioned the painting in tribute to his marriage. Much of the iconography suggests marriage, such as the dog, which indicates fidelity, and the chests in the background, which were often given as wedding gifts. According to this interpretation, Venus is the duke's wife, who casually waits on her bed and gazes knowingly out at her husband, as her maids gather the clothes she shall wear for the day.

Like the Renaissance in Venice, another style that catered often to wealthy and courtly patrons is called **Mannerism**. During the sixteenth century, this *sophisticated and elegant approach to art*—which moved against High Renaissance ideals—pervaded Italy (see *Delve Deeper: Mannerism*).

*Quick Review 15.3*: What are the two styles that appealed to wealthy patrons in Italy during the sixteenth century?

## The Renaissance in Northern Europe

Renaissance ideas about *human knowledge, rationalism,* and *individual potential* pervaded northern Europe in the fifteenth and sixteenth centuries, just as they did Italy. However, while northern artists were influenced by

**Mannerism**  A sophisticated and elegant style of art in Italy during the sixteenth century, associated with a rejection of High Renaissance Classicism and naturalism in favor of the use of distorted figures, unnatural colors, and an irrational space

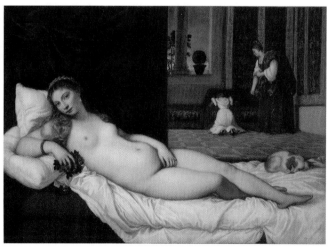

**FIGURE 15.16.**  **Titian. *Venus of Urbino.*** *c. 1538. Oil on canvas, 3′ 11″ × 5′ 5″. Uffizi Gallery, Florence, Italy.*  Titian focused so much on surface characteristics that it is as if Venus has no skeletal or muscular structure at all. She is the complete opposite of Michelangelo's strapping figures.

# DELVE DEEPER

## Mannerism

Mannerism rejected the Classical, realistic, and harmonious approach of the High Renaissance. Mannerist artists depicted contorted, weightless figures in irrational spaces and used unnatural colors.

Agnolo Bronzino (AHN-yoh-loh brawn-ZEE-noh) painted the Mannerist work *An Allegory with Venus and Cupid* (figure 15.17) for the ruler of Florence to be given as a gift to the king of France. Some art historians have suggested that the meaning of the work concerns the foolishness of love, a topic that may have appealed to the sophisticated tastes of the monarch. The painting is an odd mix of eroticism and allegory, and many of the figures symbolize abstract ideas. Bronzino, following Mannerist tendencies, also rejected Renaissance naturalism. The compressed space is filled with an impossible number of twisting, interlocking bodies, and colors are discordant.

A religious painting from this period shows a similar interest in irrational compositions and inexplicable spaces. Lavinia Fontana's *Noli Me Tangere* (*Don't Touch Me*) tells the New Testament story of Mary Magdalene discovering that Jesus's body is gone from his tomb. Fontana depicted the story in two scenes set in a shallow, confusing space (figure 15.18).

The goddess Venus is positioned in a disturbing, erotic embrace with her teenage son, Cupid.

The top of Cupid's body cannot possibly align with the bottom.

Venus seems to float in front of the glimmering, blue satin cloth on which she kneels.

This baldheaded man, opening the curtain, likely represents "time."

This child, about to throw rose petals on the couple, may represent "playfulness."

This girl with a serpent's tail probably symbolizes "fraud."

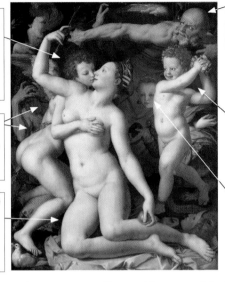

**FIGURE 15.17.** **Agnolo Bronzino. *An Allegory with Venus and Cupid.*** c. 1545. Oil on wood panel, 5' 1" × 4' 8 ¼". The National Gallery, London.

In the first scene, an angel sits atop the open vault, while Mary and two disciples stand at the entrance. Rather than recede, the scene appears to hover over the foreground Mary's head.

In the second scene, the resurrected Christ, dressed as a gardener, appears to Mary and tells her not to touch him. While the landscape behind Christ is supposed to be in the distance, it appears to spring from Christ's shoulder.

The foreground Mary seems weightless, and her upper body is oddly positioned and too small compared to the rest of her figure.

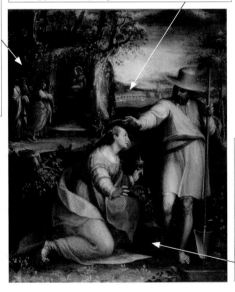

**FIGURE 15.18.** **Lavinia Fontana. *Noli Me Tangere (Don't Touch Me).*** 1581. Oil on canvas, 2' 7 ½" × 2' 1 ¾". Uffizi Gallery, Florence, Italy.

humanism, they were additionally inspired by late, northern medieval art such as the detailed work of the Limbourg brothers (see Chapter 14). In addition, their naturalism took a distinct form. Rather than focusing on the inner structure and rounded bulk of figures as artists like Michelangelo had, northern artists:

- Attempted to capture *exact, external surface textures* and *minute details of the natural world*
- Used *rich colors*
- Employed transparent glazes of *oil paint*

## Religious Art

Like their Italian counterparts, Northern Renaissance artists depicted religious scenes. However, by focusing on faith and an *individual's relationship with God* instead of ritual and the authority of Rome, northern artists *brought the divine into regular people's lives*. In northern religious art, ordinary-looking holy figures enact miraculous events inside contemporary households, furnished with everyday objects that hold symbolic, religious meaning.

Robert Campin's *Merode Altarpiece* was originally intended as a small, devotional piece for a family home. The work enabled direct, private prayer to God without the help of the church. The **triptych** depicts three scenes (figure 15.19). On the left, the patrons who commissioned the work kneel in a garden. At center, the Virgin Mary sits reading in a typical, middle-class, fifteenth-century room, while the Angel Gabriel tells her that she is to carry the Lord's child. As he speaks, a tiny baby Jesus, holding a cross, flies through the room toward Mary. At right, Joseph, Mary's husband, works in a carpentry shop building mousetraps. Throughout the three scenes, we see a *secular home*. It is filled with *ordinary people* who act in particular ways and *everyday objects* placed around the rooms—both of which *hold greater symbolic meaning* intended to notify us of the religious significance of the scene.

**triptych** A type of picture that is made in three parts that are often connected with hinges, so that the outer sections can fold over the central section

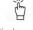

Interactive Image Walkthrough

The patrons witness the miraculous event through an open doorway, perhaps because they are not allowed to share the same space as the holy figures.

The baby Jesus has flown through a closed window, likely showing a parallel to how God impregnated Mary and left her a virgin.

The water pot and towel could represent how Christ will wash away humanity's sins.

Three lilies on the table probably symbolize Mary's purity and the trinity.

Joseph makes mousetraps, likely because they were believed to trick the devil.

Mary sits on a footstool, maybe to show she respectfully accepts God's will.

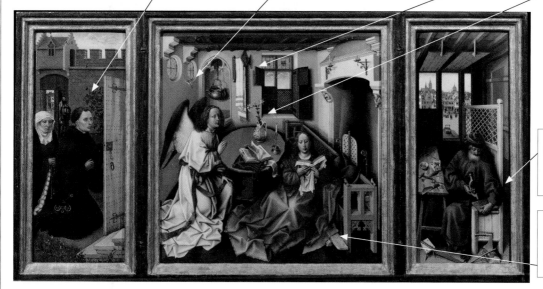

**FIGURE 15.19.** **Robert Campin.** *Merode Altarpiece. c. 1427–32. Oil on wood panel, 2' 1 ⅜" × 3' 10 ⅜". The Cloisters Collection, The Metropolitan Museum of Art, New York.*

Even though the space is not entirely correct (the floor and table are angled too high up), all individuals look *three dimensional*. Campin *depicted every surface texture accurately*. Using *oil paint*, he distinguished Mary's shimmering robe, Gabriel's curly hair, and Joseph's wrinkled hands.

*The Virgin of Chancellor Rolin* by Jan van Eyck (yahn van IKE) reflects the northern sense of an *individual's relationship with God* to an even greater degree. The patron, a government official named Rolin, boldly sits in the same space as the Virgin and Child. The holy figures are a vision that appears to him as he prays (which explains his direct access), kneeling at an open prayer book, in a private, secular room. Rolin approaches the sacred through prayer *without the help of the church as an intermediary*. Van Eyck separated him from the divine by showing the human and godly realms through slight changes in the tile floor and what is depicted in the background (figure 15.20).

Van Eyck's meticulous recreation of the natural world is extreme. He captured *realistic textures* such as the plush velvet of the Virgin's mantle and precise details such as the sparkling jewels of her crown. The dense, *rich colors* and shimmering surface are a testament to the qualities of *oil paint*.

Finally, a number of *everyday objects likely hold higher significance*. Lilies, meant to show Mary's purity, are in the garden, and Mary shows her humility by sitting on a bench rather than on a throne. Jesus holds a globe topped with a cross in one hand, probably to show his universal domain, and raises his other hand to bless the donor. In the background, the river is spanned by a bridge that is directly behind Jesus's raised hand. The bridge likely indicates the path to Christ.

The scene behind Rolin *is of vineyards* (Rolin made his fortune growing grapes).

The scene behind the Virgin and Child *shows the holy city of Jerusalem*, complete with numerous churches.

The tile that runs on the floor separating Rolin and the holy figures *differs in design*.

**FIGURE 15.20.** **Jan van Eyck.** *The Virgin of Chancellor Rolin.* c. 1434. Oil and tempera on wood panel, 2' 2" × 2' ½". Louvre Museum, Paris.

## Self-Portraits

A self-portrait by Caterina van Hemessen illustrates how northern artists were interested in *elevating their status*. As a woman, it was doubly important for van Hemessen to prove that her abilities made her worthy of a superior position. Women were actively discouraged from becoming artists. They were not allowed membership in guilds, were denied apprenticeships, and were refused access to nude models. Despite these challenges, some women, van Hemessen among them, overcame these obstacles.

In her self-portrait, van Hemessen illustrated herself painting a picture of a face and confidently staring out at the viewer (figure 15.21). She indicated her status in different ways. First, she, like the other northern artists, *captured the exact likeness of surface textures and details*, in particular the distinct way that the light reflects off the crinkled, lush fabric of her sleeves. Second, she depicted herself holding a **palette** that holds the exact colors of the self-portrait, indicating that *she is painting herself*.

Male artists also looked to elevate their positions in society. To consider one artist's bold attempts, see *Practice Art Matters 15.2: Explore an Artist's Relationship with the Divine*.

*Quick Review 15.4*: What methods did Northern Renaissance artists use to portray their surroundings accurately?

**FIGURE 15.21. Caterina van Hemessen. *Self-Portrait*. 1548.** *Oil on wood panel, 12 ¼" × 9 ¼". Öffentliche Kunstsammlung, Basel, Switzerland.* Van Hemessen wrote directly on the painting stating that she had painted the picture.

## The Reformation

In the early 1500s, a monk named Martin Luther became increasingly frustrated with the corruption and decreased piety of the Roman church. Luther saw how the church was selling indulgences, which promised the buyer salvation for a fee, to finance extravagant expenditures in Rome. Luther believed that redemption could be achieved through faith and prayer alone and that regular people did not need an intermediary in the form of an indulgence, priest, or religious ceremony to reach God. Luther additionally suspected that lavish church decorations, like Michelangelo's paintings in the Sistine Chapel, led to idolatry.

In 1517, Luther nailed a sheet of ninety-five theses to the door of a church in Wittenberg, Germany, demanding that the Roman church reform. His theses set off a firestorm throughout Europe. Reprinted by presses and widely distributed, Luther's ideas found favor among disillusioned Christians across the continent. Eventually sparking the period known as the Reformation, Luther broke with the Roman church and began his own religion. Later, other religious leaders followed Luther and also began their own Christian faiths. All of these faiths are called Protestant because they "protested" against the Catholic Church of Rome.

Protestants and Catholics fought a series of wars beginning in the mid-1500s that eventually split Europe into different factions. By the end of the sixteenth century, the map of Europe had fractured into a continent where different religions had taken hold. Protestant faiths overtook the Dutch Republic (the modern Netherlands), England, and

**palette** A surface used to hold and mix an artist's paints

## Practice artMATTERS

### 15.2 Explore an Artist's Relationship with the Divine

A self-portrait (figure 15.22) by Albrecht Dürer (AHL-brehkt DUR-uhr) shows a dedication to increasing status. Dürer created an idealized vision of himself, with long hair and raised hand, as if in blessing, likely equating himself with Christ. From the wiry kink in Dürer's hair to the luxurious fur on his collar, Dürer fashioned the most realistic details. It is as if Dürer tells us that he, in his role as artist, resembles God, creator of all things. Like van Hemessen, Dürer asserted his authorship right on the painting in a message to viewers.

Scholars suggest that Dürer additionally elevated his status by creating a work that is reminiscent of holy figures in icons (see figure 14.12):

- How is this work similar to an icon? Why would scholars make this comparison?

- In what ways would associating the work with an icon elevate Dürer's status?

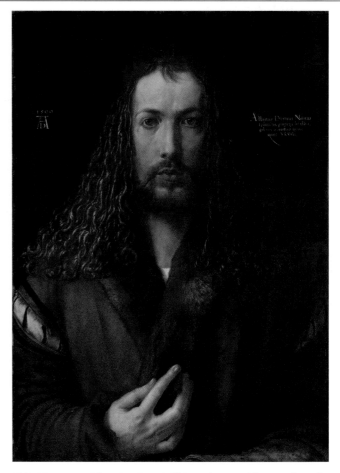

**FIGURE 15.22.   Albrecht Dürer. *Self-Portrait.* 1500. Oil on wood panel, 2′ 2 ¼″ × 1′ 7 ¼″. Alte Pinakothek, Munich.**

much of the Holy Roman Empire, while the Italian states, France, Spain and its northern province of Flanders (modern Belgium) remained Catholic (figure 15.23).

The Protestant Reformation heavily affected northern artists. Influenced by Protestant mobs that were set on destroying church art, many northern artists stopped producing religious works completely. Some northern artists turned to *secular subject matters* such as portraits and landscapes. Others, inspired by the ideas of the movement, employed the power of art in an attempt to convert individuals through *printed propaganda*.

### Secular Art

One such portrait by Hans Holbein the Younger called *The Ambassadors* depicts two Catholic ambassadors to England—the French ambassador and the ambassador to the Papal States. Holbein painted the two men when they were trying to persuade the English king to keep England Catholic (the men failed in their efforts). Holbein captured *every detail*. The French ambassador wears the stylish outfit of an upper-class landowner, his gleaming shirt and fur coat on display, while the ambassador to the Papal States wears a bishop's more conservative robe (figure 15.24).

Like other northern artists, Holbein depicted *everyday objects that held symbolic significance*. The two shelves in between the men likely represent the divided world of the Protestant Reformation. The upper shelf probably symbolizes heaven and is filled with astronomical tools. The lower shelf likely represents the Earth and contains worldly

FIGURE 15.23. The Reformation in Europe at the End of the Sixteenth Century Showing Roman Catholic– and Protestant-Controlled Areas. During the Protestant Reformation, Europe split into areas controlled by Roman Catholics and different Protestant faiths including Lutherans, Calvinists, and Anglicans.

materials. A close consideration of the objects shows both realms divided in chaos, like a math book open to a page on division. The objects seem to suggest the discord and upheaval brought on by the Reformation.

Even though the men rest their arms on a shelf representing a world in turmoil, both stare at the viewer confidently facing their destiny. They seem to know that should death come, they will be among the saved, as they have worked to right the world. A distorted skull, which can only be seen from a severe angle, comes up from the floor. Symbolizing death, the skull likely represents the fact that death is always present, yet no one knows when it will strike. Almost imperceptible in the upper left corner is a crucifixion, likely in answer to the skull. Through Christ, these Catholic men undoubtedly believed they would find redemption from a world torn apart.

FIGURE 15.24. Hans Holbein the Younger. *The Ambassadors.* 1533. Oil on wood panel, 6′ 9½″ × 6′ 10¼″. The National Gallery, London. The French ambassador (left) and the ambassador to the Papal States (right) are surrounded by numerous objects that give additional meaning to the work, including a lute that has a broken string (likely representing disorder) as well as a skull and crucifixion.

**FIGURE 15.25.** Lucas Cranach the Elder. *Christ Washing the Feet of the Disciples and the Decadence of the Papacy.* From a pamphlet contrasting the life of Jesus with the life of Pope Leo X. 1521. Woodcut, 7 ⅝" × 5 ⅝". Lambeth Palace Library, London. In this print used by Protestants to spread their message, Jesus (on the left) is contrasted with Pope Leo X (on the right), who appears to rule as if he is a secular king more interested in power than faith.

**Baroque** A style of art in Europe in the seventeenth and early eighteenth centuries, associated with realism, heightened emotion, dramatic use of light and color, innovative space, and symbolism

## Propaganda

Lucas Cranach the Elder's print (figure 15.25) illustrates how Protestants used art in the role of *propaganda*. Inexpensive and easy to mass-produce, *prints promoted the message of the Reformation* (read more on prints in Chapter 7). Here, Pope Leo X is attacked through a comparison with Jesus. On the left, Jesus washes one of his disciple's feet, showing the importance of humbleness. On the right, the pope sits enthroned and proud. People kneel in front of him like subjects, as he extends his foot to be kissed by one of his followers.

*Quick Review 15.5*: How did art change because of the Protestant Reformation?

# The Baroque

Beginning in the mid-1500s, Catholic Church officials began to challenge the Protestant onslaught. Launching a Counterreformation, they eliminated corruption, ended the sale of indulgences, and attempted to reengage the faithful. However, they did so while retaining traditional church doctrine such as the authority of the pope and the sanctity of the sacraments (ceremonies).

A new style emerged in the 1600s and early 1700s, called the **Baroque**, meant to *captivate people's emotions* and *bring them back to the Catholic Church*. As with the Protestant cause, *art became a significant method of propaganda*. The Baroque style spread, taking different forms, and eventually even moving to Protestant countries. Because the style evolved as it expanded, and because it took root among people from different countries practicing different religions, the *Baroque style has much variety*. Baroque works can look theatrical and emotional, sensuous and exuberant, ordered and rational, or sober and restrained. Despite this, a certain mindset and similar ideas pervade Baroque art, including:

- *Naturalism*: an interest in having figures and objects look real
- *Emotionalism*: a focus on the feelings and passions of the figures
- *Dramatic light and color*: a use of contrasting values and a vibrant scheme
- *Innovative use of space*: an attempt to dissolve the barriers between the figures in the work and the viewer
- *Symbolism*: a use of allegory to portray higher significance

## The Baroque in Italy

The Italians led the way in forging the new Baroque style that promoted the Counterreformation. Spurred on by Catholic Church officials, these artists attempted to create works that had the power to *persuade the masses to return to the Catholic Church*. In the hands of Italian artists, art became so *realistic and emotionally charged* that viewers were supposed to be able to experience for themselves the pain and suffering of Jesus and the saints.

**artists** MATTER

Caravaggio

## Painting

*The Deposition* (figure 15.26) by Caravaggio (kah-rah-VAH-joh) illustrates how people could be brought to a heightened emotional state in which they would reaffirm the church. In the scene in which Christ's friends lower him into his tomb, Caravaggio employed

*naturalism in its extreme.* Caravaggio used everyday people as models, creating different types of bodies, from young to old, and moving away from the idealized forms of the Renaissance. Christ's tan hands and face contrast with his pale body. Other figures are bent and struggling, ordinary and flawed. The people in this Baroque painting appear like us and seem familiar rather than divine.

The figures also *project emotion.* Radiating down in an arc from the upper right to lower left, they each approach Christ's entombment personally. At top, Mary Magdalene throws her arms up and looks heavenward, mouth open in despair. Wearing a hood at center, the Virgin Mary stretches her arms out protectively, looking determinedly at her son. At right, holding Christ's knees, Nicodemus grimaces under the strain.

*Light and color also add to the striking effect.* The figures stand against a pitch-black background, but are hit by a powerful, seemingly divine light—almost like a spotlight on a darkened stage. Using a form of painting called **tenebrism** (where the *contrast between light and shadow is intense* and there are few middle tones), Caravaggio both sculpted his figures to make them appear three-dimensional and heightened the theatrical impact of the work. Colors also work to create drama. Warm oranges and reds contrast with cool blues and greens. All colors set off the white body of Christ.

In addition, the *revolutionary depiction of space* creates a connection with the viewer. The figures stand on a stone slab whose point appears to project out from the picture plane into our space, so that the figures seem to be lowering Christ out of the picture into our sphere. Upending the traditional sense of the picture plane as a window through which we can watch scenes transpire, we now appear to join those who must be standing within the tomb ready to receive Christ's body. *Caravaggio engages us in a personal way, making us feel as though we are a part of the scene.*

The innovative space also reflects the final Baroque characteristic of *symbolism.* Caravaggio originally painted the work for a chapel in the Church of Santa Maria in Vallicella in Rome. There, the painting hung above the altar and would have made it appear that Christ's body was being placed right onto the altar. The faithful believe that the holy bread and wine placed on the altar during the Mass transform into Christ's body and blood, and the symbolism in the painting would have likely made the transformation thrillingly real. It is this exact type of miraculous experience that church officials hoped to create from the propaganda of Baroque art.

*Portia Wounding Her Thigh* (figure 15.27) by Elisabetta Sirani illustrates the dramatic Baroque style in secular paintings. Sirani used multiple devices to heighten the excitement. She started with the *climactic story*—that of Portia, a woman from ancient Rome, who stabs her thigh to prove to her husband, Brutus, that she could endure torture and that he could trust her with his secrets. Portia's husband had been plotting to kill Julius Caesar, the famous Roman general, and Portia wanted Brutus to confide in her.

Sirani picked the most *emotionally charged* moment—just as Portia lifts the dagger after already having plunged it into her thigh. Sirani also dressed Portia in contemporary,

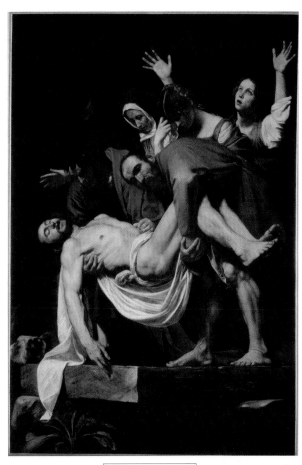

The altar was here.

**FIGURE 15.26.   Caravaggio.** *The Deposition.* *1600–4. Oil on canvas, 9′ 9 ⅛″ × 6′ 7 ¾″. Vatican Museums Pinacoteca, Rome.* Given the original placement of the painting above the altar in a chapel, it would have looked like Christ's body was being lowered directly onto the altar.

**tenebrism** A form of painting used by Caravaggio and his followers in the seventeenth century in which light and dark areas contrast sharply, and there are very few gradations of tones

**artists**
MATTER

Elisabetta
Sirani

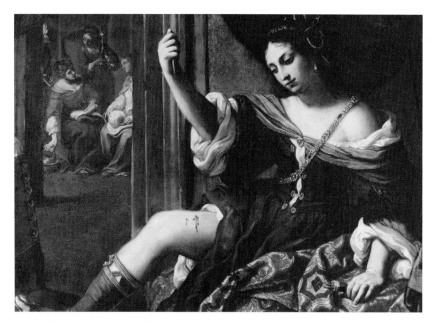

**FIGURE 15.27.** Elisabetta Sirani. *Portia Wounding Her Thigh.* 1664. Oil on canvas, 3′ 3¾″ × 4′ 6¾″. The Miles Foundation, Houston. The resolved and silent Portia is set off dramatically in an asymmetrical composition balanced by the women spinning yarn in the recessed space behind her.

*realistic attire*, probably to enhance the viewer's connection. *Color and light heighten the impact* as Portia's flaming red dress mimics her blood, and her pale skin, lit as if by spotlight, contrasts with the dark area behind her shoulder. Finally, Sirani pushed Portia up into the front, so close that her foot, cut off by the frame, seems to *protrude beyond the image*. Painted by Sirani, a woman artist who had to work in public to prove that she created her own pictures, the image establishes Portia as a woman who also had to prove herself equal to men. To see if you can identify the characteristics of the Baroque in a different violent painting, see *Practice Art Matters 15.3: Recognize Baroque Ideas in a Work.*

## Architecture

The Baroque style energized architecture as well. The dramatic approach is evident in Roman Catholic churches that helped to *reengage the faithful* during the

---

*Practice* **art**MATTERS

## 15.3 Recognize Baroque Ideas in a Work

Figure 15.28 shows a painting of the biblical heroine Judith created by Artemisia Gentileschi (ahr-tuh-MEE-zhyuh jen-till-ESS-kee), a female Italian Baroque artist. In the Old Testament story, Judith sneaks into the tent of an enemy general, who is taken with her beauty. After plying him with wine, she cuts off his head with his sword. Gentileschi shows Judith in the act, as her maidservant holds the general down.

Consider the image and answer these questions:

- Which of the five characteristics of the Baroque do you see in this image? (Hint: You should see four.)
- Where do you see these four characteristics?
- Given what you know about the Italian Baroque, why might Gentileschi have created this image?
- Given what you know about women artists, why might Gentileschi have created this image?

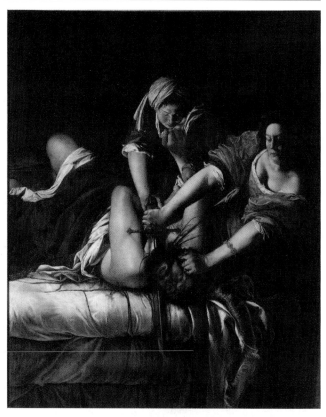

**FIGURE 15.28.** Artemisia Gentileschi. *Judith and Holofernes.* c. 1620. Oil on canvas, 6′ 6⅜″ × 5′ 4″. Uffizi Gallery, Florence, Italy.

Counterreformation. A series of concave niches and convex columns pulsate in and out across the Church of San Carlo alle Quattro Fontane in Rome (figure 15.29) designed by Francesco Borromini (frahn-CHES-koh boh-roh-MEE-nee). The rhythmic curves that swell and fall create an appearance of movement as the façade *pushes into the viewer's space*. The alternating curves additionally lead to *variations in value* as the protruding columns look lighter than the recessed niches. These changes add variety and create drama. With this design, Borromini transformed the Catholic Church into a *dynamic space*.

## Sculpture

*Ecstasy of St. Teresa* by Gian Lorenzo Bernini (jawn-loh-REN-zoh bayr-NEE-nee) illustrates the Baroque approach in sculpture. Bernini chose to depict an *emotionally charged* moment from Teresa's life. In the sixteenth-century nun's writings, Teresa described a vision in which an angel appeared to her and plunged a golden arrow into her heart, a spiritual moment she explained as both intensely painful and sweet.

To tell the story, Bernini designed the entire space of the Cornaro Chapel in the Church of Santa Maria della Vittoria in Rome, using multiple media to create the largest impact (figure 15.30A). Bernini placed Teresa and the angel in the altar, fashioning them from marble (figure 15.30B). Divine golden rays, made from gilded wooden rods, shine down on the pair from the ceiling, furthered by a real light from a hidden yellow stained glass window above. On both sides of the scene are boxes, like might be in a theater, where marble sculptures of deceased members of the Cornaro family watch the miraculous scene.

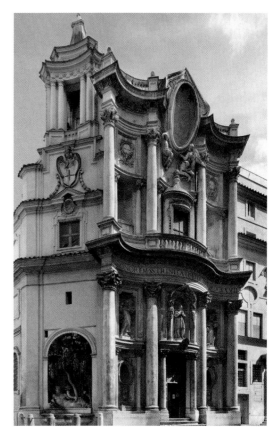

**FIGURE 15.29.** Francesco Borromini. **Church of San Carlo alle Quattro Fontane.** *1664–67, Rome.* The approach to this church is unlike those taken in the façades of Classical or Renaissance buildings (see figure 15.12), which exhibited simple, straight forms.

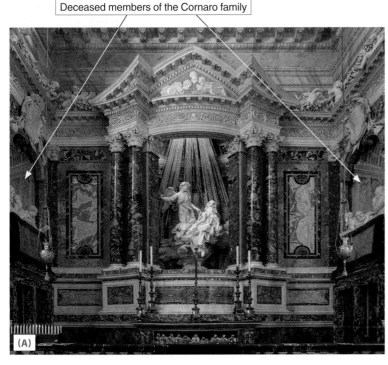

Deceased members of the Cornaro family

(A)

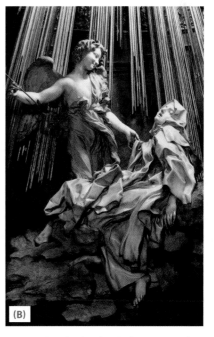

(B)

**FIGURE 15.30A AND B (DETAIL).** **Gian Lorenzo Bernini.** *Ecstasy of St. Teresa.* *From the Cornaro Chapel in the Church of Santa Maria della Vittoria, Rome. 1642–52.* Deceased members of the Cornaro family (15.30A) watch an emotional St. Teresa as she sighs in ecstasy (15.30B).

Bernini used the Baroque techniques of *realism, emotionalism, dramatic light and color, and innovative use of space to engage the faithful*. Even though fashioned from stone, the sculpture has multiple differentiated naturalistic textures, from the heavy fabric of Teresa's robe to the billowing surface of the cloud on which she rests, to the flimsy nature of the angel's garb. Teresa swoons from the pain, yet seems euphoric. Bernini placed the pair in what should have been a darkened niche, but lit them with a glowing light and surrounded them with gleaming gold to highlight the action. Finally, Bernini dissolved the barrier between the artistic and viewer's spaces. By placing the Cornaro family within boxes, both the viewer and these sculptures watch the miracle together, becoming part of the sacred world.

*Quick Review 15.6*: What are the five characteristics of Baroque art that promoted the Counterreformation in Italy?

## The Baroque in Spain and Flanders

Spain and Flanders (a Spanish northern province) show how the Baroque style changed as it moved to different countries. As Spain and Flanders were Catholic, the Baroque approach *promoted the Counterreformation*. However, artists also used the style as *propaganda to glorify individuals*.

### Propaganda for a Monarch

Marie de' Medici, queen of France, commissioned Flemish artist Peter Paul Rubens to create a cycle of twenty-four enormous paintings as *propaganda in an attempt to glorify herself*. Each illustrates a happy episode from the queen's life, yet the paintings are fantasy as the queen lived through many troubled times. Her husband, King Henry IV, had been assassinated, and her son sent her into exile. Marie had hoped to be queen, and she commissioned the paintings to promote her cause.

In one of the paintings, *Marie de' Medici, Queen of France, landing in Marseilles, 3 November 1600* (figure 15.31), Rubens used every Baroque technique to heighten the drama. Marie, at center, arrives in France for her upcoming marriage to the king. The scene looks *realistic* because of the sumptuous textures and anatomically accurate figures. (The robust figures are reminiscent of Michelangelo's.) Exuberant gestures and swirling motions of the figures heighten the *emotionalism* of the scene. Marie is also cast in a *bright light* that adds radiance to her presence, and she is framed by a *vivid, triadic color scheme* (see Chapter 3). Rubens pushed several figures into the front of the picture, so it seems that the *viewer almost stands next to them in space*, gazing up at Marie as if she is a goddess. Finally, Rubens used *allegory* to add to the effect.

### Propaganda for an Artist

The Catholic king and queen of Spain employed artist Diego Velázquez (dee-AY-goh veh-LAS-kes); however, his *Las Meninas (The Maids of Honor)* (figure 15.32A) actually *promotes his own status* in addition to that of his patrons. The image appears to be a portrait of the king and queen's daughter, Margarita, who is accompanied by her attendants. Velázquez stands at the left, holding a paintbrush and palette, beside an enormous canvas. As the colors on his palette match those in the painting, he could be painting the portrait that we see. By including himself in the same portrait as the princess, Velázquez *proclaimed his high status*.

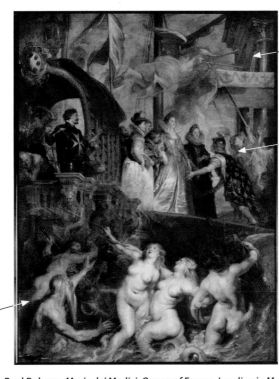

A winged figure, *probably "fame,"* blows two trumpets.

A man who *likely symbolizes "France,"* in a blue cloak with a golden fleur-de-lis pattern, greets Marie.

Several gods, including *Neptune, god of the sea,* have ensured Marie's safe arrival.

**FIGURE 15.31.** Peter Paul Rubens. *Marie de' Medici, Queen of France, Landing in Marseilles, 3 November 1600.* 1622–25. Oil on canvas, 12' 11 ½" × 9' 7". Louvre Museum, Paris.

Velázquez

Two Rubens paintings

Reflection of the king and queen

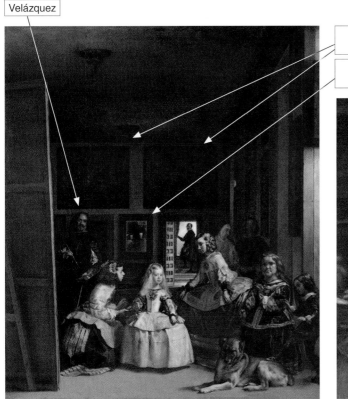

(A)

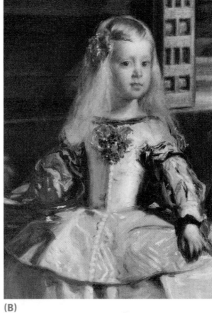

(B)

**FIGURE 15.32A AND B (DETAIL).** Diego Velázquez. *Las Meninas (The Maids of Honor).* 1656. Oil on canvas, 10' 5" × 9'. Prado Museum, Madrid. Velázquez painted a complex image with people and objects that convey different meanings (15.32A). In the detail (15.32B), Velázquez's loose dashes of paint are evident in the Princess Margarita's sleeves.

However, Velázquez also used the baroque approach of *breaking down the barrier between the artistic and viewer's spaces.* In the back of the room, a mirror portrays the reflection of the king and queen, meaning that *the two must be standing alongside the viewer in space.* Have the king and queen come to look in on the progress of the painting or are they the subject matter of the painting? The latter seems more likely as Velázquez looks out as if he is painting the pair standing next to us. If true, Velázquez daringly placed his likeness in the same painting as the king and queen.

Beyond the *innovative use of space,* Velázquez used Baroque *realism* by creating portraits of all of the identifiable figures in the painting and *depicting exquisite textures.* However, he used loose dashes of paint to do so, knowing that from a distance our minds would combine them into a whole. Figure 15.32B, shows each of Velázquez's individual brushstrokes. By capturing the essence of the surfaces rather than the exact, minuscule details, the result appears more convincing.

Finally, Velázquez also used *allegory* in his painting. In the dark recesses of the room, he depicted two Rubens paintings hanging on the wall. Velázquez might have been comparing himself to the renowned Flemish master in a further grab at status. However, the subject matters of the paintings give pause. Both depict mythical, artistic contests in which humans lose. One tells the same story depicted in the plate in figure 15.6 of King Midas. The other tells the story of Arachne, who challenged the ancient Greek goddess Athena to a weaving contest and was turned into a spider. Clearly, Velázquez understood the danger of ambition.

*Quick Review 15.7*: How was Baroque art used to glorify individuals in Spain and Flanders?

## The Baroque in France

France was a Catholic country, and like in Spain and Flanders, the Baroque style *promoted the status of monarchs.* In France, however, *artists infused the Baroque with Classicism,* leading to a new, blended expression that can be seen in both the *propaganda* of the period and the *religious art.*

### Propaganda

The Palace of Versailles (VERS-eye) (figure 15.33) illustrates how architects Louis Le Vau and Jules Hardouin Mansart *combined order and harmony* with the *Baroque approach* as *propaganda* to elevate King Louis XIV. The palace is *Classical* in its pure, elegant use of symmetrical balance and stable, geometric form. It is *Baroque* in its immense grandeur and use of allegory. Louis equated himself with the sun god, Apollo, and was known as the Sun King. In the palace, the architecture and art emphasize this symbolism to glorify the king. The overall palace resembles the sun as a number of large boulevards begin at Versailles and radiate outward. Louis's apartment also contains seven rooms dedicated to the seven known planets, and a bedroom dedicated to Apollo.

### Religious Art

Baroque Classicism also pervaded religious art in France. *Landscape with Saint John on Patmos* (figure 15.34) by Nicolas Poussin (nee-coh-LAH poo-SAN) shows John writing the Book of Revelation. John is surrounded by ancient ruins in an ordered composition reflecting a *Classical style.* Poussin arranged the landscape rationally, rather than copying the random nature of the real world. Yet, the image is also *Baroque.* John wears

appropriate, realistic attire from the ancient world, and there is a sense of somber emotion.

Also different is the *emphasis on the landscape.* John takes second place to the setting, which is *Baroque in its rich colors, contrasting values, and grand scale.* Finally, *symbolism* pervades the image. While John writes about the end of time, the viewer is likely meant to understand from the ruins that the pagan world has passed and that the current world will similarly see its demise upon Christ's Second Coming.

*Quick Review 15.8*: What distinguishes Baroque art in France from Baroque art in other countries?

**FIGURE 15.34.** **Nicolas Poussin.** *Landscape with Saint John on Patmos.* 1640. Oil on canvas, 3′ 3 ½″ × 4′ 5 ⅜″. Art Institute of Chicago, Illinois. The depiction of nature here contrasts strongly with Renaissance images such as Michelangelo's *Creation of Adam* (figure 15.2), where the landscape is almost an afterthought.

## The Baroque in the Dutch Republic

With the absence of the Catholic Church and no absolute monarch, the Protestant Dutch Republic was an ideal venue for artists to create works for middle-class buyers, such as professional groups and wealthy merchants. Art was even sold on the open market to unknown, prospective customers. To attract buyers, artists used *the same Baroque ideas* that had found favor in Catholic countries *in secular, everyday images*—including *portraits, genre scenes, still lifes, interiors, and landscapes.*

### Portraits

An example of a portrait painted for middle-class patrons is one commissioned by Captain Frans Banning Cocq's civic guard company for the company's headquarters. In *Night Watch* (figure 15.35A), Rembrandt van Rijn (rem-BRANT van RYN) painted the men marching toward the viewer along with a dog, a dwarf, and a girl with a chicken (probably the company's mascot as the Captain's name was Cocq, and *coq* is the French word

**artists**
MATTER

Rembrandt van Rijn

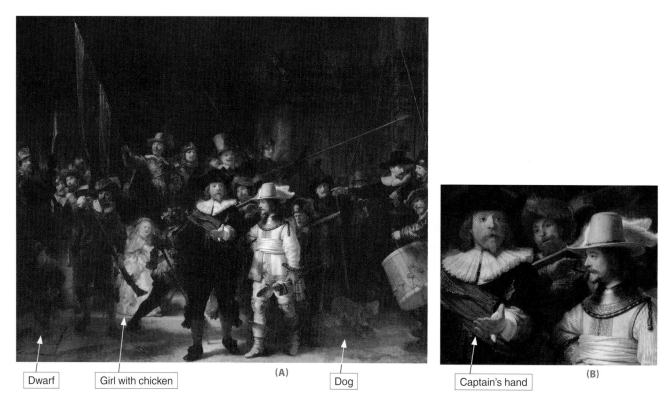

Dwarf | Girl with chicken | (A) | Dog | Captain's hand | (B)

**FIGURE 15.35A AND B (DETAIL).** Rembrandt van Rijn. *Night Watch.* *1642. Oil on canvas, 12′ 2″ × 14′ 7″. Rijksmuseum, Amsterdam, The Netherlands.* In Rembrandt's depiction of guards and other figures (15.35A), he shows a Baroque innovative space, making the captain's outstretched hand come forward toward the viewer (15.35B).

for "rooster"). Because the men paid for the portrait, the work in and of itself suggests the success of the company and prosperity of its members.

A variety of factors place the painting within the Baroque style. Because he was painting a portrait, Rembrandt had to use *naturalism* to capture the men's likenesses. He created a casual scene in which we cannot see everyone's face equally well. The design is significantly more realistic than a contrived, formal grouping in which all of the men would face forward, and additionally gives a sense of the spirit of the company. Rembrandt also *captured the men's personalities*, from the confident captain at center to the stern lieutenant at his side (figure 15.35B). Baroque *lighting* plays a role in the portrait; the light is soft and appears to emanate from the figures as if helping to reveal each man's inner character. Rembrandt also *created a continuous space between the painting and the viewer*. The captain stretches his hand forward, appearing to break through the picture plane and giving us a greater connection to the group.

### Genre Scenes

*The Proposition* (figure 15.36) by Judith Leyster (YOO-dit LYE-stur) shows a typical Dutch **genre** scene—one that shows ordinary people in everyday life—with an uncommon storyline. A woman sits sewing, minding her own business, as a man offers her money for sexual favors. (More typically women have been presented in art in the role of the seducer.)

Leyster used a number of Baroque characteristics to make the scenario dramatic. The pair is *realistically depicted* with *specific details* that tell the story. The man wears a beaver fur hat, a type typically worn by foreigners. The woman looks frightened, as she stares

**genre** A type of art that depicts ordinary people in everyday scenes from daily life

down at her work. In addition, Leyster included a candle that throws off *strong highlights and menacing shadows*. Finally, *there is symbolism* in that the woman keeps a foot warmer filled with hot coals under her skirt. According to new research, the lit foot warmer placed where it is signifies that the woman is not interested in sexual advances.

## Still Lifes

The work of another woman, Clara Peeters, illustrates how the Baroque style worked with **still lifes**, which depict inanimate objects. Her *Still Life with Fruit and Flowers* (figure 15.37) shows a table filled with numerous delicacies. Peeters, following Baroque principles, depicted a highly *realistic scene*, capturing the numerous textures of soft petals, plump grapes, and shining metals. Each piece of fruit comes alive with *vivid colors* and is *spotlighted* against the black backdrop. Peeters also employed *innovative space*—as several shrimp precariously overlap the edge of the table, appearing to push into our space.

Also typical of the Baroque is Peeters's use of *symbolism*. Still lifes, such as this one, which represent the fleetingness and fragility of human existence, are called **vanitas**. The wide-open flowers and bulging fruit are at the height of maturity. One flower droops, a single petal bending backward. Soon it will be withered. Insects appear ready to promote decay. In front are the shrimp that will spoil the most quickly. Finally, on the right are coins that will be useless after death. The still life was meant to suggest that worldly possessions and items of beauty and pleasure will have no worth in the next life.

## Interiors

The work of Jan Vermeer (yahn vair-MEER) shows the Baroque's impact on interior (indoor) images. In *Woman Holding a Balance* (figure 15.38), Vermeer depicted a woman in a quiet domestic setting, weighing pearls to see their worth. Many decisions align

**FIGURE 15.36.** **Judith Leyster.** ***The Proposition.*** *1629. Oil on wood panel, 12 ⅛″ × 9 ½″. Royal Cabinet of Paintings, Mauritshuis, The Hague, The Netherlands.* Leyster, as a female artist, transformed the traditional approach to the subject matter of a proposition into what was probably a much more likely scenario.

**still life** A type of painting or drawing that depicts inanimate objects such as flowers, books, or fruit

**vanitas** A type of still life painting in which objects such as fruit, flowers, and luxury goods symbolize the fleeting nature of life

**FIGURE 15.37.** **Clara Peeters.** ***Still Life with Fruit and Flowers.*** *c. 1612. Oil on copper, 2′ 1 ⅓″ × 2′ 11″. Ashmolean Museum, Oxford, England.* In this *trompe l'oeil* illusion, Peeters tried to fool us into thinking the scene is real rather than a painted surface.

**FIGURE 15.38.** Jan Vermeer. *Woman Holding a Balance. c. 1664. Oil on canvas, 15 ⅝" × 14". The National Gallery of Art, Washington, DC.* In the painting on the wall, Vermeer depicted the same subject matter of the Last Judgment that Michelangelo depicted in the Sistine Chapel.

the scene with the Baroque. Vermeer was so fascinated by realism that he used a *camera obscura* (see Chapter 8) to create a *replica of the natural world*. In addition, a soft light, which filters through a sheer curtain from the window, *illuminates the woman, but leaves much of the space in shadow*. Finally, a blue piece of fabric hangs over the table, breaking the picture plane and *coming toward us in space*.

While the image appears a casual moment, it probably denotes a higher significance. The painting is filled with objects that *symbolize the fleetingness of life*. The pearls, the woman's fur-trimmed coat, and her beauty reflected on the side wall mirror may point to the uselessness of material objects and vanity in the world to come.

However, Vermeer seems to have pushed this concept even further. Hanging behind the woman is a painting of the Last Judgment. In the painting, Christ weighs Christian souls, just as the woman weighs the pearls. Vermeer, who was Catholic, could be saying that all will be judged in the world to come and no material wealth will matter. However, the woman in the painting appears pregnant, so she could be symbolic of the Virgin Mary. As Catholics believe that the sacred is reachable through the church, ritual, and images of holy figures, Vermeer might be pointing to the role of the Virgin as the traditional intermediary for souls, maybe helping lessen the severity of the Lord's decree.

*Quick Review 15.9*: Why did Baroque artists in the Dutch Republic create secular, everyday images?

# HOW **art** MATTERS

## A Look Back at the Sistine Chapel Paintings

Michelangelo's paintings in the Sistine Chapel stand as a monumental achievement. The *complex arrangement*, the depiction of *three-dimensional-looking forms*, and the *revolutionary interpretation of the subject matters* are a testament to Michelangelo's genius. In fact, the paintings are considered such an incredible feat that six million people visit the Chapel every year to see them.[1] Yet, the paintings also help with an understanding of the **Renaissance** and **Baroque** periods, as they were painted over two phases and so were influenced by different approaches and in turn were influential in shaping various styles.

The ceiling paintings connect to the Early Renaissance period in Michelangelo's interest in *humanism, individual capabilities*, and *reason*. Michelangelo's *Creation of Adam* (figure 15.2) depicts a *new type of God*, one who was rational and human-like. In addition, Michelangelo's decision to depict ancient sibyls on the ceiling shows his interest in *Classicism*.

The closest connections can be made between the ceiling and the High Renaissance. The paintings are models of High Renaissance work with their *harmonious, stable compositions, anatomically correct figures*, and use of *chiaroscuro*. Michelangelo's depiction of *Jonah* (figure 15.3) additionally

seems to link the ceiling paintings to the quest during this period for greater acknowledgment of the *abilities of individual artists*.

The *Jonah* figure also finds a connection to Northern Renaissance artists, who, just like Italian artists, were interested in *elevating their status*. Scholars believe that Michelangelo chose to connect himself to the Prophet Jonah, who had been redeemed to spread the word of God. Similarly, northern artist Albrecht Dürer also likely associated himself with a holy figure, but he chose Christ, the divine creator (figure 15.22).

The painting of *The Last Judgment* (figure 15.4A) can be associated with both the Renaissance in Venice and **Mannerism**. Michelangelo painted the deep blue sky of the altar wall after spending time in Venice, where he was likely influenced by the *rich colors* of Venetian artists. Conversely, Michelangelo's *distorted figures* and *shallow space* undoubtedly influenced Mannerist artists. These artists would have looked to Michelangelo as they rejected the High Renaissance style.

Michelangelo began painting *The Last Judgment* almost twenty years after Martin Luther posted his theses. During that period, the Protestant Reformation raged, shaking the Catholic Church to its core. Numerous Christians objected to corrupt practices such as indulgences, which helped finance the Sistine Chapel ceiling. Michelangelo's *distorted and tormented figures* in *The Last Judgment* can likely be attributed to his reaction to the divided and chaotic world.

Finally, while Baroque art took a different turn, certain precursors still seem evident in Michelangelo's altar wall. Michelangelo's desperate figures foreshadow the dramatic *emotionalism of the Baroque*. Michelangelo also depicted the figures along the edges of the composition cut off, as if they *extend beyond the scene*. His image anticipates Baroque *innovations of space*. Given the force of Michelangelo's example, some Baroque artists were influenced by Michelangelo's style.

As you move forward from this chapter, consider how Michelangelo created what many would say is a masterpiece by contemplating and reinventing principles and forms from the Classical world that came before him. In that he looked back to a prior style, his frescoes represent a trend in art that we have already seen and will continue to see as we move forward through the history of art. Many artists are interested in the past, and artistic styles throughout time have often been established by artists who base their work on or defy what came before them, leading to new, exciting forms and ideas. In addition, beyond historical art examples, Michelangelo's success can serve as an example more broadly for the value in looking back to the past.

Flashcards

## CRITICAL THINKING QUESTIONS

1. Masaccio's *Holy Trinity* (figure 15.8A) is stable for a reason beyond the symmetrical balance described in the text. There is an overall shape that starts at the head of God that organizes the image. What is the shape and what figures does it include?

2. Why would Raphael's incorporating the likenesses of artists into his *School of Athens* (figure 15.15) be considered a triumph of humanism?

3. How is art from the Venetian Renaissance similar to art from the Northern Renaissance?

4. During the Reformation, prints were used for propaganda as they could reach the masses. What media would be comparable today if someone wanted to sway opinions? How would it be similar?

5. Even though Sirani's *Portia Wounding Her Thigh* (figure 15.27) is a Baroque work, there is one element that links it to Classicism. What is it?

6. How is Velázquez's realism in *The Maids of Honor* (figure 15.32A and B) different from the realism of Northern Renaissance painters like Jan van Eyck in *The Virgin of Chancellor Rolin* (figure 15.20)?

7. Why can Baroque art in France be considered a merging of Renaissance and Baroque ideals?

8. Even though Peeters's *Still Life with Fruit and Flowers* (figure 15.37) is a secular work, it can still be considered a religious painting. Why?

Comprehension Quiz     Application Quiz

# War, Death, and Remembrance

The universal theme of war, death, and remembrance is evident in artworks from this chapter and in art created by people from different backgrounds and periods from across this book. This theme concerns:

» *War, violence, and fighting*
» *Death and the afterlife*
» *Graves, mourning, and remembrance*

## War, Violence, and Fighting

The chapter we just completed depicts Artemisia Gentileschi's *Judith and Holofernes* (figure 15.28), in which the Israelite Judith cuts off the head of Holofernes, an enemy general. Painted by a woman, the image portrays the female Judith as an able fighter. She stands over Holofernes in a dominant position, wielding his sword. While portraying a gruesome scene, Gentileschi depicted Judith as a heroine, glorifying her act.

A parallel with regard to the violence of war can be seen in Exekias's amphora showing Achilles killing Penthesilea (figure C15.1), from Chapter 13. As in the Italian Renaissance painting, in this work from ancient Greece:

» One person (Achilles) stands over another (Penthesilea), but here the roles have been reversed as the man threatens the woman
» The aggressor (Achilles) plunges a sharp weapon (here a spear) into the victim (Penthesilea)
» The scene glorifies war, violence, and fighting

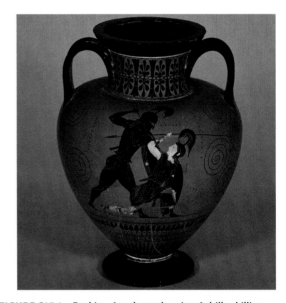

**FIGURE C15.1   Exekias. Amphora showing Achilles killing Penthesilea reconsidered.** While Exekias dignified Achilles's act of killing Penthesilea, many other artists have shown the horror of war.

## Death and the Afterlife

The last chapter discussed a scene of death in Michelangelo's vision of *The Last Judgment* (figure 15.4A). There, a dramatic view of the afterlife unfolds in the sky. Figures emerge from graves to be sent up to heaven or hurled down to hell, where the serpent-encircled judge of the underworld awaits. An intense ultramarine background emphasizes the scene.

Cai Guo-Qiang also depicted the afterlife in the sky. His *Sky Ladder* (figure C15.2), from Chapter 2, shows an explosive event performed in China in 2015. Cai based the work on a legend holding that good souls buried in Jerusalem could be the first to ascend to heaven before the apocalypse. After Cai lit the ladder on the ground, fireworks that had previously been attached to the ladder exploded upward, forming a riveting vision of life after death.

Like Michelangelo, Cai produced an image that illustrates a celestial afterlife. However, throughout time and across continents, people have created depictions of life after death, even if the specific visions differed.

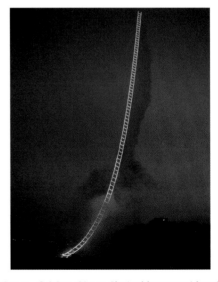

**FIGURE C15.2   Cai Guo-Qiang. *Sky Ladder* reconsidered.** Cai's ladder reached the length of five and a half football fields into the sky, creating a celestial view of death. However, other cultures believe that souls continue an existence in an afterlife and have furnished the dead with useful objects such as furniture.

## Graves, Mourning, and Remembrance

In *The Deposition* (figure 15.26), which we considered in the last chapter, Caravaggio illustrated an emotional response to death in an altarpiece originally displayed in a church. Using everyday people as models, Caravaggio transformed the religious moment when Christ is lowered into his grave into a scene of mourning to which anyone can relate. Christ's dead body looks heavy and pale. His friends show their grief; these feelings of heartache are universal.

A comparison to the *Keiskamma Altarpiece* (figure C15.3), from Chapter 11, shows how people in Africa in 2005 depicted a similar scene. Created by more than 130 villagers, this altarpiece commemorates those lost to AIDS. As in the Caravaggio image, the tragedy of death appears to loom large over those left behind. As the dead are prepared to be placed into graves, a widow and numerous orphans are left to remember the lost.

**FIGURE C15.3** **Carol Hofmeyr, Noseti Makubalo, and the people of the Keiskamma Art Project.** *Keiskamma Altarpiece,* **exterior, reconsidered.** A widow appears in mourning clothes and stands at center in front of a cross with orphaned children at her side. A funeral takes place in the panel below. While here the dead are buried in simple graves, throughout time, numerous people have been laid to rest in elaborate tombs.

## Make Connections

In 1982, the Vietnam Veterans Memorial (figure C15.4), commemorating the nearly 58,000 Americans who lost their lives in the Vietnam War, opened on the National Mall in Washington, DC. Designed by Maya Ying Lin, the memorial known as The Wall, which is described in Chapter 1, focuses on the names of the dead without taking a stance on whether the cause for the war should be glorified or critiqued. The Wall is dug into the ground almost as if it marks the edge of where our world meets the underworld. The memorial also creates a space for reflection. People leave offerings such as letters, medals, and uniforms as part of their mourning and remembering. How does the work relate to the theme of war, death, and remembrance?

What other visual examples can you come up with from across the book and from today's world that reflect this theme? How are people's motivations across time and place similar and different?

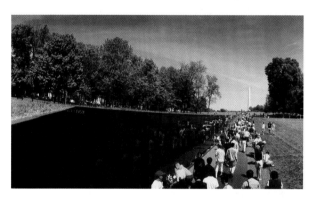

**FIGURE C15.4** **Maya Ying Lin. Vietnam Veterans Memorial reconsidered.**

# CHAPTER

# 16

**DETAIL OF FIGURE 16.1.**
One of the characteristics of traditional African art is a boldness of form, while a theme of Islamic art is an ordered design. The Great Mosque in Djenné, Mali, seen in a detail, brings together the two cultures in its monumental tower and regularly spaced wooden extensions.

# The Art of Africa and Islam

## LEARNING OBJECTIVES

**16.1** Contrast the rock art from the Sahara Desert with the sculpted heads from Nok.

**16.2** Identify six characteristics that are frequently found in traditional African art.

**16.3** List four themes that are often evident in Islamic art.

**16.4** Differentiate the Umayyads' architectural style from that of the Abbasids.

**16.5** Illustrate how the art of the Mamluks and Nasrids can be described as both secular and religious.

**16.6** Explain the ways in which an Ottoman mosque and Safavid carpet symbolically enabled worshippers to reach toward God.

# THE GREAT MOSQUE IN DJENNÉ, MALI

An old legend from Djenné (JE-nay), a West African city south of the Sahara Desert, tells how a wise Muslim man took up residence in the city. Muslims follow the religion of Islam centered on the teachings of Muhammad, who they believe was God's final prophet. The city's king, Koi Konboro, was suspicious of the Muslim man's different religious practices, and so the king and his advisor hatched a plot to kill the man. The king would lend the man some gold, which the advisor would steal, and when the king asked for the gold in return, the man would be unable to produce it. The king could then declare the man a thief and execute him.

The legend describes how the king lent the man the gold. As planned, the advisor stole the gold and returned it to the king, who threw it in the river. The next day, though, the queen purchased a fish at the marketplace, and when she opened the fish, the gold was inside. When the king demanded an explanation from the man, he replied that God had sent the fish to help the king. Impressed, the king converted to Islam.

When the king asked what he could do to serve his new God, the man replied:

Plant a tree, and for years, the people who enjoy its shade will bless you.
Dig a well, and long after your death, people who draw water will bless you.
And build a mosque. The people who pray in it will bless your name for centuries.[1]

## The First and Second Mosques

While the story may be legend, the real King Koi Konboro likely converted to Islam during the thirteenth century. He built a vast and lavish Islamic house of worship, called a *mosque*, to replace his own palace. With the mosque towering above the city, Djenné became a center of Islamic learning and pilgrimage.

Wood and stone are scarce in Djenné, so masons built the mosque from the traditional African material of sunbaked mud bricks. While plentiful in Djenné, *mud is a fragile building material that needs to be recoated annually* following every rainy season.

Konboro's mosque stood until the early nineteenth century, when Sekou Amadou, king of the Mali Empire of Masina, led an invasion of the city. Finding Konboro's mosque too glorious for his conservative taste, Amadou built a new, plainer mosque to the east. Islamic religious law prohibits the demolition of a mosque, so rather than destroying Konboro's mosque himself, Amadou blocked up its gutters. When water collected on the top from the annual rains, with no place to go, the weight led to the roof caving in.

## The Third Mosque

In 1906, the people of Djenné, at that point under the control of the French, wanted to build a new, third mosque that would rival the size and grandeur of Konboro's. The head of the Djenné guild of masons, Ismaila Traoré, designed—and local Africans built—the massive mosque that still stands today. The building's *bold form* rises up from the city. It is the *largest mud-built structure in the world*, able to hold three thousand worshippers (figure 16.1).

Similar to Konboro's mosque, the third mosque represents a traditional African structure. It features:

» *Mud bricks piled one on top of another in a load-bearing system* (see Chapter 12), making the walls thicker at the base and tapered toward the top, which lightened the load as the people built higher

How Art Matters

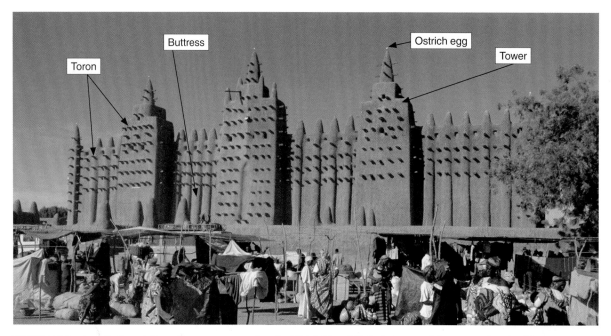

**FIGURE 16.1.** **Ismaila Traoré. Great Mosque, eastern façade.** *1906–7, Djenné, Mali.* An image of the eastern façade of the Great Mosque (which overlooks the marketplace) shows *toron* and buttresses protruding from the surface, along with three large towers that are topped with ostrich eggs.

» *Buttresses* (long, vertical structural supports) that rhythmically bulge out from the exterior faces of the building, culminating in soft points above the walls (three oversized buttresses extend beyond the walls into towers)

» *Walls plastered with mud,* which gives the mosque its smooth, sandy surface—since the region experiences a rainy season that annually washes away much of this covering, the people must reapply it every spring

» *Toron,* which are wooden rectangular beams that methodically repeat and extend out from the wall—these are decorative and serve as a scaffolding system when the mosque needs recoating

## The Annual Recoating of the Mosque

The mosque is so important to the city that for over one hundred years, the people have recoated the mosque in an annual re-plastering ritual; participants have *different roles based on gender and age* (figure 16.2). City elders and masons pick a day believed to be lucky. For weeks ahead, boys blend the mud with rice husks by stomping on the mud with bare feet. On the day of the re-plastering, boys carry mud to the mosque in baskets on their heads, while girls line the road singing and tapping instruments made from dried calabash fruit. Women bring buckets of water to the mosque to pour on the mud. Young men arrive beating drums and bearing flags, and they assist old men in constructing ladders. The old men are believed to protect the builders with blessings. Young men also pass mud up to masons, who smear it on the building by hand. Many of the people believe that should a mason fall from the building, he will turn into a lizard and scamper down the wall safely, only to return to human form when reaching the ground.

**FIGURE 16.2.** **The re-plastering of the Great Mosque in Djenné.** *The front of the image shows boys with baskets of mud on their heads, while in the rear, men stand on ladders passing the mud up to masons.*

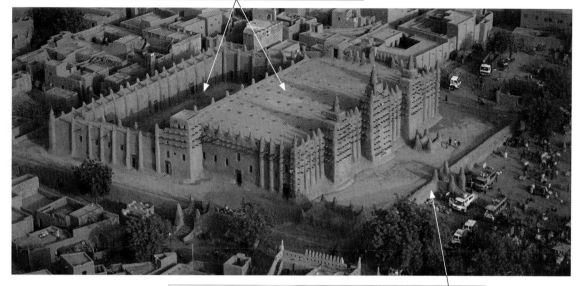

The building mimics numerous mosques that follow the design of Muhammad's home, in which a *rectangular, open courtyard abuts a roofed prayer hall.*

The mosque complex sits on a *raised platform* so that the people climb steps to enter, moving from the hustle of the everyday world to the sanctity of the house of prayer.

**FIGURE 16.3.** **Ismaila Traoré. Great Mosque, aerial view.** *1906–7, Djenné, Mali.*

## An Islamic House of Worship

The mosque *is African in terms of material, structure, and many of the people's rituals and beliefs*. However, the mosque *is also Islamic in that it is a house of worship with architectural components modeled on Muhammad's original home*. These features—including a prayer hall and courtyard—can be seen in the aerial view of the complex shown in figure 16.3.

The interior (figure 16.4) has Islamic characteristics too. Rows of columns support pointed arches (see Chapter 12), which hold up the flat roof, and *create aisles of ordered, open spaces where the faithful pray*. On the eastern edge of the hall, under the central tower, sits a *mihrab* (MEE-rahb), a niche in the wall that *indicates for worshippers the direction to pray*.

## The Mosque Today

Today, the mosque and the essential ritual needed for its re-strengthening and repair remain an *important aspect of the city*. The mosque additionally has appeared on the UNESCO World Heritage list since 1988 (see Chapter 1), showing how it likewise *matters to the world at large* as a cultural legacy. While this designation has led to financial resources for conservation, it has also sparked controversy. For example, in 2006, a restoration project began removing a hundred years of mud that had added tremendous weight to the mosque's walls. As a result, the re-plastering ritual had to stop for several years to accommodate repairs, and the city suffered financially (from a loss of tourism) and spiritually (as the people believe that re-plastering leads to their receiving God's blessings).

Even with conflicts, the Great Mosque is an excellent entrée into understanding the art of Africa and Islam. *The mosque bridges the diverse worlds*, showing how each has separate traditions, yet can live in harmony. For example,

**FIGURE 16.4.** **Ismaila Traoré. Great Mosque, interior.** *1906–7, Djenné, Mali.* The interior structure allows those praying to sit in wide, horizontal rows.

on the top of the towers of the mosque, three ostrich eggs sit. The eggs, which symbolize fertility, demonstrate how many Africans *view art as an instrument of change*—something that can influence the future and assist people with challenges in their lives. However, from up on that same roof, the call for the faithful to pray as equals is issued, *illustrating the mosque's importance in Islam.* This chapter will consider art from these two distinct cultures. Before moving forward, based on this story, in what other ways do you think African and Islamic art differ?

# Africa

Africa is vast and diverse (figure 16.5). The continent is over three times the size of the fifty United States. Across Africa, the landscape changes drastically from rainforests to mountains to deserts. Diversity is also extreme among the continent's people. Africa is home to two thousand cultural groups that speak over one thousand languages.

**FIGURE 16.5. Africa.** Africa is an enormous continent with great diversity in its landscape and people. This map shows the various locations and groups discussed in this chapter and throughout the text.

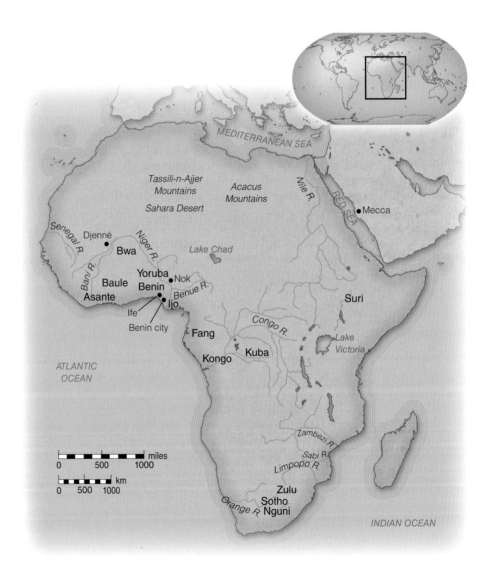

This chapter will offer a sampling of art from early and traditional cultures from different parts of the continent. Ancient Egyptian art, although part of Africa, is covered in Chapter 13 because of its influence on Western civilization. Art created by contemporary African artists can be found in a number of chapters throughout the text.

## Early Africa

While our earliest known ancestors came from Africa, little of their art survives. Shells with holes in them (probably used as beads) and pieces of ochre engraved with geometric patterns have been found in southern Africa and dated to approximately 75,000 BCE; however, *rock art* from the Sahara and *sculptures found in and around the town of Nok* (situated south of the Sahara Desert) comprise most of the earliest examples of African art.

### Rock Art

Rock art found in caves in the mountainous regions of the Sahara Desert dates back as early as 6000 BCE. Over thirty thousand images have been found, either *painted or carved* into the walls.

The rock art documents the changes in weather patterns, wildlife, and human activities in the region. Early rock art often shows *naturalistic depictions of people hunting animals*, as the Sahara once was a fertile, grassy plain, where hippos, giraffes, and now-extinct animals roamed. Later, when temperatures rose and the area dried up, *images often became more abstract and subject matters changed*. For example, by 600 BCE, images of camels were prevalent due to the introduction of the domesticated camel.

An early rock painting of a running horned woman (figure 16.6) shows a life-sized woman superimposed over tiny, abstract stick figures. The woman is a mixture of *naturalistic and abstract elements*. She runs with a steady gait and wears a skirt made of palm leaves and a horned headdress. However, she has a featureless face, and there is no indication of depth from the outlines enclosing the flat surface areas. The woman's body is covered in rows of dots that may represent body paint or skin carving scars, raised patterns formed by making tiny cuts on the skin (read more about skin carving in Chapter 2). The spots also create stylized patterns across her body.

### Nok

Sculptures of heads (figure 16.7) from the period between 800 BCE to 600 CE make up another form of early art. Originally found in the town of Nok, Nigeria, all have been designated as coming from the Nok culture, even though hundreds have now been found throughout the region:

- The sculptures are *clay-fired and freestanding.*
- The *heads are abstracted humans,* seemingly caught off guard with open mouths and wide eyes. The *bold, stylized forms* include triangular-shaped eyes, broad nostrils, arching brows, and ears placed unusually high on the head.
- The *heads look unnatural* with holes in the mouths, eyes, and noses.

Scholars are unsure about the function of these heads or the identities of those depicted. However, throughout this

Stick figures

**FIGURE 16.6.** **Running horned woman.** *From Tassili n'Ajjer, Algeria. c. 6000–4000 BCE. Rock painting.* Some scholars have suggested that the scale of the woman vis-à-vis the stick figures may indicate that she was meant to be a goddess.

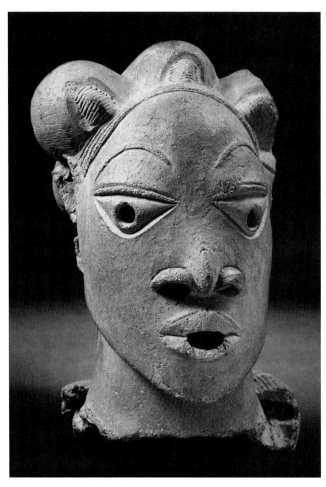

**FIGURE 16.7.** **Head.** *From Rafin Kura, Nigeria. Nok culture. c. 500 BCE–200 CE. Terracotta, 1' 2 3/16" high. National Museum, Lagos, Nigeria.* Holes in the sculpture not only affect the appearance, but also would have allowed air to circulate during firing.

area, later heads have represented honored ancestors, and these heads may have served a similar purpose.

Scholars have also theorized about the technique used to create the sculptures. The heads have a distinct sharpness to them. Unlike traditional objects modeled from clay that look pushed and squeezed, these heads, with their gouged-out surface grooves, *appear carved*. Art historians believe the artists may have allowed the clay to dry and stiffen and then incised features into the heads.

While it is not known who made the sculptures, some scholars believe the sculptors may have been women because it is common throughout this area for male blacksmiths to wed female ceramicists. Many of the heads were found alongside iron objects, giving weight to this theory.

*Quick Review 16.1*: What are the differences in the media, subject matters, and styles of the rock art from the Sahara Desert and the sculpted heads from Nok?

## Traditional Africa

Africa is large and diverse with many types and styles of traditional art. Some of the art reaches back centuries, and some is still in use today. However, much of traditional African art shares at least some of these characteristics:

- *Power of art.* The belief that art helps people enact change by interceding with spirits on the people's behalf
- *Diversity of media.* The tendency of artists to use a variety of materials in single works
- *Promotion of status.* The use of art to distinguish and advance position in society
- *Boldness of form.* The inclination of artists to distort appearances to create direct and powerful works
- *Predominance of certain methods.* The preference of media such as sculpture and performance over other techniques
- *Fascination with the human form.* The preoccupation of artists with adorning and portraying the human body

### Baule

Many traditional African people believe that two worlds exist: the human world of the village and the divine world of the spirits. When displeased, these spirits, it is thought, wreak havoc on human fortunes by causing droughts, sickness, and hardships.

Many Baule (BA-oo-lay) people from Western Africa believe in spirit spouses. Adults are thought to have spirit spouses of the opposite sex, who control the adults' personal happiness. When spirit spouses are upset, the people believe that they cause problems for their human partners. When spirit spouses are appeased, the people believe the spirit spouses will help them, just as the people of Djenné see a link between fertility and placing ostrich eggs on their mosque.

## 16.1 Identify the Features of Traditional African Art in a Work

Describe which of the following characteristics of traditional African art you see in the Baule spirit spouse in figure 16.8 (hint: you might not find all of them) and the ways in which these characteristics are realized:

- Power of art
- Diversity of media

- Promotion of status
- Boldness of form
- Predominance of certain methods
- Fascination with the human form

---

When the Baule experience familial conflict or general misfortune, they attempt to resolve the problem by showing devotion to their spirit spouses. To do so, a person works with a carver to come up with the correct form of a sculptural representation of the spirit. After the sculpture is completed, the Baule will adorn the sculpture with jewelry, polish it with oils, place it on a shrine, and bring it offerings of food. The Baule will additionally sleep with the spirit spouse (instead of the person's real spouse) one night every week until the problem has ended.

The spirit spouse in figure 16.8 shows how the sculpture was *carved in a way that was believed to enhance its power*. The sculptor created a recognizable human form, yet *exaggerated certain ideal attributes*. The calves are strong, the head, oversized, and the skin, smooth. Jewelry adorns the figure, and a luster shines from the polished surface.

The Baule spirit spouse displays common features of traditional African art. To start being able to identify these qualities, see *Practice Art Matters 16.1: Identify the Features of Traditional African Art in a Work*.

### Bwa

The Bwa people from Western Africa use art to connect with spirits during a coming-of-age ritual. The rite begins with elders removing young people from their village to participate in a transitional period in which they endure hardships and are educated about spirits and the masks used to represent them. Upon returning to the village, the male initiates don the masks, and the female initiates sing, participating in a **masquerade**—a ritual gathering of costumes, music, and dance. *The masks are instruments of change.* They *provide the power necessary to complete the transformation* into adulthood during the rite of passage and also *announce the change in status* as the young people reintegrate into the community holding more important roles. As seen in figure 16.9, the dramatic masks adorn the young men's bodies, each part communicating meaning.

### Fang

Many traditional Africans perform acts of tribute and devotion for ancestors, believing that ancestors offer protection by interceding on their behalf with other spirits. The Fang people kept the bones (relics) of remarkable ancestors in cylindrical boxes. These were so important that every family had a box. Although largely sedentary farmers today, who have settled in Central Africa, the Fang were originally nomadic, and the boxes allowed the families to keep the bones safe and honored when they traveled.

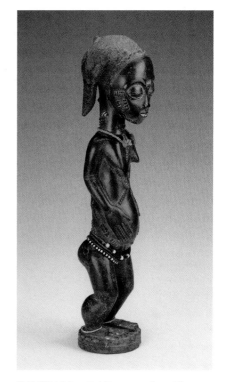

**FIGURE 16.8. Spirit spouse.** *From Côte d'Ivoire. Baule culture. Early–mid-twentieth century. Wood, glass beads, gold beads, plant fiber, and white pigment, 19 ¼" high. National Museum of African Art, Smithsonian Institution, Washington, DC.* Jewelry around the waist and neck introduces a second material beyond the wood.

**masquerade** A ritual gathering involving masks, costumes, music, and dance

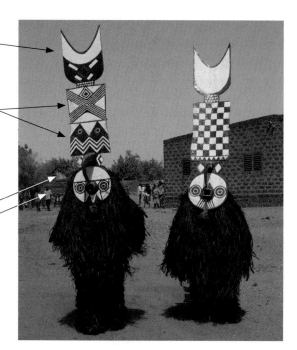

A crescent represents the moon under which the initiates slept during the transitional phase.

Rectangular planks contain bold, geometric symbols that the initiates learned during the transitional phase. Xs represent skin carving scars, while zigzags depict the paths of Bwa ancestors.

Large beaks, representing birds with links to the spiritual world, extend outward over round faces with concentric eyes.

**FIGURE 16.9.** **Masks and costumes.** *From Burkina Faso. Bwa culture. 2007. Wood and hemp.*

Fang sculptors *carved reliquary figures* that sat on the edges of the boxes. To prevent a figure from toppling, a sculptor created a vertical rod that projected down from the figure's rear. The wall of the box fit into the slot between the rod and the legs. *The figures were symbols of the family's outstanding forbearers,* and they were crafted to be *intimidating and abstract.* The figures linked the living to the exceptional deceased members of the family. The bold form of the figures, such as the one in figure 16.10, corresponds to their role as *powerful representations of entire lineages.*

## Yoruba

Artworks created by the Yoruba (yoh-ROO-bah) illustrate how *art promoted rulers in Africa.* By 800 CE, the Yoruba had established the city of Ife (EE-fay) (in present-day Nigeria). There, the *oni* (OH-nee), a king believed to be descended from a god, lived in a palace that dwarfed surrounding buildings, just as the mosque in Djenné towers over the city.

### Naturalistic Heads

In Ife, archaeologists have found sculptures of human heads. The sculptures are thought to represent kings, queens, or ancestral rulers. Like a portrait, the *heads are naturalistic and individualized.* They are also *idealized,* in that they show no blemishes.

Figure 16.11 illustrates the sensitive renditions. Thoughtful eyes look out from a rounded face of appropriate proportions and calm demeanor. The man seems just and regal. Thin lines, possibly representing skin carving scar patterns, run in stripes down his face.

Many unanswered questions about the heads have led scholars to theorize about how they functioned. The theories suggest the heads were used at court by kings to *promote their status.* Some scholars see holes on the tops of the heads as indications that the sculptures

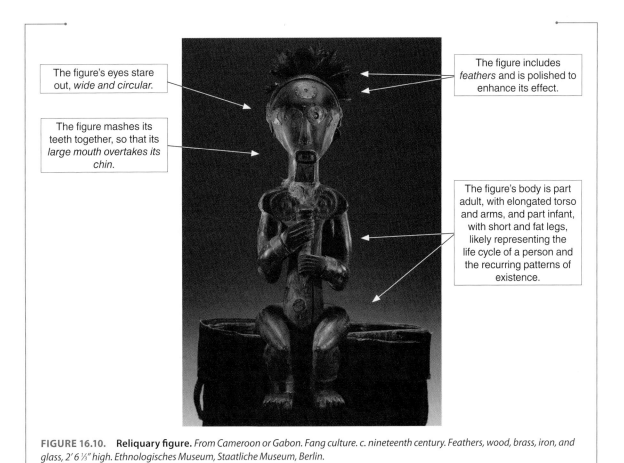

The figure's eyes stare out, *wide and circular.*

The figure mashes its teeth together, so that its *large mouth overtakes its chin.*

The figure includes *feathers* and is polished to enhance its effect.

The figure's body is part adult, with elongated torso and arms, and part infant, with short and fat legs, likely representing the life cycle of a person and the recurring patterns of existence.

**FIGURE 16.10.** **Reliquary figure.** *From Cameroon or Gabon. Fang culture. c. nineteenth century. Feathers, wood, brass, iron, and glass, 2' 6 ⅓" high. Ethnologisches Museum, Staatliche Museum, Berlin.*

held the kings' crowns. Other interpretations suggest the holes allowed veils, beads, or hair to attach to the heads. Holes in the neck, by contrast, may have allowed the heads to be attached to wooden torsos, so they could be carried in burial ceremonies, perhaps to indicate the continued influence of the *oni* even though deceased. Once the ceremonies were complete, the heads may have been used to honor these ancestors.

**Carved Verandah Posts**

Within the palace, there were a series of courtyards where the *oni* held rituals honoring ancestors. Yoruba artist Olowe of Ise (oh-loh-way of EE-say) *carved verandah posts* for porches that surrounded these enclosures. Olowe's carvings made the king's palace more extravagant than surrounding buildings and helped to *demonstrate the king's elevated status.* The sculptures:

- Show *symbolism*, with different components that conveyed higher meaning
- Contain *abstracted human forms*, with various parts elongated with embellished features (unlike the naturalistic Yoruba heads created in earlier periods)
- Display *hierarchical scaling*, with objects and figures that are most important depicted as larger
- Are *complex*, with numerous open spaces, thin parts, and incised surface details

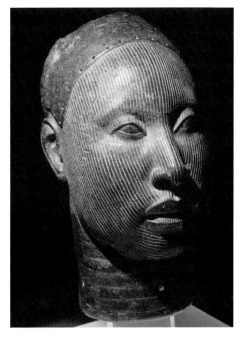

**FIGURE 16.11.** **Head of an *oni*.** *From Ife, Nigeria. Yoruba Culture. c. eleventh to fifteenth centuries. Zinc and brass, 12 ¼" high. Museum of Ife Antiquities, Ife, Nigeria.* Heads were cast from the complex lost wax method (see Chapter 10) and out of expensive brass that likely promoted the king's status.

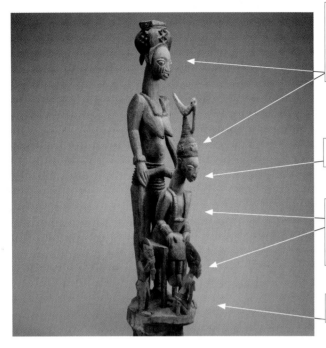

Symbolism is evident in the king's wife standing behind him (likely showing the king could produce heirs) and his crown (adorned with images of his forefathers, which may represent his ability to mediate between this world and the spiritual). Together they may represent the dual power behind the throne.

Abstraction is noticeable in the king's outstretched neck and head.

Hierarchical scaling is visible in the king, who appears larger than the two tiny servants in front of him. However, he is dwarfed by his crown and wife—Olowe probably scaled the king's crown and wife larger to represent the true sources of his authority.

Complexity is apparent in thin pieces, noticeable for example in the servant's arm, a feat in a carved work.

**FIGURE 16.12.** Olowe of Ise. *Veranda post of enthroned king and senior wife. From the courtyard of the palace of the* oni *of Ikere, Nigeria. c. 1910–14. Wood and pigment, 5′ × 1′ ½″ × 1′ 4″. Art Institute of Chicago, Illinois.*

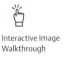

Interactive Image Walkthrough

Figure 16.12 illustrates these characteristics in one Olowe carving, which was originally located in a courtyard of the palace.

### Benin

As in Ife and other cultures in the region, brass human heads, cast from the lost wax method, form an important part of the Benin (beh-NEEN) culture from Western Africa. In Benin, as soon as a new ruler, known as an *oba*, took over, he commissioned a sculpted head for a shrine to his father, the last king. Upon death, the last king would have become an ancestor who required honoring to safeguard the kingdom. The palace contained numerous shrines to different *obas* going back through time, and it was the *current oba's responsibility to act as intermediary*. The shrines consisted of objects crafted from *different media* set out *on and around a platform* (figure 16.13A).

Each item on the shrine held *symbolic significance*. For example, staffs likely represented ancestral spirits. Bells roused the spirits. Tusks portrayed the illustrious history of the *oba*. Since tusks are an elephant's source of protection, they also might have connoted danger, signifying the *oba's power*.

*Most sacred were sculptures of heads* (figure 16.13B). The Benin people believe that the head is the most significant part of the body as it is the center of intelligence and judgment. *Through heads, new obas communicated with ancestors.*

In addition, since the *oba* had to ensure the people's security, sculptors *crafted the heads to instill fear,* so as to ward off evil. The heads were cast in brass, a metal reserved for the king, because the color red caused fright, and the polished brass gave off a reddish tinge. The color red was also apparent in coral beaded necklaces worn by the *obas*. On the sculptures, these necklaces create tall, striped, tubular forms that add to the awe-inspiring and compelling look. The heads' elongated effect is further increased by more beads that hang down from the crowns and the large tusks that spring from the heads. Oversized

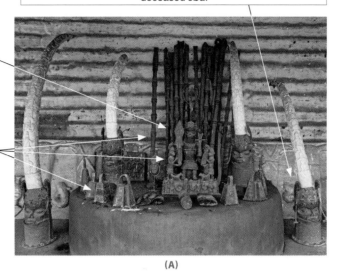

Four *metal* heads (an example of which is visible in the detail) are topped with *ivory* elephant tusks carved with stories about the deceased *oba*.

In the center stands a *metal* sculpture of the *oba*.

The *oba* is surrounded by *wooden* staffs, *metal* sculptures of servants, and *metal* bells.

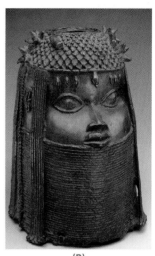

(A)                                              (B)

**FIGURE 16.13A AND B.**   **(A) Shrine.** *From Nigeria. Benin culture. c. 1959;* **(B) Head of an *oba*.** *Eighteenth century. Brass and iron, 13 ⅛″ × 9 ⅜″ × 10 ⅜″. The Metropolitan Museum of Art, New York.*

almond-shaped eyes, bulging cheeks, and strong noses likewise enhance the heads' *powerful appearance.*

## Asante

Kings, like those among the Yoruba, are not the only people in Africa who *use art to establish identity and promote status.* Many Africans distinguish their roles based on *attire that holds symbolic meaning.* In Africa, attire often conveys social information such as a person's gender, age, importance, affluence, and origin.

For the Asante (ah-SAN-tee) of Western Africa, wearing differently patterned cloths holds meaning. One of these types of fabrics, called Adinkra (ah-DEEN-krah), is named for a king defeated by the Asante in the early nineteenth century. When captured, King Adinkra was wearing this cloth. Since King Adinkra was in mourning for his defeated people, the Asante have traditionally worn Adinkra at funerals. Originally, only the king wore the pattern, and it was limited to red, brown, and black. Today, Adinkra can be worn by anyone for any occasion.

The cloth shown on the women in figure 16.14 illustrates the characteristics of Adinkra. The patterning is created by inking a carved piece of calabash with dye and stamping it on fabric and by drawing lines with combs. The cloth can be black and white or bright in color.

The fabric includes *different geometric marks enclosed in squares, and each mark holds its own significance.* In fact, the entire cloth is a form of communication. A fern indicates that a person is not frightened, while the message of a cross is to keep evil away. How the fabric is draped around the person's body also holds meaning. During a funeral, those who had a closer relationship with the deceased wear the cloth differently from others.

**FIGURE 16.14.**   **Women wearing Adinkra cloth.** *From Ghana. Asante culture. 2009. Cloth and black tar.* There are more than two hundred possible geometric marks that can be represented on Adinkra cloth.

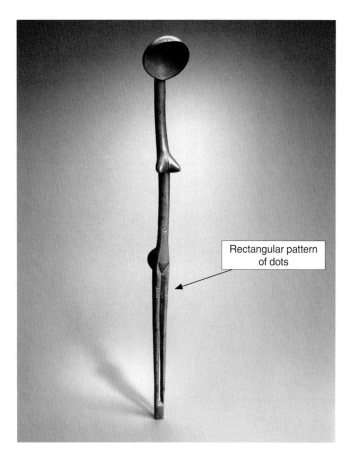

Rectangular pattern
of dots

**FIGURE 16.15. Spoon.** *From Kwazulu-Natal, South Africa. Nguni culture. Wood, 22 ½". Quai Branly Museum, Paris.* A rectangular pattern of dots adorns the woman's legs. These likely represent cattle, which are an appropriate mark on a bridal gift, as men give cattle to the bride's family upon their marriages.

## Nguni

Among the Nguni (ni-GOO-nee) of Southern Africa, *status can be relayed through the arts of daily life.* Spoons are one such example. Owning a spoon indicates a man's respected position. An elder probably received the wooden serving spoon in figure 16.15 from his bride's family upon his marriage. Spoons are so highly regarded that when a man dies, the spoon is either returned to the bride's family or, if not received as a gift, buried with the man.

The handle of this spoon is *carved like a woman's torso* and the bowl like a woman's head. The spoon, almost two feet in length, represents the female figure with a paucity of features. However, the form is recognizable because of the subtlest of manipulations—the arch of the back, the bend of the neck, and the sexual features of breasts and buttocks. The spoon embodies the African notion of *boldness of form.*

*Quick Review 16.2*: What six characteristics are frequently found in traditional African art?

# Islam

While Islam started in Arabia, the religion quickly spread across the Middle East to swaths of Africa, Europe, and Asia (figure 16.16). The Great Mosque in Djenné is an example of Islam in Africa. While African and Islamic cultures are distinct, they fit together in a single chapter in a broad text such as this one, as Africa is one of the areas to which the Islamic culture originally spread and in which it has flourished.

## Muhammad and Islam

Muhammad was born in approximately 570 CE in Arabia, a harsh desert land, populated by groups of Arabs who worshipped many gods. Muslims believe that when Muhammad was forty, the Angel Gabriel told him he was God's final prophet and that he should spread God's word to the people.

Muhammad tried to convert people to his new faith in his hometown of Mecca (in present-day Saudi Arabia). However, Mecca was a center of pilgrimage where people came to worship many gods. City leaders were angered, and so Muhammad fled Mecca for a town later known as Medina. In Medina, Muhammad became the town leader, converted many followers, and raised an army.

Muhammad's home became a place of gathering and prayer. Muslims consider his house to be the first mosque. The house surrounded an open square courtyard, and prayer was performed to the south in a roofed area supported by rows of tree trunks. To this day, *many mosques have followed this structure of a courtyard and columned prayer hall,* including the Djenné mosque.

In 630, Muhammad returned to Mecca with an army of ten thousand believers. He conquered the city and established it as the holiest city in the emerging Islamic world. Today, *Mecca remains the most sacred city in Islam,* the place toward which all Muslims face during prayers and to which they must make a pilgrimage at least once in their lives.

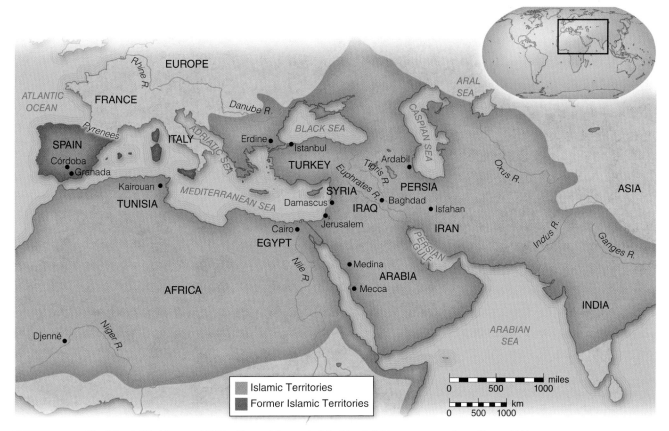

**FIGURE 16.16.** **The Islamic World around 1500.** The rapid spread of the Islamic faith was unprecedented in world history.

## The Principles of Islam

This expectation of visiting Mecca is one of five duties that Muslims must perform. The others are believing in one god, praying five times a day, giving charity, and fasting during the month of Ramadan. These five pillars are set out with other revelations in the Koran, the Islamic holy book. Other important principles include a prohibition against depicting living things in sacred contexts (so as not to promote idolatry) and the responsibility of Muslims to pray directly to God.

A belief that God had told Muhammad to spread the faith led to a rapid expansion of the religion that was unparalleled. By Muhammad's death, Islam had swept throughout Arabia. Within thirty years, Islamic armies had conquered much of the Middle East. Within a hundred years, Islam had spread west to Spain and North Africa and east to India.

## The Common Themes of Islamic Art

The many peoples, locations, and cultures to which Islam spread led to an art that is diverse. However, four different themes, all of which are demonstrated in a bowl from Central Asia (figure 16.17), are common:

- A devotion to *Arabic writing*
- An interest in *abstract or nonrepresentational art*
- A desire to include *symbolism*
- An attraction to *ordered designs*

The first theme is the devotion to *Arabic writing*. While the marks on the bowl may look like patterns, they are **calligraphy**, fine handwriting with aesthetic values. The letters,

**calligraphy** Fine handwriting with aesthetic values that are independent of its textual context

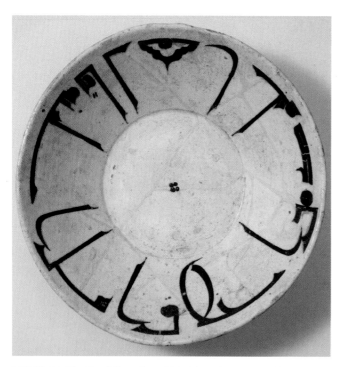

**FIGURE 16.17.** **Bowl.** *From Central Asia. Eleventh century. Earthenware with slip painted under a transparent glaze, diameter 9¾". The Nasser D. Khalili Collection of Islamic Art, London.* The bowl shows the four themes of Islamic art: its interest in writing, abstract and nonrepresentational art, symbolism, and ordered designs.

written in early Arabic script, form the saying, "Generosity is a disposition of the dweller of Paradise," meaning that a generous person will end up in heaven. The words reflect the pillar of giving charity. Since the words appear on a bowl, they would have been meaningful when it was given to a guest. If read out loud, the guest would have praised the host's generosity.

Since writing could convey the words of God, Muslims were devoted to designing beautiful letters to make them worthy of their sacred function. The letters on the bowl are bold and direct. The elongated forms flow around the bowl so that verticals appear repeatedly around the rim, creating a steady rhythm. These connect at right angles to powerful horizontals and are shown off in black script against the white ground.

The second theme is an interest in *abstract or nonrepresentational art.* Because depicting figures in sacred contexts is discouraged, Islamic art often *contains letters, stylized flowers, and nonrepresentational designs.* Even though the letters make sounds that create words, the forms have a visual appearance that is made up of nonrepresentational shapes. In addition, at the very center of the bowl, a small, stylized flower is formed from four dots.

A third theme is a desire to include *symbolism.* Much of Islamic art has meaning behind what is seen. Flowers, for example, represent the garden of paradise (a symbol for heaven). Here, the letters suggest that if a person is generous, he will end up in paradise, and the central flower conveys that message through symbolism.

A final theme is an attraction to *ordered designs.* Islamic artists created harmonious arrangements to reflect the belief that God had created a perfect world. Here, the letters are disciplined and repeating. The tops are elongated, so that they form a broken circle just inside the edge of the bowl. The upright portions hang down just to the inside of the rim. All of the strokes are the same weight, and the use of black and white is consistent.

*Quick Review 16.3*: What four themes are often evident in Islamic art?

## Early Islam

While Islam had been unified under Muhammad, after his death, divisions plagued his followers. Shiites maintained that only Muhammad's relatives could rule the community, while Sunnis believed that Muhammad's original associates were also legitimate successors. A split between Shiites and Sunnis still exists today.

### The Umayyads

In 661, a Sunni seized control and began the Umayyad (oo-MYE-yad) Dynasty. Under the Umayyads, Islam witnessed a large expansion, conquering numerous peoples.

The Umayyads built *one of the first significant buildings of the Islamic world.* Known as the Dome of the Rock (figure 16.18), the building was constructed on a raised platform above Jerusalem (in present-day Israel) in the majestic, *centrally planned style* of many Byzantine (see Chapter 14) churches.

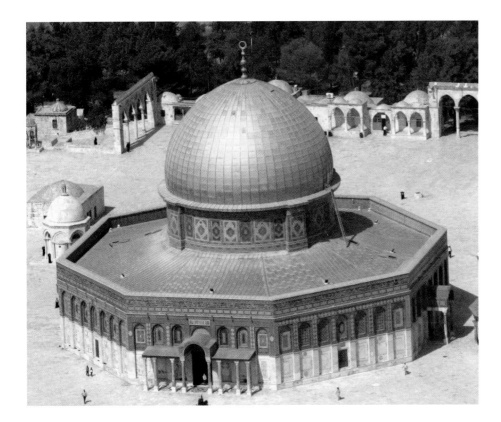

FIGURE 16.18. **Dome of the Rock, aerial view.** *687–692, Jerusalem, Israel.* The Dome of the Rock may have functioned as propaganda to support the Umayyads' position.

The building gave to the faith the four tenets of Islamic art:

- *Calligraphed Koranic writing* appears on the walls, so visitors could appreciate the meaning and splendor.
- *Nonrepresentational patterns* and stylized floral designs decorate the building.
- The floral designs probably *symbolized the garden of paradise*, while the building's dome likely symbolized heaven.
- The design is *orderly and regular.* An octagonal series of arches is topped by a golden dome.

Today, Muslims see the building as holy because they believe it marks the spot (the rock) from which Muhammad ascended on a spiritual journey. However, evidence has yet to be found that the Umayyads associated the rock with the prophet's ascent. Accordingly, scholars have suggested several additional theories as to why the Umayyads originally might have chosen such a prominent location to erect such a grand structure when previous buildings were not so conspicuously placed or striking. Because Muslims see Islam as a fulfilment of the Jewish and Christian religions, the Umayyads would have seen the location, which is a site holy to Judaism, as sacred, and, therefore, a revered spot on which to build. The prominent location also would have aided Umayyad political ambitions in cementing their position as rulers of the land holy to people of all faiths. Finally, with the dazzling Christian church, the Dome of the Holy Sepulcher, nearby, the impressive Dome of the Rock ensured that Muslims were not enticed by a more extravagant building from a competing religion.

## The Abbasids

In 750, a rebellion led to the start of a new dynasty called the Abbasid. In Kairouan, Tunisia, the Abbasids created a mosque (figure 16.19) that followed the structure of

**FIGURE 16.19.** **Great Mosque of Kairouan, aerial view.** *Eighth century and later, Tunisia.* At the Great Mosque of Kairouan, the Abbasids included some architectural features, such as an arcade and a minaret, which made the mosque more functional, and other features, such as the domes, which likely were symbolic.

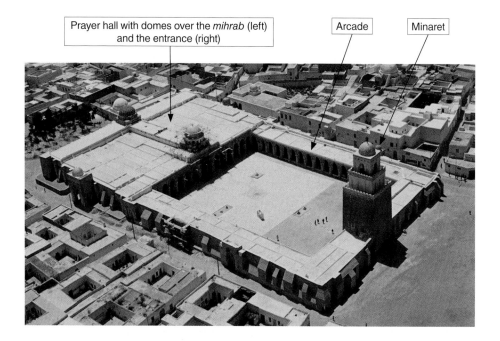

Prayer hall with domes over the *mihrab* (left) and the entrance (right)

Arcade

Minaret

**arcade** A series of arches supported by columns

**minaret** A high tower outside a mosque from which a Muslim crier calls the faithful to prayer

**mihrab** A niche in the wall of a mosque that indicates for worshippers the direction of Mecca

**qibla wall** The interior wall of a mosque, containing the *mihrab*, that is located closest to Mecca, toward which worshippers face when praying

Muhammad's home. Just like the mosque in Djenné, it has a *multi-columned prayer hall* and an *open courtyard*. The *form of the mosque's structure fits its function*:

- The courtyard has an **arcade**, a series of arches supported by columns, a popular enhancement in many mosques that creates shaded spaces and protects the faithful from the heat.
- An enormous **minaret**, a high tower used to call people to prayers, is a visual symbol of the presence of Islam.
- The *prayer hall* is wide rather than long, and regularly spaced columns create aisles where the faithful sit in orderly lines, as there are no processions and Muslims pray on the floor in long parallel rows.
- A *mihrab* (MEE-rahb) or niche in the *qibla* (KIB-luh) **wall** (the interior wall closest to Mecca) indicates the direction to face for prayers, as there is no priest save for an imam who guides the prayers, and no altars, since Muslims pray directly to God as equals.
- *Domes* top the prayer hall entrance and the *mihrab*, likely symbolizing heaven and showing that paradise can be found through entering the hall and praying.

*Quick Review 16.4*: How does the Umayyads' architectural style differ from that of the Abbasids?

## Medieval Islam

By the eighth and ninth centuries, rival regional rulers asserted their authority. Independent Islamic centers arose in such places as Egypt, Spain, Syria, and North Africa. While we cannot consider them all here, we can appreciate the variety by discussing the art of the *Mamluks* in Egypt and the *Nasrids* in Spain.

### The Mamluks

The Mamluks were originally slaves used as soldiers in Muslim armies. However, with access to military power, they eventually seized control and established their own dynasty in the

The enormous complex would have made a large impression on visitors, *reflecting back on Hassan's importance.*

Sultan Hassan's domed mausoleum is situated closest to Mecca, so the faithful's prayers from inside the complex passed through Hassan's burial chamber to reach Mecca, probably an *acknowledgment of his prestige.*

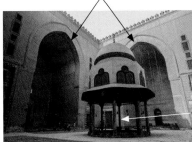

Four *iwans* (only two are visible) surround a square courtyard, one *iwan* per side. *Symbolic floral designs* and *calligraphy*, describing the rewards of paradise, decorated the walls inside the *iwans*. The *iwan* that is closest to Mecca served as the prayer hall where, on the *qibla* wall, there is a *mihrab*.

The four schools were housed in the corners of the complex between the *iwans*.

As Cairo was a crowded city, the complex was situated on an irregularly shaped lot. People entered through a dark passageway that was off axis to the courtyard, arriving into the sunlit square, as if *symbolically moving from the everyday world to the sacred.*

(A)                (B)

**FIGURE 16.20A (EXTERIOR) AND B (INTERIOR OF THE COURTYARD)**   Sultan Hasan Madrasa-Mausoleum-Mosque Complex. *1356–63, Cairo, Egypt.*

thirteenth century. While the Mamluks continued *common Islamic themes in their art*, Mamluk elites were also obsessed with *showing off their status*—a secular tendency we can see in the art.

The Mamluks built the Sultan Hasan Madrasa-Mausoleum-Mosque Complex in Cairo, Egypt. **Madrasas** are Islamic schools of higher learning, and the complex contained four schools, a burial chamber, and a mosque. The plan of the complex was based on an **iwan**, an open recessed area whose walls support a barrel vault (see Chapter 12). While the grand space *displayed Islamic themes*, it also functioned in a profoundly nonreligious way to *promote Sultan Hasan's status* (figure 16.20A and B).

Enamel-covered glass mosque lamps, which hung from the ceiling on chains, decorated the complex. As light symbolized God, the lamps held a special place in a mosque. In the lamp shown in figure 16.21 (which is from a different complex), the glowing light would have illuminated the *ordered, stylized plant-like designs* and *calligraphic writing* that described the magnificence of God. Lit lamps also illuminated the blazons or coats of arms of important people who had paid for the lamps, *promoting these people's position in secular society.*

While the blazon on the mosque lamp in figure 16.21 promoted status, the lamp still shows common ideas of Islamic art. To consider how the artist incorporated these concepts, see *Practice Art Matters 16.2: Describe the Themes of Islamic Art in a Lamp.*

### The Nasrids

Islamic leaders built secular buildings too. The Nasrids, the last Islamic dynasty in Spain, built a fortified palace called the Alhambra or "the red" (named for its rose-colored stone) atop a hill in Granada in the fourteenth century. Occupied at its height by forty thousand people, the complex contained mosques, residences, gardens, and courtyards.

**madrasa**  An Islamic school of higher learning

**iwan**  An open, recessed area whose walls support either a half dome or barrel vault

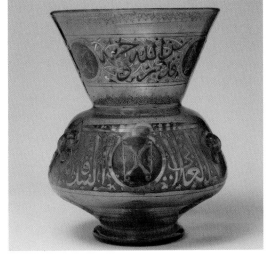

**FIGURE 16.21.**   **Mosque lamp.** *From the Mausoleum of Amir Aydakin al-'Ala'i al-Bunduqdar, Cairo, Egypt. Shortly after 1285. Enameled and gilded glass, 10⅜" high. The Metropolitan Museum of Art, New York.*  The blazon on this lamp promotes the status of the keeper of the bows. The blazon has two inward facing bows on the red circle.

Explain which of the following themes of Islamic art you see in the mosque lamp in figure 16.21 and the ways in which these themes are realized:

- A devotion to Arabic writing
- An interest in abstract or nonrepresentational art
- A desire to include symbolism
- An attraction to ordered design

One famous courtyard is the Court of the Lions (figure 16.22), which most visitors find to be a vision of elegance and harmony.

Standing in the courtyard would have been *a multisensory experience*. The sound of the fountain's splashing water, the look of the intricate ornament, the feel of the surface textures, and the smell of the flowers from gardens added to the effect.

While the courtyard was intended for the ruling family's pleasure, several features *symbolize Islamic beliefs*:

- With its four channels of water, the courtyard could be compared to the *garden of paradise* with its four rivers (see Chapter 4).
- *Calligraphy praising God* graced the walls.
- The pierced, *insubstantial nature of the walls* may have signified that *nothing is everlasting except God*.

While the Nasrids built an earthly paradise, their faith was clearly never far from their thoughts.

*Quick Review 16.5*: How can the art of the Mamluks and Nasrids be described as both secular and religious?

Interactive Image
Walkthrough

A rectangular, arcaded area surrounds a fountain.

Delicate ornament with tiny openings decorates the surfaces.

Slender, white columns support multi-lobed arches.

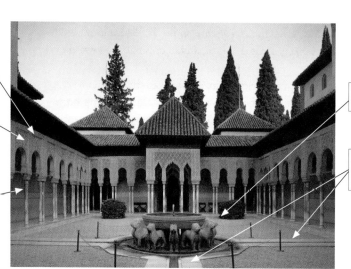

The fountain sits on the backs of twelve stone lions.

Four water channels extend out from the fountain to each side of the arcade

**FIGURE 16.22.** **Court of the Lions.** *From the Alhambra, Granada, Spain. Mid-fourteenth century.*

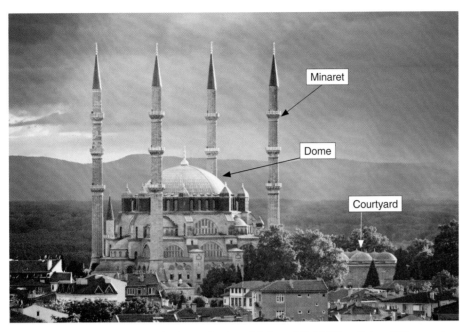

**FIGURE 16.23.** **Sinan. Mosque of Sultan Selim II, aerial view.** *1568–75, Edirne, Turkey.* Differences between the prayer hall at Djenné and here are extreme. At Djenné, the hall is shadowy, multi-columned, partitioned, and horizontally oriented. Here, the hall is light, domed, integrated, centrally planned, and expansive. However, Sinan's mosque still contains minarets and a courtyard.

## Later Islam

Three empires dominated the later Islamic world: the Ottoman, Safavid, and Mughal. This section discusses the *Ottomans* and *Safavids*, while the Mughals are discussed in Chapters 4 and 18.

### The Ottomans

Beginning in the fourteenth century, the Ottomans emerged as a force in Anatolia (what is today Turkey). In 1453, they conquered Constantinople, the capital of the Byzantine Empire (see Chapter 14), renaming it Istanbul. They eventually controlled a large swath of the Middle East, northern Africa, and Eastern Europe.

The Ottomans were influenced by the Byzantine style of churches such as the Hagia Sophia in Istanbul (see Chapter 12). However, in this *centrally planned, domed space*, they were still interested in *maintaining traditional features of the mosque*. The Mosque of Sultan Selim II (figure 16.23), in Edirne, Turkey, created by the architect Sinan, follows these two influences.

Sinan's *centrally planned mosque* differs from Muhammad's home or the four-*iwan* style. There is a vast space topped with a dome, which reaches up toward God, 197 feet off the ground. Windows allow light to shine into the prayer hall, and tiles decorate the walls. However, *traditional Islamic features* include a *mihrab* on the *qibla* wall and an arcaded courtyard that abuts the mosque. In addition, four three-hundred-foot-high minarets soar into the sky.

### The Safavids

The Safavids came to power in Iran and Central Asia in the beginning of the sixteenth century. They excelled at *carpet making* and *miniature painting.*

### Carpet Making

It is hard to understate the *importance of the carpet in the Islamic world*. People sat and reclined on carpets and pillows, as households had no furniture. Carpets were also an important part

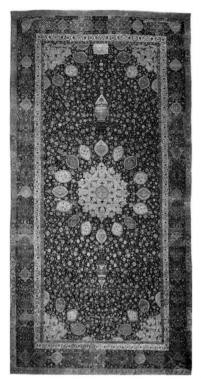

**FIGURE 16.24.** *The Ardabil Carpet* **reconsidered.** The labor involved in creating this carpet shows its importance. The carpet is made from twenty-five million knots.

of religious life. As prayer required prostration (kneeling and bowing by putting the hands and face to the floor), people began to use carpets in mosques during the Umayyad Dynasty as floors were made of sand. Before this time, Muslims clapped their hands together to clean them off. Still today, in Djenné as in most mosques, carpets cover the floor.

Chapter 11 discussed *The Ardabil Carpet* (figure 11.31A), reproduced here as figure 16.24. The carpet was one of two commissioned by the Safavid ruler of Iran for the funerary mosque of one of his predecessors. The approximately thirty-four-foot-by-seventeen-foot carpets, placed side by side, *created an enormous space for prayer* where the faithful prostrated themselves before God. The two carpets have a similar design. Sixteen smaller medallions surround a large central medallion, in addition to numerous intertwined flowers and leaves. The different components of the design had *symbolic meaning*.

There are various interpretations for what the symbols on the design represent. One theory suggests that the floral design on the carpet *signifies the garden of paradise* and the central medallion, a garden pool. An alternate interpretation suggests that the design *is based on the architectural design of the ceiling of a mosque*. According to this theory, the central medallion represents a dome. On each side of the medallion is a mosque lamp. They hang down from the medallion just as they would have from a mosque ceiling, *their light symbolizing God*. With either interpretation, when worshippers prostrated themselves, they meaningfully touched their heads to symbols for heaven and God.

### Miniature Painting

The Safavids were also known for their mastery of miniature book painting. Many of these books were secular and included images of people. An example comes from an epic poem called the *Shahnama* or *Book of Kings*, which tells the history of Iran. In the scene in figure 16.25A and B,

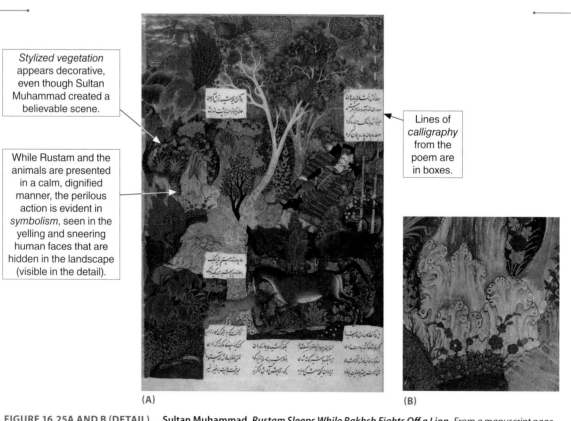

*Stylized vegetation* appears decorative, even though Sultan Muhammad created a believable scene.

While Rustam and the animals are presented in a calm, dignified manner, the perilous action is evident in *symbolism*, seen in the yelling and sneering human faces that are hidden in the landscape (visible in the detail).

Lines of *calligraphy* from the poem are in boxes.

(A)                 (B)

**FIGURE 16.25A AND B (DETAIL).** **Sultan Muhammad.** *Rustam Sleeps While Rakhsh Fights Off a Lion.* *From a manuscript page from the* Shahnama, *from Tabriz, Iran. 1515–22. Gouache on paper, 16" × 11 ½". The British Museum, London.*

the hero, Rustam, sleeps, while his trusted horse fights off a lion. While the painting may seem unlike other Islamic works discussed in this chapter, the artist, Sultan Muhammad, included a number of *common themes* that link it to Islam.

*Quick Review 16.6*: In what ways did an Ottoman mosque and Safavid carpet symbolically enable worshippers to reach toward God?

# HOW **art** MATTERS

## A Look Back at the Great Mosque in Djenné, Mali

The Great Mosque stands as a testament to the people of Djenné—their resolve to have a grand mosque and their determination to construct from the difficult material of mud. The mosque, though, also contributes to a wider understanding of Africa and Islam.

*The sun-baked mud bricks and the load-bearing structure show the mosque to be African.* The traditional building material and method are why the mosque has been placed on the United Nations' World Heritage list.

In addition, the mosque connects to Africa through the *people's belief in the power of art to intercede on their behalf.* Ideas about blessings and spirits abound. Ostrich eggs sit atop towers, and masons are believed to turn into lizards if they fall. Many of the people of Djenné see the mosque within a framework of traditional African beliefs.

The mosque can also be associated with Africa through the *use of art to help with transformations and establishing status.* Just as the Bwa **masquerade** (figure 16.9) helps young people transform into adults, so the re-plastering ritual of the Djenné mosque physically transforms the building. It does so using ritual and gender-specific roles just like the Bwa. In addition, Djenné elders play a key role in the ritual and are respected based on their power and position.

The mosque towers above the city, connecting to the *African interest in bold and powerful* works. Towers and buttresses distinguish it from its surroundings. The size and structure of the mosque show its exalted position.

*The mosque connects to Islam through its traditional plan that mimics how Muhammad's home looked in Medina.* A rectangular courtyard sits alongside a multi-columned prayer hall. Other basic features common to mosques are also present. There is a **mihrab** in the **qibla wall** that is oriented toward Mecca, and the prayer hall is oriented horizontally so the faithful can pray in rows.

Additionally, much of the floor of the mosque at Djenné is covered in carpets. The floor is understandably sandy. Carpets enable the faithful to prostrate themselves before God.

Finally, the mosque follows two of the themes common to Islamic art. With its aisles of columns and arches, *the mosque's interior design is methodical and organized.* A similar ordered design can be found on the exterior with the repeating buttresses and *toron.* In addition, *symbolism is incorporated in the mosque* in the large platform that worshippers ascend to pray. The platform likely represents the sacred world that is closer to God.

As you move forward from the chapter, consider how the people of Djenné take time out of their lives every year after the rainy season for what is an essential ritual of re-strengthening and repair. All art needs conservation, and efforts and funding for this work are essential for our cultural heritage to survive. The re-plastering process, though, also reminds us of the importance of taking time out for re-strengthening and repair in general beyond the example of conserving art—even if only once a year.

Flashcards

## CRITICAL THINKING QUESTIONS

1. Scholars suggest that the Nok heads (figure 16.7) were carved. Considering what you know about sculpture from Chapter 10, do you believe this interpretation makes sense? Why or why not?

2. The Bwa people use masquerade and masks (figure 16.9) to initiate young people into adulthood. What types of rituals, ceremonies, and art forms do you use in your culture to mark rites of passage? How are these similar or different to the masquerade and masks of the Bwa people?

3. Which cultures in Africa follow the important tradition of honoring ancestors? How is the tradition reflected in the art of these cultures?

4. In what ways is the sculpture of the head of the *oni* (figure 16.11) from the Yoruba culture so uncharacteristic of traditional African art?

5. Compare and contrast the sculptures of the heads of an *oni* (figure 16.11) and an *oba* (figure 16.13B). Consider the following in your comparison: subject matter, material, technique, form, and believed or known purpose.

6. How is identity and status displayed in the everyday arts of Africa in items such as clothing and utensils?

7. Why is the structure of Muhammad's house so significant in Islam? Pick an example from the chapter that illustrates this structure, and explain in which architectural features this significance can be seen.

8. Which particular features of the Sultan Hasan Madrasa-Mausoleum-Mosque Complex (figure 16.20) worked to honor Sultan Hasan and which had religious functions? Which features served both purposes?

9. In what ways are the architectural features of the Dome of the Rock (figure 16.18) similar to the Mosque of Sultan Selim II (figure 16.23)? In what ways are they different?

10. Considering the themes of Islamic art, in what ways does Sultan Muhammad's *Rustam Sleeps while Rakhsh Fights Off a Lion* (figure 16.25) depart from other Islamic art shown in the chapter?

11. African art primarily portrays figures while Islamic art focuses on abstract and nonrepresentational designs. Describe several examples from the chapter that illustrate these tendencies.

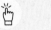 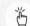

Comprehension Quiz     Application Quiz

# CONNECTIONS

## Love, Birth, and Growing Up

The universal theme of love, birth, and growing up is evident in artworks from this chapter and in art created by people from different backgrounds and periods from across this book. This theme concerns:

- » *Love, marriage, and partnership*
- » *Fertility, pregnancy, and birth*
- » *Growing up and coming of age*

### Love, Marriage, and Partnership

The chapter we completed describes how a spoon from the Nguni culture (figure 16.15), in Africa, was likely given as a gift to a man upon his marriage from the bride's family. The spoon captures the female figure in its bold, abstract form—emphasizing sexual features. As the owner would have used the spoon in daily life, the actual texture of the wood would have felt worn and smooth in his hands.

Many artworks throughout history have been associated with love, marriage, and partnership. One from the Italian Renaissance by Titian, from Chapter 15, makes for a close comparison. Recent scholarship suggests the Duke of Urbino may have commissioned *Venus of Urbino* (figure C16.1) in honor of his wedding, suggesting that the Venus in the image is actually the Duke's bride. Several features show connections between the cultures. Both works:

- » Depict nude women: Titian's Venus places her hand in a position that draws attention to her sex, just as the spoon emphasizes sexual features
- » Are associated with daily life: Titian's bride lays on her bed, while servants gather her clothes, just as the spoon was likely used normally for serving food
- » Emphasize texture: Titian's simulated surfaces are rich and soft like the spoon's actual tactile qualities

### Fertility, Pregnancy, and Birth

As we discussed, the Great Mosque (figure 16.1) displays how people in Djenné see art as an instrument of change, bringing fruitfulness and good fortune. Atop the mosque, three ostrich eggs sit, symbolizing fertility.

Similarly, other cultures have depicted images of fertility, pregnancy, and birth. At times, these have been seen as having power to provide nourishment, abundance, and help. As Chapter 15 illustrates, in 1664 in the Dutch Republic, Jan Vermeer painted what may be a pregnant woman weighing pearls (figure C16.2). As Vermeer was Catholic, he might have intended this woman to represent the Virgin Mary, pregnant with the son of God. Just as the eggs are understood to aid people in Africa, so the Virgin Mary is an intermediary thought to help with people's pleas to God.

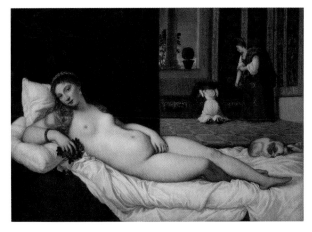

**FIGURE C16.1.    Titian.** *Venus of Urbino* **reconsidered.**  The duke may have commissioned this image of the goddess as a pretense, so he could look at the body of a courtesan. This explanation serves as a reminder that alongside traditional marriage, there are other ways to consider love.

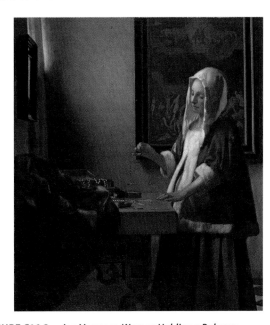

**FIGURE C16.2.    Jan Vermeer.** *Woman Holding a Balance* **reconsidered.**  Vermeer's woman may represent a pregnant Mary, but countless other images show Mary after giving birth, nursing Jesus, where she is the symbolic nurturing mother of all of humanity, aiding the faithful.

## Growing Up and Coming of Age

The chapter we just finished describes the importance art plays in coming-of-age ceremonies in Africa. Among the Bwa, masks and costumes (figure 16.9) used in masquerades help to transform young people into adults, so they may hold more significant roles in the community.

A rite of passage was similarly important during the 1400s in Italy. In one of the panels for the *Gates of Paradise*, from Chapter 15, Lorenzo Ghiberti depicted *Jacob and Esau* (figure C16.3). The tale unfolds in several scenes in which the biblical twins are born and grow up. In the foreground, Isaac accidentally gives the blessing he intended for his first-born son, Esau, to his second-born son, Jacob. Just as the Bwa have a tradition in which the older generation sends the younger on their way as adults, so Ghiberti depicted a father blessing his son who has come of age.

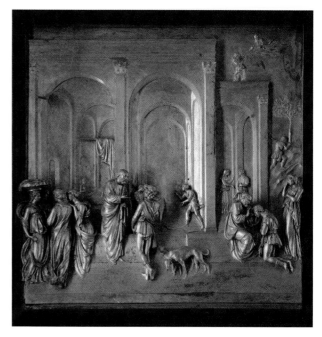

**FIGURE C16.3.** Lorenzo Ghiberti. *Jacob and Esau* reconsidered. On the right side of the image, Jacob kneels before his blind father, Isaac, who places his hands on his son in blessing. Yet, while he appears in the midst of a rite of passage, Jacob had already moved away from the innocence of childhood. Jacob had schemed to trick Isaac into giving him the blessing.

## Make Connections

In the painting in figure C16.4, from Chapter 2, Jan van Eyck, a northern European artist, depicted a man and woman in a bed chamber. Different interpretations explain the painting. Some scholars see the image, painted in 1434, as a record of the man and woman's marriage and others, as their engagement—both rites of passage. In either case, the woman's lifting her dress to appear pregnant could be a symbol of fertility in a plea for a fruitful union. A new interpretation suggests the image was a memorial portrait, honoring a different woman who had died in childbirth. How does the scene and these possible interpretations relate to the theme of love, birth, and growing up?

What other visual examples can you come up with from across the book and from today's world that reflect this theme? How are people's motivations across time and place similar and different?

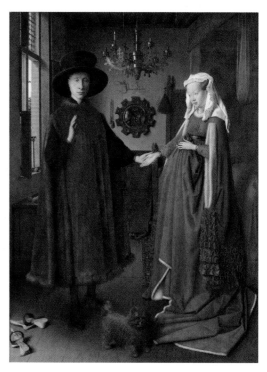

**FIGURE C16.4.** Jan van Eyck. *Portrait of Giovanni Arnolfini and His Wife* (?) reconsidered.

# 17

# The Art of the Pacific and the Americas

**DETAIL OF FIGURE 17.1.** Some populations in the Pacific and the Americas were stratified into different social classes, and art helped emphasize the power of the elites. In Hawaii, commoners had to collect hundreds of thousands of feathers for cloaks—a detail of one is shown here—that could only be worn by a Hawaiian ruler.

## LEARNING OBJECTIVES

**17.1**   Describe the concept of Dreaming and its relationship with Australian art.

**17.2**   Explain the role of ancestors in Melanesian art using examples from New Guinea and New Ireland.

**17.3**   Summarize how Polynesian art reinforced the position and prestige of certain individuals.

**17.4**   Detail the ways in which ceremonial centers with pyramids were used in different Mesoamerican cultures.

**17.5**   List the four ideas that can be seen in many South American objects of art.

**17.6**   Distinguish between two types of art produced by the people of North America—functional art and art that involved ancestral spirits and gods.

## HAWAIIAN FEATHERWORK

Sometime around 500 CE, people traveling in canoes from the Marquesas Islands in the Pacific settled on the unpopulated islands of Hawaii. Over the ensuing centuries, the inhabitants developed *a stratified society*, with high chiefs who ruled the land and, beneath them, lower chiefs and a vast population of common people.

How Art Matters

### Feathers and Featherwork

The Hawaiian people worshipped many gods. They believed their chiefs were descended from these deities—who were thought to be covered with feathers. As a result, wearing *featherwork*—artworks, such as capes and helmets, made with feathers—became *a way for the chiefs to demonstrate their divinity and rank*. Feathers were so highly prized that they became part of the tax that common people paid to the ruling class.

Yet, collecting feathers was complicated. The most desired red and yellow feathers came from rare birds that supplied on average only seven feathers each. Professional feather hunters worked with nets or spread bird lime on branches, so that when the birds landed on the limbs, they stuck to the sticky surface and could be caught and plucked.

The feathers were sacred and thought to contain *mana*—a spiritual force of supernatural power and protective strength reserved for elite people and special objects. While the common people had to supply feathers, *they were forbidden from wearing them* by *tapu* (tah-POO). Known in English as taboo, these special restrictions protected people or objects invested with *mana* from being defiled. The early Hawaiian people believed that if ordinary people broke with the *tapu* and wore the feathered objects, they would be in great danger. Of course, *such restrictions helped reinforce the control of the chiefs over society*.

### Feathered Cloaks

A cloak (figure 17.1) or cape was one of the most essential feathered objects that a chief could own. Worn over the shoulders, a chief secured the cloak with a tie at the neck. *The length of the garment and the quality of the feathers communicated the owner's status*. High chiefs wore lengthy cloaks that hung to the ground and required thousands of the highest-quality feathers. Lesser chiefs wore short capes that reached down their torsos and were made from coarser, more common feathers.

While women could sort the feathers by size and color, *only specially trained men took part in the highly ritualized act of creating cloaks*. First, the men formed a fine-mesh netting base. Then, they collected the sorted feathers into bunches and tied them to the netting with thread, creating closely fitting, overlapping rows. Throughout the process, the men chanted the names of the high-ranking dead ancestors (believed to be powerful spirits) of the chief who would wear the cloak, so that *the ancestors' strength would be "caught" within the netting* and the garment would be invested with heightened *mana*.

It is hard for us to comprehend the effort that went into creating these cloaks and the effect that they would have had on *communicating the authority of the ruler to the*

**FIGURE 17.1.** **Feathered cloak.** *From Hawaii. c. 1843. Feathers and plant materials, 4' 1 ½" × 8' ¾". Bishop Museum, Honolulu, Hawaii.* Only the supreme chief could wear a feathered cloak such as this one that was made from red and yellow feathers and hung down to the floor.

*populace*. One cloak, belonging to Kamehameha, the nineteenth-century chief who conquered all of the Hawaiian Islands and became king, had 450,000 feathers. Hunters had to catch over sixty thousand birds to create this one significant cloak.

The men tied the feathers so closely that the cloaks' surfaces resembled luxurious textiles. When Captain James Cook, the British explorer of the Pacific, arrived in Hawaii, he marveled over the cloaks, saying, "The surface might be compared to the thickest and richest velvet, which they resemble, both as to the feel, and the glossy appearance. . . ."[1]

## Feather Designs

*Not only did the quantity and quality of feathers communicate the power of the chief, but so did the designs on the cloaks.* Feathers were organized into arrangements, creating geometric shapes and simple patterns. One emblem believed to be particularly strong was the crescent, an arc shaped like the moon that sometimes had a point in the middle and resembled the raised arms of a man in prayer or about to throw a spear in battle. *The crescent symbolized the sacred and brute strength of the leader.* Often cloaks displayed multiple crescents. In figure 17.1, two yellow crescents appear against the red background in the center rear of the cloak, while four half crescents on the sides (that when worn would have met in the front) form two additional crescents.

## How Featherwork Functioned in Society

The chiefs wore feathered cloaks and helmets for religious ceremonies, communal events, and battles, illustrating the functions of the featherwork and the central role this type of art played in the society:

» *The adornment of the chiefs during sacred rites linked them with the divine.* The people associated feathers with the gods.
» *The feathers' presence at communal events distinguished the chiefs from everyday people.* The feathers were rare and difficult to acquire, and their use restricted.
» *The featherwork frightened enemy soldiers in battle, empowered the wearer, and protected him spiritually and physically from injury.* The chiefs covered themselves with hallowed and menacing crescents and the featherwork was thick and protective, especially important as the chief's *mana* was *believed to reside in his head* and backbone, the two areas most protected by the helmets and cloaks.

## Feathered Leis

While we know that elite men wore cloaks, scholars disagree as to whether elite women were occasionally allowed to wear them as well. Regardless, women too adorned themselves with featherwork, in particular with a feather necklace called a lei (LAY) (figure 17.2). While only men could create cloaks, both men and women created leis.

## Feathered Gods

The use of feathers was not limited to attire. Hawaiians also decorated depictions of gods with feathers. Although Hawaiians did not consider them real gods, they believed these representations were holy and invested with *mana*.

The depiction of the War God in figure 17.3 follows many of the conventions seen with the attire. Red and yellow feathers adorn the

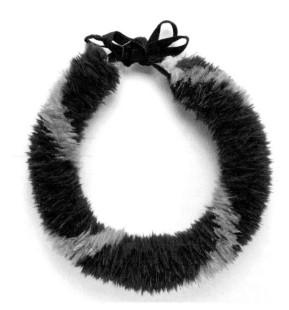

**FIGURE 17.2.** **Feathered lei.** *From Hawaii. Nineteenth century. Feathers and ribbon. Bishop Museum, Honolulu, Hawaii.* Just like men, high-ranking women coveted the rarest red and yellow feathers seen in this lei.

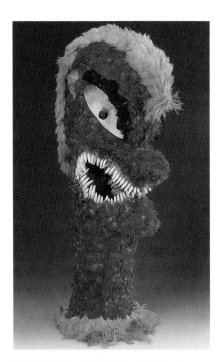

**FIGURE 17.3.** **Feathered god figure.** *From Hawaii. c. 1776–80. Feathers, fiber, dog teeth, and pearl shell, height 18 ¾". Institut und Sammlung der Kulturen, Göttingen, Germany.* The feathered god is composed of many powerfully symbolic crescents, including his crest at the top of the head, bushy eyebrows, snarling mouth (made from dogs' teeth), and jutting chin.

head, and multiple crescents appear formed from the facial features. This sculpture would have been carried on a pole during religious rites (to inspire people) and during battles (to intimidate enemies). The maker *depicted only the head of the god*, the location where its *mana* resided.

### Art in Hawaiian Culture

Hawaiian featherwork reflects a number of issues central to Hawaiian culture. The art was:

» Made by *men and women working in different roles*
» Created from certain *materials invested with mana and governed by tapu*
» Designed to *promote the status of leaders*

These views are also similar to a number of beliefs of different traditional Pacific and American cultures in general. In these cultures, it was often believed that *ancestral spirits and gods influenced the lives of the living*. Art was frequently thought to be *invested with power* and to *lend prestige to certain people*. In this way, the featherwork also informs our understanding of the *power of wearable and other art to affect others*.

This chapter will explore the traditional art of the Pacific and the Americas—two very different and distinct geographical and cultural areas. Before moving forward, based on this story, consider the different works of art covered in this opening story and created by the Hawaiians. What purpose do you think these works served—religious, political, or decorative? Might there have been multiple purposes? If so, how might that be important for understanding Hawaiian art?

## 17

# The Pacific

The Pacific region encompasses a vast and diverse area composed of over twenty-five thousand different islands and the continent of Australia. Today, people speaking hundreds of languages inhabit over fifteen hundred of these islands, many with significantly varied terrains.

People began settling the Pacific around fifty thousand years ago. They came from Southeast Asia, originally crossing onto land masses that at the time were accessible via easily passable shallow waters. When they could go no farther on land, people spread to other parts of the region via boats. Settlement occurred over thousands of years.

This chapter offers a sampling of traditional art from the Pacific. Examples of art created by contemporary artists from the Pacific can be found in a number of chapters throughout this text. In the nineteenth century, the Pacific Islands were grouped into three areas—Melanesia, Polynesia, and Micronesia (figure 17.4). As the islands of Micronesia are quite small, this chapter focuses on the traditional arts of the islands of *Melanesia* and *Polynesia* along with traditional art from the continent of *Australia*.

### Australia

Aboriginal Australians (the original inhabitants) settled on the continent of Australia approximately forty thousand years ago. For thousands of years, the people existed as hunters and gatherers.

FIGURE 17.4. **The Pacific.** This map shows the various locations in the Pacific discussed in this chapter and throughout the text.

Many Aborigines, descendants of these original inhabitants, *believe in a complex worldview called "Dreaming"* that takes many adherents their entire lives to understand. Such Aborigines believe that ancestral beings, called "Dreamings," existed before the earth was formed. During an era called "Dreamtime," these ancestors traveled over the surface of a great smooth plain of nothingness and created the irregular surface of the earth. At the end of their journey, each ancestor transformed into a different, specific feature of the landscape—a mountain, valley, desert, river, and so forth—so that individual ancestral spirits are linked today with specific places. Because of this connection between specific Dreamings and places, *all people who are born in a certain location are believed to be descendant from and linked to that ancestral spirit* and to other people born in that location.

For Aborigines who follow Dreaming, time is ongoing, and Dreamtime still exists in the present. The people imagine that as they age, they grow closer to Dreamtime and that when they die they cross into the Dreamtime realm.

Art is the primary method of *relating these creation myths to younger generations of Aborigines.* Art also *brings these ancestral spirits into the present*, often depicting specific Dreamings. As a result, *art is believed to have power.*

Aborigines have used bark paintings to depict ancestral spirits and other figures and animals. To create these paintings, Aborigines strip bark from a tree and beat it, so that the bark resembles cloth after softening. Next, to form the image, they apply black, gray, and white pigment to create contrast. Then, they place hatch marks across the surface, which forms a busy pattern and gives the surface a shimmering quality believed to make the ancestral presence feel stronger and more powerful. There is no "up" in these paintings, which means they *can be viewed and understood from any orientation*; this also underscores the complexity of the thinking behind what may initially appear to be simple artworks.

Aborigines who believe in Dreaming have the right to depict only those ancestral spirits with whom they have a connection based on the location where they were born. Painter Yilkari Kitani, who was born in Central Arnhem Land in Northern Australia in the late nineteenth century, depicted the Wagilag sister spirits' tracks as they traveled over the earth during Dreamtime, transforming the landscape as they went (figure 17.5).

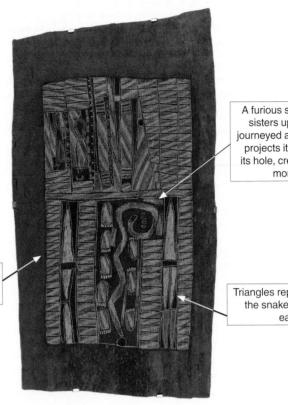

A furious snake that the sisters upset as they journeyed across the land projects its body out of its hole, creating the first monsoon.

The horizontal rectangles placed one beside the next are the sisters' tracks.

Triangles represent where the snake fell back to earth.

**FIGURE 17.5.** Yilkari Kitani. *Wagilag Story.* 1937. Natural pigments on eucalyptus bark, 4′ 1 ¾″ × 2′ 3″. The Donald Thomson Collection, University of Melbourne, Australia.

*Quick Review 17.1*: What is the concept of Dreaming and what is its relationship with Australian art?

## Melanesia

The earliest settlers of the Melanesian islands arrived approximately forty-five thousand years ago. When contrasted with the highly stratified Hawaii society, rank in Melanesia was fluid, with wealth and possessions establishing prestige.

As in Australia, Melanesian art was *often linked to ancestors*. Here, we consider the art from two islands—*New Guinea* and *New Ireland*.

### New Guinea

New Guinea is the largest island in the Pacific. It is incredibly diverse in terms of people and terrain. Numerous different peoples who speak over seven hundred languages inhabit the island.

One of these groups, the Asmat, lives in the wooded southwestern region of the island. As late as the 1950s, this group practiced headhunting. The Asmat believed that their enemies caused all deaths, either through violence or powers. They also believed that if their deceased Asmat ancestors were not avenged, the ancestral spirits would be caught in limbo, never reaching the peace of the Asmat hereafter, and thus would cause trouble in the village. Because, as in Hawaii, *the head was seen as the location of a person's spirit and power, taking the heads of adversaries allowed the Asmat to grab power from rivals*. When

**featherwork** A work of art created by the technique of tying feathers onto a mesh netting

Asmat village elders deemed that enough people in a village had died, they called for a headhunting raid.

The ritual began with the creation of enormous *bisj* (BISH) poles (figure 17.6), some of which stand as high as twenty feet. *Men and women had different roles* in the creation of these poles. Women would cut down trees, retaining one root that extended outward. When the trees were turned over by the men, the root formed a phallic projection at the top, emphasizing a link between male virility and violence. Men would then carve the trees with representations of the recently deceased people to be avenged. They would also include representations of birds, as the Asmat believed that trees were similar to humans and that a tree's fruit was its head (they understood fruit-eating birds to be headhunters). When the headhunting raid was completed and the enemy heads brought back to the village, the *spirits represented on the poles were freed to travel to the ancestral world.* The poles were then left to rot.

## New Ireland

The people of New Ireland also have a ritual that *helps ancestral spirits move to the next world.* On New Ireland, people hold a ceremony every few years called *Malagan.* While the ceremony honors the recently deceased, it also marks the ability of the living to return to normalcy after deaths in the community. The ceremony involves feasting, dancing, music, and different types of art such as carved poles, sculptures, and masks.

Special *tatanua* masks (figure 17.7) are worn by groups of men during the dance part of the festival as a *show of strength and power.* The masks differ in style, but all take a similar approach. They are worn over the head like a helmet, projecting forward from the face, and they feature the same style of haircut—typically worn by men in mourning—with the sides of the head shaved and a crest of hair down the middle. This crest, like Hawaiian **featherwork**, is often *made of feathers.*

*Quick Review 17.2*: What is the role of ancestors in Melanesian art, specifically in New Guinea and New Ireland?

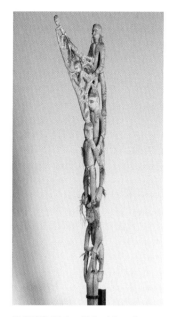

**FIGURE 17.6.** *Bisj* spirit pole. *From Jow Village, New Guinea. Asmat culture. Twentieth century. Wood, vegetable fiber, and pigment, 15' × 3' 5 ⅓" × 1' 1 ¾". Quai Branly Museum, Paris.* Carvers stacked figures of deceased ancestors up the pole.

# Polynesia

The islands of Polynesia were some of the last to be inhabited in the world, with some areas not being settled until as late as 1200 CE. Hawaii is located in Polynesia, and many of the characteristics of Hawaii, described at the beginning of this chapter, prevailed throughout Polynesia. For example, it was typical to have *strictly stratified societies* with an *upper class that was believed to have mana protected by tapu.* Art often helped *define these differences in status.* Here, we consider the islands of *Rapa Nui* (also known as Easter Island) and *New Zealand.*

## Rapa Nui (Easter Island)

Rapa Nui is located on the outermost eastern edge of Polynesia. Entirely isolated, Rapa Nui is over twelve hundred miles from the closest island.

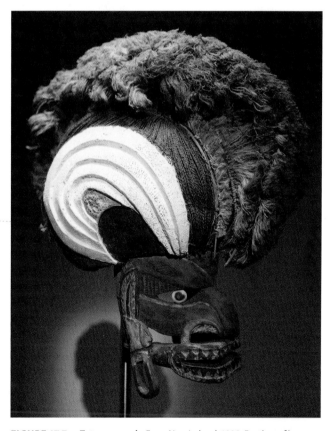

**FIGURE 17.7.** *Tatanua* mask. *From New Ireland. 1890. Feathers, fibers, and natural pigments.* This mask would have shown the strength of the community moving on after a death.

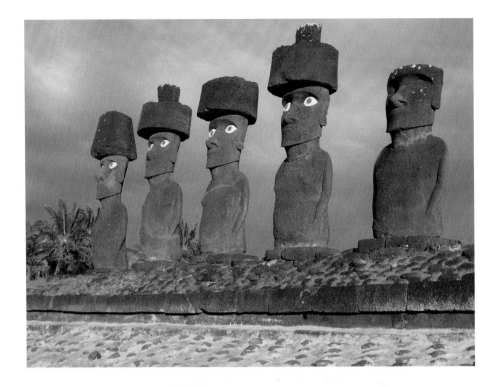

**FIGURE 17.8.** *Moai. From Anakena, Rapa Nui culture. 1200–1600 CE. Volcanic tuff, red scoria, and coral, height approximately 24′ to 32′.* None of the *moai* bears the features of a specific individual, noticeable here in their similar appearances.

*moai* A colossal stone figure encompassing a head and torso found on the island of Rapa Nui (Easter Island)

Starting around 900 CE, the people began carving enormous, abstract stone figures called ***moai*** (moh-EYE) (figure 17.8). Over eight hundred of these sculptures have been found—many in sacred ceremonial places that also included courtyards, ramps, and burials. The people originally arranged the *moai* on raised, twenty-foot-high stone altars, positioning them in a row along the coastline facing in from the water. These sculptures:

- Stand roughly *twenty to forty feet tall*, although a few are as large as sixty feet
- Feature an *oversized head* and compact torso with thin arms pressed against their bodies and no legs
- Have *topknots, made from a different colored stone*, over their heads like hats, and eyes composed of white coral with stone pupils
- *Face strictly forward* and have angular, jutting chins, pointy noses, and heavy brows
- Feature *generic faces*

While art historians are not certain about the purpose of these monumental works, current theories suggest that the *sculptures represented ancestral chiefs*. As in Hawaii, an elite class ruled Rapa Nui. Spirits of past rulers might have been thought to *empower the living chiefs*, as ancestors were believed to be intermediaries who could intercede with the gods. As in Hawaii, art was thought to be invested with *mana*, and here the strength of the figures can be seen in their *oversized heads*, where the *mana* was believed to reside.

We can get a sense of the importance of art to Rapa Nui society and the dynamics of class relations from the herculean efforts required to create these sculptures. Each weighs one hundred tons. Scholars estimate that it may have taken thirty men a year to carve a sculpture and ninety men four months to move one from the quarries to the position on an altar. *The elite class likely wielded great power* to force so many people to labor over and transport such monumental works.

## New Zealand

New Zealand was one of the last islands to be inhabited in the Pacific. Similar to Hawaii, the original population, the Maori, had a *hereditary-based ruling class*.

When Europeans started settling in New Zealand in the nineteenth century, the Maori erected meeting houses where different clans could discuss issues related to the newcomers, such as dealing with missionaries and property sales. Meeting houses were additionally used to entertain visitors, for communal events, and for rituals related to ancestors. The houses are still used today in New Zealand for funerals and group meetings.

The meeting house in figure 17.9 was completed in 1940 to honor the hundredth anniversary of the signing of a treaty related to the founding of the nation of New Zealand. While not specific to one clan, the meeting house retains hallmarks of the traditional form. Structures were designed to represent the body of a founding ancestor. Different *architectural features corresponded to this ancestor's body parts,* and depictions of more recent ancestors appeared throughout the interior.

As with the Hawaiian featherwork, everything about the meeting houses *proclaimed status* and was meant to *intimidate other groups:*

- *The meeting houses bestowed prestige on the members of the clan that built the house.* These members literally sat inside the supreme ancestor, receiving his shelter and *mana.* They were surrounded by other ancestors with *large heads,* who could invest them with power. Scholars believe that the more recent ancestral images portrayed the group's illustrative lineage, while the hardness of the wood showed their strength.
- *The meeting houses indicated rank among the individual members of the clan.* Only important men and visitors could occupy the right side of the house, while common people used the left.
- *The meeting houses illustrated the status of men.* Women were not allowed inside the meeting houses at all.

Artists in both Rapa Nui and New Zealand created freestanding sculptures. To consider how two of these works relate to each other, see *Practice Art Matters 17.1: Compare Two Polynesian Sculptures.*

Interactive Image
Walkthrough

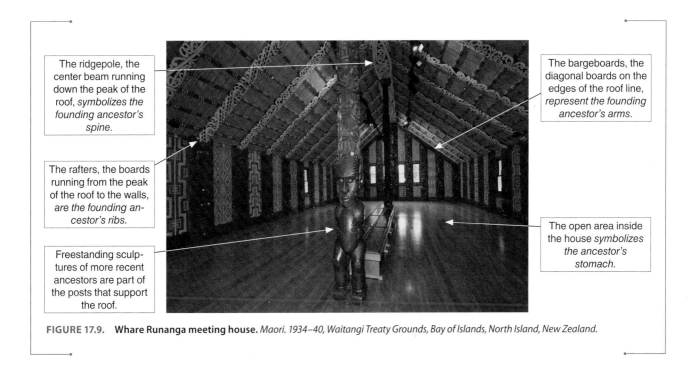

The ridgepole, the center beam running down the peak of the roof, *symbolizes the founding ancestor's spine.*

The rafters, the boards running from the peak of the roof to the walls, *are the founding ancestor's ribs.*

Freestanding sculptures of more recent ancestors are part of the posts that support the roof.

The bargeboards, the diagonal boards on the edges of the roof line, *represent the founding ancestor's arms.*

The open area inside the house *symbolizes the ancestor's stomach.*

**FIGURE 17.9.** **Whare Runanga meeting house.** *Maori. 1934–40, Waitangi Treaty Grounds, Bay of Islands, North Island, New Zealand.*

## 17.1 Compare Two Polynesian Sculptures

Consider the freestanding sculpture that is part of the post that supports the roof in the Maori meeting house (figure 17.10A) and compare it to the *moai* from Rapa Nui (figure 17.10B).

- How is the Maori sculpture (17.10A) similar to the *moai* (17.10B) in terms of its form?
- Why do you think the Maori sculpture might have been created with a similar form?

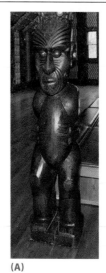
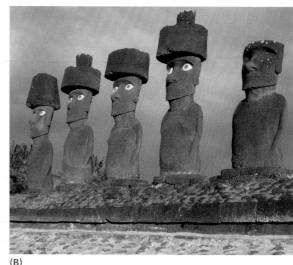

(A)          (B)

**FIGURE 17.10A AND B.** (A) Whare Runanga meeting house sculpture reconsidered in a detail; (B) *Moai* reconsidered.

*Quick Review 17.3*: How did Polynesian art reinforce the position and prestige of certain individuals?

# The Americas

Scholars have different theories as to how people first arrived in the Americas. One traditional theory suggests that during the last ice age, approximately 13,500 years ago, when waters had receded from present levels because of large glaciers, humans crossed a land bridge that existed between present-day Siberia and Alaska. Another theory hypothesizes that people from Asia first populated the Americas by landing on the North American coast in boats approximately fifteen thousand to twenty thousand years ago. Recent archaeological evidence suggests people from the Pacific Islands were the first to arrive, landing by boat in Chile. Regardless of how they got to the Americas, humans had spread throughout the continents by at least 12,500 years ago, and those people were completely isolated from all others until Europeans arrived in the fifteenth century. Many of the people in the Americas developed agriculture and complex, stratified societies.

The Americas (figure 17.11) encompass an enormous area. This chapter focuses on the art from a number of traditional representative groups from three geographic locations, including *Mesoamerica*, *North America*, and *South America*. Examples of art created by contemporary artists from the Americas are located throughout the text and in Chapter 21. In addition, the story of Maria Martinez's pottery can be found in Chapter 11.

## Mesoamerica

Mesoamerica is a discrete geographic region that includes parts of Mexico and Central America, and it is also a distinct cultural region. People in the region shared common values and performed similar practices. Over a period of thousands of years, they:

- Created an agricultural system around the *cultivation of maize* (corn)
- Practiced a *ritualistic ball game*
- Had a *common calendar*

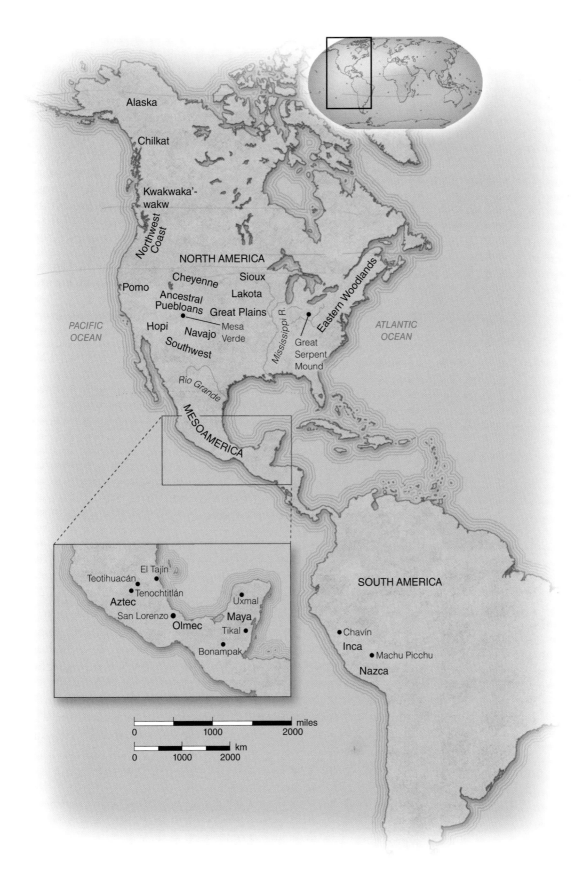

**FIGURE 17.11. The Americas.** The Americas encompass two massive continents of great geographic diversity. This map shows the various locations and groups discussed in this chapter and throughout the text.

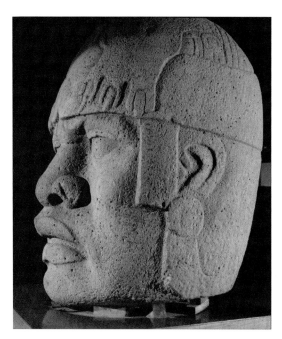

**FIGURE 17.12.** **Colossal head #4.** *From San Lorenzo, Mexico. Olmec. c. 1200–200 BCE. Basalt, 5′ 9 ½″ × 3′ 9 ½″ × 3′ 1 ¼″. National Museum of Anthropology, Mexico City.* The helmets on the figures, as here, were the type used in the ritualistic ball games.

- Believed that *human blood must be spilt to appease the gods,* so that the world would endure—toward this end, they ritualistically sacrificed prisoners and practiced bloodletting on themselves

## Olmec

The Olmec lived on the Gulf Coast of Mexico from approximately 1500 BCE until 400 BCE. Existing in farming communities with *hereditary-based, powerful rulers,* the population created *ceremonial centers,* where they gathered at plazas, earth mound pyramids, and ball courts. At these centers, the leaders performed rituals, which included sacrifice and bloodletting.

The ceremonial centers also housed *colossal stone heads* (figure 17.12). Seventeen of these sculptures have been found, the largest of which is twelve feet high. These heads most likely:

- *Represented rulers rather than gods,* as they have human characteristics of individualized features, helmets, and ear spools (stones placed in large holes in the ears)
- *Were carved upon rulers' deaths from the thrones that the rulers sat on during life,* as several of these heads have been found in workshops, where they were in the midst of being carved from what were originally these enormous thrones
- *Pointed toward the rulers' strength and elite rank,* as the sculptures represented only the rulers' heads and the Olmec believed that the *head was the most important part of the body, housing a person's soul*

As in Hawaii, where elite chiefs forced the populace to gather feathers, scholars believe that the Olmec rulers, too, wielded authority over the common people who created the sculptures. The people formed the heads from basalt, a hard and heavy stone that had to be transported sixty miles, and the heads weighed up to twenty tons each. The effort required shows how important this form of art was to the leaders.

## Teotihuacán

Beginning in approximately 100 BCE and lasting until about 600 CE, a city called Teotihuacán (tay-OH-tee-hwah-CAHN) arose in the area northeast of what is today Mexico City. At its height, Teotihuacán was home to approximately 125,000 people, making it one of the largest cities in the world at that time.

The city was *laid out in a grid with main axes pointing in directions of astrological and topographical significance.* A major avenue (that was a mile and a half long and 130 feet wide) ran down the center of the city, with streets coming off it at right angles. This design was unusual at the time as cities typically had curving streets. The avenue was aligned on a north–south axis to point at one end toward a mountain that had a spring underneath. (Water was scarce in Teotihuacán, so the spring was life giving.) On the perpendicular axis to the avenue lay the path of the sun. Along the avenue were numerous apartments, plazas, and temples.

Also located on the avenue were three structures where scholars believe ceremonies were performed:

- *The Pyramid of the Moon* was at the northern end in front of the mountain. Shaped to resemble the mountain, when individuals approached, the pyramid appeared as though the building eclipsed the peak.
- *The Pyramid of the Sun* sat partway down the avenue to the east. A two-hundred-foot-high structure, it was one of the largest pyramids in Mesoamerica.

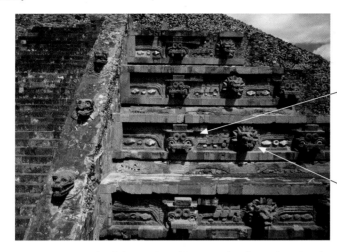

The Storm God has a *geometric face*, made from blocky cubes, and two ringed eyes.

The Feathered Serpent God has a long snout and what looks like a *feathered mane*.

**FIGURE 17.13.** **Temple of the Feathered Serpent, detail.** *Teotihuacán culture. c. 150–250 CE, Teotihuacán, Mexico.*

- *The Temple of the Feathered Serpent* stood at the opposite end surrounded by an open square that could hold one hundred thousand people—the entire adult population of the city.

The Temple of the Feathered Serpent was constructed in six tiers on which appeared alternating sculptures of two gods (figure 17.13). According to scholars, inhabitants believed *these gods promoted the longevity of the city.* One is the Storm God, representing the water needed for crops. The other is the Feathered Serpent God, believed to be an ancestor of the rulers of the city and associated with the creation of the human race and fertility. Just as in Hawaii, *rulers saw themselves as descended from feathered creatures.* The heads jut out from the façade of the temple every ten feet and are frontal and symmetrical. Each weighs four tons.

Archaeologists have found the bodies of 260 sacrificial victims buried inside the temple. All had their hands tied behind their backs, signaling that they were prisoners at the time of death. A number of the victims wore necklaces strung with human teeth and jaws, souvenirs possibly taken from prior sacrificial victims.

According to scholars, the people from Teotihuacán believed that *human blood was needed to promote fertility and agricultural success*, perhaps by transforming the blood into much-needed water. Chapter 6 illustrates a mural from Teotihuacán (figure 6.14), in which a priest sprinkles his own blood on the ground in a ritualistic offering to the earth to promote an abundant crop. If the Temple of the Feathered Serpent was a sacrificial site, the heads of the Storm and Feathered Serpent Gods would have been particularly appropriate.

## Maya

The Maya flourished between approximately 250 CE and 900 CE, living in the southeastern portion of Mesoamerica. They were excellent astronomers, botanists, and mathematicians, and they developed a sophisticated calendar and hieroglyphic writing system.

The Maya established a number of city-states, each of which had a *stratified society* with its own *hereditary-based ruler* (believed descendant from the gods), an elite class, and a mass of common people. These city-states had:

- *Ball courts*
- *Sacred pyramids* housed in ceremonial centers, some of which were used as burial sites
- *Plazas* located around the pyramids that could hold thousands of people

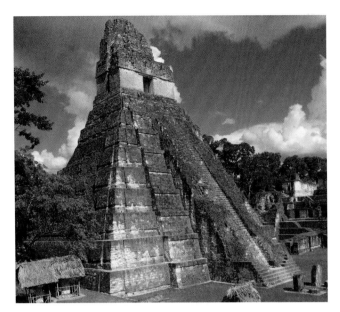

**FIGURE 17.14.** **Temple 1.** *Mayan. c. 732 CE, Tikal, Guatemala.* The nine steps on the pyramid likely represented the nine levels that the Maya believed existed in the underworld.

Scholars believe that from atop the pyramids, Maya elites—dressed in animal costumes with fur and *feathers*—honored ancestors and worshipped deities in ceremonies that included music and incense, likely entrancing the common people who attended. The Mayans believed *human sacrificial offerings were necessary to appease the gods*, who had given their blood to form humanity. Wars between Maya city-states commonly occurred to acquire sacrificial victims.

An example of a large Maya city-state is Tikal, which extended over seventy-five square miles and housed seventy thousand people. The city had a variety of ceremonial centers that were linked by causeways. The largest center featured two great, stone pyramids that faced each other on opposite sides of a plaza.

One of these pyramids, Temple 1 (figure 17.14), reached 150 feet high and sat over the tomb of an important ruler. The pyramid rose in nine steps to the peak. At the summit was a small temple that included several rooms and was topped by a sculpture-decorated roof.

The ceremonial function of these pyramids can be seen in murals from Bonampak, located in present-day Mexico. The paintings were most likely created to honor the birth of a royal heir and illustrate details of the proceedings on the pyramids that would have accompanied such a significant occasion. The murals also suggest how valuable it was to the Maya to *document events with art*. In figure 17.15, enemies are presented for sacrifice to the ruler and other dignitaries who appear atop a pyramid.

## Aztec

The people known to us today as the Aztec were nomadic raiders, who settled in Mexico in the fourteenth century CE. Just like earlier Mesoamerican cultures, the Aztec had a sophisticated society. They were superior engineers and mathematicians. They also had two

Interactive Image Walkthrough

Elite men and women stand formally upright, dressed in elaborate animal costumes of headdresses and skins with *feathers* and fur.

One prisoner, on the same level as the elite, begs the ruler for mercy. The ruler appears resolute, showing no pity.

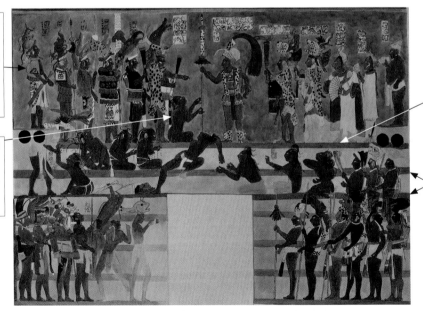

Prisoners, soon to be *sacrificial victims*, huddle nude on the steps. They hold out their hands, dripping with blood, most likely from having their fingernails pulled off.

The horizontal lines in the image represent the *stepped levels of the pyramid*.

**FIGURE 17.15.** **Presentation of captives to Lord Chan Muwan, detail.** *From Bonampak, Mexico. Mayan. c. 790 CE. Mural, 17' × 15'. Watercolor copy by Antonio Tejeda. Peabody Museum, Harvard University, Cambridge, Massachusetts.*

*Practice* art MATTERS

## 17.2 Determine the Features of Aztec Society in a Work

The first page of the *Codex Mendoza* (figure 17.16), a book made in the sixteenth century, shows a simplified view of the city Tenochtitlán. The work was commissioned by the Spanish viceroy (lead administrator) in Mexico from an Aztec illustrator after the Spanish conquest of the area. The book was created to acquaint the Spanish king with his new colony. The page shows a number of features of Tenochtitlán and the Aztec way of life. Consider the image and name five of these numbered items.

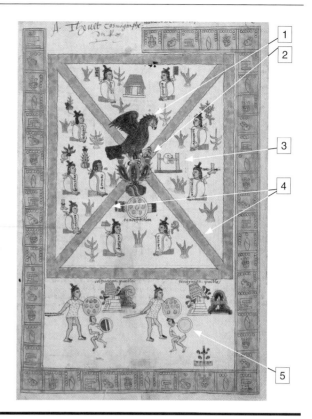

**FIGURE 17.16.** **Page from the *Codex Mendoza*.** *Folio 2, from Mexico. Aztec. 1545. Ink and color on paper, 12 ⅜″ × 8 ⅞″. Bodleian Library, University of Oxford, England.*

calendars—one consisted of a ritual calendar of 260 days and was possibly based on the length of human pregnancy, and the other was based on the 365-day year.

However, the Aztec were also *known for their sacrifices*. Like the Maya, they held *ongoing wars to capture victims*. They hoped to appease their gods to ensure that a great earthquake would not destroy their world. Sacrifice was seen as required "blood payment" to the divine, as the gods had sacrificed themselves for the benefit of humanity during creation.

The Aztec built their capital city on the island known as Tenochtitlán (tay-NOHCH-teet-LAHN), where, according to legend, the city founders had seen *an eagle with a snake in its beak sitting on a cactus*. The city was *divided into four quadrants by canals* and had twin (double) pyramids located in a ceremonial center—these two pyramids were dedicated to the Storm and Fire Gods, oriented in front of two mountains, and positioned so that during the dry season, the sun rose over the Fire God's pyramid and, during the rainy season, over the Storm God's pyramid. In the ceremonial plaza, *a rack existed for keeping the human skulls* liberated from the bodies of sacrificial victims. To try to recognize these different aspects of Aztec life in a work of art, see *Practice Art Matters 17.2: Determine the Features of Aztec Society in a Work*.

A sculpture of Coatlicue, mother of the gods, that most likely stood in Tenochtitlán's ceremonial center next to the twin pyramids, illustrates how depictions of many Aztec gods would have seemed *formidable and intimidating*. The sculpture, a compact mass, is over eleven feet tall and leans forward. The goddess would have towered over anyone walking near the pyramids. A number of specific characteristics of the sculpture—in her attire and body—likely also would have added to her menacing effect (figure 17.17).

According to legend, Coatlicue's own jealous children, the stars and the moon, tried to kill her when she was pregnant with another child, the sun. During the assault, the child emerged from Coatlicue fully formed, and fought off the attackers, but not before they beheaded her.

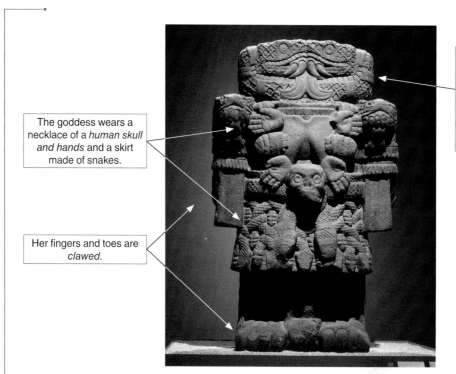

The goddess wears a necklace of a *human skull and hands* and a skirt made of snakes.

Coatlicue appears decapitated. In place of her head, two enormous serpent heads, *symbolizing streams of blood*, emerge from her torso.

Her fingers and toes are *clawed*.

**FIGURE 17.17.** **Coatlicue.** *From Tenochtitlán, Mexico City. Aztec. c. 1487–1520. Andesite, height 11′ 6″. National Museum of Anthropology, Mexico City.*

*Quick Review 17.4*: How were ceremonial centers with pyramids used in different Mesoamerican cultures?

## South America

While South America is an enormous continent, the major representative cultures on which this chapter focuses were situated on the Pacific coast. This area has extremely diverse topography and climates as it encompasses both the Andes Mountains and coastal areas. Different foods and supplies were available at different elevations, so the people traded for necessities and organized themselves into *structured societies*. Dramatic weather patterns made survival precarious and led to further collaboration among the people.

Understandably, *South American art reflects a concern for order and cooperation*. Scholars believe these interests are evident in similar ideas, some or all of which can be seen in many objects of art:

- *The use of repeating groups of abstract and nonrepresentational elements*, which might have reflected that people saw the mass of humanity as being much more important than specific individuals.
- *The use of interconnected sets and mirror images*, which may have represented the dependency of one person on another.
- *An interest in images that changed from one object into another*, which possibly symbolized the circle of life.
- *An appreciation for the overall greater meaning of an object versus its specific visual form*, which possibly represented the people's understanding of their relatively small position in the world versus larger forces.

## Chavín

One of the first civilizations that arose in South America was the Chavín, which flourished from approximately 900 BCE until 200 BCE. The people created a *ceremonial center*, complete with temples, pyramids, and plazas.

Figure 17.18 illustrates a **stele** (STEE-lee), a carved stone slab, found in the main temple. Because the carving on the actual stone is difficult to see, we show the stele as a line drawing. The stele is displayed twice, both upright and inverted, as the *image can be understood from both views*. Since the stele was not found in place, scholars have no idea how it was originally oriented. The same lines in the carving form different parts of the upright and inverted image.

The South American themes of art can be seen throughout the stele. There are:

- *Repeating abstract and nonrepresentational elements.* Both the Staff God and the Animal Gods that appear on the stele are simplified, and the Animal Gods recur.
- *Interconnected sets and mirror images.* Because there is a figure in one image and the same lines make up different elements of the other figures in the other image, the two images are interlocked and joined.
- *Images that change from one object into another.* The interconnected images change from one figure to the next depending on our view. Even different parts of the figures transform from one object to the next. For example, throughout the image, pairs of eyes switch into nostrils, while different body parts swap with snakes.
- *An overall greater meaning of an object versus its specific visual form.* The Chavín carver may have created the double image to be mystifying and otherworldly. This would have allowed the viewer to become absorbed in the process of transformation rather than being caught up in an individual form. The doubling also possibly referred to the use of mind-altering plants by shamans (people in the community with great religious and spiritual influence) in transformations.

**stele** A large upright stone slab upon which images and writing are often inscribed

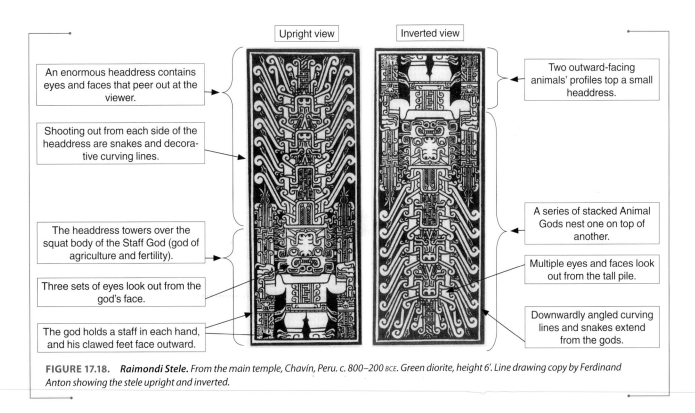

Upright view | Inverted view

An enormous headdress contains eyes and faces that peer out at the viewer.

Shooting out from each side of the headdress are snakes and decorative curving lines.

The headdress towers over the squat body of the Staff God (god of agriculture and fertility).

Three sets of eyes look out from the god's face.

The god holds a staff in each hand, and his clawed feet face outward.

Two outward-facing animals' profiles top a small headdress.

A series of stacked Animal Gods nest one on top of another.

Multiple eyes and faces look out from the tall pile.

Downwardly angled curving lines and snakes extend from the gods.

**FIGURE 17.18.** *Raimondi Stele. From the main temple, Chavín, Peru. c. 800–200 BCE. Green diorite, height 6'. Line drawing copy by Ferdinand Anton showing the stele upright and inverted.*

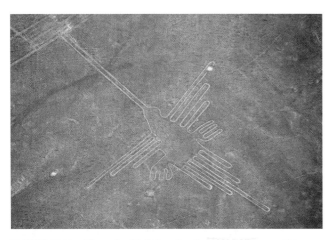

**FIGURE 17.19.** **Hummingbird.** *From Ica, Peru. Nazca culture. c. 500 CE. Earthwork, 450' × 220'.* While this earthwork represents a hummingbird, Nazca people also created earthworks of animals such as a monkey, whale, and spider.

## Nazca

From approximately the year 1 to 700 CE in what is today Peru, different clans from the Nazca culture came together *to form monumental earthworks*, works of art in which the people altered the earth. The images were created by removing a top layer of dark-colored stones that had been oxidized by the sun, and exposing lighter-colored stones underneath. The depictions represent *enormous lines, geometric shapes,* and *different animals.* One straight line goes on for five miles, while a hummingbird image (figure 17.19) is 450 feet long.

Scholars are unsure what the purpose of these images was. Some have suggested that the lines led to important shrines. Others offer agricultural explanations, theorizing that the lines pointed in the direction of the sun on the first day of the rainy season. Still others see the lines as traversing the distance between two rivers and assume they were paths to water. Another explanation holds that they might have been paths for religious processions because the lines run around the edges of the figures.

Again, here, the South American themes of art are evident. Each of the animal images is *abstracted*, and many contain *repeating elements* such as the multiple finger-like projections that form the hummingbird's wings and tail. While not an exact symmetrical image, if a dividing line were to split the bird down its length, *much of one side would almost completely mirror the other.* The theme of *dependency* can also be seen in how the images were created. None could have been formed by a lone individual. Instead, *multiple people from a variety of groups worked together* on an art form that appears to have been fundamental to the community. Finally, the images *can only be seen from a bird's eye view*, so it is not possible that the people who created the gigantic works were ever able to appreciate what they looked like. The works likely show the people revered divine forces above themselves, as *only a deity could fully grasp the totality of the image.*

## Inca

Beginning in the fourteenth century CE, the Inca began rapidly expanding their empire so that by the year 1500, they were the largest state in the world, encompassing ten million people and stretching thirty-four hundred miles. The Inca are renowned in particular for three remarkable achievements linked to art:

- *Twenty-three thousand miles of perfectly fitted, stone-paved roads*, built by masons, so that rulers could control the vast region: each road had places to stay one day's journey apart, enabling administrators to reach all areas of the empire
- *Machu Picchu* (described in Chapter 12): at the estate, masons constructed buildings, similarly made of stones cut so exactly that mortar was not needed
- *Textiles*, the finest of which had two hundred threads to the square inch: until the advent of machines, Inca cloth was the best made in the world

*Cloth was indispensable to the Inca culture.* While women primarily wove the textiles, everyone in the empire was involved with the cloth's creation. Similar to Hawaii where the masses collected feathers to pay part of their tax to the ruling class, here, the population paid taxes in cloth. Even the very young and the aged helped by spinning fiber into thread. Scholarship indicates that *cloth was more desirable than gold*, and rulers used the cloth as rewards for subjects, salary for officers, and gifts to important allies. Cloth was wrapped

around the dead, decorated temples and representations of gods, and was burned as offerings to the sun. Given the vast size of the empire, portable cloth was a practical luxury good.

Laws *dictated what type of cloth a person could wear depending on status.* Common people could wear only plain cloth. However, elites wore fine cloth, made into colorful tapestries from the best-dyed fiber and often interwoven with gold, silver, and human hair. Nothing, though, could surpass the cloth made for the rulers by the best female weavers—held prisoner in the capital city and forced to weave.

A person's status was communicated not only by the quality of the weaving and fiber, but also by the *patterns and symbols* on his or her clothing. Among common people, different social groups had their own individualized motifs, which were *repeated in an ordered manner* on their clothing. The rulers, though, wore cloth with a mixture of many of these motifs recurring to show that they ruled over numerous groups. The different motifs also appeared in a grid, likely illustrating that the rulers had ultimate control over those people. Finally, each different motif on royal cloth was placed in the design randomly to indicate, scholars believe, that the *ruler himself did not have to follow any rules.* In the royal tunic in figure 17.20, numerous different groups' emblems are unsystematically arranged in a grid.

The royal tunic incorporates the South American themes of art we have discussed in other works. To identify these themes, see *Practice Art Matters 17.3: Identify South American Themes of Art in a Tunic.*

*Quick Review 17.5*: What are four ideas that can be seen in many South American objects of art?

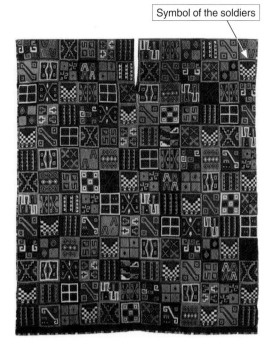

Symbol of the soldiers

**FIGURE 17.20.   Royal tunic.** *From Peru. Inca. c. 1500. Camelid fiber and cotton, 2' 11 ⅞" × 2' 6". Dumbarton Oaks Research Library and Collection, Washington, DC.* In this ruler's garment, the symbol of the soldiers, a checkerboard black and white pattern with a red triangle on top, appears haphazardly in different rows and columns throughout the cloth.

## North America

While there were cultures in North America that built agriculturally based, urban centers, many of its inhabitants lived as nomadic hunter-gatherers. They traveled in relatively small groups, and within each group all of the people were descended from a common ancestor. Rather than producing permanent architecture and monumental sculpture, these groups primarily crafted many *practical objects from perishable, portable materials* that were used in everyday life. In addition, art that focused on a higher realm, *representing ancestors and deities*, enabled the people of North America to have contact with the spiritual world.

*Practice* **art**MATTERS

### 17.3  Identify South American Themes of Art in a Tunic

The royal tunic (figure 17.20) shows how Inca cloth followed several of the themes of South American art. Which of these four themes do you recognize? Where specifically in the cloth do you see the themes that you recognize? (Hint: You should see three of the themes.)

• Repeating abstract and nonrepresentational elements

• Interconnected sets and mirror images

• Images that change from one object into another

• An overall greater meaning of an object versus its specific visual form

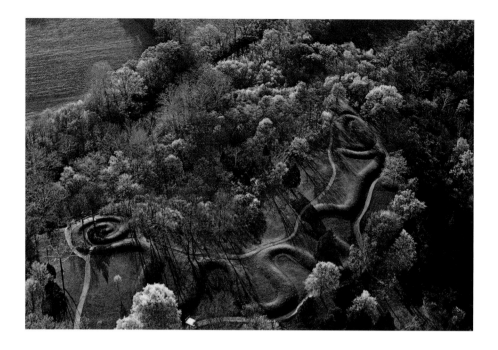

## The Eastern Woodlands

Trees originally covered the eastern section of North America, so it is known as the Eastern Woodlands. Two types of art that we will consider from this location are *earthen mounds* and *portable art*.

The people living in this part of the country in the Ohio River Valley built ceremonial centers and, beginning in about 300 CE, *earthen mounds*, often shaped like animals, birds, or other forms. One example is the Great Serpent Mound, an enormous earthwork that is approximately thirteen hundred feet long and three feet high (figure 17.21). The mound appears like a coiling snake with an egg in its mouth. The people constructed the mound by placing stones along the edges and piling dirt in between—an enormous undertaking given the size of the mound.

Scholars are unsure of the mound's purpose. Some theories point out that the Great Serpent was an important deity among native peoples, and the mound might have been a representation of a spirit that the people could call upon in times of need. Others suggest that the mound had agricultural and astronomical significance as the mouth points in the direction of where the sun sets on the summer solstice. A new theory suggests that the mound is related to the fact that Halley's Comet passed by earth in 1066 CE and was visible to humans. This presumption supposes that the mound, built in 1070 CE, is a recreation of the comet, which the people might have believed was a cosmic force. Given that *the mound can only be fully appreciated from above,* as with the Nazca lines, the people likely believed in some entity greater than themselves.

A typical example of North American *portable art* from the Eastern Woodlands is **quillwork**, works of art created by attaching quills to a surface. Women plucked quills from porcupines and used them as decorative elements on clothing, bags, and other objects.

Working with the quills was a labor-intensive and sacred activity, and *women had to be specially trained and admitted to a guild* to practice the art. The women's status and skill was similar to the male featherwork creators' positions and expertise in Hawaii. To create quillwork, the women:

- *Plucked, washed, and sorted* the rigid quills by size
- *Soaked* the quills and pulled each one through their teeth numerous times to soften and flatten them
- *Dyed* the quills to add color

**quillwork** A work of art created by the technique of attaching dyed porcupine quills to a surface

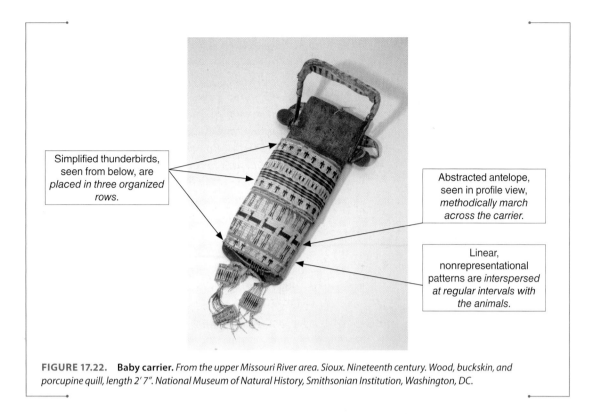

Simplified thunderbirds, seen from below, are *placed in three organized rows*.

Abstracted antelope, seen in profile view, *methodically march across the carrier*.

Linear, nonrepresentational patterns are *interspersed at regular intervals with the animals*.

**FIGURE 17.22.** **Baby carrier.** *From the upper Missouri River area. Sioux. Nineteenth century. Wood, buckskin, and porcupine quill, length 2′ 7″. National Museum of Natural History, Smithsonian Institution, Washington, DC.*

- *Stitched* two vertical lines of thread to the object where they wanted to attach the quills
- *Looped and braided* the now flexible, brightly colored quills around the threads

The technique created *parallel, linear panels and shapes of color* across the object.

The quillwork on the baby carrier from the nineteenth century in figure 17.22 illustrates the *geometric, ordered surface designs* that were characteristic. An essential component of the nomadic lifestyle, baby carriers allowed mothers to transport their children on their backs or hang them from a horse's saddle as they moved locations. The carrier displays patterns of thunderbirds and antelope, which were both thought to have protective powers.

## The Great Plains

Portable art was also necessary for the nomadic clans of the Great Plains. The people followed roaming herds of buffalo, depending on the meat for food and the hides for clothing and shelter.

The hunter-gatherer lifestyle necessitated *a light and compact architectural form* that could be easily moved and reassembled in different locations. The **tipi** (TEE-pee), a cone-shaped structure, became the common abode. Formed from twenty to forty buffalo hides, tipis were held up on a framework of poles. They offered a number of advantages:

- *Comforts against bad weather*, including waterproof hide coverings and a lining on the walls and floor that eliminated any drafts
- *Conveniences for cooking and comfort*, as a hole at the top allowed smoke to escape from a fire
- *Efficiencies in portability*, as they could be assembled in an hour or, during a move, tied to a horse in their dismantled state and used to carry other items

*Women were responsible for tipi construction, and it was a communal activity.* Working together, the women designed the tipi, treated the skins to ensure their longevity, cut the hides into the correct shapes, placed the hides on the structure, and sewed them into place. To form poles, the women cut down trees, chopped off the branches, and peeled off the bark. The entire architectural project traditionally began with a large feast to mark the important occasion. Among

**tipi** A cone-shaped abode made from animal hide or canvas and vertical supporting poles, used by people living in North America

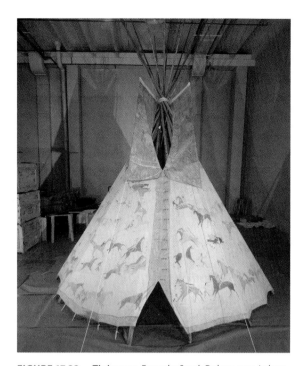

**FIGURE 17.23.** **Tipi cover.** *From the South Dakota area. Lakota. c. 1890–1910. Muslin, paint, ink, and graphite, height 9′ 5 ¼″. National Museum of the American Indian, Smithsonian Institution, Washington, DC.* The surface used on this tipi was canvas, since by the time this tipi was created, at the turn of the twentieth century, buffalo were scarce.

the Cheyenne people, tipi creation was considered so prestigious that *only women admitted to a special guild were allowed to participate.*

*Both men and women decorated tipis.* However, men decorated tipis with paint, while women decorated with quills, stitching, and beads. Figure 17.23 shows a tipi cover with typical male-painted decorations. The men painted images that show accomplishments important to the group, including both a battle scene and a horse raid. Both types of images showed the men's prowess. The images are *flat, yet naturalistic and detailed*, so that individual costumes and hairstyles are apparent. As in Hawaii, *feathers showed status*, and important men wore feathers on their heads.

## The Southwest

In the Southwest, a number of native contemporary people believe in *kachina* (kah-CHEE-nah) *spirits, kind supernatural beings that influence the people's lives.* Each kachina is thought to play a different role, representing weather patterns, animals, or plants.

Men belonging to the kachina society impersonate the spirits by wearing masks and costumes during dance ceremonies. The men give dolls (that look like miniature kachinas) to girls at the ceremony, so that they can learn the roles of over two hundred different spirits. Boys learn about the spirits during the initiation ceremony into the society and do not need dolls. The kachina doll in figure 17.24, crafted by Henry Shelton in the twentieth century, represents the wildcat

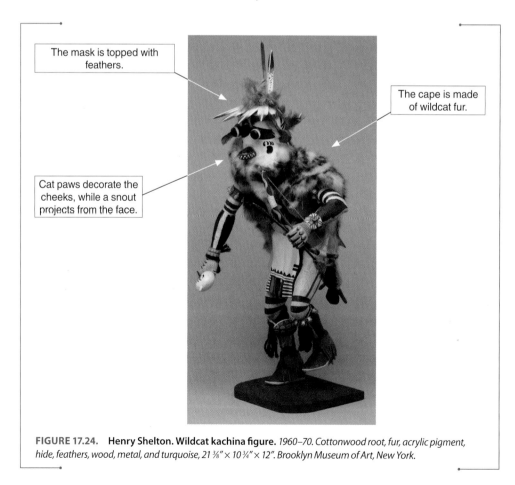

The mask is topped with feathers.

The cape is made of wildcat fur.

Cat paws decorate the cheeks, while a snout projects from the face.

**FIGURE 17.24.** **Henry Shelton. Wildcat kachina figure.** *1960–70. Cottonwood root, fur, acrylic pigment, hide, feathers, wood, metal, and turquoise, 21 ⅜″ × 10 ¾″ × 12″. Brooklyn Museum of Art, New York.*

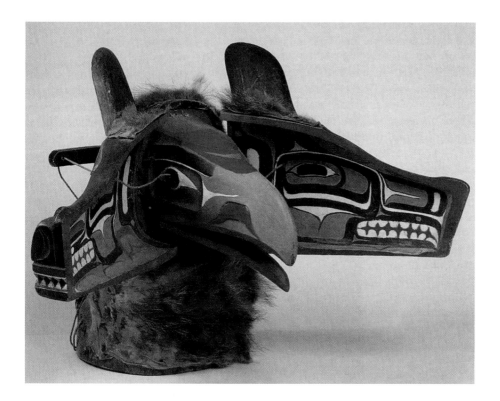

FIGURE 17.25. **Wolf transformation mask.** *From Canada. Kwakwaka'wakw. Late nineteenth century. Wood, twine, animal hide, and pigment. American Museum of Natural History, New York.* A dancer would open this mask by pulling a string to reveal the inner mask.

kachina. Its role is to bring rain to support the wildcat population, ensuring the people will have enough furs.

## The Northwest Coast

During the cold winter months, the people on the Northwest Coast held festivals, where the wealthy cemented their position in society. Elite families hosted the events, serving meals for the community and giving gifts to common people. This was also the time when elite young men performed in dances with *elaborate masks* as part of *initiation ceremonies into society*. The masks:

- Represented *spirits*
- Helped the performers reenact the legendary stories of the host *family's ancestors*
- Displayed the *family's symbols*

Figure 17.25 illustrates a transformation mask that was used during the ceremonies. Masks were often covered in *fur or feathers* to link the performers to particular spirits. Performers manipulated the masks, so that they *transformed during the dance*, switching back and forth between the outer and inner faces.

Unlike the benevolent kachina spirits, some of the spirits here were fierce. One was a human-eating spirit, who emerged wild and uncontrollable at the beginning of the dance with three bird helpers and appeared to hurt the people in the audience. The spirit would need to be calmed by women and elders. After a hiatus when the Canadian government banned the festival, because it alleged the ritual was dangerous to the community, the ceremonies (which were never actually harmful) were restarted in 1951.

*Quick Review 17.6*: What are some differences between two types of art produced by the people of North America—functional art and art that involved ancestral spirits and gods?

## A Look Back at Hawaiian Featherwork

**Featherwork** stands as a remarkable illustration of Hawaiian ingenuity and skill. Cloaks as lush as the finest velvet were made from thousands of feathers. However, the featherwork also has similarities with art from throughout the Pacific and Americas.

Ideas regarding featherwork are similar to principles in Australia and Melanesia through the people's belief in the *power of ancestral spirits to change their lives*. The men who created the featherwork in Hawaii chanted the names of important ancestors while they worked, so that the ancestors' power would get caught in the netting of the cloaks.

Not surprisingly, as Hawaii is located in Polynesia, featherwork finds parallels with objects from other *highly stratified Polynesian cultures in which leaders held extreme power*. Just like in Rapa Nui, where rulers compelled the people to carve and transport the **moai** (figure 17.8) that each weighed one hundred tons, Hawaiian leaders forced the masses to collect hundreds of thousands of feathers.

The featherwork finds likenesses with art from the cultures of Mesoamerica in that the people there too saw a *symbolic importance in feathers*. Hawaiians believed that the gods were feathered, and their leaders covered themselves in feathers to *show their relationship to the divine*.

The featherwork additionally has similarities with practices *linking art to status* in South America, such as among the Inca. In Hawaii, only chiefs could wear feathered cloaks.

Finally, the featherwork is similar to art from North America in that the people from both locations created *functional, protective, portable art*. In Hawaii, featherwork physically protected the wearer in battle, providing a useful art form.

As you move forward from the chapter, *consider how art that people wear can be extremely influential*. If a society has established certain clothing as authoritative, when people wear that type of attire, it affects our opinions of them, just as featherwork shaped the impressions of the Hawaiian population. However, establishing prestige through garments is not confined to featherwork, as we saw with the Inca ruler's tunic (figure 17.20) that was made from cloth. Throughout time and place items such as clothing, jewelry, crowns, and armor have *distinguished elites*. Similarly, today, what people wear can strongly influence the opinions of those around them. If someone in a suit walks into your class on the first day, you are likely to assume that person is the professor, even if he or she is not. Alternatively, you would probably relate differently to a person who walked into your class in a military uniform, in shorts, or in a football jersey. Each of these attires sends a certain message. Items that people wear hold power and influence.

Flashcards

## CRITICAL THINKING QUESTIONS

1. Would you describe Yilkari Kitani's *Wagilag Story* (figure 17.5) as representational, abstract, or nonrepresentational? Why? How does the notion that the painting has no "up" support your premise?
2. What are the differences in the responses to death among the people from New Guinea and the people from New Ireland? How are these responses reflected in their art?
3. How did the Maori meeting house (figure 17.9) proclaim the status of the clan that built the house? Knowing what you do about architecture from Chapter 12, do you think the building's form fit its function?
4. How do *moai* sculptures (figure 17.8) compare with Olmec colossal heads (figure 17.12)? Consider the subject matters, characteristic looks, and believed purposes.
5. The mural from Bonampak (figure 17.15) most likely documents a Maya event that was important in the life of the ruling family.

How do you record important events in your life and how are your mementos similar to and different from the Bonampak mural?
6. The *Codex Mendoza* (figure 17.16) was commissioned specifically for the Spanish king to acquaint him with his newly conquered colony. Given your understanding of what graphic design is from Chapter 9, how could you argue that the *Codex Mendoza* is a work of graphic design?
7. How are the Nazca's hummingbird (figure 17.19) and the Great Serpent Mound (figure 17.21) similar?
8. What were the different roles held by men and women in the different North American cultures discussed in the chapter in terms of both making and using art?

Comprehension Quiz    Application Quiz

# Wildlife, the Land, and the Environment

The universal theme of wildlife, the land, and the environment is evident in artworks from this chapter and in art created by people from different backgrounds and periods from across this book. This theme concerns:

» *Wildlife and plants*
» *The land*
» *The environment and the power of nature*

## Wildlife and Plants

The featherwork on capes (figure 17.1) and other objects from the chapter we just completed shows how Hawaiians used components of animals (in this instance, feathers) for important symbolic purposes. Commoners collected thousands of feathers to help rulers communicate their authority. Then, specially trained men created the featherwork in a complex process.

Across time and place, people have likewise used and depicted wildlife and plants in art. A comparison to featherwork can be found in Jane Hammond's *Fallen* (figure C17.1), a contemporary work from Chapter 4. Memorializing U.S. soldiers killed in Iraq, Hammond gathered thousands of real leaves that had fallen during the fall foliage season to create her work. Like the Hawaiians, Hammond found meaning in parts of natural objects. Unlike the Hawaiians, though, once Hammond collected the natural leaves, she fabricated and used lookalike leaves instead, so they would last. Hammond brought components together in a complex process—scanning, printing, and cutting out fabricated leaves, so each leaf mirrored a real one. On each, she printed the name of a soldier who had died in Iraq.

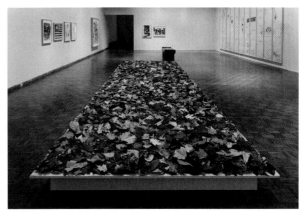

**FIGURE C17.1.   Jane Hammond. *Fallen* reconsidered.**  While birds were killed to make the Hawaiian featherwork, not a single tree was destroyed for *Fallen*. Hammond's work reflects the sensitivity many of today's artists feel about not harming the environment. Some artists even produce art that actively promotes protecting our vulnerable natural world.

## The Land

The chapter we just finished describes the bark painting of Yilkari Kitani, an aboriginal Australian whose *Wagilag Story* (figure 17.5) portrays ancestral spirits as they create the earth. The work shows Aborigines' strong connection to the land. In addition, the image illustrates how the paintings can be comprehended from any orientation.

An interest in the land can similarly be seen in American artist Helen Frankenthaler's *The Bay* (figure C17.2), a twentieth-century work from Chapter 6. Frankenthaler created the painting by pouring diluted paint onto canvas placed on the floor. Her image takes the form of a bird's-eye view of a large body of water. Like Kitani, Frankenthaler created an abstract image of the land that can be read from any direction.

**FIGURE C17.2.   Helen Frankenthaler. *The Bay* reconsidered.** Frankenthaler's image of diluted paint seems to reference the quiet aspects of nature. While she depicts the land, other artists, such as those who create earthworks, have used the earth itself in their art.

## The Environment and the Power of Nature

As discussed in Chapter 17, the Aztecs lived in fear of the power of nature, specifically of a great earthquake that could destroy their world. They performed human sacrifices atop pyramids in the hopes of preventing this devastating event as well as other environmental catastrophes, such as drought. The Aztecs' respectful relationship with the environment loomed large in their lives and can be seen in the page from the *Codex Mendoza* (figure 17.16), which shows the Aztec capital city with features displaying this connection to the forces of nature.

This natural power and people's relationship with the environment can similarly be seen in a nineteenth-century Japanese print from Chapter 7, *The Great Wave* (figure C17.3) by Katsushika Hokusai. Here, three fishing boats are at the mercy of an enormous wave that could drown the tiny men at any moment. So intense is the wave that it reaches out claw-like fingers to menace the minuscule people. In the distance, Mount Fuji, an active volcano, offers another possible danger. The men in the boats sit quietly, clearly respecting the awesome forces that loom over them.

**FIGURE C17.3.** Katsushika Hokusai. *The Great Wave* reconsidered. *The Great Wave* shows the possible destructive forces of nature, reminding us of tsunamis or hurricanes that threaten our world. Some other artists and architects, whose work falls into this theme, attempt to help after those devastating events.

## Make Connections

*March of the Penguins* (figure C17.4), from Chapter 8, is a contemporary documentary film about the lives of emperor penguins. To create the film, Luc Jacquet traveled to Antarctica and filmed the penguins' chance actions in the uncontrollable, harsh environment of the frozen land. How is this film related to the theme of wildlife, the land, and the environment?

What other visual examples can you come up with from across the book and from today's world that reflect this theme? How are people's motivations across time and place similar and different?

**FIGURE C17.4.** Luc Jacquet. *March of the Penguins* reconsidered.

# The Art of Asia

## LEARNING OBJECTIVES

**18.1** Summarize the ideas that shaped early India during the Vedic period and influenced later beliefs and art.

**18.2** Contrast how early representations of the Buddha in Indian art differed from later representations.

**18.3** Identify why the temple is important to Hinduism and how the layout and tower structure work with the function of the building.

**18.4** Detail how Mughal painting is both naturalistic and decorative.

**18.5** Describe how a belief in the afterlife had a large impact on early art in China and Korea.

**18.6** Explain how the philosophies of Confucianism, Daoism, and Buddhism affected art in China in different ways.

**18.7** Specify how foreign rulers in China used the power of art to promote their sovereignty.

**18.8** Explain what the native Japanese aesthetic is and how Shintoism helped create it.

**18.9** Describe how the features and design of a dry garden are a reflection of Zen Buddhist thought.

**18.10** Summarize the societal changes that took place during the Edo period in Japan and how these changes affected art production.

## THE JAPANESE TEA CEREMONY

In the year 1191 CE, a Japanese monk who had been studying at a Buddhist temple in China—where the monks had been using tea to help stay awake while meditating—brought a number of tea plants back to Japan, introducing tea to a broad audience in the country. By the fourteenth century, tea drinking had become popular among Japan's upper class; the practice was associated with social gatherings and luxury. Aristocratic tea drinkers also collected antique Chinese objects, made from smooth, hard pottery, to use as utensils at their tea parties.

How Art Matters

### A New, Restrained Way of Drinking Tea

In the fifteenth century, however, two factors changed the way that the Japanese drank tea. First, a brutal civil war caused many wealthy families to lose their tea accoutrements. Second, Murata Jukō, a Zen Buddhist priest, changed tea drinking from an extravagant affair into a quiet ritual. Following the *Zen Buddhist philosophy*, which *promotes simplicity*, an *appreciation of the natural world*, and a *clearing of the mind* to leave it open to greater understanding, Jukō moved the ceremony to an *austere* room and sought out *coarse* accessories to create and hold the tea.

### Tea Master Rikyū and his Taian Teahouse

Jukō's most famous follower, Sen no Rikyū, moved the tea ceremony even further from its lavish past. His simple taste is evident in the Taian (tie-on) Teahouse, which scholars believe he designed (figure 18.1). When Rikyū invited guests for tea, they strolled through a garden and *purified themselves through washing of hands and mouth* before walking to his *modest teahouse* on randomly placed stepping stones, which compelled guests to slow their paces.

**FIGURE 18.1.** **Sen no Rikyū. Taian Teahouse, replica.** *From the Myōkian Temple, Kyoto, Japan. Momoyama period, 1582 CE. Mori Art Museum, Tokyo, Japan.* A small raised door, too short for a man's stature, required participants to stoop and crawl inside the teahouse, making all equally humble. Inside, an unassuming room greeted participants.

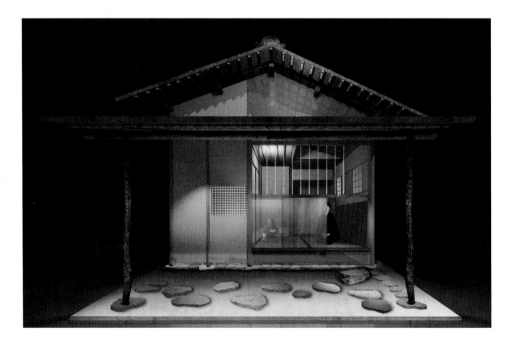

Inside, save for an alcove, where there might be a piece of calligraphy (fine handwriting), a painting, or a simple flower arrangement, there were no decorations. Rikyū designed the room to be *asymmetrical and geometric*, with strong horizontal and vertical lines. He used *natural materials* such as wood and bamboo to form the walls and ceiling, creating soothing textures and earthy tones.

## The Tea Ceremony

Guests admired the artwork in the alcove, then sat on floor mats. Rikyū prepared and served tea using different *rustic accoutrements*. As Rikyū started the ceremony, he choreographed every step. Each guest, similarly, performed *strictly controlled, set movements* and was expected to be an expert on tea ritual etiquette, gardens, architecture, flower arrangements, paintings, calligraphy, and ceramics. The entire *multisensory experience*—involving sight, smell, touch, sound, and taste—might last four hours.

## Raku Ware

Legend has it that Rikyū developed the rustic tea bowls (used in the ceremony for drinking tea) in collaboration with a Korean tile maker, who was living in Japan, named Sasaki Chōjirō (sa-sa-KEE CHOH-jee-ROH). In an incredible partnership between patron and artist, it is said that Rikyū worked with Chōjirō to develop *raku* (rah-KOO) *ware*, an unassuming, handmade pottery that was *coarse* and fired at a low temperature (see Chapter 11). Figure 18.2 shows a raku ware tea bowl designed to fit harmoniously with Rikyū's spiritual ceremony.

Recent scholarship has suggested, though, that raku ware may owe its roots to several Japanese potters working across the country during this period and also reaching back to low-temperature ceramics made in Japan for centuries. Regardless of how it was invented, raku ware was made by contemporary, local potters from soft clay. The forms were *imperfect*, and each bowl had its *own character* in terms of color, texture, and form based on how it was made, glazed, and fired. Chance accidents—in handling, in the kiln, and in cooling—added to the *individuality* and *uniqueness* of each bowl, and people often *gave the bowls names*.

The black raku ware bowl by Chōjirō in figure 18.2 was called *Jirobo*, a boy's name. Rikyū, it is said, preferred somber, black-glazed bowls, as they suited his understated cere-mony. He also favored this squat, cylindrical form, which fit comfortably in his guests' hands. *Imperfections* in the glazing, finger indentations left in the process of forming, and an uneven rim add to the *humbleness of the bowl*. It would have felt heavy and earthy in a guest's hands, *fostering contemplation and calmness*, and would have emphasized the aesthetic of *wabi* (austerity), as the bowl looks poor and plain, and *sabi* (age), as it appears worn and weathered.

## Other Pottery Types and Tea Accoutrements

By the end of the fifteenth century, the tea service had spread to the broader populace, and a number of pottery types sprang up for use in the ceremony. One of these types, made from a different kind of clay, is shown in figure 18.3. Here, the background of a water jar is covered by a milky white glaze, while minimal markings create a design. Similar to *Jirobo*, this jar includes "*faults*," including an asym-metrical top, uneven glaze, and impressions made during forming.

Tea accoutrements in materials other than pottery were also made. Rikyū's grandson, tea master Sen no Sōtan, used the vase in figure 18.4 to hold flowers. Sōtan placed a single

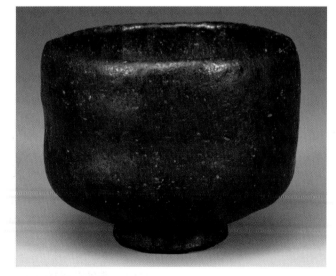

**FIGURE 18.2.** **Sasaki Chōjirō. Tea bowl named *Jirobo*.** *Momoyama period, sixteenth century CE. Raku ware, height 3 ⅓". Fukuoka Art Museum, Japan.* Rikyū, scholars believe, preferred bowls such as this one that tapered down to a foot, so the bowl would stand.

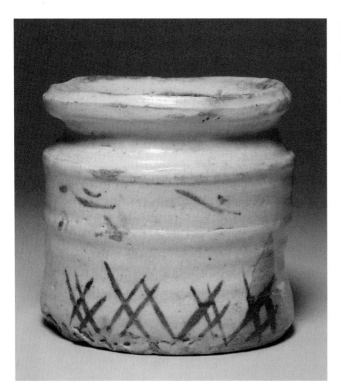

**FIGURE 18.3.** **Water jar with grasses design.** *From Japan. Momoyama period, 1500s* CE. *Glazed stoneware with underglaze iron slip decoration, height 7 ³⁄₁₆", diameter 7 ¹¹⁄₁₆". The Cleveland Museum of Art, Ohio.* The markings give the impression of reeds growing up along the bottom of the jar and simple boats floating above.

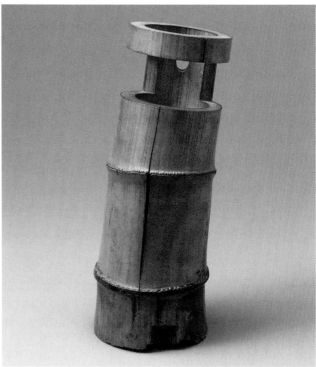

**FIGURE 18.4.** **Sen no Sōtan. Flower container named** *Ordinary Transformation.* *Momoyama or Edo period, early seventeenth century* CE. *Bamboo, height 12 ⅛", diameter 4 ¾". Fukuoka Art Museum, Japan.* Sōtan called this vase *Ordinary Transformation*, as if the rustic qualities of the bamboo transformed easily into those of the tea ceremony.

bloom within the vase and hung it on the alcove wall of his teahouse. The gentle arch formed by the cut bamboo would have mimicked the bow of the flower's stalk. The *warm coloring and natural texture* additionally would have *enhanced the peaceful setting.*

### The Tea Ceremony and Japanese Society

While the tea ceremony might have appeared to be a peaceful haven, it was also often used as a *status symbol* in Japanese society, with only certain people being permitted to hold the ceremonies. In addition, the *peacefulness of the ceremony did not extend to the warrior-based society* outside the teahouse. Rikyū himself was forced to take his own life by a warlord because of a dispute. Scholars disagree over the cause, but Rikyū was given the privilege of killing himself, rather than suffering the humiliation of being killed by someone else. Even the supreme master could not be saved by the serenity he had created. Today, tea masters still practice Rikyū's tea ceremony in Japan and elsewhere, enjoying the beauty and peace of the centuries-old ceremony.

### The Contradictory Nature of Asian Art

The tea ceremony offers an introduction to the many forms of art that surround a *ritual, which takes people away from the everyday world and allows them to find greater understanding.* However, the ceremony is also an entrée into the art of all of Asia. The ritual reflects two contradictory aspects of Asia. On the one hand, Asia is filled with numerous diverse peoples who live in widespread geographical areas. These people have often *looked to their own traditions, emphasizing differences among distinct groups.* Simultaneously, the *people of Asia have continually welcomed influences from other cultures and nations* that they have accepted and made their own, just as the Japanese tea ceremony was built around the beliefs of Buddhism, which was originally an Indian religion.

This chapter considers the art of Asia, focusing on a sampling from early through early modern periods from the Indian subcontinent and Southeast Asia, China and Korea, and Japan. Art created by contemporary Asian artists is covered in Chapter 21 and throughout the text, while the Taj Mahal is considered in Chapter 4. Before moving forward, based on this story, what do you think some of the main characteristics of Japanese art are?

# The Indian Subcontinent and Southeast Asia

The Indian subcontinent includes the present-day countries of India, Afghanistan, Pakistan, Nepal, Bhutan, Bangladesh, and Sri Lanka, while Southeast Asia includes present-day Cambodia, Laos, Myanmar, Thailand, Vietnam, Singapore, Malaysia, Indonesia, and the Philippines. Both the Indian subcontinent and Southeast Asia are noted on the map in figure 18.5, which also includes the locations of all places in Asia covered in this chapter and throughout the text.

**FIGURE 18.5.** **Asia.** Asia has been home to numerous peoples, who have lived across a vast and diverse landscape for thousands of years.

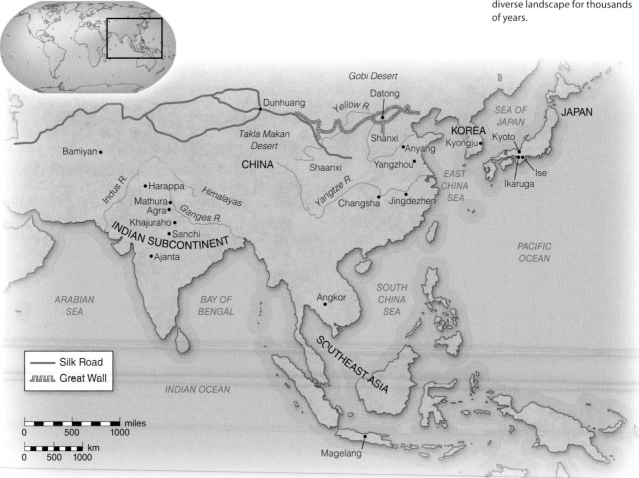

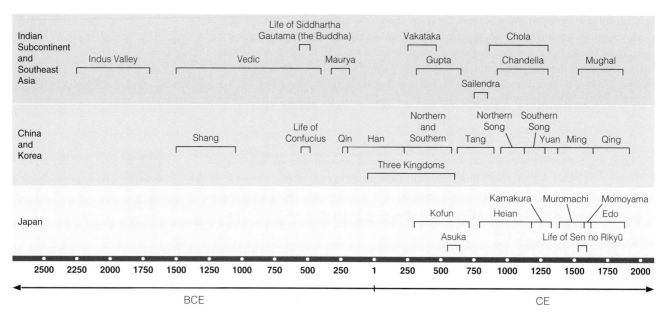

| Indian Subcontinent and Southeast Asia | | Indus Valley | | Vedic | Life of Siddhartha Gautama (the Buddha) | Maurya | | Vakataka | Gupta | Chola | Chandella | | Mughal |
|---|---|---|---|---|---|---|---|---|---|---|---|---|---|
| | | | | | | | | | | Sailendra | | | |

| China and Korea | | | Shang | | Life of Confucius | Qin | Han | Northern and Southern | Tang | Northern Song | Southern Song | Yuan | Ming | Qing |
|---|---|---|---|---|---|---|---|---|---|---|---|---|---|---|
| | | | | | | | | Three Kingdoms | | | | | | |

| Japan | | | | | | | | Kofun | Heian | Kamakura | Muromachi | Momoyama / Edo |
|---|---|---|---|---|---|---|---|---|---|---|---|---|
| | | | | | | | Asuka | | | | Life of Sen no Rikyū | |

| 2500 | 2250 | 2000 | 1750 | 1500 | 1250 | 1000 | 750 | 500 | 250 | 1 | 250 | 500 | 750 | 1000 | 1250 | 1500 | 1750 | 2000 |
|---|---|---|---|---|---|---|---|---|---|---|---|---|---|---|---|---|---|---|

BCE                                                              CE

Interactive Timeline

**FIGURE 18.6.** **Timeline of Asia.** All periods and dynasties in all regions discussed in this chapter appear on the timeline.

**FIGURE 18.7.** **Male torso.** *From Harappa, Pakistan. Indus Valley Civilization. c. 2300–1750 BCE. Red sandstone, height 3 ½". National Museum, New Delhi, India.* The roots of sensual figures reach back to the Indus Valley Civilization and are evident in this figure.

While the art throughout the Indian subcontinent and Southeast Asia during the early to early modern periods was diverse, several tendencies form a pattern:

- Art was often *figurative*, and *bodies tended to be voluptuous and sensual*, representing fertility and vitality.
- A *love for color and texture* often resulted in *highly ornamented surfaces*.
- People saw a *world filled with the divine*, where *gods existed alongside humans*.

## The Early Indian Subcontinent

Along the Indus River Basin located in present-day Pakistan and India, a civilization arose around 2250 BCE. Covering approximately twelve hundred miles, the Indus Valley Civilization boasted sophisticated cities with complex irrigation systems, large public buildings, and paved streets laid out in grids. Its people used pottery, bricks, and writing. Figure 18.6 displays a timeline showing how the Indus Valley Civilization as well as other periods and dynasties discussed in this chapter fit into the historical record.

A male torso (figure 18.7), not quite four inches high, illustrates the interest in *figurative art*, even in this early period. The nude figure consists of *fleshy curves, rounded swellings, and seemingly soft surfaces* rather than firm muscles, strong bones, and taut skin. The figure extends its stomach in a relaxed position akin to how a person who is practicing yoga stands while holding his breath, implying an internal energy.

In approximately 1500 BCE, people from Central Asia known as Aryans began migrating to the Indus Valley in waves. The Aryans had strong beliefs that they enforced as

part of a new order. As *their ideas came from sacred texts called Vedas*, we know of this era as the Vedic period. The beliefs featured several key ideas that would influence later beliefs and art:

- *Our worldly souls are part of an everlasting universal soul* that we have forgotten.
- *We are trapped in a world that is not real* in an endless cycle of birth, death, and rebirth.
- *We can be reincarnated into a higher or lower state* in our next life.
- *Our future status depends on actions in our current life*, specifically the performance of complicated religious rites involving sacrifices to gods.
- *People who reach the highest level of society can escape the endless cycle by achieving nirvana*, a spiritual rebirth or great awakening, thereby uniting their worldly souls with the greater cosmic one.

In keeping with this philosophy, the Aryans established a *caste system, a hierarchical social structure determined by heredity*. Aryans were at the top of the social order, while slaves (who had been conquered) were at the bottom. There was no way to move between castes, except, it was believed, through death and reincarnation into a higher or lower level of society. The highest caste, the priests, controlled the Aryans' religion, as only they had command of the complex rituals.

*Quick Review 18.1*: What ideas shaped early India during the Vedic period and influenced later beliefs and art?

## Buddhism on the Indian Subcontinent and in Southeast Asia

The elitist system of the Vedic period was unpopular with those in lower castes, and some suggested that the hierarchical society should be dismantled and all people given access to religion. One of these individuals, Siddhartha Gautama (see-DHAR-tah GAU-tuh-mah), lived from 563 to 483 BCE in present-day northern India and Nepal.

### The Buddha's World View and Tenets of the Buddhist Faith

When he was twenty-nine, Siddhartha, seeking the cause of human suffering, gave up a privileged life as a prince. He spent six years in the wilderness, practicing a life of self-denial. Eventually, he turned to meditating under a tree. There, Siddhartha came to an understanding that he called the Four Noble Truths, which summarized his view of the world:

- There is *great suffering* in this world.
- Suffering is *caused by desire*.
- To eliminate suffering, one must *eliminate desire*.
- The only way to end desire is to *follow an eightfold path of detachment, meditation, and morally appropriate actions*.

Siddhartha, now known as *the Buddha or enlightened one*, established certain tenets based on these truths. In doing so, he maintained certain traditions from Vedic philosophy and introduced new ideas:

- People are caught in a *cycle of birth, death, and rebirth* and *it may take many lives to achieve nirvana*.

- *By following the Buddha's eightfold path, anyone, regardless of caste, could be reborn into a better life* and even escape the cycle through his or her own actions (without the help of priests).
- *The Buddha was just one of many enlightened Buddhas,* who had achieved an understanding of the universe through numerous past lifetimes.

The Buddha's ideas appealed to the masses, especially to women and people of lower castes, who were shut out of the Vedic system. His philosophy eventually spread across Asia to China, Japan, and Korea.

### Stupas

**stupa** A dome-shaped Buddhist burial mound that is raised above sacred relics

Upon the Buddha's bodily demise, his followers placed his cremated remains in eight places connected to important moments in his life and raised **stupas** (STOO-pah), domed burial mounds, above his ashes. During the Maurya dynasty, Ashoka—the first Buddhist emperor, who ruled during the third century BCE—sought to establish Buddhism as the major religion of India. He therefore had the Buddha's remains further subdivided into 84,000 different *stupas*.

Figure 18.8 shows one of Ashoka's *stupas*, known as the Great Stupa. While Ashoka built the original domed structure, approximately one thousand loyal Buddhists, two hundred of whom were women, funded enhancements in later construction phases. The donors' generosity *shows how meaningful the stupa was to the faithful.*

Several features of the *stupa* represent aspects of the faith:

- The *hemispherical structure* mimics the form of a mountain and, because of the sacred relics (objects) within, *symbolizes nirvana.*
- Atop the structure sit *three umbrellas, symbolizing the Buddha, the Buddhist monks and nuns, and the Buddha's law.* A stone railing sets the umbrellas off in a separate realm.
- Piercing the *stupa* and running from the top to the bottom is a shaft (not visible in the photo) called the *axis mundi* (MOON-dee), which *symbolizes the axis on which the world turns.*

**FIGURE 18.8. Great Stupa of Sanchi.** *Begun during the Maurya dynasty, third century to first century BCE, Madhya Pradesh, India.* The Great Stupa encompasses a hemispherical structure topped by umbrellas and surrounded by four gates that feature carvings.

Umbrellas and stone railing

Gate

The Buddha's princely home sprawls across the surface.

A horse travels away from the buildings. An *umbrella*, symbolizing the Buddha, sits on its back.

A *tree* (the one under which the Buddha achieved enlightenment) signals the Buddha's being.

The Buddha's *footprints* represent his presence.

The horse returns home without an *umbrella*, having left the Buddha in the wilderness.

FIGURE 18.9. *The Great Departure*, detail. *From the east gate of the Great Stupa of Sanchi, Madhya Pradesh, India. Begun during the Maurya dynasty, third century to first century BCE.*

- *Four gates* allow entry to the complex, each of which faces a cardinal direction. The placement likely *symbolizes that the Buddha's preaching reaches out in all directions.*
- Visiting pilgrims ritually *circle the stupa in a clockwise direction.* Their movement *represents the path toward enlightenment.*

Each of the four enormous gateways is covered in sculpture, following the *Indian interest in decoration.* The gateways depict stories of the Buddha's life (and previous lives) along with nature spirits. Figure 18.9 illustrates the story of the Buddha's departure to live a life of poverty. Throughout the depiction, the Buddha is represented with different symbols and is *never shown in human form*, indicating that he is of a higher state. In addition, to show the passage of time, *different motifs are repeated across the image.*

Figure 18.10 shows a nature spirit called a *yakshi* from the same gate. The *Indian interest in fertility is evident* in her voluptuous form. Images of *yakshis* originated in pre-Aryan society and were placed on the door posts of homes, as people believed they would protect the inhabitants. At the Great Stupa, the Buddhists probably used *yakshis* hoping to appeal to those who looked to the old ways.

### Representations of the Buddha

In the second century CE, the image of the Buddha changed in people's minds, and art played an essential role in satisfying transforming sensibilities:

- *The Buddha was viewed as a god* and was no longer seen as a human who had become enlightened.
- *Images of the Buddha that could be worshipped were sought* rather than symbols of the Buddha's presence.
- *Representations of the Buddha incorporated certain attributes,* making him always recognizable. A Buddha carved by the monk Yasadinna from the Gupta period displays these features (figure 18.11).

FIGURE 18.10. *Yakshi*, detail. *From the east gate of the Great Stupa of Sanchi, Madhya Pradesh, India. Begun during the Maurya dynasty, third century to first century BCE. The yakshi grasps a tree that blooms with her touch, while curving in a seductive pose. Her sheer garment exposes her body.*

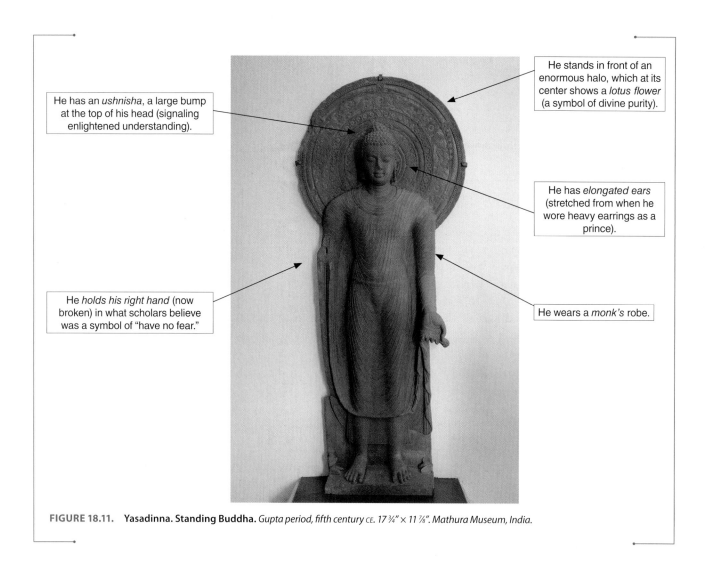

He has an *ushnisha*, a large bump at the top of his head (signaling enlightened understanding).

He stands in front of an enormous halo, which at its center shows a *lotus flower* (a symbol of divine purity).

He has *elongated ears* (stretched from when he wore heavy earrings as a prince).

He *holds his right hand* (now broken) in what scholars believe was a symbol of "have no fear."

He wears a *monk's* robe.

**FIGURE 18.11.** **Yasadinna. Standing Buddha.** *Gupta period, fifth century* CE. *17 ¾" × 11 ⅞". Mathura Museum, India.*

*The Indian love for sensuality and decoration is evident throughout the sculpture.* The sheer fabric of the Buddha's robe reveals every swelling in his figure. Folds in his garment are perfectly placed, curved, string-like lines. Their repetition creates a steady, calm rhythm. The string-like arcs are mimicked in the curves on the Buddha's halo and in arches that make up his facial features—the line at his forehead created by his evenly pleated hair, eyebrows, and eyelids. These curves, along with the decoration on the halo, create an *overall sense of ornament.*

## Bodhisattvas

The Buddha had preached of other souls who had attained understanding, and so new images appeared of figures called bodhisattvas (boh-dih-SAHT-vah). These are individuals believed to have achieved enlightenment, but who forestall their entry into nirvana to help awaken others. Like images of the Buddha, *bodhisattvas have a calm and unpretentious expression.* However, unlike the Buddha, bodhisattvas *have long hair and wear princely clothing, pearls, and a crown*; in addition, *they do not display attributes.*

Scholars have found images of bodhisattvas from the Vakataka dynasty during the fifth century CE painted at Ajanta. There, twenty-nine caves were carved directly into the cliff. During his lifetime, the Buddha had set up a community of monks, who often lived in caves. While the monks gave up luxurious, worldly possessions, the caves were covered with

murals. The bodhisattva depicted in figure 18.12 is one of two painted on either side of an entrance to one of the caves.

Even though the bodhisattva appears in a cave, the Indian *interest in decoration and luxury* is apparent. He bends his body in a *sensual arc*. A curving line flows around his body and forms the graceful arches of his eyebrows. Even his downcast eyes form gentle, bowed lids.

## Buddhism in Southeast Asia

In the eighth century CE, Buddhism spread to Southeast Asia. An example of its impact can be seen at Borobudur in Indonesia (figure 18.13), built during the Sailendra dynasty. There, an enormous *stupa*, set on a high platform, dominates the landscape. Five square levels of terraces at the bottom and three round levels above *enable visitors to circle the stupa eight times*, climbing higher with each rotation. All of the terraces are enclosed by walls that are decorated in ten miles of carved relief sculpture.

Many aspects of the *stupa* are symbolic:

- The structure is oriented in line with north, south, east, and west, likely *symbolizing Buddhism's reach.*
- The *stupa* represents the universe; on the lowest tier, pilgrims are earthly bound, and, as they move upward, they *symbolically ascend toward nirvana.*
- At the bottom of the *stupa*, walls interrupt the view, so visitors are never sure where they are in the climb, probably *symbolic of how in our unreal world on Earth, we are often unsure of the way.*
- At the top, the walls open up, leaving expansive views of the surroundings, likely *symbolic of how, as we reach closer to nirvana, our eyes awaken to reality.*
- At the very top, another smaller, yet still gigantic, *stupa* may *symbolize the reaching of spiritual bliss.*

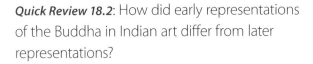

*Quick Review 18.2*: How did early representations of the Buddha in Indian art differ from later representations?

## Hinduism in India

While Buddhism held an important place in India's development, and its influence spread across Asia, today, most people from India are not Buddhists. They are Hindus. Like Buddhists, Hindus believe that we are trapped in a cycle of birth, death, and rebirth and that people are reborn into better or worse lives based on their actions in their current lives. Also like Buddhists, Hindus believe that it is possible to escape the cycle and achieve nirvana without the help of a priest. However, unlike Buddhists, *Hindus believe that nirvana is achieved by worshipping a number of gods*—the main

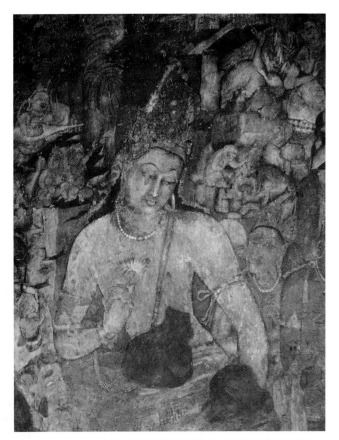

**FIGURE 18.12.** **Bodhisattva, detail of wall painting.** *From Cave 1, from Ajanta, Maharashtra, India. Vakataka dynasty, c. 475 CE.* The bodhisattva holds a blue lotus flower in his hand, offering us the symbol of divine purity.

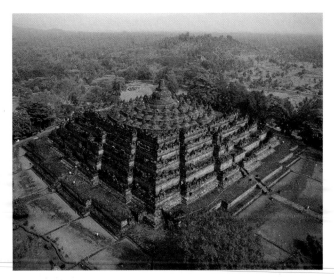

**FIGURE 18.13.** **Borobudur.** *Sailendra dynasty, late eighth century CE, Magelang, Java, Indonesia.* Each side of this huge stupa is 408 feet long—over 100 feet longer than a football field.

ones include Vishnu (the sustainer), Shiva (the destroyer; see figure 1.30), and Brahma (the creator).

## Hindu Gods

Hindus believe their gods are powerful deities that visit our world in human and other forms and interact with people on earth. Depictions of these gods *allow the faithful to connect with the deities, understand their powers, and receive their blessings.*

Figure 18.14 illustrates a sculpture of the god Vishnu in the form of a man with the head of a boar created in the fourth or fifth century CE. Hindus believe that Vishnu took this incarnation to rescue the Earth Goddess, who had been kidnapped by a monster. The goddess hangs from Vishnu's tusk, as he has just rescued her after killing the fiend. *Her body is curved and rounded.* Vishnu stands triumphant. He lifts one leg on a step and confidently places his enormous hands on his plump knee and columnar thigh. He appears as the *ideal Indian strongman.* (*See Practice Art Matters 18.1: Identify the Aspects of Indian Art in a Work.*)

## Hindu Temples

Hindus do not worship communally; instead, worship involves individuals and small groups visiting a temple to see representations of a god. The Kandarīya Mahādeva (kahn-DAHR-yuh mah-hah-DAY-vuh) Temple, from the Chandella dynasty, *honors the god Shiva,* and over two hundred images of Shiva originally appeared throughout the interior. The temple is set up in different chambers, and *visitors move from the everyday world into the sacred* in a line from east to west (figure 18.15A and B).

Above each chamber is a tower. The *towers soar into the sky as if to reach toward nirvana,* appearing from the exterior like bulbous forms growing up from the ground. The towers resemble the Himalayan Mountains, where the Hindu gods are believed to reside; they were originally covered in a mixture of glue, pigment, and powdered chalk, so they looked creamy white, like snowcapped peaks. The towers *increase in height* as they near the *garba griha* (gar-bah GREE-hah), the location of the most holy sculpture of Shiva and over which the tallest tower, at 102 feet, shoots up.

The temple is *decorated with over six hundred sculptures of gods and people.* A number of the people are erotically posed (some even in the midst of sexual acts), addressing the *interest in fertility and vitality.* It is likely the sculptures reference the Hindu belief that sexual love between two people is an appropriate symbol for how much a person should strive to be spiritually united with the divine.

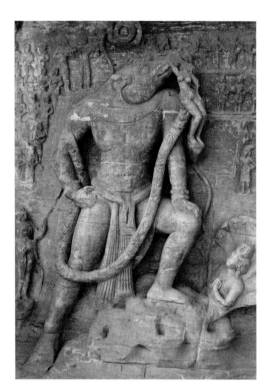

**FIGURE 18.14.** **Boar incarnation of Vishnu.** *From the Udayagiri Caves, Madhya Pradesh, India. Gupta period, fourth or fifth century CE. Sandstone.* Vishnu's bulging muscles and expansive chest make him appear filled with vitality.

*Practice* **art**MATTERS

## 18.1 Identify the Aspects of Indian Art in a Work

Which of the three aspects of Indian art are evident in the boar incarnation of Vishnu (figure 18.14)?

- Voluptuous and sensual figurative art
- Bold colors, rich textures, and overwhelmingly ornamented surfaces
- Subject matter that focuses on gods

Explain your choice(s).

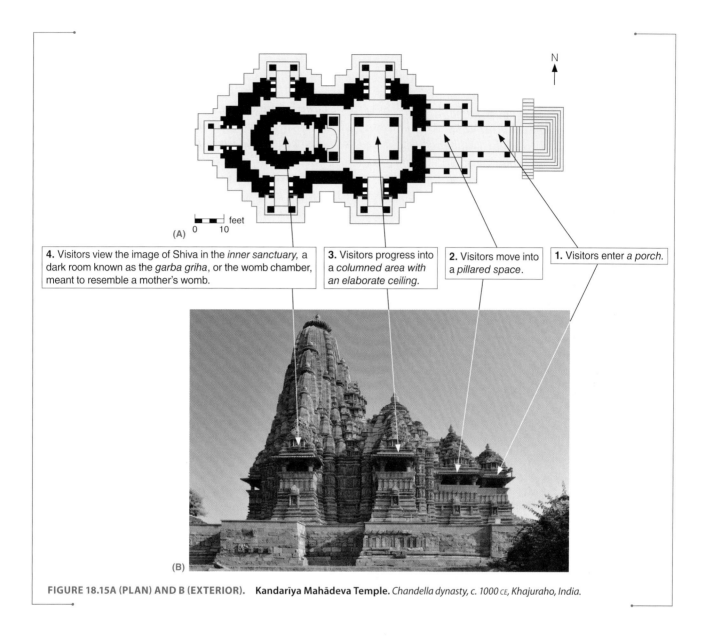

**4.** Visitors view the image of Shiva in the *inner sanctuary,* a dark room known as the *garba griha,* or the womb chamber, meant to resemble a mother's womb.

**3.** Visitors progress into a *columned area with an elaborate ceiling.*

**2.** Visitors move into a *pillared space.*

**1.** Visitors enter *a porch.*

0 10 feet

(A)

(B)

**FIGURE 18.15A (PLAN) AND B (EXTERIOR).** **Kandarīya Mahādeva Temple.** *Chandella dynasty, c. 1000 CE, Khajuraho, India.*

*Quick Review 18.3*: Why is the temple important to Hinduism and how does the layout and tower structure work with the function of the building?

## Islam in India

In the sixteenth century CE, Muslim rulers known as the Mughals (MOO-gahl) conquered India. One leader, Shah Jahan, built the Taj Mahal (see Chapter 4), a tomb for his beloved wife.

The Mughals were known for their miniature, secular paintings, often used as book illustrations or portraits and painted in small sizes on paper. The Mughals, *unlike* many other Muslims (see Chapter 16), believed that *painters should depict people realistically* to gain an admiration for the powers of God.

Sahifa Banu, a princess in the court of Shah Jahan's father, completed one such portrait of a Persian emperor (figure 18.16). The portrait follows this *realistic inclination* in the individualized rendition of the emperor's face, the soft texture of his beard, and the shading around his arms. The emperor appears humble and calm, despite his being an adversary.

**FIGURE 18.16.** **Sahifa Banu.** *Shah Tahmasp,* **detail.** *Mughal period, early seventeenth century* CE. *Opaque watercolor and gold on paper, 15 ¼" × 10". Victoria and Albert Museum, London.* With Banu's realistic approach, we get a true sense of the age and temperament of the Persian emperor.

Even though she followed this naturalistic style, Banu was still a princess of India. She preserved the *love for decoration and pattern* that has been evident throughout our look at Indian art. In an effort to display the entire design, Banu tipped the carpet up, so that it appears to be hanging vertically. The carpet floats behind the emperor, flattening the image and giving it an *ornate feel,* while the sparkling colors; gentle, bowing lines of the tree; and gold background add to the *sense of adornment.*

*Quick Review 18.4*: How is Mughal painting both naturalistic and decorative?

# China and Korea

The area that makes up China and Korea can be seen on the map in figure 18.5. While the vast area is diverse, several ideas were common among the people, including:

- *An interest in history.* Ancestors are honored and new works are often based on an earlier heritage.
- *An affinity with nature.* Individuals are believed to be an insignificant part of the natural world and must find harmony with forces that are more important than they are.
- *A broad view of art.* Highly valued works include various art forms such as calligraphy, metal craft, silk, ceramics, and jade.

## Early China and Korea

We will consider several examples of art from early China and Korea. These include *grave goods* and a *tomb.*

### Grave Goods from Royal Tombs

We can see the interest in *honoring the dead* and the *broader view of art* in Shang dynasty bronze vessels from early China. (The Shang and other Chinese and Korean dynasties are included in the timeline in figure 18.6.) Stemming from approximately 1600 BCE, people living along the Yellow River Valley in China had sophisticated walled cities. They created enormous royal tombs filled with bronze vessels, weapons, jewelry, clothing, pottery, cowrie shells (used as money), and sacrificial victims.

According to scholars, the people believed that *royal dead ancestors could intercede with the gods* to safeguard the living and bring good fortune to the community. They furnished royal tombs with *luxurious worldly possessions* (likely to sustain the ancestors) and conducted *ritualized sacrifices* (probably to enlist the ancestors' help).

The Shang used various vessels to hold offerings for different sacrifices. Like the accoutrements for the tea ceremony, *each vessel was distinguished by form* (such as pitchers or bowls), *decoration,* and *size* (ranging from several inches to four feet tall). The vessels, scholars suggest, were used for cooking and partaking of food and drink at elaborate ritualized feasts, where ancestors were believed to "eat or drink" first before the living partook. Vessels were *adorned with decorations of animals and humans,* as well as with *mythical creatures and monsters.*

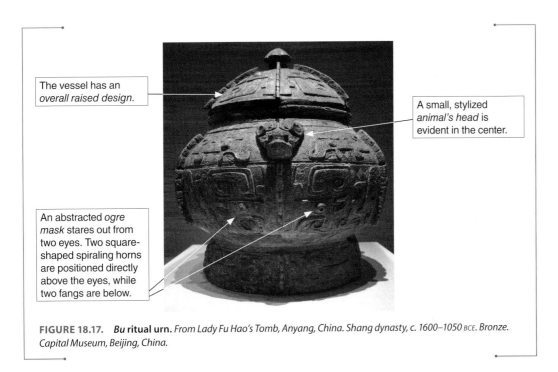

The vessel has an *overall raised design*.

A small, stylized *animal's head* is evident in the center.

An abstracted *ogre mask* stares out from two eyes. Two square-shaped spiraling horns are positioned directly above the eyes, while two fangs are below.

**FIGURE 18.17.** *Bu* ritual urn. *From Lady Fu Hao's Tomb, Anyang, China. Shang dynasty, c. 1600–1050 BCE. Bronze. Capital Museum, Beijing, China.*

Two hundred of these vessels were found in the elaborate tomb of Lady Fu Hao, wife of a Shang ruler. Figure 18.17 illustrates one of these vessels and shows the types of decorations that could be found on these objects.

## Tomb

The *most elaborate tomb ever found in China belonged to* Emperor Shihuangdi (shee-hoo-ANG-dee), *the first emperor of the Qin (chin) dynasty*. A mighty dictator, he began constructing his tomb when he first attained power, forcing seven hundred thousand convicts to labor for thirty years.

The first Qin emperor was a man of big ideas in life as well as in death. In 221 BCE, he united China as one country for the first time. He was also responsible for standardizing weights, measures, and writing; building over four thousand miles of roads and a great wall to protect northern China from invasion; and establishing a bureaucracy based on merit rather than heredity to help him govern.

The emperor's tomb is located under what was originally a six-hundred-foot-tall constructed hill. It is organized by two rectangular concentric walls, creating three separate spaces (figure 18.18A).

All of the items buried in the three areas were meant, according to scholars, to *ensure the emperor's happiness and well-being in the afterlife*:

- *Inside the interior rectangle are halls for offerings to the emperor.* Also included are graves of sacrificial victims, pits with bronze chariots and horses as well as clay figures of officials, and the emperor's as-yet-unexcavated burial location.
- *In the area between the two walls are sacrificed animals and more artifacts.* One pit is believed to be a zoo. Other pits include clay figures posed like acrobats.
- *In the area outside the outer wall are sacrificed horses and figures of clay horsemen and an entire replica of the imperial guard lined up in formation* (figure 18.18B). Consisting of approximately eight thousand life-sized men and horses, the figures include archers, infantrymen, and cavalrymen, each in the correct uniform and position.

The imperial guard figures were made from clay and both *mass produced and personalized*. Arms, legs, hands, and torsos were formed from molds and could be interchanged

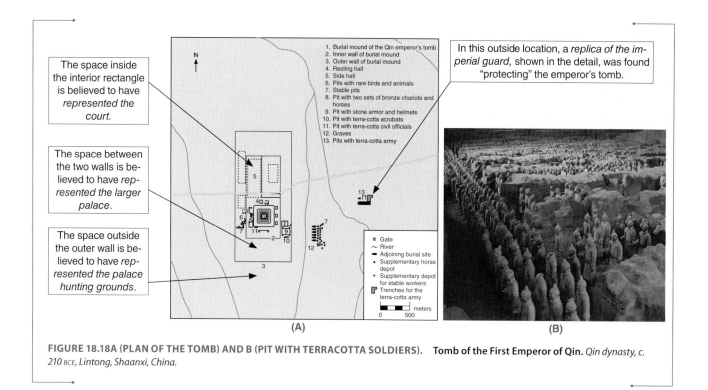

The space inside the interior rectangle is believed to have *represented the court.*

The space between the two walls is believed to have *represented the larger palace.*

The space outside the outer wall is believed to have *represented the palace hunting grounds.*

1. Burial mound of the Qin emperor's tomb
2. Inner wall of burial mound
3. Outer wall of burial mound
4. Resting hall
5. Side hall
6. Pits with rare birds and animals
7. Stable pits
8. Pit with two sets of bronze chariots and horses
9. Pit with stone armor and helmets
10. Pit with terra-cotta acrobats
11. Pit with terra-cotta civil officials
12. Graves
13. Pits with terra-cotta army

In this outside location, a *replica of the imperial guard,* shown in the detail, was found "protecting" the emperor's tomb.

■ Gate
~ River
● Adjoining burial site
● Supplementary horse depot
○ Supplementary depot for stable workers
▤ Trenches for the terra-cotta army

0 500 meters

(A) (B)

**FIGURE 18.18A (PLAN OF THE TOMB) AND B (PIT WITH TERRACOTTA SOLDIERS).** **Tomb of the First Emperor of Qin.** *Qin dynasty, c. 210 BCE, Lintong, Shaanxi, China.*

to create different figures. Heads were modeled to look like individuals, which scholars believe resembled people in the emperor's actual guard. The completed figures were fired and painted (today the colors have disappeared).

While the Qin dynasty maintained an emphasis on honoring the dead, there were some changes from the Shang. First, *power and prestige were indicated by magnitude* rather than by precious materials. The *enormous army was completed in clay* rather than bronze. In addition, while there were still a vast number of animal and human sacrifices, *some buried items were stand-ins for the living.* The clay army guarded the emperor rather than real soldiers.

### Grave Goods from the Tombs of Commoners

During the Han dynasty, the focus on *honoring the dead with art extended to the graves of commoners.* Scholars tell us that the Han believed that each person had one soul that traveled to a distant place and another that stayed in the tomb and had to be appeased with luxury goods and offerings, so that the soul would not become an evil spirit. As a result, *individuals were buried with stand-in substitute items* such as miniature replicas of homes, even more luxurious than those in which they had lived during life.

The tomb of Lady Dai, wife of a nobleman, contained food, clothing, utensils, and three nested coffins for the body of the deceased. Inside the innermost coffin, a T-shaped, painted silk banner, designed in three horizontal strips—defining the heavens, the earthly world, and the world of the dead—covered the body (figure 18.19). On an inventory found in the tomb, the cloth was categorized as the flying banner, possibly denoting that it would *transport the non-earthbound soul to the distant world.*

### Grave Goods from Korea

An interest in *honoring the dead* existed in Korea as well. According to scholars, during the Three Kingdoms period, tombs were crowded with grave goods to ensure that the occupants would have *luxurious and necessary possessions in the afterlife.* These included gold and jade objects; weapons; ceramics filled with food; and accessories, jewelry, and crowns (examples of the broad view of art).

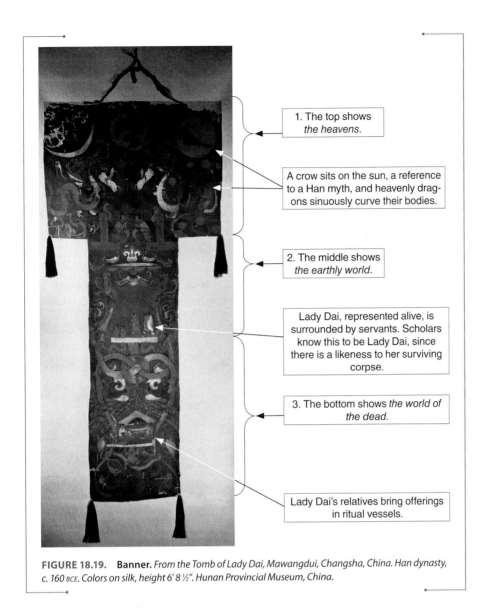

1. The top shows *the heavens*.

A crow sits on the sun, a reference to a Han myth, and heavenly dragons sinuously curve their bodies.

2. The middle shows *the earthly world*.

Lady Dai, represented alive, is surrounded by servants. Scholars know this to be Lady Dai, since there is a likeness to her surviving corpse.

3. The bottom shows *the world of the dead*.

Lady Dai's relatives bring offerings in ritual vessels.

**FIGURE 18.19.** **Banner.** *From the Tomb of Lady Dai, Mawangdui, Changsha, China. Han dynasty, c. 160 BCE. Colors on silk, height 6′ 8 ½″. Hunan Provincial Museum, China.*

The crown in figure 18.20 features antler-type projections on each side and an abstracted tree at center. Scholars suggest the antlers may signify the *rulers had spiritual influence*. Hanging down from the crown are two additional decorative elements. When worn in life, the antlers and dangling ornaments would have swayed and jingled, adding to the mystery of the ruler. When worn in death, the crown lent the wearer power, as scholars believe that Koreans from this period thought that gold and jade prevented the body from decaying, ensuring longevity in the afterlife.

*Quick Review 18.5*: In what ways did a belief in the afterlife have a large impact on early art in China and Korea?

## Confucianism, Daoism, Buddhism, and Their Offshoots in China

Three philosophies became important in China. Two, *Confucianism* and *Daoism*, were homegrown, and one, *Buddhism*, was imported from India.

### Confucianism

Confucianism was founded by Confucius, who lived in China during the fifth century BCE in a time of instability. Confucius sought to create an ordered and peaceful society, and to

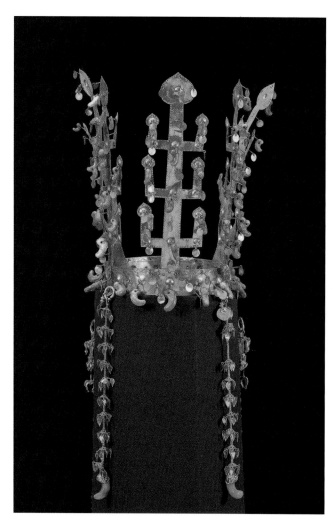

do so he taught that people should pledge loyalty to those in authority. This devotion, Confucius said, should be shown from child to parent, wife to husband, younger person to older, subject to emperor, and the living to dead ancestors. However, Confucius believed that just behavior should run in both directions, as a father, for example, could command his son's respect only if he treated him properly. In keeping with this philosophy, Confucius promoted:

- Set *rituals*
- Proper etiquette
- Moral *responsibility*
- *Loyalty* to the state

Confucianism became the official government philosophy during a number of periods in China because it promoted the social order. Many of Confucius's followers worked for the state bureaucracy.

## Daoism

Daoism also had its roots in China in the tumultuous fifth or sixth century BCE. It is in Daoism that we see the Chinese *connection to the natural world*. Daoism suggests that people follow and become one with "the Dao" or "the way"—the *natural force of the universe and the force within oneself*, even if it means ignoring societal rules and lessons learned in books (unlike Confucianism). Daoism also promotes *eternal salvation* (like Buddhism) and the *belief in a variety of gods*.

**FIGURE 18.20.** **Royal crown.** *From the Gold Crown Tomb, Kyongju, Korea. Three Kingdoms period, fifth to sixth century* CE. *Gold and jade, height 10 ¾". National Museum of Korea, Seoul.* The existence today of finds such as this crown can be credited to the discovery of a number of intact tombs that, because of their design, were difficult to loot.

**calligraphy** Fine handwriting with aesthetic values that are independent of its textual context

## How Confucianism and Daoism Figured in Chinese Art

Beautiful handwriting, known as **calligraphy**, is considered a high art in China and reflects principles of both Confucianism and Daoism, including:

- *Confucianism's sense of order.* Chinese writing includes thousands of characters that signify different words, each of which must be formed correctly.
- *Confucianism's state loyalty.* All bureaucrats were expected to be well versed in writing.
- *Daoism's spirit.* Characters are formed with a brush, just like in a painting.
- *Daoism's way.* The writer allows his disposition and the force of the universe to flow from the ink on his brush onto his paper.

**artists**
MATTER

Wang
Xizhi

The calligraphy of Wang Xizhi (wang shee-jhih) comes from the fourth century CE. The nuance of each of his characters seen in figure 18.21 reflects a combination of correct Confucian form and intense Daoist expression.

## Buddhism

The third important philosophy in China, Buddhism, was introduced during the Han dynasty, but did not become a significant influence until several hundred years later during the Northern Wei (one of the Northern and Southern dynasties), established by invading Turkish conquerors. Buddhism's universal acceptance appealed to the Northern Wei and offered common ground between the foreign emperors and their Chinese subjects.

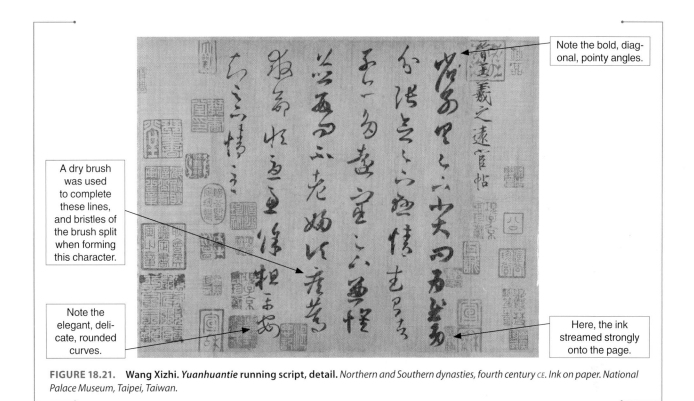

Note the bold, diagonal, pointy angles.

A dry brush was used to complete these lines, and bristles of the brush split when forming this character.

Note the elegant, delicate, rounded curves.

Here, the ink streamed strongly onto the page.

**FIGURE 18.21.** **Wang Xizhi.** *Yuanhuantie* **running script, detail.** *Northern and Southern dynasties, fourth century* CE. *Ink on paper. National Palace Museum, Taipei, Taiwan.*

## How Buddhism Figured in Chinese Art

As with Confucianism and Daoism, the Chinese incorporated Buddhism into their art. *Sculpture* and *temple architecture* enable us to see how.

### Sculpture

In 452 CE, the Northern Wei emperor began constructing five colossal Buddhas and other sacred figures in caves carved from solid rock. Each of the five enormous sculptures bears a resemblance to one of the five Northern Wei emperors. *The works were a mutually advantageous collaboration between clergy and state*—the emperors promoted Buddhism, and Buddhist monks and nuns declared that the emperors were Buddhas.

Figure 18.22 shows the forty-five-foot high colossal Buddha in one of the caves. His shoulders spread widely, falling into columnar arms that meet in monumental hands as if he could hold the entire world in his embrace. He is both an *icon of the Buddhist faith* (and the idea that all are welcome and have hope) *and of the Northern Wei dynasty* (and imperial control).

The colossal Buddha was originally flanked by sculptures of two smaller standing Buddhas and two Bodhisattvas. However, only one of the smaller Buddhas remains (see *Practice Art Matters 18.2: Recognize the Buddha's Attributes*).

### Temple Architecture

By the time of the Tang dynasty in the seventh century CE, Buddhism had spread across China. One modest surviving temple from this period, the Nanchan Temple

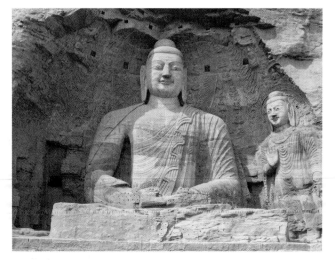

**FIGURE 18.22.** **Colossal Buddha.** *From Cave 20, Yungang Caves, Datong, China. Northern Wei dynasty, c. 460* CE. *Stone, height 45'.* The colossal Buddha sits peacefully, confidently, and in a crossed-legged, meditating position.

## 18.2 Recognize the Buddha's Attributes

We have already discussed how this sculpture from India (figure 18.23A) is recognizable as a Buddha from his attributes. Considering what you know, name three visible attributes in the Chinese figures (figure 18.23B) that indicate they are Buddhas. (Be sure to consider both Chinese figures.)

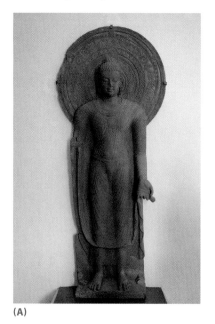 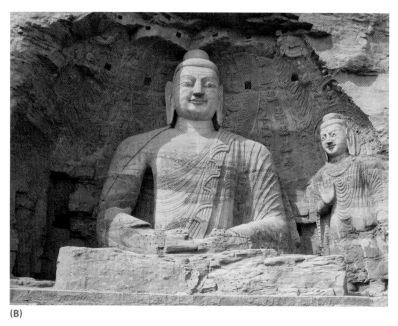

(A)                                    (B)

**FIGURE 18.23A AND B.** (A) Yasadinna. Standing Buddha reconsidered; (B) Colossal Buddha reconsidered.

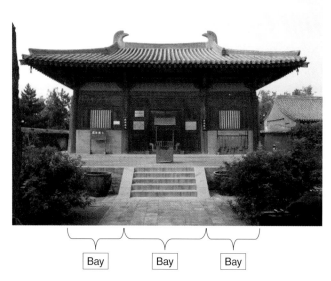

**FIGURE 18.24.** **Nanchan Temple.** *Tang dynasty, 782 CE, Wutaishan, Shanxi, China.* Three bays can be seen from the front façade of the temple. The center bay is larger than the outside two.

Bay    Bay    Bay

**bracket** A supporting piece of architecture that extends from a wall; used to brace a roof

(figure 18.24), gives an idea of what Buddhist architecture on a grander scale might have resembled:

- *The building has a curved, decorative, overhanging roof.* It extends out beyond the walls and arches up toward the outer edge.
- *The structure has an elaborate supporting system of* **brackets**. These hold up the extended roof.
- *The building was constructed with* **bays**, cubical architectural units of vertical posts, horizontal beams, and walls, which can be repeated in rows to create buildings of any size. Here, the bays' symmetrical and geometric forms seem to make the building look stable and important.

### Neo-Confucianism

During the Northern Song dynasty, the Chinese looked back to their historical roots and developed a new philosophy called neo-Confucianism that merged:

- Confucian ideas of *social order*
- Daoist concepts of our *connection to nature*
- Buddhist thoughts on *unifying our worldly souls with the cosmos*

The combined thinking can be seen in *Travelers among Mountains and Streams*, a painting almost seven feet tall. In it, Fan Kuan (fahn-kwahn) laid out three progressions in space (figure 18.25).

These three different grounds of the painting use symbolism to address the different components of neo-Confucianism:

- *In the background is the Confucian element.* There is an *ordered hierarchy among the mountaintops*, similar to the way Confucianism promotes harmonious relationships with some people at superior levels, commanding loyalty from others. Here, the tallest peak, which scholars suggest represents the emperor, emerges over lower peaks, representing others in the court beneath him.
- *In the middle ground is the Daoist element.* The *travelers and temple are tiny*, just as Daoism suggests that people are insignificant compared to the greater natural force. In addition, Fan Kuan formed his landscape from *multiple viewpoints*. If he had painted the entire scene from one viewpoint, say a low one, the mountain would have appeared to loom over us. Instead, it appears like a backdrop. With the multiple, shifting views, Fan Kuan was likely inviting us into the landscape to explore, just as Daoism asks people to follow the way and go with the flow (and as Rikyū asked his guests to wander through a garden path before entering his teahouse).

**bay** A cube-shaped architectural unit made from posts, lintels, and walls

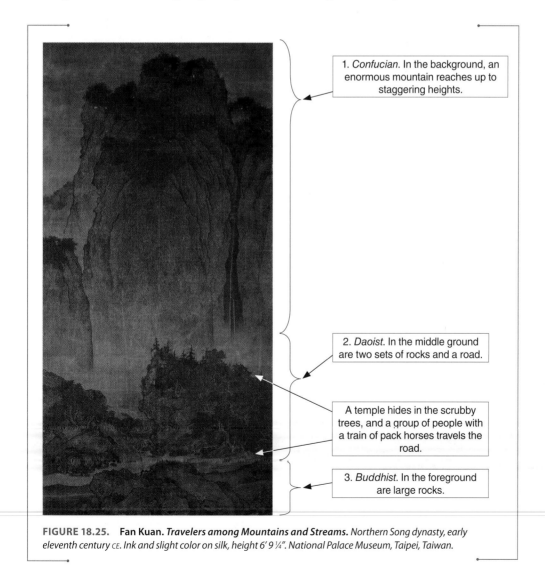

1. *Confucian.* In the background, an enormous mountain reaches up to staggering heights.

2. *Daoist.* In the middle ground are two sets of rocks and a road.

A temple hides in the scrubby trees, and a group of people with a train of pack horses travels the road.

3. *Buddhist.* In the foreground are large rocks.

**FIGURE 18.25.** **Fan Kuan.** *Travelers among Mountains and Streams.* *Northern Song dynasty, early eleventh century* CE. *Ink and slight color on silk, height 6′ 9 ¼″. National Palace Museum, Taipei, Taiwan.*

Interactive Image Walkthrough

**FIGURE 18.26.** Yujian. *Mount Lu.* Southern Song dynasty, mid-thirteenth century CE. Ink on paper, 14″ × 24 ⅝″. Okayama Prefectural Museum, Japan. Yujian's gestural strokes form values that move from creamy lights to dense darks.

- *In the foreground is the Buddhist element.* Scholars suggest that Fan Kuan's rocks display the brush technique for how he believed the spirit of the rocks should be portrayed. Similar to the Buddhist belief in two souls—a worldly one and a universal one—Fan Kuan likely sought to paint the *ideal principle of natural forms,* to unify the idea with the universal and reach enlightenment.

### Chan Buddhism

In 1126 CE, the Mongols invaded China, and the Song court fled to the south, establishing the Southern Song dynasty. No longer the powerhouse it had been in earlier periods, the country looked inward, and paintings followed suit, feeling *more intimate and subdued.*

A mountain scene just fourteen inches high from this period (figure 18.26) by Southern Song artist Yujian (YOO-jen) takes on ideas of Chan Buddhism—known as Zen Buddhism in Japan (and the same sect to which Jukō belonged when he changed the tea ceremony from its luxurious roots to his austere methods). Chan Buddhism suggests that *our world is an illusion* and that people should leave their minds free to being *spontaneously enlightened.* In the vaguely defined mountains, in which some parts are faint and others missing altogether, Yujian conveyed the fantasy that is our earthly existence. Climbing through such natural magnificence, people could spend their lives in a state of being open to a heightened sense of perception.

The work differs markedly from Fan Kuan's:

- *Nature is small.* The misty mountains seem proportionally scalable, rather than Fan Kuan's towering peaks.
- *There is a slow progression from the foreground into the distance.* The background seems to melt into haze, rather than Fan Kuan's backdrop, stopping our eyes from receding in space.
- *Spontaneous brushstrokes have created loose bold waves of ink and faint washes.* The mountains are so abstracted that, without being told, we might think the ink marks are just a nonrepresentational pattern.

*Quick Review 18.6*: How did the philosophies of Confucianism, Daoism, and Buddhism affect art in China in different ways?

### Later China

We will look at three examples from later China—the period from the thirteenth century to the beginning of the twentieth century. These examples include several works from *broad categories of art,* such as ceramics, and a *painting.*

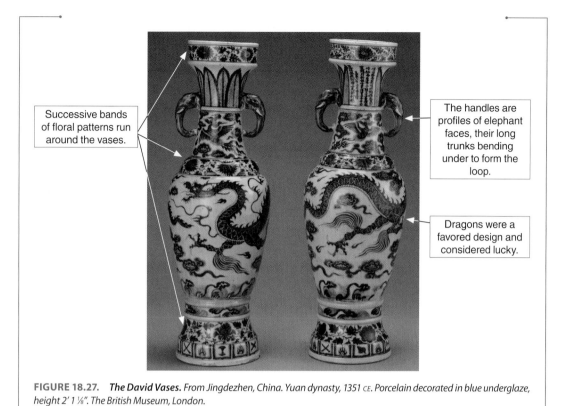

Successive bands of floral patterns run around the vases.

The handles are profiles of elephant faces, their long trunks bending under to form the loop.

Dragons were a favored design and considered lucky.

**FIGURE 18.27.** ***The David Vases.*** *From Jingdezhen, China. Yuan dynasty, 1351 CE. Porcelain decorated in blue underglaze, height 2′ 1 ⅛″. The British Museum, London.*

## Ceramics

During the Yuan (yoo-AN) dynasty, invading Mongols overran China, and foreign emperors ruled the land. In an *attempt to fit in, the foreign rulers patronized traditional Chinese arts* such as ceramics. They oversaw production and slated some pieces for use in the palace, while others were exported (Chinese porcelain was treasured in other countries).

The two vases in figure 18.27 illustrate a type of *blue and white pottery* created using a technique discovered in 1320 CE. Potters painted blue glaze on white porcelain pots, as blue was the only glaze that could withstand the heat needed to fire the porcelain (see Chapter 11). The design here includes flowers, elephants, and dragons.

### *Literati* Paintings

In 1368 CE, a Chinese ruler successfully overthrew the Mongol government, launching the Ming dynasty. However, his tyrannical rule made intellectuals shun the court. These scholars, known as *literati*, created a type of painting known as **literati paintings**. *Poet on a Mountaintop* (figure 18.28) by Shen Zhou (shen JOE) illustrates the *literati's* philosophy:

**artists**
MATTER

Shen
Zhou

- An *understanding of nature* comes from a *person's own mind.*
- This understanding of what a *person believes to be reality*, and the *connection between his mind and this ideal*, is the point of the painting, rather than a representation of the spirit of natural forms or a depiction of an illusionary world.
- The *person is master*; here, he stands prominently on the top of a cliff in front of an abyss and stares off into a poem that Shen Zhou composed and wrote.

***literati* painting** A type of painting created by intellectuals in East Asia who were not associated with the royal court

China and Korea     501

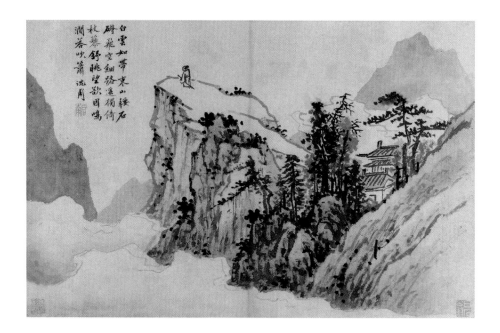

FIGURE 18.28. Shen Zhou. *Poet on a Mountaintop.* *Ming dynasty, 1496* CE. *Ink and color on paper, 15 ¼" × 23 ¾". The Nelson-Atkins Museum of Art, Kansas City, Missouri. Literati* paintings, like this one, were not associated with the royal court.

## Art by Women

During the Ming dynasty, more women artists were active than in any previous time in Chinese history. While women were not allowed to paint the most prestigious subject matters, such as landscapes, *they could paint nature in the form of flowers and insects.*

Figure 18.29 illustrates a folding fan by female artist Wen Shu on which she painted carnations and rocks. The fan originally would have been attached to a stick. The scene appears against the blank backdrop of the fan, flattening the depiction and making it look like a decorative surface design rather than a three-dimensional form. However, when folded, the design would have taken on the three dimensions of the pleated paper. Wen Shu's brushwork is both delicate and bold. The flowers are formed by dainty, fine lines, while the rocks show a loaded brush filled alternatively with full-bodied ink and watered-down washes.

## Jade

In 1644 CE, foreign invaders again overran China and launched the Qing (ching) dynasty. As before, the *invaders looked to legitimize their rule, and they used art*—such as the jade work entitled *Yu the Great Taming the Waters* (figure 18.30)—to help with the task. The heaviness, hardness, labor-intensiveness, richness, and iridescence of jade have made it a stone that is associated with *sovereignty and divine power.* In addition, the emperor selected a subject matter that associated him with the accomplishments of Yu, a legendary Chinese emperor. Yu had organized a public works project with the support of numerous Chinese workers to control flood waters.

*One thousand men and one hundred horses toiled for three years to transport the stone,* which was over seven feet tall and eleven thousand pounds and which had been discovered on the edge of the empire, to Beijing. Men had to build roads along the way to accommodate the load. Then, craftsmen formed models of the intricate work in wax and wood, and *artisans took eight years to wear away the stone* (which was too hard to carve) into the design. Finally, an artist worked for a *year to add calligraphy*—in the emperor's own handwriting— that links the Qing emperor to the legendary Emperor Yu.

FIGURE 18.29. Wen Shu. *Carnations and Garden Rock. Ming dynasty, 1627* CE. *Ink and colors on gold paper fan, 6 ½" × 21 ¼". Honolulu Museum of Art, Hawaii.* This folding fan was likely given as a present. As flowers were symbols of beauty, the gift would have been meaningful.

# Japan

Japan is situated on an island off the coast of Asia (see map in figure 18.5). Its close proximity to China and Korea and its separate island status have led Japan to vacillate between following the lead of its close neighbors and shunning their guidance to look inward. For example, in the years of luxurious tea parties, Japanese coveted all things Chinese. Contrastingly, in the years of the austere tea ceremony, Japan developed its own aesthetic.

## Classical Japan

During the classical period in Japan, there was a tendency to *waver between looking inward and looking outward*. This is evident in the art of two religions, *Shintoism* and *Buddhism*, and in a *secular book*.

### Shintoism

We can see the roots of the Japanese aesthetic, which valued *simplicity, imperfection, asymmetry, and nature*, and an *inward-facing religion* in considering Shintoism, which means "Way of the Gods." The religion began in Japan in the first few centuries CE. Shintoism:

- Focuses on *appeasing ancestors* and *nature deities*
- Encourages a *Japanese sense of unity* and *respect for the natural world*
- Promotes *gods that are believed to inhabit natural objects and animals*, including trees, waterfalls, mountains, rocks, and deer

Early Shinto shrines were quiet clearings in a forest believed to be close to the deity. The faithful entered the sacred spot to pray silently, often bringing an offering. Later, the faithful built simple shrines. It was in these shrines where coarse, low-temperature ceramics were used that later inspired the pottery Rikyū sought for his tea ceremony.

Figure 18.31 illustrates the Shinto shrine at Ise (EE-seh), originally constructed in the seventh century. The shrine was built in a forest, and, before entering, worshippers washed their hands and mouths to purify themselves (just as in the Japanese tea ceremony). To enter, visitors follow a white-pebbled path, which climbs through evergreen trees. A gateway opens to an outer rectangular-shaped complex, where there is a shrine to the grain god. In the inner complex (where only members of the imperial family and priests can go) sits the main shrine dedicated to the sun goddess along with two treasure houses holding offerings. The ground of the entire complex is covered in the same white pebbles from the path, and all buildings are composed of *unpainted, undecorated wood with simple, cypress-bark roofs. The neutral color and warm texture equate the buildings with the natural surroundings*, and the geometric forms of the structures are understated.

The buildings in figure 18.31 look pristine because the shrine is rebuilt every twenty years. When the year of construction arrives, workers purify themselves before commencing on the ritualized building process that uses no nails.

**FIGURE 18.30.** *Yu the Great Taming the Waters. From China. Qing dynasty, 1787 CE. Jade, 7' 4 ¼" × 3' 1 ¾". Palace Museum, Beijing, China.* In the design, workers toil in zigzag diagonals up the face of a mountain, ensuring that flood waters are controlled.

**FIGURE 18.31.** **Shinto shrine, aerial view.** *Rebuilt every twenty years, Ise, Japan.* The white pebbles on the ground and natural building materials of the shrine help give the complex a pure, simple feel.

Pagoda

Kondo

Entrance gate

**FIGURE 18.32. Hōryūji, aerial view.** *Asuka period, early eighth century CE, Ikaruga, Japan.* The three main structures of the complex—the entrance gate, *pagoda*, and *kondo*—are evident in the photo.

***pagoda*** A multi-storied Buddhist tower that contains sacred relics

***kondo*** The golden hall; the main Buddhist building that contains an altar with images of the Buddha

## Buddhism

While the Shinto shrine shows Japan's native tendencies, *foreign influence* can be seen in the country's acceptance of Buddhism. Buddhism took hold in Japan by the end of the seventh century CE, during the Asuka period (see the timeline in figure 18.6), when the faithful built more than five hundred Buddhist temples.

One of these, called Hōryūji (hohr-YOO-jee) (figure 18.32), was rebuilt in the early eighth century CE, after the original burned down. Today, *the compound boasts the oldest wooden structures in the world.*

The main structures in the complex include:

- An *entrance gate* that circles the main sacred buildings
- A ***pagoda*** that holds important relics and, like a *stupa*, is circled and not entered
- A ***kondo*** or golden hall that houses images of Buddhas and bodhisattvas, where the faithful can meditate and pray

While the symbolism of the buildings may have come from India, the architectural influences came from China. Like the Nanchan Temple (figure 18.24), the buildings at Hōryūji have *overhanging, curved roofs* that are *supported on brackets.* The buildings were also constructed using *bays of cubical units.*

However, even with foreign influences, the compound maintains Japanese elements. The *complex is organized asymmetrically.* The five-story, slender *pagoda* shoots into the sky, while the squat *kondo* is grounded. The complex maintains the Japanese *aesthetic of imperfection and unevenness*—the same aesthetic that Rikyū found pleasing in his teahouse and utensils.

## A Secular Book

During the Heian (hay-AHN) period, aristocrats wielded great power. Court life was formalized, with conduct and clothing controlled. People revealed their feelings in only the subtlest of ways. Men and women had to dress in specific clothing, with women required to wear twelve layers of robes.

Men had multiple wives, and the wealthiest kept each wife set up in her own building. Rooms were sectioned into smaller spaces by dividers. There was little furniture. People sat on the floor; only boxes and tables held food and other items.

Both men and women were educated. *Men learned Confucian classics and Chinese writing* (showing influence from without), while *women were taught to write in Japanese* (showing influence from within). During this period, women started a new genre of books written in their native language.

Lady Murasaki penned one such story, *The Tale of Genji* (GEHN-jee), in the late tenth or early eleventh century. A court woman herself, Lady Murasaki wrote of a prince named Genji who was not destined for the throne. While fictional, the story gives a sense of the intrigue and romance that must have been rampant at court.

While the entire story survives, we are also fortunate to have twenty illustrations that were created in the early twelfth century. The illustrations appear, alternating with calligraphy that tells the story, on **handscrolls**—rolled, wide, horizontal strips of paper meant to be viewed in twelve-inch sections.

Figure 18.33 illustrates a tense moment from the tale. Genji's wife has slept with another man, and Genji must decide what to do with the resulting child. In the image, Genji accepts the child in a ceremonial event. We see the scene from a bird's-eye view. Floors tip up at steep angles, and room separators cross the room at abrupt diagonals. Because we see them from above, the figures appear to be just heads, hands, and masses of fabric.

**handscroll** A very wide, horizontal strip of paper with paintings or calligraphy that is rolled up, so that an individual viewer can consider one section of the scroll at a time by unrolling it from hand to hand

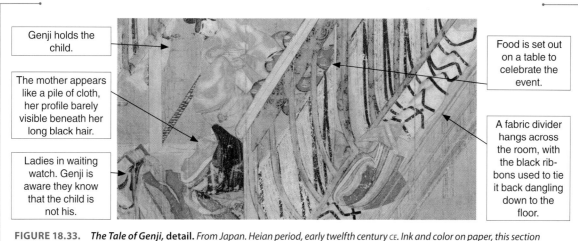

Genji holds the child.

The mother appears like a pile of cloth, her profile barely visible beneath her long black hair.

Ladies in waiting watch. Genji is aware they know that the child is not his.

Food is set out on a table to celebrate the event.

A fabric divider hangs across the room, with the black ribbons used to tie it back dangling down to the floor.

**FIGURE 18.33.** *The Tale of Genji,* detail. *From Japan. Heian period, early twelfth century* CE. *Ink and color on paper, this section 8 ⅝" × 18 ⅞". Tokugawa Art Museum, Nagoya, Japan.*

Everything in the painting follows the protocol of court life:

- Women *wear twelve layers of clothing*, evident in the multiple strips of cloth.
- Fabric *divides the rooms*.
- There *is almost no furniture*.
- The characters *show no feelings*, their mask-like faces consisting of lines for eyes, hooks for noses, and tiny marks for mouths.

We understand the characters' moods and the emotional intensity of the scene from *clues in the room structure and the positioning of the figures.* The dominating architectural features seem to weigh heavily on the characters, the room made claustrophobic by large dividers that close in on the figures. In addition, Genji is placed precariously high on the tilted floor, likely symbolizing how he is burning inside. He accepts the situation with decorum and his face shows no emotion, in keeping with courtly etiquette.

While Japanese art from this period reflects a courtly style, recall that a very different approach was prevalent in China at this point. To appreciate the differences, see *Practice Art Matters 18.3: Contrast Heian Period and Northern Song Dynasty Paintings.*

*Quick Review 18.8*: What is the native Japanese aesthetic and how did Shintoism help to create it?

Interactive Image Walkthrough

## Medieval Japan

The medieval period in Japan gives us the opportunity to consider the art of the *military elite.* We can also look to the effect Zen Buddhism had on the country and the *garden designs* it spurred.

### Military Attire

The aristocrats of the Heian period preferred to stay in the capital city at court, but they had landed estates in the country. The aristocrats, therefore, hired overseers to control their land. Eventually, however, these militant estate managers, known as *samurai* (sah-moo-RYE), became more powerful than the lords. Civil war broke out and, when one clan of *samurai* won out, they took control of Japan, launching the Kamakura period in 1185 CE.

During the Kamakura period, conflict between different military factions was rampant, so *craftsmen developed protective armor to shield the fighters.* Artisans used leather hides and metal for maximum defense.

## 18.3 Contrast Heian Period and Northern Song Dynasty Paintings

The painting from *The Tale of Genji* (figure 18.34A) is quite different from landscapes such as Fan Kuan's *Travelers among Mountains and Streams* (figure 18.34B) created in China during this period. Describe how the two paintings differ in each of these areas:

- Subject matter
- Color
- Space
- Point of view
- The importance of people

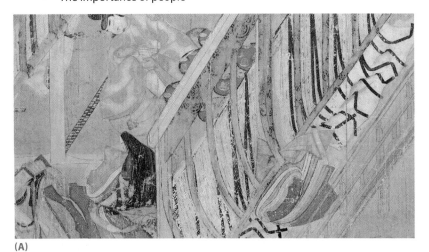

(A)

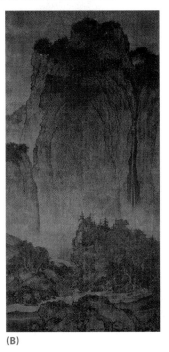

(B)

**FIGURE 18.34A AND B.** (A) *The Tale of Genji,* detail, reconsidered; (B) Fan Kuan. *Travelers among Mountains and Streams* reconsidered.

The armor in figure 18.35 was not only resilient, but also embellished. Bold, rich designs mirrored the physicality of the age and illustrated the *importance of art on functional items*. The regularly repeating geometric pattern seems to create a *stable* and *powerful appearance*, while the antler ornament, a *fierce look*.

### Garden Design

The twelfth century CE also saw the arrival of Zen Buddhism in Japan from China (where it was known as Chan Buddhism), swinging the country back to a *foreign focus*. The Zen philosophy in Japan encouraged the faithful to meditate for long hours in the hopes of becoming enlightened.

By the Muromachi period, Zen Buddhism had become a way of life among the *samurai*. The stark, direct philosophy:

- *Shuns extravagant ritual*
- *Advocates that higher understanding can be found in restraint and reflection*
- *Promotes self-examination* with the help of a learned, enlightened teacher

**dry garden** A Zen Buddhist garden created to aid with contemplation, consisting of stones, pebbles, and sometimes simple shrubs

We see the adherents' following of Zen Buddhism in garden design. Gardens are meant to aid in contemplation during meditation. The most introspective type of garden is a **dry garden**, which is set in a small enclosure and contains only large rocks, small pebbles, and, sometimes, simple shrubs. Those who contemplate a garden do not physically enter. Instead, they "walk" through a garden in their minds.

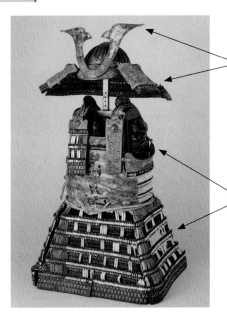

The *helmet* has decorative antler-like projections and flaps that hung down over the soldier's head and neck.

The *garment* has a knee-length skirt and originally had flaps, which were worn over the arms. The helmet flaps sat over the arm flaps, making the two together appear like wings.

**FIGURE 18.35.** **Suit of armor.** *From Japan. Kamakura period, early fourteenth century CE. Iron, lacquer, leather, silk, and gilt copper, height 3' 1 ½". The Metropolitan Museum of Art, New York.*

At Ryōanji (RYE-OH-ahn-jee) (figure 18.36), a dry garden from the Muromachi period, it was believed that each rock and rock cluster, placed asymmetrically, was the exact right size and was situated in the exact right location and relationship to the other rocks to induce the most spiritual energy and, thereby, the most enlightened thoughts. Everything appears *sparse and still*. Just as in the tea ceremony, it was thought there is *profoundness in the imperfection and simplicity* of the dry garden and that humans, as imperfect beings, could relate supremely to the sublime work.

*Quick Review 18.9*: How are the features and design of a dry garden a reflection of Zen Buddhist thought?

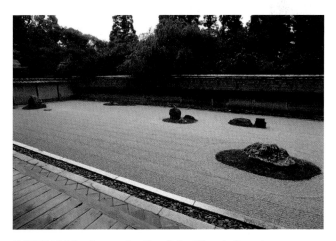

**FIGURE 18.36.** **Dry garden.** *From Ryōanji Temple, Kyoto, Japan. Muromachi period, c. 1480 CE.* This dry garden contains five groups of large stones set amid carefully raked white gravel.

## Early Modern Japan

Early modern Japan brings us to the period of Rikyū's tea ceremony. The final works that we will consider include *screens* and *garments*.

### Screens

During the Momoyama period, the military environment in Japan continued, and lords built over one thousand fortified castles to *protect their interests* and *enhance their status*. Castles were enclosed in thick, defensive walls with tiny windows and had elaborate interiors.

*To brighten ornate rooms, artists created screens decorated in large amounts of* **gold leaf** (gold pounded to paper-thin pieces shaped into squares) that reflected the minimal light entering from small windows and created an impression of flickering candlelight. Both the castles and screens were native Japanese art forms.

**gold leaf** Gold that has been hammered into paper-thin sheets to be used as a decorative application to an artwork

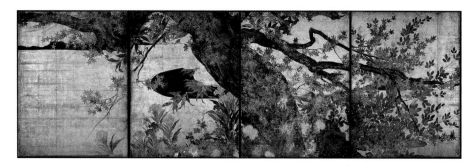

**FIGURE 18.37.** Hasegawa **Tōhaku.** *Maple Tree. From Chishakuin Temple, Kyoto, Japan. Momoyama period, late sixteenth century* CE. *Color and gold leaf on paper, 5' 7 ⅞" × 4' 6 ½".* Scholars know that, when originally placed, another group of screens depicting a different tree sat opposite, causing someone who walked between the two sets to be surrounded with richness.

The most representative surviving set of screens from the period (figure 18.37) was created by Hasegawa Tōhaku (HAH-seh-gah-wah TOH-hah-koo). While not originally from a castle, the work maintains the hallmarks of the style. An enormous, bold maple tree crosses four screens on a strong diagonal. Depicted during the fall foliage season, its leaves are brilliant. It sits in front of a *vast lake made from gold leaf,* the gold squares glimmering like water.

## Garments

During the Edo period, Japan again looked to China in that the government promoted a Confucian approach to social organization, where there were different classes of people all in leveled positions loyal to the state:

- At the top was the emperor.
- Below him were the *samurai.*
- Next came the peasants.
- Lowest were townspeople, merchants, and artisans, who, according to Confucian thought, relied on the results of other people's efforts.

They might have been at the bottom of the social hierarchy, but by the end of the seventeenth century the townspeople were the wealthiest class in the land. They became great consumers of art, purchasing such items as *ukiyo-e* prints (described in Chapter 7) and cloth. The wealthy paid huge sums to have artisans develop luscious tones and fine-weave patterns of the permitted (government laws limited what people could wear) brown and grey colors and alternative cloths. Additionally, in privacy, impermissible undergarments were exposed that no officials could see.

Such is the case with the garment in figure 18.38, an *uchikake* (oo-chee-KAH-keh), worn under an outer robe. Painted by Gion Nankai (GEE-ohn nahn-KEYE), it shows a group of bamboos in the mist. The luxurious robe was made from silk, a fabric prohibited to this class, and real gold powder forms the mist. Moreover, the subject matter is bamboo, a resilient plant that defiantly survives in severe weather and has traditionally represented the integrity of the just—in this case the townspeople who were resolved not to give in to the unfair decrees of the government.

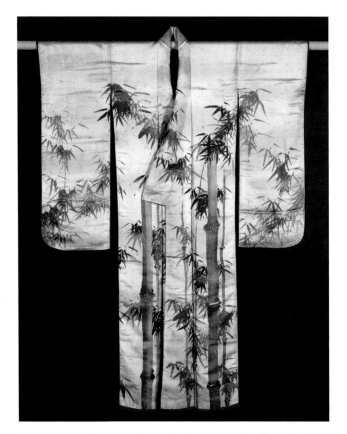

**FIGURE 18.38.   Gion Nankai.** *Uchikake* **with bamboo design.** *Edo period, c. 1700–50* CE. *Ink, gold leaf, and gold powder on white figured silk satin, 5' 4 ¾" × 4' ⅞". The Metropolitan Museum of Art, New York.* A prosperous merchant commissioned this undergarment for his mistress.

*Quick Review 18.10*: What societal changes took place during the Edo period in Japan and how did these changes affect art production?

## A Look Back at the Japanese Tea Ceremony

The Japanese tea ceremony allows us to consider the multiple forms of art that surrounded the ritual, in particular, *simple and rustic structures and utensils* that imbued the philosophical premise of the service. This philosophy was so important, it *changed the artistic values and tastes of the society*. However, the ceremony also gives us broader insight into the art of all of Asia.

The ceremony has its roots in the Indian subcontinent, where the Buddha lived a life of meditation, self-denial, and morally appropriate actions. The Buddha's preaching regarding the *importance of equality, respect, and frugality* can be seen in the austere Japanese ceremony.

Further connections can be found with China in the philosophies of different religions. Confucius's thoughts regarding *harmony, respect, and etiquette* influenced the ritual of the ceremony, while Daoism's *connection to the natural world* helped give the ceremony its affinity toward rustic materials and appearances. The closest associations with China, though, stem from Chan Buddhism. It was at a Chan temple where the Japanese monk found the tea that he brought back to Japan, and it was this sect that advocated *leaving oneself open to sudden enlightenment* by engaging in activities that took one away from everyday concerns.

Of course, in Japan, we find the most connections. Shintoism's *natural setting* and requirement that visitors to shrines (figure 18.31) *purify themselves* probably inspired Rikyū's garden and ritual. Moreover, the *natural colors and textures* of the materials employed in the shrines and the pottery originally used there likely encouraged Rikyū's *imperfect, asymmetrical, and undecorated forms*.

We can even see connections to constrained aristocratic behaviors in the Heian court. Conduct in the teahouse was *strictly controlled*, and all participants had to understand their roles. In addition, Rikyū's guests *sat on the floor*, not on furniture.

Zen Buddhism shows the most important links as followers developed tools such as tea ceremonies, **dry gardens** (figure 18.36), flower arrangements, **calligraphy**, and ink paintings to help them attain enlightenment. Such devices *allow the faithful to step away from the everyday world* and open themselves up to a greater understanding. Through these media, art became essential to adherents of the faith.

As you move forward from this chapter, consider how Rikyū used an unassuming architectural setting, expressive calligraphy, and austere tea accoutrements to create an experience in which *people could clear their minds and experience tranquility*. Zen Buddhist dry gardens, likewise, enabled adherents to contemplate simple designs of stones to enlighten their thoughts. The restorative properties of these art forms show the value in taking a break and stepping back from the stress of everyday life to enjoy simpler, calmer moments.

Flashcards

## CRITICAL THINKING QUESTIONS

1. The chapter describes how the male torso from the Indus Valley Civilization (figure 18.7) is typical of Indian sculpture because it displays an interest in figurative art. What other tendency of Indian art is displayed because of the polished surface of the stone?
2. Consider places of worship with which you may be familiar. Which artistic and architectural features are similar to or different from the ones at the Great Stupa (figure 18.8) and how might these features support the respective faiths that worship there?
3. Chapter 13 discusses the sculptures on the ancient Greek temple, the Parthenon. One of these, figure 13.4, illustrates a battle between a Greek man and a centaur, a creature that was half horse and half human. Figure 18.14 also represents a figure that is part animal and part human, Vishnu with the head of a boar. How do both forms differ? How do they both represent ideal forms in their respective cultures?
4. Why do you think it was important both to mass-produce and personalize the figures in the terracotta army (figure 18.18B)?
5. Why would Fan Kuan never have used linear perspective, a Western-derived system of organizing space (see Chapter 3), in his *Travelers among Mountains and Streams* (figure 18.25)?
6. Considering what you know about calligraphy, why might the Qing emperor have wanted calligraphy included on the jade sculpture *Yu the Great Taming the Waters* (figure 18.30)? Why might he have wanted it to be written in his own handwriting?
7. The text describes two explanations as to why, during the Heian period, we consider that Japan looked both outward to neighbors and inward to itself. Using the illustration from the *Tale of Genji* (figure 18.33) and what you know about the Buddha's Four Noble Truths, why else might we maintain that Japan was under foreign influence in this period?
8. Using examples from the chapter, how could you illustrate this statement: "Japanese art runs the gamut from works that are simple, imperfect, and rustic to those that are ornate, luxurious, and rich"?

Comprehension Quiz

Application Quiz

# CONNECTIONS

## Work, Play, and Relaxation

The universal theme of work, play, and relaxation is evident in artworks from this chapter and in art created by people from different backgrounds and periods from across this book. This theme concerns:

» *Work and labor*
» *Play, entertainment, and activity*
» *Relaxation, tranquility, and contemplation*

### Work and Labor

This chapter includes an example of labor in *Yu the Great Taming the Waters* (figure 18.30). The sculpture shows anonymous Chinese workers cooperating to drain waters from a legendary great flood. The notion of labor, though, can be seen not only in the subject matter, but also in the technique by which the sculpture was made. More than one thousand workers put extraordinary effort into transporting, designing, and forming the enormous sculpture of jade.

A similar scene of worker collaboration is evident in *Detroit Industry* (figure C18.1) by Mexican artist Diego Rivera from Chapter 6. Rivera created the painting from 1932–33, when people faced a different monumental hurdle—the Great Depression. As in the Chinese sculpture, nameless workers toil together to solve the crisis. Also similar, Rivera and his assistants exerted great effort to create the work, employing the labor-intensive fresco process to form the mural.

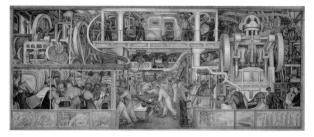

**FIGURE C18.1    Diego Rivera. *Detroit Industry* reconsidered.** While Rivera showed the benefits that come from the efficiency of men working together, he also illustrated another aspect of this theme. He included a figure of a boss, who stands among the working men at left, grim-faced and holding a clipboard, as he watches over the work.

### Play, Entertainment, and Activity

The tea ceremony from the chapter we just completed serves as an example of an activity taken up by numerous Japanese. The ritual leads participants through a series of choreographed steps, using specific tea accoutrements, an example of which is the tea bowl named *Jirobo* (figure 18.2). More than just an opportunity to drink tea, the ceremony combines aspects of an artistic performance, social gathering, and enlightened retreat.

Throughout time and place, art has played a similarly important role in depicting and enhancing play, entertainment, and activities. While some of these undertakings involve attending animated sporting events, rock concerts, or dance halls, others, like the Japanese tea ceremony, maintain a quiet, private mood. During the eighteenth century in England, tea was imported from China. As in Japan, the tea service was an important activity. The woman of the house, rather than a servant, brewed the expensive leaves, and she used different essential accoutrements, an example of which can be seen in Elizabeth Godfrey's George II tea caddies (figure C18.2) from Chapter 11. Unlike in Japan, however, in eighteenth-century England, the tea service was a luxurious affair, evident in the silver material of the caddies.

**FIGURE C18.2    Elizabeth Godfrey. Pair of George II tea caddies reconsidered.**  Many artists, like Godfrey, have formed objects that have enabled people to participate in recreation; however, other artists have produced works depicting the activity itself.

### Relaxation, Tranquility, and Contemplation

The chapter we just finished describes the tranquility of the dry garden (figure 18.36), which helps Zen Buddhists meditate for hours. The features of the garden encourage contemplation. The faithful hope that through reflection, they can find enlightenment, thereby using art to achieve a goal of the Zen Buddhist faith.

The Court of the Lions (figure C18.3), from Chapter 16, similarly offers a peaceful setting. In the courtyard, located in a fourteenth-century Islamic palace called the Alhambra, four water channels extend from a central fountain out to a rectangular, arcaded area with ornamented surfaces. The running water and rhythm of the arches create a serene, relaxing space, which was designed for the ruling family's enjoyment. Further, like the dry garden's links to Zen Buddhism, several features of the courtyard emphasize Islamic beliefs, such as the channels of water that can be compared to the four rivers in the garden of paradise.

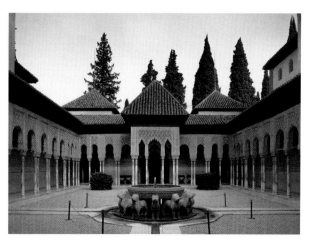

**FIGURE C18.3** **Court of the Lions reconsidered.** The channels of water in the Court of the Lions, while creating a relaxing space, also reference the garden of paradise, which is meant to symbolize heaven. Similarly, architects often design memorials to the dead as tranquil spaces that invite contemplation.

### Make Connections

*The Boating Party* (figure C18.4) by American Mary Cassatt, from Chapter 2, depicts a mother and child out for a boat ride. The nineteenth-century painting shows the child resting casually on the mother's lap. A man, whose face we mostly cannot see, rows the two around the water. How does the scene relate to the theme of work, play, and relaxation?

What other visual examples can you come up with from across the book and from today's world that reflect this theme? How are people's motivations across time and place similar and different?

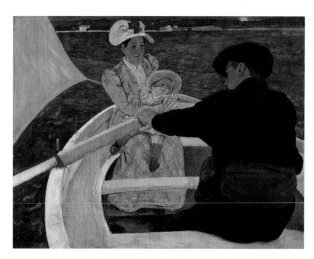

**FIGURE C18.4** **Mary Cassatt.** *The Boating Party* reconsidered.

# 19

# Eighteenth- and Nineteenth-Century Art in the West

**DETAIL OF FIGURE 19.1.**
In the nineteenth century, artists in the West rejected the smooth, neatly finished surfaces of works from the eighteenth and prior centuries. Here, in a detail of *The Luncheon on the Grass*, these new approaches to technique are evident in the painterly marks on the woman's dress and the bare canvas showing through the paint in the area under her head.

## LEARNING OBJECTIVES

**19.1** Explain how Rococo art reflected the frivolous lifestyle of the upper class during the early and mid-eighteenth century.

**19.2** Describe the features of Neoclassical art.

**19.3** Summarize the subject matters that Romantic artists depicted.

**19.4** Describe why Realism was shocking to the public.

**19.5** Identify the objectives of Impressionist artists.

**19.6** Contrast the different paths that artists took in the Post-Impressionist period.

**19.7** Explain how the Art Nouveau movement combined influences from the Rococo and Post-Impressionist styles.

## HOW art MATTERS

# EDOUARD MANET'S *THE LUNCHEON ON THE GRASS*

In 1863, as it had for almost two hundred years, the French Academy of Fine Arts prepared for its Salon (sah-law). The Salon was an art exhibition that attracted thousands of Parisians each year. At the time, the Salon was the only way for artists in France to establish a reputation. Artists who were included could expect to sell their works, while those who were rejected would find future sales a challenge.

▷

How Art Matters

The jury of renowned artists for the 1863 Salon was incredibly selective. An uproar among the excluded artists ensued. Hoping to defuse the situation, Emperor Napoleon III declared a compromise: the rejected paintings would be shown in another section of the building.

The *Salon des Refusés* (sah-law day ray-foo-zay) (Salon of the Rejected), as it came to be known, drew huge crowds—seven thousand people on opening day. Most spectators were negative, and the majority singled out a painting by French artist Edouard Manet (ayd-WAHR mah-NAY) for particular disapproval. This work (figure 19.1) is now known as *Le Déjeuner sur l'herbe (The Luncheon on the Grass)*.

It is hard to imagine today why this painting was so offensive. The nude was a popular subject matter at the time. In fact, another painting exhibited in the Salon that year, *Birth of Venus* (figure 19.2) by Frenchman Alexandre Cabanel, also featured a nude and was purchased by the emperor for his collection.

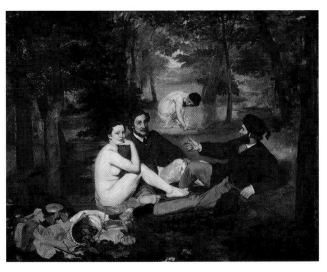

**FIGURE 19.1. Edouard Manet.** *Le Déjeuner sur l'herbe (The Luncheon on the Grass)*. *1863. Oil on canvas, 7' × 8' 8". Musée d'Orsay, Paris.* This painting shocked 1863 audiences, who found it indecent.

**FIGURE 19.2. Alexandre Cabanel.** *Birth of Venus*. *1863. Oil on canvas, 4' 3 ¼" × 7' 4 ½". Musée d'Orsay, Paris.* Cabanel's painting was considered in good taste, even though the nude exposes more of her body in a significantly more seductive pose.

## Academic Art

To appreciate these contrasting views requires an understanding of *academic art*, which refers to art that followed the Academy's prescribed and conservative artistic rules. By 1863, the Academy had established strict standards:

» The *most important works known as "history paintings,"* which depicted noble themes and figures from history, the Bible, books, or mythology, *could be produced at the largest size*.
» *Other subject matters*, including portraits, genres (scenes from daily life), landscapes, and still life paintings (inanimate objects such as flowers, books, or fruit), *were relegated to smaller sizes*.
» *Figures had to be classically inspired*, idealized, and naturalistic.
» *Brushstrokes had to be invisible*, so that surfaces appeared smooth.
» *Modeled tones had to transition softly* from dark to light.

Cabanel's *Birth of Venus* met all requirements. Its *subject matter* of the story of Venus (goddess of love), who was born from the sea, stemmed from *mythology*. In the painting, Venus floats on the water, while Cupids celebrate her birth above. In addition, the *work is large*, befitting a history painting, and Venus's body is *classic, youthful, and flawless*. It is also *neatly finished*, polished, and slick. Venus's skin is colored porcelain, and her golden hair shines. Using a time-honored technique, Cabanel first painted a dark ground and then patiently added layers of light, transparent glazes (see Chapter 6). His *dark tones melt into lights in a slow gradation*. As a result, the entire painting radiates a glossy richness.

### Manet Broke Academic Rules

By contrast, Manet's *The Luncheon on the Grass* defied Academy expectations:

» *Manet depicted a scandalous scene on an immense canvas.* Viewers were sure his work portrayed male students out with prostitutes. The fully dressed men sit in a clearing with a naked woman, while, in the background, another woman bathes in a river, wearing only a loose-fitting dress. The women appear as everyday contemporaries rather than as idealized, mythological goddesses. Manet also painted the scene on a canvas that was larger than life size, disregarding the guidelines of leaving the largest works for upstanding themes.

» *Manet intentionally combined different subject matters.* He included figures and a still life (a basket filled with ripe cherries, figs, and peaches) together. Also, the still life didn't make sense, since cherries ripen in June and figs, not until September.

» *Manet discarded academic and traditional stylistic methods.* He made no attempt to hide thick, caked-on brushstrokes and left the canvas bare in places. For example, the woman in the background (chapter-opening detail of figure 19.1) appears unfinished, as though she has been "drawn in" casually with paint, and the canvas peeks through the transparent paint in the water beneath her head. Manet also omitted middle tones traditionally used as transitions from light to dark. For example, the woman in the foreground has pasty skin that is jarring against the surrounding dark tones (figure 19.3). He also scaled the woman in the back of the painting so large that she does not follow traditional rules of diminishing size. Yet, Manet seemed to mock convention as the four figures establish a composition that had been found in paintings for centuries.

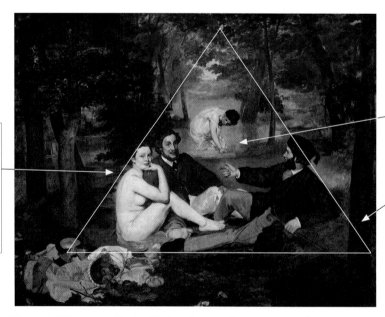

This woman *has no soft modeling.* Instead, an abrupt, dark contour line appears under her leg and neck, making her look as though she is a flat cutout stuck on the surface.

Because this woman is so large, it appears as if her hand can touch the outstretched hand of the man. Both her size and this positioning *bring her radically forward in pictorial space.*

The figures *form a stable, traditional composition* with their placement in an equilateral triangle.

**FIGURE 19.3.** Edouard Manet. *Le Déjeuner sur l'herbe (The Luncheon on the Grass)* reconsidered.

**FIGURE 19.4.** Titian. *The Pastoral Concert. c. 1509. Oil on canvas, 3′ 5 ¼″ × 4′ 6 ⅜″. Louvre Museum, Paris.* Titian's painting, like Manet's, depicts two dressed men with two female nudes; yet, here, the two men play a lute, while, unbeknownst to them, two nude mythological muses have joined them.

**FIGURE 19.5.** Marcantonio Raimondi after Raphael. *The Judgment of Paris* **reconsidered in a detail.** Raimondi's print depicts three figures sitting by a river. Manet used their same poses for his foreground figures, who likewise sit in front of a river.

## The Public Thought Manet Demeaned Two Master Artists' Works

Along with these challenges to the Academy, Manet further disturbed viewers with obvious *references to two master artists' works*. Manet had adopted his *subject matter* from a Renaissance painting by Italian artist Titian (ti-shen) (figure 19.4). He had derived his *composition* from a portion of an engraving (figure 19.5) by Italian artist Marcantonio Raimondi (we considered the entire engraving in Chapter 7). It seemed to the public as if Manet was referring to these earlier works to demean them, even though there is no evidence that this was Manet's intent.

## Why Did He Do It?

Manet was a respected member of society. He had won an honorable mention at a prior Salon for a different painting, and throughout his life, Manet submitted to the Salon, firmly believing in the exhibition as the way to gain credibility as an artist. Yet, he had the courage to move forward with new ways of thinking. So, why did Manet decide to flout convention with *The Luncheon on the Grass*?

The answer to this question lies at the core of this chapter. Many scholars see *The Luncheon on the Grass* as the *first great Modern work of art* because it challenged past conventions of subject matter, size, and style; received numerous negative critiques when it was first exhibited; and brought new focus to technique and method.

Other scholars contend that *Manet was the last great old master*, since he attempted to work within the academic mainstream by submitting his work to the Salon. He also used traditional compositions and looked to past works for inspiration.

This chapter considers the changing art of the eighteenth and nineteenth centuries in the West (Europe and the United States), which in this period moved from the old world into the modern era. Before moving forward, based on this story, what do you think were the most significant changes affecting art during this period?

CHAPTER

# 19

# The Eighteenth Century

The content of this chapter begins in the eighteenth century, an age that preceded Manet. The eighteenth century was a time of changes in the West. Initially, absolute monarchs ruled with a firm hand, believing they received their authority from God. However, following the scientific revolution of the previous century, a new philosophical movement called the *Enlightenment* was changing the way people thought about society and governance. Enlightened thinkers *applied logic to politics and the human condition*. Stressing reason as the means to a more perfect society, eighteenth-century thinkers believed that monarchs should rule with the consent of the governed and in the best interests of their subjects.

Throughout the century, the authority of kings declined as monarchs attempted to enact unpopular measures, such as new taxes, which enlightened thinkers rejected as unlawful abuses of power. Toward the century's end, enlightened political thought continued to move toward *rule by the people*. This groundbreaking idea underlay the American Revolution, where the people rejected being ruled by the British king, and the French Revolution, where radical forces sent the monarchs to their deaths.

Along with the *increased power of the people*, toward the end of the eighteenth century, the West saw its *first public museums*. While previously much art had been kept by kings, now the public had access to it. This change allowed later artists, like Manet, to study masterworks with ease.

Across Europe, the eighteenth century also saw the *triumph of art academies*, many of which had been established in the earlier two centuries. As the academies grew in power, they held exhibitions such as the French Academy's **Salon**, where artists could show their work to the public. With the increased purchasing power of the middle class, art buyers expanded from state and religious institutions and the aristocracy to the people who frequented the exhibitions. Rather than having works privately commissioned, *artists began to create art for an open market*. Accordingly, they produced works that would meet jury approval. A *consistent approach in art to subject matter and style* thus governed the artistic landscape. It was this **academic art**, which followed the prescribed and conservative artistic conventions endorsed by the academies, that Manet later rejected.

## The Rococo

After the absolute monarch Louis XIV died in 1715, the French aristocracy was no longer required to live at Versailles (see figure 15.33). Appreciating its new freedom, the upper class built elegant townhouses in Paris. In these luxurious homes, high-society women held social gatherings. Their intellectual participants valued witty conversation focused on Enlightenment thinking. From these sophisticated settings, a new style emerged called the **Rococo** (roh-coh-COH), which reflected the attitudes and pleasures of the upper class. (The Rococo along with all styles covered in this chapter can be seen on the timeline in figure 19.6)

The word Rococo comes from the French words *"rocaille"* and *"coquille,"* which refer to pebbles and seashells. The ornate and playful Rococo:

- Used *decorative items* such as shells, plants, clouds, pearls, and cherubs
- Depicted *lighthearted subject matters*
- Employed a *graceful style* that favored warm, pastel colors, creamy brushstrokes, and gentle curves
- Used *coordinated architectural forms, furniture, objects, and fine art* in unified designs

**Salon**  The French Academy of Fine Arts' official exhibition of paintings and sculptures

**academic art**  Art that the French Academy of Fine Arts and other European academies endorsed and that followed prescribed and conservative artistic conventions

**Rococo**  A style of art in the West in the eighteenth century associated with upper-class pleasure, lighthearted playfulness, and ornate decoration

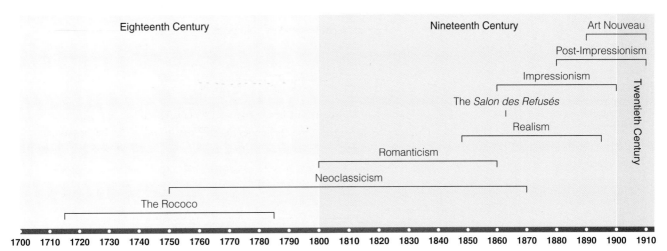

**FIGURE 19.6. Timeline of Eighteenth- and Nineteenth-Century Art in the West.** The Rococo was an eighteenth-century style, and while we also classify Neoclassicism in this chapter as an eighteenth-century style, its influence was felt into the nineteenth century. All other styles covered in this chapter were predominantly nineteenth-century styles; however, Post-Impressionism and Art Nouveau lasted into the early years of the twentieth century.

Interactive Timeline

## Decorative Objects

While a complete Rococo room is pictured in Chapter 1 (see figure 1.40), here, a pair of candlesticks (figure 19.7) gives a sense of the extreme *wealth and playfulness of the Rococo.* Cast in bronze, the candlesticks were coated in gold to create a gleaming surface. Unlike traditionally formal and matching candlesticks, these feature asymmetrical, organic forms, bulging, growing, and swirling as if they themselves are the flickering flames. Amid the swags and curves are flowers, leaves, shells, and even a butterfly. The candlesticks undoubtedly would have added an elegant, lighthearted touch to any room.

## A Lighthearted Painting

The upper class frequently decorated their homes with Rococo paintings. *Return from Cythera* by French artist Jean-Antoine Watteau (jhahn ahn-TWAHN wah-TOH) typifies their *carefree subject matters.* Here, upper-class couples return from Cythera, Venus's mythological island of love. Designed to appeal to the elite's playful tastes, the painting depicts dainty figures dallying in a rustic clearing, while behind them a river recedes (figure 19.8).

Watteau also used an *elegant style.* He depicted the couples in soft colors and a misty light that seems to make the image appear to be a dream. He also used delicate brushstrokes to create the soft curves that echo across the surface, forming a gentle rhythm.

## A Rococo Queen

While Watteau illustrated a lighthearted subject matter, *nothing was more Rococo than an image of the French queen, Marie Antoinette.* In her lavish spending on her clothing, jewelry, and palace, she symbolized the extravagance of the elite.

**FIGURE 19.7. Juste Aurèle Meissonnier. Pair of candlesticks.** *1735–50. Gilt bronze, each 12 ⅛″ × 7 ⅜″. The Metropolitan Museum of Art, New York.* Numerous flames in sumptuous candlesticks such as these lit the opulent interiors of the upper class.

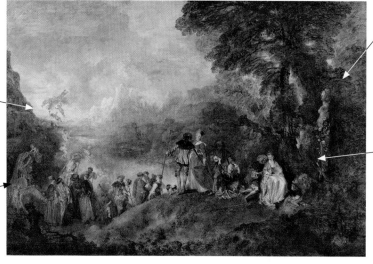

*Cupids*, who work to promote romance, fly above and intermingle with the people.

*A golden boat* waits to bring lovers back to the real world.

*A sculpture of Venus* is decorated with roses.

*Three graceful couples* illustrate the different moments of the lighthearted afternoon. At right, the couple is self-absorbed. At center, lovers rise to their feet, while at left, another couple walks toward the boat, sadly glancing behind them.

**FIGURE 19.8.** Jean-Antoine Watteau. *Return from Cythera. 1717. Oil on canvas, 4' 3" × 6' 4 ½". Louvre Museum, Paris.*

**artists**
MATTER
Elisabeth Vigée-Lebrun

In an intimate portrait by French painter Elisabeth Vigée-Lebrun (ay-leez-eh-BETT vee-JHAY leh-BRUN), the monarch seems feminine and romantic, yet assertive (figure 19.9). She poses in her finery: a satin and lace dress, powdered wig, and feathered hat. Yet, she stares out at the viewer appearing to tell us of her self-assuredness.

*Rococo stylistic tendencies are everywhere.* Bows, pearls, and feathers adorn the queen. With her pink cheeks, powdered wig, and creamy skin, she is a vision of pastel tones. Her idealized figure, the polished surface, and the soft modeling of her form follow Rococo—and academic—preferences completely. Finally, gentle curves can be found throughout the image, from the lace on her dress to the petals of the rose she displays.

*Quick Review 19.1:* How did Rococo art reflect the frivolous lifestyle of the upper class during the early- and mid-eighteenth century?

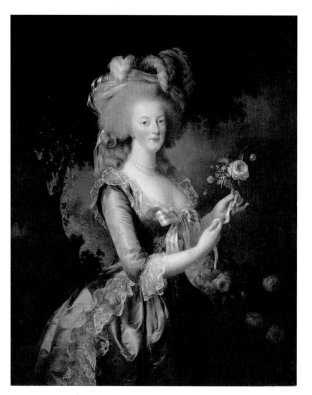

**FIGURE 19.9.** Elisabeth Vigée-Lebrun. *Marie Antoinette with a Rose. 1783. Oil on canvas, 3' 8 ½" × 2' 10 ¼". Palace of Versailles, France.* The queen holds a rose, a flower known for its beauty and delicacy.

## Neoclassicism

Ultimately, Enlightenment thinkers could not accept the superficial and fussy Rococo fashion. This elitist style could not last in an age in which thinkers were turning their attention to the good of the people.

A new style emerged, called **Neoclassicism** ("new clasicism"), in which artists looked back to Classical Greece and Rome. In the mid-1700s, archaeological excavations unearthed a number of ancient finds (see Chapter 13) that helped popularize ancient Greek and Roman values. Enlightened thinkers looked back to this heritage, hoping to educate the public on what they believed were Classical attitudes of civic duty, patriotism, and responsible citizenship. With this effort, *art became a call to action as propaganda for the French and American Revolutions.*

In Neoclassicism, artists hoped to pursue the Enlightenment goal of developing virtuous citizens by:

- Portraying *Classical subject matters*
- Imitating *Classical styles* through using idealized, naturalistic figures; crisp contours; restrained emotions; and ancient architectural settings
- Following *academic convention* by portraying noble subject matters on large-sized canvases; flawless, perfect figures; and polished surfaces with no visible brushstrokes
- Employing *rational compositions* by using balanced color schemes and overall stable shapes

**Neoclassicism** A style of art in the West in the eighteenth and nineteenth centuries in which artists, hoping to instill in the public virtues of the Enlightenment, portrayed Classical subject matters and imitated Classical form

## A Model of Classical and Academic Subject Matter and Style

*The Oath of the Horatii* (hoh-ray-SHEE-eye), by French artist Jacques-Louis David (jhahk loo-EE dah-VEED), exemplifies the Neoclassical approach. In terms of *subject matter*, David chose an *ancient Roman legend*. In the story, Rome agreed to resolve a dispute with its neighboring state of Alba by a duel. Chosen for battle were two sets of three brothers—the Horatii, fighting for Rome, and the Curiatii (kyoo-ree-ah-SHEE-eye), fighting for Alba. Poignantly, one of the Horatii brothers was married to a sister of one of the Curiatii, while one of the Curiatii was engaged to a sister of the Horatii. In figure 19.10, the beginning of the story unfolds.

Matching the ancient subject matter, David employed a *Classical style*. Idealized, naturalistic figures populate only the foreground, as if they are sculptures on an ancient architectural frieze (see Chapter 12). A sharp side-light accentuates the men's chiseled bodies, while crisp contours delineate their forms. Even though David created an intense moment, the men's emotions are restrained, as in ancient Greek sculpture (see Chapter 13). Behind the figures, three austere, round Roman arches cut off the recession into space, simplifying the composition and limiting it to a focus on the figures.

**artists**
MATTER

Jacques-Louis David

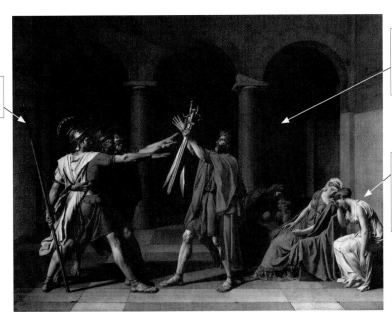

The three Horatii brothers swear allegiance to Rome.

Their father, representing the state, presents them with swords, approving their sacrifice.

Sisters of the Curiatii and Horatii weep. At the very least, they will lose either their brothers or their beloveds.

**FIGURE 19.10.** Jacques-Louis David. *The Oath of the Horatii.* 1784. Oil on canvas, 10' 8 ⅜" × 14'. Louvre Museum, Paris.

As in Cabanel's *Birth of Venus* (figure 19.2), David followed *academic convention*. He created a morally uplifting history painting at an enormous size. His figures have idealized, perfect bodies. No brushstrokes are evident anywhere on the painting.

In addition, the painting is a *model of rational, structured Enlightenment thought*. In contrast to the frilly excesses of the Rococo, there appears a calm, focused intent. The balanced, triadic color scheme (see Chapter 3) and boldly colored garments help emphasize the strength of the men's resolve. The brothers' rigid stance, one uniformly behind the next, creates a powerful rhythm that seems to reinforce their singular goal. Understandably, the painting (which, ironically, was originally painted for the king) became popular with leaders of the French Revolution. The confident Horatii men offered an inspirational message for the people to stand up for the greater good of the Republic.

On the other hand, the *women* in the painting, whose limp bodies collapse in the face of danger, appear to *represent a negative model*. Their bodies are smaller than the men's, so are seemingly insignificant. They are placed lower on the painting's surface, so beneath the men. The colors on their garments are muted versions of the strong hues on the men. Finally, the father has his back to the women, ignoring their sentimental emotions and individual despair in favor of addressing the public good.

*No longer are aristocratic women the center of attention* as they were in the Rococo. As if to make the point, the women's bodies create rounded curves—a favorite Rococo motif. There was no place for graceful forms in the harsh, Neoclassical world. To consider how a female artist worked in the Neoclassical world, see *Practice Art Matters 19.1: Identify the Neoclassical Features in a Work.*

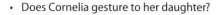

*Practice* **art**MATTERS

## 19.1 Identify the Neoclassical Features in a Work

Swiss-born Angelica Kauffmann in *Cornelia, Mother of the Gracchi, Pointing to Her Children as Her Treasures* (figure 19.11) also looked back to the ancient world and used art to educate viewers about correct moral behavior. The ancient Roman story tells of a wealthy woman who visited the widow Cornelia. The woman showed off her jewels (which sit in her lap) and asked to see Cornelia's. Prizing patriotic virtues over insignificant baubles, Cornelia nobly gestured to her sons, future Roman citizens, as her treasures.

Identify the features in Kauffmann's painting that make it Neoclassical. Focus on the work's:

- Subject matter and goal
- Classical style
- Academic style
- Rational approach

Also, consider how Kauffmann, even though a female artist, reinforces the sexist attitude that we saw in David's painting:

- Does Cornelia gesture to her daughter?
- What is her daughter doing?

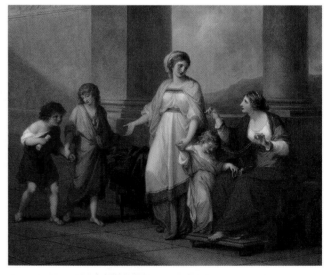

**FIGURE 19.11.** **Angelica Kauffmann.** *Cornelia, Mother of the Gracchi, Pointing to Her Children as Her Treasures.* c. 1785. Oil on canvas, 3' 4" × 4' 2". *Virginia Museum of Fine Arts, Richmond.*

## Consistency and Changes in Later Neoclassicism

Jean-Auguste-Dominique Ingres (jawn oh-GOOST dohm-een-EEK AN-gr') completed the Neoclassical work *Jupiter and Thetis* in the early years of the nineteenth century. The French artist depicted the *Classical story* of the nymph Thetis, who appealed to the supreme leader of the ancient Greek gods, Jupiter, to help her son in the Trojan War. In the painting (figure 19.12), Thetis is left in a position of *extreme subordination in the face of male power.*

Ingres's work demonstrates *conventional Neoclassical style.* Echoing a *Classical approach,* Ingres pushed Jupiter and Thetis into a narrow space close to the picture plane. He showed naturalism, in his depiction of the light fabric gathered around Thetis's legs, and idealism, in Jupiter's massive, muscular trunk. Ingres also followed *academic rules* in his polished finish with no visible brushstrokes. Finally, he took a *rational approach* in that his figures form an ordered triangular composition, with Jupiter's head at its apex. Even the characters' clear-cut positions—Jupiter who is straight on and centered and Thetis who is in perfect profile—simplify the two figures.

In these stylistic decisions, we can see the *academic conventions* that were still in place when Manet submitted *The Luncheon on the Grass* to the 1863 Salon. *Jupiter and Thetis* is a dignified history painting of a Classical subject matter depicted using a traditional technique, and it includes an idealized, nude woman.

However, some aspects of Ingres's work hint at changes that were to come. Ingres sacrificed an imitation of reality for a more *stylized approach.* The depiction of Thetis does not accurately portray a human body. She appears to have no right shoulder as her arm slopes in an elegant curve across Jupiter's lap. Moreover, her neck can barely be

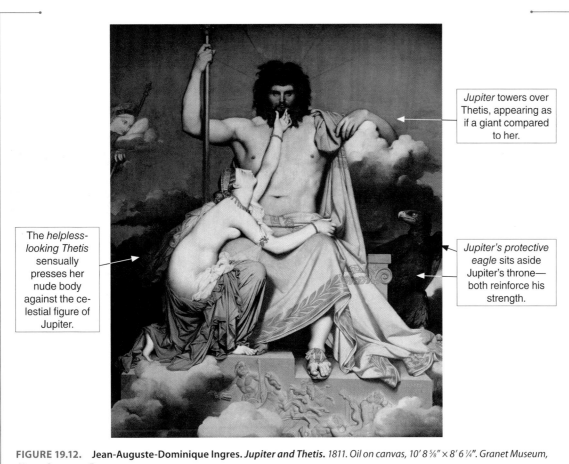

*Jupiter* towers over Thetis, appearing as if a giant compared to her.

*Jupiter's protective eagle* sits aside Jupiter's throne—both reinforce his strength.

The *helpless-looking Thetis* sensually presses her nude body against the celestial figure of Jupiter.

**FIGURE 19.12.** **Jean-Auguste-Dominique Ingres.** *Jupiter and Thetis.* 1811. Oil on canvas, 10′ 8 ⅝″ × 8′ 6 ¼″. *Granet Museum, Aix-en-Provence, France.*

FIGURE 19.13. **Thomas Jefferson. Monticello.** *1769–82 (original house) and 1796–1809 (enlarged house with dome), Charlottesville, Virginia.* Monticello shows a number of repeating architectural features including the rectangular windows and shutters, semicircular dome and window in the triangular pediment, and triangular pediment and triangle over the central door.

distinguished from her chin; her head and neck become a single shape pointing toward Jupiter's face. Ingres changed Thetis's body likely to exaggerate the graceful, curving lines that her distorted form creates. The linear quality flattens Thetis's body, which helps to emphasize the content: unquestionably, Jupiter is the unyielding male and Thetis the desperate female.

## Neoclassicism in Architecture and Objects

The Neoclassical style was not limited to painting, as ancient forms also served as a model for architecture. In the United States, Thomas Jefferson saw Classical values of democracy and republicanism as the perfect embodiment of the ideals of the new American nation. Neoclassicism supported these principles.

Jefferson modeled his home, Monticello, on *Classical architectural ideals*. The building (figure 19.13) mimics the design of the Roman Pantheon (see figure 12.1) with its central dome fronted by a post-and-lintel porch (see Chapter 12). Harmony and rationalism are also key elements of the design. The structure has pure symmetrical balance as the right side mirrors the left (see Chapter 4). Additionally, repeating geometric forms create an ordered and dignified rhythm.

Neoclassicism also influenced objects. The urn in figure 19.14 was modeled after a Hellenistic vase (see Chapter 13). Revelers celebrate with the ancient god of wine, who stands at center holding a staff. As in other Neoclassical works, a *Classical style* complements the *ancient subject matter*. Realistic, idealized figures stand in elegant poses in a row, as if on an architectural frieze, their bodies formed in low relief. They shift their weight in *contrapposto* stances (see Chapter 13), creating a flowing sense of movement and rhythm around the vase. Finally, the urn appears ordered, geometric, and balanced.

The urn is also a perfect example with which to transition to the nineteenth century, as the piece was created in Josiah Wedgwood's factory in Great Britain. During the eighteenth century, what came to be known as the Industrial Revolution found its start in England. Modern, rapid manufacturing processes began to be used to form items that had been handcrafted for centuries. Wedgwood created his factory to mass-produce Classically inspired objects fashionable among the upper and middle classes.

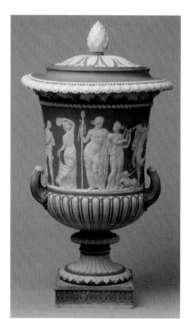

FIGURE 19.14. **Jan de Vaere (modeler). Urn with cover modeled after** the *Borghese Vase.* *From the factory of Josiah Wedgwood. c. 1780–1800. Jasperware, height with cover 18 ⅝".* *The Metropolitan Museum of Art, New York.* All figures are young and blemish-free and show restrained emotions, just like figures from ancient Greece (see Chapter 13).

*Quick Review 19.2*: What are the features of Neoclassical art?

# The Nineteenth Century

During the nineteenth century, the *Industrial Revolution spread throughout Western society*. Factories sprung up in which large numbers of workers produced goods using machinery powered by steam (and later electricity). These laborers, including children, were often exploited. Society became more urban, as people moved from agricultural to manufacturing jobs. Cities became more crowded, and slums developed that housed poor factory workers.

Industrialization led to other changes, many of them positive. For the first time, people could easily travel great distances on railroads, better-surfaced roads, and steamships. Consumers benefitted from newly available manufactured goods. People could move more easily between classes, especially as literacy surged to provide factories with educated workers. A number of medical and scientific breakthroughs were heralded, such as anesthesia, the X-ray, and the camera. Moreover, optimism flourished, with a belief in progress and the notion that individuals, with the help of science, technology, and manufacturing, would continue to improve people's lives.

Politically, the century began with the French leader, Napoleon, overtaking much of Europe (figure 19.15) before later being exiled and imprisoned. While Napoleon was a brutal dictator, he instituted numerous reforms that preserved many of the goals of the French Revolution. He standardized laws, discarded privileges of the aristocracy, and declared all men equal before the law. Democratic ideas from both the French Revolution and Napoleonic society spread through Europe, and while there

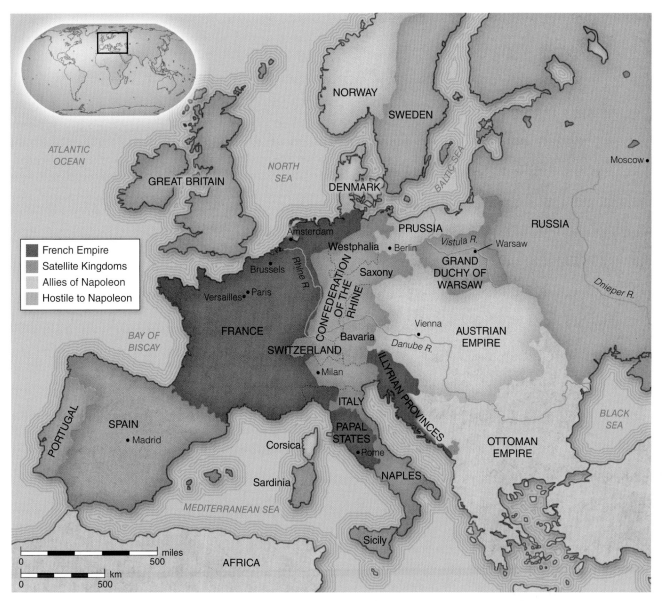

**FIGURE 19.15. Europe around 1810.** Napoleon's impact on Europe is evident in the map. Around 1810, vast areas of the continent were under either French control or influence.

were setbacks, these ideas opened the door to more representative governments across the West.

Toward the end of the century, Europeans conquered new territories in Asia, Africa, and the Pacific. These lands provided raw materials needed for the industrialized societies. The Europeans justified their expansion by claiming they were bringing "uncultured" peoples the "benefits" of civilization. Such racist views not only were accepted, but even were seen as morally necessary.

With the beginning of modern, industrialized societies, we also find the beginnings of Modern art, as established by artists such as Manet. Just as modern society turned its back on longstanding social, cultural, and political traditions, so **Modern art** moved away from time-honored, academic principles. Modern art challenged the domination of the academies and the formulaic art they championed. While not every Modern work exhibits the following principles, we will define Modern art as art that:

- *Rejected academic conventions* of subject matter, size, and style
- *Advanced original approaches* that the mainstream at first criticized and rejected, but eventually accepted
- *Drew attention to the technique*, manipulation and application of the media, and surface of a work

## Romanticism

The beginning of the nineteenth century ushered in a new artistic style called **Romanticism** that is associated with dramatic emotions. The style was born of hardship. The Napoleonic wars led to countless deaths, food shortages, and significant suffering. The world seemed to be swept by overpowering forces that were beyond people's control. This *feeling of helplessness in the face of an overwhelming world* influenced Romantic artists.

In Romanticism, to suggest the vivid passions of the times and express a mindset of powerlessness, artists:

- Sought to *capture a feeling of supreme awe* known as the *sublime* (for example, if you watch a volcano erupt from a safe distance, you are afraid of the overwhelming destruction, yet you cannot look away from the thrilling display of nature's unknowable power)
- *Portrayed sublime subject matters*, including uncontrollable current events; exotic, violent cultures; and mysterious, awe-inspiring landscapes
- Frequently *employed strong colors, contrasting values, painterly marks*, and *illusions of violent movement*

Art historians have seen *Romanticism as the root of Modernism*, as artists moved away from historical subject matters and academic conventions of crisp contours and polished surfaces. In this respect, Romantic artists influenced Manet.

### Uncontrollable Current Events

The work of Spanish painter Francisco Goya (frahn-SISS-koh GOY-ah) illustrates how Romanticism portrayed *sublime, uncontrollable, current events. The Third of May, 1808* (figure 19.16) documents how on that date Napoleon's troops brutally shot without a trial all Spanish citizens suspected of participating in an uprising against French forces. The scene appears as riveting as it is horrific.

Goya used Romanticism's *aggressive stylistic techniques* to portray the passion of the moment. Warm reds and yellows collide with cool blues. Strong value contrasts help to

**Modern art** Art that rejected academic conventions of subject matter, size, and style; advanced original approaches that the mainstream at first criticized and rejected, but eventually accepted; and drew attention to the technique, the manipulation and application of the media, and the surface of a work

**Romanticism** A style of art in the West in the nineteenth century associated with dramatic emotion, vivid passions, and depictions of the sublime human and natural worlds

**artists**
MATTER

Francisco Goya

heighten tension. Broad brushstrokes of paint, such as in the red blood slathered on the ground, make the image appear coarse and intense.

A comparison of Neoclassical and Romantic works shows just how far Romanticism had moved from the Neoclassical style. To consider two paintings with similar subject matters, see *Practice Art Matters 19.2: Contrast Neoclassical and Romantic Images*.

Interactive Image
Walkthrough

Spanish citizens about to be slaughtered *display tormented expressions.*

The men coming up the hill *show the methodical pace of the slaughter.*

The man about to be shot kneels, while extending his hands in a pose that simultaneously *communicates helplessness and resolute pride.* The man's outstretched arms remind us of Jesus on the cross.

The soldiers, in matching uniforms, raise their guns in identical stances, faceless and anonymous. Their *repetition* one after the next *gives the impression of an unending line of death.*

Men already shot lay in their own blood. One holds his arms in the same outstretched position of the figure about to be shot. The *repetition creates a rhythm of death,* as the two could be one man at different points in time.

A solitary lamp thrusts a heavenly glow on the Spanish victim. The *rest of the scene,* even the monastery in the back, *has been overcome by darkness.* Singly lit, the man is the sacrificed martyr, ready to die for Spain in the fight against evil.

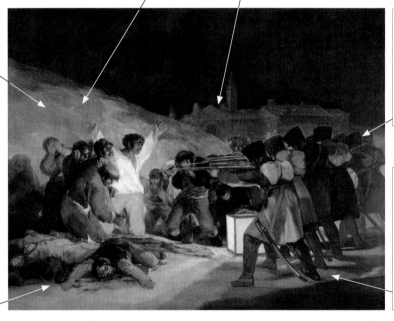

**FIGURE 19.16.** Francisco Goya. *The Third of May, 1808.* 1814. Oil on canvas, 8′ 9″ × 13′ 4″. Prado Museum, Madrid.

*Practice* **art**MATTERS

## 19.2  Contrast Neoclassical and Romantic Images

A comparison of David's *The Oath of the Horatii* (figure 19.17) with Goya's image (figure 19.16) shows the differences between the Neoclassical and Romantic styles. Even though David and Goya both portrayed scenes of impending death involving heroic men who fought for their countries, the paintings are complete opposites.

Describe the major differences in terms of:

- The emotions of the heroes and how the paintings make you feel
- The time periods of the depicted stories
- The colors and the values in the images
- The smoothness of the paint

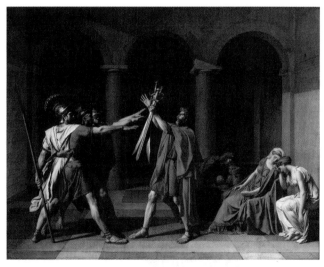

**FIGURE 19.17.**  Jacques-Louis David. *The Oath of the Horatii* reconsidered.

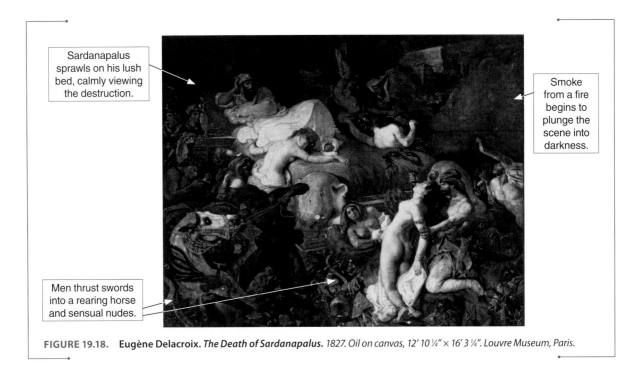

Sardanapalus sprawls on his lush bed, calmly viewing the destruction.

Smoke from a fire begins to plunge the scene into darkness.

Men thrust swords into a rearing horse and sensual nudes.

FIGURE 19.18. Eugène Delacroix. *The Death of Sardanapalus.* 1827. Oil on canvas, 12' 10 ¼" × 16' 3 ¼". Louvre Museum, Paris.

## Exotic, Violent Cultures

*The Death of Sardanapalus* by French artist Eugène Delacroix (you-JEHN duh-lah-KRWAH) illustrates a Romantic artist's venture into what nineteenth-century Europeans saw as an *"exotic" culture.* Delacroix depicted the story of Sardanapalus, a legendary Assyrian king who, when faced with defeat at the hands of rebels, killed himself. Delacroix, though, *embellished the violent account,* imagining that Sardanapalus had ordered that his family, servants, and animals be killed rather than taken by rioting forces. Delacroix's enhancements illustrate *biased Western views of non-Western cultures as being barbaric.* In the painting, Sardanapalus watches while violence and chaos unfold before him (figure 19.18).

*Romantic depictions of violent motion and energy appear throughout.* Bodies are packed into too tight a space, ready to burst out of the canvas. The illusion is so compressed that the foreground space tips up toward us. The bed seems impossibly long, and its strong diagonal appears to rush like an arrow into space. Finally, thick painterly strokes of intense, complementary colors help enliven the surface, seeming to add to the emotion and *sublime terror.*

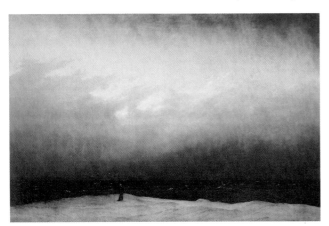

FIGURE 19.19. **Caspar David Friedrich.** *Monk by the Sea.* 1809. Oil on canvas, 3' 7" × 5' 7 ¾". Nationalgalerie, Staatliche Museen, Berlin. In a sublime picture of the infinite, Friedrich depicted a monk contemplating the vast world.

## Mysterious, Awe-Inspiring Landscapes

*Monk by the Sea* (figure 19.19), by German artist Caspar David Friedrich, illustrates the final subject matter of Romantic artists—*land and seascapes.* Here, a solitary preacher stands on top of a cliff that on the far side falls off sharply into wind-blown waves. He stares out into an infinite expanse.

*Friedrich was arguably unrivaled in suggesting the Romantic concept of the sublime.* The monk arches his back, taking in the *overwhelming vastness,* as if straightening under the weight of the immensity is too much for him. From our perspective, we stand just behind him, looking over his shoulder into the uncontrollable world. A great storm seems to be brewing in the distance. We find ourselves *powerless and alone* against its onslaught.

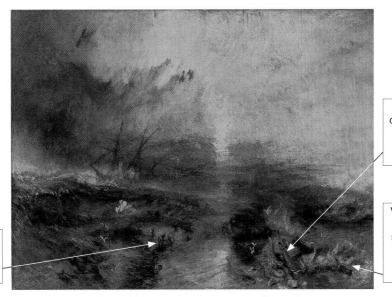

A single chained leg emerges from the sea.

Voracious fish, teeth bared, swarm around the leg, while birds dive in from above.

A slave's hands, still in chains, stretch desperately above the churning water.

**FIGURE 19.20.** **Joseph Mallord William Turner.** *Slave Ship (Slavers Throwing Overboard the Dead and Dying, Typhoon Coming On)*. 1840. Oil on canvas, 2′ 11 ¾″ × 4′ ¼″. Museum of Fine Arts, Boston.

## Combined Subject Matters

Some Romantic artists *combined subject matters*. In the violent seascape *Slave Ship (Slavers Throwing Overboard the Dead and Dying, Typhoon Coming On)*, English artist Joseph Mallord William Turner depicted a current event that had occurred only sixty years before. A slave ship tosses on angry waves as a typhoon approaches (figure 19.20). The captain, knowing the insurance company will reimburse for slaves lost in a storm, has his crew toss any sick or dead slaves overboard. The *overpowering natural forces* render the slaves who are still alive helpless.

*Romantic form adds meaning to the ghastly subject matter*, helping to communicate the horror of the image. The fiery sky and blood red patches in the water likely symbolize the greedy captain's guilt. Dark shadows contrast with glowing highlights shining off of the stormy waves. Violent, rapidly applied strokes of thick paint create a rough texture. Finally, the image is alive with motion, as diagonal lines of destructive waves crash across the surface.

Of all the Romantic painters, Turner arguably came closest to a Modern sensibility and to the work of Manet. He threw, stippled, and smeared his paint onto surfaces, and many of his images appeared unfinished to viewers accustomed to academic, mirror-perfect surfaces. These innovative techniques distorted imagery, making his subject matters appear more abstract.

*Quick Review 19.3*: What subject matters did Romantic artists depict?

## Realism

Revolutions across Europe in 1848 demanded increased rights for the masses, and with this call, a new style called **Realism** emerged that sought a more egalitarian approach to art. Like Manet, Realist artists rejected academic conventions of subject matter and style. Realists:

- *Depicted everyday people performing mundane activities*, rather than elevated subject matters

**Realism**  A style of art in the West in the nineteenth century that charged that everyday people performing mundane activities were an appropriate subject matter for art

- *Painted only what they could see*, including figures that were concrete and living, rather than historical, divine, or mythological
- *Frequently portrayed these everyday people at enormous sizes*, a practice previously reserved for history paintings
- *Worked quickly, with sketchier, broader, and coarser brushstrokes*, to capture the tactile qualities of what they saw, arguing that polished surfaces did not represent reality
- *Drew attention to the paint and how it had been applied* through their more aggressive techniques

Such radical moves were considered inappropriate for art. It was an outrage for Salon attendees to view lower-class people in general, let alone what they believed were the lower-class prostitutes whom Manet depicted. Furthermore, the Realists' crude techniques were considered degrading to the medium of painting itself.

*Realist artists showed a true move to Modernism.* In this respect, these artists were the first to consider themselves part of the *avant-garde* (ah-vahn GARD). The French term stems from military use and refers to soldiers who lead the charge in an attack. In art, **avant-garde** refers to artists who precede the rest, advancing cutting-edge styles and approaches. Initially, people misunderstand and reject these artists' works, but eventually the art becomes an accepted part of the mainstream.

### The Downtrodden

*The Stone Breakers* by French artist Gustave Courbet (goos-TAHV koor-BAY) illustrates the Modernism of Realist art. Two men of no importance break large stones into gravel to be used to pave one of the new roads constructed during the Industrial Revolution (figure 19.21). Courbet had seen the men working on the side of the road and invited them to his studio. These were not posed models of historical figures, but rather *real laborers doing their jobs.*

Nineteenth-century viewers were completely taken aback by what they felt was a *vulgar display.* Art, they believed, was supposed to portray uplifting subject matters with moral messages that would transport viewers to a higher realm. Courbet, they felt, had depicted the ugly.

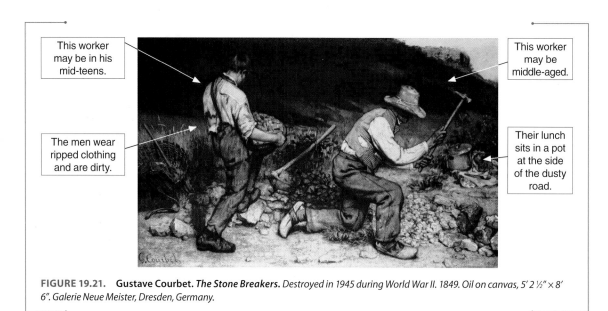

This worker may be in his mid-teens.

This worker may be middle-aged.

The men wear ripped clothing and are dirty.

Their lunch sits in a pot at the side of the dusty road.

**FIGURE 19.21.** Gustave Courbet. *The Stone Breakers. Destroyed in 1945 during World War II. 1849. Oil on canvas, 5′ 2 ½″ × 8′ 6″. Galerie Neue Meister, Dresden, Germany.*

To make matters worse, Courbet *pushed the men close to the viewer*, so they could not be ignored, *depicting them at an enormous size* that had previously been reserved for history paintings. He even *combined subject matters*, including the figures with a still life of their lunch.

In addition, as if to show the grit of the men's lives, Courbet *smeared on thick paint*, bringing out the textures of their broken shoes and rough hands. This heavy paint also *drew attention to Courbet's method of application*.

Courbet clearly understood the *power of art as propaganda*. A staunch supporter of the rights of the downtrodden, he picked subject matters to reveal how unfair life was for the poor. Here, the two men can represent the lifetime of one man. The young man will be stuck with no chance to better himself. He will eventually become like the older man, who, worn out, no longer even stands while working. By depicting the men as so central and large, yet realistic and unattractive, Courbet sought to *dignify people who had previously been ignored*.

Courbet's paintings had a significant influence on Manet. The depiction of everyday people, the mixing of subject matters on one canvas, and the large size of *The Luncheon on the Grass* had roots in Courbet's work.

## Ordinary Life

Henry Ossawa Tanner, an American artist who moved to France in the hope of escaping prejudice, also took up Realism. Tanner, who was African American himself, sought to portray everyday African Americans as they actually were, rather than in the racist, stereotypical ways of the past.

In *The Banjo Lesson* (figure 19.22), Tanner illustrated a commonplace moment. An older man teaches a child to play an instrument. The man appears knowledgeable, and the boy, capable. They sit in an ordinary room, wearing everyday clothing, surrounded by objects found in many homes.

The banjo in the work has significance because the instrument was derived from an African predecessor. In showing the lesson, Tanner *promoted the creativity of the man's and boy's ancestors*. Further adding dignity to the image, the child holds his hand in an upward plucking style. When brought to this country, African Americans had strummed the instrument downward, but when the instrument had been marketed to white Americans, it was with an upward movement to disassociate it from African American culture. In having the man teach the boy to pluck, Tanner showed that African Americans could master either method of playing.

Like Courbet, Tanner used *Realist techniques*. His figures are centrally placed close to the viewer, giving them a solemn dignity. As well, Tanner slathered thick paint on the surface, creating pronounced texture for the battered floorboards and worn clothing.

## Animals

The work of French artist Rosa Bonheur (ROH-zuh buhn-ER) illustrates how Realist artists depicted subject matters other than people. As a female artist, Bonheur did not have access to nude models, so she specialized in portraying animals. Even depicting animals was a challenge, as many places, such as the horse market in Paris, were off limits to women. Bonheur often wore men's clothing, so she would not be noticed.

Frying pan

**FIGURE 19.22. Henry Ossawa Tanner. *The Banjo Lesson.** 1893. Oil on canvas, 4' 1" × 2' 11 ½". Hampton University Museum, Hampton, Virginia.* Helping to emphasize the ordinariness of the scene, a frying pan on the floor mimics the shape and orientation of the banjo, establishing a regular rhythm.

*The Horse Fair* (figure 19.23) shows one of these displays. Several men march the animals past, illustrating the horses' power and beauty. As with Courbet and Tanner, Bonheur offered a *common scene of modern life* and depicted this image at *a gigantic scale* that honored the animals and handlers.

*Quick Review 19.4*: Why was Realism shocking to the public?

## Impressionism

In the latter part of the nineteenth century, a group of artists—some of whom had been rejected by the Salon—exhibited together in an independent venue. Likely drawing confidence from the *Salon des Refusés*, they showed work from 1874 until 1886, originally calling themselves the Anonymous Society of Artists, Painters, Sculptors, Printmakers, etc.

### Focused on What We Actually See

For centuries, academic convention had relied on how we comprehend objects in our minds. Tradition dictated that artists use local colors (see Chapter 3) and harmonious compositions. The new artists, though, *focused on what we actually see, depicting our continually moving reality.*

Objects, these artists said, rarely appear in local color. Variations in the weather or time of day or year impact what, for example, the color of the ocean appears to be. At sunset, it may be orange. However, at night, it blackens.

Similarly, objects do not normally arrange themselves in pleasing compositions. Typically, our eyes take in unplanned slices of moving life. We also see only part of a space detached from the rest of the world, just as a photo may cut off someone's legs.

These artists suggested that if they were going to capture changing settings, they couldn't take the time to paint as artists had for centuries, indoors, by building up dark-toned grounds with numerous layers of glaze, creating soft transitions between lights and darks, and modeling forms. In fact, why, they asked, should they stay inside when new paints packaged in portable tubes made it possible to go anywhere? These artists' works featured:

- *Colors seen in real life*
- *Compositions truer to the shifting world*
- *A looser method of applying paint* in which paint is quickly "sketched" in on light-toned canvases with obvious, divided brushstrokes
- *A flattening of images,* as the techniques make objects feel closer to the space of the picture plane

- *Subject matters that illustrate fleeting moments*, including landscapes, the urban middle class, and the working poor (although subject matters became less significant)
- *An approach called working **en plein air*** (on-PLEN-ayr) *or outside*, in order to capture everyday scenes and the effects of changing light and atmosphere
- *Smaller paintings designed to appeal to the open market*

**en plein air** An approach to painting in which artists paint outdoors to capture everyday scenes and effects of light and atmosphere

Ironically, in their attempt to capture reality, these artists created paintings that we could consider *less representational*. In fact, many nineteenth-century viewers had trouble making out the subject matters of the paintings, as the canvases appeared muddied to them. These paintings, thereby, fit into Modernism in their technique and *focus on method*.

The new artists looked to Manet for inspiration. While he worked in his studio, preferred traditional compositions, and never showed in their exhibitions, Manet based *The Luncheon on the Grass* on his experience of seeing bathers outdoors. He attempted to capture a fresh look with his bold and loose approach to applying paint to a light-toned canvas.

### The Name "Impressionism"

During the first exhibition of the Anonymous Society, a reviewer picked up on the title of a work by French painter Claude Monet (klohd moh-NAY) called *Impression: Sunrise* (figure 19.24). This reviewer criticized the exhibited works as *incomplete impressions*, rather than finished compositions, and called the artists "impressionists." Liking the label, the artists adopted the name. Today, we call this sketchier, lighter style that is characterized by thick, divided strokes of paint **Impressionism**.

Monet's painting illustrates the Impressionists' approach. To create the scene, he stood at the harbor in Le Havre at sunrise. *Focused on what he saw*, Monet captured the immediacy of the foggy morning, as two small boats crossed the water in front of large ships and factories spewed smog from smokestacks.

We see colors exactly as Monet did on that morning, based on the time, weather, and atmospheric conditions. Instead of using a different local color for each object, he blanketed the scene in *colors that were true to life*—purplish and greenish blues.

Monet makes us aware of the *fleetingness of the moment*. Repeating, horizontal brushstrokes in the water establish a quick, choppy rhythm as the current appears to move. In a moment, the boats will row to a different position and the sun will rise in the sky. Later, the fog will burn off. All of these changes will create a different color scheme and composition.

Style has changed drastically from what we have seen previously. *Colors are pure*, rather than having been premixed on the palette. The *figures and ground appear to merge*, save for the rowboats and the sun. The painting seems to convey an internal radiance and freshness from having been painted on a white base. Seen from up close, the lack of modeling and individual bold dabs of paint *flatten the image*. Seen from afar, the *dabs of paint combine* into a glistening surface.

Finally, the painting exemplifies Impressionism's *insignificant subject matter*. Monet picked an *everyday seascape*. There is no heroism or agenda. Monet did not try to teach viewers about important virtues or awe them with the sublime. The people are anonymous and minuscule. Everything is objectively presented. *Subject matter is secondary to approach*.

**artists**
MATTER

Claude
Monet

**Impressionism** An art movement in the West in the nineteenth century that focused on how we really see our constantly changing world (either because of the shifting effects of time and atmosphere or because of the spontaneous movement of figures and objects in space) that is characterized by thick, divided strokes of paint

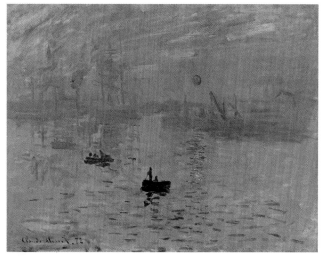

**FIGURE 19.24.** **Claude Monet.** *Impression: Sunrise.* 1872. *Oil on canvas, 1' 7½" × 2' 1½". Musée Marmottan Monet, Paris.* The sun radiates an intense orange that reflects up on the clouds and down on the water. As orange is a complement of blue, it creates simultaneous contrast (see Chapter 3) and makes both colors appear more vibrant.

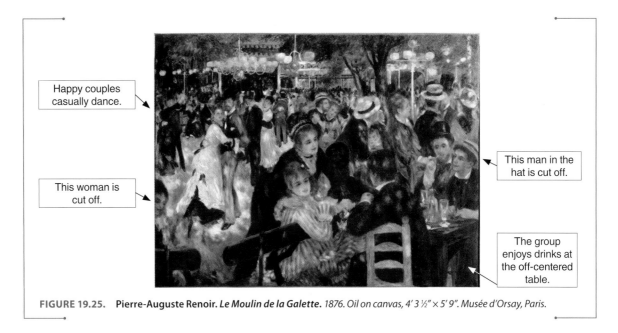

Happy couples casually dance.

This woman is cut off.

This man in the hat is cut off.

The group enjoys drinks at the off-centered table.

**FIGURE 19.25.** Pierre-Auguste Renoir. *Le Moulin de la Galette.* 1876. Oil on canvas, 4′ 3 ½″ × 5′ 9″. Musée d'Orsay, Paris.

## Composition, Light, and Shadow

Another Impressionist example, *Le Moulin de la Galette,* by Frenchman Pierre-Auguste Renoir (pyair oh-GOOST rehn-WAHR), offers a view of the middle class enjoying an afternoon socializing, eating, and dancing in the garden of a café (figure 19.25). The *composition appears random,* as if Renoir had taken a picture of some friends at a table, but accidentally moved the camera, so that they are not centered. Several figures are cut off. *The cut-off figures give an impression of a changing scene that must expand beyond its borders.*

Renoir also explored *the effect of the dappled light* as it streamed through the leafy trees, changing with every passing cloud or movement of the sun. The blotchy, uneven look of the clothes, ground, and people's faces reflect what Renoir would have seen. The *loose, short, Impressionist dabs of paint* add to the effect.

Renoir's image also demonstrates another aspect of Impressionist painting. Previously, artists had depicted shadows by adding black to a color. However, when Impressionists looked at objects in real sunlight, they saw that *shadows showed distinct colors.* Some shadows included complementary colors, while others took on a blue cast. In Renoir's image, blue shadows are seen on the ground.

## Japanese Influence

The work of French artist Berthe Morisot (BAIRT moh-ree-ZOH) illustrates another feature of Impressionist art: the *influence of Japanese prints.* During the mid-nineteenth century, Japan was opened to trading with the West. As a result, Japanese woodblock *ukiyo-e* prints (see Chapter 7) flooded onto the European market. These prints amazed the Impressionists (and Manet) because they offered an alternative way of depicting space. Japanese artists:

- Emphasized *flatness*
- Used *broad areas of color*
- Employed *stylized patterns*
- Created daring *asymmetrical compositions*

Morisot's painting *The Cradle,* in which a middle-class mother (the artist's sister) tenderly gazes at her sleeping child, picks up these Japanese techniques (figure 19.26).

Other Impressionists, similarly, adopted these Japanese practices. See *Practice Art Matters 19.3: Identify Japanese Influence in a Work* to distinguish these techniques in a painting of another artist.

**Post-Impressionism** A style of art in the West in the late nineteenth and early twentieth centuries that describes artists who followed the Impressionists and were generally inspired by their visible brushwork, but who moved in two different directions characterized either by formal structure or by emotion and symbolism

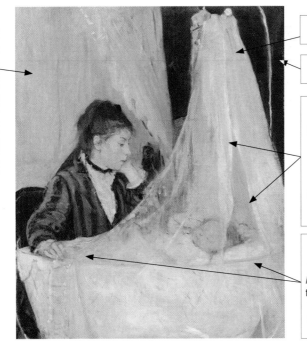

The broad, opaque curtain creates a shape that cuts off the area in back of the mother. This shape eliminates the possibility of linear perspective or diminishing size, so it *flattens the painting's surface.*

The sheer curtain creates a white shape on the canvas.

The black ground generates other *broad shapes.*

The bold *asymmetrical composition*—in which we focus on the mother because of her dark tone, patterned dress, and distinctive color—still balances visually because of the mother's gaze in an implied line, which encourages our eyes to look toward her sleeping child.

Morisot also used Impressionist stylistic tendencies, noticeable in the *loose, informal brushwork* and transparent fabric, which gives the baby a *realistic pale cast* rather than the local color of a warm skin tone.

**FIGURE 19.26.** **Berthe Morisot.** *The Cradle. 1872. Oil on canvas, 18" × 21". Musée d'Orsay, Paris.*

Interactive Image Walkthrough

*Quick Review 19.5*: What were the objectives of Impressionist artists?

## Post-Impressionism

In the final years of the nineteenth century and the early years of the twentieth, several artists used Impressionism as a jumping-off point. Art historians refer to the styles of this period as **Post-Impressionism** because the artists came after the Impressionists and generally were inspired by the Impressionists' techniques.

*Practice* **art**MATTERS

### 19.3 Identify Japanese Influence in a Work

Of all of the Impressionists, French artist Edgar Degas (ed-GAHR deh-GAH) was arguably the most interested in capturing moments in which objects appear in random compositions, just as we experience life rapidly passing in front of us from various views. In *The Dance Class* (figure 19.27), Degas's arrangement appears so spontaneous that we see only the legs of two ballerinas as they descend a staircase. Rather than focusing on the dancers who warm up in the center of the room, Degas also included ballerinas stretching on the side. One ballerina, at center, even gives us an unflattering view of her backside.

In creating his scenes of contemporary life, Degas was influenced by Japanese prints. Which of the four techniques used by the Japanese do you see in figure 19.27 and where specifically in the image do you see the techniques? (Hint: He didn't use all four in this image.)

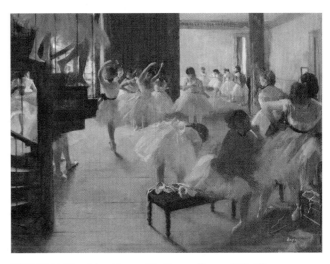

**FIGURE 19.27.** **Edgar Degas.** *The Dance Class. c. 1873. Oil on canvas, 1' 6 ¾" × 2' ½". Corcoran Gallery of Art, Washington, DC.*

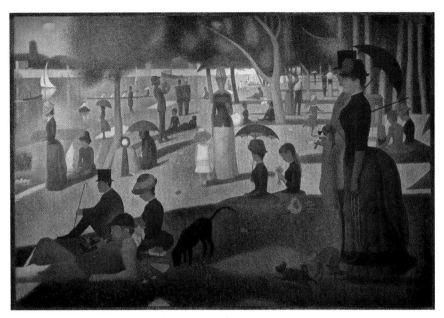

**FIGURE 19.28.** Georges Seurat. *A Sunday on La Grande Jatte* reconsidered. Seurat's subject matter portraying a river view is reminiscent of *The Luncheon on the Grass*.

Some of these artists looked back to Impressionist methods and added a *formal structure* to their work. These artists *brought order to paint application, compositions, brushstrokes, color, and space*. Other artists built on Impressionism by adding *expression and symbolism*. These artists reacted to the lack of feeling and meaning in what they saw as cool and detached Impressionist paintings.

## Paint Application and Compositions

Georges Seurat (jorjh suh-RAH) was interested in building on Impressionist techniques. We saw the French artist's painting *A Sunday on La Grande Jatte* in Chapter 3, and we reproduce it again here as figure 19.28. The painting depicts a *subject matter of modern life*. People appear in a park. Light strikes figures and trees, leaving areas in bright sunlight and shadow. *Visible marks of paint* also mottle the surface.

However, Seurat also differed from the Impressionists. He *structured the image extensively*. Seurat systematically applied thousands of small strokes of pure- and almost-pure-colored paint across his canvas, painstakingly choosing each color, so that at a distance, adjacent colors combine in viewers' eyes to form new colors. Seurat called this technique of forming blended color *divisionism*, but, today, the method is known as **Pointillism**. The optically blended colors are more brilliant than those mixed on a palette, because of simultaneous contrast and because mixed colors absorb more light and are duller (see Chapter 3).

In addition, rather than painting quickly and spontaneously in front of the scene, Seurat *toiled in his studio for over two years* to create the painting. Relying on more than fifty drawings, he plotted the overall composition and form of the figures. The image appears *frozen and tightly controlled*. Each figure poses in full frontal, back, profile, or three-quarter view. Seurat also applied *Classical mathematical proportions* to his figures, so that sizes of body parts are in ratios to sizes of whole figures. The figures look so statuesque, they would fit in on an architectural frieze. They are the *complete opposite of the casual people who populate Impressionist paintings*.

### Brushstrokes and Color

**Pointillism** Georges Seurat's Post-Impressionist method of applying small marks of pure and almost pure color across a canvas, so that at a distance adjacent colors would combine to form new, blended, brilliant colors

Like Seurat, French artist Paul Cézanne (POHL say-ZAN) also looked back to the Impressionists' approach. In *The Plate of Apples* (figure 19.29), he employed *Impressionist dabs of paint*.

However, Cézanne also brought *organization* to his work. Rather than using paint and color in a spontaneous way to show the effect of light on surfaces, Cézanne *controlled his brushstrokes and color application* to create the illusion of three-dimensional forms. We can see how this structure works by considering the light green apple that sits just to the right of the center of the plate (seen in the detail in

**artists**
MATTER

Paul
Cézanne

figure 19.30). Cézanne laid on rectangular strokes of paint, which form *small planes that recreate the curving surface of the apple.* In addition, he used *color systematically to create the illusion of three-dimensional forms.* Warm and saturated colors, because they are bright and attention grabbing, appear to come forward in space, while cool and dull colors, which are not as loud, recede (see Chapter 3).

## Space

Cézanne also organized the space in his image by offering *two different vantage points.* He realized that we do not stare at an object from a constant position, as linear perspective suggests (see Chapter 3). Instead, we usually move from our original viewing location to another point. Cézanne attempted to capture this moving reality by *showing us two distinct views of the apples in one image.*

We can see how the vantage point changes by considering the top edge of the table in *The Plate of Apples.* Cézanne emphasized this edge by using a distinct, contour line (like the dark contour that surrounds Manet's nude woman in *The Luncheon on the Grass*). *This edge shows the scene from two different views* (figure 19.31). On the left side of the painting, the table edge is horizontal. However, to the right side of the

Top edge of the table | Back edge of the plate | Light green apple

**FIGURE 19.29.** Paul Cézanne. *The Plate of Apples.* c. 1877. Oil on canvas, 1' 6 ⅛" × 1' 9 ½". Art Institute of Chicago, Illinois. Brushstrokes and colors create the illusion of mass in the light green apple, and the shifting edges of the table and plate establish two views within the image.

This top brushstroke moves from lower right to upper left, while this other brushstroke below moves from lower left to upper right. It is as if Cézanne used his paint to *build the surface of the sphere of the apple one angled facet after another.*

The part of the apple that comes *closer to us in space* at the apple's center is a warmer and more intense yellow than the part of the apple that *recedes* at the edges, which is a duller and cooler color.

**FIGURE 19.30.** Paul Cézanne. *The Plate of Apples* reconsidered in a detail.

Hold your hand over the right side of the painting, blocking it from view, and look only at this left side. Because of this horizontal edge of the table, you see the plate of apples *as if you are sitting at the table.*

Hold your hand over the left side of the image, blocking it from view, and look only at this right side. Because of the position of the table edge, which is now diagonal, it appears as if you see the plate of apples *from a standing position.*

**FIGURE 19.31.** Paul Cézanne. *The Plate of Apples* reconsidered as two halves of the painting.

painting, the same table edge is on a diagonal. This change makes it appear as if we are seeing the scene from straight on from the left side of the painting and from looking down on the right side of the painting.

Now that you see the difference in the table, you might notice other clues to how Cézanne changed the view. A distinct contour line emphasizes the back edge of the plate too. Moving from left to right, the height of the rim shifts down, and this change also helps establish the shift in vantage points. It is necessary for the rim to be higher, if we assume a sitting position, and lower, if we assume a standing position.

With these changes, Cézanne additionally *altered how we consider time*. Shifting the vantage point makes us aware of how we would normally move over time in viewing real apples. Cézanne shows us how we can gain understanding only by moving and seeing the image over time. In this way, *Cézanne revolutionized how a painting needed to be viewed*.

### Expression

Chapter 3 described how Dutch artist Vincent van Gogh (VIN-sent van-GOH) checked himself into a mental hospital. The view in *The Starry Night* (figure 19.32) was the one from his asylum window. Van Gogh is another Post-Impressionist who employed an *Impressionist subject matter* in the landscape and *Impressionist technique* in the divided brushstrokes.

However, unlike the Impressionists, van Gogh did not believe in recording exactly what he saw. Instead, he felt that *by distorting reality, he could come closer to expressing the real feeling and meaning of what he was depicting*. He changed the actual colors and forms, replacing them with *expressive color and abstract shapes* that seem to *communicate intense turmoil*. The tree gives the impression of a flame that twists and stretches upward. The hills take on the look of waves rolling on the sea. The moon pulsates beyond its own perimeter. The stars swirl through the sky, and everywhere inanimate

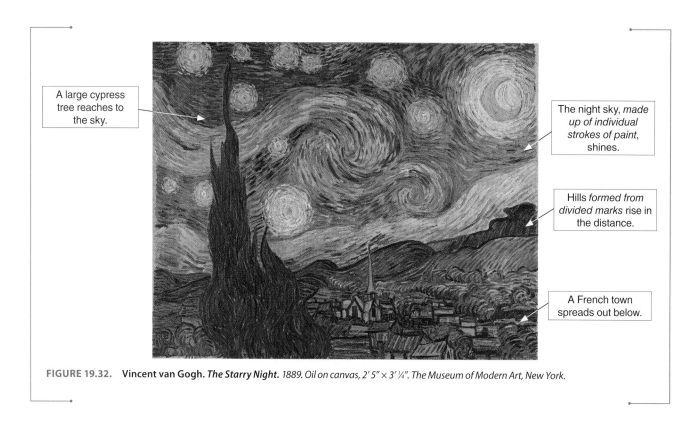

A large cypress tree reaches to the sky.

The night sky, *made up of individual strokes of paint*, shines.

Hills *formed from divided marks* rise in the distance.

A French town spreads out below.

**FIGURE 19.32.** Vincent van Gogh. *The Starry Night.* *1889. Oil on canvas, 2′ 5″ × 3′ ¼″. The Museum of Modern Art, New York.*

objects appear to move. Van Gogh also *applied paint thickly* to create bold, textured ridges across the surface. These agitated paint strokes appear to dance like rolling, rhythmic lines.

## Symbolism

Of all of the Post-Impressionist artists, Frenchman Paul Gauguin (POHL goh-GAN) has the *least in common with Impressionism*. Yet, art historians typically consider him a Post-Impressionist given that he was active after Impressionism. Gauguin had been a stockbroker, who took up painting as a hobby. Eventually, he pursued art full time and moved to Tahiti (in the South Pacific), believing he could find a natural paradise and "primitive" people to paint. On arrival, though, he was disappointed to find that Western influences had already "tainted" Tahiti. He stayed anyway, immersing himself in the culture.

Gauguin, using an approach called **Symbolism**, did not copy directly from nature, but instead employed figures, objects, forms, and colors as symbols to suggest alternate, hidden meanings and feelings. We see these different objects and forms in *Mahana No Atua* (*Day of the God*) (figure 19.33), in which Gauguin made up a fantasy of an "exotic" land. To do so, he used items such as a deity, women in particular poses, different color combinations, and nonrepresentational and decorative shapes. However, these items are not accurate illusions of what Gauguin saw in Tahiti. Instead, the objects are *visual symbols that are meant to evoke in us feelings of the mysterious and exotic*.

Gauguin turned his back on the Western tradition of representation that had existed for centuries. Rather than the viewer understanding content based on what is depicted, the *real content lies beneath the surface of what the viewer sees*.

Symbolism is also evident in the work of Edvard Munch (ED-vahrd MOONK), a Norwegian artist. In *The Scream* (figure 19.34), Munch depicted a moment in which he had been walking on a bridge with friends when he was suddenly overcome with anxiety

**Symbolism** A Post-Impressionist movement in the West in the nineteenth century in which artists did not copy directly from nature and instead employed forms and colors to suggest alternative, hidden meanings and feelings

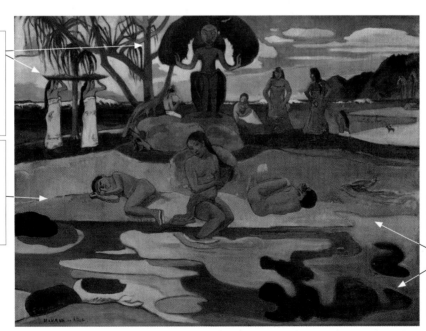

Two women carry an offering to a deity that is not Tahitian, but *a Southeast Asian god that Gauguin copied from a book*.

Three women appear on a pink beach. *Two are posed sleeping in fetal positions*, while one dangles her legs in the water.

*Nonrepresentational shapes of saturated colors* appear to float on top of the water like an oil slick. The shapes extend finger-like projections into the water and onto the beach.

**FIGURE 19.33.** **Paul Gauguin.** *Mahana No Atua (Day of the God).* 1894. Oil on canvas, 2' 2 ⅞" × 3'. Art Institute of Chicago, Illinois.

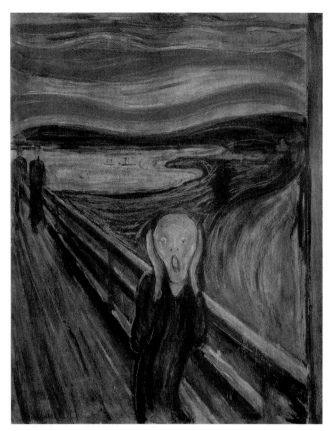

FIGURE 19.34.    Edvard Munch. *The Scream.* 1893. Oil, tempera, and pastel on cardboard. 2′ 11 ¾″ × 2′ 6″. Nasjonalgalleriet, Oslo, Norway.  The distorted head and hands and the swarming, intensely colored lines in the sky likely communicate more about the figure's state of mind than if Munch had rendered them realistically.

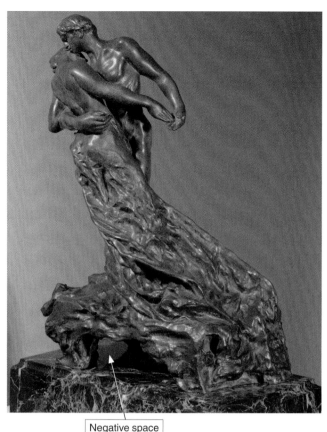

Negative space

FIGURE 19.35.    Camille Claudel. *The Waltz.* 1905. Bronze, 1′ 5″ × 1′ 1″. *Private collection, Paris.*  The woman's skirt rises up, almost as if taking a step to the left, leaving a void of negative space at the bottom where the sculpture meets the base.

and despair. The friends, unaware, walked on, while he felt a powerful, primordial scream echo through himself and the land.

The agonizing moment is conveyed through *symbols that help communicate the underlying intensity of emotion.* Using *thick brushstrokes of paint* that are rooted in the work of the Impressionists, Munch dramatically simplified the figure of himself, reducing his head, hands, and body to flattened shapes. The sky reverberates in swelling, repeating lines of contrasting blue and orange. The bridge is dramatically extended, so that Munch's friends seem a great distance away, leaving him alone with his plight. *It is through the symbols—the colors, lines, shapes, and unrealistic features—that we can understand the meaning of the scene.*

*The Waltz* (figure 19.35) illustrates how French artist Camille Claudel *used Symbolism to convey meaning in sculpture.* Claudel depicted a man and woman dancing. She modeled her pliable material, which was later cast in bronze (see Chapter 10), so that we can almost feel the uneven and irregular texture formed from her pressing with her fingers. Her approach, in which she applied an *Impressionist-like bold, loose, and almost sketchy technique to clay,* transformed the woman's skirt. It appears as if it is a pyramid-like structure that seems alive with motion that ripples down her body. *The symbol of the triangular form helps convey the energy and thrill of the dance.*

*Quick Review 19.6*: What were the different paths that artists took in the Post-Impressionist period?

## Art Nouveau

A fitting place to end this chapter is with **Art Nouveau**, a style prevalent during the last decade of the 1800s and the first decade of the 1900s in architecture, interiors, and traditional craft media. *Art Nouveau combined Rococo influences* from the beginning of the eighteenth century *with Modern influences* from the end of the nineteenth century. Artists:

- Believed that art should be a *part of everyday life* (Rococo)
- Conceived architectural forms with coordinating furniture and decoration to create *comprehensive, unified designs* (Rococo)
- Were interested in *curves, plant forms, and asymmetrical motifs* (Rococo)
- Imitated the *nonrepresentational, decorative shapes* found in Symbolist works (Modern), but *ignored the symbolic meaning*
- Created designs that were *loose, light, and unusual* (Modern)

Hotel Van Eetvelde, by Belgian architect Victor Horta, illustrates the *all-encompassing* and *decorative effect* of Art Nouveau. Figure 19.36 shows the building's ornate entrance. Here, the intertwining loops on the floor, delicate columns, graceful arches, and ornamental railings coordinate rhythmically, appearing like *Rococo* vines growing throughout the space. However, they flaunt the nonrepresentational approach of ambiguous *Modern* forms.

The desk in figure 19.37 by French designer Hector Guimard (ek-TOHR GEE-mar) illustrates how Art Nouveau impacted furniture. Like with the *Rococo*, asymmetrical, twig-like lines appear to grow across the two differently sized standing supports. However, a *Modern* sensibility can be found in the desktop that starts on the left in a mostly geometric rectangle, but ebbs and swells into a large drop-shaped form.

*Quick Review 19.7*: In what ways did the Art Nouveau movement combine influences from the Rococo and Post-Impressionist styles?

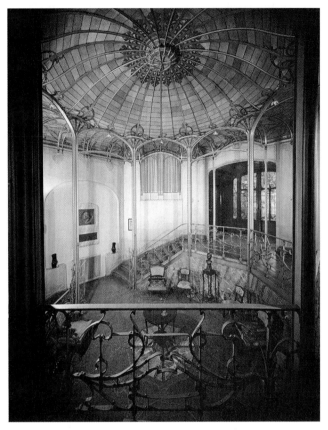

**FIGURE 19.36.**   **Victor Horta. Hotel Van Eetvelde, entrance.** *1895, Brussels, Belgium.*  Horta created a space where everything works with the coordinated design.

**FIGURE 19.37.**   **Hector Guimard. Desk.** *c. 1899. Olive wood with ash panels, 2' 4 ¾" × 8' 5" × 3' 11 ¾". The Museum of Modern Art, New York.* This atypical, decorative desk exemplifies the Art Nouveau style.

## A Look Back at *The Luncheon on the Grass*

Manet's *The Luncheon on the Grass* gives us the opportunity to consider what many believe to be both *the last great traditional and the first great Modern work of art*. The painting also gives us insight into the art of the eighteenth and nineteenth centuries.

Manet based the painting on longstanding **academic** practices rooted in traditions of the eighteenth and earlier centuries. He looked back to Renaissance masters for inspiration, picking up ideas for subject matter and design. He borrowed from **Rococo** works that depicted the *carefree lives of the elite*, modifying their presentations into an informal, lower-class scene. He also used a time-honored *centrally placed, triangular composition*, similar to the compositions of **Neoclassical** artists. Finally, he submitted paintings to the **Salon**.

However, Manet had even more connections to nineteenth-century art. Similar to **Romantic** artists, Manet *rejected noble, historical subject matters*. He also *used strong value contrasts and aggressive paint strokes*. In that Romantic artists rejected some academic conventions, Manet followed their lead.

Many art historians classify Manet as a **Realist**. Like the Realists, he provoked the establishment by flouting traditions. Manet depicted *everyday people at an enormous size*. His figures are *not idealized*, and there is no upstanding theme. He, likewise, used *coarse paint strokes* to capture the scene more accurately and *combined subject matters*, placing figures beside a still life.

Other art historians see Manet as the leader of the **Impressionists**. Like these artists, Manet started his works on a light-toned ground and added darks, making his work appear to have been painted outdoors (even though it wasn't). In addition, like the Impressionists, he *used thick brushstrokes of paint and eliminated soft modeling*, drawing attention to the surface of his work and helping to *flatten his image*. Furthermore, Manet was probably *inspired by Japanese prints*, painting the nude in the foreground as a broad, flat area of color.

Finally, the roots of **Post-Impressionism** can be seen in Manet's work. Manet *emphasized contour and rejected soft modeling* that would give the illusion of three-dimensional forms, prefiguring Cézanne (figure 19.29). In addition, Manet *did not copy directly from nature* in the still life, where he painted all of the pieces of fruit as being ripe simultaneously, foreshadowing Gauguin (figure 19.33).

As you move forward from this chapter, consider what Manet faced when he submitted *The Luncheon on the Grass* to the Salon in 1863. Yet, he still dared to do something different and advance new ideas. Amazingly, while he led the charge to **Modernism** as others ridiculed his work, very shortly thereafter, his work was accepted and recognized for its great importance to the past and future of art. At a retrospective held in Manet's honor in 1884, a year after he died, Degas summed up how feelings for him had changed: "He was greater than we thought, that Manet!"[1] *Indeed, there is arguably no painting that had a greater negative impression at the time that it was painted and a greater positive impact on the history of art in the years that followed.* The painting shows the value in having the courage to move forward with a new idea.

Flashcards

## CRITICAL THINKING QUESTIONS

1. Both Watteau's *Return from Cythera* (figure 19.8) and Friedrich's *Monk by the Sea* (figure 19.19) depict people in front of water. How are the two images different in style and content?
2. Why can Neoclassical art be considered the high point of academic convention?
3. Why is Turner's *Slave Ship* (figure 19.20) considered sublime?
4. The Realists in this chapter used paintings to protest the unfair lives of the downtrodden. What media might artists today use to support the same cause? Why might the media be effective?
5. While this chapter features only one female Impressionist artist, other women, such as Mary Cassatt (see figure 2.43), were prominent in the movement. Why do you think Impressionism was so suited to female painters compared to previous styles?
6. Art historians have compared the work of Seurat (figure 19.28) to Byzantine mosaics (figure 14.11). What about the mosaic technique and appearance would make art historians see similarities?
7. Both Monet in *Impression: Sunrise* (figure 19.24) and van Gogh in *The Starry Night* (figure 19.32) depicted views of nature. Which work would you classify as objective and which as subjective? Why would you classify them in this way?

Comprehension Quiz    Application Quiz

# CONNECTIONS

## Art, the Artist, and the Inner Mind

The universal theme of art, the artist, and the inner mind is evident in artworks from this chapter and in art created by people from different backgrounds and periods from across this book. This theme concerns:

» *Art and artifice*
» *The artist and creativity*
» *The inner mind, fantasy, and dreams*

### Art and Artifice

This chapter describes how Edouard Manet in *The Luncheon on the Grass* (figure 19.1) rejected principles such as diminishing size that artists had used for centuries to create an illusion of the three-dimensional world on a flat surface. In so doing, Manet began a dialogue about the nature of art. Should art be an artifice—a deception that fools us into believing that what we see is real? Perhaps, art should be about the techniques that artists use to create that imitation of reality? By ignoring some of those traditional techniques, Manet's painting seems disconcerting. We are apt to focus on how he constructed the image and his role as the creator, rather than understanding the art as just the scene that Manet portrayed.

Luis Buñuel and Salvador Dalí's *Un Chien Andalou (An Andalusian Dog)* (figure C19.1), from Chapter 8, similarly comments on art and artifice. The film puts shots together in ways that defy the audience's expectations. In one scene, a man appears to slice a woman's eye. The filmmakers created this effect by first showing a shot of the woman with the man holding a razor in front of her face and then showing a close-up shot of the man slicing an eye (in reality, a calf's eye). The sequence links what were actually two unrelated shots together, making the cutting of the woman's eye seem real. But, Buñuel and Dalí created an artifice. The bizarre scene forces us to focus on the technique of how shots can be manipulated, the nature of the film medium itself, and Buñuel and Dalí's roles as the artists.

**FIGURE C19.1.** **Luis Buñuel and Salvador Dalí.** *Un Chien Andalou (An Andalusian Dog)* **reconsidered.** In that *Un Chien Andalou* is a film, it reminds us that while cameras record the world, they are not copying devices. All filmmakers and photographers manipulate what we see, requiring us to question the scenes they create.

## The Artist and Creativity

The chapter we just completed includes a self-portrait of an artist, Edvard Munch, in *The Scream* (figure 19.34). Munch represented an emotional moment when he was overcome with despair. His painting uses symbols to convey his anguish. In a highly creative and original presentation, abstract features, waving lines, and complementary colors help to convey the intensity of how he felt.

Many artists throughout time have depicted their likenesses and captured their feelings and expressions. During the Italian Renaissance, Michelangelo Buonarotti formed a creative self-portrait in *The Last Judgment* on the altar wall of the Sistine Chapel. In the center of the scene, which is shown in Chapter 15, Michelangelo placed saints holding symbols of their martyrdom. Saint Bartholomew, who was flayed (executed by skin removal), grasps a knife and his own skin (figure C19.2). Upon this skin, Michelangelo placed a haunting image of himself. Like Munch's image, Michelangelo's likeness is distorted, seeming to offer a similar feeling of distress.

**FIGURE C19.2.** **Michelangelo Buonarotti.** *The Last Judgment*, **detail of Saint Bartholomew, reconsidered.** Michelangelo offered a unique vision of himself in his contorted form. Yet, other artists have created self-portraits that are highly representational.

## The Inner Mind, Fantasy, and Dreams

*The Starry Night* (figure 19.32), from the chapter we just finished, depicts the view from Vincent van Gogh's asylum window. The image appears as if out of a dream. A cypress tree shoots up like a flame, while the heavens look as though they pulse and swirl. Van Gogh believed that by distorting objects, he could more accurately express the truth and feeling of the world around him. However, others have seen his passionate image as a sign of his tormented mind.

In 1952, Belgian artist René Magritte also manipulated reality, creating a different fantasy world in *Les Valeurs Personnelles* (*Personal Values*) (figure C19.3), which Chapter 4 describes. As if in a dream, giant personal objects, such as a shaving brush and comb, have invaded a bedroom that itself bizarrely floats up in the clouds. However, unlike van Gogh, Magritte purposely sought to explore the unconscious mind in his art.

**FIGURE C19.3.** **René Magritte.** *Les Valeurs Personnelles (Personal Values)* **reconsidered.** While Magritte used painting to create a fantasy, many other artists have used different media to create worlds that appear as if out of a dream.

## Make Connections

Chapter 5 includes *Self-Portrait, Drawing* (figure C19.4) by German artist Käthe Kollwitz, which shows the artist in 1933 drawing a self-portrait. As she worked with quick and easy-to-use charcoal, Kollwitz could share a keen sense of what she was thinking (her inner mind) at the moment of creation. Kollwitz opted to depict her face and hand realistically, while forming her arm from loose, broad strokes. Those strokes are the same width as the piece of charcoal she depicted in her hand, as if that very piece of charcoal had somehow been used to create those lines. How might this self-portrait relate to the theme of art, the artist, and the inner mind?

What other visual examples can you come up with from across the book and from today's world that reflect this theme? How are people's motivations across time and place similar and different?

**FIGURE C19.4.** **Käthe Kollwitz.** *Self-Portrait, Drawing* **reconsidered.**

# Modern Art in the Twentieth-Century Western World

**DETAIL OF FIGURE 20.2.**
In the twentieth-century Western world, artists jettisoned many traditional notions of art. Here, in a detail of a photo of Ana Mendieta, the artist created a work using her own body, covering it in mud, and standing in front of a tree.

## LEARNING OBJECTIVES

**20.1** Describe how Expressionist artists manipulated form to convey emotion.

**20.2** Distinguish between Analytic Cubism and Synthetic Cubism.

**20.3** Describe how Dada and Surrealism explored the irrational in art.

**20.4** Compare three post–World War I styles that sought to better society.

**20.5** Contrast three styles of representational art prevalent in the United States before World War II.

**20.6** Summarize how New York School artists explored personal expression in their work.

**20.7** Describe four post–World War II styles that have blurred the boundary between art and life.

**20.8** Explain why meaning is incompatible with Minimalism.

**20.9** Describe how Conceptual and Performance artists have abandoned the art object.

**20.10** Explain how earthwork artists have rejected the venue of the museum.

**20.11** Describe how feminist and African American art protested discrimination.

## THE EARTH-BODY WORKS OF ANA MENDIETA

In 1959, the revolutionary leader Fidel Castro seized control of Cuba—the island nation 150 miles off the coast of Florida. Over the next two years, Castro dismantled Cuba's capitalist system, declared a communist state, and instituted ties to the Soviet Union. It was the height of the Cold War—the forty-four-year conflict consisting of tension between the democratic United States and communist Soviet Union.

How Art Matters

In response to Cuban parents fearful that the Castro government would indoctrinate their children in communist ideology, the United States airlifted out of Cuba more than fourteen thousand Cuban minors. Two of those children were twelve-year-old Ana Mendieta (AH-nah men-DYET-ah) and her fourteen-year-old sister. It is hard to imagine the suffering the two must have experienced in the United States. They spoke no English and knew no one, and so were sent to live in foster homes in Iowa. The sisters were unprepared for the racism and second-class status they faced in the predominantly white, pre–civil-rights-era community.

### Image from Yagul

It is with this context that we consider one of Mendieta's first earth-body works, the art in which she *placed herself or her image in the land*. Unable to travel to Cuba because of tensions, Mendieta connected with an alternate homeland in a trip to Mexico. There, the people spoke her language and looked like her. Traveling to the ruins in Yagul, *away from any museum*, she stripped off her clothes and laid on the rock surface of an ancient tomb. Mendieta's companion then covered *her body*—not any art object she had made—with *real, white flowers* and *took a photograph* (figure 20.1).

The image is startling and contradictory. *Is she alive or dead?* We are also unsure whether Mendieta is supposed to appear *as part of or separate from the earth*. Her skin blends with the stones. The sprigs seem to grow from her body, melding her form with the earth and returning her to the roots from which she was separated. Built by a powerful culture, the stones of the tomb push out at her from all sides. They seem rough and menacing, possibly reminiscent of the way *powerful civilizations have for centuries placed individuals, like Mendieta, at their mercy*. Finally, while the flowers mask some of her body, Mendieta is unquestionably a woman, perhaps akin to an *earth goddess* and carved Paleolithic figures (see figure 13.8) that archaeologists suggest may represent mother-earth divinities. As a woman in the United States, Mendieta had few opportunities, but in this work, Mendieta, as nature, seems *in charge and eternal*, reclaiming the land.

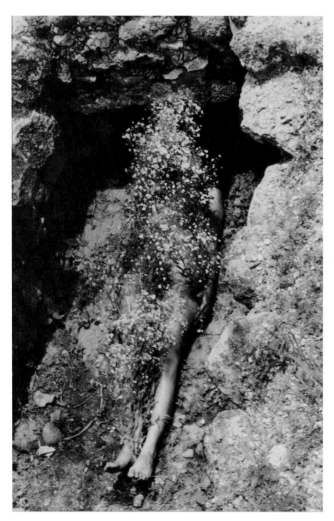

**FIGURE 20.1.** **Ana Mendieta.** *Imagen de Yagul (Image from Yagul).* 1973. Lifetime color photograph from 35 mm color slide of earth-body work with flowers executed at Yagul, Oaxaca, Mexico. 29″ × 12 ½″. © The Estate of Ana Mendieta Collection. The squared-off, geometric tomb contrasts with Mendieta's organically shaped body.

### An Eternal Earth Goddess

A different earth-body work executed in Iowa carries this notion of an earth goddess further (figure 20.2). Here, Mendieta was photographed nude, covered in mud, and standing frontally with her hands in a traditional pose of a deity set against an immense tree.

The color of the mud helps Mendieta fade into the bark, appearing as one with the tree of life. She seems *eternal, reaching back to prehistoric cultures, which honored a feminine earth as the giver of life.* Moreover, by appearing covered in brown mud, it is as if Mendieta challenges us to *see that great originator as nonwhite, defying traditional assumptions she faced regarding race* in her adopted homeland.

## A Burning *Silueta*

In addition to using her body, Mendieta also created works that used images of her form, leaving a trace of herself in natural materials. She called these works *siluetas* ("silhouettes" in Spanish).

Figure 20.3 shows a *silueta* with upraised arms mimicking Mendieta's pose in the *Tree of Life*. However, Mendieta set this *silueta* on fire. Mendieta was Catholic, and the year she left Cuba, the government expelled foreign priests and nuns from the country. Could this *silueta* represent *persecuted Catholics*? The *silueta* might link to crucifixions, given the outstretched arms; Catholic martyrs burned at the stake; a soul burning in hell; or end-of-life ideas of ashes to ashes and dust to dust.

While the *silueta* is ablaze, we know it will burn out. Perhaps Mendieta, as maker, *assumes the role of shaman* (a person with spiritual influence), controlling the supernatural force of fire and again linking herself to ancient societies. Yet another interpretation

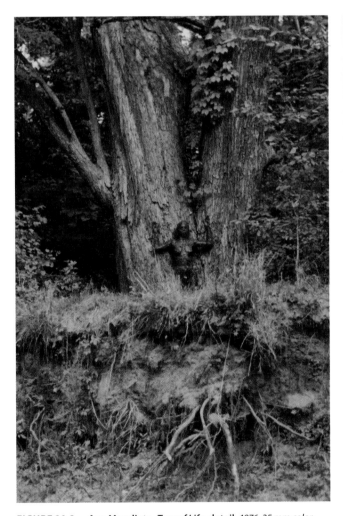

**FIGURE 20.2.** Ana Mendieta. *Tree of Life*, detail. *1976. 35 mm color slide of earth-body work executed at Old Man's Creek, Sharon Center, Iowa. 20" × 13 ¼".* © *The Estate of Ana Mendieta Collection.* The tree is all-encompassing—roots extend to the ground, the trunk reaches to the sky, and leaf-covered branches stretch sideways.

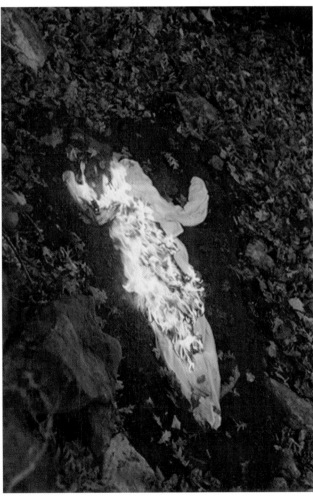

**FIGURE 20.3.** Ana Mendieta. *Alma Silueta en Fuego (Soul Silhouette on Fire). 1975. Lifetime color photograph from 35 mm color slide of a* silueta *executed near the Iowa River, Iowa, 10" × 8".* © *The Estate of Ana Mendieta Collection.* To form this work, Mendieta made a cardboard cutout of herself, which she wrapped in white fabric and set on fire.

considers that with fire, Mendieta could leave a scorched mark of herself on the earth—*a brand asserting her identity.*

## A *Silueta* of an Island

A final work that we consider shows Mendieta again using mud (figure 20.4). Here, she sculpted a form from the mire on the banks of a creek. The figure takes the appearance of figure 20.1 as the arms are held tightly to the body. Its upside-down form appears mummy-like and similarly may *reference images of death*.

When digging to gather the mud, Mendieta exposed water, so the form appears as if it is a landmass surrounded by a sea. We might imagine that Mendieta's figure has assumed the form of the island of Cuba. Just as Mendieta *experienced oppression and injustice, so, too, did her homeland.*

However, Mendieta placed this work in a group she titled *Fetish Series.* Some people believe a fetish can help them appeal to a deity and that driving sharp objects into it will provoke its assistance (see, for example, a *nkisi n'kondi* nail figure from Africa in figure 1.29). Mendieta formed her work the year her mother was diagnosed with cancer. If the earthen mound is a stand-in for Mendieta, perhaps she placed herself in the role of a fetish, helping others in a life-giving role. As in other works, then, *she appears as an essential source of energy, life, and nourishment.*

## An Impermanent Art

It is impossible to consider Mendieta's art without reflecting on the nature of loss. While she photographed and filmed her works, the *originals were transitory.* Often, as soon as Mendieta moved, they were gone. Other times, rising tides or blowing winds destroyed their traces.

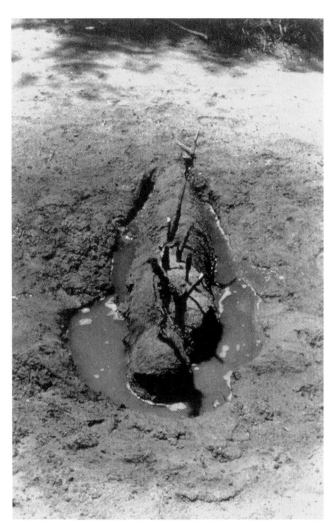

**FIGURE 20.4.** **Ana Mendieta.** *Untitled (Fetish Series). 1977. Lifetime color photograph of earth-body work of mud, water, and sticks executed at Old Man's Creek, Iowa, 20" × 13 ¼". Whitney Museum of American Art, New York.* In this fetish image, Mendieta found connections with African traditions, drawing further links to societies that were nonwhite.

Time and again, Mendieta returned to the earth, forming temporary, fragile images of herself, perhaps symbolic of her *attempts to reclaim her lost homeland and identity.* As with today's refugees, Mendieta appears the persistent, vulnerable exile. This impermanence, however, can also represent her strength as the *powerful earth goddess*—the giver of life and death—who, like the earth, is *always changing and never predictable.* In these contrasting ideas, Mendieta's work seems an apt metaphor for the human condition.

On September 8, 1985, when she was just thirty-six years old, Ana Mendieta tragically fell from an apartment window after an argument with her husband, artist Carl Andre (AHN-dray). Andre was later acquitted of Mendieta's murder. Looking at the loss, it can be unnerving to consider the numerous symbols of death in Mendieta's work. Yet, we can also consider her work, from the standpoint of *how much art mattered in her exploration of life and its challenges and triumphs.*

Seven years after Mendieta's death, at the opening of a branch of the Guggenheim Museum in New York, five hundred protesters gathered outside. They *objected to the lack of women and artists of color*—a cause Mendieta fought for during her lifetime. The protestors held signs that read, "Where is Ana Mendieta?" Inside, the work of Carl Andre hung in the exhibition, while Mendieta's did not.

Where is Ana Mendieta? Where does she fit? Does she belong as part of a nation, ethnicity, race, or gender? Does her work stem from prehistoric figures or is it Modern? As she located her body in the everyday world, does her work confuse art with life? Does the fact that

her work took little skill negate its being categorized as art? Can we consider her original work art, if it cannot be placed in a museum? The many questions, categories, and meanings are what make Mendieta's work unique, provocative, and valuable.

The story of Ana Mendieta offers us insight into her poignant art, but also introduces us to the Modern art of the twentieth century. Throughout this period, *artists pushed the envelope of what constituted art, as well as art's purpose and relationship with reality*. This chapter will consider art from the twentieth-century Western world. Before moving forward, based on this story, in what ways do you think the concept of art changed in the twentieth century?

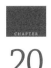

# The Early Twentieth Century through World War II

The twentieth century began in the West with optimism. Europe was prosperous. Life expectancy had increased, and people hailed numerous inventions and discoveries. In 1900, Sigmund Freud published his theory of psychoanalysis, in which he stated that human behavior could be explained by the urges of the unconscious mind; in 1903, the Wright brothers flew the first airplane; and in 1905, Einstein presented his theory of relativity.

A succession of upheavals shattered the creative time, though, causing despair.

- *World War I*, beginning in 1914, with its machineguns, poison gas, and air fights, ushered in devastation. By its conclusion, more than ten million people had died.
- *The Russian Revolution*, starting in 1917, eventually transformed Russia and the surrounding area into a communist entity called the Soviet Union.
- *The Depression*, a major economic crisis beginning in 1929, caused banks to fail, consumer confidence to dive, production to plummet, and poverty to soar.
- *World War II*, beginning in 1939, was preceded by the rise in Europe of brutal dictators, such as Adolf Hitler, and fascism—a racist and aggressive movement that placed loyalty to one's own nation above all else. World War II killed thirty to fifty million people—on battlefields, in civilian cities, and in Nazi death camps.

We will begin our consideration of the twentieth century, though, in the period before these upheavals occurred.

## Expressionist Movements

A discussion of the art of the early twentieth century must look back to art from the end of the nineteenth (see Chapter 19), when some Post-Impressionists (such as Vincent van Gogh) took Modern art so far that they were no longer objective recorders of nature. They had *distorted reality*—using thick lines, expressive color, and abstracted shapes—*to project feelings*.

Some early twentieth-century artists followed these Post-Impressionists, pushing Modernism further. They discarded naturalism and changed form so radically to stress emotion that scholars label the movement **Expressionism**. Expressionism arose in France and Germany. The Expressionist movements, along with all styles covered in this chapter, are shown on the timeline in figure 20.5.

**Expressionism**  An art movement in Europe in the early twentieth century in which artists discarded naturalism to stress emotion

**FIGURE 20.5.  Timeline of Modern Art in the Twentieth-Century Western World.**  In the West, Modern twentieth-century art splits into those styles that appeared predominantly before World War II and those that arose after. World War II lasted from 1939 to 1945. While most of these movements ended by 1980, artists created assemblages, environments/installations, Performance art, and earthworks past that date.

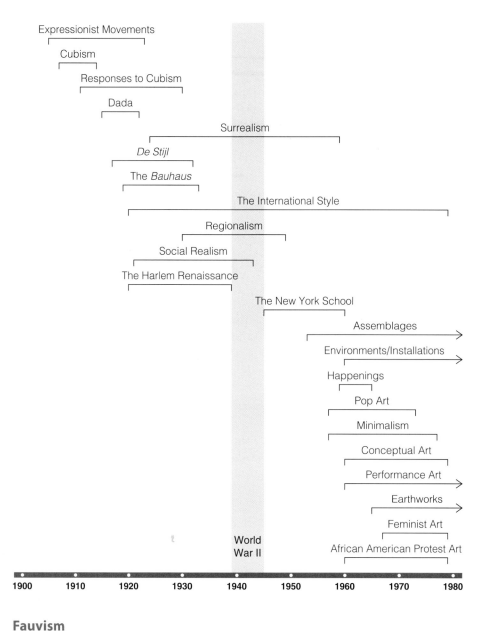

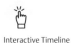
Interactive Timeline

## Fauvism

Expressionism in France began in 1905, when a group of artists showed work in an exhibition they called the *Salon d'Automne* (sah-law doh-ton) (Fall Salon). These artists hoped to distinguish themselves as the *avant-garde* (see Chapter 19) and stunned visitors by completely distorting forms to convey feelings, using:

- *Unrealistic colors*
- *Intense, clashing complements*
- *Coarse and aggressive brushstrokes*
- *Distorted and simplified objects and figures*
- *Unrealistic space*

**Fauvism**  From the French for "wild beasts"; a style of Expressionist art in France in the early twentieth century characterized by expressive color, distorted forms, and unnatural space

**artists**
MATTER

Henri Matisse

The bold, expressionist work of **Fauvism**—named because one critic labeled these artists "*Les Fauves*" (lay FOHV) ("the wild beasts")—appears in *The Joy of Life* (figure 20.6) by **Henri Matisse** (ahn-REE ma-TEES). The work features *unnatural colors* with a pink sky, green and blue tree trunks, yellow grass, and some green people. *Complementary colors also collide.* Purple sits next to yellow and green next to red, making the image seem

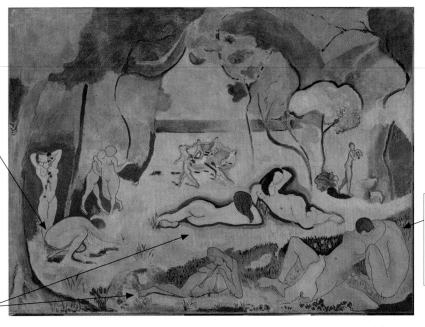

Some figures have been *intensely simplified*, reduced to just curving contour lines surrounding colors that have almost no modeling.

Objects are supposed to diminish in size as they recede, but these women at center are larger than this woman in front, which flattens the surface, bringing the two women forward and creating an *unrealistic space*.

*Distorted bodies* merge together, as here: the figures have one head for two bodies and not enough arms.

**FIGURE 20.6.** Henri Matisse. *The Joy of Life*. 1905–6. Oil on canvas, 5′ 9 ½″ × 7′ 10 ¾″. Barnes Foundation, Philadelphia.

intense because of simultaneous contrast (see Chapter 3). Matisse also laid on *aggressive brushstrokes*, so marks appear spontaneous. Additionally, *forms are abstracted*. Matisse, like Mendieta, was interested in traditional African art (see Chapter 16) where artists often distort appearances. Matisse believed he could find expression through bold form. Finally, *space in the work is confusing*.

Matisse's changes in color, brushwork, form, and space help give the painting its feeling of abandon. It is not just that lovers kiss, people dance, and women recline in the sun. They do so in *vivid colors, abstract forms, and simple shapes* that seem to project pleasure and exhilaration. Matisse *manipulated form to describe these feelings*. To see how another artist took up Fauve techniques, see *Practice Art Matters 20.1: Identify the Features of Fauve Art*.

Interactive Image Walkthrough

## *Practice* art MATTERS

### 20.1 Identify the Features of Fauve Art

André Derain (ahn-DRAY de-RA) took a Fauvist approach to a bustling bridge in *London Bridge* (figure 20.7). Tremendous activity happens on the roadway, while boats glide through the sparkling water below.

Identify the features in Derain's painting that classify it as Fauvist:

- Which objects have unrealistic colors?
- Where do you see adjacent complements?
- Where do you see coarse brushstrokes?
- Which objects are simplified?
- Why does the sky appear to push forward in space rather than recede? (Hint: consider color.)

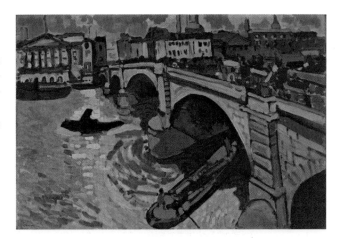

**FIGURE 20.7.** **André Derain.** *London Bridge.* 1906. Oil on canvas, 2′ 2″ × 3′ 3″. The Museum of Modern Art, New York.

## German Expressionism

In Germany, Expressionist artists also *distorted form to convey emotion*, but *portrayed more spiritual feelings*. Paula Modersohn-Becker (MOH-der-zun BEK-er) illustrates the German difference in an image of a peasant woman praying (figure 20.8). Patches of color on her hands, crude brushwork forming her brow, and simplified forms are familiar Expressionist techniques used to communicate emotion. *Colors, though, are somber.*

While Modersohn-Becker was an independent Expressionist, two groups of Expressionist artists formed in Germany in the early twentieth century. One group was called *The Bridge* and the other, *The Blue Rider*.

### The Bridge

**The Bridge** A style of Expressionist art in Germany in the early twentieth century associated with emotionally intense images that are conveyed through distortions in color, form, and space

Ernst Ludwig Kirchner (AIRNST LOOT-vik KEERSH-ner) was a founder of **The Bridge**. The expressionist artists in this movement hoped to create a bridge between their art and a better future. They made unsettling works by:

- *Distorting forms*
- *Displaying irrational spaces*
- *Using unrealistic color and clashing complements*
- *Laying on coarse brushstrokes*

Figure 20. 9 illustrates the sinister world Kirchner saw in his time. People dressed in their finery crowd a Berlin street. As in Fauvism, *figures and space are distorted*. However, Matisse's joyful curves are replaced by *slashing diagonals and pointy angles*. Bodies are unnaturally thin and elongated, and feet appear sharpened like crude spears. Fur and feathers on the women's

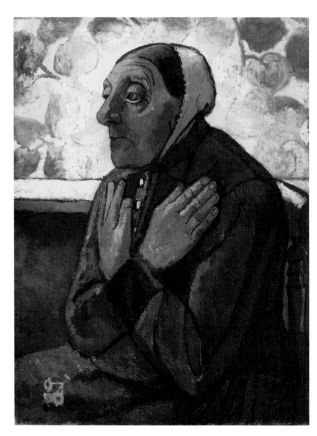

**FIGURE 20.8.** Paula Modersohn-Becker. *Old Peasant Woman.* c. 1905. Oil on canvas, 2' 5 ¾" × 1' 10 ¾". *Detroit Institute of Arts, Michigan.* Form helps create a powerful moment of devotion.

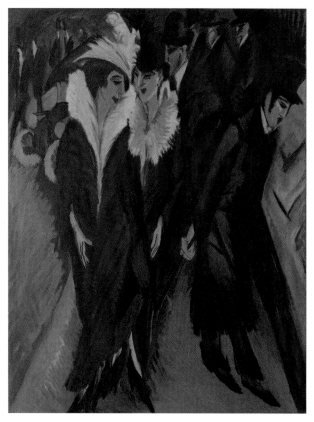

**FIGURE 20.9.** Ernst Ludwig Kirchner. *Street, Berlin.* 1913. *Oil on canvas, 3' 11 ½" × 2' 11 ⅞". The Museum of Modern Art, New York.* The woman on the left's orange hair fights with her pink face. Her purple coat feels jarring beside pink, orange, and green slashes of paint.

collars and hats are aggressive spikes. The flat, pink faces look like masks, likely indicating expressions that are a façade, and so many people are cramped into the *warped space* that they appear layered. Finally, the emotional intensity of Kirchner's world can be seen in the *biting color and rough brushstrokes*. Everywhere that the colors are not grating, Kirchner painted black and gray, seemingly making the image a conflict between boldness and gloom.

### The Blue Rider

The second German Expressionist group was called **The Blue Rider**. The name stemmed from the title of a painting by Vassily Kandinsky (vah-SEE-lee kan-DIN-skee), the group's founder. The Blue Rider artists:

- *Created nonrepresentational or highly abstracted works*
- *Conveyed emotion through line, shape, texture, value, and color* rather than through representational objects
- *Sought to convey the spiritual* rather than the physical

Kandinsky was one of the *first Western artists to create nonrepresentational paintings that conveyed expression*. (The first was Hilma af Klint; see figure 3.16.) Upon entering his studio one day, Kandinsky saw a painting turned on its side, so that it looked nonrepresentational. He realized that he *did not need objective forms to convey emotion*. It is hard to understand today just how radical a move this was. For thousands of years, Western paintings had depicted the world with objective or abstract scenes. The only nonobjective works had been decorative. Kandinsky, instead, *used nonobjective form to symbolize meaning*. Figure 20.10 illustrates his approach, with different lines, shapes, and colors conveying feeling.

In the painting, it is as though Kandinsky created a musical composition, with different forms taking on different pitches, rhythms, melodies, and harmonies. While the colored, rounded shapes can feel bloated and mellow, the black lines can seem quick and chaotic, and the colored lines, joyful and free.

*Quick Review 20.1*: How did Expressionist artists manipulate form to convey emotion?

**The Blue Rider** A style of Expressionist art in Germany in the early twentieth century characterized by nonrepresentational or highly abstracted works that convey emotion through form rather than through descriptive objects

Slashes of orange, purple, yellow, blue, and green soar in sweeping curves, while thin, black lines flit here and there. The various marks *give off different impressions*.

Large blobs of intense color bulge across the surface. As we move from a peaceful green to an energetic orange, we may *feel changing moods*.

**FIGURE 20.10.** **Vassily Kandinsky. *Black Lines*.** *1913. Oil on canvas, 4′ 3″ × 4′ 3 ⅜″. Solomon R. Guggenheim Museum, New York.*

## Cubism

Some early twentieth-century artists looked back to the Post-Impressionist Paul Cézanne (see figure 19.29) for inspiration. They *emphasized structure*, but also pushed Cézanne's concepts further.

### The Revolutionary *Les Demoiselles d'Avignon*

We get a sense of what these artists did in a revolutionary work by Spanish-born artist Pablo Picasso (pab-loh pee-CAH-soh). In this work, Picasso:

- *Merged figures and ground*
- *Created multiple views in the same painting*
- *Rejected and celebrated the Western tradition*

In the painting (figure 20.11), Picasso fractured the bodies of five nude women into *flat planes*, which *confuses the shapes of their bodies with the background area*. It is as if Picasso took Cézanne's brushstrokes and made each into a *geometric shape*. Since the women are additionally surrounded by angular planes, it is impossible to tell what is what. Adding to the confusion is the fact that traditional modeling and lighting are absent. For the *first time in the history of Western painting, the figures are no longer prioritized over the ground,* as the two merge together.

Further disorienting is the fact that Picasso, like Cézanne, *included multiple views in the same painting*. However, while Cézanne had placed different views in different parts of a painting (see figure 19.31), Picasso merged them. We look at the faces of the women who are second and third from the left from straight on, yet their noses are in profile. Conversely, we

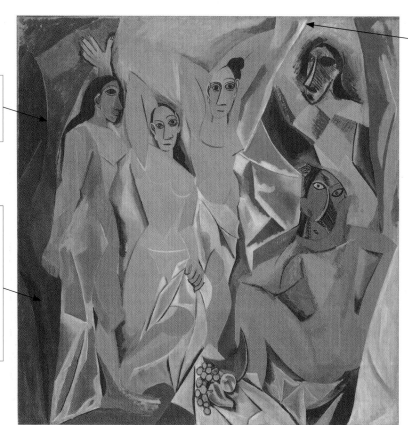

This woman's breast is a rectangular form, *making it a flat plane*.

The woman's leg is a series of elongated triangles. However, it isn't clear whether these triangles are *the figure* (the woman's leg) *or the ground* (the drapery).

The blue drapery is like sharp shards of glass. The fabric comes forward, *merging the figures with the ground* and flattening the image.

**FIGURE 20.11.** **Pablo Picasso.** *Les Demoiselles d'Avignon (The Young Women of Avignon).* *1907. Oil on canvas, 8′ × 7′ 8″. The Museum of Modern Art, New York.*

see the woman at the far left from profile, yet her eye from straight on. We see the fruit at the bottom from straight on, but the table on which the fruit rests from above. Following Cézanne's lead, Picasso *jettisoned the single vantage point of linear perspective*, illustrating what we know to be true in our minds—that we see three-dimensional objects from different views. Here was a *new way of showing three dimensions on a flat surface.*

Picasso's painting was also *a turning point—both rejecting and celebrating his predecessors*. Picasso discarded Western convention in the two right-hand figures, whose faces *resemble African masks and heads* (see figure 16.7). However, he maintained tradition in that *the subject matter* of the painting, which is called *Les Demoiselles d'Avignon* (lay DEM-wah-ZELL DA-vee-NYOH) (*The Young Women of Avignon*), was Avignon Street, a common location for prostitutes in Barcelona. Scholars are confident the painting shows women selling their bodies. There is no missing the prostitute-combined-with-still-life reference to *The Luncheon on the Grass* (see figure 19.1). Moreover, the three figures on the left also *link to art history*. The far-left figure mimics an Egyptian ruler (see figure 13.28), with its rigid position, stiff arms, and foot forward. Moving right, the next two figures copy the pose of Titian's *Venus of Urbino* (see figure 15.16), here placed vertically.

*Les Demoiselles d'Avignon* was a turning point in art history for one other reason. The painting was transitional to the style called **Cubism** (KYOOB-iz-im), which Matisse named, referring to the geometric shapes the style uses. When Matisse rejected a painting by French artist Georges Braque (zhorzh BRAHK) for the *Salon d'Automne*, he remarked that the painting *was only cubes*—the same types that are in *Les Demoiselles d'Avignon*. Picasso and Braque invented two forms of Cubism—*Analytic* and *Synthetic*.

## Analytic Cubism

**Analytic Cubism** took what Picasso had done with *Les Demoiselles d'Avignon* to the next level. The name "analytic" stems from how Picasso and Braque mimicked the real way we see masses in space. With Analytic Cubism, the artists:

- *Analyzed three-dimensional objects from multiple angles*, absorbing a series of views, just as we do in real life as we move around objects
- *Depicted entire objects by including all of their sides simultaneously* in one two-dimensional image
- *Used facets* to show these multiple views
- *Merged figures and ground*, collapsing space

Braque's *Girl with a Cross* (figure 20.12) illustrates Analytic Cubism's *multiple views in one image*. We see the head, shoulders, and chest of a girl who wears a cross around her neck. While she is *faceted*, we can make out her nose, eyes, and hair. Yet, she shifts. Her face seems visible from front-, left-, and right-hand views, while it simultaneously appears to move up and down. In presenting multiple views at once, Braque *showed an entire girl as we would see her, if we walked around her.*

While Braque and Picasso invented Analytic Cubism to depict a three-dimensional object on a flat canvas that is more akin to the way we see in real life, in the end, *their method abstracts reality*. Geometric shapes simplify and merge the girl with the background. Thick brushstrokes emphasize the paint rather than her skin and clothing. Light and shadow are nonsensical. Consider the highlight on the girl's nose and the shadow to the left of her nose. The same light from the left should hit both surfaces, yet one is light and the other, dark. Color is, also, unnatural. The girl and background are in the same neutral tones. This absence of color disassociates the painting from Expressionism and focuses us on structure rather than emotion.

All of these abstracting components emphasize that *the painting is an artifice*. No longer do traditional conventions of painting such as linear perspective, *chiaroscuro*, or simulated

**Cubism** A style of art developed by Pablo Picasso and Georges Braque in the early twentieth century that included two phases: Analytic Cubism, in which artists used facets to depict multiple views on a flat surface; and Synthetic Cubism, in which artists collaged scraps of items from the real world onto flat surfaces

**Analytic Cubism** One of two phases of Cubism developed by Pablo Picasso and Georges Braque in the early twentieth century in which artists used facets to depict multiple views on a flat surface

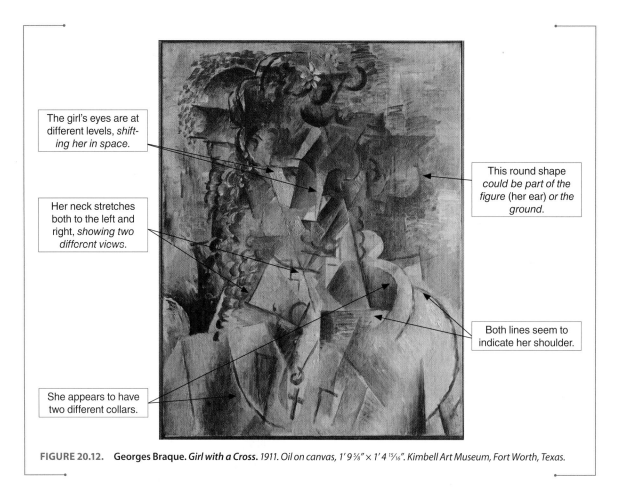

The girl's eyes are at different levels, *shifting her in space.*

Her neck stretches both to the left and right, *showing two different views.*

She appears to have two different collars.

This round shape *could be part of the figure* (her ear) *or the ground.*

Both lines seem to indicate her shoulder.

**FIGURE 20.12.** Georges Braque. *Girl with a Cross.* 1911. Oil on canvas, 1′ 9 ⅝″ × 1′ 4 ¹⁵⁄₁₆″. Kimbell Art Museum, Fort Worth, Texas.

texture (see Chapter 3) fool us into believing that we are seeing a real, three-dimensional image on a flat surface. Analytic Cubism in its exploration of reality insists that *art is an illusion.*

Analytic Cubism was such an influential style that a number of artists applied fractured forms to their art. To consider how Analytic Cubism appears in these works, see *Delve Deeper: Responses to Analytic Cubism.*

## Synthetic Cubism

Picasso and Braque continued to explore reality and illusion with **Synthetic Cubism**, but changed their technique. In Synthetic Cubism, they:

- *Synthesized individual pieces,* joining them together to create scenes
- *Used **collage*** by gluing scraps of items, such as newspaper, fabric, or wallpaper, to a two-dimensional work
- *Questioned what in art is real and what is an illusion* by attaching these items from the real world to their surfaces

In *Bottle of Suze* (figure 20.15), Picasso combined *collaged items from the everyday world*—newspaper, colored paper, wallpaper, and a label from a bottle of Suze (an alcoholic drink)—with painted and drawn marks to form a scene. We can imagine a café, where a patron sits at a table, drinking and smoking, while reading about the day's events.

Everything about the image *calls into question what is real and what is an illusion.* The wallpaper is real, but it contains stylized flowers, which are an illusion. Picasso drew the glass with charcoal, which is real, but the glass is an image. The white bottle takes on the shape of a real bottle; yet, if we did not know that it was a bottle from the label, it

**Synthetic Cubism** One of two phases of Cubism developed by Pablo Picasso and Georges Braque in the early twentieth century in which artists collaged scraps of items from the real world onto flat surfaces

**collage** French for "gluing"; a technique in which the artist glues scraps of items from the real world, such as paper or fabric, to the surface of a two-dimensional work; a work of art using this technique

# DELVE DEEPER

## Responses to Analytic Cubism

A number of artists borrowed Analytic Cubist form to support ideas that diverged from those of Braque and Picasso. Italian artist Umberto Boccioni (oom-BAIR-toh boh-CHOH-nee) was a member of the Futurists, a group that believed art should represent the speed of modern times. Cubist form allowed the Futurists to suggest this energy in their art. Boccioni applied Cubism's techniques to *Unique Forms of Continuity in Space* (figure 20.13). A gleaming, abstracted man strides forward confidently. He is fractured into Cubist fragments, each component of his body formed from a separate piece.

Russian artist Sonia Delaunay, conversely, applied Cubist facets to shoes (figure 20.14). Repeating bold triangles and diagonal lines help create a feeling of pulsating speed. The intense colors, falling one beside the next, appear to add to the dynamism. We can imagine how a woman dancing would enliven them further.

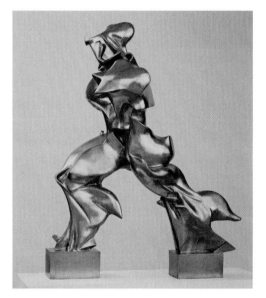

FIGURE 20.13.   Umberto Boccioni. *Unique Forms of Continuity in Space.* *1913 (cast 1931). Bronze, 3' 7 ⅞" × 2' 10 ⅞" × 1' 3 ¾". The Museum of Modern Art, New York.*  We see this man over time. His muscles barely keep up. They extend like wings behind his legs, making him appear to move faster.

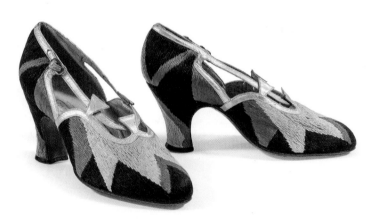

FIGURE 20.14.   Sonia Delaunay. Court shoes. *1925. Leather and silk embroidery, 5 ½" × 3 ½" × 1". Les Arts Décoratifs, Département Mode et Textile, Collection de l'Union Française des Arts du Costume, Paris.*  Cubism was such an important movement that it influenced the applied arts.

would appear as only a white shape. In addition, *objects in the image are seen from multiple views.* We see the ashtray, table, cigarette, and newspaper from above and the bottle, glass, and wallpaper from straight on. While the combined vision creates a distorted image, we know from Analytic Cubism that the basis for these different perspectives is drawn from how we see the world.

Synthetic Cubism challenged Western art that had for centuries been seen as mimicking life. Now, *life had become part of art*, blurring the definition between the two concepts (just as Mendieta's works combined the real world with art). Before Modern art, fine art had been dignified. While nineteenth-century artists had chipped away at this designation, Synthetic Cubism jettisoned the idea entirely.

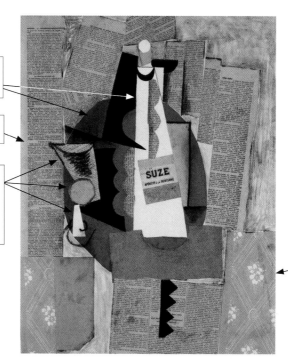

A white bottle of Suze rests on a blue circular table.

Newspapers are laid out near the table.

A tan glass and a gray ashtray with a white cigarette sit on the table. A black swirling line of smoke rises from the cigarette.

SUZE
APÉRITIF À LA GENTIANE

The wall is covered in a flower-and-diamond-patterned wallpaper.

**FIGURE 20.15.** Pablo Picasso. *Bottle of Suze.* 1912. Pasted papers, gouache, and charcoal on paper, 2′ 1 ¾″ × 1′ 7 ¾″. Mildred Lane Kemper Art Museum, Washington University in St. Louis, Missouri.

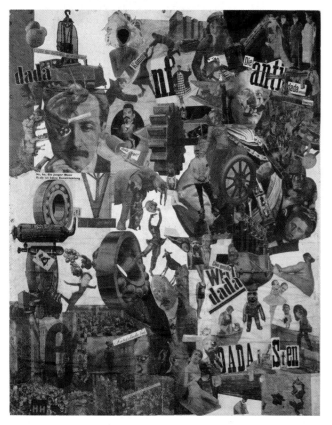

**FIGURE 20.16.** Hannah Höch. *Cut with the Dada Kitchen Knife through the Last Weimar Beer-Belly Cultural Epoch in Germany.* c. 1919. Collage, 3′ 8 ⅞″ × 2′ 11 ½″. Nationalgalerie, Staatliche Museum, Berlin. Everything in Höch's image is presented in a flat, all-over frenzy.

*Quick Review 20.2*: What is the difference between Analytic and Synthetic Cubism?

## The Art of the Irrational

Two styles in the twentieth century, *Dada* and *Surrealism*, focused on the irrational in art. Artists from these movements turned their back on traditions.

### Dada

**Dada** arose in protest to the horrors of World War I. People had entered the century full of hope. Inventions had promised progress, and artists (like the Futurists) had been idealistic about the modern world. However, World War I brought destruction. What good, Dadaists asked, was progress when it led to evil? Dada artists *suggested that we throw out rationalism,* since past logic and morals had led to war. Dada artists:

- *Attacked traditional values, culture, and convention*
- *Rejected anything promoted as worthy in the past—* science, technology, politicians, art, etc.
- *Promoted nonsense and the absurd*

*Cut with the Dada Kitchen Knife through the Last Weimar Beer-Belly Cultural Epoch in Germany* (figure 20.16) by German artist Hannah Höch (HAHN-nuh HOOHK) *attacks prominent individuals, cultural conventions, and the German*

*government.* The work is covered in images of politicians, military figures, artists, and scientists, whom Höch cut out of magazines. Höch clearly denounced "beer-bellied" individuals who had driven the country into World War I. Her *collaged photos* physically assault the figures, as she has cut off heads and absurdly placed them on alternate bodies, removed figures from their original context, and combined them in new arrangements.

Further, the use of the words "kitchen knife" in the title suggests a connection to domesticity and women. Here, *a woman is the aggressor.* As a female artist, Höch, similar to Mendieta, challenged the world dominated by men, who had created the chaos, all of which is evident in her image. Of course, it is not only Höch's method that attacks the traditional, masculine world, but also her *rejection of convention.* Figures crowd the image with no regard for diminishing size, vertical placement, or overlap (see Chapter 3).

Marcel Duchamp (mahr-SELL doo-SHAHM), a French artist, in *Mona Lisa (L.H.O.O.Q)* (figure 20.17) similarly *assaulted traditional values.* Duchamp took a postcard of Leonardo da Vinci's *Mona Lisa* (see figure 2.19), arguably the most famous woman in Western art, and penciled a mustache and goatee on her face. By defacing the image, Duchamp attacked the painting and the tradition that had created it.

The *Mona Lisa* is held up not only as a treasure of Renaissance art, but also as a model of feminine beauty. In this respect, Duchamp also seemingly *undermined art itself*, which has traditionally been linked to ideal beauty (see Chapter 2). This "perfect woman" appears masculine. Duchamp mocked what had been considered the pinnacle of societal perfection with an ordinary pencil on a cheap reproduction. To consider how a work in a different medium attacked societal values, see *Practice Art Matters 20.2: Explain Why a Work Is Classified as Dada.*

## Surrealism

Artists who followed **Surrealism** also created irrational art, but they did so in response to the work of Sigmund Freud. Freud believed that our behaviors could be explained by the conflict between our unconscious mind's inappropriate urges and civilized society's requirements. He suggested we could learn about our desires by examining dreams, as through them we could see our true mental state.

In their art, the *Surrealists explored the unconscious mind* and *formed an art of fantasy.* Some created works that appear like *dreams*, while others formed images *spontaneously.* Spanish artist Salvador Dalí (sal-vah-DOHR DAH-lee) represents the *dream-like style.* His *The Persistence of Memory* (figure 20.19) portrays a barren landscape where watches bizarrely hang limply as if melting. An amorphous form appears like a dead whale on a beach. It is a simplified face, whose gigantic eyelashes, nose, and tongue are its only recognizable features. At bottom left, ants inexplicably swarm over a metal watch cover, as if it is a piece of food.

The image is so disturbing because *Dalí rendered much of it in a precise, representational style.* The ants, tree, and cliff appear as though they could be out of everyday life. It is the combination with the deformed watches and face that makes the scene nightmarish.

*The Horde,* by German artist Max Ernst, represents the *spontaneous style* of Surrealism. Surrealists believed that they could reach their unconscious thoughts by drawing spontaneously, rather than preplanning a composition under the control of their conscious minds. Ernst achieved this goal by placing canvas over the textured surfaces of floorboards or strings and then rubbing a pencil, crayon, or paint over the canvas. He then added to or scraped the random markings, changing the images into fantastic,

**Dada** An art movement in the West that arose in response to World War I that attacked traditional values, culture, and convention and promoted the irrational

**artists**
**MATTER**

Marcel Duchamp

**FIGURE 20.17.** Marcel Duchamp. *Mona Lisa (L.H.O.O.Q.).* 1919. Pencil on reproduction, 7¾″ × 4⅞″. *Philadelphia Museum of Art, Pennsylvania.* Duchamp titled this work "L.H.O.O.Q." When said in French, the letters sound like the words "Elle a chaud au cul," which mean, "She has got a hot ass," which is yet another assault on the painting.

**Surrealism** A style of art in the West in the twentieth century, associated with Freud's work on the unconscious mind, that explored the irrational through dream images and spontaneous creation of art

## 20.2 Explain Why a Work Is Classified as Dada

Dadaism changed art. For the first time in the history of Western art, the movement was more of a mindset than a style. As long as they rejected the past, Dadaists could make works from any material and with any appearance.

American-born artist Man Ray created a Dadaist work called *Gift* (figure 20.18) (the work was a gift for the gallery owner where it was exhibited). Man Ray glued tacks to the bottom of a flat-iron, an old-fashioned iron that was heated on stoves and used to press garments.

Explain why Man Ray's work fits into Dada:

- What part of civilized society did Man Ray attack?
- In comparing the appearance of Man Ray's work to Höch's (figure 20.16) and Duchamp's (figure 20.17), how does *Gift* support the notion that Dadaism was more of a mindset than a style?

**FIGURE 20.18.** **Man Ray.** *Gift.* c. 1958 (replica of 1921 original). Painted flatiron and tacks, 6 ⅛″ × 3 ⅝″ × 4 ½″. The Museum of Modern Art, New York.

**FIGURE 20.19.** **Salvador Dalí.** *The Persistence of Memory.* 1931. Oil on canvas, 9 ½″ × 13″. The Museum of Modern Art, New York. Dalí based the distorted face in the image on his own profile.

recognizable scenes, *based on what the ambiguous designs suggested to him*. In figure 20.20, it was abstract, tree-like monsters.

*Quick Review 20.3*: How did Dada and Surrealism explore the irrational in art?

## Art for a Better World

Several movements following the destruction of World War I sought to form a better future. These artists recognized how art could play a role in transforming society. Three different movements arose: *De Stijl* (de STY-al) in the Netherlands, the *Bauhaus* (BOW-hows) in Germany, and the *International Style*, which reached across boundaries.

### De Stijl

**De Stijl**  Dutch for "The Style"; an art movement in the Netherlands following World War I, associated with a nonobjective style of art that employed rectangular and linear forms in black, white, gray, and primary colors

In the Netherlands, **De Stijl** (The Style) artists believed their movement would lead to a better world. They hoped to form a definitive artistic language that would promote unity and peace. *De Stijl* artists used:

- *Simple, rectangular shapes and straight, vertical and horizontal lines*
- *White, black, gray, and primary colors*
- *An asymmetrical design*
- *A nonobjective style*

Gerrit Rietveld (GAY-rit REET-velt) and his client, Truus Schröeder (trees SHROH-der), designed Schröeder House (figure 20.21)—an efficient, inexpensive, and compact middle-class home—taking the *De Stijl* approach. The hallmarks of the style are evident in the *flat, white planes and horizontal and vertical lines*. Also characteristic is the *asymmetrical design* in which nothing matches up, and yet nothing seems out of place.

Rietveld and Schröeder envisioned this home as a model for future dwellings. They believed building reasonably priced, straightforward, innovatively designed homes for the masses could eliminate class distinctions.

## The *Bauhaus*

Germany emerged from World War I in a shambles, and artists saw ways for art to help create a better future. Walter Gropius (VAL-tuhr GROH-pee-us) founded a school called the **Bauhaus** (the Building House). The *Bauhaus*:

- *Unified the fine and applied arts*
- *Created functional and efficient designs*
- *Promoted simple, modern-looking, geometric works*

Gropius's and Adolf Meyer's school building (figure 20.22) illustrates the approach. The complex contained classrooms, workshops, offices, and housing. While asymmetrical, *the design still feels ordered*. Flat, undecorated, white surfaces surround plain rows of windows. Stripped-down *functionality takes precedence over ornament*.

*Bauhaus* style also extended to the applied arts. Marianne Brandt's teapot (figure 20.23) shows an *austere, simple, functional object*. Repeating circular and semicircular forms with a polished metal and matte ebony surface create a *clean, practical design*.

Unfortunately, the Nazis did not tolerate a Modern style, and they shuttered the *Bauhaus* in 1933. Many proponents moved to the United States, where they were instrumental in establishing the *International Style*.

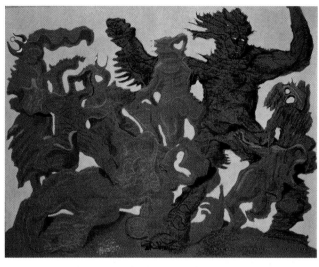

**FIGURE 20.20.** **Max Ernst. *The Horde.** 1927. Oil on canvas, 3′ 8 ⅞″ × 4′ 9 ½″. Stedelijk Museum, Amsterdam, The Netherlands.* The simulated rough surface adds to the monsters' seemingly frightening effect.

**Bauhaus** German for "Building House"; the school started in Germany following World War I that promoted artists, architects, and designers creating simple, geometric, functional designs

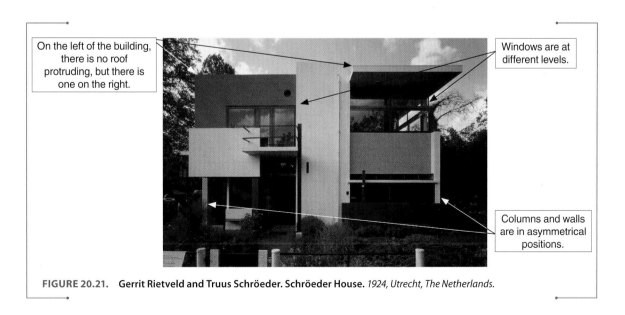

On the left of the building, there is no roof protruding, but there is one on the right.

Windows are at different levels.

Columns and walls are in asymmetrical positions.

**FIGURE 20.21.** **Gerrit Rietveld and Truus Schröeder. Schröeder House.** *1924, Utrecht, The Netherlands.*

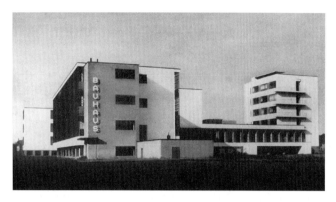

FIGURE 20.22. **Walter Gropius and Adolf Meyer. Bauhaus School.** *1926, Dessau, Germany.* A bridge (housing administrative offices) ran horizontally between vertical buildings. The left structure housed large, open spaces, and balconies on the right were for individual apartments.

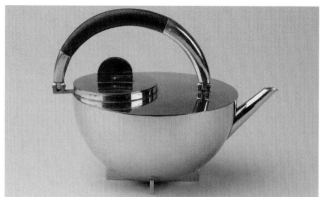

FIGURE 20.23. **Marianne Brandt. Teapot.** *1924. Nickel silver and ebony, height 7". The Museum of Modern Art, New York.* Brandt led the metal workshop at the *Bauhaus*, promoting the practical design seen in this teapot.

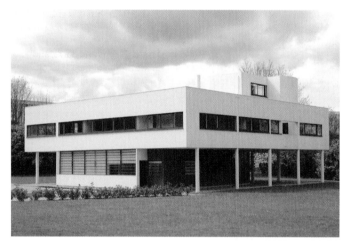

FIGURE 20.24. **Le Corbusier. Villa Savoye.** *1928–1931, Poissy, France.* This photo of Villa Savoye illustrates the three functional levels of the house.

**International Style** An architectural approach in the West in the twentieth century, associated with plain, geometric, functional structures

## The International Style

Architects in Europe and the United States, coming out of World War I, created the **International Style**, which sought to dissolve boundaries and historical precedents. These artists believed that a movement that avoided national styles would foster a peaceful world. International Style artists:

- *Shunned decorative architectural features* that would link buildings to specific countries
- *Used simple, regular, geometric forms*
- *Created practical structures in which form* (how the building looked) *was determined by function* (how the building was used)
- *Employed steel skeletons and non–load-bearing skins* (see Chapter 12)

Villa Savoye, a house by Swiss-born architect Le Corbusier (luh kohr-boo-ZYAY), takes the International Style approach (figure 20.24). On the lowest level, a circular drive leads to a garage and area for mechanical equipment. The main living area juts out over this level and is supported on thin columns. Here, because of the *skeleton-and-skin technique*, Le Corbusier placed interior and exterior open spaces based on *optimal functionality* rather than the position of interior structural supports. Finally, a ramp (not visible in the image) leads to additional outdoor living space on a flat roof.

The hallmarks of the stark International Style are everywhere. Historical style and emotion are absent. *Plain, white walls and undecorated, repeating windows* wrap around the house horizontally, while thin columns ascend vertically. Le Corbusier formed a *practical structure* for a mechanical world in which *global harmony could be attained*.

*Quick Review 20.4*: What are the similarities among three post–World War I styles that sought to better society?

## Art in the United States

Americans encountered early twentieth-century European progressive trends in two ways. First, in 1913, the *Armory Show displayed a number of avant-garde works* (see Chapter 2). The exhibition was eventually seen by approximately three hundred thousand people. Second, Alfred Stieglitz (STEEG-litz) *displayed Modern works in his Gallery 291 in New York.*

Imogen Cunningham's *Calla* (figure 20.25) illustrates what Modern art looked like in the United States during this period. Cunningham used straight photography to print exactly what she shot with her camera. The extreme close-up of the bloom *makes the image appear abstract.*

While artists such as Cunningham worked in Modernist styles, *most North American artists rejected what they considered European elitism.* As the world sank into the Great Depression and Europe descended into fascism, North American artists retreated from what they saw as the dangers of European culture and moved toward *realistic approaches* that the masses could understand. In the United States, three representational styles were common during the first half of the century:

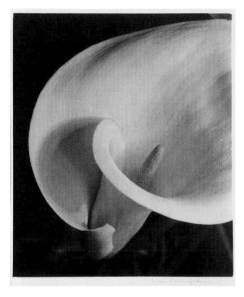

**FIGURE 20.25.** **Imogen Cunningham.** *Calla. Late 1920s. Gelatin silver print, 1′ 1 ¹⁵⁄₁₆″ × 10 ⅞″. The Museum of Fine Arts, Houston.* The curving, repeating rhythms, juxtaposition of lights and darks, and abrupt cropping at the right highlight the composition of lines and shapes.

- *Regionalism* harkened back to provincial tastes and promoted wholesome, patriotic values.
- *Social Realism* documented the hard times faced by everyday Americans.
- *The Harlem Renaissance* appeared in Harlem, New York, where African American artists, musicians, and writers used art to capture the dignity of the African American experience and in the service of achieving equal rights.

### Regionalism

Grant Wood's *American Gothic* (figure 20.26) illustrates *the stoic, nostalgic approach of Regionalism.* Wood depicted his sister and dentist, but the two could represent any rural folk across the country. Wood showed them *objectively with realistic lighting, appropriate proportions, and in a believable space.* They stand before a quaint home with obvious seriousness and determination. The image was a *symbol of the resolve of hard-working Americans during the Great Depression.*

### Social Realism

*White Angel Breadline, San Francisco* (figure 20.27) illustrates *Social Realism*, in which artists *captured the misery of this period.* Dorothea Lange (dore-THEE-ah lang) photographed a man standing in the White Angel Breadline during the Great Depression. Despair appears to hang over him, as he clenches his hands. His hat is dirty and no longer holds its form, and his cup is dented. The contrast with Cunningham's Modern image (figure 20.25) is extreme—while *Cunningham's focus was the formal design, Lange's is the wrenching subject matter.*

### The Harlem Renaissance

Aaron Douglas showed the *pride in heritage* characteristic of the *Harlem Renaissance* in his history of African Americans. In the panel

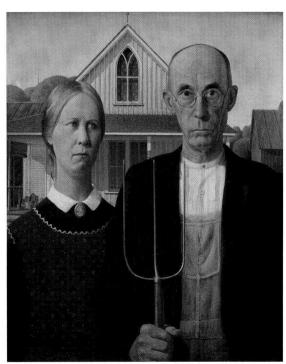

**FIGURE 20.26.** **Grant Wood.** *American Gothic. 1930. Oil on beaver board, 2′ 6 ¾″ × 2′ 1 ¾″. Art Institute of Chicago, Illinois.* The vertical tines and bottom curve of the pitchfork mimic lines on the man's overalls and shirt and in the window on the house, creating a reliable rhythm.

depicting *From Slavery through Reconstruction* (figure 20.28), silhouetted figures convey the story of this period in which African American slaves were liberated.

Similarly, Augusta Savage's *The Harp* (figure 20.29) honored the legacy of African American music. Commissioned for the 1939 World's Fair, Savage created a harp formed of singers, each of whom represents a harp string. The hand of God supports the choir, while a kneeling man stands for the foot pedal. While Savage simplified, elongated, and scaled the singers' bodies to form the strings, there is no missing the *objective depiction of the man* or the faces of the singers, who belt out their song.

*Quick Review 20.5*: What are the differences among the three representational styles that were prevalent in the United States before World War II?

# Post–World War II through 1980

While the Soviets joined with England and the United States during World War II to defeat fascism, disagreements in ideology existed between the communist and democratic governments. A period of tension, known as the Cold War, followed, in which the Soviets attempted to spread—and Americans to suppress—communism. The Cold War brought about the turmoil in Cuba that led to Mendieta's exile.

In addition, while Europe was in ruins, the United States was prosperous, and numerous new goods became available. Americans were eager to spend on items ranging from modern household appliances to automobiles. Popular culture similarly dominated the scene, as television, rock and roll, and advertising exploded.

The 1960s and '70s also ushered in a world of protest. Groups long discriminated against sought equality. When demonstrators outside the Guggenheim asked, "Where is Ana Mendieta?" and objected to the lack of women and artists of

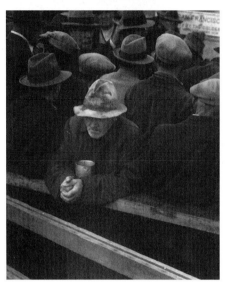

**FIGURE 20.27.** Dorothea Lange. *White Angel Breadline, San Francisco.* 1933. Gelatin silver print, 1′ ¼″ × 10 ⅛″. San Francisco Museum of Modern Art, California. Most disconcerting about this image is that the man waits with potentially hundreds more like him, since, with the cropping, we have no idea how long the line extends.

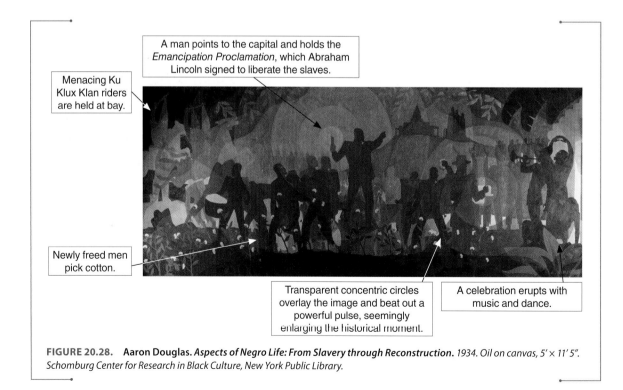

A man points to the capital and holds the *Emancipation Proclamation*, which Abraham Lincoln signed to liberate the slaves.

Menacing Ku Klux Klan riders are held at bay.

Newly freed men pick cotton.

Transparent concentric circles overlay the image and beat out a powerful pulse, seemingly enlarging the historical moment.

A celebration erupts with music and dance.

**FIGURE 20.28.** Aaron Douglas. *Aspects of Negro Life: From Slavery through Reconstruction.* 1934. Oil on canvas, 5′ × 11′ 5″. Schomburg Center for Research in Black Culture, New York Public Library.

color in the exhibition, they had been spurred on by the women's liberation and civil rights movements.

## The New York School

As Europe lay devastated at the end of World War II, the center of the art world shifted from Paris to New York. European artists had fled to the United States, bringing Modernism with them. At the same time, American artists chose *abstract and nonrepresentational styles* that were *linked with the free spirit of American democracy*, as the Soviet Union favored representation.

American artists also reacted to the devastating news that millions had been murdered by the Nazis and Stalin. *Art,* they felt, *had to change to be relevant.* Through abstract and nonrepresentational, large-scale formats, artists could *probe the depths of individual feelings.*

It is impossible to characterize a single style for this new expressive approach that came to be known as the **New York School** or **Abstract Expressionism**. However, we can classify two tracts: *Action painting* and *Color Field painting.*

### Action Painting

With **Action painting**, artists painted with *large, distinct, gestural strokes* (see Chapter 3) *that conveyed emotion.* Action painter Jackson Pollock (PAH-luk) tacked his unstretched canvases on the floor and worked above them (figure 20.30). The American artist continually stepped onto each painting, from different directions, using brushes and sticks to fling and drip paint.

Pollock's *Number 1* (figure 20.31) shows a web of twisting lines. Each strand represents the lunge of his body and arc of his arm. We can imagine what his movements must have been like when he created the work. Pollock involved *his entire self in the act of creation.*

In addition, no one else would have moved just as Pollock, and Pollock himself painted differently depending on his mood. As such, each mark *has its own path that describes Pollock's feelings,* and the paintings can be seen as deeply introspective. They addressed the need for a more *soul-searching art* that people sought following the war.

The enormous scale of the works also allows us to lose ourselves in an immense, all-over tangle of lines. We cannot orient what line is in front or behind. The sensation *creates the illusion of a never-ending depth.*

Finally, *we are aware of time* in the painting. Each stroke is associated with a Pollock motion, as if it is a permanent reconstruction of his creative act. Rather than being set objects, the works are *records of events,* just as Mendieta's photos are evidence of her actions.

Dutch-born American artist Willem de Kooning (VILL-em duh KOO-ning) shows how individualistic the New York School artists were. His style was a world apart from Pollock's; his works *were painted vertically* (not on the floor) and *were abstract rather than nonrepresentational.*

De Kooning's *Woman and Bicycle* (figure 20.32), though, still is an Action painting with *aggressive strokes that run in multiple directions.* His movements formed an emotionally charged flurry of paint. The painting appears as *a constant reworking,* as the act of creation lingers in front of us. De Kooning overlaid alternate versions of the woman at different stages of his process, displaying the action of his movements.

Some scholars have suggested de Kooning was hostile to women. The figure stares out from a skull-like head. Her wide eyes and garish, double smile can feel creepy. With her enormous breasts, she seems voluptuous; yet, with her menacing form, she can appear intense.

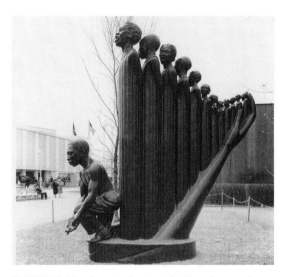

**FIGURE 20.29.** Augusta Savage. *The Harp. Destroyed. 1939. Plaster, approximate height 16'. Photograph from the New York Public Library.* By being given the honor of creating a piece for the fair, Savage displayed not only the proud history of African American music, but also the talents of an African American female artist.

**New York School** (or **Abstract Expressionism**) An American art movement after World War II in which artists expressed inner feelings in large-scale abstract and nonrepresentational works

**Action painting** A style of art in the West following World War II in which artists painted with large, gestural marks that expressed emotion

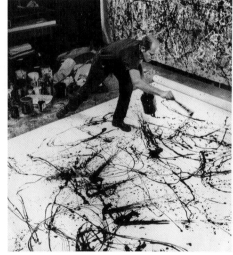

**FIGURE 20.30.** Hans Namuth. *Jackson Pollock. 1950. Gelatin silver print, 14 ¾" × 13 ¾". National Portrait Gallery, Smithsonian Institution, Washington, DC.* In this image, we can see Pollock's unconventional method of painting.

FIGURE 20.31. Jackson Pollock. *Number 1, 1949.* 1949. Enamel and metallic paint on canvas, 5′ 3″ × 8′ 6″. The Museum of Contemporary Art, Los Angeles. Imagine standing in front of *Number 1*. The painting is over five feet high and eight feet wide. The lines would encompass your entire field of vision, potentially throwing you into the feeling of infinite space.

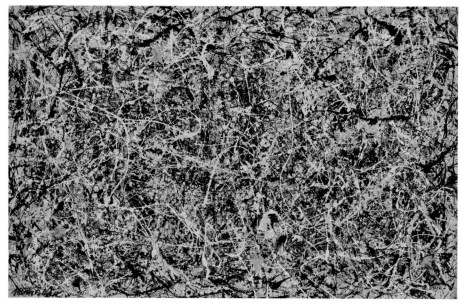

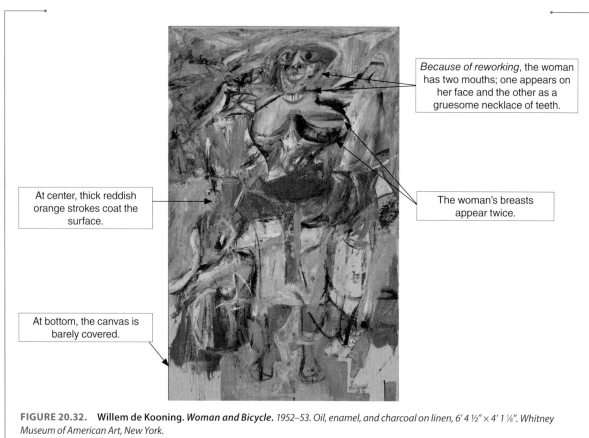

*Because of reworking,* the woman has two mouths; one appears on her face and the other as a gruesome necklace of teeth.

At center, thick reddish orange strokes coat the surface.

The woman's breasts appear twice.

At bottom, the canvas is barely covered.

FIGURE 20.32. Willem de Kooning. *Woman and Bicycle.* 1952–53. Oil, enamel, and charcoal on linen, 6′ 4 ½″ × 4′ 1 ⅛″. Whitney Museum of American Art, New York.

## Color Field Painting

**Color Field painting** A style of art in the West following World War II in which artists painted broad expanses of color meant to express emotion

**Color Field painting** is similar to Action painting in that artists attempted to communicate raw emotion, appropriate for the reflective post-war period; however, Color Field painters rejected gestural strokes. These artists conveyed feeling by:

- *Painting vast expanses of color*
- *Forming simple shapes*
- *Using glowing hues*

Russian-born Color Field artist Mark Rothko worked in series. Paintings *communicate different moods* with variously colored, large, horizontal rectangles that float on vertical canvases. In *No. 9 (Dark over Light Earth/Violet and Yellow in Rose)* (figure 20.33), Rothko thinly sponged violet and yellow shapes over a rose base. To appreciate the work, we must imagine it nearly seven feet high. If we were standing before it, the painting might *envelop us in rich color*, while the towering stack could dissolve at its soft edges and melt into the ground. The deep violet might become a mesmerizing chasm of dark sky, and the vibrant yellow, a shining earth. Even though the forms are not figurative, they could *communicate emotion*.

*Quick Review 20.6*: How did New York School artists explore personal expression in their work?

## Art and Reality

With growing American consumerism, artists in the 1950s and '60s became disillusioned with what they saw as the highbrow attitudes of the New York School. They believed *art should reflect the world in which we live*. Artists of *assemblages, environments/installations, Happenings*, and *Pop* looked back to Synthetic Cubist collages to bring real life back into art.

### Assemblages

**Assemblage** artists blurred the distinction between art and the everyday. They transposed two-dimensional Cubist collages of real objects into three-dimensional sculptures. Assemblage artists *combined found, preexisting objects into three-dimensional forms*.

In *Monogram* (figure 20.34), American Robert Rauschenberg (ROW-shen-burg) assembled a stuffed goat, ringed by a tire, standing on a horizontal painting that has been lifted onto casters. Rauschenberg gathered the *preexisting items* from trips through New York streets. The random combination can speak to the chaotic nature of daily existence, where unrelated, unexpected objects come into our lives. The work likely also *questions the nature of art*, since it hovers between sculpture, painting, and reality, never really being either media or the actual everyday world.

American sculptor Louise Nevelson similarly *combined random objects from forays through the streets*, but she transformed them into seemingly elegant forms. Her *Sky Cathedral* (figure 20.35) illustrates the cohesiveness of her wall assemblages. She placed numerous objects into milk crates and cartons; yet, the monochromatic black paint connects all, possibly suggesting a religious shrine complete with offerings.

### Environments/Installations

Artists who create **environments** (also called **installations**) bring reality into works by letting viewers intermingle with the art in a complete space. These artists:

- *Fill entire rooms with constructed and/or preexisting objects*
- *Allow viewers to enter the works*
- *Create an integrative experience of art and life*

French-born American artist Marisol (mah-ree-SOHL) installed a party as an environment by assembling different "attendees" from *crafted and everyday materials* and

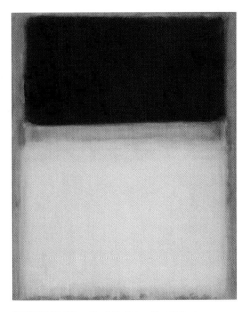

**FIGURE 20.33.** **Mark Rothko.** *No. 9 (Dark over Light Earth/Violet and Yellow in Rose).* *1954. Oil on canvas, 6′ 11 ½″ × 5′ 7 ¾″. The Museum of Contemporary Art, Los Angeles.* The floating shapes can evoke mystical thoughts.

**assemblage** A work of art formed of joined, different, preexisting found objects

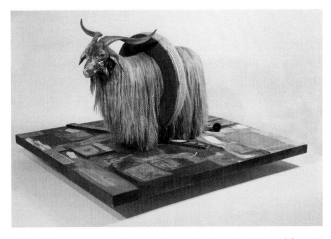

**FIGURE 20.34.** **Robert Rauschenberg.** *Monogram.* *1955–59. Oil, paper, fabric, printed paper, printed reproductions, metal, wood, rubber shoe heel, and tennis ball on canvas with Angora goat and rubber tire on wood platform mounted on four casters, 3′ 6″ × 5′ 3 ¼″ × 5′ 4 ½″. Moderna Museet, Stockholm, Sweden.* Rauschenberg may have been making fun of New York School artists, as we can connect the horizontal canvas with Pollock's method of working (figure 20.30). However, here, a goat stands over the surface.

**environment** (or **installation**) A three-dimensional work of art in which the artist uses an entire space or room to create the piece

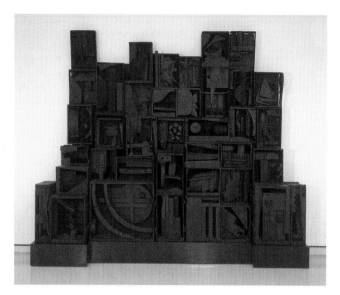

FIGURE 20.35. **Louise Nelson.** *Sky Cathedral.* 1958. Wood, painted black, 9′ 7″ × 11′ 3″ × 1′ 8″. Albright-Knox Art Gallery, Buffalo, New York. Nelson formed her works from a myriad of objects from chair legs to banister railings to moldings.

**Happening** A theatrically based work created by an artist in which participants stage an unscripted, unrehearsed event

spacing them around a room (figure 20.36A). Using artistic techniques, she fashioned guests' faces after her own image, which she photographed or cast. However, she dressed attendees in real attire, including gloves, jewelry, dresses, and shoes. The combined built and assembled pieces can be seen in the detail in figure 20.36B. The figures stand alongside *spectators, who become additional real guests at the event.*

## Happenings

**Happenings** were artist-created, three-dimensional collages of events that combined people and real-life items in haphazard ways in an attempt to recreate the experience of the frenzied, everyday world. Happenings were similar to plays, but they had no script; they just happened. These works:

- *Varied in length,* lasting minutes or days
- *Involved performers* and sometimes spectators
- *Had no rehearsals, stages, or roles*
- *Included different artistic forms* from poetry to music to dance
- *Merged art and life*

Allan Kaprow's *The Courtyard* (figure 20.37) illustrates the random, experiential art of Happenings. The American artist built an enormous tower from scaffolding covered in black paper, set in a hotel courtyard. During the piece, a woman in a white nightgown danced around the mountainous form, then climbed to the top, where a mattress awaited her. After posing for photographers, who had followed her to the peak, another large papered form descended toward the woman and photographers, engulfing them.

With Happenings, art entered a new phase. The Western tradition had always focused on an art object. Now, *a creative act was considered art.* Immediacy trumped longevity, impermanence outdid physicality, and, as in Mendieta's art, *the real world replaced the museum.* It was as if watching Pollock (figure 20.30) produce a painting was

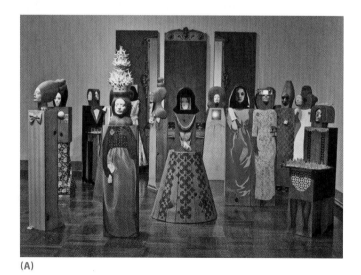

(A)

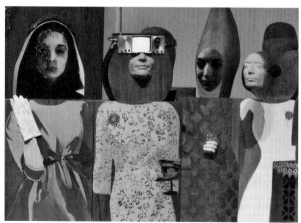

(B)

FIGURE 20.36A AND B (DETAIL). **Marisol.** *The Party.* 1965–66. Fifteen life-size figures and three wall panels, with painted wood and carved wood, mirrors, plastic, television set, clothes, shoes, glasses, and other accessories. Toledo Museum of Art, Ohio. Marisol placed guests at a party throughout a space that viewers can enter (20.36A). In the detail (20.36B), one woman's eyes are formed from a television, which sits atop a cast face.

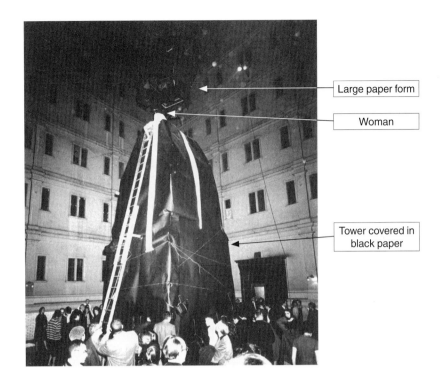

Large paper form

Woman

Tower covered in
black paper

FIGURE 20.37. **Allan Kaprow.**
*The Courtyard.* *1962. Happening*
*at the Mills Hotel, New York.* In this
Happening, a woman climbed a
tower covered in black paper, and
a large paper form descended on
her and others.

the work itself. The *ritualistic movement was more important than the record* made in the
painting.

## Pop Art

**Pop art** explored how society had become consumed with mass culture in the 1950s and
'60s. Images and information were suddenly inescapable, as televisions, movies, and ad-
vertising became pervasive. Pop artists *imitated media images, mimicked mass-production*
*techniques, and formed commercial objects.*

In the Pop work *Orange Car Crash Fourteen Times* (figure 20.38), American Andy Warhol
(WOHR-hohl) *imitated a media image* by duplicating a photograph from a fatal auto ac-
cident numerous times, just as it had appeared in tabloids. Warhol showed how we often
become numb to tragedy with widespread exposure. The front-page photograph is repli-
cated in black, similar to newspaper ink. Yet, the entire ground is bright orange, as if we
can cheerfully continue with our lives.

**Pop art** A style of art in the West
in the twentieth century that
imitated media images, mimicked
mass-production techniques, and
formed commercial objects

**artists**
MATTER

Andy
Warhol

Faint ink

Dense ink

FIGURE 20.38. **Andy Warhol.**
*Orange Car Crash Fourteen*
*Times.* *1963. Silkscreen ink on*
*synthetic polymer paint on two*
*canvases, 8' 9 7/8" × 13' 8 1/8". The*
*Museum of Modern Art, New*
*York.* Changes in the faintness and
density of the ink appear as if from
a careless printing mistake, adding
to the notion of the image being
insignificant.

FIGURE 20.39A AND B
(DETAIL). Roy Lichtenstein.
*Drowning Girl.* 1963. Oil and
synthetic polymer paint on
canvas, 5′ 7 ⅝″ × 5′ 6 ⅜″. The
Museum of Modern Art, New
York. Lichtenstein copied car-
toons (20.39A) and mimicked
Ben-Day dots (20.39B), typically
used in commercial printing, to
focus on pop culture.

(A)                    (B)

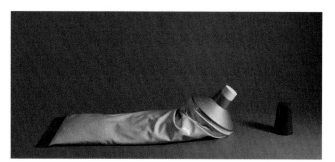

FIGURE 20.40. Claes Oldenburg. *Giant Toothpaste Tube.* 1964. Vinyl
over canvas filled with kapok, wood, metal, and cast plastic, overall 2′ 1 ½″ × 5′
6″ × 1′ 5″. The Cleveland Museum of Art, Ohio. Oldenburg reproduced con-
sumer products at gigantic sizes. Here we have toothpaste, but other
items he created included cheeseburgers and lipstick.

Warhol also *mimicked mass-production techniques* by screen-
printing (see Chapter 7) the image, a technique traditionally
used in commercially printed products. The mechanical process
*helps make the image seem worthless.* There are many cheaply pro-
duced images, rather than one valuable original. Even death, it
seemed, had become a packaged, reproducible product.

American Roy Lichtenstein (LICK-ten-styn) formed
*Drowning Girl* (figure 20.39A) by *mimicking a mass-production
technique* in forming Ben-Day dots (figure 20.39B), used to
print inexpensive color pictures by converting tonal grada-
tions into different-sized and spaced circles. The dots blend
together from a distance, forming an image. His method, in
recalling the machine-driven process, is *linked to commercial
products.* Here, even a painting, traditionally high art, is ap-
parently relegated to the lowly world of consumer culture.

Additionally, Lichtenstein borrowed designs from *mass-produced comic books.* As with
Warhol, a single original was unimportant. In the painting, Lichtenstein reconstructed a
woman struggling in rough surf. Her eyes well with tears as her clichéd words recall the
sappiest fictional dramas.

Swedish-born American artist Claes Oldenburg (klahs OHL-den-burg) *formed commer-
cial objects* by replicating consumer products in huge sizes. His *Giant Toothpaste Tube* (figure
20.40) is over five feet long. The enormous scale appears to celebrate the mundane commodity
while seeming to transform it into a monster from a nightmare. Oldenburg clearly poked fun
at the importance people place on products, while also *merging art with the everyday world.*

*Quick Review 20.7:* How have four post–World War II styles blurred the
boundary between art and life?

## Minimalism

With **Minimalism**, artists believed that nothing should get in the way of the uplifting
experience and direct connection that a viewer has with art. Minimalist artists:

- *Created stripped-down nonobjective works*
- *Produced works with minimal skill*

Minimalism A style of art
in the West in the twentieth
century associated with formal,
nonobjective works that had no
meanings, functions, or illusions

- *Formed art that had no meanings, functions, or illusions of the outside world*
- *Championed form and the physical art object instead of ideas*

American Donald Judd's Minimalist work *Untitled*, which we looked at in Chapter 2 and is reproduced here as figure 20.41, is a stack of empty, rectangular boxes symmetrically attached to a wall. Judd had the boxes fabricated by a factory from industrial materials, so there is *no personal gesture or skill*. The repeating boxes are the same size, spaced evenly, and of identical colors and texture. Furthermore, Judd called the work "Untitled," so that *we cannot imagine a subject matter*. As viewers, we can focus on only the work, divorced from any influences that could interrupt our consideration. The work has *no meaning and no function*. It is *art for art's sake*.

*Quick Review 20.8*: Why is meaning incompatible with Minimalism?

## The Art of Ideas

Two styles emerged in the 1960s that suggested the art object was a vehicle for conveying a creative idea. These styles are *Conceptual* and *Performance art*.

### Conceptual Art

Artists who created **Conceptual art** believed that all artists formulate an idea and, then, mechanically form the object that represents that idea. The object, they said, is just an unimportant byproduct of the artistic experience. With Conceptual art, artists *focused on the creative process rather than the physical art object* and *produced visually uninteresting pieces as a vehicle for presenting artistic ideas*.

American Joseph Kosuth *used mundane objects* to suggest the importance of the idea in *One and Three Chairs* (figure 20.42). At left is a photograph of a chair; at center, an actual chair; and at right, a dictionary definition of the word "chair." The three versions *hardly seem visually interesting*.

By including three versions, Kosuth *challenged us to think about what a chair is*. The idea is a broad mental category that cannot be defined with a single item. If we were to think of a chair, each of us would have a different vision of what a chair might look like based on different chairs we have seen. Each vision, even though different, represents what a chair is. Similarly, in giving us the actual chair, visual image, and verbal concept, Kosuth illustrates how each is important in constructing meaning. None of the individual objects *do justice in representing the more important idea*.

We can see similarities between Minimalism and Conceptual art in that artists from both styles used minimal skill to craft works. However, Minimalists and Conceptual artists had contrasting objectives (see *Practice Art Matters 20.3: Contrast the Goals of Minimalism and Conceptual Art.*)

### Performance Art

**Performance art** is similar to Happenings in that it is theatrically based. However, performances are enacted by the artist and often address sociopolitical issues such as racism,

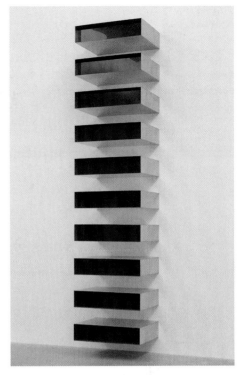

**FIGURE 20.41.** Donald Judd. *Untitled* **reconsidered.** Judd created a number of stacks, like this one, all similar save for slight changes in color and material.

**Conceptual art** A type of art in the West in the twentieth century in which artists focused on the creative process and artist's ideas rather than the physical art object

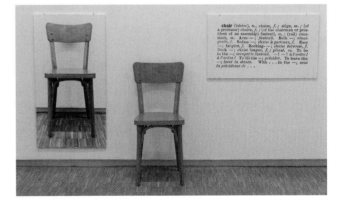

**FIGURE 20.42.** Joseph Kosuth. *One and Three Chairs.* *1965. Wood folding chair, mounted photograph of a chair, and mounted photographic enlargement of the dictionary definition of "chair," chair 2' 8⅜" × 1' 2⅞" × 1' 8⅞", photographic panel 3' × 2'⅛", text panel 2' × 2' 6". The Museum of Modern Art, New York.* As seen here, Conceptual art did not require any skill to make.

**Performance art** A theatrically based work of art in which an artist uses his or her body as a medium to express meaning

## 20.3 Contrast the Goals of Minimalism and Conceptual Art

Conceptual and Minimalist artists came at art from opposing perspectives. Consider:

• What were the Minimalists' goals?

• What were the Conceptual artists' goals?

• Why would Conceptual and Minimalist artists be considered at odds?

---

sexism, or violence. When Mendieta stood in front of the tree (figure 20.2), she was completing a performance. With Performance art, artists:

• *Use their bodies as their material* (rather than a traditional art object) to express meaning
• *Enact ritualistic, theatrical events* in front of audiences or cameras
• *Take art directly to viewers*, performing anywhere for however long they want
• *Create works that do not endure* and cannot be sold

In *How to Explain Pictures to a Dead Hare* (figure 20.43), German artist Joseph Beuys (YOH-sef BOYZ) performed in a Düsseldorf gallery. He whispered to a dead rabbit that he cradled in his arms for three hours, in a setting surrounded by unusual materials, including fat, felt, and wire.

In one interpretation of the performance, the *odd materials can be linked to a traumatic experience* Beuys claimed to have had while a pilot during World War II. Shot down during

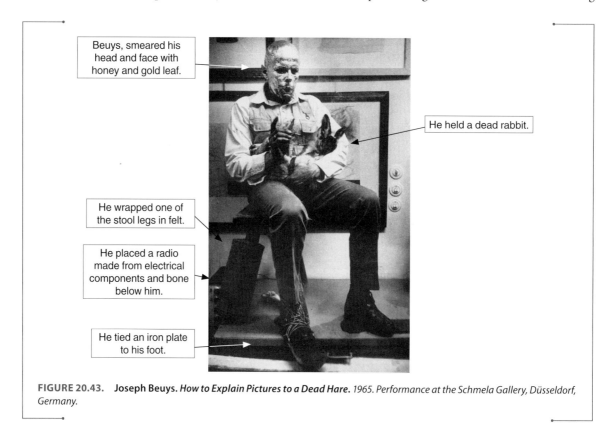

Beuys, smeared his head and face with honey and gold leaf.

He held a dead rabbit.

He wrapped one of the stool legs in felt.

He placed a radio made from electrical components and bone below him.

He tied an iron plate to his foot.

**FIGURE 20.43.** **Joseph Beuys.** *How to Explain Pictures to a Dead Hare. 1965. Performance at the Schmela Gallery, Düsseldorf, Germany.*

a snowstorm, he was rescued by nomadic Tatar people. To heal his injured, frozen body, they wrapped him in fat and felt.

However, we can see another meaning. The Tatars believe that rabbits can access the spiritual realm. Beuys, anointed in gold leaf, surrounded by life-giving materials, ritualistic objects, and art, *could be assuming the role of shaman*. In this interpretation, Beuys connected to primal societies, *bringing religious traditions into the modern world*.

*Quick Review 20.9*: How have Conceptual and Performance artists abandoned the art object?

## Earthworks

Like Performance artists, artists who create **earthworks** reject the notion that art should be a commodity or hung in galleries or museums. Artists who create earthworks:

- *Place human-made forms in natural environments, mold the earth*, or *use nature to create their pieces*
- *Locate art outside of museum and gallery spaces*, often in remote locations, similar to Mendieta
- *Often use photography and film* to share their work since some are inaccessible, impermanent, or changing over time
- *Often form works at enormous scales*

Earthworks *recall colossal prehistoric sites* (such as Stonehenge; see figure 1.8) and represent our *longstanding connection to nature*. Earthworks originally emerged when there was renewed interest in saving prehistoric sites and the environment.

While we have looked at different types of earthworks in figures 1.48, 2.6, 5.11B, and 10.17, here, we consider a work in which an artist *placed human-made materials into the environment* (figure 20.44). American Walter De Maria positioned four hundred uniform stainless-steel poles, evenly spaced in a rectangular grid, over a one-mile-by-one-kilometer area in a *non-art venue*—a remote New Mexico desert. During storms, the poles attract lightning, *interacting with the natural surroundings* and creating a dazzling display. In addition, each time a storm rolls in, the spectacle differs, illustrating the *unpredictable nature of earthworks*.

*Quick Review 20.10*: How have earthwork artists rejected the venue of the museum?

## Combatting Prejudice

A number of artists have faced hurdles because of their gender or race. These inequalities in the art world have occurred for centuries (see Chapter 2). In the late 1960s and '70s, some artists addressed this bias, *using art to try to improve conditions*.

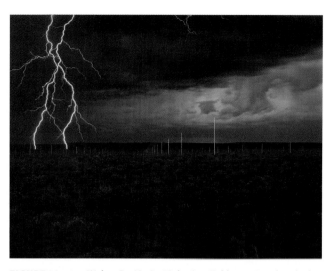

**FIGURE 20.44.** **Walter De Maria.** *Lightning Field.* *1977. Four hundred polished stainless steel poles, each 20' 7 ½" × 2" in a grid of 1 mile by 1 kilometer. Southwestern New Mexico.* Visitors who make the arduous trip to the site, which still exists today, are never guaranteed to see the show, and this aspect, along with the journey, is part of the experience.

**earthwork** A work of art in which the artist places human-made forms in a natural environment, molds the earth, or uses nature to create the piece

(A)

(B)

**FIGURE 20.45A AND B (DETAIL OF ARTEMISIA GENTILESCHI'S PLACE SETTING).**   Judy Chicago. *The Dinner Party. 1974–79. Ceramic, porcelain, textile, and triangular table, each side 48'. Brooklyn Museum, New York.* The Dinner Party (20.45A) honors women from history. Each setting, such as Artemisia Gentileschi's (20.45B), includes an individualized plate and a runner beneath it.

### Feminist Art

Feminist artists seek *rightful recognition for women artists.* They have worked to combat discrimination against *women from history* and have sought equal status for *contemporary women.*

Judy Chicago, an American artist, *promoted the accomplishments of historical women* in *The Dinner Party* (figure 20.45A). A triangular table is set with thirty-nine place settings for great women from the past, including Hatshepsut (the Egyptian pharaoh), Susan B. Anthony (a campaigner for women's right to vote), and Sacajawea (Lewis and Clark's guide of the Western United States). Each setting boasts a unique design. From the setting for Artemisia Gentileschi (ahr-tuh-MEE-zhyuh jen-till-ESS-kee) (figure 20.45B), we see similarities to her paintings (see figures 3.29 and 15.28) in the contrast between light and shadow, saturated colors, and rich, pleated fabric. On the floor, the names of 999 other important women are written (visible under the table in figure 20.45B).

Aside from showcasing famous women, Chicago's work also appears to praise women in other ways. The settings were formed from ceramics, embroidery, and weaving (see Chapter 11)—*media traditionally associated with women.* In addition, hundreds of women and several men created the components, likely *honoring collaboration, a typical way that women work.* Finally, the set table may remind one of *women's traditional role* as food preparers.

American artist Betye Saar (BEH-tee SAHR), in *The Liberation of Aunt Jemima* (figure 20.46), was interested in changing perceptions of *contemporary African American women.* Understanding the *power of images to foster stereotypes,* Saar, an African American woman herself, appropriated the impression of Aunt Jemima, the model for the pancake mix. While no longer used today, the original trademark showed an African American woman with a bandana around her head, appearing as a traditional "mammy," who cared for white children. Saar's image seems to reposition Aunt Jemima as a capable warrior. She appears to take back her rights, using whatever method necessary.

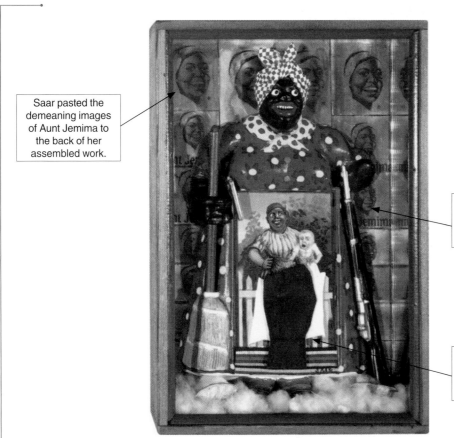

Saar pasted the demeaning images of Aunt Jemima to the back of her assembled work.

Saar's modern, three-dimensional Aunt Jemima holds a rifle and a grenade.

A large black fist, *a symbol of black empowerment*, rises in the front.

**FIGURE 20.46.** **Betye Saar.** *The Liberation of Aunt Jemima.* *1972. Mixed media, 11 ¾″ × 8″ × 2 ¾″. University of California, Berkeley Art Museum.*

Interactive Image Walkthrough

## African American Protest Art

African American artists similarly used art to combat prejudice. Some artists, such as Saar, *protested against discrimination*, while others *sought to show that African American life was similar to that of other Americans.*

*Black Manhattan* (figure 20.47) by Romare Bearden (ROH-mar BEER-den) illustrates *African American life* in a neighborhood, where young men converse on stoops and people look out windows. A bright blue sky hangs above. Bearden's collage recalls the Synthetic Cubists' works, and his capturing of reality mimics their goals. Yet, in doing so, he also *portrays the thriving community and strength of African American culture.*

*Quick Review 20.11*: How did feminist and African American art protest discrimination?

**FIGURE 20.47.** **Romare Bearden.** *Black Manhattan.* *1969.* *Collage paper and polymer paint on board, 2′ 1 ½″ × 1′ 9 ¼″. Schomburg Center for Research in Black Culture, New York Public Library.* Bearden's works are a combination of painting and collage.

## A Look Back at the Earth-Body Works of Ana Mendieta

In contemplating Ana Mendieta's work, we consider a woman who *saw art as a way to heal herself, face her condition, and protest against the world around her*. However, her work also drew from many twentieth-century Western styles, and thus gives us insight into Modern art.

Mendieta's art links to the early twentieth century. Like **Expressionists** (figure 20.6) and **Cubists** (figure 20.11), Mendieta used *bold forms relating to non-Western art* in her work. However, Mendieta also explored the cultural context of non-Western art, so that she treated the work on equal intellectual footing as her own. Like the **Synthetic Cubists** (figure 20.15), Mendieta also *merged art and life*. In creating her art in the natural world, she followed their example. In addition, like **Dadaists** (figure 20.16), Mendieta *challenged traditional society*, questioning longstanding cultural assumptions.

Mendieta's art also links to the art of the post–World War II period. Like **Action painters** (figure 20.31), who made works that can be considered records of their creative motions, Mendieta *documented her movements in photographs and films*. Her art connects to **Performance artists** (figure 20.43) in works in which she included herself. In these pieces, *her body became her material*, and she represented supernatural figures, prehistoric goddesses, and powerful shamans. She communicated with her audience through compelling symbols such as life and death, loss and exile, and earth and fire. Like **earthwork** artists (figure 20.44), Mendieta also used nature, *creating art in remote locations* and *documenting her art in photography and film*. However, while earthwork artists typically used colossal scales and either changed the earth or added human-made materials to it, Mendieta melded her body or a silhouette of it with the earth to merge the two. Finally, like feminist artists (figure 20.45A), Mendieta *fought injustice against women*. In images of nonwhite earth goddesses, she also *connected to empowerment images* that created a new role for women of color (figure 20.46).

At the beginning of this chapter, we questioned, "Where is Ana Mendieta?" But, many of the objects that Mendieta created can no longer be located. In that her works were fragile or performative, they were fleeting. The works or actions themselves have been captured in photographs, in people's memories, and in the way they impacted people's lives, just like the work of other twentieth-century artists such as Joseph Beuys (figure 20.43). These works ask us to *consider the poignant expression conveyed by art that is only with us for a short time*, and remind us of *the importance of looking carefully and being focused observers*.

Flashcards

## CRITICAL THINKING QUESTIONS

1. In the West, twentieth-century art is different from works created in previous centuries. Why is Kandinsky (figure 20.10) a key figure in making this statement true?
2. How is Höch's collage (figure 20.16) similar to and different from Synthetic Cubist Collages (20.15)?
3. Following World War I, many artists looked to art to create a better world. Can you think of art today that seeks to do the same thing? How is it similar?
4. In what ways is Aaron Douglas's work (figure 20.28) similar to Romare Bearden's (figure 20.47)?
5. Chapter 18 discussed Chinese calligraphy (figure 18.21). Why do you think some scholars have compared calligraphy to Pollock's work (figure 20.31)?
6. Kaprow called his Happenings (figure 20.37) "Collages in Action." What does this statement mean?
7. Using examples from the chapter, how could you illustrate this statement: Much of twentieth-century Modern art was not concerned with skill?
8. Both Duchamp (figure 20.17) and Saar (figure 20.46) created new identities for established images of women. How would you compare and contrast these works?

Comprehension Quiz        Application Quiz

## Suffering, Health, and Survival

The universal theme of suffering, health, and survival is evident in artworks from this chapter and in art created by people from different backgrounds and periods from across this book. This theme concerns:

» *Suffering, sickness, and pain*
» *Health and healing*
» *Necessities for survival*

### Suffering, Sickness, and Pain

Dorothea Lange's *White Angel Breadline, San Francisco* (figure 20.27), from the chapter we just completed, illustrates what appears to be a suffering man, standing in a breadline in California during the Great Depression. The man waits in a huddled mass with countless others, many of whom we cannot even see as they are cut off by the edges of the image. His hat is dirty, his cup is dented, and his coat is ripped. As he clenches his hands together, staring at something we cannot see, we might imagine that he contemplates his desperate situation.

Similarly, in *Gargantua* (figure C20.1) from Chapter 7, Honoré Daumier showed a scene of pain and despair in France in 1831. In the print, the starving poor are crowded together on the right, some cut off by the edge of the print. Like the man in the breadline, they wear shabby clothing that is ripped, and they cannot be sure of their fate, as they are forced to pay the enormous king countless sums of their money.

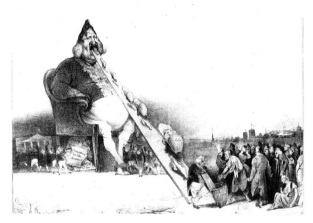

**FIGURE C20.1. Honoré Daumier. *Gargantua* reconsidered.** While Daumier focused on the plight of the poor, other artists have considered their own personal pain in images.

### Health and Healing

The chapter we just completed describes Ana Mendieta's *Untitled (Fetish Series)* (figure 20.4) that she likely formed to illustrate herself in a life-giving role when her mother was sick with cancer. Sticks protrude from the mummy-like form reminiscent of some African figures traditionally believed to assist people with problems. Through art, Mendieta seemingly encouraged the restoration of good health.

A similar attempt to use art for healing is evident in the image of the Navajo man forming a sand painting (figure C20.2) from Chapter 2. Traditionally, sand paintings have been part of a ritual meant to heal someone who is sick. To produce the works, medicine men create images of gods and heroes out of colored sand, flowers, and pollen. Several features can be compared in the sand paintings and Mendieta's form:

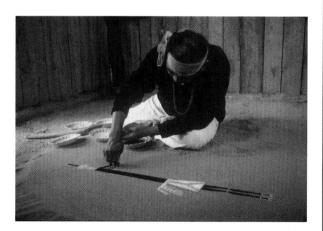

**FIGURE C20.2. Navajo man forming a sand painting reconsidered.** The Navajo have used sand paintings as an appeal to the spiritual world for healing, but other people have attempted to promote good health by wearing works of art.

» Both works illustrate figures
» Both works are fleeting and eventually destroyed
» Both the traditional African figures and sand paintings appeal to the spiritual world for assistance

## Necessities for Survival

Artworks depict the necessities of life, including food and shelter, and architects have built many types of protective structures. The chapter just completed illustrates Schröeder House (figure 20.21), designed by Gerrit Rietveld and Truus Schröeder to be a functional, middle-class home. Using inexpensive materials and a simple design, they hoped to create a model of housing for the future that could be widely copied.

A comparison can be made to the Cardboard Cathedral (figure C20.3), from Chapter 12, a structure built by Shigeru Ban. Ban constructed the church in Christchurch, New Zealand, in 2013, after a devastating earthquake destroyed the community's original cathedral. Using inexpensive paper, Ban created a straightforward, usable space for this community as he has for countless other groups across the world rebuilding after natural disasters.

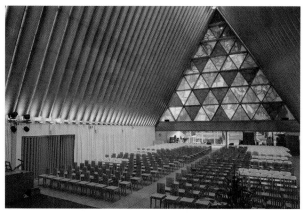

**FIGURE C20.3.** **Shigeru Ban. Cardboard Cathedral reconsidered.** Ban has helped numerous communities with architecture. Similarly, artists have helped people all over the world with works (such as pottery) that serve the essential function of storing and holding food.

## Make Connections

Chapter 1 considers Margaret Bourke-White's *Flood Victims, Louisville, Kentucky* (figure C20.4). Bourke-White photographed African Americans standing in a relief line after a devastating flood of the Ohio River during the Great Depression. Above them, white Americans are depicted on a sign as having the "World's Highest Standard of Living." How might this photograph relate to the theme of suffering, health, and survival?

What other visual examples can you come up with from across the book and from today's world that reflect this theme? How are people's motivations across time and place similar and different?

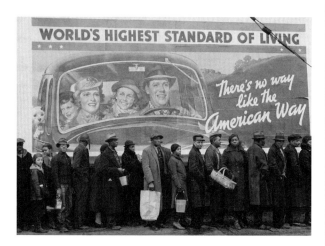

**FIGURE C20.4.** **Margaret Bourke-White.** *Flood Victims, Louisville, Kentucky* **reconsidered.**

# 21

# Art Since 1980

## LEARNING OBJECTIVES

**21.1** Identify the main characteristics of Postmodernism.

**21.2** Contrast Postmodern and Deconstructivist architecture.

**21.3** Compare Neo-Expressionist and Graffiti art.

**21.4** Summarize the different ways that artists have explored diverse media.

**21.5** Enumerate two ways artists have protested the status quo.

**21.6** Explain how art that draws on prior work calls into question the importance of originality and individual expression.

**21.7** State the main ways globalization has affected the art world.

**21.8** List three ways artists can explore their distinctive identities in creating art.

**21.9** Differentiate among three ways artists can represent our connected world in their art.

**DETAIL OF FIGURE 21.3A.** In the Postmodern and contemporary global world, artists have used a variety of media that are frequently nontraditional. Here, in a detail of Yinka Shonibare MBE's *The Swing (After Fragonard)*, the artist used a shoe as one of his materials.

## THE ART OF YINKA SHONIBARE MBE

In the mid-1980s, Yinka Shonibare MBE (YEEN-kuh show-nee-BAH-ray em-bee-ee) was studying art in London, when his instructor, a white man, asked, "You are African, aren't you? Why don't you make authentic African art?"[1] Shonibare was taken aback. While his parents were Nigerian and he had resided in Nigeria as a child, he had been born in England and lived there. Also, just because he had African roots, *did that mean he needed to be grouped with all African artists*? Shonibare later explained:

How Art Matters

> I tried to figure out what [my instructor] meant by authentic African art. I didn't know how to be authentic. What would I do if I was being authentic? . . . [I realized] there is a way in which one is perceived, and there is no getting away from it . . . if I didn't deal with it, I would just be described forever as a black artist who doesn't make work about being black.[2]

From that point on, Shonibare decided he "would deal with the construction of stereotypes, and that's what [his] work would be about."[3]

### An Unusual Victorian Parlor

*Victorian Philanthropist's Parlor* (figure 21.1) from 1996–97 begins to show how Shonibare's *experience with racism shaped his art.* A life-size room *looks nothing like the African art* depicted in Chapter 16. Instead, the decadent space appears as if from the Victorian era, a period in British history in the 1800s. The title says that the parlor belongs to a philanthropist, a person who gives money to those less fortunate. The room displays the philanthropist's wealth and appears behind velvet ropes (not visible in the image).

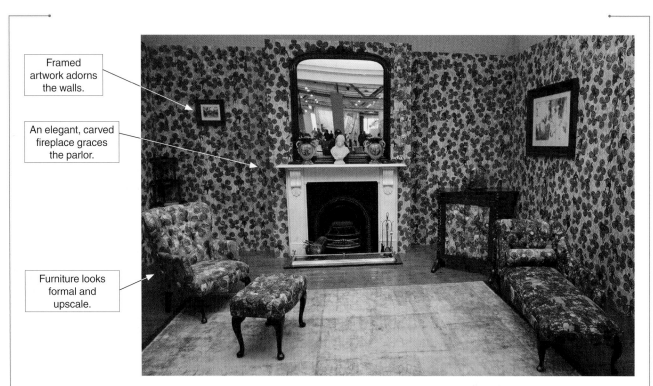

Framed artwork adorns the walls.

An elegant, carved fireplace graces the parlor.

Furniture looks formal and upscale.

**FIGURE 21.1. Yinka Shonibare MBE. *Victorian Philanthropist's Parlor.*** *1996–97. Reproduction furniture, fire screen, carpet, props, and Dutch wax-printed cotton, approximately 8′ 6 ¼″ × 16′ × 17′ 4 ½″. Collection of Peter Norton and Eileen Harris Norton, Santa Monica, California.*

No one from that proper era, however, would have decorated a parlor in such clashing patterns. Everywhere, intensely colored, busy fabrics—*made of African cloth*—scream for attention, showing us that something is out of sync.

So, what was Shonibare doing? As his roots stem from England and Africa, *was he trying to show pride in his dual heritage*? Alternatively, was Shonibare *critiquing the earlier Victorian period and its imperialism* (when Western empires colonized, controlled, and exploited non-Western nations)?

Understanding African cloth may shed light on Shonibare's motivations. Even though called "African," *African cloth is not from Africa*. It comes from Indonesia, a Southeast Asian country that was originally a Dutch colony. In the 1800s, the Dutch saw the handmade fabrics there and began manufacturing them in the Netherlands. British manufacturers copied the fabrics, introducing them into their colonies in Africa. Ironically, in the 1960s, when African nations were striving for self-rule, the cloth that stemmed from colonization became a symbol of African independence.

So, how might this context inform Shonibare's work? Perhaps Shonibare is asking us to consider the links between the haves and have-nots from both of his backgrounds. While a British philanthropist gave to the less fortunate, weren't his fortunes the result of imperialism? Also, might the velvet ropes signify that the philanthropist's riches are off limits to most? Further, what of the African cloth that came from Indonesians and Europeans? Could Shonibare be questioning *whether anything can really be original*?

## A Recreation of a Historical Event

In another work from 2003 called *Scramble for Africa* (figure 21.2), Shonibare *confronted the past and imperialism directly*. He mocked up a life-size replica of a conference meeting from 1884 and 1885, where representatives from Europe and the United States had divided Africa. No Africans were present at the meeting. Headless men of ambiguous skin tone sit around a table that shows the map of Africa on its surface.

Yet again, Shonibare fictionalized the scene, and there are *multiple possible explanations* based on different references:

» *We could consider the haves* (the men at the table) *and have-nots* (the absent Africans whose fate is to be decided) and the African cloth that was part of the colonial machine that gave the men at the table their power.

» *We could consider that the men are headless*. During the French Revolution in the late 1700s, numerous powerful people were decapitated. Might Shonibare be removing the men's power and attacking the Western world that they represented?

» *We could consider that the men are unidentifiable*. Shonibare stripped them of their identities and nationalities. Perhaps he is using art to reject the racism that leads individuals to judge someone's identity based on skin color or facial features.

## Copying an Iconic Artwork

Shonibare has not only reworked past events, but has also *copied and critiqued historical artworks*. In figure 21.3A, Shonibare mimicked *The Swing* by Jean-Honoré Fragonard (jawn oh-noh-RAY frah-goh-NAHR), which we considered in Chapter 3, repeated here as figure 21.3B. In Fragonard's image, created in 1766, over two decades before the French Revolution, a chaperone pushes a wealthy woman on a swing, while her lover hides in the bushes. Shonibare captured the carefree spirit in his life-size-mannequin replica from 2001 that shows only the woman and none of the other characters.

**FIGURE 21.2.** **Yinka Shonibare MBE.** *Scramble for Africa.* *2003. Fourteen life-size fiberglass mannequins, fourteen chairs, table, and Dutch wax-printed cotton, overall 4′ 4″ × 16′ 1⁄10″ × 9′ 2 1⁄3″. The Pinnell Collection, Dallas.* Headless men argue about the stake their countries will get in Africa.

(A)

(B)

**FIGURE 21.3A AND B.** **(A)** Yinka Shonibare MBE. *The Swing (After Fragonard).* *2001. Dutch wax-printed cotton, two shoes, life-size mannequin, swing, and artificial foliage, 10′ 10″ × 11′ 6 ¾″ × 7′ 2 ½″. Tate, London;* **(B)** **Jean-Honoré Fragonard. *The Swing* reconsidered.** In Shonibare's sculpture (21.3A), the woman kicks off her shoe, just as in Fragonard's painting (21.3B).

Here, Shonibare *copied an image from art history,* so we need to look at the *multiple possible meanings* from that perspective:

» Could Shonibare be *passing judgment on the content of the painting* or challenging Western art and the values it represents?
» If Shonibare copied an artwork, might he be *questioning whether originality in art is important*?
» What about the fact that Shonibare changed the medium? While Fragonard employed the fine art of painting, Shonibare *used nontraditional items* like shoes. Is Shonibare's art, therefore, less valuable?
» Did Shonibare create a work for a *wider, global audience,* unlike Fragonard, who created his art for French aristocrats?

Of course, in contemplating Shonibare's work, we must also consider the parts that he altered from Fragonard's painting. The woman wears African cloth, is decapitated, and has the indistinguishable skin tone (noticeable on her arm), so it seems likely he is *commenting on the historical era in the painting*—the 1700s, when aristocrats in France enjoyed leisurely activities like swinging, while others suffered. In critiquing the behaviors of the rich and powerful from different periods, is Shonibare *using history and art to say that such behaviors are universal*? If so, is it possible to see parallels with our own time?

## Two Kinds of Aliens

*Alien Woman on Flying Machine* (figure 21.4) from 2011 may answer whether Shonibare has *used history and art to protest conditions in our current world.* An alien swoops down on a flying machine, as if from some old-fashioned science fiction movie in which space creatures invade our planet. However, the work is covered in African cloth.

Knowing Shonibare's work, we must consider the *many different possible interpretations* that are beyond the surface:

» Could this alien represent the other alien, a foreigner from another country? Might Shonibare be making fun of people's fears about immigrants—equating the migration of people with an alien invasion and thereby *mirroring our world*?
» Could Shonibare be asking whether people we see as "other" *are that much different from ourselves*?
» Could Shonibare be suggesting that we need to *reject national, cultural, and racial distinctions for good*?

## A Multidimensional Artist

In 2004, Queen Elizabeth II of England awarded Shonibare the title MBE (Member of the Most Excellent Order of the British Empire) in honor of his service to the arts. Ironically, the man who throughout his career has criticized Western nations and values accepted the title and added MBE to his name. The initials remind us that we need to explore the *multiple meanings* behind what we see. Shonibare is a multidimensional person, like all of us. His use of the initials may illustrate that he can be critical of his country and traditional Western values at the same time that he can be a part of and honored by this same nation. Similarly, to *appreciate and connect to art, we must delve into its many different facets and meanings.*

The story of Shonibare is an excellent entrée into the art of our contemporary world. This world is one that:

» *Borrows from past events and art to create new works*
» *Employs a vast array of nontraditional media*
» *Searches for multiple meanings*
» *Comes from artists with diverse, hybrid backgrounds*
» *Tackles global issues*

This chapter considers art since 1980. Before moving forward, based on this story, how do you think contemporary art connects to past art history, while simultaneously rejecting that legacy?

**FIGURE 21.4.** Yinka Shonibare MBE. *Alien Woman on Flying Machine. 2011. Steel, aluminum, brass, Dutch wax-printed cotton, and rubber, 4' 11" × 14' 9" × 13' ½".* The alien has antennae and three-toed feet, but possesses human-like qualities.

# The Postmodern Period

In 1985, Mikhail Gorbachev came to power in the Soviet Union. The Cold War between the democratic United States and communist Soviet Union had dominated world politics after World War II. However, Gorbachev fostered policies that restructured Soviet political and economic systems and opened communication. Encouraged by Gorbachev's moves, starting in 1989, Eastern European countries threw off communism, and in 1991, the Soviet Union disintegrated.

Meanwhile, the world was changing economically:

• *Western nations became postindustrial states*, in which service-based companies overtook manufacturing ones.

- *East Asian nations surged industrially.*
- *European countries created a European Union* with a single currency.
- *Many countries in Africa, South America, Asia, and the Pacific continued to face challenges,* despite having achieved independence from colonial rule following World War II. Today, a number are still poor and underdeveloped with inferior healthcare systems and low levels of education. The gap between richer and poorer countries remains.

## Postmodern Ideas

**Postmodernism**—literally "after Modernism"—arose as an art movement around 1980. While not every Postmodern work exhibits the following characteristics, they all display some:

- *Rejection of a Story of Art:* Postmodern artists *reject longstanding traditions of how Western art developed in the past.* Previously, the history of art moved in a linear narrative from one style to the next. Postmodern artists instead *insert past styles and ideas into contemporary works,* negating a forward progression. Additionally, these artists *borrow from a wide array of mixed-up, eclectic historical sources.* Often prior styles are used in ways that do not support their original messages. Instead, past styles are referenced to comment on, joke about, or criticize the earlier period, *creating new meanings.* For example, Shonibare, in *The Swing,* displayed a woman from the 1700s. He inserted a past work into his contemporary art, likely to comment on the frivolous implications of a Rococo work (see Chapter 19) and the period's values.
- *Reference to Prior Work:* Postmodern artists *question whether any art is truly original,* and they **appropriate** (borrow) *or modify* the appearance of prior artworks or objects from popular culture and use them in contemporary art. For example, Shonibare drew on Fragonard's work and African cloth.
- *Abandonment of a Set Style:* Postmodern artists *create works using whatever forms best convey their ideas,* so there is no consistent look across their works. Accordingly, we cannot identify and categorize works as being part of certain styles. For example, some of Shonibare's works are headless, while others are not.
- *Diversity of Media:* Postmodern artists *work with a vast array of media,* and these media are frequently nontraditional. For example, Shonibare's works include installations, sculptures, paintings, films, photographs, and collages, and he has employed unusual materials, such as plastic foliage.
- *Complex, Personal Form that Mirrors Our Complicated World:* Postmodern artists *say art needs to respond to our troubled world.* For example, Shonibare's alien (figure 21.4) seems to protest current treatment of immigrants. To accomplish this outward focus, *artists use materials that show the individual hand of the artist* and display recognizable features, such as decoration in architecture or figures in painting. Shonibare's work, for instance, shows furnishings and figures.
- *Deconstruction:* Postmodern artists *understand that artworks can be interpreted in multiple valid ways.* Postmodern artists therefore create art that encourages this. As viewers, we need to **deconstruct**—uncover and demystify—the meaning of art because art creates meaning without our realizing it. To do so, *we need to ask where the meaning comes from, who the meaning benefits, and for whom the meaning is constructed.* For example, Shonibare's woman, who kicks off her shoe, could be a harmless image of a playful aristocrat. But what happens to the meaning when we know that Fragonard, the artist who originally designed her, worked for the upper class? Could the work, then, be seen as reinforcing the idea that the upper class was meant to engage in leisure activities, even if the wealth that enabled them to do so was at the expense of the suffering of others? With this new meaning, the work no longer seems so harmless.

**Postmodernism** The movement in art from roughly 1980 to the present when artists have rejected the assumptions of Modern art. Postmodernism is characterized by rejection of a story of art; reference to prior work; abandonment of a set style; diversity of media; complex, personal form that mirrors our complicated world; and deconstruction.

**appropriate** To borrow the appearances of prior artworks or objects from popular culture and use these forms in contemporary art

**deconstruct** To uncover and demystify the meaning of art

## Architecture

Architects were the first to embrace Postmodernism. They reacted against the International Style—stripped-down buildings that included no ornamentation or historical references (see figure 20.24). Two new approaches appeared—*Postmodern architecture* and *Deconstructivist architecture*.

### Postmodern Architecture

**Postmodern architecture**, from the 1970s and 1980s, took the opposite approach to the ordered International Style. Architects:

- *Referenced different eclectic historical styles in the same building*, combining architectural features from different periods
- *Used humor* in their structures
- *Created buildings with ornamentation*
- *Formed buildings with multiple meanings*
- *Designed structures that fit with their local environments* and culture

American Michael Graves's Public Services Building in Portland, Oregon (figure 21.5) illustrates the Postmodern approach in which the style looks back to the past. There are contradictory references in the structure to ancient Greece and Rome (see Chapter 13) and the International Style (see Chapter 20).

**Postmodern architecture**
A style of architecture in the 1970s and 1980s that moved away from the sterile forms of the International Style. Postmodern architecture is characterized by eclectic historical references, humor, ornamentation, multiple meanings, and fit with the local environment

Two column-like structures sit on the front of the building, *reminiscent of ancient Greek orders.*

Plain, undecorated square windows rise up the side of the building in a grid, *borrowed from International Style motifs.*

A trapezoid-looking form *seems like a single Greek-like capital* that the two columns share. This shape also mimics a keystone, the top stone in an arch— *a reference to ancient Roman buildings.*

Two plain blocks, *similar to International Style geometric forms*, sit below the trapezoid.

**FIGURE 21.5.** **Michael Graves. Public Services Building.** *1980–82, Portland, Oregon.*

The *mishmash of styles* makes the building appear improvised and complex. There is no single vision, and the different styles, while referencing the past, do not harken back to the content that originally supported them. In fact, the *historical touches seem to be witty jokes and decoration*. The columns are enormous, nonsupporting embellishments, as is the keystone, which is four stories high. Also, colors in mauve, red, beige, and green *playfully decorate the façade*, making the structure seem more like a toy than a serious form.

We can *interpret the design in multiple ways*. The features are components of past styles, but they also resemble a gigantic face (with the two blocks becoming eyes) or an entire figure (with the blocks becoming breasts). The colors also *relate to the Oregon landscape—* the reds reference the earth and the green, the trees, giving the building a connection to its location. *Multiple meanings* allow people to relate to the structure in different ways.

## Deconstructivist Architecture

Like Postmodern architecture, the **Deconstructivist architecture** of the twentieth and twenty-first centuries rejects the harmony and logic of the International Style. Deconstructivist architecture creates variety through:

- *Vastly dissimilar, conflicting masses* juxtaposed in an incoherent building
- *Asymmetrical*, decentered structures with diagonal pieces
- *Complex and unpredictable works that viewers must walk around* over time to appreciate
- *Different forms that enable viewers to experience multiple associations* and deconstruct (thus the name of the style) numerous meanings

American Thom Mayne's Kolon One & Only Tower, completed in 2018, exemplifies the complex form of Deconstructivist structures. The building serves as a research and development facility for a South Korean textile manufacturer and houses laboratories, offices, and social and retail spaces.

The building's façade (figure 21.6A), which is divided into *irregular masses*, folds in the middle. Yet on the side (figure 21.6B), part of the building has a traditional, rectangular form. Instead of this squared-off mass continuing across the exterior, though, a section stretches out in a *contrasting, diagonal direction*. The forms are so complex that *to appreciate the building fully we would need to move around it*. The numerous changing pieces suggest different ideas, mimicking the creative atmosphere of an innovative company.

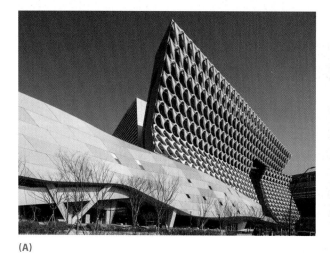

(A)

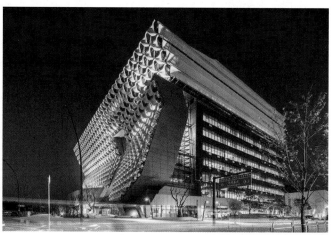

(B)

**FIGURE 21.6A AND B.** **Thom Mayne. Kolon One & Only Tower.** *2015–18, Seoul, South Korea.* Mayne's building is compiled of diverse forms arranged in an asymmetrical design. To appreciate the conflicting forms, we show front (21.6A) and side (21.6B) views.

## Painting

While painting had all but disappeared during the late Modern period, the 1980s witnessed a resurgence in the medium. Artists used *Neo-Expressionism* and *Graffiti art* to explore emotions and focus on our complex world through painting.

### Neo-Expressionism

**Neo-Expressionism** (new Expressionism)—a style of late twentieth-century Expressionist art—looked back at the German Expressionists (see Chapter 20) for inspiration. Neo-Expressionism used oil paint and other materials to create enormous paintings that:

- *Conveyed emotional content*
- *Explored troubling, past periods*, like Nazism
- *Exhibited multiple meanings*
- *Featured abstract and representational works*, rejecting nonobjective forms
- *Employed energetic brushwork, gesture, and color*

The Neo-Expressionist work *Dein Goldenes Haar, Margarethe* (*Your Golden Hair, Margaret*) *recalls the Nazi past* (figure 21.7A). In the work, Anselm Kiefer (AHN-selm KEE-fur) showed a field plowed with furrows. Given that Kiefer is German, one interpretation might suggest that he formed the painting to honor the "Fatherland," a term used by the Nazis to describe Germany. The vast, imposing landscape recedes in the distance, as powerful lines repeat across.

Like Shonibare's work, however, Kiefer's *offers different interpretations*. Kiefer's countryside is blackened and scorched, suggestive of the Nazi ovens used to burn the bodies of their victims. *In transforming a Nazi symbol into a reference to the Jewish victims*, Kiefer was possibly memorializing the people the Nazis tried to destroy.

The words "Your Golden Hair, Margaret" from the work's title also stem from a poem written by a Jewish concentration camp inmate, Paul Celan. The poem contrasts the

**Neo-Expressionism** A style of Expressionist art in the late twentieth century characterized by emotional content, historical references to troubled past periods, multiple meanings, large-scale works, abstract or representational forms, and energetic brushwork

**artists**
MATTER

Anselm Kiefer

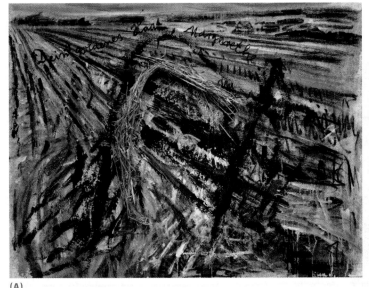

(A)

(B)

**FIGURE 21.7A AND B (DETAIL).** **Anselm Kiefer.** *Dein Goldenes Haar, Margarethe* (*Your Golden Hair, Margaret*). *1981. Oil paint, emulsion, and straw on canvas, 4' 3 ¼" × 5' 7".* Kiefer displayed an expansive landscape (21.7A), but the words and straw visible in the detail (21.7B) hint that the painting has other meanings.

golden hair of Margaret, the lover of a guard at the concentration camp, with the ashen hair of Shulamite, a Jewish inmate. The two women suggest the opposites inherent in Germany—the nation and its victims. The words are written across the top of the work, and golden straw and black gashes are curved across the surface like hair that would have fallen around the women's faces. The words and arches remind us of the *intertwined meaning of the space.*

Finally, we cannot ignore the style of the enormous painting. Gone are the pure, nonobjective forms of Minimalism (see figure 20.41). Instead, a *representational field relates to our everyday world*. Kiefer's surface is also *expressive and tactile*, built up not only with *thick brushstrokes* of oil paint, but also with the straw (figure 21.7B). The rough straw looks prickly and uncomfortable.

Kiefer's provocative images seem to ask Germans to come to grips with their disturbing heritage. With the reunification of Germany, which had been split into East and West before the fall of Communism, Kiefer *used the powerful medium of painting perhaps to suggest that Germans needed to look back in order to move forward.*

### Graffiti Art

Recall from Chapter 20 that during the late Modern period, artists moved toward alternative display locations beyond galleries and museums. Art moved into the streets, and this change included graffitists who left marks on subways and buildings. By the 1980s, some of these artists were creating **Graffiti art** on canvases using techniques similar to Neo-Expressionism to form personal expressions. Graffiti art frequently:

- *Included historical and cultural references*
- *Incorporated words and symbols*
- *Created abstract and representational works*, rejecting nonobjective forms
- *Employed energetic brushwork, gesture, and color to express emotion*

New Yorker Jean-Michel Basquiat (jawn-mee-SHELL BAHS-kee-ah) used *words, simple figures*, and *dripping paint* to create Graffiti art that resembles the writing left on buildings in the 1970s and 1980s. One interpretation suggests his *Hollywood Africans* (figure 21.8) criticizes the stereotypical roles given to African Americans in Hollywood in the 1940s. The painting appears like a wall jam-packed with scribbled marks.

*Quick Review 21.3*: How are Neo-Expressionist and Graffiti art similar?

## Diverse Media

Just as there were changes in architecture and painting, Postmodernism brought changes in other media as well. Postmodern artists use *novel media of the Modern period, innovative materials, objects from mass culture, traditional craft media, new technologies,* and *varied media.*

### Novel Media of the Modern Period

A number of artists continue to *employ innovative media first used in the Modern period*, including performances, installations, assemblages, and earthworks, but with a Postmodern mentality. In *Rest Energy* (figure 21.9) from 1980, Europeans Marina Abramović (mah-REE-nuh ah-BRAH-moh-vitch) and Ulay (OO-lye) presented a tense, four-minute performance. Dressed in similar attire, Abramović held the handle of a bow, while Ulay held an arrow that was fitted in a string and pointed at Abramović's heart. Leaning back,

**Graffiti art** A style of art in the late twentieth century associated with street art, historical and cultural references, the inclusion of words and symbols, abstract or representational forms, and energetic brushwork

Basquiat crossed out certain words, counterintuitively reinforcing them as we pause on them to figure out what they say.

Words such as "sugar cane" or "tobacco" (referring to the only character parts that were open to blacks) *are scrawled across the surface.*

Three abstract, mask-like faces are formed from *crude contour lines.*

The background is blanketed in a vivid yellow expanse, which is *smeared onto the surface.* Some yellow paint *drips down* onto an intense blue.

There is a *symbol* where Basquiat signed his name with a simplified crown.

**FIGURE 21.8.** Jean-Michel Basquiat. *Hollywood Africans.* 1983. *Acrylic and oil stick on canvas, 7′ 1/16″ × 7′. Whitney Museum of American Art, New York.*

the two supported each other and stretched the bow string, while Ulay held Abramović's life between the limits of his straining fingers. At the end, the two resumed their original stance, releasing the tension and taking Abramović out of danger.

A variety of features show the Postmodern approach. These include the *performance medium* and the *eclectic references* recalling Sebastian, the saint shot with arrows, and Robin Hood, the legendary archer. Furthermore, *a variety of meanings* can be read into the work. Given that Abramović and Ulay supported each other, we see how every relationship is dependent and that without dual efforts, the consequences can be disastrous. Another explanation might be to see one individual at the mercy of another—a citizen facing a corrupt government or an innocent in front of an assailant. Moreover, the potential for harm to Abramović is inescapable, which leads to another Postmodern characteristic—that the *artists reflected our complex world.* Here, the performers demonstrated the threat of violence against women, a terrible social problem. To see how another work uses innovative media first used in the Modern period to make a Postmodern statement, see *Practice Art Matters 21.1: Explain Why an Installation Is Postmodern.*

## Innovative Materials

In the Postmodern period, *anything has become acceptable to use as an art material.* Probably one of the most outrageous materials used was by British artist Damien Hirst in 1991. In *The Physical Impossibility of Death in the Mind of Someone Living* (figure 21.11), Hirst weighted a dead shark, so it floated symmetrically and upright in a tank of formaldehyde. The effect makes the shark appear to be alive as if swimming in water.

Several Postmodern characteristics are apparent. The work *references the fish that swallowed Jonah in the Old Testament.* In addition, Hirst *appropriated his presentation from*

**FIGURE 21.9.** **Marina Abramović and Ulay (Uwe Laysiepen).** *Rest Energy.* 1980. *Performance.* Two microphones on the couple's chests broadcast their breathing, which intensified from the exertion throughout the performance.

## 21.1 Explain Why an Installation Is Postmodern

For his installation in a San Francisco gallery in 1994, American Donald Lipski stuck approximately twenty-five thousand ordinary, double-edged razor blades into Sheetrock walls, making swirling designs (figure 21.10A). One side of each blade dangerously jutted out toward spectators, who could walk into the space. Entitled *The Starry Night*, the piece took the same name as Vincent van Gogh's painting (shown in Chapter 19 and reproduced here as figure 21.10B) in which stars swirl, just like the blades do. Recall from Chapter 3 that van Gogh cut off his own ear; scholars believe that he used a straight razor to do so. Also, consider that the deadly disease AIDS, which is transmitted through blood and other bodily fluids, rocked San Francisco in the 1980s and '90s.

Explain the features of Lipski's work that classify it as Postmodern:

- How did the work reference a prior artwork?
- In what ways did Lipski work in a diversity of media?
- What meanings can you see in the work?
- How did Lipski's complex, personal form mirror our complicated world?

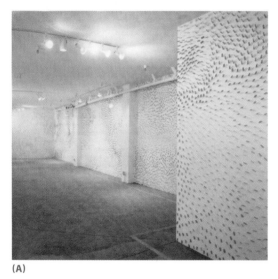

(A)

(B)

**FIGURE 21.10A AND B.** **(A) Donald Lipski.** *The Starry Night. From the installation at the Capp Street Project, San Francisco. 1994. Razor blades on wall;* **(B) Vincent van Gogh.** *The Starry Night reconsidered.*

**FIGURE 21.11.** **Damien Hirst.** *The Physical Impossibility of Death in the Mind of Someone Living.* *1991 (refurbished in 2006). Tiger shark, glass, steel, 5 percent formaldehyde solution, 6′ 11 ⅞″ × 17′ × 6′ 11 ⅞″. Steven A. Cohen Collection, Connecticut.* The ferocious fish opens its mouth wide, baring its teeth.

*displays of animals* once popular in natural history museums. The work also *projects different meanings.* The title seems to turn us into swimmers; even though we are confronted with a terrifying shark and the fragility of our existence, we perhaps cannot imagine ourselves dying. By contrast, the fact that the shark is dead and presented in such a sterile way might suggest that we should not become sentimental about death, which is always a part of our complex, fleeting lives.

### Objects from Mass Culture

Some Postmodern artists *use kitsch* (low-culture objects regarded as tasteless) in their works. For example, American Jeff Koons's *Puppy* (figure 21.12A) from 1992 mimics a low-culture commodity—a Chia Pet (figure 21.12B). Flowers grow out of the animal to look like fur, imitating the collectible figurines. The pattern of flowers on the puppy's exterior *recalls garden designs* such as those that graced the Palace of Versailles in France (figure 15.33), while the actual form of the dog is

(A)

(B)

**FIGURE 21.12A AND B.** **(A) Jeff Koons.** *Puppy.* *1992. Stainless steel, soil, and flowering plants, 41' × 27' 3" × 29' 10". Guggenheim Museum, Bilbao, Spain;* **(B) Playful Puppy Chia Pet.** *Pottery planter and plant, 8" × 7" × 4 ½".* Koons glamorized *Puppy* (21.12A), a work based on a Chia Pet (21.12B), by making the sculpture forty-one feet high and mounting it on a pedestal.

*modified from the Chia keepsakes.* The plant material additionally links the work to a *diverse medium.*

Furthermore, Koons celebrated the gimmicky item as art—by having it displayed in front of the Guggenheim Museum, Bilbao, *linking the object to our world.* As kitsch objects are materialistic goods, their use also raises questions:

- Are differences between high art and mass culture really so great?
- Should art be designed to cater to public tastes?
- Does art need to be original or can it be a reproduction?

## Traditional Craft Media

Postmodern artists have also *used craft media,* but they have done so because the *materials help them create specific meanings and have certain appearances* rather than for functional purposes. For example, Shonibare used fiber because it allowed him to convey the notion that nothing is really original. Moreover, he employed fiber for its look, as it would have been difficult to portray African cloth with traditional sculptural materials such as wood or stone. This Postmodern practice is different from a traditional one in which fiber might have been used functionally as, for example, a quilt for a bed. In using craft in this way, *artists have blurred boundaries that once existed between craft and fine art.*

Joyce J. Scott formed *Man Eating Watermelon* (figure 21.13) in 1986 from glass beads strung on thread that are joined into a meaningful sculptural form. An African American man is either dragging or being chased by a watermelon. Conscious of the numerous stereotypes of African Americans eating watermelons, Scott, African American herself, referenced a racist stigma that seemingly cannot be left behind. The sparkling surface and familiar beads, though, seem approachable. Scott purposefully draws us in with her choice of material. Yet, once engaged, we are left to confront the serious content that is a *disturbing reflection of our troubled world.*

**artists**
MATTER

Joyce J.
Scott

## New Technologies

Postmodern artists also *use new technologies*, which right now include virtual reality. To create a virtual reality film that makes viewers feel immersed in another world, artists use a camera with multiple lenses, which captures the scene to the front, sides, above, and below. When the film is played back, spectators wearing special headsets (figure 21.14) feel as though they are within the film's space because the perspective shifts to accommodate their views. For example, if viewers look down, they see the ground.

American Gabo Arora's *Ground Beneath Her* enables viewers to be part of earthquake-ravaged Nepal, where nine thousand people were killed and half a million homes were destroyed.[4] The film follows a fourteen-year-old girl named Sabita in 2016—one year after the quake—as she works as a blacksmith to try to help her family regain their lives while she also attends school and does chores around her home.

The virtual reality in the film has the ability to *impact viewers more intensely and personally* than a regular film. When Sabita hammers the hot metal, we are beside her, and when she talks about the earthquake, we are surrounded by a collapsed building. We stand next to children who work at desks in school, just like children in our own community.

*Ground Beneath Her* is one of a number of films that have been produced in conjunction with the United Nations, which sees virtual reality as a powerful way to bring attention to the plight of vulnerable populations. The complex art form *mirrors our troubled world* and allows spectators from one part of the globe to connect with people from another.

## Varied Media

Another trend of Postmodern art is the *number of individual artists working with various diverse media*. California-born Matthew Barney has not only changed materials across works, but also has explored multiple media in individual projects. The *Cremaster* series illustrates one work with numerous outputs. The series consists of five films—elaborate productions with sets, costumes, artificial body parts, and makeup. All the films are fantasies involving part-human, part-fictional creatures that perform bizarre actions. When the series has been on exhibit, Barney has also displayed drawings, photographs, collages, sculptures, costumes, and scenery. Spectators have been able to *find meaning in the work through multiple components*.

The films center on the notion of change and how throughout our lives we transform as individuals. The word "cremaster" from the title refers to changes in the testicles of male fetuses and adults. In addition, some of the sculptures and scenery were made from nonpermanent materials such as jelly or ice, which transform over time, also likely representing change.

In *Cremaster 3*, from 2002, Barney created a myth surrounding the construction of New York's Chrysler Building. He appears as an apprentice charged with completing different challenges. In one scene, he climbs the ramp that circles the interior of the Guggenheim Museum in New York. During this shot, he wears a kilt and headdress and has a rag stuffed in his bloody mouth (figure 21.15).

**FIGURE 21.15.** **Matthew Barney.** *Cremaster 3.* *2002. Two-hour-and-58-minute, 35 mm film (color digital video transferred to film with Dolby Digital sound). Solomon R. Guggenheim Museum, New York.* All of Barney's characters appear to be something out of a dream or nightmare.

*Quick Review 21.4*: In what different ways have artists explored diverse media?

## Protest Art

In our survey of Postmodern art, in addition to grouping artists by media, we can also group artists by topics they consider. For example, some artists have linked art to social engagement and shown how much art matters by giving a voice to important causes. These protest artists fall into two groups: those who use art to *protest current social, political, and environmental concerns* and those who use art to *illustrate the ways in which images and words establish power in our world*.

### Art That Protests Social, Political, and Environmental Concerns

For artists who campaign against worldly problems, *art is a medium through which to pursue activism*. Just as Shonibare took up the problem of hostility toward immigrants in *Alien Woman on Flying Machine* (figure 21.4), these artists use art to protest social, political, and environmental issues. They *manipulate form to create powerful messages* that they try to connect with people to alter their views.

Krzysztof Wodiczko (KRI-stof wah-DEECH-koh) has projected images of distressed people onto urban monuments and buildings to raise awareness about the conditions of marginalized populations. Figure 21.16A shows how in 1986–87 the Polish artist projected images of the homeless onto the Soldiers' and Sailors' Monument in Boston. Here, a man cups a hot beverage to stay warm, while his possessions are scattered below him in a garbage bag and cart. At the top is a projection of a construction project that promised urban development, the kind that can wipe out low-income housing and lead to homelessness.

**FIGURE 21.16A AND B.**
**(A) Krzysztof Wodiczko.** *The Homeless Projection 2. Shown on the Soldiers' and Sailors' Monument at night in 1986–87;*
**(B) Martin Milmore. Soldiers' and Sailors' Monument.** *1877, Boston.* By projecting images of the homeless (21.16A) on a popular memorial (21.16B), Wodiczko brought attention to an important social issue.

(A)                                    (B)

While the memorial honors the city's war heroes by day (figure 21.16B), the park in which it sits can be a place for the homeless to sleep at night. By projecting the images onto the monument, Wodiczko seemed to blur the boundary between the city's pride and shame. Rather than being just a pleasant place to sit, the memorial was transformed. The images *could connect with viewers* by taking over their daily surroundings, *raising the homeless and their cause to prominence.*

Wodiczko's work is also considered Postmodern because he used a *novel art form* (projection) to create his *powerful message.* Also, by projecting his images onto the monument, Wodiczko not only *appropriated another artwork from another period* (the existing monument created in 1877) *to take on our complex world,* but even used the artwork itself in his work.

Other artists have taken up other issues. To discover the work of an artist who explored a different concern that faces our world, see *Practice Art Matters 21.2: Consider Whether a Work Is Protest Art.*

## Art That Looks at How Images and Words Establish Power

Artists who focus on how our world represents itself have taken a different approach to protest. These artists *see images and words as powerful forms of communication that can manipulate our beliefs regarding how we see the world and our place in it.*

For example, what if every day, we were exposed to films, TV shows, and advertisements in which men were subservient to women in the workforce, such that women were lawyers, doctors, and executives and men were secretaries and assistants? Would these media be constructing a specific world, controlling how we see the world, and reinforcing values about which gender should be dominant? Would men, then, think they should be only secretaries or assistants?

Artists who look at how images and words establish power challenge such biased communications and use art to help us see such prejudice clearly. These artists:

- See images and words as *controlling forces* that establish what is "legitimate" in society
- Believe that many forms of communication *influence our views*

## Practice artMATTERS

### 21.2: Consider Whether a Work Is Protest Art

German-born Kiki Smith created *Red Spill* (figure 21.17) after her sister died from AIDS. People who contract the disease have often been discriminated against. Seventy-five pieces of red glass are strewn across the floor like droplets of blood.

Consider these issues:

- Why do you think Smith chose to place the different pieces on the ground?
- Why do you think Smith formed the piece in glass (a fragile, translucent material)?
- Why might Smith have chosen to create one work out of so many different pieces?
- Can this work be considered protest art? Why? What might Smith have been protesting?

**FIGURE 21.17.   Kiki Smith. *Red Spill.*** *1996. Glass, seventy-five elements. Private collection.*

---

- Challenge us to *recognize the agendas* behind communications
- Critique and *reject inappropriate communications*

**Images**

Fred Wilson showed how images shape our views. The New York–born artist curated an exhibition in 1992–93 called "Mining the Museum" at the Contemporary Museum and the Maryland Historical Society to show how *museums have fostered prevailing views when they have determined which objects to display.* Wilson "mined" the storage of the Historical Society to locate items not currently on display (hence the title of the exhibition). Then, he placed these items into displays that the museum staff had previously set up, or arranged these pieces as new installations.

For example, in one case that read "Metalwork 1793–1880," curators had placed fine silver from the 1700s and 1800s. Wilson added a slave manacle worn by an African American in the 1800s (figure 21.18). The jarring combination showed

**FIGURE 21.18.   Fred Wilson. Metalwork, 1793–1880.** *From the installation "Mining the Museum" at the Contemporary Museum and Maryland Historical Society, Baltimore, Maryland in 1992–93. Slave shackles with silver pieces.* The fact that the manacles (seen at center) had originally not been on display elsewhere in the museum raises questions about how curators told the story not only of the slave owners, but also of the slaves.

how one-sided the presentation had been. By displaying only the silver, the museum had *constructed a story* in which nineteenth-century Southerners were seen as refined. Such a display had *molded museum visitors' perceptions* about their ancestors.

By including the slave manacles, Wilson showed that these same wealthy Southerners were slave owners. In fact, slavery had allowed the Southerners to accumulate wealth and create such fine silver. Wilson *deconstructed the original image to show how the museum had used imagery to perpetuate a biased story and mold viewers' beliefs*, even though the museum may have had no intention to do any harm.

Wilson's art can also be considered Postmodern because he *appropriated past works* (the original silver objects) to create a new work with *new meanings*. Additionally, he used a *diverse medium* (handcuffs).

Museums have not just constructed narratives about slave owners and slaves. They also have held the power to impact our understanding of numerous different peoples across history. To consider how another artist commented on typical museum presentations of a different culture, see *Practice Art Matters 21.3: Explore How Museums Influence Our Views.*

---

*Practice* **art**MATTERS

## 21.3 Explore How Museums Influence Our Views

James Luna has opposed typical museum displays of Native people that often omit information on the people's present-day lives. In showing only past "authentic" Native societies, many museums give the impression that Native cultures have died off. Many museumgoers are left ignorant of the lives of today's Native Americans and the challenges they face.

In *The Artifact Piece* (figure 21.19), Luna, who is Native American, placed himself in a case in the Museum of Man in San Diego, California. He wore only shorts, and around him were labels pointing out scars he had received in fights when drunk. Other cases displayed his personal artifacts, such as his college degree, Native American ritual objects, and divorce papers. The performance was positioned within the regular exhibition on Native Americans in the museum.

Consider:

- How did Luna jar visitors into recognizing stereotypical views that museums had often presented, and show that museums sometimes had not told the whole story of Native life?

- What social issue was referenced in the labels that surrounded Luna's body?

- In what ways was Luna's approach similar to Wilson's?

FIGURE 21.19. James Luna. *The Artifact Piece. From the installation and performance at the San Diego Museum of Man, California, in 1987. Mixed media, 3' × 6' 6" × 3' 6".*

---

FIGURE 21.20. Jenny Holzer. Truisms. *Installed in New York, 1977. Offset poster, 24" × 18".* While Holzer originally posted her words on paper, as here, she eventually placed her sayings on electric signs.

### Words

Ohio-born Jenny Holzer has similarly looked at how society represents itself, but she has considered words rather than images. In the late 1970s, Holzer began writing short, clichéd sayings, which she called "truisms." The truisms looked like typical messages used in advertising and *reinforced the power of one group over another*. For example, they included, "Abuse of power should come as no surprise," "An elite is inevitable," and "Exceptional people deserve special concessions." Holzer posted lists of truisms all over New York City (figure 21.20).

By combining the truisms in a list, Holzer drew attention to how inappropriate such everyday concepts were. She showed how *language is a powerful force of communication that establishes social hierarchies*. Such language, she suggested, needs to be reevaluated.

*Quick Review 21.5*: In what two ways have artists protested the status quo?

## Art That Draws on Prior Work

Another group of Postmodern work useful to discuss by topic is art that is inspired by other works. Just as Shonibare drew on the work of Fragonard, other artists have *borrowed or modified the appearances of prior works, calling into question the importance of originality and individual expression*—central values of Western art for centuries. Artists who use other art as a foundation believe that complete innovation in form is unimportant and that to some degree *all art is based on former precedents*. For these artists, creativity comes from *selecting a prior work, framing it, and exhibiting the new work to suggest novel meanings to viewers*. These artists vary, however, in how closely they stick to the prior art, with some artists *directly appropriating the prior work* and others *using the prior work as a point of departure*.

### Art That Directly Appropriates Prior Art

Perhaps the artist best known for aggressively appropriating earlier work is Pennsylvania-born Sherrie Levine. While other Postmodern artists have borrowed the appearance of prior work, typically they have then made changes. For example, Shonibare changed the medium of Fragonard's painting. Levine, by contrast, has often appropriated earlier work *with minimal or no changes*. In *After Walker Evans: 7* (figure 21.21A) from 1981, Levine photographed a photograph by Walker Evans from 1936 called *Corner of Kitchen in Floyd Burroughs' Cabin, Hale County, Alabama* (figure 21.21B).

To understand such direct appropriation, we must consider the concept that no work of art is original and all art is based on prior work. *By photographing Evans's work, Levine makes us question his work too.* Was it original? While Evans photographed the corner of a home, hadn't the homeowners organized the objects in the house, making Evans's work just a job of *selecting what to shoot, framing the shot, and exhibiting the result*? Didn't Levine perform those same tasks in creating her work?

Finally, Levine's work is Postmodern in other ways too. She not only appropriated Evans's work, but also *brought a past work into the present, thereby rejecting a forward*

(A)  (B)

**FIGURE 21.21A AND B.** **(A) Sherrie Levine.** *After Walker Evans: 7.* 1981. Gelatin silver print, 5 1/16" × 3 7/8". The Metropolitan Museum of Art, New York; **(B) Walker Evans.** *Corner of Kitchen in Floyd Burroughs' Cabin, Hale County, Alabama.* 1936. Gelatin silver print, 7 11/16" × 6 5/16". Library of Congress Prints and Photographs Division, Washington, DC.  Since Levine's work is a photo of a photo, the forms of her work (21.21A) and Evans's (21.21B) are almost exactly the same.

*narrative for the story of art*. In replicating the work of Evans—an iconic, Western, male photographer—Levine is perhaps also questioning the authority of a canonical artist.

## Art That Uses Prior Work as a Point of Departure

Some artists *employ prior art as a jumping-off point to create new works*. British-born Eve Sussman has used canonical paintings as points of departure for creating films. Her *89 Seconds at Alcázar* (figure 21.22A) from 2004 is based on *Las Meninas (The Maids of Honor)* (figure 21.22B) by Diego Velázquez (dee-AY-goh veh-LAS-kes), which is discussed in Chapter 15. The film modifies the seventeenth-century painting, using costumed actors who form the scene in the Salon of the Alcázar in the Palace of the Hapsburgs.

The film shows a ten-minute narrative of the time before and after the moment shown in the painting. A variety of features of the film *take off on parts of the painting*:

- Velázquez's painting *breaks down the barrier between the artistic and viewer's spaces*—the king and queen appear in the mirror, so they must be standing in our space. Similarly, Sussman's film *uses a 360-degree take to film in every direction*.
- *Celebrated for its realism*, the painting includes portraits of the figures and displays exquisite textures. In the film, Sussman *uses high-definition video* to capture detail.
- Velázquez *captured the figures mid-motion*, and Sussman used hidden edits to make it appear that the film *is composed of a single, ten-minute-long shot* (see Chapter 8), with no apparent cuts. As a result, viewers seem to experience a moment that extends.

*Quick Review 21.6*: How does art that draws on prior work call into question the importance of originality and individual expression?

(A)

(B)

**FIGURE 21.22A AND B.** (A) **Eve Sussman.** *89 Seconds at Alcázar.* *2004. Ten-minute-loop, digital, high-definition video projection. Heather and Tony Podesta Collection, Falls Church, Virginia;* (B) **Diego Velázquez.** *Las Meninas (The Maids of Honor)* **reconsidered.** For Sussman's film (21.22A), she selected a prior work (21.22B), used it as a jumping-off point, and exhibited the new work, suggesting new meanings.

# The Contemporary Global World

Over the last few decades, the world has become more interconnected. Spurred on by advances in technology, people can now communicate with and travel to other parts of the world faster and more efficiently. This increased connectivity has led to numerous economic, social, and cultural developments. Businesses are multinational with global workforces. Mass culture and consumer goods travel to places far from where they were produced. People are migrating to find better jobs and escape hardship, leading to increased urbanization.

Despite what many people see as the positive aspects of globalization—the integration of different people, cultures, economies, and ways of life—global problems persist. The number of people populating our planet has surged to approximately seven billion, causing overcrowding, struggles for resources, and pressure on the environment. Some religious and ethnic groups have resisted influences from other societies, believing they challenge traditional values. Some have attacked ways of life they see as rival to their own, carrying out terrorist acts. In addition, with the influx of migrants, some countries have experienced growing anti-immigrant sentiment.

## Globalization and Art

Artists have considered our closer-knit world and reacted to the change. The art world today reflects the globalization taking place in the wider world through:

- *Multiculturalism:* Artists of different genders and races, from different nations, cultures, and religions, and with different experiences are valued. No longer are Western, white, male artists privileged over others.
- ***Pluralism****:* Diverse artists take a number of approaches, create a variety of forms, and work in multiple media, all of which are seen as valid and compelling.
- *Diversity within Groups:* Artists who come from the same background are no longer broadly grouped together as producing a set, characteristic kind of art.
- *Cross-cultural Identities:* Artists have blended backgrounds and experiences. They have studios in multiple nations and exhibit all over the world. They create works that reference multiple cultures.
- *Global Mindsets:* Artists celebrate the stories of diverse people, delve into the pros and cons of globalization, and explore the interconnectedness of society.

**pluralism** The trend in contemporary art in which diverse artists take a number of approaches, create a variety of forms, and work in multiple media, all of which are seen as valid and compelling

*Quick Review 21.7*: In what main ways has globalization affected the art world?

## Art of Diverse People

With a preference no longer given to white, Western men, the contemporary art world has seen an explosion of artists with diverse identities, such as Shonibare. Many of these artists consider their distinctiveness in creating form and content. They *reference their diverse identities* in their art, *defy stereotypes*, and *address social issues*.

### Referencing Diverse Identities

A number of contemporary works *reference the creating artist's heritage*. The art of Takashi Murakami (tah-KAH-shee moo-rah-KAH-mee), for example, *is unmistakably Japanese*, as it mimics popular Japanese animation (*anime*) and comic books (*manga*). Murakami creates this effect with a style that he calls "superflat," which uses broad, even areas of color to form fantastic characters. Just like *anime* and *manga* artists, Murakami has given names to favored characters and reproduced them on pop culture merchandise.

**artists**
MATTER

Takashi
Murakami

Mr. Dob is a cute character made from cheery colors and curving, balloon-like shapes.

A blotchy surface covers Mr. Dob's face, fouling his pristine appearance.

Mr. Dob rides a curling, stylized wave across what appear to be three folding screens.

**FIGURE 21.23.** Takashi Murakami. *727.* *1996. Synthetic polymer paint on canvas board, three panels, 9′ 10″ × 14′ 9″. The Museum of Modern Art, New York.*

One of these characters, a mouse-like creature called Mr. Dob, is meant to represent the Japanese people. He appears in figure 21.23 in superflat style. Even though he is a cartoon-like figure, he displays sharp teeth and is surrounded by a mottled surface, so all seems not well.

Murakami references the *superficiality of contemporary culture* that is immersed in fantasy and unable to recognize the truth. While this painting seems menacing, other paintings of his display violence, anger, and war, all with fantastic characters and happy colors.

In addition to Murakami's work relating to his Japanese identity, the painting is Postmodern. In it, Murakami *references Japanese cartoons, Katsushika Hokusai's The Great Wave* (see figure 7.17), and *Japanese screens* (see figure 18.37). To explore a work that displays a different artist's heritage, see *Practice Art Matters 21.4: Describe How a Work References Identity.*

### Defying Stereotypes

Even though artists may come from the same racial, ethnic, or cultural background, we cannot assume that their art will have a similar appearance, be made from related media, or tackle the same themes. Just as Shonibare has not created art that looks like it is from Africa, contemporary artists *have defied stereotypes.* For example, Vik Muniz (moo-NEES) and Ernesto Neto are both Brazilian, but their work differs in multiple ways.

Muniz has formed images from unusual materials (such as chocolate, garbage, and artbooks) and has taken photographs of the results. In figure 21.25A, Muniz selected a painting by Caspar David Friedrich, a nineteenth-century artist we considered in Chapter 19 (figure 19.19), and used the work as a jumping-off point to create a collage in 2017. Muniz created his image out of pieces cut from artbooks, advertisements, and papers (figure 21.25B) and, when completed, took a photograph of the collage.

Muniz's photo is also Postmodern because he *formed the image by modifying another artist's work.* Further, Friedrich originally painted an image of the ruins of the Temple of Juno, an ancient Greek temple. Accordingly, in his new image, Muniz *referenced both the painting and the temple.*

Muniz's photograph does not seem like stereotypical South American art. If anything, the work links to Friedrich, a nineteenth-century German artist. Moreover, Muniz's work *differs from the work of other contemporary Brazilian artists,* such as Neto.

## 21.4 Describe How a Work References Identity

Jaune Quick-to-See Smith's work relates to her identity as a Native American woman. Like Luna (figure 21.19), she has represented her identity as mixed between both traditional Native American and contemporary American worlds.

Consider her work *Sources of Strength* (figure 21.24), looking at all of the different objects in the drawing:

- Which images from Native American culture do you see?
- Which images from contemporary society do you see?
- How does this work show the reality of contemporary Native American life?
- Why is this work an appropriate example of an artist who references her identity?

**FIGURE 21.24.** **Jaune Quick-to-See Smith.** *Sources of Strength.* 1990. Pastel and ink, 2' 5 ¼" × 3' 5 ¼". *Minneapolis Institute of Art, Minnesota.*

(A)

(B)

**FIGURE 21.25A AND B (DETAIL).** **Vik Muniz.** *Temple of Juno in Agrigento, after Caspar David Friedrich. From the series "Afterglow."* 2017. Digital Chromogenic print, 3' 4" × 4' 3 ¾". Muniz's photographs are enormous—this image (21.25A) is over four feet wide. Viewers can easily appreciate the components that make up the image (21.25B).

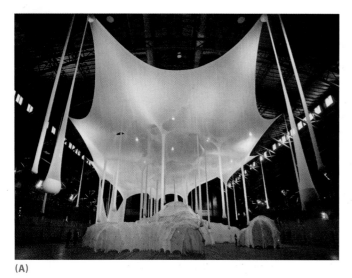

(A)

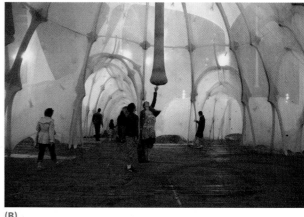

(B)

**FIGURE 21.26A AND B (DETAIL).** Ernesto Neto. *Anthropodino.* 2009. Mixed media installation: tulle, plywood, spices (clove, black pepper, red pepper, cumin, ginger, turmeric), sand, black gravel, river stones, lavender flowers, chamomile flowers, rice, plastic balls, glass beads, polypropylene string, styrofoam beads, and polyurethane foam, overall area of floor elements 27' × 122' × 82' and canopy 192' × 122'. Neto's installation filled the enormous hall in the Park Avenue Armory (21.26A). Tunnels throughout the form enabled people to move through the work (21.26B).

Neto has created enormous installations, which take over buildings. His *Anthropodino* (figure 21.26A) occupied approximately two thousand square feet in the Park Avenue Armory in New York in 2009. Neto stretched tulle to form walls and ceilings, creating passageways through his work (figure 21.26B). Since the tulle was transparent, light entered, establishing an enveloping and ethereal space. Neto additionally placed clove, black pepper, red pepper, cumin, ginger, turmeric, sand, black gravel, river stones, lavender flowers, chamomile flowers, and rice inside long, drop-shaped pieces of tulle, which hung from the ceiling, producing stalactite-like creations.

The organic form of the work produced a structure reminiscent of an amoeba (a single-celled animal). As people walked through, rested on pillows, or smelled the spices placed throughout the structure, they formed a vibrant force that seemed to add to the animated feeling. Each person *explored the work in a different way and could find different meanings*, characteristic of Postmodern work.

Neto's work *reaches out to all of humanity*. It does not relate specifically to other Brazilian artists' works (like Muniz's) or to Brazil. Likewise, the work *cannot be stereotyped* as typically South American.

## Addressing Social Issues

Some artists have used art to *address social issues that are tied to their identities*. For example, Kara Walker has explored the issue of racism that links to her own identity as an African American artist. Using cut paper, which she attaches to walls, she has created room-size scenes of silhouettes.

In *Insurrection! (Our Tools Were Rudimentary, Yet We Pressed On)* (figure 21.27), a 2002 installation at the Guggenheim Museum in New York, Walker showed the typical violence and racism that slaves faced on plantations in the pre–Civil War South. She also represented the slave rebellion, which the title of the work references.

In typical Postmodern fashion, Walker *adapted the figures from the art of the past*—the work of traditional silhouette cutters, who in the nineteenth century cut profiles of people, so they could have a record of their likeness. The technique also renders all figures black, so that we cannot distinguish races, short of looking for facial features. As we stare at the individual figures, we too become "racist" in a way, as we try to distinguish one person

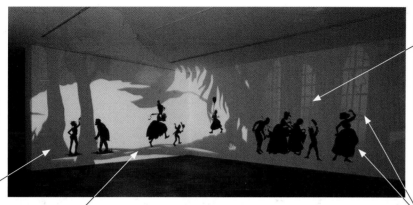

A white plantation owner eyes a naked African American woman.

Slaves attack their master with household tools such as a ladle and a frying pan.

An African American woman, with a noose around her neck and a baby on her head, appears to flee, possibly from a lynching.

To form the installation, Walker worked with projections and paper silhouettes. The projections are the shadowy gray, red, and blue backgrounds, and the silhouettes comprise the figures shown in black.

**FIGURE 21.27.** **Kara Walker.** *Insurrection! (Our Tools Were Rudimentary, Yet We Pressed On).* *From the installation at the Solomon R. Guggenheim Museum, New York, in 2002. 2000. Cut paper and light projections, installation dimensions variable.*

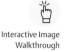

Interactive Image Walkthrough

from the next based only on general assumptions of physical characteristics. In so doing, we perhaps begin to blend with the racist characters on the walls.

At the time of the installation, projections also directly involved the audience in the work. Since the plantation's trees and windows were created with projected light, when spectators entered the space, their shadows were cast on the walls. The viewers became additional silhouettes, seemingly incriminated in the work. Their inclusion *appeared to bring the work into the present, perhaps asking whether such racism still exists today.*

Walker's work has been controversial because of the inclusion of caricatures. Her African American figures have large lips and curly hair. Some critics have suggested that Walker has fostered stereotypes. If we remember that Walker is a Postmodern artist, however, we can understand how she is actually asking viewers to confront stereotypes. Just like Wilson (figure 21.18), Walker has *considered how images establish power.* By depicting traditional racist images, Walker has shown the *power of art to define what people believe.* Just like Wilson, Walker jars viewers into *deconstructing the imagery,* so they can see racism from the past and today.

Rather than focusing on race, Subodh Gupta (soo-bohd GOOP-tuh), an artist from India, has *explored social issues related to his national identity.* He has been concerned about tensions between India and Pakistan, two countries that possess nuclear weapons.

Gupta's *Line of Control* (figure 21.28) displays an enormous mushroom cloud, the form created by the debris after a nuclear explosion. Gupta constructed the cloud from thousands of kitchen utensils and pots.

The title of the work refers to "lines" or contested borders. Given his identity, Gupta was likely referring to the territory of Kashmir, a region that both India and Pakistan claim. The mushroom cloud may represent the concern that in arguing over who has control of Kashmir, both countries could end up with nothing left. Gupta's work could be asking us to consider the threat from nuclear weapons.

This Postmodern work *leads to other interpretations* as well. For example, everyday kitchen utensils are universal. Might Gupta be

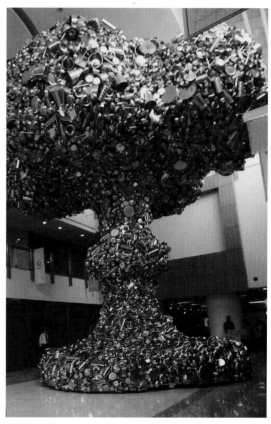

**FIGURE 21.28.** **Subodh Gupta.** *Line of Control. From the installation at the Kiran Nadar Museum, New Delhi, India, in 2012. 2008. Stainless-steel and steel structure, stainless-steel utensils, 32' 9 ¾" × 32' 9 ¾" × 32' 9 ¾".* The stainless-steel material and huge size of this work create a striking image that may look inviting, until we recognize the overall form, which connotes mass destruction.

suggesting that we are all contributing to the problem? However, kitchen utensils also relate to food, sustenance, and survival. Perhaps Gupta is saying that we all need to work together to survive.

*Quick Review 21.8*: In what three ways can artists explore their distinctive identities in creating art?

## Art of a Global World

In our global world, we cannot look solely at the differences among the artists creating art; we also need to *consider their interconnectedness*. Today's artists *represent global communities, illustrate our connected world*, and *give a voice to global issues and concerns*.

### Representing Global Communities

Today, many nations are multicultural, and individuals embrace a variety of identities, which are connected to the wider world. A number of today's artists *show their cross-cultural and global identities in their work*.

**artists**
MATTER

Shahzia
Sikander

Shahzia Sikander (SHAHZ-yuh sik-AN-dur) was born in Pakistan, lives in both Pakistan and the United States, and is a world-renowned international artist. Her work *Pleasure Pillars* (figure 21.29) is a comment on how throughout history and across different cultures women have been underrepresented in the arts. In the painting, she juxtaposes Western and non-Western symbols and figures to show *the multiple identities inherent in women*.

The artist's head appears at center.

Two headless bodies of an ancient Greek goddess (at left) and a Hindu goddess (at right) are *symbolic of how both Western and non-Western women have traditionally been cut out of the historical narrative.*

Two hearts, one blue and one red, are connected by a single artery, *representing interconnections between cultures.*

A modern jet drops bombs on everything below, violently wiping out the stories of women.

A winged figure from traditional Hindu mythology flies near the jet.

This dancer and three others at the remaining corners represent dancers from the *Chronicle of Shah Jahan*, the history of the Muslim Emperor who built the Taj Mahal.

**FIGURE 21.29.** **Shahzia Sikander.** *Pleasure Pillars.* 2001. Vegetable color, dry pigment, watercolor, ink, and tea on wasli paper, 12″ × 10″.

Interactive Image Walkthrough

Other characteristics also connect Sikander to multiple identities including her *Western and non-Western heritage*. Her technique uses the classical style of Indo-Persian miniature painting. However, she took this method as a point of departure to develop new images that convey ideas about history and culture. She also adopted traditional feminine representations such as the Western goddess from images of Aphrodite (see figure 2.9) and the non-Western goddess from depictions of Hindu goddesses (see figure 18.14). These contrasting images can be seen as a comment on the underrepresentation of women in history in all cultures.

The references also show Sikander's *connections to the wider world*. Specifically, the two hearts likely reference *The Two Fridas* (figure 1.44) by Mexican artist Frida Kahlo. In giving a nod to Kahlo, Sikander showed her connection to the international world, not just her own identity.

## Illustrating Our Connected World

Migrations, technology, and multinational corporations all help to connect the world. A number of artists have aimed to *show how our lives are linked to countries across the globe*.

Ai Weiwei (eye way-way), of China, has shown how his country's corruption affects the entire world. His *World Map* (figure 21.30) displays two thousand pieces of cloth cut and layered to form a three-dimensional world map. The work likely references exploited workers toiling in Chinese factories to produce garments, which are worn in the United States and around the globe. Because American corporations manufacture clothing in China, the work further seems to suggest that *all of us are connected* to inexcusable labor practices, such as poor working conditions, low wages, and long workdays.

## Giving a Voice to Global Issues and Concerns

There are a number of transnational issues that transcend boundaries, such as saving the environment, promoting human rights, and combating disease. Artists have *voiced their concerns about these topics* in their work.

Australian-born Margaret and Christine Wertheim have *drawn attention to the destruction of coral reefs* from pollution and global warming. For the *Crochet Coral Reef* project, the artists have crocheted yarn replicas of coral (figure 21.31). The artists have also launched a communal art initiative for the project. Since 2005, thousands of people have contributed crocheted pieces through programs in museums, schools, and aquariums.

In using a *nontraditional medium* (one typically linked to women and craft) and *responding to an issue that affects our complex world*, the project is also Postmodern. In addition, given that we know from Postmodernism that *imagery has the power to change people's beliefs*, we can look at this work from another perspective: *art is a perfect medium*

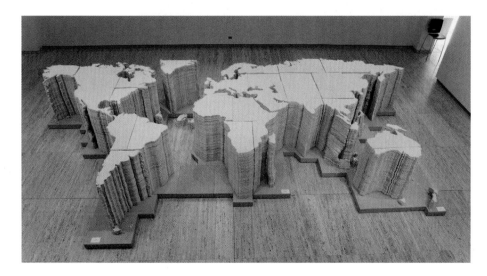

**FIGURE 21.30. Ai Weiwei.** *World Map. From the installation at the Sixteenth Biennale of Sydney at the Art Gallery of New South Wales, Sydney, Australia, in 2006. 2006. Fabric, cotton, nylon, and wood base, 3′ 3 ½″ × 26′ 3″ × 19′ 8 ¼″.* The piles of cloth are perfectly cut, exact stacks, created from many hours of work, yet they are unstable, just like the lives of the Chinese workers who create the cut cloth.

**FIGURE 21.31.** Margaret and Christine Wertheim and the Institute for Figuring. *Toxic Reef*, detail. *From the "Crochet Coral Reef" project, photographed at the Smithsonian National Museum of Natural History, Washington, DC, in 2011. 2005–ongoing. Yarn, discarded plastic shopping bags, and plastic debris, 6′ × 8′ × 4′. Photo © Institute for Figuring.* This example of a reef displays the numerous variations possible with different fibers, colors, and configurations.

**FIGURE 21.32.** Blast Theory. *2097: We Made Ourselves Over. 2017. Smartphone app, films, and performance-based live events.* In one of the films, refugees from the town wade through areas swamped by coastal flooding to get to the new place they are sent to live.

*for activism.* Since art shapes perceptions, it has the power to help move people and, also, motivate them to act in ways that can change the world.

A final example of artists concerned with global issues comes from the U.K.-based artist collective Blast Theory. The group is led by three artists, but other artists also participate in projects. In 2017, the group launched *2097: We Made Ourselves Over.* The project tells the story of a future town from the year 2097 ruled by three teenage girls who, when the town is *faced with global concerns,* must determine the town's fate. Their decisions lead to difficulties for the residents (figure 21.32). Viewers have been able to watch films, interact with characters on a smartphone app, or, when the project was first launched, directly experience the artists' vision of the year 2097 in performance events created with special effects.

The project additionally looks at several issues important in Postmodernism and globalization and is an appropriate place to end this survey. In terms of Postmodernism, the artists chose cutting-edge media with which to bring our attention to complex issues. The app also changes with each participant interaction, creating different meanings for different people. With regard to globalization, anyone around the world can watch the films and use the app. Further, these artists give us a window into current transnational issues, such as concerns involving refugees, the food supply, and global warming. For example, like current refugees, people in the film are forced to leave their town because of destruction, are allowed to bring only one small case of belongings with them, and face difficult paths to get to an unfamiliar destination. Artists such as Blast Theory play an important role in bringing such global issues to our attention.

*Quick Review 21.9*: How do the three ways in which artists can represent our connected world in their art differ?

## A Look Back at the Art of Yinka Shonibare MBE

Considering the work of Yinka Shonibare MBE gives us an opportunity to contemplate the art of a *multidimensional artist*. However, it also gives us insight into the art of the contemporary world.

Shonibare's work is **Postmodern**. Like Postmodern architects, Shonibare has *used past styles in his work*, refusing to follow the tradition of a great narrative in Western art. In addition, like **Postmodern** architects and **Deconstructivist** architects, he has formed works with *multiple meanings that challenge Western values and the concept of originality*. Similar to **Neo-Expressionist** and **Graffiti** artists, Shonibare has also *referenced history in his contemporary works* and *created representational depictions*. Further, Shonibare has *explored numerous techniques* and *moved from one medium to the next*, similar to other artists who work in a diversity of media, and he has *created art to address social issues*, like protest artists. In this respect, he has tried to jar viewers into seeing how traditional *imagery creates power*, by showing us past canonical images in a new light. Finally, like artists who **appropriate** or modify other work, Shonibare has *quoted the work of prior artists*, showing that art is based on precedents and *questioning the originality and authority of canonical artists*.

Shonibare's work is also *global*. Similar to diverse artists across the contemporary art scene, Shonibare has *shown his identity in his art* and has *addressed issues important to his background*, such as showing the racism inherent in imperialism. Additionally, Shonibare, like other artists concerned with global connections, has *represented multiple nationalities* in his art and has *shown our linked world* through his use of objects such as African cloth. Finally, Shonibare has *given a voice to global concerns* like immigration, drawing our attention to important issues.

The beginning of this chapter described how Shonibare had ironically incorporated MBE into his name. It is almost as though these initials represent the psyche of the Postmodern and contemporary global art world. They are Postmodern in that *they bring the past* (an order established in 1917) *into the present* (the name of a contemporary man), *negating a forward linear progression*. They also *suggest divergent meanings*, as the initials recognize service to the British Empire, yet Shonibare has been critical of that empire. They additionally may make us *consider our complex world* as the award was made to a man with roots in a former British colony, while they simultaneously *demonstrate how words create power*, as the influential initials can lead to assumptions about who Shonibare is.

Similarly, the initials are *contemporary and global*. They show *pluralism* and *cross-cultural identity* as the British award has been given to a man who has roots in two countries, emphasizing how people today do not have single backgrounds, but rather hybrid identities. Furthermore, they *showcase global concerns* in the inconsistency of Shonibare accepting the designation.

As you move forward from this chapter, and this book, *consider the value in numerous interpretations*. Art reaches out to all of us on multiple fronts offering different meanings. One meaning may be compelling to one individual, while another idea might find favor with someone else. *These different interpretations allow for possible common ground between the artwork and individuals. These connections help make art matter in our lives.*

Flashcards

---

## CRITICAL THINKING QUESTIONS

1. While previous chapters have been divided according to styles such as the Baroque, Romanticism, or Dada, this chapter is not predominantly divided in this way. Why not?
2. Both Kiefer's *Dein Goldenes Haar, Margarethe (Your Golden Hair, Margaret)* (figure 21.7A) and Walker's *Insurrection (Our Tools Were Rudimentary, Yet We Pressed On)* (figure 21.27) reference disturbing images from the past. In what way do both artists reject the offensive imagery?
3. Scholars have suggested that Hirst's *The Physical Impossibility of Death in the Mind of Someone Living* (figure 21.11) is a modern-day *vanitas* (see figure 15.37). Can you support this claim?
4. Think of a television show, movie, or advertisement where images are shown that reinforce stereotypical thinking about race, class, or gender. What is this show, movie, or advertisement
and how do the images help maintain people's positions in our world?
5. Many people struggle with seeing Levine's work (figure 21.21A) as art. Is it art? Why or why not?
6. Just like Gupta (figure 21.28), Lipski (figure 21.10A) used everyday objects in his work. How might this point make Lipski's work more powerful?
7. Both Hirst (figure 21.11) and Shonibare are British artists. How does their art illustrate the concept of diversity within groups?
8. Given the discussion in this chapter, the virtual reality film *Ground Beneath Her* can be considered a global work. In what ways can you defend this statement?

Comprehension Quiz

Application Quiz

# Identity, Discrimination, and Social Ties

The universal theme of identity, discrimination, and social ties is evident in artworks from this chapter and in art created by people from different backgrounds and periods from across this book. This theme concerns:

» *Race, gender, and ethnic identity*
» *Prejudice, discrimination, and protest*
» *Social ties, community, and shared identities*

## Race, Gender, and Ethnic Identity

In the chapter we just completed, Shahzia Sikander's *Pleasure Pillars* (figure 21.29) showed how women are absent from the historical narrative. Sikander's Western and non-Western goddesses represent traditional female ideal bodies and the stereotypical roles that have been constructed for women when they are included. Such identities have historically reinforced gender roles in which women are valued solely for their bodies.

A parallel can be seen in American Judy Chicago's *The Dinner Party* (figure C21.1), from Chapter 20. Chicago arranged place settings for famous women from history around a table to honor their accomplishments and reject traditional gender roles assigned to women in the past. As in Sikander's contemporary painting, in this work from the 1970s, various objects within each place setting symbolize the identities of women from different backgrounds. Chicago also used historical models to relay her message.

**FIGURE C21.1.** Judy Chicago. *The Dinner Party* reconsidered. Placed around Chicago's table are settings for women from different races and ethnic identities, celebrating both the accomplished women and their diversity.

## Prejudice, Discrimination, and Protest

The chapter we just completed depicts Yinka Shonibare MBE's *Alien Woman on Flying Machine* (figure 21.4). The figure flies through the air as if it is a space creature ready to attack Earth. In that the figure has African cloth covering its body and feet made of three toes, it looks different from us. However, in most other respects, this figure is quite similar to us. Shonibare likely meant to equate this alien with a person of foreign origin. Perhaps Shonibare is making fun of people's fears of today's immigrants and as a protest against such reactions.

A comparison can be made with another contemporary work from Chapter 6, American artist Roger Shimomura's *American Infamy* (figure C21.2), in which he showed the internment camp where he and his family were unjustly incarcerated during World War II. Appallingly, when the United States was at war with Japan, the U.S. government held Japanese American citizens against their will, claiming they were a threat. Even though Germany was similarly an enemy, no German Americans were interned. The internment of the

**FIGURE C21.2.** Roger Shimomura. *American Infamy* reconsidered. Shimomura's painting shows the unfair treatment of Japanese Americans during World War II. Other artworks also have actively protested discrimination.

Japanese Americans was clearly prejudiced and discrimina-tory, based solely on appearance and cultural differences. The image shows how the victims were regular people—an innocent young girl jumps rope in the center foreground, while peaceful adults chat. Menacing, dark clouds hang over the scene.

## Social Ties, Community, and Shared Identities

This past chapter includes a film, created by Gabo Arora and the United Nations, about Sabita, a young girl in Nepal whose family is trying to rebuild their lives after a devastat-ing earthquake. One goal of the film is to bring attention to people living in crisis, with the hope that publicity will yield support. To make the film more impactful, filmmakers employed virtual reality so that we may "stand" in Sabita's house next to her. In so doing, we may see that she is not so different from children living near us. The film stresses our social ties, community, and shared identities with the people of Nepal.

A comparison can be made with an effort described in Chapter 1 of this text, in which the United Nations led a campaign to save ancient Egyptian temples (figure C21.3) that would have been flooded with the building of a dam. Recognizing our global, communal interest in rescuing the world's cultural heritage, the United Nations secured the funds necessary to move the temples to higher ground in 1966. By convincing the world's countries of our shared con-nections, the United Nations persuaded over fifty different countries from across the globe to assist in the effort.

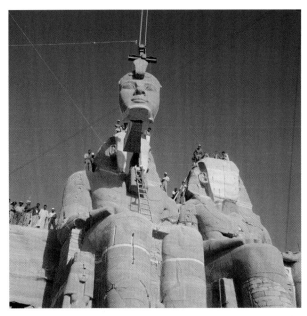

**FIGURE C21.3.** **Ramses II's temple at Abu Simbel being moved in 1966 reconsidered.** The global community worked together to save works of art at Abu Simbel. Similarly, sometimes the creation of works of art involves numerous people acting collectively.

## Make Connections

In *Shibboleth* (figure C21.4), a 2008 installation described in Chapter 10, Colombian artist Doris Salcedo formed a five-hundred-foot-long crack across the floor of the enor-mous, five-story hall in London's Tate Modern Museum. Starting out as a barely noticeable hairline, the crack ex-panded to a foot in width and six feet in depth. Salcedo intended the work to symbolize the divide between London's Western residents and its immigrants. Yet, when visitors attended the exhibition, all stood together viewing the work. How does the work relate to the theme of identity, discrimination, and social ties?

What other visual examples can you come up with from across the book and from today's world that reflect this theme? How are people's motivations across time and place similar and different?

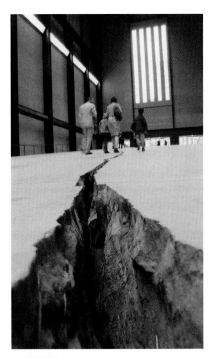

**FIGURE C21.4.** **Doris Salcedo.** *Shibboleth* reconsidered.

# Glossary

**absolute symmetry**—A design in which one side is an exact mirror image of the other (Chapter 4)

**abstract art**—Art in which objects from the real world are purposely distorted or changed (Chapter 2)

**Abstract Expressionism**—An American art movement after World War II in which artists expressed inner feelings in large-scale abstract and nonrepresentational works (Chapter 20)

**academic art**—Art that the French Academy of Fine Arts and other European academies endorsed and that followed prescribed and conservative artistic conventions (Chapter 19)

**acrylic**—A type of paint made with pigments suspended in a synthetic emulsion binder; a method of painting using this paint (Chapter 6)

**Action painting**—A style of art in the West following World War II in which artists painted with large, gestural marks that expressed emotion (Chapter 20)

**actual line**—A line that exists in reality that we can see and that is continuous (Chapter 3)

**actual texture**—Texture that is real that we could feel physically with our fingers (Chapter 3)

**actual weight**—The physical heaviness of an object (Chapter 4)

**additive color system**—The method by which light is mixed by adding different refracted waves of light (Chapter 3)

**additive process**—A technique in sculpture in which the artist starts with nothing and builds up and adds material to create a form (Chapter 10)

**aesthetics**—The philosophy or study of the arts, the nature of beauty, and the multisensory reaction we have to phenomena that make us feel differently than we do ordinarily (Chapter 2)

**afocal**—A type of work that has no focal point or area of emphasis (Chapter 4)

**aisle**—The corridors that run on either side of the nave (Chapter 14)

**ambulatory**—The semicircular walkway that surrounds the apse and allows visitors to walk to the chapels without disturbing the church service (Chapter 14)

**analogous color scheme**—a color scheme that uses hues that are close to one another on the color wheel and that feel related (Chapter 3)

**Analytic Cubism**—One of two phases of Cubism developed by Pablo Picasso and Georges Braque in the early twentieth century in which artists used facets to depict multiple views on a flat surface (Chapter 20)

**animal style**—The abstract, geometric style of interlocking creatures created by Germanic peoples in Western Europe during the ancient and early medieval periods (Chapter 14)

**animated film**—A film in which the camera photographs a series of slightly different, static, traditional or computerized drawings or objects one frame at a time to create the illusion of movement (Chapter 8)

**appropriate**—To borrow the appearances of prior artworks or objects from popular culture and use these forms in contemporary art (Chapter 21)

**apse**—The semicircular extended area of a church where the altar is (Chapter 14)

*aquarelle*—French for "transparent watercolor"; a type of transparent paint made with pigments suspended in gum arabic; a method of painting using this paint; a work of art produced using this method (Chapter 6)

**aquatint**—An intaglio printmaking technique that creates tones by the artist applying a porous, acid-resistant ground to a metal plate and allowing acid to bite around each particle (Chapter 7)

**arcade**—A series of arches supported by columns (Chapter 16)

**arch**—In architecture, a curved or pointed structure that spans an open space (Chapter 12)

**Archaic period**—The period of Greek art history from 600 to 480 BCE characterized by sculptures of large-scale, rigid, frontal figures (Chapter 13)

**architecture**—The art of structural design (Chapter 12)

**architrave**—The horizontal architectural element that forms the lowest band of the entablature (Chapter 12)

**armature**—A rigid skeletal structure made commonly of wire used in sculpture for support in the interior of soft materials such as clay (Chapter 10)

**Art Nouveau**—A style of architecture, interiors, and traditional craft media in the West in the late nineteenth and early twentieth centuries characterized by ornate comprehensive designs, curves, and plant forms (Chapter 19)

**assemblage**—A work of art formed of joined, different, preexisting found objects (Chapters 10 and 20)

**assembling**—A technique in sculpture in which an artist joins together different pre-existing pieces that he or she has found (Chapter 10)

**asymmetrical balance**—An even distribution of visual weight in a design achieved even though the different sides of a work of art do not match (Chapter 4)

**atmospheric perspective**—The technique of illustrating distant, three-dimensional space on a two-dimensional surface in which the artist imitates the atmosphere's effects on light, so that objects that are farther in the distance appear blurrier, lighter, and duller (Chapter 3)

**atrium**—An open courtyard placed at the entrance to a church (Chapter 14)

*auteur*—French for "author"; the person who is the author of a film, whose artistic decisions leave a mark on the film (Chapter 8)

**avant-garde**—Artists who advance new, cutting-edge styles and approaches that the status quo originally rejects, but whose work eventually becomes part of the mainstream (Chapter 19)

*avant-garde* **film**—A film that purposely does not tell a story or follow a logical progression and that challenges ideas about what a film is (Chapter 8)

**balance**—An even distribution of weight throughout a design (Chapter 4)

**Baroque**—A style of art in Europe in the seventeenth and early eighteenth centuries, associated with realism, heightened emotion, dramatic use of light and color, innovative space, and symbolism (Chapter 15)

**barrel vault**—A curved roof or ceiling built in the form of a tunnel (Chapter 12)

**basilica**—A Roman secular administrative building whose form Christians appropriated for use in churches (Chapter 14)

*bas* **relief**—*Bas* is French for "low"; a relief sculpture in which the design protrudes from the background just a little (Chapter 10)

*Bauhaus*—German for "Building House"; the school started in Germany following World War I that promoted artists, architects, and designers creating simple, geometric, functional designs (Chapter 20)

**bay**—A cube-shaped architectural unit made from posts, lintels, and walls (Chapter 18)

**bending**—A method of forming wood furniture in which straight wooden rods are exposed to steam so that they become pliable and can be bent into curved forms (Chapter 11)

**binder**—The adhesive substance in a medium that holds the particles of pigment together and to the ground (Chapters 5 and 6)

**The Blue Rider**—A style of Expressionist art in Germany in the early twentieth century characterized by nonrepresentational or highly abstracted works that convey emotion through form rather than through descriptive objects (Chapter 20)

**bracket**—A supporting piece of architecture that extends from a wall; used to brace a roof (Chapter 18)

**The Bridge**—A style of Expressionist art in Germany in the early twentieth century associated with emotionally intense images that are conveyed through distortions in color, form, and space (Chapter 20)

*buon fresco*—Italian for "good" or "true *fresco*"; a technique of mural painting in which pigments suspended in water are applied to a fresh, wet lime plaster wall (Chapter 6)

**burr**—The rough ridge pushed up on an intaglio plate, which holds the ink and creates a velvety line (Chapter 7)

**calligraphy**—Fine handwriting with aesthetic values that are independent of its textual context (Chapters 16 and 18)

*camera obscura*—Italian for "dark chamber"; a dark box with a pinhole through which reflected light shines and creates an upside-down image on the opposite wall (Chapter 8)

**canon**—The established body of work accepted by the art world as part of the story of art (Chapter 2)

**cantilever**—In architecture, a beam that extends beyond a wall or column, creating an overhang (Chapter 12)

**capital**—A decorative architectural element that crowns the top of a column (Chapter 12)

**cartoon**—A full-size preparatory drawing intended for transfer to a painting, tapestry, or other work of art (Chapter 6)

**carving**—A technique in sculpture in which an artist begins with a material such as wood, stone, or ivory and gouges and cuts away unwanted portions to create a form; a work of art produced using this method (Chapter 10)

**casting**—A technique in sculpture in which an artist creates a model in a soft material and uses a mold to replicate the model in a permanent material (Chapter 10)

**catacomb**—An underground complex of vaults and tunnels used as a burial place (Chapter 14)

**ceramics**—Clay pieces that have been fired in a kiln (Chapters 10 and 11)

**chalk**—A drawing material made from pigment and a nonfat binder (Chapter 5)

**charcoal**—A drawing material made from baked hard wood (Chapter 5)

*chiaroscuro*—Italian for "light-dark"; a technique in two-dimensional art in which the artist uses contrasting light and dark tones, mimicking how light plays across solid objects in the real world, to render the illusion of three-dimensional forms on a flat surface (Chapter 3)

**cinematography**—The artistic way in which a movie camera is used to film a scene (Chapter 8)

**Classical**—Art that recalls images from ancient Greece and ancient Rome characterized by idealized, proportioned, and harmonious forms (Chapter 14)

**Classical period**—Narrowly defined as the period of Greek art history from 480 to 330 BCE characterized by sculptures of large-scale, idealized, weight-shifting figures (Chapter 13); more generally defined as the period covering ancient Greek and ancient Roman art history (Chapter 14)

**clay body**—A mixture that includes one or more types of clay along with other ingredients specifically formulated to improve the plasticity and firing properties of the clay (Chapter 11)

**clerestory**—The area on the uppermost part of the nave walls that is set with windows that allow light to enter the nave (Chapter 14)

**close-up**—A shot in which the camera is focused very close to the actors or objects in a scene; a close-up shot of a person shows only his or her face (Chapter 8)

**coiling**—A method of forming a clay pot in which the potter builds up walls by placing rope-like pieces of clay one on top of another in spirals around a hollow core (Chapter 11)

**collage**—French for "gluing"; a technique in which the artist glues scraps of items from the real world, such as paper or fabric, to the surface of a two-dimensional work; a work of art using this technique (Chapter 20)

**color**—The sensation we perceive upon seeing different wavelengths of light because of how our eyes and brains interpret the wavelengths (Chapter 3)

**Color Field painting**—A style of art in the West following World War II in which artists painted broad expanses of color meant to express emotion (Chapter 20)

**color wheel**—A way to organize the visible spectrum in a circle that helps illustrate color relationships (Chapter 3)

**complementary color scheme**—a color scheme that uses hues that are opposite each other on the color wheel and that feel contrasting (Chapter 3)

**composition**—The selection, arrangement, and organization of the visual elements specifically in a two-dimensional work of art (Chapter 4)

**compression**—The squeezing force that pushes down on a structure (Chapter 12)

**Conceptual art**—A type of art in the West in the twentieth century in which artists focused on the creative process and artistic ideas rather than the art object (Chapter 20)

**constructing**—A technique in sculpture in which an artist joins together different pieces that he or she has created (Chapter 10)

**conté crayon**—A drawing material with a crumbly texture and slightly waxy binder that combines features of both chalk and crayon (Chapter 5)

**content**—The meaning, message, mood, or idea conveyed in a work of art (Chapter 2)

**context**—The cultural, historical, social, economic, political, religious, and personal factors around a work of art that affect its meaning (Chapter 2)

**contour line**—A type of actual or implied line that creates an edge or border of a form or figure (Chapter 3)

*contrapposto*—A stance first used in Greek sculptures of standing figures during the Classical period to give the appearance of the potential for movement by having weight rest on one leg, while the other leg is relaxed and the rest of the body shifts (Chapter 13)

**cool color scheme**—a color scheme that uses hues on the green, blue, and violet side of the color wheel that remind us of the sky and water (Chapter 3)

**corbel**—In architecture, a stone or brick that extends slightly beyond the one below it (Chapter 12)

**Corinthian**—The most decorative architectural order used by the Greeks and the Romans; contains a capital of stylized leaves (Chapter 12)

**cornice**—The architectural element that forms the top band of the entablature (Chapter 12)

**crayon**—A drawing material made from pigment and either a waxy or oily binder (Chapter 5)

**cross-hatching**—A technique in which intersecting sets of lines are closely spaced to darken an area to suggest shading (Chapter 3)

**Cubism**—A style of art developed by Pablo Picasso and Georges Braque in the early twentieth century that included two phases: Analytic Cubism, in which artists used facets to depict multiple views on a flat surface; and Synthetic Cubism, in which artists collaged scraps of items from the real world onto flat surfaces (Chapter 20)

**cuneiform**—The writing developed in ancient Mesopotamia that consisted of wedge-shaped marks (Chapter 13)

**cut**—In film, a way to combine two shots so that when the sequence is shown, one shot instantaneously ends and the next shot instantaneously begins (Chapter 8)

**Dada**—An art movement in the West that arose in response to World War I that attacked traditional values, culture, and convention and promoted the irrational (Chapter 20)

**daguerreotype**—A type of photograph, invented by Louis-Jacques-Mandé Daguerre, which used treated metal plates to capture a brightly lit scene, creating a detailed, unique positive image (Chapter 8)

**deconstruct**—To uncover and demystify the meaning of art (Chapter 21)

**Deconstructivist architecture**—A style of architecture in the late twentieth and twenty-first centuries associated with dissimilar forms, asymmetrical structures, the visual element of time, and numerous meanings (Chapter 21)

**design**—The selection, arrangement, and organization of the visual elements in a work of art; the process of organizing the elements in a work of art (Chapter 4)

*De Stijl*—Dutch for "The Style"; an art movement in the Netherlands following World War I, associated with a nonobjective style of art that employed rectangular and linear forms in black, white, gray, and primary colors (Chapter 20)

**diminishing size**—The technique of illustrating three-dimensional space on a two-dimensional surface in which objects are depicted in different sizes, with objects that are the smallest being understood as the farthest in the distance (Chapter 3)

**dissolve**—A technique in film of transitioning two shots in which the end of the first shot is superimposed on the beginning of the next shot, so that the first shot blends into the next (Chapter 8)

**documentary film**—A film that is not scripted, in which the filmmaker does not control the *mise en scène* and is therefore presented to viewers as a reliable depiction of events, people, places, and things (Chapter 8)

**dome**—In architecture, a hemispherically shaped roof (Chapter 12)

**Doric**—The plainest, boldest architectural order used by the Greeks and the Romans; contains a simple, rounded capital (Chapter 12)

**drawing**—The technique of running a tool over a two-dimensional surface and leaving descriptive marks; a work of art created by this technique (Chapter 5)

**dry garden**—A Zen Buddhist garden created to aid with contemplation, consisting of stones, pebbles, and sometimes simple shrubs (Chapter 18)

**dry media**—Drawing materials that scratch the surface and are abrasive (Chapter 5)

**drypoint**—An intaglio printmaking technique in which the artist scratches the lines of the design into a metal plate using a drypoint needle, which pushes up a burr that will print with a velvety effect (Chapter 7)

**earthenware**—A type of clay body, made from a reddish-brown clay and fired at relatively low temperatures, that is porous and easily chipped after firing (Chapter 11)

**earthwork**—A work of art in which the artist places human-made forms in a natural environment, molds the earth, or uses nature to create the piece (Chapters 10 and 20)

**easel painting**—A painting that is a self-contained, portable work of art (Chapter 6)

**editing**—The process of organizing a film by putting shots together (Chapter 8)

**edition**—The total number of original prints pulled from a matrix by an artist or under an artist's supervision, not counting any proofs (Chapter 7)

**embroidery**—A method of creating a surface design on a piece of fabric using needlework; a work created using this technique (Chapter 11)

**emphasis**—The visual dominance of an area in a design that attracts the viewer's attention (Chapter 4)

**encaustic**—From the Greek *enkaustikos*, meaning "to burn in"; a type of paint made with pigments suspended in a hot wax binder; a method of painting using this paint (Chapter 6)

**engraving**—An intaglio printmaking technique in which the artist carves the lines of the design into a metal plate using a burin (Chapter 7)

***en plein air***—An approach to painting in which artists paint outdoors to capture everyday scenes and effects of light and atmosphere (Chapter 19)

**entablature**—The horizontal part of a building that sits on top of a column that supports the pediment or roof (Chapter 12)

**environment**—A three-dimensional work of art in which the artist uses an entire space or room to create the piece (Chapter 20)

**etching**—An intaglio printmaking technique in which the artist lays an acid-resistant ground on a metal plate, draws on the plate with a needle exposing the plate below, and immerses the plate into an acid bath, allowing the acid to eat away at the exposed areas of the plate (Chapter 7)

**experimental film**—A film that purposely does not tell a story or follow a logical progression and that challenges ideas about what a film is (Chapter 8)

**Expressionism**—An art movement in Europe in the early twentieth century in which artists discarded naturalism to stress emotion (Chapter 20)

**fade**—A technique in film of transitioning two shots in which the final image in a shot slowly changes to darkness and the darkness slowly changes back into the first image in another shot (Chapter 8)

**Fauvism**—From the French for "wild beasts"; a style of expressionist art in France in the early twentieth century characterized by expressive color, distorted shapes, and unnatural space (Chapter 20)

**featherwork**—A work of art created by the technique of tying feathers onto a mesh netting (Chapter 17)

**fiber**—A threadlike strand made from natural or synthetic sources (Chapter 11)

**figure–ground relationship**—In two-dimensional art, the connection between the dominant shape that the artist depicts and the background area (Chapter 3)

**figure–ground reversal**—In two-dimensional art, ambiguity between the figure (the dominant shape that the artist is depicting) and the ground (the background area), so that at different moments what we perceive as the figure becomes the ground and what we perceive as the ground becomes the figure (Chapter 3)

**film**—The process of recording moving images on a photosensitive surface with light (Chapter 8)

**firing**—The process of baking clay pieces in a kiln; through firing, clay pieces are changed physically and chemically so they are durable and hard (Chapter 10)

**fixative**—An adhesive liquid usually sprayed on charcoal, chalk, or pastel drawings to prevent the pigments from rubbing off (Chapter 5)

**flashback**—A nonlinear film technique in which a film is interrupted with a scene that shows events that happened in a prior time period (Chapter 8)

**fluid media**—Drawing materials that are wet and flow onto a surface (Chapter 5)

**flying buttress**—A structure that extends in an arched bridge from an exterior nave wall, at the point where the outward thrust from the main interior vault is the greatest, down to a solid, vertical support (Chapter 12)

**focal point**—A particular spot in a design that attracts attention (Chapter 4)

**form**—The physical appearance of a work of art including its materials and how those materials are organized, presented, and manipulated (Chapter 2)

**found object**—An item that an artist selects or finds that is incorporated into a sculpture without being altered; through juxtaposition with other objects or through placement, a found object will take on new or additional meaning (Chapter 10)

**frame construction**—An architectural structural system that has a skeleton made out of a strong material such as iron, wood, or steel and a skin made out of a fragile material (Chapter 12)

**freestanding sculpture**—A sculpture that is not attached to anything and that stands on its own, and can be completely circled by the observer and viewed from any angle (Chapter 10)

***fresco secco***—Italian for "dry *fresco*"; a technique of mural painting in which pigments suspended in a binder are applied to a dry lime plaster wall (Chapter 6)

**frieze**—The horizontal architectural element that forms the middle band of the entablature, often decorated with relief sculpture (Chapter 12)

**genre**—A type of art that depicts ordinary people in everyday scenes from daily life (Chapter 15)

**geodesic dome**—An architectural structural system in which a dome is created out of a frame of triangular-shaped metal rods (Chapter 12)

**Geometric period**—The period of Greek art history from 900 to 600 BCE characterized by pots with geometric patterns (Chapter 13)

**geometric shape**—A type of shape that is mathematical and regular such as a circle, square, or rectangle (Chapter 3)

**gesture**—A form of expression that emphasizes or sums up the overall impulse and expressive and physical qualities of its subject matter (Chapter 3)

**glassblowing**—The process of blowing air through a tube into molten glass to form glass objects (Chapter 11)

**glaze**—In painting, a technique in which a thin, transparent color is applied over a previously painted coating of another color to modify the color and appearance of the lower layer; the transparent layer of paint created using this technique (Chapter 6); in ceramics, a finely ground mixture of minerals and water that vitrifies into a glass-like surface when fired, used to decorate and seal a work in clay (Chapter 11)

**golden rectangle**—A rectangle that has the ideal proportions of the golden section in which the longer side divided by the shorter side equals 1.618 (Chapter 4)

**golden section**—A type of proportion in a work of art thought to have inherent beauty whereby a whole is cut into two unequal parts and the smaller section is in the same ratio to the larger section as the larger section is to the whole (Chapter 4)

**gold leaf**—Gold that has been hammered into paper thin sheets to be used as a decorative application to an artwork (Chapter 18)

**Gothic**—The style of Western European art lasting from 1150 to 1400 characterized in architecture by towering churches with pointed arches, stained glass windows, and ribbed groined vaults (Chapter 14)

**gouache**—Opaque watercolor; a method of painting using this paint (Chapter 6)

**Graffiti art**—A style of art in the late twentieth century associated with street art, historical and cultural references, the inclusion of words and symbols, abstract or representational forms, and energetic brushwork (Chapter 21)

**grain**—The roughness of a surface, which creates a texture in a work (Chapter 5)

**graphic design**—Print or digital material that communicates a client's specific message to a targeted audience (Chapter 9)

**graphite**—A drawing material made of a form of carbon (Chapter 5)

**grid**—An underlying structure that establishes certain consistent parameters in a layout (e.g., number of columns, margin widths, page number location, etc.) that guide a designer in the placement and sizing of images and type so that a consistent look can be created across a multipage work (Chapter 9)

**groin vault**—The structure created when two barrel vaults intersect at right angles to each other (Chapter 12)

**ground**—A preparatory coating applied to a two-dimensional surface as a base for a painting or a drawing (Chapter 6); in etching and aquatint printmaking, a preparatory acid-resistant coating applied to a metal plate used to protect the covered areas of the plate from acid (Chapter 7)

**gum arabic**—A sticky substance used in art materials, which comes from the acacia tree (Chapter 6)

**handscroll**—A very wide, horizontal strip of paper with paintings or calligraphy that is rolled up, so that an individual viewer can consider one section of the scroll at a time by unrolling it from hand to hand (Chapter 18)

**Happening**—A theatrically based work created by an artist in which participants stage an unscripted, unrehearsed event (Chapter 20)

**hatching**—A technique in which parallel lines are closely spaced to darken an area to suggest shading (Chapter 3)

***haut* relief**—*Haut* is French for "high"; a relief sculpture in which some parts of the design protrude from the background by more than half their modeled form (Chapter 10)

**Hellenistic period**—The period of Greek art history from 330 to 31 BCE characterized by sculptures of large-scale, dramatic, fully in-the-round figures (Chapter 13)

**hierarchical scaling**—The technique of depicting different figures or objects using different scales so that people or objects of greater importance are depicted larger (Chapter 4)

**hieroglyph**—Writing developed in ancient Egypt that consisted of pictorial representations and symbols of sounds and ideas (Chapter 13)

**highlight**—The lightest, most intensely lit area on an object or in a work (Chapter 3)

**high relief**—a relief sculpture in which some parts of the design protrude from the background by more than half their modeled form (Chapter 10)

**horizon line**—In linear perspective, the line that the artist creates that distinguishes between the earth and sky (Chapter 3)

**hue**—The standard characteristics of colors that allow us to group them in families such as red, green, or blue (Chapter 3)

**icon**—A religious or sacred image of a saint or other holy person venerated by the faithful and believed to have powers to convey messages to God (Chapter 14)

**iconoclasm**—The destruction of icons or other religious images (Chapter 14)

**iconography**—Symbols or images in a work of art that have been invested with additional meaning and that are specific to a particular culture and time period (Chapter 2)

**illuminated manuscript**—A handmade manuscript or book painted with illustrations and decorations (Chapter 14)

**impasto**—A style of painting in which thick, built-up, opaque paint stands away from the surface in textured brushstrokes; the paint applied to a surface using this technique (Chapters 3 and 6)

**implied line**—A line that we visually complete that does not actually exist, but that we feel is present because it is suggested by the artist by way of segments, a glance, or a motion (Chapter 3)

**impression**—A single print out of the total number of prints pulled from a printmaking matrix (Chapter 7)

**Impressionism**—An art movement in the West in the nineteenth century that focused on how we really see our constantly changing world (either because of the shifting effects of time and atmosphere or because of the spontaneous movement of figures and objects in space) that is characterized by thick, divided strokes of paint (Chapter 19)

**installation**—A three-dimensional work of art in which the artist uses an entire space or room to create the piece (Chapters 10 and 20)

**intaglio**—Italian for "cut into"; a matrix in which the carved-out areas below the surface hold the ink and print and the areas on the surface of the plate do not print; a printmaking technique using this matrix (Chapter 7)

**intensity**—The degree of pureness or brightness of a color (Chapter 3)

**International Style**—An architectural approach in the West in the twentieth century, associated with plain, geometric, functional structures (Chapter 20)

**in-the-round sculpture**—A sculpture that is not attached to anything and that stands on its own, and can be completely circled by the observer and viewed from any angle (Chapter 10)

**Ionic**—The most delicate, graceful architectural order used by the Greeks and Romans; contains a scrolled capital (Chapter 12)

**iron-frame construction**—A frame architectural structural system in which iron is used as the skeleton (Chapter 12)

*iwan*—An open, recessed area whose walls support either a half dome or barrel vault (Chapter 16)

**keystone**—The highest, centered voussoir in an arch that, when added, locks all of the voussoirs in place (Chapter 12)

**kiln**—An oven that reaches temperatures of 1,200 to 2,700 degrees Fahrenheit, used for firing ceramics (Chapters 10 and 11)

**kinetic art**—A work of art that appears to move or has moving elements propelled either through a motor, magnet, crank, or natural phenomena (Chapter 10)

*kondo*—The golden hall; the main Buddhist building that contains an altar with images of the Buddha (Chapter 18)

*kore*—A sculpture from the Archaic period of Greek art history of a standing, clothed, female youth (Chapter 13)

*kouros*—A sculpture from the Archaic period of Greek art history of a standing, nude, male youth (Chapter 13)

**layout**—The organization of the images and type in a design (Chapter 9)

**light**—A form of electromagnetic energy that can be seen by human eyes (Chapter 3)

**line**—Any actual or perceived mark or area that has a notably greater length than width (Chapter 3)

**linear**—A style of a work of art characterized by the dominance of line (Chapter 5)

**linear perspective**—The mathematical technique of creating the illusion of three-dimensional space on a two-dimensional surface in which parallel lines, which recede in the distance, converge at one or more vanishing points (Chapter 3)

**linocut**—A relief printmaking technique in which a piece of linoleum is carved to create a matrix (Chapter 7)

**liquid media**—Drawing materials that are wet and flow onto a surface (Chapter 5)

*literati* **painting**—A type of painting created by intellectuals in East Asia who were not associated with the royal court (Chapter 18)

**lithography**—Greek for "stone drawing"; a printmaking technique in which the matrix is made from a stone and printing and non-printing areas are separated chemically, since grease and water don't mix (Chapter 7)

**load-bearing**—In architecture, a method of construction in which rocks or bricks are piled one on top of another (Chapter 12)

**local color**—The actual color we expect an object to be because we see the object in that color during regular daylight (Chapter 3)

**logo**—Short for logotype; a type of trademark that uses only type and no images (Chapter 9)

**long shot**—A shot in which the camera is focused very far away from the actors or objects in a scene, giving an overall view (Chapter 8)

**loom**—A structure used in weaving and carpet making that holds the warp threads taut and lifts or depresses select warp threads so that weft threads may be easily interlaced (Chapter 11)

**lost wax casting**—A hollow casting technique used to create a sculpture in which molten metal replaces wax; a wax replica is created from an artist's model, encased in a mold, and heated so that the wax drains away, then molten metal is poured into the cavity that the wax vacated (Chapter 10)

**low relief**—a relief sculpture in which the design protrudes from the background just a little (Chapter 10)

*madrasa*—An Islamic school of higher learning (Chapter 16)

**Mannerism**—A sophisticated and elegant style of art in Italy during the sixteenth century, associated with a rejection of High Renaissance Classicism and naturalism in favor of the use of distorted figures, unnatural colors, and an irrational space (Chapter 15)

**masquerade**—A ritual gathering involving masks, costumes, music, and dance (Chapter 16)

**mass**—A solid form that has bulk that occupies volume in space (Chapter 3)

**matrix**—In printmaking, the surface that the artist manipulates that will create the print (Chapter 7)

**medium** (singular)/**media** (plural)—The material used by an artist to create a work of art; an art form or type of art that uses a particular material (Chapter 2); the material that together with the pigment forms paint (Chapter 6)

*mihrab*—A niche in the wall of a mosque that indicates for worshippers the direction of Mecca (Chapter 16)

**minaret**—A high tower outside a mosque from which a Muslim crier calls the faithful to prayer (Chapter 16)

**miniature**—A small, independent painting (Chapter 6)

**Minimalism**—A style of art in the West in the twentieth century associated with formal, nonobjective works that had no meanings, functions, or illusions (Chapter 20)

*mise en scène*—French for "put in the scene"; everything that is filmed by a movie camera (Chapter 8)

**mixed media**—The combination of two or more media in a single work of art (Chapter 5)

*moai*—A colossal stone figure encompassing a head and torso found on the island of Rapa Nui (Easter Island) (Chapter 17)

**modeling**—In two-dimensional art, the depiction of the illusion of a three-dimensional form on a flat surface (Chapter 3); in sculpture, a technique in which an artist shapes a soft, pliable material such as clay or wax to create a three-dimensional form (Chapter 10)

**Modern art**—Art that rejected academic conventions of subject matter, size, and style; advanced original approaches that the mainstream at first criticized and rejected, but eventually accepted; and drew attention to the technique, the manipulation and application of the media, and the surface of a work (Chapter 19)

**mold**—An exact negative impression of a model that forms a pattern for a replacement material in casting (Chapter 10)

**monochromatic color scheme**—A color scheme that uses only one hue in different values (Chapter 3)

*montage*—In film, a group of shots that have been organized specifically to highlight graphic and rhythmic relationships between shots rather than spatial and temporal ones (Chapter 8)

**mosaic**—A technique in which small, cut pieces of materials, such as glass or stone, are set in a cement or plaster foundation to

create a picture or design; a work created using this technique (Chapter 14)

**mural**—A large painting that is painted on a wall or ceiling (Chapter 6)

**narrative film**—A film that tells a story or that follows a logical progression (Chapter 8)

**narthex**—A porch placed at the entrance to a church (Chapter 14)

**nave**—The central hall in a church (Chapters 12 and 14)

**negative**—In photography, the exposed image in which the values (lights and darks) are reversed from the way they are in real life (Chapter 8)

**negative shape**—In two-dimensional art, a shape that we perceive as being in the background (Chapter 3)

**negative space**—The empty, unfilled area around and within a mass (Chapter 3)

**Neoclassicism**—A style of art in the West in the eighteenth and nineteenth centuries in which artists, hoping to instill in the public virtues of the Enlightenment, portrayed Classical subjects and imitated Classical form (Chapter 19)

**Neo-Expressionism**—A style of Expressionist art in the late twentieth century characterized by emotional content, historical references to troubled past periods, multiple meanings, large-scale works, abstract or representational forms, and energetic brushwork (Chapter 21)

**New York School**—An American art movement after World War II in which artists expressed inner feelings in large-scale abstract and nonrepresentational works (Chapter 20)

**nib**—The sharp point or tip of a pen (Chapter 5)

**nonobjective art**—Art that does not depict anything representational from the real world (Chapter 2)

**nonrepresentational art**—Art that does not depict anything representational from the real world (Chapter 2)

**oil paint**—A type of paint made with pigments suspended most commonly in linseed oil; a method of painting using this paint (Chapter 6)

**one-point perspective**—The mathematical technique of illustrating three-dimensional space on a two-dimensional surface in which parallel lines, which recede in the distance, converge on one vanishing point (Chapter 3)

**order**—A standardized architectural style of columns and beams used by the ancient Greeks and Romans (Chapter 12)

**organic shape**—A type of shape that is irregular that resembles those found in nature (Chapter 3)

**original print**—A print created from a design made by an artist, on a matrix created or supervised by an artist, and pulled by hand under the artist's supervision (Chapter 7)

**outsider artist**—An artist who works outside of the established art world (Chapter 2)

**overlapping**—The technique of illustrating three-dimensional space on a two-dimensional surface in which objects are positioned one in front of another, with objects that are blocked being understood as farthest in the distance (Chapter 3)

*pagoda*—A multi-storied Buddhist tower that contains sacred relics (Chapter 18)

**painting**—The application of fluid color to a two-dimensional surface; a work of art created by this technique (Chapter 6)

**palette**—A surface used to hold and mix an artist's paints (Chapters 6 and 15); the colors used in a work of art or the colors available for use (Chapter 6); a flat stone with an indentation used for grinding eye makeup that the Egyptians used to ease sun glare and for decoration (Chapter 13)

**pan**—The technique in film in which, during a single shot, the camera moves from side to side, achieved by swiveling the camera on a stationary axis (Chapter 8)

**pastel**—A high-quality, finely textured chalk; a drawing made from this material (Chapter 5)

**patina**—A brownish- or greenish-colored film that develops on the surface of bronze or copper, either through oxidation or from the introduction of a chemical treatment by an artist or foundry so that the corrosive reaction is immediate; the coloring gives the sculpture a distinct aesthetic quality (Chapter 10)

**patron**—A person who supports an artist by commissioning works of art (Chapters 1 and 4)

**pattern**—A repetitive design of exact or similar forms, figures, elements, or motifs in either regular or irregular intervals (Chapter 2)

**pediment**—A triangular-shaped part of a building that sits on top of the entablature (Chapter 12)

**pendentive**—A curved, triangular structural element that bridges the gap between a round dome and a square building (Chapter 12)

**Performance art**—A theatrically based work of art in which an artist uses his or her body as a medium to express meaning (Chapter 20)

**photogenic drawing**—A type of photographic process, invented by William Henry Fox Talbot, which used treated paper to capture a negative image of an object; a work created using this process (Chapter 8)

**photography**—Greek for "writing with light"; the process of recording images on a photosensitive surface with light (Chapter 8)

**pictograph**—An image that communicates an idea by representing an object, place, or event in an abstracted and simplified way (Chapter 9)

**picture plane**—The flat surface of a two-dimensional work of art (Chapter 3)

**pigments**—Substances that absorb and reflect different wavelengths of light that allow us to see color (Chapters 3 and 6)

**pinching**—A method of forming a clay pot in which the potter builds up walls by making an indentation in the center of a clay ball and then pressing and squeezing the clay up and outward (Chapter 11)

**planographic**—A matrix in which the flat surface prints; a printmaking technique using this matrix (Chapter 7)

**plate**—In printmaking, the surface that the artist manipulates that will create the print (Chapter 7)

**pluralism**—The trend in contemporary art in which diverse artists take a number of approaches, create a variety of forms, and work in multiple media, all of which are seen as valid and compelling (Chapter 21)

**Pointillism**—Georges Seurat's Post-Impressionist method of applying small marks of pure and almost pure color across a canvas, so that at a distance adjacent colors would combine to form new, blended, brilliant colors (Chapter 19)

**Pop art**—A style of art in the West in the twentieth century that imitated media images, mimicked mass-production techniques, and formed commercial objects (Chapter 20)

**porcelain**—A type of clay body, made from a white clay called kaolin and fired at relatively high temperatures, that is nonporous, hard, translucent, and glossy after firing (Chapter 11)

**positive shape**—In two-dimensional art, a shape that we perceive as dominant, significant, and in the foreground (Chapter 3)

**post-and-lintel construction**—A type of architectural structural system in which two vertical uprights or posts support a horizontal beam or lintel (Chapter 12)

**Post-Impressionism**—A style of art in the West in the late nineteenth and early twentieth centuries that describes artists who followed the Impressionists and were generally inspired by their visible brushwork, but who moved in two different directions characterized either by formal structure or by emotion and symbolism (Chapter 19)

**Postmodern architecture**—A style of architecture in the 1970s and 1980s that moved away from the sterile forms of the International Style. Postmodern architecture is characterized by eclectic historical references, humor, ornamentation, multiple meanings, and fit with the local environment (Chapter 21)

**Postmodernism**—The movement in art from roughly 1980 to the present when artists have rejected the assumptions of Modern art. Postmodernism is characterized by rejection of a story of art; reference to prior work; abandonment of a set style; diversity of media; complex, personal form that mirrors our complicated world; and deconstruction (Chapter 21)

**pottery**—Fired clay vessels (Chapter 11)

**primary colors**—Colors that theoretically cannot be made by mixing other colors and which can be used to make all of the other colors (Chapter 3)

**priming**—Applying a preparatory coating to a surface as a base (Chapter 6)

**print**—An image made by an artist's creating a design on one surface and transferring that design to another surface (Chapter 7)

**printmaking**—The technique of creating a design on a matrix and transferring that design to a surface (Chapter 7)

**proof**—A trial print made before the regular edition is pulled (Chapter 7)

**proportion**—The mathematical relationship between the size of a part of an object and the size of the whole (Chapter 4)

**pure symmetry**—A design in which one side is an exact mirror image of the other (Chapter 4)

**qibla wall**—The interior wall of a mosque, containing the *mihrab*, that is located closest to Mecca, toward which worshippers face when praying (Chapter 16)

**quill**—A pen made from a bird's feather (Chapter 5)

**quillwork**—A work of art created by the technique of attaching dyed porcupine quills to a surface (Chapter 17)

**radial balance**—An even distribution of visual weight in a design achieved because the forms are positioned around a central point (Chapter 4)

**radiating chapel**—A semicircular space in a church that protrudes from the ambulatory or transept and often contains altars holding relics (Chapter 14)

**raising**—The process of hammering a metal sheet inward around a stake to form the walls of a vessel (Chapter 11)

**Realism**—A style of art in the West in the nineteenth century that charged that everyday people performing mundane activities were an appropriate subject for art (Chapter 19)

**register**—A technique of alignment used with color printmaking to ensure that successive matrices print their respective colors in the right place on the paper (Chapter 7); a horizontal strip in a work of art (Chapter 13)

**reinforced concrete**—A building material composed of concrete that has been strengthened with embedded metal rods (Chapter 12)

**relief**—A matrix in which the raised areas on the surface hold the ink and print and the areas that are carved away do not print; a printmaking technique using this matrix (Chapter 7)

**relief sculpture**—A sculpture that is made up of both a background and a projecting design (Chapter 10)

**reliquary**—A container that holds the remains or objects associated with holy people (Chapter 14)

**Renaissance**—The period in Western history during the fifteenth and sixteenth centuries, associated with an artistic and intellectual revival of values of the ancient Greek and Roman worlds (Chapter 15)

**replacement technique**—A process in sculpture in which one material replaces another (Chapter 10)

**representational art**—Art in which recognizable objects and figures from the real world are depicted (Chapter 2)

**rhythm**—The repetition of a particular visual element or similar visual elements in a work of art (Chapter 4)

**Rococo**—A style of art in the West in the eighteenth century associated with upper class pleasure, lighthearted playfulness, and ornate decoration (Chapter 19)

**Romanesque**—The style of Western European art lasting from approximately 1000 to 1150 characterized in architecture by stone churches with round arches, heavy walls, and barrel vaults (Chapter 14)

**Romanticism**—A style of art in the West in the nineteenth century associated with dramatic emotion, vivid passions, and depictions of the sublime human and natural worlds (Chapter 19)

**Salon**—The French Academy of Fine Arts' official exhibition of paintings and sculptures (Chapter 19)

**sans serif**—Letters that do not have serifs (the small strokes that finish and come off the ends of the main strokes of letters) (Chapter 9)

**saturation**—The degree of pureness or brightness of a color (Chapter 3)

**scale**—The size of an object relative to what is normal (Chapter 4)

**screenprinting**—a stencil printmaking method in which a stencil is attached to a mesh material stretched on a frame and printed with ink or paint being forced through the openings (Chapter 7)

**sculpture**—A three-dimensional, tangible work of art that conveys meaning and may have a purpose, but is not functional (Chapter 10)

**secondary colors**—Colors resulting from the mixing of two primary colors (Chapter 3)

**serif**—The small stroke that finishes and comes off of the end of the main stroke of a letter (Chapter 9)

**serigraphy**—*Seri* is Latin for "silk" and *graphos* is Greek for "to write"; a stencil printmaking method in which a stencil is attached to a mesh material stretched on a frame and printed with ink or paint being forced through the openings; serigraphy was the particular name given to the fine arts technique of screenprinting to distinguish it from the commercial use of the process (Chapter 7)

**sfumato**—A technique in painting in which the artist softly blends the transitions between colors and tones so that there are no precise lines or contours in a painting, giving the painting an overall smoky or hazy effect (Chapter 15)

**shade**—A dark color formed from mixing a hue with black (Chapter 3)

**shading**—A technique in two-dimensional art in which an artist darkens an area (Chapter 3)

**shadow**—The dark area behind an object that is being blocked from the light (Chapter 3)

**shape**—A two-dimensional area that we perceive as distinct and that is separated from the surrounding area by a distinguishable boundary (Chapter 3)

**shell system**—In architecture, a structural system in which one material both supports and sheathes a building (Chapter 12)

**shot**—A segment of film in which the camera runs continuously (Chapter 8)

**silkscreen**—a stencil printmaking method in which a stencil is attached to a mesh material stretched on a frame and printed with ink or paint being forced through the openings (Chapter 7)

**simulated texture**—Texture suggested by an artist through illusion (Chapter 3)

**simultaneous contrast**—The effect created when two complementary colors are placed together, making each appear more intense (Chapter 3)

**sinking**—The process of hammering a metal sheet outward against a piece of wood or a sandbag to shape the form of a vessel (Chapter 11)

**site specific**—A sculpture that is designed for a particular location (Chapters 1 and 10)

**size**—A preliminary coating of diluted glue applied to a surface to seal it, reduce its absorbency and porosity, and separate it from the paint (Chapter 6)

**skeleton-and-skin system**—In architecture, a structural system that has a skeleton or frame made out of a strong material sheathed in a skin or covering made out of a more fragile material (Chapter 12)

**slab building**—A method of forming a clay object in which the artist builds a structure by creating flat sheets of clay and then assembling the sheets together (Chapter 11)

**slip**—A mixture of clay and water used to decorate, cast, or join pieces of clay (Chapter 11)

**solvent**—A rapidly evaporating material that dilutes paint (Chapter 6)

**space**—In three-dimensional art, the actual area in which forms exist; in two-dimensional art, the area of the flat surface and the illusion on the flat surface of an actual, three-dimensional area in which forms exist (Chapter 3)

**stained glass**—A type of art form in which cut pieces of colored glass are held together with lead strips or in which glass is painted on with pigment (Chapter 11)

**state**—A proof stage of a print pulled while the plate is being developed to see how the plate is shaping up (Chapter 7)

**steel-frame construction**—A frame architectural structural system in which steel is used as the skeleton (Chapter 12)

**stele**—A large upright stone slab upon which images and/or writing are often inscribed (Chapters 13 and 17)

**stencil**—A flat masking material in which a design has been cut to allow ink or paint to pass through the open areas onto a surface below; a printmaking technique using this cut-out material (Chapter 7)

**still life**—A type of painting or drawing that depicts inanimate objects such as flowers, books, or fruit (Chapter 15)

**stippling**—A technique in which tiny dots are closely spaced to darken an area to suggest tones (Chapter 7)

**stoneware**—A type of clay body, made from a brownish-gray clay and fired at relatively high temperatures, that is nonporous and hard after firing (Chapter 11)

**stupa**—A dome-shaped Buddhist burial mound that is raised above sacred relics (Chapter 18)

**style**—The way in which a work of art is characteristically expressed that allows us to identify and categorize a work of art as part of an individual's, group's, or culture's common work (Chapter 2)

**stylizing**—A way of representing objects from the natural world so that they conform to the overall design of a work of art rather than imitate reality (Chapter 2)

**stylus**—A small pointed implement (Chapter 5)

**subject matter**—The person(s), object(s), or event(s) that a work of art portrays (Chapter 2)

**subordination**—The deemphasis of certain areas in a design so that they do not attract attention (Chapter 4)

**substitution technique**—A process in sculpture in which one material replaces another (Chapter 10)

**subtractive color system**—The method by which pigments are mixed by subtracting different reflected waves of light (Chapter 3)

**subtractive process**—A technique in sculpture in which the artist starts with a block of material and cuts away or subtracts unwanted material (Chapter 10)

**support**—The surface on which an artist creates a two-dimensional work (Chapter 5)

**Surrealism**—A style of art in the West in the twentieth century, associated with Freud's work on the unconscious mind that explored the irrational through dream images and spontaneous creation of art (Chapter 20)

**suspension structure**—An architectural structural system in which a roadbed or roof is hung on cables from columns or walls (Chapter 12)

**symbol**—An image that communicates an idea that is understood because of prior familiarity with the form (Chapter 9)

**Symbolism**—A Post-Impressionist movement in the West in the nineteenth century in which artists did not copy directly from nature and instead employed forms and colors to suggest alternative, hidden meanings and feelings (Chapter 19)

**symmetrical balance**—An even distribution of visual weight in a design achieved because of the similarity of form on both sides of an imaginary central dividing line (Chapter 4)

**Synthetic Cubism**—One of two phases of Cubism developed by Pablo Picasso and Georges Braque in the early twentieth century in which artists collaged scraps of items from the real world onto flat surfaces (Chapter 20)

**tapestry**—A textile in which the material is woven on a loom using differently colored threads that create a design or image, making the image an integral part of the material; often hung on walls or used as upholstery (Chapter 11)

**tempera**—A type of paint made with pigments suspended in an emulsion; a method of painting using this paint (Chapter 6)

**tenebrism**—A form of painting used by Caravaggio and his followers in the seventeenth century in which light and dark areas contrast sharply, and there are very few gradations of tones (Chapter 15)

**tensile strength**—The ability of a substance to support the tension of stretching or projecting out (Chapter 10)

**tension**—The stretching force that pulls apart a structure (Chapter 12)

**tertiary colors**—Colors resulting from the mixing of a primary and neighboring secondary color from the color wheel (Chapter 3)

**texture**—The surface characteristic of a work that relates to our experience of touch (Chapter 3)

**thinner**—A rapidly evaporating material that dilutes paint (Chapter 6)

**three-dimensional**—Having height, width, and depth (Chapter 2)

**tilt**—The technique in film in which during a single shot the camera moves up or down, achieved by swiveling the camera on a stationary axis (Chapter 8)

**time**—An interval of a certain duration (Chapter 3)

**tint**—A light color formed from mixing a hue with white (Chapter 3)

**tipi**—A cone-shaped abode made from animal hide or canvas and vertical supporting poles, used by people living in North America (Chapter 17)

**tooth**—The roughness of a surface, which creates a texture in a work (Chapter 5)

**tracking**—A type of shot in which the film camera moves along with the actors or objects in a scene (Chapter 8)

**trademark**—A simple image and/or group of letters that spell out an organization's name in a particular type that visually identifies, distinguishes, and gives a sense of the personality of an organization (Chapter 9)

**transept**—The arm of a cross-shaped church that is placed perpendicular to the nave (Chapter 14)

**transparent watercolor**—A type of transparent paint made with pigments suspended in gum arabic; a method of painting using this paint; a work of art produced using this method (Chapter 6)

**triadic color scheme**—A color scheme that uses three hues which are equidistant on the color wheel (Chapter 3)

**triptych**—A type of picture that is made in three parts that are often connected with hinges, so that the outer sections can fold over the central section (Chapter 15)

*trompe l'oeil*—French for "deceives the eye"; a painting that tries to fool us into thinking it is real rather than a painted surface (Chapter 2)

**truss**—In architecture, a triangular supporting structure (Chapter 12)

**two-dimensional**—Having height and width, but not depth (Chapter 2)

**two-point perspective**—The mathematical technique of illustrating three-dimensional space on a two-dimensional surface in which parallel lines, which recede in the distance, converge on two vanishing points (Chapter 3)

**typeface**—A full set of letters and punctuation marks that have been designed to have a certain appearance and work together cohesively (Chapter 9)

**typography**—The art of designing, sizing, and arranging the visual appearance of letterforms (Chapter 9)

*ukiyo-e*—Japanese for "pictures of the transient world"; woodcut prints created in the seventeenth through nineteenth centuries in Japan that focused on the everyday world (Chapter 7)

**unity**—The quality of oneness, coherence, or wholeness among the visual elements of a work of art (Chapter 4)

**value**—The degree of lightness or darkness of a tone or color (Chapter 3)

**vanishing point**—In linear perspective, the point toward which parallel lines converge (Chapter 3)

*vanitas*—A type of still life painting in which objects such as fruit, flowers, and luxury goods symbolize the fleeting nature of life (Chapter 15)

**vantage point**—In linear perspective, the artist's viewing location (Chapter 3)

**variety**—The quality of contrast, difference, or diversity among the visual elements in a work of art (Chapter 4)

**vault**—In architecture, a roof or ceiling formed by extending an arch in depth (Chapter 12)

**vehicle**—The material that together with pigment forms paint (Chapter 6)

**vertical positioning**—The technique of illustrating three-dimensional space on a two-dimensional surface in which objects are placed at different heights, with objects at the top being understood as farthest in the distance (Chapter 3)

**video**—Latin for "I see"; the process of recording moving images electronically with light (Chapter 8)

**visible spectrum**—The band of colors that we can see when white light is refracted (Chapter 3)

**visual weight**—The apparent heaviness of an object based on the amount of attention it attracts (Chapter 4)

**voussoir**—A wedge-shaped stone used to create an arch (Chapter 12)

**warm color scheme**—a color scheme that uses hues on the yellow, orange, and red side of the color wheel that remind us of fire and the sun (Chapter 3)

**warp**—In weaving and carpet making, the vertical, lengthwise threads that are held taut (Chapter 11)

**wash**—A thin transparent layer of diluted ink or paint spread on an area of a surface with a brush (Chapter 5)

**weaving**—A method of interlacing vertical and horizontal threads to form a fabric (Chapter 11)

**weft**—In weaving and carpet making, the horizontal, widthwise threads that are interlaced (Chapter 11)

**wheel throwing**—A method of forming a clay pot in which the potter raises walls by making an indentation in the center of a mound of clay placed on a revolving disk and then puts pressure on both the inside and outside of the pot simultaneously (Chapter 11)

**woodcut**—A relief printmaking technique carved on a wood-block plank, in which the areas around the lines of a design are cut away, leaving the lines to hold the ink and print; a print created using this technique (Chapter 7)

**wood engraving**—A relief printmaking technique carved on an end grain wood block, in which the lines of the design are cut away, leaving the background areas to hold the ink and print (Chapter 7)

**wood-frame construction**—A frame architectural structural system in which wood boards are nailed together to create a skeleton (Chapter 12)

**ziggurat**—An enormous platform structure upon which a temple stood, from which Mesopotamian rulers communed with the gods and ran the city-state (Chapter 13)

**zoom**—A film technique, achieved during a single shot with a special lens, in which the camera appears to move closer or farther away from the scene when in actuality it remains still (Chapter 8)

# Endnotes

Complete publication information for sources in the endnotes can be found in the annotated bibliography, which is included in the *Art Matters* digital resources. These can be accessed at https://oup-arc.com/access/gordon, in your OUP Dashboard course, or wherever you access the online materials for this text.

## Preface

1. Evans, "The Power of the Emoji, Japan's Most Transformative Modern Design."

## Chapter 1

1. Lopes 87.
2. National Park Service Visitor Use Statistics, "Annual Park Recreation Visitation, Vietnam Veterans Memorial."
3. The Metropolitan Museum of Art, "Report from the President from the Annual Report for the Year 2017–2018" 9.
4. UNESCO, "Museums."
5. Chicago Gallery News.
6. The Smithsonian Institution, "Fiscal Year 2020 Budget Justification to Congress."
7. UNESCO, "World Heritage List."
8. Prim.
9. Parsad 5.
10. Donnelly.
11. D'Addario.
12. UNESCO, "Illicit Trafficking of Cultural Property."
13. The Names Project Foundation, "Quick Facts about the AIDS Memorial Quilt."
14. National Park Service Visitor Use Statistics, "Annual Park Recreation Visitation, Vietnam Veterans Memorial."

## Chapter 2

1. *The Holy Bible*, Matthew 27:46, 784.
2. *The Holy Bible*, Deuteronomy 4:12, 139.
3. Guerrilla Girls.

## Chapter 3

1. *The Complete Letters*, Volume II, 401.
2. *The Complete Letters*, Volume III, 28–9.

## Chapter 4

1. Rizzo.

## Chapter 7

1. Ramus 122.

## Chapter 8

1. Lang 159.
2. "*Slumdog Millionaire* (2008)." *The Numbers*.
3. "THEME Report, 2018." Motion Picture Association of America.

## Chapter 9

1. Li 54.
2. Du 1.
3. The Ad Council.

## Chapter 11

1. Peterson, *The Living Tradition of Maria Martinez*, 191.

## Chapter 12

1. "Buildings and Their Impact on the Environment."
2. "Pomona Studio Art Hall—Sustainability."

## Chapter 15

1. Pullella.

## Chapter 16

1. Bourgeois 54.

## Chapter 17

1. Buck 215.

## Chapter 19

1. Thompson 209.

## Chapter 21

1. Sontag.
2. Sontag.
3. Sontag.
4. United Nations Virtual Reality.

# Credits

**Chapter 1:** 1.1 LoC, Prints & Photographs Division, LC-DIG-ppmsca-09504; 1.2 LoC, Prints & Photographs Division, Carol M. Highsmith's America, LC-DIG-highsm-04696; 1.3 Steve Mack / Contributor / GI; 1.4 Yuri Gripas / Reuters; 1.5 Irene Owsley / GI; 1.6 Jacques Langevin / Contributor; 1.7 BigTunaOnline / Shutterstock; 1.8 LAWRENCE MIGDALE / GI; 1.9 Couresty Sand in Your Eye. http://www.sandinyoureye.co.uk. Photo by Jamie Wardley; 1.10 Education & Exploration 4 / ASP; 1.11 J. Paul Getty Museum. Los Angeles, California. Licensed by Art + Commerce. © The Robert Mapplethorpe Foundation; 1.12 Photograph © The Estate of Fred W. McDarrah, all rights reserved; 1.13 Georg Gerster / National Geographic Creative; 1.14A Courtesy World Monuments Fund; 1.14B JOSEPH EID / Stringer; 1.15 dpa picture alliance / ASP; 1.16A Photo Marina Milella. (CC BY-SA 4.0); 1.16B Photo JOSEPH EID / AFP / GI; 1.17 Marmaduke St. John / ASP; 1.18 PHILIPPE DESMAZES / Staff / GI; 1.19 Courtesy Tulane University, School of Architecture; 1.20 Universal/Kobal/REX/Shutterstock; 1.21 Nsdap/Kobal/REX/Shutterstock; 1.22 Courtesy of the author and Prospect Park Books. Editor Michelle Fellner.; 1.23A Antonia Tozer; 1.23B DESHAKALYAN CHOWDHURY / Stringer; 1.24 © NG/L / AR; 1.25 MOHAMMED SAWAF / Stringer / GI; 1.26 ASSOCIATED PRESS; 1.27A Martin Gnedt / Associated Press; 1.27B © Atlantide Phototravel/Corbis/VCG; 1.28 Photo Bradley Weber. (CC BY 2.0); 1.29 Detroit Institute of Arts, USA / Founders Society Purchase / Eleanor Clay Ford Fund for African Art / BA; 1.30 Denver Art Museum. Denver, Colorado. Dora Porter Mason Collection, (1947.2). Photo © Denver Art Museum; 1.31 Smithsonian Institution. Washington, DC. National Museum of African Art. Eliot Elisofon Photographic Archives. (EEPA EECL 2141). Photo Eliot Elisofon, 1971; 1.32 Whitney Museum of American Art, New York. Purchase with funds from the Painting and Sculpture Committee.

(2006.604a-b.) © Emily Jacir; 1.33 Andrew Burton / Staff; 1.34 © Musée de l'Armée/Dist. RMN-Grand Palais / AR; 1.35 Margaret Bourke-White / Contributor; 1.36 Courtesy National Gallery of Art. Washington, DC. Corcoran Collection. Museum Purchase, Gallery Fund. (2014.79.10); 1.37 MFA/B. Fenollosa-Weld Collection. (11.4000). www.mfa.org. (US-PD-1923); 1.38 Jeff Wall. The Flooded Grave. 1998–2000; 1.39 Fogg Art Museum, Harvard Art Museums, USA / Richard and Ronay Menschel Fund for the Acquisition of Photographs / BA; 1.40 Image copyright © MMA. Image source: AR; 1.41 The British Museum, London. Sir Percival David Collection. (PDF.4). © BM. All rights reserved.; 1.42 Courtesy South Dakota Art Museum; 1.43 Albright-Knox Art Gallery / AR; 1.44 Schalkwijk / AR; 1.45 Museo del Prado, Madrid. (2823). (US-PD-1923). Photo Google Earth; 1.47 Courtesy Obscura Digital; 1.48 Ulrich Museum of Art, Wichita State University. Wichita, Kansas. Museum Purchase. (2003.14.a). © Andy Goldsworthy; 1.49 PPE Portrait Project c. Mary Beth Heffernan. Photo Marc Campos; 1.50 Collection Fondation Alberto & Annette Giacometti / © The Estate of Alberto Giacometti (Fondation Giacometti, Paris and ADAGP, Paris), licensed in the UK by ACS and DACS, London 2018 / BA; A1.1 Fred W. McDarrah / GI; A1.2 Courtesy of the artist. Photo John McRae; A1.3 Margaret Bourke-White / Contributor; A1.4 Hieronymous Bosch (tempera on panel), Dutch School, (16th century) / Mead Art Museum, Amherst College, MA, USA / BA.

**Chapter 2:** 2.1 National Gallery of Canada, Ottawa. Photo NGC. Licensed by ARS/NY. © Estate of Barnett Newman; 2.2 The Menil Collection. Houston, Texas. Gift of Annalee Newman. (1986-29). Photo Paul Hester; 2.3 National Gallery of Art, Washington, DC. Collection of Robert and Jane Meyerhoff. (1986.65.1). Licensed by ARS/NY. © Estate of Barnett Newman; 2.4 National Gallery of Canada, Ottawa. Photo NGC. Licensed by ARS/NY. © Estate of Barnett Newman; 2.5 Peter Horree / ASP; 2.6 Courtesy of the artist. Photo Kevin O'Dwyer; 2.7 Courtesy Cai Studio. Photo by Wen-You Cai; 2.8 National Gallery of Canada, Ottawa. Photo NGC. (US-PD-1923); 2.9 With permission of the Vatican Museum; 2.10A ERIC LAFFORGUE / Alamy Stock Photo; 2.11 Courtesy Ronald Feldman Gallery. © Vitaly Komar and Alexander Melamid; 2.12 © MoMA/Licensed by SCALA / AR; 2.13A Hamburger Kunsthalle, Hamburg, Germany / © The Henry Moore Foundation. All Rights Reserved, DACS 2018 / www.henrymoore.org / BA; 2.13B Scala / AR; 2.14 Smithsonian American Art Museum, Washington, DC / AR; 2.15 Courtesy National Gallery of Art. Washington, DC. Gift of Mr. and Mrs. Robert Woods Bliss. 1949.6.1. (US-PD-1923); 2.16 Courtesy Guerilla Girls. www.guerillagirls.com. © Guerrilla Girls; 2.17 Courtesy of the artist and the Museum of Contemporary Art San Diego, California. Photo Pablo Mason; 2.18A MMA, New York. Harris Brisbane Dick Fund, 1939. (39.20). (CC0 1.0); 2.18B

MMA, New York. Harris Brisbane Dick Fund, 1939. (39.20). (CC0 1.0); 2.19 Louvre Museum, Paris. (INV. 779). (US-PD-1923); 2.20 © MoMA/Licensed by SCALA / AR; 2.21 © 1964 Marcel Duchamp / ARS/NY / AR; 2.22 Photo by Andrzej Otrębski. (CC BY-SA 4.0); 2.23 Photo Michael Heron; 2.24 Collection of the Modern Art Museum of Fort Worth, Texas. Museum purchase made possible by a grant from the Burnett Foundation. (1995.10); 2.25B Te Pehi Kupe. Self-portrait. 1826. From Leo Frobenius, *The Childhood of Man* (New York: J.B. Lippincott, 1909). (US-PD-1923); 2.26 Collection Walker Art Center. Minneapolis, Minnesota. McKnight Acquisition Fund, 1998. (1998.27); 2.27 LoC, Washington, DC. Rare Book and Special Collections Division. (LC-USZ62-44000). (US-PD-1923); 2.28 Courtesy Reynolda House Museum of American Art, Affiliated with Wake Forest University. (1980.2.). © Audrey Flack; 2.29 Tate Gallery, London, Great Britain; 2.30 © RMN-Grand Palais / AR; 2.31 The Baltimore Museum of Art: The Cone Collection, formed by Dr. Claribel Cone and Miss Etta Cone of Baltimore, Maryland, BMA 1950.228. Photography By: Mitro Hood; 2.32 Private Collection / Photo © Christie's Images / BA; 2.33 CMA. Cleveland, Ohio. James Albert and Mary Gardiner Ford Memorial Fund (1961.198); 2.34 Tretyakov Gallery, Moscow. Photo Stas Kozlovsky. (US-PD-1996); 2.35 Digital Image © MoMA/Licensed by SCALA / AR; 2.36 Courtesy Mary Boone Gallery, New York. © Barbara Kruger; 2.37 Image copyright © MMA. Image source: AR; 2.38 The Art Institute of Chicago / AR; 2.39 Metropolian Art Society of New York. Courtesy Robert Vizzini. Photo Robert Vizzini; 2.40 Foto Marburg / AR; 2.41 Toledo Museum of Art. Toledo, Ohio. Purchased with funds from the Libbey Endowment, Gift of Edward Drummond Libbey (1978.44); 2.42 MFA/B. Bequest of Betty Bartlett McAndrew. (1986.496); 2.43 National Gallery of Art, Washington, DC. Chester Dale Collection. (1963.10.94). (US-PD-1923); 2.44 Milwaukee Art Museum, Gift of Mrs. Harry Lynde Bradley, M1977.128. Photgrapher credit: Efraim Lever. © ARS/NY / ADAGP, Paris; 2.45A © NG/L / AR; 2.45B National Gallery, London, UK / Bridgeman Images; 2.46A L/AR, NY; 2.47 Digital Image © MoMA/Licensed by SCALA / AR; A2.1 Jeff Vespa / Contributor; A2.2 Chris Felver / Contributor; A2.3 George Stroud / Stringer; A2.4 bpk Bildagentur / AR.

**Chapter 3:** 3.1 Van Gogh Museum, Amsterdam, The Netherlands / Bridgeman Images; 3.2 Van Gogh Museum, Amsterdam. Courtesy Vincent Van Gogh Museum Foundation. (b 0437 V/1962); 3.3 Yale University Art Gallery. New Haven, Connecticut. Bequest of Stephen Carlton Clark, B.A. 1903. (1961.18.34). (US-PD-1923); 3.4 L/AR, NY; 3.5 Courtesy Pace Gallery. Photo Joshua White. © Tim Hawkinson; 3.6 © 2018 The Jacob and Gwendolyn Knight Lawrence Foundation, Seattle / ARS/NY / AR; 3.7 Wallace Collection, London. (P430). Photo Alonso de Mendoza. (US-PD-1996); 3.8 Collection of the Museum of Contemporary Art of Georgia, Atlanta. (2001.008). Licensed by VAGA, NY. © Estate of Benny Andrews; 3.9 The Art Institute of Chicago / AR; 3.11 *Alice's Adventures in Wonderland,*

1865. (US-PD-1923); 3.12 Photo Peter Harholdt; 3.13 Louvre Museum, Paris. (INV 4884). (US-PD-1923); 3.14 Collection Nerman Museum of Contemporary Art, Johnson County Community College. Overland Park, Kansas. © Elizabeth Murray; 3.15 Digital Image © MoMA/Licensed by SCALA / AR; 3.16 Historic Images / Alamy Stock Photo; 3.18A © M.C. Escher Company; 3.18B © M.C. Escher Company; 3.19 Image copyright © MMA. Image source: AR; 3.20 Detroit Institute of Arts, USA / Founders Society Purchase / © The Henry Moore Foundation. All Rights Reserved, DACS 2018 / www.henrymoore.org / BA; 3.21 Photo Peter Harholdt; 3.22 Yale University Art Gallery; 3.23 MMA, New York. Gift of Julia A. Berwind, 1953. (53.225.5). (US-PD-1923); 3.24 Philbrook Museum of Art. Tulsa, Oklahoma. Museum purchase. Contemporary Consortium Fund. (1994.7); 3.28 MMA, New York. Rogers Fund, 1950. (50.56). (US-PD-1923); 3.29 Detroit Institute of Arts, USA / Gift of Mr Leslie H. Green / BA; 3.30 Installation at the Indianapolis Museum of Art, Indiana. Courtesy of the artist. © Alyson Shotz; 3.39B Fund for the Twenty-First Century. Digital Image © MoMA/Licensed by SCALA / AR; 3.40B Collection of the New-York Historical Society, USA / BA; 3.41B Whitney Museum of American Art, New York. Gift of Mary Ryan. (96.45). © The Pollock-Kranser Foundation / ARS/NY; 3.42B © Musée du Louvre, Dist. RMN-Grand Palais / AR; 3.43B Georgia O'Keeffe Museum, Santa Fe / AR; 3.44B Visual Arts Library / AR; 3.46 The Solomon R. Guggenheim Foundation / AR; 3.47A Peter Barritt / Alamy Stock Photo; 3.47B Art Institute of Chicago, Illinois. Helen Birch Bartlett Memorial Collection. (1926.224). Photo Google Art Project. (US-PD-1923); 3.48A View Pictures / GI; 3.48B View Pictures / GI; 3.49 The British Museum, London. (104712). © BM. All rights reserved; 3.50 MFA/B. Special Chinese and Japanese Fund. (12.889); 3.51 MMA, New York. Rogers Fund, 1919. (19.164). (US-PD-1923); 3.54A From the Refectory, Monastery of Santa Maria delle Grazie, Milan, Italy. (US-PD-1923); 3.54B From the Refectory, Monastery of Santa Maria delle Grazie, Milan, Italy. (US-PD-1923); 3.55A The Art Institute of Chicago, IL, USA / Harold Joachim Purchase Fund / BA; 3.55B The Art Institute of Chicago, IL, USA / Harold Joachim Purchase Fund / BA; 3.56 Mondadori Portfolio / Getty Images; 3.57 From the Brancacci Chapel, Santa Maria del Carmine, Florence, Italy. (US-PD-1923); 3.58 MFA/B, Massachusetts, USA / Museum purchase with general funds / BA; 3.59B Scala / AR; A3.1 Private Collection / © Look and Learn / Elgar Collection / BA; A3.2 Private Collection / BA; A3.3 Courtesy of the artist; A3.4 Courtesy of the American Academy in Rome. Photo Gerardo Gaetani.

**Chapter 4:** 4.1 Dorling Kindersley/UIG / BA; 4.2 De Agostini Picture Library / N. Cirani / BA; 4.4 Photo Rakami Art Studio. (CC BY-SA 4.0); 4.5 Tim Graham / Contributor; 4.6 Hirshhorn Museum and Sculpture Garden, Smithsonian Institution, Washington, DC. Gift of Joseph H. Hirschhorn, 1966. Photo Cathy Carver; 4.7A Courtesy of the artist and Jack Shainman Gallery, New York. © El Anatsui; 4.7B Courtesy of the artist and Jack Shainman Gallery, New York. © El Anatsui;

4.8 Sidney and Lois Eskenazi Museum of Art. Bloomington, Indiana. Allocated by the U.S. Government, Commissioned through the New Deal Art Projects. (42.1). © Estate of Stuart Davis/Licensed by VAGA, New York, NY; 4.9 Davis Museum and Cultural Center, Wellesley College, MA, USA / Museum purchase, Erna Bottigheimer Sands (Class of 1929) Art Acquisition Fund / BA; 4.10 Courtesy James Cohan, New York. © Xu Zhen; 4.12 Scala / AR; 4.13 Collection of the University of Kentucky Art Museum. Gift of Dr. Harvey Slatin; 4.14 Unterlinden Museum. Colmar, France. (88.RP.139). (US-PD-1923); 4.16 Heritage Images / Getty Images; 4.17 Photograph: Courtesy of the artist. Beverly Pepper Studio.; 4.18 BFA / Alamy Stock Photo; 4.19 Freer Gallery of Art, Smithsonian Institution, USA / BA; 4.21 © Henri Cartier-Bresson/Magnum. Gilman Collection, Purchase, Denise and Andrew Saul Gift, 2005; 4.22 From the Refectory, Monastery of Santa Maria delle Grazie, Milan, Italy. (US-PD-1923); 4.23 Cameraphoto Arte, Venice / AR; 4.24A Jane Hammond (b.1950), Fallen, 2004–ongoing. Assemblage of Inkjet prints with matte medium, adhesive, fiberglass, ink, acrylic and opaque watercolor, dimensions variable. Whitney Museum of American Art, New York. Photograph by Jerry Thompson. © Jane Hammond; 4.24B Jane Hammond (b.1950), Fallen, 2004–ongoing. Assemblage of Inkjet prints with matte medium, adhesive, fiberglass, ink, acrylic and opaque watercolor, dimensions variable. Whitney Museum of American Art, New York. Photograph by Jerry Thompson. © Jane Hammond; 4.25 L/AR, NY; 4.26 Whitney Museum of American Art, New York. Gift of the Howard and Jean Lipman Foundation, Inc. (68.73); 4.28 San Francisco Museum of Modern Art, purchase through a gift of Phyllis C. Wattis. © Charly Herscovici, Brussels / ARS/NY. Photograph: Katherine Du Tiel; 4.29 Minneapolis Institute of Arts, MN, USA / The John R. Van Derlip Fund / BA; 4.31 Werner Forman / AR; 4.32 Art Institute of Chicago, Illinois.; 4.33 Gallerie dell'Accademia, Venezia. (228r). (US-PD-1923); 4.36A DEA / G. Dagli Orti / Getty Images; 4.37 Courtesy of the artist and Jack Shainman Gallery, New York. © Donald Odita; 4.38 Collection of the Fine Art Museum of San Francisco, California. Museum purchase, Achenbach Foundation for Graphic Arts Endowment Fund. (1972.53.75). Courtesy of the artist; 4.39 Photo Benh LIEU SONG. (CC BY-SA 3.0); 4.40 Collection of the New Jersey State Museum. Trenton, New Jersey. (FA1984.92a-x). © Ben Jones.; A4.1 Rob Kim / Stringer; A4.2 Galleria Borghese, Rome, Lazio, Italy / BA; A4.3 © SZ Photo / Sammlung Megele / BA; A4.4 Marianne Rosenstiehl / GI.

**Chapter 5:** 5.1 Museo Nacional Centro de Arte Reina Sofía, Madrid; 5.2 Museo Nacional Centro de Arte Reina Sofía, Madrid; 5.3 Museo Nacional Centro de Arte Reina Sofía, Madrid; 5.4 Museo Nacional Centro de Arte Reina Sofía, Madrid; 5.5 Museo Nacional Centro de Arte Reina Sofía, Madrid; 5.6 Courtesy of the Keith Haring Foundation and Muna Tseng Dance Projects; 5.7 The Solomon R. Guggenheim Foundation / AR; 5.8 National Gallery of Art, Washington, DC. Rosenwald Collection. (1943.3.5217); 5.9A Digital Image © MoMA/Licensed by SCALA / AR; 5.9B Digital Image © MoMA/Licensed by SCALA / AR; 5.10 Royal Collection, Windsor Castle, Royal Library, London. (RCIN 919102). Photo Luc Viatour. (US-PD-1923); 5.11A Courtesy of the artist. © Christo Javacheff; 5.11B Courtesy of the artist. © Christo Javacheff and the Estate of Jeanne-Claude; 5.12 MFA/B. Bequest of Forsyth Wickes. The Forsyth Wickes Collection. (65.2655); 5.13 Museum of Art, Rhode Island School of Design, Providence. Gift of Mrs. Murray S. Danforth. (42.210); 5.14 Courtesy of the artist. © Yooah Park; 5.15 Location: Fogg Art Museum, Harvard Art Museums, Cambridge, Massachusetts, U.S.A. Photo Credit: © Harvard Art Museum / AR; 5.16 The Art Institute of Chicago, IL, USA / Gift of Lannan Foundation / BA; 5.17 National Gallery of Art, Washington, DC. From the Collection of Dorothy Braude Edinburg. (1978.38.1); 5.18 The Broad Art Foundation; 5.19 MMA, New York. Purchase, Joseph Pulitzer Bequest, 1924. (24.197.2). (US-PD-1923); 5.20 Sterling and Francine Clark Art Institute, Williamstown, Massachusetts, USA / BA; 5.21 National Museum of Natural History, Washington, DC. National Anthropological Archives. (NAA MS 166,032); 5.22 Mead Art Museum, Amherst College, MA, USA / Purchase with Wise Fund for Fine Arts / BA; 5.23 Smith College Museum of Art, Northampton, Massachusetts. Purchased with the Dorothy C. Millter, Calls of 1925, Fund. © Whitfield Lovell. Courtesy of DC Moore Gallery, New York; 5.24 © 2018 Jean Dubuffet / ARS/NY / AR; 5.25 Whitney Museum of American Art, New York. Purchase 36.31. © Estate of Isabel Bishop; 5.26 Gift of Charles Lang Freer / Freer Gallery of Art; 5.27 The British Museum, London. Prints & Drawings Collection. (18,950,915.13). © BM. All rights reserved; 5.28 Private Collection / Photo © Christie's Images / BA; 5.29 Courtesy of the artist. © David Hockney; 5.30 Collection of the Digital Art Museum. Courtesy of the artist. © Roman Verostko.; A5.1 PVDE / BA; A5.2 The Art Institute of Chicago / AR; A5.3 Patrick McMullan / Contributor; A5.4 Pictures from History / BA.

**Chapter 6:** 6.1 The Great Wall of Los Angeles. Photo courtesy of SPARC Archives. www.SPARCinLA.org. © Judith F. Baca, 1976; 6.2 The Great Wall of Los Angeles. Photo courtesy of SPARC Archives. www.SPARCinLA.org. © Judith F. Baca, 1976; 6.3 David Zanzinger; 6.4 David Zanzinger; 6.5 The Great Wall of Los Angeles. Photo courtesy of SPARC Archives. www.SPARCinLA.org. © Judith F. Baca, 1976; 6.7A Courtesy Queens Museum. Photograph Shruti Garg; Sandra "Lady Pink" Fabara; 6.8 Private Collection / Courtesy of Thomas Brod and Patrick Pilkington / Bridgeman Images; 6.9A Digital Image © MoMA/Licensed by SCALA / AR. © Estate of Joan Mitchell; 6.9B Digital Image © MoMA/Licensed by SCALA / AR; © Estate of Joan Mitchell; 6.10 National Gallery of Canada, Ottawa. Photo NGC; 6.11 The Metropolitan Museum of Art, New York; 6.12A Albright-Knox Art Gallery / AR; 6.12B Albright-Knox Art Gallery / AR; 6.14 CMA. Cleveland, Ohio. Purchase from the J.H. Wade Fund (1963.252); 6.15 Scala / AR; 6.16A Detroit Institute of Arts, USA / Gift of Edsel B. Ford / BA; 6.16B Detroit Institute of Arts, USA /

Gift of Edsel B. Ford / BA; 6.17A L/AR, NY; 6.17B L/AR, NY; 6.18A Courtesy National Gallery of Art. Washington, DC. Andrew W. Mellon Collection. 1937.1.39. (US-PD-1923); 6.18B Courtesy National Gallery of Art. Washington, DC. Andrew W. Mellon Collection. 1937.1.39. (US-PD-1923); 6.19A The Philadelphia Museum of Art / AR; Purchased with the W.P. Wilstach Fund, 1899; 6.20 The Philadelphia Museum of Art / AR; 6.21 Mary and Leigh Block Museum of Art, Northwestern University. Gift of Howard and Judith Tullman; 6.22 Jacob Lawrence. Harlem Series: You Can Buy Bootleg Whiskey for Twenty-five Cents a Quart, 1943. Gouache on paper. Portland Art Museum, Portland, Oregon. Museum Purchase: Helen Thurston Ayer Fund, 43.9.2; 6.23 MFA/B. Denman Waldo Ross Collection. (22.683); 6.24 Detroit Institute of Arts, USA / BA; 6.25 Collection Nerman Museum of Contemporary Art, Johnson County Community College. Overland Park, Kansas. Acquired with funds provided by JCCC and Marti and Tony Oppenheimer and the Oppenheimer Brothers Foundation. © Roger Shimomura; 6.26 Museum of Fine Arts, Houston, Texas, USA / Museum purchase funded by the National Endowment for the Arts and Caroline Wiess Law / BA; 6.27 Courtesy Petzel Gallery. Photo Lamay Photo. © Wade Guyton; 6.28A Commissioned for Installation at the Contemporary Jewish Museum, San Francisco. Courtesy Haines Gallery. Photo Johnna Arnold. © Camille Utterback; 6.28B Commissioned for Installation at the Contemporary Jewish Museum, San Francisco. Courtesy Haines Gallery. Photo Brett Bowman. © Camille Utterback; 6.29 Courtesy of the artist and Gallery Chemould, Prescott Road. © Nilima Sheikh.; A6.1 Dimitrios Kambouris / Staff; A6.2 Photo Robert W. Kelley / The LIFE Picture Collection / GI; A6.3 Robert W. Kelley / Contributor.

**Chapter 7:** 7.1 Detroit Institute of Arts. Founders Society Purchase, Robert H. Tannahill Foundation Fund. 71.54. Licensed by BA; 7.2 Bibliotheque Nationale de France. Paris, France. (US-PD-1923); 7.3 Los Angeles County Museum of Art, California. Gift of Mr. and Mrs. David Gensburg (M.68.29). www.lacma.org. (US-PD-1923); 7.4 Minneapolis Institute of Art. Gift of Mrs. C. C. Bovey. P.8,036. (US-PD-1923); 7.5 Spencer Museum of Art, University of Kansas. Lawrence, Kansas. William Bridges Thayer Memorial. 1928.7879; 7.6 MMA, New York. Rogers Fund, 1919. 19.74.1. (CC0-1.0); 7.7 British Library. Werner Forman / AR; 7.8 Digital Image © MoMA. Licensed by SCALA / AR; 7.9 HIP / AR; 7.10 MFA/B. Katherine E. Bullard Fund in memory of Francis Bullard and Bequest of Mrs. Russell W. Baker. 1977.747. www.mfa.org. (US-PD-1923); 7.11 Philadelphia Museum of Art. Philadelphia, Pennsylvania. Acquired with the Muriel and Philip Berman Gift (by exchange) and with the gifts (by exchange) of Lisa Norris Elkins, Bryant W. Langston, Samuel S. White 3rd and Vera White, William Goldman, Herbert T. Church, R. Edward Ross, Jay Cooke, Carl Zigrosser, John Sheldon, the Charles M. Lea Collection, the William S. Pilling Collection, the Louis E. Stern Collection, the Print Club of Philadelphia Permanent Collection, and with funds contributed (by exchange) from John Howard McFadden,

Jr., Thomas Skelton Harrison, the Philip and A.S.W. Rosenbach Foundation and the Edgar Viguers Seeler Fund, 2003. 2003-188-1. www.philamuseum.org. (US-PD-1923); 7.14 Courtesy National Gallery of Art. Washington, DC. Patrons' Permanent Fund and Print Purchase Fund (Horace Gallatin and Lessing J. Rosenwald). 2008.109.5. (US-PD-1923); 7.15 Digital Image © MoMA. Licensed by SCALA / AR; 7.17 Courtesy Honolulu Museum of Art. Gift of James A. Michener, 1955 (13695). (US-PD-1923); 7.19 Smithsonian American Art Museum. Gift of Lynn and John Mina. 1981.164.4. Licensed by Art Resource / VAGA. © Estate of Fritz Eichenberg; 7.21 The Art Institute of Chicago. Licensed by AR / VAGA. © Estate of Elizabeth Catlett; 7.23 Nelson-Atkins Museum of Art. Purchased by William Rochkill Nelson Trust. 34-188. Image courtesy Google Cultural Institute. (US-PD-1923); 7.25 University of Kentucky Art Museum, Lexington, Kentucky. The Collectors Fund in honor of the Art Museum's 25th anniversary; 7.27 MMA. Harris Brisbane Dick Fund, 1925. 25.31.2. Image licensed by AR. © VAGA; 7.29 Whitney Museum of American Art, New York. Gift of Arthur and Susan Fleischer. 2011.123.2. © Jane Dickson; 7.31 Courtesy Mount Holyoke College Art Museum. South Hadley, Massachusetts. Gift of the Mount Holyoke College Printmaking Workshop. 1984.9.4. Photograph Laura Shea; 7.33 Smithsonian American Art Museum, Washington, DC. Gift of Tomás Ybarra-Frausto. 1995.50.32. Licensed by AR. © Ester Hernandez; 7.34 Courtesy Pace Gallery. Photograph courtesy the artist and Pace Prints. © Chuck Close; 7.35 Courtesy Pace Gallery. Photograph Kerry Ryan McFate. © Tara Donovan; 7.36 Courtesy of the artist. www.randyboltonartist.com. © Randy Bolton; 7.37 Courtesy of the artist. © Lari Gibbon; 7.38 MMA, New York. Rogers Fund, 1919. 19.74.1. (CC0-1.0); A7.1 Private Collection. Licensed by Sean Sprague / Mexicolore / BA; A7.2 Archives of American Art, Smithsonian Institution. Frederick A. Sweet research material on Mary Cassatt and James A. McNeill Whistler, 1872–1975. 4001; A7.3 Photo by Oscar White. Corbis Historical Collection. Licensed by Corbis / VCG / GI; A7.4 Courtesy of the artist and Pace Gallery.

**Chapter 8:** 8.1 Photofest; 8.2 Photofest; 8.3 Photofest; 8.4 Epoch/Kobal/REX/Shutterstock; 8.5 Photofest; 8.8 Bayerisches Nationalmuseum, Munich. (US-PD-1923); 8.9 Courtesy J. Paul Getty Museum (86.XM.621). (US-PD-1923); 8.10 Courtesy J. Paul Getty Museum (84.XO.1232.1.36). (US-PD-1923); 8.11 Courtesy J. Paul Getty Museum (84.XM.695.19). (US-PD-1923); 8.12 LoC, Prints & Photographs Division, FSA/OWI Collection, LC-DIG-fsa-8b29516; 8.13 Radioactive Cats. © 1980 Sandy Skoglund. Courtesy of the artist; 8.14 Wakkanai 1977 from the series Ravens. Courtesy of Micheal Hoppen Gallery, London. © Masahisa Fukase Archives; 8.15 Filip DUJARDIN - gmrs 003 - 2012; 8.16 Photograph by Ansel Adams. Courtesy Center for Creative Photography, University of Arizona. © The Ansel Adams Publishing Rights Trust; 8.17 Private Collection / Photo © Christie's Images / BA; 8.18 Lynsey Addario / Contributor; 8.19 North Dakota Museum of Art. Photo Rik Sferra. Licensed by Wendi Morris Gallery. ©

Maria Magdalena Campos-Pons; 8.20 Collection of the J. Paul Getty Museum. Los Angeles, California. Courtesy of the artist. © Alison Rossiter; 8.21 LoC, Prints & Photographs Division, LC-USZ62-45683; 8.22 Selznick/MGM/Kobal/REX/Shutterstock; 8.23A Photofest; 8.23B Photofest; 8.23C Citizen Kane / Everett Collection; 8.24A Photofest; 8.24B Photofest; 8.24C Photofest; 8.25 Jaap Buitendijk/Amblin/Dream Works/Kobal/ REX/Shutterstock; 8.26 Bettmann / Contributor; 8.27 Photo 12 / ASP; 8.28 Courtesy HBO; 8.29 AF archive / ASP; 8.30 Entertainment Pictures / ASP; 8.31 RGR Collection / ASP; 8.32 PictureLux / The Hollywood Archive / Alamy Stock Photo; 8.33 Dale Robinette/Black Label Media/Kobal/REX/Shutterstock; 8.34 Licensed by ARS/NY; 8.35 © Peter Campus; 8.36 Bill Viola. Mary 2016. Executive Producer Kira Perov. Performers Lola Gayle, Kian Sandgren, Alessia Patregnani, Jy Prishkulnik, Ariana Afradi, Guillermo Martinez, Deborah Puette, Braeden Marcott, Phil Pressler, Blake Viola, Shinichi Iova-Koga. Photo Peter Mallet. Courtesy of the artist. © Bill Viola Studio; 8.37 Digital Image © Museum Associates / LACMA. Licensed by AR; 8.38 Courtesy of the artist and Lehman Maupin Gallery. © Tony Oursler; 8.39A Courtesy of the artist and Gladstone Gallery. © Shirin Neshat; 8.39B Courtesy of the artist and Gladstone Gallery. © Shirin Neshat; A8.1 Alinari Archives, Florence / BA; A8.2 Licensed by GI. Photo Lynsey Addario; A8.3 Michael Ochs Archives / Stringer; A8.4 Chris Felver / Contributor.

**Chapter 9:** 9.1A Courtesy of the International Olympic Committee. © International Olympic Committee; 9.2 Courtesy of the International Olympic Committee. © International Olympic Committee; 9.3 Courtesy of the International Olympic Committee. © International Olympic Committee; 9.4 Courtesy of the International Olympic Committee. © International Olympic Committee; 9.5 Ng Han Guan / Associated Press; 9.6 David Litschel / ASP; 9.7 Courtesy of the Ad Council. © 2014 The Advertising Council, Inc. All Rights Reserved; 9.8 Courtesy of the artist. © Ronny Edry and Michal Tamir; 9.9 MFA/B. Henry Lillie Pierece Fund. (98.706); 9.10 AF Fotografie / ASP; 9.11 Private Collection / Photo © Christie's Images / BA; 9.12 Courtesy of the MIT Press. © 2014 Xu Bing; 9.15 Courtesy of the artist and Pentagram Design; 9.17 Courtesy of the artist; 9.18 MMA, New York. Harris Brisbane Dick Fund, 1932. (32.88.12). (US-PD-1923); 9.19 Courtesy of the United States Postal Service, Postmaster General's Collection. (US-PD-17 U.S. Code § 105); 9.20 Courtesy of the Herb Lubalin Study Center; 9.21 Courtesy of Paul Rand and IBM; 9.22 Courtesy of Paul Rand and IBM; 9.23A Courtesy of EA. © 2016 Electronic Arts Inc; 9.23B Courtesy of EA. © 2016 Electronic Arts Inc; 9.24 Courtesy of Six Flags Entertainment Corporation; A9.1 Photo by Minehan. ullstein bild / Contributor. GI; A9.2 Rob Kim / Contributor. GI; A9.3 Photo by Xavier ROSSI. Gamma-Rapho Collection. GI; A9.4 CBS Photo Archive / Contributor. GI.

**Chapter 10:** 10.1 Photo Herbert Cole; 10.2 © musée du quai Branly - Jacques Chirac, Dist. RMN-Grand Palais / AR; 10.3 Photo Herbert Cole; 10.4 Image copyright © MMA. Image source: AR; 10.5 Courtesy Fralin Museum of Art, University of Virginia, Charlottesville. Anonymous Gift. (1938.38.1); 10.6A Courtesy of the Nasher Sculpture Center. Dallas, Texas; 10.6B Raymond and Patsy Nasher Collection, Nasher Sculpture Center, Dallas; 10.7A Commission for BALTIC. Centre for Contemporary Art, Gateshead. Photo Jerry Hardman-Jones, Leeds. © Antony Gormley; 10.7B Commission for BALTIC. Centre for Contemporary Art, Gateshead. Photo Stephen White, London. © Antony Gormley; 10.8 Art Institute of Chicago; 10.9 Permission granted by the ARS; 10.10 Heritage Image Partnership Ltd / Alamy Stock Photo; 10.11 Courtesy of the Seattle Art Museum. Partial and promised gift of Jon and Mary Shirley, in honor of the 75th Anniversary of the Seattle Art Museum. (2000.221). Photo Paul Macapia; 10.12A Scala/ Ministero per i Beni e le Attività culturali / AR; 10.12B Scala/ Ministero per i Beni e le Attività culturali / AR; 10.12C Scala / AR; 10.13A Courtesy of the artist. © U-Ram Choe; 10.13B Courtesy of the artist. © U-Ram Choe; 10.14 Werner Forman / AR; 10.15 Courtesy Saint-Gaudens National Historic Site. National Park Service. (US-PD-1923); 10.16 © Nancy Holt Estate / ARS/NY; 10.17 © Estate of Robert Smithson / licensed by VAGA, New York, NY; 10.18 Courtesy of the artist Tanya Bonakdar Gallery, New York neugerriemschneider, Berlin. Photo Hyunsoo Kim. © Olafur Eliasson; 10.19 Courtesy of the Adrian Piper Research Archive Foundation Berlin. © APRA Foundation Berlin; 10.20 © Tate, London / AR; 10.22 Nimatallah / AR; 10.23 MFA/B. Harvard University, Boston Museum of Fine Arts Expedition. (11.1738); 10.24 Photo © Marie-Lan Nguyen. (CC-BY 2.5); 10.26 Museum of International Folk Art. Sante Fe, New Mexico. Gift of the Girard Foundation Collection. (A.1979.53.59). Photo © Museum of International Folk Art; 10.28 Detroit Institute of Arts, USA / Gift of Horace H. Rackham / BA; 10.29A Photo Duane Hanson. © Estate of Duane Hanson. Licensed by VAGA / ARS/NY; 10.29B Photo Duane Hanson. © Estate of Duane Hanson. Licensed by VAGA / ARS/NY; 10.30 Untitled Sculpture (Construction Worker), 1970, Hanson, Duane (1925–96) / BA; 10.31 Courtesy of the artist. Photo Soir Photography. © Alice Aycock; 10.32 Newark Museum / AR; 10.33 Courtesy of the artist © Jon Isherwood; 10.34 Courtesy of the artist. Photo Lee Fatherree. © Bruce Beasley; 10.35A L/AR, NY; 10.35B Courtesy of the artist. Photo Lee Fatherree. © Bruce Beasley; A10.1 Galleria Borghese, Rome, Lazio, Italy / BA; A10.2 Jack Robinson / Contributor; A10.3 Courtesy of the Solomon R. Guggenheim Foundation. Photo David Heald. (CC0 1.0); A10.4 Photo by Steven Ferdman /Patrick McMullan. GI.

**Chapter 11:** 11.1 Smithsonian American Art Museum, Washington, DC / AR; 11.2 Photo Wyatt Davis. Potter Maria Martinez, San Ildefonso Pueblo, New Mexico, 1938. Courtesy of the Palace of the Governors Photo Archives (NMHM/DCA), Negative Number 044191; 11.3 Photo Wyatt Davis. Maria Martinez, the famous potter of San Ildcfonso Pucblo, shaping vessel walls, 1938. Courtesy of the Palace of the Governors Photo Archives (NMHM/DCA), Negative Number HP.2007.20.1112; 11.4

/ AR; 14.4A L/AR, NY; 14.4B AR; 14.5 The Good Shepherd and the story of Jonah. From the Catacomb of Saints Pietro and Marcellino, Rome. Fourth century. Fresco. With permission of the Vatican Museum; 14.6B Courtesy Wadsworth Cengage Learning. From Gardner's *Art through the Ages* 13th edition (2010); 14.7B Courtesy Wadsworth Cengage Learning. From Gardner's *Art through the Ages* 13th edition (2010); 14.8 Museo del Palazzo dei Conservatori, Rome. Photo © José Luiz Bernardes Ribeiro. Wikimedia Commons. (CC BY-SA 4.0); 14.10B Scala / AR; 14.11 S. Vitale, Ravenna, Italy. Photo Cameraphoto Arte, Venice / AR; 14.12 L/AR, NY; 14.13 Cameraphoto Arte Venezia / BA; 14.14 The British Museum, London. (1939,1010.2.a-l). © BM. All rights reserved; 14.16 Odo of Metz. Palace Chapel of Charlemagne, interior. 792–805, Aachen, Germany; 14.17 Photo Myrabella. Wikimedia Commons. (CC0 1.0); 14.18A De Agostini Picture Library / N. Cirani / BA; 14.19 L/AR, NY; 14.20 Scala / AR; 14.21B © DeA Picture Library / AR; 14.21C Paul Almasy / Contributor; 14.22A De Agostini Picture Library / N. Cirani / BA; 14.22B © DeA Picture Library / AR; 14.23 Photo Loïc LLH. Wikimedia Commons. (CC BY-SA 3.0); 14.24 Uffizi Gallery. Photo Google Cultural Institute. (US-PD-1923); 14.25 © RMN-Grand Palais / AR; A14.1 Private Collection / © Look and Learn / Elgar Collection / BA.

**Chapter 15:** 15.1A Michelangelo Buonarotti. Sistine Chapel ceiling. From the Vatican, Rome. 1508–12. Fresco, 45' × 128'. With permission of the Vatican Museum; 15.2 Sistine Chapel. *A Treasury of Art Masterpieces: from the Renaissance to the Present Day* catalog code: 26. Wikimedia Commons. (US-PD-1923); 15.3 Michelangelo Buonarotti. *The Prophet Jonah.* From the Sistine Chapel ceiling. With permission of the Vatican Museum; 15.4A Michelangelo Buonarotti. *The Last Judgment.* From the Sistine Chapel altar wall, the Vatican, Rome. 1536–41. Fresco, 48' × 44'. With permission of the Vatican Museum; 15.4B Michelangelo Buonarotti. *The Last Judgment.* From the Sistine Chapel altar wall, the Vatican, Rome. 1536–41. Fresco, 48' × 44'. With permission of the Vatican Museum; 15.5 No credit line stipulated; 15.6 MMA, New York. Robert Lehman Collection, 1975. (1975.1.1019). (US-PD-1923); 15.8A L/AR, NY; 15.9 Galleria degli Uffizi, Florence, Tuscany, Italy / Bridgeman Images; 15.10 L/AR, NY; 15.11 Photo Saiko. Wikimedia Commons. (CC BY 3.0); 15.12 Scala / AR; 15.13 Photo Dennis Jarvis. Wikimedia Commons. (CC BY-SA 2.0); 15.14A Photo Jörg Bittner Unna. Wikimedia Commons. (CC BY-SA 3.0); 15.14B Scala/Ministero per i Beni e le Attività culturali / AR; 15.15 Raphael. School of Athens. From the Room of the Segnatura, the Vatican, Rome. 1510–11. Fresco, 26' × 18'. With permission of the Vatican Museum; 15.16 Scala/Ministero per i Beni e le Attività culturali / AR; 15.17 © NG/L / AR; 15.18 L/AR, NY; 15.19 MMA, New York. The Cloisters Collection, 1956. (56.70a–c). (US-PD-1923); 15.20 L/AR, NY; 15.21 Öffentliche Kunstsammlung, Kunstmuseum, Basel. Dépôt de l'Institut Professeurs Bachofen et J.J. Burckhardt, 1921. Wikimedia Commons. (US-PD-1923); 15.22 bpk Bildagentur / Art Resource, NY; 15.24 © NG/L / AR; 15.25 Lambeth Palace Library, London, UK / BA; 15.26 Vatican Museums Pinacoteca,

Rome. With permission of the Vatican Museum; 15.27 The Picture Art Collection / ASP; 15.28 Uffizi Gallery. Photo Google Cultural Institute. (US-PD-1923); 15.29 Francesco Borromini. Church of San Carlo alle Quattro Fontane. 1664–67, Rome. With permission of the Vatican Museum; 15.30A De Agostini Picture Library / BA; 15.30B De Agostini Picture Library / BA; 15.31 © RMN-Grand Palais / AR; 15.32A Copyright of the image Museo Nacional del Prado / AR; 15.32B Copyright of the image Museo Nacional del Prado / AR; 15.33 © RMN-Grand Palais / AR; 15.34 The Art Institute of Chicago / AR; 14.35A Collection of the Rijksmuseum. Amsterdam, The Netherlands. (SK-C-5). (CC0 1.0); 15.35B Collection of the Rijksmuseum. Amsterdam, The Netherlands. (SK-C-5). (CC0 1.0); 15.36 ART Collection / Alamy Stock Photo; 15.37 Ashmolean Museum, University of Oxford, UK / Bridgeman Images; 15.38 National Gallery of Art, Washington DC, USA / Bridgeman Images; A15.1 Scala / AR; A15.2 © Look and Learn / Elgar Collection / BA; A15.3 Scala / AR; A15.4 HIP / AR; A15.5 Scala / AR.

**Chapter 16:** 16.1 Robert Harding/ASP; 16.2 Photo Timothy Allen. Photonica World Collection. GI; 16.3 George Steinmetz; 16.4 Michel RENAUDEAU / Contributor / GI; 16.6 Pictures from History / BA; 16.7 Scala / AR; 16.8 National Museum of African Art, Smithsonian Institution. Washington, DC. (85-15-2). Photo Franko Khoury; 16.9 Photo Christopher D. Roy; 16.10 bpk Bildagentur / AR; 16.11 Ancient Art and Architecture Collection Ltd. / BA; 16.12 The Art Institute of Chicago / AR; 16.13A National Museum of African Art. Smithsonian Institution. Washington, DC. Eliot Elisofon Photographic Archives. (EEPA EECL 7590); 16.13B MMA, New York. Gift of Mr. and Mrs. Klaus G. Perls, 1991. (1991.17.2). (US-Pd-1923); 16.14 Max Milligan / GI; 16.15 © musée du quai Branly - Jacques Chirac, Dist. RMN-Grand Palais / AR; 16.17 Courtesy The Khalili Collections. (US-PD-1923); 16.18 AFP / Stringer / GI; 16.19 Roger Wood / GI; 16.20 Leonid Andronov / ASP; Sputnik via AP; 16.21 MMA, New York. Gift of J. Pierpont Morgan, 1917. (17.190.985). (US-PD-1923); 16.23 Photo F. Gorgon. GI; 16.24 HIP / AR; 16.25 The British Museum, London. (1948,1211,0.23). © BM. All rights reserved.; A16.1 Pictures from History / BA.

**Chapter 17:** 17.1 Seth Joel / Bishop Museum; 17.2 Bishop Museum. Ethnology Collection. Purchased in 1962 from the Estate of Victoria Ward. (D.0260/1962.062). Photo Hal Lum and Masayo Suzuki. © Bishop Museum; 17.5 Courtesy Museums Victoria. University of Melbourne. Donald Thompson Collection. (DT58); 17.6 © musée du quai Branly - Jacques Chirac, Dist. RMN-Grand Palais / ARl; 17.7 Universal History Archive / UIG via GI; 17.8 Easter Island statues with replica eyes in place at the reconstructed site of Ahu Nau Nau III, Anakena. Photo by Cristián Arévalo Pakarati. © Easter Island Statue Project; 17.12 Museo Nacional de Antropologia, Mexico City, Mexico / Jean-Pierre Courau / BA; 17.13 © DeA Picture Library / AR; 17.14 Photograph by Kyle Hammons; 17.15 © Harvard University; 17.16 © Bodleian Library, University of Oxford, England; 17.17

Album / AR; 17.18 Tallandier / BA; 17.19 Andrew Watson; 17.20 ART Collection / ASP; 17.21 Tony Linck / SuperStock; 17.22 Smithsonian Institution. National Museum of Natural History. Department of Anthropology. (E73311); 17.23 Smithsonian Institution. National Museum of the American Indian. (T207873). Photo NMAI Photo Services; 17.24 Brooklyn Museum of Art, New York, USA / Gift of Edith and Hershel Samuels / BA; 17.25 American Museum of Natural History, New York. Division of Anthropology. (ID 16/2359); A17.1 HIP / AR.

**Chapter 18:** 18.1 Sen no Rikyū. Taian Teahouse, replica. From the Myōkian Temple, Kyoto, Japan. Momoyama period, 1582 CE. Mori Art Museum, Tokyo, Japan; 18.2 Courtesy Fukuoka Art Museum, Japan; 18.3 CMA, Ohio. John L. Severance Fund. (1972.9); 18.4 Courtesy Fukuoka Art Museum, Japan; 18.7 National Museum of India, New Delhi, India / BA; 18.8 Scala / AR; 18.9 Madhya Pradesh, India / Dinodia / BA; 18.10 robertharding / ASP; 18.11 Photo Christophe Boisvieux. age FOTOSTOCK; 18.12 Soltan Frédéric / GI; 18.13 Philippe Bourseiller / GI; 18.14 Dinodia Photos / ASP; 18.15B Dinodia Photos / ASP; 18.16 V&A Images, London / AR; 18.17 Lou-Foto / ASP; 18.18B O. Louis Mazzatenta/National Geographic Creative; 18.19 Photo by © Asian Art & Archaeology, Inc. / CORBIS / GI; 18.20 Courtesy National Museum of Korea, Seoul. National Treasure 87. (Bongwan-009435-00001); 18.21 The Collection of National Palace Museum. Taipei, Taiwan. (US-PD-1923); 18.22 Antonio Ciufo / GI; 18.23A Photo Christophe Boisvieux. age FOTOSTOCK; 18.23B Antonio Ciufo / GI; 18.24 VCG / Contributor; 18.25 The Collection of National Palace Museum. Taipei, Taiwan. (US-PD-1923); 18.26 The Picture Art Collection / ASP; 18.27 The British Museum, London. (PDF,B.614). © BM. All rights reserved; 18.28 The Nelson-Atkins Museum of Art, Kansas City, Missouri. Purchase William Rockhill Nelson Trust. (46-51/2). Photo Nelson Atkins Media Services / John Lamberton; 18.29 Honolulu Museum of Art, Hawaii. Gift of Robert Allerton, 1957. (2306.1); 18.30 Ruan chuanju - Imaginechina; 18.31 The Asahi Shimbun / Contributor / GI; 18.33 Courtesy Tokugawa Art Museum. Nagoya, Japan. (US-PD-1923); 18.34A Courtesy Tokugawa Art Museum. Nagoya, Japan. (US-PD-1923); 18.34B The Collection of National Palace Museum. Taipei, Taiwan. (US-PD-1923); 18.35 MMA, New York. Gift of Bashford Dean, 1914. (14.100.121a–e). (US-PD-1923); 18.36 Wolfgang Kaehler / Contributor / GI; 18.37 Courtesy Chishaku-ji, Kyouo, Japan. (US-PD-1923); 18.38 MMA, New York. The Harry G. C. Packard Collection of Asian Art, Gift of Harry G. C. Packard, and Purchase, Fletcher, Rogers, Harris Brisbane Dick, and Louis V. Bell Funds, Joseph Pulitzer Bequest, and The Annenberg Fund Inc. Gift, 1975. (1975.268.88). (US-PD-1923); 18.39 The Nelson-Atkins Museum of Art, Kansas City, Missouri. Purchase William Rockhill Nelson Trust. (46-51/2). Photo Nelson Atkins Media Services / John Lamberton; A18.1 Courtesy University of Michigan, Asian Art Photographic Distribution Project. (US-PD-1923); A18.2 Courtesy Palace Museum, Beijing. (US-PD-1923).

**Chapter 19:** 19.1 L/AR, NY; 19.2 Musee d'Orsay, Paris, France / BA; 19.3 L/AR, NY; 19.4 Scala / AR; 19.5 MMA, New York. Rogers Fund, 1919. 19.74.1. (CC0-1.0); 19.7 MMA, New York. Gift of Mrs. Charles Wrightsman, 1999. (1999.370.1a, b, .2a, b). (CC0-1.0); 19.8 Louvre, Paris, France / BA; 19.9 Chateau de Versailles, France / BA; 19.10 Scala / AR; 19.11 Virginia Museum of Fine Arts, Richmond. Adolph D. and Wilkins C. Williams Fund. Photo Travis Fullerton. © Virginia Museum of Fine Art; 19.12 L/AR, NY; 19.13 Thomas Jefferson. Monticello. 1769–82 (original house) and 1796–1809 (enlarged house with dome), Charlottesville, Virginia; 19.14 MMA, New York. Gift of Frank K. Sturgis, 1932. (32.95.10a, b). (CC0-1.0); 19.16 Copyright of the image Museo Nacional del Prado / AR; 19.17 Scala / AR; 19.18 Louvre, Paris, France / BA; 19.19 Nationalgalerie, Staatliche Museen, Berlin; 19.20 MFA/B, Massachusetts, USA / Henry Lillie Pierce Fund / BA; 19.21 Galerie Neue Meister, Dresden, Germany / © Staatliche Kunstsammlungen Dresden / BA; 19.22 Hampton University Museum Collection. Hampton University, Hampton, VA. (US-PD-1923); 19.23 MMA, New York. Gift of Cornelius Vanderbilt, 1887. (87.25). (CC0-1.0); 19.24 Musee Marmottan Monet, Paris, France / BA; 19.25 Scala / AR; 19.26 Musee d'Orsay, Paris, France / BA; 19.27 National Gallery of Art, Washington, DC. Corcoran Collection (William A. Clark Collection). (2014.79.710); 19.28 Peter Barritt / Alamy Stock Photo; 19.29 The Art Institute of Chicago / AR; 19.30 The Art Institute of Chicago / AR; 19.31 The Art Institute of Chicago / AR; 19.32 Museum of Modern Art, New York, USA / Bridgeman Images; 19.33 The Art Institute of Chicago / AR; 19.34 Nasjonalgalleriet, Oslo, Norway / BA; 19.35 L/AR, NY; 19.36 Victor Horta. Hotel Van Eetvelde, entrance. 1895, Brussels, Belgium; 19.37 Digital Image © MoMA/ Licensed by SCALA / AR; 19.38 Courtesy Howard University Gallery of Art. Howard University. Washington, DC; A19.1 Ickworth House, Suffolk, UK / National Trust Photographic Library / BA; A19.2 North Carolina Museum of Art, Raleigh, USA / Purchased with funds from the State of North Carolina / BA; A19.3 Real Academia de Bellas Artes de San Fernando, Madrid, Spain / BA; A19.4 Bridgeman-Giraudon / AR; A19.5 Hulton Archive / Stringer.

**Chapter 20:** 20.1 © The Estate of Ana Mendieta Collection, LLC. Courtesy Galerie Lelong & Co; 20.2 © The Estate of Ana Mendieta Collection, LLC. Courtesy Galerie Lelong & Co; 20.3 © The Estate of Ana Mendieta Collection, LLC. Courtesy Galerie Lelong & Co; 20.4 © The Estate of Ana Mendieta Collection, LLC. Courtesy Galerie Lelong & Co; 20.6 The Barnes Foundation, Philadelphia, Pennsylvania, USA / © 2018 Succession H. Matisse/DACS, London / BA; 20.7 Digital Image © MoMA/ Licensed by SCALA / AR; 20.8 Detroit Institute of Arts, USA / Gift of Robert H. Tannahill / BA; 20.9 Digital Image © MoMA/ Licensed by SCALA / AR; 20.10 The Solomon R. Guggenheim Foundation / AR; 20.11 Digital Image © MoMA/Licensed by SCALA / AR; 20.12 Kimbell Art Museum, Fort Worth, Texas / AR; 20.13 Digital Image © MoMA/Licensed by SCALA / AR; 20.14 Sonia Delaunay / Louvre; 20.15 Washington University, St. Louis, USA / Artothek / BA; 20.16 bpk Bildagentur / AR; 20.17

# Index

Note: Page numbers in *italics* refer to photographs or illustrations of works of art

## A

Abakanowicz, Magdalena, 252–53
  *Bronze Crowd, 252,* 252–53
Abbasid dynasty, 443–44
Abel, Rudolph, 218
Aboriginal art from Australia, 456–58
"About to Forget" (Searle), *88*
Abramović, Marina, 586–87
  *Rest Energy,* 586–87, *587*
absolute symmetry, 111, *112*
abstract art, 59, *59,* 585
  African, *438*
  Islamic, 442
Abstract Expressionism, 563–65
academic art, 513–14, 516, 519–20
*Accelerator* (Odita), 123, *125*
Acropolis, Greece, 331, *331,* 334
  *see also* Parthenon (Iktinos and Kallikrates)
acrylic, 159, 170–72
Action painting, 563–64
actual lines, 71, 74
actual texture, 79–80
actual weight, 110, *111*
The Ad Council, *Buzzed Driving is Drunk Driving,* 234, *234*
Adams, Ansel, 212
  *The Tetons and the Snake River, Grand Teton National Park, Wyoming,* 212, *212*
Addams, Jane, 204
Addario, Lynsey, *212,* 212–13
  *Syrian Refugees Riding a Bus,* 212–13, *213*
additive color system, 84
additive process, in sculpture, 262, 265–70
Adinkra cloth of the Asante, 439, *439*
Adler, Dankmar, Wainwright Building, St. Louis, *304*
aesthetics, 39–41, 45
  defined, 39
af Klint, Hilma, 75
  *The Ten Biggest No. 7, Adulthood,* 75, *76*
Afghanistan, destruction of art works in, 17, 18
afocal works, 117–18
Africa and arts of Africa, 21, 22–23, 41, 54, 120, 121, 432–40
  abstract art, 438
  Asante, *248, 249,* 249–51, 272, 439
  Baule, 434–35
  Benin, 438–39
  Bwa, 435, *436,* 452
  characteristics of, *428,* 435
  cloth, origin of, 579
  crafts in, 280–81, 427
  early cultures and styles of, 433–34
  Fang, 435–36, *437*
  Great Mosque in Djenné, Mali, 429–32, 449
  map of, *432*
  Nguni, 440, 451
  Nok, 433–34
  South Africa, 141–42, 280–81
  traditional, 434–40
  Yoruba, 436–38
  *see also* specific locations and cultures
African Americans, *154*
  films of, 204–5
  The Harlem Renaissance and, 561–62
  Protest Art of, 573
  racism and violence against, 203–4, 227, 261, 270, 529, 589–90
  sharecroppers, 189
  *see also* slavery in U.S. history
*After Abel and Other Stories* (Lemberger), 17, *17*
*After the Mona Lisa 8* (Sperber), 278, *278*
*After Walker Evans: 7* (S. Levine), *595,* 595–96
"Afterglow" (Muniz), *599*
Ai Weiwei, 603
  *World Map,* 603, *603*
AIDS epidemic, 31–32, 280, 427, 593
*AIDS Memorial Quilt, 31,* 31–32
aisle, 374
*Ajitto (Back)* (Mapplethorpe), *11*
Akhenaten, 347–48, *349*
Akhenaten, Nefertiti, and their three daughters, Egypt, 348, *349*
Akkad, 341
*akua'mma* sculptures of the Asante, *248, 249,* 249–51, *250,* 253, 272
Al-Aqiser archaeological site, *19*
al-Asa'ad, Khaled, 13
Aldred (monk), 370
Alhambra, Spain, 445–46, *446*
*Alice, the Duchess, and the Baby* (Tenniel), 72, *73*
*Alien Woman on Flying Machine* (Shonibare), 580–81, *581,* 582, 591, 606
*An Allegory with Venus and Cupid* (Bronzino), 408, *408*
*Alma Silueta en Fuego (Soul Silhouette on Fire)* (Mendieta), *545,* 545–46
Altar of Augustan Peace, Roman, *360,* 360–61
Amadou, Sekou, 429
*The Ambassadors* (Holbein), 412–13, *413*
ambition, universal theme of, 365
ambulatory, 384
American Civil War
  in film, 202, 203–5, 215–16, 227
  memorial of, 258–59
  in photography, 208–9
*American Gothic* (Wood), 561, *561*
*American Infamy* (Shimomura), 171, *171, 606,* 606–7
The Americas and arts of the Americas, 462–75
  map of, *463*
  Mesoamerica, 462–68
  North America, 471–75
  South America, 255, 311–12, 468–71
  *see also* specific locations and cultures
Amiens Cathedral, France, *386,* 386–87, *387*
amphitheater of ancient Rome, 358, *358*
amphora showing Achilles killing Penthesilea (Exekias), 351, *351, 426, 426*
analogous color scheme, *87,* 88, *89*
analysis in art conservation, 14
Analytic Cubism, 553–54, 555
Anatsui, El, 108
  *Metas 1,* 108, *108*
Ancestral Puebloans, 305–6
Andre, Carl, 546
Andrews, Benny, 72
  *Chalking Up,* 72, *72.*
Angkor, Cambodia, restoration of, 13
animal style, 380
animals in Realism, 529–30
animated film, 221–23
*Annunciation* (Martini), 164–65, *165,* 166, 277, *277*
*Annunciation* (Tanner), 168, *168*
*The Annunciation,* stained glass window, 277, *277*
*The Annunciation* (van Eyck), 166, *167,* 168
Anthemius of Tralles, Hagia Sophia, 321, *322*
*Anthropodino* (Neto), 600, *600*
*Aphrodite of Knidos* (Praxiteles), 40, *40,* 58, 402
*Apollo and Daphne* (Bernini), 256, *256*
Apple, 233
  Apple Watch billboard, *233,* 233–34
  iPhone icons, 7, *7*
*Apple Tree* (Mondrian), 59, *59*
appropriation, in Postmodernism, 582, 595–96
apse, 374
*aquarelle,* 166
aquatint, 190, 194, 195, *195*
  and etching, compared, 195
aqueduct of ancient Rome, 125, *126*
Arabic writing and Islam, 441–42
arcade, in architecture, 444
arch, 311, 317–19, *320*
  in the Pantheon, 301–2
  Roman use of, 125, *126*
  in the Taj Mahal, 107, 123
Archaic period of ancient Greece, 352–54
architecture, 299–328
  Art Nouveau, 539
  Baroque, 416–17
  *Bauhaus,* 559, *560*
  Chinese Buddhist, 497–98, 504
  of a church, 374–75, 383–84, 387
  *De Stijl,* 559
  Deconstructivist, 584
  digital, 304–5
  Egyptian tomb, 345–46
  function and forms of, 303–10
  Gothic, 386–88
  innovations in, 326–27
  International Style, 560
  Islamic, 392, 442–47, 449
  materials in, 309–10

architecture (*continued*)
  of Mesoamerica, 464–66
  Neoclassical, 522
  Postmodern, 583–84, 605
  in the Renaissance, 403–4
  Romanesque, 384–85, 387
  shell construction methods, 311–22
  skeleton-and-skin construction methods, 310, 311, 323–26
  structural systems of, 310
architrave, 314
*The Ardabil Carpet*, Safavid Empire, 294–95, *295*, 448, *448*
Arena Chapel, interior (Giotto), *318*, 318–19
armature, in sculpture, 265
Armor of George Clifford, Third Earl of Cumberland (Halder), 290, *290*
Armory Show, New York 1913, 53, 64, 561
Arora, Gabo, 590, 607
  *Ground Beneath Her*, 590, 607
*The Arrival of Spring in Woldgate, East Yorkshire in 2011—11 May* (Hockney), 149, *149*
art, defining, 37–55
  as aesthetic experience, 39–41
  as crafted with skill, 45–47
  as creative work, 52–55
  as object from artistic materials, 38–39
  as object of value, 41–42
  as part of canon, 42–45
  universal theme of, 541
  as work with meaning, 47–52
  *see also* themes, universal
*Art Matters*, page layout design (Laseau), 241, *241*
Art Nouveau, 539
art therapy, 15–16
*The Artifact Piece* (Luna), 594, *594*
artist, universal theme of, 542
artistic expression photography, 212, 213
Aryans of Indian Subcontinent, 484–85
Asante people of Ghana, *248, 249*, 249–51, 439
  *akua'mma* sculptures from, *248, 249*, 249–51, *250*, 253, 272
Ashoka, 486
Asia and arts of Asia, 146, 479–509
  China, 492–503
  Indian subcontinent, 483–85
  Japan, 503–8
  Korea, 278, 492, 494–95
  map of, *483*
  mass production of pottery, 279–80
  Southeast, 484, 489
  tea ceremony and, *479*, 480–82, 509, 510
  timeline of, *484*
  *see also* specific locations and cultures
Asmat people of New Guinea, 458–59
*Aspects of Negro Life: From Slavery through Reconstruction* (Douglas), 561–62, *562*
assemblage, 268, 565
assembling, in sculpture, 262, 268, 270
Assyria, 342–43
asymmetrical balance, 112–13, *113, 114*
*At the Café Concert* (Seurat), 138, *138*
Atlanta Botanical Garden, Georgia, 287, *288*
atmospheric perspective, 93, *94*, 399
atrium, 374
augmented reality technology, 305

Augustus (emperor), 360–61
Aulenti, Gae, 306
  Musée d'Orsay, 306, *306*
Australia and arts of Australia
  Aboriginal art from, 456–58
  architecture in, 322, *322*
*auteur,* 219
*avant-garde,* 528
*avant-garde* film, 220–21
Aycock, Alice, 268, 270
  *Passion/Passiflora Incarnation*, 268, 270, *270, 272*
Aztecs, 466–68, 478

**B**
baby carrier of the Sioux, 473, *473*
Babylonia, 341–42
Baca, Judith F., 151, 152–54, 163, 174
  *The Great Wall of Los Angeles*, 151, 152–54, *153, 154*, 174
balance, design principle of, 106, 109–14
  defined, 103
Ban, Shigeru, 327, *327*
  Cardboard Cathedral, 327, *327*, 576, *576*
bandolier bag of Native Americans, 29, *29*
*The Banjo Lesson* (Tanner), 529, *529*
banner, tomb, of the Han dynasty, 494, *495*
Banu, Sahifa, 491–92
  *Shah Tahmasp*, 491–92, *492*
*Barcelona Fan* (Schapiro), 56–57, *57*
bark paintings, 457
Barney, Matthew, 591
  *Cremaster 3*, 591, *591*
Baroque, 414–24, *425*
  architecture of, 416–17
  in Dutch Republic, 421–24
  factors defining, 414
  in France, 420–21
  in Italy, 414–18
  in Spain and Flanders, 418–20
  timeline of, *401*
barrel vault, 318, *318, 319*
*Bars and String-Piece Columns* (Pettway), *296*, 296–97
*bas* relief sculpture, 257
basilica, 374
basket making, 292, 295–96
Basquiat, Jean-Michel, 586
  *Hollywood Africans*, 586, *587*
*The Battle of Little Big Horn* (Yellow Nose), 143, *144*
*Battle of the Nudes* (Pollaiuolo), *191*, 191–92
*Battleship Potemkin* (Eisenstein), 217, *218*
*Bauhaus* movement, 559–60
Bauhaus School (Gropius and Meyer), 559, *560*
Baule people, 434–35
bay, in architecture, 498, *499*
*The Bay* (Frankenthaler), 171, *171*, 477, *477*
Bayeux Tapestry, 382, *382*
*Be 1* (Newman), 35, *35*
Bearden, Romare, 573
  *Black Manhattan*, 573, *573*
Beasley, Bruce, 271
  *Coriolis XXIII*, 271, *271*
beauty and aesthetics in art, 40–41
*The Beauty of Seal Characters* (Hang Hei and design team), 231, *231*

*The Beauty of Seal Characters* (Qian Zhe and design team), 230, *230*
Beijing Olympics
  emblem for, *229*, 229–30, 236–37
  graphic design for, *228*, 229–32, *230–232*, 246–47
  mascots of, 231–32, *232*
  pictographs of, *230*, 230–31, *231*, 233, 234, 237–38
  protests against, 232, *232*, 246, 247
  trademark for, 243
bending wood, 291
Benin people, 438–39
Bennett, John, *Tribute in Light*, 57
Bergisel Ski Jump, Austria (Hadid), 308, *308*
*Bermuda* (Homer), 168, *169*
Bernini, Gian Lorenzo, 110, *110*, 256, *256*, 417–18
  *Apollo and Daphne*, 256, *256*
  *David*, 110, *111*
  *Ecstasy of St. Teresa*, 417, *417–18*
Beuys, Joseph, 570–71
  *How to Explain Pictures to a Dead Hare*, 570, *570–71*
binder
  in drawing, 143
  in painting, 138, 155
Bird, Brad, 223
*Bird in Space* (Brancusi), 255, *255*
*Birds* (Buraimoh), 79, *79*
birth, universal theme of, 451
*The Birth of a Nation* (Griffith), *202, 203*, 203–5, *204*, 217, 220, 227
*Birth of Venus* (Botticelli), 402, *402*
*Birth of Venus* (Cabanel), 513, *513*, 514
Bishop, Isabel, 146
  *Waiting*, 146, *146*
*bisj* spirit pole, 459, *459*
*Black Lines* (Kandinsky), 551, *551*
*Black Manhattan* (Bearden), 573, *573*
black-on-black pottery, *274*, 274–75, *275*, 278, 298
*Black Panther* poster (Marvel Studios), 115, *115*
*Black Venus* (de Saint-Phalle), 119, *119*
blanket, Navajo, 99, *99*
Blast Theory collective, 604
  *2097: We Made Ourselves Over*, 604, *604*
*Blue Nude* (Matisse), *52*, 52–53, 59, 64
The Blue Rider, art movement, 551
boar incarnation of Vishnu, 490, *490*
*Boating* (Münter), 59–60, *61*
*The Boating Party* (Cassatt), 59–60, *60*, 511, *511*
Boccioni, Umberto, 555
  *Unique Forms of Continuity in Space*, 555, *555*
bodhisattva wall/cave paintings, 488–89, *489*
body art, 41, 49, *50*
Boko Haram attacks, 16, *16*
bold lines, 70
Bolton, Randy, 200
  *Happy + Sad*, 200, *200*
Bonevardi, Gustavo, *Tribute in Light*, 57
Bonheur, Rosa, 529–30
  *The Horse Fair*, 530, *530*
*Book from the Ground: From Point to Point* (Xu B.), 238, *238*
*Book of the Dead* (Nakht), 94, *94*, 393, *393*

bookplate design for John Edwards (Macdonald), 237, *237*
Borobudur stupa, Indonesia, 489, *489*
Borromini, Francesco, 417
    Church of San Carlo alle Quattro Fontane, 417, *417*
Bosch, Hieronymus, 30–31
    *The Garden of Earthly Delights,* 30–31, *31*
Botticelli, Sandro, 402
    *Birth of Venus,* 402, *402*
bottle, stoneware, Southern Song dynasty, 29, *29*
*Bottle of Suze* (Picasso), 554–55, *556*
*Bounty* (Flack), 51, *51,* 58
Bourgeois, Louise, 77
    *Eyes,* 77, *77,* 78, 79–80
Bourke-White, Margaret, 25, *25,* 576
    *Flood Victims, Louisville, Kentucky,* 25, *25,* 576, *576*
bowl, Islamic, 441–42, *442*
bowl (Martinez), *273,* 274, *274*
Boyle, Danny, 219
    *Slumdog Millionaire,* 219, *219*
bracket, in architecture, 498
Brancusi, Constantin, 255
    *Bird in Space,* 255, *255*
Brandt, Marianne, 559
    teapot, 559, *560*
Braque, Georges, 553
    *Girl with a Cross,* 553, *554*
bridge, suspension, 325–26
The Bridge, art movement, 550–51
*Bridge of Spies* (Spielberg), 218, *218,* 223
British Museum, 333–34
*Bronze Crowd* (Abakanowicz), *252,* 252–53
Bronzino, Agnolo, 408
    *An Allegory with Venus and Cupid,* 408, *408*
Brooklyn Bridge (J. Roebling and W. Roebling), 326, *326*
Brooklyn Museum of Art, 54
Bruegel, Pieter, 94
    *The Harvesters,* 94, *95,* 98
Brunelleschi, Filippo, 403–4
    Hospital of the Innocents, 403–4, *404*
brush and ink, 145, 146
brush and wash, 145, 146–48
*bu* ritual urn, Shang dynasty, 493, *493*
*Bucci* (Voulkos), 278, *279,* 281
Buchanan, Beverly, 143–44
    *Five Shacks,* 143–44, *144*
Buddhism and Buddhist art, 485–89
    in Afghanistan, 17, *18*
    in China, 181, 392, 496–98, 500
    on Indian Subcontinent, 485–89, 498
    in Japan, 480, 504, 506–7, 509
    representations of, 487–88
    in Southeast Asia, 489
    *stupas* of, 486–87
    world view of, 485–86
*Bull's Head* (Picasso), 52, *52,* 59
Buñuel, Luis, 221, 541
    *Un Chien Andalou (An Andalusian Dog),* 221, *221,* 541, *541*
*buon fresco,* 161
Buraimoh, Jimoh, 79
    *Birds,* 79, *79*
*The Burghers of Calais* (Rodin), 107–8, *108*

burr, in drypoint printmaking, 192
Butterfield, Deborah, 254
    *Rosey,* 254, *254*
Buzio, Lidya, 284
    *IX,* 284, *285*
*Buzzed Driving is Drunk Driving* (The Ad Council), 234, *234*
Bwa people, 435, *436,* 452
Byzantine Empire, 376–79, 407
    icons and iconoclasm in, 377–79
    map of, *381*
    timeline of, *376*

## C

Cabanel, Alexandre, 513, 514
    *Birth of Venus,* 513, *513,* 514
Cai Guo-Qiang, 38, *38*–39, 426
    *Sky Ladder,* 38–39, *39,* 426, *426*
*Calla* (Cunningham), 561, *561*
calligraphy, 45, 441–42, 496
*camera obscura,* 206, *207*
cameras
    in film, 215
    in photography, 206–8
Cameron, Julia Margaret, 212
    *Sir John Frederick William Herschel,* 212, *213*
Campin, Robert, 409–10
    *Merode Altarpiece,* 409, 409–10
Campos-Pons, Maria Magdalena, 213
    *The Seven Powers,* 213, *213*
Campus, Peter, 224
    *Three Transitions,* 224, *224*
Canada and arts of Canada, 158, 325, 475
    public opinion on, 35, 42
candlesticks (Meissonnier), 517, *517*
canon, the, 42–45, 64
    women, exclusion from, 44–45, 56–57, 278
canteen, from Syria, 114, *115*
cantilever, 311, 315, *315*
capital, in architecture, 314
Caravaggio, *414,* 414–15, 427
    *The Deposition,* 414–15, *415,* 427
Cardboard Cathedral (Ban), 327, *327,* 576, *576*
Carnase, Tom, 244
*Carnations and Garden Rock* (Wen Shu), 502, *502*
carpet marking, 292, 293–95, *295,* 447–48
Carracci, Annibale, 81
    *Head of a Woman Looking to Upper Left,* 81, *81*
Carriera, Rosalba, 137–38
    *Louis XV as a Young Man,* 137, 137–38
Carson, David, 242
    "is techno dead" (*Ray Gun* magazine), 242, *242*
Cartier-Bresson, Henri, 116
    *Valencia,* 116, *116*
cartoon, in painting, 161, 396, 568, 598
cartoon as art, reactions to, 7, 176–78
carving, 262–64, *263*
Cassandre, A. M., 236
    *Nord Express,* 236, *236*
Cassatt, Mary, 59–60, 192, *192*
    *The Boating Party,* 59–60, *60,* 511, *511*
    *Quietude,* 192, *193*
casting, 262, 266–68, *267,* 269, 289
Castro, Fidel, 544
catacombs, 372, *373*
cathedrals. *see* specific cathedrals

Catholic Church
    Baroque and, 414, 416–20, 421, 424
    Reformation resistance to, 411–14, 425
    *see also* Christianity and Christian art
Catlett, Elizabeth, 189
    *Sharecropper,* 189, *189*
cave paintings. *see* wall paintings
Celan, Paul, 585–86
Celmins, Vija, 140–41
    *Untitled (Ocean),* 140, 140–41
censorship and art, 17–19
Central America. *see* Mesoamerica and traditional art of Mesoamerica
ceramics, 265, 282, 286, 501
    *see also* clay works
ceremonial robe of the Tlingit, 111, *112*
Cézanne, Paul, *534,* 534–36, 552–53
    *The Plate of Apples,* 534–36, *535*
*Chair No. 14* (Thonet), 291, *291*
Chalice of Emperor Romanos II, 379, *379*
chalk, 139, 142–43
*Chalking Up* (Andrews), 72, *72*
Chan Buddhism. *see* Zen Buddhism (Chan Buddhism)
charcoal, 139, 141–42
Charlemagne, 381
Charles X of France, 176
Chartres Cathedral, France, 319–20, *320,* 388, *388*
Chauvet Cave painting, 336, *336*
Chavín people, 469
Chazelle, Damien, 223
    *La La Land,* 223, *223*
Cheyenne people, 143, 474
Chia Pet, 588–89, *589*
*chiaroscuro,* 81, 399, 401, 405
Chicago, Judy, 572, *572,* 606
    *The Dinner Party,* 572, *572,* 606, *606*
Chicano Movement, 152
Chihuly, Dale, 287, *287*
    *Three Graces Tower,* 287, *288*
children, art and, 15, 16
China and arts of China, 6, *7,* 29, 94, 278, 492–503
    architecture of, 326–27, *327,* 328
    Buddhism in, 181, 392, 496–98, 500
    ceramics in, 501
    Confucianism in, 495–96
    Daoism in, 496
    mass production of pottery, 279–80
    Neo-Confucianism in, 498–500
    seals of, 229–30, 231
    timeline of, *484*
    tombs of, 492–494
    women artists in Ming dynasty and, 502
    Zen Buddhism in, 500
    *see also* Beijing Olympics
China Central Television Headquarters (Koolhaas and Scheeren), 326–27, *327,* 328
*Chinese Seal, Dancing Beijing* (Guo Chunning and design team), 229, *229,* 236–37
Chinese students' dream of democracy and art, 6, *7*
Choe, U-Ram, 257
    *Imago,* 257, *257*

Chōjirō, Sasaki, 481
  *Jirobo* tea bowl, 481, *481*, 510
*Christ Crucified between the Two Thieves (The Three Crosses)* (Rembrandt), 183, *183*
*Christ Washing the Feet of the Disciples and the Decadence of the Papacy* (Cranach), 414, *414*
Christianity and Christian art, 367–70
  in the Byzantine Empire, 376–79
  under Charlemagne, 381
  under Constantine, 373–75
  in Gothic period, 385–88
  icons and iconoclasm in, 54, 377–79
  in the late Roman empire, 372–75
  modern, 36–37
  pre-Renaissance innovations in, 388–89
  in the Renaissance, 403, 409–10
  in Romanesque period, 382–85
  *see also Lindisfarne Gospels* (Eadfrith); Sistine Chapel
Christo, 136–37
  *The Floating Piers, Lake Iseo, Italy, 2014-16*, 136–37, *137*
  *Floating Piers Drawing*, 136–37, *137*
Church, Frederic Edwin, 25
  *Niagara*, 25, *26*
Church of Saint-Lazare, France, 385, *385*
Church of Saint-Sernin, France, *383*, 383–84, 387, *387*, 392
Church of San Carlo alle Quattro Fontane, Italy (Borromini), 417, *417*
Church of San Vitale, Italy, *376*, 376–77, *377*, 381
Church of Santa Maria Della Vittoria, Cornaro Chapel, Italy, 417, *417*
churches. *see* specific churches
cinematography, 216, 225
*Citizen Kane* (Welles), 216, *217*
*Cityscape Pink* (Lady Pink), 156–57, *157*
Civil War. *see* American Civil War; Spanish Civil War
class distinctions, in the art of ancient Rome, 361–62
classical art, defined, 373
classical period of ancient Greece, 354, 362–63, 373
  Baroque and, 420
  Christian art and, 373
  and Neoclassicism, 518–22
  Renaissance renewal of, 399, 404
Claudel, Camille, 538
  *The Waltz*, 538, *538*
clay body, 282
clay works, 278, 282–86
  earthenware, 282
  forming, 282–85, *283–285*
  modeling in, *265*, 265–66
  porcelain, 282, 501
  stoneware, 282
  *see also* ceramics; pottery
clerestory, 374
Cliff Palace at Mesa Verde, Colorado, 306–7, *307*
cloak, Hawaiian featherwork, 453–55
Close, Chuck, 198
  *Self-Portrait*, 198, *199*
close-up, in film, 216
Coatlicue sculpture, Aztec, 467, *468*
*Codex Mendoza*, Aztec, 467, *467*, 478
coiling, in clay works, 282, *283*

coin showing the head of Vespasian, *359*, 359–60
Cold War, 218, 562, 581
Cole, Willie, 50
  *Stowage*, 50, 50–51
collaboration
  in architecture, 307–9
  in film, 218–19
  in graphic design, 233
  in printmaking, 176, 179–80
collage, 554–55, 573
Cologne Cathedral, stained-glass window from, 288, *288*
color, as a visual element of art, 82–92
  in asymmetrical design, 113
  characteristics of, 91–92
  defined, 67, 83
  emphasis, achieving, 116
  properties of, 85–86
  schemes of, 86–90
  subtractive and additive systems, 83–84
*Color Field* (Lou), 45, *45*
Color Field painting, 564–65
color wheel, 85, *85*, 90, *91*
color woodcut, 187, *187*
colossal Buddha, China, 497, *497*
colossal head #4, Olmec, 464, *464*
column-and-beam construction, 313
  *see also* post-and-lintel construction
combined subject matters in Romanticism, 527
commissioning art by patrons, 13, 114, 319
  in the Renaissance, 399, 402, 404, 407
common concerns in art, 56
communication
  with graphic design, 234
  as purpose of art, 25–28
  and visual elements of art, 67
communism, 544, 562, 581
complementary color scheme, *87*, 88, *88*, 549–50
composition, 107
*Composition 8* (Kandinsky), 113, *114*
*Composition Study* (Picasso), 130, *131*, 150
*Composition with Red, Blue, Yellow, Black, and Gray* (Mondrian), 58, *58*, 63
compression, in architecture, 309, 310
computer-controlled loom, 294
Conceptual art, 569, 570
conceptual representation, 93, 94
concert poster, Fillmore Auditorium (W. Wilson), 123, *125*
concrete, reinforced, 309
configuration, 113, 116
Confucianism and the art of Confucianism, 495–96, 498–500, 508
*Connect to Me* (Cook), 294, *294*
conservation of art, *12*, 12–14, *13*
Constantine (emperor), 373–75, *375*
constructing, in sculpture, 262, 268
conté crayon, 139, 144–45
Contemporary Museum and the Maryland Historical Society, 593
content, 59, 60–61, 64
context of art, 48
contour lines, 72
*contrapposto*, 354
controversy
  Beijing Olympics, 232

film, 205, 227
  in government-supported art, 10–12
  *Le Déjeuner sur l'herbe (The Luncheon on the Grass)*, 513, *514*
  public art, 270
  Sistine Chapel ceiling, 398
Cook, James, 455
Cook, Lia, 294
  *Connect to Me*, 294, *294*
cool color scheme, *87*, 89, *90*
corbel construction, 311, 312, *312*, *313*
Cordero, Helen, 266
  male storyteller figure, 266, *266*
Corinthian order, 314–316
*Coriolis XXIII* (Beasley), 271, *271*
Cornaro family, 417, 418
*Cornelia, Mother of the Gracchi, Pointing to Her Children as Her Treasures* (Kauffmann), 520, *520*
*Corner of Kitchen in Floyd Burroughs' Cabin, Hale County, Alabama* (Evans), 595, *595*–96
cornice, 314, 315
Coronation of the Virgin, from Chartres Cathedral, 388, *388*
corporate identities, 243–44
Counterreformation, 414–18
Courbet, Gustave, 528–29
  *The Stone Breakers*, 528, 528–29
Court of the Lions in Alhambra, Spain, 446, *446*, 511, *511*
Court shoes (Delaunay), 555, *555*
*The Courtyard* (Kaprow), 566, *567*
*The Cradle* (Morisot), 532, *533*
craft. *see* traditional crafts
craftsmanship and art, 46–47
Cranach, Lucas the Elder, 414
  *Christ Washing the Feet of the Disciples and the Decadence of the Papacy*, 414, *414*
crayon, 139, 143–44
*Creation of Adam* (Michelangelo), 396, *396*, 399, 424
creative process, understanding the, 135–36
*Cremaster 3* (Barney), 591, *591*
*Crochet Coral Reef* project (Wertheim and Institute for Figuring), 603–4, *604*
cross-hatching technique for lines, 72, *73*
*The Crown Fountain*, Millennium Park, Chicago (Plensa), 10, *10*
Crystal Palace (Paxton), 323, *323*
Cuba and the arts of Cuba, 213, 544, 562
Cubism, 552–56
  Analytic, 553–54, 555
  Synthetic, 554–56, 573
cultural perception, 49–51
cuneiform, 340
Cunningham, Imogen, 561
  *Calla*, 561, *561*
cut, in film, 203, 217, 219
*Cut with the Dada Kitchen Knife through the Last Weimar Beer-Belly Cultural Epoch in Germany* (Höch), 556, *556*–57
Cuthbert (saint), 367, 370

**D**
Dada, 556–57, 558
Daguerre, Louis-Jacques-Mandé, *206*, 206–7

*Le Boulevard du Temple,* 207, *207*
daguerreotype, 206
Dalí, Salvador, 221, 557
   *The Persistence of Memory,* 557, *558*
   *Un Chien Andalou (An Andalusian Dog),* 221,
     *221,* 541, *541*
*The Dance Class* (Degas), 533, *533*
Daoism, 496, 499
Daumier, Honoré, 175, 176–78, 201, 575
   *Gargantua, 175,* 177, *177,* 180, 575, *575*
   *Poor sheep oh! You struggle in vain. You will*
     *always be fleeced,* 175, *175*
   *Rue Transnonain (Transnonain Street),* 177,
     177–78, 201
   *So this is all we got ourselves killed for!,* 178, *178*
David, Jacques-Louis, 519, *519*
   *The Oath of the Horatii, 519,* 519–20, 525
*David* (Bernini), 110, *111*
*David* (Donatello), 402–3, *403*
*David* (Michelangelo), *405,* 405–6
*The David Vases,* Yuan dynasty, 501, *501*
Davis, Stuart, 109
   *Swing Landscape,* 109, *109*
Day of the Dead, Mexico, 182
de Kooning, Elaine, 197
   *Lascaux #4,* 197, *197*
de Kooning, Willem, 563
   *Woman and Bicycle,* 563, *564*
De Maria, Walter, 571
   *Lightning Field,* 571, *571*
de Saint-Phalle, Niki, 119, *119*
   *Black Venus,* 119, *119*
*De Stijl* art movement, 63, 558–59
de Vaere, Jan, urn with cover modeled after the
   *Borghese Vase,* 522, *522*
death, universal theme of, 426
*The Death of Sardanapalus* (Delacroix), 526, *526*
deconstruct, in Postmodernism, 582
Deconstructivist architecture, 584
decoration, as purpose of art, 28–29
Degas, Edgar, 143, 533, 540
   *The Dance Class,* 533, *533*
   *Entrance of the Masked Dancers,* 142, *143*
   *Dein Goldenes Haar, Margarethe (Your Golden*
     *Hair, Margaret)* (Kiefer), *585,* 585–86
Delacroix, Eugène, 72, *72,* 526
   *The Death of Sardanapalus,* 526, *526*
   *Studies of Lions,* 72, *72*
Delaunay, Sonia, 555
   *Court shoes,* 555, *555*
Denver Art Museum extension (Libeskind),
   92–93, *93*
*The Deposition* (Caravaggio), 414–15, *415,* 427
Derain, André, 549
   *London Bridge,* 549, *549*
design, defined, 107
design principles, 103–26, 126
   balance, 103, 106, 109–14
   emphasis and subordination, 114–18
   proportion, 103, *121,* 121–23
   rhythm, *104, 106,* 123–25
   scale, 103, *104,* 118–20, *121*
   of the Taj Mahal, 103–7
   unity, 103–9, *110*
   variety, 103, 106, 107–9
Desk (Guimard), 539, *539*

destruction of art, 12, 17–18, *18*
   iconoclasm, 379
*Detroit Industry* (Rivera), 163, *164,* 174, 510, *510*
Detroit Institute of Arts, 7, 163
diagonal lines, 70
*Diamond Sutra* of the Tang dynasty, 181, *181,*
   185, 201, 392, *392*
Dickson, Jane Leone, 195
   *White-Haired Girl,* 195, *195*
*Die Witwe I (The Widow I)* (Kollwitz), 186, *186*
difficult art, 53–55
   approaches to, 55
digital
   architecture, 304–5
   camera, 208
   drawing, 149
   glass design, 288
   interactive media, 245–46
   painting, 172–73
   printmaking, 199–200
   sculpting, 270–71
   weaving, 293, 294
diminishing size, 93, 94, 514, 557
*Diner 10 A.M.* (Goings), 168–69, *169*
*The Dinner Party* (Chicago), 572, *572,* 606, *606*
Dipylon Master, 352
   Geometric amphora, 352, *352*
discrimination, universal theme of, 606–7
dissolve, in film, 217
divine representations in art, 21–22
   *see also* specific religions
the divine, universal theme of, 392
Djenné, Mali. *see* Great Mosque in Djenné, Mali
   (Traoré)
documentary film, 220, 221
documentary photography, 212, 213
*Domain Field* (Gormley), 253, *253*
dome, 311, 320–21, *322*
   geodesic, *324,* 324–25
   of the Pantheon, 301–2, 321
   round, *320,* 321
Dome of the Rock, Jerusalem, 442–43, *443*
Donatello, 264, *402,* 402–3, 405–6
   *David, 402,* 402–3
   *Mary Magdalene,* 264, *264*
Donovan, Tara, 199, *199*
   *Untitled,* 199, *200*
Doric order, 314–316, 332–33
Douglas, Aaron, 561–62, *562*
   *Aspects of Negro Life: From Slavery through*
     *Reconstruction,* 561–62, *562*
dragonfly lamp (Tiffany Studios), *88*
drawing, 128–50
   binder in, 143
   creative process with, 135–37
   defined, 133
   digital, 149
   materials for, 138–49
   surface for, 138, 139
*The Drawing Class* (Eisenman),
   122, *122*
*Drawing for Other Faces* (Kentridge),
   141–42, *142*
Dreaming, by the Australian Aborigines, 457
driving drunk prevention, 234, *234*
*Drowning Girl* (Lichtenstein), 568, *568*

Drury, Chris, 38
   *Ponderosa Whirlpool,* 38, *39*
dry garden, 506–7, 511
   Ryōanji Temple, Japan, 507, *507*
dry media, 138, 139
   chalk as, 142–43
   charcoal as, 141–42
   conté crayon as, 144–45
   crayon as, 143–44
   graphite as, 140–41
drypoint, 190, 192
Dubuffet, Jean, 145–46
   *Tumultuous Landscape,* 145–46, *146*
Duchamp, Marcel, 47, 557
   *Fountain,* 47, *48*
   *Mona Lisa (L.H.O.O.Q.),* 557, *557*
Dujardin, Filip, 211–12
   *Guimarães 003,* 211–12, *212*
Duquesnoy, Jerôme, 47
   *Manneken Pis,* 47, *48*
Dürer, Albrecht, 185–86, 412, 425
   *The Four Horsemen,* 185–86, *186*
   *Self-Portrait,* 412, *412,* 425
Dutch Republic, Baroque art in, 421–24
   genre scenes, 422–23
   interiors, 423–24
   portraits, 421–22
   still lifes, 423

**E**

EA Sports, *FIFA 17,* 245, *245*
Eadfrith, 367–70, 380, 390, 392
   *Lindisfarne Gospels, 366,* 367–70, *368, 369,*
     380, 390, 392
earth-body works, 544–46, 574
earthenware, 282
earthwork, 259–60, 470, 472, 571, 574
easel painting, 155
Easter Island, 459–60, 462
Eastern Woodlands, 472–73
Ebola crisis photo project (Heffernan), *32,* 32–33
*Ecstasy of St. Teresa* (Bernini), *417,* 417–18
editing, in film and video, 215–18, 220–21,
   225, 596
edition, in printmaking, 180
Edo period, Japan, 508
Edry, Ronny, 234
   *Iranians We Will Never Bomb Your Country, We*
     ♥ *You,* 234, *234*
education, benefit of art, 15
Edwards, Melvin, 270, *270*
   "Lynch Fragments," 270, *271*
   *Resolved,* 270, *271*
Egypt and arts of Egypt, 94, 339, 343–49,
   363, 393
   elite and non-elite people, sculptures of,
     348, 364
   encaustic portraits of, 159, *160*
   map of ancient, *339*
   sculpture of, 263–64, 347, 353
   temples of, 12, 309–10, *310,* 346, *347,* 607
   tombs of, 345–46
Eichenberg, Fritz, 188
   *The Follies of Old Age,* 188, *188*
eighteenth-century art in the West, 516–22
   Neoclassicism, 518–22

eighteenth-century art in the West (*continued*)
The Rococo, 516–18
timeline of, *517*
*89 Seconds at Alcázar* (Sussman), 596, *596*
Eisenman, Nicole, 122
*The Drawing Class,* 122, *122*
Eisenstein, Sergei, 217
*Battleship Potemkin,* 217, *218*
*Elegy to the Spanish Republic No. 34* (Motherwell),
*29,* 29–30
Eliasson, Olafur, 261
*Rainbow Assembly,* 261, *261*
elite male and maguey cactus leaves
(Teotihuacán), 162, *162, 393, 393,* 465
Emancipation Proclamation, 243
emblem for Beijing Olympics, 229–30, 236–37
embroidery, 297, 382
emoji, xviii
emotionalism, 414, *415*
Emperor Justinian and his attendants, Church of
San Vitale, 377, *377*
emphasis, design principle of, 114–18
achieving, *116*
defined, 103, 114
Empire State Building, 32, *32,* 42
*en plein air,* 531
encaustic, 159–60
engraving
and etching, compared, 193
intaglio printing, 190–92, *191*
wood, 184, 186–88, *188,* 190
Enlightenment movement, 516, 518–19
entablature, 300, 314
*Entangled* (Utterback), 173, *173*
*Entrance of the Masked Dancers* (Degas), 142, *143*
environment
architecture and, 305–7
installation, 565–66, 588, 594, 600–601
protection of, 591, 603–4
sculpture and, 260–62
universal theme of, 478
Erasmus, 188
Ernst, Max, 557–58
*The Horde,* 557–58, *559*
Escher, M. C., 76
*Sky and Water I, 76,* 76–77
Escobedo, Frida, 305
Serpentine Pavilion, virtual reality
visualization of, 305, *305*
etching, 190, 192–94
and aquatint, compared, 195
and engraving, compared, 193
Europe and arts of Europe
Baroque, 414–24
Byzantine Empire, 376–79
early twentieth century through World War II,
547–60
eighteen century, 516–22
Greece, ancient, 350–56
Middle Ages, 379–88
nineteenth century, 522–39
pre-Renaissance innovations in, 388–90
prehistoric art, 335–37
Renaissance, 399–414
Roman empire, late, 370–75
Rome, ancient, 357–62

twentieth-century art in the West after World
War II, 570–71
*see also* specific locations and periods
Evans, Walker, 595–96
*Corner of Kitchen in Floyd Burroughs' Cabin,
Hale County, Alabama, 595,* 595–96
*The Event of a Thread* (Hamilton), 99, *99*
*Excalibur* (Pepper), 113, *114*
Exekias, 351, 426
amphora showing Achilles killing Penthesilea,
351, *351,* 426, *426*
experimental film, 220–21
expression, as purpose of art, 29–31
Expressionism, 547–51
Cubism, 552–56
defined, 547
Fauvism, 548–49
German, 550–51
Neo-Expressionism, 585–86
Eyck, Jan van, 61, 63, 166, 410, 452
*The Annunciation,* 166, *167,* 168
*Portrait of Giovanni Arnolfini and His Wife (?),*
61–62, *62,* 452, *452*
*The Virgin of Chancellor Rolin,* 410, *410*
*Eyes* (Bourgeois), 77, *77,* 78, 79–80

**F**
Fabara, Sandra (Lady Pink), *156,* 156–57
*Cityscape Pink* (Lady Pink), 156–57, *157*
Facebook, censorship in, 17
fade, in film, 217
faint lines, 70
*Fallen* (Hammond), 118, *118,* 126, 477, *477*
*The Fallen* (Wardley and Moss), 9
Fallingwater (Edgar Kaufmann Residence)
(Wright), 315, *315*
Fan Kuan, 499–500
*Travelers among Mountains and Streams, 499,*
499–500, 506, *506*
Fang people, 435–36, *437*
*Fantasia* (Disney), 222, *222*
Fauvism, 548–49
Feathered basket of the Pomo, 296, *296*
feathered lei, 455
featherwork, Hawaiian, 454–56, 458, 476, 477
cloak, *453, 454,* 454–55
god figure, 455–56, *456*
lei, 455, *455*
feminist art, 572–73, *574*
*Fetish Series* (Mendieta), 546, *546,* 575
*The Fetus in the Womb* (Leonardo), 136, *136*
feudalism, 382
fiber, 291–97
Asante, 439
garments of Edo period, 508
Inca, 470–71
*FIFA 17* (EA Sports), 245, *245*
figure-ground relationship, 76
figure-ground reversal, 76
Fillmore Auditorium concert poster (W. Wilson),
123–25, *125*
film, 214–23
artistic techniques in, 203–4, 215–18, 596
controversy in, 205, 227
defined, 214
genre of, 223

history of, 214–15
influence of, 16–17, *202,* 204–5, 219–20
manipulation possible with, 220, 227
process of, 218–19
types of, 220–23
virtual reality, 246, 590
*see also* specific films
financial value of art, 41–42
firing, in sculpture, 265
*First Composition Study for Guernica* (Picasso),
130, *131*
*First Station* (Newman), 36, *36*
*Five Persons at a Meal* (van Gogh), 68
*Five Shacks* (Buchanan), 143–44, *144*
fixative, 141
Flack, Audrey, 51
*Bounty,* 51, *51, 58*
Flanders, Baroque art in, 418–20
flashbacks, in film, 216, 217
Fleming, Victor, 215–16
*Gone with the Wind,* 215–16, *216*
*The Floating Piers, Lake Iseo, Italy, 2014-16*
(Christo and Jeanne-Claude), 136–37, *137*
*Floating Piers Drawing* (Christo), 136–37, *137*
*Flood Victims, Louisville, Kentucky* (Bourke-
White), 25, *25,* 576, *576*
*The Flooded Grave* (Wall), 26, *27*
fluid lines, 70
fluid media, 138
*see also* liquid media
flying buttress, 319–20, *320*
focal point, 116, 117
focus for emphasis, achieving, 116
Fontana, Lavinia, 408
*Noli Me Tangere (Don't Touch Me),* 408, *408*
forces in architecture, 309–10
form, 59, 60, 64
found object, 268
*Fountain* (Duchamp), 47, *48*
*The Four Horsemen* (Dürer), 185–86, *186*
Foy (saint), reliquary statue of, 384, *384, 393*
Fragonard, Jean-Honoré, 71, 579
*The Swing,* 71, *71,* 90, *91,* 99, 579, *580, 582*
frame construction, 311, 322, 323–25
France and arts of France, 21
architecture in, 306, 319–20
Baroque art in, 420–21
Gothic, 386–88
protests against monarchy, 175, 176–78
Romanesque church of, 383–85
tapestry, 293
Franco, Francisco, 130, 133
Frankenthaler, Helen, 171, 477
*The Bay,* 171, *171,* 477, *477*
*Free Space* (Krasner), 88, *89*
freestanding sculpture, 256–57
French Academy of Fine Arts, 365, 513–14, 516
standards of, 513
*see also* Salon
*French Mist* (Isherwood), 270, *271*
French Revolution, 523–24
*fresco,* 159, *161,* 161–64, *393*
*fresco secco,* 161
Freud, Sigmund, 557
Friedrich, Caspar David, 526, 598

*Monk by the Sea,* 526, *526*
frieze, 314, 315, 332, 333
"From Here I Saw What Happened and I Cried"
(Weems), *27*
Fukase, Masahisa, 211
*Wakkanai, Japan,* 211, *211*
Fuller, R. Buckminster, 325
U.S. Pavilion, 1967 Montreal Expo, 325, *325*
funerary relief of a freedman's family in ancient
Rome, 361, *361, 363,* 365
funerary temple of Hatshepsut, Egypt (Senmut),
346, *347*
*fuwa (friendlies)* (Han), *231,* 231–32, 243

G
Gallic chieftain killing his wife and himself, from
the Hellenistic period, *355,* 355–56
Gandini, Marcello, 73
Lancia (Bertone) Stratos HF Zero car, 73, *73,
78, 78*
*Ganymede Earrings,* ancient Greece, 289, *289*
garden design
Taj Mahal, *104,* 104–5
Zen Buddhist, 506–7, 511
*The Garden of Earthly Delights* (Bosch),
30–31, *31*
Gardner, Alexander, 208
*Gargantua* (Daumier), *175,* 177, *177,* 180, 575,
*575*
*The Gate* (Hofmann), *91,* 91–92
*Gates of Paradise* (Ghiberti), 403, *403,* 452, *452*
Gauguin, Paul, 537
*Mahana No Atua (Day of the God),* 537, *537*
Gee's Bend, Alabama, quilts of, 296, 298
Gehry, Frank, 304, *304*
Guggenheim Museum, 304, *305*
genre of film, 223
genre scene, 422–23
Gentileschi, Artemisia, 82, *82,* 416, 426, 572
*Judith and Her Maidservant with the Head of
Holofernes,* 82, *82*
*Judith and Holofernes,* 416, *416,* 426
*Susanna and the Elders,* 17
geodesic dome, *324,* 324–25
geometric mass, 78
Geometric period of ancient Greece, 352
geometric shape, 75
*Geometry of Light* (Shotz), 82, *82*
George II tea caddies (Godfrey), 290, *290,
510, 510*
*Gerard Malanga* (Neel), *38*
Géricault, Théodore, 74
*Raft of the "Medusa,"* 74, *74*
German Expressionism, 550–51
Germany and arts of Germany, 556–57
*Bauhaus* movement in, 559–60
*see also* Nazis
gesture lines, 72
Ghana. *see* Asante people of Ghana
Ghiberti, Lorenzo, 402, 452
*Gates of Paradise,* 403, *403,* 452, *452*
*Jacob and Esau,* 403, *403,* 452, *452*
*Giant Toothpaste Tube* (Oldenburg), 568, *568*
Gibbons, Lari, 200
*Paths II,* 200, *200*

*Gift* (Man Ray), 558, *558*
Giotto di Bondone, 162, 319, *388,* 388–89
Arena Chapel, interior, *318,* 318–19
*The Lamentation,* 162–63, *163,* 319
*Madonna Enthroned,* 389, *389*
*A Girl in the River: The Price of Forgiveness*
(Obaid-Chinoy), 220, *220*
*Girl with a Cross* (Braque), 553, *554*
*Girl with a Pearl Earring* (Vermeer), *14*
Gislebertus, Last Judgment, from Church of
Saint-Lazare, 385, *385*
glass crafts, 286–88
stained glass, 277, 288
glassblowing, 286–87, *287*
glaze
in clay works, 286
in painting, 157
global contemporary art, 597–604
diverse cultures and identities in, 597–602
globalization and, 597, 602–4
social action of, 603–4
*Goddess of Democracy,* 6, *7*
Godfrey, Elizabeth, 290
George II tea caddies, 290, *290,* 510, *510*
Gogh, Johanna van, 67, 69–70
Gogh, Vincent van, 65, 67–70, 79, 96, 100,
536–37, 542, 588
*Five Persons at a Meal,* 68
letters of, 67–70, 96, 100
*The Night Café,* 68, *69,* 79, 98, 100
*The Potato Eaters,* 67–68, *68,* 96, 100
*Self-Portrait,* 65, *66,* 68–69, *69,* 74, 100
*The Starry Night,* *536,* 536–37, 542, 588, *588*
visual elements of paintings of, 67
Goings, Ralph, 168–69
*Diner 10 A.M.,* 168–69, *169*
gold, in sculpture, 255
gold leaf, 507–8
golden rectangle, 123, *124*
golden section, 123, *124*
Goldsworthy, Andy, 32
*Torn Leaf Line Held to Fallen Elm with Water,*
32, *32*
*Gone with the Wind* (Fleming), 215–16, *216*
Gonzalez-Torres, Felix, 46–47
*"Untitled" (Death by Gun),* 46, 46–47
The Good Shepherd and the story of Jonah,
Catacomb of Saints Pietro and Marcellino,
372–73, *373*
Gorbachev, Mikhail, 581
Gormley, Antony, 253
*Domain Field,* 253, *253*
Gothic period, 385–88
timeline of, *376*
gouache, 159, 169–70
Gould, Richard Nash, *Tribute in Light,* 57
government support of art, 10–12
Goya, Francisco, 182, 194, *524,* 524–25
"Los Caprichos," 182, *182*
*The Sleep of Reason Produces Monsters,* 182, *182,* 194
*The Third of May, 1808,* 524–25, *525*
graffiti art, 156, 586, *587*
grain of a surface, 138
graphic design, 228–47
communication with, 234
components of, 236–42

defined, 233
function of, 233–34
history of, 235–36
image, 237
layout, 240–42
pictograph, 237–38
symbols, 238–39
and traditional art form, compared, 235–36
type, *239,* 239–40, 242–46
*see also* Beijing Olympics
graphic designers, 7
graphite, 139, 140–41
grave goods
from China, 492–93, 494
from Korea, 494–95
Graves, Michael, 583
Public Services Building, Oregon, *583,* 583–84
*The Great Departure,* from Great Stupa of Sanchi,
*487, 487*
Great Depression, 25, *25,* 547, 561
Great Mosque, prayer hall, Spain, 318, *318,
392, 392*
Great Mosque in Djenné, Mali (Traoré), 429–32,
449, 451
aerial view of, *431, 431*
eastern facade of, *428,* 430
interior of, 431, *431,* 448
re-plastering of, 430, *430,* 449
Great Mosque of Kairouan, Tunisia,
443–44, *444*
Great Plains, North America, 473–74
Great Pyramids, Egypt, 345–46, *346*
Great Salt Lake, Utah, 260
Great Serpent Mound, North America, 472, *472*
Great Stupa of Sanchi, India, *486,* 486–87, *487*
*The Great Wall of Los Angeles* (Baca), *151,* 152–54,
*153, 154,* 174
*The Great Wave* (Hokusai), 187, *187,* 478, *478*
Greco-Roman World, 350–62
Greece, 350–56
Rome, 357–62
*see also* Greece and arts of ancient Greek; Rome
and arts of Rome
Greece and arts of ancient Greek, 40, 350–56,
362–63, 364
acropolis in, 331, *331,* 334
architectural orders of, 314–15, 316
Hellenistic period, 355–56
map of, *350*
Parthenon in, *124, 124,* 316, *316, 331,
331–34, 332*
Parthenon sculptures in, 329, *330,* 331–34,
*333, 334,* 362–63
status in, 351
green architecture, 306–7
grid, in graphic design, 241–42
Griffith, D. W., 202, 203–5, 227
*The Birth of a Nation,* 202, *203,* 203–5, *204,*
217, 220, 227
groin vault, 318, *318,* 319
Gropius, Walter, 559
Bauhaus School, 559, *560*
Grossman, Robert, *Too Hot to Handle,* 240
ground
in etching, 192
in painting, 156

*Ground Beneath Her* (Arora), 590, 607
growing up, universal theme of, 452
Grünewald, Matthias, 111–12, 281
    *Isenheim Altarpiece,* 111–12, *112,* 281
Gruppo Bertone, 73, 78
*Guernica* drawings (Picasso), 130–33, *131, 132,*
    149–50
*Guernica* (Picasso), 130, 132–33, *133,* 149–50
*Guerrilla Girls* poster, 45, *45*
Guggenheim Museum (Gehry), 304, *305*
*Guimarães 003* (Dujardin), 211–12, *212*
Guimard, Hector, 539
    desk, 539, *539*
gum arabic, 166
Guo Chunning and design team, 229, 236–37
    *Chinese Seal, Dancing Beijing,* 229, *229,*
        236–37
Gupta, Subodh, 601–2
    *Line of Control, 601,* 601–2
Guyton, Wade, 172–73
    *Untitled,* 172–73, *173*

**H**
Hadid, Zaha, 308
    Bergisel Ski Jump, Austria, 308, *308*
Hadrian (emperor), 300, 302, 308, 328
Hagia Sophia (Anthemius and Isidorus), 321, *322*
Halder, Jacob, 290
    Armor of George Clifford, Third Earl of
        Cumberland, 290, *290*
Hamilton, Ann, 99, *99*
    *The Event of a Thread,* 99, *99*
Hammond, Jane, 118, 126, 477
    *Fallen,* 118, *118,* 126, 477, *477*
Hammurabi and the Sun God Shamash, 342,
    *342*
Hampton, James, 44
    *The Throne of the Third Heaven of the Nation's*
        *Millennium General Assembly,* 44, *44*
Han dynasty, 494, *495*
Han Meilin, 231–32
    *fuwa (friendlies),* 231, 231–32, 243
handmade feel of crafts, 280
handscroll, 504
Hang Hei and design team, *The Beauty of Seal*
    *Characters,* 231, *231*
*haniwa* sculptures of Japan, 254, *254*
Hanson, Duane, 269, 364
    *The Jogger,* in progress, 269, *269*
    *Untitled Sculpture (Construction Worker),* 269,
        *269,* 364, *364*
Happening, 566–67
*Happy + Sad* (Bolton), 200, *200*
Haring, Keith, 133–34
    New York subway drawings, 134, *134*
"Harlem" (Lawrence), 170, *171*
The Harlem Renaissance, 561–62
Harold swears a sacred oath to William, from
    *Bayeux Tapestry, 382, 382*
*The Harp* (Savage), 562, *563*
"Harriet Tubman" (Lawrence), *71*
Hart, Frederick, 4
    *Three Servicemen, 4, 4*
*A Harvest of Death, Gettysburg, Pennsylvania*
    (O'Sullivan), *208,* 208–9
*The Harvesters* (Bruegel), 94, *95,* 98

hatching technique for lines, 72, *73, 142*
*haut* relief, 258
Hawaiian featherwork, *453, 454,* 454–56, *455,*
    *456,* 476, 477
Hawkinson, Tim, 70
    *Lophophore,* 70, *70*
Head of a Roman from ancient Rome, 359, *359*
*Head of a Woman Looking to Upper Left*
    (Carracci), 81, *81*
head of an Akkadian ruler, 341, *341*
head of an *oba* of the Benin people, 438, *439*
head of an *oni* of the Yoruba people,
    436–37, *437*
head sculpture from Nok, 433–34, *434*
healing power of art, 15–16
health, universal theme of, 575
Heffernan, Mary Beth, 32–33
    Ebola crisis photo project, *32,* 32–33
Heian period, Japan, 504–5, *506*
Hellenistic period, 355–56
Hemessen, Caterina van, 411
    *Self-Portrait,* 411, *411*
henna hand and feet painting, 41, *41*
Hernandez, Ester, 198
    *Sun Mad,* 198, *199,* 201
Herschel, John Frederick William, 212, *213*
Hesse, Eva, 148
    *Untitled,* 148, *148*
Hewett, Edgar Lee, 274
hierarchical scaling, 120, 437
hieroglyph, 343, 465
high relief, 258–59, 332–33
High Renaissance in Italy, *401,* 404–6
highlight, 81
Hill Gary, 224
    *Windows,* 224, *224*
Hinduism and Hindu art, 170, 602–3
    in Cambodia, 21–22
    in India, 489–91
Hirst, Damien, 587–88
    *The Physical Impossibility of Death in the Mind*
        *of Someone Living,* 587–88, *588*
Hitchcock, Alfred, 219
    *Psycho,* 219, *219,* 223
Hitler, Adolf, 17, 252, 547
    *see also* Nazis
Höch, Hannah, 556–57
    *Cut with the Dada Kitchen Knife through the*
        *Last Weimar Beer-Belly Cultural Epoch in*
        *Germany,* 556, 556–57
Hockney, David, 149
    *The Arrival of Spring in Woldgate, East Yorkshire*
        *in 2011—11 May,* 149, *149*
Hofmann, Hans, 91–92
    *The Gate,* 91, 91–92
Hofmeyr, Carol, 280, 427
    *Keiskamma Altarpiece,* 280, 281, *281,* 427, *427*
Hokusai, Katsushika, 146, *146,* 187, 478
    *The Great Wave,* 187, *187,* 478, *478*
    *A Maid Preparing to Dust,* 146, *147*
    "Thirty-Six Views of Mount Fuji," 187
Holbein, Hans the Younger, 412–13
    *The Ambassadors,* 412–13, *413*
*Hollywood Africans* (Basquiat), 586, *587*
Holocaust Monument, 20
Holt, Nancy, 259–60

*Sun Tunnels, 259,* 259–60
*Holy Trinity* (Masaccio), 400–401, *401,* 405
*The Holy Virgin Mary* (Ofili), *53,* 53–54
Holzer, Jenny, 594
    "Truisms," 594, *594*
*The Homeless Projection 2* (Wodiczko),
    591–92, *592*
Homer, Winslow, 168
    *Bermuda,* 168, *169*
Honolulu Museum of Art, 19, *19*
Hopi Native American, 266
Hopper, Edward, 194, *194*
    *Night Shadows,* 194, *194,* 195
*The Horde* (Ernst), 557–58, *559*
horizon line, 70, *95,* 96
*The Horse Fair* (Bonheur), 530, *530*
horse sculpture from Japan, 254, *254*
Horta, Victor, 539
    Hotel Van Eetvelde, Belgium, 539, *539*
*Hōryūji* temple, Japan, 504, *504*
Hospital of the Innocents, Italy (Brunelleschi),
    403–4, *404*
Hotel Van Eetvelde, Belgium (Horta), 539, *539*
*The Hour of Cowdust,* India, 170, *170*
*How to Explain Pictures to a Dead Hare* (Beuys),
    *570,* 570–71
hue, 85–86
humanism, 399, 402, 403
hummingbird earthwork of the Nazca people,
    470, *470*
"The Hunt of the Unicorn" tapestries, 293, *293*
Hutter, Sidney, 287–88
    middy polished plate glass vase, 287–88, *288*

**I**
IBM logo (Rand), 243–44, *244,* 247
icon
    Buddha as, 497
    in Christianity and Christian art, 54, 377–79
    in social media, 7, *7*
iconoclasm, 379
iconography, 61–62, 392
idealized beauty in art, 40
ideas and the meaning of art, 47
identity
    global contemporary art and, 597–602
    universal theme of, 606
Iktinos, Parthenon, 124, *124, 316, 331,*
    331–32, *332*
illegal trafficking of art, 18–19
illuminated manuscript, 367, 390
*Imagen de Yagul (Image from Yagul)* (Mendieta),
    544, *544*
images
    in graphic design, 237
    as power in art, 593–94
*Imago* (Choe), 257, *257*
impasto, 79, 157–58
impermanent art, 260, 546–47, 566–67
implied lines, 71, 74
importance of art, 6–20
    as a central part of life, 7–10
    in conservation of, 14
    power basis of, 16–20
    societal benefits and, 15–16
    in support of, 10–13

impression, in printmaking, 179
*Impression: Sunrise* (Monet), 531, *531*
impressionism, 530–33, 540
    defined, 530–31
    Japanese influences on, 532–33
*In Just a Blink of an Eye* (Xu Z.), 110, *110*
*In Praise of Folly* (Erasmus), 188
in-the-round sculpture, 256–57
Incan Empire, 470–71
    architecture of, 311, *312*
    art of, 255
inclusion and art, 153–54, 357–58
*Incredibles 2* (Bird), 222, 223, *223*
Indian Subcontinent and arts of the Indian
        Subcontinent, 41, 483–85
    artifacts stolen from, 19, *19*
    Buddhism in, 485–89, 498
    film of, 219
    Hinduism in, 170, 489–91
    Islam in, 491–92
    social issues in art of, 601
    Taj Mahal in, *102,* 103–7, *104–106,* 111,
        126, 491
    timeline of, *484*
    *see also* specific locations and cultures
indirect art of printmaking, 179
individual support of arts, 12–13
Indus Valley Civilization, art of, 484–85
Industrial Revolution, 522–23
influence of art, 16–17
    film, 202, 204–5, 219–20
information recording and communication, as
        purposes of art, 25–28
ingredients of art, 59–64
Ingres, Jean-Auguste-Dominique, 24, 140,
        521–22
    *Jupiter and Thetis, 521,* 521–22
    *Napoleon Enthroned, 24,* 24–25
    *Portrait of Madame Hayard, 140, 140*
inner mind, universal theme of, 542
installation, 565–66, 594, 600–601
    in the Museum of Modern Art in New York,
        135–36, *136*
    postmodern, 588
    in sculpture, 260–62
Institute for Figuring, *Toxic Reef, 604*
*Insurrection! (Our Tools Were Rudimentary, Yet We
        Pressed On)* (Walker), 600–601, *601*
intaglio printmaking, 184, *184,* 190–94
intensity, in color, 86, *86*
interactive digital media, 245–46
interconnectedness, global, 602–4
interior, paintings of, 423–24
*Interior of the Pantheon, Rome* (Panini), 301, *301*
intermediaries in religious art, 21, 378, 424, 438,
        460
International Olympic Committee (IOC), 229, 232
International Style, 560
    reaction against, 583
international support of arts, 12
Ionic order, 314–316
iPhone icons (Apple), 7, *7*
*Iranians We Will Never Bomb Your Country, We ♥
        You* (Edry and Tamir), 234, *234*
Iraq, art trafficking in, 18–19
Iraq War, 136, 477

art commemorating, 118, 126
iron-frame construction, 322, 323
*"is techno dead"* (*Ray Gun* magazine) (Carson and
        Ritter), 242, *242*
*Isenheim Altarpiece* (Grünewald), 111–12,
        *112,* 281
Isherwood, Jon, 270
    *French Mist,* 270, *271*
Isidorus of Miletus, Hagia Sophia, 321, *322*
Islam and Islamic art, 226, 440–49
    architecture of, 392, 442–47, 449
    early cultures and styles of, 442–44
    Great Mosque in Djenné and, *428,* 429–32,
        *430, 431,* 449, 451
    in Indian subcontinent, 491–92
    later cultures and styles of, 447–49
    map of Islamic world in 1500, *441*
    medieval cultures and styles of, 444–46
    Muhammad and, 429, 431, 440–42, 449
    principles of, 441
    Taj Mahal and, *102,* 103–7, *104–106,* 111,
        126, 491
    themes of art, 441–42, 443
Israel, 234
    in Neolithic period, 338
    protest against social order of, 22–23
Italy and arts of Italy
    Baroque art in, 414–18
    Byzantine art in, 376–77
    early Renaissance in, 400–404
    High Renaissance in, *401,* 404–6
    pre-Renaissance, 388–89
    *see also* Rome and arts of ancient Rome
*iwan,* 445, 447
*IX* (Buzio), 284, *285*

## J

Jacir, Emily, *22,* 22–23
    *Munir, 23*
    "Where We Come From," 23, *23*
*The Jack Pine* (Thomson), 158, *158*
*Jackson Pollock* (Namuth), 563, *563*
*Jacob and Esau* (Ghiberti), 403, *403,* 452, *452*
Jacquet, Luc, 221, 478
    *March of the Penguins,* 221, *222,* 478, *478*
jade work in China, 502, *503*
Japan and arts of Japan, 26, 503–8, 597–98
    Buddhism/Zen Buddhism in, 480, 504,
        506–7, 509
    classical period, 503–5
    early modern, 507–8
    *haniwa* sculpture of, 254, *254*
    Impressionism influenced by, 532–33
    medieval, 505–7
    military attire in, 505–6
    Shintoism in, 503, 509
    tea ceremony and pottery in, *479,* 480,
        480–82, *481, 482,* 509, 510
    timeline of, *484*
    *ukiyo-e* prints, 180, 508, 532
Japanese Americans, internment of, 153–54, 171,
        606–7
*Jaws* (Spielberg), 16, 16–17
Jeanne-Claude, 136–37
    *The Floating Piers, Lake Iseo, Italy, 2014-16,*
        136–37, *137*

Jefferson, Thomas, 522
    Monticello, 522, *522*
Jewish art. *see* Judaism and Jewish art
*A Jig beyond the Grave* (Posada), 182, *182*
*jing,* 229, 230, 238
*Jirobo* tea bowl (Chōjirō), 481, *481,* 510
*The Jogger,* in process (Hanson), 269, *269*
Johns, Jasper, 160
    *Numbers in Color,* 160, *160*
Johnson, Phillip, Seagram Building, New York,
        324, *324*
Jonah and the whale, 372–73, 396
*The Joy of Life* (Matisse), 548–49, *549*
Judaism and Jewish art
    holocaust and, 20, 585–86
    in the late Roman Empire, 371–72
Judd, Donald, 52, 569
    *Untitled, 52, 52,* 569, *569*
*The Judgment of Paris* (Raimondi after Raphael),
        181, *181,* 515, *515*
*Judith and Her Maidservant with the Head of
        Holofernes* (Gentileschi), 82, *82*
*Judith and Holofernes (Gentileschi),* 416, *416,*
        426
Jukō, Murata, 480
Julius II (pope), 395, 406
*Jupiter and Europa* (Reni), 40, *40*
*Jupiter and Thetis* (Ingres), *521,* 521–22
Justinian (emperor), 321, 376–77

## K

*ka* sculpture of Egypt, 263–64, *264,* 347, *347,*
        353, *353*
kachina spirits, 474–75
Kahlo, Frida, 30, 603
    *The Two Fridas,* 30, *30,* 603
Kalabari Ijaw memorial screen, 120, *120*
Kallikrates
    Parthenon, 124, *124, 316, 331,* 331–32, *332*
    Temple of Athena Nike, *316*
Kamakura period of Japanese art, 26, 505
Kamehameha (chief), 455
Kandarīya Mahādeva Temple, India, 490, *491*
Kandinsky, Vassily, 113, *113,* 551
    *Black Lines,* 551, *551*
    *Composition 8,* 113, *114*
Kaprow, Allan, 566
    *The Courtyard,* 566, *567*
Kauffmann, Angelica, 520
    *Cornelia, Mother of the Gracchi, Pointing to Her
        Children as Her Treasures,* 520, *520*
*Keiskamma Altarpiece* (Hofmeyr, Makubalo, and
        Keiskamma Art Project), 280, 281, *281,*
        427, *427*
Keiskamma Art Project, *281,* 427
Kentridge, William, 141–42
    *Drawing for Other Faces,* 141, 141–42
    *Other Faces* film, 141–42
keystone, 318, 319, *583*
Kiefer, Anselm, *585,* 585–86
    *Dein Goldenes Haar, Margarethe (Your Golden
        Hair, Margaret), 585,* 585–86
*Kilbourn Acme Kruxo, exact expiration date
        unknown, ca. 1940s, processed in 2013*
        (Rossiter), 214, *214*
kiln, 265, 286

*Kin XXXII (Run Like the Wind)* (Lovell), 144–45, *145*
kinetic art, 257
King Assurnasirpal II hunting lions, 342, *343*
Kirchner, Ernst Ludwig, 550–51
   *Street, Berlin, 550,* 550–51
Kitani, Yilkari, 457, 477
   *Wagilag Story,* 457, *458,* 477
*kitsch,* 588–89
Klee, Paul, 89
   *Rainy Day,* 89, *90*
Kollwitz, Käthe, 135, 186, 542
   *Die Witwe I (The Widow I),* 186, *186*
   *Self-Portrait, Drawing,* 135, *135,* 542, *542*
Kolon One & Only Tower (Mayne), 584, *584*
Komar, Vitaly, 41
   *United States: Most Wanted Painting,* 41, *42*
Konboro, Koi, 429
*kondo,* 504
Koolhaas, Rem, 326
   China Central Television headquarters, 326–
      27, *327,* 328
Koons, Jeff, 588–89
   *Puppy,* 588–89, *589*
*kore,* 353
Korea and arts of Korea, 278, *484,* 492, 494–95
Kosuth, Joseph, 569
   *One and Three Chairs,* 569, *569*
*kouros,* 352–54, *353*
Krasner, Lee, 88
   *Free Space,* 88, *89*
Kruger, Barbara, 56
   *Untitled (Your gaze hits the side of my face),* 56, *56*
Ku Klux Klan, 203, 204, *562*
Kuba king in state dress, 22, *23*
Kurita, Shigetaka, xviii

**L**

*La Belle Jardinière (The Beautiful Plant Box)*
   (Raphael), 88, *89*
*La Caricature* newspaper, 176–178, 201
*La La Land* (Chazelle), 223, *223*
Labille-Guiard, Adélaïde, 79, 365
   *Self-Portrait with Two Pupils,* 79, *79,*
      365, *365*
Lady Pink (Sandra Fabara), *156,* 156–57
   *Cityscape Pink,* 156–57, *157*
*The Lamentation* (Giotto), 162–63, *163,* 319
Lancia (Bertone) Stratos HF Zero car (Gandini),
   73, *73,* 78, *78*
*Landing* (Murray), 75, *75*
landscape photography, 212
*Landscape with Saint John on Patmos* (Poussin),
   420–21, *421*
the land, universal theme of, 477
Lange, Dorothea, 209, 561, 575
   *Migrant Mother,* 209, *210*
   *White Angel Breadline, San Francisco,* 561, *562,*
      575
*Las Meninas (The Maids of Honor)* (Velázquez),
   418–20, *419,* 596, *596*
*Lascaux #4* (E. de Kooning), 197, *197*
Laseau, Michele, 241
   *Art Matters,* page layout design, 241, *241*
Last Judgment, from Church of Saint-Lazare
   (Gislebertus), 385, *385*

*The Last Judgment* (Michelangelo), *397,* 397–98,
   425, 426, 542, *542*
*The Last Supper* (Leonardo), 96, *97,* 116–17, *117*
*The Last Supper* (Tintoretto), 116–17, *117*
Laverdiere, Julian, *Tribute in Light,* 57
Lawrence, Jacob, 70–71, 169, *169*
   "Harlem," 170, *171*
   "Harriet Tubman," *71*
   *Panel #4,* 70–71, *71*
   *You Can Buy Bootleg Whiskey for Twenty-Five*
      *Cents a Quart,* 169, *170*
layers of a painting, 156
layout, in graphic design, 240–42
   defined, 241
Laysiepen, Uwe (Ulay), 586–87
   *Rest Energy,* 586–87, *587*
*Le Boulevard du Temple* (Daguerre), 207, *207*
Le Corbusier, 560
   Villa Savoye, France, 560, *560*
*Le Déjeuner sur l'herbe (The Luncheon on the*
   *Grass)* (Manet), *512, 513,* 513–15, *514,* 529,
   531, 540, 541, 553
*Le Moulin de la Galette* (Renoir), 532, *532*
Le Vau, Louis, 420
   Palace of Versailles, France, 420, *421*
*Leaves of Orchidea* (Talbot), 207, *208*
Léger, Fernand, 75
   *Three Women,* 75, *76*
Lehmann Maupin Gallery exhibition (Oursler),
   225, *226*
Lemberger, Michal, 17
   *After Abel and Other Stories,* 17, *17*
Leonardo da Vinci, 45, 63, 121, 136, 404–5
   *The Fetus in the Womb,* 136, *136*
   *The Last Supper,* 96, *97,* 116–17, *117*
   *Mona Lisa,* 42, 45, *46,* 557
   *Proportion of the Human Figure, after Vitruvius,*
      121, *122*
   *The Virgin and Child with Saint Anne, 404,*
      404–5
*Les Demoiselles d'Avignon (The Young Women of*
   *Avignon)* (Picasso), *552,* 552–53
*Les Valeurs Personnelles (Personal Values)*
   (Magritte), 120, *120,* 542, *542*
Levine, Marilyn, 80
   *Spot's Suitcase,* 80, *80*
Levine, Sherrie, 595–96
   *After Walker Evans: 7,* 595, 595–96
Leyster, Judith, 44, 422–23
   *The Proposition,* 422–23, *423*
   *Self-Portrait,* 44, *44*
*The Liberation of Aunt Jemima* (Saar), 572,
   *573*
Libeskind, Daniel, 92
   Denver Art Museum extension, 92–93, *93*
Lichtenstein, Roy, 568
   *Drowning Girl,* 568, *568*
light, as a visual element of art, 67, 80–82, 84
   defined, 67, 80
*Lightning Field* (De Maria), 571, *571*
Limbourg brothers, 389, 409
   *October,* 389, 389–90
Lin, Maya, 3–4, 7, *307,* 307–8, 427, *427*
   Riggio-Lynch Chapel, 307, *307*
   Vietnam Veterans Memorial Competition
      Drawing, *4*

Vietnam Veterans Memorial (The Wall), 1, 2,
   *2,* 3–6, *5, 6,* 29, 33, 427, *427*
*Lindisfarne Gospels* (Eadfrith), *366,* 367–70, *368,*
   *369,* 380, 390, 392
line, as a visual element of art, 70–74, *104*
   defined, 67, 70
   uses of, 71
*Line of Control* (Gupta), *601,* 601–2
linear perspective, 93, 94, *95,* 95–96
linear style of art, 140
linocut, 184, 188–89, *189*
Lipski, Donald, 588
   *The Starry Night,* 588, *588*
liquid media, 138, 145
   brush and ink, 146
   brush and wash, 146–48
   pen and ink, 145–46
   pen and wash, 146
*literati* paintings, 501, *502*
lithography, 176, 178, 194–97
live action film, 221–22
load-bearing construction, 311
local color, 86, 530, 531
logo, 243–44, *244,* 247
*London Bridge* (Derain), 549, *549*
long shot, in film, 216, *217*
loom, 292
   computer-controlled, 294
looting, 19, *19*
*Lophophore* (Hawkinson), 70, *70*
Los Angeles
   *The Great Wall of Los Angeles* in, 151,
      152–54, *153, 154,* 174
"Los Caprichos" (Goya), 182, *182*
lost wax casting, 266–68, *267*
Lou, Liza, 45
   *Color Field,* 45, *45*
Louis IX of France, 21
Louis-Philippe of France, 176–77, 178
Louis XIV of France, 420, 516
*Louis XV as a Young Man* (Carriera), *137,* 137–38
love, universal theme of, 451
Lovell, Whitfield, 144, *144*
   *Kin XXXII (Run Like the Wind),* 144–45, *145*
low relief sculpture, 257–58, 333
Lubalin, Herb, 243
   *Mother & Child* logo, 243, *244*
Lubelski, Nava, 297
   *Pop-up,* 297, *297*
Lumière, Auguste and Louis, 215
Luna, James, 594
   *The Artifact Piece,* 594, *594*
Luther, Martin, 411
"Lynch Fragments" (Edwards), 270, *271*

**M**

Macdonald, Margaret, 237
   bookplate design for John Edwards, 237, *237*
Machu Picchu, Inca, 311, *312,* 470
*Madonna Enthroned* (Giotto), 389, *389*
*madrasa,* 445
Magritte, René, 120, 542
   *Les Valeurs Personnelles (Personal Values),* 120,
      *120,* 542, *542*
*Mahana No Atua (Day of the God)* (Gauguin),
   537, *537*

*A Maid Preparing to Dust* (Hokusai), 146, *147*
Makubalo, Noseti, 280
   *Keiskamma Altarpiece*, 280, 281, *281*, *427*, *427*
*Malagan* ceremony, 459
male storyteller figure (Cordero), 266, *266*
male torso, Indian Subcontinent, 484, *484*
Mamluk people, 444–45, 446
*Man Eating Watermelon* (Scott), 589, *590*
Man Ray, 558
   *Gift*, 558, *558*
*mana*, 454, 455
Manet, Edouard, 513–15, 529, 531, 540, 541
   *Le Déjeuner sur l'herbe (The Luncheon on the
      Grass)*, *512*, *513*, 513–15, *514*, 529, 531,
      540, 541, 553
manipulation of truth, possibility of
   with film, 220, 227
   with photography, 209
   with video, 224
*Manneken Pis* (Duquesnoy), 47, *48*
Mannerism, *401*, 407, 408
Mansart, Jules Hardouin, 420
   Palace of Versailles, 420, *421*
*Many Mansions* (Marshall), 57, *57*
Maori, 460–61, 462
   tattoos of, 49, *50*
   wood craft of, 291
map
   of Africa, *432*
   of the Americas, *463*
   of ancient Greece, *350*
   of ancient Mesopotamia and Egypt, *339*
   of Asia, *483*
   of Europe around 1810, *523*
   Holy Roman Empire and the Byzantine
      Empire in 814, *381*
   of Islamic world in 1500, *441*
   of the Pacific, *457*
   of prehistoric Mediterranean world, *335*
   of Reformation period, *413*
   of Roman empire, *357*
*Maple Tree* (Tōhaku), 508, *508*
Mapplethorpe, Robert, 11, *11*
   *Ajitto (Back)*, 11
Marantz, Paul, *Tribute in Light*, 57
*March of the Penguins* (Jacquet), 221, *222*,
   478, *478*
Maria Martinez. *see* Martinez, Maria and Julian
*Marie Antoinette with a Rose* (Vigée-Lebrun),
   517–18, *518*
*Marie de Medici, Queen of France, landing in
   Marseilles, 3 November 1600* (Rubens), 418,
   *419*
Marisol, 565–66
   *The Party*, 565–66, *566*
Marshall, Kerry James, 57
   *Many Mansions*, 57, *57*
Martinez, Maria and Julian, *274*, 274–76, *275*,
   278, 279, 282, 286, 298
   black-on-black pottery of, *274*, 274–75, *275*,
      278, 298
   bowl, *273*, *274*, 274
Martini, Simone, 164, 166, 277
   *Annunciation*, 164–65, *165*, 166, 277, *277*
*Mary Magdalene* (Donatello), 264, *264*
*Mary* (Viola), 225, *225*

Masaccio, 98, 400–401
   *Holy Trinity*, 400–401, *401*, 405
   *The Tribute Money*, 98, *98*
mascots of the Beijing Olympics, 231–32, 232
masks and costumes of the Bwa, 435, *436*, 452
masquerade, 435, 452
mass, 77–78, 252–53, 304
   defined, 77
mass culture, 567–68
mass production of art, 279–80, 568
Matisse, Henri, 52, *548*, 548–49
   *Blue Nude*, *52*, 52–53, 59, 64
   *The Joy of Life*, 548–49, *549*
matrix, in printmaking, 179, 180–81, *184*
   in aquatint, 194, *195*
   in drypoint, 192, *192*
   in engraving, *191*
   in etching, 192, *193*
   in intaglio printing, 190
   in linocut, 188–89, *189*
   in lithography, 196, *196*
   nontraditional, 199, 200
   in relief printing, 184, 185
   in screenprinting, 197, *198*
   in wood engraving, 186, 188, *188*
   in woodcut, *185*, *187*
*Matthew* (Peyton), 134, *134*, 150
Matthew's cross page, *Lindisfarne Gospels*
   (Eadfrith), 368, *369*
Matthew's initial page, *Lindisfarne Gospels*
   (Eadfrith), 368, *369*
Matthew's portrait page, *Lindisfarne Gospels*
   (Eadfrith), *366*, 367–68, *368*
*Mattress Performance (Carry That Weight)*
   (Sulkowicz), *23*, 23–24
Maya and Mayan art, 312, *313*, 465–66
Mayne, Thom, 584
   Kolon One & Only Tower, 584, *584*
*Maypole-War* (Spero), 42, *43*
meaning, art as work with, 47–52
   *"Untitled" (Death by Gun)*, 47
Mecca, 440–41, 444, *445*
media. *see* medium
Medici family, 402
medieval period, in Europe, 379–88
   early, 380–81
   *Lindisfarne Gospels and*, 380
   timeline of, *376*
   *see also* Middle Ages
Mediterranean, Prehistoric cultures in, 335–38
   map of, *335*
medium, 37
   diverse, 586–91
   dry, 138–45
   liquid, 138, 145–48
   in painting, 155, 159–72
Meissonnier, Juste Aurèle, pair of candlesticks,
   517, *517*
Melamid, Alexander, 41
   *United States: Most Wanted Painting*, 41, *42*
Melanesia and arts of Melanesia, 458–59
memorial screen of Nigeria, 120, *120*
memorials
   AIDS quilt, 31–32
   American Civil War, 258–59
   Holocaust, 20

Iraq War, 477
Vietnam Veterans Memorial (The Wall), 1, 2,
   *2*, 3–6, *5*, *6*, 29, 33, 427, *427*
Mendieta, Ana, *543*, 544–47, 570, 574, 575
   *Alma Silueta en Fuego (Soul Silhouette on Fire)*,
      *545*, 545–46
   *Fetish Series*, 546, *546*, 575
   *Imagen de Yagul (Image from Yagul)*, 544, *544*
   *Tree of Life*, *543*, 544–45, *545*
   *Untitled*, 546, *546*, 575
Menkaure and a queen, Egypt, 263–64, *264*,
   353, *353*
*Merode Altarpiece* (Campin), *409*, 409–10
Mesa Verde, 306–7, *307*
Mesoamerica and arts of Mesoamerica, 462–68
   Aztec, 466–68, 478
   Maya, 312, *313*, 465–66
   Olmec, 464
   Teotihuacán, 162, 464–65
Mesopotamia and arts of Mesopotamia,
   339–43, 363
   Akkad, 341
   Assyria, 342–43
   Babylonia, 341–42
   map of, *339*
   seals of, 235
   Sumer, 340–41
metal crafts, 289–90
*Metalwork, 1793-1880* (F. Wilson), *593*, 593–94
*Metas 1* (Anatsui), 108, *108*
Metropolitan Museum of Art, 8, 45
Mexican Americans, 154, 198
Mexico and arts of Mexico, 43, 258, 312, *313*
   frescos of, 162, *162*, 393
   prints of, 181–82
   *see also* Mesoamerica and arts of Mesoamerica
Meyer, Adolf, 559
   Bauhaus School, 559, *560*
Micheaux, Oscar, 205
   *Within Our Gates*, 205, *205*
Michelangelo Buonarroti, 142, 263, 365,
   395–98, 404, 405–6, 424–25, 426, 542
   *Creation of Adam*, *396*, 396, 399, 424
   *David*, *405*, 405–6
   *The Last Judgment*, *397*, 397–98, 425, 426,
      542, *542*
   *The Prophet Jonah*, *396*, 396, 424–25
   Sistine Chapel ceiling, 142, *394*, *395*, 395–98,
      *396*–398, 424–25
   *Studies for the Libyan Sibyl*, 142, *142*
   *Unfinished Slave*, *263*, 263, 264, 365, *365*
Middle Ages, 379–90
   early medieval period, 380–81
   Gothic, 385–88
   and the Renaissance, 388–90
   Romanesque, 382–85
   timeline of, *376*
Middle East and arts of Middle East
   Islam and, 440, *441*
   pottery of, 284–85
   woodcut fabrics of, 185
middy polished plate glass vase (Hutter), 287–88,
   *288*
Mies van der Rohe, Ludwig, 324
   Seagram Building, New York, 324, *324*
*Migrant Mother* (Lange), 209, *210*

*mihrab,* 45, *46,* 59, 431, 444
Milmore, Martin, Soldiers' and Sailors' Monument, 591–92, *592*
minaret, 106, 444
Ming dynasty of China, 501–2
miniature llama figurine, Peru, 255, *255*
miniature painting, 170, 448–49
Minimalism, 568–69, 570
*mise en scène,* 215–16
Mitchell, Joan, 157
*Wood, Wind, No Tuba,* 157, *158*
mixed media, in drawing, 148
Mo Ti, 206
*moai* of Rapa Nui, *460, 460, 462, 462,* 475
model of a man making beer, Egypt, 348, *348*
modeling, 262, *265,* 265–66
in two-dimensional work, 81
Modern art in the West, 515, 540, 543–74
assemblage, 565
*Bauhaus,* 559–60
Christianity and Christian art, 36–37
Conceptual art, 569
Cubism and, 552–56
Dada and, 556–57, 558
De Stijl, 558
defined, 524
earthworks, 571
environments, 565–66
Expressionism and, 547–51
Happenings, 566–67
International Style, 560
Mendieta's place in, 546–47
Minimalism, 568–69
New York School, 563–65
Performance art, 569–71
Pop art, 567–68
prejudice, combatting, 571–73
societal transformation movements in, 558–60
Surrealism and, 557–58
timeline of, *548*
U.S. movements in, 561–73
Modersohn-Becker, Paula, 550
*Old Peasant Woman,* 550, *550*
mold, in casting, 266–68, *267*
Momoyama period, Japan, 507–8
*Mona Lisa* (Leonardo), 42, 45, *46,* 557
*Mona Lisa (L.H.O.O.Q.)* (Duchamp), 557, *557*
Mondrian, Piet, 58–59, 63
*Apple Tree,* 59, *59*
*Composition with Red, Blue, Yellow, Black, and Gray,* 58, *58,* 63
*Tree* (Study for *The Gray Tree*), 58, *58*
Monet, Claude, 531, *531*
*Impression: Sunrise,* 531, *531*
monetary support of the arts, 12–13
*see also* patronage of the arts
*Monk by the Sea* (Friedrich), 526, *526*
monochromatic color scheme, *87,* 88, *88*
*Monogram* (Rauschenberg), 565, *565*
montage, 217–18
Monticello (Jefferson), 522, *522*
Moore, Henry, 43, 77
*Reclining Figure,* 77, *77,* 78
*Three Standing Figures,* 43, *43*
Moreno, Luisa, *153*
Morisot, Berthe, 532

*The Cradle,* 532, *533*
mosaic, 45, 377
mosque lamp of the Mamluk people, 445, *445, 446*
Mosque of Sultan Selim II (Sinan), 447, *447*
mosques. *see* specific mosques
Moss, Andy, 9
*The Fallen,* 9
mother-and-child figure, Africa, 54, *54*
*Mother & Child* logo (Lubalin), 243, *244*
*Mother with Dead Child on Ladder* (Picasso), 132, *132,* 150
*Mother with Dead Child* (Picasso), 128, *129,* 131–32, *132,* 149, 150
Motherwell, Robert, 29–30
*Elegy to the Spanish Republic No. 34,* 29, *29*–30
motion graphics, 245–46
*Motion Study* (Muybridge), 214, *214*
*Moulin Rouge: La Goulue* (Toulouse-Lautrec), 242, *243*
*Mount Lu* (Yujian), 500, *500*
*Movement II* (Park), 138–39, *139*
mud-built structure, 429–30
Mughal Empire, 103, 105, 491–92
*see also* Taj Mahal
Muhammad, Prophet, 429, 431, 449
cartoon of, 7
and Islam, 429, 431, 440–42, 449
Muhammad, Sultan, 448–49
*Rustam Sleeps While Rakhsh Fights Off a Lion,* 448, 448–49
multisensory appreciation of art, 39–40
Mumtaz Mahal, 103, 104, *106*
Munch, Edvard, 537–38, 542
*The Scream,* 537–38, *538,* 542
*Munir* (Jacir), 23
Muniz, Vik, 598
"Afterglow," *599*
*Temple of Juno in Agrigento, after Caspar David Friedrich,* 598, *599*
Münter, Gabriele, *59,* 59–60
*Boating,* 59–60, *61*
Murakami, Takashi, 597–98
*727,* 597–98, *598*
mural, 152–54, 155, 174, 466
Murasaki, *The Tale of Genji,* 504–5, *505,* 506, *506*
Murray, Elizabeth, 75
*Landing,* 75, *75*
Musée d'Orsay (Aulenti), 306, *306*
Museum of Modern Art in New York
emojis, collection of, xviii
installation art, 135–36, *136*
museums. *see* specific museums
Muslim. *see* Islam and Islamic art
Muybridge, Eadweard, 214–15
*Motion Study,* 214, *214*
Myoda, Paul, *Tribute in Light,* 57

## N

Nakht, *Book of the Dead,* 94, *94, 393, 393*
Nameless Library Holocaust Monument (Whiteread), 20, *20*
Namuth, Hans, *Jackson Pollock,* 563, *563*
Nanchan Temple, China, 497–98, *498*
Nankai, Gion, *Uchikake* with bamboo design, 508, *508*

Napoleon, 523–24
*Napoleon Enthroned* (Ingres), *24,* 24–25
Napoleon III, 513
narrative film, 220, 221
narthex, 374, 376
Nasrid, 445–46
Court of the Lions in Spain, 446, *446*
National Association for the Advancement of Colored People (NAACP), 204
National Endowment for the Arts (NEA), 11
National Gallery of Canada, 35, *40,* 42, 55
Native Americans, 274, 275, 599
adornment, art of, 29, *29*
baskets of, 296, *296*
discrimination against, 594
*see also* North America and arts of North America; specific native peoples
naturalism, 388, 389, 400, 414–15
rejection of, by Expressionism, 547
Navajo people
blanket, 99, *99*
sand paintings, 48, *49,* 59, 575, *575*
nave, 319, *320,* 374
Nazca, 470
Nazis, 559, 585–86
propaganda of, 17, 364
necklace ornament of the Princess Mereret, Egypt, 343, *344*
Neel, Alice, 38
*Gerard Malanga,* 38
negative image, in photography, 207
negative shape, 75–76, *76*
negative space, 78, *538*
Neo-Confucianism, 498–500
Neo-Expressionism, 585–86
Neoclassicism, 518–22
in architecture, 522
defined, 519
Romanticism contrasted with, 525
Neolithic period, 337–38
Neshat, Shirin, 226
*Turbulent,* 226, *226*
Neto, Ernesto, 598, 600
*Anthropodino,* 600, *600*
Nevelson, Louise, 565
*Sky Cathedral,* 565, *566*
New Guinea, 458–59
New Ireland, 459
*The New Revolution Virtual Reality Coaster* (Six Flags Magic Mountain), 246, *246*
New York School, 563–65
New York subway drawings (Haring), 134, *134*
New Zealand and arts of New Zealand, 327, 460–61
*see also* Maori
Newman, Barnett, 34, 35–37, 42, 64
*Be 1,* 35, *35*
*First Station,* 36, *36*
*Voice of Fire,* 34, 35, *35,* 36, *37,* 42, 45, 47, 55, 59–60, 64
Newton, Isaac, 83
Nguni people, 440, 451
*Niagara* (Church), 25, *26*
nib, in drawing, 145

Nicola da Urbino, 399
*The Story of King Midas,* 399, *400*
*Night Attack on Sanjo Palace* (Kamakura period), 26, *26*
*The Night Café* (Van Gogh), 68, *69,* 79, 98, 100
*Night Shadows* (Hopper), 194, *194,* 195
*Night Watch* (Rembrandt), 421–22, *422*
*Nike of Samothrace,* from the Hellenistic period, 356, *356*
nineteenth-century art in the West, 522–39
  academic *art* in, 513–14
  Art Nouveau and, 539
  foreign cultures, views of, 524, 526
  impressionism and, 530–33, 540
  Industrial Revolution and, 522–23
  map of Europe around 1810, *523*
  Post-impressionism and, 533–38, 540
  Realism and, 527–30
  Romanticism and, 524–27
  timeline of, *517*
*nkisi n'kondi* nail figure, 21, *21,* 546
*No. 9 (Dark over Light Earth/Violet and Yellow in Rose)* (Rothko), 565, *565*
Nok, head from, 433–34, *434*
*Noli Me Tangere (Don't Touch Me)* (Fontana), 408, *408*
nonobjective art, 58, *58,* 60, 64, 551
  Islamic, 442
  meaning of, 113, 157, *157,* 255
nonrepresentational art. *see* nonobjective art
*Nord Express* (Cassandre), 236, *236*
North America and arts of North America, 471–75
  black-on-black pottery, *274,* 274–75, *275,* 278, 298
  Eastern Woodlands, 472–73
  Great Plains, 473–74
  map of, *463*
  Northwest Coast, 475
  Southwest, 474–75
  *see also* specific locations and cultures
Northern Song dynasty, 498, 506
Northwest Coast of North America, 475
*Number 1, 1949* (Pollock), 563, *564*
*Numbers in Color* (Johns), 160, *160*

**O**

*The Oath of the Horatii* (David), *519,* 519–20, 525
*oba,* 438, *439*
Obaid-Chinoy, Sharmeen, 220, 227
  *A Girl in the River: The Price of Forgiveness,* 220, *220*
*Object (The Luncheon in Fur)* (Oppenheim), 55, *55*
*October* (Limbourg brothers), *389,* 389–90
Odita, Odili Donald, 123
  *Accelerator,* 123, *125*
Odo of Metz, Palace Chapel of Charlemagne, 381, *381*
Ofili, Chris, 53–54
  *The Holy Virgin Mary,* 53, 53–54
oil paint, 159, 166, 168
O'Keeffe, Georgia, 89, 141, *141*
  *The Shell,* 141, *141*
  *Stump in Red Hills,* 89, *90*
*Old Peasant Woman* (Modersohn-Becker), 550, *550*

Old St. Peter's church, *374,* 374–75, *375*
Olden, Georg, 243, *243*
  stamp for the centenary of the Emancipation Proclamation, 243, *243*
Oldenburg, Claes, 568
  *Giant Toothpaste Tube,* 568, *568*
Olmec people, 464
Olowe of Ise, 437
  veranda post of enthroned king and senior wife, 437–38, *438*
Olympics. *see* Beijing Olympics
*On Either Side* (Searle), 88, *88*
*One and Three Chairs* (Kosuth), 569, *569*
one-point perspective, 96, 401
*oni,* 436, 437
Oppenheim, Meret, 55
  *Object (The Luncheon in Fur),* 55, *55*
*Orange Car Crash Fourteen Times* (Warhol), 567, *567*
order, in architecture, 314–316
ordered designs in Islam, 442
*Ordinary Transformation* (Sōtan), 482–83, *483*
organic mass, 78
organic shape, 75
original print, 180
originality of art, 52
ostrich egg, *430,* 432, 451
O'Sullivan, Timothy H., 208–9
  *A Harvest of Death, Gettysburg, Pennsylvania,* 208, 208–9
*Other Faces* film (Kentridge), 141–42
Ottoman Empire, 333–34, 447
Oursler, Tony, 225
  Lehmann Maupin Gallery exhibition, 225, *226*
outsider artist, 43–44
overlapping, 93, 94, 557

**P**

Pacific and arts of the Pacific, 456–62
  Australia, 456–58
  Hawaiian featherwork and, *453, 454,* 454–56, *455, 456,* 476, 477
  map of, *457*
  Melanesia, 458–59
  New Zealand, 327, 460–61
  Polynesia, 327, 459–62, 475
  *see also* specific locations and cultures
*pagoda,* 504
Paik, Nam June, 225, *225*
  *Video Flag Z,* 225, *225*
painting, 151–74
  defined, 155
  digital, 172–73
  meaning of, 158
  medium type, 155, 159–72
  Postmodernism, 585–86
  in the Renaissance style, 400–402
  tools and techniques of, 155–58
Pakistan and arts of Pakistan, 220, 601, 602
Palace Chapel of Charlemagne, Germany (Odo of Metz), 381, *381*
Palace of the Governor, Mayan, 312, *313*
Palace of Versailles, France (Le Vau and Mansart), 420, *421*
Paleolithic period, 335–37

palette, 156, 344–45, 411
*Palette of Narmer,* Egypt, *344,* 344–45
Palmyra, Syria, ruins of, 13
pan, in film, 216
*Panel #4* (Lawrence), 70–71, *71*
Panini, Giovanni Paolo, *Interior of the Pantheon, Rome,* 301, *301*
Pankhurst, Emmeline, 18
Pantheon, *299, 300,* 300–303, *301, 302,* 308, 316, 321, 328
Paralympics pictographs, 231
Park, Yooah, 138–39
  *Movement II,* 138–39, *139*
Parthenon (Iktinos and Kallikrates), 124, *124,* 316, *316,* 331, 331–34, *332*
Parthenon sculptures, 329, *330,* 331–34, *333, 334,* 362–63
*The Party* (Marisol), 565–66, *566*
*Passion/Passiflora Incarnation* (Aycock), 268, 270, *270,* 272
pastel, 139, 141, 142–44
*The Pastoral Concert* (Titian), 515, *515*
*Paths II* (Gibbons), 200, *200*
patina, 254
patronage of the arts, 13, 114, 319, 399, 402, 404, 407
pattern, defined, 41
Paxton, Joseph, 323
  Crystal Palace, 323, *323*
Peckolick, Alan, *244*
pediment, 314, 315
  of the Parthenon, 332
Peeters, Clara, 423
  *Still Life with Fruit and Flowers,* 423, *423*
pen and ink, 145–46
  Pablo Picasso's use of, 128, *129*
pen and wash, 145, 146
pendentive, 321, *321*
Pepper, Beverly, 113
  *Excalibur,* 113, *114*
perceiving culturally, 49–51
perceiving physically, 51
Performance art, 23–24, 569–71, 574, 594
  Happening, 566–67
Perjovschi, Dan, 135–36
  *WHAT HAPPENED TO US?,* 135–36, *136*
*The Persistence of Memory* (Dalí), 557, *558*
Peru, 255, 311
Pettway, Jessie, 296–97
  *Bars and String-Piece Columns,* 296, 296–97
Peyton, Elizabeth, 134
  *Matthew,* 134, *134,* 150
The Pharaoh Khafre, Egypt, 347, *347*
Phidias, 331–32
photo journalism, 212–13
photogenic drawing, 206, 207–8
photography, 205–14
  American Civil War, 208–9
  artistic vision and choice with, 209–12
  defined, 205
  history of, 206–8
  manipulation possible with, 209
  of slavery in U.S. history, 27–28
  types of, 212–14
*The Physical Impossibility of Death in the Mind of Someone Living* (Hirst), 587–88, *588*

physical perception, 51
Picasso, Pablo, 52, *52*, 128, *129*, 130–32, 135, 149–50, 189, 552–53, 554–55
   *Bottle of Suze*, 554–55, *556*
   *Bull's Head*, 52, *52*, 59
   *Composition Study*, 130, *131*, 150
   *First Composition Study for Guernica*, 130, *131*
   *Guernica*, 130, 132–33, *133*, 149–50
   *Guernica* drawings, 130–33, *131, 132*, 149–50
   *Les Demoiselles d'Avignon (The Young Women of Avignon)*, *552*, 552–53
   *Mother with Dead Child*, 128, *129*, 131–32, *132*, 149, 150
   *Mother with Dead Child on Ladder*, 132, *132*, 150
pictograph, *230*, 230–31, *231, 233*, 234, 237–38
picture plane, 93, *95*, 224, 415, 530
pigment, 83, *84*, 155
pinching, in clay works, 282–84, *283*
Pineau, Nicolas, 28–29
   *Varengeville Room in Hôtel de Varengeville, Paris, France*, *28*, 28–29
Piper, Adrian, 261
   *Vote/Emote*, 261, *261*
placement, 113, 116
planographic printmaking, 184, *184*, 194–97
plate. *see* matrix, in printmaking
*The Plate of Apples* (Cézanne), 534–36, *535*
play, universal theme of, 510
*Pleasure Pillars* (Sikander), *602*, 602–3, 606
Plensa, Jaume, *The Crown Fountain*, Millennium Park, Chicago, *10*
pluralism, 597
*Poet on a Mountaintop* (Shen), 501, *502*
pointed arch, 319, *319*
Pointillism, 534
politics and social order, as purpose of art, 22–25
Pollaiuolo, Antonio, 191–92
   *Battle of the Nudes*, *191*, 191–92
Pollock, Jackson, 563, *563*
   *Number 1, 1949*, 563, *564*
Polykleitos, 354
   *Spear Bearer*, 354, *354*
Polynesia and arts of Polynesia, 459–62, 475
   New Zealand, 327, 460–61
   Rapa Nui (Easter Island), 459–60
Pomo people, 296, *296*
Pomona College Studio Art Hall (Yantrasast), 306–7, *307*
*Ponderosa Whirlpool* (Drury), 38, *39*
Pont du Gard, France, 125, *126*
*Poor sheep oh! You struggle in vain. You will always be fleeced* (Daumier), 175, *175*
Pop art, 567–68
*Pop-up* (Lubelski), 297, *297*
porcelain, 282, 501
portable art, 472, 473
   sculpture, 337
*Portia Wounding Her Thigh* (Sirani), 415–16, *416*
portrait in the Baroque style, 421–22
*Portrait of Constantine*, 375, *375*
*Portrait of Giovanni Arnolfini and His Wife (?)* (van Eyck), 61–62, *62*, 452, *452*
*Portrait of Madame Hayard* (Ingres), 140, *140*
*Portrait of Maori Chief Te Pehi Kupe Wearing European Clothes* (Sylvester), 49, *50*

*Portrait of the boy Eutyches*, Egypt, 159, *160*
portrait photography, 212
Posada, José Guadalupe, *181*, 181–82
   *A Jig beyond the Grave*, 182, *182*
positive shape, 75–76, *76*
post-and-lintel construction, 311, *313*, 313–14, *314*
Post-Impressionism, 533–38, 540
   expression in, 536–37
   space in, 535–36
   symbolism in, 537–38
Postmodernism, 581–96
   in architecture, 583–84, 605
   defined, 582
   diverse media forms of, 586–91
   in global contemporary art, 597–604
   installation, 588
   new technologies in, 590
   painting, 585–86
   prior works drawn on in, 595–96, 598, 605
   protest art of, 591–94
   traditional crafts, 589–90
*The Potato Eaters* (van Gogh), 67–68, *68*, 96, 100
potter's wheel, 285, *285*
pottery, 281, 282
   black-on-black, *274*, 274–75, *275*, 278, 298
   Japanese tea ceremony, *479, 480*, 480–82, *481, 482*, 509, 510
   mass production of, in Asia, 279–80
   of the Middle East, 284–85
   of Neolithic people, 338
   *see also* clay works
Poussin, Nicolas, 420–21
   *Landscape with Saint John on Patmos*, 420–21, *421*
power, 16–20, 592–94
   universal theme of, 364
Praxiteles, *Aphrodite of Knidos*, 40, *40*, 58, 402
prayers, universal theme of, 393
Preah Khan, Angkor, Cambodia, restoration of, 13, *13*
prehistoric cultures
   cave paintings of, 197
   map of Europe and Mediterranean, *335*
   Neolithic period, 337–38
   Paleolithic period, 335–37
presentation of captives to Lord Chan Muwan, Mayan, *466*, 466
preventative work in art conservation, 14
primary colors, 83, *85*
priming, in painting, 156
principles of design. *see* design principles
print, 179, 180
printmaking, 175–201
   defined, 179
   digital, 199–200
   intaglio, 190–94
   multiple originals of, 179–82
   planographic, 184, *184*, 194–97
   process and characteristics of, 179–83
   relief, 184–89
   stencil, 184, *184*, 197–98
*Projecting Change: Empire State Building* (Psihoyos and Threlkel), 32, *32*, 42
proof, in printmaking, 182
propaganda and art, 17, 414, 418–20
   the downtrodden and Realism, 529

Nazis, 17, 364
*The Prophet Jonah* (Michelangelo), 396, *396*, 424–25
proportion, design principle of, *121*, 121–23
   defined, 103, 121
*Proportion of the Human Figure, after Vitruvius* (Leonardo), 121, *122*
*The Proposition* (Leyster), 422–23, *423*
Protest art, 573, 591–94
   Israel social order, 22–23
Protestant Reformation, 411–14, 425
   propaganda and, 414
prow from a war canoe (Maori), 291, *291*
Psihoyos, Louie, 32
   *Projecting Change: Empire State Building*, 32, *32*, 42
*Psycho* (Hitchcock), 219, *219*, 223
public art, 10–12, 270
Public Services Building, Portland, Oregon (Graves), *583*, 583–84
*Puppy* (Koons), 588–89, *589*
pure symmetry, 111
purpose of art, 20–33
   communication as, 25–28
   decoration as, 28–29
   expression as, 29–31
   figuring out the, 24
   information recording and communication as, 25–28
   politics and social order as, 22–25
   religion and spirituality as, 21–22
   social action as, 31–33
purse cover (early medieval), 380, *380*
Pyramid of the Moon, Mexico, 464
Pyramid of the Morning Star, Mexico, 43, *43*
Pyramid of the Sun, Mexico, 464

## Q

Qian Zhe and design team, *The Beauty of Seal Characters*, 230, *230*
*qibla* wall, 444
Qin dynasty, 493–94
Qing dynasty, 279, 502
*Quietude* (Cassatt), 192, *193*
quill, 145
quillwork, 472–73
quilting, 280, 292, 296–97, 298
   *AIDS Memorial Quilt*, 31, *31*–32

## R

radial balance, 113–14
radiating chapel, 384
*Radioactive Cats* (Skoglund), 210–11, *211*
*Raft of the "Medusa"* (Géricault), 74, *74*
Raimondi, Marcantonio, 181, 515
   *The Judgment of Paris*, 181, *181*, 515, *515*
*Raimondi Stele*, Peru, 469, *469*
*Rainbow Assembly* (Eliasson), 261, *261*
*Rainy Day* (Klee), 89, *90*
raising, in metal craft, 289
raku ware, 481
Ramses II's temple, Abu Simbel, Egypt, 12, *12*, 607, *607*
Rand, Paul, 243–44
   IBM logo, 243–44, *244*
Rapa Nui (Easter Island), 459–60, 462

Raphael, 88, 181, 404, 406
  *The Judgment of Paris,* 181, *181*
  *La Belle Jardinière (The Beautiful Plant Box),*
    88, *89*
  *School of Athens,* 406, *406*
Rauschenberg, Robert, 565
  *Monogram,* 565, *565*
*Ray Gun* magazine, 242, *242*
Realism, 418, 420, 527–30
  animals in, 529–30
  defined, 527–28
  the downtrodden and, 528–29
  ordinary life in, 529
*Reclining Figure* (Moore), 77, *77,* 78
recurrence as emphasis, achieving, 116
recycling, in architecture, 306
*Red Banner* (Rothenberg), 172, *172*
*Red Blue Chair* (Rietveld), 63, *63*
*Red Spill* (K. Smith), 593, *593*
Reformation period and art, 411–14
  Catholic Church resistance in, 411–14, 425
  map of, *413*
Regionalism, 561
register
  in printmaking, 197
  as a strip in a work of art, 340–41, 371
reinforced concrete, 309, 311, 322
relaxation, universal theme of, 511
reliability of images, 26–28
relics, 384, 486
relief panel depicting the sacrifice of a ball player
    (Mexico), 258, *258*
relief printing, *184,* 184–89
relief sculpture, 257–59
religion and spirituality
  as purpose of art, 21–22
  themes of, 392–93
  *see also* specific religions
reliquary, 384, 393
  Fang figures, 435–36, *437*
reliquary statue of Sainte Foy, 384, *384*
Rembrandt van Rijn, 147–48, 180, 183, 421–22
  *Christ Crucified between the Two Thieves (The
    Three Crosses),* 183, *183*
  *Night Watch,* 421–22, *422*
  *A Young Woman Sleeping,* 147, *147*–48
remembrance, universal theme of, 427
Renaissance period and art, 81, 276, 399–414
  architecture, 403–4
  early Italian, 400–404
  factors defining, 399–400
  High Renaissance in Italy, *401,* 404–6
  innovations of, 388–90
  Mannerism and, 407, *408*
  in Northern Europe, 407–11
  patrons/patronage of, 399, 402, 404, 407
  photography and, 206
  Reformation and, 411–14
  secular art, 412–13
  self-portraits in, 411
  timeline of, *401*
  in Venice, 407
  *see also* Sistine Chapel
Reni, Guido, 40
  *Jupiter and Europa,* 40, *40*
Renoir, Pierre-Auguste, 532

*Le Moulin de la Galette,* 532, *532*
replacement technique, in sculpture, 266
Reporters without Borders, Beijing Olympics
    protest sign, 232, *232*
representational art, 58, *58,* 561, 586
Republican period of ancient Rome, 358–59
*Resolved* (Edwards), 270, *271*
*Rest Energy* (Abramović and Ulay), 586–87, *587*
restoration in art conservation, 14
*Return from Cythera* (Watteau), 517, *518*
rhythm, design principle of, *104, 106,* 123–25
  defined, 103
Richardson, Henry Hobson, 323
  Stoughton House, 323, *324*
Richardson, Mary, 17–18
Richter, Gerhard, 288
  window from Cologne Cathedral, 288, *288*
Riefenstahl, Leni, 17, 364
  *Triumph of the Will,* 17, *17,* 25, 364, *364*
Rietveld, Gerrit, 63, 559, 576
  *Red Blue Chair,* 63, *63*
  Schröeder House, The Netherlands, 559, *559,*
    576
Riggio-Lynch Chapel (Lin), 307, *307*
Rikyū, Sen no, 480–81, 482, 509
  Taian Teahouse, replica, *480,* 480–81
Ringgold, Faith, 280
  *Tar Beach,* 280, *280*
Ritter, John, "is techno dead" (*Ray Gun*
    magazine), *242*
Rivera, Diego, 30, 163, 174, 510
  *Detroit Industry,* 163, *164,* 174, 510, *510*
*The Robert Gould Shaw Memorial* (Saint-
    Gaudens), 258–59, *259*
rock art, 433
Rococo, 516–18
Rodin, Auguste, 107–8, 268
  *The Burghers of Calais,* 107–8, *108*
  *The Thinker,* 268, *268*
Roebling, John A. and Washington A., Brooklyn
    Bridge, 326, *326*
*The Rokeby Venus* (Velázquez), 17–18, *18*
Romanesque period, 382–85, 387
  architectural sculpture in, 384–85
  timeline of, *376*
Romanticism, 524–27
  combined subject matters in, 527
  defined, 524
  Neoclassicism contrasted with, 525
Rome and arts of ancient Rome, 357–62, 363
  aqueduct design of, 125, *126*
  architectural orders of, 314–316
  Germanic people in, 380
  inclusion and multiculturalism in, 357–58
  the late Roman Empire, 370–75
  map of, *357, 381*
  Pantheon and, *299, 300,* 300–303, *301, 302,*
    308, 316, 321, 328
  timeline of, *376*
  *see also* Italy and arts of Italy
*Rosey* (Butterfield), 254, *254*
Rossiter, Alison, 214
  *Kilbourn Acme Kruxo, exact expiration date
    unknown, ca. 1940s, processed 2013,*
    214, *214*
Rothenberg, Susan, 172, *172*

*Red Banner,* 172, *172*
Rothko, Mark, 565
  *No. 9 (Dark over Light Earth/Violet and Yellow
    in Rose),* 565, *565*
round arch, 318, *318*
round dome, *320, 321*
royal crown, Korean tomb, 495, *496*
royal tunic, Inca, 471, *471*
Rubens, Peter Paul, 418
  *Marie de' Medici, Queen of France, landing in
    Marseilles, 3 November 1600,* 418, *419*
*Rue Transnonain (Transnonain Street)* (Daumier),
    *177,* 177–78, 201
running horned woman rock painting (Africa),
    433, *433*
Ruscha, Edward, 96
  *Standard Station,* 96, *97*
Russian Revolution, 547
*Rustam Sleeps While Rakhsh Fights Off a Lion*
    (Sultan Muhammad), *448,* 448–49
Ruysch, Rachel, 157
  *Still Life with Flowers,* 157, *157*
Ryōanji Temple, Japan, 507, *507*

**S**

Saar, Betye, 572
  *The Liberation of Aunt Jemima,* 572, *573*
Saarinen, Eero, 308
  Trans World Airline Terminal, 308, *309*
Sabon typeface, *239,* 240, *240,* 241
sacred spaces, universal theme of, 392
sacrifices, human, ritualized, 464, 466–67, 478,
    492–94
Safavid Empire, 447–49
  *The Ardabil Carpet* from, 294–95, *295,* 448, *448*
Saint-Gaudens, Augustus, 258
  *The Robert Gould Shaw Memorial,*
    258–59, *259*
Sainte-Chapelle, France, 21, *21,* 45
Salcedo, Doris, *261,* 261–62, 607
  *Shibboleth,* 261–62, *262,* 607, *607*
Salon, 513–15, 528, 540
  defined, 516
*Salon d'Automne,* 548, 553
*Salon des Refusés* (Salon of the Rejected), 513
*samurai,* 505, 506
sand paintings by Navajo medicine man, 48, *49,*
    59, 575, *575*
sans serif letters, 239
saturation, in color, 86, *86,* 398
Savage, Augusta, 562
  *The Harp,* 562, *563*
scale, design principle of, *104,* 118–20, *121*
  defined, 103
scarification body art, 41, *41*
Schapiro, Miriam, 56–57
  *Barcelona Fan,* 56–57, *57*
Scheeren, Ole, 326
  China Central Television Headquarters,
    326–27, *327,* 328
Scher, Paula, *240,* 240–41
  *Too Hot to Handle,* 240, 240–41
*School of Athens* (Raphael), 406, *406*
Schröeder, Truus, 559, 576
  Schröeder House, The Netherlands, 559,
    *559,* 576

Schröeder House, The Netherlands (Rietveld and Schröeder), 559, *559*, 576
Scott, Joyce J., 589, *589*
  *Man Eating Watermelon*, 589, *590*
*Scramble for Africa* (Shonibare), 579, *579*
scratchy lines, 70
*The Scream* (Munch), 537–38, *538, 542*
screenprinting, 197–98
screens of Japan, 507–8
scripted film, 221
Scruggs, Jan C., 3, 6
sculpture, 248–72
  *akua'mma, 248, 249,* 249–51, *250,* 253, 272
  Buddhist, 497
  defined, 251
  installations, 260–62
  materials of, 253–55
  Parthenon, 329, *330,* 331–34, *333, 334,* 362–63
  portable, 337
  of the Renaissance, 402–4
  site specific, 11, 253, 259–60
  Symbolism in, 538
  techniques of, 262–71
  types of, 255–62
Seagram Building (Mies van der Rohe and Johnson), 324, *324*
seals
  Chinese art of, 229–30, 231
  Mesopotamian use of, 235
Searle, Berni, 88, *88*
  "About to Forget," *88*
  *On Either Side,* 88, *88*
secondary colors, 83–84, *85*
secular art
  in Baroque style, 415, 421
  of Islamic leaders, 445–46, 448–49, 491
  in Japanese book, 504–5
  in the Reformation, 412–13
*Self-Portrait* (Close), 198, *199*
*Self-Portrait* (Dürer), 412, *412,* 425
*Self-Portrait* (van Gogh), 65, *66,* 68–69, *69,* 74, 100
*Self-Portrait* (van Hemessen), 411, *411*
*Self-Portrait* (Leyster), 44, *44*
*Self-Portrait* (Te Pehi Kupe), 49, *50,* 59
*Self-Portrait, Drawing* (Kollwitz), 135, *135, 542, 542*
*Self-Portrait with Two Pupils* (Labille-Guiard), 79, *79,* 365, *365*
self-portraits, 30, 411, 412
  *see also* individual self-portraits
Senefelder, Alois, 194
Senmut, funerary temple of Hatshepsut, 346, *347*
September 11 terrorist attacks, 57
serif, 239
serigraphy, 197–98
Serpentine Pavilion, virtual reality visualization of (Escobedo), 305, *305*
Serra, Richard, 11–12
  *Tilted Arc, 11,* 11–12
servitude, universal theme of, 364
setting of architecture, 305–6
Seurat, Georges, 92, 138, *138,* 534
  *At the Café Concert, 138, 138*
  *A Sunday on La Grande Jatte,* 92, *92,* 534, *534*

*The Seven Powers* (Campos-Pons), 213, *213*
*727* (Murakami), 597–98, *598*
*sfumato,* 405
shade, 86, *86*
shading technique, 72
shadow, 81
Shah Jahan, 103, 105, *106,* 106–7, 126, 491
*Shah Tahmasp* (Banu), 491–92, *492*
Shang dynasty, 492–93
shape, as a visual element of art, 74–77
  defined, 67, 74
*Sharecropper* (Catlett), 189, *189*
shell construction system, 310, 311–22
  arch, 317–18, 319, *320*
  cantilever, 315, *315*
  corbel, 312, *312, 313*
  description of, 311
  dome, 320–21
  load-bearing, 311
  post-and-lintel, *313,* 313–14, *314*
  vault, 318, 319, *320*
*The Shell* (O'Keeffe), 141, *141*
Shelton, Henry, 474–75
  wildcat kachina figure, *474,* 474–75
Shen Zhou, 501, *501*
  *Poet on a Mountaintop,* 501, *502*
Sherman, Cindy, 49
  *Untitled Film Still #65,* 49, *49*
*Shibboleth* (Salcedo), 261–62, *262,* 607, *607*
Shihuangdi (emperor), 493
Shimomura, Roger, 171, 606–7
  *American Infamy, 171, 171, 606,* 606–7
Shinto shrine, Japan, 503, *503*
Shintoism and the art of Shintoism, 503, 509
*Shiva, Lord of the Dance,* 21, *22*
Shonibare MBE, Yinka, 578–81, 582, 605, 606
  *Alien Woman on Flying Machine,* 580–81, *581,* 582, 591, 606
  *Scramble for Africa,* 579, *579*
  *The Swing (After Fragonard), 577,* 579, *580,* 582
  *Victorian Philanthropist's Parlor, 578,* 578–79
shot, in film, 215
Shotz, Alyson, 82
  *Geometry of Light,* 82, *82*
shrine
  Asante, 249, *249*
  Benin, 438, *439*
Siddhartha Gautama, 485–86
  *see also* Buddhism and Buddhist art
Sikander, Shahzia, 602–3, 606
  *Pleasure Pillars, 602,* 602–3, 606
silkscreen, 197–98
*silueta,* 545–46
Simpson, Lorna, 109, *109*
  *Wigs,* 109, *110*
simulated texture, 79–80
simultaneous contrast, 88, 534, 549
Sinan, 447
  Mosque of Sultan Selim II, *447, 447*
sinking, in metal craft, 289–90
Sioux, 143, 473
*Sir John Frederick William Herschel* (Cameron), 212, *213*
Sirani, Elisabetta, *415,* 415–16
  *Portia Wounding Her Thigh,* 415–16, *416*

Sistine Chapel
  ceiling, 142, *394, 395,* 395–98, *396–398,* 424–25
  *The Last Judgment, 397,* 397–98, 425, 426, 542, *542*
site specific art, 11, 253, 259–60
Six Flags Magic Mountain Virtual Reality Coaster, 246, *246*
size, 113, 116
size, coating for painting, 156
skeleton-and-skin construction system, 310, 311, 323–26
  frame construction, 323–25
skill, 45–47
  distinctions of, 276–78
Skoglund, Sandy, 210–11
  *Radioactive Cats,* 210–11, *211*
*Sky and Water I* (Escher), *76,* 76–77
*Sky Cathedral* (Nevelson), 565, *566*
*Sky Ladder* (Cai), 38–39, *39,* 426
skyscraper, 303–4
slab building, in clay works, 282, 284, *284*
*Slave Ship (Slavers Throwing Overboard the Dead and Dying, Typhoon Coming On)* (Turner), 527, *527*
slavery in U.S. history, 70, 144–45, 593, 600–601
  Emancipation Proclamation, 243
  photographs of, 27–28
  slave ships, *50,* 50–51
*The Sleep of Reason Produces Monsters* (Goya), 182, *182,* 194
slip, in clay works, 275, 286
*Slumdog Millionaire* (Boyle and Tandan), 219, *219*
Smith, Jaune Quick-to-See, 599
  *Sources of Strength,* 599, *599*
Smith, Kiki, 593
  *Red Spill,* 593, *593*
Smithson, Robert, 260
  *Spiral Jetty,* 260, *260*
*So this is all we got ourselves killed for!* (Daumier), 178, *178*
social action, 31–33, 601
  in global contemporary art, 603–4
  Protest art, 573, 591–94
social media, design of, 7
social order, as purpose of art, 22–25
Social Realism, 561
social ties, universal theme of, 607
societal benefits of art, 15–16
Society of Independent Artists, 47
Soldiers' and Sailors' Monument (Milmore), 591–92, *592*
solvent, for paint, 155
"The Sorcerer's Apprentice" (Disney), 222, *222*
Sōtan, Sen no, 482–83
  *Ordinary Transformation* flower container, 482–83, *483*
sound, in film, 16–17, 218
*Sources of Strength* (J. Smith), 599, *599*
South Africa, 141–42, 280–81
South America and arts of South America, 468–71
  Chavín, 469
  Inca, 255, 311–12, 470–71
  map of, *463*

Nazca, 470
*see also* specific locations and cultures
Southeast Asia and arts of Southeast Asia, *484,* 489
*see also* specific locations and cultures
Southern Song dynasty, 29, 94, 500
Southwest North America, 474–75
space, 67
architecture and, 304
in Cézanne's work, 535–36
defined, 92
negative, 78, *538*
three-dimensional, 37, 91–93, 252
two-dimensional, 37, 92, 93–98
as a visual element of art, 92–98
Spain, 445–46, 511
architecture in, 304, 305, 318, 392
Baroque art in, 418–20
Spanish Civil War, 29–30, 130
*Spear Bearer* (Polykleitos), 354, *354*
Sperber, Devorah, 278
*After the Mona Lisa 8,* 278, *278*
Spero, Nancy, 42, *42*
*Maypole-War,* 42, *43*
Spielberg, Steven, 16, 218
*Bridge of Spies,* 218, *218,* 223
*Jaws,* 16, 16–17
*Spiral Jetty* (Smithson), 260, *260*
spirit spouse of the Baule, 434–35, *435*
spirituality and religion
as purpose of art, 21–22
themes of, 292–93
*see also* specific religions
spoon of the Nguni, 440, *440,* 451
*Spot's Suitcase* (M. Levine), 80, *80*
staff, top, African, 121, *121*
stained glass, 277, 288
stamp-cylinder seal of Mesopotamia, 235, *235*
stamp for the centenary of the Emancipation
  Proclamation (Olden), 243, *243*
*Standard of Ur,* Sumerian, 340–41, *341*
*Standard Station* (Ruscha), 96, *97*
Standing Buddha (Yasadinna), 487–88, *488,*
  498, *498*
Stanford, Leland, 214
*The Starry Night* (Lipski), 588, *588*
*The Starry Night* (van Gogh), *536,* 536–37, 542,
  588, *588*
state, in printmaking, 182, 183, *183*
steel-frame construction, *323,* 323–24, *324*
*The Steerage* (Stieglitz), 209, *210*
stele, 342, 469
stencil printmaking, 184, *184,* 197–98
stereotypes, 205, 572, 589, 598–600
Stieglitz, Alfred, 209, 561
*The Steerage,* 209, *210*
still cameras, 208
still life, 157, 423, 514
*Still Life with Flowers* (Ruysch), 157, *157*
*Still Life with Fruit and Flowers* (Peeters),
  423, *423*
stippling, 179
*The Stone Breakers* (Courbet), *528,* 528–29
Stonehenge, 8, *9*
stoneware, 282
stop-action images, 142, 214–15

*The Story of King Midas* (Nicola), 399, *400*
Stoughton House (Richardson), 323, *324*
*Stowage* (Cole), *50,* 50–51
*Street, Berlin* (Kirchner), *550,* 550–51
*Studies for the Libyan Sibyl* (Michelangelo), 142,
  *142*
*Studies of Lions* (Delacroix), 72, *72*
*Stump in Red Hills* (O'Keeffe), 89, *90*
stupa, 486–87, 489
style, 62–64
*see also* specific styles of art
stylizing, 59
stylus, 145
subject matter, 59, 60, 64
subordination, design principle of, 114–18
  defined, 103, 117
substitution technique, in sculpture, 266
subtractive color system, 83, 84, *84,* 85
subtractive process, in sculpture, 262–64
suffering, universal theme of, 575
suit of armor, Kamakura period, 506, *507*
Sulkowicz, Emma, 23–24
*Mattress Performance (Carry That Weight),* 23,
  23–24
Sullivan, Louis, 303
  Wainwright Building, St. Louis, 303, *304*
Sultan Hasan Madrasa-Mausoleum-Mosque
  Complex, Egypt, 445, *445*
Sumer, 340–41
*Sun Mad* (Hernandez), 198, *199,* 201
*Sun Tunnels* (Holt), *259,* 259–60
*A Sunday on La Grande Jatte* (Seurat), 92, *92,*
  534, *534*
support of arts, 10–13
  governmental, 10–12
  individual, 12–13
  international, 12
support (surface), 138, 156
surface design, in fiber craft, 292, 297
surface for drawing, 138, 139
Surrealism, 557–58
survival, universal theme of, 576
*Susanna and the Elders* (Gentileschi), *17*
suspension construction, 311, *325,* 325–26
Sussman, Eve, 596
  *89 Seconds at Alcázar,* 596, *596*
sustainable architecture, 306–7
*Swing Landscape* (Davis), 109, *109*
*The Swing (After Fragonard)* (Shonibare), *577,*
  579, *580,* 582
*The Swing* (Fragonard), 71, *71,* 90, *91,* 99, 579,
  *580,* 582
Sydney Opera House (Utzon), 322, *322*
Sylvester, John, 49
  *Portrait of Maori Chief Te Pehi Kupe Wearing
  European Clothes,* 49, *50*
symbol, 238–39
symbolism, denoting meaning with, 414, 415,
  423, 438
  in Islam, 442
Symbolism, nineteenth-century art movement,
  537–38
symmetrical balance, 111–12, 380
synagogue reconstruction in Syria, *371,* 371–72
Synthetic Cubism, 554–56, 573
Syria

synagogue reconstruction in, *371,* 371–72
war and ancient ruins of, 13, 14
*Syrian Refugees Riding a Bus* (Addario), 212–13,
  *213*

**T**

Taian Teahouse, replica (Rikyū), *480,* 480–81
Taj Mahal, *102,* 103–7, *104–106,* 126, 491
  absolute symmetry of, 111
  arches of, 107, 123
Takaezu, Toshiko, 285
  *Untitled Form,* 285, *286*
Talbot, William Henry Fox, 206, 207–8
  *Leaves of Orchidea,* 207, *208*
*The Tale of Genji* (Murasaki), 504–5, *505,*
  506, *506*
Taliban, destruction of art by, 17, 18
Tamir, Michal, 234
  *Iranians We Will Never Bomb Your Country, We
  ♥ You,* 234, *234*
Tandan, Loveleen, 219
  *Slumdog Millionaire,* 219, *219*
Tang dynasty, 181
Tanner, Henry Ossawa, 168, 529
  *Annunciation,* 168, *168*
  *The Banjo Lesson,* 529, *529*
tapestry, 150, 292–93, 382
*tapu* (taboo), 454
*Tar Beach* (Ringgold), 280, *280*
*tatanua* mask, 459, *459*
Tate Modern Museum, London, 261–62
tattoos of Maori, 49, 50
Te Pehi Kupe, 49
  *Self-portrait,* 49, *50,* 59
tea ceremony and pottery of Japan, *479,* 480,
  480–82, *481, 482,* 509, 510
tea set (Walch), 284, *284*
teapot (Brandt), 559, *560*
technologies
  Postmodern, 590
  virtual reality, 246, 590
tempera, 159, 164–65
Temple 1, Mayan, 466, *466*
*Temple among Snowy Hills* (Southern Song
  dynasty), 94, *94*
Temple of Amun, Egypt, 309–10, *310*
Temple of Athena Nike (Kallikrates), 316
Temple of Baal-Shamin, Syria, 14
*Temple of Juno in Agrigento, after Caspar David
  Friedrich* (Muniz), 598, *599*
Temple of the Feathered Serpent, 465, *465*
temporary art, 260, 546–47, 566–67
*The Ten Biggest No. 7, Adulthood* (af Klint), 75, *76*
tenebrism, 415
Tenniel, John, 72
  *Alice, the Duchess, and the Baby,* 72, *73*
tensile strength, 263
tension, in architecture, 309, 310
Teotihuacán, 162, 464–65
tertiary colors, 85
*The Tetons and the Snake River, Grand Teton
  National Park, Wyoming* (Adams), 212, *212*
texture, 286
  in asymmetrical design, 113
  defined, 78
  as a visual element of art, 67, 78–80

themes, universal, 56–57
  of ambition, 365
  of art, 541
  of the artist, 542
  of birth, 451
  of death, 426
  of discrimination, 606–7
  of the divine, 392
  of the environment, 478
  of growing up, 452
  of health, 575
  of identity, 606
  of the inner mind, 542
  of the land, 477
  of love, 451
  of play, 510
  of power, 364
  of prayers, 393
  of relaxation, 511
  of remembrance, 427
  of sacred spaces, 392
  of servitude, 364
  of social ties, 607
  of suffering, 575
  of survival, 576
  of war, 426
  of wildlife, 477
  of work, 510
Theodora (empress), 376–77
therapy with art, *15,* 15–16
*The Thinker* (Rodin), 268, *268*
thinner, for paint, 155
*The Third of May, 1808* (Goya), 524–25, *525*
"Thirty-Six Views of Mount Fuji" (Hokusai), *187*
Thomson, Tom, 158
  *The Jack Pine,* 158, *158*
Thonet, Michael, 291
  *Chair No. 14,* 291, *291*
three-dimensional, 92–93
  actual weight and, 110
  architecture, as a definition of, 304–5
  defined, 37
  mass in, 77
  representations on a two-dimensional
    surface, 93–98
  sculpture, as a definition of, 251–53
  space, illusion of, 91–92
  texture in, 79–80
*Three Graces Tower* (Chihuly), 287, *288*
*Three Servicemen* (Hart), 4, *4*
*Three Standing Figures* (Moore), 43, *43*
*Three Transitions* (Campus), 224, *224*
*Three Women* (Léger), 75, *76*
3D digital architectural technology, 304–5, *305*
3D film, 222–23
3D printer, 271
Threlkel, Travis, 32
  *Projecting Change: Empire State Building,* 32,
    *32,* 42
*Throne of the Third Heaven of the Nation's
  Millennium General Assembly* (Hampton),
  44, *44*
Tiffany Studios, dragonfly lamp, *88*
tilt, in film, 216
*Tilted Arc* (Serra), *11,* 11–12
time, as a visual element of art, 67, 98–99, 536

time-lapse video, 225
timeline
  of Asia, *484*
  of Eighteenth- and Nineteenth-Century Art in
    the West, *517*
  of Late Roman, Byzantine, and Medieval Art,
    *376*
  of Modern Art in the Twentieth-Century
    Western World, *548*
  of Renaissance and Baroque art, *401*
tint, 86, *86*
Tintoretto, 116–17
  *The Last Supper,* 116–17, *117*
tipi, 473–74
tipi cover of the Lakota, 474, *474*
Titian, 407, *407,* 451, 515
  *The Pastoral Concert,* 515, *515*
  *Venus of Urbino,* 407, *407,* 451, *451,* 553
Tlingit people, 111, *112*
Tōhaku, Hasegawa, 508
  *Maple Tree,* 508, *508*
Tomb of the First Emperor of Qin, China,
  493–94, *494*
tombs
  architecture of, 345–46
  of China, 492–94
  *see also* Taj Mahal
*Too Hot to Handle* (Scher and Grossman), *240,*
  240–41
tooth of a surface, 138
*Torn Leaf Line Held to Fallen Elm with Water*
  (Goldsworthy), *32, 32*
Toulouse-Lautrec, Henri de, 242, *242*
  *Moulin Rouge: La Goulue,* 242, *243*
tower, Jericho, Israel, 338, *338*
*Toxic Reef* (Wertheim and Institute for Figuring),
  603–4, *604*
tracking, in film, 216, 217
trademark, 242, 243
traditional crafts, 273–98
  clay, 278, 282–86
  definitions of, 276–81
  fiber, 291–97, 439, 470–71
  glass, 277, 286–88
  metal, 289–90
  Postmodern, 589–90
  Western and discriminatory distinctions
    of, 277–78
  wood, 291
Trans World Airline Terminal, New York
  (Saarinen), 308, *309*
transept, 374
transparent watercolor, 159, 166, 168–69
Traoré, Ismaila, 429
  Great Mosque in Djenné, Mali, 429–32, *430,*
    *431,* 449, 451
*Travelers among Mountains and Streams* (Fan
  Kuan), *499,* 499–500, 506, *506*
*Tree of Life* (Mendieta), *543,* 544–45, *545*
*Tree (Study for The Gray Tree)* (Mondrian),
  58, *58*
triadic color scheme, *87,* 88, *89*
*Tribute in Light* (Bennett, Bonevardi, Gould,
  Laverdiere, Myoda, and Marantz), 57, *57*
*The Tribute Money* (Masaccio), 98, *98*
triptych, 409

*Triumph of the Will* (Riefenstahl), 17, *17,* 25, 364,
  *364*
*trompe l'oeil,* 58, *423*
"Truisms" (Holzer), 594, *594*
truss, 323
Tubman, Harriet, 70
Tulane University's URBANbuild, *16*
*Tumultuous Landscape* (Dubuffet), 145–46, *146*
Tunisia, 443–44
  Roman architecture in, 358
*Turbulent* (Neshat), 226, *226*
Turner, Joseph Mallord William, 527
  *Slave Ship (Slavers Throwing Overboard the
    Dead and Dying, Typhoon Coming On),* 527,
    *527*
Turner, Nat, 205
Tutankhamun, 349
  innermost coffin of, 349, *349*
twentieth-century art in the West after World
  War II
  in Europe, 570–71
  Expressionism, 547–51
  in U.S., 561–62, 562–73
twentieth-century art in the West through World
  War II, 547–62
  in Europe, 547–60
*2097: We Made Ourselves Over* (Blast Theory
  Collective), 604, *604*
two-dimensional
  *chiaroscuro* in, 81
  defined, 37
  drawing, as a definition of, 133
  lines in, 72
  painting, as a definition of, 155
  printmaking, as a definition of, 179
  shape in, 74, 75–76
  space in, 92, 93–98
  texture in, 79
*The Two Fridas* (Kahlo), 30, *30,* 603
two-point perspective, 96, *97*
type, in graphic design, *239,* 239–40, 242–46
typeface, *239,* 240, 241
typography, 240

**U**

*Uchikake* with bamboo design (Nankai), 508,
  *508*
*ukiyo-e* print, 180, 508, 532
Ulay (Uwe Laysiepen), 586–87
  *Rest Energy,* 586–87, *587*
Umayyad dynasty, 442–43
*Un Chien Andalou (An Andalusian Dog)* (Buñuel
  and Dalí), 221, *221,* 541, *541*
UNESCO (United Nations Educational,
  Scientific, and Cultural Organization), 12,
  19, 126, 431
*Unfinished Slave* (Michelangelo), 263, *263,* 264,
  365, *365*
*The Unicorn in Captivity,* 293, *293*
*Unique Forms of Continuity in Space* (Boccioni),
  555, *555*
United Nations Educational, Scientific and
  Cultural Organization (UNESCO), 12, 19,
  126, 431
United Nations Security Council, 150
United Nations' virtual reality films, 590, *590,* 607

*United States: Most Wanted Painting* (Komar and Melamid), 41, *42*
United States modern art, 561–73
  African American protest art, 573
  Conceptual art, 569
  earthworks, 571
  feminist art, 572–73, *574*
  Harlem Renaissance, 561–62
  Minimalism, 568–69
  New York School, 563–65
  Performance art, 569–71
  reality and art, 565–68
  Regionalism, 561
  Social Realism, 561
unity, design principle of, 103–9, *110*
  defined, 103, 107
*"Untitled" (Death by Gun)* (Gonzalez-Torres), 46, 46–47
  meaning of, interpreting, 47
*Untitled* (Donovan), 199, *200*
*Untitled Film Still #65* (Sherman), 49, *49*
*Untitled Form* (Takaezu), 285, *286*
*Untitled* (Guyton), 172–73, *173*
*Untitled* (Hesse), 148, *148*
*Untitled* (Judd), 52, *52, 569, 569*
*Untitled* (Mendieta), 546, *546,* 575
*Untitled (Ocean)* (Celmins), *140,* 140–41
*Untitled Sculpture (Construction Worker)* (Hanson), 269, *269,* 364, *364*
*Untitled (Your gaze hits the side of my face)* (Kruger), 56, *56*
urn with cover modeled after the *Borghese Vase* (de Vaere), 522, *522*
U.S. Pavilion, 1967 Montreal Expo (Fuller), 325, *325*
Utamaro, Kitagawa, 180
  *Woman at the Height of Her Beauty,* 180, *180*
Utterback, Camille, 173
  *Entangled,* 173, *173*
Utzon, Jørn, 322
  Sydney Opera House, 322, *322*

**V**

*Valencia* (Cartier-Bresson), 116, *116*
value
  in asymmetrical design, 113
  of color, 85–86
  defined, 80
  emphasis, achieving, 116
  as a visual element of art, *80,* 80–82
van Eyck, Jan. *see* Eyck, Jan van
van Gogh, Johanna. *see* Gogh, Johanna van
van Gogh, Vincent. *see* Gogh, Vincent van
van Hemessen, Caterina. *see* Hemessen, Caterina van
vanishing point, *95,* 96
*vanitas,* 423
vantage point, 96, 152, 535–36, 553
Varengeville Room in Hôtel de Varengeville, Paris, France (Pineau), *28,* 28–29
variety, design principle of, 106, 107–9
  defined, 103, 107
vase with nine peaches (Qing dynasty), 279, *279*
Vatican. *see* Sistine Chapel
vault, in construction, 311, 318, 319, *320*
vehicle, in paint, 155

Velázquez, Diego, 418–20, 596
  *Las Meninas (The Maids of Honor),* 418–20, *419,* 596, *596*
  *The Rokeby Venus,* 17–18, *18*
Venice, Renaissance in, *401,* 407
*Venus of Urbino* (Titian), 407, *407,* 451, *451,* 553
Veranda post of enthroned king and senior wife (Olowe), 437–38, *438*
Vermeer, Jan, 423–24, 451
  *Girl with a Pearl Earring,* 14
  *Woman Holding a Balance,* 423–24, *424,* 451, *451*
vertical lines, 70, 113
vertical positioning, 93, 94, 557
Vespasian (emperor), 359–60
*Victorian Philanthropist's Parlor* (Shonibare), *578,* 578–79
video, 224–26
  manipulation possible with, 224
  types of, 225–26
  video games, 245, *245*
*Video Flag Z* (Paik), 225, *225*
Vietnam Veterans Memorial (The Wall) (Lin), 1, 2, *2,* 3–6, *5, 6,* 29, 33, 427, *427*
  Competition Drawing, *4*
  design of, 3–4
Vigée-Lebrun, Elisabeth, 518, *518*
  *Marie Antoinette with a Rose,* 517–18, *518*
Villa Savoye, France (Le Corbusier), 560, *560*
Viola, Bill, 225
  *Mary,* 225, *225*
Virgin and Child between Saints Theodore and George, 378, *378*
*The Virgin and Child with Saint Anne* (Leonardo), *404,* 404–5
*The Virgin of Chancellor Rolin* (van Eyck), 410, *410*
"Virgin of Humility," 54
*Virgin of Vladimir,* 54, *54,* 59
virtual reality, 246, 305, 590
visible spectrum of light, 83
visual elements of art, 66–101
  color, 82–92
  light, 67, 80–82, 84
  line, 67, 70–74, *104*
  mass, 77–78, 252–53, 304
  shape, 67, 74–77
  space, 92–98
  texture, 67, 78–80
  time, 67, 98–99, 536
visual weight, 110, *111,* 113, 115
Vitruvius, 121
*Voice of Fire* (Newman), 34, 35, *35, 37,* 42, 64
  criticism of, 35, 42, 45, 55
  meaning of, 36, 47
  subject matter, form, and content of, 59–60
*Vote/Emote* (Piper), 261, *261*
Voulkos, Peter, 278, *278,* 281
  *Bucci,* 278, *279,* 281
voussoir, 318, *319*

**W**

*Wagilag Story* (Kitani), 457, *458,* 477
Wainwright Building, St. Louis (Sullivan and Adler), 303, *304*
*Waiting* (Bishop), 146, *146*

*Wakkanai, Japan* (Fukase), 211, *211*
Walch, Barbara, 284
  tea set, 284, *284*
Walker, Kara, 600–601
  *Insurrection! (Our Tools Were Rudimentary, Yet We Pressed On),* 600–601, *601*
Wall, Jeff, 26
  *The Flooded Grave,* 26, *27*
"The Wall" (Lin). *see* Vietnam Veterans Memorial (The Wall) (Lin)
wall paintings
  bodhisattva, 488–89, *489*
  Paleolithic period, 335–37
  prehistoric cultures, 197
  from the tablinum of ancient Rome, 361–62, *362*
*The Waltz* (Claudel), 538, *538*
Wang Jie, 231
Wang Xizhi, 496, *496*
  *Yuanhuantie* running script, 496, *497*
war, universal theme of, 426
War God, Hawaiian, 455–56, *456*
Wardley, Jamie, 9
  *The Fallen,* 9
Warhol, Andy, *567,* 567–68
  *Orange Car Crash Fourteen Times,* 567, *567*
warm color scheme, 87, 89, *90*
warp, in weaving, 292, *292*
warrior columns at Pyramid of the Morning Star, Mexico, 43, *43*
wash, in drawing, 145, 146–48
  defined, 147
water jar with grasses design, Japan, 481, *482*
watercolor, transparent, 159, 166, 168–69
Watteau, Jean-Antoine, 517
  *Return from Cythera,* 517, *518*
weaving, *292,* 292–93
  digital, 293, *294*
Wedgwood, Josiah, 522
Weems, Carrie Mae, 27
  "From Here I Saw What Happened and I Cried," 27
  *You Became a Scientific Profile,* 27, *27*–28
weft, 292, *292*
weight
  actual, 110, *111*
  visual, 110, *111,* 113, 115
Welles, Orson, 216, *216*
  *Citizen Kane,* 216, *217*
Wen Shu, 502
  *Carnations and Garden Rock,* 502, *502*
Wertheim, Margaret and Christine, 603
  *Crochet Coral Reef* project, 603–4, *604*
  *Toxic Reef,* 603–4, *604*
Whare Runanga meeting house (Maori), 461, *461, 462, 462*
*WHAT HAPPENED TO US?* (Perjovschi), 135–36, *136*
wheel throwing, 282, 284–85, *285*
"Where We Come From" (Jacir), 23, *23*
*White Angel Breadline, San Francisco* (Lange), 561, *562,* 575
*White-Haired Girl* (Dickson), 195, *195*
Whiteread, Rachel, 20
  Nameless Library Holocaust Monument, Austria, 20, *20*

impson), 109, *110*
wildcat kachina figure (Shelton), *474,* 474–75
wildlife, universal theme of, 477
Williams, John, 16–17
Wilson, Fred, 593–94
    Metalwork 1793-1880, *593,* 593–94
Wilson, Wes, 123–25
    Fillmore Auditorium concert poster, 123–25, *125*
window from Cologne Cathedral (Richter),
    288, *288*
*Windows* (Hill), 224, *224*
*Within Our Gates* (Micheaux), 205, *205*
Wodiczko, Krzysztof, 591–92
    *The Homeless Projection 2,* 591–92, *592*
wolf transformation mask of North America,
    475, *475*
*Woman and Bicycle* (W. de Kooning), 563, *564*
*Woman at the Height of Her Beauty* (Utamaro),
    180, *180*
*Woman from Willendorf,* prehistoric, *118,* 118–19,
    *119,* 337, *337*
*Woman Holding a Balance* (Vermeer), 423–24,
    *424,* 451, *451*
women artists, 79, 411, 546
  in China, 502
    exclusion from canon of, 44–45, 56–57, 278
    Feminist art and, 572–73, 574

*see also* specific women artists
wondrous spaces in religious art, 21
Wood, Grant, 561
    *American Gothic,* 561, *561*
*Wood, Wind, No Tuba* (Mitchell), 157, *158*
wood crafts, 291
wood engraving, 184, 186–88, *188,* 190
wood-frame construction, 323, *323*
woodcut, 184, *185,* 185–86
  color, 187
work, universal theme of, 510
World Heritage List, 12, 126, 431
*World Map* (Ai), 603, *603*
World Monuments Fund (WMF), 12–13
World War I, 547, 556–60
World War II, 153–54, 171, 252, 547,
    562
Wright, Frank Lloyd, 315, *315*
    Fallingwater (Edgar Kaufmann Residence),
    315, *315*

## X

Xu Bing, 238, *238*
    *Book from the Ground: From Point to Point,*
    238, *238*
Xu Zhen, 110
    *In Just a Blink of an Eye,* 110, *110*

## Y

*yakshi,* 487, *487*
Yantrasast, Kulapat, 306–7
    Pomona College Studio Art Hall, California,
    306–7, *307*
Yasadinna, 487
    Standing Buddha, 487–88, *488,* 498, *498*
Yellow Nose, 143
    *The Battle of Little Big Horn,* 143, *144*
Yoruba people, 436–38
*You Became a Scientific Profile* (Weems), *27,*
    27–28
*You Can Buy Bootleg Whiskey for Twenty-Five
    Cents a Quart* (Lawrence), 169, *170*
*A Young Woman Sleeping* (Rembrandt), *147,*
    147–48
*Yu the Great Taming the Waters,* Qing dynasty,
    502, *503,* 510
*Yuanhuantie* running script (Wang X.), 496, *497*
Yujian, 500
    *Mount Lu,* 500, *500*

## Z

Zen Buddhism (Chan Buddhism), 480, 500, 509
  dry garden of, 506–7, *507,* 511
ziggurat, Sumerian, 340, *340*
zoom, in film, 216